THE NATIONAL GALLERY

COMPLETE
ILLUSTRATED
CATALOGUE

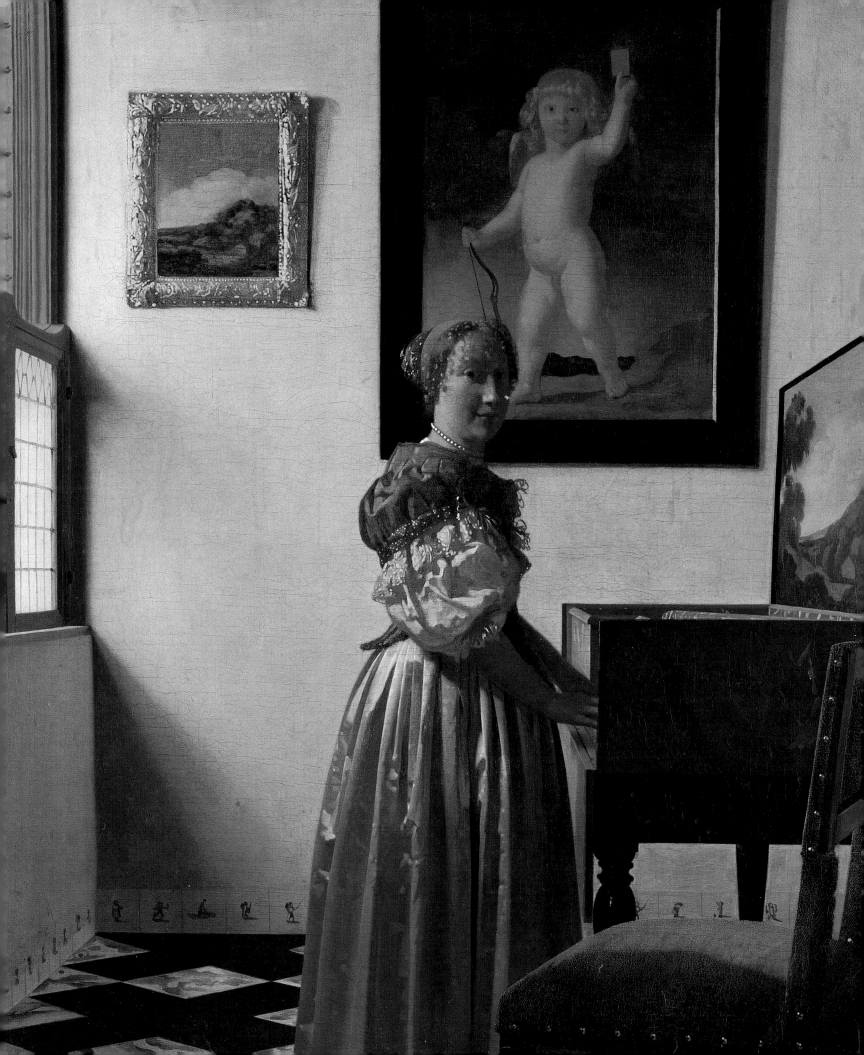

THE NATIONAL GALLERY

COMPLETE

ILLUSTRATED

CATALOGUE

Compiled by Christopher Baker and Tom Henry

National Gallery Publications, London

DISTRIBUTED BY YALE UNIVERSITY PRESS

First published in Great Britain in 1995 by National Gallery Publications Limited
5/6 Pall Mall East, London SW1Y 5BA

NGPL ISBN 1 85709 050 0

NGPL ISBN book + CD/ROM 1 85709 089 6

Yale ISBN 0 300 06359 8

Yale ISBN book + CD/ROM 0 300 06362 8

British Library Cataloguing-in-Publication Data
A catalogue record is available from the British Library

Library of Congress Catalog Card Number : 94-74919

Produced by Hugh Tempest-Radford *Book Producers*

Design consultant: Gillian Greenwood

Jacket design: Tim Jaques

Electronic production services and layout: Cognitive Applications Limited, Brighton

Index: Indexing Specialists, Hove

Colour origination: Wace Publication Imaging, London

Printed in Hong Kong by Midas Printing Limited

PLATES

Page ii Vermeer *A Young Woman standing at a Virginal*
Page vi Monet *Bathers at La Grenouillère*, detail
Page viii Canaletto *Campo S. Vidal and Santa Maria della Carità*
 (*'The Stonemason's Yard'*), detail
Page xi Raphael *Saint Catherine of Alexandria*
Page xiii Van Gogh *Sunflowers*

Photo credits

Page xii Courtesy of the Board of Trustees of the V&A
Page xv BELOW By permission of the British Library, London
Page xvi LEFT The Builder, July 1876; The Illustrated London News Picture Library
Pages xviii and xiv PHOTOS: Phil Starling
Page 441 Matisse *Portrait of Greta Moll* ©Succession H. Matisse/DACS 1995
Page 529 Picasso *Child with a Dove* and *Fruit Dish, Bottle and Violin* ©DACS

Contents

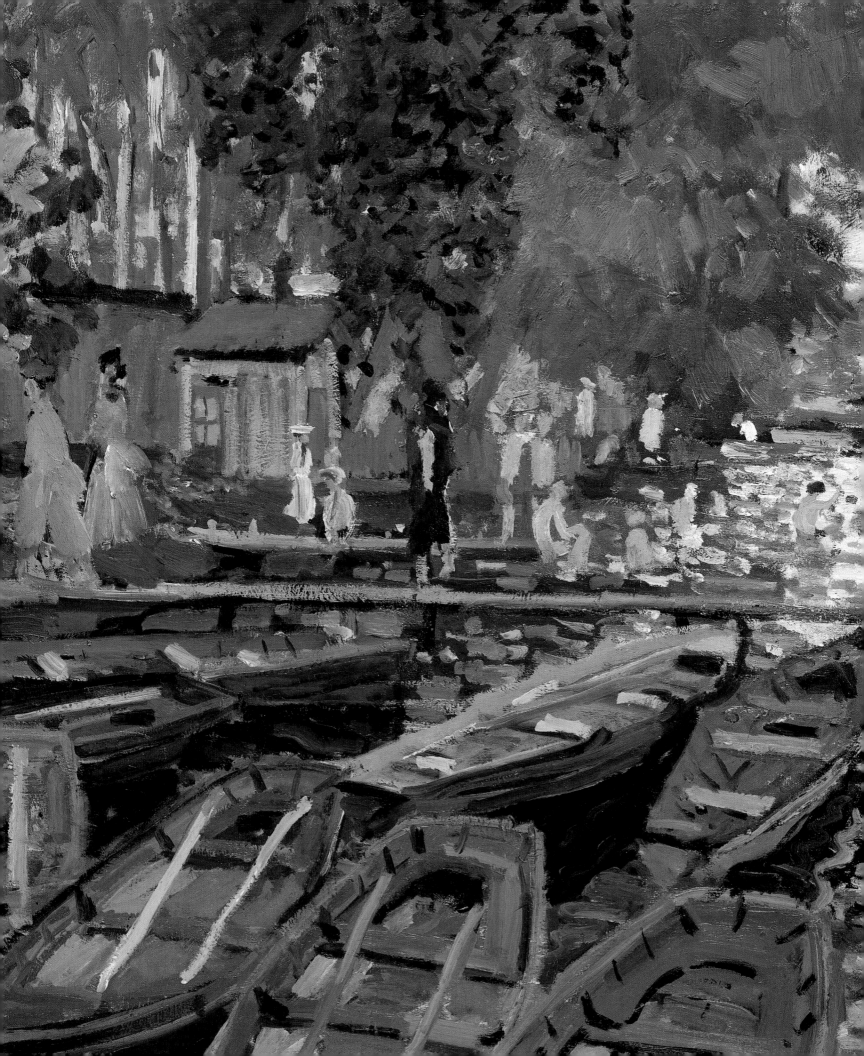

Sponsor's preface

Morgan Grenfell is delighted to sponsor this comprehensive record of the collection of the National Gallery, London, one of the world's greatest holdings of Western European art.

Through our sponsorship we have sought to enable the National Gallery to take advantage of the major advances in new technology: in the design and presentation of text, in colour reproduction, and in the dissemination of information. Specialists in art history as well as the wider general audience of art lovers will have access to the invaluable information contained in this catalogue both on the printed page and in electronic form.

Morgan Grenfell, a leading investment banking and asset management group, has a history nearly as long as this collection, which was first formed over a century and a half ago. Sharing a common tradition and common objectives of quality, excellence and innovation, it is appropriate that we should collaborate with the National Gallery to present this outstanding legacy of some of the world's finest masterpieces.

Michael Dobson
GROUP CHIEF EXECUTIVE

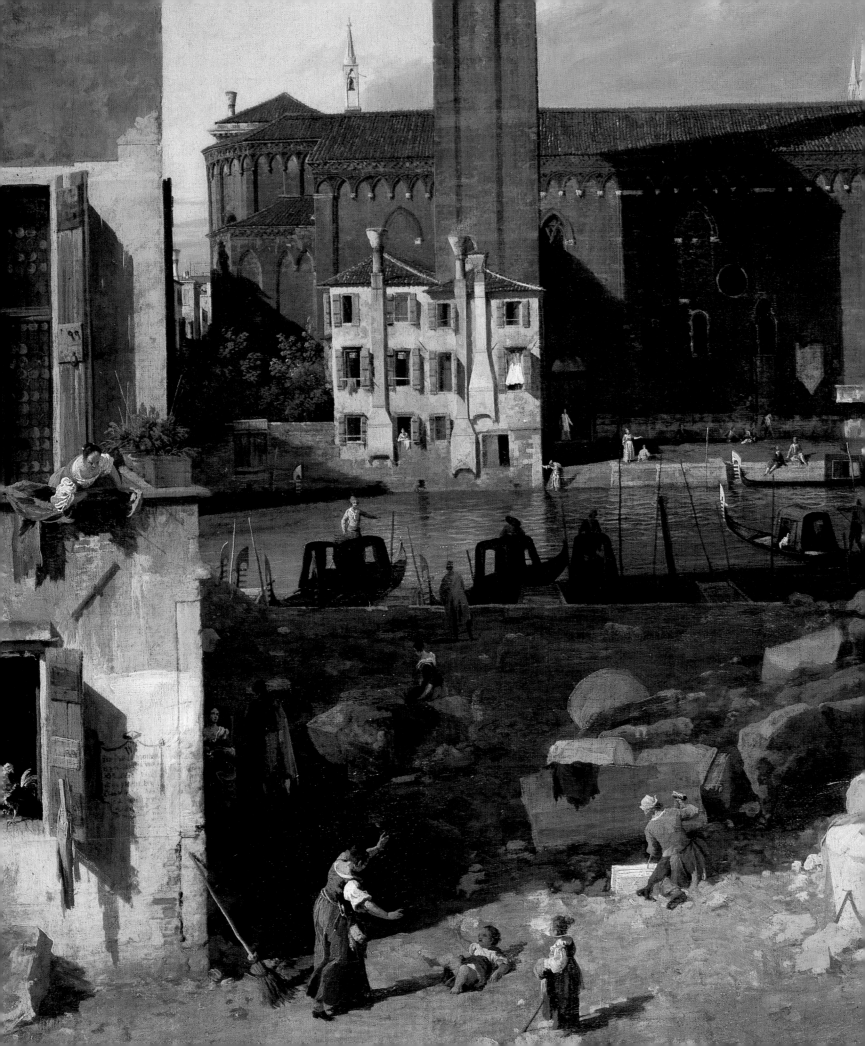

Director's introduction

Perhaps the proudest boast of the National Gallery – and, as it happens, a true one – is that among the great picture collections of the world it is uniquely accessible to the people that own it: under normal circumstances, every one of its two thousand or so paintings is on public view, and can be seen without charge. But if it is easily visible, it is less easily graspable. The pictures range in date from the end of the thirteenth century to the beginning of the twentieth, in place of origin across the whole of Western Europe, and in scale from over life-size altarpieces to landscape sketches no bigger than a postcard. Making such a collection your own is inevitably a slow business. Not everybody, however, can come to see it often, or spend a long time in the Gallery when they do. There are of course a number of publications already available on the pictures, and these are a help, but they deal for the most part only with aspects of the Gallery, not the whole. One of the principal aims of this Catalogue, therefore, is to allow readers to take hold of the collection as a totality, to gain an overview of its defining characteristics, its strengths and its weaknesses, to familiarise themselves with it, and to decide what particular pictures they want to come and look at.

But it is much more than that. Looking at pictures not only gives pleasure. It also, and very quickly, raises questions which even the most ambitious label cannot answer. What else did this artist paint? How many of those paintings are in the Gallery? How did the picture come to be here? Where can I find out more about the work, and the circumstances of its making?

These are the questions this Catalogue tackles. We have tried to give, for every picture, the fundamental information about its physical state – materials, dimensions and so forth – a biography of the artist, a commentary on the subject of the picture, a brief list of publications where more information can be found, and the salient facts of the picture's history. Where a picture was once part of a larger whole, this is explained. Every picture is reproduced, the majority in colour. And since this Catalogue is also being published as a compact disc, all the information it contains on any particular aspect may be easily hunted down.

Because of the idiosyncratic history of the National Gallery, briefly told in the next few pages, its collection is perhaps the most evenly balanced, across all European schools, of any in existence. As a result, this Catalogue gives an extraordinarily rich view of the whole European tradition, while the deep holdings of particular artists – Botticelli or Rembrandt, Titian or Cézanne – make it possible, as in very few other galleries, to trace the development of the greatest masters across the decades of their achievement. And the slow building of this inheritance by purchase, government allocation and gift (two thirds of the paintings were given to the public) can be followed through the notes on the pictures' history.

None of this could have been published without the generous and enthusiastic support of Morgan Grenfell plc. All of us at the National Gallery are grateful to them for allowing us to provide, at a modest price, what we believe to be the most comprehensive catalogue of its kind available anywhere in the world. We hope it will enable the public who own the pictures to possess them and enjoy them more fully than ever before.

Neil MacGregor
DIRECTOR

Alone among the great national collections of Europe, the National Gallery was formed not by making public a royal collection, but by a decision of Parliament to provide great pictures for the enjoyment of all. On 2 April 1824 the House of Commons voted £60,000 for the purchase of thirty-eight pictures which had belonged to the banker John Julius Angerstein: these were to form the nucleus of a national collection. The group consisted of Italian works, including the large altarpiece *The Raising of Lazarus* by Sebastiano del Piombo (now number one in the Gallery's collection), and fine examples of the Dutch, Flemish, French and British schools.

In anticipation of this purchase, a Treasury Minute of 23 March 1824 announced the appointment of a Keeper, William Seguier, to look after the pictures, but made no arrangements to house them. For the time being, they were shown in 100 Pall Mall, Angerstein's private house, which was opened to the public.

These first steps might never have been taken by the government of the time had it not been for the campaign for the foundation of a national gallery mounted in the early years of the nineteenth century by an enthusiastic group, with influence both in and beyond political circles, that included George Agar Ellis, afterwards Lord Dover, and the notable private collector Sir George Beaumont. In 1823 Beaumont had promised his own collection of paintings to the nation, provided a suitable building could be found for their proper display and conservation. This generous offer was matched soon afterwards by the Reverend Holwell Carr, who promised his pictures on the same conditions.

Beaumont's undertaking did not fall on deaf ears. In his budget speech of February 1824 the Chancellor of the Exchequer argued the case for the founding of a national gallery, and referred to a 'Valuable collection at present in the possession of a high-spirited individual...which through his liberality, would be likely to find its way to a National Gallery. Should this prove to be the case,' he continued, 'I am sanguine in my hope that the noble example would be followed by many similar acts...the result of which will be the establishment of a splendid Gallery...worthy of the nation.' This hope was justified and the example set by Sir George is still being followed today. Of the over two thousand paintings now in the Gallery, nearly two-thirds are bequests or gifts from private individuals.

In 1824 the ultimate destination of the national collection was still uncertain. There was a strong body of opinion in favour of making it part of the British Museum, with galleries provided for the purpose in the new British Museum building then being planned. There was also strong opposition to this idea and it is probable that the Treasury Minute of 2 July 1824 was an attempt at a compromise. It referred to the nomination by the Treasury of a 'Committee of Six Gentlemen' to 'undertake the superintendence of the National Gallery of pictures, and to give such directions as may be necessary from time to time, to Mr. Seguier, who will be instructed to conform to their orders'. This is the first mention of the duties of the 'gentlemen' who later became 'trustees'. The gentlemen in question were all Trustees of the British Museum, but this did not apparently imply a commitment to the collection becoming part of that institution. The six were Lord Liverpool, then Prime Minister and First Lord of the Treasury, Frederick Robinson (later Lord Ripon) who was then Chancellor of the Exchequer, Sir Charles Long (later Lord Farnborough), George Hamilton Gordon, Earl of Aberdeen, Sir George Beaumont and the painter Sir Thomas Lawrence. These Trustees were to serve for life unless they chose to resign.

This flimsy framework proved inadequate and the chaotic period that ensued was described in retrospect in the 1853 Select Committee Report:

For the first three years and a half of their (the six gentlemen's) appointment no meetings were held. Their interference seems to have consisted in occasional visits to the Gallery, and in offering such suggestions to the Keeper as might occur to them. During this period, consequently, no authentic record was kept, in the establishment, of the transactions of the Gallery, of the purchase of pictures, the prices paid or of other details of the management. But as the collection increased, chiefly by gifts and bequests from public-spirited individuals, the character and functions of the Committee, and the

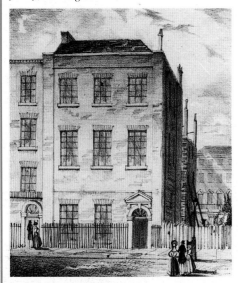

Britain's first National Gallery opened at 100 Pall Mall, the former town house of John Julius Angerstein.

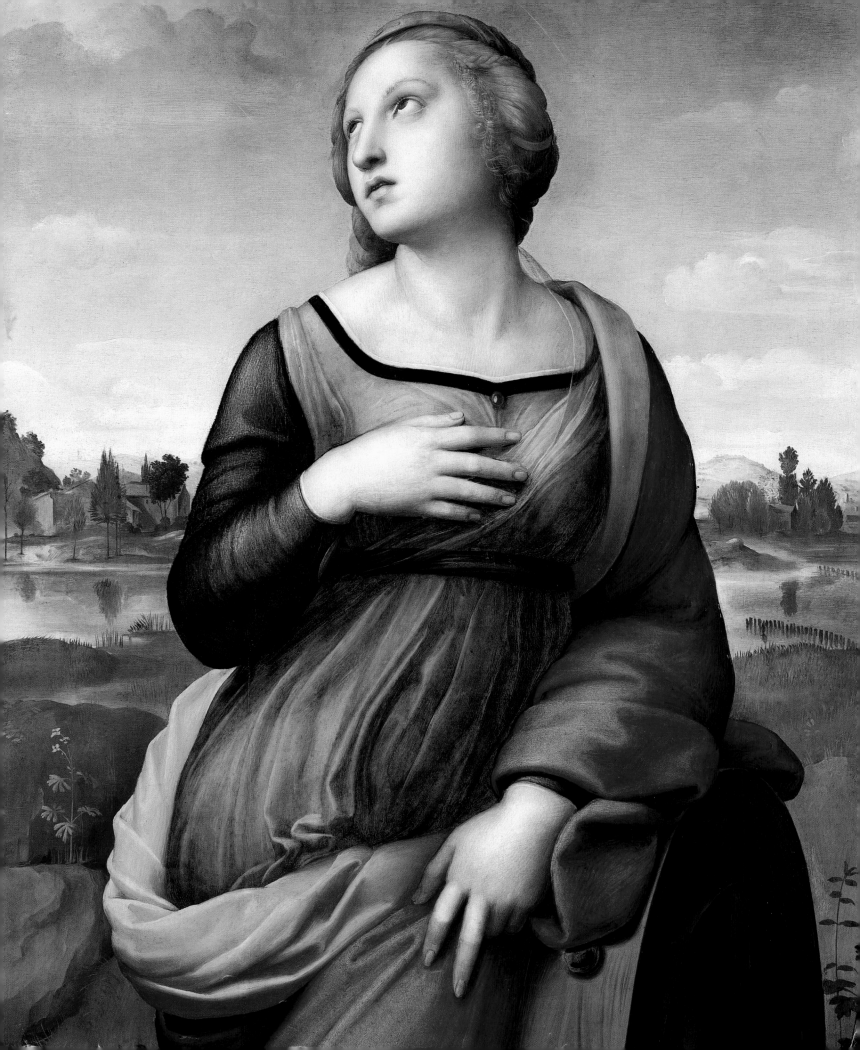

Interior of 100 Pall Mall by F. MacKenzie, (about 1789–1854).

relative positions of that Body and of the Keeper, underwent considerable alteration. The number of the Committee was augmented from time to time (amounting at one period to seventeen) while the members acquired the title of Trustees.

These haphazard arrangements meant that decisions on picture purchases were in the hands of enthusiastic amateurs among the Trustees or of those with an interest in the fine arts who held government office during the first twenty-five years of the Gallery's life. The collection reflected this state of affairs, developing according to the taste of private collectors at the time rather than as a public collection with an educational and art-historical role. By the end of 1843 as few as thirteen artists were credited with two-fifths of all works in the gallery. The fashionable Italian painters were Correggio, Titian and the three Carracci; Rubens and Rembrandt predominated in the Flemish and Dutch schools; the French were represented overwhelmingly by Claude, Poussin and Gaspard Dughet, while Reynolds, Hogarth and Lawrence held pride of place among the British. At this point, the entire collection numbered just under two hundred paintings.

It was partly this failure to follow a more ambitious and wide-ranging acquisitions policy and to define either the duties of the Keeper and the Trustees or the relationship between them, as well as controversy over the conservation and cleaning of the paintings, which led in the late 1840s to increasing public criticism of both the Gallery and its Trustees. This reached a crescendo in the early 1850s, and resulted in the setting up of a Select Committee of the House of Commons in 1853, which carried on its inquiry into the affairs of the Gallery from April to July and produced its report (quoted above) in August.

One of the main criticisms was that the Trustees had neglected the earlier Italian schools, then known as Primitives, when the acquisition of outstanding examples was still so remarkably easy. As early as 1836, a previous Committee of the House of Commons had recommended that an attempt be made to add some works by Raphael and his predecessors to the national collection. It was typical of the confusion of arrangements then obtaining in the Gallery that when the first Raphael, *Saint Catherine of Alexandria,* was bought in March 1839 it was not as a matter of policy but of whim. The Chancellor of the Exchequer had bought it without reference to the other Trustees.

The report of the Select Committee resulted in a constitution for the National Gallery with the introduction of the directorship and the appointment of Charles Lock Eastlake as the first Director in 1855. The Director was put in complete charge of the collection and his decision as to both the purchase of paintings and the management of the Gallery was to be final but 'the national property... deposited therein', as it was referred to in the Treasury Minute, was to be 'vested in Trustees and a Director'. The Trustees were given the right to have their dissent from the Director's decisions put on record in the minutes of Board Meetings and communicated to Parliament. There were guidelines on purchases: 'Preference should be given to fine pictures for sale abroad', and in particular to 'good specimens of the Italian school, including those of the earlier masters'.

Eastlake was to carry out this policy with outstanding energy and flair. To start with, he had the help of a travelling agent, Otto Mündler, whose short-lived but useful office was created by the Minute of 1855 but swept away in July 1858 by a House of Commons which had failed to appreciate its value. However, in his three terms of office, Eastlake managed to ensure that the collection of Italian painting in the National Gallery was augmented and widened in scope to take its place among the foremost in Europe. Among the great paintings he acquired in Italy were *The Baptism of Christ* by Piero della Francesca and *The Family of Darius before Alexander* by Veronese, as well as a significant group of early Italian paintings from the Lombardi-Baldi collection in Florence which included Botticelli's *Adoration of the Kings* and the famous *Battle of San Romano* by Uccello. He was only just in time as conditions in Italy and elsewhere were changing rapidly with a shrinking market and increasingly hot competition.

The next Director, William Boxall, made his most spectacular acquisition at home when in 1871 seventy-seven paintings from the Peel collection were bought for £75,000. Consisting mainly of Dutch and Flemish paintings, including Hobbema's *The Avenue at Middleharnis*, and Rubens's *Chapeau de Paille*, these added a new dimension to the national collection. During the directorship of Frederick Burton, from 1874 to 1894, the aim of the Gallery's acquisitions policy concentrated on preventing the loss of works of art at home to the superior purchasing power of collectors from abroad.

In 1894, the sale to Berlin of Rembrandt's double portrait of Cornelis Claesz. Anslo and his wife from the Ashburnham collection caused widespread dismay and protests from both public and press. The Finance Act of 1896 followed which declared that on the death of the owner, 'such pictures...as appear to the Treasury to be of national, scientific or historic interest...shall be exempt from estate duty, but if...sold...shall become liable to estate duty.' Nevertheless, demands were made that further steps should be taken to prevent a continued exodus of the country's national art treasures. 1903 saw the foundation of the National Art-Collections Fund which was instrumental in saving for the nation two years later, in 1905, Velázquez's *Rokeby Venus* through the raising of £45,000 to outbid foreign buyers.

Fortunately, the Gallery continued to receive magnificent bequests; the largest from George Salting came in 1910, followed by the Mond Bequest in 1924. In 1918, the Lane Bequest brought a number of Impressionist paintings into the collection, including the extremely popular Renoir, *The Umbrellas*. Samuel Courtauld's generous donation of £50,000 enabled the Gallery to buy further modern French masterpieces, such as Seurat's *Bathers at Asnières* and Van Gogh's *Sunflowers*.

The British Collection and the Foundation of the Tate Gallery

The National Gallery's collection has from the beginning included works by British artists. The Angerstein collection contained a Reynolds, *Lord Heathfield*, and seven Hogarths. Contemporary British painting was introduced in 1836 when William IV presented to the nation three portraits by Lawrence including, appropriately, one of John Julius Angerstein himself. The following year, 1837, admirers of Constable subscribed to donate *The Cornfield* to the Gallery.

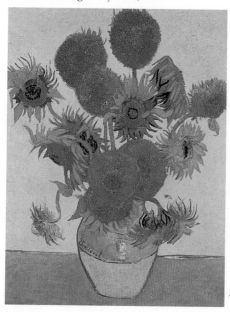

Vincent van Gogh *Sunflowers*, 1888

Later, acquisitions of large numbers of works by British painters created such congestion in the already crowded rooms of the National Gallery that the pictures had to be shown elsewhere. This was the fate of the Robert Vernon Gift of paintings by some seventy modern British artists of the time. These had first to stay in Vernon's house, number 50 Pall Mall, and were later removed for exhibition to Marlborough House, where they remained for many years. They were joined there in 1856 by works from Turner's huge bequest of paintings, drawings and watercolours, thirty-four of which had just been released to the National Gallery by the Court of Chancery following the settlement of Turner's complicated will.

In 1859, both the Vernon collection and the Turners were moved to South Kensington into a building next to the South Kensington Museum. They returned to Trafalgar Square when the Gallery building was enlarged in 1876, but by that time a precedent had been set for exhibiting contemporary British painting in separate premises.

In 1890, negotiations began for permission to build a gallery to be funded by Sir Henry Tate on a government site at Millbank. The new building opened in 1897 and although referred to variously as the National Gallery, Millbank, and the National Gallery (British Art), it soon became known as the Tate. A large number of British pictures from Trafalgar Square were transferred there, to which were added Sir Henry Tate's own collection of English pictures, the Chantrey collection and works by G.F. Watts, as well as the Muller watercolours presented by Sir Joseph Weston. Only a selection of masterpieces by British artists remained at Trafalgar Square, where they can still be seen to this day.

The Tate was at first under the control of the Director and Board of Trustees of the National Gallery who supervised its Keeper, and only in 1917 was a separate Board of Trustees established. The 1954 National Gallery and Tate Gallery Act finally established the Tate as a fully separate and independent institution with its own collections vested in its own Board of Trustees, who were responsible for its management and its trust funds.

The Tate is the national collection both of British Art and of European painting after 1900. The dividing line with the National Gallery is a fluid one and pictures move in both directions, but broadly, artists whose careers were well established by 1900 are represented in Trafalgar Square, while artists whose work belongs more to the twentieth century are to be found at Millbank.

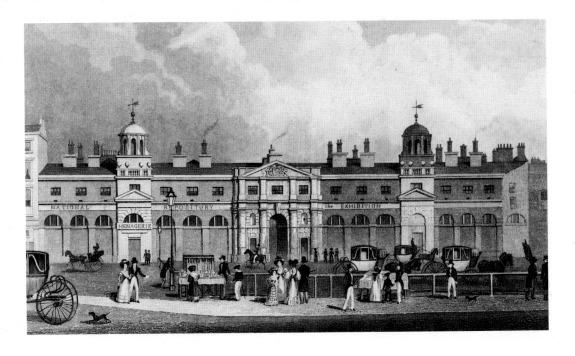

The King's Mews designed by William Kent, engraving after T. H. Shepherd.

Trafalgar Square, engraving by T.H. Shepherd.

BELOW
Original entrance stairs designed by Wilkins.

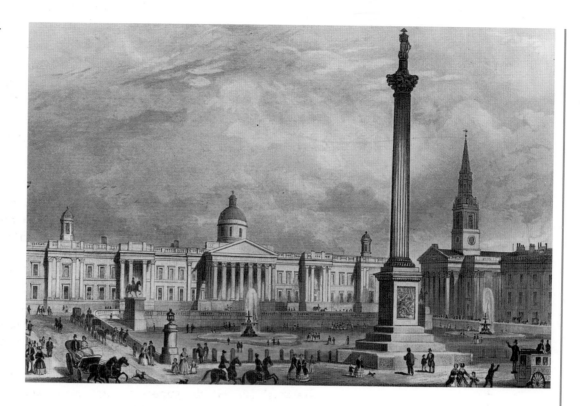

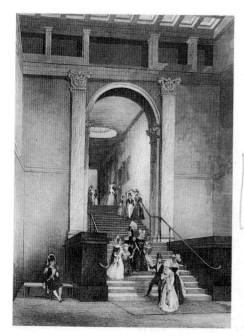

The Building

When the National Gallery opened in what had been Angerstein's house, 100 Pall Mall, it was held up for ridicule in contemporary cartoons, which compared its modest and private façade with the monumental magnificence of the Louvre. In 1834, the collection was moved to another equally small, neighbouring house, number 105, when the construction of Smirke's Carlton Club threatened to undermine the old house and the pictures inside were put at risk.

In 1831, the plans drawn up by the architect William Wilkins for a building to house the Gallery on a site across the north of what is now Trafalgar Square were approved. Building began in 1833, reaching completion in 1837. The Wilkins building replaced the King's Mews, designed by William Kent in 1732. Comparison of the two buildings reveals that Wilkins retained many of the features of the earlier building.

At the outset, the National Gallery occupied only the west end of the Wilkins building, which was anyway only one room deep. The east side was allocated to the Royal Academy. By 1844, Eastlake, then the Keeper, was complaining of the congestion and the following year a statement on the building's defects and unfitness for its purpose was addressed to Sir Robert Peel. The question of larger premises was considered by two Select Committees of the House of Commons in 1843 and 1853 and many proposals were made for rehousing the over-crowded Gallery. Finally, in 1866, a competition was held to find a design for an entirely new building for the collection. Although ten architects submitted their ideas, the Committee in charge failed to reach a decision, but, in 1868, the Royal Academy moved to Burlington House.

At the same time, E. M. Barry was asked to submit designs for rebuilding the entire gallery on the same site. After further vicissitudes, the foundations of what had dwindled into a new wing only, by Barry, were laid on 20 May 1872. When finished in 1876, this added seven new exhibition rooms at the east end. These included the splendid dome room with its four chapels now known as the Barry Rooms.

The collection continued to increase and there was always too little space. By the 1880s a further extension was desperately needed, and the Trustees were demanding a government

 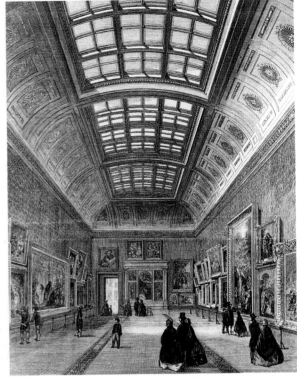

grant of £5,000 to enable a start to be made on what had become a vital building project. In 1884 the present main staircase and the five rooms beyond were built to the design of Sir John Taylor and were opened to the public in the year of Queen Victoria's Golden Jubilee. This gain was followed by a setback in 1889 when part of what had always been thought of as a site earmarked for expansion of the National Gallery was given to the National Portrait Gallery.

In 1897 the Tate Gallery opened at Millbank to house the British and modern collections. The Trustees had, nevertheless, to continue to fight for further space and a prolonged campaign was waged to obtain the removal of St George's Barracks from behind the west side of the Wilkins building to release land for a further expansion of the Gallery. This was at last accomplished and in 1907 work began on five new galleries on the west to balance the Barry Rooms on the east. These were opened in 1911.

Further exhibition rooms have since been added on the main floor, a number of lower floor galleries were opened in 1964, and in 1975 the northern extension was built. In 1985 the National Gallery was the recipient of one of the most generous endowments ever accorded a national institution, when the three Sainsbury brothers, Sir John, Simon and Timothy, came forward to finance the extension on the Hampton Site to the west of the main building. Called the Sainsbury Wing, it was designed specifically to display the entire Early Renaissance collection. The architects were Venturi, Scott Brown & Associates Inc. and the building was opened by Her Majesty The Queen in 1991.

This continued expansion of the Gallery's buildings was necessary not only to find hanging space for additions to the collection but also to meet the increasing expectations of its twentieth-century visitors. Nowadays, museum and galleries aim to provide extra amenities such as restaurants, cinemas, lecture theatres, and other education facilities for schoolchildren, students and the general public.

When the National Gallery Trustees took over full responsibility for the buildings from the government's Property Services Agency in 1988, surveys revealed a considerable backlog of repairs and other building work deferred as a result of decades of under-funding. The galleries

were under-equipped and in need of redecoration. The Trustees drew up a long-term restoration and improvement plan involving a considerable fund-raising effort to make it possible. It is hoped that by the end of the century the repair and restoration of the entire building will have been completed.

The last fifty years

During the First World War, pictures were stored for safety in the Strand underground station while part of the National Gallery in Trafalgar Square was used for government offices. But the greater dangers threatening from the Second World War led to complete evacuation of the pictures from London to a slate quarry at Manod in Wales buried, as

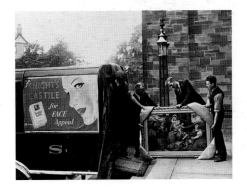

Paintings being loaded into a van for their evacuation to Manod in Wales, during the Second World War, and (right) the amazing journey through the mountains.

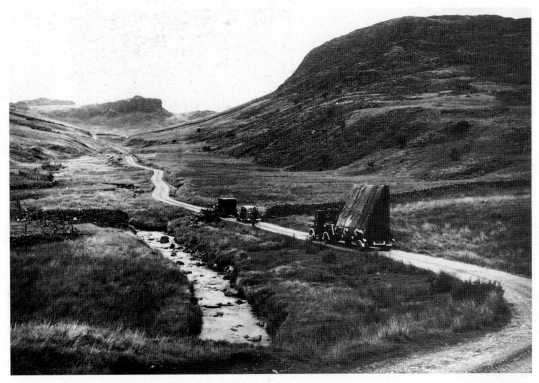

Winston Churchill put it, 'in the bowels of the earth'. Londoners, however, missed their paintings and a letter appeared in *The Times* in January 1942 asking for a glimpse of the recently acquired Rembrandt portrait of Margaretha de Geer. The Director, Kenneth Clark, and the Trustees, having weighed the difficulties and risks involved against the 'delight and refreshment which the sight of a great picture would give', decided with considerable courage to bring back each month from the safety of Wales one of the collection's master-pieces to hang in Trafalgar Square at the heart of London. This 'picture of the month' and the famous concerts of Dame Myra Hess made the Gallery a haven from the gloom and deprivation of the war years.

Twentieth-century developments, particularly in science, education and technology, inevitably involved the Gallery in new activities and led to the setting up of new depart-ments. The first official lecturer was appointed in 1914, forerunner of the Education Department of today. A photographic and publications department began in 1915, launched with a loan of £1,000 from Gallery Trust Funds; in 1988, the publishing side was incorporat-ed and became National Gallery Publications Limited. In 1934, a Scientific Adviser was appointed, the first step towards what is now the Scientific Department, which works close-ly with the Conservation Department. This was founded in 1946 when the pictures returned from the ideal conditions in which they had been stored in Wales to face the pollution of

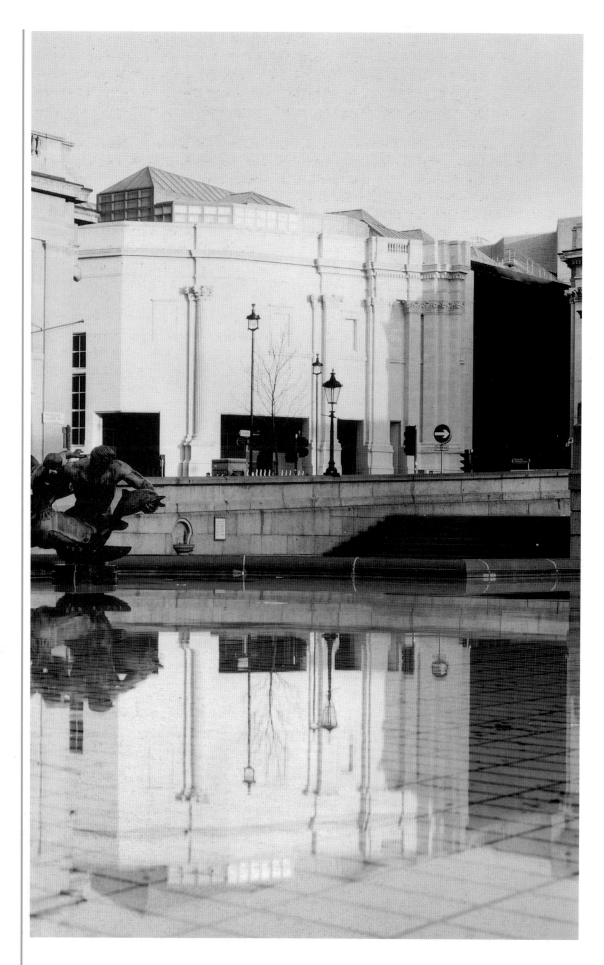

A SHORT HISTORY OF THE NATIONAL GALLERY

The stone façade of the Sainsbury Wing, opened in July 1991.

BELOW
The National Gallery as seen from Trafalgar Square.

London. To help resist this, the first air-conditioned gallery was opened in 1949. Now only a handful of rooms remain without air-conditioning and the Scientific and Conservation Departments have been able vastly to improve the environment in which the paintings are kept and displayed – protecting them against dirt, over-exposure to light, and abrupt swings in humidity, while monitoring and recording unavoidable changes for the benefit of future generations.

Meanwhile the traditional activities of the Gallery continue. As from the beginning, great pictures are added every year through gifts, bequests and purchases, although opportunities are fewer and prices continue to rise. In March 1987, a version of *Sunflowers*, very similar to the one in the Gallery's permanent collection, sold for almost £25m, a world record auction price. As the government purchase grant had been frozen since 1985, the Gallery would have been severely handicapped as a player in an art market with such high stakes had it not been for the munificence of Mr J. Paul Getty Jnr. Since his endowment of £50m came to the Gallery in 1985/6, it has played a crucial part in securing many masterpieces for the nation, including most notably, in 1992, Holbein's *A Lady with a Squirrel and a Starling*.

When the Gallery first opened to the public, a catalogue of sorts was available, although it amounted to little more than a list giving the most basic information: the name of the artist, and of the donor, if any, of the work, its title, support and dimensions. The detailed scholarly catalogues of the collection published during the 1950s and 1960s were essentially initiated by the Keeper, later Director, Martin Davies, who found time during the Second World War to make a start on the necessary research. A new series of these schools catalogues is currently being undertaken. The first illustrated general catalogue emerged in 1973 and it is hoped that the present catalogue will prove a worthy successor and that, in Ruskin's words, readers will find 'that it tells them, about every picture and its painter, just the things they wish to know'.

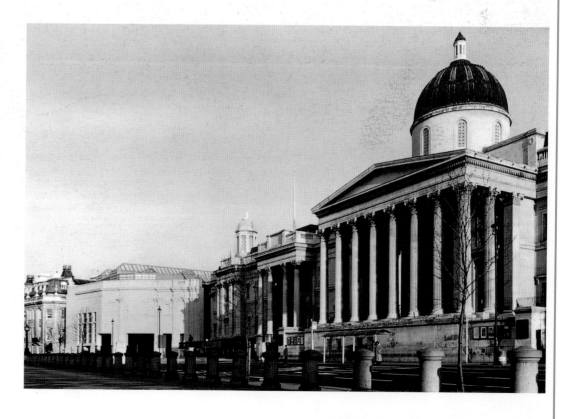

Organisation of the catalogue

The paintings in the National Gallery collection are catalogued alphabetically by artist's name. A concise biography is provided for every painter.

Attribution

Works believed to be by the artist are catalogued first, followed by works attributed to him, and then works which may have been painted by members of his or her studio, or are later copies. The attribution hierarchy is summarised below:

REMBRANDT	Painted by Rembrandt.
ATTRIBUTED TO REMBRANDT	Indicates some uncertainty about the authorship of the painting.
WORKSHOP OF/STUDIO OF REMBRANDT	Indicates works which are thought to have been produced by a painter either taught by, or working under the guidance of, the named artist's studio or workshop.
CIRCLE OF REMBRANDT	Indicates the painter was part of the immediate entourage of the named artist, but did not work in his or her workshop.
FOLLOWER OF	Indicates work by a follower, sometimes of a later period.
STYLE OF REMBRANDT	Indicates the painting has been executed, to a greater or lesser degree, in the style of the named artist but may be of a later date.
IMITATOR OF REMBRANDT	Indicates the painting is by a later painter who has sought to duplicate the style of the named artist.
AFTER REMBRANDT	Indicates the painting is a later imitation of a specific work by the named artist.

Within each attribution category paintings are ordered chronologically. For example, all the paintings considered to be by Rembrandt are given in chronological order by date of execution, followed by paintings less securely attributed to him, also arranged in chronological order by date.

Arrangement of individual entries

The information contained within each entry has been arranged in the following manner:

ARTIST'S NAME AND ATTRIBUTION QUALIFIER	i.e. by/attributed to/workshop of/circle of etc.
THE NATIONAL GALLERY INVENTORY NUMBER	i.e. the number given to the painting when it entered the National Gallery's collection.
DATE OF EXECUTION	i.e. the date the work was painted.
REPRODUCTION OF THE PAINTING	Paintings are reproduced in colour wherever possible. Paintings which cannot be reproduced legibly in the body of the text (for example works with extreme landscape formats such as predellas) are shown larger at the back of the catalogue, as are reconstructions of complex altarpieces and in some cases reverses of paintings.
	Sculptures are shown in black and white at the end of the catalogue.
DIMENSIONS	Dimensions are given in centimetres, height before width.
SUPPORT	The material (e.g. wood, canvas, copper, etc.) on which a painting is executed. The type of wood is given where this has been positively identified.
MEDIUM	The binding agent for pigments in a painting, e.g. tempera, oil. See note opposite.
INSCRIPTIONS	Inscriptions are given in full and where possible translated.
TEXT	The information in the text deals with different aspects of the work: e.g. subject; origin and dating; other relevant issues such as function, history, condition, etc.
PROVENANCE	Gives the earliest known owner of the painting, other major collections it passed through, the date it entered the National Gallery collection and the means of acquisition (bequest, purchase, gift, etc.).
BIBLIOGRAPHICAL REFERENCES	Abbreviated references to National Gallery publications and other major sources. References are given in full in the bibliography.

Reconstructions

Larger reproductions

Bibliography

Index by inventory number

Subject index

The paint medium

NAME OF ARTIST | **UGOLINO di Nerio**
TITLE | *The Betrayal of Christ*
DATE | about 1324-5

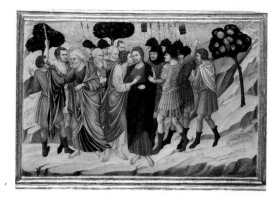

INVENTORY NO | **NG 1188**
MEDIUM, SUPPORT AND DIMENSIONS | Tempera on poplar, 40.5 x 58.5 cm
EXPLANATION OF THE SUBJECT | The Roman soldiers have come to arrest Christ. At the centre Judas betrays Christ with a kiss as described in the New Testament (Matthew 26: 47–52). On the left Saint Peter cuts off the ear of Malchus. Only Christ and Peter are depicted with haloes. The scene takes place at night; illumination is provided by the torches held aloft.
ORIGIN | The panel formed the second scene after the *Last Supper* (New York, Metropolitan Museum of Art, Lehman Collection) in the predella of the high altarpiece of S. Croce, Florence. It is assumed that the work post-dates the artist's high altarpiece, now lost, for S. Maria Novella in Florence (probably 1320–4). The S. Croce altarpiece was probably paid for by the Alamanni family whose coat of arms was originally on it.
COMMENT | The altarpiece (see Appendix A for a reconstruction) remained complete until the late eighteenth century when an inscription beneath the central panel depicting the Virgin and Child was recorded: *Ugolino de Senis me Pinxit* (Ugolino of Siena painted me). Technical analysis of the surviving fragments dispersed among several collections has confirmed that the arrangement of the panels shown in an eighteenth-century drawing (Rome, Biblioteca Vaticana: Vat. Lat., 9847, f.92r) is correct.
PROVENANCE: FIRST DOCUMENTED REFERENCE FOLLOWED BY MEANS OF ACCESSION | *Collection of W. Young Ottley by 1835; bought from the Fuller Russell collection, 1885.*
BIBLIOGRAPHY | Stubblebine 1979, pp. 164–8; Pope-Hennessy 1987, pp. 8–11; Boskovits 1988, pp. 163–75; Gordon 1988, pp. 100, 108–16; Bomford 1990, pp. 98–123; Dunkerton 1991, pp. 222–5.
ARTIST'S BIOGRAPHY | **UGOLINO di Nerio**
active 1317; died 1339/49?

Ugolino is documented in Siena in 1325 and 1327. The style of his work suggests that Duccio may well have taught him there. Ugolino's only autograph painting is the altarpiece, which originally bore a signature, from S. Croce, Florence (about 1324–5), from which all the fragments catalogued here come.

For each painting, an attempt has been made to indicate the nature of the paint binder – the medium within which the pigment particles of the paint are suspended.

The words 'identified as' under an entry for a painting means that chemical and/or instrumental analytical techniques have been applied to paint samples from the work. However, an entry indicated as 'identified as oil' does not preclude the presence of some glazes containing both oil and resin, or particular areas or underlayers having egg tempera as binder. Equally, the description 'identified as egg' merely indicates that most of the samples examined, in themselves possibly not representative of the whole painting, were based on egg medium even though a little drying oil may also be detected.

Where specific analytical examination has yet to be undertaken, the paint binder type may be indicated as 'oil', 'tempera', 'fresco' etc. This is an estimate based on knowledge of practice – either recorded in the literature for a particular artist or school, or where there is a sufficient corpus of analytical results for the same – coupled with optical examination of the paint. More detailed accounts of a picture's paint medium are published in the *National Gallery Technical Bulletins* and exhibition catalogues.

Glossary

beato (pl. **beati**) Someone whose veneration is permitted locally under church law, but who is not canonised (q.v.). Many beati subsequently became saints. Italian, blessed, beatified.

Byzantine Relating to the Byzantine Empire, the continuation of the Roman Empire in the East after the deposition of the last emperor in Rome, AD 476. Named after its capital, the ancient Greek city of Byzantium on the Bosphorus, rebuilt by Constantine in 330 and renamed Constantinople; present-day Istanbul.

camera A room used both as a bedchamber and reception room, often lavishly decorated and furnished. Italian, chamber. See also **cassone**, **spalliera**.

cangiante A shot silk which varies in colour according to the angle of the light, made by weaving the textile using different coloured threads for the warp and the weft. In painting, these silks are represented by using one colour for the shadow and another quite different colour for the highlight. Italian, literally, changing.

canonise, **canonisation** The process by which a person is declared a saint, worthy of veneration in all Roman Catholic churches.

capriccio (pl. **capricci**), **caprice** A term used to describe imaginary topographical scenes. From the Italian *capriccio* meaning whimsical or fantastic.

cartellino A small piece of paper or parchment often painted as if attached to the inner frame below half-length or bust-length portraits or images of the Madonna, sometimes inscribed with the artist's signature.

cassone A modern word used to designate the large painted or carved storage chests which formed part of the furnishings of a camera (q.v.). Italian, large chest. See also **spalliera**.

chiaroscuro The modelling of a painted form by means of dark and light tones.

dado The lower part of an interior wall; mural decoration usually distinguishes between the upper part of the wall and the more easily damaged dado.

desco (pl. **deschi**) **da parto** Decorated circular or twelve-sided trays given as presents to new mothers or in anticipation of a birth, often painted on both sides. Italian, birth tray.

diptych A painting or carving on two panels, normally hinged like a book.

dossal Simple altarpiece, usually rectangular. Early dossals may have originated as frontals (q.v.) and been moved from in front of the altar to above and behind it. See **retable**.

ex-voto A painting, sculpture or other object given to a church or chapel in accordance with a vow, for prayers answered. Latin.

fresco A wall painting, usually executed using colours applied to fresh (Italian, *fresco*) and still-wet plaster.

frontal A decorated panel or cloth hanging down in front of the altar table.

gable A triangular pointed feature of architectural character, as in a frame (corresponding to the pitch of a roof in a building).

gesso The material used for grounds (q.v.) on panel.

glaze A transparent or translucent surface paint layer.

glory A representation of the light which emanates from, or surrounds, a saint or the Deity; another word for halo, but used to distinguish radial patterns, as on beati (q.v.), from the disc shape reserved for God and for saints in Italian art.

grisaille A painting entirely in dark to light shades of a single colour – not necessarily grey – often simulating relief, carved in stone or cast in metal. French, from *gris*, grey.

ground The first layer or layers laid onto a canvas or panel support to prepare it for painting.

halo A disc or ring of light, usually represented in gold, around the head of a saint, angel or the Deity. See also **glory**.

hatching In painting, the application of paint with long thin parallel brushstrokes. In drawing, the use of a series of lines, usually parallel, to suggest volume and the distribution of light and shade. If the strokes are in more than one direction and cross one another this is known as cross hatching.

hortus conclusus One of the metaphors for the Virgin Mary, derived from the Song of Solomon 4:12. In art, expressed through the depiction of a walled garden in images of the Virgin and Child. Latin, enclosed garden.

impasto Paint applied thickly, so that brushmarks etc. are evident.

lunette A semi-circular architectural or sculptural opening or frame; by extension a painting made for such an opening.

Maestà An image of the Virgin Mary enthroned as Queen of Heaven, surrounded by angels and sometimes saints. Italian, majesty.

mahlstick or **maulstick** A long stick, padded at one end, used by artists to steady the hand holding the brush. From German, *mahlen*, to paint.

mandorla An almond-shaped halo or glory (q.v.) surrounding the Deity or the Virgin Mary. Italian, literally, almond.

medium The binding agent for pigments in a painting. See also **tempera**.

metalpoint A metal wire, usually of silver but sometimes also of lead or even gold, employed in a holder as a drawing tool on coated paper. The point deposits a thin coating of metal on the slightly rough surface, which (in the case of lead or silver) rapidly tarnishes, producing a fine grey line like that of a hard graphite pencil.

modello (pl. **modelli**) A sketch for a painting or other work of art.

morse A clasp or fastening on the ornamental cape – cope – of clerical dress.

pastiglia Raised patterns made from gesso (q.v.).

pentimento (pl. **pentimenti**) An alteration made by the artist to an area already painted. From Italian *pentire*, to repent.

Pietà A representation of the dead Christ supported by the grieving Virgin Mary. Italian, pity.

pinnacle A tall crowning element, generally of Gothic architecture, used also for the topmost projections of a picture frame or the topmost panel of a multi-tiered altarpiece.

polyptych An altarpiece consisting of several panels.

pouncing Transferring a design by dusting a coloured powder through holes pricked along the outlines of a drawing on paper or parchment; the traces of this process in the finished work.

predella The long horizontal structure supporting the main panels of an altarpiece commonly decorated with diminutive images of saints or with narratives of their lives. Italian, literally, plinth, altar-step or dais.

putto (pl. **putti**) The representation in painting or sculpture of naked or half-dressed infants, often precociously employed, influenced by antique Roman art. Sometimes loosely used to include child angels. Italian, small boy.

quatrefoil An ornamental shape used in Gothic art and architecture having four lobes arranged about a common centre, like a four-leafed clover. See also **trefoil**.

retable Literally, behind the (altar)table. A structure above and behind an altar, often comprising both sculpted and painted elements. See also **dossal**.

roundel A picture which is round in format, or, more commonly, a small round element of a complex picture such as an altarpiece. See also **tondo**.

sgraffito A technique in which paint is applied over gold or silver leaf and then partially scraped away; particularly used to represent cloth-of-gold textiles. Italian, literally, scratched.

size An adhesive used to make gesso and in gilding; made from animal skin and waste. The finest size was made from parchment clippings.

spalliera (pl. **spalliere**) A benchback, the headboard or footboard of a bed or any similar vertical element of furniture, often decorated. Italian, from *spalle*, shoulders.

spandrel The space between the curve of an arch and the rectangular framework within which the arch is placed.

stippling In decoration of gilding, very small indentations of the surface made with a needle or clump of needles. In painting, the application of paint in short dabs or spots of colour.

stretcher The wooden framework over which a canvas is stretched.

studiolo A small room often lavishly decorated, generally of relatively private character, dedicated to reading, studying, writing. Italian, little studio.

tempera In its wider sense, any one of several paint media, hence the verb to temper, meaning to combine pigments with a paint medium, but it now often refers to egg tempera alone, that is, paint made using egg yolk as a medium (q.v.).

tondo (pl. **tondi**) A circular painting or relief sculpture. Italian, literally a circle, from *rotondo*, round.

transfer To convey and reproduce a design from one surface, for example paper, to another, for example a gessoed panel. Alternatively, to remove the original painting support and replace it with a new support.

trefoil Three-lobed decorative motif common in Gothic art and architecture. See also **quatrefoil**.

triptych An altarpiece consisting of three panels.

trompe l'oeil A trompe l'oeil painting is one which creates the illusion that the viewer is looking at the object itself, not a painting of the object. From the French, meaning to trick the eye.

underdrawing Preliminary drawing on the prepared panel before the application of paint.

vanishing point The point on the horizon where all receding parallel lines seem to meet.

vanitas A type of still-life painting in which objects symbolically refer to the transience of worldly life. 'Vanity of vanities, saith the preacher; all is vanity.' Ecclesiastes 12: 8. From the Latin *vanitas*, meaning futility.

veduta (pl. **vedute**) The Italian term for a topographical view, especially one with architectural elements. See also **capriccio**.

X-ray A form of radiation which passes through solid objects but is obstructed to differing degrees by differing materials. The heavier the atoms of which a substance is made, the more opaque it is to X-rays. Lead compounds are particularly opaque, thus in an X-ray image of a painting, areas of paint containing lead pigments will appear almost white, while areas containing lighter materials will appear grey or dark.

Abbreviations

IN INSCRIPTIONS

F. fe.	Latin: fecit: he made (this)
INRI	Latin: Iesus Nazarenus Rex Judaeorum: Jesus of Nazareth King of the Jews
p. pinx.	Latin: pinxit: he painted (this)
SPQR	Latin: Senatus Populusque Romanus: The Senate and People of Rome

IN TEXT

ARA	Associate of the Royal Academy
NACF	National Art Collections Fund
NHMF	National Heritage Memorial Fund
RA	Royal Academy

Director's acknowledgements

The Director of the National Gallery, Neil MacGregor, would like to thank all those members of staff from the National Gallery and National Gallery Publications, together with experts from outside the Gallery, who have contributed their skill, enthusiasm and time to the preparation of this catalogue.

The Gallery owes a very considerable debt to Christopher Baker and Tom Henry, the compilers of the catalogue; to the National Gallery's editor, Diana Davies, who, assisted by Sarah Perry, took responsibility for checking and editing successive drafts and proofs; to Jan Green, who coordinated the project on behalf of National Gallery Publications, and to Hugh Tempest-Radford, who oversaw the design and production. Invaluable advice and support was provided by Neil Aberdeen, Christopher Brown, Lorne Campbell, Nicola Coldstream, Jill Dunkerton, Judy Egerton, Gabriele Finaldi, Susan Foister, Dillian Gordon, Gillian Greenwood, Grizelda Grimond, Bettina von Hase, Sara Hattrick, Elspeth Hector, Laura Henderson, Nik Honeysett, Denise King, Erika Langmuir, John Leighton, Jacqui McComish, Elizabeth McGrath, Alex Morrison, Nicholas Penny, Cathy Pollock, Emma Shackleton, Rupert Shepherd, Zara Waldeback, Patricia Williams, Michael Wilson and Humphrey Wine.

Compilers' acknowledgements

In the preparation of this catalogue we have received tremendous encouragement from many people, and we would especially like to thank the curatorial staff of the National Gallery from whose support, advice and scholarship we have benefited. We are particularly grateful to Neil MacGregor, Director of the National Gallery, Christopher Brown, Chief Curator, and Patricia Williams, Director of Book Publishing of National Gallery Publications, who initiated and made possible the publication of this book. Our thanks are also due to David Franklin, John Smith, Nigel Wilson and Alison Wright, for access to unpublished research.

Christopher Baker and Tom Henry

Catalogue of paintings

Hans von AACHEN
The Amazement of the Gods (?)
probably 1590s

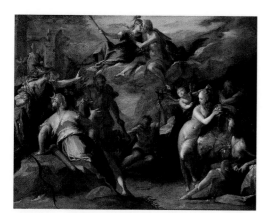

NG 6475
Oil on copper, 35.5 x 45.8 cm

Jupiter embraces his daughter Minerva in the sky. Below, Diana, with her crescent moon, bow and quiver is seated at the left; Mercury with his winged hat and caduceus stands beside her; Ceres may be beside him; Hercules with a club, draped in skins, stands below Minerva; Hades is seated in the centre next to the three-headed dog Cerberus; Apollo sits at the right with his lyre; the standing female unveiled by a putto may be Hebe; behind her Neptune rests on a rock with his trident. It has been suggested that the subject is that of a related drawing by the artist in Stuttgart (Württembergisches Landesbibliothek). The inscription on this drawing, made in about 1600 by its owner at the time, Paul Jenisch, reads in translation: 'This shows how Jupiter abandons Venus and loves Minerva, to the amazement of all other pagan gods'.

NG 6475 may conceivably have been painted for Emperor Rudolph II, perhaps as an allegory, with the union of Jupiter and Minerva representing that between princely power and wisdom. Rudolph enjoyed such subjects and had himself represented as Jupiter.

Bought, 1982.

National Gallery Report 1982–4, p. 16; Smith 1985, p. 106.

Johannes van der AACK
An Old Woman seated sewing
1655

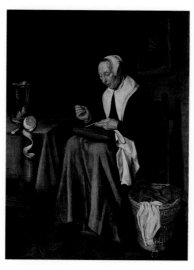

NG 1397
Oil on canvas, 108.8 x 82 cm

Inscribed in the lower margin of the engraving on the wall: Joannes-Ab Aack fecit/16 55. On the lower border of the engraving: VIN (CERE) AU(T) MORI (Victory or Death).

Behind the woman hangs a print of a portrait of Christian, Duke of Brunswick (1599–1626), who was a Protestant general in the Thirty Years War. He fought for a time in the service of the United Provinces. The print is Willem Jacobsz. Delff's engraving of 1623 after a portrait by Michiel van Miereveld.

Presented by Henry J. Pfungst, 1894.

MacLaren/Brown 1991, p. 1.

Pieter AERTSEN
Scenes from the Life of an Unidentified Bishop Saint
about 1560

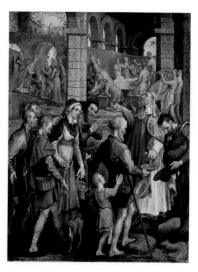

L578
Oil on wood, 75 x 56 cm

Three scenes are included in this painting, in each of which an unidentified bishop is shown doing good works. It has been suggested that he might be Saint Albinus, Bishop of Angers from 529, who was a patron saint of the blind. In the foreground the bishop is shown giving money to a beggar, who is perhaps blind like those behind him. In the background on the left he heals a blind man (the other figures are perhaps the same as those in the main scene), and in the corresponding scene on the right, at which a feast is shown, the bishop appears to be preparing to wash the feet of a beggar, perhaps again the same man as in the foreground.

L578 may have been painted as a single devotional work, rather than as part of an altarpiece, and dates from about 1560, when Aertsen had moved from Antwerp to Amsterdam.

The bright, evenly lit colours and the robust, animated depictions of ordinary people are characteristic of Aertsen's paintings, whether on a large scale or, as here, in a smaller work.

On loan from a private collection since 1991.

Filedt Kok 1986, pp. 406–7, no. 297; National Gallery Report 1991–2, pp. 20–1.

Hans von AACHEN
1552–1615

The artist was born and trained in Cologne; he takes his name from the birthplace of his father. Aachen visited Italy and Bavaria (1589–about 1596). He was appointed court painter to Emperor Rudolph II in Prague in 1591, permanently settling in the city in 1596. He specialised in mythological subjects and advised the court about the acquisition of works of art.

Johannes van der AACK
1635/6–after 1680

Johannes Claesz. van der Aack, or Aeck, was born in Leiden, the son of a wine-merchant. He entered the city's university in 1650, and in 1658 joined the artists' guild. Later he served as an officer of the guild. In 1676 he is recorded as a wine-merchant. His rare paintings are of genre subjects.

Pieter AERTSEN
1507/8–1575

Aertsen was probably born in Amsterdam but spent much of his working life in Antwerp. He was one of the most important artists working in the Netherlands in the mid-sixteenth century and was principally responsible for the development of a new type of subject painting in which still life is prominent.

Attributed to ALLEGRETTO Nuzi
Saint Catherine and Saint Bartholomew
about 1350

Albrecht ALTDORFER
Landscape with a Footbridge
about 1518–20

Albrecht ALTDORFER
Christ taking Leave of his Mother
probably 1520

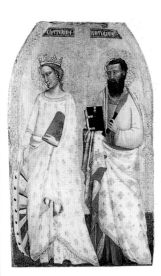

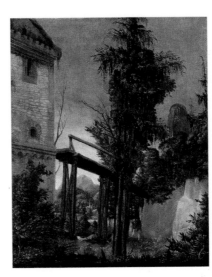

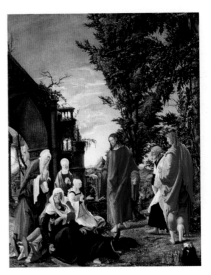

NG 5930
Tempera on wood, painted surface 83 x 51 cm

NG 6320
Oil on vellum on wood, 41.2 x 35.5 cm

NG 6463
Oil (identified) on lime, 141 x 111 cm

Inscribed at the top on the left: [S] / .CHATERINA.; on the right: S. / .BARTHOLOMEV.

Saint Catherine stands by the wheel on which she was tortured and Saint Bartholomew holds a flaying knife, the instrument of his martyrdom. The panel was the right-hand panel of a triptych, or possibly a polyptych.

Once catalogued as Florentine School, the panel is now attributed to Allegretto Nuzi on the basis of the decorative punchwork which is similar to that on other works associated with Allegretto, including a signed triptych dated 1365 (Rome, Vatican Museums). No surviving fragments appear to be directly related to this panel.

Allegretto shows the influence of Florentine painters, especially that of Bernardo Daddi, in this and other works.

Collection of Herbert Charles Coleman by 1920; by whom bequeathed, 1949.

Gordon 1988, pp. 1–2.

A wooden bridge spans a river. In the distance are mountains, and then a church spire and the houses of a village. The details of the composition may be based on the topography of specific locations in the Danube valley, but the landscape is probably not intended as a view of a particular place.

NG 6320 is a very early example by a Western European artist of an independent landscape painted without figures. A second landscape by Altdorfer in Munich (Alte Pinakothek) is also without figures; the present picture possibly dates from about 1518–20 and may be the earlier of the two.

Bought, 1961.

Smith 1985, p. 88.

Perhaps inscribed on the column behind the Holy Women: [1]520

Christ, standing centrally, blesses his mother, the Virgin, on the left. She has collapsed with grief because of his departure for Jerusalem and imminent Passion. The Virgin is attended by four holy women: Mary Cleophas, Mary Salome, Mary Jacobi and the Magdalen. On the column behind them the Flagellation of Christ, yet to come, is depicted in relief. To the right stand Saint John the Evangelist and the aged Saint Peter. In the foreground are a diminutive family of unidentified donors. There is no biblical source for this event, but two fourteenth-century religious texts describe it: Fra Johannes Calibus's *Meditations on the Life of Christ* (1308), and Brother Philipp the Carthusian's *Marienleben* (about 1330). The subject was a relatively popular one in early sixteenth-century Northern Europe.

The original location of the painting is unknown.

Collection of Celestin Steiglehner, Prince-Abbot of St. Emmeram, Regensburg, 1809; bought from the Trustees of the Wernher Estates, with contributions from the NACF (Eugene Cremetti Fund), the Pilgrim Trust and the National Heritage Memorial Fund, 1980.

Smith 1983, pp. 50–64; Smith 1985, p. 90.

ALLEGRETTO Nuzi
active 1345; died 1373/4

Allegretto Nuzi (or Nucci) was born in Fabriano in the Marches and was in Florence by 1346 where he was influenced by the work of Bernardo Daddi. His signed works date from 1345 to 1372 and consist of polyptychs and frescoes. He returned to the Marches in about 1353 where he worked for the rest of his career painting altarpieces at San Severino Marche (1366) and Urbino (1369 and 1372).

Albrecht ALTDORFER
shortly before 1480–1538

Altdorfer spent most of his life in Regensberg, where he became a citizen in 1505. There he worked as a painter, draughtsman, designer, architect and printmaker; he was also a councillor. He is chiefly famed for his landscape paintings.

Attributed to ANDREA di Aloigi
The Virgin and Child
probably about 1490–1500

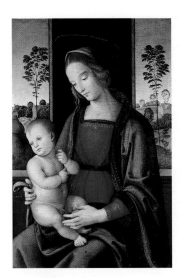

NG 1220
Oil on wood, painted surface 64.8 x 43.5 cm

Inscribed, probably with a signature: A.A.P. [for Andreas Assisiensis, or possibly Andrea [di] Aloigi Pinxit].

Landscapes are seen through windows to either side of the Virgin and Child.

If the identification of the inscription as a signature is accepted, this is the only known painting by Andrea di Aloigi. On the basis of comparison with NG 1220, a tondo (Paris, Louvre) has recently been attributed to this artist. NG 1220 probably dates to the 1490s and is obviously indebted to Perugino.

Collection of Giovanni Metzger, Florence, by 1821; collection of the Revd J. Sanford by 1837; bought from Lord Methuen, 1886.

Davies 1961, pp. 13–14; Scarpellini 1984, p. 81.

Attributed to ANDREA di Bonaiuto da Firenze
The Virgin and Child with Ten Saints
probably 1360–70

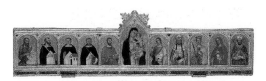

NG 5115
Tempera on wood, 27.9 x 106 cm

Inscribed from left to right : S. MARCHUS; S. PETRUS.; S. THOMAS.; S. DOMINICUS; S. LUCAS; S. MARIA UIRGO.; S. IOHANNES; S. GREGORIUS; S. KATERINA; S. MARIA MAD; S. THOMAS (D?). (Saint Mark, Saint Peter Martyr, Saint Thomas Aquinas, Saint Dominic, Saint Luke, the Virgin and Child, Saint John the Evangelist, Saint Gregory, Saint Catherine of Alexandria, Saint Mary Magdalene, and Saint Thomas à Becket (?)).

NG 5115 can be associated with the Dominican church of S. Maria Novella in Florence because of the artist's links with this church and the choice of saints, some of whom are Dominican, and all of whom had altars dedicated to them in the church. Additionally, the format of the altarpiece and the choice and treatment of the saints may reflect aspects of now lost Sienese altarpieces which were originally in S. Maria Novella.

NG 5115 is dated by stylistic comparison with frescoes in the Chapter House of S. Maria Novella, the so-called Spanish Chapel, and may be by an assistant of the artist.

Original gesso covers the mouldings, proving that the framing is original and that the altarpiece is complete. Embedded in the *pastiglia* are semi-precious stones and beads of coloured glass. (See Appendix B for a large reproduction of this work.)

Collection of Mrs F.W.H. Myers; presented by her daughter, Mrs Richard F.P. Blennerhassett, 1940.

Gordon 1988, pp. 3–5.

Attributed to Pierre ANDRIEU
Still Life with Fruit and Flowers
probably about 1850–64

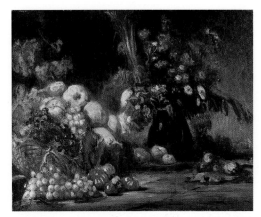

NG 6349
Oil on canvas, 65.8 x 81 cm

NG 6349 has on its reverse the seal of the Delacroix studio sale. However, it is close in style to a signed picture by Andrieu (Delacroix's pupil), and is probably his work. It can almost certainly be dated to before 1864 (unless the seal of the Delacroix studio sale was attached at a later date).

Apparently Delacroix collection, Paris, by 1864; collection of Edgar Degas, 1898–1918; bought, 1964.

Davies 1970, p. 9.

ANDREA di Aloigi
active 1484–1501

Often called L'Ingegno, he was first recorded, apparently as a painter, in Assisi. He was working with Perugino in 1490 and was considered as one of the best pupils from Perugino's studio. Not recorded as a painter after 1501, he is otherwise documented until 1521.

ANDREA di Bonaiuto da Firenze
active about 1346; died 1379

The painter is recorded as a member of the Florentine artists' guild, the Arte dei Medici e Speziali, in 1346. He lived in the parish of S. Maria Novella and painted the fresco cycle in the Chapter House of that church (called the Spanish Chapel) from 1365 to 1367. He completed a fresco cycle in the Camposanto at Pisa in 1377.

Pierre ANDRIEU
1821–1892

Andrieu was a pupil and assistant of Delacroix. In his independent pictures he painted animal subjects.

Fra ANGELICO
Christ Glorified in the Court of Heaven
1419–35

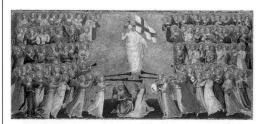

NG 663.1
Tempera on poplar, 32 x 73 cm

Fra ANGELICO
The Virgin Mary with the Apostles and Other Saints
1419–35

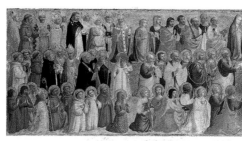

NG 663.2
Tempera on poplar, 32 x 63.5 cm

Fra ANGELICO
The Forerunners of Christ with Saints and Martyrs
1419–35

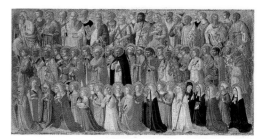

NG 663.3
Tempera on poplar, 32 x 63.5 cm

Christ is shown holding the banner of the Resurrection. He is surrounded by choirs of angels; Saint Michael is identifiable at the left of the third row on the right.

NG 663.1–5 are the panels which formed the predella of Fra Angelico's high altarpiece for the church of S. Domenico, Fiesole (Fra Angelico's own Dominican friary). It was probably painted in the mid-1420s, certainly before 1435 when the high altar was dedicated. The predella was painted with the substantial help of a second artist, and the main panel (still in S. Domenico, Fiesole) was repainted in about 1501 by Lorenzo di Credi. Other panels from the pilasters of the frame survive in various collections. (See Appendix A)

S. Domenico, Fiesole, by 1568; Valentini collection, Rome, by 1827; bought, 1860.

Davies 1961, pp. 16–31; Pope-Hennessy 1974, pp. 189–90; Dunkerton 1991, pp. 48–9, 51; Hood 1993, pp. 66–72.

Inscribed with various names. Top row (right to left): S. SILVESTER, ILARI', S.MARTINVS, [on St Dominic's book: OS IVST[I] / MEDI/TABIT[UR] / SAPIE/NTIA[M] / & LIN/GVA EI[US]/ LOQVET[UR JUDICIUM] (The mouth of the righteous speaketh wisdom, and his tongue talketh judgement), S.G[R]EGORI. Second row: SANC/TVS . YE/ RONIM[US] / DOCTO[RUM] / MASSI/MVS: AD / EVSTO/CIA'; on St Thomas's book: R[I]GA[NS]/ M[O/NTES D]E / [SVPER]IOR[IBVS] / [SVI]S DE / FRV[C]T[V] / OPERV[M] / TVORV[M] / SATIA[BITVR TERRA] (He watereth the hills from his chambers: the earth is satisfied with the fruit of thy works).

The figures have been identified as the Virgin Mary (top right) with apostles and the evangelists. Saints Peter, Paul and John are identified with their attributes. Other saints are identified in the group to the left as follows (Davies 1961). Top row (right to left): Saints Silvester, Hilary, Martin, unidentified, Dominic (with an inscription from Psalm 37: 30), unidentified, Gregory, Nicholas of Bari, Francis and Zenobius. Second row: Saints Jerome (with his letter to the Eustochians), Anthony Abbot, Maurus (?), Benedict, Augustine, unidentified, Thomas Aquinas (with an inscription from Psalm 104: 13), Anthony of Padua, unidentified, Bernard (?). Bottom row: Saints Paul the Hermit, three unidentified, Giovanni Gualberto, unidentified, Louis of Toulouse, an unidentified Franciscan, Onuphrius, and two unidentified saints.

NG 663.2 was part of the predella of the high altarpiece painted by Fra Angelico for the church of S. Domenico, Fiesole; see commentary under NG 663.1 for further discussion and for the provenance and bibliography.

Inscribed with various names. Top row (left to right): NON [H]ABE/BIS DEOS A/LIENOS: [... N ...]/ NON ASS/VMES NO/MEN DEI / TVI IN / VANV[M] (Thou shalt have no other Gods ... Thou shalt not take the name of God in vain), [...] ET MA[TREM] / TVAM /[... NON] OCIDES / [NON] MEECC/ABERIS / NO[N] FVR/T FA[CIES] (... and thy mother ... Thou shalt not kill, Thou shalt not commit adultery, Thou shalt not steal), ARON, jesue, YOEL, DAVId, YSAYA, EZECIEL, YEREMIA, daniel, SACCARIA, IONA, ABACVC. Second row: S. CIPRIANVS. S: CLEMENS, S: THOMA. S SIXTVS, S: ARASMVS. Third row: SANCTA. LENA.

The three rows represent the various precursors of Christ, male martyrs (with palms) and female saints. They have been identified as follows (Davies 1961). Top row (left to right): Adam, Eve, Noah, unidentified, Abraham, unidentified, Moses, unidentified, Aaron, Joshua, Saint John the Baptist, Joel, David, Isaiah, Ezekiel, Jeremiah, unidentified, Daniel, Zechariah, Jonah, Habbakkuk. Second row: Saints Stephen, Cyprian, Clement, unidentified, Vincent, Lawrence, unidentified, Barnabas (?), Thomas à Becket, Peter Martyr, Cosmas and Damian, Sebastian, unidentified, Ignatius, unidentified, George (?), Miniato (?), unidentified, Christopher, Sixtus, Erasmus. Bottom row: Saints Anne, Thecla, Mary Magdalene, Martha (?), two unidentified, Agnes, two unidentified, Cecily, unidentified, Catherine of Alexandria, Margaret, Elizabeth of Hungary (?), two unidentified, Helen, Flavia (or Felicitas), Bridget of Sweden, Clare, Reparata (?), unidentified.

NG 663.3 was part of the predella of the high altarpiece painted for the church of S. Domenico, Fiesole; see NG 663.1 for further discussion and for the provenance and bibliography.

Fra ANGELICO
about 1395–1455

Guido di Pietro became a friar at S. Domenico, near Fiesole, before 1423. By 1441 he had moved into the Dominican friary of S. Marco, Florence, where he painted his greatest works for the friars and their Medici sponsors. Summoned to Rome in 1445 by Pope Eugenius IV, he was active there and in Orvieto until 1449/50 when he returned to Florence. He died in Rome in 1455.

Fra ANGELICO
Dominican Beati
1419–1435

Fra ANGELICO
Dominican Beati
1419–1435

Attributed to Fra ANGELICO
A Martyr Bishop or Abbot
probably 1430–40

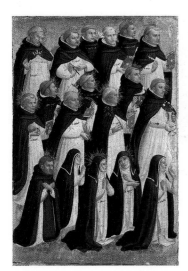

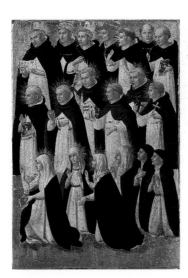

NG 663.4
Tempera on poplar, 32 x 22 cm

NG 663.5
Tempera on poplar, 32 x 22 cm

NG 2908
Tempera on wood, total dimensions
(about 3.8 cm on the left is modern) 16 x 15.5 cm

Inscribed with various names. Top row (right to left): . b ioban', . b . reginaldus, b. a[m]brosi', . b. nichlaus, . b. jachob' (who writes IYU, Christ, on his chest), . b. ERichu',. Second and third rows: . b . iacob', . b . erichus, . b . sinuus, . b . boninsegia, . b . uiceti', . b . amandu', . b . ioban'. Bottom row: . b . ma[r]garita, . b . agnies, . b . sib[e/r]ina.

Both NG 663.4 and 663.5 contain Dominican *beati* (blessed), all shown with rays around their heads. They can be identified as follows (Davies 1961). Top row (right to left): Jordanus of Saxony (died 1237), Reginald of Orléans (died 1220), Ambrogio Sansedonio of Siena (died 1286/7), Nicholas of Palea (died 1255), James (who has been given the attribute of Henry Amandus Suso), Henry. Second and third rows: James of Salomonio (died 1314), Henry, Sinuus, Buoninsegna (died about 1268), Saint Vincent Ferrer (died 1419), Amandus, Jordanus of Pisa (died 1311). Bottom row: Saint Margaret of Hungary (died 1271), Saint Agnes of Montepulciano (died 1317), Sibyllina de Biscossis (died 1367). The last two figures are unnamed.

NG 663.4 was part of the predella of the high altarpiece painted by Fra Angelico for the church of S. Domenico, Fiesole; see commentary under NG 663.1 for further discussion and for the provenance and bibliography.

Inscribed with various names. Top row (left to right): BEAT/VS AL/BERTV' / MAN/[GN]VS, b . benedict, . b . beltad, . b . latinus, . b . gualteri', . b . petrus (YHS, Jesus, inscribed in his mouth), .b . unbert'. Second and third rows: . b . raimu[n]d, . b . iacob' (holding his heart inscribed YHS, Jesus), . b . bona/speme, . b . johes, . b . ve[n]turin', . b . maculin'. Bottom row: . b . caterina, . b . ma[r]garita, . b . joha. d . floretia.

Both NG 663.4 and 663.5 contain Dominican *beati* (blessed) with rays around their heads. They can be identified as follows (Davies 1961). Top row (left to right): Saint Albert the Great (died 1280), Saint Benedict XI (died 1304), Bertrand, Cardinal Latino Malabranca (died 1294), Walter of Strasbourg (died before 1260), Peter González (died 1246), Humbert of Romans (died 1277/8). Second and third rows: Saint Raymond, James, Bonaspeme, John of Salerno (died 1242), Venturino of Bergamo (died 1346), Marcolino Amanni (died 1397). Bottom row: Saint Catherine of Siena, Margaret of Città di Castello (died 1320), Jane of Florence. The last three figures are unnamed.

NG 663.5 was part of the predella of the high altarpiece painted by Fra Angelico for the church of S. Domenico, Fiesole; see commentary under NG 663.1 for further discussion and for the provenance and bibliography.

Inscribed in the right background: ...MEVS (probably the remains of a name).

NG 2908 is a roundel and probably formed part of the decoration of a frame or predella. It has been suggested that it could have come from the frame of an altarpiece painted by Fra Angelico for S. Domenico, Fiesole (see also NG 663), although there is no evidence for this. Another roundel of similar dimensions showing a bishop saint and evidently from the same work as NG 2908 is in the Metropolitan Museum, New York. The execution of this roundel has sometimes been given to Fra Angelico's workshop.

Collection of Lady Lindsay by 1893; by whom bequeathed, 1912.

Davies 1961, pp. 31–2; Pope-Hennessy 1974, p. 227.

Workshop of Fra ANGELICO
Christ Blessing
about 1435

L10
Tempera on wood, 28 x 22 cm

Christ is shown holding a book inscribed with the letters Ā and Ʊ for Alpha and Omega.

L10 has been attributed to various artists, but is generally called workshop of Fra Angelico. Presumed to be from a pinnacle, it has been associated with the altarpiece that Fra Angelico painted for S. Domenico at Fiesole, of which NG 663.1–5 formed the predella.

Collection of William Blundell Spence, Florence, by 1851; bought by Queen Victoria, 1854; on loan from Her Majesty The Queen since 1975.

Shearman 1983, pp. 13–15; Hood 1993, p. 66.

Follower of Fra ANGELICO
The Adoration of the Kings
perhaps about 1430–50

NG 582
Tempera on poplar, painted surface 19 x 47.6 cm

The Three Kings journeyed to Bethlehem to honour the new-born Jesus. They brought gifts of gold, frankincense and myrrh. The king kneeling to kiss the Child's foot has handed his gift to Joseph. New Testament (Matthew 2: 2–12).

NG 582 was probably painted in Florence by a follower of Fra Angelico. It seems to have formed part of a predella of an altarpiece. Similar panels of the *Marriage of the Virgin* and *Death of the Virgin* (Florence, Museo di S. Marco) and the *Nativity* (private collection) may have formed part of the same predella.

Collection of Professor Rosini, Pisa; bought from the Lombardi-Baldi collection, Florence, 1857.

Davies 1961, pp. 32–3.

Follower of Fra ANGELICO
The Vision of the Dominican Habit
perhaps about 1435–50

NG 3417
Tempera on wood, cut at the top, 23.8 x 29.8 cm

The story represented refers to the origin of the Dominican habit. On the left the Virgin and two beautiful damsels appear to the Blessed Reginald of Orléans with the habit that the Dominicans should wear. One of the damsels holds a box of healing balm with which to anoint the Blessed Reginald. On the right they appear to Saint Dominic holding the new habit. The reverse of NG 3417 has the remains of a marbled decoration.

The picture is probably part of a cupboard or tabernacle door; there appears to be a hinge mark on the left.

Collection of the Revd H.E. Richards, Claygate, by 1885; presented by Sir Charles Archer Cook, 1919.

Davies 1961, pp. 35–6; Pope-Hennessy 1974, p. 228.

Follower of Fra ANGELICO
The Virgin and Child with Angels
probably about 1440–50

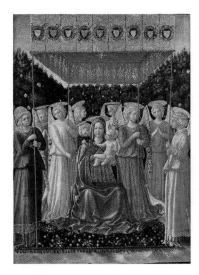

NG 5581
Tempera on poplar, painted surface 29.2 x 21.6 cm

The Virgin and Child are shown under a canopy ornamented with shields. An angel gives the Christ Child a goldfinch, probably symbolising the Passion. The figures stand on a fringed carpet with a pattern of flowers echoing the flowering shrubs behind.

NG 5581 is clearly influenced by Fra Angelico, and is here catalogued as the work of a follower. This panel has been attributed to a number of artists, including Benozzo Gozzoli.

Collection of Sarah Rogers by 1844 and then Samuel Rogers until 1856; bought from the Cook collection, Richmond, 1945.

Davies 1961, pp. 36–7; Pope-Hennessy 1974, p. 228; Wohl 1980, pp. 158–9; Bellosi 1990, pp. 114–17; Dunkerton 1991, p. 84.

Follower of Fra ANGELICO
The Abduction of Helen by Paris
about 1450

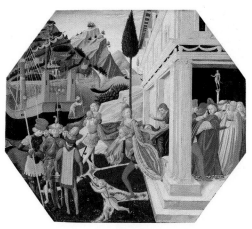

NG 591
Tempera on poplar, irregular octagon, painted surface 50.8 x 61 cm

Helen, wife of King Menelaus of Sparta, is being carried off by Paris, together with other women, from the Temple of Apollo and Artemis at Helaea in Cythera to a waiting ship. This action precipitated the Trojan War. The principal sources for the Trojan War are Homer's *Iliad* and Virgil's *Aeneid*, but NG 591 includes some details that suggest that *Daretis Phrygii de excidio Trojae historia* (an account of the war reputedly by Dares of Phrygia, a Trojan priest) was the source used.

NG 591 may have been part of the decoration of a piece of furniture, possibly a marriage chest. The panel was formerly attributed to Benozzo Gozzoli, as a very early work, but it has also been attributed to Fra Angelico or a close follower.

Collection of the Marchese Albergotti, Arezzo, before 1845; bought from the Lombardi–Baldi collection, Florence, 1857.

Davies 1961, pp. 33–4; Wohl 1980, pp. 161–2; Woolf 1988, pp. 14–15; Bellosi 1990, p. 117; Dunkerton 1991, p. 113.

Follower of Fra ANGELICO
The Annunciation
probably about 1450

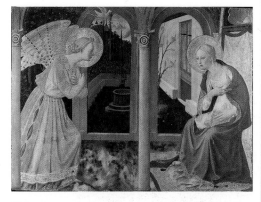

NG 1406
Tempera on wood, cut on all sides, 103.5 x 141.6 cm

The Virgin is seated at prayer in her bedchamber. The Archangel Gabriel announces that she will bear the Son of God. The dove of the Holy Spirit is seen above Gabriel. New Testament (Luke 1: 26–38). A lily in a clear glass vase (right of centre in the background) symbolises the Virgin's purity, as do the walled garden (*hortus conclusus*) and the closed gate (*porta clausa*).

On the capitals (at left and centre) are the Lanfredini arms. NG 1406 is probably the picture mentioned by Vasari (as by Fra Angelico) in S. Francesco fuor della Porta a S. Miniato, Florence (usually called S. Salvatore al Monte), where a Lanfredini Chapel is recorded. Fra Angelico and his studio painted variants of this composition on numerous occasions; NG 1406 is probably the work of a close follower of the artist.

Woodburn collection by 1860; bought, 1894.

Davies 1961, pp. 34–5; Pope-Hennessy 1974, p. 194.

ANTONELLO da Messina
Christ Blessing
apparently dated 1465

ANTONELLO da Messina
Christ Crucified
1475

ANTONELLO da Messina
Portrait of a Man
about 1475

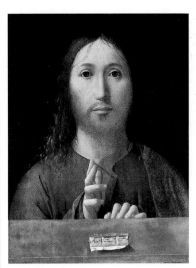

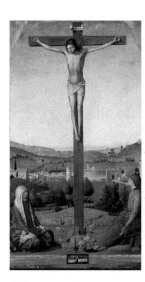

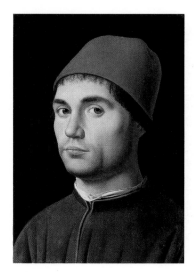

NG 673
Oil (identified) on wood, painted surface 38.7 x 29.8 cm

Inscribed on a cartellino on the ledge: Millesimo quatricentessimo sexstage/simo quinto viije Indi(ctionis) antonellus/ messaneus me pinxit. (In the year 1465 of the eighth indiction Antonello da Messina painted me.)

Christ's gesture of blessing was altered by Antonello to make the hand more foreshortened, thus demonstrating his skill as well as increasing the drama. This change is now evident on the surface and is clear in infra-red photographs.

The date given in the inscription has usually been taken as 1465, but the meaning of 'indiction' here has been the matter of much debate, and a date in the 1470s has recently been proposed.

Private collection, Genoa, by 1861 (apparently from Naples in the 1840s); bought, 1861.

Davies 1961, pp. 38–9; Previtali 1980, pp. 27–34; Howell Jolly 1982, pp. 129, 155, 161, 163, 176–9, 187; Sricchia Santoro 1986, p. 162; Dunkerton 1991, p. 197.

NG 1166
Oil on wood, painted surface, excluding addition with signature, 41.9 x 25.4 cm

Inscribed on a cartellino (retouched) below the cross: 1475/ Antonellus Messaneus / me pinxit.

Christ is shown on the cross at his Crucifixion. The Virgin Mary and Saint John the Evangelist are on either side. The minute figures in the landscape background – one of whom holds a ladder – are perhaps coming to remove Christ's body.

Another version of the composition – also dated 1475 – is in Antwerp (Musée des Beaux-Arts). Antonello was in Venice in this year.

The rectangular addition to the centre of the lower edge of the painting (which includes the signature) may originally have formed part of the frame.

Collection of the 2nd Marquess of Bute by 1848; bought, 1884.

Davies 1961, pp. 39–40; Sricchia Santoro 1986, p. 165.

NG 1141
Oil on poplar, painted surface 35.6 x 25.4 cm

Once described as a self portrait (perhaps as a result of the mis-reading of an inscription that is said to have been at the bottom of the picture), the sitter in NG 1141 has not been identified.

It was probably painted in about 1475; the tradition that it is a self portrait may favour the identification of the picture with that described in the Canonici collection in 1632.

X-radiographs reveal that the eyes were first painted turned the other way, and this (as well as Antonello's normal portrait practice) would make it unlikely that NG 1141 is a self portrait.

Possibly Roberto Canonici collection, Ferrara, by 1632; Molfino collection, Genoa, by 1871; bought (Lewis Fund), 1883.

Davies 1961, p. 39; Wright 1980, pp. 41–60; Howell Jolly 1982, pp. 65, 179; Sricchia Santoro 1986, p. 165.

ANTONELLO da Messina
active 1456; died 1479

Possibly trained in Naples (where he might have known Netherlandish artists and their paintings in oil) Antonello was a leading painter in Sicily. He visited Venice in 1475–6 where he painted an altarpiece for S. Cassiano (Vienna, Kunsthistorisches Museum) and probably small collectors' pieces and portraits which were much esteemed.

ANTONELLO da Messina
Saint Jerome in his Study
about 1475

NG 1418
Oil (identified) on lime, 45.7 x 36.2 cm

Saint Jerome (about 342–420), who translated the Bible into Latin from the original Greek and Hebrew, is shown reading in his study. He is surrounded by books, an inkwell and a crucifix. Jerome's traditional attribute of a lion (from whose paw, according to legend, the saint had removed a thorn) is seen in the shadows on the right, and there are also a cat, a peacock (often a symbol of immortality) and a partridge (perhaps an allusion to the truth of Christ).

NG 1418 is now accepted as the work of Antonello da Messina, and generally dated about 1475. Even in the early sixteenth century the attribution of this picture was disputed – some considering it to be partly by Jacometto and others regarding it as Netherlandish.

NG 1418 is an extraordinary imitation of a Netherlandish style and subject (Jerome had not normally been represented in his study in Italy) by an Italian artist of the fifteenth century. To a sophisticated pattern of linear perspective the artist has added the depiction of light entering the room from in front (where we stand) and behind.

Collection of Antonio Pasqualino, Venice, by 1529; collection of Thomas Baring by 1835; bought by William Coningham, 1848; bought from the Earl of Northbrook, 1894.

Davies 1961, pp. 40–1; Fletcher 1981, p. 453; Howell Jolly 1982, pp. 152–259; Howell Jolly 1982a, pp. 27–9; Dunkerton 1991, p. 318; Haskell 1991, pp. 678, 680.

Attributed to ANTONELLO
The Virgin and Child
probably about 1460–70

NG 2618
Oil on wood, painted surface 43.2 x 34.3 cm

The Virgin Mary is shown not only as the mother of Christ but as the Queen of Heaven, with two angels holding an ornate crown over her head. Christ holds a pomegranate, a symbol of the Passion.

Previously catalogued as by a follower of Antonello, NG 2618 was probably made in the 1460s when Antonello was working in Sicily (he is documented in Messina every year from 1460 to 1465). It probably served for private devotion. The attribution to the artist can be supported by comparing the geometric treatment of the features of the Virgin with the head of the Virgin in the documented S. Gregorio Altarpiece of 1473 (Messina, Museo Regionale).

Collection of George Salting by 1904; by whom bequeathed, 1910.

Davies 1961, p. 41; Howell Jolly 1982, pp. 167, 186, 191; Sricchia Santoro 1986, p. 156; Dunkerton 1991, p. 46.

Attributed to APOLLONIO di Giovanni and Workshop
Cassone with a Tournament Scene
probably about 1455–65

NG 4906
Carved and gilded wood, painted surface of the main panel 38.1 x 130.2 cm

Inscribed in Latin and Italian on shields and other heraldic devices: LIBERTAS (Liberty) and P[ER] NON FALIRE (So as not to fail).

Tournaments, such as the one depicted on the front of this *cassone*, were frequently held to celebrate weddings between great families. This tournament may be taking place in the Piazza S. Croce, Florence. On the painted panels at the ends of the *cassone* are armoured figures with footmen.

Among the coats of arms and heraldic devices on NG 4906 are those of the Spinelli and perhaps the Tanagli families. The painting must date from the second half of the fifteenth century. The chest has been heavily restored. The main panel has been associated with the Master of the Jarves Cassoni, and with the workshop of Marco del Buono (1402?–89?) and Apollonio di Giovanni. Attribution to the latter is likely and a date of about 1455–65 is probable.

Bequeathed by Sir Henry Bernhard Samuelson, Bt, in memory of his father, 1937.

Davies 1961, pp. 192–4; Callmann 1974, p. 63; Dunkerton 1991, p. 110.

APOLLONIO di Giovanni
1415/17–1465

Apollonio di Giovanni was recorded by 1446 as head of a Florentine workshop which specialised in paintings for *cassoni* and other such furniture. He worked in partnership with Marco del Buono Giamberti, whose son, also a painter, became Apollonio's heir. Apollonio was also active as a painter of miniatures. His mature work displays the influence of Domenico Veneziano.

Arent ARENTSZ.
Fishermen near Muiden Castle
about 1630

Gioacchino ASSERETO
The Angel appearing to Hagar and Ishmael
about 1640

AUGSBURG, Unknown artist
Portrait of a Man
about 1530

NG 3533
Oil on oak, 23.3 x 38.8 cm

L596
Oil on canvas, 119 x 167 cm

NG 2604
Oil on poplar, 38.1 x 28.3 cm

Signed at the left on the bridge: AA (in monogram).
 The castle of Muiden, which is here seen from the west, is seven and a half miles east of Amsterdam. (For another view of Muiden, see Beerstraaten NG 1311.)
 Arentsz. used the figure of the fisherman on the left, in reverse, in another landscape (formerly Amsterdam, Wetzlar collection).

Possibly in the Simon Fokke sale, Amsterdam, 1784; presented by Dr J. Seymour Maynard through the NACF, 1920.

MacLaren/Brown 1991, pp. 2–3.

Hagar was the Egyptian servant of Sara, Abraham's wife. Abraham had a child, Ishmael, by Hagar, and when Sara miraculously gave birth to Isaac, she asked Abraham to banish Hagar and her son. Abraham duly sent them into the wilderness. Their supplies ran out and Hagar sat down and turned away from Ishmael so as not to see him die. An angel appeared and told her not to be afraid and to pick up her child who would become father of a great nation (the Ishmaelites). She then saw a source of water from which she could fill her water bottle. Old Testament (Genesis 16: 1–16; 21: 1–21).
 L596 was probably painted in the 1640s, and is later than Assereto's version of the subject in Genoa (Palazzo Rosso).

Bought by (Sir) Denis Mahon, 1950; on loan since 1992.

Newcome 1992, p. 84; National Gallery Report 1992–3, pp. 24–5.

NG 2604 has in the past been variously attributed to Amberger, Niklaus Manuel Deutsch and the Nuremberg School. It has been extensively repainted.

Said to have been from the Leyland collection; bought by George Salting, 1893; Salting Bequest, 1910.

Davies 1959, p. 7.

Arent ARENTSZ.
1585/6–1631

Arentsz., who was born and worked in Amsterdam, was also known as Cabel, after the name of his family house in the city. He painted landscapes with figures of peasants, fisherman or hunters prominent in the foreground. His work is dependent on that of Hendrick Avercamp. His earliest dated painting is of 1629.

Gioacchino ASSERETO
1600–1649

Assereto was born in Genoa. In 1639 he went to Rome for a brief period and his subsequent works show that he was much impressed by the painting of Caravaggio and his followers. His pictures are characterised by vibrant light effects and dramatic compositions. He died in Genoa.

AUSTRIAN
The Trinity with Christ Crucified
about 1410

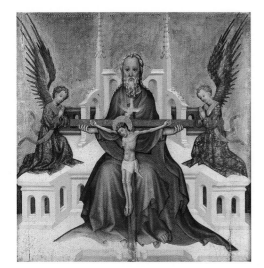

NG 3662
Egg (identified) on silver fir, painted surface
118.1 x 114.9 cm

NG 3662 shows the Trinity, with God the Father seated supporting the crucified Christ, and the dove of the Holy Ghost between them. This type of image is known as the Throne of Mercy (*gnadenstuhl*).

The picture was originally the central panel of an altarpiece protected by two shutters; the marks of their hinges are visible in the frame. The top and the sides of the frame are original, but the bottom is modern. The panel may have been cut at the bottom. The reverse is painted with a pattern of green leaves on a white ground. Four panels at Schloss Rastenberg may be the original shutters. They show Saint Lawrence, Saint Stephen (?), the Virgin and Child, and a nun saint. A date of about 1410 has been suggested.

A Swiss customs stamp is on the reverse; bought with a contribution from the NACF, 1922.

Levey 1959, pp. 7–9; Dunkerton 1991, p. 30.

Hendrick AVERCAMP
A Winter Scene with Skaters near a Castle
about 1608/9

NG 1346
Oil on oak, diameter 40.7 cm

Signed centre bottom: HA (in monogram).
The castle is an invention of the artist. On the back of the carved and gilt sledge at the right is a lion rampant, which is also on the side. The barrel at the centre in the middle distance is marked with a crescent and a star.

A very similar composition, treated in a closely related manner with skaters in comparable costumes, can be seen in an early winter landscape of 1608 (Bergen, Billedgalleri). NG 1346 is also an early work and should be dated about 1608/9.

Edward Habich collection, Cassel, by 1881; from whom bought, 1891.

MacLaren/Brown 1991, pp. 3–4.

Hendrick AVERCAMP
A Scene on the Ice near a Town
about 1615

NG 1479
Oil on oak, 58 x 89.8 cm

Signed centre foreground: HA (in monogram).
Several figures in the distance play *kolf*, an early form of golf. The sleigh at the left is decorated with figures and a horseman. It has been suggested that the building at the right is The Half Moon brewery in Kampen, but there are only a few barrels to suggest such a use, and the town on the horizon, rather than looking like Kampen, appears reminiscent of Rhenen.

NG 1479 is thought to date from about 1615.

Bought from J. St Hensé of Bradford (Lewis Fund), 1896.

MacLaren/Brown 1991, pp. 4–5.

Hendrick AVERCAMP
1585–1634

Hendrick Barentsz. Avercamp, known as 'de stom van Campen' (the Mute of Kampen) because he was dumb, worked in Kampen for most of his career, but had been born in Amsterdam. He mainly painted winter scenes, and probably trained in the studio of Pieter Isaacsz. whose style was based on that of Pieter Breugel the Elder. Arent Arentsz. was a close follower, as was his nephew Barent Avercamp.

BACCHIACCA

Joseph receives his Brothers on their Second Visit to Egypt, probably 1515

BACCHIACCA

Joseph pardons his Brothers
probably 1515

Attributed to BACCHIACCA

Marcus Curtius
probably about 1520–30

NG 1218
Oil on wood, 36.2 x 142.2 cm

NG 1219
Oil (identified) on wood, 36.2 x 141.6 cm

NG 1304
Oil on wood, painted surface 25.4 x 19.4 cm

Three scenes are represented. On the left, Joseph's brothers – on their second visit to Joseph having been sent away on the first – are shown bringing him presents from Jacob (his father, who thought Joseph was dead). In the centre, they present the gifts to Joseph, who demands news of his father. On the right, the brothers leave for home with their sacks full of grain; unknown to them Joseph's silver cup has been hidden in Benjamin's sack (Benjamin is in blue, and the outline of the cup can be seen below his hand). Old Testament (Genesis 43: 15, 26; 44: 3).

NG 1218 and 1219 were painted as part of the decoration of the bedroom of Pierfrancesco Borgherini, who was married in 1515; see further under Pontormo NG 6453 and for a larger reproduction see Appendix B.

A partial cartoon and a study for NG 1218 survive (Oxford, Christchurch Picture Gallery; Vienna, Albertina).

Painted for Pierfrancesco Borgherini and in the Borgherini palace, Florence, until about 1584; bought by the Revd John Sanford, 1834; bought from the collection of Lord Methuen, 1886.

Gould 1975, pp. 8–9, 199–201; Braham 1979, pp. 754–65.

The brothers are seen on the left being escorted back to Joseph after his silver cup had been discovered in Benjamin's sack (Benjamin is bound as a prisoner). On the right, they beg for Joseph's mercy. Old Testament (Genesis 44: 12–15).

NG 1218 and 1219 were painted as part of the decoration of the bedroom of Pierfrancesco Borgherini, who was married in 1515; see further under Pontormo NG 6453 and for a larger reproduction see Appendix B.

A cartoon and two studies for NG 1219 survive (Paris, Louvre; Florence, Uffizi; Vienna, Albertina).

Painted for Pierfrancesco Borgherini and in the Borgherini palace, Florence, until about 1584; bought by the Revd John Sanford, 1834; bought from the collection of Lord Methuen, 1886.

Gould 1975, pp. 8–9, 199–201; Braham 1979, pp. 754–65.

According to Livy's *History of Rome* (VII, 6), a great chasm opened in the centre of Rome and could be closed only by throwing in the city's greatest treasure. Marcus Curtius sacrificed himself by plunging on horseback into the chasm to save the city (on the grounds that the Romans were Rome's greatest asset).

NG 1304 has been attributed to Bacchiacca on stylistic grounds; a date of about 1520–30 seems probable.

Possibly identifiable as the 'piccolo con Quinto Curcio a cavallo che salta nella voragine' in the ducal collections at Mantua, 1627; bought with the Edmond Beaucousin collection, Paris, 1860.

Gould 1975, pp. 9–10.

BACCHIACCA

1495–1557

His real name was Francesco d'Ubertino. Vasari – who presumably knew Bacchiacca – claimed that he was a pupil of Perugino and a friend of Andrea del Sarto. Bacchiacca worked with Sarto, Pontormo and Sogliani and was one of the second rank of Florentine artists of the early sixteenth century.

Sisto BADALOCCHIO
Christ carried to the Tomb
after 1609

Ludolf BAKHUIZEN
A Beach Scene with Fishermen
about 1665

Ludolf BAKHUIZEN
A View across a River near Dordrecht (?)
about 1665

NG 818
Oil on oak, 34.2 x 48.5 cm

NG 1000
Oil on oak, 34.1 x 47.8 cm

NG 86
Oil on copper, 43.7 x 33.6 cm

This event, which is not described in the Gospels, takes place after the Lamentation over the dead Christ at the foot of the cross, and before his Entombment.

NG 86 has in the past been attributed to Ludovico Carracci, but is now thought likely to be an autograph work by Badalocchio, perhaps based upon a Ludovico Carracci prototype. Several versions of the subject, analogous in composition and associated with Badalocchio, survive (e.g. the autograph painting, Rome, Patrizi collection; see also a variant composition, London, Dulwich Picture Gallery).

Anon. (W.Y. Ottley) sale, London, 1801; bequeathed by Lt.-Col. J.H. Ollney, 1837.

Levey 1971, pp. 7–8.

Signed bottom left: L.B.
NG 818 is a relatively early work by Bakhuizen and shows the influence of Hendrick Dubbels. It was probably painted in the mid-1660s.

Collection of Willem Lormier, The Hague, by 1763; collection of J.-B.-P. Le Brun, Paris, by 1785; bought with the Peel collection, 1871.

MacLaren/Brown 1991, p. 8.

The vessel on the right is a *snaauwschip* (a square-rigged two masted vessel usually employed as a despatch vessel; in English, a snow) flying a blue ensign with a coat of arms. In the middle distance is a man-of-war with its sails furled and under Dutch colours. The town on the horizon seems to be Dordrecht, with the Grote Kerk on the left and, towards the right, the Groothoofdspoort.

NG 1000 was probably painted in the mid-1660s, and almost certainly before about 1692–4 when the spire of the Groothoofdspoort was replaced by a dome (as seen in Calraet NG 3024, and Attributed to Willem van Drielenburgh NG 960).

Collection of William Wells, Redleaf, by 1832; Wynn Ellis Bequest, 1876.

MacLaren/Brown 1991, p. 9.

Sisto BADALOCCHIO
1585–after 1621?

Sisto Rosa (called Badalocchi or Badalocchio) was born in Parma. He travelled to Rome with Lanfranco, and in 1607 they published there a book of engravings after Raphael, dedicated to their master, Annibale Carracci. Badalocchio is documented as being at Reggio in 1613.

Ludolf BAKHUIZEN
1630/1–1708

Born in Emden, Bakhuizen (also Backhuizen) settled in Amsterdam in about 1650. He trained with Allart van Everdingen and Hendrick Dubbels and specialised in seascapes, usually with rough water. He was patronised by Peter the Great and other princes, and after the van de Veldes left for England in 1672 Bakhuizen was the leading marine painter in Holland.

Ludolf BAKHUIZEN
The Eendracht and a Fleet of Dutch Men-of-war
about 1670–5

Ludolf BAKHUIZEN
Dutch Men-of-war entering a Mediterranean Port
1681

Ludolf BAKHUIZEN
Dutch Men-of-war and Small Vessels in a Fresh Breeze off Enkhuizen, 1683

NG 223
Oil on canvas, 75.5 x 105.5 cm

NG 1050
Oil on canvas, 118.5 x 163 cm

NG 204
Oil on canvas, 100.5 x 136.5 cm

Inscribed on the stern of the main vessel: EEND[R]ACHT (Union).

The main vessel in the centre is the *Eendracht* with the lion of the United Provinces on her stern, and flying the Dutch ensign and the flag and pennant of the commander-in-chief. Numerous other warships are visible.

The *Eendracht*, built in 1653, was the 76-gun flagship of Lieutenant-Admiral Jacob van Wassenaer van Obdam. She was blown up, with the loss of her crew and the admiral, at the battle of Lowestoft in 1665, which was an English victory. The rendering of the ship is not accurate in all details. NG 223 was probably painted from memory in the early 1670s.

Collection of Lady Holland by 1826; Bredel Bequest, 1851.

MacLaren/Brown 1991, pp. 6–7.

Signed on the man-of-war on the left: L Back[huizen] f[eci]t. Dated on a floating spar bottom right: 1681

The man-of-war on the left flies Dutch colours and has the arms of Amsterdam on her stern. Another man-of-war in the right middle distance carries the flag of the States-General and a plain red ensign. Other small vessels are visible and fly Dutch colours. The view is probably imaginary, but the galleys show that a Mediterranean scene is intended.

Collection of Edward Solly by 1837; Miss Sarah Solly Bequest, 1879.

MacLaren/Brown 1991, pp. 9–10.

Signed and dated on the small vessel in the left foreground: 1683 L Bakhuizen. Signed a second time with initials on the stern of the yacht on the right: L B.

Two men-of-war with Dutch ensigns are seen in the right middle distance. The nearer has the arms of Amsterdam on her stern and is firing a salute. A number of other vessels are identifiable, and the town of Enkhuizen is visible in the centre distance. Enkhuizen is seen from the south-east, surrounded by its sea wall.

In the possession of John Smith by 1822; Richard Simmons Bequest, 1846.

MacLaren/Brown 1991, p. 6.

Ludolf BAKHUIZEN
An English Vessel and a Man-of-war in a Rough Sea off a Coast with Tall Cliffs, probably 1680s

NG 819
Oil on canvas, 98.5 x 132 cm

Alesso BALDOVINETTI
Portrait of a Lady in Yellow
probably 1465

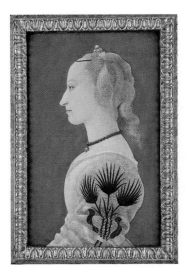

NG 758
Tempera and oil on wood, 62.9 x 40.6 cm

Hans BALDUNG Grien
The Trinity and Mystic Pietà
1512

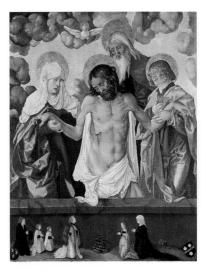

NG 1427
Oil on oak, 112.3 x 89.1 cm

The two-masted vessel in the centre foreground has the English ensign and flies a St George's cross. In the left middle distance is a man-of-war flying the Union flag and a St George's cross.

NG 819 was probably painted in the 1680s. There is a preparatory drawing in the Royal Collection.

The old identifications of NG 819 as a view off Deal and as the mouth of the river Thames are incorrect; the coastline is almost certainly imaginary and differs from that shown in the preparatory drawing.

Lafontaine collection by 1824; in the collection of Sir Robert Peel, Bt, by 1835; bought with the Peel collection, 1871.

MacLaren/Brown 1991, pp. 8–9.

The sitter is unknown but the device of the three palm leaves stitched upon her sleeve presumably indicates her family or that of her betrothed – a connection with the Palma family of Urbino seems possible.

NG 758 was purchased as by Piero della Francesca. The attribution to Baldovinetti has long been accepted.

The frame is original but has been regilded.

Said to have been owned by Conte Pancrazi, Ascoli Piceno; bought from Egidi, a dealer in Florence, 1866.

Davies 1961, pp. 42–3; Dunkerton 1991, p. 92, p. 100.

Signed and dated along the parapet of the tomb: .HBG. (in monogram) BALDVNG 1512

This is an unusual conflation of different subjects – The Trinity with Christ Crucified (the Holy Ghost, represented by the dove, God the Father, and Christ) (see Austrian School NG 3662), and the Lamentation over Christ in the tomb with the Virgin and Saint John. Below the edge of the tomb are the donor family and, in the corners, two coats of arms. The left one has been identified as that of the Bettschold family from Strasbourg; the other may be that of the Heilmann family.

The dress of the donor at the left suggests that he was a canon, presumably from the Bettschold family. Three members of the family were canons of St Pierre-le-Vieux in Strasbourg. It seems likely therefore that NG 1427 was painted for this church.

Collection of Dr Richard Farmer, Cambridge, by 1777; bought from Sir George Donaldson (Lewis Fund), 1894.

Levey 1959, pp. 12–14.

Alesso BALDOVINETTI
about 1426–1499

Baldovinetti, as well as being a painter on panel and in fresco, designed mosaics and stained glass. He joined the Compagnia di S. Luca in Florence in 1448 or 1449. His work displays the influence of Domenico Veneziano, Fra Angelico and Andrea dal Castagno, among others.

Hans BALDUNG Grien
1484/5–1545

Baldung's family came from Swabia. He may have trained (before 1505) in Dürer's workshop in Nuremberg. He is recorded in Strasbourg from 1508, and worked for the Baden court from 1510 to 1511. There are a number of signed and dated pictures by him from 1507 onwards; as well as painting he designed stained glass and was a printmaker.

Hans BALDUNG Grien
Portrait of a Man
1514

Hendrick van BALEN the Elder and a follower of Jan BRUEGHEL the Elder
Pan pursuing Syrinx, possibly after 1615

Jacopo de' BARBARI
A Sparrowhawk
1510s

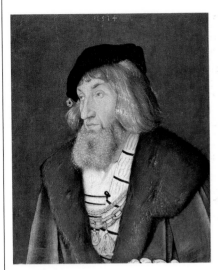

NG 245
Oil on lime, 59.3 x 48.9 cm

NG 659
Oil on copper, 25 x 19.4 cm

NG 3088
Oil on oak, 17.8 x 10.8 cm

Dated top centre: 1514.

It is not known who the sitter is, but the insignia hanging from the gold chain around his neck have been identified. The Virgin and Child badge is part of the insignia of the religious confraternity of Our Lady of the Swan which was founded in 1440. Noblemen and women could be admitted to the order and membership could be inherited. The other badge appears to be that of the Swabian Fish and Falcon jousting company.

When the painting was cleaned in 1957 a false Dürer monogram was removed.

Bought at the E. Joly de Bammeville sale, London, 1854.

Levey 1959, pp. 10–12; Smith 1985, p. 86.

Pan chased the nymph Syrinx through Arcadia. When she came to the river Ladon she could flee no further; her prayer for escape was answered as she was transformed into reeds, from which Pan subsequently made the pan pipes. Ovid, *Metamorphoses* (I, 689–713).

NG 659 is thought to be a work in which Hendrick van Balen the Elder painted the figures, and the landscape was executed by a follower of Jan Brueghel the Elder. The composition was probably inspired by a print of *Pan and Syrinx* by Hendrick Goltzius.

Possibly Jan François d'Orvielle sale, Antwerp, 1741; bought with the Edmond Beaucousin collection, Paris, 1860.

Martin 1970, pp. 9–11.

The bird is thought to be a female sparrowhawk. The panel is painted up to the edges all around; it may have been cut from a larger picture.

The back of a former frame was inscribed in the nineteenth century: *Grif d'Anversa. Jacopo de Barbaris* (Antwerp falcon [or hawk]. Jacopo de' Barbari). The *Grif d'Anversa* prompted an attribution to an artist called Adriaen Gryef who was active about 1700. This is now rejected in favour of one to Barbari which is generally agreed upon. The only comparable surviving painting by the artist is one of the earliest independent still lifes in modern European art, his *Dead Bird* (Munich, Alte Pinakothek).

Count Castellani collection, Turin, by 1859; Layard Bequest, 1916.

Davies 1961, pp. 43–4.

Hendrick van BALEN the Elder
1575?–1632

Balen, who was a figure painter, was born in Antwerp, where, according to van Mander, he was taught by Adam van Noort. He entered the Antwerp guild of St Luke in 1592/3 and then probably travelled to Italy. The artist became dean of the guild in 1609. Van Dyck was one of his many pupils.

Jacopo de' BARBARI
active 1500; died 1516?

Jacopo de' Barbari is referred to as Venetian, but little is known of his early activity. He was appointed painter to the Emperor Maximilian in Nuremberg in 1500, and subsequently worked at various German courts and in the Netherlands in the service of Margaret of Austria. He was an influential printmaker as well as a painter.

BARNABA da Modena
Pentecost
about 1360–83

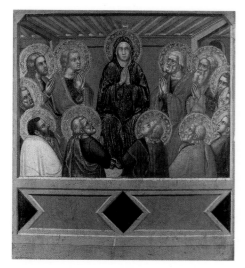

NG 1437
Tempera on wood, 54.5 x 50.2 cm

The Virgin Mary and the twelve apostles are gathered together sometime after Christ's Ascension into Heaven. They are shown with their hands joined in prayer, and they receive the Holy Spirit, which descends as a dove and grants them the power to speak 'in tongues', that is, preach the Gospel to people of all nations in their native languages. New Testament (Acts 2: 1–4).

NG 1437 was probably part of a composite picture, which may have included an *Ascension* (Rome, Capitoline Museum). A *Nativity* and a *Flight into Egypt* (both Bologna, Pinacoteca Nazionale) have also been associated with these two pictures, but the connection appears unlikely as the Bolognese pictures are significantly smaller.

Collection of Charles Simpson by 1895; from whom bought, 1895.

Gordon 1988, pp. 6–7.

BARNABA da Modena
The Coronation of the Virgin; The Trinity; The Virgin and Child; The Crucifixion, 1374

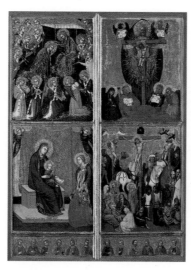

NG 2927
Tempera on poplar, 82 x 60.5 cm

Inscribed bottom left on the Virgin's halo: AVE. [MARIA] GRATIA. PLEN[A] (Hail [Mary], full of Grace); and on Raphael's halo: SANCTUS: RAFAELIS. (Saint Raphael). The crosses seen in the top and bottom right are inscribed: INRI. Signed and dated bottom left: barnabas. de mutina pinxit. 1374 (Barnaba da Modena painted this in 1374).

Top left: the Coronation of the Virgin. Top right: the Trinity with Christ on the cross supported by God the Father, and the Holy Ghost as a dove; at the corners of the cross the symbols of the four evangelists (eagle, John; man, Matthew; ox, Luke; lion, Mark); the Virgin and Saint John are at the foot of the cross. Bottom left: the Virgin and Child with Saint Raphael presenting two donors (see below). Bottom right: the Crucifixion with angels carrying off the soul of the good thief and devils that of the bad thief, the Magdalen, the fainting Virgin attended by the Holy Women and Saint John. The predella: the twelve apostles.

The donors were once identified as Doge Domenico Fregoso of Genoa and his wife. However it seems more probable that they are Juana Manuel (1335–81) and her father Don Juan Manuel. Barnaba painted two large altarpieces which were sent to the Manuel Chapel in Murcia Cathedral (Spain).

Now framed as a single panel, NG 2927 may originally have formed two wings of a diptych.

Collection of Séroux d'Agincourt by about 1785; presented by the Countess of Carlisle, 1913.

Gordon 1988, pp. 7–9.

Federico BAROCCI
The Madonna and Child with Saint Joseph and the Infant Baptist (La Madonna del Gatto)
probably about 1575

NG 29
Oil on canvas, 112.7 x 92.7 cm

The young John the Baptist holds a goldfinch, a bird frequently kept as a pet but also a traditional symbol of Christ's Passion; the Baptist is teasing the cat shown in the left foreground by holding the bird above his head. The Virgin is suckling the Child and Saint Joseph looks on from the right.

NG 29 may be the picture painted, according to Bellori (1672), for Count Antonio Brancaleoni, who lived near Perugia. The design was engraved in reverse in 1577 by Cornelius Cort and the painting probably dates from about 1575. Numerous drawings made in preparation for NG 29 are known; a highly finished drawing made by Barocci in preparation for the engraving and formerly in the National Gallery is now in the British Museum.

The window and the bench in the background seem to be based on windows in the Palazzo Ducale, Urbino. There are several copies and workshop versions of the picture.

Cesarei collection, Perugia, by 1784; acquired in Italy by Buchanan, about 1805; collection of Revd Holwell Carr, 1807; by whom bequeathed, 1831.

Gould 1975, pp. 11–12; Emiliani 1985, I, pp. 93–103.

BARNABA da Modena
active 1361–1383

Barnaba came from a Milanese family that had settled in Modena. He was principally active in Genoa, where he was recorded from 1361 to 1383. He painted frescoes and panels of the Virgin and Child, and was influenced by Bolognese and Sienese artists. He also worked in Pisa.

Federico BAROCCI
1535–1612

Barocci was in Rome in 1560/3, and thereafter he worked in his native Urbino, only occasionally travelling to other cities. He mainly painted altarpieces. These were sent to all parts of Italy, and he was probably the most admired painter in Italy in the late sixteenth century.

Fra BARTOLOMMEO
The Virgin adoring the Child with Saint Joseph
before 1511

Attributed to Fra BARTOLOMMEO
Costanza Caetani
probably about 1480–90

Attributed to Fra BARTOLOMMEO
The Madonna and Child with Saint John
perhaps about 1516

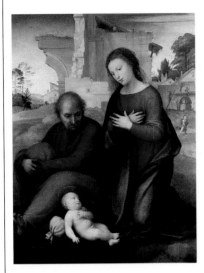

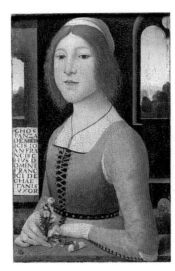

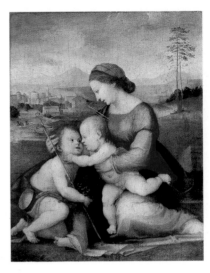

NG 3914
Oil on wood, 137.8 x 104.8 cm

NG 2490
Tempera and oil on wood,
painted surface 57.2 x 37.5 cm

NG 1694
Oil on canvas, transferred from wood
88.3 x 71.1 cm

The ruins behind the Virgin and Child and Saint Joseph symbolise the old order which Christ will replace. Saint John the Baptist appears in the right background, where painters are depicted at work frescoing the wall above the archway. In the left background figures are seen by a building with a sign of the Lamb and Flag, emblems respectively of Saint John and of the city of Florence.

NG 3914 can probably be dated before 1511, at a time when Fra Bartolommeo was working with Mariotto Albertinelli (1475–1515). A version of NG 3914 by Albertinelli (Rome, Borghese Gallery), dated 1511, is probably based on Fra Bartolommeo's cartoon.

There is a drawing for the figures by Fra Bartolommeo (Paris, Louvre) and some others by him which may be preparatory for the composition.

Collection of Sir Richard Colt Hoare by 1822 (probably by 1800); Mond collection, 1885; Mond Bequest, 1924.

Gould 1975, pp. 13–14.

Inscribed on the left: .GHOS/TANZA / DEMED/ICIS IO/ANFRA/NCISC/HVS D/OMINI / FRANC/ICI DE / GHAE/TANIS / VXOR. (Costanza de' Medici, wife of Giovanni Francesco di Ser Francesco de' Caetani.)

According to her father's tax returns, Costanza de' Medici was born in about 1469. She was recorded in Florence in 1489 and 1507. Her husband (Giovanni Francesco Caetani) is known to have died by 1530. The exact date of their marriage is not known.

NG 2490 may have been painted on the occasion of the sitter's marriage. Her rings are conspicuous in the foreground, and the needles may allude to another aspect of married life. If the pet in the right background is a dog it may have been included to suggest fidelity. NG 2490 has previously been attributed to Domenico Ghirlandaio, or to an artist painting in his style. Recently an attribution to the young Fra Bartolommeo – at the time of his association with Domenico Ghirlandaio – has been proposed. This suggestion would necessitate a date nearer to 1490.

The portrait is in its original frame.

Bought by Bardini from the Biondi collection at the castle of Castelfalfi (once owned by Giovanni Francesco Caetani), about 1890; apparently in the collection of Sir George Donaldson, 1894; collection of George Salting by 1895; Salting Bequest, 1910.

Davies 1961, pp. 223–4; Fahy 1969, p. 150.

The Virgin and Child with the young Saint John was a popular subject in Florence. The motif of the two children embracing derives from a design by Leonardo.

Numerous variants of the composition of NG 1694 are known. They are more or less closely related to Fra Bartolommeo and two of them are signed by him and dated 1516. The fact that the Virgin's hand was changed on the panel may support the attribution to Fra Bartolommeo himself, but the condition of NG 1694 is very poor and makes authorship hard to judge.

Two drawings related to this composition – though not necessarily by Fra Bartolommeo – are in the Uffizi, Florence.

Collection of Cav. Nicola Landolfi, Rome, by 1900; bought (Lewis Fund), 1900.

Gould 1975, pp. 14–15.

Fra BARTOLOMMEO
1472?–1517

Bartolommeo di Paolo del Fattorino, known as Baccio della Porta or Fra Bartolommeo, trained as a painter with Cosimo Rosselli, and also collaborated with Domenico Ghirlandaio. Influenced by Savonarola, he became a Dominican novice (1500–4). He sometimes worked in partnership with Mariotto Albertinelli. Fra Bartolommeo was much influenced by Leonardo, and later by Giovanni Bellini and by Raphael, and was a pioneer in the study of landscape.

BARTOLOMMEO Veneto
Portrait of a Lady
early 16th century

BARTOLOMMEO Veneto
Portrait of Ludovico Martinengo
probably 1546

Antoine-Louis BARYE
The Forest of Fontainebleau
1820–75

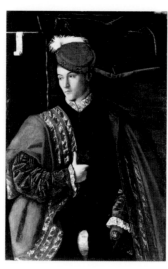

NG 3233
Oil on canvas, 29.8 x 38.1 cm

NG 2507
Oil on wood, 55.9 x 43.8 cm

NG 287
Oil on wood, 105.4 x 71.1 cm

One of the beads worn by the lady is inscribed: SAP.

The beads the lady wears are ornamented with the emblems of the Passion.

The costume suggests that NG 2507 can be dated to the early years of the sixteenth century. It resembles costumes in frescoes in the Palazzo Costabili, Ferrara; this association may suggest a Ferrarese origin for the picture. The differences in style between this portrait and some of the artist's other portraits implies that NG 2507 may be one of his relatively early works.

From the collection of Conte Alessandro Castellani; Salting Bequest 1910.

Gould 1975, pp. 17–18.

Inscribed on the cartellino, restored (but still fragmentary): LVDOVI/ CVM MARTI/ -TATIS/ SV AE/ ANN-/ BARTOL-M/ VENETVS/ FACIEBAT/ M.D XXX/ XVI I (or Z) VN (which when completed translates: Ludovico Martinengo, aged -, Bartolommeo Veneto made this June 1546).

Ludovico Martinengo came from a noble family of Brescia. The provenance supports the identification of the sitter.

The fragmentary inscription has been thought in the past to give the date 16 June 1530. But the costume is of later date, and this would suggest that the date ought to be read as MDXXXXVI spread over two lines (i.e. 1546).

Bought in Venice from representatives of Conte Girolamo Michiel Pisani, heir of Conte Girolamo Martinengo, 1855.

Gould 1975, pp. 16–17.

Signed (or stamped?): BARYE.

From about 1840 Barye associated with the artists working around Barbizon and the Forest of Fontainebleau. He produced numerous paintings and drawings of this area which are often close in style to the work of Théodore Rousseau and Diaz. The attribution of this painting to Barye seems secure and it may represent rocks at the Gorges d'Apremont, a favourite motif near Barbizon.

Sir Hugh Lane Bequest, 1917; on loan to the Hugh Lane Municipal Gallery of Modern Art, Dublin, since 1979.

Davies 1970, p. 10.

BARTOLOMMEO Veneto
active 1502–1546

A number of signed paintings by this artist are known – the earliest are religious pictures in imitation of Giovanni Bellini, the later works are all fashionable portraits. The painter may possibly be identified as an artist who worked for Lucrezia Borgia in Ferarra and elsewhere; he may also have been employed in Bergamo and Milan.

Antoine-Louis BARYE
1796–1875

Barye was born in Paris. He initially trained as an engraver under Fourier and Biennais. In 1816 he is recorded as being with the sculptor Bosio, and in the following year with the painter Gros. He is best known for his sculptures of exotic animals, but he also produced oils and watercolours, often inspired by the Forest of Fontainebleau.

Marco BASAITI
Portrait of a Young Man
about 1495–1500

Marco BASAITI
The Virgin and Child
about 1496–1505

Jacopo BASSANO
The Way to Calvary
about 1545–50

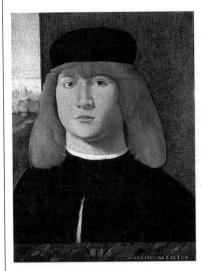

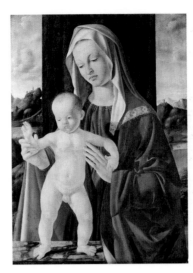

NG 2498
Oil on wood, 36.2 x 27.3 cm

NG 2499
Oil on poplar, 62.9 x 47 cm

NG 6490
Oil on canvas, 145 x 133 cm

Signed on the parapet at the bottom: . MARCHVS: BAXAITI. P[INXIT].

The youthful male sitter in this portrait has not been identified.

NG 2498 was probably painted in Venice.

Collection of Edward Cheney by 1871; collection of George Salting by 1907; Salting Bequest, 1910.

Davies 1961, p. 47.

Signed lower left (the second line is partially cut): . MARCO ./ BAXAITI . P[INXIT].

The Child Jesus stands on a parapet. He is steadied by the Virgin Mary who is seen against a cloth of honour.

NG 2499 was probably painted for private devotion.

Probably in the collection of the Baron de Beurnonville by 1881; collection of George Salting by 1894; Salting Bequest, 1910.

Davies 1961, pp. 47–8.

Christ carries his cross to Calvary, which can be seen in the landscape at the upper left. He has fallen to the ground and Saint Veronica, who kneels to the right, holds out her veil to him. According to Veronica's legend, which is not related in the Bible, she wiped Christ's face with her veil (sudarium), and his features were miraculously imprinted on it. The name Veronica means true likeness (vera ikon). Behind her are the Virgin and Saint John.

NG 6490 is dated on stylistic grounds to about 1545–50.

The composition, like several others by Bassano, was inspired by an engraving after Raphael's version of the subject (Madrid, Prado).

Gift from the States of Holland to King Charles II on his accession to the throne of England, 1660; bought from the Trustees of the Earl of Bradford (with a contribution from the National Heritage Memorial Fund), 1984.

National Gallery Report 1982–4, p. 31.

Marco BASAITI
active 1496–1530

Perhaps of Greek origin, Basaiti was probably born in Venice or Friuli. There are many paintings signed by him (mostly small religious works and altarpieces, some of them dated), and he was influenced by Cima da Conegliano, the Vivarini, and especially the later painting of Giovanni Bellini.

Jacopo BASSANO
active about 1535; died 1592

Jacopo dal Ponte was called Bassano after his native town, which was then part of the mainland dominions of Venice. He worked there throughout his life. By 1545 he was the leading painter in his region and by 1555 he enjoyed a great reputation also in Venice and beyond. He was celebrated for his painting of animals and rural life. Jacopo's sons Francesco, Leandro and Girolamo were also artists.

Jacopo BASSANO
The Good Samaritan
probably 1550–70

Jacopo BASSANO
The Purification of the Temple
probably about 1580

After Jacopo BASSANO
The Departure of Abraham
late 16th century

NG 228
Oil on canvas, 158.7 x 265 cm

NG 2148
Oil on canvas, 85.1 x 117.3 cm

NG 277
Oil on canvas, 101.5 x 79.4 cm

According to Christ's parable, a traveller was attacked by robbers and beaten senseless. A priest and a Levite both passed by without offering him help, but eventually a Samaritan stopped, as is shown here, and cared for the man, treating his wounds with oil and wine. New Testament (Luke 10: 25–38). The priest and the Levite are in the left middle distance, and the city beyond is Bassano, the artist's birthplace.

Other versions of the subject either by, or associated with, Bassano are known (e.g. London, Royal Collection, Hampton Court; Rome, Capitoline). A chalk sketch of the figures in NG 277 survives (London, Courtauld Institute).

Probably Pisani collection; Sir Joshua Reynolds sale, 1795; Dowager Marchioness of Thomond sale, 1821; bought at the Samuel Rogers sale, 1856.

Gould 1975, pp. 20–1.

Christ came to the Temple in Jerusalem and found it being used like a market place and so he cast out all the traders and money-lenders. New Testament (Matthew 21: 12–13). Left of centre, Christ can be seen driving them through the doorway. In the distance are the indignant Chief Priests and Scribes, also the blind and lame whom Christ healed.

The painting is related to several other versions, some of different format, some with the composition reversed. In many of these, collaboration with other artists in his family is certain. In this case the figure painting is very characteristic of Jacopo's late manner.

Presented by Philip L. Hinds, 1853.

Gould 1975, pp. 19–20.

Abraham, with Sarah and Lot, leaves Ur of the Chaldees for Canaan. God appears in the sky above. Old Testament (Genesis 14: 11–12).

NG 2148 is a studio version of a Bassano design of which the original is signed by both Jacopo and Francesco (Berlin, Staatliche Museen). A number of other versions of it are known.

Said to have been in the Casa Savorgnan; bought with the Galvagna collection, Venice, 1855.

Gould 1975, p. 21.

Leandro BASSANO
The Tower of Babel
after 1600

Follower of the BASSANO
The Adoration of the Shepherds
17th century

Bartholomeus van BASSEN
Interior of St Cunerakerk, Rhenen
1638

NG 60
Oil on canvas, 136.5 x 189.2 cm

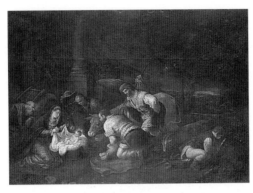

NG 1858
Oil on canvas, 64.5 x 90.1 cm

NG 3164
Oil on oak, 61.1 x 80.5 cm

Signed on the stone at the lower left: LEANDER A PONTE BASS.

The people attempted to build a tower which would reach the heavens. But God humbled their pride by confusing their language so that no one could communicate, and the building ceased. Old Testament (Genesis 11: 1–9).

The costume of the horseman at the left suggests a dating soon after 1600.

Bequeathed by Lt.-Col. J.H. Ollney, 1837.

Gould 1975, p. 22.

NG 1858 is a later derivative of a design by Jacopo Bassano which is known in several versions (the best version is probably the one in the Galleria Nazionale, Rome).

Bequeathed by Sir John May, 1847.

Gould 1975, p. 23.

Signed and dated bottom left: B:. van . Bassen . 1638
Inscribed on the tablet on the column behind two men in the left foreground: DOM
NG 3164 is a view of the west end of the St Cunerakerk, Rhenen.

The St Cunerakerk was the court chapel of the exiled Frederick V of the Palatinate, King of Bohemia, and his queen, Elizabeth Stuart. NG 3164 is one of the few of van Bassen's pictures that accurately represent an actual building (though van Bassen has made some changes and has invented some elements of the architecture and the church furniture). Despite van Bassen's changes to the church, the identification of the site can be confirmed by comparing NG 3164 with drawings made of the St Cunerakerk by Pieter Saenredam in 1644.

Collection of J.D. Ichenhauser by 1910; presented by F.A. White through the NACF, 1917.

MacLaren/Brown 1991, pp. 11–12.

Leandro BASSANO
1557–1622

Leandro dal Ponte was the third of Jacopo Bassano's sons. He trained in Bassano, but settled in Venice by 1588. He completed works by his brother Francesco, who died prematurely in 1592. The artist worked at the Doge's Palace, Venice and was chiefly famed as a portraitist.

Bartholomeus van BASSEN
active 1613; died 1652

Van Bassen was first recorded in the Delft guild in 1613, but he may have been Flemish. By 1622 he had settled in The Hague, where he worked for the rest of his life. He was a painter of church interiors and fanciful views of palaces, and an architect (working for The Hague burgomasters from 1639).

Attributed to van BASSEN
Interior of a Church
possibly 1644

NG 924
Oil on oak, 68.5 x 98.5 cm

Lazzaro BASTIANI
The Virgin and Child
probably 1480–90

NG 1953
Tempera and oil on wood, 83.2 x 64.1 cm

Pompeo Girolamo BATONI
Time orders Old Age to destroy Beauty
1746

NG 6316
Oil on canvas, 135.3 x 96.5 cm

Inscribed on a tablet above a tomb on the right: P. NEEFS. f. 1644.
 This church interior has not been identified, and is probably imaginary.
 The inscribed signature is false but the date of 1644 may well be original (it seems to be painted in the same paint as the simulated lettering of the inscription on the tablet, rather than in the later paint of the false signature). NG 924 was previously attributed to Pieter Neeffs the Elder, but the signature is misspelt and the style is not that of Neeffs.

Presented by (Sir) Henry H. Howorth, 1875.

MacLaren/Brown 1991, p. 12.

Inscribed on the parapet: LAZARVS BASTIANVS PINXIT.
 Jesus holds a string attached to a goldfinch, a symbol of the Passion, though birds were also kept as children's pets.

Monte di Pietà, Rome, 1857; presented by the NACF, 1905.

Davies 1961, p. 48.

Signed and dated on the rock on the right: P.B. 1746. Inscribed, lower right, with the Koucheleff Besborodko collection inventory number: 187.
 The winged figure of Time, who holds his scythe and hourglass, has ordered Old Age to destroy Beauty.
 NG 6316 was painted for the collector Bartolomeo Talenti of Lucca, with its pendant, *La Lascivia* ('An Allegory of Lasciviousness'; St Petersburg, Hermitage), which is dated 1747. The commission is first referred to in a letter of 4 July 1744 from Batoni to the patron.

Bartolomeo Talenti, Lucca, 1746; Besborodko collection; Count Koucheleff Besborodko sale, London, 1869; bought from Thos Agnew and Sons (Colnaghi Fund), 1961.

Levey 1971, pp. 9–10; Clark 1985, p. 239, no. 108.

Lazzaro BASTIANI
active 1449; died 1512

Described as a painter in Venice in 1449. Several signed works by Lazzaro Bastiani are known, the earliest dated 1484. His style is derived from the Vivarini, the Bellini and from Carpaccio (according to Vasari, however, Carpaccio was Bastiani's pupil). He painted altarpieces and small devotional works.

Pompeo Girolamo BATONI
1708–1787

Batoni was born in Lucca, the son of a goldsmith. In 1727 he settled in Rome where he painted altarpieces and history pictures. He became most famous for his portraits, notably of foreign and often British visitors to the city. He was elected to the Accademia di San Luca in 1741.

Pompeo Girolamo BATONI
Portrait of a Gentleman
probably 1760s

Pompeo Girolamo BATONI
Portrait of John Scott (?) of Banks Fee
1774

Lubin BAUGIN
The Holy Family with Saints Elizabeth and John and Angels, 1630–63

NG 6459
Oil on canvas, 134.6 x 96.3 cm

NG 6308
Oil on canvas, 101.3 x 74 cm

NG 2293
Oil on wood, 31.4 x 22.5 cm

The identity of the sitter has not been firmly established. He has traditionally been called Nicholas Pelham. He points to the place name 'Grisons', in Switzerland, on a map of northern Europe and Italy, and a 'Mr Pelham' was recorded in Switzerland in 1763, but it is by no means clear if this is the same person. The portrait came from the collection of the Earl Sondes (see provenance), and so other possible candidates for the sitter could be Richard Milles, whose daughter married the 2nd Baron Sondes, or Lewis Monson Watson, who became the 1st Baron Sondes in 1760. The bust above the map is based on one of the young Marcus Aurelius (Rome, Museo Capitolino).
 A miniature by Batoni of the same sitter is in Cambridge (Fitzwilliam Museum).

The 4th Earl Sondes, Lees Court, Faversham, Kent; bought, 1980.

National Gallery Report 1980–1, pp. 26–7; Clark 1985, p. 273, no. 211.

Signed and dated on the plinth on the right:
P. BATONI PINXIT ROMEA/ANNO 1774
(Painted by Batoni in Rome in the year 1774).
 The sitter's identity is traditional and unverified. Banks Fee is near Stow-on-the-Wold in Gloucestershire and was bought by John Scott in 1753. A 'Mr Scott' was recorded by Charles Burney in 1770 as being in Rome, but it is not known if he is the same person as the sitter. He wears a coat of blue silk lined with sable, and a formal wig.

Bequeathed by Mrs E.M.E. Commeline in memory of her husband Col. C.E. Commeline, RE, 1960.

Levey 1971, p. 9; Clark 1985, p. 333, no. 378.

The Christ Child and the infant Saint John embrace each other across the lap of the Virgin. Saint Elizabeth kneels at the right, and Saint Joseph is in the shadows further back.
 The style of NG 2293 is influenced by the work of Parmigianino, and its composition seems Raphaelesque in inspiration. The painter's alteration of the outline of the angel's wings is visible.

George Fielder collection, Leatherhead, by 1878; bequeathed by George Fielder, 1908.

Davies 1957, pp. 11–12; Wilson 1985, p. 24.

Lubin BAUGIN
about 1612–1663

Baugin was born at Pithiviers and so is likely to have been influenced by paintings at Fontainebleau nearby. He became a master painter at St Germain-des-Prés, near Paris, in 1629 and was admitted to the Académie in 1651, having meanwhile possibly visited Italy. His work was influenced by Parmigianino, Correggio and Reni.

Francisco BAYEU y Subias
Saint James being visited by the Virgin with a Statue of the Madonna of the Pillar, 1760

Giuseppe BAZZANI
Saint Anthony of Padua with the Infant Christ
probably 1740–50

Domenico BECCAFUMI
Tanaquil
probably about 1520–5

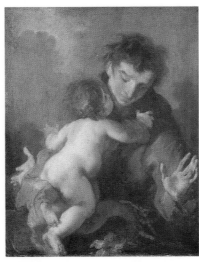

NG 6501
Oil on canvas, 53 x 84 cm

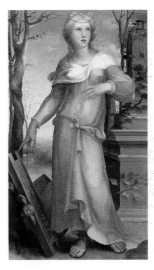

NG 3663
Oil on canvas, 85.1 x 69 cm

NG 6368
Oil on wood, 92.1 x 53.3 cm

Signed and dated on the reverse: Franciscus Bayeu fecit Caesaraugustae MDCCLX (Made by Francisco Bayeu at Zaragoza, 1760).

Saint James, who is credited with having brought Christianity to Spain, was passing through what subsequently became the city of Zaragoza when he was visited by the Virgin Mary, who presented him with a statuette of herself and a column of jasper on which to place it.

This subject is common in Spain, especially in Zaragoza, where an enormous basilica (El Pilar) was built, becoming one of the most venerated shrines in Spain. The basilica houses the statuette of the Virgin Mary and the column of jasper. NG 6501 is indebted to Antonio González Velázquez's frescoes of 1753 (and the oil sketches that preceded them), painted in the dome over the central chapel of the basilica of El Pilar. NG 6501, which is in very good condition, is not necessarily a preparatory sketch for a lost or unknown work, and may have been painted as an independent work. There is a highly finished drawing for it (private collection).

NG 6501 shows how strongly Bayeu was affected by the art of Giaquinto.

Bought, 1985.

National Gallery Report 1985–7, pp. 18–19; Helston 1989, pp. 38–9.

Saint Anthony (1195–1231), one of the foremost Franciscan saints, was Portuguese by birth but spent his later years in Padua. He had a vision of the Infant Christ when preaching on the Incarnation.

NG 3663 was acquired as a work by Amigoni but was soon given to Bazzani. It has been compared with Bazzani's *S. Luigi Gonzaga* (private collection) and with a *Saint Joseph* (Bergamo, Accademia Carrara). It can probably be dated to the 1740s.

Bazzani painted the subject on other occasions (e.g. Tours, Musée des Beaux-Arts).

Presented by F.D. Lycett Green through the NACF, 1922.

Tellini Perina 1970, pp. 66–7; Levey 1971, pp. 11–12.

Inscribed on the tablet, left: .SVM TANAQVIL BINOS FECI QVE PROVIDA REGES / PRIMA VIRVM SERVVM [F]OEMINA [D][E][I]NDE M[E]VM (I am Tanaquil, whose foresight turned two men into kings, first my husband, then my slave).

Tanaquil was a famous heroine of antiquity, whose actions were praised by Livy and who had persuaded her husband (Lucomo) to move to Rome where he was elected king and called Tarquinius Priscus; after his assassination she brought about the election of his successor, Servius Tullius.

NG 6368 and 6369 are clearly connected and were probably painted to decorate a palace in Siena. They have been related to a panel of Cornelia (Rome, Doria-Pamphili collection), and perhaps to a picture of Venus (Birmingham, Barber Institute). Two smaller panels (Florence, Martelli collection) have also been associated with the same series of inspiring heroines. It has been suggested that they might all have been part of the bedroom decoration for which Beccafumi pursued payment in 1526 and 1527. He claimed that he had painted these for Francesco di Camillo Petrucci eight years previously (i.e. about 1519); he must certainly have painted them before 1523, when Petrucci was expelled from Siena. NG 6368 and 6369 have, however, also been dated to the early 1520s.

Collection of Charles O'Neil by 1833; collection of Lord Northwick by 1864; acquired by application of the 1956 Finance Act, 1956.

Gould 1975, pp. 24–5; Tátrai 1979, pp. 48–9; Torriti 1990, pp. 132–3.

Francisco BAYEU y Subias
1734–1795

Bayeu was a native of Zaragoza and studied under Antonio González Velázquez in Madrid. He was an accomplished fresco painter and was much in demand in Madrid, Toledo and Zaragoza. In 1777 he was made director of the royal tapestry factory in Madrid and in 1788 was appointed court painter to Charles IV.

Giuseppe BAZZANI
1690–1769

Bazzani was born in Mantua, where he was active as a painter of religious and other pictures. He was president of the Mantuan Academy in 1767.

Domenico BECCAFUMI
1486?–1551

Except for visits to Rome (before 1513), Genoa and Pisa, Beccafumi was active in Siena throughout his life. From 1517 he supplied designs for the pavement of the cathedral in Siena. He painted a number of altarpieces, as well as frescoes, small devotional pictures and secular decorative panels. He was also active as a sculptor and was an innovative printmaker.

Domenico BECCAFUMI
Marcia
probably about 1520–5

NG 6369
Oil on wood, 92.1 x 53.3 cm

Inscribed on the tablet, right: .ME CATO COGNOVIT VIR MOX HORTENSIVS ALTER. / DEINDE CATONIS EGO MARTIA NVPTA FVI. (Cato was the first to take me to wife, Hortensius - soon after - the second, then I, Marcia, (again) became Cato's bride).

Marcia was a heroine of antiquity, whose deeds were recorded in Plutarch's Life of Cato of Utica. Originally she was Cato's wife, but she agreed to be given to his friend Hortensius. On Hortensius' death she remarried Cato.

NG 6369 was part of a series of furniture pictures, together with NG 6368. Both pictures are discussed under NG 6368.

Collection of Charles O'Neil by 1833; collection of Lord Northwick by 1864; acquired by application of the 1956 Finance Act, 1965.

Gould 1975, pp. 24–5; Tátrai 1979, pp. 48–9; Torriti 1990, pp. 132–3.

Domenico BECCAFUMI
An Unidentified Scene
probably 1540–50

NG 1430
Oil on wood, 74 x 137.8 cm

NG 1430 was formerly supposed to represent Esther before Ahasuerus, or the meeting of the Queen of Sheba and Solomon, but it may illustrate a scene from Roman history, such as the story of Virginia, or an episode from the life of an early Christian martyr. The setting must be intended to represent Rome. The building beside the bridge on the right clearly recalls the Castel Sant'Angelo, and other buildings may be based on the Colosseum and the Arch of Constantine.

The shape and size of the painting indicate that it was part of a piece of furniture or for the panelling of a room. Its style suggests that it was painted in the 1540s.

Possibly in the Medici collection, Rome, by 1670; probably in the collection of Lord Northwick by 1859; presented by George Salting, 1894.

Gould 1975, p. 24.

Jan BEERSTRAATEN
The Castle of Muiden in Winter
1658

NG 1311
Oil on canvas, 96.5 x 129.5 cm

Signed and dated below right: I. BEER-STRAATE̶N./ 1658.

The castle of Muiden is seven and a half miles east of Amsterdam at the entry of the Vecht river into the Zuider Zee. It was begun in about 1285 for Count Floris V of Holland. It is seen here from the north-east. (For another view of Muiden, see Arentsz. NG 3533.)

The existing building, which dates mostly from the fourteenth century, looks much the same today as it appears in the picture, but the rest of the scene has been rearranged for pictorial reasons. Some of the skaters on the frozen moat in the foreground carry *kolf* clubs.

Possibly anon. sale, Amsterdam, 1739; bought, 1890.

MacLaren/Brown 1991, pp. 14–16.

Jan BEERSTRAATEN
1622–1666

Jan Abrahamsz. Beerstraaten was born in Amsterdam, where he appears to have spent most of his life. The artist painted Dutch towns and castles from other parts of Holland that he visited, and imaginary seaports and sea battles. There are dated paintings by him from 1653 until the year of his death.

Cornelis BEGA
An Astrologer
1663

Abraham BEGEIJN
Peasants with Cattle by a Ruin
probably about 1665–90

Gentile BELLINI
The Virgin and Child Enthroned
about 1475–85

NG 78
Oil on canvas, 54.3 x 66 cm

NG 1481
Oil on oak, 36.9 x 29.6 cm

NG 3911
Oil on wood, painted surface 121.9 x 82.6 cm

Signed and dated bottom left: CP bega / A ° 1663 (CP in monogram).
 The man wears a scholar's cap and gown. He is described as an astrologer because of the presence of the celestial globe on the table behind him and the open book at the right, which shows an illustration of a hand and presumably refers to an interest in palmistry. His pose, slumped in his chair and lost in thought, suggests melancholy. The painting belongs to the visual tradition of *Melancholia*, the scholar's malady, of which the best-known example is Dürer's famous print, *Melencolia I*. Melancholy was thought to be the inevitable consequence of the scholar's work, which serves only to confirm the futility of his efforts and the certainty of his own mortality.

Possibly in the Baronne Douaieriere de Boonem sale, Brussels, 1776; presented by Martin H. Colnaghi, 1896.

MacLaren/Brown 1991, p. 17.

Inscribed bottom right on the end of a block of stone: NB (in monogram).
 The monogram is false, and was added to suggest that NG 78 is the work of Nicolaes Berchem. The picture does not resemble his work and comparison with signed paintings by Begeijn makes it clear that he was the artist. Begeijn's work shows little stylistic development and is therefore difficult to date precisely.

Bequeathed by Richard Frankum, 1861.

MacLaren/Brown 1991, pp. 18–19.

Signed: .OPVS. GENTILIS. BELLINI. VENETI. EQVITIS. (Work of Gentile Bellini, of Venice, Knight.)
 The Virgin Mary is shown on an inlaid marble throne, with an Eastern carpet at her feet. The Child Jesus holds a pomegranate, a symbol of the Passion.
 The form in which Gentile Bellini has signed NG 3911 indicates that the picture cannot have been painted before 1469, the year he was knighted.

Probably in the studio of Paolo Fabris, Venice, by 1857; acquired by Sir Charles Eastlake between 1855 and 1865; bought by J.P. Richter for Ludwig Mond, 1894; Mond Bequest, 1924.

Davies 1961, pp. 49–50; Meyer zur Capellen 1985, p. 128; Dunkerton 1991, pp. 44–5.

Cornelis BEGA
1631/2–1664

Cornelis Pietersz. Bega was born in Haarlem. According to Houbraken, Bega was a pupil of Adriaen van Ostade. In 1653 the artist travelled to Germany and Switzerland. He settled in Haarlem for the rest of his life and principally painted and etched peasant scenes in a style derived from that of Ostade.

Abraham BEGEIJN
active from 1655; died 1697

Born in Leiden, Abraham Begeijn (or Bega) worked there and in Amsterdam, London and The Hague. He travelled to Italy in about 1660. In 1688 he was appointed court painter to the Elector of Brandenburg in Berlin (where he died). Begeijn specialised in Italianate landscapes, port scenes and paintings of plants with reptiles and insects.

Gentile BELLINI
active about 1460; died 1507

Gentile was the son and probably a pupil of Jacopo Bellini. In about 1460 he apparently collaborated with his brother Giovanni Bellini, but thereafter he seems to have worked independently. His earliest signed work is of 1464. He enjoyed a great reputation and was knighted in 1469. He visited Constantinople from 1479 to 1481.

Attributed to Gentile BELLINI

Doge Niccolò Marcello

probably 1474

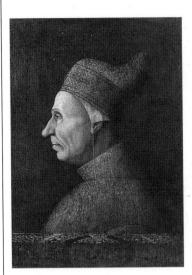

NG 3100
Oil on wood, painted surface 62.2 x 45.1 cm

Inscribed on the reverse, perhaps in an eighteenth-century hand: Nicolaus. Marcello. Dux / 1474 / Bellinus: F. (Niccolò Marcello, Doge 1474, Bellini made this.)

Comparison of the sitter's distinctive features with other likenesses (e.g. portrait medals) confirms the identification with Niccolò Marcello, Doge of Venice from 1473 to 1474.

Pentimenti visible by infra-red examination suggest that NG 3100 is not (as had previously been supposed) a copy of a portrait of Marcello.

Possibly in the collection of John Strange, Venice, before 1799; given to Sir A.H. Layard by Sir William Boxall, 1876; Layard Bequest, 1916.

Davies 1961, pp. 52–3; Meyer zur Capellen 1985, pp. 130–1, 180–1.

Attributed to Gentile BELLINI

The Sultan Mehmet II

1480

NG 3099
Oil (19th-century repaint) on canvas, perhaps transferred from wood, 69.9 x 52.1 cm

There is a very damaged fragment of an inscription on the left and on the right: MCCCCLXXX / DIE XXV ME/NSIS NOVEMBRIS (1480, day 25, month November).

Sultan Mehmet II (1432–81) was ruler of the Ottoman Empire.

NG 3099 has traditionally been attributed to Gentile Bellini who is documented as having visited the Sultan's court at Constantinople in the years 1479–81. This attribution has recently been defended (and is compatible with the date given in the inscription), but NG 3099 is almost entirely repainted and a degree of doubt must be retained.

Three variants of this portrait are known. A later inscription (which refers to Gentile Bellini and to Sultan Mehmet II) has been added over the original inscription on the left.

Bought in Venice in 1865 by Sir A.H. Layard (and said to have come from the collection of the Venturi family); Layard Bequest, 1916.

Davies 1961, pp. 51–2; Byam Shaw 1984, pp. 56–8; Meyer zur Capellen 1985, pp. 128–9; Dunkerton 1991, p. 91.

Attributed to Gentile BELLINI

A Man with a Pair of Dividers (?)

about 1500

NG 1213
Oil on canvas, 69.2 x 59.1 cm

The sitter was once thought to be a mathematician, perhaps Girolamo Malatini (living about 1494), because he is holding a pair of dividers. Malatini is said to have taught perspective to Giovanni Bellini and to Carpaccio. More recently the dividers have been taken to indicate an architect or artist and the sitter has been taken to be Giovanni Bellini. It has also been observed that the instrument may not be a pair of dividers.

NG 1213 has usually been attributed to Gentile Bellini, and this attribution has been adduced to support the identification of the sitter as the artist's brother Giovanni. The latest monograph on Gentile Bellini rejects the attribution and suggests that NG 1213 is the work of an artist active in Venice in the early sixteenth century.

Bought by James Irvine from Carlo Sanquirico, Milan, for Sir William Forbes, 1827; bought, 1886.

Davies 1961, pp. 50–1; Gould 1968, p. 626; Brigstocke 1982, pp. 27, 480; Meyer zur Capellen 1985, p. 153.

Giovanni BELLINI
The Blood of the Redeemer
probably 1460–5

Giovanni BELLINI
The Agony in the Garden
about 1465

Giovanni BELLINI
The Dead Christ supported by Angels
perhaps 1465–70

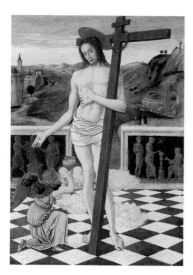

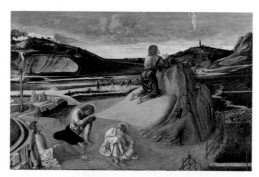

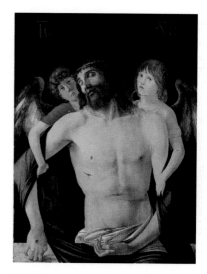

NG 1233
Egg (identified) on poplar, 47 x 34.3 cm

NG 726
Egg (identified) on wood, 81.3 x 127 cm

NG 3912
Tempera and oil on wood, 94.6 x 71.8 cm

Inscribed on the cross: INRI; and on the reliefs: DIS MANIB (VS)/ AVR(EL)IVS. / ()TI (). This is a standard epitaph formula.

Blood pours from the spear wound in Christ's side into a chalice held by an angel. The reliefs on the parapet seem to represent the pagan rites which Christianity superseded. A monk is visible in the right background, and a church in the left.

NG 1233 probably dates from the early 1460s and served as a tabernacle door, enclosing the bread of the Mass. Christ's sacrificed body, and his blood pouring into a chalice, were commonly represented on tabernacles.

NG 1233 shows Bellini's admiration for Mantegna's strongly drawn figures and antiquarianism. The clouds have been damaged (at one time they were painted over) but originally they contained cherubim.

Roupell collection by 1887; bought, 1887.

Davies 1961, pp. 60–1; Braham 1978, pp. 11–24; Goffen 1989, pp. 82, 224–5; Dunkerton 1991, pp. 22, 120.

Jesus prays in the Garden of Gethsemane while three of his disciples – Peter, James and John – sleep. An angel reveals a chalice and patten, symbols of his impending sacrifice. In the background Judas approaches with the Roman soldiers who will arrest Jesus. New Testament (Mark 14: 32–43).

NG 726 resembles the version of the same subject by Giovanni Bellini's brother-in-law Andrea Mantegna, which was probably painted at an earlier date (NG 1417), but it is also related to a still earlier composition recorded in a drawing by his father Jacopo Bellini. When compared with Mantegna's painting Bellini's displays a greater sensitivity to natural light.

Probably collection of Consul Smith, Venice, 1770; bought, 1863.

Davies 1961, pp. 58–60; Goffen 1989, pp. 106–7; Dunkerton 1991, pp. 294–5.

Inscribed at the top in Greek: IC XC (Jesus Christ).

The picture depicts Christ in his tomb prior to the Resurrection, encouraging meditation on his Passion. As in Early Christian imagery, the inscription gives Christ's name in Greek.

Bellini painted pictures like this both as separate works and for the centre of the upper tier of compound altarpieces. NG 3912 was probably a self-contained image to encourage veneration of Christ's wounds. It is generally considered to be an early work, possibly of the late 1460s.

Christ's pose is reversed and adapted in a picture in Berlin (Staatliche Museen). The surface is much worn but part of Christ's head and that of the angel on the left are well preserved.

Perhaps Mantua (collections of Conte Nuvoloni and Cesare Menghini); acquired in 1889 by Ludwig Mond; Mond Bequest, 1924.

Davies 1961, p. 64.

Giovanni BELLINI

active about 1459; died 1516

Probably taught by his father Jacopo, Giovanni Bellini became the leading painter in Venice. His workshop – perhaps including the young Giorgione and Titian – specialised in altarpieces, devotional pictures and portraits. He was much influenced in his early work by his brother-in-law Mantegna. He was one of the first great Italian painters to use oil paint.

Giovanni BELLINI
Saint Jerome reading in a Landscape
perhaps 1480–5

NG 281
Tempera and oil on wood, 47 x 33.7 cm

Saint Jerome is shown in his penitential retreat in the Syrian wilderness, where he retired about 374–6. He studies the Bible, which he translated into Latin from the original Greek and Hebrew, and is accompanied by the lion from whose paw, according to legend, he drew out a thorn. His cave is in the wilderness, but a walled city like those in the mainland territories of Venice can be seen in the distance.

The painting has sometimes been regarded as the work of a follower of Bellini. It is known in other versions (Florence, Contini-Bonacossi; Oxford, Ashmolean).

Bought, Venice, 1855.

Davies 1961, pp. 71–2.

Giovanni BELLINI
The Virgin and Child
probably 1480–1500

NG 3913
Oil and tempera on wood, 78.7 x 58.4 cm

Signed on a label on the parapet: IOANNES BELLINVS.

The attribution of NG 3913 to Giovanni Bellini has usually been accepted. A number of revisions to the composition are visible. The picture is normally dated to Bellini's middle period, probably about 1480–1500.

Collection of Giacomo Lazzari, Naples, by 1843; bought by Sir Charles Eastlake, and from his sale for Ludwig Mond; Mond Bequest, 1924.

Davies 1961, pp. 64–5; Heinemann 1962, p. 14.

Giovanni BELLINI
The Madonna of the Meadow
about 1500

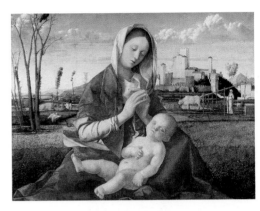

NG 599
Oil and egg (identified) on synthetic panel, transferred from wood, 67.3 x 86.4 cm

Jesus sleeps in the Virgin's lap. His pose may prefigure the Pietà, when his adult body was mourned on his mother's knees after the Deposition. The Virgin was often represented enthroned with her Child asleep on her lap, but here she sits on the ground, like the medieval Virgin of Humility (e.g. Dalmatian School NG 4250). The wading bird in combat with a snake may be an allegory of sin defeated, but such a sight may have been no more uncommon than the labourers, the cattle and the well which appear in the background.

NG 599 probably dates from about 1500 and can be compared stylistically with Bellini's *Baptism* of 1502 (Vicenza, S. Corona).

Bellini modelled the landscape on that of the Venetian mainland. The buildings in the background recur in other works from his studio. The flesh and drapery are much damaged.

Bought in Faenza, 1858.

Davies 1961, pp. 57–8; Goffen 1989, pp. 60–3; Dunkerton 1991, p. 356.

Giovanni BELLINI
The Doge Leonardo Loredan
1501–4

Giovanni BELLINI
The Assassination of Saint Peter Martyr
probably about 1507

Workshop of Giovanni BELLINI
The Virgin and Child
perhaps about 1475

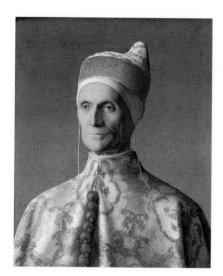

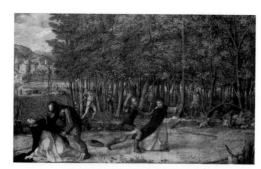

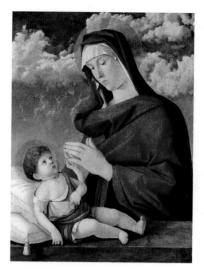

NG 189
Oil on poplar, 61.6 x 45.1 cm

NG 812
Oil and tempera on wood, painted surface
99.7 x 165.1 cm

NG 2901
Oil on wood, 81.9 x 62.2 cm

Signed on the small piece of paper apparently attached to the centre of the parapet: IOANNES BELLINUS.

The sitter in this portrait is identified as Doge Loredan by comparison with portrait medals. The doge was the elected head of the oligarchic Republic of Venice. Loredan wears the ceremonial robes and hat of his office.

Leonardo Loredan (1436–1521) was elected doge in 1501 and the painting may have been commissioned to commemorate his appointment. Giovanni Bellini is known to have worked for Loredan in 1504, and NG 189 has also been dated to that year.

The painting is exceptionally well-preserved.

Acquired from the Grimani collection, Venice, by Lord Cawdor before 1821; William Beckford collection by 1822, from whom bought, 1844.

Davies 1961, pp. 55–6; Goffen 1989, pp. 205–12; Dunkerton 1991, p. 364.

Inscribed on the small piece of paper in the right corner (much retouched, with uncertain spelling, and possibly false): Ioannes Bellinus .p[inxit].

Saint Peter Martyr was a Dominican friar and an Inquisitor. In 1252 he was murdered in a wood by heretics. He accepts his murder (left) in the cause of Christ. His companion (centre) was wounded but escaped. Cattle and a small town are visible in the left background.

X-radiographs show that the stance of the soldier who murders Saint Peter Martyr has been changed from upright to stooping. It has been suggested that in revising his composition at this stage Bellini must have made drawings of the figure groups. These have been reused as the basis of a workshop version at the Courtauld Institute (London) which was said to have once been dated 1509 on its reverse, and in which the four central figures exactly repeat the outlines of those in NG 812, which was probably painted in about 1507. The woodsmen in the background chopping trees (which bleed in the Courtauld version) are the pictorial equivalent of a poet's simile.

Bought by Sir Charles Eastlake, Venice, 1854; presented by Lady Eastlake, 1870.

Davies 1961, pp. 65–7; Fletcher 1991, pp. 4–9.

Numerous other versions of the composition exist. NG 2901 was once falsely signed on an illusionistic paper label [I]OANNES BELLINVS / PINXIT, but it seems to be a comparatively early workshop picture. Dates from about 1475 to 1480 have been suggested, and NG 2901 has been described as a development of a lost composition by Bellini of about 1475.

Collection of Lady Lindsay by 1894; by whom bequeathed, 1912.

Davies 1961, p. 70; Heinemann 1962, p. 7.

Workshop of Giovanni BELLINI
The Virgin and Child
probably 1480–90

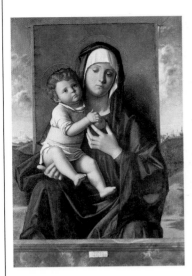

NG 280
Oil on poplar, 90.8 x 64.8 cm

Signed on a cartellino on the parapet: IOANNES / BELLINUS. P[INXIT].

The Virgin and Child are shown seated in front of a cloth of honour and behind a parapet. The picture is often called the 'Madonna of the Pomegranate', after the object held by the Virgin which may be a pomegranate, a symbol of the Passion.

The composition is derived from an altarpiece by Giovanni Bellini in which the Virgin was depicted full-length on a throne. This altarpiece is now known only through copies, including Francesco Tacconi's *Virgin and Child*, dated 1489, NG 286 of the Collection. NG 280 is probably a reduced variant by Bellini of his own altarpiece, and probably also dates from the 1480s.

Bellini had a large workshop which was probably involved in the execution of this picture, though the quality is high and probably indicates the master's intervention.

Bought from Baron Francesco Galvagna, Venice, 1855.

Davies 1961, pp. 56–7.

Workshop of Giovanni BELLINI
The Virgin and Child
about 1490–1500

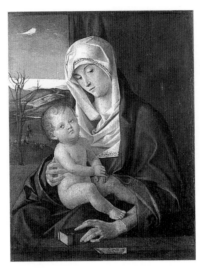

NG 3078
Oil and tempera on poplar, 80 x 64.8 cm

Signed on a cartellino in the centre of the parapet: [I]OA[N]NES BE[L]LINVS.

Numerous versions are known; the composition is generally dated to the 1490s. The picture is usually described as a poor workshop piece.

Bought in Paris by Sir A.H. Layard before 1868 (perhaps soon after 1856); Layard Bequest, 1916.

Davies 1961, p. 71; Heinemann 1962, p. 12.

Workshop of Giovanni BELLINI
The Circumcision
about 1500

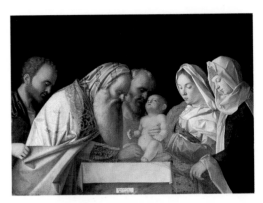

NG 1455
Oil on wood, 74.9 x 102.2 cm

Signed on a cartellino: IOANNES/ BELLINVS.

After Jesus' birth he was circumcised according to Jewish tradition. New Testament (Luke 2: 21). The High Priest performs the act, while Mary, Joseph and two other figures (a man and a woman) look on.

NG 1455 probably dates from about 1500 though the composition may date to the 1480s. Other versions of it exist. The execution is often thought to be by Bellini's workshop. Paintings of this subject were likely to have been commissioned by members of a lay association with a special veneration for the blood – and perhaps a particular relic of the blood – of Christ. His blood was first shed in the Circumcision.

The black background seems to be original.

Probably Muselli collection, Verona, by 1648; came to Britain from the Orléans collection, 1798; presented by the Earl of Carlisle, 1895.

Davies 1961, pp. 68–70.

Workshop of Giovanni BELLINI
A Dominican, with the Attributes of Saint Peter Martyr, probably about 1510–16

Workshop of Giovanni BELLINI
Saint Dominic
about 1515

Style of Bernardo BELLOTTO
A Caprice Landscape with Ruins
1740–1800

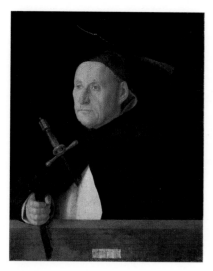

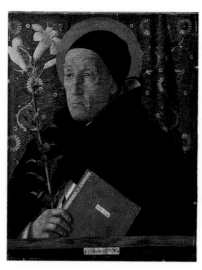

NG 135
Oil on canvas, 54 x 74.3 cm

NG 808
Oil on poplar, 59.1 x 48.3 cm

NG 1440
Oil on canvas, 63.9 x 49.5 cm

Signed on a cartellino attached to the parapet (retouched): ioannes bellinnus/pinxit.

Saint Peter Martyr was a Dominican friar, murdered in a wood in 1252. The saint's attributes (a halo, martyr's palm and the sword and cleaver of his martyrdom) have been added at a later date to a portrait of an unidentified friar.

Despite its inscription, the painting is generally considered to be from the artist's workshop.

X-radiographs show that the sitter originally held a roll of paper and not a palm. Bellini painted Peter Martyr's assassination on a number of occasions, including NG 812.

Sommi–Picenardi collection, Torri de' Picenardi (near Cremona), about 1827; bought from Basilini, Milan, 1870.

Davies 1961, pp. 67–8.

Signed on a piece of paper apparently attached to the parapet: IOANIS BELLINI OP[US] (Work of Giovanni Bellini). Inscribed on the parapet: MDXV IMAGO FRATRIS THEODORI VRBINATIS (1515 the image of Brother Theodore from Urbino).

Inscribed on the book: Sanct' Dominic'.

Saint Dominic (1170–1221) was the founder of the Dominican Order, and is commonly shown holding a lily; the label on the parapet and the inscription identify the sitter or model as Fra Teodoro da Urbino.

Teodoro was a Dominican friar at SS. Giovanni e Paolo, Venice, in 1514. Bellini painted two altarpieces for this church and was buried there. The inscription appears to have been an early addition to NG 1440, but the identification and the date of 1515 are generally accepted.

The painting may have been intended as a portrait of Fra Teodoro who, as a Dominican, would have identified himself with the founder of his order. Alternatively, Fra Teodoro may have served Bellini as a model for Saint Dominic (who was however, normally represented as a younger man). NG 1440 can be compared with NG 808, also from Bellini's workshop, which was changed from a portrait into a religious picture.

Probably Palazzo Pesaro, Venice, 1797; on loan from the Victoria and Albert Museum since 1895.

Davies 1961, pp. 61–4; Dunkerton 1991, p. 105.

This imaginary landscape combines a number of elements: the building in the centre is based on the type of gatehouses built beside the river Brenta on the outskirts of Padua, and the city in the distance includes buildings that suggest Padua, such as the long roof to the left which recalls the Palazzo della Ragione. However, the circular temple on the right is a caprice on the Pantheon in Rome.

The composition was popular – several versions are known – and may have been Canaletto's, but the execution, especially of the figures, in NG 135 seems nearer to Bellotto, though the quality is not high enough for it to be accepted as an autograph work by either painter.

Bequeathed by Lt.Col. J.H. Ollney, 1837.

Levey 1971, pp. 12–14; Kozakiewicz 1972, pp. 493–4.

Bernardo BELLOTTO
1720–1780

Bellotto was born in Venice, where he trained as a painter with his uncle Antonio Canaletto. He specialised in views of Venice and other Italian cities; after leaving Italy in 1747, he was active in Dresden, Vienna and Munich. In 1767 he moved to Warsaw where he remained until his death.

BENOZZO Gozzoli
The Virgin and Child Enthroned among Angels and Saints, 1461–2

After BENOZZO
The Virgin and Child Enthroned with Angels
1460s

Ambrosius BENSON
The Magdalen Reading
about 1525

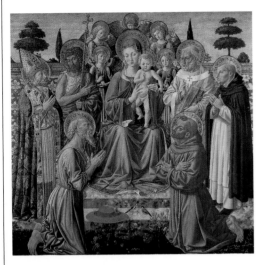

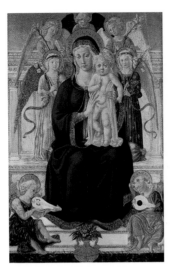

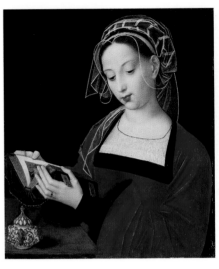

NG 283
Tempera on wood, 161.9 x 170.2 cm

NG 2863
Tempera on wood, 137.2 x 88.9 cm

NG 655
Oil on oak, original painted surface 41 x 36.2 cm

Inscribed on the Virgin's halo: .AVE MARIA GRATIA PLENA DOMINV(S TECUM) (Hail Mary full of Grace the Lord (is with you)); on the hem of her robe: AVE REGINA CELORVM MATER ANGELORVM SANCTA EX QVA MVNDO LVX EST ORT(A) (Hail Queen of Heaven, Holy mother of the angels from whom the light came into the world); on the collar of Saint Peter's garment: TV ES PETRVS APOSTOLVS & SVPER (H)ANC (Thou art Peter and upon this (rock I will build my church)); on the book he holds: TV ES CRISTVS FILIVS DEI VIVI (Thou art Christ, son of the living God); in addition Christ and the saints are named on their haloes.

Saints John the Baptist and Zenobius stand on the left near the kneeling Saint Jerome. The orphrey of Saint Zenobius' cope is ornamented with scenes from the life of the Virgin and Christ. On the right are Saints Peter and Dominic with Saint Francis kneeling.

Benozzo was contracted to paint NG 283 on 23 October 1461 for the Compagnia di Santa Maria della Purificazione e di San Zanobi in Florence, a confraternity for boys also known as the Compagnia di San Marco because it was attached to the Dominican convent there. The work was to be finished by 1 November 1462. Five predella panels are known: London, Royal Collection; Milan, Brera; Berlin, Gemäldegalerie; Washington, Kress collection; Philadelphia, J.G. Johnson collection.

Commissioned as explained above, 1461; in the Oratory of the Via San Gallo, Florence, 1518; Refectory of the Ospedale del Melani, Florence, 1757; Rinuccini collection, Florence, 1842; bought from the Rinuccini estate, 1855.

Davies 1961, pp. 73–6.

BENOZZO Gozzoli
about 1421–1497

Benozzo di Lese (Alesso), usually known as Gozzoli, came from a Florentine family. He was studying painting in 1442, and subsequently worked for Ghiberti as a sculptor in Florence, and as principal assistant to Fra Angelico in Rome and Orvieto in 1447. He is recorded in Montefalco (1450–2), Viterbo (1453), San Gimignano and Pisa (1468–94/5). The artist, whose major works are in fresco, died in Pistoia.

Inscribed on the Virgin's halo: AVE. MARIS. STELLA. DEI. MATE(R) (Hail Star of the Sea. Mother of God); on Christ's halo: PAX. VOBIS (Peace be with you); on the haloes of the angels: .AVE. (MARIA) GRAZIA. PLENA (Hail Mary, full of Grace).

This is a variant of Benozzo's altarpiece NG 283. The attendant saints have been omitted and two seated angels added.

NG 2863 may have been executed not very long after NG 283, which is documented as dating from 1461–2. It may be the work of a member of Benozzo's workshop.

Revd Walter Davenport Bromley Sale, 13 June, 1836 (lot 149); presented by Henry Wagner, 1912.

Davies 1961, pp. 76–7.

Mary Magdalene is identified by the pot of ointment with which she anointed Christ.

NG 655 is one of many versions or variants of a design by Benson. This may ultimately derive from a fifteenth-century image (such as that in Rogier van der Weyden NG 654); similar paintings are attributed to 'Ysenbrandt' and the Master of the Female Half-Lengths. NG 655 has been dated about 1525.

Collection of Granville John Penn by 1851; bought with the Edmond Beaucousin collection, Paris, 1860.

Marlier 1957, pp. 197, 310; Davies 1968, p. 11.

Ambrosius BENSON
active 1519?; died 1550

Benson came from Lombardy, but was active in Bruges, where he became a master in the guild in 1519 and worked until his death. Benson had lived and worked with Gerard David but left him before 11 February 1519 when they were in dispute.

BENVENUTO di Giovanni
The Virgin and Child, with Saint Peter and Saint Nicholas 1479

NG 909
Tempera on wood, 170.8 x 166 cm

Signed and dated at the bottom of the central panel: OPVS BENVENVTI IOANES DE SENIS MCCCCLXXVIIII (Work of Benvenuto di Giovanni of Siena 1479). Inscribed below the Virgin and Child: REGINA CELI LETTARE ALLELVIA (Rejoice the Queen of Heaven, Alleluia); and repeatedly: AVE and GR[ATI]A (Hail and Grace). Inscribed below the two saints, left: SANTVS PETRVS APOSTOLVS right: SANTVS NICHOLAVS DEBARI.

Saint Peter was entrusted with the keys to Heaven and became the first bishop of Rome. Saint Nicholas of Bari was the fourth-century Archbishop of Myra; in 1087 his remains were translated to Bari. The inscription below the Virgin Mary identifies her as the Queen of Heaven and derives from an Easter antiphon.

NG 909 is signed and dated 1479 and may have been painted for a church in Orvieto. In the early nineteenth century it was apparently in the church of the Gesù there, which had been founded in 1618.

Apparently removed from the church of the Gesù, Orvieto, 1813; studio of Giovanni Emili, Rome, about 1825; Grazioli collection, Rome, by 1839; collection of Alexander Barker by 1868; bought, 1874 .

Davies 1961, pp. 77–8; Kanter 1983, pp. 53–4.

BENVENUTO di Giovanni
The Virgin and Child
about 1480

NG 2482
Tempera on wood, 52.1 x 34.3 cm

Inscribed on the Virgin's halo: AVE GRASIA PLENA DOMINVS TECVM (Hail [Mary] full of Grace, the Lord be with you).

The inscription is taken from the New Testament (Luke 1: 28 in the Vulgate) and records the Angel Gabriel's salutation to the Virgin at the Annunciation.

NG 2482 was probably painted as a private devotional work.

Collection of George Salting by 1883; Salting Bequest, 1910.

Davies 1961, p. 78.

Nicolaes BERCHEM
A Man and a Youth ploughing with Oxen
probably 1650–5

NG 1005
Oil on canvas, 38.2 x 51.5 cm

Signed at the bottom, left of centre: cBerghem (cB in monogram).

NG 1005 was probably painted at about the same time as a very similar picture by Berchem that is dated 1653 (Vienna, Akademie). This dating is supported by the form of the signature, which was used by Berchem until the mid-1650s but rarely later.

Collection of François Boucher, Paris, by 1771; Wynn Ellis Bequest, 1876.

MacLaren/Brown 1991, pp. 22–3.

BENVENUTO di Giovanni
1436–after 1509/17

Benvenuto was first recorded as a painter in 1453, when he was working with Vecchietta, his probable teacher, on the frescoes in the Baptistery, Siena. He painted altarpieces for many locations in central Italy. He also painted miniatures and provided cartoons for the mosaic floor of Siena Cathedral.

Nicolaes BERCHEM
1620–1683

Nicolaes Pietersz., son of the still-life painter Pieter Claesz., adopted the surname Berchem. He was born and active in Haarlem, where he painted Italianate pastoral scenes: he probably visited Italy in about 1650–4. By 1677 he was working in Amsterdam (where he died). He was a productive and versatile artist with many pupils and followers.

Nicolaes BERCHEM
Peasants with Four Oxen and a Goat at a Ford by a Ruined Aqueduct, probably 1655–60

Nicolaes BERCHEM
Mountainous Landscape with Muleteers
1658

Nicolaes BERCHEM
A Peasant playing a Hurdy-Gurdy to a Woman and Child in a Woody Landscape, with Oxen, Sheep and Goats, 1658

NG 820
Oil on oak, 47.1 x 38.7 cm

NG 1004
Oil on canvas, 109 x 126 cm

NG 1006
Oil on mahogany, 34.5 x 38.3 cm

Signed bottom left: Berchem
NG 820 was probably painted in the late 1650s as it is similar to a landscape by Berchem dated 1658 (Amsterdam, Rijksmuseum).

Possibly in the collection of Samuel van Huls, The Hague, by 1737; collection of Simon H. Clarke, Bt, by 1823; bought by Sir Robert Peel, Bt, 1840; bought with the Peel collection, 1871.

MacLaren/Brown 1991, pp. 21–2.

Signed and dated on some rocks bottom left: 1658 Berchem
NG 1004 is close in style to the Italianate landscapes of Jan Both. Details of the composition are based on drawings made by Berchem during his stay in Italy, which probably took place in the early 1650s.

Collection of Loveden Pryse, Buscot Park, by 1859; probably in the Wynn Ellis collection by 1861; Wynn Ellis Bequest, 1876.

MacLaren/Brown 1991, p. 22.

Signed and dated bottom left: Berchem 1658
Berchem interpreted the Italian landscape and the life of its peasants in an idyllic manner. Many of his compositions were based on the drawings of the Roman Campagna and its inhabitants that he made during his years in Italy.

Probably in the collection of the Marquis de Ménars by 1782; collection of Sir Thomas Baring by 1848; Wynn Ellis Bequest, 1876.

MacLaren/Brown 1991, p. 23.

Nicolaes BERCHEM
Peasants with Cattle fording a Stream
about 1670–80

NG 240
Oil on oak, 29.5 x 45.3 cm

Gerrit BERCKHEYDE
The Interior of the Grote Kerk, Haarlem
1673

NG 1451
Oil on oak, 60.8 x 84.9 cm

Gerrit BERCKHEYDE
The Market Place and the Grote Kerk at Haarlem
1674

NG 1420
Oil on canvas, 51.8 x 67 cm

Signed lower left: Berchem
 The painting was cleaned in 1981 and the signature, the authenticity of which had been doubted, discovered to be original. The painting's handling is entirely consistent with Berchem's style in the 1670s.

Collection of Randon de Boisset, Paris, by 1777; collection of N.W. Ridley Colborne (later Lord Colborne), by 1821; bequeathed by Lord Colborne, 1854.

MacLaren/Brown 1991, pp. 20–1.

Signed and dated lower centre: Gerrit Berkheijde 1673. The central panel of the pulpit is inscribed: Psalm 138, and along the base of the organ gallery are the letters: ZA ZYIN E.
 The interior of the fifteenth-century Grote Kerk (St Bavo) is here seen from the west, looking towards the choir; its appearance remains much the same today. In the foreground at the left is an alms chest. At the right in the middle distance is an organ; the interior of its left door is painted with the Resurrection. Below the organ hangs a painting of the exterior of the Grote Kerk. The congregation is seated around and facing the pulpit as is the practice in the Dutch Reformed Church.
 NG 1451 is the only known dated interior by Gerrit Berckheyde. His brother Job painted a number of views of the interior of the same church (e.g. Haarlem, Frans Halsmuseum; Detroit Institute of Arts).

Possibly in the Seger Tierens sale, The Hague, 1743; bought, 1895.

MacLaren/Brown 1991, pp. 25–7.

Signed and dated on the third column from the right: Gerrit Berck Heyde/1674.
 The view is from the north-west from beside the town hall, the Doric portico of which is on the right. On the opposite side of the square is the fifteenth-century Grote Kerk (St Bavo) with its spire of 1519/20, which is largely unchanged today. Berckheyde painted this view many times, but this seems to be the only version to include the portico of the town hall.

Bought, 1894.

MacLaren/Brown 1991, pp. 24–5.

Gerrit BERCKHEYDE
1638–1698

Gerrit Adriaensz. Berckheyde was born in Haarlem and probably taught there by his elder brother Job. They travelled to Germany and worked at the court of the Elector Palatine at Heidelberg, before returning to Haarlem. Gerrit specialised in townscapes, especially of Haarlem, Amsterdam and The Hague, and he also painted a few landscapes and church interiors.

Gerrit BERCKHEYDE
The Market Place and Town Hall, Haarlem
about 1691

Dirck van den BERGEN
Two Calves, a Sheep and a Dun Horse by a Ruin
probably about 1665

Ambrogio BERGOGNONE
The Virgin and Child with Two Angels
probably about 1480–5

NG 1863
Oil on oak, 31.9 x 40.3 cm

NG 984
Oil on oak, 23.8 x 30 cm

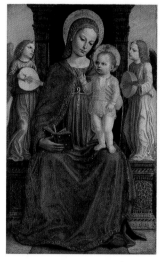

NG 1077
Oil on wood, painted surface 92.7 x 57.5 cm

Signed at the bottom edge to the left: G Berck Heyde.

The view is of the west side of the market place (Grote Markt). Facing the spectator is the town hall, which was built in the fourteenth century as a palace of the Counts of Holland and altered in the 1630s. On the gable of the projecting part of the building is a statue of Justice and, above it, the arms of Haarlem. On the right, beside the town hall, is the beginning of the Zijlstraat. The entrance to the Grote Houtstraat is between the houses on the extreme left. On the roof of the town hall are nesting boxes for storks.

NG 1863 is a late version of a composition repeated a number of times by Berckheyde.

It is possible that in this composition Berckheyde had in mind the similar view of the Grote Markt etched by Jan van de Velde after Pieter Saenredam in Samuel Ampzing's *Beschrijvinge ende Lof van Stad Haerlem* of 1628. A chalk sketch by Berckheyde of the left half of this view is in the Teylers Museum, Haarlem.

Bequeathed by George Mitchell to the South Kensington (Victoria and Albert) Museum, 1878; on loan to the National Gallery since 1895.

MacLaren/Brown 1991, pp. 27–8.

NG 984 has in the past been catalogued as by Adriaen van de Velde. It certainly reflects his style, but is now attributed to van den Bergen, on the basis of comparison with signed pictures, such as *Landscape with Herdsmen and Cattle* (Amsterdam, Rijksmuseum).

Wynn Ellis Bequest, 1876.

MacLaren/Brown 1991, p. 29.

Inscribed on the hem of the Virgin's mantle:
B'NARDINO.

NG 1077 is an early work by Ambrogio Bergognone, probably dating from about 1480–5 when the artist was strongly influenced by Foppa.

NG 1077 entered the Collection as the central part of an altarpiece that also included NG 1077.1 and 1077.2. However, the latter are of later date. The name Bernardino which is incorporated with other letters in the hem of the Virgin's mantle is hard to explain. It has been taken to indicate authorship by Ambrogio's brother of that name.

Melzi collection, Milan, before 1879; bought, 1879.

Davies 1961, p. 80.

Dirck van den BERGEN
1645–about 1690

According to Houbraken, Dirck van den Bergen was born in Haarlem. Houbraken also says that van den Bergen was taught by Adriaen van de Velde in Amsterdam. Van den Bergen travelled to England and was involved in the decoration of Ham House in the 1670s, and then returned to Haarlem. He was a painter of landscapes and animals.

Ambrogio BERGOGNONE
active 1481; died 1523?

Ambrogio (di Stefano) da Fossano, called Bergognone, was active in Milan, where he appears in the guild registers in 1481. Between 1488 and 1494/5 he worked in the Certosa (Charterhouse) at Pavia. His style largely derives from Foppa. Many signed and documented works are known, including large frescoes as well as small devotional paintings.

Ambrogio BERGOGNONE
The Virgin and Child
about 1488–90

Ambrogio BERGOGNONE
The Virgin and Child with Saint Catherine of Alexandria and Saint Catherine of Siena, about 1490

Ambrogio BERGOGNONE
The Agony in the Garden
probably 1501

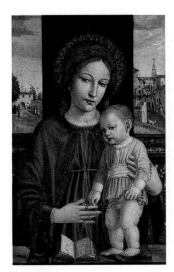

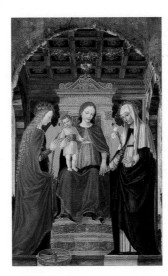

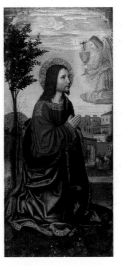

NG 1410
Oil on poplar, painted surface 55.2 x 35.6 cm

NG 298
Oil (identified) on poplar, painted surface 187.5 x 129.5 cm

NG 1077.1
Oil on wood, painted surface 99.7 x 45.1 cm

Inscribed on the Virgin's halo: AVE MARIA GRATIA PLENA DOMIN[US TECUM] (Hail Mary, full of Grace, the Lord [is with you]); and on the book on the parapet: Domine labra / m[ea] aperies e[t] / os meum / anuntiabit laudez / tuam Deus in / adiutoriu[m] meu[m] / intende [Do]m[in]e ad / adiuvandum me / festina Gr[at]ia p[ad]ri / et filio et sp[iri]to / sancto Sicut / erat in pri[nci]pi[o] / n[un]c & semp[er] (O Lord open Thou my lips; and my mouth shall show forth Thy praise'; 'Make haste, O God, to deliver me; make haste to help me, O Lord'; 'Glory be to the father, the son and the Holy Spirit. As it was in the beginning is now and ever shall be').

The inscription on the book comprises Psalm 51: 15, Psalm 70: 1 and a prayer. This combination is said at matins, according to the Roman Catholic Breviary, and in the Anglican morning service. The Christ Child holds a rosary.

In the right background the unfinished façade, and beyond that the transept, of the Certosa (Charterhouse) at Pavia can be seen. This probably indicates a date of about 1488–90. Bergognone was then busy painting for the Certosa (see NG 298). NG 1410, which shows a number of Carthusians prominently in the background, may have been commissioned by a member of the order for his private devotions.

Collection of Contessa Elisabetta Ottolini Visconti, Milan, by 1865 (said to be a gift from one of Napoleon's generals or from Napoleon himself); acquired by Lady Eastlake, 1867; bought, 1894.

Davies 1961, pp. 81–2.

Inscribed on the Virgin's halo: AVE MARIS STELLA DEI MA(TER ALMA) (Hail, Star of the Sea, [gentle] Mother of God); and on the Virgin's mantle: MARIA MATER GRATIE / ... /[T]IBI DOM[INU]/S EST DEV[S] / PIETATE TVA NOS...(Mary mother of Grace, ... to you the Lord is God, by your piety we...). Inscribed on the saints' haloes, left: (SAN)CTA KATERINA MARTIR; right: SANCTA KATERINA DE SE(NIS).

Saint Catherine of Siena (1347?–1380; canonised in 1461) is depicted as a Dominican tertiary holding a lily, a symbol of purity (and also a symbol of the Virgin and Saint Dominic); Saint Catherine of Alexandria is shown with her attribute of a wheel at her feet and with a martyr's palm. The Christ Child places a ring on her finger, a reference to her vision in which she received this token of his love – the so-called 'mystic marriage of Saint Catherine'. He also holds a ring for the other Catherine, whose hand the Virgin holds in preparation.

NG 298 was painted as an altarpiece for the altar in the Certosa (Charterhouse) of Pavia that was dedicated to the two Saints Catherine. It was probably painted in about 1490 during Bergognone's first and chief period of activity in the Certosa, for which he painted ten altarpieces. NG 298 originally had a lunette of the *Pietà* with Saint John and Mary Magdalene; this was bought by the National Gallery at the same time as NG 298, but was lost at sea.

Perugino painted an altarpiece for the Certosa, NG 288 in the Collection.

Recorded in the Certosa, Pavia, 1645; bought, 1857.

Davies 1961, pp. 78–80; Fabjan 1986, pp. 25–32.

Inscribed on Christ's halo: IESVS CRISTVS; and on his robe: MERITIS.

Jesus prays in the Garden of Gethsemane while three of his disciples – shown in the middle distance – sleep. An angel presents him with a chalice containing the Instruments of the Passion (cross, crown of thorns, spear and sponge). Judas enters the garden through a gate. New Testament (Mark 14: 32–43).

NG 1077.1 was a panel from an altarpiece. See commentary under NG 1077.2.

Melzi collection, Milan, before 1879; bought, 1879.

Davies 1961, pp. 80–1.

Ambrogio BERGOGNONE
Christ carrying the Cross
probably 1501

Style of BERGOGNONE
Saint Paul
late 15th century

Style of BERGOGNONE
Saint Ambrose (?)
late 15th century

NG 1077.2
Oil on wood, painted surface 99.7 x 45.1 cm

NG 3080
Oil on poplar, painted surface 110.5 x 41.9 cm

NG 3081
Oil on poplar, painted surface 110.5 x 41.9 cm

Inscribed on Christ's halo: IESVS AVE NAZARENVS (Hail Jesus of Nazareth); and lower left corner: 1501 / FF. Q.O.

The townscape background is reminiscent of lakeside towns in northern Italy, but is probably not a specific view and is reused in other works by Bergognone (Tours, Musée des Beaux-Arts).

NG 1077.1 and 1077.2 were panels from an altarpiece. The date of 1501 in the inscription is acceptable though it may not be original and the second line is unclear. NG 1077 was once thought to form the central part of the altarpiece, but this is not likely.

Melzi collection, Milan, before 1879; bought, 1879.

Davies 1961, p. 81.

Saint Paul is identified by his attributes of a sword and a book.

NG 3080, together with NG 3081, was a panel of a polyptych altarpiece and probably from the higher register. It is likely to date from about 1480–1500.

Sir A.H. Layard collection by 1869 (probably about 1856); Layard Bequest, 1916.

Davies 1961, pp. 83–4.

This bishop saint is probably to be identified with the patron saint of Milan: Saint Ambrose (about 340–398), Bishop of Milan.

NG 3081, together with NG 3080, was a panel of a polyptych altarpiece and probably from the higher register.

Sir A.H. Layard collection by 1869 (probably about 1856); Layard Bequest, 1916.

Davies 1961, pp. 83–4.

BERNARDINO da Asola
The Death of Saint Peter Martyr
1540s

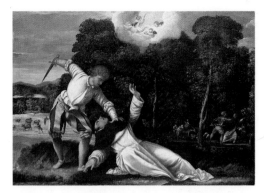

NG 41
Oil on canvas, 101.5 x 144.8 cm

Attributed to BERNARDINO
The Adoration of the Shepherds
probably 1525–30

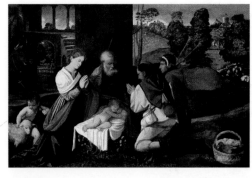

NG 1377
Oil on canvas, 109.2 x 160.6 cm

Attributed to BERNARDINO
The Madonna and Child
probably 1525–35

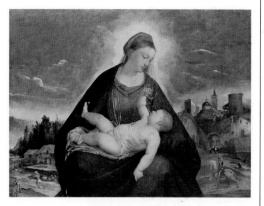

NG 2907
Oil on wood, 77.5 x 102.9 cm

Saint Peter Martyr was a Dominican friar and an Inquisitor. In 1252 he was murdered in a wood by heretics. He accepts his murder (foreground) for the cause of Christ (angels appear above his head with a martyr's palm). His colleague (right) was also attacked and wounded but escaped.

NG 41 was formerly attributed to Giorgione or Cariani, but is now widely accepted as the work of Bernardino da Asola. Dates proposed for this painting have varied but it is most likely to have been made in the 1540s. Despite the traditional format that echoes Bellini's treatment of the subject (NG 812), a date after 1530 seems likely as the pose of the saint (and the appearance of angels with a martyr's palm) seems to be indebted to the same figure in Titian's great altarpiece of that year (once in SS. Giovanni e Paolo, Venice; now destroyed). The costume is said to suggest a date in the 1540s.

Collection of Queen Christina of Sweden, Rome, by 1689; collection of the Duc d'Orléans by 1727; Orléans sale, London, 1800; Holwell Carr Bequest, 1831.

Gould 1975, pp. 26–7; Pallucchini 1983, p. 304.

The young Saint John the Baptist is included at the left and the Annunciation to the Shepherds can be seen in the centre background. The Journey of the Magi is depicted in the right background.

NG 1377 was probably painted in about 1525–30 and is closely related to an altarpiece of the same subject by Giovanni da Asola (died 1531) in the cathedral at Asola. NG 1377 was formerly said to be by Savoldo, but has now been attributed to Bernardino da Asola. Several similar pictures of the same subject – and seemingly by the same hand – are known (e.g. Kansas City, Nelson Atkins Museum). They all derive – perhaps indirectly – from various works by Titian.

Manfrin collection, Venice, by 1856; bequeathed by Sir William H. Gregory, 1892.

Gould 1975, pp. 27–8; Stradiotti 1990, pp. 249–50.

The group of the Madonna and Child is derived from an influential fresco by Titian in the Doge's Palace, Venice (painted in about 1523).

Collection of the Contessa Cotterell by 1873; bequeathed by Lady Lindsay, 1912.

Gould 1975, pp. 28–30.

BERNARDINO da Asola
active about 1525–50

Bernardino da Asola was an artist from Asola (between Mantua and Brescia), active in northern Italy in the second quarter of the sixteenth century. He collaborated with his father (Giovanni) in painting a pair of double-sided organ shutters (Venice, Museo Correr) for S. Michele in Isola, Venice, in April 1526.

Attributed to BERNARDINO
The Garden of Love
about 1535–50

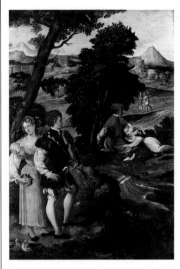

NG 930
Oil on canvas, 221 x 148.3 cm

NG 930 is known as 'The Garden of Love' on account of the foreground figures who have some of the attributes of love – flowers, musical instruments and paired doves – and the couple embracing in the middle distance.

NG 930 has been attributed to Bernardino da Asola, but might be the work of either a Brescian or a Ferrarese artist of the second quarter of the sixteenth century. Giovanni Mario Verdizzotti (died 1600) has also been suggested as the author. The costume is said to date from about 1540 and may be Brescian in character.

Wynn Ellis Bequest, 1876.

Venturini 1970, pp. 33–73; Gould 1975, p. 27.

Gian Lorenzo BERNINI
Saints Andrew and Thomas
before 1627

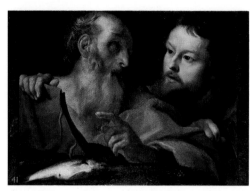

NG 6381
Oil on canvas, 61.5 x 78.1 cm

At bottom left: 41 (an old inventory number).

Saint Andrew holds a book, an attribute derived from the apocryphal Acts of Andrew. Before him lies a fish, a reference to his activity as a fisherman. Thomas clasps a carpenter's square, which alludes to the apocryphal Acts of Thomas, in which he is described as being summoned to build a palace for a king in India.

This work is listed in an inventory of Palazzo Barberini, Rome, of 1 June 1627, and probably dates from a few years earlier. As such it is Bernini's earliest documented painting, but it is not clear if it was a commissioned work. A painting of 'two heads of Apostles' by Sacchi is recorded as being paid for by the Barberini in 1627 and may have been intended as a pendant to NG 6381. Sacchi NG 6382 has been tentatively identified by some as that picture.

The Barberini collection by 1627; bought, 1967.

Martinelli 1950, pp. 95–104; Fagiolo dell'Arco 1967, p. 42 and text under no. 39; Levey 1971, pp. 15–16.

Jan van BIJLERT
Portrait of an Elderly Man and Woman, and a Younger Woman, outside a House, probably 1660s

NG 1292
Oil on canvas, 127 x 101 cm

Signed bottom left: Jv bijlert·fe: (Jv in monogram).

The younger woman is presumably the couple's daughter. She grasps the stem of a rose bush while the older woman holds a peach.

M.S.B. Bos sale, Amsterdam, 21 February 1888; bought from the trustees of A.W. Thibaudeau, through Messrs Deprez and Gutekunst, London (Clarke Fund), 1889.

MacLaren/Brown 1991, pp. 68–9.

Gian Lorenzo BERNINI
1598–1680

Bernini was born in Naples, the son and pupil of the Florentine sculptor Pietro Bernini. He moved to Rome in 1604–5, and mainly worked there as sculptor and architect to the Papacy. In 1665 he was employed in France by King Louis XIV. Paintings by the artist are rare.

Jan van BIJLERT
1598–1671

Jan Harmensz. van Bijlert was born in Utrecht, the son of a glass painter. He was a pupil of his father and then of Abraham Bloemaert. The artist travelled to France and was a founder member of the society of Netherlandish painters in Rome in 1623. He returned to Utrecht by 1625 and became a prominent figure in the artists' guild. Bijlert painted religious, mythological and genre subjects, and portraits.

Giovanni BILIVERT
Saint Zenobius revives a Dead Boy
probably 1610–20

Francesco BISSOLO
The Virgin and Child with Saints Michael and Veronica and Two Donors, probably 1500–25

Francesco BISSOLO
The Virgin and Child with Saint Paul and a Female Martyr, probably 1505–30

NG 1282
Oil on canvas, 205 x 164.4 cm

NG 3083
Oil on wood, painted surface 62.2 x 84.1 cm

NG 3915
Oil on wood, 78.1 x 117.5 cm

The gloves of Saint Zenobius are embroidered with the monogram of Christ: IHS.

Saint Zenobius was a fifth-century bishop of Florence, and is a patron of the city. He is shown with his deacons, Saints Eugenius and Crescentius. He miraculously restored to life the son of a French woman, who had left the boy with the saint when going on a pilgrimage. The dalmatic of the deacon on the left is decorated with scenes of the Resurrection and Betrayal of Christ, while that of the deacon on the right shows a scene which is probably the Ascension.

NG 1282, which appears to be an altarpiece of some significance, has in the past been catalogued as by Jacopo da Empoli but it is now generally accepted as by Bilivert. The picture is probably the one which Bilivert is recorded as having painted for his friend Giuliani Gerolami.

Probably painted for Giuliani Gerolami; collection of George Salting by 1867; by whom presented, 1889.

Levey 1971, pp. 16–17.

The Archangel Michael is identified on his breastplate: .MICHA EL.

The two unidentified donors are accompanied by Saints Michael and Veronica – perhaps their name-saints. Saint Veronica holds the sudarium with which she wiped Christ's face on the Way to Calvary. According to legend his image was miraculously imprinted on the cloth.

The figures of the Virgin and Child, which recur in other paintings by Bissolo, are probably developed from a design by Giovanni Bellini (of about 1500).

Perhaps in the Pesaro collection, Venice, by 1797; Sir A.H. Layard collection by 1869; Layard Bequest, 1916.

Davies 1961, pp. 84–5.

Saint Paul holds his traditional attributes of a sword and a book; the female saint has sometimes been identified as Saint Catherine, but her only attribute is the palm indicating martyrdom.

The group of the Virgin and Child, found in other paintings by Bissolo, is derived from Bellini's great altarpiece in San Zaccaria, Venice (dated 1505).

Collection of Conte F. Balladoro, Verona, by 1887; Mond collection by 1888; Mond Bequest, 1924.

Davies 1961, p. 85.

Giovanni BILIVERT
1585–1644

Bilivert was born in Florence, the son of a Dutch goldsmith employed at the Tuscan court. He was trained by Cigoli, with whom he went to Rome in 1604. Bilivert returned to Florence before Cigoli's death in 1613, and remained principally active in Tuscany. He was employed by the Grand Ducal Court.

Francesco BISSOLO
active 1492; died 1554

Bissolo was first mentioned as a painter in the Doge's Palace, Venice, perhaps as part of the Bellini studio then at work in the palace. Bissolo's style is derived from Giovanni Bellini's of about 1500, and there are many signed works (altarpieces and devotional works, dated 1513–30) which demonstrate Bellini's influence.

Marie BLANCOUR
A Bowl of Flowers
17th century

Attributed to Boccaccio BOCCACCINO
The Way to Calvary
probably 1500

Louis-Léopold BOILLY
A Girl at a Window
after 1799

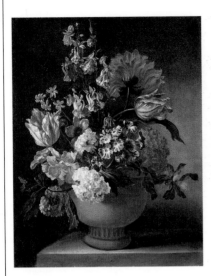

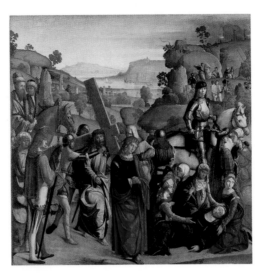

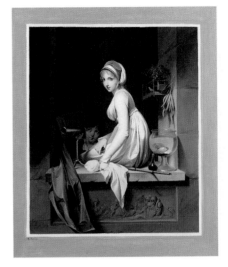

NG 6358
Oil on canvas, 65.4 x 52.1 cm

NG 806
Oil on wood, painted surface 132.1 x 130.8 cm

NG 5583
Oil on canvas, 55.2 x 45.7 cm

Signed on the ledge: Marie Blancour F.[ecit].
The artist is recorded only by her signature on this work, which is probably seventeenth century.

Bequeathed by Capt. E.G. Spencer-Churchill, 1964.

Inscribed on the banners of two soldiers, top right: (S)[ENATUS] P[OPULUS] Q[UE] R[OMANUS] ([By order of] the Senate and the People of Rome).
Christ carries his cross to Golgotha (seen in the right background). The Virgin has fainted in his path and is tended by the Holy Women and Saint John. The two thieves are further ahead on the road to Golgotha. New Testament (e.g. John 19: 17). The man on the left with a sword might be the donor of the altarpiece.
NG 806 may be the 'small altarpiece of Christ carrying the cross' by Boccaccino recorded by Marcantonio Michiel (in a note probably made in the 1520s) in S. Domenico, Cremona. The painting comes from a collection near Cremona and is likely to be the one Michiel mentions, not least because such an altarpiece would probably date from about 1500 which seems right for the style of this work.
A drawing for the figure of the Virgin has been identified in Budapest.

Possibly recorded in S. Domenico, Cremona, by about 1522; certainly in the collection of the Marchese Sommi-Picenardi, near Cremona, by about 1827; bought, 1870.

Davies 1961, pp. 85–8; Tanzi 1991, p. 136, n. 9.

Signed on the picture: Boilly; and on the imitation mount: L. Boilly.
Painted as a grisaille (a work of varying tones, but a single colour), NG 5583 is intended as an imitation of a mounted engraving, although the subject does not duplicate that of any known print.
The artist exhibited a painting at the 1799 Salon in Paris (no. 28), the description of which matches the design of NG 5583, but other contemporary descriptions suggest that the Salon work was not a grisaille, so it is likely that NG 5583 derives from it.

From Russia; bought by the Comte M. de Camondo, Paris, 1898; passed from the Duchess of Manchester (died 1909) to her sister Emilie Yznaga; by whom bequeathed, 1945.

Davies 1957, p. 14.

Marie BLANCOUR
seventeenth century

Nothing is known of Blancour who was presumably French and active in the seventeenth century. The signed painting in the National Gallery is her only known work.

Boccaccio BOCCACCINO
active 1493; died 1524/5

Boccaccino worked in Genoa in 1493, Ferrara from 1497 to 1500, and in Venice, but he was chiefly active in Cremona, especially from 1506. Altarpieces, frescoes and small devotional works have been attributed to him.

Louis-Léopold BOILLY
1761–1845

Boilly was born at La Bassée near Lille. He painted first in Douai, then at Arras, and finally in Paris from 1785. The artist exhibited at the Paris Salon from 1791 to 1824. He painted genre scenes and numerous small portraits.

Ferdinand BOL
A Lady with a Fan
about 1645–50

Ferdinand BOL
An Astronomer
1652

Giovanni Antonio BOLTRAFFIO
The Virgin and Child
probably about 1493–9

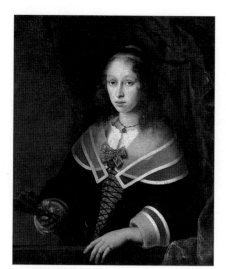

NG 5656
Oil on canvas, 83.5 x 69.5 cm

NG 679
Oil on canvas, 127 x 135 cm

NG 728
Oil on wood, painted surface 92.7 x 67.3 cm

The sitter has not been identified. Both the style and the costume (particularly the collar) suggest a date in the second half of the 1640s when Bol's portraiture still displays the strong influence of Rembrandt's work.

Robert Needham Philips (died 1890); bequeathed by Miss A.M. Philips, 1946.

MacLaren/Brown 1991, p. 31.

Signed and dated on the paper, left: fBol·fec[it]/1652 (fB in monogram).

Two globes on the table – one celestial, the other terrestrial – identify the sitter as an astronomer. His pose and preoccupied manner may be intended to suggest a state of melancholy, induced by the futility of his studies in view of the inevitability of death.

Possibly collection of J. Hickman, Edinburgh, 1802(?); presented by Miss E.A. Benett, 1862.

MacLaren/Brown 1991, pp. 30–1.

Inscribed on the curtain (partly new): AVE / AVE / .MA.[RIA] (Hail, hail Mary); and with two inventory numbers: 1114 and +.103.+.

The painting may be a fragment of a larger altarpiece – a low viewpoint seems to be expected and the forms are both monumental and the composition highly centralised, which supports this idea.

NG 728 was probably painted relatively early in Boltraffio's career and is a variant of the so called 'Litta Madonna' by Leonardo of which the original is probably the painting in St Petersburg (Hermitage). The figure of the Christ Child reappears in a similar pose in a painting by an unidentified follower of Leonardo, NG 1300.

Collection of Lord Northwick by 1854; bought, 1863.

Davies 1961, pp. 88–9.

Ferdinand BOL
1616–1680

Ferdinand Bol was baptised in Dordrecht, where he may have been taught by Jacob Cuyp. He settled in Amsterdam and was a pupil (and assistant) of Rembrandt in the late 1630s. There are dated works by him from 1642 to 1669. He was one of the leading painters in the city: he specialised in history paintings and portraits, which show the influence of Rembrandt and Bartholomeus van der Helst.

Giovanni Antonio BOLTRAFFIO
about 1466/7?–1516

Boltraffio appears to have been Leonardo's pupil in Milan. He was mentioned in Leonardo's studio in 1491, and was apparently working independently by 1498. He was principally a painter of portraits for the courts of northern Italy, but also painted altarpieces and devotional works.

Giovanni Antonio BOLTRAFFIO
A Man in Profile
possibly 1498–1516

Follower of BOLTRAFFIO
The Virgin and Child
probably about 1500–25

Attributed to Benedetto BONFIGLI
The Adoration of the Kings, and Christ on the Cross, about 1465–75

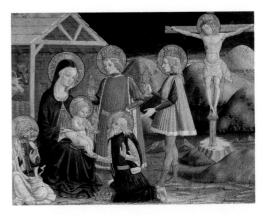

NG 1843
Tempera on wood, painted surface 37.5 x 49.5 cm

NG 3916
Oil on wood, painted surface 56.5 x 42.5 cm

NG 2496
Oil on wood, painted surface 50.8 x 37.5 cm

NG 3916 has sometimes been regarded as a portrait of the poet Gerolamo Casio. This identification is insecure.

This portrait can be compared with a donor portrait by Boltraffio in an altarpiece in Paris (Louvre), probably of 1500.

Frizzoni collection, Bergamo, 1855; acquired by Sir William Boxall who bequeathed the painting (1879) to Lady Eastlake; at whose sale (1894) bought for Ludwig Mond; Mond Bequest, 1924.

Davies 1961, pp. 89–90.

Inscribed on the parapet: [?SALV]E ... [M]ARIA PRO ME FILIUM ORA (Hail Mary, pray to your son for me ...)

NG 2496 is clearly by a Milanese follower of Boltraffio. Related compositions date from the first quarter of the sixteenth century, a probable date for this picture.

Possibly in the collection of Lord Shrewsbury by 1857; collection of George Salting by 1900; Salting Bequest, 1910.

Davies 1961, pp. 90–1.

The Three Kings have journeyed from the East to seek out the Child Jesus in the stable. They bear gifts of gold, frankincense and myrrh. New Testament (Matthew 2: 10–12). On the right Christ is shown on the cross at his Crucifixion.

NG 1843 may be a fragment of a predella; however, it is unusual for Christ on the Cross to be included in a narrative predella scene. This element explains the painting's old title 'Mystic Adoration', and might suggest that the picture was made for private devotion (see Botticelli NG 1034). It has repeatedly been suggested that NG 1843 may in fact be the work of Bartolomeo Caporali (documented 1442–1505).

Fabiani sale, Gubbio, 1882; bought, 1901.

Davies 1961, pp. 92-3.

Benedetto BONFIGLI
active 1445; died 1496

In 1450 Bonfigli was working in the Vatican in Rome and in 1454 he was commissioned to paint frescoes in the town hall of Perugia, his native city. He painted altarpieces, processional banners and occasionally collaborated with Bartolomeo Caporali.

Rosa BONHEUR and Nathalie MICAS
The Horse Fair
1855

NG 621
Oil on canvas, 120 x 254.6 cm

BONIFAZIO di Pitati
The Madonna and Child with Saints James the Greater, Jerome, the Infant Baptist and Catherine of Alexandria, about 1530

NG 1202
Oil on wood, 73 x 116.8 cm

Studio of BONIFAZIO
A Huntsman
early 16th century

NG 2145
Oil on canvas, 116.9 x 64.8 cm

Signed: Rosa Bonheur
The scene is the the horse market in Paris. The dome of La Salpêtrière is visible in the background.

NG 621 is a reduced (and slightly varied) version of a larger picture, exhibited by Bonheur at the Salon of 1853 (now New York, Metropolitan Museum of Art). The larger version was acquired in 1855 by the dealer Ernest Gambart, who wanted to have it engraved by Thomas Landseer. Bonheur offered to supply Gambart with a smaller version that could be engraved more easily. NG 621 was begun in 1855 by Bonheur's lifelong friend Nathalie Micas (about 1824–89). It was finished and signed by Bonheur.

Ernest Gambart, 1855; sold by August of that year to Jacob Bell; by whom bequeathed, 1859.

Davies 1970, pp. 10–12; Ashton 1981, pp. 82ff.

Saint James at the left has a pilgrim's hat thrown over his shoulder – the hat badge features his shell, a cross and Veronica's veil. Beside him is Saint Jerome wearing cardinal's robes – his lion seems to be creating havoc in the background. Saint Catherine of Alexandria at the right holds part of the wheel upon which she was tortured. The coat of arms above the door in the background appears indecipherable. Below and to the right of it are traces of cabalistic characters on the wall.

NG 1202 was formerly ascribed to Palma Vecchio, who died in 1528. But it is looser and coarser in handling than paintings by his hand, and it is now generally dated to about 1530.

From the Terzi and Andreossi collections, Bergamo; bought from the heirs of Enrico Andreossi (Walker Fund), 1886.

Gould 1975, p. 31.

It has been suggested that this work may derive from a series representing the Labours of the Months (see NG 3109 and 3110).

NG 2145 has been attributed to the School of Giorgione, but is more probably by Bonifazio or his studio.

Collection of Baron Galvagna, Venice, 1855; from whom bought, 1855; (said to have been in the Casa Savorgnan).

Gould 1975, pp. 31–2.

Rosa BONHEUR
1822–1899

Rosa (Rosalie) Bonheur was born in Bordeaux; she moved to Paris in 1829, and studied with her father Raimond Bonheur. She exhibited at the Salon from 1841, and became famous as an animal painter.

BONIFAZIO di Pitati
1487–1553

The artist's family came from Verona. His father appears to have moved to Venice in 1505 and Bonifazio is first recorded there as an artist in 1528. His earliest known dated picture is *Christ enthroned with Saints* of 1530 (Venice, Accademia). Notable among the large number of other paintings associated with him is a series – now dispersed – dating from 1530 for Palazzo Camerlenghi, Venice.

Style of BONIFAZIO

The Labours of the Months: January – June
early 16th century

Style of BONIFAZIO

The Labours of the Months: July – December
early 16th century

Style of BONIFAZIO

The Madonna and Child with Saints John the Baptist, Elizabeth and Catherine of Alexandria
probably 1530–5

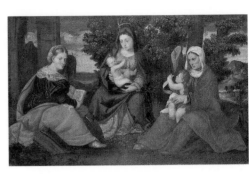

NG 3536
Oil on canvas, 73 x 119.4 cm

NG 3109
Oil on canvas mounted on wood, each 13.3 x 10.2 cm

NG 3110
Oil on canvas mounted on wood, each 13.3 x 10.2 cm

There are traces of scribbled characters on the pier behind Saint Catherine.

Saint Catherine rests on her wheel at the left, while Elizabeth is seated at the right with the Baptist on her lap.

The costumes suggest a dating in the early 1530s. NG 3536 was formerly attributed to Palma Vecchio, but it appears to be a pastiche by a follower of Bonifazio.

According to a label on the back from the Manfrin collection, Venice; collection of the Earl of Dudley by 1868; presented by Alfred A. de Pass, 1920.

Gould 1975, pp. 33–4.

January is represented by an old man asleep by a stove, February by a youth asleep on a rampart, March by a scene of pig-killing, April by a falconer with hounds, May by a man cutting corn and June by a man ploughing.

NG 3109, along with NG 3110, form a series representing the twelve Labours of the Months. Such subjects had been popular in medieval art and interest in them was revived in the mid-sixteenth century in northern Italy. This set has been attributed to Bonifazio, but the character of the draughtsmanship suggests that it is by a follower or imitator.

Bought from Marini by Sir A.H. Layard, 1888; Layard Bequest, 1916.

Gould 1975, pp. 32–3.

July is represented by a man threshing, August by a man squeezing grapes, September by a man coopering, October by a man pointing vine poles, November by a man making vine-trellises and December by a man dressing vines.

For further discussion of the series see NG 3109.

Bought from Marini by Sir A.H. Layard, 1888; Layard Bequest, 1916.

Gould 1975, pp. 32–3.

After BONIFAZIO
Dives and Lazarus
early 16th century

NG 3106
Oil on wood, 47 x 84.5 cm

BONO da Ferrara
Saint Jerome in a Landscape
perhaps 1440–50

NG 771
Tempera on poplar, 52 x 38 cm

Francesco BONSIGNORI
Portrait of an Elderly Man
1487

NG 736
Tempera on wood, 41.9 x 29.8 cm

'There was a certain rich man [Dives] which was clothed in purple and fine linen, and fared sumptuously every day: And there was a certain beggar named Lazarus, which was laid at his gate, full of sores, And desiring to be fed with the crumbs which fell from the rich man's table...' New Testament (Luke 16: 19ff).

According to a manuscript note in the Gallery archives by Layard (see provenance) NG 3106 had on the back of it, before being cradled, an inscribed label which implied that it was a modello for a much larger painting by the artist of the same subject, now in the Accademia, Venice. There are a number of differences in details between the two works, but the present picture is damaged and its apparent feebleness of execution seems to suggest that it is a free copy, rather than a modello.

NG 3106 seems to have belonged to the Giustiniani and Donà families; bought by Sir A.H. Layard, from Vason, Venice, February 1868; Layard Bequest, 1916.

Gould 1975, pp. 34–5.

Signed on a cartellino lower right: .BONVS. FERARIENSIS. / .PISANJ. DISIPVLVS. (Bono of Ferrara, pupil of Pisanello).

The saint wears cardinal's robes, his hat rests on the rock at the right. Before him is the lion from whose paw, according to legend, he removed a thorn.

The style of NG 771 is near to that of Pisanello, and the picture has been attributed to him in the past. But it seems to be, as the inscription states, the work of a pupil. It may derive from a lost painting by Pisanello of this subject.

In the Costabili collection, Ferrara, by 1838; bought by Sir Charles Eastlake; bought from Lady Eastlake, 1867.

Davies 1961, pp. 93–4.

Signed and dated on a cartellino: Franciscus. Bonsignorius. Veronensis. p[inxit] / .1487.

The sitter has not been identified but has been described as a Venetian Senator since 1851; his costume favours such an identification.

Bonsignori was probably still resident in Verona in 1487 (although there is no conclusive evidence for his whereabouts in that year).

NG 736 is closely related to a black chalk drawing (Vienna, Albertina), variously attributed to Bonsignori and Mantegna. This drawing is identical in size and must either be preparatory for NG 736, or a copy of it kept for record, a practice followed by Bonsignori (according to Vasari). Most recently the drawing has been attributed to Mantegna on the grounds that it, and related drawings, is beyond the talents of Bonsignori as known from his painted works. In painting this portrait Bonsignori could have been working from a drawn portrait by Mantegna (Mantegna was known to have supplied such on occasion). Bonsignori was working for Mantegna's Gonzaga patrons from 1490, and perhaps from as early as 1485. Infra-red examination has shown the existence of an underdrawing in a style hard to reconcile with that of the drawing in Vienna.

Apparently in the Museo Cappello, Venice, by 1732; bought from Cesare Bernasconi, Verona, 1864.

Davies 1961, p. 95; Campbell 1990, p. 185; Christiansen 1992, pp. 339–41.

BONO da Ferrara
active 1442?–1461?

The artist described himself as a pupil of Pisanello on NG 771. He may be the painter who is documented as being active in Siena Cathedral in 1442 and 1461, and at the court in Ferrara in 1450. He may also have worked in the chapel of the Eremitani in Padua in 1451.

Francesco BONSIGNORI
1455/60?–1519?

Bonsignori was probably born in Verona, where he painted his first recorded work in 1483. While in Verona he painted altarpieces and portraits, before moving to Mantua where, from about 1490, he worked for the Gonzaga court. His later work shows the influence of Mantua's foremost painter – Mantegna.

Francesco BONSIGNORI
The Virgin and Child with Four Saints
about 1490–1510

NG 3091
Oil on canvas, 48.3 x 106.7 cm

François BONVIN
The Meadow
1869

NG 1448
Oil on canvas, 45.7 x 55.2 cm

François BONVIN
Still Life with Book, Papers and Inkwell
1876

NG 3234
Oil on zinc, 36.2 x 48.3 cm

The four saints are not identifiable, although, the one on the left with a book is probably a Franciscan.

NG 3091 has generally been attributed to Bonsignori and dated to the 1490s or 1500s. The picture has also been associated with Gian Francesco Caroto (1480–1555). The central portion of the composition occurs in a drawing after Mantegna (Rotterdam, Museum Boymans-van Beuningen) and in a print after Mantegna by Giovanni Maria da Brescia (active 1502–12). The young male saint on the right is also highly Mantegnesque.

Bought by Sir A.H. Layard from Baslini, Milan, about 1863; Layard Bequest, 1916.

Davies 1961, pp. 95–6; Christiansen 1992, pp. 247–9.

Signed and dated: F. Bonvin Verberie 1869.
Verberie (Oise) is between Senlis and Compiègne. NG 1448 was exhibited at the Salon in 1870 as 'Le pâturage, effet de matin' (The meadow, morning effect).
There is a signed and dated drawing for the cattle and cowgirl (private collection).

Collection of H. Mosselmann by 1875; presented by Mrs Edwin Edwards, 1895.

Davies 1970, p. 12; Weisberg 1979, pp. 94, 248, no. 210.

Signed and dated: F. Bonvin 1876.
Bonvin's still lifes are almost invariably composed of humble, everyday objects and deliberately invoke the precedent of Dutch seventeenth-century still lifes as well as the art of Chardin.
This work is, unusually, painted on zinc.

Probably in the Seure collection by 1888; collection of Sir Hugh Lane by 1906; Lane Bequest, 1917; on loan to the Hugh Lane Municipal Gallery of Modern Art, Dublin, since 1979.

Davies 1970, pp. 12–13; Weisberg 1979, p. 228.

François BONVIN
1817–1887

Bonvin was born and studied in Paris. He regularly visited the Louvre and was much influenced by seventeenth-century Dutch painting. He exhibited at the Salon from 1847 and was a leading figure in the Realist movement. Bonvin was in London during the Franco-Prussian War (1870–1) and was impressed by the Dutch and Flemish pictures in the National Gallery.

Gerard ter BORCH
The Swearing of the Oath of Ratification of the Treaty of Münster, 1648

NG 896
Oil on copper, 45.4 x 58.5 cm

Gerard ter BORCH
An Officer dictating a Letter
about 1655–8

NG 5847
Oil on canvas, 74.5 x 51 cm

Gerard ter BORCH
Portrait of a Young Man
probably about 1663–4

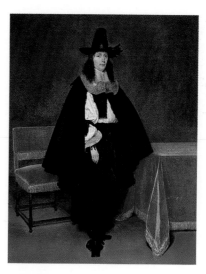

NG 1399
Oil on canvas, 67.3 x 54.3 cm

Signed and dated on the tablet on the left wall: GTBorch. F. Monasterij. A. 1648 [GTB in monogram]. (Gerard ter Borch made it Monasterij. A. 1648)

The ratification of the Treaty of Münster took place publicly in the Ratskammer of the Rathaus in Münster, on 15 May 1648. 77 people are shown in the Ratskammer; more than twenty of these have been identified (for identifications, see MacLaren/Brown 1991). Standing at the centre table with their hands raised are six of the Netherlandish delegates; on the right are the Spanish delegates. The delegates are shown simultaneously swearing the oath (in fact the Spaniards were the first to swear). Ter Borch's self portrait is at the extreme left of the front row.

The ratification of the Treaty of Münster in 1648, after two years of negotiations, secured Spain's *de jure* recognition of the Dutch nation after an 80-year struggle. Ter Borch's painting agrees closely with the account published in 1648 by Johannes Cools, and with the physical appearance of the Ratskammer. Houbraken stated that ter Borch asked six thousand guilders for NG 896, but kept it as he was offered less.

Collection of Hendrick ter Borch, Deventer, by 1672/4; bought by William Buchanan from the Prince de Talleyrand, 1817; collection of Prince Anatole Demidoff, Florence, 1837; presented by Sir Richard Wallace, 1871.

MacLaren/Brown 1991, pp. 34–9.

Signed on the left end of the stretcher of the table: GTB (in monogram).

The man seated on the left wears a cuirass and a helmet (morion). The model for the young man in the centre was Caspar Netscher. This identification is based on Wallerant Vaillant's mezzotint after a lost self portrait by Netscher.

Caspar Netscher was ter Borch's pupil in or about 1655. He left Holland in 1658/9 and NG 5847 can be dated to about 1655–8.

Infra-red photographs reveal a number of changes in the shape of the table and the figure on the left. A playing card (the ace of hearts) just in front of the dog's hind leg was subsequently painted out. A variant (Dresden, Gemäldegalerie), possibly by Netscher, largely follows the original composition of NG 5847 as revealed by infra-red photographs.

Collection of Lothar Franz, Graf von Schönborn, Pommersfelden, by 1719; collection of Khalil Bey, Paris, by 1867; collection of Arthur James, London, by 1890; bequeathed by Mrs M.V. James from the Arthur James collection, 1948.

MacLaren/Brown 1991, pp. 41–3.

The sitter has not been identified.

NG 1399 has been dated on the basis of style and costume to about 1663–4. It was probably painted as the pair to a *Portrait of a Young Woman* in the Cleveland Museum of Art.

Collection of the Earl of Northwick, probably by 1846; bought by Sir Charles Eastlake, 1859; purchased from Lady Eastlake, 1894.

MacLaren/Brown 1991, pp. 39–40.

Gerard ter BORCH
1617–1681

Born in Zwolle, the son of an artist who was his first master, ter Borch later trained in Haarlem with Pieter Molijn. He subsequently travelled throughout Europe, settling in Deventer in 1654 (where he remained until his death). Ter Borch evolved an individual style in genre painting and introduced a new type of small full-length portrait.

Gerard ter BORCH
Portrait of Hermanna van der Cruis
probably 1665–9

Gerard ter BORCH
A Woman playing a Theorbo to Two Men
about 1667–8

Paris BORDONE
Pair of Lovers
probably about 1535–50

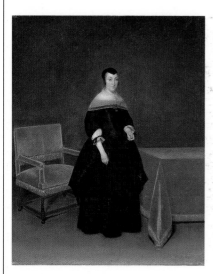

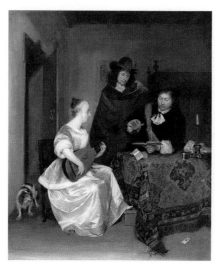

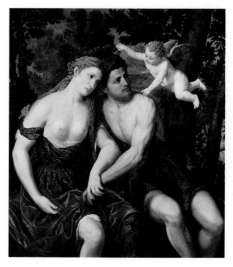

NG 4596
Oil on canvas, 71.9 x 57.7 cm

NG 864
Oil on canvas, 67.6 x 57.8 cm

NG 637
Oil (identified) on canvas, 135.9 x 120.6 cm

Hermanna van der Cruis (1615–1705) was the wife of Abraham van Suchtelen (1600–61), a burgomaster of Deventer. The identification of the sitter is based on an inscription on the back of a repetition of the portrait formerly in the collection of Viscount d'Abernon.

NG 4596 was probably painted shortly before the d'Abernon painting which shows the sitter wearing a narrower collar, an alteration corresponding to a change in fashion. There is a third autograph version, with a still life on the table, in the Kunsthistorisches Museum, Vienna.

Sold anonymously, London, 1858; collection of (Sir) Otto Beit (Bt) by 1913; bequeathed by Sir Otto Beit, 1931.

MacLaren/Brown 1991, pp. 40–1.

A woman is shown playing a theorbo for two men. A bed can be seen in the background, and a playing card (the ace of spades) is on the floor below the table, which is covered by a Turkish carpet.

NG 864 has been dated on stylistic grounds to the late 1660s. A number of related pictures include motifs from NG 864, of which there is a second variant (collection of Baroness Bentinck).

In Dutch genre painting music-making often suggests love. Here, as in many of ter Borch's interior scenes from the 1650s and 1660s, he deliberately creates an ambiguous situation in which the spectator is intrigued by the relationships between the figures.

Chevalier de Julienne collection by 1754; collection of the Duc de Choiseul, 1767; bought by Sir Robert Peel, Bt, 1826; bought with the Peel collection, 1871.

MacLaren/Brown 1991, pp. 32–4.

The subject of NG 637 has not been convincingly identified. The picture was previously catalogued as 'Daphnis and Chloe' presumably because the man's tentative advances suggest the problems which this pair of lovers had as related in the Greek pastoral romance of that title by Longus, probably of the third century AD. But many other subjects are possible.

NG 637 may have been the companion piece to a *Jupiter and Io* of approximately the same size and signed by Bordone (Göteborg, Konstmuseum). A *Venus and Adonis* in Dubrovnik may also be related.

Bought with the Edmond Beaucousin collection, Paris, 1860.

Gould 1975, p. 36.

Paris BORDONE
1500–1571

Paris Bordone was born in Treviso, but spent most of his life in Venice, where he was established as a painter by 1518. According to Vasari he trained with Titian; this seems likely, although the chronology of his works (portraits, altarpieces, frescoes) is uncertain. He travelled to France in 1538 and/or 1559 and probably to Augsburg in about 1540.

Paris BORDONE
Christ as the Light of the World
probably about 1540–60

Paris BORDONE
Christ baptising Saint John Martyr, Duke of Alexandria, about 1540–70

Paris BORDONE
Portrait of a Young Woman
probably about 1550

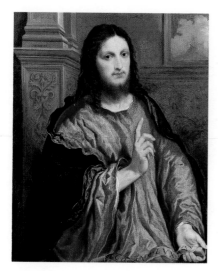

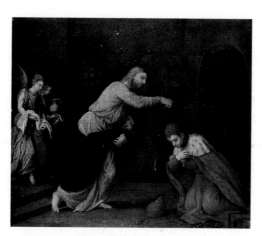

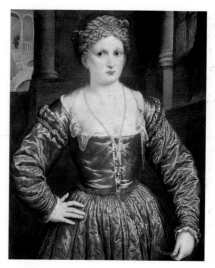

NG 1845
Oil on canvas, 90.8 x 73 cm

NG 3122
Oil on canvas, painted area 61.5 x 67.9 cm

NG 674
Oil on canvas, 106.7 x 85.7 cm

Signed top left: O[?] PARIDIS. bor-on-. Inscribed on the scroll: EGO. .SVM. LVX. MV[N]D[I] (I am the Light of the World).

Christ is represented as the Saviour of Mankind; the inscription is from the New Testament (John 8: 12).

NG 1845 is one of the later versions of this subject painted by Bordone. One version of a related design was painted over with a portrait dated 1540 (Paris, Louvre).

Presented to Dr Henry Greenwood in about 1829 by a member of the Sicilian embassy in London; presented by Mrs Mary M. Wood through her brother, the Revd G. Greenwood, 1901.

Gould 1975, p. 38.

Saint John Martyr, Duke of Alexandria (Alexandretta), was said to have been miraculously baptised by Christ in prison, but his cult was unofficial as his legend had been taken over from that of Saint Procopius of Caesarea. NG 3122 was described in the mid-seventeenth century as depicting Saint Procopius.

The body of Saint John Martyr had been brought to Venice from Constantinople in about 1214 and placed in the church of S. Daniele (now demolished). For this reason the saint was venerated in Venice.

Collection of Gradenica Gradenico, Venice, by 1647; Layard Bequest, 1916.

Gould 1975, pp. 38–9; Lennon 1987, p. 143.

Inscribed: .AETATIS.SVAE / ANN. XVIIII. (At the age of 19). Traces of a signature are visible lower left.

NG 674 was formerly believed to be a lady of the Brignole family, Genoa. But there is no evidence to support this identification.

The costume and style suggest a date of about 1550. The portrait was probably companion with a portrait of a young man now in the Uffizi, Florence, which is of a similar size and date, has a related background, and is complementary to it in pose.

Bought in Naples from the Duca di Cardinale, 1861.

Gould 1975, pp. 36–8.

Anthonie van BORSSUM
A Garden Scene with Waterfowl
probably about 1660–5

Johannes BOSBOOM
The Interior of the Bakenesserkerk, Haarlem
probably 1870–5

Hieronymus BOSCH
Christ Mocked (The Crowning with Thorns)
about 1490–1500

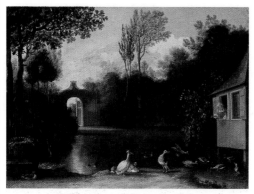

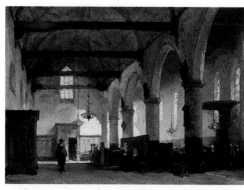

NG 3314
Oil on canvas, 33.7 x 45.8 cm

NG 2712
Oil on mahogany, 24.7 x 34.1 cm

NG 4744
Oil on oak, 73.5 x 59.1 cm

Signed, bottom right: A V Borsfom f (A V B in monogram).

The painting has been dated to the early 1660s on the basis of comparisons with paintings of fowl by Melchior d'Hondecoeter, who was a very influential painter in this genre.

Collection of Sir Edmund Lechmere (Bt) by 1918; presented by John P. Heseltine, 1918.

MacLaren/Brown 1991, p. 44.

Signed bottom left: I Bosboom.

This is a view of the south aisle of the fifteenth-century church, looking towards the east end. The figures are shown in seventeenth-century costumes.

Bosboom made a number of sketches and paintings of the church. This is similar to a larger painting (Amsterdam, Historisch Museum, Fodor Collection) which is thought to have been painted in about 1860. NG 2712 is broader in execution, and can consequently be dated to about 1870–5.

Collection of John Forbes White, Dundee, by 1888; presented by J.C.J. Drucker, 1910.

MacLaren/Brown 1991, pp. 44–5.

In this devotional image four torturers surround Christ. In contemporary accounts of Christ's Passion his torturers were frequently compared to savage beasts – this may explain why the man at the top right appears to wear a spiked dog collar. The figure at the lower left has a crescent moon and star on his head-dress. In paintings of the Passion of the period the tormentors are often shown with yellow stars marking them as Jews. In addition the Islamic crescent may suggest that he is in every sense an infidel.

NG 4744 is probably one of the artist's earlier paintings. There are a number of pictures of this subject by Bosch and his followers in existence (e.g. El Escorial).

In many areas, the paint is thinly applied and the layers have become transparent, notably on Christ's garment, so revealing the drawing beneath. By contrast the crown of thorns and the oak sprig have been very meticulously defined.

Collection of Hollingworth Magniac, Colworth, before 1867; bought from the Sangiorgi Gallery, Rome (Temple–West Fund), 1934.

Davies 1953, pp. 18–21; Davies 1968, p. 12; Dunkerton 1991, pp. 348–9.

Anthonie van BORSSUM
1630–1677

Born and active in Amsterdam, Borssum may have been a pupil of Rembrandt from about 1645 to 1650. A versatile and eclectic artist, he principally painted landscapes (including moonlight and winter scenes), as well as pictures of plants and animals, and church interiors. Many landscape drawings survive. He died in Amsterdam.

Johannes BOSBOOM
1817–1891

Bosboom was born in The Hague. He was a pupil of Johannes van Hove, and in 1835 travelled to the Rhineland. He set up as an independent painter in 1836. He visited Belgium in 1837 and Paris and Rouen in 1839. He settled in The Hague but travelled widely within the Netherlands. He specialised in church interiors, but also painted town views and landscapes. He was also a distinguished watercolourist.

Hieronymus BOSCH
living 1474; died 1516

Jerome or Hieronymus van Aken was recorded in 's-Hertogenbosch (North Brabant) from 1474. His most characteristic works contain small and often fantastic figures. His paintings were much admired and imitated in the sixteenth century, and were collected by Philip II of Spain.

Attributed to Pieter van den BOSCH
A Woman scouring a Pot
about 1650–60

NG 2551
Oil on oak, 19.4 x 25.8 cm

Jan BOTH
A Rocky Landscape with an Ox-cart
about 1640–5

NG 1917
Oil on canvas, 120.5 x 160.5 cm

Jan BOTH
A View on the Tiber, near the Ripa Grande, Rome (?)
about 1641

NG 958
Oil on oak, 42.1 x 55 cm

The attribution of NG 2551 to van den Bosch is based on comparison with a signed picture of the same subject (Berlin, Staatliche Museen). The painting displays the influence of Gerrit Dou and on the grounds of style can be dated in the 1650s.

A label on the back of the panel suggests that it was in an Italian collection in 1795; Salting Bequest, 1910.

MacLaren/Brown 1991, p. 47.

Signed in the middle of the large rock at the right: J Both f (JB in monogram).
NG 1917 has been dated to the first half of the 1640s. The composition and the treatment of the sunlight are similar to a landscape by Both in The Hague (Mauritshuis).

Earl of Shaftesbury sale, London, 15 May 1852 (lot 57); bequeathed by Lord Cheylesmore 1902.

MacLaren/Brown 1991, pp. 52–3.

Signed bottom left on a rock: JBoth fc (JB in monogram).
The church tower in the centre background resembles that of S. Maria della Torre in Rome, which was beside the Ripa Grande, the old port of the city, opposite the Aventine. The other buildings seem to have been invented by the artist. The picture appears to be a slightly inaccurate reminiscence of the site.
NG 958 is painted on oak, an unusual support to have been used in Italy, and probably dates from shortly after Both's return to Utrecht in 1641.
The artist also painted a more topographically accurate view of the Ripa Grande from the south-west (Frankfurt, Städelsches Kunstinstitut).

Almost certainly anon. sale, London, 30 May 1863; Wynn Ellis Bequest, 1876.

MacLaren/Brown 1991, pp. 50–2.

Pieter van den BOSCH
about 1613/15–after 1663

Van den Bosch was first recorded as a painter in Amsterdam in 1645. He was active there until 1660 and is generally thought to have painted a group of genre interiors, which show the influence of Gerrit Dou and Quiringh van Brekelenkam. In 1663 he may have been living in London.

Jan BOTH
about 1615–1652

Both was born in Utrecht and was a pupil there of Abraham Bloemaert. He was in Rome from about 1635 until 1641, when he returned to Utrecht. While in Rome Both collaborated – with Claude, Poussin and others – on a series of landscape paintings for the Buen Retiro Palace in Madrid. Almost all his works are landscapes based on Italian scenery, occasionally with religious or mythological subjects.

Jan BOTH
Peasants with Mules and Oxen on a Track near a River about 1641

NG 959
Oil on copper, 39.6 x 58.1 cm

Signed on a stone at the left edge and towards the bottom: JBoth (JB in monogram).
 Probably painted shortly after Both's return to Utrecht from Italy. It shows his familiarity with the landscape of the Roman Campagna.

Imported into England by John Smith, 1826; in the collection of Artis, London, by 1835; sold by him to Wynn Ellis, 1845; Wynn Ellis Bequest, 1876.

MacLaren/Brown 1991, p. 52.

Jan BOTH
A Rocky Italian Landscape with Herdsmen and Muleteers mid-1640s

NG 956
Oil on canvas, 103 x 125 cm

Signed, right: JB. . .(f?) (JB in monogram).
 NG 956 was probably painted in the mid-1640s. Two variants of the composition are recorded.

Sir Gregory Page Turner sale, London, 1815; Wynn Ellis Bequest, 1876.

MacLaren/Brown 1991, pp. 49–50.

Jan BOTH
A Rocky Landscape with Peasants and Pack Mules about 1645

NG 71
Oil on canvas, 119.5 x 160 cm

Signed centre left: J Both f· (JB in monogram).
 A man is beating one of the pack mules in the middle distance.
 NG 71 is dated on grounds of style to about 1645.

Collection of Sir George Beaumont by 1790; by whom presented to the British Museum, 1823; transferred to the National Gallery, 1828.

MacLaren/Brown 1991, p. 49.

Jan BOTH
Muleteers, and a Herdsman with an Ox and Goats by a Pool, about 1645

NG 957
Oil on oak, 57.2 x 69.5 cm

Jan BOTH and Cornelis van POELENBURGH
A Landscape with the Judgement of Paris
about 1645–50

NG 209
Oil on canvas, 97 x 129 cm

Sandro BOTTICELLI
The Adoration of the Kings
about 1470

NG 592
Tempera on wood, painted surface 50.2 x 135.9 cm

Signed, bottom left: JBoth (JB in monogram).

The cattle in the foreground, unusually prominent for a composition by Both, are by the artist himself and not by another artist, as has been suggested.

Wynn Ellis Bequest, 1876.

MacLaren/Brown 1991, p. 50.

Signed left foreground: J Both (JB in monogram).

Paris hands the apple of discord to Venus, who stands between Minerva and Juno. (For further information on the subject see Wtewael NG 6334.)

NG 209 is a collaborative work . The landscape and animals were painted by Both, while the figures are by Cornelis van Poelenburgh. The picture is dated on grounds of style to about 1645–50.

Possibly in the Benjamin da Costa collection, The Hague, by 1752; bequeathed by Richard Simmons, 1847.

MacLaren/Brown 1991, p. 53.

The Three Kings journeyed to Bethlehem to honour the new-born Jesus. They followed a star, and brought gifts of gold, frankincense and myrrh. New Testament (Matthew 2: 2–12). The accompanying figures to the left are the kings' retinue. The figures on the right are probably intended to be the arriving shepherds. Legendary embellishments of the biblical narrative told of fighting between the entourages of the kings, as depicted here on the left.

NG 592 is an early work by Botticelli in which the influence of Fra Filippo Lippi is marked. The subject of the Adoration of the Kings was popular with wealthy Florentines, many of whom belonged to a lay association (the Compagnia dei Magi) which venerated the Three Kings.

Pentimenti can be seen (left of centre) where several heads have been painted out. On the reverse there is a drawing of a female figure with a shield, a face and various scribbles (drawn onto the unprimed wood).

In the collection of the Marchese Ippolito Orlandini, Florence; Lombardi–Baldi collection, Florence, by 1845; from where bought, 1857.

Davies 1961, pp. 97–8; Lightbown 1978, II, pp. 20–1; Dunkerton 1991, p. 66.

Sandro BOTTICELLI
about 1445–1510

Sandro di Mariano Filipepi, called Botticelli, was a pupil of Filippo Lippi and probably also trained with the goldsmith Maso Finiguerra. Active by 1470, he was painting in the Sistine Chapel, Rome, in 1481–2, and was subsequently active in Florence, where he frequently worked for the Medici family. He ran a large workshop, and was apparently influenced by the religious teachings of Savonarola.

Sandro BOTTICELLI
The Adoration of the Kings
about 1470–5

NG 1033
Tempera on poplar, diameter 130.8 cm

The Three Kings journeyed to Bethlehem to honour the new-born Jesus. They brought gifts of gold, frankincense and myrrh. New Testament (Matthew 2: 2–12; Luke 2: 8–17). The figures in the foreground are the kings' retinues. The shepherds approach from behind. The ruined Roman temple probably alludes to the crumbling of the old pagan order.

Circular paintings (*tondi*) of the Adoration were popular in the palaces of wealthy Florentines, many of whom belonged to a lay association (the Compagnia dei Magi) which venerated the Three Kings. Portraits may be included among the foreground figures.

The architecture has been constructed on the panel with a system of incised lines and is used to marshal the composition; the format of a tondo was an obvious stimulus towards centralised compositions.

Possibly mentioned by Vasari (1568) in the Casa Pucci, Florence; in the Palazzo Guicciardini, Florence, 1807; collection of William Coningham by 1849; collection of W. Fuller Maitland by 1854; bought, 1878.

Davies 1961, pp. 101–2; Lightbown 1978, II, pp. 25–6; Dunkerton 1991, p. 312.

Sandro BOTTICELLI
Portrait of a Young Man
probably about 1480–5

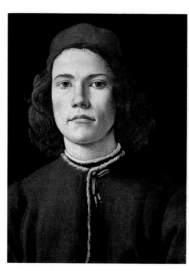

NG 626
Tempera and oil on wood, painted surface 37.5 x 28.3 cm

This unidentified young man is set against a black background. He wears a red hat of the type known as a *beretta*, and a brown tunic.

Botticelli was one of the first Italian artists to abandon the profile format in his portraiture. More of the sitter's body may originally have been included.

In the collection of Col. Matthew Smith before 1804; bought by Lord Northwick, and recorded in his collection, 1837; bought, 1859.

Davies 1961, pp. 98–9; Lightbown 1978, II, p. 65; Dunkerton 1991, pp. 95, 164.

Sandro BOTTICELLI
Venus and Mars
about 1485

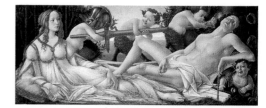

NG 915
Tempera and oil on poplar, painted surface 69.2 x 173.4 cm

Mars, the god of war, is vanquished by Venus, the goddess of love and beauty. The shell may allude to Venus' birth from the sea. The wasps (*vespe* in Italian) in the top right corner could be an allusion to the Vespucci family (whose crest included wasps and who were active patrons of Botticelli). Alternatively – or additionally – the wasps may relate to the subject (suggesting that love can have a sting, or demonstrating – together with the blowing of a shell in Mars' ear – how deeply the god of war is sleeping). There may also be an allusion to a lost classical painting. Lucian described a painting of the marriage of Alexander and Roxana in which cupids played with Alexander's spear and armour. The satyrs can be seen to do this in NG 915.

The shape of the panel suggests that the painting was designed as the *spalliera* (backboard) of a bench or *cassone* (chest) in a Tuscan palace bedchamber. The imagery would have been regarded as suitable for a married couple and weddings were the pretexts for the decoration of such rooms. NG 915 was probably painted in the mid-1480s. The *Allegory* by a follower of Botticelli (NG 916) was once regarded as a pendant.

Bought in Florence by Alexander Barker before 1869; bought, 1874.

Davies 1961, pp. 99–101; Gombrich 1972, pp. 66–9; Lightbown 1978, II, pp. 55–6; Woolf 1988, pp. 49–50; Dunkerton 1991, p. 336.

Sandro BOTTICELLI
'Mystic Nativity'
1500

Sandro BOTTICELLI
Four Scenes from the Early Life of Saint Zenobius
about 1500

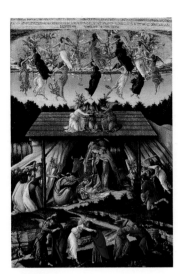

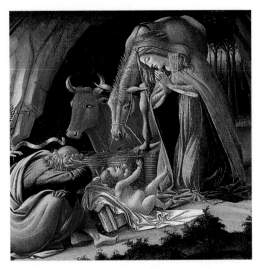

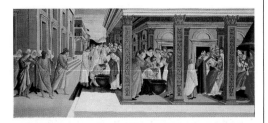

NG 3918
Tempera on wood, painted surface 66.7 x 149.2 cm

NG 1034
Oil on canvas, 108.6 x 74.9 cm

NG 1304, detail

Inscribed in Greek at the top: I Alessandro made this picture at the conclusion of the year 1500 in the troubles of Italy in the half time after the time according to the 11th [chapter] of Saint John in the second woe of the Apocalypse during the loosing of the devil for three and a half years then he will be chained in the 12th [chapter] and we shall see him burying himself as in this picture. Inscribed in Latin on the scrolls held by the angels above the stable: SACRA / RIVM. I(INEFFABILE) (ineffable sanctuary); MATER DE(I) (Mother of God); VIRGO VIRGINVM (Virgin of virgins); SPO[N]SA DEI PATRIS ADMIRANDA (admirable bride of God the Father); VE[RGO?] FECHVNDA (fecund [virgin]); SPERAN[ZA] (hoped for...); REGINA SOPRA TVT... (Queen above all...); REGINA SOLA MV[N]DI (Sole Queen of the world); GLORIA IN EXCELSIS DEO (Glory to God on high) and on the scrolls held by the angels in the foreground: [H]OMINIBVS BO[NAE VOLVNTATIS] (to men of goodwill); ET IN TER[R]A PAX (and [peace] on earth); [H]OMINIBVS. BON[A]E VOLVNTATIS (to men of goodwill [a continuation of the last inscription held by one of the angels above]). And in addition inscribed in Latin on the scroll of one of the angels who point at the Christ child: [AG]NVS DEI ([Behold] the lamb of God).

The Virgin, kneeling to adore the new-born Christ in front of the stable, is larger in scale than the adoring shepherds (to the right) and the three figures, perhaps the Magi (to the left). The scrolls in the foreground abbreviate a quotation from the New Testament (Luke 2: 14), and the devils bury themselves. The inscription at the top has been the subject of much debate, but essentially links the picture to the New Testament Book of Revelation, and to the Incarnation as the way in which peace

was brought to earth (symbolised by olive branches being passed by angels to men).

NG 1034 is dated 1500 and was probably painted as a private devotional work for a Florentine patron.

Aldobrandini collection, Rome, by about 1791–9; collection of W. Young Ottley by 1811; bought by W. Fuller Maitland, 1847; bought, 1878.

Davies 1961, pp. 103–8; Lightbown 1978, II, pp. 99–101; Dunkerton 1991, p. 354; Wilson 1992, pp. 232–41.

Saint Zenobius, who lived in the fifth century, became one of the patron saints of Florence. NG 3918 apparently follows Fra Clemente Mazza's Life of Saint Zenobius (first printed in 1487). From left to right the four scenes are: Zenobius rejecting the marriage his parents propose for him; his baptism by the bishop of Florence; the subsequent baptism of his mother; Zenobius, now bearded, being invested as Bishop of Florence by the Pope, Saint Damasus.

NG 3918 and 3919 formed part of a series of the miracles of Saint Zenobius (two other panels are in Dresden, Gemäldegalerie; and one is in New York, Metropolitan Museum of Art). The series were probably *spalliere* (backboards) in a Florentine palace, and it has recently been suggested that they may have been made for a member of the Girolami family who had a special devotion to Saint Zenobius. It has further been suggested that they were painted for the marriage of either Raffaello (Raphael) Girolami in 1497 or his brother Zanobi (Zenobius) in 1500.

Said to have come from the Rondinelli collection, Florence; bought by J.P. Richter for Ludwig Mond, 1891; Mond Bequest, 1924.

Davies 1961, pp. 108–10; Lightbown 1978, II, pp. 106–7; Callmann 1984, pp. 492–5; Dunkerton 1991, pp. 110–13.

Sandro BOTTICELLI
Three Miracles of Saint Zenobius
about 1500

Workshop of BOTTICELLI
The Virgin and Child
probably about 1475–1500

Workshop of BOTTICELLI
The Virgin and Child with a Pomegranate
probably about 1480–1500

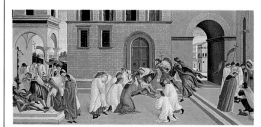

NG 3919
Tempera on wood, painted surface 64.8 x 139.7 cm

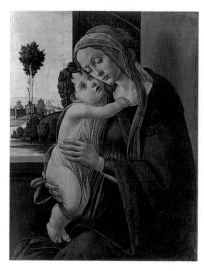

NG 782
Tempera on wood, painted surface 83.2 x 64.8 cm

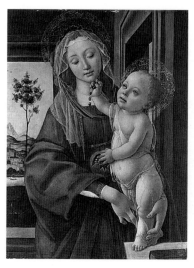

NG 2906
Tempera on wood, painted surface 67.9 x 52.7 cm

NG 3919 apparently follows Fra Clemente Mazza's Life of Saint Zenobius (first printed in 1487) and shows three of his miracles. From left to right: the saint exorcises devils from two youths who had been cursed by their mother (she subsequently repented and prayed for their cure at the foot of a crucifix); Zenobius raises a dead youth to life at the supplication of his mother, a noble lady of Gaul; and Zenobius restores the sight of a blind pagan who had promised in return to convert to Christianity.

For further information on the series of which NG 3919 was part, see under NG 3918.

Said to have come from the Rondinelli collection, Florence; bought by J.P. Richter for Ludwig Mond, 1891; Mond Bequest, 1924.

Davies 1961, pp. 108–10; Lightbown 1978, II, pp. 108–9; Callmann 1984, pp. 492–5; Dunkerton 1991, pp. 110–13.

Versions of this design are very frequent; they may all derive from a Botticelli *Virgin and Child* now in Paris (Louvre). This version was probably painted in the last quarter of the fifteenth century by the artist's workshop.

In the collection of Conte Angiolo Tassi before 1863; bought from Baslini, Milan, 1867.

Davies 1961, pp. 111–12; Lightbown 1978, II, pp. 127–8.

The Christ Child holds a pomegranate (a traditional symbol of the Passion) and is showing some of its seeds to his mother, the Virgin Mary.

The picture has been extensively retouched, and has been cut at the bottom and on the right-hand side.

Apparently in the collection of Prince Jerome Napoleon before 1872; bequeathed by Lady Lindsay, 1912.

Davies 1961, p. 113; Lightbown 1978, II, p. 137.

Workshop of BOTTICELLI
The Virgin and Child with Saint John the Baptist
probably about 1482–98

Workshop of BOTTICELLI
The Virgin and Child with Saint John and an Angel, about 1490

Workshop of BOTTICELLI
The Virgin and Child with Saint John and Two Angels, probably about 1490–1500

NG 2497
Tempera and oil on wood, painted surface
95.3 x 94 cm

Inscribed on Saint John's scroll: .ECCE. AGNVS. / .DEI.
(Behold the Lamb of God).
 The words on Saint John's scroll are from his Gospel. New Testament (John 1: 29 or 36).
 Other versions of this tondo are known – one is in Cardiff (National Museum of Wales).

Said to have come from the Marchese Patrizi, Rome; collection of George Salting by 1889 (perhaps earlier); Salting Bequest, 1910.

Davies 1961, pp. 112–13; Lightbown 1978, II, pp. 153–4.

NG 275
Tempera on wood, painted surface 84.5 x 84.5 cm

Inscribed on the reverse: M.[?] Giuljano da san Ghallo (Master Giuliano da San Gallo).
 The Virgin suckling the Child Jesus is shown flanked by a youthful Saint John the Baptist (left) and an angel (right).
 The strongly outlined figures clearly derive from Botticelli's workshop and must be by a good studio assistant; the quality is not of a standard to warrant attributing the picture to Botticelli himself. The number of versions of the picture suggests that the composition was popular.
 The inscription, which is apparently contemporary, presumably refers to the Florentine stonemason, wood carver and builder/architect Giuliano da Sangallo. He may have commissioned NG 275, but it is more likely that he was responsible for the original frame. The present frame of about 1505 is on loan from the Victoria and Albert Museum.

Bianconi collection, Bologna, by 1855; bought, 1855.

Davies 1961, pp. 110–11; Lightbown 1978, II, p. 132; Dunkerton 1991, pp. 70, 156.

NG 226
Tempera and oil on wood, painted surface
114.3 x 113 cm

The Virgin is crowned by angels and thus the emphasis is on her role as the Queen of Heaven.
 Some parts of this tondo are of higher quality in execution than others. It has been suggested that NG 226 dates from the 1490s and that it may be based on a design by Botticelli.

In the collection of the Polli family, Florence, before 1855; bought from J.H. Brown, Florence, 1855.

Davies 1961, p. 110; Lightbown 1978, II, pp. 133–4.

Follower of BOTTICELLI
The Virgin and Child
probably about 1485–1500

NG 3082
Tempera on wood, painted surface 29.5 x 19.7 cm

Inscribed on the reverse: .S. Bartholomeo / L'.ANNO M.CCCCXII[I?]. (1412 (3)).

This Virgin and Child group is derived from the central part of Botticelli's S. Barnaba altarpiece (Florence, Uffizi).

The inscription on the reverse is obscure; the year referred to may be 1412 or 1413, but NG 3082 was probably painted in the late fifteenth century.

Given to Sir A.H. Layard by 'J. Miner Kellogg' before 1869; Layard Bequest, 1916.

Davies 1961, pp. 117–18.

Follower of BOTTICELLI
Saint Francis
probably about 1490–1500

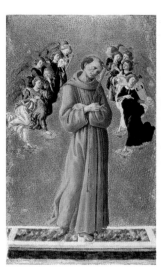

NG 598
Tempera and oil on wood, 49.5 x 31.8 cm

Saint Francis of Assisi (about 1181–1226) is shown holding a crucifix. The stigmata can be seen in his side, hands and feet. He wears the traditional brown habit of the Franciscan Order, which he founded.

Words from a hymn to Saint Francis and the date 1492 were once written along the lower edge. Although not original, this inscription may have been copied from an original inscription on the picture or its frame. Sometimes attributed to Botticelli, NG 598 is more likely to be the work of a follower.

It was probably made for domestic devotion.

In the collection of Conte Giovanni Battista Costabili, Ferrara, by 1841; from where bought, 1858.

Davies 1961, pp. 115–16.

Follower of BOTTICELLI
An Allegory
probably about 1490–1550

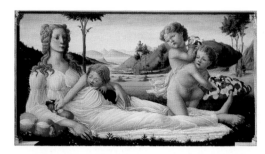

NG 916
Tempera and oil on wood, painted surface (sight) 92.1 x 172.7 cm

The subject may be an allegory of fertility; three putti present a woman with flowers and grapes. A painted architectural frame surrounds the main image.

NG 916 was once attributed to Jacopo del Sellaio (about 1441–93), but is probably the work of a follower of Botticelli. The composition seems to derive in part from Botticelli NG 915.

NG 916 was celebrated as a Botticelli when in the collection of Alexander Barker. It was regarded as a companion piece of the *Venus and Mars* (NG 915) and the Gallery paid more for it than for the latter at Barker's sale in 1874 (see provenance). That it is a pastiche in Botticelli's style painted much later has often been suspected but it seems to date from the sixteenth century.

Probably in the collection of Cardinal Fesch by 1841; in the collection of Alexander Barker by 1857; bought, 1874.

Davies 1961, pp. 116–17.

Follower of BOTTICELLI
A Lady in Profile
about 1490

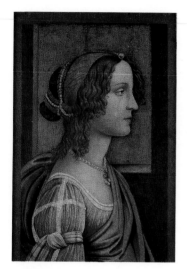

NG 2082
Tempera on wood, painted surface 59.1 x 40 cm

NG 2082 is a weak version of a picture attributed to Botticelli and formerly in the Noak collection, Berlin. Similar profile portraits by Botticelli's circle are known; they may be no more than illustrations of some female ideal.

The reverse of NG 2082 is painted with a winged figure, presumably an angel, standing on a rock before a wood. The angel holds a sphere and a scroll (which is inscribed: CHI B / I / N). The object in this figure's right hand has alternatively been described as moss or a handkerchief. The figure probably personifies some moral allegory.

Bequeathed by the Misses Cohen as part of the John Samuel collection, 1906.

Davies 1961, p. 117; Lightbown 1978, II, pp. 118–19; Dunkerton 1991, pp. 100–1.

NG 2082, reverse

Francesco BOTTICINI
The Assumption of the Virgin
probably about 1475–6

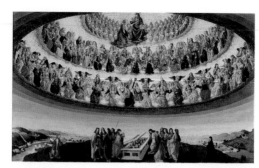

NG 1126
Tempera on wood, 228.6 x 377.2 cm

The book held by Christ is inscribed with the Greek characters alpha and omega which refer to the New Testament (Revelation 1: 8): [I am] Alpha and Omega, the beginning and the end.

The Assumption of the Virgin is not described in the Bible, but is related in various early medieval devotional works, including *The Golden Legend*. In the centre the apostles marvel at the tomb of the Virgin filled with lilies, while above Christ receives her into the highest circle of Heaven. Angels are ranged in nine choirs, divided into three hierarchies. The highest of these represent Councillors (Seraphim, Cherubim and Thrones), the middle represent Governors (Dominions, Virtues and Powers); then follow the Ministers (Principalities, Archangels and Angels). Unusually, saints and prophets have been incorporated into the ranks of angels. This may reflect the theological speculations of Matteo Palmieri, which were embodied in a poem, the *Città di Vita*, later regarded as heretical.

NG 1126 was erected as an altarpiece in the chapel in S. Pier Maggiore, Florence, of Matteo Palmieri (depicted kneeling on the left), soon after his death in 1475. Opposite him is his widow, Niccolosa, in the habit of a Benedictine nun (the order which owned the church). The view behind Matteo includes both Florence and Fiesole and also a farm belonging to him; behind Niccolosa there are farms in the hills of Val d'Elsa which were part of her dowry.

Recorded in S. Pier Maggiore, Florence, 1550; bought, 1882.

Davies 1961, pp. 122–7; King 1987, pp. 275–8; Dunkerton 1991, pp. 49–50, 82.

Francesco BOTTICINI
about 1446–1497

Francesco di Giovanni, called Botticini, was active in Florence in the last third of the fifteenth century. His only two documented works are a tabernacle in Empoli commissioned in 1484 (and probably finished after his death by his son Raffaello) and an altarpiece commissioned in 1492 (New York, Metropolitan Museum of Art). Pictures attributed to him date from 1471. He was influenced by Botticelli.

Francesco BOTTICINI
Saint Jerome in Penitence with Saints and Donors
about 1490

NG 227.1–2
Tempera on poplar?, including frame 235 x 258 cm

Inscribed at the base of the inner frame with the names of the saints: .S.IERONIMVS.; S.DAMMASVS.; S.EVSHBIVS.; .S.PAVLA.; .S.EVSTOCIV[M]; and on Jerome's crucifix: INRI.

Saint Jerome is on a panel in the centre. To either side are Saints Damasus (as Pope), Eusebius, Paula and Eustochium (with a lily). Two donors, possibly father and son, kneel at prayer in the foreground. The father may be Gerolamo di Piero di Cardinale Rucellai (died 1497?), whose tomb is near where the picture hung.

NG 227.1-2 was almost certainly painted for the church of the Hermits of Saint Jerome (S. Gerolamo) of Fiesole at Fiesole. A date of about 1490 seems likely. The predella NG 227.2 has the Rucellai arms at each end and four narrative scenes: Jerome taking the thorn out of the lion's paw; his vision that he was beaten for still enjoying pagan literature; his death; and his appearance with Saint John the Baptist to Saint Augustine. (See Appendix B for a larger reproduction of this work.)

The frame appears to be the original one, but extensively remade and regilded in about 1850. The back of the altarpiece has a monogram that is probably a panel-maker's stamp. A drawing for Saint Jerome is in Budapest.

Recorded in the church of the Hermits of Saint Jerome of Fiesole, Fiesole, 1761, by which time the church had passed to the Bardi family; and in 1798 their property passed to the Ricasoli family; from whom bought, 1855.

Davies 1961, pp. 119–22; Dunkerton 1991, pp. 54, 154.

François BOUCHER
Landscape with a Watermill
1755

François BOUCHER
Pan and Syrinx
1759

Studio of BOUCHER
The Billet-Doux
1754

NG 6374
Oil on canvas, 57.2 x 73 cm

NG 1090
Oil on canvas, 32.4 x 41.9 cm

NG 4080
Oil on canvas, 95.3 x 127 cm

Signed and dated: F. Boucher/1755.

NG 6374 has sometimes been described as a landscape with washerwomen and the principal activities in the picture are of a woman doing her washing in a river and another fetching water. Men are less arduously employed, fishing, at rest and herding cattle across a bridge.

Denis-Pierre-Jean Papillon de la Ferté, a patron and biographer of Boucher, and probably the first owner of NG 6374, engraved it as in his own collection in 1758.

There are two drawings known for NG 6374 (USA, private collection; Vienna, Albertina).

Collection of M. Denis-Pierre-Jean Papillon de la Ferté, Paris, by 1758; Bergeret, Paris, 1786; bought, 1966.

Ananoff 1976, II, pp. 136–7; Ananoff 1980, pp. 124–5; Wilson 1985, p. 96.

Signed and dated: f. Boucher/1759

Syrinx, a devotee of the chaste huntress Diana, was fleeing from Pan's amorous pursuit when she came to the river Ladon and could flee no more. Syrinx begged 'her sisters of the stream' to let her change form, so that when Pan lunged to grab her, he grasped instead the marsh reeds Syrinx had become. Ovid, *Metamorphoses*, I, 793–820.

At least two preparatory drawings are known (private collection; Bloomington, Indiana University Art Museum).

Collection of Armand-Pierre-François de Chastre de Billy by 1784; Charles de Wailly by 1788; collection of Robert Hollond by about 1840 and presented by Mrs Robert Hollond, 1880.

Davies 1957, pp. 17–18; Ananoff 1976, II, p. 190; Ananoff 1980, p. 130; Wilson 1985, p. 98; Bailey 1991, pp. 326–31.

Signed and dated: Boucher/1754.

NG 4080 shows the arrival or despatch of a love letter (French: *billet-doux*) carried by a dove. The principal figure, barefoot on the right, has a basket of flowers, symbols of Venus, the goddess of love.

NG 4080 is one of many studio versions of a picture dated 1750 (*The Love Letter*, Washington, National Gallery of Art) which was painted for Madame de Pompadour and engraved by Charbonnier with the caption: 'La Poste secrète des amoureux' (The secret correspondence of lovers). NG 4080, which is dated 1754, can be seen as a demonstration of the popularity of the original following its exhibition (together with its pendant, *The Interrupted Sleep*, New York, Metropolitan Museum of Art) in the Salon of 1753.

Bequeathed by Mrs Edith Cragg, daughter of John Webb, as part of the John Webb Bequest, 1925.

Davies 1957, p. 18; Ananoff 1976, II, p. 66; Ananoff 1980, p. 117.

François BOUCHER
1703–1770

Boucher lived in Paris apart from a period in Italy from 1727 to 1731. He was a leading painter of erotic mythologies and landscapes. He also painted portraits, genre and hunting scenes, and designed tapestries and stage sets. He was appointed First Painter to the King in 1765 and remained active until his death.

Eugène BOUDIN
Beach Scene, Trouville
about 1860–70

Eugène BOUDIN
L'Hôpital-Camfrout, Brittany
about 1870–3

Eugène BOUDIN
Beach Scene, Trouville
about 1870–4

NG 6309
Oil on wood, 21.6 x 45.8 cm

NG 6311
Oil on wood, 20.3 x 39.4 cm

NG 6310
Oil on wood, 18.2 x 46.2 cm

Signed at the bottom on the right: E. Boudin

NG 6309 shows groups of people on a beach, probably the beach at Trouville, then a fashionable resort on the Normandy coast.

Boudin painted many views of the beach at Trouville in the 1860s and 1870s. In NG 6309 all the ladies appear to be wearing crinolines, a fashion of the 1860s, and the painting is usually dated to that decade.

NG 6309 is painted on a piece of carved wooden panelling that originally might have been part of a piece of furniture. By tradition, NG 6309 and 6310 were both owned by Monet, though they were probably not painted as a pair. In 1869 Monet painted a group of studies of his wife and other figures on the beach at Trouville, one of which is NG 3951.

Hôtel Drouot, Paris, 1899; Viscount Rothermere by 1937; bequeathed by Miss Judith E. Wilson, 1960.

Davies 1970, p. 15; Schmit 1973, I, p. 224, no. 616.

Signed at the bottom on the left: E. Boudin

L'Hôpital-Camfrout is a small market town near Plougastel in western Brittany. Boudin visited this area on several occasions in the early 1870s.

Hôtel Drouot, Paris, 1892; bequeathed by Miss Judith E. Wilson, 1960.

Davies 1970, pp. 15–16; Schmit 1973, I, p. 215, no. 584.

Signed at the bottom on the left: E. Boudin

Boudin painted many views of the beach at Trouville in the 1860s and 1870s. In NG 6310 all the ladies appear to be wearing bustles, a fashion of the 1870s, and the painting is usually dated about 1870–4.

For further commentary on NG 6310, see under NG 6309.

Viscount Rothermere by 1937; bequeathed by Miss Judith E. Wilson, 1960.

Davies 1970, p. 15; Schmit 1973, I, p. 223, no. 615.

Eugène BOUDIN
1824–1898

Born at Honfleur, Boudin studied in Paris and came into contact with the Barbizon School, and with Isabey and Jongkind. He is best known for seascapes and beach scenes on the Normandy coast. He produced many paintings in the open air, often working rapidly and on a small scale. On occasion he worked with the young Monet, who was influenced by Boudin's approach.

Eugène BOUDIN
Brussels Harbour
1871

NG 6530
Oil on canvas, 42 x 65 cm

Eugène BOUDIN
Beach Scene, Trouville
1873

NG 6312
Oil on wood, 15.2 x 29.8 cm

Eugène BOUDIN
Laundresses by a Stream
about 1885–90

NG 6313
Oil on wood, 17.8 x 22.9 cm

Signed and dated at the bottom on the right: Boudin 71

NG 6530 is one of a number of views of the harbour at Brussels painted by Boudin in the winter of 1870–1, when the painter had moved to Brussels to escape the Franco-Prussian war.

Gérard collection, Paris, by 1900; bequeathed by Helena and Kenneth Levy, 1990.

Schmit 1973, I, p. 230, no. 635; National Gallery Report 1990–1, p. 20.

Signed and dated at the bottom on the left: E. Boudin 73. Inscribed at the bottom on the right: Trouville

NG 6312 shows groups of people sitting and standing on the beach (which is identified in the inscription as the beach at Trouville).

Boudin painted many views of the beach at Trouville in the 1860s and 1870s, see also NG 6309 and 6310.

Nunès collection, Paris, by 1894; bequeathed by Miss Judith E. Wilson, 1960.

Davies 1970, p. 16; Schmit 1973, I, p. 301, no. 850.

Signed at the bottom on the left: E. Boudin

Boudin is best known for seascapes and beach scenes depicting the Normandy coastline. However, he was a prolific artist who tackled a variety of subjects, including scenes of traditional peasant life, like this one of women washing laundry in a stream.

Collection of Ferdinand Heilbuth, Paris, by 1890; bequeathed by Miss Judith E. Wilson, 1960.

Davies 1970, p. 16; Schmit 1973, II, p. 295, no. 2075; Hamilton 1992–3, pp. 123ff.

Eugène BOUDIN
The Entrance to Trouville Harbour
1888

NG 2078
Oil on mahogany, 32.4 x 40.9 cm

Eugène BOUDIN
Deauville Harbour
about 1888–90

NG 3050
Oil on oak, 28.8 x 41.3 cm

Eugène BOUDIN
The Beach at Tourgéville-les-Sablons
1893

NG 3235
Oil on canvas, 50.8 x 74.3 cm

Signed and dated at the bottom on the left:
E.[?] Boudin / 88
 In the central middle distance the two jetties at the mouth of the river Touques (forming the entrance to the harbour of Trouville-Deauville) can be seen. NG 2078 is inscribed on its reverse, possibly by the painter, 'Boudin Entre les jetées – Trouville' (Boudin, Between the jetties – Trouville).
 The two jetties at the mouth of the Touques are seen from another angle in Boudin NG 3235.

Collection of Pieter van der Velde, Le Havre; presented by the NACF, 1906.

Davies 1970, p. 13; Schmit 1973, II, p. 359, no. 2250.

Signed and inscribed at the bottom on the left:
E. Boudin. / Deauville
 NG 3050 appears to show the *bassin à flot*, part of the harbour which separates Deauville and Trouville. The *port des yachts* can be seen beyond the bridge, and the tower on the left is a lighthouse.
 NG 3050 is generally dated in the second half of Boudin's life, and was probably painted in about 1888–90.

Collection of Henry L. Florence by 1909; by whom bequeathed, 1916.

Davies 1970, p. 14; Schmit 1973, II, p. 376, no. 2303.

Signed and dated at the bottom on the left:
E. Boudin 93. Inscribed at the bottom on the right:
Tourgeville [sic]
 NG 3235 was painted at Tourgéville-les-Sablons or Tourgéville-sur-Mer.
 In the central middle distance the two jetties at the mouth of the river Touques (forming the entrance to the harbour of Trouville-Deauville) can be seen. These are shown from another angle in Boudin NG 2078.

Collection of Charles de Bériot, Paris, by 1911; bequeathed by Sir Hugh Lane, 1917; on loan to the Hugh Lane Municipal Gallery of Modern Art, Dublin, since 1979.

Davies 1970, pp. 14–15; Schmit 1973, III, p. 206, no. 3137.

Eugène BOUDIN
Beach at Trouville
probably 1890s

NG 2758
Oil on canvas, 35.6 x 58.1 cm

Louis de BOULLONGNE
Nessus and Dejanira
about 1705

NG 6506
Oil on canvas, 65.4 x 80.6 cm

Sébastien BOURDON
The Return of the Ark
perhaps 1659

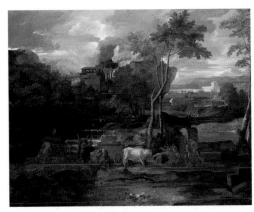

NG 64
Oil on canvas, 107.3 x 135.2 cm

Inscribed at the bottom on the right: 7 Août (7 August).

Traditionally called 'A Squall from the West', NG 2758 probably shows the beach at Trouville.

This sketch was presumably painted on the spot on 7 August, perhaps in the 1890s.

The bleak mood of this empty beach is in contrast to the crowded beach scenes that Boudin painted on other occasions. This feature of NG 2758 can be compared with Courbet's beach scenes of the 1860s (e.g. Courbet NG 2767).

Collection of Sir Frederick Wedmore by 1909; presented by T.W. Bacon through the NACF, 1910.

Davies 1970, pp. 13–14; Schmit 1973, III, p. 164, no. 3016.

Nessus was a centaur who carried travellers over the river Euenus. When Hercules and his bride, Dejanira, came to the river, Hercules swam ahead. Nessus then attempted to rape Dejanira and was killed by one of Hercules' arrows, the tip of which carried poison. Before dying, he dipped his tunic in his blood and gave it to Dejanira, telling her that if she were ever worried that Hercules was unfaithful, she should give him the garment and his affections would return to her. Later she believed Hercules was in love with Iole, and so sent him Nessus' tunic. When he put it on it stuck to his skin with burning heat, and eventually he died of the unbearable pain. Ovid, *Metamorphoses*, IX.

NG 6506 was probably part of a decorative scheme, perhaps illustrating the life of Hercules or stories of thwarted love. It is dated on grounds of style to around 1705.

Bequeathed by Jeffery Daniels, 1986.

National Gallery Report 1985–7, pp. 25–6.

The Ark of the Covenant which held the tablets of the law (the Ten Commandments) is being transported by the plague-stricken Philistines back to the Beth-shemites. Old Testament (1 Samuel 6).

The Philistines are crossing the bridge behind the Ark which is pulled by two oxen. It has been miraculously stopped by the stone of Abel and is hailed by a group of Beth-shemites.

NG 64 is inspired in part by the style of the landscapes of Poussin of the later 1640s. According to an inscription on the back of the original canvas the work dates from 1659 and was intended for a 'Mr Thomas'.

In his *Fourteenth Discourse* at the Royal Academy of Arts in 1788 Sir Joshua Reynolds referred to this picture as a work 'in which the poetical style of landscape may be seen happily executed'.

Collection of Jean Baptiste Maximilien Titon by 1768?; Robert Strange sale, London, 1775; according to a worn inscription at bottom right, repeated on the back of the canvas, bequeathed to Sir George Beaumont by Sir Joshua Reynolds, 1792; Sir George Beaumont Gift, 1823/8.

Ponsonailhe 1883, p. 298; Davies 1957, p. 21; Wilson 1985, p. 66; Owen 1988, p. 35, no. 2; Lavergne-Durey 1989, p. 99.

Louis de BOULLONGNE
1654–1733

Louis de Boullongne the Younger was born in Paris, the second son of the painter Louis de Boullongne the Elder. With his elder brother Bon he studied at the Académie, and then in Rome. He became director of the Paris Académie in 1722, and First Painter to the King in 1725. He was involved with many of the most prestigious religious and mythological commissions of his day, notably at Versailles.

Sébastien BOURDON
1616–1671

Born in Montpellier, Bourdon was apprenticed to Jean Barthélemy in Paris. In 1634 he went to Rome where he painted low-life genre scenes. Accused of heresy, he returned to Paris in 1637. From the 1640s his works were notably influenced by Poussin. A founder member (1648) and later director of the Académie, he became a court painter in Stockholm (1652–4).

Style of Aelbrecht BOUTS
Christ Crowned with Thorns
early 16th century

Dieric BOUTS
The Entombment
probably 1450s

Dieric BOUTS
The Virgin and Child
about 1460

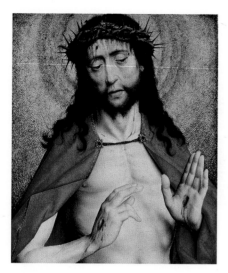

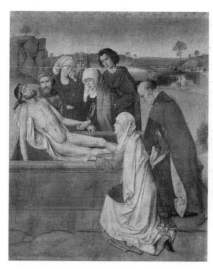

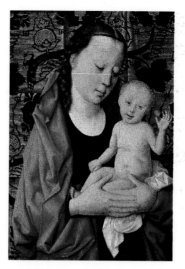

NG 1083
Oil on canvas backed onto board, transferred from wood, 43.5 x 36.8 cm

NG 1083 is one of a large number of varying versions of the subject associated in style with Aelbrecht Bouts. Its composition derives ultimately from Dieric Bouts (see Workshop of Dieric Bouts NG 712).

Collection of Karl Aders, a German merchant living in London, by 1817; bequeathed by Mrs Joseph H. Green, 1880.

Davies 1953, pp. 21–4; Davies 1968, pp. 13–14.

NG 664
Glue size on linen, 90.2 x 74.3 cm

The dead Christ is lowered into a tomb set in an open landscape. The Virgin, supported by John the Evangelist and two Holy Women, stand behind the tomb, while Joseph of Arimathea(?) supports the body, and Nicodemus(?) stands at the right. The Magdalen kneels at Christ's feet. New Testament (Matthew 27: 57–61).

NG 664 may have formed part of a large winged altarpiece of the Life of Christ. Other paintings from the same series are: *The Annunciation* (Malibu, J. Paul Getty Museum); an unpublished *Adoration of the Kings* (private collection, known also from a pen drawing after Bouts in the Uffizi, Florence) and *The Resurrection* (Pasadena, Norton Simon Museum). A *Crucifixion* (Brussels, Musées Royaux des Beaux-Arts) was possibly the central section of this altarpiece. The choice of linen as a support may have been intentional so as to ease transportation to an Italian patron.

Works on linen were extremely common in the fifteenth century, but very few have survived (see also Massys NG 3664).

Foscari collection before 1814; bought, 1860.

Davies 1953, pp. 24–7; Davies 1968, pp. 15–16; Bomford 1986, pp. 39–57; Dunkerton 1991, pp. 296–7.

NG 708
Oil on oak, 20.3 x 14.6 cm

The Christ Child holds an apple. Behind the Virgin is a cloth-of-gold hanging (see also those in Bouts NG 774 and 2595).

This is a devotional work probably intended for domestic use. Although the flesh areas are in poor condition, the quality of the rest suggests the work of Bouts himself.

Count Joseph von Rechberg collection, Mindelheim, before 1815; collection of Prince Ludwig Kraft Ernst von Oettingen-Wallerstein; acquired by the Prince Consort, 1851; presented by Queen Victoria at the Prince Consort's wish, 1863.

Davies 1953, pp. 28–31; Davies 1968, pp. 19–20.

Aelbrecht BOUTS
living 1473; died 1549

Aelbrecht was the second son of Dieric Bouts. He was active in Louvain. A triptych of the *Assumption of the Virgin* in Brussels (Musées Royaux des Beaux-Arts, no. 574) is almost certainly by him. It shows the influence of Dieric Bouts and, more particularly, Hugo van der Goes.

Dieric BOUTS
1400?–1475

Originally from Haarlem, Bouts is first certainly recorded in Louvain in 1457. He painted the Altarpiece of the Sacrament in 1464–7 for St Peter's, Louvain, and *Scenes of Justice* for the town hall (now Brussels, Musées Royaux des Beaux-Arts). Rogier van der Weyden's work influenced his output. His sons Dieric and Aelbrecht were also painters.

Dieric BOUTS
The Virgin and Child
about 1460

Dieric BOUTS
Portrait of a Man
1462

Dieric BOUTS
The Virgin and Child with Saints Peter and Paul
probably 1460s

NG 2595
Oil and egg (identified) on oak, 37.1 x 27.6 cm

NG 943
Oil on oak, 31.8 x 20.3 cm

NG 774
Oil on oak, 68.6 x 51.4 cm

The Virgin offers her breast to the Christ Child, who is seated on a cushion upon a window ledge. Behind her is a cloth-of-gold hanging. Further back is a second, partially glazed window. Beyond, a landscape can be seen, with the walls of a town encircling rooftops and church spires.

NG 2595 is probably an independent devotional work.

Evidently in Spain in 1863; Frédéric Spitzer collection, Paris; Salting Bequest, 1910.

Davies 1953, pp. 45–8; Davies 1968, p. 18; Bomford 1986, pp. 39–57; Dunkerton 1991, pp. 288–9.

Dated top right: .1462.

The sitter, who has not been identified, rests his hands at the bottom of the picture as though upon a ledge. It has been suggested that he may be wearing livery. To the left through an open window can be seen a landscape with a church.

NG 943 is Bouts's earliest dated work and the earliest dated example of a portrait set in a room with a view out of a window, a type which subsequently became popular (see also Petrus Christus NG 2593).

Possibly noted by Marcantonio Michiel, with an attribution to Rogier van der Weyden, in the collection of Giovanni Ram, Venice, 1530/1; Wynn Ellis Bequest, 1876.

Davies 1953, pp. 42–5; Davies 1968, pp. 17–18; Campbell 1990, p. 113.

The Virgin is enthroned with the Christ Child upon her lap. She places her hand on an illuminated book held by Saint Peter at the left, whose attribute, a key, lies on the step before him. Christ receives a carnation, symbolic of the Passion, from Saint Paul, who kneels at the right, his sword resting against the throne. A landscape can be seen through the arch above his head, while on the left are windows decorated with representations of an unidentified saint and Christ in Majesty.

The saints are comparable to the Saint Peter and the apostle behind him in the artist's *Altarpiece of the Sacrament* of 1464–7 (Louvain, St Peter's).

Zambeccari collection, Bologna, by 1796; bought, 1867.

Davies 1953, pp. 38–42; Davies 1968, pp. 16–17.

Workshop of BOUTS
Mater Dolorosa
probably 1475–1500

Workshop of BOUTS
Christ Crowned with Thorns
probably 1475–1500

Sir William BOXALL
Self Portrait
1820–40

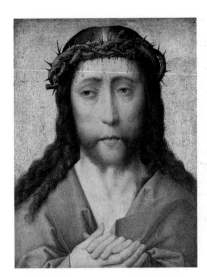

NG 711
Oil on oak, 36.8 x 27.3 cm

NG 712
Oil on oak, 36.8 x 27.3 cm

NG 6482
Oil on canvas, 53 x 41.6 cm

The Virgin, here portrayed as the *Mater Dolorosa* (Sorrowing Mother), turns to the right, her hands clasped in prayer. Her pose complements that of Christ in the pendant to this work – NG 712, *Christ Crowned with Thorns*, where he looks to the left.
 NG 711, and a number of comparable pictures, derives from a prototype by Bouts.

Frf. von Welden collection, Laupheim, before 1813; collection of Prince Ludwig Kraft Ernst von Oettingen-Wallerstein; acquired by the Prince Consort, 1851; presented by Queen Victoria at the Prince Consort's wish, 1863.

Davies 1953, pp. 31–8; Davies 1968, pp. 18–19.

Christ, crowned with thorns, clasps his hands before him and looks to the left. His pose complements that of the Virgin in the pendant to this work – NG 711 – where she looks to the right.
 NG 712, and a number of comparable pictures, derives from a prototype by Bouts.

Frf. von Welden collection, Laupheim, before 1813; collection of Prince Ludwig Kraft Ernst von Oettingen-Wallerstein; acquired by the Prince Consort, 1851; presented by Queen Victoria at the Prince Consort's wish, 1863.

Davies 1953, pp. 31–8; Davies 1968, pp. 18–19.

This is the earliest known likeness of the artist.

Presented by Christopher Wood, 1983.

National Gallery Report 1982–4, p. 24.

Sir William BOXALL
1800–1879

Sir William Boxall served as the second director of the National Gallery from 1866 until 1874. He trained as a painter at the Royal Academy Schools, and then spent three years in Italy from 1829. As an artist he regularly exhibited subject pictures and portraits; he was elected ARA in 1851 and RA in 1863.

Jan de BRAIJ
Portrait of a Woman with a Black Cap
1657

NG 1423
Oil on oak, 66.4 x 50.5 cm

Inscribed in Dutch on the left: 1657 / Ouwt 52 jaar (1657 /52 years old). Signed below the inscription: Braij

The sitter has not been identified.

The panel may have been cut on the left, and the initials preceding the surname of the signature lost.

X-radiographs show a number of changes in the position of the head and in the collar and the peak of the cap.

Collection of Edward H. Pares, Derby, by 1891; presented by Alfred Fowell Buxton, 1894.

MacLaren/Brown 1991, p. 54.

BRAMANTINO
The Adoration of the Kings
about 1500

NG 3073
Oil (identified) on poplar, 56.8 x 55 cm

The Magi have come to adore the Christ Child. The figure to the right of the Virgin and Child may be either Saint Joseph or Saint John the Baptist. The figures are arranged in a ruined classical building that is probably intended as a reference to the passing of the old dispensation, which is now to be replaced with Christianity. A tiny figure flying before the mountains at the right may be the angel who announced Christ's birth to the shepherds.

NG 3073 is dated on grounds of style to about 1500.

Lines incised in the gesso were used to plot the architectural elements and the perspective. This scheme centres on a single vanishing point, at the centre of the Virgin's body, approximately two fifths of the way up the panel.

Manfrin collection, Venice; bought from there by Sir A.H. Layard about 1863; Layard Bequest, 1916.

Davies 1961, pp. 128–9; Dunkerton 1991, pp. 173–4; Dunkerton 1993a, pp. 42–61.

Bartholomeus BREENBERGH
The Finding of the Infant Moses by Pharaoh's Daughter, 1636

NG 208
Oil on oak, 41.5 x 56.7 cm

Signed and dated bottom right: BBreenberg.f./A 1636 (BB in monogram).

In order to escape Pharaoh's order to kill Israelite boys Moses was placed in an ark of bulrushes in the Nile. He was discovered by Pharaoh's daughter and her attendants. Moses' sister Miriam offered to find a nurse for the child and so was able to return him to his mother. Old Testament (Exodus 2: 1–6). The landscape is dotted with pseudo-classical ruins. The stela is probably based on J. della Porta's Forum fountain.

Président Le Rebourg sale, Paris, 1778; bequeathed by Richard Simmons, 1847.

MacLaren/Brown 1991, pp. 55–6.

Jan de BRAIJ
about 1626/7–1697

Jan Salomonsz. de Braij was born in Haarlem, son of the painter and architect Salomon de Bray, who may have been his teacher. He spent most of his life in Haarlem, and painted portraits, some religious pictures and a few genre and mythological subjects. He also made etchings and was active as an architect.

BRAMANTINO
active 1490; died 1530

Bartolomeo Suardi was known as Bramantino, a diminutive which suggests a connection with the great architect Bramante, who was also a painter. Bramantino was active in Milan and recorded in Rome in 1508. In 1525 he was appointed painter and architect to Francesco Sforza II, the ruler of Milan. Bramantino's works owe something to those by earlier Lombard artists: Butinone and especially Foppa .

Bartholomeus BREENBERGH
1598–1657

Breenbergh was born in Deventer. He is recorded in Amsterdam in 1619, and then in Rome, where he was associated with Paul Bril. He was one of the founders of the *Schildersbent*, the society of Netherlandish painters in Rome, in 1623. By 1633 the artist was back in Amsterdam. He painted Italianate landscapes with religious and mythological subjects, influenced by Pynas and Poelenburgh.

Quiringh van BREKELENKAM
A Woman Asleep by a Fire
about 1648

NG 2550
Oil on oak, 43.7 x 32.8 cm

Quiringh van BREKELENKAM
An Interior, with a Man and a Woman seated by a Fire, 1653

NG 1329
Oil on oak, 51.4 x 70.5 cm

Quiringh van BREKELENKAM
Interior of a Tailor's Shop
about 1655–61

NG 2549
Oil on oak, 42.7 x 50 cm

The stoneware jug on the table has a relief that appears to show Adam and Eve before God the Father. It is similar to a *Siegburger Schnelle* (a type of Rhenish jug) with a relief of the same subject in the Rheinisches Landesmuseum, Bonn. The book open on the woman's lap is presumably the Bible.

The subject of an old woman seated in a chair, dozing, spinning or gazing into a fire, was a favourite one of Brekelenkam and his Leiden contemporaries. This example is similar to a painting in the Louvre that is dated 1648.

Floris Drabbe sale, Leiden, 1743; collection of Jean-Etienne Liotard, Geneva, by 1760; Salting Bequest, 1910.

MacLaren/Brown 1991, pp. 59–60.

Signed and dated in the right background: Q·VB·1653 (VB in monogram). The map is inscribed: H (?)ARE(E?) GE(R?)WANIC UM (MARE GERMANICUM)/ DE NO(O?)RT ZEE.

The map hanging on the wall at the right shows the Netherlands: as is often the case in the seventeenth century, north is not at the top, but on the right.

In the [Lt.-Col. Worthington Wilmer] sale, London, 1890; bought from Horace Buttery, 1891.

MacLaren/Brown 1991, p. 57.

In the background at the upper left is a still-life painting in the manner of Pieter Claesz; Brekelenkam painted still lifes in this style and this picture may be after one of his own works.

The artist painted the subject of a Tailor's Shop many times, using the same basic composition in which he rearranged the figures and details of the interior. His earliest treatment is from 1653 (Worcester, Mass., Art Museum), and the latest from 1664 (private collection).

NG 2549 can probably be dated to a little before 1661.

Possibly Lord Rendlesham sale, 1806; Salting Bequest, 1910.

MacLaren/Brown 1991, pp. 57–8.

Quiringh van BREKELENKAM
active 1644; died 1668

Quiringh Gerritsz. van Brekelenkam may have been born in Zwammerdam, near Leiden. He was a founder member of the Leiden guild in 1648, and continued to work in the town. He painted peasant and artisan interiors. His earliest dated work is of 1644.

Andrea and Raffaello del BRESCIANINO
The Madonna and Child with the Infant Baptist (?)
and Saints Paul and Catherine of Siena, 1506–45

BRITISH (possibly Sir William Boxall)
Portrait of a Man aged about 45
about 1830

BRITISH (possibly Sir William Boxall)
Portrait of a Woman aged about 45
about 1830

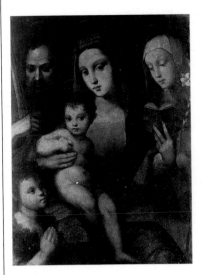

NG 4028
Oil on wood, 71.8 x 53.6 cm

NG 6352
Oil on board, 30.5 x 24.6 cm

NG 6353
Oil on board, 30.2 x 25.6 cm

The Madonna and Child are shown with the young Saint John the Baptist, Saint Paul with his traditional attribute of a sword, and Saint Catherine of Siena (1347?–1380) shown as a Dominican tertiary holding a lily.

NG 4028 has been given to either or both of the Brescianino brothers, but is closely related to pictures otherwise given to Andrea.

Sir Claude Phillips Bequest, 1924.

Gould 1975, pp. 40–1.

NG 6352 and 6353 are said to have been given by Sir William Boxall RA, director of the National Gallery from 1865 to 1874, to a forebear of H.W. Standen, who presented them to the National Gallery in 1964 as a 'Self-Portrait of William Boxall and a companion portrait of his wife'. However, the features in NG 6352 are unlike those in Boxall's self portrait (NG 6482) and he was unmarried. If indeed by William Boxall, NG 6352 and 6353 may be portraits of his parents.

Collection of James Wyatt before 1853; presented by H.W. Standen, Wyatt's great-grandson, 1964.

This may be a portrait of Sir William Boxall's mother.

For discussion of this picture see the entry for NG 6352.

Collection of James Wyatt before 1853; presented by H.W. Standen, Wyatt's great-grandson, 1964.

Andrea (active 1506–1525) and Raffaello (active 1506; died 1545) del BRESCIANINO

Andrea and Raffaello del Brescianino were brothers and collaborated on various altarpieces in Siena. Their work cannot be clearly separated. They painted mythological figures as well as altarpieces and small devotional works.

BRONZINO

An Allegory with Venus and Cupid
probably 1540–50

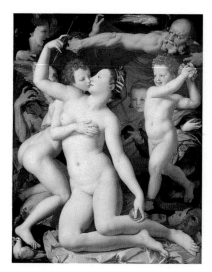

NG 651
Oil on wood, 146.1 x 116.2 cm

Agreement on the meaning of this picture has not been reached. The central group of Cupid and Venus are identified by traditional attributes (Cupid with wings and a quiver; Venus with a golden apple). Time (upper right) is shown as an old man with an hour glass. The boy on the right (throwing rose petals) may be Folly, behind him is Pleasure (holding both a honeycomb and a sting). The most contentious identifications are for the figures behind Cupid. The figure with a mask (top left) may be Fraud or Oblivion and the figure behind Cupid has been interpreted as Suffering, as Jealousy and as representing the effects of syphilis. The main theme of the allegory appears to centre upon the disarming of Cupid by Venus at which Time is frustrated or angry.

There is no certain evidence for the early history of NG 651 but it corresponds with the picture described by Vasari that was sent to King Francis I of France before 1547. A picture by Bronzino of similar theme and design is in Budapest (Szépmüvészeti Múzeum).

Apparently in the collection of Lord Spencer, Althorp, before 1742; bought with the Edmond Beaucousin collection, Paris, 1860.

Gould 1975, pp. 41–4; Gaston 1991, pp. 249–88.

BRONZINO

The Madonna and Child with Saint John the Baptist and a Female Saint, probably Saint Anne
probably about 1540–50

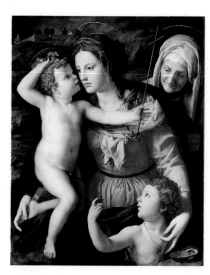

NG 5280
Oil (identified) on wood, 101.6 x 81.3 cm

Signed lower left: B[R]ONZ[O] / FIORE[N]TIN[O] (Bronzino of Florence).

The Christ Child removes a garland from his head and grasps the reed cross from the infant Saint John the Baptist, who wears his camel skin cloak and carries a baptismal bowl. The female saint might be Saint Elizabeth, but is more likely to be Saint Anne. The reed cross foreshadows Christ's Passion, while the wild strawberries offered to Christ by Saint John may be interpreted as referring to the fruitful and righteous life of Christ.

NG 5280 was probably painted in the 1540s and has been related both to the style of NG 651 and to other works of this period. Another version (Parma, Galleria Nazionale) omits the female saint.

Collection of W.A.L. Fletcher before 1914; bequeathed by Sir Lionel Faudel-Phillips, 1941.

Gould 1975, pp. 44–5.

BRONZINO

Portrait of a Young Man
probably 1550–5

L40
Oil on wood, 75 x 57.5 cm

This sitter has not been securely identified; it has been suggested that he is Cosimo de' Medici, Grand Duke of Tuscany. The statuette in the background represents Bacchus with a child satyr.

On loan from a private collection since 1979.

Baccheschi 1973, p. 101.

BRONZINO
1503–1572

Agnolo di Cosimo, called Bronzino, was the pupil then the assistant of Pontormo. He was later court painter to Duke Cosimo I of Tuscany, and the greatest Florentine portraitist of the sixteenth century. His work also included secular allegories, tapestry design, frescoes and large altarpieces. Alessandro Allori was his pupil.

BRONZINO
Portrait of Piero de' Medici ('The Gouty')
probably about 1550–70

Studio of BRONZINO
Portrait of Cosimo I de' Medici, Grand Duke of Tuscany, probably before 1574

Follower of BRONZINO
Portrait of a Lady
probably 1575–85

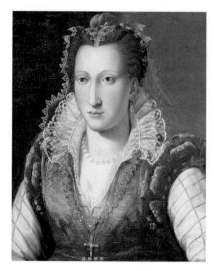

NG 1323
Oil on wood, 58.4 x 45.1 cm

NG 704
Oil on wood, 21.3 x 17.1 cm

NG 2085
Oil on wood, 58.7 x 48.6 cm

Piero de' Medici (1416–69) was the son of Cosimo de' Medici, and father of Lorenzo the Magnificent.

NG 1323 is a posthumous portrait, perhaps based on a marble bust (Florence, Museo Bargello) by Mino da Fiesole (1429–84). As court artist Bronzino was required to supply many such images and NG 1323 is likely to be in part the work of his studio.

Said to have been in the collection of Conte Galli Tassi, Florence, before 1868; collection of Sir W.R. Drake by 1868; by whom bequeathed, 1891.

Gould 1975, p. 44.

Cosimo I de' Medici (died 1574) united the two branches of the Medici family and was the founder of the Grand Duchy of Tuscany.

Numerous other versions are known, some of larger format.

From the collection of the Maréchal de Luxembourg; collection of Prince Ludwig Kraft Ernst von Oettingen-Wallerstein; acquired by the Prince Consort, 1851; presented by Queen Victoria at the Prince Consort's wish, 1863.

Gould 1975, pp. 45–6.

NG 2085 was formerly believed to be a portrait of Bianca Cappello, the mistress and later the wife of Francesco de' Medici (died 1587), Cosimo I's elder son. This has been rejected and the sitter has not been otherwise identified.

Bequeathed by the Misses Cohen as part of the John Samuel collection, 1906.

Gould 1975, p. 46.

Style of Adriaen BROUWER
Four Peasants in a Cellar
probably 1630s

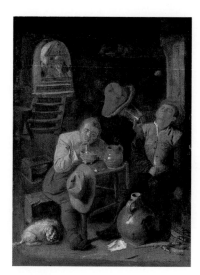

NG 2569
Oil on wood, 27.7 x 22 cm

In the background men are working a bale attached to a pulley.

NG 2569 has in the past been been attributed to Brouwer, but it is too weak to be by him and is merely in his style.

George Salting collection, 1900; Salting Bequest, 1910.

Martin 1970, pp. 11–12.

John Lewis BROWN
The Performing Dog
probably about 1860–90

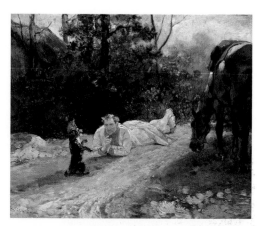

NG 3236
Oil on canvas, 36.8 x 44.4 cm

Signed bottom left: John Lewis Brown

A dog performs on its back legs in front of a man lying on the ground. A horse stands to the right.

Lane Bequest, 1917; on loan to the Hugh Lane Municipal Gallery of Modern Art, Dublin, since 1979.

Pieter BRUEGEL the Elder
The Adoration of the Kings
1564

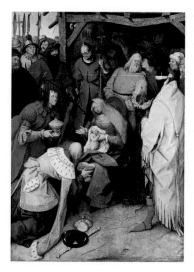

NG 3556
Oil on oak, 111.1 x 83.2 cm

Signed and dated: BRVEGEL M. D. LXIIII. (1564).

Balthazar, the Moorish king, stands on the right. Caspar kneels at the lower left. A figure at the right is wearing spectacles; on other occasions the artist used these to signify in an ironic manner the inability of the subject to see the truth – such may be the intention here. Most of the figures appear to be caricatures who are gently mocked by the artist.

The upright format and large scale of the figures are unusual for Bruegel; aspects of their depiction appear to have been influenced by the work of Bosch.

The thin paint in a number of areas reveals underdrawing beneath.

Probably in the Imperial collection at Vienna, about 1619; bought from Guido Arnot with contributions from the NACF and Arthur Serena through the NACF, 1920.

Davies 1968, pp. 21–2.

Adriaen BROUWER
1606?–1638

Brouwer was probably born in Oudenaarde. He may have been a pupil of Frans Hals in Haarlem in about 1620–1; he became a master in the Antwerp Guild of St Luke in 1631/2. Brouwer was a painter of peasant scenes and landscape whose work was admired and collected by Rubens.

John Lewis BROWN
1829–1890

Brown was born in Bordeaux of Scottish parents. He was active in Paris from 1841 and worked there until his death. He exhibited at the Salon from 1848, and painted battle scenes and pictures of horses.

Pieter BRUEGEL the Elder
active 1550/1; died 1569

His birthplace is unknown, but van Mander says he was a pupil of Pieter Coecke van Aalst. In 1551–2 Bruegel became a master in Antwerp. In 1552/3 he journeyed in France, Switzerland, Austria and Italy, and in about 1563 he settled in Brussels. Many of his designs were engraved for Hieronymus Cock. He painted religious subjects, landscapes and genre scenes.

Jan BRUEGHEL the Elder
The Adoration of the Kings
1598

Hendrick ter BRUGGHEN
A Man playing a Lute
1624

Hendrick ter BRUGGHEN
The Concert
about 1626

NG 3547
Bodycolour on vellum, 32.9 x 48 cm

NG 6347
Oil on canvas, 100.5 x 78.7 cm

NG 6483
Oil on canvas, 99.1 x 116.8 cm

Signed and dated: (.)RUEGHEL in 1598

The shepherds have also come to adore the Christ Child. New Testament (Matthew 2: 1ff.). The view in the background has not been identified as representing any particular town.

NG 3547 is one of the earliest of a series of similar compositions by Jan Brueghel the Elder. The design was probably influenced by Pieter Bruegel the Elder's interpretations of the subject (Brussels, Musées Royaux des Beaux-Arts, and NG 3556). It also includes elements such as the kneeling king that derive, presumably indirectly, from Hieronymus Bosch's *Adoration* (Madrid, Prado).

The support is damaged and the signature has been bent over the mount with the consequence that the first letter is lost and the next three are faint.

Presented by Alfred A. de Pass, 1920.

Martin 1970, pp. 13–15.

Signed and dated: H T Brúgghen. fecit. i624 (HTB in monogram).

In the early 1620s, after the return to Utrecht from Rome of Gerrit van Honthorst and Dirck van Baburen, the subject of a half-length single figure in flamboyant dress playing a musical instrument became very popular among the so-called Utrecht Caravaggisti.

Ter Brugghen first treated such a theme in a pair of paintings of flute-playing boys in Cassel (Staatliche Kunstsammlungen). Subsequently he painted numerous pictures of musicians.

Solly Flood collection, Ireland; bought from Flood by James Murnaghan, Dublin, about 1925–30; bought from Murnaghan, 1963.

MacLaren/Brown 1991, p. 63.

The subject of a group of richly dressed musicians seen by candlelight was favoured by Caravaggio and his Roman followers. Among the prototypes for this composition are Caravaggio's own *Musical Party* (New York, Metropolitan Museum of Art) and Bartolommeo Manfredi's *The Concert* (Florence, Uffizi). The artist may also have been familiar with Honthorst's depiction of similar subjects.

NG 6483 is dated to about 1626 by analogy with ter Brugghen's *Concert* in St Petersburg (Hermitage), which is dated 1626.

Somers collection, Eastnor Castle, Ledbury, Herefordshire; the seventeenth-century Dutch paintings in the collection are said to have been bought by Lord Somers (1651–1716) in about 1700; passed by descent to the Hon. Mrs E. Hervey–Bathurst; bought, with contributions from the National Heritage Memorial Fund, the NACF and the Pilgrim Trust, 1983.

MacLaren/Brown 1991, pp. 64–5.

Jan BRUEGHEL the Elder
1568–1625

The artist was born in Brussels, the son of Pieter Bruegel the Elder. According to van Mander, he was taught in Antwerp by Pieter Goetkint and subsequently visited Cologne. Brueghel was active in Italy from 1590 to 1596, and later worked in Antwerp and made visits to Brussels. He painted landscapes, figurative subjects and flowers, and collaborated with other artists, including Rubens.

Hendrick ter BRUGGHEN
1588?–1629

Hendrick Jansz. ter Brugghen was born either in Utrecht or in The Hague. He visited Italy, possibly as early as 1604, and arrived back in Utrecht before April 1615. He studied the work of Caravaggio and his Roman followers in Italy and was the first of the northern Caravaggisti to return to Holland. He reinterpreted the style of Caravaggio and his followers in a strikingly original manner.

Hendrick ter BRUGGHEN
Jacob reproaching Laban for giving him Leah in place of Rachel, 1627

NG 4164
Oil on canvas, 97.5 x 114.3 cm

Signed and dated on the base of the table: HTBrúgghen·fecit 1627 (HTB in monogram).

The painting probably shows Jacob reproaching Laban. Laban had substituted his elder daughter Leah for Rachel, for whose hand in marriage Jacob had worked in Laban's service for seven years. Old Testament (Genesis 29: 21–6). Leah is presumably the woman standing beside the seated Laban, while Rachel is in the left background.

The artist reinterpreted the subject of NG 4164 in a painting in Cologne (Wallraf-Richartz Museum) which probably dates from the following year.

Bought in Leeds by W. Haffety, Scarborough; bought at the [W. Haffety] sale, London, 26 March 1926 (lot 119) (Claude Phillips Fund).

MacLaren/Brown 1991, pp. 62–3.

After the BRUNSWICK MONOGRAMMIST ?
Itinerant Entertainers in a Brothel
1550s

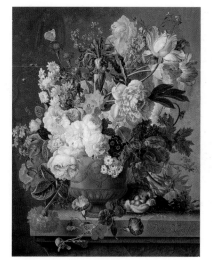

NG 5577
Oil on oak, 45.5 x 60.7 cm

An inscription on the picture hanging from the wall has not been fully deciphered: Hier sit ic ... prin... / vander hoogher co ... / ...leet(?) is ... / met eenen / muts ... kee ...

The composition, with variations, is known in several versions (e.g. Antwerp, Museum; Maastricht, Bonnefantenmuseum).

The costumes are probably of the 1550s.

Collection of Sir Theodore F. Brinckman by 1919; presented by Thomas Esmond Lowinsky in memory of Lt. T.M.F.E. Lowinsky, 1945.

Davies 1968, pp. 8–9; Schubert 1970, p. 212.

Paulus Theodorus van BRUSSEL
Flowers in a Vase
1789

NG 5174
Oil on mahogany, 78.4 x 61.2 cm

Signed and dated on the marble ledge: P.T. v. Brussel. fecit. /1789.

The flowers include peonies, roses, iris and tulips. The vase has a relief medallion on its side which is decorated with an antique head in profile.

Said to have been in the collection of the King of Holland (presumably William II); bequeathed by Sir Arthur Jackson, 1940.

MacLaren/Brown 1991, p. 66.

The BRUNSWICK MONOGRAMMIST
active about 1540

He is named after a monogrammed painting of *The Feeding of the Poor* in the Herzog Anton Ulrich-Museum in Brunswick. The monogram has not been convincingly deciphered but the picture, executed in about 1540, may be associated with several others of religious and secular subjects. The painter has often been identified as Jan van Amstel, active in Antwerp by 1527 and dead by 1543.

Paulus Theodorus van BRUSSEL
1754–1795

Van Brussel was born in Zuid Polsbroek and became a pupil of Jan Augustini in Haarlem and worked in his master's *behangsel-fabrijk* (wall-hanging factory) there. His speciality was painting flower pictures for overmantels and overdoors. After 1774 he concentrated on independent flower and fruit paintings. He later settled in Amsterdam.

Paulus Theodorus van BRUSSEL
Fruit and Flowers
1789

Paulus Theodorus van BRUSSEL
Flowers in a Vase
1792

Bartholomeus BRUYN the Elder
The Virgin, Saint John, Saint Mary Magdalene and a Holy Woman, probably 1530–40

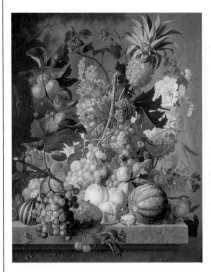

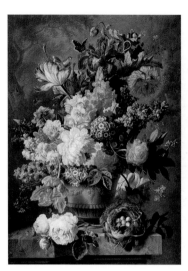

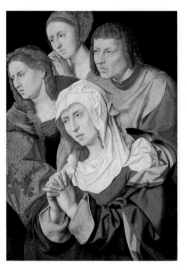

NG 5800
Oil on mahogany, 78.4 x 61 cm

NG 3225
Oil on mahogany, 81.1 x 58.9 cm

NG 3903
Oil on oak, 67.9 x 48.3 cm

Signed and dated lower right: P.T. v. Brussel. fecit.
1789
 The still life includes grapes, peaches, plums,
melons and a pineapple, as well as a number of
insects.

*Said to have been in the collection of the King of Holland
(presumably William II); presented by Frederick John
Nettlefold, 1947.*

MacLaren/Brown 1991, p. 66.

Signed and dated on the marble ledge: P.T. van.
Brussel./ fecit 1792
 In the vase are tulips, poppies, narcissi and
peonies, and there are roses lying on the ledge.

*William Benoni White sale, London, 1879; bequeathed
by W.W. Aston, 1919.*

MacLaren/Brown 1991, p. 65.

The Virgin Mary (dressed in traditional red and
blue), Saint John the Evangelist (identified by his
red dress and his support of the Virgin), Saint
Mary Magdalene (identified by her rich dress and
long blond hair) and a Holy Woman are shown
weeping (presumably over a figure of the dead
Christ on the left).
 NG 3903 was probably painted in Cologne in
the 1530s, and must have been the right wing of a
diptych. The left-hand panel of this diptych has
not been traced.
 A version of NG 3903 was destroyed in Dresden
during World War II. It was approximately the
same size, and differed only in minor details.

*Collection of Howel Wiles, Florence, 1894; presented
by Henry Wagner, 1924.*

Levey 1959, pp. 16–17.

Bartholomeus BRUYN the Elder
1492/5–1555

Active in Cologne by 1518 (when he was recorded
as a member of the painters' guild), Bruyn is
documented as the painter of two altarpieces (at
Essen, 1522–5, and at Xanten, 1529–34), and many
portraits, as well as religious pictures, are
attributed to him.

Bartholomeus BRUYN the Elder
A Man, probably of the Strauss Family
probably about 1534

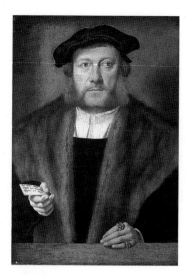

NG 2605
Oil on oak, 36.2 x 24.8 cm

Inscribed in German on the paper held by the sitter: das wortt gotzs / bleyptt inn ewygkaytt / esayas 40. capt. (The word of our God shall stand for ever. Isaiah, chapter 40).

The sitter holds a paper with an inscription from the Old Testament (Isaiah 40: 8) in his right hand. On the forefinger of his left hand he wears two rings, one of which appears to show the arms of the Strauss family (the other ring seems to have shown another coat of arms but this can no longer be deciphered).

It has been suggested that the sitter is Andreas zum Kampe, called Struyss. However, the man seems to be too young for this identification; a number of other members of the Strauss family are recorded in Cologne in the relevant years.

Collection of the Marquess of Normanby; collection of George Salting, 1888; Salting Bequest, 1910.

Levey 1959, pp. 15–16; Westhoff-Krummacher 1965, pp. 153–4.

Giovanni BUONCONSIGLIO
Saint John the Baptist
probably 1525–37

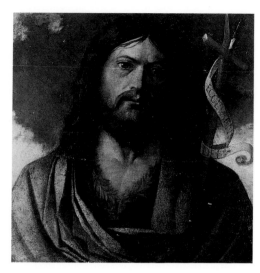

NG 3076
Oil on wood, painted surface 47.6 x 41.9 cm

Inscribed on the scroll: ECCE. AGN[U]S / DEI. (Behold the Lamb of God).

The words on Saint John the Baptist's scroll are taken from his Gospel. New Testament (John 1: 29 and 26).

NG 3076 was previously attributed to Montagna, but is probably a late work by Buonconsiglio of about 1525–37. It appears to have been painted as an independent picture.

Bought from the Conte di Thiene, Vicenza, by Sir A.H. Layard, probably about 1860; Layard Bequest, 1916.

Davies 1961, p. 129.

Andrea BUSATI
The Entombment
probably after 1512

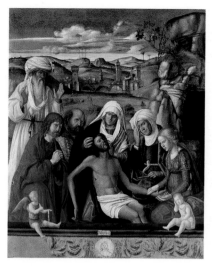

NG 3084
Oil (identified) on poplar, 111.1 x 91.4 cm

Inscribed on a cartellino on the marble ledge in the centre foreground: Andreas busatti f(eci)t do/(s)i (p)ulus Ioanne(s) belinu(s) (Andrea Busati, disciple of Giovanni Bellini, made this).

Christ's dead body is held by the Virgin. Mary Magdalene and one of the Holy Women (perhaps Mary the mother of James) are on the right. Saints John the Evangelist, Nicodemus and Joseph of Arimathea are on the left. Three crosses are visible in the distance. New Testament (all Gospels, e.g. John 19: 38–42).

The inscription has been the subject of some discussion and the reading (especially of the second line) is not certain. NG 3084 is closely related to Cima's *Lamentation* of about 1512 (Moscow, Pushkin Museum), on which Busati may have collaborated with Cima.

The figure group in NG 3084 depends on Cima's *Lamentation,* and the bridge, buildings and distant hill are derived from a *Resurrection* by Giovanni Bellini (Berlin, Staatliche Museen) – perhaps by means of a Bellini workshop drawing (Milan, Ambrosiana). Busati used this landscape motif on other occasions (e.g. his *Saint Mark Enthroned,* Venice, Accademia). Cleaning has revealed two putti on the parapet. Nicodemus – who looks out at the viewer – is perhaps a self portrait of Busati.

Manfrin collection, Venice, by 1801; bought by Sir A.H. Layard, 1862; by whom bequeathed, 1916.

Davies 1961, pp. 130–2; Humfrey 1983, pp. 183–4; Mills 1983, p. 65.

Giovanni BUONCONSIGLIO
active 1495; died 1535/7

Buonconsiglio, called Il Marescalco, was born in Vicenza. From 1495 he was active as a painter in Venice, but throughout his career he kept up his contacts with Vicenza. There are dated works (particularly altarpieces) from 1497. His style was influenced by Montagna and by Giovanni Bellini.

Andrea BUSATI
active 1503; probably died 1528

Busati was active as a painter in Venice by 1503 and it has been assumed that he was born in about 1470. His work was much influenced by Cima, whose assistant he may have been, and by Giovanni Bellini, whose disciple he claimed to be.

Bernardino BUTINONE
The Adoration of the Shepherds
about 1480–5

NG 3336
Tempera on poplar, 24.8 x 21.6 cm

NG 3336 is comparable in terms of size and style to thirteen other panels in various collections which in the main depict incidents from the Life and Passion of Christ. It has been suggested that these works, probably with some others which are now lost, came from a single ensemble – this may have been an elaborate altarpiece involving much sculpture such as were popular in Lombardy. They are now generally agreed to be early works by the artist.

Bought in Paris by Roger Fry about 1905; from whom bought (Florence Fund), 1918.

Davies 1961, pp. 132–3.

Willem BUYTEWECH the younger
A Dune Landscape
probably 1660–70

NG 2731
Oil on oak, 25.7 x 34.2 cm

Signed faintly bottom right: W. bujtew ()
 Buytewech's paintings are rare and nothing is known about his training. This painting strongly recalls the dune landscapes of the Haarlem painter Jan Wijnants, to whom NG 2731 was once attributed.

Collection of the 2nd Earl of Beverley by 1851; bought by Sir Thomas Baring, 1851; bought from his descendant, the 2nd Earl of Northbrook, 1910.

MacLaren/Brown 1991, p. 67.

Alexandre CALAME
The Lake of Thun
1854

NG 1786
Oil on canvas, 59.1 x 78.1 cm

Signed: A. Calame (mark) 1854.
 Calame painted the Lake of Thun (near Interlaken) several times in 1853 and 1854. The snow-covered mountain is apparently the Blümlisalp. A larger picture of this subject with a very similar composition is in a private collection in Switzerland.
 The painter's record-book shows that the picture was commissioned in 1852 by H. Vaughan.

Henry Vaughan Bequest, 1900.

Davies 1970, p. 16; Anker 1987, p. 420, no. 577.

Bernardino BUTINONE
active 1475 to about 1510

The artist came from Treviglio. He was active there and in Milan, and worked in conjunction with Bernardo Zenale. His earliest signed work is a triptych now in the Brera, Milan, which probably dates from 1484. Butinone's paintings were influenced by those of Mantegna and Foppa.

Willem BUYTEWECH the younger
1625–1670

Willem Willemsz. Buytewech was the son of the genre painter Willem Pietersz. Buytewech. He was born in Rotterdam, where he was apparently active as a landscape and figure painter, although only a few works by him are known.

Alexandre CALAME
1810–1864

Calame was born in Vevey. He studied in Geneva from 1829 under Diday. He travelled widely in Europe and was familiar with contemporary French landscape painting. Calame became celebrated as the painter of dramatic Swiss mountain scenery which he rendered in large-scale set pieces as well as in vivid sketches and studies.

Abraham van CALRAET
Scene on the Ice outside Dordrecht
about 1665

NG 3024
Oil on oak, 33.5 x 57.5 cm

Abraham van CALRAET
A Brown and White Skewbald Horse with a Saddle beside it, about 1680

NG 1683
Oil on oak, 34.2 x 44.4 cm

Abraham van CALRAET
The Interior of a Stable
about 1690

NG 1851
Oil on oak, 39.3 x 57.3 cm

Signed bottom left: AC.

Dordrecht is depicted here as seen from the north, across the river Maas. In the left background is the Groothoofdspoort, a watergate which still survives, although it was altered in the late seventeenth century. To the right of it is the Grote Kerk which is largely unchanged today. Some of the figures on the ice skate, while others travel in horse-drawn sledges.

NG 3024 has in the past been attributed to Cuyp. The background derives with slight variations from a work by him, *View of Dordrecht* (Ascott, Buckinghamshire, National Trust), which was probably painted in the 1650s. The costumes cannot date from after the 1660s, but it is possible that such imitations of Cuyp were painted later but with the costume of an earlier time. For other views of the Groothoofdspoort, Dordrecht, see Attributed to Willem van Drielenburgh NG 960 and Bakhuizen NG 1000.

Baron Huntingfield collection, Heveningham Hall, Suffolk, by 1907; bought at the Lord Huntingfield sale, 1915.

MacLaren/Brown 1991, p. 71.

Signed bottom left: AC.

This horse appears in other pictures by Calraet (see below).

NG 1683, like many other works by the artist, was once attributed to Aelbert Cuyp, but it is related to paintings which are now considered to be by Calraet, such as *Stable Interior with Two Dapple-Grey Horses* (Rotterdam, Museum Boymans-van Beuningen).

Bequeathed by the Revd Chauncey Hare to the South Kensington (Victoria and Albert) Museum, 1869; from where on loan since 1897.

MacLaren/Brown 1991, p. 70.

Signed near the left edge (level with the head of the old man at the door): AC.

In the archway a family can be seen begging for alms.

NG 1851 has in the past been attributed to Aelbert Cuyp but it is in fact a signed work by Calraet which shows the profound influence of paintings of stable interiors by Philips Wouwermans (see Wouwermans NG 879).

The surface of the work is considerably worn so that the wood grain shows, notably in the sky.

Collection of Miss Susannah Caught by 1895; by whom bequeathed, 1901.

MacLaren/Brown 1991, pp. 70–1.

Abraham van CALRAET
1642–1722

Abraham Pietersz. van Calraet was born in Dordrecht, the son of a woodcarver. He seems to have spent his life in the city painting still lifes, landscapes, stables and riding schools and other scenes with horses as well as a few portraits. He may have been a pupil of Aelbert Cuyp, whose work he often imitated.

Attributed to van CALRAET
A Boy holding a Grey Horse
probably 1670–1722

Robert CAMPIN
A Man
probably about 1430

Robert CAMPIN
A Woman
probably about 1430

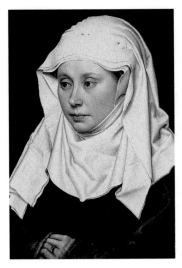

NG 2548
Oil on oak, 36.2 x 32.4 cm

NG 653.1
Oil and egg (identified) on oak, 40.7 x 27.9 cm

NG 653.2
Oil and egg (identified) on oak, 40.7 x 27.9 cm

Falsely signed lower left: A.c(·)yp.

NG 2548 has previously been attributed to Cuyp and bears a false Cuyp signature. The horse appears in a painting by Cuyp in the Royal Collection and in another which is thought to be by Calraet (formerly Paris, the Rodolphe Kann collection). It is here attributed to Calraet because of its closeness in style to signed paintings by him, such as *Halt at an Inn* (formerly B. de Geus van den Heuvel collection).

Collection of the Earl of Dunmore by 1857; Salting Bequest, 1910.

MacLaren/Brown 1991, pp. 72–3.

The sitter has not been identified. His dress – a red hat and a fur-lined gown – suggests that he was a prosperous burgher.

NG 653.1 and NG 653.2 were painted as paired portraits. They presumably depict a man and wife and may originally have formed a diptych. The backs of both panels are marbled, perhaps implying that they were originally intended to be visible.

Campe collection, Nuremberg, by 1832; bought with the Edmond Beaucousin collection, Paris, 1860.

Davies 1953, pp. 49–52; Davies 1968, pp. 27–8; Davies 1972, pp. 252–3; Dunkerton 1991, p. 246.

The sitter has not been identified. Her dress – a fur-lined gown and a head-dress of white fabric – suggests that she was a wealthy townswoman.

NG 653.2 was painted as the pair of NG 653.1, where both pictures are discussed.

Campe collection, Nuremberg, by 1832; bought with the Edmond Beaucousin collection, Paris, 1860.

Davies 1953, pp. 49–52; Davies 1968, pp. 27–8; Davies 1972, pp. 252–3; Dunkerton 1991, p. 246.

Robert CAMPIN
1378/9–1444

Campin was active at Tournai from 1406 to 1444. No pictures signed by him are known; a mural in Tournai which may be his only surviving documented work is in ruinous condition. A group of pictures has been associated with his name (e.g. Frankfurt, Städelsches Kunstinstitut). Rogier van der Weyden probably trained with Campin, who appears to have been one of the most important painters of his generation.

Workshop of CAMPIN
The Virgin and Child in an Interior
about 1435

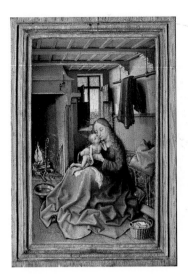

NG 6514
Oil on oak, painted surface 18.7 x 11.6 cm

The Virgin and Child are shown in a richly appointed chamber remarkable for the meticulous description of different effects of natural and artificial light.

The frame is original and is carved in one piece with the panel on which the picture is painted: the mouldings are identical with those of NG 6377 by a follower of Campin but the two paintings do not appear to have been joined together.

This picture shows strong resemblances to a documented altarpiece by Jacques Daret of which several parts survive. Jacques Daret is recorded between 1428 and 1432 as one of Campin's apprentices.

Bought, 1987.

National Gallery Report 1985–7, pp. 36–7; Dunkerton 1991, pp. 44, 107, 154, 244.

Follower of CAMPIN
Portrait of a Man
about 1435

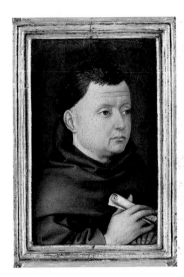

NG 6377
Oil on oak, including the frame, 22.7 x 15.2 cm

The sitter was probably a member of a religious order. As his habit is grey, he is perhaps a Franciscan. He has not been identified.

The frame is original and is integral with the panel; its mouldings are identical to those of NG 6514. However, the absence of hinge marks as well as the pose of the sitter suggest that NG 6377 was painted as an independent portrait rather than as a part of a diptych or triptych.

X-radiographs reveal that the sitter originally held a book rather than a scroll.

Collection of W.H. Nicholson; bought, 1966.

Davies 1968, p. 27; Davies 1970, pp. 1–3; Davies 1972, p. 254; Dunkerton 1991, p. 154.

Follower of CAMPIN
The Virgin and Child before a Firescreen
probably about 1440

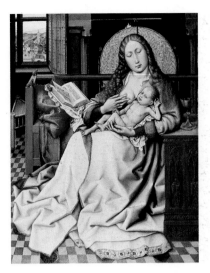

NG 2609
Oil (identified) on oak, 63.5 x 49.5 cm

The Virgin is seated in front of a bench and a wicker firescreen (the shape of which suggests a halo). The carved lions on the bench may be a reference to King Solomon's throne (the throne of wisdom). The townscape seen from the window is minutely detailed, but may not record a specific place.

NG 2609 was probably painted in about 1440 as a private devotional image. It may be based in part on a lost work by Robert Campin: its quality appears to be that of a follower.

Areas three centimetres wide along the top and nine centimetres wide along the right-hand side of the picture, including the cupboard and the chalice, are modern and were evidently painted by a nineteenth-century restorer. Another picture probably of the later fifteenth century (present location unknown) seems to derive from NG 2609 and includes what may be the original design of the cupboard.

Apparently in the Conte di Bardi collection; acquired in Venice by Léon Somzée, 1875; collection of George Salting, 1903; Salting Bequest, 1910.

Davies 1953, pp. 65–9; Davies 1968, pp. 25–7; Davies 1972, p. 253; Dunkerton 1991, p. 244; Campbell 1994, pp. 20–35.

After CAMPIN (?)
The Virgin and Child with Two Angels
about 1500 ?

NG 2608
Oil on oak, 56.2 x 44.1 cm

The Virgin and Child are shown in an apse attended by two angels.

Numerous versions of this composition – thought to have originated with Robert Campin – exist. A similar composition was also painted by Massys (NG 6282). The frame of NG 2608 is original.

Collection of Félix Ravaisson-Mollien by 1903; collection of George Salting by 1904; Salting Bequest, 1910.

Davies 1953, pp. 60–5; Davies 1968, pp. 28–9; Davies 1972, pp. 253–4; Dunkerton 1991, p. 346.

CANALETTO
Venice: Campo S. Vidal and Santa Maria della Carità ('The Stonemason's Yard'), 1726–30

NG 127
Oil (identified) on canvas, 123.8 x 162.9 cm

Inscribed on the wall at the extreme left: *Per P* (?) (Per Piovan). Above which can be read: *W* (Evviva). This incomplete inscription is of the kind put up in Venice in connection with the election of parish priests.

The view is across the Campo S. Vidal and the Grand Canal towards the church of S. Maria della Carità. The campo is filled with a temporary workman's hut beside a well-head, and large pieces of masonry in various stages of preparation; they are probably intended for the façade of the nearby church of S. Vidal (S. Vitale), which is not visible in the picture. The campo and well-head still exist. The campanile of the church of S. Maria della Carità collapsed in 1744 and the church and the Scuola to the right of it became the Accademia di Belle Arti in the early nineteenth century.

It is not known for whom NG 127 was painted. It is dated to 1726–30 on stylistic grounds.

Collection of Sir George Beaumont by 1808; passed from the British Museum to the National Gallery, 1828.

Levey 1971, pp. 18–22; Constable/Links 1976, pp. 283–4; Helston 1982.

CANALETTO
Venice: The Feast Day of Saint Roch
about 1735

NG 937
Oil (identified) on canvas, 147.7 x 199.4 cm

Saint Roch was invoked to provide protection from the plague. His body was placed in the church of S. Rocco (right) in 1485. In 1576 there was a severe outbreak of the plague and his intercession was deemed responsible for preventing a greater calamity. His feast day, 16 August, was thereafter annually celebrated by the Republic. The Doge (left of centre), dressed in gold, having visited the church and the Scuola di San Rocco, which dominates the picture, returns to his palace. Behind are paintings which traditionally decorated the Scuola on this occasion. The officials, many with nosegays, can be identified (from left to right) as Secretaries (in mauve); the Doge's chair – and cushion – bearers; the Cancelliere Grande (in scarlet); the Doge; the Guardiano Grande di S. Rocco; the bearer of the sword of state; the Senators (in scarlet); and the Ambassadors.

NG 937 is dated to about 1735 on stylistic grounds. In 1735 Alvise Pisani was Doge; portraits of him are similar to Canaletto's figure.

The artist has deviated from strict topographical accuracy since the church of the Frari on the near side of the campo is too close to the Scuola to permit such a view. Canaletto completed the architecture, with the use of ruled lines and compasses, before painting the figures.

Littlehales sale, London, 2 March 1804 (lot 37); Wynn Ellis Bequest, 1876.

Levey 1971, pp. 24–6; Constable/Links 1976, pp. 354–5; Bomford 1982, pp. 40–3.

CANALETTO
1697–1768

Giovanni Antonio Canal, known as Canaletto, was born in Venice. From the 1720s he specialised in topographical views of the city (*vedute*), and he also published etchings. He was much patronised by foreign visitors, especially the English, and he made several visits to England (1746–50, 1751–3 and from 1754 to about 1756). He often made use of studio assistants. The chief influence on him was Carlevaris.

CANALETTO
Venice: A Regatta on the Grand Canal
about 1735

NG 938
Oil on canvas, 117.2 x 186.7 cm

CANALETTO
Venice: The Doge's Palace and the Riva degli Schiavoni, late 1730s

NG 940
Oil on canvas, 61.3 x 99.8 cm

CANALETTO
Venice: The Upper Reaches of the Grand Canal with S. Simeone Piccolo, about 1738

NG 163
Oil on canvas, 124.5 x 204.6 cm

This section of the Grand Canal leads from the Volta di Canal to the Rialto Bridge in the distance. On the left can be seen the Palazzo Balbi, with obelisks on the roof, and beyond it the Palazzo Papadopoli. The buildings on the right include the Palazzo Contarini dalle Figure, the Mocenigo Palazzi, the Palazzo Corner-Spinelli and the Palazzo Grimani. People watch the regatta from windows, balconies and boats moored on the canal. The race is for single-oared gondolas. It may have been part of the carnival festivities because some observers wear the black and white *bauta* carnival costume. At the extreme left, beside the Palazzo Balbi is the *macchina della regatta*, a temporary pavilion from which prizes for the races were given; it is decorated with the arms of Doge Alvise Pisani (reigned 1735–41).

NG 938 is dated on stylistic grounds to the early part of the reign of Doge Pisani.

The composition derives from a depiction of the regatta of 1709 by Carlevaris (1663–1730) which was engraved. A number of versions of it associated with Canaletto survive, including an autograph painting also in this Collection, NG 4454.

Lord Northwick sale, London, 25 May 1838 (lot 91); Wynn Ellis Bequest, 1876.

Levey 1971, pp. 26–7; Constable/Links 1976, p. 366; Potterton 1976, no. 1.

The buildings are (from left to right): the column of St Mark; the Doge's Palace; the Ponte della Paglia; the prisons; along the Riva degli Schiavoni can be seen the uncompleted church of the Pietà (S. Maria della Visitazione). The architecture in this area is a generalised version of that which can actually be seen there. In front of the Ponte della Paglia is a temporary hut and a knife-grinder's stall.

The style of NG 940 suggests a date of execution in the late 1730s.

The composition appears in two surviving drawings by Canaletto (Windsor, Royal Collection; formerly Darmstadt). The drawings are closer to the true topography of the scene than NG 940.

Wynn Ellis collection by 1854; Wynn Ellis Bequest, 1876.

Levey 1971, pp. 40–1; Constable/Links 1976, p. 240; Potterton 1976, no. 2.

The church dominating the left of the Grand Canal is S. Simeone Piccolo (SS. Simeone e Giuda); further down on the same side is S. Croce. On the right can be seen the Scalzi and beyond it the church of S. Lucia. Gondolas cross the canal, while a *burchiello* (passenger barge) travels along on the left. The view on the right is now altered by Venice's modern railway station.

The dating of NG 163 is established by the depiction of S. Simeone Piccolo as complete. The church was rebuilt according to a design of Scalfarotto between 1718 and 1738. The style of this picture also accords with others painted by Canaletto around 1738. A painting and a drawing (both Windsor, Royal Collection) by Canaletto record earlier stages in the construction of the church.

Collection of Lord Farnborough by 1832; by whom bequeathed, 1838.

Levey 1971, pp. 22–4; Constable/Links 1976, p. 318.

CANALETTO
Venice: The Basin of San Marco on Ascension Day
about 1740

CANALETTO
A Regatta on the Grand Canal
about 1740

CANALETTO
London: Interior of the Rotunda at Ranelagh
1754

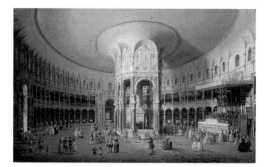

NG 4453
Oil on canvas, 121.9 x 182.8 cm

NG 4454
Oil on canvas, 122.1 x 182.8 cm

NG 1429
Oil on canvas, 47 x 75.6 cm

The principal features are (from left to right): S. Maria della Salute; the entrance to the Grand Canal; the State Granaries; the Mint; the Library; the columns of St Theodore and St Mark; the Doge's Palace, with the campanile of S. Marco behind; and the prisons. The gold state barge moored at the Molo is the *Bucintoro*. The Doge leaves his palace; his parasol can be seen in the crowd. He will be rowed out into the lagoon on the *Bucintoro* and drop a gold ring into the sea to symbolise the marriage of Venice and the sea. The annual ceremony of the Wedding of the Sea had its origins in a tenth-century naval victory, which occurred on Ascension Day, and in the gift of a ring in 1178 from Pope Alexander III to the Venetian Doge with which he and his successors were to wed the sea. The coat of arms of Doge Alvise Pisani (reigned 1735–41) appears on the *Bucintoro*.

NG 4453 is a pendant to NG 4454; the two works are dated on stylistic grounds to about 1740.

Various versions of this composition survive; one drawing (Windsor, Royal Collection) can be related to it.

Collection of the Duke of Leeds by 1867; bequeathed by Lord Revelstoke, 1929.

Levey 1971, pp. 33–6; Constable/Links 1976, p. 357.

This section of the Grand Canal leads from the Volta di Canal to the Rialto Bridge in the distance. On the left can be seen the Palazzo Balbi, with obelisks on the roof, and beyond it the Palazzo Papadopoli. The buildings at the right include the Palazzo Contarini dalle Figure, the Mocenigo Palazzi, the Palazzo Corner-Spinelli and the Palazzo Grimani. The race is for one-oared gondolas. It may have been part of the carnival festivities because some observers wear the black and white *bauta* carnival costume. At the extreme left, beside the Palazzo Balbi, is the *macchina della regatta*, a temporary pavilion from which prizes for the races were given; it is decorated with the arms of Doge Alvise Pisani (reigned 1735–41).

NG 4454 is a pendant to NG 4453; the two works are dated on stylistic grounds to about 1740.

The composition derives from a depiction of the regatta of 1709 by Carlevaris (1663–1730) which was engraved. A number of versions of it associated with Canaletto survive, including an autograph painting also in this Collection, NG 938.

Collection of the Duke of Leeds by 1867; bequeathed by Lord Revelstoke, 1929.

Levey 1971, pp. 36–8; Constable/Links 1976, p. 367.

Written on the reverse of the canvas: *Fatto nel anno 1754 in Londra per la prima ed ultima volta con ogni maggior attentzione* [sic] *ad istanza del signor Cavaliere Hollis padrone mio stimatissᵒ – Antonio del Canal detto il Canaletto*. (Made in the year 1754 in London for the first and last time with the utmost care at the request of Mr Hollis, my most esteemed patron – Antonio del Canal, called Canaletto.) The inscription was probably intended by the artist as a form of certificate, indicating that the view was unique in his oeuvre.

The Rotunda was a public venue for various entertainments, built in Ranelagh Gardens in Chelsea, London, in 1741. Visitors could attend orchestral performances, organ recitals and also dine there. Canaletto has depicted a large number of elegantly dressed figures wandering about, conversing and listening to the orchestra on the right. The Rotunda was a fashionable rendezvous which attracted well-known musicians, including Mozart who performed there in 1764. The building was closed in 1803, and later demolished.

The inscription dates the picture to 1754. It is one of a series depicting English sites which the artist executed for the writer Thomas Hollis and included the *View of Old Walton Bridge* (London, Dulwich Picture Gallery).

Thomas Hollis, 1754; bought from H. Buttery, 1894.

Levey 1971, pp. 29–31; Constable/Links 1976, p. 413.

CANALETTO
Eton College
about 1754

CANALETTO
Venice: Piazza San Marco
about 1756

CANALETTO
Venice: Piazza San Marco and the Colonnade of the Procuratie Nuove, about 1756

NG 942
Oil on canvas, 61.6 x 107.7 cm

NG 2515
Oil on canvas, 46.4 x 37.8 cm

NG 2516
Oil on canvas, 46.4 x 38.1 cm

The school is here shown from the east; it is viewed from across the river Thames. The general position of the chapel appears as it would be seen from this direction, but many of the other details of the buildings are invented.

NG 942 is dated on grounds of style. Canaletto was staying nearby at Windsor in 1747, but this seems to be a later work, more akin to paintings such as NG 1429, which is dated to 1754.

The composition as it appears here is recorded in a drawing by Canaletto (formerly Mereworth Castle, collection of Lord Harmsworth).

Sir John Tobin sale, Liverpool, 22 March 1860 (lot 33); Wynn Ellis Bequest, 1876.

Levey 1971, pp. 27–9; Constable/Links 1976, pp. 431–2.

The piazza is shown through an arch from the west end, looking towards S. Marco with the campanile and the Procuratie Nuove at the right. The artist has omitted the flagstaffs before S. Marco.

NG 2515 is a pendant to NG 2516 which shows a view from the other side of the piazza. The two works are dated on stylistic grounds to about 1756, after Canaletto's final return to Venice.

Collection of George Salting, 1886: Salting Bequest, 1910.

Levey 1971, p. 31; Constable/Links 1976, p. 195.

This is a view of S. Marco and the campanile from beneath the colonnade of the Procuratie Nuove on the south side of the piazza. One of the figures in the foreground is holding a cup and saucer; nearby (but out of the picture) is the site of the famous Café Florian, a well-known centre of Venetian social life.

This painting is a pendant to NG 2515. The pair are dated on stylistic grounds to about 1756, after Canaletto's final return to Venice.

A number of preparatory drawings survive that can be related to NG 2516 (Windsor, Royal Collection; the David Villiers collection; formerly the Reverly collection). These works show compositions which extend further to the left than that of the painting. Additional studies for the figure group include a work in New York (Metropolitan Museum of Art, Lehman Collection), and a drawing formerly in the National Gallery, but now transferred to the British Museum.

Collection of George Salting, 1886: Salting Bequest, 1910.

Levey 1971, pp. 31–2; Constable/Links 1976, pp. 194–5.

Studio of CANALETTO
Venice: Entrance to the Cannaregio
probably 1734–42

Studio of CANALETTO
Venice: S. Pietro in Castello
probably 1734–42

Studio of CANALETTO
Venice: The Piazzetta from the Molo
about 1740

NG 1058
Oil on canvas, 47 x 76.4 cm

NG 1059
Oil on canvas, 46.4 x 77.5 cm

NG 939
Oil on canvas, 100.4 x 107.4 cm

This view shows on the left S. Geremia with its campanile and the Palazzo Labia. At the centre can be seen the Ponte di Cannaregio, beyond which is the Ghetto Vecchio. At the right edge of the picture is the Palazzo Querini detti Papozze.

NG 1058 is dated to the 1730s on grounds of style and because of its relationship with a drawing by the artist which is apparently dated 1734 (Windsor, Royal Collection). It is considered to be a good product of Canaletto's studio.

The composition is recorded, with variations, in other painted versions (e.g. Windsor, Royal Collection), and in a drawing by the artist (also Windsor, Royal Collection), and an engraving by Visentini of 1735. The Windsor painting includes a statue of St John Nepomuk which was erected in front of S. Geremia in 1742; this date and that of the drawing provide the range for the execution of NG 1058.

Collection of John Henderson by 1857; Henderson Bequest, 1879.

Levey 1971, pp. 42–3; Constable/Links 1976, p. 313.

This is a view of the late sixteenth-century façade of the church of S. Pietro in Castello, which was until 1807 the cathedral church of Venice; after that date this distinction was transferred to S. Marco. The building between the church and its campanile is the patriarchal palace. On the right can be seen the Ponte di S. Pietro.

Stylistically the painting is close to NG 1058, and is similarly dated.

The composition is broadly based upon a drawing by Canaletto (Windsor, Royal Collection).

Collection of John Henderson by 1857; Henderson Bequest, 1879.

Levey 1971, pp. 44–5; Constable/Links 1976, pp. 345–6.

This view shows the piazzetta, an open area between the Piazza S. Marco and the Molo, from the sea. On the right is the Doge's Palace, S. Marco and, almost in the centre, the Torre dell'Orologio in the distance. On the left are the Procuratie Vecchie, the campanile of S. Marco and the Library. The column with the lion of Saint Mark has been omitted.

NG 939 is dated on stylistic grounds to about 1740. It is considered a weak work by a member of Canaletto's studio.

The composition is repeated in numerous versions; the best of these is in the Duke of Bedford's collection at Woburn.

Wynn Ellis Bequest, 1876.

Levey 1971, pp. 38–40; Constable/Links 1976, p. 216.

Studio of CANALETTO
Venice: Palazzo Grimani
about 1756–68

Follower of CANALETTO
Venice: S. Simeone Piccolo
after 1738

Follower of CANALETTO
Venice: Upper Reaches of the Grand Canal facing Santa Croce, after 1738

NG 941
Oil on canvas, 30.5 x 38.8 cm

NG 1885
Oil on canvas, 38.8 x 47 cm

NG 1886
Oil on canvas, 38.8 x 46.3 cm

This view is across the Grand Canal towards the sixteenth-century Palazzo Grimani designed by Sanmicheli. On the right is the Rio di S. Luca. The details of the architecture are inaccurately depicted.

On grounds of style NG 941 is attributed to a member of Canaletto's studio, and dated after his final return to Venice in 1756.

Collection of Wynn Ellis by 1854; Wynn Ellis Bequest, 1876.

Levey 1971, pp. 41–2; Constable/Links 1976, p. 349.

Inscribed on the reverse of the original canvas (uncovered during relining): *Original del Canaletto* (Original by Canaletto).

This view across the Grand Canal shows the façade of S. Simeone Piccolo (the church was completed in 1738).

The painting is a pendant to NG 1886. In spite of their inscriptions the two works are considered pastiches in the manner of Canaletto. Past attributions to Marieschi and Tironi can no longer be sustained.

The church was also depicted in another painting by Canaletto in the Collection (NG 163).

Bought with the Edmond Beaucousin collection, Paris, 1860.

Levey 1971, p. 45; Constable/Links 1976, p. 348.

Inscribed on the reverse of the original canvas (uncovered during relining): *Original del Canaletto* (Original by Canaletto).

To the right of the Grand Canal is the church of S. Croce. Further in the distance are the dome of S. Simeone Piccolo and, beyond, the campanile of S. Geremia.

NG 1886 is a pendant to NG 1885. In spite of their inscriptions they are considered pastiches in the manner of Canaletto.

The composition of this work may be derived from part of an engraving by Visentini of 1742. The composition appears as part of another work in the Collection, NG 2514, which may be by the same artist.

Bought with the Edmond Beaucousin collection, Paris, 1860.

Levey 1971, pp. 45–6; Constable/Links 1976, p. 320.

Follower of CANALETTO
Venice: Upper Reaches of the Grand Canal facing Santa Croce, perhaps after 1768

NG 2514
Oil on canvas, 59.7 x 92.1 cm

Bartolomeo CAPORALI
The Virgin and Child with Saints Francis and Bernardino, probably 1475–80

NG 1103.1–3
Tempera and oil on wood, cut, originally arched at the tops, central panel 122.6 x 83.2 cm; side panels 122.9 x 48.9 cm

Jan van de CAPPELLE
Vessels in Light Airs on a River near a Town probably 1645–55

NG 964
Oil on canvas, 37.5 x 48.6 cm

To the right of the Grand Canal is the church of S. Croce. In the distance are the dome of S. Simeone Piccolo and, beyond, the campanile of S. Geremia. On the left is the church of Corpus Domini, and nearer the centre S. Lucia and the Scalzi. There is a *burchiello* (passenger barge) in the left foreground.

In spite of the correlation between this work and a drawing by Canaletto (see below), NG 2514 is not considered a product of his studio; it is a pastiche in Canaletto's manner, perhaps executed after his death.

The composition is derived from a drawing by Canaletto (Windsor, Royal Collection, probably mid-1730s); an engraving of 1742 by Visentini shows a similar view. The right half of the composition appears in another work in the Collection (NG 1886) which may be by the same artist.

Collection of George Salting by 1900; Salting Bequest, 1910.

Levey 1971, pp. 47–8; Constable/Links 1976, pp. 319–20.

Inscribed on the Baptist's scroll: ECC / IE / AGN / VS DEI. (Behold the Lamb of God).

The Virgin is seated on a throne, with Saint Francis (identified by his stigmata) presenting a lay donor and Saint Bernardino (whose facial type was standardised in the painting of the period), on either side; behind are four angels. Saint Bartholomew is shown in the right panel with the attribute of his martyrdom: a flaying knife. Saint John the Baptist on the left holds a glass staff with a cross; the inscription on his scroll is from the New Testament (John 1: 29, 36).

The painting is attributed to Caporali on account of its closeness in style to a triptych in Perugia (Galleria Nazionale dell'Umbria) which is documented as Caporali's work and dated to 1475. It was previously attributed to Fiorenzo di Lorenzo.

The central panel is a reworking of a picture by Niccolò di Liberatore dated 1457 (Deruta, Pinacoteca).

Monaldi Collection, Perugia, by 1872; from where bought, 1881.

Davies 1961, pp. 181–2; Bury 1990, pp. 473–4.

The vessel on the left with a Dutch flag may be a *smalschip* (a small sprit-rigged transport vessel). The church in the right background resembles St Lawrence's, Rotterdam.

Probably collection of William Delafield by 1870; Wynn Ellis Bequest, 1876.

MacLaren/Brown 1991, pp. 74–5.

Bartolomeo CAPORALI
active 1467–1491

Caporali is recorded as a junior collaborator of Benedetto Bonfigli in Perugia in 1467. Altarpieces and chapel frescoes survive in Perugia and elsewhere in Umbria.

Jan van de CAPPELLE
1626–1679

Van de Cappelle was born and active in Amsterdam. He was a wealthy man who was successful in business, and is said to have been self-taught as a painter. He was influenced by Simon de Vlieger, whose work was well represented in van de Cappelle's large collection of paintings and drawings. He painted calm waterscapes, and winter landscapes reminiscent of Aert van der Neer.

Jan van de CAPPELLE
A Small Dutch Vessel before a Light Breeze
probably about 1645–55

Jan van de CAPPELLE
*A Dutch Yacht firing a Salute as a Barge pulls
away, and Many Small Vessels at Anchor,* 1650

Jan van de CAPPELLE
A River Scene with Dutch Vessels Becalmed
about 1650

NG 2588
Oil on canvas, 44.3 x 55.6 cm

NG 965
Oil on oak, 85.5 x 114.5 cm

NG 4456
Oil on canvas, 112 x 153.5 cm

The vessel in the centre, with a red and white
ensign and other flags, is probably a *wijdschip* (a
small Dutch transport vessel). A ship with a red
and white flag at the main is in the right distance.

*Collection of Major Corbett, London, by 1879; bought
by George Salting, 1901; Salting Bequest, 1910.*

MacLaren/Brown 1991, pp. 77–8.

Signed and dated bottom left: J V Capelle 1650.
　　Most of the vessels have Dutch flags. In the centre
is a States yacht (*statenjacht*) with Dutch colours and
a coat of arms on her stern. A trumpeter on board is
sounding, and a salute is being fired. A barge in the
right foreground appears to have a distinguished
group of figures on board.
　　It has been suggested that Frederik Hendrik,
Prince of Orange (died 1647), and his son are
depicted in the barge, but this is unlikely.

*Perhaps in the collection of Charles Scarisbrick by 1861;
Wynn Ellis Bequest, 1876.*

MacLaren/Brown 1991, p. 75.

Signed bottom left: J.V. Cappelle
　　The row-barge in the foreground towards the left
has a Dutch ensign, and most of the other vessels
have Dutch flags. One of the men in the row-barge
wears an order on a blue ribbon.
　　NG 4456 is comparable in style to NG 965, which
is dated 1650.

*Possibly in the Warnar Wreesman sale, Amsterdam,
1816; bequeathed by Lord Revelstoke, 1929.*

MacLaren/Brown 1991, p. 78.

Jan van de CAPPELLE
A Coast Scene, with a Small Dutch Vessel landing Passengers, 1650–5

NG 2586
Oil on oak, 59.5 x 79.2 cm

Jan van de CAPPELLE
A Small Vessel in Light Airs, and Another Ashore
probably 1650–60

NG 865
Oil on canvas, 34.8 x 48.1 cm

Jan van de CAPPELLE
Vessels Moored off a Jetty
probably 1650–60

NG 6406
Oil on oak, 35.2 x 42.3 cm

The vessel on the left (probably a *wijdschip*, a small Dutch transport vessel) has Dutch colours; other vessels have red and white flags, and one a blue and red flag.

Said to have been in the collection of James Whatman; in the collection of George Salting by 1906; Salting Bequest, 1910.

MacLaren/Brown 1991, p. 77.

Signed bottom right (rubbed and very faint): J V Cappelle
 A *smalschip* (a small sprit-rigged transport vessel) with a Dutch flag is on the left. A *kaag* (a clinker-built vessel with a straight raking stem) is ashore on the right.
 NG 865 is a fairly early work, probably of the 1650s.

Collection of Ralph Bernal by 1824; collection of Sir Robert Peel, Bt, probably in 1824; bought with the Peel collection, 1871.

MacLaren/Brown 1991, p. 74.

The overall condition is poor and, in particular, the paint surface is extensively rubbed. The painting appears, however, to be an authentic work of the 1650s.

Collection of W.C. Alexander, 1886; presented by the Misses Rachel F. and Jean I. Alexander; entered the Collection in 1972.

MacLaren/Brown 1991, pp. 78–9.

Jan van de CAPPELLE
A River Scene with a Dutch Yacht firing a Salute as Two Barges pull away, mid-1660s

NG 966
Oil on canvas, 93 x 131 cm

Jan van de CAPPELLE
A River Scene with a Large Ferry and Numerous Dutch Vessels at Anchor, about 1665

NG 967
Oil on canvas, 122 x 154.5 cm

Michelangelo Merisi da CARAVAGGIO
Boy bitten by a Lizard
1595–1600

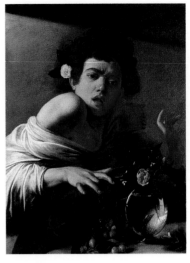

NG 6504
Oil (identified) on canvas, 66 x 49.5 cm

Signed and dated in the centre foreground (the last figure is almost obliterated): J V Cappelle A. 166()

A States yacht (*statenjacht*) is firing a salute in the right middle distance. Both this vessel and the nearer of the two barges in the foreground fly Dutch colours.

The date on NG 966 cannot be read with certainty, but the picture was probably painted in the mid-1660s.

Collection of Wynn Ellis by 1871; Wynn Ellis Bequest, 1876.

MacLaren/Brown 1991, p. 76.

Signed on the rudder of the ferry: J V Cappelle.

The ferry (*veerpont*) in the foreground, with a cannon in its cargo, has a red and white striped ensign and a yellow and white flag draped over the side. Other vessels have Dutch colours.

NG 967 was probably painted in the mid-1660s, at about the same time as NG 966.

Collection of Wynn Ellis, perhaps by 1855; Wynn Ellis Bequest, 1876.

MacLaren/Brown 1991, pp. 76–7.

The youth has been bitten by a lizard on the middle finger of his right hand; the creature tenaciously hangs on. A window is reflected in the glass of the vase which holds jasmine. Cherries lie beside it. Numerous, often conflicting, allegorical interpretations of this subject have been proposed. It has been suggested that it represents the sense of touch, the choleric temperament, a vanitas subject, sensual indulgence leading to death, and the pain that can derive from love.

NG 6504 belongs to a group of pictures which the artist executed in the 1590s in Rome, where he found buyers for semi-erotic works of this kind in the circle of Cardinal Francesco del Monte. During this decade Caravaggio worked briefly in the workshop of the Cavaliere d'Arpino, specialising in painting fruit and flowers. On a number of occasions Caravaggio either reinterpreted or repeated subjects. Another version of this work, also generally thought to be by the artist, is in Florence (Fondazione Longhi). On stylistic grounds it has been suggested that the London work is the more mature.

Collection of Sir Paul Methuen; Viscount Harcourt collection, Nuneham, by 1809; bought from Vincent Korda, with the aid of a contribution from the J. Paul Getty Jr Endowment Fund, 1986.

National Gallery Report 1985–7, pp. 22–3; Gregori 1991–2, pp. 124–37.

Michelangelo Merisi da CARAVAGGIO
1571–1610

Caravaggio was probably born in Milan; he studied there under Simone Peterzano. From 1592/3 he worked in Rome, briefly in the workshop of the Cavaliere d'Arpino, and received commissions for important altarpieces. In 1606 he killed a man in a duel and fled to Naples, he then travelled to Malta (1608), Sicily and Naples (1608–9); on his way back to Rome he died of fever at Porto Ercole.

Michelangelo Merisi da CARAVAGGIO
The Supper at Emmaus
1601

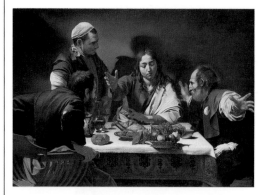

NG 172
Oil and tempera on canvas, 141 x 196.2 cm

Michelangelo Merisi da CARAVAGGIO
Salome receives the Head of Saint John the Baptist
1607–10

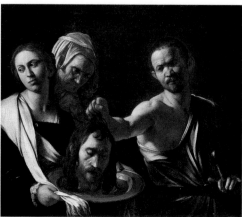

NG 6389
Oil on canvas, 91.5 x 106.7 cm

CARIANI
A Member of the Albani Family
perhaps about 1520

NG 2494
Oil on canvas, 108.6 x 83.2 cm

At the bottom right is an old inventory number: Nº I (Borghese inventory, Rome 1693).

After the crucifixion two of Christ's disciples, one of whom is named as Cleophas, were approached by a stranger as they made their way from Jerusalem to Emmaus. They persuaded him to dine with them, and as he blessed the bread, they recognised him as the risen Christ. New Testament (Luke 24: 13–32). This is the dramatic moment Caravaggio has chosen to represent. The inn-keeper looks on inquiringly, unaware of the significance of his guest. The scallop shell worn by the disciple on the right signifies that he is a pilgrim. The grapes in the foreground may be intended to have eucharistic significance.

NG 172 was commissioned by the Roman nobleman Ciriaco Mattei and was painted in 1601. Shortly afterwards it entered the collection of Cardinal Scipione Borghese.

The composition of the picture may derive from Venetian precedents and the beardless Christ appears in Milanese painting of the sixteenth century. Caravaggio painted a variant of this picture several years later (Milan, Brera). NG 172 was engraved by Pierre Fatoure (died 1629).

Ciriaco Mattei, Palazzo Mattei, Rome, 1602; Cardinal Scipione Borghese, before 1633; Hon. George Vernon by 1831; by whom presented, 1839.

Levey 1971, pp. 49–53; Hibbard 1983, pp. 73–80; Gregori 1991–2, p. 79.

Salome, on the left, danced for King Herod. She performed so well that he offered to grant any request she might have. Her mother Herodias, the elderly woman beside her, persuaded her daughter to ask for the head of Saint John the Baptist because she had been rebuked by him in the past. Caravaggio has depicted the moment when the executioner hands the head of the saint to the women. New Testament (Mark 4: 21–8).

Doubts have in the past been raised about the attribution of NG 6389, but most scholars now accept it as autograph. The very sharp contrasts of dark and light apparent here are characteristic of Caravaggio's late works. The picture is perhaps the one referred to by Bellori as having been sent by the artist from Naples to Malta after he had fled from the island.

Swiss private collection, 1959; bought from the estate of Major A.E. Allnatt (Grant-in-Aid, and Florence, Hornby Lewis, Clarke, Champney and Mackerell Funds), 1970.

Levey 1971, pp. 53–6.

The sitter has been identified as a member of the Albani family by an early version or copy of NG 2494 (Bergamo, Casa Suardi) which contains the Albani arms. It has been suggested that the sitter is Francesco Albani on the basis that his signet ring has the initials FA in reverse.

NG 2494 is generally dated about 1520, a date suggested for the dress of the sitter. The Albani were the leading family in Bergamo, for whom Cariani worked on other occasions. (Francesco Albani was later known in Bergamo as 'Pater Patriae'.)

Said to have been in the Noli collection, Bergamo; Salting collection by 1883; Salting Bequest, 1910.

Gould 1975, pp. 47–8; Pallucchini 1983, p. 123, no. 42.

CARIANI
active 1509–after 1547

Giovanni Busi, called Cariani, was apparently from the area around Bergamo, but lived in Venice. He painted portraits, altarpieces and small devotional works, often in a style derived from Palma Vecchio.

Attributed to CARIANI
The Madonna and Child (La Vierge aux Lauriers)
after 1515

Vittore CARPACCIO
Saint Ursula taking Leave of her Father (?)
probably about 1500

Attributed to CARPACCIO
The Adoration of the Kings
probably about 1490

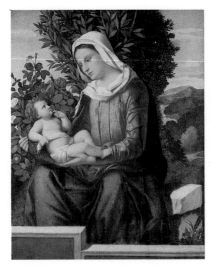

NG 3098
Oil on canvas, 109.9 x 208.9 cm

NG 2495
Oil on canvas, transferred from wood, 90.2 x 72.4 cm

NG 3085
Oil on spruce, painted surface 74.9 x 88.9 cm

The Virgin is seated in front of a laurel bush (hence the French title 'La Vierge aux Lauriers'), which was associated with distinction, and here acts as a halo. A rose bush surrounds the Child Jesus; its flowers were associated with purity and suffering.

The painting, which was formerly attributed to Giorgione, Moretto and Palma Vecchio, has been attributed to Cariani (although recently this has been rejected by one authority in favour of an artist in the circle of Palma Vecchio). NG 2945 has been extensively overpainted so attribution becomes hazardous.

Leuchtenburg collection by 1828; Salting Bequest, 1910.

Gould 1975, pp. 48–9; Pallucchini 1983, pp. 302–4, no. A46.

The subject of NG 3085 is obscure. The principal figures may be Saint Ursula, her father, King Maurus, and a few of the 11,000 virgins who accompanied her to Cologne. However, the episode is treated differently by Carpaccio in his painting of the same subject in Venice (Accademia) and the crowned figure seems to be too young to be Ursula's father. The pieces of paper on the parapet in the foreground are not legible; the goldfinch has not been explained. The picture has also been related to Boccaccio's *Decameron*.

NG 3085 may be partly the work of Carpaccio's studio, but in general it has been accepted as by the artist. A drawing for the woman on the left is in St Petersburg (Hermitage).

Bought by Sir A.H. Layard from the Manfrin collection, Venice, about 1862; Layard Bequest, 1916.

Davies 1961, pp. 134–5; Lauts 1962, pp. 244–5.

The Three Kings journeyed to Bethlehem to honour the new-born Jesus. They followed a star (towards the left, at the top), and brought gifts of gold, frankincense and myrrh. New Testament (Matthew 2: 2–12). The accompanying figures to the right are the kings' retinue. The figure on the left, perhaps in penitential garb, might be the donor.

NG 3098 was formerly catalogued as by Gentile Bellini, and the name of the Veronese artist Domenico Morone has also been suggested. The attribution to Carpaccio remains tentative. Some figures recur in a drawing and in other works associated with the artist. The picture may be an early work, perhaps from the late 1480s – a period in which Carpaccio's style may have been developing under the influence of Gentile and Giovanni Bellini.

The retinue of the kings is striking for the Oriental costumes that are depicted. This has been related to Gentile Bellini's visit to Constantinople in 1479–81 (see under Gentile Bellini NG 3099).

Bought by Sir A.H. Layard from Favenza of Venice in 1865; said to have been acquired by Favenza from Count Thieni of Vicenza (and previously to have been in the family chapel in the church of S. Bortolo [S. Bartolomeo], Vicenza); Layard Bequest, 1916.

Davies 1961, pp. 135–7; Lauts 1962, p. 244; Byam Shaw 1984, p. 57; Meyer zur Capellen 1985, p. 154.

Vittore CARPACCIO
active 1490; died 1525/6

Carpaccio – the name is correctly Scarpazza, Latinised into Carpathius – probably trained with Lazzaro Bastiani, and was influenced by Giovanni Bellini and Antonello da Messina. He is most famous for the cycles he painted for the Venetian 'scuole' (e.g. the Saint Ursula series, 1490–about 1498), but he also painted altarpieces and other smaller pictures.

Agostino CARRACCI
Cephalus carried off by Aurora in her Chariot
about 1597

NG 147
Charcoal and white chalk (a grey wash applied later over the whole) on paper, 202.5 x 398.8 cm

Agostino CARRACCI
A Woman borne off by a Sea God (?)
about 1599

NG 148
Charcoal and white chalk (a grey wash applied later over the whole) on paper, 203.2 x 410.2 cm

Annibale CARRACCI
Silenus gathering Grapes
1597–1600

NG 93.1–2
Oil and egg (identified) on wood, 54.5 x 88.5 cm

The goddess of the dawn, Aurora, attempts to seduce the mortal Cephalus. On the right Aurora's aged husband Tithonus slumbers. Ovid, *Metamorphoses* (VII, 701–14).

NG 147 is the cartoon made in preparation for one of the fresco scenes on the ceiling of the Galleria in the Palazzo Farnese, Rome. These show stories from classical mythology and illustrate the theme of divine and earthly love. Commissioned by Cardinal Odoardo Farnese, the ceiling was begun in 1597/8 and completed in 1600. The early sources attribute the fresco scenes of *Cephalus carried off by Aurora* and the *Woman borne off by a Sea God (?)* to Agostino, and it is therefore reasonable to assume that he was responsible for the cartoons (NG 147 and 148), although Annibale, who executed the other frescoes, may also have played some part.

The cartoon is made up of rectangular sheets of blue-grey paper which have been glued together. Unlike NG 148, this cartoon was not pricked along the outlines for transfer; instead it was cut into sections and the outlines of the design were scored through the paper on to the wet plaster on the ceiling. After use the cartoon was re-assembled.

J.B.P. Lebrun, Paris, by 1809; Sir Thomas Lawrence (died 1830); presented by Lord Francis Egerton, 1837.

Levey 1971, pp. 56–9.

The exact subject represented in this work, and in the fresco to which it is related, is not clear. It has been interpreted variously as the Triumph of Galatea, Thetis carried to the chamber of Peleus, and Glaucus and Scylla. None of these interpretations is entirely satisfactory.

NG 148 is the cartoon made in preparation for one of the two scenes by Agostino on the frescoed ceiling of the Galleria in the Palazzo Farnese, Rome (see the entry for NG 147). It is reasonable to assume that Agostino executed the cartoon, although some participation by Annibale is possible.

The cartoon is made up of rectangular sheets of blue-grey paper which have been glued together. The outlines of the composition have been extensively pricked in order to transfer the design to the wet plaster on the ceiling. Unlike NG 147, this cartoon has not been cut into sections. The fresco differs in some respects from the cartoon, notably in the figure of the Triton on the right, which is turned away from the viewer and is based on a drawing by Annibale (Malibu, J. Paul Getty Museum).

J.B.P. Lebrun, Paris, by 1809; Sir Thomas Lawrence (died 1830); presented by Lord Francis Egerton, 1837.

Levey 1971, pp. 59–61.

Silenus, the god of wine, is lifted to reach grapes from a vine above. A putto also picks grapes. NG 93.1-.2 would appear to have formed the decoration of the inside of the lid of a keyboard instrument, perhaps a harpsichord.

The classical scholar and collector Fulvio Orsini, a protégé of the Farnese family and a friend of Annibale, owned two keyboard instruments which he states he had had decorated, and it is likely that NG 93.1-.2 come from one of these. NG 94 may derive from the same instrument or the other one Orsini owned.

Probably part of one of the instruments mentioned in the will of Fulvio Orsini, 1600; Palazzo Lancellotti, Rome, 1664; Holwell Carr Bequest, 1831.

Levey 1971, p. 65; Posner 1971, p. 51.

Agostino CARRACCI
1557–1602

Agostino was born in Bologna. He was the elder brother of Annibale Carracci, cousin of Ludovico Carracci, and father of Antonio Carracci. Signed works by him date from 1580 onwards. For a brief period between 1597 and 1600 the artist collaborated with Annibale on the decoration of the gallery in the Palazzo Farnese, Rome. He was also active as an engraver, and died in Parma.

Annibale CARRACCI
1560–1609

Annibale was born in Bologna, where he initially worked. He was the younger brother of Agostino Carracci and cousin of Ludovico Carracci. Annibale visited Parma and Venice, and then in 1595 moved to Rome where he principally worked on the fresco decoration of the gallery in the Palazzo Farnese. From 1605 he was troubled by illness, but continued to paint, frequently in collaboration with pupils.

Annibale CARRACCI
Marsyas and Olympus
1597–1600

NG 94
Oil on wood, 35.4 x 84.2 cm

Annibale CARRACCI
Christ appearing to Saint Anthony Abbot during his Temptation, about 1598

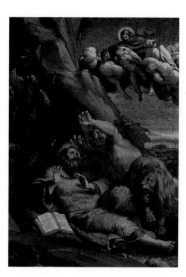

NG 198
Oil on copper, 49.5 x 34.4 cm

Annibale CARRACCI
Christ appearing to Saint Peter on the Appian Way (Domine, Quo Vadis ?), 1601–2

NG 9
Oil (identified) on wood, 77.4 x 56.3 cm

Marsyas, a musician satyr, was the teacher of Olympus, who plays a syrinx. The figure of Marsyas is closely based on an antique gem, and that of Olympus is derived from an ancient sculpture. Both were in the Farnese collection. On the reverse is a decoration of formal diamond patterns and a small chequerwork framing.

It is thought that NG 94 originally decorated the lid of a keyboard instrument, probably a harpsichord, of which NG 93 may also have formed part. (For further discussion see the entry for the latter picture.)

A preparatory drawing for the whole composition is in Frankfurt and shows a cupid in the place of Olympus.

Probably part of one of the instruments mentioned in the will of Fulvio Orsini, 1600; Palazzo Lancellotti, Rome, 1664; J.J. Angerstein, 1810; bought, 1824.

Levey 1971, pp. 65–9; Posner 1971, p. 51.

The story of the life of the third-century Saint Anthony Abbot is recounted in *The Golden Legend*. He retired to the desert, where he was several times tempted by the devil. In this depiction he receives a vision of Christ during his torment.

NG 198 is considered to date from the early part of Annibale's activity in Rome, that is, about 1598. Northern Italian and Roman influences appear to have been brought to bear on the composition. The group of Christ and the angels seems to have been inspired by figures from Correggio's decoration of the cupola of S. Giovanni Evangelista, Parma. The figures of Christ and Saint Anthony also recall Michelangelo's *Creation of Adam* on the ceiling of the Sistine Chapel in the Vatican. A preparatory drawing for the devils (Paris, Louvre) can be stylistically dated to the same period as Annibale's studies for the Galleria Farnese (1597–1600).

Villa Borghese, Rome, 1650; bought, 1846.

Levey 1971, pp. 69–70; Posner 1971, p. 46.

This incident is not recounted in the New Testament, but forms part of an old tradition and is described in *The Golden Legend*. Saint Peter fled Rome during the persecutions of the Christians under Nero. On the Appian Way he had a vision of Christ carrying his cross. He asked, 'Domine, Quo Vadis' (Lord, where are you going?), and Jesus replied that he was on his way to Rome to be crucified again. Peter was inspired also to return to the city, where he was later martyred.

NG 9 is dated to 1601–2; similarities in handling are apparent with the artist's *Assumption of the Virgin* of this period in the Cerasi Chapel in S. Maria del Popolo, Rome. The Christian name of its first recorded owner, Cardinal Pietro Aldobrandini, links with the subject; it is assumed that he commissioned the work, presumably after his return to Rome from France in March 1601.

A preparatory drawing survives (Munich, Graphische Sammlung). Pentimenti in the figure of Peter in NG 9 show how he was moved further away from Christ, probably in order to emphasise his surprise.

Inventory of the Cardinal Pietro Aldobrandini collection, 1603; Alexander Day by 1800; bought, 1826.

Levey 1971, pp. 62–4; Posner 1971, p. 60.

Annibale CARRACCI
The Dead Christ Mourned ('The Three Maries')
about 1604

Circle of Annibale CARRACCI
Saint John the Baptist seated in the Wilderness
early 17th century

Circle of Annibale CARRACCI
Landscape with a Hunting Party
early 17th century

NG 2923
Oil (identified) on canvas, 92.8 x 103.2 cm

NG 25
Oil on canvas, 133.7 x 96.6 cm

NG 63
Oil on canvas, 96.6 x 135.3 cm

This incident is not described in the Gospels, but the lamentation over the body of the dead Christ had become a traditional subject for depiction; unusually, this picture shows only women mourners. Christ rests on the Virgin's lap. Saint Mary Magdalene is probably the prominent kneeling figure on the right. The other women are likely to be Mary, the mother of James, and Mary Salome.

NG 2923 is thought to be an autograph work of about 1604, which is comparable with Annibale's *Pietà* of about 1603 (Vienna, Kunsthistoriches Museum).

An underlying composition, possibly a 'Temptation of Saint Anthony Abbot', conceived in an upright format, is revealed by X-radiographs.

Collection of the Marquis de Seignelay (died 1690); acquired by the Duc d'Orléans; Lord Carlisle by 1800; presented by Rosalind Countess of Carlisle, 1913.

Levey 1971, pp. 70–3; Posner 1971, pp. 73–4.

Inscribed on the scroll (some letters repainted): ECCE. A/GES (Behold the Lamb of God).

The saint rests in the wilderness, drinking water from a spring.

NG 25 was thought to be a work by Annibale until it was cleaned in 1960. Since then it has been considered, on qualitative grounds, the work of a pupil. An attribution to Antonio Mario Panico (active early seventeenth century) has recently been suggested.

X-radiographs reveal what appears to be a landscape with figures beneath the present composition.

Duc d'Orléans collection by 1724; bought with the J.J. Angerstein collection, 1824.

Levey 1971, pp. 73–4.

No literary source has been associated with the hunt depicted.

NG 63 has in the past been considered a work by Annibale, but this attribution is no longer sustainable. However, the buildings on the hill in the middle distance recall similar details in Annibale's *Flight into Egypt* (Rome, Galleria Doria Pamphili).

Recorded as from the Giustiniani collection, Rome; Holwell Carr Bequest, 1831.

Levey 1971, pp. 74–5.

Circle of Annibale CARRACCI
Erminia takes Refuge with the Shepherds
early 17th century

NG 88
Oil on canvas, 147.3 x 214.6 cm

Style of Annibale CARRACCI
Landscape with a River and Boats
17th century

NG 56
Oil on canvas, 95.3 x 132.1 cm

Attributed to Antonio CARRACCI
The Martyrdom of Saint Stephen
about 1610

NG 77
Oil on canvas, 64 x 50.1 cm

Erminia, dressed in armour, having fled from Jerusalem, encounters a shepherd who offers her shelter. For the subject see Tasso's *Gerusalemme Liberata* (7: 6ff).

Formerly attributed to Annibale Carracci, NG 88 is now thought to be by a painter trained by him.

A drawing tentatively attributed to Antonio Carracci (Windsor, Royal Collection) includes a study of a seated man similar to the shepherd in this work.

Referred to as in the collection of Vincenzo Camuccini, Rome, 1804; bought for W. Buchanan and imported to England, 1805; bought with the J.J. Angerstein collection, 1824.

Levey 1971, pp. 75–7.

No specific literary source has been associated with the figure groups.

NG 56 is considered a pastiche of Annibale Carracci motifs. A drawing showing a boatload of figures in the Duke of Sutherland collection appears to have inspired the comparable group in this work. A landscape (London, collection of Sir Denis Mahon) considered to be by Domenichino appears to have provided a source for the general disposition of the landscape in NG 56.

Recorded as coming from the Prince of Cellamare collection, Naples; Holwell Carr Bequest, 1831.

Levey 1971, pp. 77–8.

Saul (Saint Paul) guards the clothes of those who stone Saint Stephen outside the city. New Testament (Acts of the Apostles 7: 58–60). At the upper left over-paint conceals God the Father and Christ in the sky.

In the past NG 77 has been attributed to Domenichino, but this is no longer sustainable. The composition in various ways draws on both Domenichino's version of the subject (Chantilly, Musée Condé) and Annibale Carracci's (Paris, Louvre). The use of these sources and comparison with figures in works by Antonio Carracci such as *The Flood* (Paris, Louvre) prompt the attribution to him.

J.-P. Lebrun sale, Paris, 1791; Lucien Bonaparte collection by 1812; Holwell Carr Bequest, 1831.

Levey 1971, pp. 79–80.

Antonio CARRACCI
1589?–1618

Antonio was the son of Agostino Carracci. He was born in Venice, and according to Bellori his godfather was Tintoretto. The artist was in Rome with Annibale Carracci from 1602 and later resided briefly in Siena and Bologna. He worked mostly in Rome and Bologna, where he died.

Ludovico CARRACCI
The Marriage of the Virgin
about 1589

Ludovico CARRACCI
The Agony in the Garden
about 1590

Ludovico CARRACCI
Susannah and the Elders
1616

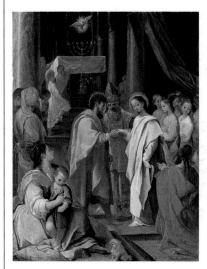

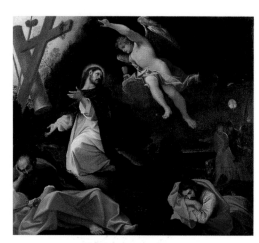

L630
Oil on canvas, 100.3 x 114.3 cm

L413
Oil on copper, 41.3 x 32.4 cm

NG 28
Oil on canvas, 146.6 x 116.5 cm

The story of the marriage of the Virgin to Saint Joseph is recounted in *The Golden Legend*. Saint Joseph holds the flowering rod which identified him as the suitor who would marry the Virgin.

Painted with great delicacy and a rich palette, L413 recalls the works of Federico Barocci, an important influence on Ludovico Carracci. It would appear to date from the late 1580s.

Ludovico is reported by Malvasia (1678) to have painted two small paintings on copper of this subject: one was in the church of S. Maria Lacrimosa degli Alemanni in Bologna, and the other in the collection of the Marchesi Tanari, Bologna. L413 is almost certainly one of these. The other is in a private collection in Italy.

On loan from a private collection since 1988.

Emiliani 1993–4, p. 62, no. 29.

As Christ prays in the Garden of Gethsemane the apostles sleep. An angel appears to him and points out the instruments of the Passion. In the background Judas approaches with soldiers to arrest Christ. New Testament (Luke 22: 39–47).

The scene takes place at night and several light sources are apparent: the lantern carried by the soldiers, the moon disappearing behind a cloud, and the divine light emanating from the instruments of the Passion. The composition is elaborate and the figures self-consciously elegant. The precious quality of this small-scale nocturne is emphasised by the intense local colour of the robes of the principal figures.

Robert Napier, West Shandon, until 1877; acquired by (Sir) Denis Mahon, 1960; on loan since 1993.

Emiliani 1993–4, p. 58, no. 27.

Signed and dated on the balustrade lower left: LUD CAR BO PIN 1616. (Ludovico Carracci [of] Bologna painted this 1616.)

The beautiful Susannah was watched by two elders while at her toilet. They said that if she did not submit to them they would accuse her of adultery. She resisted and was tried, but Daniel recognised her innocence, and the elders were executed. Apocryphal Book of Daniel (chapter 13).

NG 28 was executed for Cavalier Tito Buosio of Reggio. It is described in letters of 1616 from Ludovico Carracci to Don Ferrante Carlo.

The composition is comparable to a version of the subject by Agostino Carracci (Florida, Ringling Museum).

Probably collection of the Duke of Modena; collection of the Duc d'Orléans (died 1785); bought with the J.J. Angerstein collection, 1824.

Levey 1971, pp. 81–2.

Ludovico CARRACCI
1555–1619

Ludovico was born in Bologna. He was a cousin of Agostino and Annibale Carracci. He was trained by Prospero Fontana, and then by Passignano in Florence. The artist visited Parma, Venice and Rome but was mainly active in Bologna. He took a leading part in establishing the Carracci workshop there. His earliest dated work is the *Madonna dei Bargellini* of 1588 (Bologna, Pinacoteca).

Rosalba Giovanna CARRIERA
Portrait of a Man
early 18th century

After CARRIERA
Rosalba Carriera
18th century

Attributed to Andrea dal CASTAGNO
The Crucifixion
about 1440–60

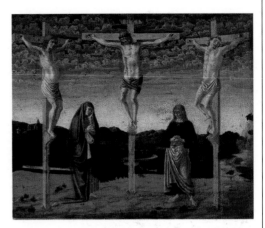

NG 1138
Tempera on wood, 28.5 x 35 cm

NG 3126
Pastel on paper, 57.8 x 47 cm

NG 3127
Oil on canvas, 57.6 x 39.4 cm

The sitter has not been identified, but the provenance of the portrait suggests that he is probably Italian.

Bought in Venice by Sir A.H. Layard, 1880; Layard Bequest, 1916.

Levey 1971, p. 83.

NG 3127 appears to derive from a pastel self portrait of about 1744 which was executed for Joseph 'Consul' Smith (now Windsor, Royal Collection).

Bought in Venice by Sir A.H. Layard, 1880; Layard Bequest, 1916.

Levey 1971, pp. 83–4.

Inscribed on the cross: INRI.

Christ is shown at his Crucifixion. The Virgin Mary and Saint John the Evangelist stand on either side of his cross. The good thief is on the left and has been given an aureole; the bad thief is on the right.

NG 1138 was the predella panel of an unidentified altarpiece (presumably destroyed). Other panels from the same predella include *The Resurrection* (New York, Frick Collection) and *The Last Supper* (Edinburgh, National Gallery). Two other panels have been discussed in relation to this series: a *Flagellation* (Florence, ex-Berenson, now private collection) and a *Capture of Christ* (Arezzo, ex-Funghini collection; now lost).

The attribution to Castagno has generally been accepted with reservations, and given the scale and function of the picture as a predella panel (and the possibility that it was therefore left to an assistant to execute Castagno's design). NG 1138 has, however, also been attributed to Francesco Botticini, and to an unknown painter of the third quarter of the fifteenth century. The landscape has darkened and Saint John's head is damaged.

Said to have been in a collection in Perugia in the 1870s; bought from Charles Fairfax Murray, Florence, 1883.

Davies 1961, pp. 138–9; Fahy 1967, p. 137; Horster 1980, p. 194.

Rosalba Giovanna CARRIERA
1675–1757

Carriera was born in Venice. She studied oil painting under Giuseppe Diamantini and Balestra, and then took up pastel portraits, probably under Felice Ramelli and perhaps Gianantonio Vucovich Lazzari. The artist was elected a member of the Accademia di San Luca in Rome in 1705, and visited Paris in 1720–1. In 1745 she went blind.

Andrea dal CASTAGNO
about 1421?–1457

Andrea di Bartolo di Simone, known as Andrea dal Castagno (from his place of birth) was active in Florence and in Venice (S. Tarasio and S. Marco). In 1444 he joined the painters' guild in Florence, the Arte dei Medici e Speziali. He painted altarpieces and frescoes, and designed stained-glass windows and mosaics.

Vincenzo CATENA
Saint Jerome in his Study
probably about 1510

Vincenzo CATENA
Portrait of a Young Man
probably about 1510

Vincenzo CATENA
A Warrior adoring the Infant Christ and the Virgin, after 1520

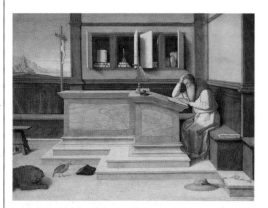

NG 694
Oil on canvas, 75.9 x 98.4 cm

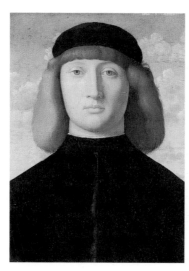

NG 1121
Oil on wood, 30.5 x 23.5 cm

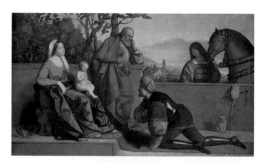

NG 234
Oil on canvas, 155.3 x 263.5 cm

Saint Jerome (about 342–420), who translated the Bible into Latin from the original Greek and Hebrew, is shown reading in his study. He is surrounded by books, an inkwell, an unlit candle and a crucifix (which seems not to be attached to the desk and may be a vision). A quail (a bird also included by Catena in NG 234 and possibly symbolic of truth) and Jerome's traditional attribute of a lion (from whose paw, according to legend, the saint had removed a thorn) are seen in the foreground.

The pink and blue of Jerome's robes and the blue of his cardinal's hat are unusual in representations of the saint. Saint Jerome was traditionally shown in red, although until the 1460s it was customary for cardinals to wear a violet or blue cape unless granted the privilege of wearing red when acting on papal business.

Manfrin collection, Venice, by 1856; from where bought, 1862.

Robertson 1954, p. 50; Gould 1975, pp. 51–2; Rice 1985, pp. 106–7.

The sitter has not been identified.

NG 1121 has been attributed to Catena for stylistic reasons since 1897. It may be identical with a portrait recorded as the artist's work in 1643.

Collection of the Duke of Hamilton, Hamilton Palace, by 1882 (possibly by 1643); bought, 1882.

Robertson 1954, p. 46; Gould 1975, pp. 52–3.

NG 234 appears to be a votive picture, but its exact meaning has not been established. The warrior wears European armour but the silk of his head-dress is from Islamic North Africa, the trappings of his horse are from Islamic Spain, and a dagger and belt hanging on the wall are also of Islamic style. If he is a Saracen convert to Christianity, NG 234 may commemorate his conversion. The quail may be a symbol of truth as baby quail are said always to recognise their (true) mother's call.

Standish collection by 1841; Woodburn collection by 1853; bought, 1853.

Robertson 1954, pp. 68–9; Gould 1975, pp. 50–1.

Vincenzo CATENA
active 1506–1531

Catena was referred to in 1506 as a partner of Giorgione in an inscription on the back of Giorgione's portrait of *Laura* (Vienna, Kunsthistorisches Museum). His style seems to have developed from Giorgione's. He seems to have been wealthy and to have moved in cultivated noble circles in Venice.

Vincenzo CATENA
Portrait of the Doge, Andrea Gritti
probably 1523–31

NG 5751
Oil on canvas, 97.2 x 79.4 cm

The sitter in this portrait is identified as Andrea Gritti by comparison with medals of Doge Gritti. The doge was the elected head of the oligarchic Republic of Venice.

Andrea Gritti (1455–1538) was elected doge in 1523 and the painting may have been commissioned at that time. He wears the ceremonial robes and hat of his office, and his ring shows an image of him with a standard before Saint Mark, the patron saint of Venice. The profile view may have been dictated by the intended location, perhaps beside the altar in a chapel. NG 5751, recently accepted as by Catena, must have been painted before the artist's death in 1531.

Gritti was portrayed by Titian in a votive picture of 1531. This was destroyed in 1574 and Tintoretto was commissioned to replace it with a painting now in the Sala del Collegio of the Doge's Palace. His source for Gritti's likeness appears to have been NG 5751.

Palazzo Contarini, Venice, by 1855; collection of John Ruskin by 1864; collection of Otto Gutekunst, 1917; presented by Mrs Otto Gutekunst in memory of her husband, 1947.

Robertson 1954, p. 69; Gould 1975, pp. 53–5; Furlan 1988, pp. 333–4.

Attributed to CATENA
The Madonna and Child with the Infant Saint John the Baptist, about 1506–15

NG 3540
Oil on wood, 72.4 x 57.2 cm

The composition is very similar to that of Catena's *The Virgin and Child with Saint John the Baptist, Saint Zacharias and a Female Saint* now in Poland (Poznań, Museum Wielko Polski, Raczyński loan).

Catena's larger composition at Poznań is datable to about 1510–11. Another very similar composition was also painted on a canvas later used by Giorgione for his *Self Portrait as David* (Braunschweig, Herzog Anton Ulrich-Museum), painted about 1508. The composition may have originated with either Catena or Giorgione, or it might have been a collaborative design. NG 3540 may have been painted about 1506–15 by a painter imitating Catena, perhaps in his workshop. Several other versions are known.

Collection of Alfred A. de Pass by 1920; by whom presented, 1920.

Robertson 1954, p. 79; Müller Hofstede 1957, pp. 13–34; Gould 1975, pp. 55–6.

Bernardo CAVALLINO
Christ driving the Traders from the Temple
about 1645–50

NG 4778
Oil (identified) on canvas, 101 x 127.6 cm

Christ found the Temple in Jerusalem was like a market because of the money changers and traders there, and so using a makeshift whip he drove them from the building. New Testament (Matthew 21: 12–13; Mark 11: 15–18; Luke 19: 45–6; John 2: 14–17).

NG 4778 is thought to be a mature work by Cavallino, which may be dated to about 1645–50.

Collection of Ettore Sestieri, Rome, 1921; presented by Count Alessandro Contini-Bonacossi, 1935.

Levey 1971, pp. 85–6.

Bernardo CAVALLINO
1616–1656?

Cavallino was baptised in Naples, the city in which he worked throughout his life. He trained under Vaccaro and Stanzione, and was influenced by Venetian sixteenth-century art as well as by the work of Rubens and Van Dyck. It is thought that the artist died of the plague.

Giacomo CERUTI
Portrait of a Priest
about 1724–34

CESARE da Sesto
Salome
probably about 1510–20

Paul CEZANNE
The Painter's Father, Louis-Auguste Cézanne
about 1862

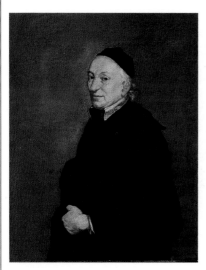

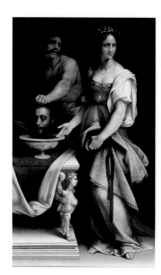

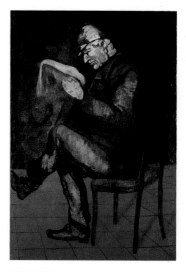

NG 4205
Oil on canvas, 99.7 x 78.1 cm

The sitter has not been identified.

NG 4205 was formerly attributed to Piazzetta, but is now generally given to Ceruti and sometimes stated to be the pendant to another portrait of an ecclesiastic (private collection). NG 4205 has recently been dated to Ceruti's years in Brescia.

Collection of Publio Podio, Bologna, by 1926; bought, 1926.

Levey 1971, p. 86; Gregori 1982, p. 430; Frangi 1987, p. 172.

NG 2485
Oil on poplar, painted surface 135.3 x 80 cm

Saint John the Baptist was beheaded at the request of Herodias, the wife of Herod, and his head presented to her daughter Salome on a charger. Salome then brought the head to her mother. New Testament (e.g. Matthew 14: 1–12).

There is another version of identical quality, different only in small details (Vienna, Kunsthistorisches Museum).

There are four drawings related to the composition of NG 2485 and the version in Vienna; some drawings in pigment are also to be seen on the unprimed wood of the reverse of NG 2485. These do not appear to be related to the composition and may represent Christ appearing to the Magdalen.

Possibly collection of Galeazzo Sforza by 1519; collection of Caterina Sforza, Rome, by 1597; bought by the Revd Walter Davenport Bromley, 1861; collection of George Salting, 1875; Salting Bequest, 1910.

Davies 1961, pp. 140–2.

NG 6385
Oil on house paint on plaster mounted on canvas scrim, 167.6 x 114.3 cm

Louis-Auguste Cézanne (1798–1886) was probably in his early sixties when this portrait was painted.

NG 6385 was originally painted directly onto the wall of the salon of the family home, the Jas de Bouffan, near Aix-en-Provence. A photograph said to have been taken in about 1905 shows the portrait still in place in an alcove flanked by four paintings of the *Seasons* (Paris, Petit Palais; probably painted slightly earlier). Louis-Auguste bought the Jas de Bouffan in 1859 and it remained in the family until 1899. Sometime after 1907 the paintings were removed from the wall and sold to a Paris art dealer.

Cézanne painted his father a second time in the autumn of 1866 (Washington, National Gallery of Art). Cézanne's relations with his father were not particularly happy (Louis-Auguste had hoped his son would become a lawyer); Cézanne's friend Emile Zola planned to base a novel on this father and son relationship.

Jas de Bouffan until after 1907; bought, 1968.

Venturi 1936, p. 73, no. 25; Davies 1970, pp. 24–6; Rewald 1985, pp. 76–8; Gowing 1988, p. 76.

Giacomo CERUTI
1697–1767

Born in Milan, Ceruti was active in Brescia, Venice, Padua and Piacenza. He was a prolific portrait painter, and also painted genre pictures of poor peasants and beggars.

CESARE da Sesto
about 1477–1523

Cesare da Sesto was probably born in Sesto Calende. He seems to have trained in Milan, where he was principally active. He also worked in Rome in 1508 and in Naples in about 1515. He painted a number of altarpieces and smaller panels.

Paul CEZANNE
1839–1906

Cézanne was born in Aix-en-Provence, where he studied drawing at the local academy. Despite opposition from his father, a wealthy banker, he abandoned his training as a lawyer, and from 1861 onwards he made frequent trips to Paris, where he was in contact with his boyhood friend Zola and met Manet, Monet and Pissarro. In later life he spent increasingly lengthy and isolated periods in Provence.

Paul CEZANNE
The Stove in the Studio
probably 1865–70

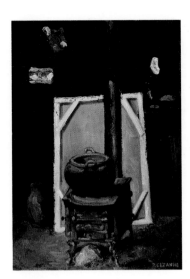

NG 6509
Oil on canvas, 41 x 30 cm

A few modest accessories are ranged around the stove: an earthenware pot, a large canvas with its face to the wall and a single white flower in a vase; a palette and what appears to be a small painting hang on the wall behind. The setting seems familiar from novels by Cézanne's boyhood friend Emile Zola, and in particular, the descriptions of artists' studios in *L'Oeuvre* (*The Masterpiece*, 1886) in which the central character is based on Cézanne.

NG 6509 probably dates from the second half of the 1860s but, as with the majority of Cézanne's works of this period, it is difficult to date with precision, and it is possible that he worked on it over a period of years. *The Stove in the Studio* evokes the privations of this period in Cézanne's life, projecting a Romantic image of Bohemian life in a lonely garret studio.

Emile Zola, Médan; Emile Zola sale, Paris, March 1903; Ambroise Vollard; Auguste Pellerin, Paris(?); purchased by Mrs Edith Chester Beatty, 1935; acquired from the estate of Mrs Helen Chester Beatty under the acceptance-in-lieu procedure, 1992.

Venturi 1936, p. 80, no. 64; Rewald 1936, pp. 71, 161, pl. IX; Rewald 1939, p. 100, pl. 19; Gowing 1988, pp. 13, 55, 60, 62; National Gallery Report 1991–2, pp. 10–12.

Paul CEZANNE
Self Portrait
about 1880

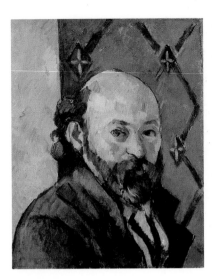

NG 4135
Oil on canvas, 33.6 x 26 cm

The diamond-shaped patterns of the wallpaper in the background appear in several other paintings by Cézanne.

Renoir signed and dated a pastel portrait of Cézanne in 1880 (private collection). This self portrait dates from approximately the same period, when Cézanne was about 41 years old. Cézanne painted his self portrait on numerous occasions throughout his career.

Apparently acquired from Cézanne by Bernheim-Jeune, Paris, 1902; bought by the Trustees of the Courtauld Fund, 1925.

Venturi 1936, p. 144, no. 365; Cooper 1954, p. 85; Davies 1970, pp. 17–18; Rewald 1986, p. 134.

Paul CEZANNE
Landscape with Poplars
about 1883–8

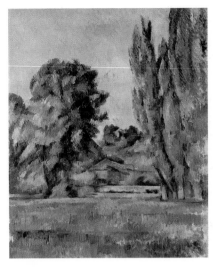

NG 6457
Oil on canvas, 71 x 58 cm

By tradition, this painting is linked to the works that Cézanne painted at Chantilly in 1888 (see NG 6525) but the exact site has not been identified.

Cézanne's varied yet controlled handling of paint is typical of this period in his career. The pale cream colour of the original priming of the canvas remains clearly visible in places (e.g. bottom right), while elsewhere the paint is densely worked with a network of brushstrokes.

Ambroise Vollard, Paris, by 1908; collection of Bruno Cassirer by 1921; subsequently bequeathed by Mrs M.S. Walzer as part of the Richard and Sophie Walzer Bequest from the Cassirer collection, 1979.

Venturi 1936, p. 202, no. 633; National Gallery Report 1978–9, pp. 44–5; Götz Adriani 1993, p. 166, no. 50.

Paul CEZANNE
Hillside in Provence
probably about 1886–90

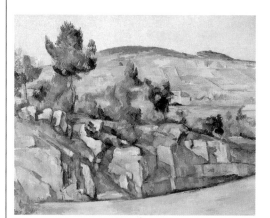

NG 4136
Oil (identified) on canvas, 63.5 x 79.4 cm

Paul CEZANNE
Avenue at Chantilly
1888

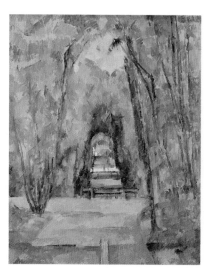

NG 6525
Oil on canvas, 82 x 66 cm

Paul CEZANNE
Still Life with Apples and Melons
about 1890–4

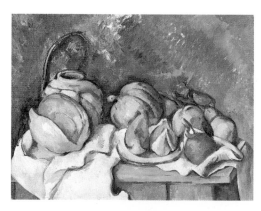

L35
Oil on canvas, 70.5 x 85.6 cm

Cézanne rarely gave titles to his pictures and NG 4136 was first recorded in 1925 as 'Aix: Paysage rocheux' (Aix: rocky landscape). Since then there have been attempts to recognise the specific hillside (some suggesting Les Lauves, near Aix; others a view near Gardanne), but no site has been definitely identified. The rock formations in the foreground may be part of a quarry.

In technique and composition NG 4136 relates closely to a group of paintings produced at Gardanne near Aix in about 1885–6. The design is simple, yet carefully calculated on the canvas before Cézanne began to paint. The composition was first loosely sketched out in pencil, this was then laid in with parallel hatchings of paint. These serve to model form and their colour accents link parts of the picture into a coherent whole.

Leicester Galleries, London, by 1925; bought by the Trustees of the Courtauld Fund, 1926.

Venturi 1936, p. 170, no. 491; Cooper 1954, p. 86; Davies 1970, pp. 18–19; Bomford 1990, pp. 196–9.

NG 6525 shows a tree-lined path leading towards a group of buildings. It probably represents an avenue in the park surrounding the Château at Chantilly, to the north of Paris. There are similar compositions in Toledo (Ohio) and in the Berggruen collection (see L501).

NG 6525 was probably painted in 1888 when (according to his son Paul) Cézanne spent about five months in and around Chantilly.

Ambroise Vollard, Paris; acquired from the Chester Beatty family under the acceptance-in-lieu procedure, 1990.

Venturi 1936, p. 200, no. 626; National Gallery Report 1989–90, pp. 16–17.

The still life was one of the principle themes of Cézanne's work. Using a repertoire of everyday objects such as fruit, jugs, bottles and plates, he experimented continuously with relationships of form, colour and pattern. The groupings can seem casual, but Cézanne is known to have taken great care with the arrangement, sometimes spending hours positioning the objects.

The brushwork in this still life is fresh and vigorous, although the degree of finish varies throughout the picture. Some areas of the composition, such as the slices of melon, are quite closely worked, whereas the canvas priming remains visible in other areas, including parts of the background.

On loan from a private collection since 1977.

Venturi 1936, p. 194, no. 596.

Paul CEZANNE
An Old Woman with a Rosary
probably 1896

Paul CEZANNE
The Grounds of the Château Noir
about 1900–6

Paul CEZANNE
Bathers (Les Grandes Baigneuses)
about 1900–6

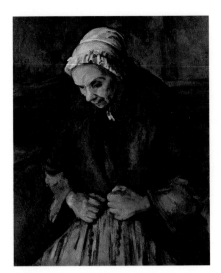

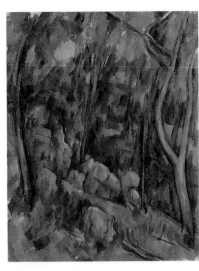

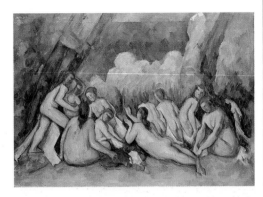

NG 6359
Oil on canvas, 127.2 x 196.1 cm

NG 6195
Oil on canvas, 80.6 x 65.5 cm

NG 6342
Oil on canvas, 90.7 x 71.4 cm

NG 6195 is identifiable as the picture seen in 1896 by Joachim Gasquet at the Jas de Bouffan, Cézanne's family house near Aix-en-Provence. Gasquet described how he found the picture lying on the floor of Cézanne's studio with a pipe dripping on it. The lower left corner of NG 6195 has apparently been marked by the splashing of water or steam.

Joachim Gasquet, a poet and writer, gave a colourful account of the sitter whom he described as an old nun who, having lost her faith and escaped from her convent, wandered aimlessly until the painter took her on as a servant. While Gasquet's account may not be wholly reliable, it certainly accords with the mood of this picture where the old woman is shown with her head bowed, fingering a rosary as if saying her prayers.

Recorded in Cézanne's studio by Joachim Gasquet, 1896; acquired by Gasquet by 1902; bought, 1953.

Gasquet 1926, pp. 110–13; Venturi 1936, p. 216, no. 702; Davies 1970, pp. 19–21; Rubin 1977, p. 18; Rewald 1989, pp. 133, 136–7.

This is probably a view of one of the wooded hillsides near the Château Noir in Provence.

The area around the Château Noir (a picturesque house near the Mont Sainte Victoire) provided Cézanne with numerous motifs in his later years. He rented an outhouse at the château as a store, and in 1899 he tried in vain to buy the château.

NG 6342 was first recorded in the possession of Ambroise Vollard, the picture dealer who, in 1895, gave Cézanne his first one-man show. John Rewald published a photograph of the forked tree seen in NG 6342 in 1935.

Ambroise Vollard; bought, 1963.

Rewald 1935, p. 21; Venturi 1936, p. 233, no. 787; Davies 1970, p. 21; Rubin 1977, p. 391; House 1979–80, p. 57, no. 47; Rewald 1986, p. 238.

During the last decade of his life Cézanne produced three large canvases depicting female bathers. The version now in the Barnes Foundation (Merion, Pennsylvania) was perhaps begun as early as 1895; NG 6359 seems to have been begun in about 1900; the largest version (now in the Philadelphia Museum of Art) was probably painted around 1906, although Cézanne seems to have been working on all three pictures until 1906.

Cézanne's bather compositions were 'imaginary', although he did make use of his own studies and drawings after the nude. These compositions were the culmination of his interest in integrating figures and landscape. The theme had preoccupied him throughout his career, and related his work to the classical tradition by recalling the Venetian scenes of bathing nymphs, particularly associated with Titian and, later, with Poussin. NG 6359 was exhibited at the Salon d'Automne in 1907 and was very influential on the younger generation (e.g. Picasso).

Inherited by Cézanne's son; from whom bought by Bernheim-Jeune and Vollard; Auguste Pellerin, Paris, by 1908; purchased with a special grant and the aid of the Max Rayne Foundation, 1964.

Venturi 1936, p. 221, no. 721; Davies 1970, pp. 22–4; Rewald 1986, p. 223; Krumrine 1989.

Philippe de CHAMPAIGNE
Cardinal Richelieu
about 1637

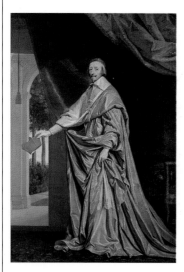

NG 1449
Oil (identified) on canvas, 259.7 x 177.8 cm

Inscribed: P.DE CHAMPAIGNE.
 Cardinal Richelieu (1585–1642) wears the Order of the Saint-Esprit. The background may be intended to represent part of the garden of the cardinal's château at Rueil.
 NG 1449 is one of several full-length portraits of Richelieu by Champaigne (see also Paris, Louvre; London, Royal Collection). It could have been painted for the château at Rueil in about 1637. The face of the sitter is similar to the central head in NG 798.

Possibly from the Palais Royal; anon. sale, Paris, 1834; presented by Charles Butler, 1895.

Davies 1957, pp. 26–7; Dorival 1976, II, pp. 115–16.

Philippe de CHAMPAIGNE
The Vision of Saint Joseph
about 1638

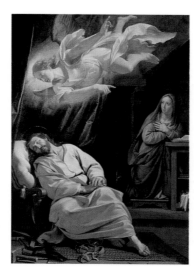

NG 6276
Oil on canvas, 208.9 x 155.6 cm

'… behold, the angel of the Lord appeared unto him in a dream, saying, Joseph, thou son of David, fear not to take unto thee Mary thy wife: for that which is conceived in her is of the Holy Ghost. And she shall bring forth a son, and thou shalt call his name JESUS: for he shall save his people from their sins.' New Testament (Matthew 1: 20–1). Mary kneels at a desk at the right, in a manner similar to the way in which she is depicted at the Annunciation. The tools at Joseph's feet refer to his trade as a carpenter.
 NG 6276 is possibly the painting commissioned for the now demolished church of the Minimes near the present Place des Vosges, Paris, where it is first recorded.

Inventory of the church of the Minimes, Paris, 1790; Cardinal Fesch sale, 1845; bought from the Jacques Seligmann and Co. Gallery, New York, 1957.

Dorival 1976, II, pp. 21–2.

Philippe de CHAMPAIGNE
Triple Portrait of Cardinal Richelieu
1642

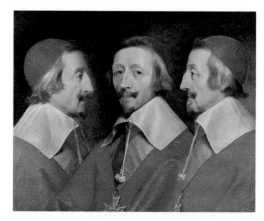

NG 798
Oil on canvas, 58.4 x 72.4 cm

Inscribed over the central head: Celui cy … plus/Resamblant au naturel (this one is the best likeness); and over the right head: De ces deux profilz c[elui]/cy est le meilleur (of the two profiles, this is the better). Inscribed on an old piece of canvas stuck to the stretcher: RITRATTO DEL CARDINALE DI RICHELIEV DI/ MONSV SCIAMPAGNA DA BRVSSELLES. LO FECE/ IN PARIGI PER ROMA AL STATVARIO MOCCHI QVALE POI FECE LA STATVA E LA MANDO A PARIGI.
 Armand-Jean du Plessis, Duc de Richelieu (1585–1642), wears the Order of the Saint-Esprit. The sitter became a cardinal in 1622 and later Chief Minister of France. He is depicted from three angles, because this work was intended to be used by a sculptor, as the basis for a bust, in a similar manner to the way in which Van Dyck's *Triple Portrait of Charles I* (Windsor Castle, Royal Collection), was employed.
 According to the inscription on the reverse (see above), the sculptor in question was Francesco Mocchi (1580–1654) and the statue is probably that now at the Musée Lapidaire, Niort. But the issue is confused by the existence of other busts of the cardinal (e.g. Paris, Louvre) which are linked with Bernini. These sculptures have also been connected with NG 798.
 See also NG 1449.

Collection of Frederick Franks (died 1844); presented by his son Sir Augustus Wollaston Franks, 1869.

Davies 1957, pp. 25–6; Dorival 1976, II, pp. 120–1, no. 213.

Philippe de CHAMPAIGNE
1602–1674

Champaigne was born in Brussels, but principally painted in Paris from 1621. He became a French citizen in 1629 by when he was working for Marie de Médicis and Richelieu. He painted portraits and religious subjects, and was a founder member of the Académie in 1648.

Jean-Siméon CHARDIN
The Cistern (La Fontaine)
1733 or later

Jean-Siméon CHARDIN
The Young Schoolmistress
probably 1735–6

Jean-Siméon CHARDIN
The House of Cards
about 1736–7

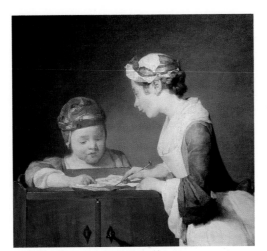

NG 1664
Oil on canvas, 37.5 x 44.5 cm

NG 4077
Oil (identified) on canvas, 61.6 x 66.7 cm

NG 4078
Oil (identified) on canvas, 60.3 x 71.8 cm

Called *La Fontaine* from the copper cistern from which the maid is drawing water, and which may be the same as one included in inventories of the artist's household.

This composition, which is known in other versions, is closely related to a picture by the artist, dated to 1733, that was exhibited at the Salon, possibly in 1735, and definitely in 1737 (Stockholm, Nationalmuseum). It was popularised by the engraving of the Stockholm version of 1739.

An early owner of the work was the painter Baron Louis-Auguste Schwiter whose portrait is also in the Collection (see Delacroix NG 3286).

Possibly either the Jacques-Augustin de Silvestre collection, from 1773, or the Lempereur sale, 1773; certainly the Baron Schwiter collection before 1848; bought, 1898.

Wildenstein 1921, p. 157; Davies 1957, p. 28; Rosenberg 1979, pp. 195–8.

Signed at the right: Chardin.

In 1740 the painting was engraved by Lépicié with a French inscription (here translated): 'If this charming child takes on so well/ The serious air and imposing manner of a schoolmistress/ May one not think that dissimulation and ruse/ At the latest come to the Fair Sex at birth.'

NG 4077 is thought to be the painting exhibited at the the Salon in 1740 (no. 62) with the title *La Petite Maîtresse d'Ecole*. Some affinity with the design and handling of Chardin's *A Lady taking Tea* (Glasgow, Hunterian Museum and Art Gallery) of 1735 suggests the date of execution to be then or soon after. Other versions of the composition, not necessarily autograph, exist (Dublin, National Gallery; Washington, National Gallery of Art).

James Stuart sale, 1850; bequeathed by Mrs Edith Cragg, as part of the John Webb Bequest, 1925.

Wildenstein 1921, p. 170; Davies 1957, pp. 28–9; Rosenberg 1979, pp. 228–31.

Signed right centre: Chardin. A counter lying on the table is inscribed: 500.

NG 4078 is thought to have been exhibited at the Salon in 1741 (no. 72) with the title (here translated) 'The Son of M. Le Noir amusing himself in making a house of cards'. Le Noir, a Parisian cabinet-maker, was a friend of Chardin's. In 1743 the work was engraved by Lépicié, who appended the inscription (in French): 'Charming child, pursuing your pleasure/ We smile at your fragile endeavours/ But confidentially, which is more solid/ Our projects or your house ?' The *British Magazine*, which gave subscribers to its January 1762 edition a free copy of the engraving, emphasised the significance of the work as symbolising 'the vanity of human pursuits'.

NG 4078, which is thought to date from 1736–7, is one of a group of paintings by the artist of comparable subjects (private collection; Paris, Louvre).

James Stuart sale, 1850; bequeathed by Mrs Edith Cragg as part of the John Webb Bequest, 1925.

Wildenstein 1921, p. 168; Davies 1957, p. 29; Rosenberg 1979, pp. 231–3.

Jean-Siméon CHARDIN
1699–1779

Chardin was born in Paris and apprenticed to P.-J. Cazes, later assisting Noel-Nicolas Coypel and J-B. Van Loo. A member of the Académie de Saint-Luc, before being received into the the Académie Royale in 1728, he regularly exhibited still lifes and genre scenes at the Salon. From 1763 he had charge of the Salon hang. Towards the end of his life he painted a few portrait pastels.

Imitator of CHARDIN
Still Life with Bottle, Glass and Loaf
19th century

NG 1258
Oil on canvas, 38.1 x 45.1 cm

Inscribed bottom left: Chardin.1754.
 This work has in the past been considered to be by Chardin, but neither its style nor the handling of the paint sustains such an attribution. His paintings were quite widely imitated after his death and, in spite of the inscribed date, this picture is considered the work of an unknown nineteenth-century artist.

Anon. sale, Paris, 1869; presented by Lord Savile, 1888.

Wildenstein 1921, p. 235; Davies 1957, pp. 29–30.

Nicolas-Toussaint CHARLET
Children at a Church Door
about 1817–45

NG 4140
Oil on canvas, 24.1 x 33 cm

The priest has a tag pinned to his back, which is inscribed: hane. This is presumably a childish misspelling for *âne* (ass). The same word was also inscribed on a dunce's cap in one of the artist's lithographs of 1826.

Anon. sale, Christie's, 1921; presented by Sir Robert and Lady Witt to the Tate Gallery through the NACF, 1926; transferred, 1956.

Davies 1970, p. 26.

Antoine CHINTREUIL
Landscape with Cliffs
probably 1861

NG 4382
Oil on paper mounted on canvas, 40.6 x 31.1 cm

Signed: Chintreuil
 The site depicted may be in the neighbourhood of Fécamp, which the artist visited in 1861. The modest subject and the sensitive treatment of light are typical of the artist.

Bought from J. Fletcher Dodd by the Tate Gallery, 1928; transferred, 1956.

Davies 1970, p. 27.

Nicolas-Toussaint CHARLET
1792–1845

Charlet was born in Paris, where he is recorded as being in the studio of Gros in 1817. He visited London in 1820 with Géricault, and from 1836 exhibited at the Salon. The artist is chiefly known for his lithographs.

Antoine CHINTREUIL
1814–1873

Chintreuil was born in Pont-de-Vaux (near Mâcon). He concentrated on painting from 1838 and soon moved to Paris where he spent a brief period in the studio of Delaroche. Under the influence of Corot (whom he met in 1843) and the Barbizon School, Chintreuil became an accomplished landscape artist. He exhibited at the Salon from 1844.

Petrus CHRISTUS
Edward Grimston
1446

Petrus CHRISTUS
Portrait of a Young Man
1450–60

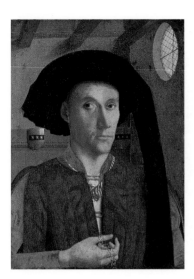

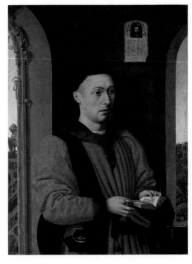

L3
Oil on oak, painted surface 32.5 x 24 cm

NG 2593
Oil on oak, 35.5 x 26.3 cm

NG 2593, detail

Inscribed on the back: PETRVS X̄P̄I, ME FECIT. Aº 1446.

The sitter holds a collar of SS. On the rear wall are two shields with his coat of arms (repeated on the reverse of the panel).

The sitter, identified by the coats of arms, is Edward Grimston of Rishangles in Suffolk, who died in 1478. On several occasions during the 1440s Henry VI sent him as envoy to the courts of France and Burgundy. During his mission, he clearly passed through Bruges and there sat to Petrus Christus.

By descent to the Earl of Verulam, Gorhambury; on loan from the Earl of Verulam since 1927.

Franks 1866, pp. 455–70; Scharf 1866, pp. 471–82.

On the prayerbook the inscription starts: Bedice (for Benedice). The clasp appears to be inscribed: mai. The illuminated paper or parchment hung on the wall is inscribed with a popular fifteenth-century hymn to the Holy Vernicle (or Sudarium): Incipit or[ati]o ad s[an]c[t]am V[ero]nica[m.]/ Salve sa[n]cta facies/ Nostri rede[m]p(t)oris/ In q[ua] (ni)tet (spec?)ies/ Di[vi]ni splendoris/ Impressa paniculo/ Nivei coloris / Data quae (?dataque) Veronice/ Signu[m] ob (amo)ris (.)/ Salve n[ost]ra gloria/ In hac vita dura/ Labili q[ua]m? (?=et) fragili/ Cito transitura/ Nos p[er]duc ad p[at]riam/ O felix figura/ Ad videndu[m] faciem/ Que est xpi (= Christi) pura(.) / Salve o sudariu[m] / Nobile iocale/ Es n[ost]r[u]m solaciu[m] / Et memoriale/ Non depicta ma[n]ibus/ Scolpta vel polita/ Hoc scit su[mmus] Artifex/ Qui te fecit ita(.) / Est(o) nobis qu[ae]sim[us] / tutu[m] adiuvame[n] / Dulce refrigeriu[m] / Atque [c]o[n]solamen / Ut nobis no[n] noceat / Hostile gravamen / Sed fruamur requie / Dicam[us] o[m]nes ame[n] (.)/ Explicit. (Prayer to the Holy Sudarium. Hail, holy face of our Redeemer, shining with the vision of divine splendour which was imprinted on the white cloth given to Veronica as a token of love. Hail, our glory in this hard life of ours – fraught, fragile and soon to be over – lead us, wonderful image, to our true homeland, that we may see the face of Christ himself. Hail Sudarium, excellent jewel, be our solace and reminder. No human hand depicted, carved or polished you, as the heavenly Artist knows who made you as you are. Be to us, we beg, a trusty help, a sweet comfort and consolation, that the enemy's aggression may do us no harm, but we may enjoy rest. Let us together say amen.)

The abbreviated form of Christ's name in the hymn (xpi) is similar to the form of Christus' signature.

At the top of the illuminated sheet on the wall is the head of Christ in a cruciform aureole. The sitter has not been identified.

NG 2593 was possibly originally a donor portrait from a diptych or triptych. It is datable on grounds of style to about 1450–60.

Bought from Farrer by Thomas Baring, 1863; Salting Bequest, 1910.

Davies 1953, pp. 70–3; Davies 1968, pp. 33–4.

Petrus CHRISTUS
active 1444; died 1475/6

Christus was born in Baarle. He is recorded in 1444 in Bruges, where he was active. There are several signed paintings by the artist. His signatures perhaps imitate those of Jan van Eyck, whose work Christus knew. The style of his work also shows a knowledge of the paintings of Rogier van der Weyden.

Attributed to Antonio CICOGNARA
Mystic Figure of Christ
late 15th century

Giovanni Battista CIMA da Conegliano
The Virgin and Child
probably about 1496–9

Giovanni Battista CIMA da Conegliano
The Virgin and Child
about 1499–1502

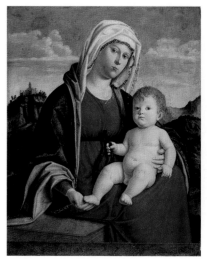

NG 3069
Tempera on wood, 50.8 x 33.3 cm

NG 300
Oil on wood, 69.2 x 57.2 cm

NG 2506
Oil on wood, painted surface 64.8 x 52.1 cm

Christ is depicted seated, apparently on a tree trunk, beneath a barrel vault. He wears the crown of thorns and has a rope tied around his neck – objects associated with the Mocking and the Carrying of the Cross. The painting is not intended to illustrate any particular episode in the Passion of Christ but is an image of his suffering. The reverse of the panel is marbled.

NG 3069 has been associated, on grounds of style, with the work of Marco Zoppo; it is closer to the work of Cicognara, which was of Ferrarese inspiration, and in particular with the *Ecce Homo adored by Mary Magdalene* (Athens, Georgia Museum of Art).

Costabili collection, Ferrara, by 1838; bought by Sir A.H. Layard, probably 1866; Layard Bequest, 1916.

Davies 1961, pp. 177–8.

Signed on the parapet: .IOANNES BAPTISTA. P.
The Virgin and Child are seen against a landscape background that includes a fairly accurate view of Conegliano, Cima's native town. This view is repeated in a picture of Saint Helena (Washington, National Gallery of Art).

NG 300 was probably painted in the late 1490s. The composition recurs in other pictures from Cima's workshop (e.g. Raleigh, North Carolina Museum of Art).

The picture bears the remains of an inventory number (29); but the provenance is unknown.

Bought, 1858.

Davies 1961, pp. 142–3; Humfrey 1983, p. 109.

Signed on the parapet: IOANNES BAPTISTA. P.
The Virgin and Child are seated behind a marble parapet. Jesus holds the Virgin's belt; both figures look straight out of the picture.

The design is known in other versions by Cima and his workshop, including compositions in reverse. It also served as the basis of a signed picture by Previtali (Detroit, Institute of Arts) which can probably be dated about 1502.

Perhaps from the Patrizi collection, Rome; bought by George Salting, 1898; Salting Bequest, 1910.

Davies 1961, pp. 146–7; Humfrey 1983, p. 112.

Antonio CICOGNARA
active 1480–1500

Antonio Cicognara is recorded as working as an illuminator in Cremona in the early 1480s and later as working there on panels and murals. His earliest signed work is a *Madonna and Child* of 1480 (Ferrara, Pinacoteca).

Giovanni Battista CIMA da Conegliano
about 1459/60–about 1517/18

Cima was born in Conegliano and was one of the leading artists in Venice from about 1490 to 1510. He painted altarpieces for churches in Venice and elsewhere in northern Italy (remarkably, more than thirty survive). He also painted many images of the Virgin and Child and occasional small mythologies.

Giovanni Battista CIMA da Conegliano
Saint Mark (?)
about 1500

NG 4945
Oil (identified) on wood, painted surface
103.2 x 40.6 cm

The saint is probably to be identified as Saint Mark by his general appearance and attribute of a quill pen (suggesting an evangelist).

In the seventeenth century *Saint Mark* and *Saint Sebastian* (NG 4946) were recorded together as parts of an altarpiece in the chapel of the silkweavers' guild in the church of S. Maria dei Crociferi in Venice. They flanked an *Annunciation* (St Petersburg, Hermitage) by Cima but were probably only assembled as parts of this triptych at a later date.

The figures seem to be indebted to Venetian sculpture: the saints by Pietro Lombardo (about 1435–1515) on Doge Mocenigo's monument in SS. Giovanni e Paolo are similarly framed in shell niches.

Probably in S. Maria dei Crociferi in Venice by 1648; Schiavone collection, Venice, by 1854; Eastlake collection, 1854–94; Mond Bequest, 1924; entered the Collection in 1938.

Davies 1961, pp. 147–8; Humfrey 1983, pp. 113–14.

Giovanni Battista CIMA da Conegliano
Saint Sebastian
about 1500

NG 4946
Oil (identified) on wood, painted surface
103.2 x 40.6 cm

Sebastian was a centurion sentenced to death by the Emperor Diocletian for his Christian faith. He was shot with arrows and left for dead. The arrows did not kill him and he was eventually stoned to death. His story is told in *The Golden Legend*.

In the seventeenth century NG 4946 was recorded with NG 4945 as part of an altarpiece in the church of S. Maria dei Crociferi in Venice. For further comments see under NG 4945.

Probably in S. Maria dei Crociferi in Venice by 1648; Schiavone collection, Venice, by 1854; Eastlake collection, 1854–94; Mond Bequest, 1924; entered the Collection in 1938.

Davies 1961, pp. 147–8; Humfrey 1983, pp. 113–14.

Giovanni Battista CIMA da Conegliano
Saint Jerome in a Landscape
about 1500–10

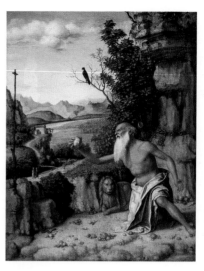

NG 1120
Oil on wood, painted surface 32.1 x 25.4 cm

Saint Jerome (about 342–420) kneels before a wooden cross – not a crucifix as is usually depicted – and strikes his chest with a rock. Jerome was the chief inspiration for Christian penitents and for hermits. His traditional attribute of a lion (from whose paw, according to legend, the saint had removed a thorn) looks on. A serpent crawls out from below the cross, and a bird of prey sits in a tree behind the saint; both suggest the wilderness to which the saint had retired.

The blue of the saint's robes, which have fallen around his hips, is unusual in representations of the saint. Jerome was traditionally shown in red, although until the 1460s it was customary for cardinals to wear a violet or blue cape unless granted the privilege of wearing red when acting on papal business.

Apparently bought in Venice, 1770; collection of John Strange by 1799; collection of William Beckford by 1822; by descent to the collection of the Dukes of Hamilton; from where purchased, 1882.

Davies 1961, p. 145; Humfrey 1983, p. 111; Rice 1985, pp. 106–7.

Giovanni Battista CIMA da Conegliano
The Incredulity of Saint Thomas
about 1502–4

Giovanni Battista CIMA da Conegliano
The Virgin and Child
about 1505

Giovanni Battista CIMA da Conegliano
David and Jonathan (?)
about 1505–10

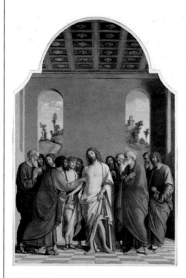

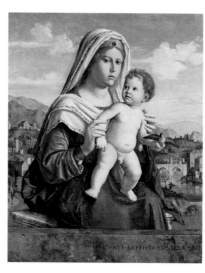

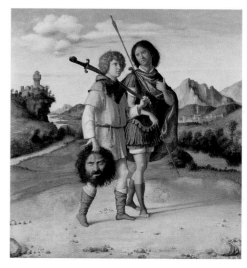

NG 816
Oil (identified) on synthetic panel, transferred from poplar, painted surface 294 x 199.4 cm

Signed and dated on the cartellino, lower right: Joanes Baptiste Coneglane[n]sis / opus 1504; and inscribed on another cartellino, lower centre, with the names (much damaged) of the officers of the Scuola di San Tommaso who commissioned the painting.
 After his Resurrection Christ appeared to the disciples and showed them his wounds. Thomas was absent and when they told him that they had seen the Lord he would not believe them and said: 'Except I shall see in his hands the print of the nails, and put my finger into the print of the nails, and thrust my hand into his side, I will not believe.' Thomas placed his finger in the wound in Christ's side eight days later and was convinced that he had risen from the dead. New Testament (John 20: 19–27).
 NG 816 was commissioned in 1497 by the Scuola di S. Tommaso dei Battuti for their altar in the church of S. Francesco in Portogruaro, north of Venice. The Scuola was a penitential and charitable lay association which administered four hospitals in Portogruaro. The altarpiece was completed in 1504 but was probably started several years before; Cima did not receive final payment until 1509.
 Numerous paint losses, due to blistering, have been restored.

Bought, 1870.

Davies 1961, pp. 144–5; Humfrey 1983, pp. 110–11, 202–4; Dunkerton 1985, pp. 38–59; Dunkerton 1986, pp. 4–27; Dunkerton 1991, pp. 64, 134, 183, 200.

NG 634
Oil and egg (identified) on poplar, painted surface 53.3 x 43.8 cm

Signed on the parapet: .IOANES. BAPTISTA. CONEGLAS. P.[INXIT].
 The bird held by the infant Christ is a linnet. It probably alludes symbolically to the Passion of Christ, although the bird generally employed for this purpose was a goldfinch (who according to legend was spotted with Christ's blood during the Passion). Birds were also given to children as pets.
 The Virgin's garments are bordered *alla perosina* (with ornament in the Persian style) – a reminder of the textiles imported into Venice from the Islamic East.

Collection of Lord Powerscourt by 1845; collection of W. Coningham by 1849; bought with the Edmond Beaucousin collection, Paris, 1860.

Davies 1961, pp. 143–4; Humfrey 1983, pp. 109–10; Dunkerton 1991, p. 200.

NG 2505
Oil on wood, painted surface 40.6 x 39.4 cm

David, the son of Jesse, defeated Saul and became the King of Israel. He is represented holding the head of Goliath, whom he had felled with a slingshot, and with Goliath's sword, with which he had decapitated the Philistine champion. Old Testament (1 Samuel 17: 49–51). It is, however, unusual for David to be shown with Jonathan, the son of Saul, at this stage in his life and odd for Jonathan to be carrying a javelin.
 The two-figure composition has been compared with pictures of Tobias and the Archangel Raphael.

Said to come from the Modici collection, Naples; bought by George Salting, 1898; Salting Bequest, 1910.

Davies 1961, p. 146; Humfrey 1983, pp. 111–12.

Giovanni Battista CIMA da Conegliano
Christ Crowned with Thorns
about 1510

Attributed to CIMA
The Virgin and Child with Saint John the Evangelist (?) and Saint Nicholas, about 1513–18

After CIMA
The Virgin and Child with Saint Paul and Saint Francis, perhaps about 1508–30

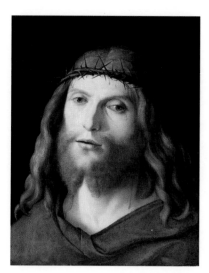

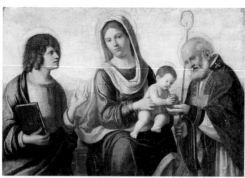

NG 3113
Oil on canvas, 50.8 x 70.5 cm

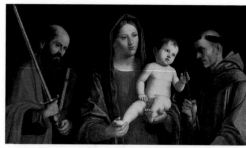

NG 3112
Oil on poplar, painted surface 49.5 x 87 cm

NG 1310
Oil on wood, painted surface 36.8 x 29.2 cm

Christ is represented as the Man of Sorrows wearing the crown of thorns and the robe given him by the soldiers in the Mocking of Christ. New Testament (e.g. John 19: 1–3).

NG 1310 was probably painted in the last years of Cima's life as a private devotional image. Such paintings were popular in Venice and probably derived from Netherlandish prototypes.

Infra-red photography has revealed a detailed and highly finished underdrawing with the drapery and face modelled using a fine, hatched technique. This underdrawing was almost certainly intended to show through the very thin, translucent paint layers and to contribute to the modelling of Christ's features.

Perkins collection by 1856; bought, 1890.

Davies 1961, pp. 145–6; Humfrey 1983, p. 111; Dunkerton 1991, p. 169.

The saint on the left of the Virgin and Child is probably Saint John the Evangelist. Saint Nicholas of Bari, the fourth-century Archbishop of Myra, is shown on the right with the three golden spheres which he gave to three young women who could not afford a dowry. The Christ Child picks up one of these balls.

NG 3113 has been damaged and retouched, but may be an autograph work by Cima, probably from his late period.

Bought in Venice by Sir A.H. Layard, about 1866; Layard Bequest, 1916.

Davies 1961, p. 148; Humfrey 1983, p. 113.

Saint Paul is shown on the left of the Virgin and Child with a sword and a book, his traditional attributes. Saint Francis is on the right, with a wooden cross, which is touched by the infant Christ.

NG 3112 was once thought to be by Cima, but has recently been rejected on account both of its execution and its design. The figure types relate to those of Cima's later career, and the composition may have been pieced together by an assistant from workshop drawings.

Bought in Venice by Sir A.H. Layard, about 1866; Layard Bequest, 1916.

Davies 1961, pp. 148–9; Humfrey 1983, pp. 112–13.

Attributed to Jacopo di CIONE
The Crucifixion
about 1368–70

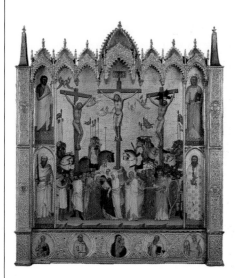

Attributed to Jacopo di CIONE and workshop
The Coronation of the Virgin
1370–1

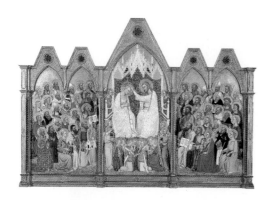

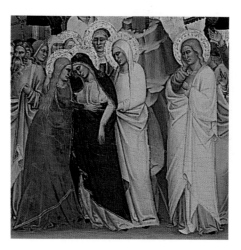

NG 1468, detail

NG 1468
Tempera on poplar, including the frame
154 x 138.5 cm

Inscribed on the book held by Saint Bernard: Dic mat[er] / domini si / in ierusale[m] / eras qua[n]/do captus / fuit filius / tuus & vi[nc]/tus. Cui illa / R[espond]et. / In ierusa/lem era[m] / qua[n]do / hoc aud(i)/vi & gres(su) (Say, Mother of the Lord, whether you were in Jerusalem when your son was captured and bound ... To which she replies. I was in Jerusalem when I heard this and by walking ... [where I could I came weeping to my Lord]).

 Inscribed on some of the arms and armour: S.P.Q.R. (The Senate and the People of Rome). Inscribed on the cross: I.N.R.Y.
 Centre: the Crucifixion. On Christ's right is the good thief with a polygonal halo; angels carry his soul to heaven. On his left is the bad thief whose pink flesh colour shows he is still alive; his legs are being broken and devils hold a brazier with burning coals over his head. In the frame, on the left of the Crucifixion: Saints John the Baptist and Paul; on the right, Saints James the Greater and Bartholomew. The predella depicts (left to right) a female saint, Saint Bernard with a book inscribed from his *Liber de Passione Christi et doloribus et planctibus matris ejus* (Book of the Passion of Christ and the Sorrows and Lamentations of his Mother), the Virgin and Child, a monk saint, probably Anthony Abbot, and Saint Catherine of Alexandria.
 NG 1468 was possibly painted for a sacristy or private oratory and perhaps for a Cistercian foundation – as suggested by the inclusion of Saint Bernard of Clairvaux. It appears to be the work of at least two artists, principally Jacopo di Cione. The frame with its starred canopy and the pilasters with decorative *pastiglia* and painted shields are original.

Jacopo di CIONE

probably active 1362; died 1398/1400

Jacopo was the youngest of four brothers, three of whom were painters in Florence (see also Nardo di Cione NG 581). Jacopo was certainly active by 1366, and in 1368 completed an altarpiece started by his brother Andrea Orcagna for Orsanmichele . He headed a large workshop that painted altarpieces and frescoes, and collaborated with other artists, especially Niccolò di Pietro Gerini.

Beckford collection by 1823 (said to be from the Camposanto, Pisa); bequeathed by the Revd Jarvis Holland Ash, 1896.

Gordon 1988, pp. 54–6; Bomford 1989, pp. 140–55.

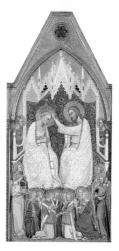

NG 569.1
Egg (identified) on poplar, 206.5 x 113.5 cm

The Virgin Mary is crowned Queen of Heaven by her son Jesus Christ, in the presence of saints (NG 569.2–3) and choirs of angels with musical instruments. The Coronation of the Virgin was one of the most popular subjects in religious art, especially in fourteenth-century Florence.
 NG 569.1 was part of the high altarpiece of S. Pier Maggiore, Florence; see commentary under NG 578 and the reconstruction in Appendix A.

Bought from the Lombardi–Baldi collection, 1857.

Gordon 1988, pp. 45–54; Bomford 1989, pp. 156–89; Dunkerton 1991, pp. 232–4, 399.

Attributed to Jacopo di CIONE and workshop
Adoring Saints
1370–1

Attributed to Jacopo di CIONE and workshop
Adoring Saints
1370–1

Attributed to Jacopo di CIONE and workshop
The Trinity
1370–1

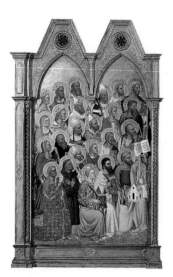

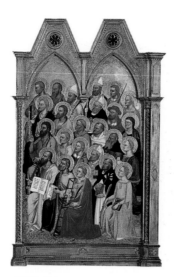

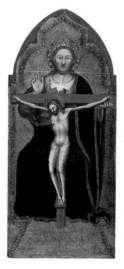

NG 569.2
Egg (identified) on poplar, painted surface
169 x 113 cm

Inscribed on Saint John the Evangelist's book: Vydi
tur/bam ma/gna[m] quam dinume[r]a/re nemo /
poterat. / ex om[n]ibus / gentibus / stantes an/te
thronu[m] / & in conspectu / agni amicti (I saw a
great multitude which no man could number of all
nations ... standing before the throne and in sight
of the Lamb, clothed ... [with white robes]).

There are five rows of saints which can be
identified as follows. Front row (right to left):
Saints Peter (with a model of the church of S. Pier
Maggiore, Florence, also symbolising the Christian
Church), Bartholomew, Stephen. Second row:
Saints John the Evangelist, Philip (?), Miniato (?),
Zenobius (?), Francis, Mary Magdalene. Third row:
Saint Andrew (?), a youthful saint, Saints Blaise,
Gregory, Benedict, Lucy. Fourth row: an apostle,
Saint Luke (?), a martyr pope, Saint Ambrose or
Giles, one of the Magi, possibly Caspar. Back row:
the two remaining Magi (possibly Melchior and
Balthazar), Saint Reparata (?). The inscription on
Saint John the Evangelist's book is taken from the
Book of Revelation (7: 9).

NG 569.2 was part of the high altarpiece of S.
Pier Maggiore, Florence; see commentary under
NG 578 and the reconstruction in Appendix A.

Bought from the Lombardi–Baldi collection, 1857.

Gordon 1988, pp. 45–54; Bomford 1989, pp. 156–89;
Dunkerton 1991, pp. 232–4, 399.

NG 569.3
Egg (identified) on poplar, painted surface
169 x 113 cm

Inscribed on Saint Paul's book: Nos o[mne]s /
revelata / facie glo/riam do/mini spe/culantes /
in ea[m]dem / ymagi/ne[m] transformam[ur] / a
clarita/te in cla/ritatem / tanqua[m] (We all,
beholding the glory of the Lord with open face, are
transformed into the same image from glory to
glory, as [if] ... [by the spirit of the Lord]) (2
Corinthians 3: 18). Inscribed on Saint Matthew's
book: Lybe[r] (gene)/ration(nis) / ih(s)u x(= christi)
/ filii d(avid) / filii a/braam (The book of the
generation of Jesus Christ, the son of David, the son
of Abraham ...) (Matthew 1: 1).

There are five rows of saints which can be
identified as follows. Front row (left to right):
Saints Paul, Matthew, Lawrence. Second row:
Saints John the Baptist, a youthful saint, Julian (?),
Nicholas, Dominic, Catherine of Alexandria. Third
row: Saint James the Greater, an apostle, Saints
John Gualberto (?), Bernard (?), Anthony Abbot,
Agnes. Fourth row: an apostle, Saint Mark (?), a
holy martyr pope, Saints Augustine (?), Jerome,
Scholastica. Back row: Saint Ambrose (?), a young
saint with a sword (Julian ?), Saint Ursula (?).

NG 569.3 was part of the high altarpiece of S. Pier
Maggiore, Florence; see commentary under NG 578
and the reconstruction in Appendix A.

Bought from the Lombardi–Baldi collection, 1857.

Gordon 1988, pp. 45–54; Bomford 1989, pp. 156–89;
Dunkerton 1991, pp. 232–4, 399.

NG 570
Tempera on poplar, 87 x 40 cm

God the Father holds one arm of the cross with the
crucified Christ; the dove represents the Holy Spirit.

NG 570 was the central pinnacle panel of the high
altarpiece of S. Pier Maggiore, Florence; see
commentary under NG 578 and the reconstruction
in Appendix A.

Bought from the Lombardi–Baldi collection, 1857.

Gordon 1988, pp. 45–54; Bomford 1989, pp. 156–89;
Dunkerton 1991, pp. 232–4, 399.

Attributed to Jacopo di CIONE and workshop
Seraphim, Cherubim and Adoring Angels
1370–1

Attributed to Jacopo di CIONE and workshop
Seraphim, Cherubim and Adoring Angels
1370–1

Attributed to Jacopo di CIONE and workshop
The Nativity and Annunciation to the Shepherds
1370–1

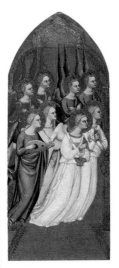

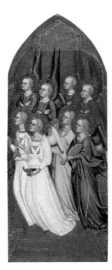

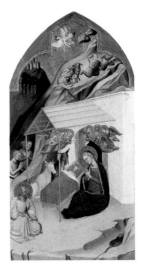

NG 571
Tempera on poplar, 87 x 37.5 cm

NG 572
Tempera on poplar, 87 x 37.5 cm

NG 573
Tempera on poplar, 95 x 49 cm

Seraphim, cherubim and adoring angels with musical instruments and incense-burners originally flanked The *Trinity* (NG 570). Seraphim and cherubim belong to the highest order in the hierarchy of the angelic host. Seraphim are usually painted red as representative of Divine Love. Cherubim, representing Divine Wisdom, are portrayed in blue.

 NG 571 was a pinnacle panel of the high altarpiece of S. Pier Maggiore, Florence; see commentary under NG 578 and the reconstruction in Appendix A.

Bought from the Lombardi–Baldi collection, 1857.

Gordon 1988, pp. 45–54; Bomford 1989, pp. 156–89; Dunkerton 1991, pp. 232–4, 399.

Seraphim, cherubim and adoring angels with musical instruments and incense-burners originally flanked The *Trinity* (NG 570). Seraphim and cherubim belong to the highest order in the hierarchy of the angelic host. Seraphim are usually painted red as representative of Divine Love. Cherubim, representing Divine Wisdom, are portrayed in blue.

 NG 572 was a pinnacle panel of the high altarpiece of S. Pier Maggiore, Florence; see commentary under NG 578 and the reconstruction in Appendix A.

Bought from the Lombardi–Baldi collection, 1857.

Gordon 1988, pp. 45–54; Bomford 1989, pp. 156–89; Dunkerton 1991, pp. 232–4, 399.

The Virgin and Child and Saint Joseph are shown with an ox and an ass outside the stable. The Annunciation to the Shepherds can be seen in the right background; the shepherds adore the Child Jesus on the lower left. New Testament (Luke 2: 8–17).

 NG 573 was part of the upper tier of the high altarpiece of S. Pier Maggiore, Florence; see commentary under NG 578 and the reconstruction in Appendix A.

 The background of NG 573 is one of the earliest attempts in Italian panel painting to represent a night scene.

Bought from the Lombardi–Baldi collection, 1857.

Gordon 1988, pp. 45–54; Bomford 1989, pp. 156–89; Dunkerton 1991, pp. 232–4, 399.

Attributed to Jacopo di CIONE and workshop
The Adoration of the Kings
1370–1

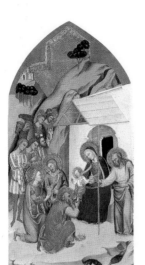

NG 574
Tempera on poplar, 95 x 49 cm

The Three Kings bear gifts of gold, frankincense and myrrh; they have journeyed from the East, as is suggested by the inclusion of camels in the background. New Testament (Matthew 2: 10–12). Unusually, the Child is shown handing the eldest king's gift to Joseph to hold.

NG 574 was part of the upper tier of the high altarpiece of S. Pier Maggiore, Florence; see commentary under NG 578 and the reconstruction in Appendix A.

Bought from the Lombardi–Baldi collection, 1857.

Gordon 1988, pp. 45–54; Bomford 1989, pp. 156–89; Dunkerton 1991, pp. 232–4, 399.

Attributed to Jacopo di CIONE and workshop
The Resurrection
1370–1

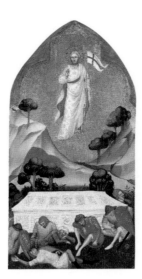

NG 575
Tempera on poplar, 95 x 49 cm

The shields of two of the soldiers are inscribed: SPQR

Christ rises from his sealed tomb while the Roman soldiers who were guarding it sleep. New Testament (all Gospels, e.g. Matthew 28: 1–8).

The composition may derive from frescoes of 1365–7 in the Chapter House (the so-called Spanish Chapel) of S. Maria Novella, Florence, by Andrea da Firenze. NG 575 was part of the upper tier of the high altarpiece of S. Pier Maggiore, Florence; see commentary under NG 578 and the reconstruction in Appendix A.

Bought from the Lombardi–Baldi collection, 1857.

Gordon 1988, pp. 45–54; Bomford 1989, pp. 156–89; Dunkerton 1991, pp. 232–4, 399.

Attributed to Jacopo di CIONE and workshop
The Maries at the Sepulchre
1370–1

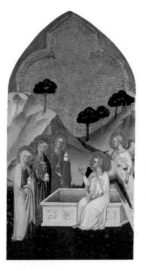

NG 576
Tempera on poplar, 95 x 49 cm

On the morning of Christ's Resurrection the three Maries (Mary Magdalene, Mary the wife of Cleophas, and Mary the mother of James) went to his tomb to anoint Christ's body. They found the tomb empty but encountered two angels dressed in shining garments who explained that Christ had risen from the dead. New Testament (Luke 24: 1–4).

NG 576 was part of the upper tier of the high altarpiece of S. Pier Maggiore, Florence; see commentary under NG 578 and the reconstruction in Appendix A.

The landscape background between NG 575 (*The Resurrection*) and NG 576 is the same, but the tomb is made slightly smaller to accommodate the three Maries. The gold background has been almost entirely regilded.

Bought from the Lombardi–Baldi collection, 1857.

Gordon 1988, pp. 45–54; Bomford 1989, pp. 156–89; Dunkerton 1991, pp. 232–4, 399.

Attributed to Jacopo di CIONE and workshop
The Ascension
1370–1

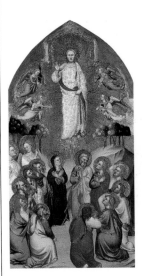

NG 577
Tempera on poplar, 95 x 49 cm

Forty days after his Resurrection Christ and the apostles went to the Mount of Olives where Christ ascended into Heaven on a cloud. Two angels in white (left) appeared and explained that Christ would return as he had gone. New Testament (Acts 1: 9–11). Saint Peter kneels next to the Virgin Mary; the altarpiece was made for a church dedicated to him and therefore he features prominently in it.

The composition may derive from the frescoes in the Chapter House of S. Maria Novella, Florence, painted by Andrea da Firenze in 1365–7. NG 577 was part of the upper tier of the high altarpiece of S. Pier Maggiore, Florence; see commentary under NG 578 and the reconstruction in Appendix A.

Bought from the Lombardi–Baldi collection, 1857.

Gordon 1988, pp. 45–54; Bomford 1989, pp. 156–89; Dunkerton 1991, pp. 232–4, 399.

Attributed to Jacopo di CIONE and workshop
Pentecost
1370–1

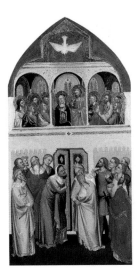

NG 578
Tempera on poplar, 95 x 49 cm

The Virgin Mary and the twelve apostles are gathered together after Christ's Ascension into Heaven. The Holy Spirit descends upon the Virgin and the assembled apostles in the form of a dove and tongues of fire. Outside people from different nations marvel at hearing the apostles preach in their language. New Testament (Acts 2: 1–6).

NG 578, together with NG 569–77, was part of the high altarpiece of S. Pier Maggiore, Florence (see Appendix A for a reconstruction). The altarpiece, probably designed by Niccolò di Pietro Gerini who collaborated with Jacopo di Cione on a number of occasions, was begun in 1370; the painting has been attributed to Jacopo and his workshop. Documents concerning materials used – including pigments, eggs and gold – and work involved – such as varnishing – survive. The altarpiece was probably paid for by the Albizzi family. The high altar was dedicated to Saint Peter and six panels of his life (now in various collections) probably formed the predella mentioned in documents of 1371. The altarpiece was finished in that year.

The composition of NG 578 may derive from Andrea da Firenze's fresco of the subject in the Chapter House (now known as the Spanish Chapel) at S. Maria Novella, Florence, painted in 1365–7. Unusually the light radiating from the dove is shown as straight lines tooled in the gold, which become diffused painted light.

S. Pier Maggiore, Florence, by 1568, presumably since 1371 and until the eighteenth century; bought from the Lombardi–Baldi collection, 1857.

Gordon 1988, pp. 45–54; Bomford 1989, pp. 156–89, 197–200; Dunkerton 1991, pp. 232–4, 399.

Nardo di CIONE
Saint John the Baptist with Saint John the Evangelist (?) and Saint James, about 1365

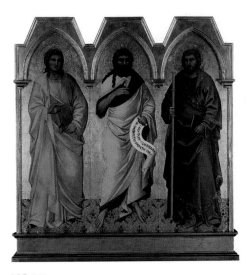

NG 581
Egg (identified) on poplar, total dimensions 159.5 x 147.5 cm

Inscribed on the scroll held by Saint John the Baptist: EGO. VOS(sic). CLAMANTE / IN DEXERTO. PARATE VIA (I am the voice of one crying in the wilderness, Prepare ye the way [of the Lord]).

The scroll held by Saint John the Baptist (centre) is inscribed with the words he was said to have uttered when preaching in the wilderness of Judea (New Testament, Matthew 3: 3). Saint James the Greater (right) is shown with a pilgrim's staff. The male saint (left) may be Saint John the Evangelist (with his Gospel), whose type he resembles.

Probably painted in about 1365, NG 581 was an altarpiece and is said to have come originally from the church of S. Giovanni della Calza (then S. Giovanni Gerosolomitano), Florence, which belonged to the Knights of Malta. This would explain the central position given to Saint John the Baptist. The church was built by Bindo di Lapo Benini, who may also have commissioned this altarpiece, hence the presence of Saint James (Lapo = Jacopo = James).

The imitation textile with its pattern of birds was often used by Nardo. Underdrawing is visible on the Baptist's robe where the pink paint has become transparent.

Bought from the Lombardi–Baldi collection, Florence, 1857.

Gordon 1988, pp. 84–6; Bomford 1989, pp. 126–39.

Nardo di CIONE
active 1343; died between 1365 and 1366

Nardo was the brother of Andrea, Matteo and Jacopo di Cione. All attributions to Nardo are based on Ghiberti's statement that he painted the frescoes in the Strozzi Chapel in S. Maria Novella, Florence.

Style of Giacomo Francesco CIPPER
Head of a Man in Blue
probably 1700–50

NG 5468
Oil on canvas, 47 x 36.2 cm

The man's neck is disfigured by a goitre.
　The practice of choosing sitters afflicted by some disease is characteristic of certain eighteenth-century genre painters.

Bequeathed by Maurice Woolff Jacobson, 1944.

Levey 1971, p. 87.

Style of Giacomo Francesco CIPPER
Head of a Man in Red
probably 1700–50

NG 5469
Oil on canvas, 46.1 x 35.9 cm

Presumably a genre subject rather than a portrait.
　NG 5469 is probably by the same hand as NG 5468, and is likely to date from the first half of the eighteenth century.

Bequeathed by Maurice Woolff Jacobson, 1944.

Levey 1971, p. 87.

Pieter CLAESZ.
Still Life with Drinking Vessels
1649

NG 2592
Oil on oak, 63.5 x 52.5 cm

Signed and dated on the knife: 1649·PC (PC in monogram).
　The glass at the left is a *roemer*, and in the centre is an octagonal *pas-glas*. The porcelain bowl is an example of Chinese export ware which can be dated to the Wan-Li period (1573–1619).
　The work appears to have been cut down on both sides and at the top and bottom, perhaps by as much as five centimetres.

[J. Marsh, Ipswich] sale, London, 1890; Salting Bequest, 1910.

MacLaren/Brown 1991, pp. 79–80.

Giacomo Francesco CIPPER
active early 18th century

Probably German by birth, but active in Lombardy. He painted until at least 1736. There is an affinity between his style and that of Ceruti.

Pieter CLAESZ.
1597/8–1660

Claesz. was born in Burgsteinfurt, Westphalia. He had settled in Haarlem by 1617. He was a still-life painter who initially worked in the style of the older Haarlem still-life painters such as Floris van Dijck. Subsequently Claesz. painted the almost monochrome 'breakfast pieces' (*ontbijtjes*) which are characteristic of the later school of Haarlem still-life painting, of which he and Willem Claesz. Heda were the founders.

CLAUDE
A View in Rome
1632

NG 1319
Oil on canvas, 59.7 x 83.8 cm

CLAUDE
Landscape with a Goatherd and Goats
about 1636–7

NG 58
Oil on canvas, 51.4 x 41.3 cm

CLAUDE
A Seaport
1639

NG 5
Oil (identified) on canvas, 99.1 x 129.5 cm

Inscribed on the base of the upturned capital, right foreground: CLAVDE. I.V. / ROM(AE ?). 1632.

This painting combines a real view of Rome with an imagined one. At the left can be seen the Convento del Sacro Cuore and the church of Trinità de' Monti and further to the right the pope's summer palace on the Quirinal. By contrast the ruins on the far right are imaginary. The old woman receiving money may be a beggar, a fortune-teller or, most likely, a procuress.

NG 1319 does not correspond with any compositions in the *Liber Veritatis* (London, British Museum).

It has been suggested that the view of the church and the convent would have been similar to that which could be seen from the roof of Claude's home which was in what is now the Via Babuino.

Possibly collection of Sir Gregory Page, Blackheath, by 1761; bought, 1890.

Davies 1957, p. 49; Roethlisberger 1961, pp. 477–8, no. 214; Roethlisberger 1975, p. 88, no. 29; Langdon 1989, pp. 35–6; Wine 1994, p. 65, no. 4.

There is no specific literary source for this arcadian scene, but it can be associated with the mood of Virgil's pastoral poetry which inspired a number of Claude's works. The scene may show the park of the Villa Madama in Rome, a property of the Medici family.

NG 58 is dated on grounds of style to about 1636–7 and is related to the left half of a landscape-format drawing in the *Liber Veritatis*, no. 15 (London, British Museum), for which a date of 1637 has been suggested. Another painting that can be more closely related to this sheet also survives (Rome, Rospigliosi-Pallavicini collection).

NG 58 particularly inspired John Constable who made a copy of it in 1823 (Sydney, Art Gallery of New South Wales).

Probably Robert Asnell sale, 1772; Sir George Beaumont Gift, 1823/8.

Davies 1957, p. 45; Roethlisberger 1961, pp. 127–31, no. 15; Roethlisberger 1975, p. 93, no. 69; Kitson 1978, pp. 61–2; Langdon 1989, p. 51; Wine 1992, pp. 122–5; Wine 1994, p. 68, no. 9.

Signed on a block of stone, left foreground: CLAVDIO. G.I.V ROMAE 1639 (?).

Claude has depicted an imaginary port at sunset. The artist painted a number of imaginary seaports (see also NG 14 and 30), partly based upon his experience of Naples and the works of Paul Brill. The palace front at the left has been adapted from a gateway built in about 1570 and leading to the Farnese Gardens from the Forum in Rome. Behind it is the antique Arch of Titus. On the nearer building, a clock with a single hand gives the time as five o'clock. Above it fleur-de-lys are depicted on a blue ground. On the balustrade is a statue after the Medici Venus recorded for certain at the Villa Medici in 1638.

The dating on the inscription is difficult to decipher and has been read as 1639 and 1644; the earlier date is now favoured. NG 5 corresponds with sheet no. 43 from the *Liber Veritatis* (London, British Museum), the inscription on which records the painting as having been made for Angelo Giorio (1586–1662) who was made a cardinal in 1643.

Painted for Cardinal Angelo Giorio, 1639(?); Marquis de Lassay (died 1738); Duc de Praslin by 1777, and bequeathed in 1785(?) to M. de Choiseul-Praslin; bought with the J.J. Angerstein collection, 1824.

Davies 1957, pp. 33–4; Roethlisberger 1961, pp. 174–6, no. 43; Roethlisberger 1975, p. 98, no. 107; Kitson 1978, pp. 78–9; Wine 1994, p. 70, no. 13.

CLAUDE

1604/5?–1682

Claude Gellée (called Claude Lorrain) was born in the Duchy of Lorraine. He travelled to Rome in about 1617 where, save for brief interludes in Naples and Nancy, he remained for the rest of his life. He painted, mainly for aristocratic patrons, idealised landscapes and port scenes, some with subjects from the Bible or the works of ancient authors.

CLAUDE

Seaport with the Embarkation of Saint Ursula
1641

CLAUDE

Landscape with Narcissus and Echo
1644

CLAUDE

Landscape with Cephalus and Procris reunited by Diana, 1645

NG 30
Oil on canvas, 113 x 149 cm

NG 19
Oil on canvas, 94.6 x 118 cm

NG 2
Oil on canvas, 101.6 x 132.1 cm

Inscribed bottom left (doubted): EMBARQUE... /ORS...
Signed bottom left: CLAVDIO. I. V.F. ROMAE. 1641.

The story of Saint Ursula is recounted in the *The Golden Legend* by Jacobus da Voragine. A daughter of a king of Britain or Brittany, she was asked to marry a pagan prince. Ursula managed to delay the marriage by setting off on a pilgrimage with eleven ships, each of which contained a thousand virgins. When returning from Rome they encountered the Huns at Cologne, and because she refused to marry their chief, Ursula was killed along with all her companions. Claude depicts the saint on the steps at the left, holding a standard, watching over some of her companions who are about to embark on their fateful voyage from Rome. The virgins carry bows and arrows alluding to their future martyrdom, although in *The Golden Legend* while Saint Ursula was shot with a bow and arrow, most of her party were beheaded. The building at the right recalls Bramante's Tempietto di S. Pietro in Montorio, Rome.

NG 30 was painted with a pendant picture – Claude's *Landscape with Saint George* (Hartford, Wadsworth Atheneum). Its composition corresponds very closely with *Liber Veritatis* sheet no. 54 (London, British Museum), the inscription on which identifies the patron as Fausto Poli (1581–1653) who was made a cardinal in 1643.

Fausto Poli, 1641; inherited by Cardinal Francesco Barberini, 1653; Desenfans' collection by 1786; bought with the J.J. Angerstein collection, 1824.

Davies 1957, pp. 44–5; Roethlisberger 1961, pp. 190–5, no. 54; Roethlisberger 1975, pp. 100–1, no. 118; Kitson 1978, pp. 85–7; Wine 1992, pp. 126–31; Wine 1994, p. 72, no. 15.

Signed and dated lower left: CLAVDE GILLEE... 1644.

Narcissus was a beautiful youth who rejected all those who pursued him. The nymph Echo fell in love with him, but could not express her feelings because she had been cursed and could only repeat the last words spoken to her. Eventually her body disintegrated and only her voice remained. The goddess Nemesis then caused Narcissus to fall in love with his reflection, which he saw in a limpid pool, and he died because his love remained unrequited; his corpse was transformed into the flower which bears his name. Ovid, *Metamorphoses*, III. Narcissus in the foreground stares at his reflection; Echo is probably the middle nymph at the left, who seems to be calling out. The lower figure was originally draped and was repainted as a nude probably in the later eighteenth century.

The composition of NG 19 is recorded on sheet no. 77 of Claude's *Liber Veritatis* (London, British Museum), which is inscribed: *quadro faict pour Angleter*. As such it is one of only two paintings by Claude known to have been made for an English patron (the other is *Landscape with a Temple of Bacchus*, Ottawa, National Gallery of Canada). The identity of the patron or patrons has not been established.

Collection of Peter Delmé, London, 1743; collection of Sir George Beaumont by 1790; his Gift, 1823/8.

Davies 1957, pp. 43–4; Roethlisberger 1961, pp. 222–3, no. 77; Roethlisberger 1975, p. 103, no. 139; Kitson 1978, pp. 99–101; Wine 1992, pp. 132–5; Wine 1994, p. 106, no. 67.

Signed and dated centre bottom: CGL . (in monogram) I.V. ROMA /1645.

Procris fled her husband Cephalus because he had doubted her fidelity. When they were reunited Procris gave him a magic hound and spear which were gifts from the hunter goddess Diana. Ovid, *Metamorphoses*, VII, 752–65. It appears that Claude has depicted the moment of reunion in the foreground right, although Ovid's account does not refer to Diana – in the centre next to the dog – being present. The magic spear is held by a child attendant. Later, Procris was mistakenly killed by Cephalus with the spear (see After Claude NG 55). Other versions of the subject by Claude are recorded.

The composition corresponds with sheet no. 91 from Claude's *Liber Veritatis* (London, British Museum), which records the painting having been executed for an unnamed patron in Paris.

Collection of La Livre de Jully, probably by 1757; bought with the J.J. Angerstein collection, 1824.

Davies 1957, pp. 32–3; Roethlisberger 1961, pp. 248–9, no. 91; Roethlisberger 1975, pp. 105–6, no. 154; Kitson 1978, pp. 110–11; Wine 1994, p. 107, no. 69.

CLAUDE
Landscape with Hagar and the Angel
1646

CLAUDE
Landscape with the Marriage of Isaac and Rebekah ('The Mill'), 1648

CLAUDE
Seaport with the Embarkation of the Queen of Sheba
1648

NG 12
Oil (identified) on canvas, 149.2 x 196.9 cm

NG 14
Oil (identified) on canvas, 148.6 x 193.7 cm

NG 61
Oil on canvas mounted on wood, 52.7 x 43.8 cm

Signed and dated: [C]LAVD/1646.

The servant girl Hagar (seated and dressed in blue) conceived a son by Abraham, the master of the house in which she worked. Abraham's wife, Sarah, who was childless, made her leave and go into the wilderness. An angel descended, prophesied the birth of her son Ishmael, and told her to return to Abraham's wife. Old Testament (Genesis 16). The angel points to the hilltop town where Abraham and Sarah presumably live.

The composition of NG 61 corresponds with *Liber Veritatis* sheet no. 106 (London, British Museum), which records the painting having been executed for an unnamed Paris patron.

The design derives from paintings by Domenichino such as his *Landscape with Tobias* (NG 48). Claude's painting was admired by John Constable, whose *Cornfield* (NG 130) may in turn recall its structure.

Possibly the Comtesse de Verrue sale, Paris, 1737; Sir George Beaumont Gift, 1823/8.

Davies 1957, pp. 45–7; Roethlisberger 1961, pp. 268–70, no. 106; Roethlisberger 1975, p. 107, no. 171; Kitson 1978, pp. 117–18; Wine 1994, p. 74, no. 19.

Inscribed on the stump, centre: MARI[AGE]/ DISAC/ AVEC REBECA (Marriage of Isaac and Rebecca). Signed and dated on a stone, bottom right foreground: CLAVDIO G.L.(perhaps over GILLE) /I.N.V. ROMAE 1648/.F (?)(C or 6).

Claude has depicted events which accompanied the marriage, creating an idyllic celebration not related in the Bible. Old Testament (Genesis 24: 6ff.). The water mill which gives the painting its popular name is in the middle distance, left of centre. The temple by the mill recalls the Temple of Vesta, Rome.

The composition of NG 12 corresponds with *Liber Veritatis* drawing no. 113 (London, British Museum), the inscription on which records that the painting was made for Cardinal Camillo Pamphili (1622–65), nephew of Pope Innocent X. Following Pamphili's disgrace, however, it was sold to the Duc de Bouillon (1605–52), a French general in the papal army who also bought its pendant, NG 14. Pamphili later acquired a version of NG 12 (now Rome, Palazzo Doria Pamphili).

Duc de Bouillon, 1648; bought with the J.J. Angerstein collection, 1824.

Davies 1957, pp. 35–42; Roethlisberger 1961, pp. 279–85, no. 113; Roethlisberger 1975, p. 109, no. 180; Kitson 1978, pp. 121–3; Wine 1994, p. 75, no. 21.

Inscribed on the steps near the queen at the right: LA REINE DE SABA VA / TROV(ver) SALOMON (The Queen of Sheba goes to find Solomon). A shield on the tower is possibly inscribed with four or five letters, ET perhaps forming the first line. Signed on the masonry, bottom left: CLAUDE GIL I.V.FAICT. POVR.SON. ALTESSE. LE. DVC. DE./ BVILLON. A ROMA 1648 (Claude Gellée made this for his excellency the Duc de Bouillon, Rome 1648).

The Queen of Sheba visited King Solomon in Jerusalem because she wanted to test his faith and wisdom by questioning him. Old Testament (Kings 10: 1–13). Claude has painted the queen's departure from the city, an incident not described in the Bible. She descends the steps at the right with her attendants.

This work was painted, with its pendant, Claude NG 12, as inscribed, in 1648 for the Duc de Bouillon (1605–52), a general in the papal army under Urban VIII. The composition corresponds with sheet no. 114 in the *Liber Veritatis* (London, British Museum).

The artist specialised in depictions of seaports at sunrise or sunset (see also NG 5 and 30). Works such as this were greatly admired by Turner, one of whose paintings, NG 498, is a homage to Claude's picture, and as a result of the wishes expressed in his will hangs beside it.

Duc de Bouillon, 1648; bought with the J.J. Angerstein collection, 1824.

Davies 1957, p. 42; Roethlisberger 1961, pp. 285–7, no. 114; Roethlisberger 1975, p. 109, no. 182; Kitson 1978, pp. 123–4; Wine 1994, p. 77, no. 26.

CLAUDE

Landscape with David at the Cave of Adullam
1658

NG 6
Oil on canvas, 112.4 x 185 cm

CLAUDE

Landscape with Psyche outside the Palace of Cupid ('The Enchanted Castle'), 1664

NG 6471
Oil on canvas, 87 x 151 cm

CLAUDE

Landscape with Aeneas at Delos
1672

NG 1018
Oil on canvas, 99.7 x 134 cm

Signed and dated bottom right: CLAVDIO Gellee/IVF. ROMAE 1658.

Three Israelite soldiers broke through the ranks of the Philistines who were besieging them, in order to satisfy King David's frivolous desire for some water from Bethlehem, which is situated beyond the camp in the landscape at the left. On their return he refused to drink, declaring that the water was '... the blood of the men that went in jeopardy of their lives'. Old Testament (2 Samuel 23: 13–17). The moment depicted is that at which David rejects the water offered to him in a helmet.

NG 6 corresponds with *Liber Veritatis* drawing no. 145 (London, British Museum), the inscription on which shows the painting to have been made for Prince Agostino Chigi (1634–1705), a nephew of Pope Alexander VII and captain of the papal guards. The nature of the subject was appropriate in view of the patron's military career. It was hung by the patron as a pendant to Salvator Rosa's *Mercury, Argus and Io* (Kansas City, Nelson-Atkins Museum of Art).

Painted for Agostino Chigi, 1658; Holwell Carr Bequest, 1831.

Davies 1957, p. 35; Roethlisberger 1961, pp. 343–5, no. 145; Roethlisberger 1975, p. 114, no. 215; Kitson 1978, pp. 142–3; Wine 1992, pp. 146–9; Wine 1994, p. 78, no. 27.

Cupid, the god of love, fell in love with Psyche, a beautiful princess, who entered his palace. Because of his divinity he forbade her to look at him, visiting her only at night. Persuaded by her jealous sisters, but after much hesitation, she resolved to murder Cupid, whom she believed to be a monster, while he slept. She discovered his true identity by lamplight but a drop of the lamp's oil woke Cupid. For disobeying him Psyche was abandoned, and attempted to drown herself. Apuleius, *The Golden Ass*, IV-VI. It is thought that Claude has depicted Psyche brooding over the decision whether or not to murder Cupid.

NG 6471 was executed in 1664 for Prince Lorenzo Onofrio Colonna. The composition corresponds with sheet no. 162 of the *Liber Veritatis* (London, British Museum). Claude painted a pendant for it – *Landscape with Psyche saved from drowning herself* (Cologne, Wallraf-Richartz Museum) – in 1665.

Preparatory drawings survive (London, private collection; Chantilly, Musée Condé; Karlsruhe, Staatliche Kunsthalle). The title 'The Enchanted Castle' dates from William Woollett's engraving of 1782. It is thought John Keats referred to NG 6471 in his *Ode to a Nightingale*.

Lorenzo Onofrio Colonna, 1664; Marchese Pallavicini by 1696; in England by 1730; bought, 1981.

Roethlisberger 1961, pp. 384–6, no. 162; Roethlisberger 1975, p. 118, no. 233; Kitson 1978, pp. 153–4; Wilson 1982; Russell 1982–3, pp. 177–9, no. 45A; Russell 1984, pp. 67–8; Levey 1988, pp. 812–20; Langdon 1989, p. 133; Wine 1992, pp. 150–3; Wine 1994, p. 86, no. 38.

Inscribed on the parapet by the figures: ANVIS ROY. SACER(D)OTE (DI) APOLLO., ANCHISE, ENEA. (King Anius priest of Apollo, Anchises, Aeneas.) Signed and dated: CLAVDE. GILLE. INV. FE. ROMAE./1672. (Claude Gellée made this in Rome/1672.)

Aeneas, in red, has arrived with his companions on Delos, the home of Apollo. They are shown the sites by its king, Anius, the priest of Apollo. The bearded man in blue is Aeneas' father, Anchises, and further to the left is his son, Ascanius. The king points to a palm and an olive tree, to which Latona clung when she gave birth to Apollo and Diana. The domed building to the right, which recalls the Pantheon, Rome, is the Temple of Apollo. In the upper right a relief illustrates Apollo and Diana killing the giant Tityus who tried to ravish their mother. Virgil, *Aeneid*, III, 73–82, and Ovid, *Metamorphoses*, XIII, 630ff.

This composition corresponds with sheet no. 179 in the *Liber Veritatis* (London, British Museum), the inscription on which indicates the painting to have been made for one Monsieur Dupassy le Gout.

Dupassy le Gout, 1672; De Fonterspuis sale, 1748; Blondel de Gagny collection by 1757; Wynn Ellis Bequest, 1876.

Davies 1957, pp. 47–8; Roethlisberger 1961, pp. 420–4, no. 179; Roethlisberger 1975, p. 121, no. 255; Kitson 1978, pp. 164–5; Langdon 1989, p. 146; Wine 1994, p. 96, no. 53.

After CLAUDE
Landscape with the Death of Procris
1650–1700

Paul Jean CLAYS
Ships lying off Flushing
1869

Paul Jean CLAYS
Ships lying near Dordrecht
1870

NG 55
Oil on canvas, 38.1 x 48.3 cm

NG 814
Oil on wood, 59.9 x 86.8 cm

NG 815
Oil on canvas, 75 x 110.2 cm

Procris gave her husband Cephalus a magic dog and a spear which had been given to her by Diana, the goddess of the hunt. She believed him to have been unfaithful to her and so hid when he approached, but Cephalus by mistake killed her with the spear. Ovid, *Metamorphoses*, VII, 752–65. Here Cephalus is shown accompanied by a dog, discovering in horror his dead wife. Behind the foreground group a deer is silhouetted against the setting sun.

This canvas is a seventeenth-century copy of a work by Claude, the whereabouts of which (if it survives) is unknown; the composition of the original is recorded in the *Liber Veritatis* (London, British Museum) on sheet no. 100.

Collection of Jacques-Louis de Beringhen, Marquis de Châteauneuf (died 1723); collection of Sir George Beaumont by 1799; his Gift, 1823/8.

Davies 1957, pp. 48–9; Kitson 1978, p. 115.

Signed and dated bottom right: P. J. Clays, 1869

A label on the reverse, signed by the artist and dated Brussels 1868, identifies the view.

Clays may have signed NG 814 some while after painting it, which would perhaps explain the discrepancy between the date on the label and that on the painting.

Bequeathed by J.M. Parsons, 1870.

Martin 1970, pp. 15–16.

Signed and dated bottom right: P. J. Clays, 1870.

A label on the reverse, signed by Clays and dated Brussels 1870, identifies the view as being in the environs of Dordrecht. It also states that NG 815 was painted for 'Joh [sic] Parsons (à Londres)'.

Bequeathed by J.M. Parsons, 1870.

Martin 1970, p. 16.

Paul Jean CLAYS
1819–1900

Clays, who was born in Bruges, was a marine painter. He was taught in Paris by Horace Vernet and Théodore Gudin. The artist lived in Antwerp until 1856, and then moved to Brussels, where he died.

Pieter CODDE
A Woman holding a Mirror
1625

NG 2584
Oil on oak, 38.1 x 33.7 cm

Signed and dated on the frame of the landscape: PCodde. Anno 1625 (PC in monogram).

The woman's features are not sufficiently individualised for NG 2584 to be a portrait. The object she holds is almost certainly a mirror, and it is possible that the picture is an allegory of *superbia* (pride). However, the woman does not look at her reflection and the picture might also be a *vanitas* (a picture symbolising the vanities and transience of human life).

NG 2584 appears to be Codde's earliest dated work.

Salting Bequest, 1910.

MacLaren/Brown 1991, pp. 81–2.

Pieter CODDE
1599–1678

Born and active in Amsterdam, Pieter Jacobsz. Codde was a portrait and genre painter. He also completed a large militia group left unfinished by Frans Hals (Amsterdam, Rijksmuseum) and painted history pictures. Codde was influenced in his portraiture by Hals and may have taught Willem Duyster.

Pieter CODDE
Portrait of a Man, a Woman and a Boy in a Room
1640

NG 2576
Oil on oak, 48.3 x 65 cm

Signed bottom left: PC (in monogram). Dated over the doorway: 16—40.

On the back wall is a landscape tapestry. The painted landscape over the fireplace is in the style of the Haarlem School of the 1630s (possibly Pieter Molijn). The door in the left background leads to a room which contains a chair and a bed.

Codde painted a number of family groups in the early 1640s. It has been suggested (on the basis of comparison with engravings by Pontius after Codde) that the sitters are Hendricus Meursius and Judith Cotermans and their son but the resemblances are not very close.

Apparently in the collection of the first Baron Dover (died 1831), London; Salting Bequest, 1910.

MacLaren/Brown 1991, p. 81.

Attributed to the Workshop of Pieter COECKE van Aalst
The Virgin and Child Enthroned, 1527–50

NG 2606
Oil on wood, including frame, 32 x 48.5 cm

Inscribed on the back of the central panel: RESPICE FINEM ET NON/ PECCABIS IN ETERNVM ('Remember the end, and thou shalt never do amiss', Ecclesiasticus 7: 36).

This small triptych is in its original frame. The central panel shows the Virgin and Child enthroned; a figure in the background may be Saint Joseph. On the right wing is Saint Louis, and on the left a bishop saint. On the reverse of the left wing Saint James the Great is represented as a pilgrim. On the reverse of the right wing is Saint Anthony of Padua who holds a crucifix and a book on which the infant Christ is seated.

The design and inscription on the reverse of the centre panel may not be contemporary with the rest.

Benito Garriga, Madrid; sale, Paris, 24 March 1890 (lot 20); Salting Bequest, 1910.

Davies 1968, pp. 36–8.

NG 2606, reverse

Pieter COECKE van Aalst
1502–1550

According to van Mander the artist was taught by Bernaert van Orley and visited Rome. He became a master in Antwerp in 1527, where he was chiefly active. He visited Constantinople (1533) and worked as painter to Mary of Hungary and the Emperor Charles V. He also designed buildings, sculptures, stained glass and tapestries and translated Vitruvius and Serlio. Coecke seems to have had many assistants.

COLOGNE, Unknown artist
Portrait of a Woman
about 1495

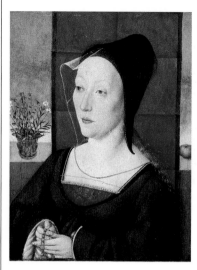

NG 2670
Oil on oak, 38.4 x 28.5 cm

David de CONINCK
Dead Birds and Game with Gun Dogs and a Little Owl, probably about 1672–94

NG 1903
Oil on canvas, 96.2 x 133.5 cm

John CONSTABLE
Weymouth Bay, with Jordan Hill
probably 1816

NG 2652
Oil on canvas, 53.3 x 74.9 cm

The unidentified sitter holds a rosary. She is depicted in front of a cloth and a window ledge on which are displayed an apple and a beaker of flowers. The beaker is of a type common in the Rhineland at the beginning of the sixteenth century.

The style of the clothes can be dated to about 1495. It has been suggested that the portrait may be part of a diptych or triptych, but as the sitter is not praying, NG 2670 is likely to be an early example of the independent portrait in the Rhineland.

Collection of Léon de Somzée (died 1901), Brussels; Salting Bequest, 1910.

Levey 1959, pp. 17–18; Zehnder 1977, p. 84, no. 29.

The dead birds include song thrushes, jays and a redstart. The dead game includes a hare, duck and partridge. The owl is a Little Owl which was commonly used as a decoy bird in hunting. The dogs are a type of spaniel.

De Coninck's stylistic development is unclear and so it is difficult to date his paintings with any precision. This picture is, however, similar to game scenes painted during his stay in Rome and so probably dates from the period of his residence in the city (about 1672–94). It has, in addition, an Italian provenance.

Bought from 'an Italian nobleman' by John Benjamin Smith, about 1850; presented by his son-in-law Sir Edwin Durning-Lawrence, Bt, 1902.

Martin 1970, pp. 17–18.

This is a view towards the west across Bowleaze Cove, which forms part of Weymouth Bay in Dorset. The small river Jordan can be seen running across the sands to the sea. Beyond are Furzy Cliff and Jordan Hill. By the wall at the right a shepherd and his flock are summarily sketched. The sand is indicated by the primed canvas which has not been painted over.

Constable married Maria Bicknell in St Martin-in-the-Fields, London, on 2 October 1816. The couple spent much of their honeymoon at a vicarage belonging to their friends the Fishers, at Osmington, near Weymouth. The painting is thought to date from this period.

Its freshness suggests that NG 2652 was painted in the open air. Constable executed other works of comparable subjects around this time: *Weymouth Bay (Bowleaze Cove)* (London, Victoria and Albert Museum), a smaller more rapidly executed sketch of a storm; and *Weymouth Bay* (Paris, Louvre), a larger work of a very similar view with darkened sky, probably exhibited by the artist at the British Institution in 1819.

Possibly the work sold by the artist's administrators, Foster's, 16 May 1838 (lot 41); Salting Bequest, 1910.

Davies 1946, pp. 33–4; Parris 1991, pp. 173–4.

David de CONINCK
about 1643/5–1699 or later

De Coninck was born in Antwerp but spent most of his career in Rome. He also worked in Paris and in 1699 was recorded in Brussels, where he died. He was a painter of animal and still-life pictures.

John CONSTABLE
1776–1837

Born in East Bergholt, Suffolk, Constable was largely self-taught and in 1799 entered the Royal Academy Schools. He first exhibited there in 1802, becoming RA in 1829. The artist was principally a landscape painter who notably depicted Suffolk, Hampstead and Salisbury.

John CONSTABLE
Stratford Mill
1818–23

NG 6510
Oil on canvas, 127 x 182.9 cm

John CONSTABLE
The Hay-Wain
1821

NG 1207
Oil on canvas, 130.2 x 185.4 cm

John CONSTABLE
Salisbury Cathedral and Archdeacon Fisher's House, from the River Avon, probably 1821

NG 2651
Oil on canvas, 52.7 x 76.8 cm

Stratford Mill at Stratford St Mary, about two miles from Flatford in Suffolk, is depicted at the left. The river Stour winds into the distance at the right. A barge slowly advances, while two men and young children fish. At the left a boy lets his horse drink. After 1840 the painting was known as 'The Young Waltonians' after the title of an engraving of it which referred to the *The Compleat Angler* by Izaak Walton.

The picture is the second of Constable's 'six-foot' Stour canvases (see also Constable NG 1207). It was exhibited at the Royal Academy in 1820, and subsequently reworked by the artist.

The composition was developed in three earlier sketches: an upright study of fishermen, *Anglers at Stratford Mill* (1811; Hart Collection); a free, small version of the composition of NG 6510, *Sketch for 'Stratford Mill'* (about 1819; private collection); and a full size preparation, *Sketch for 'Stratford Mill'* (about 1819; New Haven, Yale Center for British Art). Details such as the lilies and timber in the foreground are taken from Constable's sketchbook of 1813 (London, Victoria and Albert Museum).

Bought from Constable by John Fisher, 1821; presented to the National Gallery under the acceptance-in-lieu procedure, 1987.

National Gallery Report 1985–7, pp. 31–2; Parris 1991, pp. 201–2.

Signed and dated bottom right of centre: John Constable pinx^t. London 1821.

The river Stour winds through the Suffolk countryside near Flatford. At the left is a building known as Willy Lott's cottage, situated behind Flatford Mill. In the water is an empty horse-drawn cart (the hay-wain). In the distance men can be seen cutting hay.

Painted in 1821 and exhibited that year at the Royal Academy, this painting was the third of the artist's 'six-foot' Stour canvases (see also Constable NG 6510).

Willy Lott's cottage had been painted by Constable before, but this composition with its extension to the left of the cottage was worked up in two preparatory studies specific to it (New Haven, Yale Center for British Art, Paul Mellon Collection; London, Victoria and Albert Museum). In the foreground, left of centre, a horse and a barrel were suppressed in turn. In 1824 the painting was exhibited at the Paris Salon; it received far more attention than in England and was awarded a gold medal by Charles X.

Bought from Constable by John Arrowsmith, Paris, 1824; presented by Henry Vaughan, 1886

Davies 1959, pp. 12–15; Parris 1991, pp. 203–5.

This animated sketch shows a view across the river Avon towards Salisbury Cathedral, the spire of which can be seen rising above the trees. A rowing boat is tied up, and people promenade by the water. The white building at the right, partly hidden by trees, is the canonical house, Leydenhall, which Constable's friend Archdeacon John Fisher was granted as a residence for life in 1819. To the left are the grounds of King's House.

Constable travelled to Salisbury on a number of occasions to visit Archdeacon John Fisher. NG 2651 can probably be dated to the early 1820s, and may have originated when Constable and his family stayed with Fisher in July and August 1821.

The artist made a number of sketches of similar views of the cathedral; this one does not recur in his work, but such studies culminated in large finished paintings (see Constable L47, *Salisbury Cathedral from the Meadows*). The freedom of the handling suggests that it was painted out of doors.

Possibly the sketch (no. 294) lent to the Grosvenor Gallery by Isabel Constable, 1889; Salting Bequest, 1910.

Davies 1959, p. 20.

John CONSTABLE
The Cornfield
1826

John CONSTABLE
Salisbury Cathedral from the Meadows
1831

John CONSTABLE
The Cenotaph to Reynolds' Memory, Coleorton
probably 1833

NG 130
Oil on canvas, 142.9 x 121.9 cm

L47
Oil on canvas, 151.8 x 189.9 cm

NG 1272
Oil on canvas, 132.1 x 108.6 cm

Signed bottom right: John Constable. f. London. 1826.

This is probably a view of Fen Lane, which led through trees from Constable's birthplace, East Bergholt, to a cornfield and the village of Dedham in the distance. A boy drinks from the stream, while a donkey grazes and a sheepdog is distracted by a bird. In the middle distance a plough rests by the open gate, and men harvest in the fields.

NG 130 was exhibited at the Royal Academy in 1826. In 1827, with a view to selling it, Constable called the painting 'Landscape: Noon', attaching to it lines from Thomson's *Summer* : 'while now a fresher gale, sweeping with shadowy gusts the fields of corn...' The current title seems to have been first used by the subscribers who presented it to the Gallery.

Presented by subscribers, including Wordsworth, Faraday and Sir William Beechey, 1837.

Davies 1959, pp. 9–11; Parris 1991, pp. 301–5.

Salisbury Cathedral is seen from the north-west, with Long Bridge over the river Avon on the extreme right. Constable began making sketches for this composition in 1829, while staying with his friend Archdeacon Fisher at Salisbury, whose house in shown on the right, below the rainbow's end. Fisher nicknamed the composition 'The Church under a cloud', evidently alluding to his fears concerning church reform, but it is doubtful whether Constable himself intended any such symbolism. The rainbow, however, appears to have been introduced only at a late stage in planning the picture, in which the atmospheric effects are established with extensive use of the palette knife.

The painting was first exhibited by Constable at the Royal Academy in London in 1831. He worked on it again before it was exhibited in 1833 at the British Institution.

A full-size preparatory oil sketch for the composition survives (London, Guildhall Art Gallery).

The artist's administrators; bought by Samuel Ashton, 1850; and thence by descent; on loan from a private collection since 1983.

Parris 1991, pp. 365–7, no. 210.

Inscription on the cenotaph: REYNOLDS.

The cenotaph was erected in 1812 in the grounds of the home of Sir George Beaumont (see Hoppner NG 6333) in Leicestershire to honour Sir Joshua Reynolds, first president of the Royal Academy. It was inscribed with lines specially composed by Wordsworth in 1811. Busts of Michelangelo, on the left, and Raphael, on the right, artists whom Reynolds highly regarded, are included by Constable. The setting is an autumnal wooded glade; a startled stag turns before the monument.

Constable made a drawing of the cenotaph in 1823 (London, Victoria and Albert Museum). This formed the basis of the composition. In 1833 the artist wrote: 'I have laid by the *Cenotaph* for the present...' NG 1272 was exhibited at the Royal Academy in 1836.

Bequeathed by Miss Isabel Constable as the gift of Maria Louisa Isabel and Lionel Bicknell Constable, 1888.

Davies 1946, pp. 27–8; Parris 1976, pp. 186–8; Reynolds 1984, pp. 286–7.

Gonzales COQUES
Sight (Portrait of Robert van den Hoecke)
before 1661

Gonzales COQUES
Hearing
before 1661

Gonzales COQUES
Touch
before 1661

NG 1114
Oil on oak, 25.2 x 19.5 cm

NG 1115
Oil on oak, 25.1 x 19.4 cm

NG 1116
Oil on oak, 25.1 x 19.4 cm

Inscribed on the plan on the table: OSTENDE.
 Robert van den Hoecke (1622–68) was a painter and engraver who worked in Antwerp and Brussels. He became 'Contrôleur des fortifications' in Flanders, and the plan, baldric and sword presumably refer to this office. The identification of the sitter is dependent upon the inscription on an engraving of the portrait by Caukercken, which appeared in a book published in 1661. The artist represents Sight, one of the Five Senses. The other four (NG 1115, 1116, 1117 and 1118) form the rest of the series. *Taste* (NG 1118) is probably a copy after a lost original.
 The series can be dated on grounds of style to the second half of the 1650s. It must have been painted before 1661, when NG 1114 was engraved (see above).

Bought from Dr Decordes, Brussels, by the Vicomte Bernard Du Bus de Gisignies, 1857; bought at the Du Bus de Gisignies sale, Brussels, 1882.

Martin 1970, pp. 21–2.

The sitter may be the flower painter Jan Philip van Thielen (1618–77). He plays a lute and has a music score lying on the table beside him. He represents the sense of Hearing.
 NG 1115 is one of a series of the Five Senses by Coques in the Collection. For further discussion see NG 1114.

Bought from Dr Decordes, Brussels, by the Vicomte Bernard Du Bus de Gisignies, 1857; bought at the Du Bus de Gisignies sale, Brussels, 1882.

Martin 1970, p. 22.

The sitter is unidentified. He is shown letting blood from his arm. He is a personification of the sense of Touch.
 NG 1116 is one of a series of the Five Senses by Coques in the Collection. For further discussion see NG 1114.

Bought from Dr Decordes, Brussels, by the Vicomte Bernard Du Bus de Gisignies, 1857; bought at the Du Bus de Gisignies sale, Brussels, 1882.

Martin 1970, pp. 22–3.

Gonzales COQUES
1614/18–1684

Coques was born and worked in Antwerp. He was a portrait and figure painter who is recorded as a pupil of Pieter Bruegel the Younger and of David Rijckaert. He entered the Antwerp guild as a master in 1640/1, and enjoyed the patronage of the Spanish Regents of the Southern Netherlands and the House of Orange.

Gonzales COQUES
Smell (Portrait of Lucas Fayd'herbe)
before 1661

Gonzales COQUES
A Family Group
about 1664

Gonzales COQUES
Portrait of a Man
about 1670

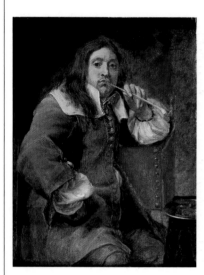

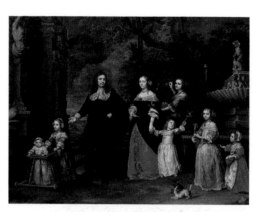

NG 821
Oil on canvas, 64.2 x 85.5 cm

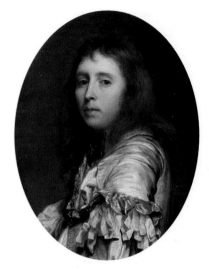

NG 1117
Oil on oak, 25.3 x 19.3 cm

NG 2527
Oil on copper, 16.1 x 12.2 cm

Lucas Fayd'herbe (1617–97) was a sculptor and architect; he was one of Rubens's last pupils. He worked principally in Malines, and is also depicted in Franchoijs NG 1012. Here he is shown smoking a pipe, as a representation of the sense of smell.

 NG 1117 is one of a series of the Five Senses by Coques which is in the Collection. For further discussion see NG 1114.

Bought from Dr Decordes, Brussels, by the Vicomte Bernard Du Bus de Gisignies, 1857; bought at the Du Bus de Gisignies sale, Brussels, 1882.

Martin 1970, pp. 23–4.

The identity of the family has not been established. The youngest child is being pushed along in a *loopstoel*. The girl on the right plays an instrument which is probably a cittern. The older girl picks roses; because they are the flowers of Venus, the goddess of Love, this action may be a reference to her forthcoming marriage.

 The landscape and trees in NG 821 are possibly by another artist. The work is dated by comparison of the costumes with those in Coques's *Verbiest Family* (London, Royal Collection), which is inscribed 1664.

Collection of Mr Mettepenning, Antwerp, from whom bought by C.J. Nieuwenhuys, 1826; bought with the Peel collection, 1871.

Martin 1970, p. 19; Brown 1987, p. 108.

The identity of the sitter has not been established.
 His costume can be dated to the period around 1670.

Probably J. Lumsden Propert (died by 1902) collection; Salting Bequest, 1910.

Martin 1970, pp. 24–5.

Gonzales COQUES
Portrait of a Woman as Saint Agnes
about 1680

Imitator of COQUES
Portrait of a Woman
about 1650

After COQUES
Taste
after 1661

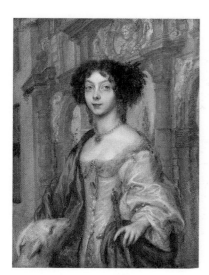

NG 1011
Oil on silver, 18.3 x 14.4 cm

NG 6160
Oil on oak, 20.1 x 16.7 cm

NG 1118
Oil on oak, 25.3 x 19.4 cm

The unidentified sitter is presented in the guise of Saint Agnes, with her attributes the lamb and sword. This may be a reference to her Christian name, or possibly to the fact that she was about to be married. The portico in the background resembles the one that Rubens designed for his Antwerp home. It is possible that the sitter was a member of a family who later inhabited the property, such as the Hillewerves.

The costume can be dated to about 1680. If it is Rubens's property in the background, then the work must pre-date a print of the building of 1684 which includes additions not in the painting.

Dr Thomas Newton (1704–82), Lord Bishop of Bristol, sale, London, 1788; collection of Lord Northwick by 1858; Wynn Ellis Bequest, 1876.

Martin 1970, pp. 19–21; Brown 1987, p. 110.

The costume and hairstyle of the unidentified subject seem to date from about 1650.

NG 6160 has in the past been attributed to Coques, but it is now recognised as a work of an imitator.

Bequeathed by Mrs Elizabeth Carstairs, 1952.

Martin 1970, pp. 25–6.

The sitter is not identified. He is shown drinking and eating as a representation of the sense of taste.

NG 1118 is probably a copy after a lost original which was one of a series of the Five Senses by Coques. For further discussion of the other works in the series see NG 1114.

Bought from Dr Decordes, Brussels, by the Vicomte Bernard Du Bus de Gisignies, 1857; bought at the Du Bus de Gisignies sale, Brussels, 1882.

Martin 1970, p. 25.

Attributed to CORNEILLE de Lyon
Portrait of a Man
1534–74

Attributed to CORNEILLE de Lyon
Bust Portrait of a Man
1534–74

Attributed to CORNEILLE de Lyon
Portrait of a Man
1534–74

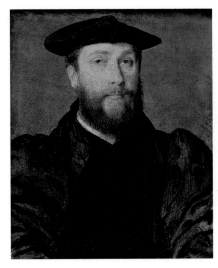

NG 2610
Oil on wood, painted surface 19.1 x 15.6 cm

The bearded sitter, who holds a paper in his left hand, has not been identified.
 NG 2610 has been attributed to Corneille de Lyon, and probably dates from the middle of the sixteenth century.

Wildenstein collection by 1907; Salting Bequest, 1910.

Davies 1957, pp. 50–1.

NG 2611
Oil on oak, painted surface 16.5 x 13.7 cm

The sitter has not been identified.
 NG 2611 has been attributed to Corneille de Lyon, and probably dates from the middle of the sixteenth century.

Collection of George Salting, 1903; Salting Bequest, 1910.

Davies 1957, p. 51.

NG 6415
Oil on wood, painted surface 16.4 x 14.1 cm

The sitter, who might be an ecclesiastic, has not been identified.
 NG 6415 may have been made in preparation for a more finished version of the same size (private collection). It was probably painted in the mid-sixteenth century.

Presented by the Misses Rachel F. and Jean I. Alexander; entered the Collection in 1972.

National Gallery Report 1971–2, pp. 38–9.

CORNEILLE de Lyon
about 1500/15–about 1574

Corneille was a native of The Hague but was recorded in Lyon from 1534 and naturalised as French in 1547; he was Painter to the King under Henry II and Charles IX. He painted small portraits which were often imitated, creating problems in establishing which pictures are autograph.

Attributed to CORNEILLE de Lyon
Portrait of a Woman
probably about 1550

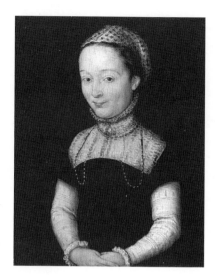

NG 2616
Oil on wood, painted surface 20.3 x 16.5 cm

The woman has not been identified.

NG 2616 has been attributed to Corneille de Lyon, and probably dates (on the basis of the sitter's costume) from about 1550.

Collection of George Salting by 1900; Salting Bequest, 1910.

Davies 1957, p. 51.

CORNELIS van Haarlem
Two Followers of Cadmus devoured by a Dragon
1588

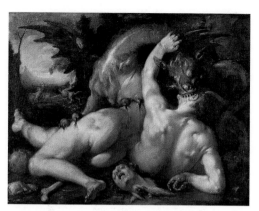

NG 1893
Oil on canvas stuck on oak, 148.5 x 195.5 cm

Signed and dated on a stone, bottom right: Cor Corneli... fecit Ao 1588.

Cadmus was ordered by the Delphic oracle to follow a cow and build a town where it sank from exhaustion. The cow stopped on the future site of Thebes, and Cadmus, intending to sacrifice it, sent men for water to the neighbouring well of Ares. They were killed by the guardian of the well, a dragon who was the son of Ares. Cadmus then killed the dragon and on the advice of Athena sowed its teeth into the ground, from which sprang up armed men who slew each other, with the exception of five who became the ancestors of the Thebans. The subject comes from Ovid's *Metamorphoses* (III, 1–151). In the foreground are the dismembered corpses of Cadmus's followers; while in the left background he is depicted attacking the dragon.

NG 1893 corresponds almost exactly (but in reverse) with a composition engraved in 1588 by Hendrick Goltzius. Recent cleaning revealed the remains of the signature and date. Van Mander in his account of the artist's life described a work by Cornelis as an 'oblong Serpent-biting [*serpent-bijtinghe langwerpigh*]', which may be NG 1893.

Perhaps in the collection of Jacob Rauwart, Amsterdam, in 1588 and sold from the estate of Claus Rauwart, Amsterdam, 1612; collection of the Earl of Northumberland at Syon House by 1671; presented by the Duke of Northumberland, 1838.

MacLaren/Brown 1991, pp. 83–5.

CORNELIS van Haarlem
The Preaching of Saint John the Baptist
1602

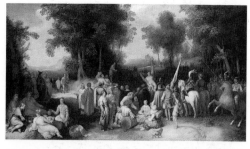

NG 6443
Oil on canvas, 100 x 180 cm

Signed and dated lower right: CvH 1602 (CvH in monogram).

Saint John the Baptist preached in the Jordan valley to large crowds from Jerusalem and the surrounding countryside. New Testament (all Gospels e.g. Matthew 3: 1–12). John is the small figure in the middle background. It is thought that the group of standing figures at the left wearing robes may be intended for Judaeans and that the seated group in the left foreground are those who remain deaf to God's word. The robed standing figures to the right may be the Pharisees and Sadducees mentioned in Saint Matthew's account. The soldiers at the left are mentioned by Saint Luke.

Anon. sale at Phillips, Son and Neale, 14 March 1977 (lot 81); sold to Edward Speelman Ltd; bought from Speelman, 1978.

MacLaren/Brown 1991, pp. 85–6.

CORNELIS van Haarlem
1562–1638

Cornelis Cornelisz., who was a leading Dutch Mannerist, was born in Haarlem. Carel van Mander says that he studied there with Pieter Pietersz. and then travelled to Rouen and Antwerp where he was a pupil of Gillis Congnet. He had returned to Haarlem by 1581, and received a number of important commissions for municipal group portraits. He also executed religious and mythological pictures, and made designs for prints.

Jean-Baptiste-Camille COROT
The Roman Campagna, with the Claudian Aqueduct, probably 1826

NG 3285
Oil on paper, laid down on canvas, 21.6 x 33 cm

Jean-Baptiste-Camille COROT
The Seine near Rouen
probably 1830–5

NG 4181
Oil on canvas, 20.3 x 34.3 cm

Jean-Baptiste-Camille COROT
Avignon from the West
probably 1836

NG 3237
Oil on canvas, 33.7 x 73 cm

Signed: COROT.
This view is from near the Via Appia Nuova, in the countryside south-east of Rome. The arched structures to the left and right are the Claudian Aqueduct; in the centre of the composition a medieval tower stands next to the Papal Aqueduct, the Aqua Felice.
NG 3285 dates from Corot's first visit to Italy (1825–8), and probably from the spring of 1826. During this period, Corot went on several sketching expeditions and produced a great many rapid oil studies of the Campagna and other areas around Rome.

Collection of Comte Armand Doria by 1896; bought by Degas, 1899; bought at the Degas sales (with a special grant), 1918.

Robaut 1905, II, p. 38, no. 98 bis; Davies 1970, pp. 32–3; Clarke 1991, pp. 15–20; Galassi 1991, pp. 170–2.

Stamp of the Corot studio sale: Vente Corot.
Traditionally described as a view of the Seine near Rouen, the site of NG 4181 has not been securely identified.
NG 4181 was probably painted in about 1830–5, a period when Corot travelled widely in France.

Bought by Martin at the Corot studio sale, 1875; presented by the NACF, 1926.

Robaut 1905, II, p. 120, no. 337; Davies 1970, pp. 33–4.

Signed: COROT.
The Papal Palace is prominent in the middle distance and the Cathedral of Notre-Dame des Doms can be seen left of centre.
Corot painted several views of Avignon when he visited the area in the summer of 1836. Corot frequently painted panoramic views of distant towns, using a soft, broken touch to capture subtle shifts of tone and colour.

Collection of E. May by 1890; collection of Sir Hugh Lane by 1905; Lane Bequest, 1917.

Robaut 1905, II, p. 116, no. 328; Davies 1970, pp. 30–2.

Jean-Baptiste-Camille COROT
1796–1875

One of the most successful and versatile nineteenth-century landscape painters, Corot was a pupil of Achille-Etna Michallon and Jean-Victor Bertin. He was in Italy from 1825 to 1828, and again in 1834 and 1843. He painted in many areas of France and was frequently in the region of Fontainebleau where he associated with the Barbizon School painters. He also visited Switzerland, Holland and England.

Jean-Baptiste-Camille COROT
Peasants under the Trees at Dawn
about 1840–5

NG 6439
Oil on canvas, 28.2 x 39.7 cm

Signed bottom right: COROT
NG 6439 probably depicts a site in the Morvan, west of Dijon (in Burgundy).
Corot's family originated in the Morvan and NG 6439 is one of several pictures that date from his visits to the region in the early 1840s.

Collection of William Wyld by 1890 (originally a gift from the artist); bought, 1977.

Robaut 1905, II, p. 154, no. 431; National Gallery Report 1975–7, pp. 38–9; Clarke/Leighton 1991, p. 56.

Jean-Baptiste-Camille COROT
Monsieur Pivot on Horseback
about 1850–5

NG 3816
Oil on canvas, 39.1 x 29.8 cm

Signed: COROT
Monsieur Pivot was a neighbour of Corot's at Ville-d'Avray, south-west of Paris. He died in 1856.
There is a tradition that NG 3816 was painted during a chance encounter in the woods near Corot's home. It is Corot's only equestrian portrait.

By descent from the Pivot family until bought by Tudor-Hart; from whom bought, 1923.

Robaut 1905, II, p. 228, no. 665; Davies 1970, p. 33; Clarke/Leighton 1991, p. 58.

Jean-Baptiste-Camille COROT
Dardagny, Morning
1853

NG 6339
Oil on canvas, 26 x 47 cm

Traces of a signature lower left.
Dardagny is a small town in Switzerland (about ten miles west of Geneva).
Corot visited Dardagny with Charles Daubigny in 1852 and 1853. They stayed with their mutual friend, the painter Armand Leleux (1818/20–85), and went sketching together in the nearby countryside.

Collection of Emile Duhousset by 1905; presented by William Edward Brandt, Henry Augustus Brandt, Walter Augustus Brandt and Alice Mary Bleecker in memory of Rudolph Ernst Brandt, 1963.

Robaut 1905, II, p. 242, no. 720; Davies 1970, p. 34.

Jean-Baptiste-Camille COROT
The Leaning Tree Trunk
about 1855–60

Jean-Baptiste-Camille COROT
Summer Morning
about 1855–60

Jean-Baptiste-Camille COROT
Sketch of a Woman in Bridal Dress
1855–65

NG 3238
Oil on wood, possibly mahogany, painted surface
22.9 x 34.3 cm

NG 2625
Oil (identified) on canvas, 50.2 x 61 cm

NG 4733
Oil on canvas, 36.2 x 27 cm

Signed bottom right: COROT

This picture was included in the memorial exhibition of Corot's works at the Ecole des Beaux-Arts, Paris, in the year of his death, 1875.

In the 1850s and 1860s Corot became well known for his idealised, wooded landscapes with soft forms and muted colours. The landscapes were painted in the studio and he often described them as *souvenirs* (memories). The settings and the costumes of the figures recall the opera – one of Corot's greatest passions.

Duparc collection by 1875; collection of George Salting, 1906; Salting Bequest, 1910.

Robaut 1905, II, p. 362, no. 1121; Davies 1970, pp. 27–8.

Signed: COROT

The general theme of this picture was repeated in countless variations by Corot in his later years. It is a good example of how, for Corot, the evocation of mood eventually became more important than the specific nature of a particular location.

F. Gérard collection by 1880; James Staats Forbes by 1904; Lane Bequest, 1917; on loan to the Hugh Lane Municipal Gallery of Modern Art, Dublin, since 1979.

Robaut 1905, II, p. 280, no. 876; Davies 1970, p. 32.

Stamp of the Corot studio sale: Vente / Corot

The woman in this painting is traditionally described as a bride. Corot painted numerous studies of women in traditional costumes.

NG 4733 was probably painted late in Corot's career, perhaps 1855–65. He painted many figure studies, but rarely exhibited them in public.

The oval edge is perhaps intended to suggest the frame of a mirror.

Bought at the Corot studio sale by Henri Rouart, 1875; bought, 1934.

Robaut 1905, III, p. 50, no. 1384; Davies 1970, p. 34; McConkey 1989, p. 151; Clarke 1991a, p. 104.

Jean-Baptiste-Camille COROT
Cows in a Marshy Landscape
probably 1860–70

NG 2630
Oil on canvas, 24.1 x 34.9 cm

Jean-Baptiste-Camille COROT
The Wood Gatherer
perhaps 1865–70

NG 2626
Oil on canvas, 45.7 x 64.1 cm

Jean-Baptiste-Camille COROT
A Flood
probably 1870–5

NG 2629
Oil on canvas, 54 x 65.1 cm

Signed: COROT.
 Corot painted numerous variations of this generalised, pastoral theme in the 1860s.

Possibly collection of Alexander Young by 1908; Salting Bequest, 1910.

Robaut 1905, III, p. 232, no. 1978; Davies 1970, pp. 29–30.

Signed: COROT
 The view through a screen of trees to a distant town or castle(?) is one of Corot's standard compositions in his later years.
 NG 2626, which is a late work, was apparently exhibited in 1871.

Collection of Alexander Young before 1907, when sold by Agnew to George Salting; Salting Bequest, 1910.

Davies 1970, p. 28.

Signed: (?) COROT.
 First described by Robaut as Le Cap Boisé.
 NG 2629, which may be unfinished, probably dates from the early 1870s.

Apparently in the Guillot collection by 1893; Salting Bequest, 1910.

Robaut 1905, III, p. 338, no. 2221; Davies 1970, p. 29.

Jean-Baptiste-Camille COROT
The Marsh at Arleux
1871

Jean-Baptiste-Camille COROT
A Wagon in the Plains of Artois
1871

Jean-Baptiste-Camille COROT
The Oak in the Valley
1871

NG 2135
Oil on canvas, 27.9 x 57.2 cm

NG 2628
Oil on canvas, 27.3 x 35.2 cm

NG 6466
Oil on canvas, 40 x 53 cm

Stamp of the Corot studio sale: Vente Corot

The village of Arleux is between Cambrai and Douai in north-east France.

This sketch dates from April – July 1871. In April 1871 Corot moved away from Paris and the upheaval of the Commune to stay with his friend and biographer Alfred Robaut in Douai. Corot described his particular fascination with the marshes around Arleux. Four other pictures that he started on this trip to the Artois are in the National Gallery: NG 2628, 6466, 6467 and 6531.

The fence in the foreground appears to have been scratched in the wet paint with the end of a brush.

Bought by Fantin-Latour at the Corot studio sale, 1875; bequeathed by Mrs Edwin Edwards, 1907.

Robaut 1905, III, p. 252, no. 2024; Davies 1970, p. 27.

Signed: COROT

Corot painted numerous views around Douai in the Artois region of north-east France.

According to his biographer Alfred Robaut, Corot painted NG 2628 at Douai in May 1871. Corot stayed with Robaut between April and July 1871. Four other pictures that Corot started on this trip to the Artois are in the National Gallery: NG 2135, 6466, 6467 and 6531.

Détrimont collection by 1878; Salting Bequest, 1910.

Robaut 1905, III, p. 344, no. 2254; Davies 1970, p. 29.

Signed bottom left: COROT

Corot painted numerous landscapes around Douai in the Artois region of north-east France.

NG 6466 was painted in May 1871 when Corot was a guest of Alfred Robaut at Douai. Four other pictures that were started on this trip to the Artois are in the National Gallery: NG 2135, 2628, 6467 and 6531.

Bought from Corot by Monsieur Cléophas; presented by Mrs Alice Bleecker, 1981.

Robaut 1905, III, p. 338, no. 2223; National Gallery Report 1980–1, pp. 40–1.

Jean-Baptiste-Camille COROT
Souvenir of Palluel
1871

Jean-Baptiste-Camille COROT
Landscape at Arleux-du-Nord
1871–4

Jean-Baptiste-Camille COROT
Evening on the Lake
about 1872

NG 6467
Oil on canvas, 27 x 35 cm

NG 6531
Oil on canvas, 48 x 59 cm

NG 2627
Oil on canvas, 25.1 x 36.2 cm

Signed bottom right: COROT
 NG 6467 was based on a sketch by Robaut, and is a close copy except for the cottage, which was a detail added by Corot. It is a view of the marshy landscape around Douai in the north-east of France.
 The picture was painted in May 1871 when Corot was Robaut's guest at Douai. Four other pictures that Corot started on this trip to the Artois are in the National Gallery: NG 2135, 2628, 6466 and 6531.

Offered by Corot to Monsieur Préault; presented by Mrs Alice Bleecker, 1981.

Robaut 1905, III, p. 252, no. 2023; National Gallery Report 1980–1, pp. 42–3.

Signed lower right: Corot
 Corot painted numerous views around the village of Arleux, near Douai in the Artois region of north-east France.
 NG 6531 is a late work dating from the early 1870s. According to Robaut, NG 6531 was started at Arleux in July 1871 and was finished in his Paris studio in November 1874.
 Four other pictures that Corot started on this trip to the Artois are in the National Gallery: NG 2135, 2628, 6466 and 6467.

Collection of Alfred Robaut, Paris, by 1905; bought by Kenneth Levy, 1936; bequeathed by Helena and Kenneth Levy, 1990.

Robaut 1905, III, p. 252, no. 2017; National Gallery Report 1990–1, p. 21.

Signed: COROT
 The subject is typical of Corot's late work and the style is consistent with the date of around 1872, as suggested by Robaut.

Collection of Lord Leighton by 1896; Salting Bequest, 1910.

Robaut 1905, III, p. 342, no. 2248; Davies 1970, p. 28.

Jean-Baptiste-Camille COROT
Souvenir of a Journey to Coubron
1873

Jean-Baptiste-Camille COROT
The Wagon ('Souvenir of Saintry')
1874

Follower of COROT
A Peasant Woman
probably after 1860

NG 2631
Oil on canvas, 32.4 x 46 cm

NG 6340
Oil on canvas, 47 x 56.8 cm

NG 3239
Oil on canvas, 31.8 x 29.2 cm

Signed: COROT
 Once called 'The Fisherman's Hut', NG 2631 was identified by Robaut as a view of Coubron (close to Paris, on the east, near Le Raincy). According to Robaut it was based on a sketch made early in 1873 at Coubron. In May of that year Corot painted this picture in his studio at Ville-d'Avray.

Sold by Corot to Grédelue; Salting Bequest, 1910.

Robaut 1905, III, p. 354, no. 2306; Davies 1970, p. 30.

Signed and dated: COROT 1874
 Saintry, near Corbeil, is about twenty miles south-east of Paris.
 Corot often described his pictures as *souvenirs* ('memories') to distinguish them from pictures painted directly from nature.

Vagliano collection by 1913; presented by William Edward Brandt, Henry Augustus Brandt, Walter Augustus Brandt and Alice Mary Bleecker in memory of Rudolph Ernst Brandt, 1963.

Robaut 1905, III, p. 232, no. 1976; Davies 1970, pp. 34–5.

Signed, probably falsely: COROT
 The picture, which is not included in the *catalogue raisonné* by Robaut, is unlikely to be by Corot. It is perhaps a pastiche of a type of figure subject painted by Corot in the 1850s and 1860s.

Sir Hugh Lane Bequest, 1917; on loan to the Hugh Lane Municipal Gallery of Modern Art, Dublin, since 1979.

Davies 1970, p. 35.

Follower of COROT
Seascape with Figures on Cliffs
probably 1865–75

NG 6416
Oil on canvas, cut all round, 21.6 x 36.8 cm

Previously known as 'View over the Mediterranean', the site depicted in NG 6416 has not been positively identified.

It is perhaps a view on the north coast of France, probably painted by a follower of Corot. The costumes of the figures might suggest a date in the late 1860s or early 1870s.

Collection of W.C. Alexander; presented by the Misses Rachel F. and Jean I. Alexander; entered the Collection in 1972.

National Gallery Report 1971–2, p. 39.

CORREGGIO
Christ taking Leave of his Mother
probably before 1514

NG 4255
Oil (identified) on canvas, 86.7 x 76.5 cm

The subject, which does not figure in any of the Gospels, is rare in Italian Renaissance painting, though common at this time in German painting (see Altdorfer NG 6463) and engraving. Saint John stands behind Christ, while the Virgin is supported by a figure probably representing one of the Three Maries.

NG 4255 is an early work and was probably painted before 1514.

X-radiographs reveal an earlier version of the composition; originally Christ was to be shown standing and another holy woman was to be included. The artist then inverted the canvas before starting again with the present design.

Probably in the Rossi collection, Milan, by 1786 (and apparently in the collection of Signor D. Antonio Rossi, Milan, by 1821); bought in about 1882 by Charles Fairfax Murray who sold the picture to R.H. Benson; bought from Benson by Sir Joseph (later Lord) Duveen, by whom presented 1927.

Gould 1975, pp. 68–9; Gould 1976, pp. 35, 222–3; Emiliani 1986, p. 96.

CORREGGIO
Head of an Angel
probably about 1522

NG 3920
Fresco, maximum dimensions 35.6 x 35.6 cm

NG 3920 is a fragment that survives from Correggio's *Coronation of the Virgin*, painted in the apse of the church of S. Giovanni Evangelista at Parma. Judging by a copy, NG 3920 was the head of the angel reclining at the feet of Saint John the Evangelist. See also NG 3921 and 4067.

The Coronation of the Virgin, which was part of a scheme of decoration completed between 1520 and 1524, was probably painted in 1522. It was destroyed in about 1586 (when the choir was enlarged) and the remaining fragments (including NG 3920, 3921 and 4067) are now in various collections (e.g. Parma, Galleria Nazionale; Boston, Museum of Fine Arts). The whole composition is also known from copies.

Removed from the apse of the church of S. Giovanni Evangelista, Parma, in about 1586; probably recorded in the Palazzo Rondanini, Rome, from 1760; in the collection of Lord Ward by 1854; bought by J.P. Richter for Ludwig Mond, 1892; Mond Bequest, 1924.

Gould 1975, pp. 67–8; Gould 1976, pp. 60–6, 246–7.

CORREGGIO
about 1494; died 1534

Antonio Allegri (known as Correggio from his birthplace) was active mainly in Correggio and Parma, painting frescoes, altarpieces, devotional works, also allegories and mythologies for the Gonzagas. He was influenced in different ways by Mantegna, Costa, Leonardo and Raphael, but was one of the most original and innovative artists of his day and exerted a profound influence on the later development of Italian painting.

CORREGGIO
Heads of Two Angels
probably about 1522

CORREGGIO
Head of an Angel
probably about 1522

CORREGGIO
The Madonna of the Basket
about 1524

NG 3921
Fresco, maximum dimensions 44.5 x 61 cm

NG 4067
Fresco, 36.9 x 33 cm

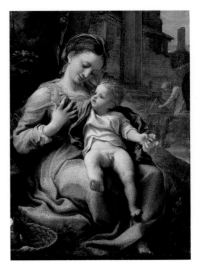

NG 23
Oil on wood, 33.7 x 25.1 cm

NG 3921 is a fragment that survives from Correggio's *Coronation of the Virgin*, painted in the apse of the church of S. Giovanni Evangelista at Parma. Judging by a copy, NG 3921 shows the heads of the two angels behind, and to the viewer's left, of Saint John the Evangelist.

For further information on NG 3921 see under NG 3920.

Removed from the apse of the church of S. Giovanni Evangelista, Parma, in about 1586; probably recorded in the Palazzo Rondanini, Rome, from 1760; in the collection of Lord Ward by 1854; bought by J.P. Richter for Ludwig Mond, 1892; Mond Bequest, 1924.

Gould 1975, pp. 67–8; Gould 1976, pp. 60–6, 246–7.

NG 4067 is a fragment that survives from Correggio's *Coronation of the Virgin*, painted in the apse of the church of S. Giovanni Evangelista at Parma. Judging by Cesare Aretusi's copy, NG 4067 was the head of the angel who held the crozier on the left of the Virgin.

For further information on NG 4067 see under NG 3920.

Removed from the apse of the church of S. Giovanni Evangelista, Parma, in about 1586; probably recorded in the Palazzo Rondanini, Rome, from 1760; bought by G. Croker Fox from the Marchese O.P. del Bufalo, Rome, about 1841; bought from Captain Croker Fox by Sir Robert Witt, 1925; by whom presented, 1925.

Gould 1975, pp. 67–8; Byam Shaw 1976, p. 274, no. 1066; Gould 1976, pp. 60–6, 246–7.

The subject is an unusual one of the Virgin dressing the Christ Child; it is described by Vasari. The jacket into which the Child has put one arm has been made by the Virgin: wool of the same colour is in the basket beside her. Saint Joseph is busy with his carpentry in the background. The outstretching of Christ's arms may be taken to foreshadow his Crucifixion.

NG 23 has been dated to about 1524 on the strength of stylistic comparisons with the *Pietà* (Parma, Galleria Nazionale).

A number of copies are known. NG 23 has always been accepted as the original of the design.

Described in 1568 as in the collection of Cavaliere Boiardo in Parma (and probably identifiable with a picture listed in the Baiardi inventory of about 1561); Spanish royal collections by 1666; brought to Britain by William Buchanan, 1813; subsequently in the Nieuwenhuys collection; from where bought, 1825.

Gould 1975, pp. 63–6; Gould 1976, pp. 219–22.

CORREGGIO

Venus with Mercury and Cupid ('The School of Love'), about 1525

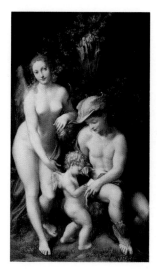

NG 10
Oil (identified) on canvas, 155.6 x 91.4 cm

NG 10 has been known as 'The School of Love' since the eighteenth century. The exact meaning of the picture has not been established; it is unusual for Venus to be shown with wings. Mercury is associated with calculation (and hence elementary education).

A drawing for the figure of Cupid (London, British Museum) has a study for the *Agony in the Garden* (London, Apsley House – see After Correggio NG 76) on its verso. Both compositions probably date from the mid-1520s. NG 10 is related to Correggio's *Venus, Cupid and a Satyr ('Antiope')* (Paris, Louvre) which also comes from the Gonzaga collection, is of a similar format, and is at once mythological and allegorical. However, it seems to be of a later date and the nature of the relationship between the two pictures has not been conclusively established.

NG 10 was cut down at an early date (before the measurements recorded in van der Doort's inventory of 1639). Several copies and an engraving were made after the picture.

Recorded in the Gonzaga collection, Mantua, 1627; bought for King Charles I in 1628 and recorded in van der Doort's inventory of 1639; bought in London about 1653–4 on behalf of the Code-Duque de Olivares; in the collection of the Duke of Alba by about 1770; subsequently in the collection of Emmanuel Godoy; brought to Britain by Baron Stewart (later 3rd Marquess of Londonderry) about 1822–3; bought from the 3rd Marquess of Londonderry, 1834.

Gould 1975, pp. 57–61; Gould 1976, pp. 213–16.

CORREGGIO

Christ presented to the People (Ecce Homo) probably about 1525–30

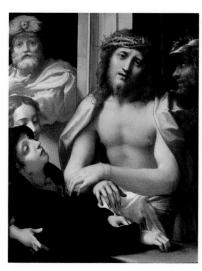

NG 15
Oil on poplar, 99.7 x 80 cm

'Ecce Homo' (Behold the Man) were the words used by Pilate when he presented Christ to the people before the Crucifixion. New Testament (John 19: 2–5). The turbaned figure of Pilate points to Jesus, while in the foreground, the Virgin Mary, supported by a companion, faints. The Virgin is not mentioned as present in the Gospels and is not usually represented in this scene.

NG 15 was probably painted in Parma in the late 1520s.

X-radiographs reveal a number of revisions made by the artist; particularly around the Virgin's face. NG 15 was engraved by Agostino Carracci in 1587, and numerous copies of the painting (including NG 96) are known. That NG 15 is the original version is demonstrated by the changes visible in the X-radiographs.

Probably the picture engraved by Agostino Carracci in the Prati collection, Parma, in 1587; recorded in the Colonna Gallery, Rome, in 1783; from where bought by Alexander Day before 1802 when he sold the picture to Ferdinand IV of Naples; bought from the 3rd Marquess of Londonderry, 1834.

Gould 1975, pp. 61–3; Gould 1976, pp. 216–19.

Attributed to CORREGGIO

The Magdalen perhaps about 1518–19

NG 2512
Oil on canvas, painted area 38.1 x 30.5 cm

The Magdalen holds the pot of ointment with which she anointed Christ's body. She is shown in penitential retreat in the wilderness.

Other versions of this composition are known but NG 2512 appears to be the best and a pentimento has been considered as evidence for its autograph status. But many scholars regard it as a copy.

Apparently in the Ravaisson-Mollien sale, Paris, 1903; in the collection of George Salting by 1907; Salting Bequest, 1910.

Gould 1975, pp. 66–7; Gould 1976, pp. 59, 222.

After CORREGGIO

Christ presented to the People (Ecce Homo)

16th century

NG 96
Oil on canvas, 100.3 x 78.7 cm

'Ecce Homo' (Behold the Man) were Pilate's words to the people when he presented Christ to them before the Crucifixion. New Testament (John 19: 2–5). The turbaned figure of Pilate points to Jesus, while in the foreground, the Virgin Mary faints. Her inclusion (together with a holy woman) is not related in the Gospels.

NG 96 is a copy of the Correggio NG 15. Numerous copies of Correggio's original version are known.

Possibly in the collection of Robert Udny by 1804; bequeathed (as by Ludovico Carracci) by the Revd William Holwell Carr, 1831.

Gould 1975, p. 71; Gould 1976, p. 217.

After CORREGGIO

Group of Heads

before 1587

NG 7
Oil on canvas, 137.2 x 107.3 cm

NG 7 is a copy after a group of angels in Correggio's *Coronation of the Virgin*, painted in the apse of the church of S. Giovanni Evangelista at Parma.

The *Coronation of the Virgin* was probably painted in 1522, and was destroyed in about 1586 (when the choir of S. Giovanni Evangelista was enlarged). A number of fragments (including NG 3920, 3921 and 4067) survive, and several copies are known. Among the artists known to have copied Correggio's frescoes in Parma was Annibale Carracci. NG 7 – and NG 37 – have sometimes been supposed to be Annibale's copies, but there is no evidence to support this.

In the collection of Queen Christina of Sweden, and subsequently (by 1727) in the collection of the Duc d'Orléans; bought with the J.J. Angerstein collection, 1824.

Gould 1975, pp. 70–1.

After CORREGGIO

Group of Heads

before 1587

NG 37
Oil on canvas, 137.2 x 106 cm

NG 37 is a copy after a group of angels in Correggio's destroyed *Coronation of the Virgin* (destroyed in about 1586), painted in the apse of the church of S. Giovanni Evangelista at Parma.

For further information see under NG 7.

In the collection of Queen Christina of Sweden, and subsequently (by 1727) in the collection of the Duc d'Orléans; bought with the J.J. Angerstein collection, 1824.

Gould 1975, pp. 70–1.

After CORREGGIO
The Agony in the Garden
probably about 1640–1750

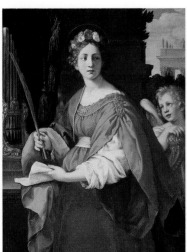

NG 76
Oil on poplar, 38.1 x 41.9 cm

An angel appears to Jesus as he prays in the Garden of Gethsemane, near Jerusalem. New Testament (Mark 14: 32–42). Three of his disciples sleep in the right background.

NG 76 is a copy of Correggio's *Agony in the Garden* (London, Apsley House). It records the modifications made to that composition after its damage by fire in the late sixteenth century.

Purchased by J.J. Angerstein on the advice of Benjamin West and Thomas Lawrence, 1802; bought with the J.J. Angerstein collection, 1824.

Gould 1975, p. 71; Gould 1976, pp. 212–13.

Pietro da CORTONA
Saint Cecilia
1620–5

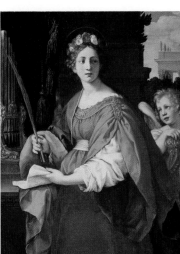

NG 5284
Oil (identified) on canvas, 143.5 x 108.9 cm

Saint Cecilia was an early Christian martyr and holds the palm of martyrdom. She is also the patron saint of music and the portable organ seen on the left is her attribute. The angel on the right holds a harp.

NG 5284 was formerly attributed to Domenichino and has more recently been described as a work of the Roman School. It is, however, an original work by Cortona dating from the first half of the 1620s.

As from the Pallavicini collection, in the Robert Udny sale, London, 19 May 1804 (lot 98); bought at the Miss E. Talbot sale, Margam Castle, 29 October 1941.

Bellosi 1970, pp. 74–6; Schleier 1970, pp. 752–9; Levey 1971, pp. 198–9; Briganti 1982, pp. 345–6.

Francesco del COSSA
Saint Vincent Ferrer
probably about 1473–5

NG 597
Egg (identified) on poplar, painted surface 153.7 x 59.7 cm

Some isolated letters on the book held by Saint Vincent can be deciphered, but they do not read as a complete inscription.

Saint Vincent Ferrer (about 1350–1419; canonised in 1455) was one of the great preachers of the fifteenth century. He is depicted in Dominican robes and holding the Gospels. Above, Christ appears in a mandorla, and is flanked by angels holding instruments of his Passion (a sponge of vinegar on a pole, the cross, spear, column, nails, and scourges).

NG 597 was originally the central panel of an altarpiece in the chapel dedicated to Saint Vincent Ferrer, in S. Petronio, Bologna. Saint Peter and Saint John the Baptist were shown to either side (now Milan, Brera), and in panels above there were images of Saint Florian, Saint Lucy and the Crucifixion (now Washington, National Gallery of Art). Twelve small panels of saints were incorporated into the flanking pilasters, and the Annunciation was shown in two small roundels. Episodes from the life of Saint Vincent were represented in the predella (now Rome, Vatican Museums; see also NG 597.1). This altarpiece, the appearance of which is recorded in a drawing of 1725, was commissioned by Floriano Griffoni.

Last reliably recorded in the Griffoni chapel, S. Petronio, Bologna, 1686 (Malvasia); subsequently in the Aldovrandi and Costabili collections; bought from the Costabili collection at Ferrara, 1858.

Davies 1961, pp. 149–53; Torella 1989, pp. 43–60; Dunkerton 1991, pp. 61, 302–5, 400; Torella 1991, pp. 39–46.

Pietro da CORTONA
1596–1669

Pietro Berrettini was called after his native town of Cortona in Tuscany. He was trained by Andrea Commodi and in 1612 he moved to Rome. He painted frescoes, altarpieces, secular paintings and portraits. From 1633 to 1639 he executed one of the most splendid and influential decorative schemes in Rome, the Barberini Palace ceiling. He painted frescoes in the Pitti Palace in Florence (1637–8 and 1640–7) and was active as an architect.

Francesco del COSSA
about 1435/6–about 1477/8

Cossa was first recorded in Ferrara in 1456 and again in 1470. His most famous works there are frescoes in the Palazzo Schifanoia. He settled in Bologna from about 1472 and painted altarpieces and frescoes there as well as designing stained glass. He was apparently influenced by Mantegna and by other followers of Squarcione, and by Piero della Francesca.

After COSSA (Carrine PALMIERI and Rosa FALCONE)
Scenes from the Life of Saint Vincent Ferrer
1929

NG 597.1
Oil on wood, 30.5 x 215 cm

Lorenzo COSTA
A Concert
about 1485–95

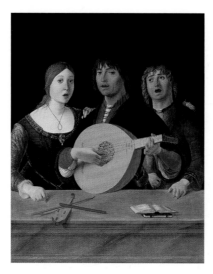

NG 2486
Oil on poplar, 95.3 x 75.6 cm

Lorenzo COSTA with Gianfrancesco MAINERI
The Virgin and Child Enthroned between a Soldier Saint, and Saint John the Baptist (La Pala Strozzi)
probably 1499

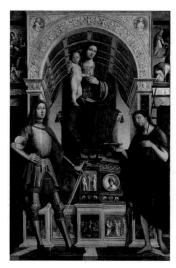

NG 1119
Oil and tempera on wood, 247 x 163.8 cm

NG 597.1 depicts six miracles performed by Saint Vincent Ferrer (about 1350–1419) during his life.

NG 597.1 is a copy of the predella that was painted as part of the Griffoni altarpiece (discussed further under NG 597). The predella (which has been attributed to Ercole de' Roberti as well as to Cossa) is in the Vatican Museums in Rome. This copy was painted by Carrine Palmieri and Rosa Falcone in 1929 (see Appendix B for a larger reproduction).

Presented by Pope Pius XI, 1930.

Davies 1961, p. 152.

NG 2486 does not appear to have a narrative or allegorical subject, and is unlikely to be a group portrait. It may have been painted for a room in which music was played, either as one of a series of paintings of musicians, or as a painting of Music, companion with paintings of the sister arts. The *Concert* is remarkable for representing people singing in harmony. The two singers on either side are beating time on the marble parapet.

NG 2486 probably dates from the later 1480s or 1490s when Costa was working in Bologna.

Probably Ercolani collection, Bologna, by 1780; bought by George Salting, 1877; Salting Bequest, 1910.

Gould 1975, pp. 74–5; Dunkerton 1991, pp. 342–3.

The Virgin and Child are flanked by Saint John the Baptist (right) and a soldier saint (left), probably William of Aquitaine, an eighth-century warrior who joined the Benedictine Order. New Testament narratives are represented on the plinth of the Virgin's throne: (right to left) the Nativity, the Presentation in the Temple, the Massacre of the Innocents, the Flight into Egypt and Christ among the Doctors. The Temptation of Adam and Eve is represented below the Virgin's feet, alluding to her role as the 'second Eve'. The Annunciation is shown in the spandrels above the Virgin's throne. On either side of the arch are: the Sacrifice of Isaac (right) and probably Esther before Ahasuerus.

NG 1119 was painted for the high altar of the Oratory of the Conception (attached to the church of S. Francesco) in Ferrara. It was probably commissioned by Carlo and Camillo Strozzi and was begun by Maineri (active 1489–1506) who is responsible for the highly ornamental throne and for the smaller narratives. It was finished, probably in 1499 in Maineri's absence, by Costa who completed and revised the large figures (but only modifying Saint William slightly). A lunette of the *Pietà with Four Saints* (Ferrara, private collection) has been associated with NG 1119.

Recorded in the Oratorio della Concezione, S. Francesco, Ferrara, 1621; bought from the Marchese Massimiliano Strozzi, 1882.

Gould 1975, pp. 77–80; Lippincott 1991, pp. 6–22.

Lorenzo COSTA
about 1459/60–1535

Costa was born in Ferrara, trained with Ercole de' Roberti, and probably settled in Bologna by 1483, working there for the Bentivoglio court until 1506. In 1507, a year after Mantegna's death, he was appointed as his successor to the Gonzaga court in Mantua. He painted mythologies, portraits, altarpieces and devotional images.

Lorenzo COSTA

The Adoration of the Shepherds with Angels
about 1499

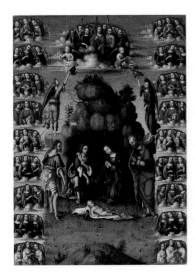

NG 3105
Oil on wood, 52.4 x 37.5 cm

Nine choirs of music-making angels are shown on each side; above are two angels blowing trumpets and a group of angels (centre) bearing the instruments of the Passion.

NG 3105 has been dated about 1499 on the grounds of its style.

Costabili collection, Ferrara, by 1838; bought by Sir A.H. Layard, 1866; Layard Bequest, 1916.

Gould 1975, p. 75.

Lorenzo COSTA

The Virgin and Child with Saints Peter, Philip, John the Evangelist and John the Baptist, 1505

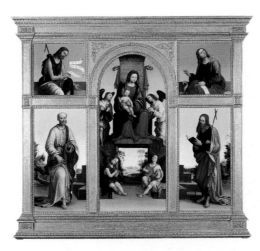

NG 629.1–5
Oil (identified) on canvas, transferred from wood, central panel 167.6 x 73 cm; lower side panels 109.8 x 57.1 cm; upper side panels 55.2 x 57.1 cm

Signed and dated on the lintel below the Virgin's throne (central panel): LAVRENTIVS . COSTA . F[ECIT] . 1505. Inscribed on the scroll held by Saint John the Baptist (top left panel): . ECCE . AGNVS . DEI . (Behold the Lamb of God).

The Virgin and Child are shown with four angels. The reliefs on the Virgin's throne represent (left) the Presentation in the Temple and (right) the Marriage of the Virgin.

NG 629 seems once to have been on the high altar of the Oratory of S. Pietro in Vincoli at Faenza. There was originally a separate horizontal compartment on top, with a painting of the dead Christ supported by angels. John the Baptist and John the Evangelist may have been seated on this level – their slightly larger size would be explained by this. Despite the divisions of the frame, the three largest compartments depict the same landscape and the steps of the throne in the central compartment project into the side ones. (See Appendix B for a larger reproduction.)

Ercolani collection, Bologna, by 1765; bought from Frédéric Reiset, 1859.

Gould 1975, pp. 72–3.

Lorenzo COSTA

Portrait of Battista Fiera
about 1507–8

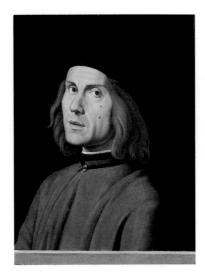

NG 2083
Oil (identified) on wood, 51.4 x 38.7 cm

Inscribed on the parapet: BATT[IST]A . FIERA . MEDIC[VS] . MANTVA (Battista Fiera Doctor of Mantua).

The sitter is identified as the Mantuan poet and writer on medicine Battista Fiera (about 1465–1538) by an old tradition; NG 2083 was the source for an engraved portrait of Fiera that appeared as the frontispiece to his *Coena* (The Supper) in 1649.

The inscription – once legible on the parapet (and still partially visible in infra-red photographs) – was recorded on the reverse of NG 2083, presumably when its legibility was deteriorating. NG 2083 was probably painted within a few years of Costa's arrival in Mantua in 1507. Costa suffered from syphilis in about 1507–8, and may have sought the services of the Gonzaga court physician (possibly painting this portrait in return for treatment received), who seems to be about the right age for the portrait to have been painted in these years.

A drawing related to NG 2083 is known (formerly Rotterdam, Museum Boymans-van Beuningen). It may be a copy.

John Samuel collection by 1894; bequeathed by the Misses Cohen as part of the John Samuel collection, 1906.

Gould 1975, pp. 73–4; Martineau 1981, pp. 153–4.

Lorenzo COSTA
The Story of Moses (The Israelites gathering Manna), after 1508

Lorenzo COSTA
The Story of Moses (The Dance of Miriam) after 1508

Jean-Désiré-Gustave COURBET
Self Portrait (L'Homme à la Ceinture de Cuir) 1845–50

NG 3103
Glue on linen, 119.3 x 78.7 cm

NG 3104
Glue on linen, 119.3 x 78.7 cm

NG 3240
Oil on millboard, 45 x 37.8 cm

During their exodus from Egypt, the Israelites were short of food in the wilderness, and God provided manna, a miraculous food, from Heaven. Old Testament (Exodus 16: 14–36). Moses, on the left, directs the Israelites to gather up the heavenly bread.

NG 3103 and 3104 are probably two of the eight Old Testament pictures by Costa recorded in the ducal collections in Mantua in 1665. The paintings have often been regarded as the work of a follower but their quality has been obscured by their poor condition. Eight pictures of a similar subject – then attributed to Ercole Grandi (1463–before 1525) – were subsequently recorded in the Costabili collection, Ferrara, in 1838, from where these two pictures were acquired by Layard in 1866. See also Roberti NG 1217.

Bought by Sir A.H. Layard, 1866; Layard Bequest, 1916.

Gould 1975, pp. 75–7.

During the exodus from Egypt, the Red Sea parted for the fleeing Israelites, and closed again to drown Pharaoh's pursuing army. Miriam and other Israelite women danced to celebrate this escape. Old Testament (Exodus 15: 20–21). Moses is in the foreground to the right.

NG 3103 and 3104 are probably two of the eight Old Testament pictures by Costa which were recorded in the ducal collections in Mantua in 1665. See also under NG 3103.

Costabili collection, Ferrara, by 1838; bought by Sir A.H. Layard, 1866; Layard Bequest, 1916.

Gould 1975, pp. 75–7.

Signed: G. Courbet

The artist rests his right elbow on a book and holds his belt with his left hand. On the reverse is an unfinished painting of a hand and a chair.

NG 3240 is a reduced replica of a painting in the Musée d'Orsay, Paris, which is usually dated to 1845–6 and which may have been shown at the 1846 Salon. At the outset of his career Courbet frequently copied in the Louvre and this self portrait is clearly indebted to Italian Renaissance portraiture and to Titian in particular. The Musée d'Orsay version is painted on top of a copy by Courbet of Titian's *Man with a Glove* (Paris, Louvre).

Henri Rouart sale, Paris, 1912; Sir Hugh Lane Bequest, 1917; on loan to the Hugh Lane Municipal Gallery of Modern Art, Dublin, since 1979.

Davies 1970, pp. 36–7; Fernier 1977, I, p. 58, no. 94; Bowness 1978, p. 90.

Jean-Désiré-Gustave COURBET
1819–1877

Courbet was born in Ornans. He studied under Flajoulot and then under Steuben in Paris from 1839. Courbet was a controversial figure in both art and politics. He exhibited at the Salon from 1844 and became known as the principal exponent of Realism in French painting. He was imprisoned in 1871–2 because of his revolutionary activity during the Commune, and from 1873 lived in exile in Switzerland.

Jean-Désiré-Gustave COURBET
Young Ladies on the Bank of the Seine
before 1857

NG 6355
Oil on canvas, 96.5 x 130 cm

Jean-Désiré-Gustave COURBET
In the Forest
1859

NG 3241
Oil on canvas, 80 x 99.1 cm

Jean-Désiré-Gustave COURBET
The Diligence in the Snow
1860

NG 3242
Oil on canvas, 137.2 x 199.1 cm

Courbet exhibited a larger version of this composition (Paris, Musée du Petit Palais) at the 1857 Salon. The authenticity of NG 6355 has been doubted in the past but it is now generally considered to be one of several preparatory studies for the Salon painting.

The finished picture provoked a scandal when it was first exhibited. Several critics were outraged by the erotic implications of the subject, with the reclining women shown in a state of semi-undress.

Juliette Courbet (died 1915) collection; bought with a special grant and an anonymous contribution, anon. sale, Sotheby's, 1 July 1964.

Davies 1970, pp. 39–40; Fernier 1977, I, p. 127, no. 206; Bowness 1978, p. 129.

A stag rests in the foreground, while a hind drinks from the pool in the background at the left.

Although Courbet did not exhibit at the Salon of 1859, the critic Zacherie Astruc published an account of the works in his studio, including NG 3241. It was exhibited in 1863 with the title 'Amours de Cerfs' but had acquired its present title by 1873.

James Staats Forbes (died 1904) collection; Sir Hugh Lane Bequest, 1917; on loan to the Hugh Lane Municipal Gallery of Modern Art, Dublin, since 1979.

Davies 1970, pp. 36–7; Fernier 1977, I, p. 150, no. 243.

Signed and dated: G. Courbet. .60[?]
NG 3242 was originally called 'Naufrage dans la Neige', with 'Montagnes du Jura' sometimes added. The present title was also used by Courbet. He is said to have witnessed a similar accident when on a hunting expedition in the forest of Levier in the Jura.

The inscribed date is barely legible, but probably reads as 1860; the painting was exhibited at the Exposition Universelle in Besançon that year.

Courbet sale, Paris, 1882; Sir Hugh Lane Bequest, 1917; on loan to the Hugh Lane Municipal Gallery of Modern Art, Dublin, since 1979.

Davies 1970, pp. 37–8; Fernier 1977, I, p. 160, no. 267.

Jean-Désiré-Gustave COURBET
Still Life with Apples and a Pomegranate
1871–2

NG 5983
Oil on canvas, 44.5 x 61 cm

Jean-Désiré-Gustave COURBET
Beach Scene
1874

NG 6396
Oil on canvas, 37.5 x 54.5 cm

Studio of COURBET
The Pool
probably 1870–80

NG 3243
Oil on canvas, 72.4 x 58.7 cm

Signed and dated at the lower right: G.Courbet ..71.
 NG 5983 is one of a group of still lifes painted about the time of Courbet's imprisonment. An X-radiograph has revealed that it was painted over an earlier, unrelated, still life of fruit.
 Courbet was actively involved in the Paris Commune of 1871. After the collapse of the Commune he was tried and imprisoned in the Sainte-Pélagie prison before being moved to a clinic at Neuilly.

Latouche collection; bought from Tooth and Sons, 1951.

Davies 1970, p. 39; Fernier 1977, II, p. 122, no. 764; Faunce 1978, p. 197, no. 81; Bowness 1978, pp. 189–90.

Signed and dated: G.Courbet 74.
 This picture probably belongs to a group of views of Lac Léman painted in 1874. In technique and composition it recalls Courbet's earlier views of the Channel coast which were influenced by Boudin and Whistler.
 Courbet went into exile in Switzerland in 1873, following his imprisonment for his political activities during the Paris Commune. He eventually settled at La Tour-de-Peilz beside Lac Léman (Lake Geneva).

Bequeathed by Sir Robert Hart, Bt, 1971.

Fernier 1977, II, p. 198, no. 950.

Signed: G. Courbet.
 The site may possibly be above Montreux in Switzerland. There is an old label on the back of the canvas on which it is written: Vue prise aux environs/ De Vevey en/ Suisse (View of the outskirts of Vevey in Switzerland).
 NG 3243 is first recorded this century. Courbet collaborated with numerous pupils, especially in his later years, and he often finished or simply signed their work.

Acquired from Freund-Deschamps by Bernheim-Jeune, 1905; Sir Hugh Lane Bequest, 1917; on loan to the Hugh Lane Municipal Gallery of Modern Art, Dublin, since 1979.

Davies 1970, pp. 38–9; Fernier 1977, II, p. 248, no. C30.

Imitator of COURBET
Landscape
19th century

NG 4182
Oil on canvas, 83.2 x 105.4 cm

After COURBET
The Sea near Palavas
1850–1900

NG 2767
Oil on canvas, 43.2 x 60 cm

Imitator of Thomas COUTURE
Caught by the Tide
1860–90

NG 4613
Oil on canvas, 64.1 x 80.6 cm

Signed, probably falsely: G. Courbet.
 The painting has previously been titled 'L'Orage'.
 In spite of the presence of a signature there seems little reason to accept this as the work of Courbet or even one of his collaborators.

Bought at Charpentiers, Paris; presented by the NACF to the Tate Gallery, 1926; transferred, 1950.

Davies 1970, pp. 40–1.

Signed at the lower right: G. Courbet.
 The subject has been identified as the coast near Palavas-les-Flots, looking south-west. Courbet was in this district (near Montpellier) on several occasions in the 1850s.
 In composition NG 2767 bears a resemblance to Courbet's seascapes of this area yet the style and the atmospheric effect seem unusually timid for the artist. The lack of any nineteenth-century provenance for the work casts further doubt on the attribution. It is not included in the catalogue raisonné by Robert Fernier.

Presented in memory of William Lomas, 1911.

Davies 1970, p. 36.

NG 4613 was attributed to Géricault when it first entered the Collection. Later it was thought to be a study for Couture's *Marie Protectrice dans le Danger (Les Naufragés)* of about 1851–4 in the Chapel of the Virgin in St-Eustache, Paris. Although there are some similarities with the composition of the latter, NG 4613 is probably an independent work by a pupil or imitator of Couture.

Label of the Heinemann Gallery, Munich, on the reverse; bought by the Tate Gallery, 1932; transferred 1956.

Davies 1970, pp. 41–2.

Thomas COUTURE
1815–1879

Couture was born in Senlis. He studied under Gros and Delaroche, and exhibited at the Salon in Paris from 1840. He painted history paintings and portraits and was highly influential as a teacher.

Lucas CRANACH the Elder
Saints Genevieve and Apollonia
1505–8

Lucas CRANACH the Elder
Saints Christina and Ottilia
1505–8

Lucas CRANACH the Elder
Portrait of Johann the Steadfast
1509

NG 6511.1
Oil on lime, 120.5 x 63 cm

NG 6511.2
Oil on lime, 123.0 x 67 cm

NG 6538
Oil on wood, 41.3 x 31 cm

Saint Genevieve's bodice is embroidered with 'GSE'(?).

Saint Genevieve of Paris, at the left, holds a candle which, according to her legend, was miraculously relit when she grasped it after it had been extinguished. On the brooch at her neck are the alpha and omega signs. Saint Apollonia has pincers on her brooch because she was tortured by having her teeth removed.

NG 6511.1 and 6511.2 are the outside shutters of the *Saint Catherine* altarpiece, signed and dated 1506 (Dresden, Gemäldegalerie). It was one of the first works Cranach painted after having entered the service of Frederick the Wise, Elector of Saxony in Wittenberg in 1505. A copy of the altarpiece of 1586 made by Daniel Fritsch of Torgau shows the shutters in place (Wörlitz, Gotisches Haus).

Possibly made for the Marienkirche, Torgau; Dresden sale, 1786; bought from the Loyd Trustees by private treaty sale, 1987.

National Gallery Report 1985–7, pp. 32–4.

Saint Christina of Bolsena, at the left, stands on a millstone. According to her legend, she was tied to such a stone and thrown into a lake, but was miraculously saved because the stone floated. Her companion, Saint Ottilia of Alsace, wears a Benedictine habit and displays a pair of eyes, a reference to the curing of her blindness.

NG 6511.1 and 6511.2 are the outside shutters of the *Saint Catherine* altarpiece (Dresden, Gemäldegalerie). For further discussion see under NG 6511.1.

Possibly made for the Marienkirche, Torgau; Dresden sale, 1786; bought from the Loyd Trustees by private treaty sale, 1987.

National Gallery Report 1985–7, pp. 32–4.

This portrait of the Elector of Saxony (1468–1532) is joined as a diptych with the portrait of his son, Johann Friedrich (NG 6539), who succeeded him as elector, in what is almost certainly the original frame. On the back of the portrait of the boy Johann Friedrich are the coats of arms of Saxony and Mecklenburg, also painted by Cranach. Johann Friedrich's mother, Sophia of Mecklenburg, died giving birth to him in 1503. It is probably for this reason that the portrait of the six-year-old heir to the Electorship of Saxony appears in the position which would normally have been accorded to his mother in such a diptych.

Although the sitters do not look towards each other and are placed on backgrounds of different colour, Cranach has carefully related the two portraits through different combinations of green and black. His portrait of Johann the Steadfast is probably based on an image which he would reuse to produce further portraits, but the very spontaneous likeness of Johann Friedrich presumably resulted from a sitting specifically for this portrait. The sitters were staunch Lutherans and Cranach's chief employers.

Margrave of Baden-Durlach, Karlsburg, Durlach, before 1688; Peter Vischer-Sarasin, Basel, 1808; Christie's, London, 6 July 1990 (lot 42); bought 1991.

Koepplin 1974, pp. 25–34; National Gallery Report 1991–2, pp. 16–17.

Lucas CRANACH the Elder
1472–1553

The artist's name derives from his birthplace, Kronach. He was probably taught by his father Hans, and from 1505 painted at the court of the Electors of Saxony at Wittenberg, where he met Martin Luther to whom he remained close. He visited the Netherlands in 1509; from 1550 to 1553 he worked at Augsburg. He had a large workshop, designed prints, and painted portraits, religious works and secular subject pictures.

Lucas CRANACH the Elder
Portrait of Johann Friedrich the Magnanimous
1509

Lucas CRANACH the Elder
Portrait of a Man
1524

Lucas CRANACH the Elder
Portrait of a Woman
probably 1520s

NG 6539
Oil on wood, 42 x 31.2 cm

NG 1925
Oil on beech, 40.7 x 26.1 cm

NG 291
Oil on beech, 35.9 x 25.1 cm

Dated upper right: 1509.
 Johann Friedrich (1503–54) was six years old when this picture was painted. He succeeded his father as Elector of Saxony in 1532.
 For discussion of this picture see NG 6538.

Margrave of Baden-Durlach, Karlsburg, Durlach, before 1688; Peter Vischer-Sarasin, Basel, 1808; Christie's, London 6 July 1990 (lot 42); bought 1991.

Koepplin 1974, pp. 25–34; National Gallery Report 1991–2, pp. 16–17.

At the upper left and right are two coats of arms. At the left: Coupé: au I d'argent aux trois figues de vert; au 2de gueules. At the right: De gueules à la fasce d'or, accompagné de trois oeillets (?) au naturel. Signed under the left-hand shield with Cranach's device, a crowned winged serpent, and dated: 1524.
 Inscriptions on the reverse of the panel identify the sitter as Franz von Sickingen or, alternatively, a member of the Luther family. The left-hand coat of arms, however, is that of Johann Feige, Chancellor of Hesse (1482?–1543). As the sitter seems to be older than the 45 years which biographical information suggests, another member of the Feige family may be shown.

Said to have been in an anon. (?) London sale (Christie's), 1902; presented by John P. Heseltine, 1903.

Levey 1959, pp. 19–20.

Signed bottom left with Cranach's device, a crowned winged serpent.
 On the woman's bodice is an embroidered pattern with the letter M. Paintings of this type by Cranach are not necessarily portraits of individuals; they may be idealised variations on a theme.
 NG 291 can be grouped with a number of other similar works by the artist which are thought to date from the 1520s.

Bought by the Earl of Shrewsbury from a Nuremberg collection, probably that of Friedrich Campe; at Alton Towers by 1835; bought at the Earl of Shrewsbury sale, Alton Towers, 1857.

Levey 1959, p. 19.

Lucas CRANACH the Elder
The Close of the Silver Age (?)
1527–35

NG 3922
Oil on oak, 50.2 x 35.7 cm

In the background, two men with darker skins than the rest of the figures have beaten their male opponents to the ground. In the foreground are three women with small children. The subject may be the Close of the Silver Age. The ancient Greek writer Hesiod described the early history of the world as having taken place in three stages – the Golden, Silver and Bronze. The figures who seem to be winning the fight may be the 'terrible and strong' Bronze Age men he referred to, and the sticks they use could refer to their 'ashen spears'. The painting is perhaps based on a contemporary German adaptation of Hesiod.

Similar subjects occur in a number of paintings by Cranach; some of these are dated 1527, 1529 and 1535. NG 3922 probably dates from the same period.

Edward Habich collection, Cassel, by 1880; bought by J.P. Richter for Dr Ludwig Mond at the Habich sale, Cassel, 1892; Mond Bequest, 1924.

Levey 1959, pp. 21–3; Smith 1985, p. 94.

Lucas CRANACH the Elder
Cupid complaining to Venus
probably early 1530s

NG 6344
Oil (identified) on wood, 81.3 x 54.6 cm

Inscribed top right: DVM PVER ALVEO(LO) F(VRATVR ME)LLA CVPIDO/FVRANTI DIGITVM CV(SPIDE) F(IXIT) APIS/SIC ETIAM NOBIS BREVIS ET (PERI)TVRA VOLVPTAS/QVAM PETIMVS TRI(S)T(I) (M)IXTA DOLORE N(O)CET. (While the boy Cupid plunders honey from the hive, the bee fastens on his finger with piercing sting; and so in like manner the brief and fleeting pleasure which we seek is hurtful, mingled as it is with wretched pain.) Signed on the stone bottom right with Cranach's device of a winged serpent.

The subject derives from two Latin translations by German scholars of Theocritus' *Idyll* (19), dated 1522 and 1528, but these lines do not occur in either. However, Johann Hess, a humanist, made the manuscript note 'Tabella Luce' ('Picture by Lucas') in his copy of one of the translations.

Bought, 1963.

Smith 1985, p. 92.

Lucas CRANACH the Elder
Charity
1537–50

NG 2925
Oil (identified) on beech, 56.3 x 36.2 cm

Inscribed top left: CHARITAS. Signed bottom left with Cranach's device of a serpent with folded wings.

Charity, one of the three theological virtues, is here personified as a woman suckling a child, flanked by a girl with a doll and a smaller boy. The virtue is commonly depicted in this form from the fourteenth century onwards.

The particular form of serpent device that Cranach has used on NG 2925 occurs in his work only after 1537. It has been suggested that the painting might date from about 1550, and it seems likely that it is a product of the artist's later years. Cranach mentions two depictions of Charity when describing his work in Augsburg (1550–1). The subject is common in his work, but he usually depicted the figure of Charity herself seated or lying down.

Presented by Rosalind Countess of Carlisle, 1913.

Levey 1959, p. 21.

Giuseppe Maria CRESPI
Saint Jerome in the Desert
1710–20

Carlo CRIVELLI
The Dead Christ supported by Two Angels
about 1470–5

Carlo CRIVELLI
Saints Peter and Paul
probably 1470s

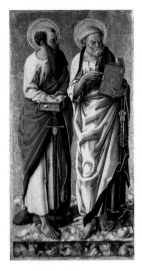

NG 6345
Oil on canvas, 87 x 66.6 cm

NG 602
Tempera on poplar, painted surface 72.4 x 55.2 cm

NG 3923
Tempera on poplar, 93.3 x 47 cm

Saint Jerome (about 342–420) is depicted studying the Bible, which he translated into Latin from the original Greek and Hebrew. He is shown in the desert with his books, the lion from whose paw he had drawn a thorn, and the crucifix before which he prayed.

Crespi painted this subject on several occasions in his career, but this picture cannot be securely identified with any of the recorded versions. It may be a reduced version of a larger work. NG 6345 is thought to date from the middle of Crespi's career, perhaps from the second decade of the eighteenth century.

Bought, 1963.

Levey 1971, p. 88; Viroli 1990, p. 44.

Inscribed, probably not by the artist, on the parapet on the left: CAROLVS. CRIVELLVS. VENETVS. PINSIT.

The dead Christ supported by two angels was a common subject in the fifteenth century.

NG 602 was probably painted as the central panel of the upper tier of an altarpiece for the church of S. Francesco in Montefiore dell'Aso, near Fermo; the subject was conventional for this position (NG 630 is a contemporary example by Giorgio Schiavone). The polyptych originally included the Virgin and Child, and two tiers of saints, together with a predella. These panels are now dispersed in several collections (e.g. Brussels, Musée Royaux des Beaux-Arts; Montefiore, church of S. Lucia).

The signature on NG 602 may be false and is likely to have been added when the altarpiece was dismembered (apparently during the Napoleonic period). Some parts of the painting, most notably the profile of one angel, have been conjecturally restored.

Collection of Cav. P. Vallati, Rome, by 1858; from whom bought, 1859.

Davies 1961, pp. 153–6; Zampetti 1986, pp. 265–7.

Saint Peter holds the keys of the Kingdom of Heaven. New Testament (Matthew 16 :18–19). They were subsequently adopted as an emblem by the popes, his successors as Bishops of Rome. He also holds a book and is represented in his traditional colours as an apostle rather than as the Bishop of Rome. Saint Paul is shown with his traditional attributes of a sword and a book.

NG 3923 formed the left-hand side of a polyptych in the parish church of S. Giorgio in Porto S. Giorgio (Porto di Fermo). This altarpiece was apparently signed and dated 1470, the year in which it was said to have been commissioned (the documentation has apparently been lost). Other elements of the altarpiece survive: the central panel of the *Virgin and Child* is in Washington (National Gallery of Art), the *Pietà* is in Detroit (Michigan, Institute of Fine Arts) and a *Saint George* is in Boston (Isabella Stewart Gardner Museum). Two small lunettes are in Tulsa and Cracow. The attribution to Crivelli has sometimes been queried on grounds of quality.

Recorded in the church of S. Giorgio in Porto S. Giorgio (Porto di Fermo), 1834; Mond Bequest, 1924.

Davies 1961, pp. 167–9; Zampetti 1986, pp. 254–6.

Giuseppe Maria CRESPI
1665–1747

Crespi was born and died in Bologna, but was also active in Venice, Florence and elsewhere. He travelled in northern Italy and was an internationally patronised painter. Employed by Grand Prince Ferdinando de' Medici and Pope Benedict XIV, he painted religious scenes, frescoes, portraits and still lifes, and was most famous for his approach to genre subjects.

Carlo CRIVELLI
about 1430/5–about 1494

Carlo was the son of Jacopo Crivelli, a little-known Venetian painter. He was born in Venice, where in 1457 he was sentenced to prison for adultery. In 1465 he was living at Zara. By 1468 he had settled at Ascoli Piceno and was active mostly in the Marches. He enjoyed great success there, chiefly as a painter of altarpieces. He was knighted in 1490 by Ferdinand II of Naples.

Carlo CRIVELLI
The Virgin and Child
1476

Carlo CRIVELLI
Saint John the Baptist and *Saint Peter*
1476

Carlo CRIVELLI
Saint Catherine of Alexandria and *Saint Dominic*
1476

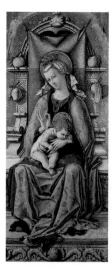

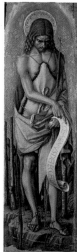
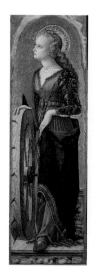

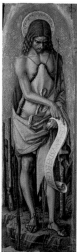
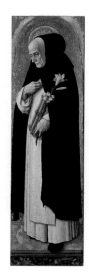

NG 788.1
Tempera on lime, painted surface 148.6 x 63.5 cm

Signed and dated on the step below the Virgin and Child: OPVS. KAROLI. CRIVELLI. VENETI. 1476.

NG 788.1 is the central panel of a polyptych painted by Crivelli in 1476 as the high altarpiece of S. Domenico, Ascoli Piceno. A reconstruction is in Appendix A. Originally there was a predella and a lunette-shaped *Lamentation* (now New York, Metropolitan Museum of Art) above the Virgin and Child enthroned.

When acquired by the Gallery, the altarpiece had a third tier of four smaller full-length saints (NG 788.10–13); these are now acknowledged as parts of a separate altarpiece and are discussed under NG 788.10-11. The entire complex has been known as 'The Demidoff Altarpiece' since it was framed as one polyptych when in the Demidoff collection. NG 788.1–9 are in their nineteenth-century framing elements. The thirteen panels combined in this ensemble have stylistic and technical affinities and appear to date from the same period. That they shared a provenance was probably sufficient reason in the past to assume they all formed part of one three-tiered polyptych.

Collection of Prince Anatole Demidoff about 1854; from whose family bought, 1868.

Davies 1961, pp. 161–5; Zampetti 1986, pp. 271–2; Dunkerton 1991, p. 334.

NG 788.2–3
Tempera on poplar (NG 788.2), 138.5 x 40 cm, and tempera on lime (NG 788.3), 139 x 40.5 cm

Inscribed on the Baptist's scroll: ECCE. AGNVS. DEI. QVI [TOLLIT PECCATUM] / MO[NDI] (Behold the lamb of God who takes away the sins of the world).

Saint Peter holds two raised keys, one silver, the other gold. These are the keys of the Kingdom of Heaven (New Testament, Matthew 16: 18–19) which were his emblem and were subsequently adopted by the popes, his successors as bishops of Rome. He also holds a book and a bishop's crook surmounted by a crucifix.

NG 788.2-3 are parts of a polyptych signed by Carlo Crivelli and dated 1476 on the step below the Virgin and Child in the central panel. The altarpiece is discussed under NG 788.1, and see Appendix A for a reconstruction. When acquired by the Gallery, the altarpiece had a third tier of four smaller full-length saints (NG 788.10–13); these are now acknowledged as parts of a separate altarpiece and are discussed under NG 788.10-11.

Collection of Prince Anatole Demidoff about 1854; from whose family bought, 1868.

Davies 1961, pp. 161–5; Zampetti 1986, pp. 271–2; Dunkerton 1991, p. 334.

NG 788.4–5
Tempera on poplar, each painted surface 137.5 x 40 cm

The fourth-century Saint Catherine of Alexandria is shown with a martyr's palm and her traditional attribute of the wheel on which she was tortured.

Saint Dominic (1170–1221) the founder of the Dominican Order of Preachers, is shown in his traditional black habit and with his attribute of a lily.

NG 788.4-5 are parts of a polyptych signed by Carlo Crivelli and dated 1476 on the step below the Virgin and Child in the central panel. The altarpiece is discussed under NG 788.1, and see Appendix A for a reconstruction. When acquired by the Gallery, the altarpiece had a third tier of four smaller full-length saints (NG 788.10–13); these are now acknowledged as parts of a separate altarpiece and are discussed under NG 788.10-11.

Collection of Prince Anatole Demidoff about 1854; from whose family bought, 1868.

Davies 1961, pp. 161–5; Zampetti 1986, pp. 271–2; Dunkerton 1991, p. 334.

Carlo CRIVELLI
Saint Francis and *Saint Andrew*
1476

Carlo CRIVELLI
Saint Stephen and *Saint Thomas Aquinas*
1476

Carlo CRIVELLI
Saint Jerome and *Saint Michael*
about 1476

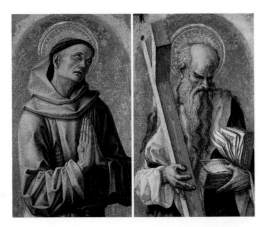

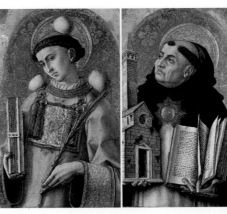

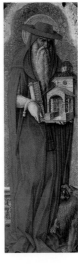

NG 788.6–7
Tempera on poplar, painted surface 61 x 39.5 cm
and 61 x 40 cm

NG 788.8–9
Tempera on poplar, painted surface 61 x 40 cm
and 60.5 x 39.5 cm

NG 788.10–11
Tempera on poplar, painted surface 91 x 26 cm
and 90.5 x 26.5 cm

Saint Francis of Assisi (about 1181–1226), founder of the Franciscan Order, is shown at prayer, with the stigmata in his hands and side clearly visible. He wears the traditional brown habit of his order.

Saint Andrew the apostle is shown with the cross on which he was martyred, and a book.

NG 788.6-7 are parts of a polyptych signed by Carlo Crivelli and dated 1476 on the step below the Virgin and Child in the central panel. The altarpiece is discussed under NG 788.1, and see Appendix A for a reconstruction. When acquired by the Gallery, the altarpiece had a third tier of four smaller full-length saints (NG 788.10–13); these are now acknowledged as parts of a separate altarpiece and are discussed under NG 788.10-11.

Collection of Prince Anatole Demidoff about 1854; from whose family bought, 1868.

Davies 1961, pp. 161–5; Zampetti 1986, pp. 271–2; Dunkerton 1991, p. 334.

Saint Stephen was one of the first deacons of the church and was stoned to death in about AD 35. He is shown with the stones as they struck his body.

Saint Thomas Aquinas (about 1225–74) joined the Dominican Order – whose habit he wears – and became one of the great medieval doctors of the church (he is shown holding the church which he had illuminated with his doctrines). On his chest is his traditional attribute of a star.

NG 788.8-9 are parts of a polyptych signed by Carlo Crivelli and dated 1476 on the step below the Virgin and Child in the central panel. The altarpiece is discussed under NG 788.1, and see Appendix A for a reconstruction. NG 788.8-9 were on the right of the *Pietà* (now New York, Metropolitan Museum of Art) in the upper tier. When acquired by the Gallery, the altarpiece had a third tier of four smaller full-length saints (NG 788.10–13); these are now acknowledged as parts of a separate altarpiece and are discussed under NG 788.10-11.

Collection of Prince Anatole Demidoff about 1854; from whose family bought, 1868.

Davies 1961, pp. 161–5; Zampetti 1986, pp. 271–2; Dunkerton 1991, p. 334.

Saint Jerome (about 342–420), a doctor of the church and the chief inspiration for Christian penitents and hermits, is shown in the red habit of a papal legate. He holds a book and a model church, and is accompanied by his traditional attribute of a lion, from whose paw, according to legend, he had removed a thorn.

The Archangel Michael tramples on Satan (whom he cast to the ground in aerial combat; New Testament, Revelation 12: 7–9). Michael also holds a balance in which the souls of the dead are weighed at the Last Judgement.

NG 788.10-11 are parts of a polyptych signed by Carlo Crivelli and probably painted in about 1476. See Appendix A for a reconstruction. NG 788.10-11 were on the left of the central panel of the Virgin and Child (now Budapest, Szépmüveszéti Museum). When acquired by the Gallery NG 788.10-13 made up the third tier of another polyptych by Crivelli (NG 788.1–9), discussed under NG 788.1. Both altarpieces came from the church of S. Domenico, Ascoli Piceno; NG 788.10–13 were in a chapel dedicated to Saint Peter Martyr.

Collection of Prince Anatole Demidoff about 1854; from whose family bought, 1868.

Davies 1961, pp. 162–5; Zampetti 1986, pp. 271–4; Dunkerton 1991, pp. 332–4.

Carlo CRIVELLI
Saint Lucy and *Saint Peter Martyr*
about 1476

Carlo CRIVELLI
The Annunciation, with Saint Emidius
1486

Carlo CRIVELLI
The Vision of the Blessed Gabriele
probably about 1489

NG 788.12–13
Tempera on lime (NG 788.12), 91 x 26.5 cm;
tempera on poplar (NG 788.13), 90.5 x 26.5 cm

Saint Lucy was a fourth-century virgin martyr. She
holds a martyr's palm and, on a plate, the eyes
which she removed and presented to a pagan suitor
infatuated by her beauty.

Saint Peter Martyr was a Dominican friar – he
wears a Dominican habit. He was murdered in a
wood in 1252. The instruments of his martyrdom (a
sword in his chest and a cleaver in his head) became
his attributes.

NG 788.12-13 are parts of a polyptych signed by
Carlo Crivelli and probably of about 1476. The
altarpiece is discussed under NG 788.10, and see
Appendix A for a reconstruction. When acquired by
the Gallery, NG 788.12-13 were parts of the third tier
of another polyptych by Crivelli (NG 788.1–9),
discussed under NG 788.1.

*Collection of Prince Anatole Demidoff about 1854; from
whose family bought, 1868.*

Davies 1961, pp. 162–5; Zampetti 1986, pp. 271–4;
Dunkerton 1991, pp. 332–4.

NG 739
Egg and oil (identified) on canvas, transferred from
wood, 207 x 146.7 cm

Inscribed along the base: .LIBERTAS. ECCLESIASTICA.
(Freedom of the Church). Signed on the central
pilaster: OPVS. CARO/LI. CRIVELLI. / VENETI; and dated
on the right pilaster: .1486.

The Virgin, at prayer in her bedchamber, receives
the Holy Spirit. The Archangel Gabriel kneels
outside with a lily (here a symbol of the Virgin's
purity). New Testament (Luke 1: 26–35). Unusually,
Gabriel is accompanied by Saint Emidius, first
bishop and patron saint of Ascoli (a model of which
he holds). The coats of arms at the base of the picture
(left to right) are those of Prospero Caffarelli (Bishop
of Ascoli, 1464–1500), Innocent VIII (who succeeded
Sixtus IV as Pope in 1484) and the city of Ascoli.

NG 739 was painted for the church of SS.
Annunziata in Ascoli Piceno in 1486. The choice of
subject, the inscription and the presence of Saint
Emidius and the various coats of arms can be
explained with reference to contemporary political
events. News that Pope Sixtus IV was to grant
Ascoli a degree of self-government reached the
town on 25 March (the Feast of the Annunciation)
1482. Thereafter they celebrated the freedom
granted to them in this Papal Bull – entitled *Libertas
Ecclesiastica* – at the church of SS. Annunziata on the
Feast of the Annunciation.

*Recorded in the church of SS. Annunziata, Ascoli
Piceno, about 1724; presented by Lord Taunton, 1864.*

Davies 1961, pp. 159–61; Zampetti 1986, pp. 284–6;
Dunkerton 1991, pp. 77, 344.

NG 668
Egg and oil (identified) on poplar, painted surface
141 x 87 cm

Signed on the ground, right: OPVS. KAROL[VS].
CRIVELLV[S]. / VENETI. (Work of Carlo Crivelli from
Venice.)

A vision of the Virgin and Child appears to the
Blessed Gabriele as he prays in a wood near the
convent of S. Francesco ad Alto, Ancona. Gabriele
Ferretti, a much-venerated superior of this convent,
died in 1456.

In 1489 the Blessed Gabriele's body was
transferred, by permission of the pope, to a
sculptured tomb in the convent church of S.
Francesco ad Alto. NG 668, which was probably
painted in the same year, was recorded in 1753
hanging above this tomb, and (like the tomb) it may
have been commissioned by the Ferretti family.

The iconography of the Blessed Gabriele's vision
is paralleled with that of Saint Francis when he
received the stigmata (e.g. Sassetta NG 4760).

*Collection of Alexander Barker by 1858; from whom
bought, 1861.*

Davies 1961, pp. 156–8; Zampetti 1986, p. 282;
Dunkerton 1991, pp. 61–2.

Carlo CRIVELLI
La Madonna della Rondine (The Madonna of the Swallow), about 1490–2

NG 724.1–2
Egg and oil (identified) on poplar, 150.5 x 107.3 cm

Signed on a cartellino on the step in the main panel, bottom right: . CAROLVS . CRIVELLVS . VENETVS . MILES . PINXIT. (Carlo Crivelli from Venice, knight, painted this.)

The altarpiece represents the Virgin and Child enthroned with Saints Jerome and Sebastian but is named after the swallow (*rondine* in Italian) perched above, which may be intended as a symbol of the Resurrection. Saint Jerome (about 342–420) appears in the main panel as a doctor of the church in the red habit of a cardinal. Saint Sebastian, another fourth-century saint, is shown as a young warrior. The predella (NG 724.2) includes Saint Jerome in the Wilderness, the Nativity at Night and the Martyrdom of Saint Sebastian. At either end are Saint Catherine of Alexandria, with her traditional attribute of a wheel, and Saint George in combat with the dragon.

The painting comes from the church of S. Francesco dei Zoccolanti in Matelica, and bears the arms of the Ottoni family. Ranuzio Ottoni (Lord of Matelica) and Giorgio di Giacomo (guardian of the local convent of S. Francesco) commissioned the altarpiece in March 1490. The former paid 60 ducats towards the cost of this commission; the latter paid 310 florins.

The painting is in its original frame (see Appendix B for a larger reproduction).

Recorded in S. Francesco dei Zoccolanti, Matelica, by 1796; bought, 1862.

Davies 1961, pp. 158–9; Zampetti 1986, pp. 295–7; Smith 1989, pp. 29–43.

Carlo CRIVELLI
The Virgin and Child with Saints Francis and Sebastian, 1491

NG 807
Egg and oil (identified) on poplar, painted surface 175.3 x 151.1 cm

Inscribed along the base: ALMAE CONSOLATIONIS MATRI. MARIAE: PRIORES. POSTEROSQ'[UE] MISERATA SVOS: ORADEA. IOAMNIS: AERE PROPRIO / NON MODICO DICAVIT (Oradea [widow] of Giovanni in compassion for her forbears and descendants, with a large sum of her own money, dedicated this picture to the Virgin Mary, bountiful Mother of Consolation). Signed and dated at the bottom of the Virgin's throne: OPVS. CAROLI. CRIVELLI. VENETI. MILES. 1491 (Carlo Crivelli of Venice, Knight, painted this in 1491).

The Virgin and Child are enthroned between Saint Sebastian (a fourth-century Roman centurion who was discovered to be a Christian and sentenced to be shot to death with arrows) and Saint Francis of Assisi (about 1181–1226, founder of the Franciscan Order, with the stigmata in his side and his hands clearly visible). The donatrix Oradea, widow of Giovanni Becchetti, is shown at Saint Francis's feet. There are a number of symbols: the snail and the glass vase may both allude to the virginity of Christ's mother, the Virgin Mary.

Oradea fulfilled Giovanni Becchetti's wish, as expressed in his will, by founding an altar dedicated to S. Maria della Consolazione in the church of S. Francesco in Fabriano in 1490; she also endowed it herself. The altarpiece was placed in the chapel in 1491.

Recorded in the chapel of S. Maria della Consolazione in the church of S. Francesco, Fabriano, 1747; presented by Elizabeth Mary, widow of the second Marquess of Westminster, 1870.

Davies 1961, p. 165; Ettlinger 1978, p. 316; Zampetti 1986, pp. 294–5.

Carlo CRIVELLI
Saint Catherine of Alexandria
probably about 1491–4

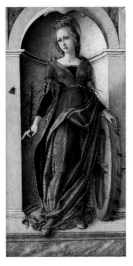

NG 907.1
Tempera on lime, painted surface 38 x 19 cm

The fourth-century Saint Catherine of Alexandria is shown with a martyr's palm and her traditional attribute of the wheel on which she was tortured.

NG 907.1 and 907.2 were probably elements of a frame or a predella. They have often been regarded as studio work.

The fly on the left of NG 907.1 is a trick painted to demonstrate the power of art to deceive (see also Swabian School NG 722).

Alexander Barker collection, London, by 1865; bought, 1874.

Davies 1961, pp. 166–7; Zampetti 1986, p. 307.

Carlo CRIVELLI
Saint Mary Magdalene
probably about 1491–4

NG 907.2
Tempera on lime, 37.5 x 18.5 cm

Mary Magdalene wears her traditional red dress and holds a jar of oil (with which she anointed Christ).

NG 907.1 and 907.2 were probably elements of a frame or a predella. They have often been regarded as studio work.

Alexander Barker collection, London, by 1865; bought, 1874.

Davies 1961, pp. 166–7; Zampetti 1986, p. 307.

Carlo CRIVELLI
The Immaculate Conception
1492

NG 906
Egg (identified) on wood, painted surface
194.3 x 93.3 cm

Signed and dated on a cartellino: KAROLI. CHRIVELLI. VENETI. MILITIS. PINSIT. / 1492 (Carlo Crivelli of Venice, knight, painted this, 1492). Inscribed on the scroll held by the two angels: VT. INMENTE. DEI. ABINITIO. CONCEPTA. FVI. ITA. ET. FACTA. SVM. (As from the beginning I was conceived in the mind of God, so have I in like manner been conceived in the flesh.)

NG 906 may be the earliest dated picture of the Virgin of the Immaculate Conception. The inscription relates to the Old Testament (Ecclesiasticus 24: 14 in the Vulgate, and Proverbs 8: 23–4); however, the quotation is not direct and was probably part of another text that has not been identified. The Virgin's purity is here symbolised by a lily in a pure crystal glass (a new invention). At the top of the panel two angels crown the Virgin at the behest of God the Father and the Holy Spirit; the Coronation of the Virgin was a common subject in the fifteenth century and was the only other occasion when she was represented alone in an altarpiece.

NG 906, which is signed and dated 1492, comes from the church of S. Francesco, Pergola. It was therefore painted soon after the bull (Ineffabilis Deus) of Pius IX that forbade the dispute between the Franciscans and the Dominicans over the controversial doctrine that the Virgin was conceived miraculously without taint of original sin. The Franciscans supported the doctrine, which enjoyed increasing popularity in the late fifteenth century, and NG 906 was painted for a Franciscan church.

Alexander Barker collection, London, by 1871; bought, 1874.

Davies 1961, pp. 165–6; Zampetti 1986, pp. 298–9.

Aelbert CUYP
A River Scene with Distant Windmills
about 1640–2

NG 2545
Oil on oak, 35.6 x 52.4 cm

Signed bottom right: A cuÿp.

The scene has been identified as Beverwyck, but it is unlikely that a precise location was intended.

NG 2545 is an early work painted in the manner of van Goyen. It was probably painted shortly after 1640.

Collection of Charles Bredel by 1851; Salting Bequest, 1910.

MacLaren/Brown 1991, pp. 94–5.

Aelbert CUYP
1620–1691

Cuyp was born and active in Dordrecht, where he trained with his father. He was influenced by Jan van Goyen, and later by the Italianising landscape painters of Utrecht, particularly Jan Both. Principally a landscape painter, he travelled widely in the United Provinces and was involved in local and church government from 1659.

Aelbert CUYP
The Maas at Dordrecht in a Storm
about 1645–50

NG 6405
Oil on oak, 49.8 x 74.4 cm

Aelbert CUYP
Portrait of a Bearded Man
1649

NG 797
Oil on oak, octagonal, 68.9 x 60.2 cm

Aelbert CUYP
A Distant View of Dordrecht, with a Milkmaid and Four Cows, and Other Figures ('The Large Dort')
about 1650

NG 961
Oil on canvas, 157.5 x 197 cm

Signed bottom right: A. c'uÿp
 Dordrecht, dominated by the profile of the Grote Kerk, is visible on the right.
 Storm scenes are very unusual in Cuyp's work. Those that are known seem to have been painted early in his career and NG 6405 probably dates from the second half of the 1640s.

Possibly in the collection of the Earl of Halifax by 1782; collection of W.C. Alexander, 1886; presented by the Misses Rachel F. and Jean I. Alexander; entered the Collection in 1972.

MacLaren/Brown 1991, pp. 95–6.

Inscribed, signed and dated lower left: AEtatis: 56:1649 / A: cuÿp. fecit:
 NG 797 may be a portrait of Jacob Cuyp, the painter's father, who was 56 in 1649. There is, however, no documented portrait of Jacob Cuyp.
 NG 797 is closely related in style to the portraits by Jacob, with whom Aelbert trained and with whom he jointly signed two pictures in 1641.
 NG 797 seems to have been cut down from a rectangular format to an octagonal one.

Collection of John Barnard and then of Thomas Hankey by 1799; bought, 1869.

MacLaren/Brown 1991, pp. 88–9.

Signed below right: A. cuyp
 Dordrecht (Dort) is seen in the background from the south-east, with the Grote Kerk in the centre, and the Vuilpoort, one of the town's water-gates (built in 1578 and demolished in 1864), on the left.
 The chronology of Cuyp's work is difficult to establish, not least because he dated so few paintings. This painting has been tentatively dated about 1650.
 This distant view is almost exactly repeated in *'The Small Dort'* (NG 962), and in a drawing by Cuyp (London, British Museum). The Grote Kerk and the Vuilpoort are seen from another angle in NG 6405. A number of the cows and landscape elements occur in other pictures by Cuyp.

Possibly in the Delahante et al. sale, London, 1810; Wynn Ellis collection by 1858; Wynn Ellis Bequest, 1876.

MacLaren/Brown 1991, pp. 91–2.

Aelbert CUYP
A Distant View of Dordrecht, with a Sleeping Herdsman and Five Cows ('The Small Dort')
about 1650–2

NG 962
Oil on oak, 66.4 x 100 cm

Aelbert CUYP
A Herdsman with Five Cows by a River
about 1650–5

NG 823
Oil on oak, 45.4 x 74 cm

Aelbert CUYP
River Landscape with Horseman and Peasants
probably 1650–60

NG 6522
Oil on canvas, 123 x 241 cm

Signed on the top bar of the fence at the right: A: cuyp:
Dordrecht (Dort) is seen in the background from the south-east, with the Grote Kerk in the centre, and the Vuilpoort, one of the town's water-gates (built in 1578 and demolished in 1864), on the left.
NG 962 almost exactly repeats the view of Dordrecht seen in NG 961, and has been tentatively dated to the early 1650s.
The Grote Kerk and the Vuilpoort are seen from another angle in NG 6405. The two cows appear in an etching (with slight variations and reversed) attributed to Cuyp.

Probably collection of Captain Baillie by 1771; collection of Wynn Ellis by about 1840; Wynn Ellis Bequest, 1876.

MacLaren/Brown 1991, pp. 92–3.

Signed bottom right: A: cuÿp:
The chronology of Cuyp's landscapes is difficult to establish but NG 823 was perhaps painted in about 1650–5.

Perhaps in the Nogaret collection by 1780; Choiseul-Praslin collection, 1793; collection of Sir Robert Peel, Bt, by 1834; bought with the Peel collection, 1871.

MacLaren/Brown 1991, pp. 89–90.

Signed lower right: A cuijp
The composition was engraved, but with an extended sky, by William Elliott in 1764. The subject was then identified as a view on the Maas at Dordrecht, but NG 6522 is probably an imaginary view.
NG 6522 – the largest surviving landscape by the artist – was presumably intended for the house of a member of the regent class of Dordrecht, Cuyp's principal patrons, and was probably painted in the 1650s.
According to the painter Benjamin West (in 1818) it was this picture which began the rage for Cuyp's work among British collectors in the eighteenth and nineteenth centuries.

Bought in the United Provinces by Captain William Baillie for the collection of the 3rd Earl of Bute by 1764; bought from the Marquess of Bute, with the assistance of the National Heritage Memorial Fund and the NACF, 1989.

MacLaren/Brown 1991, pp. 555–6.

Aelbert CUYP
Ubbergen Castle
about 1655

NG 824
Oil on oak, 32.1 x 54.5 cm

Aelbert CUYP
A Hilly River Landscape with a Horseman talking to a Shepherdess, 1655–60

NG 53
Oil (identified) on canvas, 135 x 201.5 cm

Aelbert CUYP
A Horseman with a Cowherd and Two Boys in a Meadow, and Seven Cows, probably about 1655–60

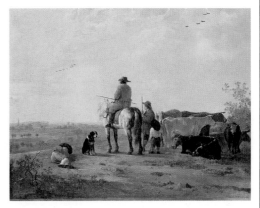

NG 822
Oil on canvas (the edges have been made up),
80 x 106 cm

Ubbergen is near Nijmegen in the Province of Gelderland. The castle, which had long been a ruin, was pulled down in 1712.

NG 824 was probably painted in the mid-1650s. A signed preparatory drawing (Vienna, Albertina) extends the composition slightly on both sides.

Collection of De Preuil by 1811; collection of (Sir) Robert Peel (Bt), 1822; bought with the Peel collection, 1871.

MacLaren/Brown 1991, p. 90.

Signed below right: A: cuÿp.
This important work of Cuyp's maturity was probably painted around 1655–60. Weaknesses in the drawing of, for example, the shepherdess, are entirely consistent with Cuyp's style at that period.

Collection of Sir Lawrence Dundas by 1794; bought by J.J. Angerstein; bought with the J.J. Angerstein collection, 1824.

MacLaren/Brown 1991, pp. 87–8.

Signed bottom right: A.c'uÿp
There is a drawing for the sleeping boy on a signed sheet of studies (Amsterdam, Rijksprentenkabinet).

Possibly collection of Richard Hulse by 1806; collection of Sir Robert Peel, Bt, by 1834; bought with the Peel collection, 1871.

MacLaren/Brown 1991, p. 89.

Aelbert CUYP
Peasants and Cattle by the River Merwede
about 1655–60

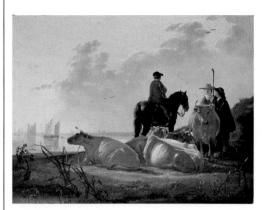

NG 1289
Oil on oak, 38.1 x 50.8 cm

Imitator of CUYP
A Herdsman with Seven Cows by a River
probably about 1750–1800

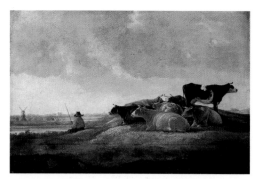

NG 2547
Oil on oak, 61.4 x 90.8 cm

Bernardo DADDI
The Marriage of the Virgin
about 1330–40

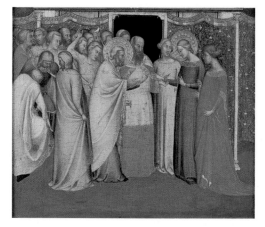

L13
Tempera on wood, 25.5 x 30.7 cm

Signed bottom right: A. cuyp
 On the left, in the distance across a river, is the ruined castle of Merwede (Huis te Merwede), which is about a mile to the east of Dordrecht. It was built in the thirteenth century, destroyed in about 1418, and still survives as a ruin.
 Cuyp painted and drew the ruined castle of Merwede on several occasions. There is a drawing for the figure on the extreme right (Vorden, Victor de Steurs collection).
 The cows occur in a number of other pictures (e.g. the cow on the far left appears in NG 961).

Collection of William Herring by 1754; bequeathed by John Staniforth Beckett, 1889.

MacLaren/Brown 1991, pp. 93–4..

Falsely signed lower left of centre: A c'uyp
 This is probably a copy after an unknown landscape by Cuyp, or a pastiche of his style. Such pastiches were painted by Jacob van Strij (1756–1815), who may be the artist of this picture.

Collection of Ralph Bernal by 1824; Salting Bequest, 1910.

MacLaren/Brown 1991, pp. 96–7.

The Marriage of the Virgin is described in the apocryphal lives of the Virgin. Here Saint Joseph is shown joining hands with the Virgin Mary as an act of betrothal. Her suitors had been told to present a rod to the temple, and the one whose rod flowered would marry Mary. Disappointed suitors are shown breaking their rods, while Joseph's is in flower.
 L13 was one of the predella panels of the high altarpiece, painted by Bernardo Daddi for the church of San Pancrazio, Florence. The other seven are in the Uffizi and it is clear that L13 has been cut down. Attributed by Vasari to Agnolo Gaddi, this altarpiece was probably painted by Daddi in the 1330s.

Recorded in San Pancrazio, Florence, 1568; acquired by Queen Victoria from the Metzger collection, 1845; on loan from Her Majesty The Queen since 1975.

Shearman 1983, pp. 85–6.

Bernardo DADDI
about 1300–1348

Signed works by Bernardo Daddi exist from 1328 until the year of his death in 1348. He was probably a member of Giotto's workshop, but was also influenced by Sienese developments. His son Daddo was also a painter.

DALMATIAN
The Altarpiece of the Virgin Mary
1375–1400

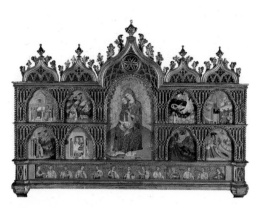

NG 4250
Tempera on wood, 75 x 46.8 cm

NG 4250, detail

Charles-François DAUBIGNY
River Scene with Ducks
1859

NG 2622
Oil on oak, 20.3 x 40 cm

Inscribed on the centre panel: MARIA. /(MATE)R. HVM/ (ili)S (or perhaps better, [ilitati]s) (Mary Mother of Humility); on the outer left panel, top: .S./ IVACHI/NVS.; bottom: .S. ANA., and S/IVACH/INV[S].; on the inner left panel, top: .SIV/ACHI/NVS.; bottom: .S. ANA., and MP. ΘY. (= MHTHP ΘEOY)(Mother of God); on the inner right panel, top: Vis. mo/rtem. e/uader/e. conc/(ep)cioe[n]em. Virg/inis. ce/lebra/bis. /vi. i/dus / dec (If you want to escape death celebrate the [immaculate] Conception of the Virgin on 8 December; literally the sixth day before the Ides of December); bottom: MP.ΘY.; on the outer right panel, top: quando cho[m]/prasemo/ le pare/dare [lira]; bottom: MP. ΘY.; on the predella, on Christ's book: E(G)O S/ON (=SUM) LV/X. MO/ NDI. / VIA./ VER./ITA/S. ET/VIT(A). (I am the light of the world, the way, the truth and the life) New Testament (John 8: 12; 14: 6); the apostles' names from left to right: S./ FELI/PV[S]., S./ MATEV[S]., (S. JAC)HOBV[S]./ MINOR., .S./ .MATIA., .S./ .IACHOBV[S]., .S./ .PETRV/(S)., .S./ .IOVAN(NES) (E)/VA[NGELISTA]., S./.BARTO/LOME/V[S]., S. .ANDRE/AS, .S./ TADEV[S]., S. SIMON, S/T(OMASUS).
Centre: the Virgin and Child. Left side: story of the Birth of the Virgin – Saint Joachim's offering rejected; the Angel appearing to Saint Joachim; the Meeting at the Golden Gate; the Birth of the Virgin. Right side: Miracles of the Virgin connected with the Feast of the Conception – Helsinus saved from shipwreck; Helsinus preaching in favour of the celebration of the Conception; a French canon drowned by devils; the canon restored to life by the Virgin. Predella: Christ and the twelve apostles.

NG 4250 may have been planned with reference to the theme of the Immaculate Conception of the Virgin. The two rarely depicted miracles of the Virgin represented are given in additions to *The Golden Legend*. The central panel represents the Madonna of Humility. The altarpiece has previously been catalogued as Venetian, but seems to be Dalmatian, and to date from the end of the fourteenth century.
The frame is probably late nineteenth century.

William Graham sale, 8 April 1886 (lot 224), bought by Clifford; bequeathed by H.E. Luxmoore, 1927.

Gordon 1988, pp. 10–13.

Signed and dated: Daubigny 1859.
The river depicted here is thought to be the Oise, near Auvers. The object in the right middle distance is probably the artist's boat, *Le Botin*, a studio boat from which he painted many river scenes in the open air.

Alexander Young collection, 1906; Salting Bequest, 1910.

Davies 1970, pp. 42–3; Hellebranth 1976, p. 92, no. 257.

Charles-François DAUBIGNY
1817–1878

Daubigny was trained by his father and he first worked as a painter of ornaments and as an engraver. He travelled to Italy in 1836 and exhibited at the Salon from 1838. A landscape painter, he travelled widely through France, sometimes working in the company of Corot.

Charles-François DAUBIGNY
The Garden Wall
1860–78

Charles-François DAUBIGNY
Honoré Daumier
probably 1870–6

Charles-François DAUBIGNY
Alders
1872

NG 2624
Oil on oak (?), 18.7 x 35.9 cm

NG 3245
Oil on canvas, 76.2 x 62.9 cm

NG 2623
Oil on mahogany (?), 33 x 57.1 cm

Signed: Daubigny
 NG 2624 has in the past been entitled 'Outskirts of a Village'. The site is probably either in, or near, Auvers-sur-Oise where the artist lived from 1860.

Salting Bequest, 1910.

Davies 1970, p. 43; Hellebranth 1976, p. 60, no. 161.

Inscribed on the stretcher: Portrait de H. Daumier par Daubigny/ acheté à Auvers-s-oise le 10 8bre 1911 aux Vallées/G.C (Portrait of H. Daumier by Daubigny/ bought at Auvers-s-oise on 10 October 1911, at Les Vallées [see below]/ G. C. [see provenance]).
 The identity of the sitter is secured by comparison with other documented portraits of Daumier, the painter and caricaturist (see Daumier NG 3244). The portrait probably dates from after 1870.
 The attribution to Daubigny seems acceptable. The two artists were friends and from 1874 Daumier lived at Valmondois near Daubigny's home at Auvers (the inscription refers to 'Les Vallées', the name of the latter's house).

The G.C. on the inscription may be Camentron who sold the work to Durand-Ruel in 1911; Sir Hugh Lane collection, 1912; Lane Bequest, 1917; on loan to the Hugh Lane Municipal Gallery of Modern Art, Dublin, since 1979.

Davies 1970, p. 44; Hellebranth 1976, p. 331, no. 1009.

Signed and dated lower left: Daubigny 1872.
 Daubigny painted several variants of this composition, including a painting dated 1873 in Glasgow (Art Gallery and Museum).

Salting Bequest, 1910.

Davies 1970, p. 43; Hellebranth 1976, p. 232, no. 707; Bomford 1990, pp. 22–3.

Charles-François DAUBIGNY
Landscape with Cattle by a Stream
1872

Charles-François DAUBIGNY
St Paul's from the Surrey Side
1873

Charles-François DAUBIGNY
View on the Oise
1873

NG 6324
Oil on wood, 35.6 x 66 cm

NG 2876
Oil on oak (?), 44 x 81.3 cm

NG 6323
Oil on wood, 38.7 x 66 cm

Signed and dated: Daubigny 1872
NG 6324 has in the past been titled 'Cattle Grazing. Sunset' and has been identified as a scene on the banks of the river Cure in the Morvan region.

Alexander Young sale, Christie's, 1910; bequeathed by Pandeli Ralli, 1928.

Davies 1970, p. 45; Hellebranth 1976, p. 152, no. 468.

Signed and dated: Daubigny 1873
This view shows St Paul's Cathedral in London in the distance, left of centre. The vantage point of the artist was between Waterloo Bridge and Blackfriars Bridge (which traverses the composition) on the south, or Surrey, side of the river Thames.
NG 2876 is dated as inscribed. The artist was in London in 1866 and in 1870–1 during the Paris Commune.
A work with this title was in the 8th Exhibition of the Society of French Artists, London, 1874.

Alexander Young collection; presented by friends of Mr. J.C.J. Drucker, 1912.

Davies 1970, pp. 43–4; Hellebranth 1976, p. 249, no. 756.

Signed and dated: Daubigny 1873
Daubigny had a house at Auvers and often painted scenes on the river Oise.

Sir Cuthbert Quilter collection by 1898; bequeathed by Pandeli Ralli, 1928.

Davies 1970, p. 45; Hellebranth 1976, p. 122, no. 370.

Charles-François DAUBIGNY
Willows
probably 1874

NG 2621
Oil on canvas, 54.6 x 80 cm

Honoré-Victorin DAUMIER
The Fugitives
about 1850

L44
Oil on wood, 16 x 31 cm

Honoré-Victorin DAUMIER
Don Quixote and Sancho Panza
probably before 1866

NG 3244
Oil on oak, 40.3 x 64.1 cm

Signed and dated: Daubigny 187(?4).
The site has not been identified.
NG 2621 is first recorded this century. The last figure of the date on the inscription seems most likely to be a 4.

Alexander Young collection by 1906; Salting Bequest, 1910.

Davies 1970, p. 42; Hellebranth 1976, p. 305, no. 942.

Signed bottom left: h. Daumier.
Daumier treated this subject many times in drawings, paintings and bronze reliefs. A Republican sympathiser, he is said to have been troubled by the mass deportations that followed the suppression of the Revolution in 1848. However, unlike his lithographs which were often inspired by specific events, Daumier's paintings tend to depict rather generalised subjects. Emigration and displacement were experienced by many in the last century and here the artist offers an expressive image of hardship and suffering.

Béguin; W. Van Horne; on loan from a private collection since 1980.

Maison 1968, I, no. 27; Vincent 1968, pp. 153–4; Barzini 1971, pp. 90–1, no. 34; Ives 1992, pp. 96–7.

NG 3244 is a sketch for a more finished picture painted in 1867/8 (private collection). One of a number of paintings by Daumier based on Cervantes' story of Don Quixote, it shows the knight errant charging a flock of sheep. Sancho Panza, seated on a donkey, appears to be drinking from a gourd.
Traces of an earlier sketch of Don Quixote are still visible in the sky.

Owned by the Dutch Gallery, 1904; Lane Bequest, 1917.

Davies 1970, pp. 45–6.

Honoré-Victorin DAUMIER
1808–1879

Daumier was born in Marseilles. He worked chiefly as a draughtsman, caricaturist and lithographer, but also painted in oil and watercolour and executed some sculptures. As a printmaker he specialised in scenes of political and social satire, whereas his paintings tend to depict more general subjects, often inspired by literature or mythology.

Gerard DAVID
Christ Nailed to the Cross
probably 1480s

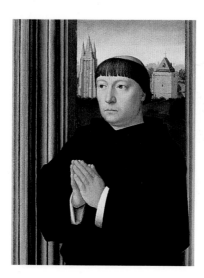

NG 3067
Oil (identified) on oak, 48.3 x 94 cm

This brutal scene is not described in the Bible, although it forms part of a literary and visual tradition (see Pseudo Bonaventura, *Meditations,* and Memlinc's *Passion Scenes* in the Galleria Sabauda, Turin). It illustrates the preparations for the Crucifixion on Golgotha. Christ's clothes have been discarded at the left; soldiers hammer the final nails into his hands and feet, and a figure digs the hole in which the foot of the cross will be placed. Jesus gazes out at the viewer. In the foreground are a bone and a skull which is sniffed at by an inquisitive dog. According to legend Golgotha was also the site of Adam's burial, hence the presence of the skull – this motif which appears in many depictions of the Crucifixion links the old and new dispensations.

NG 3067 may have been the central part of a triptych; the side panels are thought to be the *Pilate and the Jews* and the *Holy Women with Saint John* now in Antwerp (Koninklijk Museum voor Schone Kunsten). The reconstructed triptych is regarded as one of the artist's earlier works, and has usually been dated to the early 1480s. Some of the background figures are copied, directly or indirectly, from an Eyckian *Crucifixion* (now New York, Metropolitan Museum of Art).

Acquired from Count (Ercole?) di Thiene of Vicenza by Sir A.H. Layard, probably in 1860; Layard Bequest, 1916.

Davies 1953, pp. 112–16; Davies 1968, pp. 45–6.

Gerard DAVID
An Ecclesiastic Praying
about 1500

NG 710
Oil on oak, 34 x 26.7 cm

Judging by his habit the sitter may be either an Augustinian hermit or a Cistercian monk. The tower in the background at the left may be that of the church of Our Lady in Bruges; the one at the right may be that of St Salvator.

NG 710 probably originally formed the right wing of a diptych. The other wing would have contained a devotional image.

From the collection of Count Joseph von Rechberg, Mindelheim, 1815; collection of Collection of Prince Ludwig Kraft Ernst von Oettingen-Wallerstein; acquired by the Prince Consort, 1851; presented by Queen Victoria at the Prince Consort's wish, 1863.

Davies 1953, pp. 76–80; Davies 1968, pp. 39–40.

Gerard DAVID
Canon Bernardinus de Salviatis and Three Saints
after 1501

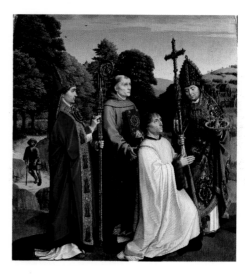

NG 1045
Oil on oak, 103 x 94.5 cm

Saint Martin of Tours is on the left (behind him is the beggar whom he clothed), Saint Bernardino is in the centre with the donor, and Saint Donatian on the right. Saint Martin's cope is decorated with an Adoration of the Magi, a Virgin and Child and other saints. On his morse is Saint Martin, and on his crozier another Virgin and Child. Saint Donatian's morse and cross have, respectively, a Virgin and Child and a Virgin and Child and Saints. On the reverse of the panel is a damaged Christ at a window. The top of the work was originally curved.

The donor is thought to be Canon Bernardinus de Salviatis who in 1501 obtained permission to restore the altar of Saint John the Baptist in St. Donatian, Bruges. This panel is considered to be the left-hand shutter of the altarpiece. No documentation links Salviatis with the painting, but the choice of saints creates a strong association; the donor is presented by his namesake and the patron of the church also appears. No other parts of the altarpiece survive.

Apparently the wings of the altarpiece remained in situ until 1787; acquired by Thomas Barrett, 1792; bequeathed by William Benoni White, 1878.

Davies 1953, pp. 80–7; Davies 1968, pp. 40–1.

Gerard DAVID
active 1484; died 1523

David was born at Oudewater in Holland. In 1484 he joined the Bruges painters' guild, of which he was dean in 1501–2; an altarpiece of 1509 is now in Rouen (Musée des Beaux-Arts). He was probably the 'Gerard of Bruges' who became a master of the Antwerp guild in 1515. His work is particularly indebted to Hugo van der Goes.

Gerard DAVID
The Virgin and Child with Saints and Donor
probably 1510

Gerard DAVID
The Deposition
1515–23

Gerard DAVID
The Adoration of the Kings
1515–23

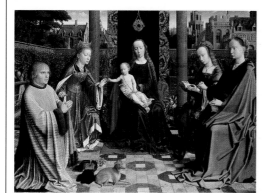

NG 1432
Oil (identified) on oak, 106 x 144.1 cm

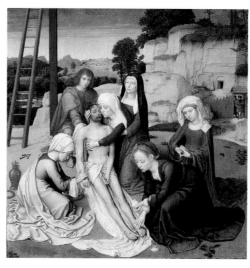

NG 1078
Oil (identified) on oak, 62.9 x 62.2 cm

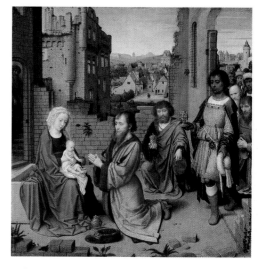

NG 1079
Oil (identified) on oak, 59.7 x 58.4 cm

Inscribed on the jar held by the Magdalen: M (?)MA .
On her headband: MAGDALEN.

The Virgin and the Christ Child are enthroned in a walled garden (the *hortus conclusus*, a metaphor for her virginity). He gives a ring to Saint Catherine, whom, according to legend, Christ mystically married; her attributes, a wheel and sword, rest between them. Seated on the right is Saint Barbara, whose attribute, a tower, appears on her head-dress and again in the townscape, perhaps intended for Bruges, behind her. The half-length figure of Saint Anthony Abbot can be seen next to the pillar. The Magdalen with an ointment jar faces the kneeling donor. At the extreme left an angel picks grapes. The vine trained around the garden has eucharistic significance, while the flowers near the throne – an iris, lilies and roses – are associated with the Virgin. The donor's staff, which lies beside his prayer book and hat, is surmounted by an image of the Trinity.

The arms on the greyhound's collar identify his master as Richard de Visch van Capelle, canon and cantor of St Donatian, Bruges. In 1500 he sought to restore its chapel of Saint Anthony; NG 1432 was almost certainly intended for the altar of Saint Catherine there. It is comparable to David's Rouen altarpiece of 1509.

Stated to have remained in situ until 1793; bequeathed by Mrs Lyne Stephens, 1895.

Davies 1953, pp. 96–105; Davies 1968, pp. 44–5; Wyld 1979, pp. 51–65; Dunkerton 1991, p. 386.

Inscribed on the head-dress of the Magdalen: M.A.M.A. Ma(ria) Ma(gdalena).

This event is not described in the Bible, but forms part of a long pictorial tradition. Christ's body, which has been taken down from the cross, is embraced by the Virgin who is supported by Saint Anne(?). Saint John the Evangelist assists at the left. The Magdalen applies ointment to Christ's feet and two Holy Women attend; one washes his wounds and the gesture of the other signifies her grief. In the right background Joseph of Arimathea and Nicodemus walk away from the tomb which is neatly hewn from the rock. On the ground at the left are a ewer and basin, three nails from the cross and the crown of thorns.

This work is similar in style and dimensions to *The Adoration of the Kings* (NG 1079), and is thought to be from the same altarpiece. They appear to date from after 1515 and illustrate an affinity with the palette of Quinten Massys's paintings.

Collection of Karl Aders, 1831; bequeathed by Mrs Joseph H. Green, 1880.

Davies 1953, pp. 88–91; Davies 1968, p. 42; Ainsworth 1989, pp. 5–38.

Inscribed on the purse of Balthazar: AW, probably a decorative misuse of the letters alpha and omega (the first and last letters of the Greek alphabet). At the bottom left corner OUVVATER is scratched into the paint. It is considered a much later addition (about 1800?).

The Christ Child sits on his mother's lap within the ruins of a castle, before a townscape. The Virgin rests on a stone manger, while Joseph descends a stairway at the left. The Magi proceed to pay homage and a crowd of onlookers peer in at the right. Caspar kneels before the Virgin (the ox and ass can be seen above his head); a little further back Melchior prepares to make his offering; and Balthazar enters the ruin from the right. In the town beyond people stand in the street and look up at the spectacle. New Testament (John 2: 1–2, 11).

This work and NG 1078 are similar in terms of style and dimensions, and are thought to be from the same altarpiece. They appear to date from after 1515 and illustrate an affinity with the palette of Quinten Massys's paintings.

Collection of Karl Aders , 1831; bequeathed by Mrs Joseph H. Green, 1880.

Davies 1953, pp. 92–6; Davies 1968, pp. 42–3.

Workshop of Gerard DAVID
Saint Jerome in a Landscape
about 1500

Follower of Gerard DAVID
Saint Peter and a Male Donor
about 1525 or later

Follower of Gerard DAVID
Saint Paul and a Female Donor
about 1525 or later

NG 2596
Oil on oak, 35.2 x 23.5 cm

NG 657.1
Oil on oak, 81.3 x 26.7 cm

NG 657.2
Oil on oak, 81.3 x 26.7 cm

Inscribed on the cross: inri.

Saint Jerome as a penitent kneels before a crucifix in a landscape which includes a lake and tower. His lion, from whose paw the saint had removed a thorn, rests on the path. The saint has a stone in his hand and wounds on his chest which indicate his self-chastisement. Behind him lie his red cardinal's hat and gown.

The origin of the panel remains unknown; it is considered a product of the artist's workshop.

Léon Somzée collection, Brussels, by 1882; Salting Bequest, 1910.

Davies 1953, pp. 105–8; Davies 1968, pp. 46–7.

The unidentified donor wears a fur-lined garment and has two rings on his left hand. He is presented by Saint Peter, who holds his attribute – the key to heaven. A cloudscape is painted behind the figures. On the reverse of the panel Saint Jerome, dressed as a cardinal, is depicted in a niche, in grisaille.

NG 657.1 and 657.2 are shutters from the same triptych; this work would have been joined at the right to the now lost central devotional panel. They are considered the work of a weak follower of David and are dated, because of the costume of the donors, to about 1525 or later.

From a collection at 's Hertogenbosch; bought with the Edmond Beaucousin collection, Paris, 1860.

Davies 1953, pp. 73–6; Davies 1968, p. 48.

The unidentified donatrix wears a furred dress and a white head-dress; a rosary hangs from her belt. She is presented by Saint Paul, who carries his attribute, a sword. A cloudscape is painted behind them. On the reverse of the panel Saint Nicholas is depicted in a niche, in grisaille. He is shown restoring three children to life.

NG 657.2 and 657.1 are shutters from the same triptych; this work would have been joined at the left to the now lost central devotional panel. They are considered the work of a weak follower of David and are dated, because of the costume of the donors, to about 1525 or later.

From a collection at 's Hertogenbosch; bought with the Edmond Beaucousin collection, Paris, 1860.

Davies 1953, pp. 73–6; Davies 1968, p. 48.

Jacques-Louis DAVID
Portrait of Jacobus Blauw
1795

NG 6495
Oil on canvas, 92 x 73 cm

Inscribed on the paper: J. BLAUW, ministre Plénipotentiaire [aux?] Etats Généraux des provinces unies (Jacobus Blauw, Plenipotentiary minister to the States General of the United Provinces.) Signed and dated bottom left: L. DAVID 4 (the '4' refers to the fourth year of the French Republic, i.e. 1795).

Jacobus Blauw (1756–1829) was a leading Dutch patriot, who helped establish the Batavian Republic in 1795. After the French army invaded the Netherlands, he was involved in negotiating a peace settlement in Paris. Only after the Treaty of The Hague of 16 May 1795 was he officially recognised as Ministre Plénipotentiaire. He later served as such in Venice, Genoa and Turin. After the fall of Napoleon, Blauw, who had acquired French citizenship, retired to Paris where he died.

NG 6495 was probably commissioned following the sitter's recognition as Ministre Plénipotentiaire in May 1795. The artist was, however, imprisoned between 29 May and 3 August of that year, and so probably did not work on the painting until October or November. A letter from the sitter, thanking David for the portrait, is dated *8 Frimaire An IV* (29 November 1795).

Descendants of the sitter, France; bought, 1984.

National Gallery Report 1982–4, pp. 36–7; Leighton 1987, pp. 3–27.

Jacques-Louis DAVID
1748–1825

David was taught by Vien, and studied in Rome from 1775 to 1780. He became a member of the Académie in 1783 before taking an active role in the Revolution. He was elected a Deputy, and then after Robespierre's execution was imprisoned. He later became First Painter to Napoleon, but following the latter's fall, sought exile in Brussels.

Jacques-Louis DAVID
Portrait of the Vicomtesse Vilain XIIII and her Daughter, 1816

NG 6545
Oil on canvas, 95 x 76 cm

Signed and dated: L. David 1816. BRUX.

Like David, the Vicomtesse Vilain XIIII (born Sophie-Louise-Zoë de Feltz, 1780–1853), who is shown with her five-year-old daughter, Louise, was associated with the Napoleonic cause. Her husband, Philippe Vilain XIIII, had been mayor of Ghent and was ennobled by Napoleon in 1811 (the numerals stem from an ancestor who had presented Louis XIV with the keys of the city of Ghent). The Vicomtesse was formerly lady-in-waiting to the Empress Marie-Louise and had held Napoleon's son at his baptism. She was later *dame d'honneur* to Queen Louise-Marie, wife of Leopold I, King of the Belgians.

NG 6545 dates from 1816, the first year of David's exile in Brussels after the fall of Napoleon. It seems likely that the painter, much fêted in Brussels, was introduced to Sophie Vilain by her father, who was president of the Académie. During his exile David painted several former revolutionaries and supporters of Napoleon and he maintained close links with the Bonaparte family.

The Vicomtesse described the experience of sitting for David in a series of letters to her husband. She complained about the length of the sittings and became irritated by David's fastidious approach. Eventually, however, the Vicomtesse conceded that the portrait was not only a good likeness but a beautiful piece of painting.

By descent in the family of the sitters until 1993; bought, 1994.

David 1880, p. 650; Cantinelli 1930, p. 114, no. 148; Wildenstein 1973, p. 206, no. 1798, p. 227, no. 1938; Schnapper 1980, pp. 289–90; Schnapper 1989–90, pp. 514–15; National Gallery Report 1993–4, pp. 12–13.

Attributed to Antonio DE BELLIS
The Finding of Moses
1645–55

NG 6297
Oil on canvas, 91.5 x 131.4 cm

Pharaoh ordered the death of all male infants, and so Moses' mother hoping to save her child hid him in a basket of bulrushes on the river. Pharaoh's daughter with her attendants found him, and his sister, who had been watching, offered to find him a nurse, and thus succeeded in returning him to his mother. Old Testament (Exodus 2: 1–10).

NG 6297 was formerly catalogued as by Cavallino and then attributed to Domenico Gargiulo. The landscape is close to Gargiulo but the figures strongly suggest that the whole work is by De Bellis.

Apparently in the collection of Lord Darnley, Cobham Hall, 1808; bought from Julius Weitzner, 1959.

Levey 1971, pp. 107–8.

Antonio DE BELLIS
mid–1610s–about 1660

According to De Dominici, the eighteenth-century biographer of Neapolitan artists, De Bellis was a pupil of Stanzione. In the late 1630s he painted a set of canvases illustrating the life of Saint Charles Borromeo for the Neapolitan church of S. Carlo alle Mortelle. His style is similar to Cavallino's.

Cornelis DECKER
A Cottage among Trees on the Bank of a Stream
1669

NG 1341
Oil on canvas, 65.2 x 77.5 cm

Hilaire-Germain-Edgar DEGAS
Young Spartans Exercising
about 1860

NG 3860
Oil on canvas, 109.2 x 154.3 cm

Hilaire-Germain-Edgar DEGAS
Princess Pauline de Metternich
about 1865

NG 3337
Oil on canvas, 40 x 28.8 cm

Signed and dated at the bottom, right of centre: C.D. 1669.
This is typical of Decker's landscapes in the manner of Jacob van Ruisdael.

Perhaps bought in Paris by Edward Habich, before 1881; bought from the Habich collection, Cassel, 1891.

MacLaren/Brown 1991, p. 98.

The subject is probably based on Plutarch's *Life of Lycurgus*. Degas described the subject as 'young girls and young boys wrestling in the Plane-tree grove, under the eye of the aged Lycurgus, beside the mothers'. Lycurgus, the legislator of ancient Sparta, ordered girls to engage in contests of wrestling. Lycurgus and the Spartan mothers are in the background, and beyond them the city of Sparta can be seen and the precipitous rock from which malformed Spartan infants were thrown.

NG 3860 is among the most significant of Degas's attempts at history painting. It was probably begun in 1860, and might have been reworked on several occasions until about 1880. It was listed in the catalogue of the 1880 Impressionist exhibition but, for unknown reasons, was not shown.

Numerous drawings and studies survive for the composition and for individual poses. An abandoned version of this subject (Chicago, Art Institute) was followed by a small, preparatory oil sketch (Cambridge, Massachusetts, Fogg Art Museum) for NG 3860. Degas paid particular attention to the grouping of the figures, making many alterations, some of which remain visible in the final picture.

Degas studio sale, 1918; collection of Jacques Seligmann by 1921; Goupil Gallery by 1923, from where bought by the Trustees of the Courtauld Fund, 1924.

Lemoisne 1946, II, p. 34, no. 70; Davies 1970, pp. 48–51; Boggs 1988, pp. 98–100; Thomson 1988, pp. 40–8.

Stamped signature of the Degas studio sale: Degas
Princess Pauline de Metternich was the wife of the Austro-Hungarian ambassador at the court of Napoleon III. Degas based this portrait on a photograph of 1860 by Eugène Disderi (1819–89) that the Prince and Princess used as a visiting card. The floral wallpaper background was the artist's own invention.

Presented by the NACF, 1918, having been bought in the same year at the first Degas studio sale.

Lemoisne 1946, II, p. 46, no. 89; Davies 1970, pp. 47–8; Sutton 1986, p. 80; Kendall 1989, p. 28.

Cornelis DECKER
before 1623; died 1678

Decker was active in Haarlem by 1643 and there are a number of signed pictures from 1649 onwards. He was principally a landscape painter in the style of Jacob van Ruisdael, but he also imitated Philip Wouwermans and Jan Wijnants and painted a number of peasant scenes.

Hilaire-Germain-Edgar DEGAS
1834–1917

Degas studied at the Ecole des Beaux-Arts (1855), and was subsequently in Italy (1856–9). From the late 1860s he specialised in scenes of contemporary life, including the ballet, *café-concerts* and race courses, and his work was represented in all but one of the Impressionist group shows. In later life, and with failing eyesight, he worked mainly in pastel and became increasingly interested in sculpture.

Hilaire-Germain-Edgar DEGAS
Beach Scene
probably 1868–77

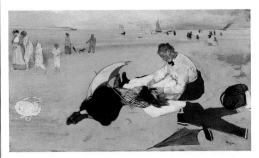

NG 3247
Oil (identified) on paper, three pieces, mounted on canvas, 47 x 82.6 cm

Signed: Degas
 This picture was first exhibited at the third Impressionist exhibition in Paris in 1877 with the title 'Bains de mer; petite fille peignée par sa bonne' (Sea-bathing. Young girl being combed by her maid).
 Traditionally the picture has been dated 1876/7, but it may have been painted as early as the late 1860s. Degas's treatment of this popular subject is quite distinct from the 'open air' beach scenes of Boudin and Monet and the central group was probably painted from models in the studio. Their poses are apparently based on an allegorical painting designed by Mantegna and executed by Lorenzo Costa, which Degas would have seen in the Louvre.

Collection of Henri Rouart, Paris, by 1877; bought by Sir Hugh Lane, 1912; Lane Bequest, 1917.

Lemoisne 1946, II, p. 222, no. 406; Davies 1970, pp. 46–7.

Hilaire-Germain-Edgar DEGAS
At the Café Châteaudun
about 1869–71

NG 6536
Oil on paper laid down on card, 23.5 x 19.5 cm

Two men are seated at a café table, examining what appears to be a newspaper or a menu; the man on the right holds a magnifying glass and his elder companion wears a monocle. Degas captures their gestures and expressions with a pictorial shorthand that borders on caricature and recalls his enthusiasm for the work of Daumier.
 The café and *café-concert* eventually became one of Degas's preoccupations and the unpretentious setting of NG 6536 looks forward to pictures like *At the Café* of about 1876–7 (Cambridge, Fitzwilliam Museum).

Charles Vignier, Paris; his sale, Drouot, Paris, 21 May 1931 (lot 7); Sam Salz, New York, by 1958; sale, Sotheby's, London, 30 March 1966 (lot 9); bought by Mr and Mrs Charles Wilmers; by whom presented, 1991.

Vollard 1937, pl. 48; Lemoisne 1946, I, p. 110, no. 215; Reff 1976, I, pp. 110ff.; National Gallery Report 1991–2, pp. 14–15.

Hilaire-Germain-Edgar DEGAS
Portrait of Elena Carafa
probably about 1875

NG 4167
Oil on canvas, 69.8 x 54.6 cm

Elena Carafa (1855–1925) was a first cousin of Degas on the Italian side of his family (she was the daughter of Stefanina, Duchess de Montejasi-Cicerale, the youngest sister of Degas's father).
 Degas made several trips to Italy in the 1870s and NG 4167 may have been painted in 1875 when he visited his relatives in Naples. His visit was occasioned by the funeral of his uncle, and the predominantly black dress of Elena Carafa may indicate that she is in mourning.
 An X-radiograph reveals that the sitter's head was originally turned towards the right. Traces of the earlier outline of her hair are still visible on the left.

Collection of Vincent Imberti, Bordeaux; collection of Paul Rosenberg, Paris; from whom bought by the Trustees of the Courtauld Fund, 1926.

Lemoisne 1946, II, p. 168, no. 327; Boggs 1962, p. 124; Davies 1970, pp. 53–4; Boggs 1988, pp. 252–4; Kendall 1989, p. 29.

Hilaire-Germain-Edgar DEGAS
Miss La La at the Cirque Fernando
1879

NG 4121
Oil on canvas, 116.8 x 77.5 cm

Signed: degas
 The acrobat Miss La La caused a sensation at the Cirque Fernando in Paris (on the corner of the boulevard Rochechouart and the rue des Martyrs), performing various feats of strength. In NG 4121 Miss La La is suspended from the rafters of the circus building by a rope clenched between her teeth.
 Degas sketched at the Cirque Fernando in January 1879, and made several studies, including a pastel study of Miss La La (London, Tate Gallery), before embarking on NG 4121.
 NG 4121 was exhibited in April 1879 at the fourth Impressionist exhibition.

Acquired from Degas by Durand-Ruel, 1904; bought by the Trustees of the Courtauld Fund, 1925.

Lemoisne 1946, II, p. 294, no. 522; Davies 1970, pp. 51–3; Pickvance 1979, p. 47, no. 47.

Hilaire-Germain-Edgar DEGAS
Hélène Rouart in her Father's Study
about 1886

NG 6469
Oil on canvas, 161 x 120 cm

Stamped signature of the Degas studio sale: Degas
 Hélène Rouart, the only daughter of Degas's lifelong friend the industrialist Henri Rouart (1833–1912), is shown in the family house on the rue de Lisbonne in Paris. She is surrounded by objects from her father's collection: three Egyptian wood statues, a Chinese wall-hanging, an early oil study by Corot of the Bay of Naples and the Castello dell'Ovo, and a drawing by Millet of a seated peasant girl.
 NG 6469 was painted in about 1886. Originally Hélène's mother was to be included (she is seen in preparatory sketches), but she was probably omitted from the finished painting because of ill-health.

Bought at the first Degas studio sale, 1918, by Paul Rosenberg; bought by René Gimpel, 1924; bought by private treaty from his son, Peter Gimpel, 1981.

National Gallery Report 1980–1, pp. 46–9; Gordon 1984; Kendall 1989, pp. 18–23.

Hilaire-Germain-Edgar DEGAS
After the Bath, Woman drying herself
probably 1888–92

NG 6295
Pastel on paper mounted on cardboard, 103.8 x 98.4 cm

Stamped signature of the Degas studio sale: Degas
 In the late 1880s and 1890s Degas produced a large number of studies of women combing their hair, or sponging and drying themselves. This pastel is executed on several pieces of paper mounted on cardboard and probably dates from about 1888–92. The pose of the model, viewed from the back, is repeated with variations in a sequence of related pastels and charcoal drawings.

Degas studio sale, 1918; collection of Georges Viau by 1942; collection of Harry Walston by 1951; from whom bought, 1959.

Lemoisne 1946, III, p. 554, no. 955; Davies 1970, p. 55.

Hilaire-Germain-Edgar DEGAS
Ballet Dancers
probably 1890–1900

NG 4168
Oil on canvas, 72.4 x 73 cm

Stamped signature of the Degas studio sale: Degas
 Dance classes and rehearsals were the theme of many of Degas's later paintings and drawings.
 Although traditionally catalogued as a work of the 1880s, NG 4168 probably dates from the 1890s and relates to a group of drawings and paintings by Degas (e.g. *Ballet Class*, Zurich, Bührle Collection). The pose of the foreground dancer adjusting her slipper is repeated in several paintings and a sculpture.
 The broad handling and the use of a coarse canvas are typical of Degas's later work (see also NG 4865).

Degas studio sale, 1918; bought by the Trustees of the Courtauld Fund, 1926.

Lemoisne 1946, II, p. 332, no. 588; Davies 1970, p. 54.

Hilaire-Germain-Edgar DEGAS
Combing the Hair (La Coiffure)
about 1896

NG 4865
Oil on canvas, 114.3 x 146.1 cm

Degas painted this subject many times in his later years.
 This picture was probably painted in about 1896 and is based on several drawings and an earlier pastel. The palette is dominated by an orange-red and Degas has worked within a limited range of colour. The bold treatment and unfinished appearance are typical of Degas's late work.

Degas studio sale, 1918; collection of Henri Matisse, probably by about 1921; sold to Pierre Matisse, about 1936; from whom bought, 1937.

Lemoisne 1946, III, p. 654, no. 1128; Davies 1970, pp. 54–5; Boggs 1988, pp. 553–4.

Ferdinand-Victor-Eugène DELACROIX
Abel Widmer
about 1824

NG 3287
Oil on canvas, oval, perhaps adapted from a smaller rectangle, 59.7 x 48.3 cm

In the 1820s Delacroix was commissioned by Prosper Parfait Goubaux, the founder of a boys' secondary school in Paris, to paint portraits of his pupils who won prizes in the *Concours général*.
 The portrait of Abel Widmer (1805–38) dates from about 1824, and was probably the first of ten such portraits by Delacroix that hung in the reception room at the school until Goubaux's death in 1859. Abel Widmer won a second prize in mathematics in 1824; he later became an industrialist.

Collection of Prosper-Parfait Goubaux by 1859; Degas collection by 1907; bought with a special grant at the Degas sale, 1918.

Davies 1970, pp. 56–7; Johnson 1981–9, I, p. 47, no. 71.

Ferdinand-Victor-Eugène DELACROIX
1798–1863

Delacroix was born in Charenton-St-Maurice (Val de Marne) but moved to Paris in 1805. A student of Guérin from 1815, he first exhibited at the Salon in 1822 and was soon hailed as the leader of the Romantic school. He visited England in 1825, Morocco and Algiers in 1832. The range of his work is extraordinary, embracing literary and mythological subjects, as well as portraits, animal studies and still lifes.

Ferdinand-Victor-Eugène DELACROIX
Louis-Auguste Schwiter
1826–30

NG 3286
Oil on canvas, 217.8 x 143.5 cm

Signed: Euge Delacroix.
Louis-Auguste (later Baron) Schwiter (1805–89) was a landscape and portrait painter. He exhibited a portrait of Delacroix at the Salon of 1833.
NG 3286 was painted in 1826 but rejected by the Salon in 1827. Delacroix made several changes (X-radiographs show that the perspective of the balustrade was altered) and the portrait was finally completed in 1830. The landscape background is said to have been painted by Delacroix's friend, the landscape painter Paul Huet (1803–69). Delacroix apparently made some preparatory sketches for the portrait (present whereabouts unknown) and also produced a lithograph and a pen and ink drawing of Schwiter (both 1826).
Since it was painted soon after Delacroix's return from England NG 3286 is sometimes said to show the influence of Sir Thomas Lawrence, whose work Delacroix particularly admired.

Sold from the estate of Baron Schwiter, 1890; collection of Edgar Degas by 1907; bought with a special grant at the Degas sale, 1918.

Davies 1970, p. 56; Johnson 1981–9, I, pp. 54–6, no. 82.

Ferdinand-Victor-Eugène DELACROIX
Christ on the Cross
1853

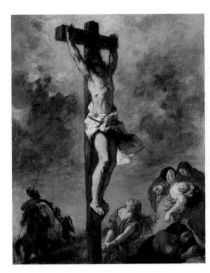

NG 6433
Oil on canvas, 73.5 x 59.7 cm

Signed and dated at the foot of the cross: Eug. Delacroix 1853
Mary Magdalene mourns at the foot of the cross, the Virgin has fainted behind her. Soldiers are visible in the left background.
Delacroix tackled this subject several times throughout his career and most notably in a painting of 1846 (Baltimore, Walters Art Gallery). This was perhaps inspired by Rubens's *'Le Coup de Lance'* (Antwerp, Museum Schone Kunsten; see NG 1865) and by Prud'hon's *Christ on the Cross* (Paris, Louvre).

Beugniet or Bocquet collection, 1853; Baron Denys Cochin by 1910; bought, 1976.

Johnson 1981–9, III, p. 240, no. 460.

Ferdinand-Victor-Eugène DELACROIX
Ovid among the Scythians
1859

NG 6262
Oil on canvas, 87.6 x 130.2 cm

Signed and dated lower right: Eug. Delacroix. /1859.
The subject of NG 6262 was described in the catalogue of the Salon of 1859: 'Ovid in exile among the Scythians. Some of them examine him with curiosity. Others welcome him in their own manner, offering wild fruit and mare's milk.' The Roman poet Ovid was banished from Rome to Tomis, a port on the Black Sea near the present-day town of Constantza, in AD 8 by order of the Emperor Augustus. The milking of a mare, shown in the foreground, illustrates the Roman belief that the natives of this region, the Scythians, fed on mares' milk.
Delacroix first painted this subject in 1844 as part of his decorations for the ceiling of the Deputies' Library in the Palais Bourbon in Paris. He started work on this composition in about 1855 (in an oil sketch, whereabouts unknown) and was commissioned to paint this canvas in 1856 by Benoît Fould. He finished the picture in 1859, but Fould had died and the picture went to his widow and subsequently to his niece, Madame de Sourdeval.
There are several related pencil studies (seven of which are at Poitiers, Musée des Beaux-Arts). Delacroix painted a smaller variant of NG 6262 in 1862 (private collection). The choice of subject was possibly inspired by Chateaubriand's *Les Martyrs* published in 1809.

Collection of Madame de Sourdeval by 1892; bought, 1956.

Davies 1970, pp. 58–60; Johnson 1981–9, III, pp. 150–2, no. 334.

Paul DELAROCHE
The Execution of Lady Jane Grey
1833

Dirck van DELEN
An Architectural Fantasy
1634

DELFT
An Interior, with a Woman refusing a Glass of Wine, probably 1660–5

NG 1909
Oil on canvas, 246 x 297 cm

NG 1010
Oil on mahogany, 46.7 x 60.5 cm

NG 2552
Oil on canvas, 117 x 92 cm

Signed and dated: Paul DelaRoche 1833.

The seventeen-year-old Lady Jane Grey is guided to the block by Sir John Brydges, Lieutenant of the Tower. Two of her grieving handmaidens are shown at the left. Lady Jane Grey was the great-granddaughter of Henry VII and, following the death of Edward VI in 1553, reigned for nine days as Queen. She was deposed by the supporters of the Catholic Queen Mary and tried for treason. She was beheaded at Tower Hill on 12 February 1554.

NG 1909 was probably commissioned by the Russian collector Comte Anatole Demidoff; it was shown at the Salon of 1834. The Salon catalogue specifies Delaroche's source as a Protestant Martyrology published in 1588.

Comte Anatole Demidoff; Demidoff sale; bequeathed by the Second Lord Cheylesmore 1902.

Signed and dated at the base of the twisted column in the left foreground: D. V. DELEN. F. 1634.

The fountain in the foreground is surmounted by a small gilt statue of Hercules fighting Hydra. Two of the other statues may represent Mercury and Minerva.

The figures in NG 1010 are by another painter. It has been suggested that he was Anthonie Palamedesz. (1601–73) or Jan Olis.

Wynn Ellis collection by 1864; Wynn Ellis Bequest, 1876.

MacLaren/Brown 1991, pp. 99.

The picture above the fireplace appears to be based on a print of *Abraham liberating his Nephew Lot* by Antonio Tempesta. The legs of the fire-dog are decorated with sea-horses.

The attribution of NG 2552 has been much discussed. It has been·said to be by Pieter de Hooch, Johannes Vermeer, Hendrick van der Burch (1627–after 1666) and Carel Fabritius but none of these attributions is persuasive. Most recently the name of Ludolf de Jongh (1616–76) has been mentioned. The painting appears to be the work of an artist active in Delft between 1655 and 1665. It has analogies with the interiors painted by Vermeer and de Hooch and can be related to the experiments with perspective painting associated with the circle of Fabritius. It should probably be placed in the first half of the 1660s.

The highlights of the fire-dog and parts of the gilt leather wall-hanging are rendered in gold leaf.

Pierre Grand-Pré sale, Paris, 16–24 February 1809 (lot 103); Salting Bequest, 1910.

MacLaren/Brown 1991, pp. 99–101.

Paul DELAROCHE
1795–1856

Delaroche was born in Paris. He was a pupil of Watelet (1816) and of Gros (from 1818). He exhibited at the Salon from 1822 to 1837 and was awarded many official commissions. He enjoyed popular success in the 1830s with his large-scale pictures of modern historical subjects, although he met increasing critical resistance in his later years.

Dirck van DELEN
1604/5–1671

Van Delen was born in Heusden and may have been taught by Hendrick Aertsz., a painter of architectural fantasies. By 1626 he had settled in Arnemuiden, near Middelburg, where he worked for the rest of his life. He painted imaginary architecture, particularly church interiors and palaces, in a style influenced by that of Hendrick van Steenwyck the Younger.

Jean-François DETROY
Time unveiling Truth
1733

Jean-François DETROY
Jason swearing Eternal Affection to Medea
1742–3

Jean-François DETROY
The Capture of the Golden Fleece
1742–3

NG 6454
Oil on canvas, 203 x 208 cm

NG 6330
Oil (identified) on canvas, 56.5 x 52.1 cm

NG 6512
Oil on canvas, 55.6 x 81 cm

Signed and dated on the globe: De Troy 1733.

The winged figure of Time, holding a scythe in the sky, reveals Truth, his daughter, who is above worldly matters, hence the presence of the globe at her feet. She unmasks an old woman at the right who personifies either Fraud or Deceit. At the left personifications of the four Cardinal Virtues kneel in tribute to Truth. Fortitude rests by a lion which symbolises her courage, while Justice carries a sword and scales which refer to her power and impartiality. Further back Temperance carries a pitcher of water which signifies abstinence, and Prudence carries a snake, an allusion to her wisdom. At the upper right is a building which recalls the Pantheon in Rome.

NG 6454 is dated as inscribed. The original patron remains unknown.

Laetitia Bonaparte (Napoleon's mother); Earl of Shrewsbury collection by 1829; bought from the Estate of the late Dr E. I. Schapiro, 1979.

National Gallery Report 1978–9, pp. 38–9; Wilson 1985, pp. 82–3.

According to Ovid's *Metamorphoses*, Book VII, Jason was sent to steal the Golden Fleece. He was aided by Medea, daughter of the king of Colchis and a sorceress, whom in return he promised to marry. After their adventures he abandoned her, and she killed his new bride and her own children by him. Here he swears affection to her before the altar of Hecate; she is about to give him some magic herbs which will save his life. At the upper left a cupid aims an arrow at the couple.

The subject is the first of a series of seven illustrating the story of Jason executed by Detroy in 1742–3 as modelli for the large cartoons which he later prepared for the Gobelins tapestry works. The modelli were finished by February 1743 and the cartoons by September 1746. The latter were at the Gobelins works by 1752, and over the next 40 years twelve complete or partial sets of tapestries were produced for the Crown. Another of the modelli is in the Gallery (NG 6512).

Along with five other modelli from the series, in the Detroy sale, Paris, 1764; bequeathed by Francis Falconer Madan, 1962.

Wilson 1985, p. 84.

According to Ovid's *Metamorphoses*, Book VII, the dragon guarding the Golden Fleece was put to sleep by Medea's potion so Jason could safely take possession of it. He stands over the dragon holding the fleece, while Medea, a sorceress and his betrothed, stands to the left. In the background at the left are the ships of the Argonauts which are being prepared to take them back to Greece.

This is a modello for the fourth of a series of tapestry designs the artist was commissioned to execute for the Gobelins tapestry works. The series consisted of seven sketches illustrating the story of Jason (the Gallery also has another work from the same series, NG 6330). The Jason modelli were finished by February 1743; the large-scale cartoons were exhibited at the Paris Salon in 1748, and are now in the museums of Angers, Brest, Clermont-Ferrand, Le Puy and Toulouse.

De Troy sale, 1764; presented by Mr and Mrs Eliot Hodgkin through the NACF, 1987.

National Gallery Report 1985–7, pp. 34–5.

Jean-François DETROY
1679–1752

Born in Paris, the son of a portrait painter, Detroy studied in Italy from 1699 to about 1706. He returned to Paris where he had a successful career. In 1738 he was appointed director of the French Academy in Rome, a post he held until his death. He executed both historical and genre paintings.

After DETROY
The Game of Pied de Bœuf
after 1725

Olivier van DEUREN
A Young Astronomer
about 1685

Benedetto DIANA
Salvator Mundi
probably about 1510–20

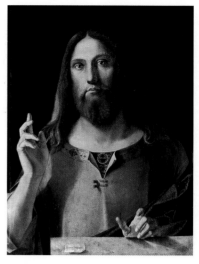

NG 2216
Oil on wood, 33.7 x 27.6 cm

NG 2589
Oil on oak, 15.3 x 12.7 cm

NG 2725
Oil on wood, painted surface 76.2 x 59.1 cm

Inscribed: De Troy.

The game was in origin a children's one, in which the participants put their hands one on top of another, counting upwards from one; whoever had nine had to seize a hand not on the pile and say: 'Je tiens mon pied de bœuf.'

The painting is a copy of an original exhibited at the Salon in 1725; the composition has been inverted and a different background has been added.

Presented by Lt.-Col. George Babington Croft Lyons, 1908.

Davies 1957, p. 81.

The astronomer holds a celestial globe, the stand for which is on the right. The constellations are shown in the form of animals. Among those visible are some of the northern and zodiacal constellations: at the top, Draco; on the left, Ursa Major and, below it, Leo; on the right, beneath the encircling brass ring, Bubuleus. A quadrant is in the foreground. The curtain is intended as a *trompe-l'oeil* representation of a curtain over the picture (see also Pape NG 1221).

NG 2589 has been attributed to Frans Mieris the Elder, and 'Leiden School, second half of the seventeenth century'. It is now considered the work of van Deuren, by comparison with his signed *Astronomer* of 1685 (New York, Christophe Janet, 1978). The model and globe appear to be the same in both works.

In the possession of Messrs Agnew, London; collection of George Salting, London; Salting Bequest, 1910.

MacLaren/Brown 1991, pp. 102–3.

Signed on a cartellino attached to the parapet: Benedictus. diana. pinxit.

The image of the Salvator Mundi (Saviour of the World) was popular in Venice. Christ is shown raising his right hand in a gesture of blessing. The type is close to Previtali's paintings of the subject (see NG 2501 and 3087).

Although the signature has been retouched there is no reason to doubt it.

From the collection of Conte Contin di Castel-Seprio; presented by Sir Claude Phillips in memory of his sister Eugénie, 1910.

Davies 1961, p. 169.

Olivier van DEUREN
1666–1714

Olivier Pietersz. van Deuren was baptised in Rotterdam. A poem addressed to him in 1697 suggests that he was a pupil or follower of Peter Lely, Frans Mieris the Elder and Caspar Netscher. The only two known signed works by him date from 1684 and 1685. He was a *hoofdman* (senior official) of the Rotterdam guild in 1697, 1705, 1709 and 1713, and died in the city.

Benedetto DIANA
active 1482; died 1525

His surname was Rusconi, but Diana was the name used in the signatures on his paintings. He seems to have been trained in the tradition of Gentile Bellini, and was described as a painter from 1482; he was principally active in Venice where he received a number of commissions in the first decade of the sixteenth century.

Narcisse-Virgilio DIAZ de la Peña
Venus and Two Cupids
1847

Narcisse-Virgilio DIAZ de la Peña
Common with Stormy Sunset
1850

NG 2633
Oil on wood, probably mahogany, 37.1 x 54.6 cm

Narcisse-Virgilio DIAZ de la Peña
Sunny Days in the Forest
probably 1850–60

NG 2058
Oil on canvas, 38.7 x 55.9 cm

NG 3246
Oil on canvas mounted on wood, 33.7 x 20.6 cm

Signed and dated: N. Diaz. 47
 NG 3246 is sometimes called 'The Offspring of
Love', but appears to represent the goddess of Love
with two cupids.
 The painting is dated 1847 and is typical of the
small nude figure compositions that Diaz painted
throughout his career and which were much
imitated by artists such as Monticelli.

*Collection of James Staats Forbes, possibly by 1871;
collection of Sir Hugh Lane by about 1906; Lane Bequest,
1917; on loan to the Hugh Lane Municipal Gallery of
Modern Art, Dublin, since 1979.*

Davies 1970, p. 62.

Signed and dated: N. Diaz. 50
 NG 2633 is sometimes called 'The Fisherman'; it
was also described in the nineteenth century as 'The
Sunset'.

*Possibly collection of Ferd Bischoffsheim by 1877;
collection of Alexander Young, probably by 1886;
collection of George Salting, 1907; Salting Bequest, 1910.*

Herbert 1962–3, p. 123, no. 40; Davies 1970, pp. 61–2.

Signed bottom right: N. Diaz
 The title of NG 2058 is traditional. The scene was
probably inspired by the Forest of Fontainebleau,
where Diaz painted a great deal.

*Stated to be from the collection of the Duke of Saxe-
Coburg; presented by Charles Hartree in accordance with
his wishes, 1906.*

Davies 1970, p. 61.

Narcisse-Virgilio DIAZ de la Peña
1807–1876

Diaz was born in Bordeaux of Spanish parents.
From 1822 to 1830 he worked as a porcelain painter.
In the 1830s and 1840s he painted typically
Romantic subjects: bathers, nymphs and Oriental
women. Under the influence of Rousseau he
gradually developed his characteristic landscape
style, working mainly at Fontainebleau.

Narcisse-Virgilio DIAZ de la Peña
The Storm
1871

NG 2632
Oil on mahogany, 62.2 x 76.5 cm

Attributed to DIAZ
Cows at a Pool
1840–76

NG 4579
Oil on wood, probably mahogany, 23 x 34.5 cm

Arent (?) DIEPRAEM
A Peasant seated smoking
about 1650

NG 3534
Oil on oak, 28.5 x 23 cm

Signed and dated: N. Diaz. 71
 The dramatic sky, bold brushwork and colour are typical of Diaz's later work.

Collection of Paul Casimir-Perier by 1892; collection of Alexander Young by 1898; collection of George Salting, 1907; Salting Bequest, 1910.

Davies 1970, p. 61.

Possible remains of Diaz's signature bottom left.
 NG 4579 depicts an unidentified landscape.
 The attribution to Diaz is traditional, and seems plausible.

Probably collection of Sir William Eden by 1918; bequeathed by Hans Velten to the Tate Gallery, 1931; transferred, 1956.

Davies 1970, pp. 62–3.

Signed centre right: A Diepraem.
 This picture may have been meant to be interpreted as a *vanitas*, smoke from the peasant's pipe symbolising the vanity and transience of earthly life. The peasant in a picture of this type is certainly intended as an object of humorous ridicule.
 The blue and grey jug in the foreground is Rhenish stoneware of the seventeenth century and occurs in another picture by Diepraem (private collection).

Collection of B.C. Creasy by 1918; presented by Dr J. Seymour Maynard through the NACF, 1920.

MacLaren/Brown 1991, pp. 103–4.

Arent (?) DIEPRAEM
1622–1670

There are a number of paintings of peasant life signed A. Diepram, the earliest dated 1648 and the latest 1665. They are probably by Arent Diepraem who was born in Rotterdam in 1622 and died there in 1670.

Christian Wilhelm Ernst DIETRICH
The Wandering Musicians
1745

NG 205
Oil on oak, 43.3 x 33 cm

Signed and dated bottom right: Dietricij fecit 1745.
 In the background at the right is an inn with the sign of a jug and compasses. The figures in the foreground play a hurdy-gurdy and a fiddle. The composition appears to be derived from the work of the seventeenth-century Dutch artist Adriaen van Ostade and the style imitates his manner.
 Dietrich himself later made an etching of the composition. It was also engraved by his friend Jean-George Wille (1715–1808) in 1764 (see provenance). In 1761 Wille asked Dietrich to paint a pendant for the work, and this picture, of a woman selling pancakes, reached Paris in 1764.

Almost certainly in the collection of Jean-George Wille, Paris, by June 1761; bequeathed by Richard Simmons, 1846.

Levey 1959, pp. 24–5.

Carlo DOLCI
The Adoration of the Kings
1649

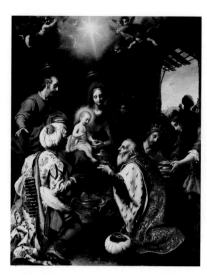

NG 6523
Oil on canvas, 117 x 92 cm

Signed and dated in Latin and Italian on the reverse: ANO/SALVATIS/MDCIL/Al Sig*re* Tommaso generotti,/di mia età il trentesima/terzo/Io carlo dolci/Fiorentino (Year of Salvation 1649. To Signore Tommaso Generotti, in my thirty-third year. I Carlo Dolci, Florentine).
 Various other inscriptions appear on the reverse.
 The Three Kings sought out the Christ Child in the stable where he was born bearing gifts (gold, frankincense and myrrh). They journeyed from the East (suggested here by the inclusion of camels in the background). New Testament (Matthew 2: 10–12).
 NG 6523 is inscribed on the reverse with the name of the patron, Tommaso Generotti, who commissioned the picture for his personal collection. The picture is the largest version of this subject painted by Dolci (other versions are at Glasgow, City Museum and Art Gallery, and Blenheim Palace, Duke of Marlborough collection), and it is exceptionally well-preserved. The composition derives from an altarpiece painted by Santi di Tito in 1596 (now in the church of S. Marcina, Krzeszowice, Poland).

Gerini collection, Florence, seventeenth century; bought, 1990.

National Gallery Report 1990–1, pp. 8–11.

Carlo DOLCI
The Virgin and Child with Flowers
1650–86

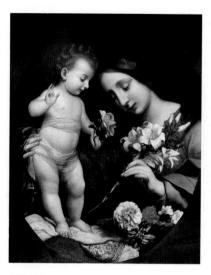

NG 934
Oil on canvas, 78.1 x 63.2 cm

The Virgin holds an entwined branch of lilies and carnations, the Christ Child a red rose. The flowers have a symbolic meaning: the rose is a symbol of martyrdom and of the Passion, and the rose of sorrow suffered by the Virgin. The lily is a symbol of the Virgin's purity.
 Baldinucci recorded four versions of this design and at least four are known to exist. An autograph version in Montpellier (Musée Fabre) is signed and dated 1642; another in Munich (Alte Pinakothek) is signed and dated 1649. NG 934 seems to have been painted after both of these pictures and probably dates from 1650 to 1686.

Walsh Porter collection, London, by 1810; Wynn Ellis Bequest, 1876.

Levey 1971, pp. 89–91; Gaskell 1990, pp. 6–7.

Christian Wilhelm Ernst DIETRICH
1712–1774

Dietrich was born in Weimar. He trained with the landscapist Alexander Thiele in Dresden from about 1724 to 1725, and was appointed court painter to the Elector Frederick Augustus II of Saxony in Dresden in 1741. He visited Italy in 1743. In 1764 he was made professor of the Dresden academy. He painted, etched and decorated porcelain, and was known for his pastiches of seventeenth and eighteenth-century works.

Carlo DOLCI
1616–1686

Dolci was born and died in Florence, where he was the leading portraitist and painter of devotional pictures. He worked for the Grand Ducal Court, the English Resident and visitors to Florence. His technique was painstakingly slow. Many of his works are known in multiple versions.

DOMENICHINO
The Vision of Saint Jerome
before 1603

DOMENICHINO
Saint George killing the Dragon
about 1610

DOMENICHINO
Landscape with Tobias laying hold of the Fish
about 1610–13

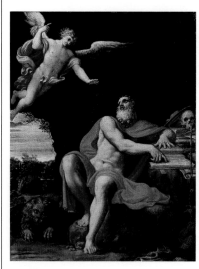

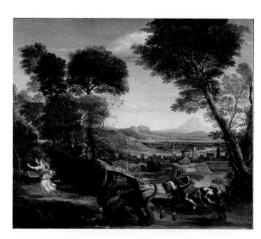

NG 75
Oil (identified) on wood, 52.7 x 61.8 cm

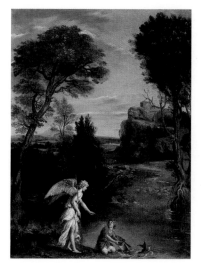

NG 85
Oil on canvas, 51.1 x 39.8 cm

NG 48
Oil (identified) on copper, 45.1 x 33.9 cm

Saint Jerome (about 342–420) translated the Bible into Latin. He spent several years as a penitent in the Syrian desert, and is depicted here in the wilderness, accompanied by the tame lion which his legend associates with him, receiving divine inspiration in the form of an angel.

NG 85 is one of the two earliest documented paintings by Domenichino. It was recorded in 1603 in Cardinal Aldobrandini's collection in Rome, and must have been painted shortly after the artist's arrival in the city in 1602.

The artist also treated the subject later (London, Sir Denis Mahon collection). NG 85 notably illustrates the influence of Annibale Carracci on Domenichino (see Carracci NG 194). X-radiographs reveal a standing figure behind the saint.

Inventory of Cardinal Pietro Aldobrandini's collection, Rome, 1603; Holwell Carr Bequest, 1831.

Levey 1971, pp. 95–6; Spear 1982, p. 126.

The legend of Saint George is recounted in Jacopo de Voragine's *The Golden Legend* and elsewhere. Saint George rescued a princess who had been sacrificed to appease the dragon which was terrorising the inhabitants of a city. He is shown charging the beast while the princess flees to the left.

NG 75 is considered to be an early work by the artist, probably of the period 1610–11, or a little before.

Elements of the landscape, including the town, may be derived from north Italian, or northern European, precedents.

Arthur Champernowne sale, Christie's, 30 June 1820 (lot 38); Holwell Carr Bequest, 1831.

Levey 1971, pp. 93–5; Spear 1982, p. 127.

The angel commands Tobias to catch the fish which attacked him in the river Tigris. Subsequently the boy used its gall to cure the blindness of his father Tobit. The Book of Tobit (6: 3). Buildings are depicted on the cliff in the distance.

NG 48 is probably the picture recorded in the Colonna collection in 1693, where it hung with the *Moses and the Burning Bush* (New York, Metropolitan Museum of Art). The latter work is also on copper and is of similar dimensions and figure scale and it is likely that the two were conceived as pendants. They are datable to the early 1610s.

Probably Palazzo Colonna, Rome, 1693; Holwell Carr Bequest, 1831.

Levey 1971, pp. 91–3; Spear 1982, pp. 173–4.

DOMENICHINO
1581–1641

Domenico Zampieri (Giampieri), called Domenichino, was born in Bologna. He was a pupil of Ludovico Carracci and in about 1602 went to Rome, where after working with Annibale Carracci he became a leading painter. Domenichino, who executed mainly religious works and a few influential landscapes, also worked in Bologna and Naples.

DOMENICHINO and Assistants
Apollo slaying Coronis
1616–18

DOMENICHINO and Assistants
The Judgement of Midas
1616–18

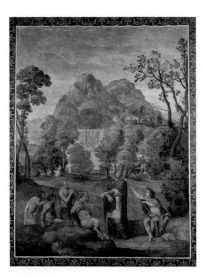

DOMENICHINO and Assistants
The Transformation of Cyparissus
1616–18

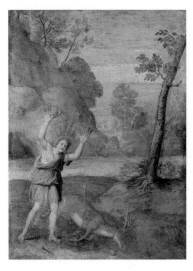

NG 6284

Fresco, transferred to canvas and mounted on board, 199.4 x 89.5 cm

Apollo loved Coronis, but she was unfaithful to him and her infidelity was revealed by the god's raven. Apollo killed her with his bow. Ovid, *Metamorphoses* (II, 600ff.).

This fresco, which has been transferred to canvas, comes from a series of ten scenes painted in the Stanza di Apollo in the garden pavilion at the Villa Aldobrandini, Frascati. Domenichino began work there in 1616 and received his final payment in June 1618. Seven fresco scenes and a fragment of one more are at the National Gallery. The remainder are still *in situ*. Their quality of execution varies; early sources record Domenichino's employment of assistants. The frescoes show episodes from the story of Apollo and the subjects are, with one exception (NG 6290), taken from Ovid's *Metamorphoses*.

The figure of Apollo is much weaker than that of Coronis. A preparatory drawing for the composition and two studies for the figures survive (all Windsor, Royal Collection).

Stanza di Apollo, Villa Aldobrandini, Frascati, until about 1834; bought, 1958.

Levey 1971, pp. 96–106; Spear 1982, pp. 195–201.

NG 6285

Fresco, transferred to canvas and mounted on board, 267 x 224 cm

Apollo and Pan had a musical contest. Midas chose Pan as the victor, and Apollo punished Midas by giving him ass's ears. Midas stands between Apollo who is seated with his lyre on the right, and Pan with his pipes to the left. Ovid, *Metamorphoses* (XI, 172ff.).

This fresco (transferred to canvas) comes from a series painted in the Stanza di Apollo in the garden pavilion at the Villa Aldobrandini, Frascati, for which final payment was received in June 1618. For further discussion see Domenichino NG 6284.

The figures are thought to be by Domenichino, but doubts have been raised about the authorship of the landscape. The incisions around the figures resulting from the transfer of the design from a cartoon can be seen. The painted border is modern. Seven chalk drawings for the figure group survive (Windsor, Royal Collection). Another sheet attributed to Annibale Carracci (formerly Ellesmere collection) which relates to Midas, Pan and the landscape may have been known to the artist.

Stanza di Apollo, Villa Aldobrandini, Frascati, until about 1834; bought, 1958.

Levey 1971, pp. 96–106; Spear 1982, pp. 195–201.

NG 6286

Fresco, transferred to canvas and mounted on board, 120 x 88.3 cm

Apollo loved Cyparissus, who accidentally killed a favourite stag. He was so distressed that he begged to be allowed to mourn for ever, and was turned into a cypress. He stands beside the dead stag with his bow at his feet, being gradually transformed into a tree. Ovid, *Metamorphoses* (X, 126ff.).

This fresco (transferred to canvas) comes from a series painted in the Stanza di Apollo in the garden pavilion at the Villa Aldobrandini, Frascati, for which final payment was received in June 1618. For further discussion see Domenichino NG 6284.

The upper portion of the composition, with Apollo seated on clouds, remains *in situ*. It is thought that Domenichino provided the design, but did not execute the fresco himself. A chalk drawing for Apollo by the artist survives (Windsor, Royal Collection).

Stanza di Apollo, Villa Aldobrandini, Frascati, until about 1834; bought, 1958.

Levey 1971, pp. 96–106; Spear 1982, pp. 195–201.

DOMENICHINO and Assistants
Apollo pursuing Daphne
1616–18

DOMENICHINO and Assistants
The Flaying of Marsyas
1616–18

DOMENICHINO and Assistants
Apollo and Neptune advising Laomedon on the Building of Troy, 1616–18

NG 6288
Fresco, transferred to canvas and mounted on board, 210.2 x 331.4 cm

NG 6287
Fresco, transferred to canvas and mounted on board, 311.8 x 189.2 cm

Apollo pursued Daphne. She cried for help to her father, the river god Peneus. He transformed her into a laurel bush. Ovid, *Metamorphoses* (I, 540ff.).

This fresco (transferred to canvas) comes from a series painted in the Stanza di Apollo in the garden pavilion at the Villa Aldobrandini, Frascati, for which final payment was received in June 1618. For further discussion see Domenichino NG 6284.

NG 6287 is of uniform quality, and was probably painted entirely by Domenichino. An ink drawing for the whole composition is known (Windsor, Royal Collection) and a chalk study for the figures in reverse (Rome, Gabinetto Nazionale).

Stanza di Apollo, Villa Aldobrandini, Frascati, until about 1834; bought, 1958.

Levey 1971, pp. 96–106; Spear 1982, pp. 195–201.

Apollo and the satyr Marsyas had a contest, with Apollo playing the lyre and Marsyas the pan pipes. Marsyas lost and was flayed by Apollo. Ovid, *Metamorphoses* (VI, 382ff.). Here Marsyas is bound to a tree and Apollo has just started cutting into his skin. Nymphs, a satyr and a shepherd grieve for Marsyas.

This fresco (transferred to canvas) comes from a series painted in the Stanza di Apollo in the garden pavilion at the Villa Aldobrandini, Frascati, for which final payment was received in June 1618. For further discussion see Domenichino NG 6284.

NG 6288 was originally above the door of the Stanza di Apollo. The patterned border is a modern addition. The fresco is considered to be mostly autograph. Incised lines, resulting from the transfer of the design from a cartoon, can be seen. Five preparatory drawings for the figures (Windsor, Royal Collection) and one for the landscape (location unknown) are recorded.

Stanza di Apollo, Villa Aldobrandini, Frascati, until about 1834; bought, 1958.

Levey 1971, pp. 96–106; Spear 1982, pp. 195–201.

NG 6289
Fresco, transferred to canvas and mounted on board, 305.8 x 183.4 cm

Apollo and Neptune disguised themselves as mortals and helped build the city of Troy. When Laomedon refused to pay them the agreed price the gods took revenge by bringing a series of disasters upon the city. Ovid, *Metamorphoses* (XI, 199ff.). The three are here shown consulting a plan and pointing to the city in the background.

This fresco (transferred to canvas) comes from a series painted in the Stanza di Apollo in the garden pavilion at the Villa Aldobrandini, Frascati, for which final payment was received in June 1618. For further discussion see Domenichino NG 6284.

The execution seems to be by an assistant, although Domenichino did make four preparatory chalk drawings for the painting (Windsor, Royal Collection).

Stanza di Apollo, Villa Aldobrandini, Frascati, until about 1834; bought, 1958.

Levey 1971, pp. 96–106; Spear 1982, pp. 195–201.

DOMENICHINO and Assistants
Apollo killing the Cyclops
1616–18

DOMENICHINO and Assistants
Mercury stealing the Herds of Admetus guarded by Apollo, 1616–18

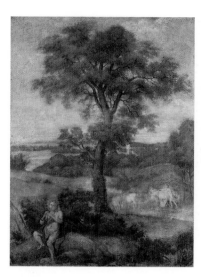

DOMENICO Veneziano
Head of a Saint
about 1440

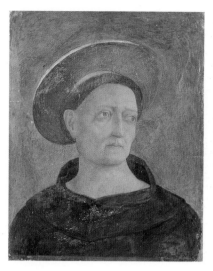

NG 6290
Fresco, transferred to canvas and mounted on board, 316.3 x 190.4 cm

Apollo killed the one-eyed race of giants, the Cyclops, because they provided Zeus with the thunderbolts which caused the death of his son, Aesculapius. Apollodorus, *Library* (III; X, 4). One already lies dead and Apollo is about to shoot at a second giant. The scene is painted as a *trompe-l'oeil* tapestry. Before it in the right foreground is a chained dwarf with a cat eating some leftovers on a plate and fruit. This is a portrait of a dwarf who was a member of the Aldobrandini household. He was apparently depicted in this derisive fashion because of his insolence (see Passeri, G., *Vite de' pittore,* Rome 1672).

This fresco (transferred to canvas) comes from a series painted in the Stanza di Apollo in the garden pavilion at the Villa Aldobrandini, Frascati, for which final payment was received in June 1618. For further discussion see Domenichino NG 6284.

A drawing of the dwarf's head survives (Windsor, Royal Collection).

Stanza di Apollo, Villa Aldobrandini, Frascati, until about 1834; bought, 1958.

Levey 1971, pp. 96–106; Spear 1982, pp. 195–201.

NG 6291
Fresco, transferred to canvas and mounted on board, 261.6 x 201.9 cm

The probable source for the subject is Ovid's *Metamorphoses* (II, 680ff.). Ovid does not name the owner of the herd guarded by Apollo, but the composition was engraved at an early date with a reference to Admetus.

This fresco (transferred to canvas) comes from a series painted in the Stanza di Apollo in the garden pavilion at the Villa Aldobrandini, Frascati, for which final payment was received in June 1618. For further discussion see Domenichino NG 6284.

NG 6291 is in such poor condition that its quality is very difficult to establish. The intervention of Domenichino has been doubted because the composition and handling do not appear to fit comfortably with other works in the series. This is the only painting from the room for which no preparatory drawings survive.

Stanza di Apollo, Villa Aldobrandini, Frascati, until about 1834; bought, 1958.

Levey 1971, pp. 96–106; Spear 1982, pp. 195–201.

NG 766
Fresco, transferred to tile, 43 x 35.5 cm

NG 1215, 766 and 767 are fragments from a street tabernacle painted at the Canto de' Carnesecchi, Florence; see under NG 1215 for further comment.

Bought by Sir Charles Eastlake, 1862; bought, 1867.

Davies 1961, pp. 170–1; Wohl 1980, pp. 114–17.

DOMENICO Veneziano
active 1438; died 1461

Domenico Veneziano was a Venetian artist, who was principally active in Florence. In 1438 he was in Perugia and from 1439 to 1445 he was painting frescoes (now mostly lost) in S. Egidio (S. Maria Nuova), Florence. A signed altarpiece for S. Lucia dei Magnoli is in the Uffizi, Florence.

DOMENICO Veneziano
Head of a Saint
about 1440

DOMENICO Veneziano
The Virgin and Child Enthroned
about 1440

G. DONCK
A Family Group (Jan van Hensbeeck and his Wife, Maria Koeck, and a Child ?), probably 1630s

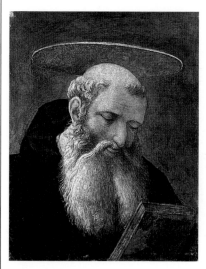

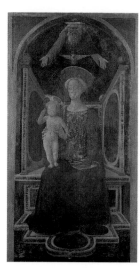

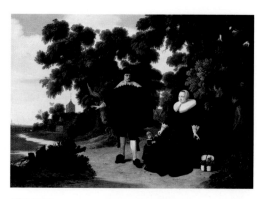

NG 1305
Oil on oak, 76 x 106.2 cm

NG 767
Fresco, transferred to tile, 45 x 35.5 cm

NG 1215, 766 and 767 are fragments from a street tabernacle painted at the Canto de' Carnesecchi, Florence; see under NG 1215 for further comment.

Bought by Sir Charles Eastlake, 1862; bought, 1867.

Davies 1961, pp. 170–1; Wohl 1980, pp. 114–17.

NG 1215
Fresco, transferred to canvas, 241 x 120.5 cm

Signed on the step at the base of the throne: DOMI[NI]CVS D[E] VENECIIS P[INXIT].

The Virgin Mary is seated on an elaborate throne decorated with cosmati work. The Christ Child gives a sign of blessing; above, the foreshortened figure of God the Father is seen to dispatch the dove of the Holy Spirit.

NG 1215, 766 and 767 are badly damaged fragments from a street tabernacle painted at the Canto de' Carnesecchi, near the Piazza S. Maria Novella in Florence. (This is now the point where the Via de' Banchi meets the Via de' Panzani.) The two heads are fragments of two full-length saints who stood on either side of the tabernacle. Vasari says that this tabernacle was one of Domenico's first works in Florence; later commentators have suggested dates between about 1433–4 and after 1454–5.

Bought by Lord Lindsay, 1865; presented by his son, the 26th Earl of Crawford and Balcarres, 1886.

Davies 1961, pp. 170–1; Wohl 1980, pp. 114–17; Dunkerton 1991, pp. 77, 79.

Signed below the tree stump: G Donck (GD in monogram).

The sitters appear to have first been described as Jan van Hensbeeck and Maria Koeck in 1891. The gesture of the man may refer to the ownership of the estate in which the family is shown. The basket of grapes is intended as a symbol of the woman's fertility ('Thy wife shall be as a fruitful vine...', Old Testament, Psalm 128: 3).

NG 1305 was formerly catalogued as bearing the date 1636. There is no trace of this inscription now, but the costume of the figures appears to be of the 1630s. The landscape may be by another artist.

J.H. Cremer sale, Amsterdam, 1886; bought from S. Richards, 1890.

MacLaren/Brown 1991, pp. 104–5.

G. DONCK
active 1627–1640

The signature of this artist appears on several small genre and portrait paintings which bear dates ranging from 1627 to 1640. He apparently engraved or provided designs for the illustrations in J.H. Krul's *Eerlycke Tytkorting* (Haarlem, 1634). His style has connections with contemporary painting in Amsterdam – there are similarities with the work of Pieter Codde – and perhaps Haarlem.

DOSSO Dossi
Lamentation over the Body of Christ
perhaps about 1510–20

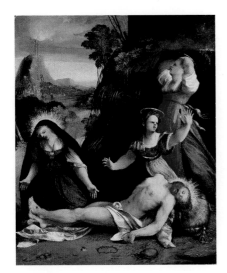

NG 4032
Oil on wood, 36.5 x 30.5 cm

DOSSO Dossi
A Man embracing a Woman
probably about 1524

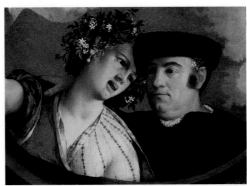

NG 1234
Oil (identified) on poplar, 55 x 75.5 cm

DOSSO Dossi
The Adoration of the Kings
probably 1530–42

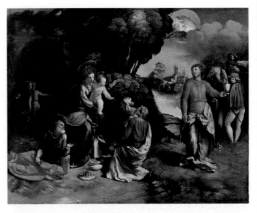

NG 3924
Oil on wood, 85.1 x 108 cm

The Virgin mourns the dead body of Christ after his Crucifixion (crosses can be seen in the left background), an episode not explicitly related in the New Testament. Mary Magdalene, traditionally dressed in red and with strands of long blond hair visible, kneels at Christ's head; behind her is another holy woman, and the tomb (set into a rock). The dice with which soldiers gambled for Christ's robe and the crown of thorns can be seen in the foreground.

Said to have been in the family of Baron Bernard de Rothem for more than a century before bought, about 1905, by Sir Claude Phillips; Sir Claude Phillips Bequest, 1924.

Gould 1975, pp. 82–3.

The subject of NG 1234 is unclear. The picture was acquired as 'Fiametta and Boccaccio', and was subsequently catalogued as 'A Muse inspiring a Court Poet'. In 1650 the tondo of which NG 1234 is a fragment (see below), was said to include a portrait of the clown Il Gonnella, and the male figure in NG 1234 may indeed be Gonnella.

NG 1234 is a fragment of a ceiling decoration painted in the form of a circular opening through which figures could be glimpsed. It is probably the ceiling picture in the Camera del Pozzuolo (or Poggiolo) in the Castello at Ferrara for which Alfonso d'Este paid Dosso in September and December 1524.

A seventeenth-century description makes it clear that this ceiling picture originally had five figures; one other figure survives as a fragment in Florence (Fondazione Roberto Longhi). The tondo was probably adapted for sale in the early nineteenth century. This fragment was built up to a rectangular shape using seven other smaller fragments of the same ceiling painting.

Probably identifiable in the Villa Borghese, Rome, 1650 (as a result of a gift to Scipione Borghese about 1607–8); bought in 1828 by T.B. Bulkeley Owen (in whose catalogue it is stated to have a Borghese provenance); bought by Charles Fairfax Murray, 1887; from whom bought, 1887.

Gould 1975, pp. 81–2; Braham 1981a, pp. 27–37.

The Three Kings journeyed to Bethlehem to honour the new-born Jesus. They brought gifts of gold, frankincense and myrrh. New Testament (Matthew 2: 2–12).

Dosso's admiration for the work of Giorgione is especially clear in the figures on the right, which can be compared with Giorgione NG 1160, and it is significant that Giorgione was noted for his paintings of night and evening.

Collection of Sir William Knighton before 1885; collection of Sir Ludwig Mond, 1888; Mond Bequest, 1924.

Gould 1975, p. 82.

DOSSO Dossi
active 1512; died 1542

Giovanni di Luteri, called Dosso in the sixteenth century and Dosso Dossi in the nineteenth, was active from 1514 in Ferrara in the service of Alfonso and Ercole d'Este. He is also recorded in Mantua, Venice, Florence, Rome and Modena. He worked with his brother Battista.

Attributed to DOSSO Dossi
A Bacchanal
probably about 1515–20

After DOSSO Dossi
A Female Saint
after 1600

Gerrit DOU
Self Portrait
1635–40

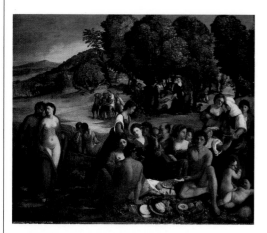

NG 5279
Oil on canvas, 140.9 x 168.2 cm

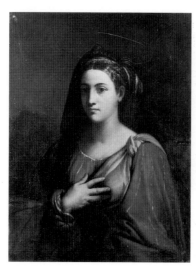

NG 4031
Oil on wood, 95.9 x 74.3 cm

NG 192
Oil on oak, 18.9 x 14.7 cm

The subject may be taken from Ovid's *Fasti* (VI, 319–48) and represent an episode during the Feast of Cybele. However, this is not certain and other bacchanalian subjects are possible.

The painting is in very poor condition and the quality is hard to assess. It has sometimes been mistaken for the picture which Dosso is known to have made for the Camerino d'Alabastro in the Castello at Ferrara. It seems to reflect the influence of the paintings made for that room by Titian (e.g. NG 35).

Possibly in the collection of Thomas Lawrence by 1830; in the collection of William Coningham by 1849 (as Bonifazio Veronese); subsequently in the Breadalbane family collection; bequeathed by Sir Lionel Faudel-Phillips, 1941.

Gould 1975, p. 83; De Marchi 1986, pp. 22, 28; Hope 1987, pp. 25–42; Haskell 1991, p. 681.

This female saint has a halo, but has not been identified.

NG 4031 has been associated with Giulio Romano, Parmigianino and Girolamo da Carpi and was recently catalogued as the work of a follower of Raphael. It is certainly greatly indebted to Raphael's *Donna Velata* (Florence, Pitti). Another version is known, superior in execution if not condition, in which the handling is clearly that of Dosso Dossi.

Collection of Lady Beryl Gilbert by 1918; Sir Claude Phillips Bequest, 1924.

Gould 1975, pp. 224–5; Mezzetti 1977, p. 91.

Signed centre right: GDOV (Gd in monogram).

The sitter is the same as in another self portrait (Amsterdam, Rijksmuseum), and as in an etched portrait of the artist by Godfried Schalcken who was his pupil.

NG 192 was probably painted in about 1635–40 when Dou was in his mid-twenties.

X-radiographs show that the portrait was painted over another portrait head.

Probably in the Pieter Locquet sale, Amsterdam, 1783; bought, 1844.

MacLaren/Brown 1991, p. 106.

Gerrit DOU
1613–1675

Dou, a genre, portrait and history painter, was born in Leiden. He was first trained by his father as a glass engraver, and then became a pupil of Rembrandt (1628–31/2). He worked in Leiden all his life. His highly finished pictures were greatly admired and his patrons included Charles II, Queen Christina of Sweden and Archduke Leopold Wilhelm. Among his pupils were Frans van Mieris and Godfried Schalcken.

Gerrit DOU
Portrait of a Young Woman
about 1640

NG 968
Oil on oak, 14.5 x 11.7 cm

Signed left centre: Gdov (GD in monogram).
 The sitter has been described as the artist's wife, but in fact Dou never married.
 On grounds of style and costume NG 968 can be dated to about 1640.

Collection of Robert de Saint-Victor, Rouen, before 1822; Wynn Ellis Bequest, 1876.

MacLaren/Brown 1991, p. 108.

Gerrit DOU
A Poulterer's Shop
about 1670

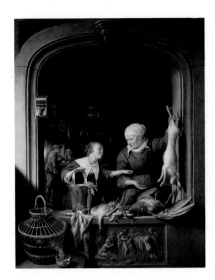

NG 825
Oil on oak, 58 x 46 cm

Signed on the edge of the sill: GDOV (GD in monogram).
 Dou popularised 'niche' pictures of this type, with an interior seen through an aperture. The sculpted panel showing children playing with a goat is after a marble bas-relief by François Duquesnoy (1597–1643) (Rome, Galleria Doria Pamphili), the design of which is also recorded on an ivory plaquette (London, Victoria and Albert Museum). It often appears in Dou's work. The old woman is depicted in a number of the artist's paintings from at least 1647 onwards.
 The style of NG 825 suggests that it is one of Dou's later paintings: it can be compared, for example, with his *Grocer's Shop* of 1672 (London, Royal Collection).

Collection of Willem Lormier, The Hague, until 1748; Duc de Choiseul sale, Paris, April 1772; Prince de Conti sale, Paris, April 1777; bought in Paris by William Beckford, 1814; in the collection of Sir Robert Peel, Bt, by 1829; bought with the Peel collection, 1871.

MacLaren/Brown 1991, pp. 107–8.

Attributed to Willem van DRIELENBURGH
A Landscape with a View of Dordrecht
probably about 1655–60

NG 960
Oil on canvas, 113.5 x 195 cm

Remains of a signature centre lower edge:
(D?) (h?)
 The roofs of Dordrecht, seen from the south, are visible on the skyline. In the centre are the Grote Kerk and the Vuilpoort. On the right is the Groothoofdspoort.
 The picture once bore a false signature of Aelbert Cuyp but is probably by Willem van Drielenburgh: the remains of the signature support this attribution. Although van Drielenburgh is not recorded in Dordrecht before 1668, NG 960 was probably painted before about 1655–60. For other views of the Groothoofdspoort, Dordrecht, see Calraet NG 3024 and Bakhuizen NG 1000.

Wynn Ellis Bequest, 1876.

MacLaren/Brown 1991, pp. 112–13.

Willem van DRIELENBURGH
1632–after 1677

Van Drielenburgh was born in Utrecht, where he was probably a pupil of Abraham Bloemaert. He was later influenced by Jan Both. He had moved to Dordrecht by 1668; among his pupils there were Arnold Houbraken and Willem Bens. Few of Drielenburgh's works are known. He painted a number of Italianate landscapes but most of his paintings are landscapes with topographically accurate town views in the background.

Attributed to Willem DROST
Portrait of a Young Woman with her Hands Folded on a Book, probably about 1653–5

François-Hubert DROUAIS
Le Comte de Vaudreuil
1758

François-Hubert DROUAIS
Madame de Pompadour
1763–4

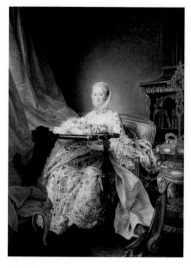

NG 237
Oil on canvas, 66 x 58.5 cm

NG 4253
Oil on canvas, 225.4 x 161.3 cm

NG 6440
Oil (identified) on canvas, 217 x 156.8 cm

Falsely signed on the right: Rembrandt/f 1666.

Formerly attributed to Rembrandt, from whose style it derives and whose false signature it bears, NG 237 has been attributed to Drost on the basis of comparisons with works certainly by Drost. These date from the early 1650s and NG 237 was probably painted at about that time.

Collection of N.W. Ridley Colborne (later Lord Colborne) by 1829; by whom bequeathed, 1854.

MacLaren/Brown 1991, pp. 114–15.

Inscribed on the maps: PARTIES DE/ L'AMÉRIQUE MERIDION/et/ISLE DE S. DOMINGUE, and LEMPIRE DALLEMA and LAFRIQUE.

Signed and dated: Drouais le fils. 1758.

Joseph-Hyacinthe-François de Paule de Rigaud, Comte de Vaudreuil (1740–1817), was the son of the Governor of San Domingo, which was a French possession, and where the sitter was born. He points to it on the map. He acted as aide-de-camp to the Prince of Soubise during the Seven Years War; the map of Germany indicates the scene of the service he was about to take up, while the armour lying on the floor shows his military interests.

NG 4253 may have been exhibited at the Salon in Paris in 1759 (no. 84).

In the collection of the sitter's eldest son, Charles-Philippe; presented by Barons Emile-Beaumont d'Erlanger, Frédéric d'Erlanger and Rodolphe d'Erlanger, in memory of their parents, 1927.

Davies 1957, pp. 83–4.

Signed and dated on the work-table to the right: Peint par Drouais le fils/la tête en avril 1763: et le/tableau fini en mai 1764 (Painted by Drouais/ the head in April 1763 and the/ painting finished in May 1764).

Jeanne-Antoinette Poisson (1721–64) married Charles-Guillaume le Normant d'Etioles in 1741, and then in 1745 became Louis XV's mistress and Marquise de Pompadour. She was a patron of the arts and letters and a leader of fashion who exercised considerable influence on the public policy of France. Here she is shown as though in her apartments at Versailles, working at a tapestry frame, with her pet dog Bébé. The mandolin, chalks, wools and books attest to her various talents.

As the inscription on NG 6440 indicates, the head of the sitter was painted in 1763, but the remainder of the work was not completed until a month after her death in 1764. The head is actually painted on a separate piece of canvas which has been carefully incorporated into the rest of the work.

A number of bust-length versions of the portrait exist.

Recorded at Mentmore, collection of Baron Meyer-Amschel Rothschild by 1874; bought by private treaty from the Earl of Rosebery, 1977.

Gabillot 1906, pp. 155–6; Wilson 1985, p. 112.

Willem DROST
1633–after 1663

Drost was born in Amsterdam and worked in Rembrandt's studio from about 1650 until 1654. Subsequently he travelled to Rome and Venice, where he collaborated with Johann Carl Loth. He was back in the Netherlands in 1663 and may have died in the plague of 1663–4 in Amsterdam. Before his departure for Italy he painted works in Rembrandt's style of the early 1650s.

François-Hubert DROUAIS
1727–1775

Drouais was born in Paris. He was initially taught by his father, Hubert Drouais, and then later studied under Nonette, Carle van Loo, Natoire and Boucher. He became a fashionable portrait painter.

Hendrick DUBBELS
A Dutch Yacht and Other Vessels Becalmed near the Shore, about 1660–70

Claude-Marie DUBUFE
The Surprise
before 1827

DUCCIO
The Annunciation
1311

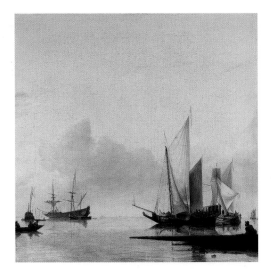

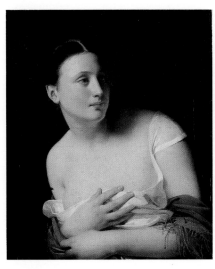

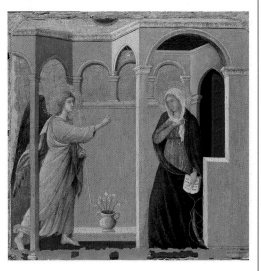

NG 2587
Oil on canvas, 48.3 x 48.1 cm

NG 457
Oil on canvas, 65.2 x 54.3 cm

NG 1139
Egg (identified) on poplar, painted surface
43 x 44 cm

On the right is a States yacht (*statenjacht*) with Dutch colours; on the left another fires a salute near a man-of-war.

NG 2587 was previously attributed to Jan van de Cappelle, but has now been securely identified as a work of Hendrick Dubbels. It was probably painted in the 1660s when Dubbels was influenced by the work of Willem van de Velde the Younger.

Collection of S. Herman de Zoete, Hayes, by 1884; bought by George Salting, 1908; Salting Bequest, 1910.

MacLaren/Brown 1991, pp. 115–16.

Signed bottom left: Dubufe.
A startled woman draws her shawl around her.
NG 457 was painted in about 1827 and exhibited at the Royal Academy in 1828. The pose is based on the classical sculpture *The Medici Venus*.

Lord Charles Townsend sale, 1835; presented by Robert Vernon, 1847.

Davies 1970, p. 63.

Inscribed on the book held by the Virgin: Ecce / virgo / concipi/et & pa/[ri]et / filiu[m] / & voc/abitur (Behold a Virgin shall conceive and bear a son and he shall be called [Emmanuel]). Old Testament (Isaiah 7: 14).

The Archangel Gabriel announces to the Virgin that she is to bear the Son of God, as prophesied by Isaiah. New Testament (Luke 1: 26–35). The Holy Spirit descends from Heaven in the form of a dove; the lilies in a vase symbolise the Virgin's purity.

NG 1139 was the first scene on the front predella of Duccio's *Maestà*, which was installed in Siena Cathedral in 1311. Further information on this altarpiece is given under NG 1330.

The little finger of the angel's blessing hand was originally extended. The style of underdrawing, found also in NG 566, which is visible in infra-red reflectography, suggests that NG 1139 was designed by Duccio himself. The orange area below the angel's wing was once intended to be gilded like the section above. The damage to the base was probably caused by the removal of the integral frame.

Bought from the collection of Charles Fairfax Murray, Florence, 1883.

Stubblebine 1979, pp. 6–7, 54–5; White 1979, p. 120; Gordon 1988, pp. 16–22; Bomford 1989, pp. 72–83; Dunkerton 1991, pp. 216–18.

Hendrick DUBBELS
1621–1707

Dubbels was born in Amsterdam, where he studied with Abraham de Verwer, and was active until his death. He painted marine pictures and a few winter landscapes. He had close contacts with Bakhuizen and was also influenced by the style of the van de Veldes and that of Abraham Storck.

Claude-Marie DUBUFE
1790–1864

Claude-Marie Dubufe was born in Paris. He studied as a pupil of Jacques-Louis David and exhibited at the Salon from 1810. In his later career Dubufe became a successful portraitist.

DUCCIO
active 1278; died 1318/19

Duccio worked mainly in his native Siena. His major surviving works are a large *Maestà* or Virgin in Majesty (the *Rucellai Madonna*) for S. Maria Novella, Florence (now in the Uffizi), and the signed *Maestà* (see NG 1139, 1140 and 1330) installed in Siena Cathedral in 1311. Duccio also painted small devotional pictures and ran a large workshop. He was one of the most important painters of the fourteenth century.

DUCCIO
Jesus opens the Eyes of a Man born Blind
1311

DUCCIO
The Transfiguration
1311

DUCCIO
The Virgin and Child with Saints Dominic and Aurea, about 1315

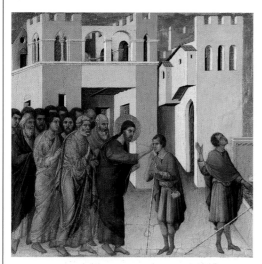

NG 1140
Tempera on poplar, painted surface 43.5 x 45 cm

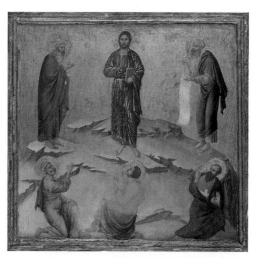

NG 1330
Tempera on poplar, painted surface 44 x 46 cm

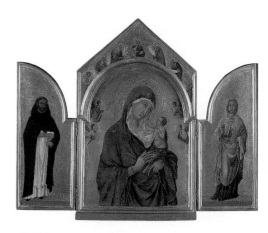

NG 566
Tempera on poplar, central panel 42.5 x 34.5 cm; shutters 42 x 16.5 cm each

Christ is made the compositional centre of the scene and the blind man is shown twice: first having his eyes touched, and then at the moment his sight is miraculously restored. The two episodes are linked visually by the blind man's stick. New Testament (John 9: 1–7).

NG 1140 was one of the scenes on the back predella of Duccio's *Maestà*. Further information on this altarpiece is given under NG 1330. The back predella illustrated scenes from Christ's life and ministry, and NG 1140 was originally immediately to the left of the *Transfiguration* (NG 1330), hence the blind man appeared to look with his newly restored sight at a vision of Christ transfigured.

The figures and the architecture were probably painted by different artists from Duccio's workshop. The face of the blind man at the fountain was damaged in the past and is a modern restoration.

Bought from the collection of Charles Fairfax Murray, Florence, 1883.

Stubblebine 1979, pp. 41, 49, 51; White 1979, p. 122; Gordon 1988, pp. 18–22; Bomford 1989, pp. 72–8, 83–9; Dunkerton 1991, pp. 216–18.

Christ appears in a transfigured state to the apostles Peter, John and James. Either side of Christ are Moses (left) and the prophet Elijah (right). New Testament (all Gospels except John, e.g. Matthew 17: 1–8).

NG 1330 was part of the back predella of Duccio's *Maestà*, and was immediately to the right of NG 1140. The *Maestà* was a monumental double-sided altarpiece ceremoniously delivered to Siena Cathedral in June 1311, and placed on the high altar. At the time it was the richest and most complex altarpiece in Christendom, but it was dismembered in 1771, and although most of it is now in the Cathedral Museum at Siena, several predella panels and pinnacles are dispersed in collections throughout the world. The front of the altarpiece shows the Virgin and Child enthroned with saints and apostles, the predella depicts Christ's childhood (commencing with NG 1139), and the pinnacles the last days of the Virgin. On the reverse the narrative runs from Christ's earthly ministry (in the predella, including NG 1140 and 1330) through his Passion (main panel) to his latter-day appearances (pinnacles).

NG 1330 retains its original frame but has suffered some damage in the past; this is particularly evident in the figure of the apostle at the centre.

Acquired in Siena, a few years before 1891, by R.H. Wilson; by whom presented, 1891.

Stubblebine 1979, pp. 56–7; White 1979, p. 122; Gordon 1988, pp. 19–22; Bomford 1989, pp. 72–8, 83–9; Dunkerton 1991, pp. 216–18.

For the inscriptions on the scrolls held by the prophets in the tympanum above the Virgin and Child, see Gordon 1988. The two principal saints are identified by inscriptions as Saint Dominic (S DO/MINIC) and Saint Aurea (SCA AU[REA?]).

The seven Old Testament prophets in the tympanum are (left to right): Daniel, Moses, Isaiah, David, Abraham, Jacob and Jeremiah.

NG 566 has identical underdrawing to that found in NG 1139. It may have been made for the private devotion of Cardinal Niccolò da Prato (died 1321), a high-ranking Dominican who was Cardinal of Ostia and would therefore have had reason to venerate Saint Aurea of Ostia, otherwise rarely shown. This type of small-scale altarpiece with closing shutters was intended to be portable.

The dimensions of NG 566 are identical to those of a triptych of *The Crucifixion* with *Saints Nicholas and Gregory* on the shutters (Boston, Museum of Fine Arts) which also seems to have ben painted in Duccio's workshop. The exterior of the shutters in both triptychs have the same geometric patterns.

Said to be from a private collection in Pisa; bought from the Lombardi–Baldi collection, Florence, 1857.

White 1979, pp. 46–61; Gordon 1988, pp. 14–16; Bomford 1989, pp. 90–7; Dunkerton 1991, p. 220.

NG 566, with shutters closed

Follower of DUCCIO
The Virgin and Child with Four Angels
about 1315

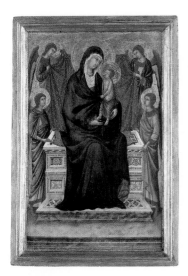

Attributed to Joseph DUCREUX
Portrait of a Man
possibly 1791

Gaspard DUGHET
Landscape with Herdsman
about 1633–5

NG 6386
Tempera on wood, including the original frame,
41 x 28.6 cm

This small panel was probably painted in about
1315, and hinge marks at the side suggest that it
may once have once formed part of a diptych,
perhaps pairing a Crucifixion. The picture has been
attributed to a number of followers of Duccio, but
none of these identifications is certain and there is
little comparative material with which to make a
confident attribution.

The frame of NG 6386 is original but has been
regilded. The painting may be a replica of a larger
image.

*In the collection of James F. Hutton, Manchester,
probably by 1878; bought with contributions from the
Lewis Fund and the NACF (Eugene Cremetti Fund),
1968.*

White 1979, pp. 152–3; Gordon 1988, pp. 23–4;
Dunkerton 1991, p. 68.

NG 2162
Oil on canvas, 55.2 x 45.7 cm

NG 2162 may be the 'Portrait of a Gentleman (M. le
Texier)' exhibited by Ducreux at the Royal
Academy, London, in 1791 (no. 184).

Bought (Lewis Fund), 1907.

Davies 1957, p. 85; Lyon 1958, pp. 183–4.

NG 2619
Oil on canvas, 54 x 45.7 cm

NG 2619 is unlikely to have a literary source, but
was once identified as depicting the mythological
subject of Mercury and Io. The landscape is
presumably Italian.

NG 2619 was attributed to Dughet when in the
collection of Lucien Bonaparte in Rome. It was later
attributed to Nicolas Poussin, or to a follower of
Poussin, but the attribution to Dughet (as an early
work) has recently been defended.

*Collection of Lucien Bonaparte, Rome, by 1812; Salting
Bequest, 1910.*

Davies 1957, p. 192; Boisclair 1986, pp. 170–1.

Joseph DUCREUX
1735–1802

**Ducreux was born in Nancy. He became a pupil of
Maurice Quentin de La Tour and was influenced
by Greuze. He was later First Painter to Queen
Marie-Antoinette. In 1791 he was in London and
exhibited at the Royal Academy. He also exhibited
at the Paris Salon from 1791 to 1801.**

Gaspard DUGHET
1615–1675

**Dughet, who was born in Rome, adopted the name
of his brother-in-law Nicolas Poussin (with whom
he had trained) and is sometimes referred to as
Gaspard Poussin. He was a landscape painter (both
on canvas and in fresco), largely active in Rome
and its vicinity. He was also influenced by Claude.**

Gaspard DUGHET
Landscape with a Storm
about 1653–4

Gaspard DUGHET
Landscape with Abraham and Isaac approaching the Place of Sacrifice, probably about 1655–60

Gaspard DUGHET
Landscape with Elijah and the Angel
about 1658–9

NG 36
Oil on canvas, 135.9 x 184.8 cm

NG 31
Oil on canvas, 152.4 x 195 cm

NG 1159
Oil on canvas, 201.3 x 153 cm

NG 36 does not appear to have a subject. Two figures seem to be in flight as a storm approaches.

A date of about 1653–4 for the execution of the painting has recently been suggested.

First surely recorded when bought with the rest of the J.J. Angerstein collection, 1824.

Davies 1957, p. 86; Boisclair 1986, p. 213.

God tested Abraham's obedience by commanding him to sacrifice his own son, Isaac. Abraham and the trusting Isaac set out for the sacrifice, together with two servants. Old Testament (Genesis 22: 1–8).

It has recently been suggested that NG 31 and 1159 were the canvases for which Dughet received payment from Prince Colonna in February 1660. NG 31 certainly appears in catalogues of the Colonna collection in the late eighteenth century.

Colonna collection, Rome, by 1783; bought with the rest of the J.J. Angerstein collection, 1824.

Davies 1957, p. 86; Boisclair 1986, pp. 232–3.

The subject of NG 1159 has been variously identified but is now considered to be taken from the Old Testament (1 Kings 19: 5–12). An angel appears to the prophet Elijah on Mount Horeb and instructs him 'to stand upon the mount before the Lord'. At this there was a great wind 'and the Lord passed by'.

It has recently been suggested that NG 1159 and 31 were the canvases for which Dughet received payment from Prince Colonna in February 1660. NG 1159 certainly appears in catalogues of the Colonna collection in the eighteenth century.

There is a detailed drawing for NG 1159 in Düsseldorf (Kunstmuseum). It has been stated that the figures are probably by a collaborator, but most recently the drawing has been claimed as evidence that Dughet himself could paint such figures. A number of engravings and copies after NG 1159 are known.

Colonna collection, Rome, by 1715; William Beckford collection; bought, 1884.

Davies 1957, pp. 88–9; French 1980, p. 42, no. 15; Boisclair 1986, pp. 234–6; Wine 1992, pp. 78–81.

Gaspard DUGHET and probably Carlo MARATTA
Landscape with the Union of Dido and Aeneas
about 1664–8

NG 95
Oil on canvas, 152.4 x 224.2 cm

Gaspard DUGHET
Landscape in the Roman Campagna (near Albano?)
about 1670

NG 68
Oil on canvas, 48.3 x 66 cm

Gaspard DUGHET
Landscape in the Roman Campagna
about 1670

NG 98
Oil on canvas, 49 x 66.7 cm

The Trojan hero Aeneas was forced ashore near Carthage and was the guest of Dido, who fell in love with him. While hunting they were caught in a storm and sheltered in a cave (on the right). Dido became Aeneas' lover, as desired by Venus and instigated by Juno (Juno, Venus and Hymen appear in the sky on the left). When Aeneas abandoned her to journey to Latium, Dido committed suicide. Virgil, *Aeneid*, IV, 119ff.

The figures are closely related to the style of Carlo Maratta (1625–1713), and a storm picture of this size by Dughet and with the figures painted by Maratta is known to have been in the Palazzo Falconieri, Rome, in 1717. NG 95 was probably painted in the mid-1660s, and the landscape has generally been accepted as by Dughet.

Falconieri collection, Rome, probably by 1717; acquired by Holwell Carr in 1805; his bequest, 1831.

Davies 1957, p. 87; Boisclair 1986, pp. 247–8.

NG 68 depicts a landscape scene in the countryside around Rome, probably near Albano to the southeast of Rome.

Apparently painted as a pendant to NG 98, NG 68 has recently been dated about 1670.

A drawn copy of the composition (Bliss collection) has been attributed to Gainsborough, and it has been suggested that NG 68 inspired van Bloemen's *Landscape with Travellers* (Rome, Doria Pamphili).

Probably Corsini collection, Rome, by 1787; collection of William Young Ottley by 1800; bought by Holwell Carr in 1818; his bequest, 1831.

Davies 1957, pp. 86–7; Boisclair 1986, pp. 276–7.

NG 98 possibly depicts a landscape view in the countryside around Rome. The traditional location of the view at Ariccia has recently been doubted.

Apparently painted as a pendant to NG 68, NG 98 has recently been dated about 1670.

Probably Corsini collection, Rome, by 1787; collection of William Young Ottley by 1800; bought by Holwell Carr in 1818; his bequest, 1831.

Davies 1957, p. 87; Boisclair 1986, pp. 276–7.

Gaspard DUGHET
Landscape in the Roman Campagna (Tivoli?)
about 1670

NG 161
Oil on canvas, 71.8 x 166.4 cm

Attributed to DUGHET
Landscape with Herdsman
1633–5

NG 2619
Oil on canvas, 54 x 45.7 cm

Karel DUJARDIN
A Woman with Cattle and Sheep in an Italian Landscape, 1650–5

NG 828
Oil on copper, 22.6 x 29.4 cm

First recorded as a view of Nemi, NG 161 has been tentatively identified as a view of Tivoli to the east of Rome.

A date of about 1670 has recently been suggested. There exists what is probably a preparatory drawing, in red chalk (Raleigh, North Carolina Museum of Art).

Colonna collection, Rome, by 1783; probably in William Young Ottley's sale of 1811, where acquired by Sir George Beaumont; presumably sold by him to Lord Farnborough, by whom bequeathed, 1838.

Davies 1957, p. 88; Boisclair 1986, pp. 274–5.

Cattle are herded at the edge of woodland. The buildings in the middle distance have not been related to a particular site.

NG 2619 was attributed to Dughet when in the collection of Lucien Bonaparte. It has recently been re-attributed to him as an early work, and its composition is similar to other early works by Dughet.

Collection of Lucien Bonaparte, Rome, about 1800–15; collection of Lord Ashburton, Bath House by 1890; Salting Bequest 1910.

Davies 1957, p. 192; Blunt 1966, p. 179; Boisclair 1986, pp. 170–1.

Signed bottom right: K·D·J·

Dujardin visited Italy between 1640 and 1650, and his knowledge of the Roman Campagna formed the basis of his Italianate landscapes.

NG 828 was probably painted shortly after his return from Italy, in the early 1650s.

Jacobus Willemsen sale, Middleburg, 1780; bought with the Peel collection, 1871.

MacLaren/Brown 1991, pp. 118–19.

Karel DUJARDIN
about 1622–1678

Dujardin was probably born in Amsterdam, the son of a painter. He was trained in the studio of Nicolaes Berchem in Haarlem. He painted Italianate landscapes, genre scenes, subjects from mythology and classical history, and portraits. Dujardin was in Italy at some time between 1640 and 1650; he visited France, and painted in The Hague and Amsterdam, before returning to Italy (1675) and then visiting Tangier. He died in Venice.

Karel DUJARDIN
Portrait of a Young Man (Self Portrait?)
about 1655

Karel DUJARDIN
Farm Animals in the Shade of a Tree, with a Boy and a Sleeping Herdswoman, 1656

Karel DUJARDIN
A Woman and a Boy with Animals at a Ford
1657

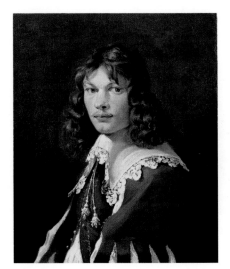

NG 1680
Oil on canvas, 62 x 52.5 cm

NG 826
Oil on canvas, 34.6 x 39.7 cm

NG 827
Oil on canvas, 37.7 x 43.5 cm

The identification of the painting as a self portrait is not certain because there is no documented portrait of Dujardin, but the man painted here seems to be represented, somewhat older, in a drawing by Dujardin of 1658 (London, British Museum) which has traditionally been identified as a self portrait. A number of other paintings have also been described as self portraits of Dujardin, but they show different sitters.

NG 1680 was probably painted in Amsterdam in about 1655.

X-radiographs show that the portrait is painted over another figure facing in the opposite direction, and analysis of the paint layers reveals a third head, apparently between these two.

[M.H. Colnaghi] sale, London, 1899; bought from Horace Buttery, 1899.

Dunkerton 1982, pp. 19–25; MacLaren/Brown 1991, pp. 119–20.

Signed and dated bottom right: K·DU·JARDIИ· fe./ 1656 .

The style is strongly reminiscent of that of Paulus Potter.

Collection of the Duc de Praslin; Choiseul-Praslin sale, Paris, 1793; bought with the Peel collection, 1871.

MacLaren/Brown 1991, pp. 117–18.

Signed and dated on the left: K·DU·JARDIИ·/fe/1657.

The woman and the mule also appear, in reverse, in an undated etching by the artist.

Possibly Pieter Leendert de Neufville collection, Amsterdam, by 1752; in the collection of Sir Robert Peel, Bt, by 1834; bought with the Peel collection, 1871.

MacLaren/Brown 1991, p. 118.

Karel DUJARDIN
The Conversion of Saint Paul
1662

Karel DUJARDIN
Sheep and Goats
1673

Jules-Louis DUPRE
Willows, with a Man Fishing
probably before 1867

NG 6296
Oil on canvas, 186.7 x 134.6 cm

NG 985
Oil on copper, 18 x 20.9 cm

NG 2634
Oil on canvas, 21.6 x 27 cm

Signed and dated: K du IARDIИ·fe / 1662.
' ... and suddenly there shined round about him a light from heaven: And he fell to the earth, and heard a voice saying unto him, Saul, Saul, why persecutest thou me? ... And the men which journeyed with him stood speechless, hearing a voice, but seeing no man.' New Testament (Acts of the Apostles 9: 3–7). Paul is at the lower right. In the sky at the upper left cherubs hold a torch and an olive branch. The composition is based on a print by Antonio Tempesta, whose work was widely circulated in the Netherlands and influenced a number of Dutch artists, among them Rembrandt and Bol. The print has an oblong format.

The size of NG 6296, and the fact that its subject was rarely represented in the Netherlands in the seventeenth century, suggest that it was specially commissioned. The patron may have been a member of the family of the first recorded owner. There is another work by the artist of similar dimensions, which shows *Saint Paul healing the Sick at Lystra*, and is said to have formerly borne the date 1663. It was sold in London in 1987 (Christie's, 11 December, lot 29).

Jan François d'Orvielle sale, Amsterdam, 1705; presented by Mrs Violet Van der Elst, 1959.

MacLaren/Brown 1991, pp. 120–1.

Signed and dated bottom left: K DV IARDIИ f 1673 .
This composition was etched by Dujardin in 1655, and then painted on this small copper plate eighteen years later.

Probably Charles Scarisbrick sale, London, 1861; Wynn Ellis Bequest, 1876.

MacLaren/Brown 1991, p. 119.

Signed: Jules Dupré.
Dupré made several visits to England, where he admired in particular the work of Crome (1768–1821) and Constable. Of all the artists associated with the Barbizon School, Dupré was perhaps the most influenced by English landscape art, as witnessed by this small and intimate picture.

Probably in the collection of Duplessis by 1867; subsequently stated to be in the collection of Jules Van Praet; collection of John W. Wilson, 1873; Salting Bequest, 1910.

Davies 1970, pp. 63–4.

Jules-Louis DUPRE
1811–1889

Dupré was born in Nantes. Like Diaz, he trained as a porcelain painter, and was later a pupil of Jean-Michel Diébolt in Paris. He first exhibited at the Salon of 1831 and soon became associated with the artists of the Barbizon School, especially Rousseau. After 1850 Dupré exhibited infrequently and lived in virtual retirement.

Attributed to Albrecht DÜRER
The Painter's Father
1497

Style of Albrecht DÜRER
The Virgin and Child ('The Madonna with the Iris')
16th century

DUTCH
Portrait of a Young Man in Black
about 1635–40

NG 1938
Oil on lime, 51 x 40.3 cm

NG 5592
Oil on lime, 149.2 x 117.2 cm

NG 3725
Oil on canvas, 73.8 x 58.2 cm

Inscribed at the top: 1497 . ALBRECHT . THVRER . DER . ELTER . VND . ALT . 70 IOR. (1497 Albrecht Dürer the Elder, aged 70); inscribed at the bottom right: 208 (possibly an old inventory number).

Dürer's father was a Hungarian goldsmith who settled in Nuremberg in 1455 and later taught the craft to his son.

NG 1938 appears to have been presented to Charles I of England in 1636/7 by the city of Nuremberg, together with the self portrait of Dürer now in the Prado, Madrid, and dated 1498. The two pictures were not apparently intended as pendants. The unusual pink background of NG 1938 and the quality of the painting itself, especially of the hands and body, have frequently raised doubts about Dürer's authorship.

A portrait of his father painted by Dürer in 1490 is in the Uffizi, Florence.

Probably presented to Charles I, 1636/7; bought from the Marquess of Northampton, 1904.

Levey 1959, pp. 26–32; Dunkerton 1991, p. 352.

Signed with a false monogram and falsely dated 1508.

The Virgin is seated in a walled garden (the *hortus conclusus*) and suckles the Christ Child. The ruined arch and the sea visible beyond are unusual features. God the Father appears in the sky above the central group. The iris, to the left of the Virgin, is a flower often associated with her (it is a symbol of the sword of the Seven Sorrows of the Virgin), as is the rose to the right of her hand. The vine might be intended to have eucharistic significance.

NG 5592 was probably painted by an artist in imitation of the style of Dürer, possibly after his death. It is unlikely to have been intended as a forgery, and the false monogram and date appear to have been added later.

Said to have been at Nuremberg before 1821; Felsenberg collection, Vienna, by 1821; bought from the trustees of the Sir Francis Cook collection, through the NACF, 1945.

Levey 1959, pp. 32–7.

Inscribed right, below a small crowned Cupid(?) seated on a flaming heart, which he seems to be piercing with an arrow: Sic puer ille manet (This is how that boy takes hold?).

The sitter has in the past been identified as Lucius Cary, Viscount Falkland (1609/10–1643), but a documented portrait of Falkland in the collection of the Duke of Devonshire shows a different man. The costume of the sitter is of the second half of the 1630s.

NG 3725 may be the work of a minor painter connected with the school of The Hague.

Collection of the 6th Marquess Townshend; bequeathed by John G. Griffiths, 1923.

MacLaren/Brown 1991, p. 122.

Albrecht DÜRER
1471–1528

Born in Nuremberg, Dürer worked there under Michael Wolgemut from 1486 to 1489, and resided in the city for most of his life. He travelled to the Upper Rhineland (1489–94), Venice (possibly in 1494–5 and certainly in 1506–7) and the Netherlands (1520–1). Such experiences fuelled his innovative and extraordinarily influential output as a painter, graphic artist and theoretician.

DUTCH
Portrait of a Man
1640–5

DUTCH
Portrait of a Seated Woman and a Girl in a Landscape, about 1640–5

DUTCH
Portrait of a Man and a Woman
probably 1640s

NG 145
Oil on oak, 31.1 x 24.3 cm

The sitter has not been identified. His costume is probably of the earlier 1640s.

The weak quality and diminutive size of NG 145 may suggest it is a copy after a work by a painter of the Amsterdam School.

Bequeathed by Lt.-Col. J.H. Ollney, 1837.

MacLaren/Brown 1991, pp. 122–3.

NG 2546
Oil on canvas, 92.7 x 68.3 cm

NG 2546 has in the past been attributed to either Aelbert or Jacob Gerritsz. Cuyp; neither suggestion is convincing. The landscape and figures may be by two different artists.

The costume of the child could date from as early as the 1630s but not later than 1645. The collar of the woman is in a much earlier fashion.

M.M. Zachary sale, London, 1828; Salting Bequest, 1910.

MacLaren/Brown 1991, p. 123.

NG 6414
Oil on oak, 40.3 x 27.2 cm

NG 6414 was formerly attributed to Thomas de Keyser; it is now considered to be by an unidentified artist who was active in Amsterdam in the 1640s.

Bought by W.C. Alexander from P. and D. Colnaghi, 1886; presented by the Misses Rachel F. and Jean I. Alexander; entered the Collection in 1972.

MacLaren/Brown 1991, p. 124.

DUTCH

Portrait of a Lady with a Fan
1647

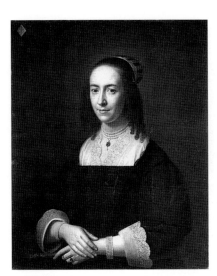

NG 140
Oil on oak, 84.8 x 69.9 cm

DUTCH

A Company of Amsterdam Militiamen
19th century

NG 1343
Oil on canvas, 75 x 133 cm

DUTCH (?)

Sportsmen Resting
about 1650

NG 2150
Oil on canvas, 151.8 x 207 cm

Inscribed below the escutcheon, top left: Anno 1647
 The sitter has not been identified; she wears pearls at her wrist, neck and in her head-dress, and holds a fan. At the top left is a small lozenge-shaped escutcheon which bears the arms of the Gillon family who were barons of Basseghem, near Bruges. The shape of the escutcheon suggests that the sitter is an unmarried lady or a widow.
 NG 140 may be by an Amsterdam painter. Bartholomeus van der Helst has been suggested, but this attribution is unconvincing.

Bequeathed by Lt.-Col. J.H. Ollney, 1837.

MacLaren/Brown 1991, p. 124.

The arms of Amsterdam are on the standard carried by the man on the left. During the war with Spain militia companies were formed to defend the towns of the Dutch Republic; by the mid-seventeenth century they had become largely ceremonial in their duties and social in character.
 NG 1343 is an imitation of Dutch mid-seventeenth-century painting; it either records a lost seventeenth-century work or is a nineteenth-century invention. In the past it has been associated with the work of various seventeenth-century artists, notably Govert Flinck, but such links are superficial. Samples of paint from the work have been analysed and found to contain a pigment which was not available to artists until the 1840s.

Bought from Edward Habich, Cassel, 1891.

MacLaren/Brown 1991, p. 125.

This picture was previously attributed to the school of Nicolaes Maes. It dates from about 1650 and is strongly Dutch in style but may well be the work of a south German or Polish artist working in the Netherlands.

Presented by R. Goff, 1856.

DUTCH (?)
A White House among Trees
19th century

NG 3140
Oil on millboard, 38.1 x 49.5 cm

Willem DUYSTER
Soldiers fighting over Booty in a Barn
about 1623–4

NG 1386
Oil on oak, 37.6 x 57 cm

Willem DUYSTER
Two Men playing Tric-trac, with a Woman scoring, about 1625–30

NG 1387
Oil on oak, 41 x 67.6 cm

Signed, falsely, bottom left: M. Maris
This nineteenth-century landscape has the false signature of Matthijs Maris, who studied in The Hague and Antwerp and worked in Paris and later in London. Although not by him, it is probably the work of a close imitator.

Bequeathed by A.N. Macnicoll, 1916; transferred from the Tate Gallery, 1956.

Signed on a package on the ground at the left: DVYSTER, and on a bale next to the package: WCD (in monogram).

Duyster's treatment of this subject – unique in his oeuvre – is presumably intended to be satirical. There was both a literary and a visual tradition of the satirical treatment of soldiers. These particular mercenaries are dressed in silks and velvets, quite unsuitable for a real theatre of war, and squabble over booty.

The soldier on the left taking aim with his firelock is in the correct position as shown by Jacob de Gheyn in his book on the use of firelocks, muskets and pikes (Amsterdam 1608).

Said to have been brought to England by Colonel Wolfgang William Romer when he accompanied William III in 1688; bought from his descendant, Romer Williams, 1893.

MacLaren/Brown 1991, pp. 126–7.

Signed on the border of the table rug: WC.DVYSTER. (WC in monogram).

The woman is scoring with a piece of chalk on the side of the board.

A similar painting by Duyster of tric-trac players (Amsterdam, Rijksmuseum) has been related to Netherlandish traditions of representing gambling scenes as symbolic of idleness and mortality.

Said to have been brought to England by Colonel Wolfgang William Romer when he accompanied William III in 1688; bought from his descendant, Romer Williams, 1893.

MacLaren/Brown 1991, p. 127.

Willem DUYSTER
1599–1635

Duyster was born and active in Amsterdam. He painted genre scenes and small-scale portraits until his death in the plague of 1635. A contemporary of Pieter Codde and Simon Kick (his brother-in-law), he may have trained with Barent van Someren or with Cornelis van der Voort.

Anthony van DYCK
The Emperor Theodosius is forbidden by Saint Ambrose to enter Milan Cathedral, about 1619–20

NG 50
Oil on canvas, 149 x 113.2 cm

The Emperor Theodosius (about 346–395) – in armour and a laurel wreath – is prevented from entering Milan Cathedral by Saint Ambrose (about 340–398), bishop of the city. The saint had banned Theodosius from the cathedral after the massacre of a subject population in Thessalonica. Van Dyck has identified one of Theodosius' companions as Ruffinus, whose shameless arrogance Saint Ambrose compared to a dog (which is at his feet). The story of Saint Ambrose is related in *The Golden Legend*.

This picture is a 'free copy' by Van Dyck of a larger picture (Vienna, Kunsthistorisches Museum) of about 1618. That painting was designed by Rubens and executed in his studio, probably by Van Dyck in his 'Rubensian' style. NG 50, which is in a far freer style, was probably painted about 1619–20.

The second man from the right is a portrait of Nicolaes Rockox (1560–1640), the Antwerp patron who commissioned *Samson and Delilah* (NG 6461) from Rubens and may well have commissioned this picture too.

Probably Peter Paul Rubens sale, Antwerp, 1640; first recorded in Britain, 1764; bought with the J.J. Angerstein collection, 1824.

Martin 1970, pp. 29–34; Larsen 1988, II, p. 107, no. 253; Muller 1989, pp. 134–5, no. I.223; Wheelock 1991, pp. 100–2, no. 10.

Anthony van DYCK
Portrait of Cornelis van der Geest
about 1620

NG 52
Oil on oak, 37.5 x 32.5 cm

The sitter has been identified as Cornelis van der Geest on the basis of the head of him in *The Iconography*, the series of engraved portraits made by Paulus Pontius (1603–58) after Van Dyck's designs.

Cornelis van der Geest (1555–1638) was a wealthy spice merchant in Antwerp. He was also an important patron (commissioning Rubens's *Raising of the Cross* for St Walburga, Antwerp) and collector, and can be seen in a painting by Willem van Haecht (Antwerp, Rubenshuis) showing his famous collection to the Governors of the Netherlands, the Archduke Albert and the Archduchess Isabella. NG 52 was painted shortly before Van Dyck travelled to England for the first time in 1620. At a later date (before 1637) the portrait was enlarged; originally only the head and shoulders of van der Geest were visible, in a simulated, oval, porphyry surround.

This portrait is one of the most animated and effective portraits of Van Dyck's early years in Antwerp. Van Dyck's later drawing of van der Geest (Stockholm, Nationalmuseum) was made for the portrait print by Paulus Pontius in *The Iconography*.

Liss collection, Antwerp, by 1796; bought by J.J. Angerstein, 1798; purchased with the J.J. Angerstein collection, 1824.

Martin 1970, pp. 34–7; Held 1982, pp. 35–6, 55, 59; Brown 1987, p. 74; Larsen 1988, II, p. 29, no. 45.

Anthony van DYCK
Portrait of a Woman and Child
about 1620–1

NG 3011
Oil on canvas, 131.5 x 106.2 cm

The sitters have not been identified but it has been suggested that NG 3011 was one of a pair of portraits and that the woman's husband was shown in a companion portrait (towards which the child looks and gestures).

NG 3011 was painted either in Antwerp just before Van Dyck left for Italy in 1621 or immediately after his arrival in Genoa that year.

First recorded in the Palazzo Balbi, Genoa, 1758; collection of Sir Abraham Hume by 1815; bought from a descendant (Earl Brownlow), 1914.

Martin 1970, pp. 47–8; Brown 1987, p. 76; Larsen 1988, II, pp. 45–6, no. 81.

Anthony van DYCK
1599–1641

Taught by Hendrick van Balen in Antwerp, where he subsequently worked with Rubens. He travelled to Italy in 1621 and enjoyed great success as a portrait painter in Genoa. In 1627 he returned to Antwerp, and in 1632 moved to London to become court painter to Charles I. For the rest of his life he was based in London. He also painted histories and allegories.

Anthony van DYCK
Portrait of George Gage with Two Attendants
probably 1622–3

NG 49
Oil on canvas, 115 x 113.5 cm

The central figure has been identified as George Gage (about 1582–1638) whose family arms (a saltire and sun in splendour) entwined with the family crest (a ram's head) are on the sculpted pedestal (bottom right). Gage was a diplomat and an agent in Italy and the Netherlands for the great English collectors of the early seventeenth century. He is shown here being offered a piece of sculpture.

NG 49 was painted in Italy, probably in the summer of 1622 or 1623, when both the artist and the sitter were in Rome.

Collection of Sir Joshua Reynolds by 1795; bought by J.J. Angerstein, 1795; bought with the J.J. Angerstein collection, 1824.

Martin 1970, pp. 58–61; Millar 1982, p. 40, no. 1; Larsen 1988, II, p. 150, no. 370; Wheelock 1991, pp. 158–60, no. 30.

Anthony van DYCK
The Balbi Children
about 1625–7

NG 6502
Oil on canvas, 219 x 151 cm

Though traditionally called *The Balbi Children*, the sitters have not been identified. The youngest boy (right) holds a bird, while the eldest (left) gestures towards two choughs.

During Van Dyck's years in Italy (1621–7) he was based in Genoa. He enjoyed great success as a portraitist to the local nobility and this portrait was painted there in about 1625–7. The picture was first recorded in Costantino Balbi's collection and may portray members of his family. However, Balbi was also a collector – he owned Giordano NG 6487 and Rubens NG 66 and 278 – and could have bought NG 6502 from another Genoese family. One suggestion is that the sitters are the sons of Gerolamo de Franchi. The choughs may have heraldic significance.

Collection of Costantino Balbi, Genoa, by 1724; collection of William Berwick, Attingham, about 1824/5; bought by the 2nd Earl de Grey, 1842; by descent to the collection of the Earl Cowper, Panshanger; bought from his descendant, Lady Lucas, with a contribution from the J. Paul Getty Endowment Fund, 1985.

National Gallery Report 1985–7, pp. 19–20; Brown 1987, p. 80; Larsen 1988, II, p. 135, no. 329.

Anthony van DYCK
Charity
about 1627–8

NG 6494
Oil on oak, 148.2 x 107.5 cm

The figure has been identified as a depiction of Charity, the theological virtue (with Faith and Hope; see Old Testament, 1 Corinthians 13: 13) that combines the love of God with the love of one's neighbour. From the sixteenth century onwards Charity (Caritas) was commonly represented as a woman suckling children.

NG 6494 was probably painted in about 1627–8, shortly after Van Dyck returned to Antwerp from his extended stay in Italy.

Van Dyck painted a second version of the composition, which was formerly in the Methuen collection at Corsham Court. The composition was engraved by Cornelis van Caukercken shortly after Van Dyck's death.

Goubau collection, Antwerp, by 1763; bought for Sir James Lowther, 1763; bought from his descendant, the Earl of Lonsdale, 1984.

National Gallery Report 1982–4, pp. 34–5; Brown 1987, p. 82.

Anthony van DYCK
William Feilding, 1st Earl of Denbigh
about 1633–4

NG 5633
Oil on canvas, 247.5 x 148.5 cm

The identification of the sitter as William Feilding, 1st Earl of Denbigh (about 1582–1643), is confirmed by comparison with an engraved portrait of Feilding published in 1631.

Feilding was created Earl of Denbigh in 1622 and visited Persia and India from 1631 to 1633. The portrait was commissioned to commemorate that journey. Denbigh wears a silk Indian jacket and pyjamas, carries a hunting gun, and has a parrot pointed out to him by an Indian servant. The picture was probably painted in London, in about 1633–4, and is recorded in an inventory as the work of Van Dyck as early as 1643.

Duke of Hamilton collection by 1644 (by inheritance: Hamilton was Denbigh's son-in-law) and until 1919; bought by Count Antoine Seilern, 1938; by whom presented, 1945.

Martin 1970, pp. 52–5; Millar 1982, pp. 56–8, no. 16; Brown 1987, p. 84; Larsen 1988, II, p. 326, no. 830.

Anthony van DYCK
Carlo and Ubaldo see Rinaldo conquered by Love for Armida, 1634–5

NG 877.2
Oil on wood, 57 x 41.5 cm

The crusaders Carlo and Ubaldo have been sent to find their companion Rinaldo who has been bewitched by the sorceress Armida. In NG 877.2 Carlo and Ubaldo wearing Spanish-type helmets can be seen on the extreme left, concealed behind a bush. Putti are playing around the two lovers. The subject is from Torquato Tasso's long poem *Gerusalemme Liberata* (Canto 16: 17–23), published in 1574.

NG 877.2 is the oil sketch or modello for an engraving (in the same direction) by Pieter de Jode the Younger which is dated 1644 (three years after Van Dyck's death). The reverse of the panel bears the initials of the Antwerp panel maker, Michiel Vriendt (died 1636/7). The picture dates from the years 1634–5 when Van Dyck was in the Southern Netherlands.

The use of a monochrome grisaille technique is particularly suited to a preparatory work for an engraving. The panel has been squared up by the engraver to facilitate the design's transfer to his engraving plate.

Collection of Jan-Baptista Anthoine, Antwerp, by 1687; collection of Sir Thomas Lawrence by 1830; acquired by Woodburn and subsequently bought by Sir Robert Peel, Bt, 1837; bought with the Peel collection, 1871.

Martin 1970, pp. 37–41; Brown 1987, p. 88; Larsen 1988, II, p. 295, no. 744.

Anthony van DYCK
The Abbé Scaglia adoring the Virgin and Child
1634–5

NG 4889
Oil on canvas, 106.7 x 120 cm

Cesare Alessandro Scaglia (died 1641) was identified in the inscription on an engraving after NG 4889 by Coenrad Waumans (1619–after 1675). The identification is confirmed by comparing the features of the donor with the engraved portrait of the Abbé Scaglia in *The Iconography* and with Van Dyck's full-length portrait of Scaglia (private collection). The features of the Virgin Mary may have been modelled on those of the Duchess of Savoy, Christina of France (1606–63).

NG 4889 was painted in Brussels in 1634 or 1635. The full-length portrait and a *Lamentation* (Antwerp, Museum voor Schone Kunsten) were painted for Scaglia at the same time. The Abbé was a diplomat in the service of the House of Savoy who had retired to Brussels. He was a discerning patron of the arts and a friend of Rubens.

Van Dyck's composition derives from a lost painting by Titian recorded in a pen drawing in Van Dyck's *Italian Sketchbook* (London, British Museum). There is a preparatory drawing in black chalk for the position of Scaglia's head which is also in the British Museum.

Bequeathed by Scaglia to the Princess of Phalsbourg; collection of Madame La Douairière Peytier de Merchten by 1791; collection of John Knight by 1819; Anthony de Rothschild collection, 1846; presented by Anthony de Rothschild in memory of Louisa, Lady de Rothschild, and Constance, Lady Battersea, 1937.

Martin 1970, pp. 48–52; Brown 1974; Brown 1987, p. 86; Larsen 1988, II, p. 406, no. 1035.

Anthony van DYCK

Lady Elizabeth Thimbelby and Dorothy, Viscountess Andover, about 1637

NG 6437
Oil (identified) on canvas, 132.1 x 149 cm

Anthony van DYCK

Equestrian Portrait of Charles I about 1637–8

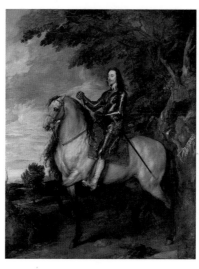

NG 1172
Oil on canvas, 367 x 292.1 cm

Anthony van DYCK

Lord John Stuart and his Brother, Lord Bernard Stuart, about 1638

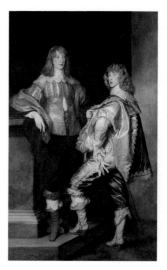

NG 6518
Oil on canvas, 237.5 x 146.1 cm

The two sitters were the daughters of Thomas, Viscount Savage. Elizabeth stands on the left, her elder sister Dorothy is seated on the right.

Elizabeth had married Sir John Thimbelby, a notable recusant in 1634; Dorothy married Charles Howard, Viscount Andover, in 1637. This portrait of the two sisters was probably painted in 1637 to mark Dorothy's wedding. The winged putto with a basket of roses is the attribute of Saint Dorothy, a virgin martyr and patron saint of brides and newly-weds. Both sisters were Catholics but Dorothy's elopement and subsequent marriage caused a particular scandal; her portrayal as Saint Dorothy presumably refers to her faith.

Van Dyck's double portraits are among the greatest pictures of his years in England and this portrait can be seen to have influenced Sir Peter Lely (e.g. *Mary Capel and Elizabeth, Countess of Carnarvon,* New York, Metropolitan Museum of Art) who owned numerous Van Dycks, including NG 6437.

Collection of Sir Peter Lely; bought at the sale of that collection by the Earl of Sunderland, 1684; purchased from the Trustees of the Earl Spencer, 1977.

Millar 1982, pp. 73–4, no. 29; Brown 1987, p. 90; Larsen 1988, II, p. 385, no. 981; Wheelock 1991, pp. 63–5.

Inscribed on the tablet hanging on the tree: CAROLUS / REX MAGNAE / BRITANIAE (Charles King of Great Britain).

King Charles I is portrayed on horseback in armour, with a general's baton, wearing the Lesser George (the badge of the Order of the Garter) and accompanied by an equerry (traditionally identified as Sir Thomas Morton), who carries his helmet.

Charles I (1600–49) succeeded to the throne of Great Britain and Ireland in 1625. He attempted to rule without recourse to Parliament which led to the outbreak of the Civil War, culminating in the king's death in 1649.

Charles I's armour (which may be the suit in the Royal Armouries) was made in the Royal Workshops at Greenwich in about 1610–20 and was used by portrait painters until about 1650. A drawing survives for the horse (London, British Museum). It has been observed that the composition is based on Titian's *Portrait of Charles V at the Battle of Mühlberg* (Madrid, Prado). There is an earlier equestrian portrait of the king (with his French riding-master) by Van Dyck in Windsor Castle.

Painted for King Charles I; at Hampton Court Palace by 1639; sold to Sir Balthazar Gerbier, 1650; bought in Antwerp by Duke Maximilian II Emanuel, Elector of Bavaria, 1698; looted from Munich by Emperor Joseph I and presented by him to the 1st Duke of Marlborough, 1706; bought from the 8th Duke of Marlborough, 1885.

Martin 1970, pp. 41–7; Strong 1972; Brown 1987, p. 92; Larsen 1988, II, p. 314, no. 795.

This full-length double portrait shows two of the sons of the 3rd Duke of Lennox: Lord John Stuart (left, in brown and gold) and Lord Bernard Stuart (right, in blue and silver). Lord John (1621–44) and Lord Bernard, later Earl of Lichfield (1622–45), were both Royalists who were killed during the Civil War.

The two Stuart brothers were granted a licence to travel abroad early in 1639 and this portrait must date from just prior to their intended departure on a Grand Tour, probably 1638.

A black chalk drawing (London, British Museum) studies the pose and the costume of Lord Bernard. Van Dyck's double portraits are remarkable for the range of compositional solutions employed, and in NG 6518 his composition elegantly captures the dignity and pride of the two young men. Gainsborough painted a copy (St Louis, Art Museum) of NG 6518 which he saw in 1785 in the collection of the 4th Earl of Darnley.

Collection of the Dukes of Lennox; subsequently collection of the Earls of Darnley; bought from Lady Pamela Hicks (with a contribution from the J. Paul Getty Endowment Fund), 1988.

Millar 1982, p. 89; Larsen 1988, II, p. 395, no. 1009; National Gallery Report 1988–9, pp. 10–12.

Gerbrand van den EECKHOUT
Rebekah and Eliezer at the Well
1661

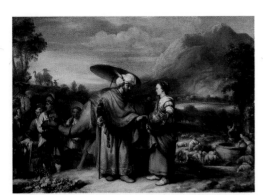

NG 6535
Oil (identified) on canvas, 76.2 x 105.5 cm

Adam ELSHEIMER
The Baptism of Christ
probably 1598–1600

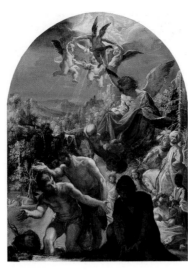

NG 3904
Oil on copper, 28.1 x 21 cm

Adam ELSHEIMER
Saint Paul on Malta
about 1600

NG 3535
Oil on copper, 16.8 x 21.3 cm

Signed and dated on a rock, lower right: G. V. Eeckhout. fecit/Ao 1661.

Abraham's servant Eliezer was sent to the city of Nahor in Mesopotamia to find a wife for Abraham's son, Isaac. He encountered Rebekah outside the city as she was carrying water from the well (seen on the right), and asked if he could drink a little. Rebekah returned with Eliezer, married Isaac, and was the mother of Esau and Jacob. Old Testament (Genesis 24: 11–17).

NG 6535 is typical of van den Eeckhout's mature style as a history painter. A drawing for NG 6535 is in the De Grez collection (Brussels, Musées Royaux des Beaux-Arts).

Collection of J.A. Versijden van Varick by 1791; presented by Herman Shickman, in gratitude for the hospitality shown to his mother, a refugee from Germany, by the British people during the Second World War, 1991.

National Gallery Report 1990–1, pp. 22–3.

Christ's Baptism by John the Baptist which according to the Gospels takes place in the river Jordan, is depicted here before a wooded and mountainous landscape. God the Father is at the very top of the work, surrounded by angels, and below him is the dove of the Holy Ghost, encircled by four putti. An angel descends with a red robe for Christ. The moment shown is that at which God declares: 'This is my beloved son in whom I am well pleased'. New Testament (Matthew 3: 17). Since cleaning it has become clear that the old view that the foreground figure is merely a man removing a shoe is correct. Similarly, the people in the boat are probably no more than background figures

This work is thought to have been painted during the artist's stay in Venice (1598–1600); the spiralling composition and use of colour and light seem to illustrate the influence of Tintoretto and Veronese.

Probably anon. sale, London, 27 March 1797; probably Sir Joshua Reynolds sale, 1795; presented by Henry Wagner, 1924.

Levey 1959, p. 43; Andrews 1977, p. 142; Smith 1985, p. 11.

Saint Paul and his companions were shipwrecked during a terrifying storm on the Mediterranean island of Malta. The event is described in the New Testament (Acts of the Apostles 28: 2–3) as having taken place during the day but Elsheimer has chosen to show the scene at night. The islanders lit fires to warm the survivors. A viper emerged from some sticks Paul placed on a fire and fastened on his hand. When the natives saw the creature they thought the saint was a murderer who was receiving justice. But when he shook off the snake and they saw that he had suffered no harm, they were convinced that he was a god.

NG 3535 is thought to be dated to about 1600. It shows stylistic affinities with Elsheimer's *The Burning of Troy* (Munich, Alte Pinakothek).

G.B. Crescenzi, probably about 1630; Methuen collection, 1761; presented by Walter Burns, 1920.

Levey 1959, p. 42; Andrews 1977, p. 143; Shakeshaft 1981, pp. 550–1; Smith 1985, p. 112.

Adam ELSHEIMER
1578–1610

Elsheimer was one of the most influential painters of the early seventeenth century, famed for the lighting effects he achieved in his landscapes, especially his night landscapes. Born and trained in Frankfurt, by 1598 he was recorded in Munich. After working in Venice (1598–1600), he settled in Rome (1600–10) where he was influenced by Rottenhammer and Tintoretto. His compositions were disseminated in prints.

Adam ELSHEIMER
Saint Lawrence prepared for Martyrdom
about 1600–1

NG 1014
Oil on copper, 26.7 x 20.6 cm

Inscribed, on the horseman's banner: S.P.Q. [R] (Senatus Populusque Romanus); and, on the pedestal of the statue: FA/OE(?)/HE (possibly either from Ovid's *Metamorphoses* (IX, 255–7), or the following invented inscription: FActus Di-/ ONysus est/ HErcules).

According to *The Golden Legend* Saint Lawrence was martyred for his faith in the year AD 258 in Rome; the architecture in the background is reminiscent of the ruins of the ancient city. He was burnt over a gridiron which is being prepared at the right. The saint, at the left, is being disrobed, surrounded by exotic figures. An angel above him holds a palm, a symbol of his impending martyrdom. Lawrence was killed because he refused to reveal what were thought to be the Treasures of the Church. In NG 1014 he also seems to be refusing to worship false gods; the bearded figure to his left points towards the statue of Hercules at the right.

NG 1014 can probably be dated to the very early years of the seventeenth century when the artist was first in Rome.

Possibly S. Feitama sale, Amsterdam, 16 October 1758 (lot 64); Wynn Ellis Bequest, 1876.

Levey 1959, pp. 38–40; Andrews 1977, pp. 142–3.

After Adam ELSHEIMER
Tobias and the Archangel Raphael returning with the Fish, mid-17th century

NG 1424
Oil on copper, 19.3 x 27.6 cm

According to the Book of Tobit in the biblical Apocrypha, the blind Tobit sent his son Tobias out to collect some money; the boy was accompanied by the Archangel Raphael in disguise. Raphael helped him to catch a fish, the heart, liver and gall of which were used by Tobias to drive away a demon and cure his father's blindness. Here the boy and angel are shown travelling together, the fish being dragged between them. The flowers in the foreground are cabbage poppies, and in the middle ground is a herd of cows. The painting has been executed on a copper plate engraved with a coat of arms.

The original of this composition is lost; it was engraved by Hendrick Goudt in 1613. NG 1424 is considered to be one of a number of versions to be derived from it and is thought to have been painted in the mid-seventeenth century. A large version is in the Statens Museum for Kunst, Copenhagen.

Possibly Dr Richard Mead sale, London, 21 March 1754; William Beckford (junior) sale, 1802; bequeathed by Samuel Sandars, 1894.

Levey 1959, pp. 40–2; Andrews 1977, p. 154.

Allart van EVERDINGEN
A Saw-mill by a Torrent
about 1670

NG 1701
Oil on oak, 44.8 x 60.3 cm

Signed bottom right: A V EVERDINGEN.

Everdingen travelled to Scandinavia in 1644 and on his return introduced a new type of landscape into Dutch painting – rocky, mountainous scenes with waterfalls – based on drawings made there.

This example was painted late in his career, in about 1670.

Samuel Rogers sale, London, April–May 1856; presented by George H. Boughton RA, 1900.

MacLaren/Brown 1991, p. 131.

Allart van EVERDINGEN
1621–1675

Allart Pietersz. van Everdingen, brother of Cesar van Everdingen, was born in Alkmaar. He may have been taught by Roelandt Savery in Utrecht and by Pieter de Molijn in Haarlem. He visited Norway and Sweden (1640s), worked in Haarlem (1645–51) and in Amsterdam (from 1652). His Scandinavian journey inspired a new type of landscape – mountain scenes with waterfalls – which was imitated by Jacob van Ruisdael and others.

Attributed to Cesar van EVERDINGEN
Portrait of a Dutch Commander (?)
probably 1651

NG 3315
Oil on canvas, 120 x 86.5 cm

Falsely signed and dated bottom left: G. Honthorst f./1651

The unidentified subject carries a commander's baton in his right hand. The bridge and towers in the background at the right seem to be a reminiscence of those of the Castel Sant' Angelo in Rome; their inclusion may indicate that the sitter wished to record a visit to the city.

NG 3315 can be compared to portraits by Everdingen such as *Wollebrandt Geleynsz. de Jongh* (Alkmaar, Stedelijk Museum) and *Albert Capelman* (Leiden, Sint Salvator-hof). Both of these paintings are dated 1648. The work catalogued here may have been made a little later, possibly in 1651, the date on the false inscription.

Presented by an anonymous donor, 1918.

MacLaren/Brown 1991, p. 132.

Jan van EYCK
Portrait of a Young Man
1432

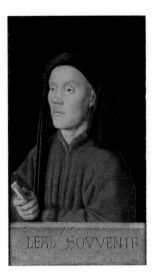

NG 290
Oil on oak, 33.4 x 19 cm

Inscribed in Greek lettering on the parapet: TYM. WØEOC. (see below); and in larger chiselled script: LEAL SOVVENIR (True Remembrance). Along the bottom of the parapet: Actu[m] an[n]o d[omi]ni. 1432. 10. die octobris. a. ioh[anne] de Eyck (Done in the year of Our Lord 1432 on the 10th day of October by Jan van Eyck).

The sitter clasps in his right hand a rolled paper which is marked with lettering that cannot be deciphered. The inscription on the cracked stone parapet declares the authorship and date of the painting but does not clearly state the identity of the subject. It has been suggested that the Greek may be translated as Tymotheos (Timothy) and could relate directly to the sitter (although this is unlikely because it would be a highly unusual Christian name for the period), or refer to the musician Timotheus of Miletus (about 400 BC), so indicating the sitter's profession.

Bought from Karl Ross, Munich, 1857.

Davies 1954, pp. 132–5; Davies 1968, pp. 54–5.

Jan van EYCK
A Man in a Turban
1433

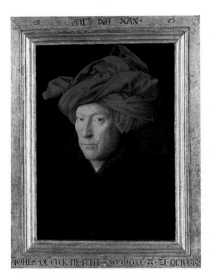

NG 222
Oil on oak, 33.3 x 25.8 cm

Inscribed, signed and dated on the original frame, at the top: . AΛC. IXH. XAN. (in Flemish, using Greek letters: As I can). Along the bottom: JOH[ANN]ES. DE. EYCK. ME. FECIT. A[N]NO. MᵒCCCCᵒ. 33ᵒ. 21. OCTOBRIS (abbreviated Latin: Jan van Eyck made me, 21 October 1433).

The sitter is depicted against a dark blue background; he wears a fur-trimmed dark coat, a white undergarment and a red head-dress. The inscription at the top may be intended as a pun on the artist's name, related to a Flemish saying: 'As I [Eyck] can but not as I [Eyck] would.' The work was described in about 1655 as a self portrait; the direct eye-contact with the viewer and inscription provide some support for such a view, but no certain portrait of the artist survives.

The 'Als ich can' inscription appears on several other paintings by van Eyck, including his portrait of his wife, Margaret, of 1439 (Bruges, Groeningemuseum).

Collection of Lord and Lady Arundel before 1655; bought, 1851.

Davies 1953, pp. 129–32; Davies 1968, pp. 53–4; Campbell 1990, p. 12; Dunkerton 1991, pp. 256–7.

Cesar van EVERDINGEN
about 1617–1678

Cesar Pietersz. van Everdingen, brother of Allart van Everdingen, was born in Alkmaar. He was a pupil of Jan van Bronchorst, and the style of his work is related to that of the Haarlem 'classicists' such as Pieter de Grebber. He worked in Alkmaar and Haarlem, painting history subjects, militia pieces and portraits.

Jan van EYCK
active 1422; died 1441

Famed for his mastery of the oil medium, van Eyck painted devotional works, secular subjects and portraits. He was employed by John of Bavaria in The Hague in 1422–4, and from 1425 by Philip the Good, Duke of Burgundy, principally in Bruges. Among his most important works is the Ghent Altarpiece begun by Hubert van Eyck and completed by Jan in 1432 (Ghent, St Bavo).

Jan van EYCK
The Portrait of Giovanni (?) Arnolfini and his Wife Giovanna Cenami (?) ('The Arnolfini Marriage')
1434

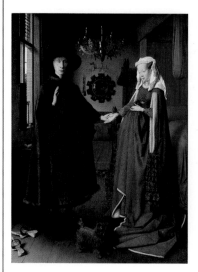

NG 186
Oil on oak, 81.8 x 59.7 cm

Signed and dated above the mirror: Johannes de eyck fuit hic./.1434. (Jan van Eyck was here/1434).

Early inventories identify the man as 'Hernoul le Fin' or 'Arnoult Fin' (Arnolfini), probably the Lucchese merchant Giovanni di Arrigo Arnolfini (about 1400–72) who resided in Bruges. His wife was Giovanna Cenami; the date of their marriage is unknown. Two further figures, one of whom may be the artist, are reflected in the mirror on the rear wall which is surrounded by scenes from the Passion. A carved figure of Saint Margaret(?) appears on the chairback. The dog, shoes, single burning candle, prayer beads, brush, oranges, etc., have been variously interpreted as having religious, nuptial and sexual significance. The man's gestures may suggest that he is taking an oath, but the theory that NG 186 is a painted record of an actual marriage ceremony remains unproven.

NG 186 was first recorded in 1516, when it had shutters, and when it was owned by Margaret of Austria (see Netherlandish NG 2613.2).

There is a notable pentimento in the man's right hand. The woman's apparently swollen form does not imply pregnancy.

Gift from Don Diego de Guevara (died 1520) to Margaret of Austria (1480–1530); bought, 1842.

Davies 1954, pp. 117–28; Davies 1968, pp. 49–52; Campbell 1990, pp. 115, 135–6; Dunkerton 1991, pp. 258–61.

Follower of van EYCK
Marco Barbarigo
about 1449

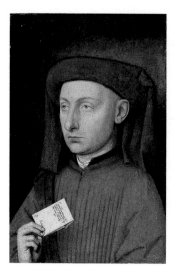

NG 696
Oil on oak, 24.1 x 15.9 cm

Inscribed on the letter: Spetabilj et Egregio D[omin]o / Marcho barbaricho q[uon]da[m] Spe / tabillis d[omi]nj franzisy p[ro] / churatoris S[an]ti marzj / dd (To the most worthy and distinguished lord Marco Barbarigo, son of the late worthy lord Francesco, Procurator of San Marco) and lower down: Londonis (in London); in the bottom corners what appears to be 'f' and 'n'(?).

The subject prominently displays a letter addressed to Marco Barbarigo (1414–86). Marco, son of Francesco Barbarigo, Procurator of San Marco (who died in August 1448), was in London from about 1445 and in February 1449 was Venetian consul in England.

The portrait was probably painted during the sitter's stay in London, possibly by a follower of van Eyck settled in London.

Seen in Venice by the dealer Sasso, 1791; Manfrin collection, Venice; bought, 1862.

Davies 1953, pp. 135–8; Davies 1968, pp. 55–6.

Barent FABRITIUS
The Naming of Saint John the Baptist
probably 1650–5

NG 1339
Oil on canvas, 36.8 x 48 cm

The infant John the Baptist lies in the cradle. To the left sits Saint Elizabeth; at the right Saint Zacharias writes John's name on a tablet. The woman with a halo may be intended as the Virgin, although Saint Luke's Gospel says she had left Elizabeth's house before John's birth. New Testament (Luke 1: 59–63).

NG 1339 is dated to 1650–5 by comparison with other works by the artist, such as *Peter in the House of Cornelius* (Braunschweig, Herzog Anton Ulrich-Museum) which is dated 1653.

There are two drawings by Barent Fabritius related to this work (Stuttgart, Staatsgalerie; Vienna, Albertina). The former is closest to the painting. The artist made another painting of the subject, but with a different composition (Frankfurt, Städelisches Kunstinstitut).

Possibly in the George Bruyn sale, Amsterdam, March 1724; Edward Habich collection, Cassel, by 1881; from whom bought, 1891.

MacLaren/Brown 1991, pp. 134–5.

Barent FABRITIUS
1624–1673

Born in Midden-Beemster (North Holland), Barent was the younger brother of Carel Fabritius. He was described as a carpenter in 1641, but was principally active as a painter of religious and genre subjects and portraits; he was in Amsterdam from the late 1640s, possibly in Delft in the early 1650s, and in Leiden from 1656. Later he returned to his birthplace and Amsterdam. His early works were influenced by Rembrandt.

Barent FABRITIUS
The Adoration of the Shepherds
1667

Carel FABRITIUS
A View of Delft, with a Musical Instrument Seller's Stall, 1652

Carel FABRITIUS
A Young man in a Fur Cap and a Cuirass (Self Portrait?), 1654

NG 1338
Oil on canvas, 66 x 61 cm

NG 3714
Oil on canvas stuck on to walnut panel,
15.5 x 31.7 cm

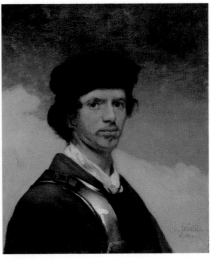

NG 4042
Oil (identified) on canvas, 70.5 x 61.5 cm

Signed and dated on the manger:(·).Fab(·) it(·)u /1667
 Saint Joseph stands behind the Virgin who kneels by the Christ Child. The ox and ass are in the stall behind the manger. New Testament (Luke 2: 15–16).
 The composition derives from Rembrandt's versions of the subject, notably those of 1646 in Munich (Alte Pinakothek) and the National Gallery (NG 47).

Possibly Cornelis Wittert, Heer van Valkenburg sale, Rotterdam, 1731; Edward Habich collection, Cassel, by 1881; from whom bought, 1891.

MacLaren/Brown 1991, p. 134.

Signed and dated on the wall at the left: C. FABRITIVS./ 1652.
 In the centre is the Nieuwe Kerk and just to the left of it, in the distance, the town hall; on the right are the houses of the Vrouwenrecht. The view is taken from the corner of the Oude Langendijk and Oosteinde, looking roughly north-west. The Nieuwe Kerk and town hall still exist in much the same state as they appear here. On the left is, apparently, the booth of a musical instrument vendor with, in the foreground, a viola da gamba and, against the wall, a lute.
 The function and method of display of NG 3714 have been much debated. Its exaggerated perspective and the cutting-off of the foreshortened viola da gamba are the two principal features which lend support to the suggestion that the painting formed part of a perspective box or peepshow. Such a box probably had a curved back. But no closely comparable box survives and so any reconstruction must remain hypothetical. However Fabritius, who according to early biographers was interested in perspective and illusionism, is described in four documents as having made perspective boxes.

Bought in Naples, 1836; in the collection of Sir William Eden, Bt, by 1909; bought from his son, Sir Thomas Eden, Bt, by the NACF and presented, 1922.

MacLaren/Brown 1991, pp. 137–8; Keith 1994, pp. 54–63.

Signed and dated bottom right: c. fabritius./.1654.
 The sitter wears a steel breastplate and backplate. He has been generally accepted as Fabritius, although no documented portrait of the artist is known. The same man appears in a bust portrait (Rotterdam, Museum Boymans-van Beuningen) which can be dated to about 1648–50. The directness of the gaze and the unconventionality of dress and pose in both works support their identification as self portraits. In NG 4042 use has been made of a self-portrait type familiar from the work of Rembrandt and his pupils. Rembrandt had painted a number of self portraits wearing a breastplate or gorget in the late 1620s and 1630s. Fabritius was clearly aware of these precedents, but chose a highly original background – he placed himself starkly against a cloudy sky.

An undescribed portrait of Fabritius was in the inventory of Catharina Scharkens, widow of Cornelis Smout, Amsterdam, 1654; NG 4042 was bought in Bruges by George Rimington, Penrith, about 1824; bought (Claude Phillips Fund) at the T. A. Brewerton sale, London, 12 December 1924 (lot 135).

MacLaren/Brown 1991, pp. 139–40.

Carel FABRITIUS
1622–1654

Carel Fabritius was one of the most innovative and skilful of Rembrandt's pupils. He was baptised in Midden-Beemster and was in Amsterdam in about 1641–3. From 1650 he settled in Delft, where he was killed when the municipal gunpowder magazine exploded in 1654 (see Egbert van der Poel NG 1061). Few works by the artist survive: some portraits, genre scenes, a cityscape (NG 3741), and a *Raising of Lazarus* (Warsaw).

Ignace-Henri-Théodore FANTIN-LATOUR
Still Life with Glass Jug, Fruit and Flowers
1861

Ignace-Henri-Théodore FANTIN-LATOUR
The Rosy Wealth of June
1886

Ignace-Henri-Théodore FANTIN-LATOUR
A Basket of Roses
1890

NG 3726
Oil on canvas, 48.9 x 60.3 cm

NG 3248
Oil on canvas, 47 x 47.6 cm

NG 1686
Oil on canvas, 70.5 x 61.6 cm

Signed and dated: Fantin 61
 The composition recalls the still lifes of François Bonvin.
 Fantin-Latour spent some time painting in England in 1861 and this picture may have entered a British collection soon after it was painted. His flower-pieces were popular in England, and he exhibited at the Royal Academy from 1862 onwards.

Bought by Sir Hugh Lane from the Staats Forbes collection by 1904; Lane Bequest, 1917; on loan to the Hugh Lane Municipal Gallery of Modern Art, Dublin, since 1979.

Fantin-Latour 1911, p. 26, no. 180; Davies 1970, p. 64.

Signed: Fantin.
 This still life of delphiniums, lilies and roses is known by the title apparently given to the picture by the artist.
 According to the catalogue of Fantin-Latour's work published by his wife in 1911, NG 1686 was painted in 1886. It was exhibited by the artist at the Royal Academy in 1898 and presented to the National Gallery in the following year by Mrs Edwin Edwards. Fantin's work was well known in England and Mr and Mrs Edwin Edwards were the artist's most important dealers and patrons in this country.

Collection of Fantin-Latour until 1898; presented by Mrs Edwin Edwards, 1899.

Fantin-Latour 1911, p. 131, no. 1264; Davies 1970, p. 64.

Signed and dated: Fantin. 90
 In his later career Fantin-Latour preferred to paint imaginative compositions rather than still lifes. However, these remained popular with collectors, especially the British; this work was acquired by an English collector in the 1890s.

Collection of Richard Yates by 1899; bequeathed by Mrs M.J. Yates, 1923.

Fantin-Latour 1911, p. 149, no. 1421; Davies 1970, p. 65.

Ignace-Henri-Théodore FANTIN-LATOUR
1836–1904

Fantin-Latour was born in Grenoble and studied painting with his father, Théodore, with Lecoq de Boisbaudran and, briefly, at the Ecole des Beaux-Arts in Paris. At various stages, he was friendly with Courbet, Whistler and Manet, yet he remained an independent figure. He painted portraits and imaginative compositions but specialised in flower pictures and small still lifes.

Style of Defendente FERRARI

Saint Peter Martyr and a Bishop Saint
1511–35

NG 1200
Oil on poplar, 76.2 x 52.1 cm

Saint Peter Martyr, at the right, was a thirteenth-century Dominican who pursued heretics and was murdered in a wood in 1252. He is depicted with a hatchet in his head, holding a palm, symbol of his martyrdom. The figure beside him wears the mitre and cope of a bishop, but has not been identified. On the reverse is a drawing of concentric squares.

NG 1200 is part of the upper tier of an altarpiece, from which NG 1201 also derives. Other sections from this work survive: main tier, left, *Saints Francis and Agatha with a Kneeling Donor* (Turin, Galleria Sabauda); main tier, centre, *Saint Andrew* (Milan, Brera); main tier, right, *Saints Catherine and Sebastian* (Milan, Brera). All the works are associated with the style of Ferrari, but could be related to the work of Martino Spanzotti (active 1480; died 1525/8), or another as yet unidentified painter.

From Piedmont; bought from Baslini, Milan (Walker Fund), 1885.

Davies 1961, pp. 179–81.

Style of Defendente FERRARI

Saints Nicholas of Tolentino and John the Baptist
1511–35

NG 1201
Oil on poplar, 76.2 x 52.1 cm

Inscribed on the book: PRE/CEP/TA/PAT/RIS/ MEI/SER/VAVI. (The Teaching of the Lord is sufficient for me); inscribed on the Baptist's scroll: ECCE AGN[VS]/DEI QVI TOLLIT ... (Behold the Lamb of God which taketh away [the sins of the world].)

Saint Nicholas of Tolentino, at the left, who was often depicted in Piedmontese works, was a thirteenth-century Augustinian friar. He has a miraculous star on his chest.

Both this picture and NG 1200 are from the upper tier of a compartmentalised altarpiece. See under NG 1200 for further discussion.

From Piedmont; bought from Baslini, Milan (Walker Fund), 1885.

Davies 1961, pp. 179–81.

Attributed to FIORENZO di Lorenzo

The Virgin and Child
probably about 1515–25

NG 2483
Tempera on wood, 48.3 x 36.8 cm

The Child Jesus is shown standing on a carpet on a parapet. He holds a crystal orb and is gently supported by the Virgin Mary. Beyond a second parapet there is a distant landscape.

NG 2483 has also been attributed to Pintoricchio, but this is unlikely.

The composition is indebted, perhaps indirectly, to paintings made by Verrocchio's workshop.

NG 2483 is in its original frame.

Collection of George Salting by 1898; Salting Bequest, 1910.

Davies 1961, pp. 182–3; Dubos 1971, p. 117.

Defendente FERRARI
active 1510–1535?

The artist was from Chivasso in Piedmont. The earliest work by him is thought to be a *Nativity at Night* (Turin, Civic Museum) of 1510. There seems to be little evolution in the style of his paintings.

FIORENZO di Lorenzo
about 1440?–before 1525

Fiorenzo matriculated as a painter in Perugia between 1463 and 1469. He was mainly active in Perugia; there are documented works from 1476 until 1498, though he was recorded as a painter for another twenty years. He painted altarpieces, frescoes and small religious works; he also designed stained glass.

FLEMISH

Cognoscenti in a Room hung with Pictures

about 1620

NG 1287
Oil on oak, 95.9 x 123.5 cm

The eleven 'cognoscenti' depicted may be intended as portraits, but the collection which surrounds them appears to be an invention. It consists of paintings, sculpture, prints, works of art and scientific instruments which reflect aspects of contemporary learning and connoisseurship. This ideal gallery represents works which would have been available to collectors and scholars in Antwerp in the first third of the seventeenth century. Most of the objects can be identified: the paintings all seem to be of the sixteenth and seventeenth-century Antwerp School.

NG 1287 has in the past been attributed to Hans Jordaens the Younger. It has also been said to be a collaboration between Frans Francken II and Hieronymus Francken the Younger. None of these suggestions is convincing, although it is possible that the work is a collaboration between two artists, one of whom painted the figures. The picture is thought to have been painted in Antwerp in about 1620.

Count de Morny sale, Phillips, 1848; bequeathed by John Staniforth Beckett, 1889.

Martin 1970, pp. 68–73; Filipczak 1987, pp. 58–72.

FLEMISH

Portrait of a Man

1626

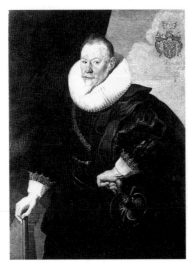

NG 1895
Oil on canvas, 116.2 x 85.8 cm

Inscribed later beneath the coat of arms: AETATIS· (A E linked) SVE/ 63 1626. (His age 63. 1626.)

The composition derives from a print of 1624 by Paulus Pontius (1603–58) made after a portrait by Rubens of Prince Vladislav Sigismond (1598–1648), later King of Poland. The coat of arms is of the Waha family of the Southern Netherlands; however, the sitter has not been identified.

NG 1895 has in the past been attributed to Rubens and to Jordaens, but is in fact by a Flemish contemporary influenced by Rubens's style.

Said to have been in the possession of a Maastricht family; bought from T. Humphry Ward, 1902.

Martin 1970, pp. 75–6.

FLEMISH

Portrait of a Man

1636

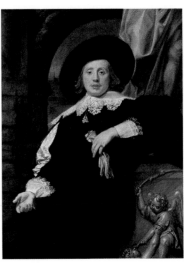

NG 5631
Oil on canvas, 136.2 x 102.2 cm

Inscribed: AETAT'. 26½ / MCM (Aged 26½) Dated: 1636.

The unidentified sitter stands in front of an arch, leaning against a stone relief decorated with Divine Love triumphing over a blindfolded cupid, or Earthly Love. This may imply that the portrait was made at the time of the sitter's marriage.

An attribution to Jordaens has been suggested.

Probably Viscount Midleton sale, Christie's, 1851; bought, 1945.

Martin 1970, p. 77.

FLEMISH
Portrait of a Man
probably 1645–55

FLEMISH
Portrait of a Boy holding a Rose
about 1660

FLEMISH
Portrait of an Elderly Woman
late 17th century

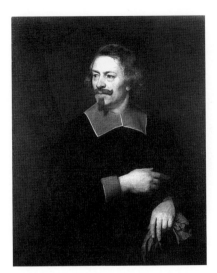

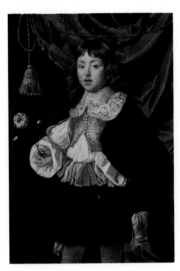

NG 1700
Oil on canvas, 100 x 80.7 cm

NG 1810
Oil on canvas, 93.4 x 64.8 cm

NG 3963
Oil on canvas, 70.9 x 60.6 cm

The sitter has not been identified. The costume seems to be of the late 1640s or the 1650s.

NG 1700 has been catalogued in the past as being Dutch, but is probably Flemish, and may be associated with the work of Lucas Franchoijs the Younger.

Bequeathed by Miss Pilbrow, 1900.

Martin 1970, pp. 73–4.

The youth holds a rose in his right hand which suggests that this may be a betrothal portrait. His costume seems to date from around 1660.

NG 1810 has previously been attributed to François Duchastel (1625?–1694?), but there are few real similarities in handling to Duchastel's rare signed works. Paintings by David Teniers III (1638–85), who was in Spain in the 1660s, show a related technique, but in the present state of knowledge an attribution to the Flemish School seems preferable.

Bequeathed by Henry Vaughan, 1900.

Martin 1970, pp. 74–5.

The woman has not been identified. Her costume is thought to be of the 1670s, or perhaps later.

NG 3963 may be the work of a Flemish artist, but there seem to be stylistic connections with the work of the Middelburg painter Pieter Borsseler (active 1665–87).

Sir Claude Phillips Bequest, 1924.

Martin 1970, pp. 77–8.

Govert FLINCK
Self Portrait aged 24
1639

Vincenzo FOPPA
The Adoration of the Kings
perhaps about 1500

Jean-Louis FORAIN
Legal Assistance
probably 1900–12

NG 3249
Oil on canvas, 61 x 73 cm

NG 4068
Oil (identified) on oak, 65.8 x 54.4 cm

NG 729
Oil on poplar, painted surface 238.8 x 210.8 cm

Signed and dated lower right: G.flinck/1639.

This portrait in terms of the costume, lighting and pose is conceived in a Rembrandtesque manner (see, for example, Rembrandt NG 672). It has in the past been identified as a portrait of Rembrandt and was once signed with his signature, but it is now seen as a Flinck self portrait; the identification is made by comparison of the sitter with other self portraits by the artist, such as that engraved by Blootelingh (1640–90).

Probably collection of Graf von Schönborn, Pommersfelden, by 1857; presented by Ayerst H. Buttery, 1925.

MacLaren/Brown 1991, p. 141.

The Three Kings journeyed to Bethlehem to honour the new-born Jesus. They brought gifts of gold, frankincense and myrrh. New Testament (Matthew 2: 2–12). The stable is set among ruins; this setting is probably intended to suggest that the new Christian order was born out of the decay of the old pagan order.

NG 729 may be a late work by Foppa, perhaps of about 1500.

Collection of Cardinal Fesch before 1815; the Revd W. Davenport Bromley collection, 1845; bought, 1863.

Davies 1961, pp. 196–7.

Signed: forain.

In his later career, Forain became preoccupied with law-court scenes, many of which recall the work of Daumier. This picture focuses on the plight of a poor man, accompanied by his little girl and carrying a child in his arms, who hands a paper to his counsel.

In the collection of Henri Rouart by 1912; bought by Sir Hugh Lane, 1912; Lane Bequest, 1917; on loan to the Hugh Lane Municipal Gallery of Modern Art, Dublin, since 1979.

Alley 1959, p. 78; Davies 1970, p. 65.

Govert FLINCK
1615–1660

Govert Teunisz. (Anthonisz.) Flinck was born in Cleves. He travelled to Leeuwarden to study with Lambert Jacobsz. and then settled in Amsterdam in 1631–2 where he worked in Rembrandt's studio. Abandoning his early dependence on Rembrandt's style in the 1640s, he was subsequently influenced by the work of van der Helst and Van Dyck. As a portrait and history painter Flinck achieved great success, receiving major municipal commissions.

Vincenzo FOPPA
active 1456–1515/16

Foppa came from Brescia and was living in Pavia from about 1456. He travelled frequently and worked in Genoa and Savona, as well as in his native Brescia. He painted polyptychs, single-panel altarpieces, frescoes and processional standards.

Jean-Louis FORAIN
1852–1931

Forain was born in Reims, and grew up in Paris where he studied at the Ecole des Beaux-Arts and subsequently with Carpeaux. He is best known as an illustrator, but was also a painter and etcher. He contributed to the Impressionist exhibitions in Paris from 1879 to 1886 and was a friend of Degas.

Mariano FORTUNY
The Bull-Fighter's Salute
probably 1869

Jean-Honoré FRAGONARD
Psyche showing her Sisters her Gifts from Cupid
1753

Attributed to FRAGONARD
Interior Scene
late 18th century

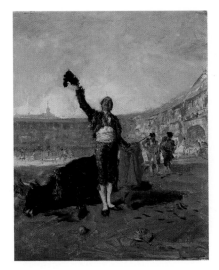

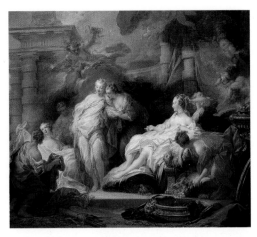

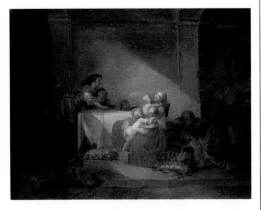

NG 2620
Oil on canvas, 37.5 x 48.3 cm

NG 6445
Oil (identified) on canvas, 168.3 x 192.4 cm

NG 3138
Oil on canvas, 61 x 50.2 cm

Signed lower right: Fortuny.
 The bull-fighter salutes the crowd after having killed the bull. This may be a depiction of the bull-ring in Madrid, and the figure could be a portrait.
 NG 3138 is one of a small number of scenes of this type executed by the artist. It probably originates from one of his trips to Spain in 1867/8 and 1870/2. The stamp of a Paris maker which was visible on the canvas before re-lining suggests that the painting was perhaps ordered on the artist's last visit to Paris, which was in 1869.

Charles Waring sale, London, 1888; bequeathed by Marcus van Raalte, 1916.

MacLaren/Braham 1970, pp. 7–8.

The subject derives from the classical myth of Cupid and Psyche, which was originally recounted by Apuleius in his *Golden Ass*, but was probably best known to Fragonard from La Fontaine's *Les Amours de Psyché et de Cupidon*. The god of love, Cupid, fell for Psyche and took her to his magical palace. He forbade her to look at him and only visited her there during the night. Here she is shown displaying the sumptuous gifts she has received from him to her two sisters. They were jealous and so tried to ruin her happiness by persuading her to murder the sleeping Cupid. She later took a lamp and saw him, but he awoke and as punishment abandoned her. The Fury in the sky represents the sisters' envy.
 NG 6445 was painted in 1753 when Fragonard was a pupil at the Ecole Royale des Elèves-Protégés, and exhibited at Versailles in 1754, where it was seen by Louis XV. Executed when the artist was 21, it is influenced by the work of Boucher, and is comparable in terms of composition and treatment to Fragonard's *Jereboam sacrificing the Idols* (Paris, Louvre) of 1752.
 NG 6445 is cut down along the top and left sides.

Sold as a Carle van Loo 'Toilet of Venus' at the Earl of Rosebery sale, Mentmore, 1977; bought, 1978.

National Gallery Report 1978–9, pp. 22–3; Wilson 1985, p. 100.

This sketch has in the past been given the title 'The Happy Mother'.
 The attribution of NG 2620 has been questioned.

Salting Bequest, 1910.

Davies 1957, p. 91.

Mariano FORTUNY
1838–1874

Fortuny was born in Catalonia and trained in Barcelona. He won a scholarship to Rome in 1858/9 and from the early 1860s was mainly resident there. Fortuny was a genre and history painter whose work is loosely related to that of Meissonier.

Jean-Honoré FRAGONARD
1732–1806

Fragonard was born in Grasse. He studied as a pupil of Chardin and Boucher, then won the Premier Prix at the Académie and attended the French Academy in Rome from 1756 to 1761. At the 1765 Salon he exhibited his *Coresus and Callirhoe* to great acclaim. Later he travelled in the Netherlands and revisited Italy.

Attributed to FRANCESCO di Antonio
The Virgin and Child with Six Angels and Two Cherubim, about 1440

Associate of FRANCESCO di Giorgio
Saint Dorothy and the Infant Christ
probably 1460s

Attributed to Pieter FRANCHOIJS
Portrait of Lucas Fayd'herbe (?)
about 1640–50

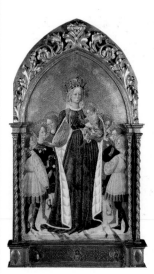

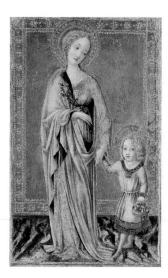

NG 1456
Tempera on wood, 85 x 54 cm

NG 1682
Tempera on wood, painted surface 33.3 x 20.6 cm

NG 1012
Oil on canvas, 99.1 x 79.7 cm

The sleeves of the angels are decorated with fragmentary inscriptions, including: ave yhs – apparently for Hail Christ – presumably from hymns or anthems.

The Virgin, crowned as the Queen of Heaven, holds the Christ Child who blesses. They are surrounded by six angels wearing contemporary Florentine costume. They all stand on a semi-circular marbled platform. The predella is ornamented with *pastiglia* and includes three painted quatrefoils showing the Virgin, the Dead Christ and Saint John.

NG 1456 has been attributed to various Florentine and Sienese artists, including School of Sassetta, Primo della Quercia (active about 1438–1467), the brother of the sculptor Jacopo della Quercia, and Andrea di Giusto. It is now linked on grounds of style with the work of Francesco di Antonio, but differs from his triptych of 1415 at Cambridge (see biography).

Presented by J.P. Heseltine, 1895.

Davies 1961, pp. 197–8; Berti 1990, p. 254.

Saint Dorothy (died about 300) was being taken to her martyrdom when the Christ Child appeared to her bearing a basket of roses and apples (only roses are shown here). She asked that they be given to Theophilus, who had scorned her vision, and he was converted by this proof. *The Golden Legend* (VII, 46–7).

NG 1682 is sometimes said to be a very early work, probably from the 1460s and perhaps from before 1466. In common with many paintings designed by Francesco di Giorgio, it seems likely to have been executed by an associate. This small picture was presumably painted for private devotion. The back is painted with a crude imitation of antique serpentine (green Greek porphyry) with a pink marble border.

Stefano Baldini collection by 1898; bought, 1899.

Davies 1961, pp. 198–9; Bellosi 1993, pp. 120-1.

The sitter is probably Lucas Fayd'herbe (1617–97), a pupil of Rubens who was a sculptor and architect. The portrait can be compared with an engraved portrait of Fayd'herbe by Gonzales Coques in Cornelis de Bie's *Het Gulden Cabinet* (1661).

Fayd'herbe was a native of Malines and had returned there from Rubens's studio in Antwerp by 1640. He was a cousin of the artist and this portrait was probably painted in the 1640s, a date indicated by the costume and by the age of the sitter.

Fayd'herbe was also portrayed by Coques in one of a series of the Five Senses (NG 1117).

Collection of Wynn Ellis possibly by 1861; Wynn Ellis Bequest, 1876.

Martin 1970, pp. 78–9.

FRANCESCO di Antonio
active 1393–1433 or later

The artist is presumably the Francesco Fiorentino who, according to Vasari, was a follower of Lorenzo Monaco. He joined the artists' guild, the Arte dei Medici e Speziali, in Florence in 1409. His works include a triptych dated 1415 (Cambridge, Fitzwilliam Museum), and organ shutters painted for Orsanmichele, Florence in 1429 (Florence, Accademia).

FRANCESCO di Giorgio
1439–1501

Francesco di Giorgio Martini was born in Siena. He was active as a painter and a sculptor in 1464 and from at least 1477 he was in the service of the Duke of Urbino, principally as an architect and engineer. He was active chiefly in Siena, but he also worked in Naples and elsewhere in Italy, especially in the Marches.

Pieter FRANCHOIJS
1606–1654

Franchoijs was born and principally active in Malines. He also worked in Paris, Fontainebleau and for Archduke Leopold-Wilhelm, Governor of the Southern Netherlands. He was a portrait and figure painter and was said to have trained with Gerard Seghers in Antwerp.

Francesco FRANCIA
Bartolomeo Bianchini
perhaps about 1485–1500

Francesco FRANCIA
The Virgin and Child with Two Saints
perhaps about 1500–10

Francesco FRANCIA
The Virgin and Child with Saint Anne and Other Saints, probably about 1511–17

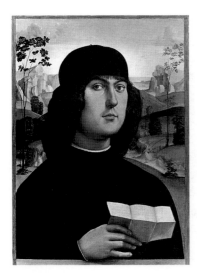

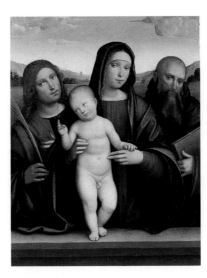

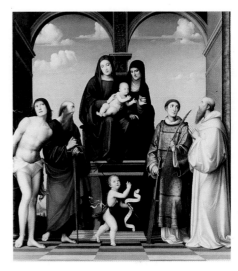

NG 2487
Oil on wood, painted surface 56.5 x 40.6 cm

Inscribed on the letter: Bar(tolomeo?) Blanchino / bono(niae?) (Bartolomeo Bianchini of Bologna).

The sitter was a Bolognese humanist of noble family; he was esteemed by his contemporaries but left few writings (e.g. *Vita di Codro*, 1502). He was alive in 1497 and died before 1528. There is evidence that he was friendly with Francia.

Collection of the Duke of Buckingham by 1848; collection of George Salting by about 1889; Salting Bequest, 1910.

Davies 1961, pp. 204–5.

NG 638
Oil (identified) on wood, painted surface 78.1 x 62.2 cm

The young saint on the left with a palm may be Saint John the Evangelist; the saint on the right wears a purple habit and is holding a book.

NG 638 probably dates from the early years of the sixteenth century; an earlier date of about 1495–9 has also been suggested. Francia varied this composition on other occasions.

From the collection of Col. Bourgeois, Paris; bought with the Edmond Beaucousin collection, Paris, 1860.

Davies 1961, pp. 203–4.

NG 179
Oil (identified) on canvas, transferred from wood, 195 x 180.5 cm

Inscribed on the scroll: ECCE AGNVS DEI (Behold the Lamb of God). Signed: FRANCIA.AVRIFEX. BONONIE[N]SIS. P.[INXIT] (Francia goldsmith of Bologna painted this).

The Virgin and Child with Saint Anne are shown on a throne; Saints Sebastian and Paul and Saints Lawrence and Benedict are on either side, with the young Saint John the Baptist in the centre (his scroll is inscribed with words from the New Testament, John 1: 29, 36).

NG 179 and the lunette of the *Pietà* (NG 180) were commissioned as an altarpiece for the chapel of Saint Anne in the church of San Frediano in Lucca by Benedetto Buonvisi, a local silk merchant. The chapel was completed in 1511, and the altarpiece (which was commissioned sometime after 1510) was delivered after this date, but before Francia's death in 1517.

Saint Anne (mother of the Virgin) was the titular saint of this chapel. Saints Benedict, Paul and Lawrence were the name saints of the patron and his relatives (Benedetto, his brother Paolo and their deceased father Lorenzo are mentioned in documents related to the chapel's decoration). Saint Sebastian, who was often invoked against plague, was probably included on account of the plague which broke out in Lucca in 1510.

Collection of the Buonvisi and their heirs until about 1823, when sold into the ducal collection at Lucca; bought, 1841.

Davies 1961, pp. 200–3; Tazartes 1983, pp. 5–9.

Francesco FRANCIA
about 1450–1517/18

Francesco Raibolini (known as Il Francia) was born and worked in Bologna. He matriculated in the goldsmiths' guild in 1482 and was first mentioned as a painter in 1486. He painted altarpieces, small devotional pictures and frescoes, often working for the Bentivoglio court, and sometimes for patrons outside Bologna (e.g. Lucca).

Francesco FRANCIA
Pietà
probably about 1511–17

Attributed to FRANCIA
Mourning over the Dead Christ
probably about 1510–17

Imitator of FRANCIA
The Virgin and Child with an Angel
about 1870–90

NG 180
Oil (identified) on wood, flattened semicircle,
painted surface 94 x 184.5 cm

NG 2671
Oil on wood, painted surface, cut at left and right
30.5 x 34.3 cm

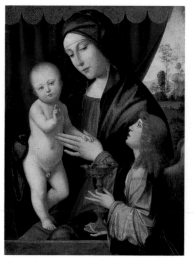

NG 3927
Wood, painted surface 58.5 x 44.5 cm

Christ's dead body is held by the Virgin Mary in her
lap. His head is held by an angel, while another
looks at the wounds in his feet.

NG 180 was the lunette to NG 179 (which formed
the altarpiece formerly in the chapel of Saint Anne
in the church of San Frediano, Lucca). For further
discussion of the altarpiece see under NG 179.

*Collection of the Buonvisi and their heirs until about
1823, when sold into the ducal collection at Lucca;
bought, 1841.*

Davies 1961, pp. 200–3; Tazartes 1983, pp. 5–9.

Christ is shown after the Deposition from the Cross,
with the Virgin standing in the centre, the
Magdalen at Christ's feet, and Joseph of Arimathea
and Nicodemus at his head.

NG 2671 is a fragment of a small panel, perhaps
from a predella. The figure of the Virgin, and to a
lesser degree the figure of Christ, correspond with
an engraving by Marcantonio Raimondi.

*Collection of the Princes of Cellamare; Salting Bequest,
1910.*

Davies 1961, p. 205.

Inscribed on the parapet (much damaged): OPVS
FRANCIAE AVR[EFIC]IS / [M] CCCLXXXX (Work of
Francesco [Francia] goldsmith, 1490).

An angel presents a chalice containing cherries
(sometimes known as the fruit of paradise and a
symbol of heaven) to the Virgin and Child. Two
figures, probably soldiers, are visible in the right
background.

NG 3927 has been shown by technical
examination in 1955 to have been painted relatively
recently, presumably in the late nineteenth century.
It was acquired by Ludwig Mond as the work of
Francia in 1893 and retained this attribution until
1955. The composition appears to be a variant of an
altarpiece by Francia painted for the church of the
Misericordia in Bologna. The chalice is an attractive
addition to a painting purporting to be by an artist
who signed himself as a goldsmith.

*Acquired by Ludwig Mond from the Spitöver-Haas
collection, Rome, 1893; Mond Bequest, 1924.*

Davies 1961, p. 206; Jones 1990, pp. 194–6.

FRANCIABIGIO
Portrait of a Knight of Rhodes
1514

FRENCH
The Virgin
15th century

FRENCH, Fontainebleau School
Cleopatra
16th century

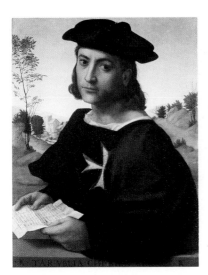

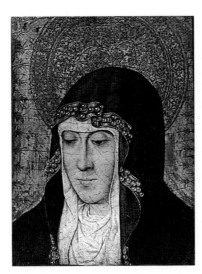

NG 1035
Oil on wood, painted surface 60.3 x 45.7 cm

Inscribed in provençal French on the parapet: .TAR. VBLIA. CHI. BIEN. EIMA. (He who loves well is slow to forget); at either end of the inscription is a monogram, consisting of F, R and C interlaced, associated with Franciabigio.

The writing on the paper held by the sitter is not legible, but the date 1514 can be read at the end.

The sitter, who has not been identified, wears the cross of the Order of Saint John at Rhodes.

NG 1035 is probably of 1514, although the date has also been read as 1516.

The Order of Saint John was expelled from Rhodes in 1522–3 and established in Malta in 1530 (another member of the order was painted by Rosso, see NG 932).

Collection of W. Fuller Maitland by 1863; bought, 1878.

McKillop 1974, pp. 140–1; Gould 1975, pp. 90–1.

NG 1335
Oil on pine, 34.9 x 26 cm

The head has apparently been cut from a larger picture.

Probably a fake. An attribution to Cimabue is inscribed on the back.

Bought from Miss Sorel (Clarke Fund), 1891.

Davies 1957, p. 101.

NG 5762
Oil on wood, diameter 46 cm

The ancient Egyptian queen Cleopatra who was known for her beauty and intellect is here depicted lounging on a divan.

NG 5762 when bequeathed to the Gallery was described as coming from the School of Fontainebleau. This appears to be the case, although the artist may be Flemish, rather than French. It is possible that the work is from a series.

Bequeathed by Maurice Woolff Jacobson, 1947.

Davies 1957, p. 91.

FRANCIABIGIO
about 1484–1525

Francesco di Cristofano, called Franciabigio, was of Milanese origin but spent most of his career in Florence. According to Vasari he was trained by Fra Bartolommeo's collaborator, Mariotto Albertini. He was subsequently associated with Andrea del Sarto's workshop. He painted frescoes, altarpieces, and portraits, for which he is chiefly remembered.

FRENCH
Portrait of a Man (Paul, Sire d'Andouins?)
1543

NG 660
Oil on oak, 31.8 x 23.5 cm

Inscribed top right: 1543. Written on the back of the panel: Léonar de Vincy.

The sitter is thought to be Paul, Sire d'Andouins, Vicomte de Louvigny (1520?–62). This is based on a comparison with a drawing at Chantilly (Musée Condé).

Bought with the Edmond Beaucousin collection, Paris, 1860.

Davies 1957, pp. 101–2.

FRENCH
Portrait of a Lady
1570–5

NG 2617
Oil on oak, 34.9 x 25.4 cm

It has been suggested at different times that the sitter is the Duchesse d'Angoulême, or Françoise d'Orléans, Princesse de Condé. Neither of these identifications is convincing.

NG 2617 is dated by the costume of the sitter, which is thought to be of the mid-1570s.

Baron de Beurnonville sale, Paris, 1881; Salting Bequest, 1910.

Davies 1957, p. 102.

FRENCH
Phineas and his Followers turned to Stone
about 1660

NG 83
Oil on canvas, 166.4 x 245.4 cm

Phineas and his followers interrupted the wedding feast of Perseus and Andromeda. Perseus transformed them to stone by showing them the Gorgon's head (Ovid, *Metamorphoses*, V).

NG 83 has formerly been catalogued as by a follower of Poussin, and as by Bertholet Flémalle (1614–75), a Flemish artist who worked in Rome and Paris.

Presented by Lt.-General W. Thornton, 1837.

FRENCH
Cardinal de Retz
probably 1660s

NG 2291
Oil on canvas, 71.1 x 57.2 cm

Bears later inscription: Le Cardinal de Retz.

Jean-François-Paul de Gondi (1613–79) became a cardinal in 1652. He was a leader in the troubles of the Fronde, 1648–52, and travelled in Europe between 1654 and 1662.

NG 2291 has traditionally been attributed to Philippe de Champaigne, but bears little relation to his work. It is dated, by comparison with other engraved portraits of the sitter, to the 1660s.

Collection of George Fielder, Leatherhead, by 1878; by whom bequeathed, 1908.

Davies 1957, p. 27; Dorival 1976, II, p. 329.

FRENCH
Prince Charles Edward Stuart (The Young Pretender), after 1748

NG 1882
Oil on wood, 7.6 x 7 cm

The composition is derived from an engraving after a portrait by Louis Tocqué of 1748.

Bequeathed by Miss Julia Gordon, 1896.

FRENCH
Portrait of a Lady (Madame de Gléon?)
about 1760

NG 5584
Oil on canvas, 64.1 x 54.6 cm

Geneviève Savalette, Marquise de Gléon (about 1732–95), was a writer and amateur actress. The identification is traditional. The dress and the hairstyle are of about 1760.

NG 5584 has been attributed to Greuze. This may be reasonable, but the work is damaged at the face and neck, making a firm attribution problematic.

Probably passed from the Duchess of Manchester (died 1909) to her sister Emilie Yznaga; by whom bequeathed, 1945.

Davies 1957, p. 105.

FRENCH
Portrait of a Boy
before 1810

NG 4034
Oil on canvas, 55.9 x 42.5 cm

This portrait was once wrongly attributed to
Jacques-Louis David but it may be by one of his
pupils or by a follower of Baron Gros (1771–1835).
 The costume and hair-style suggest a date of
around 1810.

*Anon. sale, London, 1908; Sir Claude Phillips Bequest,
1924.*

Davies 1970, pp. 65–6.

FRENCH
An Académie
early 19th century

NG 4061
Oil on canvas, 80.6 x 64.8 cm

Signed, falsely: david 1805
 The title describes a study from the life made as
part of the curriculum in an art academy (see also
NG 3391).

Sir Claude Phillips Bequest, 1924.

Davies 1970, p. 66.

FRENCH
Portrait of a Lady
19th century

NG 2218
Oil on canvas, 32.7 x 25.4 cm

The sitter was at one time described as the singer
Mme Malibran, but there seems to be no
justification for this identification.
 NG 2218 has been associated with Ingres and
with the American artist John Vanderlyn (1775?–
1852), but neither suggestion is satisfactory.

Bought (Lewis Fund), 1908.

FRENCH
An Allegory
19th century

NG 2289
Oil on canvas, 177 x 137 cm

Falsely signed: DELACROIX, 1855(?)

It has been suggested that the allegory shows Attila driving Beauty, Art and Pleasure before him but there is no connection with Delacroix's painting of Attila (Paris, Library of the Chambre des Députés).

NG 2289 was formerly catalogued as by Delacroix, but this attribution is now rejected. The work was severely damaged by a flood in the Tate Gallery in 1928.

Said to have passed from the studio of Delacroix; presented by Frédéric Mélé, 1908.

Davies 1970, p. 60.

FRENCH
A Struggle in a Desert
19th century

NG 2910
Oil on canvas, 34.3 x 22.9 cm

Apparently a free copy after a rather earlier picture (possibly seventeenth century) known as *The Slaying of Aaron's Grandson* (private collection).

NG 2910 was probably painted in the early nineteenth century and was once attributed to Alexandre-Gabriel Decamps (1803–60).

Bequeathed by Lady Lindsay, 1912.

Tate Gallery 1934, p. 29.

FRENCH
A Black Woman
19th century

NG 3250
Oil on canvas, 81.3 x 66.7 cm

NG 3250 has been attributed variously to Delacroix, Fromentin and Marie-Guillemine Benoist (1768–1826). It is now thought to be probably French and of the later nineteenth century.

Sir Hugh Lane Bequest, 1917; on loan to the Hugh Lane Municipal Gallery of Modern Art, Dublin, since 1979.

Davies 1970, p. 66.

FRENCH
An Académie
probably 1800–50

NG 3391
Oil on canvas, apparently cut at top and bottom
67.5 x 37 cm

This male nude seen from behind is an *académie*, a life study made as part of the curriculum of a classical training in painting in early nineteenth-century France (see also NG 4061).

 Although this picture entered the Collection as a Géricault, this attribution is no longer acceptable.

Presented to the Tate Gallery by wish of Sir Charles Holroyd, 1919; transferred, 1956.

Davies 1970, pp. 68–9; Bazin 1987, II, pp. 275, 371, no. 138.

FRENCH
Victor Considérant
probably about 1830–50

NG 3686
Oil on canvas, 28.5 x 22 cm

The sitter has been identified as the French social reformer Victor Considérant (1808–93) by tradition and by comparison with known portraits of him.

 If the sitter is Considérant, NG 3686 was probably painted in the 1830s or 1840s. It may be unfinished. The portrait was once attributed to Delacroix but there is no evidence to support this.

Presented by Walter Sickert to the Tate Gallery, 1922; transferred, 1956.

Davies 1970, pp. 60–1.

FRENCH (?)
Portrait of a Man
probably 16th century

NG 947
Oil on lime, 39.4 x 29.2 cm

A half-length portrait of an unidentified sitter who holds a paper and a pair of gloves.

 NG 947 has been catalogued as Flemish, and attributed to Corneille de Lyon. It is not clear if it is French or Flemish, or indeed if it was painted in the sixteenth century, although the suggestion that it is a modern work can probably be disregarded.

 X-radiographs and infra-red photographs show how the composition was altered. Originally the sitter's right hand was raised higher, and it appears that he was holding an object which may have been a dagger.

Wynn Ellis Bequest, 1876.

Davies 1957, p. 103.

FRENCH (?)
Portrait of a Boy
16th century

NG 1190
Oil on canvas, possibly transferred from wood,
 37.5 x 27.3 cm

A profile portrait of an unidentified youth.
 NG 1190 has in the past been attributed to the
School of Clouet, and more understandably to the
School of Fontainebleau. It has also been suggested
that its origins may not be French at all.
 X-radiographs show changes made by the artist to
the nose and collar.

*Given by William Russell to G.F. Watts, 1862; by whom
presented, 1885.*

Davies 1957, pp. 102–3.

FRENCH (?)
Portrait of a Man
probably 16th century

NG 3539
Oil on oak, 28.6 x 23.5 cm

A heavily repainted bust-length portrait of an
unidentified sitter.
 NG 3539 has been attributed to Clouet (about
1475–1541) and to Corneille de Lyon, but the
condition of the panel, which is badly rubbed,
precludes a firm attribution.

Presented by Alfred A. de Pass, 1920.

Davies 1957, p. 103.

FRENCH (?)
Portrait of a Young Lady
after 1580

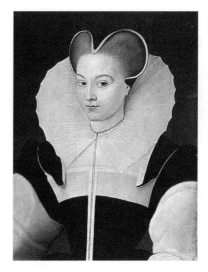

NG 3582
Oil on oak, 46.4 x 35.6 cm

A half-length portrait of an unidentified sitter. She
has been catalogued as 'A Young Widow', but
because she has no veil this seems unlikely. The
fashion of her clothes can be dated to soon after 1580.
 NG 3582 was acquired as by the School of Clouet.
It may actually be by an Anglo-Flemish artist, and it
is possible that it was executed later than the
sixteenth century.
 The panel is worn and has been repainted. It has
apparently been cut down on all sides.

*Henry Labouchere, Baron Taunton, collection; possibly
seen by Waagen at Stoke, 1854; bought (Temple-West
Fund), 1921.*

Davies 1957, pp. 103–4.

FRENCH (?)
The Visitation
17th century

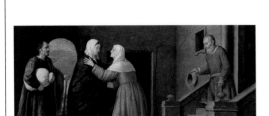

NG 5448
Oil on canvas, 114.3 x 218.4 cm

Caspar David FRIEDRICH
Winter Landscape
probably 1811

NG 6517
Oil (identified) on canvas, 32.5 x 45 cm

Eugène FROMENTIN
The Banks of the Nile
1874

NG 3511
Oil on canvas, 54 x 78.7 cm

The Virgin visited her pregnant cousin Elizabeth after the Annunciation. New Testament (Luke 1: 36–56).

NG 5448 was at one time attributed to Murillo; it has also been described as Italian.

Lord Boston collection, Hedsor, Bucks; bought from Colnaghi's (Martin Colnaghi Fund), 1944.

Gould 1975, pp. 125–6.

A man, having discarded his crutches, prays before a crucifix in the foreground. The silhouette of a Gothic cathedral emerges from the bank of mist in the distance.

NG 6517 probably dates from 1811, the year in which a work with this subject is described in the correspondence of two visitors to Friedrich's studio. Friedrich seems to have devised the composition as a pendant to a work of the same date and title (now Schwerin, Staatliches Museum). In the Schwerin painting, a figure on crutches is shown wandering among dead oak trees in an empty snow-covered landscape. Friedrich combined landscape motifs with religious symbolism, and it seems that if the Schwerin painting may be interpreted as an image of despair and hopelessness, then by contrast, the National Gallery picture was intended to convey the promise of salvation through the Christian faith. Although the attribution of NG 6517 is secure, it is complicated by the existence of a very similar version of the composition in the Museum für Kunst und Kulturgeschichte, Dortmund. Several other works by Friedrich exist in at least one other version, but only one 'Winter Landscape' is mentioned in the early literature on the artist. A comparison of the London and Dortmund paintings suggest that the latter is probably a second version of the composition, either by Friedrich or by one of his pupils or followers.

Private collection, Paris; bought, 1987.

Wettengl 1990, p. 121, no. 25; Koerner 1990, p. 22; Leighton 1990, pp. 44–60.

Signed and dated: Eug. Fromentin 74
This is one of many African scenes painted by Fromentin.

Tiltzer, Manchester; Boussod Valadon sale, New York, 1902; presented by Roland F. Knoedler to the Tate Gallery, 1920; transferred, 1956.

Davies 1970, p. 67.

Caspar David FRIEDRICH
1774–1840

Friedrich was born in Greifswald, Pomerania. He studied under Gottfried Quistorp at the University of Greifswald (1790–4), and at the Academy of Fine Arts, Copenhagen (1794–8) with C.A. Lorentzen, Jens Juel and Nicolai Abildgaard. In 1798 he moved to Dresden, which eventually became his permanent home. Influenced there by a circle of Romantic scholars and poets, he made landscape drawings, watercolours, sepias and oil paintings.

Eugène FROMENTIN
1820–1876

Fromentin was born at La Rochelle and studied under Jean-Charles-Joseph Rémond and Louis Cabat. He exhibited at the Salon from 1847. Fromentin specialised in African scenes and wrote a celebrated book on Dutch and Flemish painting, *Les Maîtres d'Autrefois* (1876).

Bernardino FUNGAI
The Virgin and Child with Cherubim
probably about 1495–1510

Studio of Francesco FURINI
The Three Graces
after 1638

Jan FYT
Dead Birds in a Landscape
probably 1640s

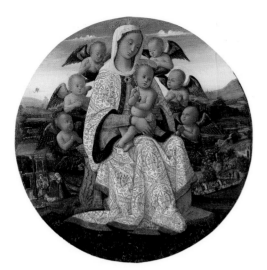

NG 1003
Oil on canvas, 41.6 x 56.8 cm

NG 1331
Tempera and oil on wood, 119.4 x 118.1 cm

NG 6492
Oil on canvas, 220 x 175 cm

The Virgin and Child are seated on a throne and surrounded by six angels. In the background the Virgin and Saint Joseph adoring the Child Jesus and the Annunciation to the Shepherds can be seen. The journey of the Three Kings and their followers is shown in the right background.

The composition of the Virgin and Child may derive from Perugino.

Probably acquired in Siena, 1827; collection of J.W. Faulkner by 1865; collection of William Connal, 1886; by whom presented, 1891.

Davies 1961, pp. 206–7.

The Three Graces of Antiquity – Aglaia, Euphrosyne and Thalia, the daughters of Zeus – were often associated with giving and receiving, and with pleasure, chastity and beauty.

The composition of NG 6492 repeats in reverse a painting by Furini of the same subject of 1638 (St Petersburg, Hermitage). Furini's cartoon may have been re-used by a member of his studio. A drawing made in preparation for Furini's original version of the Grace here seen seated on the right survives (Paris, Louvre).

Presented by Sir Alfred Mond, 1920.

Signed: Joannes Fyt·

The dead birds in the foreground are a brace of partridges, a greenfinch, a chaffinch, a brambling, a robin and a quail. It has been suggested that the object behind the tree trunk is a bird trap, but it is more likely to be a birdcage used to carry a decoy bird or a bird of prey.

Wynn Ellis Bequest, 1876.

Martin 1970, pp. 81–2.

Bernardino FUNGAI
1460–probably 1516

Bernardino Cristofano da Fungaia was documented as a pupil of Benvenuto di Giovanni in 1482. Paintings made before about 1496 have not been securely attributed to him. His work shows the influence of Orioli and Signorelli. He worked in Siena for most of his life, painting frescoes, altarpieces, processional banners and small devotional works.

Francesco FURINI
1603–1646

Furini was born in Florence where he spent much of his career, working for the Medici family and other private patrons. He painted altarpieces and collectors' pictures, and visited Rome and Venice following his apprenticeship with Cristofano Allori, Passignano and Bilivert.

Jan FYT
1611–1661

Fyt was born and spent most of his life in Antwerp. In 1620/1 he is recorded as a pupil of Hans van den Berch. He then worked under Frans Snijders, and in 1630 is documented as a master in the Antwerp guild. Fyt, who painted still lifes, animals and flowers, and was also active as an engraver, visited Paris (1633–4), Venice and Rome.

Attributed to FYT
A Still Life with Fruit, Dead Game and a Parrot
late 1640s

NG 6335
Oil on canvas, 84.7 x 113.4 cm

Inscribed: J·f·

The parrot is an African Grey. The dead game consists of a hare and a brace of partridges; next to them is a jay.

NG 6335 is reminiscent of the works of Fyt of the late 1640s, but the handling of paint is rather coarse and so an element of doubt about the attribution remains.

Claude Dickason Rotch by 1953; by whom bequeathed, 1962.

Martin 1970, p. 82.

Attributed to Agnolo GADDI
The Coronation of the Virgin
probably about 1380–90

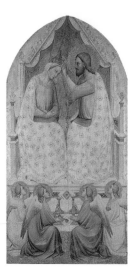

NG 568
Tempera on poplar, trimmed all round 182 x 94 cm

NG 568 was probably the central panel of an altarpiece and was said to be from the Convent of the Minori Osservanti (a branch of the Franciscan Order) of S. Miniato al Tedesco between Florence and Pisa. It may have been transferred there from the church of S. Giovanni de' Fieri, near Pisa. Two other panels (both Pisa, Museo Nazionale di San Matteo), sometimes attributed to Agnolo Gaddi, and possibly once part of the same altarpiece as NG 568, came from this church.

The pinks in the robes of Christ and the Virgin may have originally been richer and have faded with time. Many of the old retouchings have become discoloured.

Bought from the Lombardi–Baldi collection, Florence, 1857.

Cole 1977, pp. 16–19, 83; Gordon 1988, pp. 27–8.

Eduard GAERTNER
The Friedrichsgracht, Berlin
probably 1830s

NG 6524
Oil on paper laid down on millboard, 25.5 x 44.6 cm

This view looks across the Friedrichsgracht, a canal that ran through the centre of Berlin, from a house in the Wallstrasse. The Friedrichsgracht still survives in Berlin, although much of the area has been rebuilt since the Second World War.

NG 6524 was probably painted in the 1830s, possibly for Pierre Louis Ravené who moved into the building in the foreground in 1833. No figures are seen in NG 6524, which may suggest that it was made in preparation for another picture, although no other version of this composition is known.

The striking composition, dominated by the geometrical precision of the zinc roof in the foreground, is typical of Gaertner's work.

Collection of Dr Ernst-Jürgen Otto, Berlin, by 1950; bought with assistance from private bequests, 1989.

National Gallery Report 1989–90, pp. 14–15.

Agnolo GADDI
active 1369; died 1396

Agnolo Gaddi's father Taddeo was a Florentine painter and presumably Agnolo's first teacher. Agnolo was working in the Vatican, probably as assistant to his brother Giovanni in 1369, and subsequently painted numerous fresco cycles in Florence including, probably, the choir of S. Croce. In the 1390s he painted frescoes in Prato Cathedral. He also painted altarpieces. One of his chief patrons was the merchant of Prato, Francesco Datini.

Eduard GAERTNER
1801–1877

Gaertner was born in Berlin and trained at the Berlin Academy, with Karl Wilhelm Gropius, and with Jean-Victor Bertin in Paris (1825–8). On his return to Berlin he painted panoramic views of the city and pictures of everyday life. His most important patron was King Friedrich Wilhelm III of Prussia, but he travelled widely in Europe and also worked in Moscow and St Petersburg.

Thomas GAINSBOROUGH
Gainsborough's Forest ('Cornard Wood')
about 1748

NG 925
Oil on canvas, 121.9 x 154.9 cm

Thomas GAINSBOROUGH
Portrait of the Artist with his Wife and Daughter
about 1748

NG 6547
Oil on canvas, 92.1 x 70.5 cm

Thomas GAINSBOROUGH
Mr and Mrs Andrews
about 1748–9

NG 6301
Oil on canvas, 69.8 x 119.4 cm

An engraving of NG 925 published two years after Gainsborough's death is titled *Gainsborough's Forest*, but the painting is generally known as *Cornard Wood*, from the wooded land near Sudbury, Suffolk. The church tower seen through the wood in the background appears to be that of Great Henny.

According to Gainsborough's own account, the picture was painted in 1748.

Collection of Richard Morrison by 1788; bought (Lewis Fund), 1875.

Davies 1959, pp. 36–7; Hayes 1982, pp. 342–5.

This is the only known portrait in which Gainsborough included himself with his family. With him are his wife, Margaret Barr, whom he married in July 1746, and their daughter. Gainsborough holds in his hand a paper, perhaps once showing a sketch, but now transparent with age. The child was assumed to be Gainsborough's eldest surviving daughter Mary, born shortly before February 1750. However, both the style of the background and the evident difficulties Gainsborough had with the proportions of the rather stiff-limbed figures suggest a date closer to 1747–8, when Gainsborough was still working in London, than the early 1750s. The child may, therefore, be the Gainsboroughs' first-born but short-lived daughter, also named Mary. Her date of birth is so far untraced, but the child in the picture would seem to be around eighteen months old. Mary Gainsborough was buried in March 1748 at St Andrews, Holborn, nearly twenty months after her parents' marriage.

By descent to the great-nephew of the artist, the Revd Edward Richard Gardiner (born 1799); by descent to his grandson, Edward Netherton Harward (1838–1922); his widow's sale, Christie's, 11 May 1923 (lot 103), bought Knoedler; D.H. Carstairs, New York, by 1927; Sir Philip Sassoon, Bt, by 1930; bequeathed to his sister, 1939; presented by the Dowager Marchioness of Cholmondeley in memory of Sir Philip Sassoon, 1994.

Waterhouse 1958, p. 69, no. 296; Tyler 1992–3, pp. 27–32; National Gallery Report 1993–4, pp. 16–17.

Robert Andrews (1726?–1806) of The Auberies, near Bulmer in Suffolk, married Frances Mary Carter (about 1732–80) of Ballingdon House, near Sudbury, on 10 November 1748 at All Saints, Sudbury, the church whose tower is seen in the centre background of this painting. NG 6301 was probably painted soon after the marriage, about 1748–9. The fields in the landscape setting are part of The Auberies estate.

The unfinished object in Mrs Andrews' lap remains puzzling; it was once thought to be a pheasant shot by her husband, but the season in which sheaves of ripe corn have been harvested is too early for pheasant-shooting.

By descent to G.W. Andrews; bought, 1960.

Hayes 1991, p. 76.

Thomas GAINSBOROUGH
1727–1788

Gainsborough was born in Sudbury, Suffolk. He became a pupil of Gravelot in London from about 1740. In 1748 he returned to Suffolk, working in his native Sudbury until moving to Ipswich about 1752. In 1759 he moved to Bath, finally settling in 1774 in London, where he died. He was a foundation member of the Royal Academy in 1768, and painted landscapes and subject-pieces as well as portraits.

Thomas GAINSBOROUGH
John Plampin
about 1755

Thomas GAINSBOROUGH
The Painter's Daughters chasing a Butterfly
probably about 1756

Thomas GAINSBOROUGH
The Painter's Daughters with a Cat
about 1760–1

NG 5984
Oil on canvas, 50.2 x 60.3 cm

NG 1811
Oil on canvas, 113.7 x 104.8 cm

NG 3812
Oil on canvas, 75.6 x 62.9 cm

The sitter is John Plampin (?1727–1805), portrayed in about 1755. He inherited Shimpling and Chadacre Hall, near Bury St Edmunds, Suffolk, in 1757.

Gainsborough may have borrowed the pose from an engraving after Watteau's lost picture, *Antoine de la Roque*, combining it with currently fashionable notions of deportment.

Remained with descendants until sold at Christie's, 1903; bequeathed by Percy Moore Turner, 1951.

Davies 1959, pp. 42–4.

This is the earliest of six known double portraits by Gainsborough of his daughters Mary (baptised on 4 February 1750) and Margaret (baptised on 22 August 1751). Both girls were baptised in Sudbury, Suffolk; although their dates of birth are not known, there was probably only about eighteen months between them.

NG 1811 was probably painted in about 1756 in Ipswich, where Gainsborough lived and worked from 1752 until his move to Bath in 1759. The picture is unfinished. Another portrait of his daughters can be seen in NG 3812.

Probably given by the artist to Revd Robert Hingeston before 1766; Henry Vaughan Bequest, 1900.

Davies 1959, pp. 38–9; Tyler 1991–2, pp. 50–65.

Gainsborough's daughters Mary and Margaret were baptised in February 1750 and August 1751. In NG 3812 Mary appears to be about nine or ten years old, and Margaret about eight or nine.

Gainsborough had moved with his family from Ipswich to Bath in the autumn of 1759 and NG 3812 may therefore have been painted in Bath rather than in Ipswich. NG 3812 is unfinished (the cat is particularly sketchy).

Passed from the sitters to descendants of Gainsborough's sister Susannah Gardiner; sold, 1923; bought, 1923.

Davies 1959, pp. 40–1; Tyler 1991–2, pp. 50–65.

Thomas GAINSBOROUGH
Dr Ralph Schomberg
about 1770

NG 684
Oil (identified) on canvas, 233 x 153.7 cm

Dr Ralph Schomberg (1714–92), a physician, settled in 1761 in Bath where Gainsborough had been working since 1759. Dr Schomberg was occasionally called in by Gainsborough to attend his family, and is known to have attended his elder daughter Mary in 1771. Gainsborough hoped that Dr Schomberg had cured her of a recurring illness which other doctors had pronounced to be hereditary. This portrait may have been painted in lieu of medical fees.

By family descent from the sitter to J.T. Schomberg QC; from whom bought, 1862.

Davies 1959, p. 36; Bomford 1988a, pp. 44–56.

Thomas GAINSBOROUGH
The Watering Place
about 1774–7

NG 109
Oil on canvas, 147.3 x 180.3 cm

NG 109 was exhibited by Gainsborough at the Royal Academy in 1777 (no. 136) and was highly praised by several contemporary critics, including Horace Walpole who declared it to be 'in the Style of Rubens'. In particular it was influenced by Rubens's landscape 'The Watering Place' (NG 4815), a picture Gainsborough records having seen in 1768, when in the collection of the Duke of Montagu.

Bought at Mrs Gainsborough's second sale at Christie's, 11 April 1797, by Charles Long MP, later Lord Farnborough; by whom presented, 1827.

Davies 1959, pp. 34–5; Hayes 1982, pp. 465–7.

Thomas GAINSBOROUGH
Mrs Siddons
about 1783–5

NG 683
Oil on canvas, 126.4 x 99.7 cm

Sarah Siddons (1755–1831) was the outstanding tragic actress of her day. The daughter of Roger Kemble, she married William Siddons in 1773.

Gainsborough had finished NG 683 by the end of March 1785. He is said to have begun a full-length portrait of her in 1783; she was also portrayed by Reynolds and other artists.

Gainsborough is reported to have had difficulties with the nose and to have exclaimed: 'Confound the nose, there's no end to it.' Pentimenti can be seen in both the nose and the right hand.

Bought from the husband of a descendant of the sitter, 1862.

Davies 1959, p. 35.

Thomas GAINSBOROUGH
Mr and Mrs William Hallett ('The Morning Walk')
about 1785

Thomas GAINSBOROUGH
The Market Cart
1786

GAROFALO
The Virgin and Child with Saints Dominic and Catherine of Siena, probably 1500–5

NG 6209
Oil on canvas, 236.2 x 179.1 cm

NG 80
Oil on canvas, 184.2 x 153 cm

NG 3102
Oil on wood, 46.3 x 34.8 cm

William Hallett (1764–1842) married Elizabeth Stephen (1764–1833) on 30 July 1785.

Gainsborough was paid 120 guineas for the portrait in March 1786. The title *'The Morning Walk'* was not applied to the picture until the late nineteenth century.

By family descent until 1884; bought with a contribution from the NACF (Sir Robert Witt Fund), 1954.

Davies 1959, pp. 44–5; Hayes 1991, p. 118.

The market cart is laden with fresh produce. On the right is a woodcutter, a favourite motif of Gainsborough's, but the composition is dominated by the grandeur of the trees.

NG 80 was described by Bate-Dudley in the *Morning Herald* in December 1786; it was certainly finished by that date, and probably begun earlier in that year.

Collection of Peter Burrell by 1787; presented by the Governors of the British Institution, 1830.

Hayes 1982, pp. 566–9.

The two saints were among the most prominent of the Dominican Order. Saint Dominic is identified by the miraculous star on his chest. The tethered monkey may represent man's bad nature disciplined by the Christian faith. Christ's sacrifice is symbolised by the goldfinch which the Child holds on a string.

Costabili collection, Ferrara, by 1838; bought by Sir A.H. Layard, probably 1866; Layard Bequest, 1916.

Gould 1975, p. 85.

GAROFALO
about 1476–1559

Benvenuto Tisi from Garofalo, was probably born in Ferrara, where he was mainly active, and trained with Boccaccio Boccaccino. He visited Rome where he was strongly influenced by Raphael. He was a prolific painter of frescoes and religious subjects (both altarpieces and small devotional works), and he also painted a few mythologies.

GAROFALO

The Madonna and Child, with Saints William of Aquitaine, Clare, Anthony of Padua and Francis 1517–18

NG 671
Oil (identified) on wood, original painted area 198.1 x 208.3 cm

The Virgin and Child are flanked (left to right) by a soldier saint probably William of Aquitaine (an eighth-century warrior who joined the Benedictine Order), Saint Clare of Assisi (about 1194–1253, who established an order of nuns who followed the rule of Saint Francis), Saint Anthony of Padua (1191–1231) and Saint Francis of Assisi (about 1181–1226, founder of the Franciscan Order).

NG 671 was painted for the high altar of the Franciscan church of S. Guglielmo, Ferrara. There is documentary evidence for dating the altarpiece to 1517–18: Garofalo received his payment of 60 lire, and a bonus of 18 lire from Antonio de' Costabili for having done the job so well.

High altar of the church of S. Guglielmo, Ferrara, until about 1832; collection of Conte Antonio Mazza by 1856; from whom bought, 1860.

Gould 1975, pp. 93–4.

GAROFALO

Saint Augustine with the Holy Family and Saint Catherine of Alexandria ('The Vision of Saint Augustine'), about 1520

NG 81
Oil on wood, 64.5 x 81.9 cm

Saint Augustine (right, about 354–430) talked to a child (centre) who was trying to empty the sea into a hole dug in the sand. When Saint Augustine told him that this was impossible, the child, a messenger from God, replied that Augustine, who was pondering how to explain the Trinity, was engaged on an equally impossible task. Saint Augustine is accompanied by Saint Catherine of Alexandria, with her traditional attribute of a wheel. Saint Stephen, who was one of the first deacons of the church and was stoned to death in about AD 35, is probably the saint visible (perhaps holding stones) in the left background. In the top left corner the Virgin and Child appear upon the clouds with Saint Joseph and music-making angels.

The picture can be seen in Panini's view of the Gallery of Cardinal Valenti (Hartford, Wadworth Athenaeum).

Probably in the collection of Cardinal Giuseppe Renato Imperiali by 1737; collection of Cardinal Silvio Valenti, Rome, by 1749; Holwell Carr collection by 1816; Holwell Carr Bequest, 1831.

Gould 1975, pp. 91–2; Rodinò 1987, pp. 26–7, 44, 55–6.

GAROFALO

The Holy Family with Saints John the Baptist, Elizabeth, Zacharias and (?) Francis, about 1520

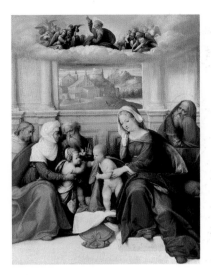

NG 170
Oil (identified) on canvas, 60.3 x 47.8 cm

The Holy Family are shown on the right. Saints John the Baptist, Elizabeth, Zacharias and a male saint, probably Francis of Assisi (about 1181–1226, founder of the Franciscan Order), are on the left. A goldfinch held by the Christ Child probably symbolises the Passion (according to legend it gained its red markings when spotted by Christ's blood on the Way to Calvary).

NG 170 reflects Garofalo's close study of Raphael's work.

Said to have been from the Aldobrandini collection, and probably recognisable in an inventory of that collection, Rome, 1603; Beckford collection by 1822; from whom bought, 1839.

Gould 1975, pp. 92–3.

GAROFALO
The Agony in the Garden
probably about 1520–39

GAROFALO
A Pagan Sacrifice
1526

GAROFALO
An Allegory of Love
probably about 1527–39

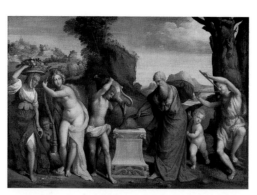

NG 3928
Oil on canvas, 128.3 x 185.4 cm

NG 1362
Oil on canvas, 127 x 177.8 cm

NG 642
Oil on canvas, transferred from wood,
49.2 x 38.7 cm

Jesus prays in the Garden of Gethsemane, near
Jerusalem (seen in the left background), while three
of his disciples sleep. An angel reveals a chalice
containing a cross. Judas approaches on the right
with the Roman soldiers who will arrest Jesus. New
Testament (Mark 14: 32–43).

Dramatic nocturnes were a novelty in north
Italian painting associated with Giorgione.

*Bought with the Edmond Beaucousin collection, Paris,
1860.*

Gould 1975, p. 93.

Dated on the base of the altar: MDXXVI AG.[OSTO]
(1526 August).

Although NG 3928 is related to the text and
woodcut illustrations of the *Hypnerotomachia
Poliphili* (Dream of Polyphilus, published in Venice
in 1499), it was probably intended as a generic scene
of pagan sacrifice rather than an incident from the
life of Polyphilus.

*Collection of the Marqués de Salamanca by 1867; Mond
collection by 1895; Mond Bequest, 1924.*

Gould 1975, pp. 95–6.

This painting, which may have had a specific
literary source that has not yet been identified, may
represent an episode from Romance (many of which
involved the adventures of twins) or it may be that
some allegory is intended. It has been suggested
that the painting shows the growth of love,
illustrated by the elements *Amor* (on the left),
Pulchritudo (the centre couple contemplating each
other's beauty) and *Voluptas* (the right-hand group).
Alternatively the subject may be the Garden of Love
with Cupid's presence (left) explaining the attitudes
of the two couples. The goat and the lizard are
likely to have a symbolic meaning.

NG 1362 may well have been a commission from
the Ferrarese court.

*Collection of Edmond Beaucousin, Paris, by 1860
(possibly bought from the collection of Lord Middleton,
1852); bought with the Beaucousin collection, 1860.*

Gould 1975, pp. 94–5.

Attributed to GAROFALO

Saint Catherine of Alexandria
probably about 1515–30

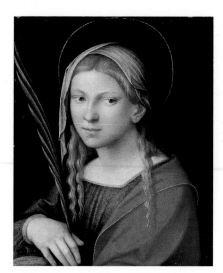

NG 3118
Oil on wood, 45.1 x 38.7 cm

The fourth-century Saint Catherine of Alexandria is shown with a martyr's palm and her traditional attribute of the wheel on which she was tortured.

NG 3118 has often been thought to be by Garofalo. A suggestion that it is a very early work by Correggio has also been made.

Costabili collection, Ferrara, by 1838; Sir A.H. Layard collection by about 1866; Layard Bequest, 1916.

Gould 1975, p. 95.

GAUDENZIO Ferrari

The Annunciation: The Angel Gabriel
before 1511

NG 3068.1
Oil and tempera on poplar, 58.4 x 58.4 cm

Inscribed on the angel's scroll: ·Ave·grã·pleã· dns·tecu (Ave Gratia Plena Dominus Tecum; Hail (Mary) full of Grace, the Lord be with You).

The Angel Gabriel announces to the Virgin that she will bear the son of God. New Testament (Luke 1: 26–38).

NG 3068.1 and 3068.2 are closely related to a set of four other panels by the artist (Turin, Pinacoteca). All of these works appear to be earlier in style than Gaudenzio's Arona altarpiece which is dated to 1511. The Turin altarpiece may have been arranged as follows; main tier, *Madonna and Child with Saint Anne and Angels* flanked by the *Meeting of Joachim and Anne* and the *Expulsion of Joachim*; upper tier, the *Almighty* centrally placed above the *Madonna and Child*, flanked by the *Angel Gabriel* (NG 3068.1) and the *Virgin Mary* (NG 3068.2). The low vanishing point certainly suggests that NG 3068.1-2 were intended to be placed very high.

Bought by Sir A.H. Layard from Baslini, Milan, before 1864; Layard Bequest, 1916.

Gould 1975, p. 97.

GAUDENZIO Ferrari

The Annunciation: The Virgin Mary
before 1511

NG 3068.2
Oil and tempera on poplar, 58.4 x 58.4 cm

The Angel Gabriel announces to the Virgin, who is seated and reading, that she will bear the son of God. New Testament (Luke 1: 26–38).

NG 3068.2 and 3068.1 are closely related to a set of four other panels by the artist; see under NG 3068.1 for further information.

Bought by Sir A.H. Layard from Baslini, Milan, before 1864; Layard Bequest, 1916.

Gould 1975, p. 97.

GAUDENZIO Ferrari
active 1508; died 1546

The description 'de Vrali' that appears after the artist's name in documents indicates that he came from Varallo in north Italy. He may have been a pupil with Luini of Stefano Scotto, and his work was generally influenced by the Milanese followers of Leonardo. The artist painted throughout Lombardy and Piedmont.

GAUDENZIO Ferrari
Christ rising from the Tomb
1530–46

GAUDENZIO Ferrari
Saint Andrew (?)
1530–46

Paul GAUGUIN
A Vase of Flowers
1896

NG 3289
Oil on canvas, 64 x 74 cm

NG 1465
Oil on poplar, 152.4 x 84.5 cm

NG 3925
Oil on poplar, 150.5 x 84.5 cm

Christ, triumphant over death, rises from the tomb, holding a banner and blessing.

NG 1465 is said to have been the centre panel of an altarpiece from the church of S. Pietro at Maggianico, near Lecco. Gaudenzio NG 3925 appears to have come from the same work; refer to this entry for further discussion.

Acquired by Professor Antonio Scarpa of Pavia before 1821; placed in the gallery at Motta di Livenza (Treviso) by Antonio's heir Giovanni Scarpa; Pinacoteca Scarpa sale, Milan, 1895; Mond Bequest, 1924.

Gould 1975, pp. 96–7.

It is not certain if the saint depicted here is intended as Andrew, even though he has previously been described as such, because Andrew is normally shown with an X-shaped cross.

NG 3925 and 1465 are thought to come from the same altarpiece; the dimensions of the panels, scale of the figures and style of the works suggest this. In 1821 NG 1465 was recorded as the central panel of an altarpiece from Maggianico, near Lecco. From 1881 three of the sections from this work were recorded as being in S. Pietro at Maggianico. These panels (Saint Anthony Abbot flanked by a saint who is presumably Ambrose and one who may either be Bonaventura or Jerome) are still in the church. A reconstruction is problematic because the sources diverge over identifying the subjects of the panels, and the style of the Maggianico pictures is far removed in terms of quality from the works catalogued here, which are thought to date from the later phase of the artist's career.

First recorded by Mündler, 1855; Mond Bequest, 1924.

Gould 1975, pp. 98–9.

Signed: *P Gauguin 96.*

Painted in Tahiti, this is probably the picture described by Gauguin in a letter of 14 February 1897 to Daniel de Monfreid as a 'Bouquet of Flowers'. NG 3289 is one of a small number of still lifes with flowers painted by Gauguin in Tahiti. Writing to the dealer Ambroise Vollard, Gauguin played down the significance of these works, noting that he did not copy nature: 'With me everything happens in my exuberant imagination ... Besides, this is not really a land of flowers.'

NG 3289 is one of ten paintings by Gauguin that were formerly in the collection of Edgar Degas.

Daniel de Monfreid, from whom bought by Degas, June 1898; bought with a special grant at the Degas sale, 1918.

Davies 1970, pp. 67–8.

Paul GAUGUIN
1848–1903

Gauguin was born in Paris and spent part of his childhood in Peru. He served in the merchant marine (1867–71) and then worked as a stockbroker. In 1883 he abandoned his job to paint full-time. He made frequent visits to Pont-Aven from 1886, and stayed with Van Gogh at Arles in 1888. He was in Tahiti from 1891 to 1893 and 1895 to 1901, and died in the Marquesas Islands.

Giovanni Battista GAULLI, called Baciccio
Portrait of Cardinal Marco Gallo
1681–3

GEERTGEN tot Sint Jans
The Nativity, at Night
late 15th century

Attributed to Girolamo GENGA
A Jesse-Tree
16th century

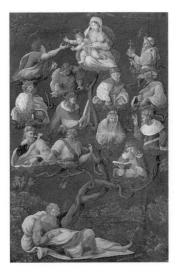

NG 6534
Oil on canvas, 72.6 x 63.5 cm

NG 4081
Oil on oak, 34.3 x 25.1 cm

NG 3119
Gum or egg white? on parchment or paper,
22.2 x 14 cm

Marco Gallo was born in Como. By 1629 he was an apostolic protonotary in Rome and he subsequently held the governorships of several towns in the Papal States, including Ascoli, Perugia and Ancona. In 1659 he was appointed Bishop of Rimini and in 1681 he was made a cardinal. He died in 1683.

Gaulli is reported to have made many portraits, including those of seven popes, but only a few are known today. According to his biographer Pascoli, Gaulli wanted his sitters to converse and move about while he was painting them. The portrait of Cardinal Marco Gallo is incisive, accomplished and engaging.

The identity of the sitter in NG 6534 is established by an inscription on an engraving after the portrait by Blondeau of 1751.

Perhaps acquired by Sir William FitzHerbert in Rome in the late 1760s; FitzHerbert collection, Tissington Hall; bought, 1991.

Enggass 1964, pp. 158–9; National Gallery Report 1990–1, pp. 24–5.

The Virgin, angels, and the ox and the ass surround the manger, while Saint Joseph stands at the right. In the background is the Annunciation to the Shepherds. The scenes are lit by supernatural light – from the angel and the Christ Child – and by natural light, from the shepherds' fire and Joseph's candle (itself no longer visible). Such a depiction of natural and supernatural radiance may ultimately derive from the writings of the fourteenth-century mystic, Saint Bridget of Sweden, who had a vision of Christ's birth.

NG 4081 may be dated to about 1480–90. Nocturnal compositions of this type probably reflect that of a lost work by Hugo van der Goes (see NG 2159). The painting has been slightly cut down on all sides.

Bought in Paris for the Richard von Kauffmann collection, Berlin, before 1901; bought, 1925.

Davies 1968, pp. 57–8; Dunkerton 1991, p. 340.

The Virgin, with Christ upon her lap, appears at the top of the Jesse-tree; Christ's lineage is represented below.

NG 3119 was formerly attributed to Giulio Clovio (1498–1578), the leading illuminator of the sixteenth century in Italy. It is more likely to be by Girolamo Genga, to whose work it is very close in style.

Bought by Sir A.H. Layard from Grüner of Dresden, 1866; Layard Bequest, 1916.

Gould 1975, p. 124.

Giovanni Battista GAULLI, called Baciccio
1639–1709

Gaulli was born in Genoa (Baciccio is a local nickname for Giovanni Battista) but moved to Rome in his teens. There he met Bernini who helped to further his career. By 1662 he was a member of the Accademia di San Luca, and he obtained numerous commissions for frescoes, altarpieces and portraits. His most important work is the ceiling decoration of the Gesú (1676–9), the mother church of the Jesuits.

GEERTGEN tot Sint Jans
about 1455/65; died about 1485/95

Geertgen ('little Gerard') tot Sint Jans (of the brethren of Saint John, of Haarlem) has not been identified in contemporary documents. He is described in seventeenth-century biographies as having been born in Leiden, as having been a pupil of Albert van Ouwater, and as having died at about the age of 28.

Girolamo GENGA
1476–1547

Genga trained under Signorelli and Perugino and was an associate of Raphael and of Timoteo Viti. He worked chiefly in his native Urbino and the Marches, but also in Florence, Siena, Rome and Mantua. Although mainly active as a painter, he also worked as an architect towards the end of his life.

GENTILE da Fabriano
*The Madonna and Child with Angels
(The Quaratesi Madonna), 1425*

Jean-Louis-André-Théodore GERICAULT
A Horse frightened by Lightning
about 1813–14

GERMAN
Portrait of a Woman
16th century

NG 4927
Oil on canvas, 48.9 x 60.3 cm

NG 2158
Oil on oak, 41 x 27.9 cm

L37
Tempera on poplar, painted area of the main panel
139.9 x 83 cm

Inscribed on the Virgin's halo: AVE. MARIA. GRATIA
PLENA. (Hail Mary, full of Grace); on the Child's halo:
YHS. XPS. FILII (Jesus Christ, Son [of God]); on Christ's
halo in the gable: DS. PR. O ME ([God pray] for me).

The Virgin Mary is surrounded by angels and
seated on a richly patterned cloth covered throne.
Above, Christ as ruler of the world imparts a
blessing.

L37 was the central panel of the high altarpiece
painted by Gentile da Fabriano in 1425 for the
church of S. Niccolò Oltrarno, Florence. This
altarpiece, which also comprised four standing
saints (Florence, Uffizi) and a predella with scenes
from the life of Saint Nicholas (Rome, Vatican
Museums; Washington, National Gallery of Art) was
commissioned by a member of the Quaratesi family.

L37 has often been compared to Masaccio NG
3046, which was painted in 1426 and exhibits
qualities associated with the Florentine Renaissance;
in L37 more attention is given to ornate decoration.

*Recorded in the collection of William Young Ottley,
1835; bought from Warner Ottley by Prince Albert,
1846; on loan from Her Majesty The Queen since 1975.*

Shearman 1983, pp. 111–14.

NG 4927 is one of numerous studies of horses in a
variety of attitudes and settings painted by
Géricault.

Géricault is said to have painted horses in the
imperial stables at Versailles in 1813. Despite its
modest size NG 4927 was probably painted as an
independent, finished work.

*Apparently in the collection of Madame Martin by 1856;
collection of the Duc de Trévise by 1938; bought, 1938.*

Davies 1970, p. 68; Eitner 1983, p. 36; Laveissière
1991–2, p. 336, no. 28.

The sitter has not been identified.

The style perhaps bears some resemblance to the
work of Hans Muelich (or Mielich, 1515–73), but the
damaged condition of the work precludes a more
precise attribution.

*Krüger collection, Minden, by 1848; from where bought,
1854.*

Levey 1959, pp. 43–4.

GENTILE da Fabriano
about 1385–1427

Gentile was born in Fabriano about 1370. He is
first documented in Venice in 1408 and again in
1411. From 1414 to 1419 he worked for Pandolfo
Malatesta in Brescia. In 1422 he enrolled in the
Florentine artists' guild, the Arte dei Medici e
Speziali, and in 1423 painted the *Adoration of the
Magi* (Florence, Uffizi). In 1427 he was working
for Pope Martin V in Rome, where he died.

Jean-Louis-André-Théodore GERICAULT
1791–1824

Géricault was born in Rouen, but was brought up
in Paris where he studied under Carle Vernet
(1808–10), and then with Guérin. He visited Italy
from 1816 to 1817, and was in London from 1820 to
1822. A leading figure of the French Romantic
movement, he exhibited in the Salon from 1812.

GERMAN
Saint Christopher carrying the Infant Christ
17th century

NG 2156
Oil on copper, 9.8 x 13.6 cm

GERMAN (?)
The Virgin and Child with an Angel in a Landscape
probably 15th century

NG 2157
Oil on oak, 24 x 17.2 cm

GERMAN, NORTH
Christ carrying the Cross
about 1490–1510

NG 2160
Oil on oak, 42.9 x 29.2 cm

According to legend Saint Christopher was a man of giant stature. A hermit (presumably the figure at the left) told him to carry travellers across a river, a group of whom appear to be waiting at the right. He carried a small child who became heavier and heavier and then revealed himself as Christ, declaring that the saint had been carrying the 'weight of the world'.

NG 2156 is thought to be a seventeenth-century work which remotely displays the influence of Elsheimer; it might be either Flemish or German in origin.

Krüger collection, Minden, by 1848; from where bought, 1854.

Levey 1959, p. 44.

The very poor condition of this picture makes attribution impossible; however, it is now clear that it is not a fake as previously believed and probably dates from the fifteenth century.

Krüger collection, Minden, by 1848; from where bought, 1854.

Levey 1959, pp. 44–5.

Christ, carrying his cross to Golgotha, is surrounded by his tormenters. New Testament (John 19: 17).

NG 2160 has previously been catalogued as a work of the Westphalian School, but is now thought to be North German, probably in the style of work from Lübeck. It may originally have formed part of a series of paintings of Christ's Passion, and probably dates from the very late fifteenth or early sixteenth century.

Krüger collection, Minden, by 1848; from where bought, 1854.

Levey 1959, p. 98.

GERMAN, SOUTH
Saint John on Patmos
about 1460–70

GERMAN, SOUTH
Portrait of a Man
about 1530–40

GEROLAMO dai Libri
The Virgin and Child with Saint Anne
1510–18

NG 4901
Oil (identified) on oak, 42.8 x 43.8 cm

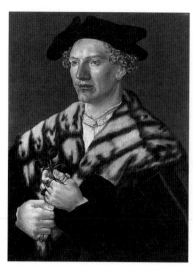

NG 1232
Oil on beech, 49.9 x 39.1 cm

NG 748
Oil on canvas, 158.1 x 94 cm

The saint was exiled to the island of Patmos where it is traditionally thought he experienced the divine revelations he recorded in the biblical Book of Revelation. Beside him his symbol, an eagle, rests upon a closed book.

NG 4901 appears to be South German in origin, but shows strong Netherlandish influence. Stylistically it has been associated with the circle of Konrad Witz (1400/10–44/6), but also with painting of the Alsace area.

Chamberlin collection, Hove, by 1906; bequeathed by W.B. Chamberlin, 1937.

Levey 1959, pp. 104–5.

The unidentified sitter is holding two pinks.

NG 1232 is the pendant to a *Portrait of a Woman* in the Oscar Reinhart collection, Winterthur. The two paintings may be betrothal or marriage portraits. They may originate from the Danube region.

Ralph Bernal sale, London, 13 March 1855; J. Whatman sale, London, 2 July 1887; bought (Walker Fund), 1887.

Levey 1959, pp. 105–6.

The book held by the central angel is inscribed: No 4 Solfegio; a cartellino contains illegible remains of writing: decepta (concepta?); a mostly false signature, based upon the remains of a true one: HIERONIMVS .A. LIBRIS .F.

The Christ Child holds an olive branch in one hand and raises the other in blessing; the Virgin's foot is set upon a dead dragon intended to represent the serpent of the Fall, the implication being that the Redemption of Man is possible through the agency of the Virgin, 'the second Eve'. The tree behind her presumably represents the Tree of Knowledge. The figures, with Mary seated on Saint Anne's lap, are set in an enclosed garden (the *hortus conclusus*), perhaps intended here as a metaphor for the purity of Mary.

NG 748 was the central panel of a triptych in a chapel dedicated to the Immaculate Conception in S. Maria della Scala, Verona. Its commission was connected with an outbreak of the plague in 1510–12 . One wing of the triptych was the *Saint Roch* by Morando, dated 1518 (NG 735), the other a *Saint Sebastian* (now missing) painted by Torbido (about 1482–after 1562) – both saints were invoked against the plague.

The altarpiece is referred to by Vasari, 1568; removed from the church of S. Maria della Scala, 1742; bought from the heirs of Cav. Andrea Monga, Verona, 1864.

Davies 1961, pp. 209–13.

GEROLAMO dai Libri
about 1474–1555?

Gerolamo was the son and pupil of the miniaturist Francesco I dai Libri, and worked in Verona. His pictures are particularly influenced by the work of Mantegna, and his style is close to that of Francesco Morone, who was also active in Verona.

Attributed to GEROLAMO da Santacroce
A Youthful Saint Reading
probably about 1512–25

NG 632
Oil on poplar, transferred from another panel,
painted surface 118.7 x 47.6 cm

This saint has sometimes been identified as Saint
John the Evangelist, which is possible; the attribute
of a book might perhaps refer to his Gospel.
 NG 632 is a pendant with NG 633; see under NG
633 for further discussion.

*Apparently once in the collection of Samuel Woodburn;
bought with the Edmond Beaucousin collection, Paris,
1860.*

Davies 1961, pp. 214–15.

Attributed to GEROLAMO da Santacroce
A Saint with a Fortress and a Banner
probably about 1512–25

NG 633
Oil on spruce, painted surface 117.8 x 47.6 cm

This saint has been identified as Saint George
(which is possible, but unlikely), as Saint Alexander
and as Saint Terentius.
 NG 632 and 633 are panels from an altarpiece.
This altarpiece has sometimes been identified as one
described by Boschini in 1664 at the oratory of the
Madonna della Pace at SS. Giovanni e Paolo in
Venice; but there is no evidence to support the
conclusion that NG 632 and 633 are the pictures
described.

*Apparently once in the collection of Samuel Woodburn;
bought with the Edmond Beaucousin collection, Paris,
1860.*

Davies 1961, pp. 214–15.

GEROLAMO da Vicenza
The Dormition and Assumption of the Virgin
1488

NG 3077
Tempera on wood, painted surface 33.7 x 22.9 cm

Signed and dated on the balustrade: HIERONIMVS.
VINCENTINVS. / PINCSIT. / VENETIIS. 1488.
(Gerolamo da Vicenza painted this (in) Venice, 1488.)
 The Virgin is lying on a bier in the middle
ground; above, the Assumption of the Virgin is
combined with the Coronation. The figures in the
foreground are probably the apostles; it has been
suggested that the figure kneeling at the front may
be a donor.
 The setting in a contemporary town square may
reflect the kind of religious theatrical event that was
common in fifteenth-century Italy; the heavenly
figure of the Virgin appears to be represented on a
cloth suspended from the buildings on either side.

*Bought from Conte di Thiene, Vicenza, by Sir A.H.
Layard before 1869; Layard Bequest, 1916.*

Davies 1961, pp. 216–17; Dunkerton 1991, pp. 81–2.

GEROLAMO da Santacroce
active 1516; died 1556?

Several members of the Santacroce family were
active as painters in Venice, some with contacts in
Bergamo. Gerolamo may have worked for Gentile
or Giovanni Bellini in about 1503/7. There are
signed and dated works from 1516 but his earlier
style has not been securely identified.

GEROLAMO da Vicenza
active 1488

This artist, whose name derives from the signature
of NG 3077, may be identifiable with Gerolamo di
Stefano d'Alemania, who was recorded in Vicenza
several times between 1481 and 1510. Until at least
1494 he was apparently closely associated with
Bartolomeo Montagna. Three other works
(including an altarpiece) are signed by this artist.

Jean-Léon GEROME
Portrait of Armand Gérôme
1848

GHERARDO di Giovanni del Fora
The Combat of Love and Chastity
probably 1475–1500

After Jacob de GHEYN III
Saint Paul seated reading
about 1620

NG 3251
Oil on canvas, 50.2 x 43.8 cm

NG 1196
Tempera on wood, 42.5 x 34.9 cm

NG 3590
Oil on canvas, 120.2 x 96.8 cm

Signed: J. L.GEROME.
NG 3251 is perhaps a study for a larger portrait of Gérôme's brother, Armand, exhibited at the Salon of 1848 and now lost.
The sitter is shown in the uniform of a student at the Ecole Polytechnique.

Sir Hugh Lane Bequest, 1917; on loan to the Hugh Lane Municipal Gallery of Modern Art, Dublin, since 1979.

Davies 1970, p. 69; Ackerman 1986, p. 188, no. 22.

Love's arrows break against Chastity's shield; Chastity waves the chain with which Love will be bound.
NG 1196 seems to have been part of a series illustrating the *Triumphs* by the poet Petrarch (1304–74). It was probably part of a piece of Florentine furniture made towards the end of the fifteenth century. One related painting shows Love bound in Chastity's triumphal chariot (Turin, Sabauda). Other panels (formerly Genoa, Adorno collection; formerly England, private collection) are known today from old photographs.

Collection of Marchese Crosa di Vergagni, Genoa, by 1885; bought (Lewis Fund), 1885.

Fry 1918, p. 201; Davies 1961, pp. 184–5; Fahy 1967, p. 128; Zeri 1991, pp. 155–9.

NG 3590 is a copy with slight variations of an etching of Saint Paul by Jacob de Gheyn III. The etching is inscribed: S. PAVLVS.
NG 3590 appears to be contemporary and probably dates from about 1620.

Collection of Percy Ravenscroft, Tunbridge Wells; bought, 1921.

MacLaren/Brown 1991, pp. 142–3.

Jean-Léon GEROME
1824–1904

Gérôme was born in Vesoul. He studied in Paris under Delaroche and Gleyre, and exhibited at the Salon from 1847. During the Second Empire he enjoyed fame and success for his paintings of ancient and classical history and especially for his scenes of oriental life, inspired by his travels in the Near East and Africa.

GHERARDO di Giovanni del Fora
1444/5–1497

Gherardo, who ran a large family workshop, was active in Florence in the second half of the fifteenth century. He painted large panels, miniatures and frescoes and worked for the most powerful patrons of the city, including the Medici family.

Jacob de GHEYN III
about 1596–1641

Jacob de Gheyn III, also known as Jacob de Gheyn the Younger, was probably born in Haarlem or Leiden. Both his father and grandfather were artists. From an early age he lived in The Hague but had settled in Utrecht by 1634. A few paintings – which display the influence of the Utrecht Caravaggisti and Jacob Jordaens – are known and more than a hundred drawings survive.

David GHIRLANDAIO
The Virgin and Child with Saint John
probably about 1490–1500

Domenico GHIRLANDAIO
A Legend of Saints Justus and Clement of Volterra
probably 1479

Domenico GHIRLANDAIO
Portrait of a Young Man in Red
probably about 1480–90

NG 2902
Tempera on wood, painted surface 14 x 39.4 cm

NG 2502
Tempera on wood, painted surface 78.8 x 46.5 cm

NG 2489
Tempera on wood, painted surface 38.7 x 27.6 cm

The buildings in the right background are based on notable monuments in Rome and include the Pantheon, the Colosseum, the Arch of Constantine, the Castel Sant'Angelo, Old Saint Peter's and the Vatican. These reminiscences are possibly based on drawings by another artist. Figures shown on the road to Rome may be pilgrims.

NG 2502 has recently been attributed to David Ghirlandaio.

Underdrawing is now visible in some parts of NG 2502 and reveals that the artist originally intended to depict the Virgin's right hand on Christ's right leg.

In the collection of Conte Guido di Bisenzo, Rome, by 1835; bought in 1847 by Lord Ward (later the Earl of Dudley); in the collection of George Salting by about 1875; Salting Bequest, 1910.

Davies 1961, pp. 222–3.

According to an obscure legend, during a long siege the granaries of Volterra were miraculously refilled in answer to the prayers of Saints Justus and Clement. The two saints ordered that loaves be baked and that these should be put on the ground outside the city – following the instruction in the New Testament (Romans 12: 20): 'if thine enemy hunger, feed him'. The besieging Vandals thought that the starving populace were using the loaves as paving stones and, having accepted some loaves to feed themselves, they departed. Saints Justus and Clement are shown at the city gate distributing bread.

NG 2902 is one of the predella panels for the high altarpiece of S. Giusto alle Mura, just outside Florence, and was probably painted in 1479. The altarpiece (Florence, Uffizi) represents *The Virgin and Child with Saints Michael, Justus, Raphael and Zenobius*. Four other predella panels survive (*Fall of the Rebel Angels*, Detroit, Institute of Arts; *Marriage of the Virgin, Tobias and the Archangel Raphael, Burial of Saint Zenobius*, New York, Metropolitan Museum of Art). This panel would have been below the image of Saint Justus.

S. Giusto alle Mura, Florence, until 1529; subsequently recorded in S. Giusto della Calza, Florence; bequeathed by Lady Lindsay, 1912.

Davies 1961, pp. 217–20.

No identification has been proposed for the sitter.

NG 2489 has in the past been attributed to Francesco Granacci, Sebastiano Mainardi (active 1493; died 1513) and to a follower of Domenico Ghirlandaio, but is probably the work of Domenico himself.

By about 1480 the three-quarter view had replaced the profile as the most popular type of portrait in Florentine painting. This development, and still more the use of landscape background behind the head, was influenced by Netherlandish portraiture, especially that by Memlinc.

Barberini collection, Rome, by 1870; exported from Italy about 1903; Salting Bequest, 1910.

Davies 1961, pp. 221–2.

David GHIRLANDAIO
1452–1525

David Ghirlandaio was the partner of his brother Domenico. After Domenico's death he concentrated on mosaic, but maintained the workshop and was probably responsible for training his nephew Ridolfo Ghirlandaio. He is known to have collaborated on the *Last Supper* fresco at the Badia di Passignano and a number of other frescoes and panels have been attributed to him.

Domenico GHIRLANDAIO
1449–1494

Domenico Bigordi, called Ghirlandaio, probably trained with Baldovinetti. He subsequently became one of the leading artists in Florence, where he ran an active studio in partnership with his brother David. He also worked in Rome, San Gimignano and Pisa. Domenico is best known as a painter of frescoes, but he also produced altarpieces, portraits and small devotional works.

Domenico GHIRLANDAIO
The Virgin and Child
probably about 1480–90

Workshop of Domenico GHIRLANDAIO
Portrait of a Girl
probably about 1490

Ridolfo GHIRLANDAIO
The Procession to Calvary
probably about 1505

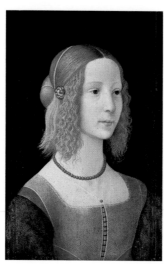

NG 3937
Tempera on poplar, painted surface 88.9 x 57.8 cm

Christ stands on a cushion on a sill and the edge of the painting is treated as a window opening. It has recently been restored to its original arched shape.

NG 3937 probably dates from the 1480s, and is unusually well-preserved. It was once thought to be a workshop piece, but recent cleaning has revealed the high quality of the picture, and the handling is characteristic of Domenico Ghirlandaio. The composition seems to have been repeated by Ghirlandaio's workshop for an altarpiece in Pisa.

In the collection of Sir Charles Eastlake by 1857; bought by Ludwig Mond, 1894; Mond Bequest, 1924.

Davies 1961, pp. 220–1.

NG 1230
Tempera on wood, painted surface 44.1 x 29.2 cm

The sitter has not been identified.

NG 1230 was formerly attributed to Sebastiano Mainardi (active 1493; died 1513) but, despite his known collaboration with Domenico Ghirlandaio (who was his brother-in-law), there is very little evidence of his style and the portrait is therefore given to the Workshop of Domenico Ghirlandaio. A date of about 1490 has been proposed on the basis of the hairstyle.

In the James Whatman collection, Maidstone, by 1859; bought (Walker Fund), 1887.

Davies 1961, p. 220.

NG 1143
Oil on canvas, transferred from wood,
166.4 x 161.3 cm

Christ carries the cross, on his way to Golgotha; Simon of Cyrene (centre left) attempts to share the burden. Saint Veronica holds the cloth miraculously impressed with Christ's image. Behind her is the Virgin accompanied by Saint John the Evangelist and two Holy Women. New Testament (Matthew 27: 30–3).

NG 1143 is identifiable with a picture mentioned by Vasari in 1550 as painted for the church of S. Gallo, Florence. He claimed that it contained recognisable portraits; the figure looking out of the picture on the far left would seem to be a portrait – so too perhaps is the figure on the extreme right. The narrative subject of the picture is rare in Florentine altarpieces of the period (although it recurs in a similar altarpiece by Benedetto Ghirlandaio in the Louvre, Paris), and the picture may have come from a chapel dedicated to Saint Veronica who is prominent in the foreground. Vasari implies that NG 1143 was one of Ridolfo's earliest important commissions. The influence of Leonardo is apparent in the head of the soldier to the right of Christ.

Recorded in the church of S. Gallo, Florence, 1550; bought from the heirs of the Antinori family in Florence, 1883.

Gould 1975, p. 100; Chiarini 1986, p. 44.

Ridolfo GHIRLANDAIO
1483–1561

Ridolfo, whose father Domenico Ghirlandaio was a leading fifteenth-century artist, probably trained with his uncle David Ghirlandaio, who continued the family workshop into the sixteenth century. Ridolfo accepted commissions for altarpieces, decorative work, frescoes, private devotional works and portraits, and worked for many patrons, principally in Florence.

Attributed to Ridolfo GHIRLANDAIO
Portrait of a Man
probably about 1510–20

NG 2491
Oil on wood, 70.5 x 56.2 cm

The sitter has been alternatively identified as Girolamo Benivieni or Bernardo del Nero. Both suggestions appear to be later traditions, but may have been based on lost information.

Said to have passed by inheritance to the Florentine families of Salimbeni and Torrigiani; bought by Sir George Salting about 1901; Salting Bequest, 1910.

Gould 1975, pp. 101–2.

Michele GIAMBONO
A Saint with a Book
mid-15th century

NG 3917
Egg (identified) on poplar, 38.5 x 28.5 cm

The saint has in the past been described as Mark the Evangelist.

NG 3917 is probably from the upper tier of a polyptych. A *Saint Michael* (Settignano, Berenson collection) may have been the centre panel of the main tier. Other panels which could also have been part of the altarpiece include *Saint Peter* (Washington), *Saint John the Baptist* (Florence, Bardini Museum), a *Bishop* and a *Pope* (Padua) which could have formed the side panels of the main tier; and, on the upper tier; a *Martyr Bishop* (Padua), a *Bishop* (Boston, Isabella Stewart Gardner Museum) and *Saint Stephen* (Bellagio, Gibert (formerly Frizzoni) collection).

With Guggenheim, Venice; bought by J.P. Richter, 1884; Mond Bequest, 1924.

Davies 1961, pp. 225–6.

GIAMPIETRINO
Christ carrying his Cross
probably about 1510–30

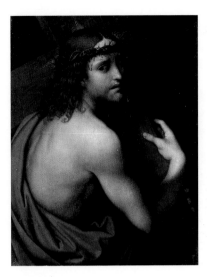

NG 3097
Oil on poplar, painted surface 59.7 x 47 cm

Christ, carrying his cross to Golgotha, turns his head to look out of the picture.

This composition may derive from a design by Leonardo, who greatly influenced Giampietrino and other artists working in Milan in the first half of the sixteenth century.

Bought by Sir A.H. Layard from Baslini, Milan, about 1865; Layard Bequest, 1916.

Davies 1961, pp. 226–7.

Michele GIAMBONO
active 1420–1462

Michele (di Taddeo) Bono, called Giambono, is categorised as a Venetian. The style of his work is that of the so-called International Gothic, influenced by Venetian painting. He may have been influenced by Jacobello del Fiore, and by Gentile da Fabriano, who was probably working in Venice in about 1409–14.

GIAMPIETRINO
active about 1500–50

A group of paintings have been attributed to Giampietrino, or Giovanni Pedrino. They all reflect the influence of Leonardo da Vinci, and seem to have been painted in Milan. The only dated work is an altarpiece of 1521 (Pavia, S. Marino – formerly in the Cathedral).

GIAMPIETRINO
Salome
probably about 1510–30

Attributed to GIANNICOLA di Paolo
The Annunciation
late 15th century

NG 1104
Oil on wood, top corners cut, painted surface
61 x 105.4 cm

Corrado GIAQUINTO
The Brazen Serpent
1743–4

NG 6515
Oil on canvas, 136.5 x 95 cm

NG 3930
Oil on poplar, painted surface 68.6 x 57.2 cm

Salome requested, at the suggestion of her mother Herodias, that Herod grant her the head of Saint John the Baptist. The executioner on the right has decapitated the saint, whose head Salome holds on a charger. New Testament (Mark 6: 22–9).

NG 3930 shows a subject popularised in Milan by Leonardo da Vinci; another version (attributed to Luini) is recorded.

Bought by Ludwig Mond from M. Guggenheim, Venice, 1895; Mond Bequest, 1924.

Davies 1961, p. 227.

Inscribed on the prie-dieu: AVE GRATIA (Hail [Mary full of] grace).

The Archangel Gabriel, with a lily (here symbol of the Virgin's purity), kneels before the Virgin and brings the Lord's salutation. New Testament (Luke 1: 26–35).

NG 1104 may have been the upper part of an altarpiece. If the attribution is accepted, this would have to be a fairly early work by Giannicola while he was strongly influenced by Perugino.

Monaldi collection, Perugia, by 1872; from where bought, 1881.

Davies 1961, p. 228.

Moses, on the right, calls to the people of Israel, who are being attacked by a plague of serpents which God sent them because of their sinfulness. He tells them to look at a bronze serpent he has set up on a pole, upper right, because 'everyone that is bitten, when he looketh upon it shall live'. The incident can be considered a prefiguration of the crucifixion. Old Testament (Numbers 21: 6–9).

NG 6515 and its pair, NG 6516, are highly finished modelli for frescoes in the apse of the church of S. Croce in Gerusalemme, Rome. The church underwent a complete remodelling, beginning in 1741, which was instituted by Raimondo Besozzi, abbot of S. Croce, and the pope, Benedict XIV. Giaquinto was commissioned to decorate the two ceilings and the apse walls in 1744. He is documented as having begun work on the ceiling paintings in February 1744, but it seems probable that he did not complete work on the apse walls until 1746. He probably submitted all four of the modelli for the pope's approval before beginning work in the church, so the likeliest date for NG 6515 and 6516 would be either late 1743 or early 1744.

Sketches for Giaquinto's ceiling paintings are in St Louis (Art Museum) and Kansas City (Nelson-Atkins Museum).

Reportedly in the collection of Cardinal Silvio Valenti Gonzaga, Rome; bought, 1987.

National Gallery Report 1985–7, pp. 37–9.

GIANNICOLA di Paolo
active 1484; died 1544

Giannicola di Paolo was first mentioned as a painter in Perugia in 1493. He is said to have been a pupil of Perugino; in his early works Perugino's influence is obvious.

Corrado GIAQUINTO
1703–1766

Giaquinto was born in Molfetta, near Bari. In about 1719 he studied in Naples under Nicola Maria Rossi and Solimena. He arrived in Rome in 1723 and worked on decorative schemes both there and in Turin. In 1740 he was elected to the Accademia di San Luca in Rome; during the period 1753–61 he painted in Madrid at the invitation of Ferdinand VI. He died in Naples.

Corrado GIAQUINTO
Moses striking the Rock
1743–4

NG 6516
Oil on canvas, 136.5 x 95 cm

Moses struck the rock and water miraculously came forth for the Israelites in the wilderness. Old Testament (Exodus 17: 1–7).

NG 6516 and its pair, NG 6515, are highly finished modelli for frescoes in the apse of the church of S. Croce in Gerusalemme, Rome. For further discussion see the entry for NG 6515.

Reportedly in the collection of Cardinal Silvio Valenti Gonzaga, Rome; bought, 1987.

National Gallery Report 1985–7, pp. 37–9.

Corrado GIAQUINTO
Apotheosis of the Spanish (?) Monarchy (?)
about 1751

NG 6229
Oil on canvas, 96.5 x 43.2 cm

In the upper part of the composition are Jupiter, who holds a crown, and Juno. Below them to the left are Venus and Cupid and Bacchus, and on the right Minerva presenting a female figure with a spear and shield. She is possibly a personification of Spain. In the lower part of the composition Hercules is depicted overcoming the Hydra.

NG 6229 is one of several autograph sketches which relate to a ceiling painting originally in the central hall of the Palazzo Santa Croce in Palermo (now in the Palazzo Rondinini-Sanseverino, Rome). The floor of the hall in the Palazzo Santa Croce was inscribed 1751, hence the dating suggested above.

Bought in Brussels by Herbert Bier, 1954; bought from him and the Matthiesen Gallery, 1954.

Levey 1971, pp. 109–12.

Attributed to Niccolò GIOLFINO
The Giusti Family of Verona (?)
probably about 1520

NG 749
Oil on canvas, 55 x 153 cm

This group of six men and nine women has traditionally been identified as the Giusti family of Verona, although none of the family can be identified by comparison with other portraits.

NG 749 was originally the lower part of an altarpiece, which was probably in the church of S. Maria in Stelle, near Verona. In 1864 the upper part showed the *Virgin and Child with Saints* (Verona, Museo Civico; by another artist and probably a later assembly) and bore an inscription stating an association with the Giusti family chapel in S. Maria in Stelle. This picture was described *in situ* in 1720 and the identification of the sitters as members of the Giusti family therefore seems probable.

Bought from the heirs of Cav. Andrea Monga, 1864.

Davies 1961, pp. 228–30.

Niccolò GIOLFINO
about 1476/7–1555

Giolfino is generally thought to have been a pupil of Liberale da Verona. He was principally active in Verona in the first half of the sixteenth century.

Luca GIORDANO
Perseus turning Phineas and his Followers to Stone, early 1680s

Luca GIORDANO
The Martyrdom of Saint Januarius
about 1690

Luca GIORDANO
A Homage to Velázquez
about 1692–5

NG 6487
Oil on canvas, 285 x 366 cm

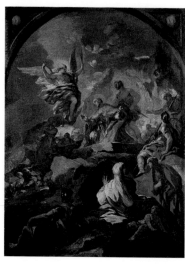

NG 6327
Oil (identified) on canvas, 106.7 x 80.6 cm

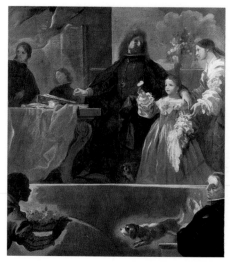

NG 1434
Oil (identified) on canvas, 205.2 x 182.2 cm

Andromeda was betrothed to Phineas, until Perseus rescued her from a sea monster and it was agreed she would marry him instead. At the wedding celebrations Phineas and his followers burst in to attack Perseus, who unveiled the severed head of the gorgon, Medusa, and turned them to stone. The subject comes from Ovid's *Metamorphoses* (V, 1–235).

NG 6487 is one of several versions of the subject by Giordano. The identity of the patron is not known but it was acquired with its companions, *The Death of Jezabel* (private collection) and *The Rape of the Sabines* (private collection), in Genoa in 1709 by Costantino Balbi. The picture dates from the early 1680s.

Palazzo Balbi, Genoa, from 1709 to about 1823; bought, 1983.

National Gallery Report 1982–4, p. 28; Ferrari and Scavizzi 1992, I, pp. 74–5, 296–7.

Saint Januarius was Bishop of Benevento and patron of Naples. He was beheaded near Pozzuoli in about AD 305. The executioner stands behind the saint and an angel descends with a palm of martyrdom.

NG 6327 is the modello for the large altarpiece of the same subject in S. Spirito dei Napoletani, Rome, commissioned by Cardinal Tommaso Ruffo, probably just before Giordano's Spanish period (1692–1702).

Cardinal Tommaso Ruffo; recorded as with a Florentine dealer, pre–1939; bought (Martin Colnaghi Fund), 1962.

Levey 1971, pp. 116–17; Ferrari and Scavizzi 1992, I, p. 357.

At the lower right is a portrait of Giordano; he can be identified by comparison with other portraits. The artist seems to point at the upper portion of the picture, possibly so as to signify that he painted it. The man seated centrally wears the Cross of the Order of Santiago. He may be intended as a portrait of the artist Velázquez, but this is by no means certain. The title used here was coined in 1938.

The style of the work appears to be intentionally reminiscent of the works of Velázquez (such as *Las Meninas*, Prado, Madrid), which particularly impressed Giordano when he worked in Spain (1692–1702). NG 1434 is thought to date from the beginning of this period.

NG 1434 has in the past been variously attributed to Velázquez, Coello and Francesco Maffei.

Claimed to have been in the collection of the Spanish diplomat Bernardo Yriarte (died 1814); apparently collection of Henri-Joseph Fradelle, London, from 1845; collection of Sir Edwin Landseer by 1873; presented by Lord Savile, 1895.

Levey 1971, pp. 113–14; Whitfield 1982, pp. 178–9; Ferrari and Scavizzi 1992, I, p. 130.

Luca GIORDANO
1634–1705

Giordano was born in Naples and trained in the circle of Ribera. He travelled to Rome, Florence and Venice. His work – which ranges from small paintings to fresco cycles – was inspired by Pietro da Cortona, sixteenth-century Venetian art and Rubens. Giordano, who became famed for the speed at which he painted, was employed by Charles II in Spain from 1692 to 1702. He died in Naples.

Luca GIORDANO
Saint Anthony of Padua miraculously restores the
Foot of a Self-Mutilated Man, before 1700

Style of GIORDANO
The Toilet of Bathsheba
after 1705

GIORGIONE
The Adoration of the Kings
1506–7

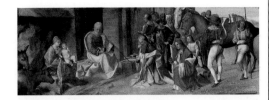

NG 1160
Oil on wood, 29.8 x 81.3 cm

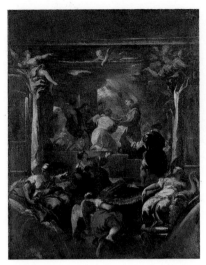

NG 1844
Oil (identified) on canvas, 105.5 x 80.3 cm

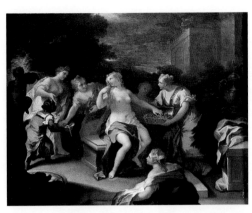

NG 4035
Oil on canvas, 50.1 x 63.4 cm

According to legend, the saint heard that a man
called Leonardo had kicked his mother. Anthony
declared that the offending foot should be cut off.
Leonardo then followed this advice, but the saint
miraculously restored the foot.

NG 1844 is a preparatory sketch for one of the
series of six frescoes illustrating aspects of the life of
Saint Anthony in the church of San Antonio de los
Portugeses, now Alemanes, Madrid. It is fairly close
to the final fresco. The intervening stage in the
composition's evolution is represented by a
drawing (Ann Arbor, University Gallery) recorded
in an engraving of 1792 by F. Lamarra. An exact
date for the frescoes is not established, but they
were probably executed shortly before 1700.

Mrs Parkhurst sale, Christie's, 19 July 1884 (lot 137);
presented as by Thornhill by C.W. Dopson, 1901.

Levey 1971, pp. 114–16.

King David spied on the beautiful Bathsheba while
she was at her toilet; he is depicted on the roof of
the building at the upper right. Old Testament
(2 Samuel 11: 2).

NG 4035 is too weak to be by Giordano. It may
have been painted after Giordano's death, and
possibly in Rome rather than Naples.

Anon. sale, Christie's, 21 February 1913 (lot 101); Sir
Claude Phillips Bequest, 1924.

Levey 1971, p. 117.

The Three Kings have come to adore the new-born
Christ Child and offer gifts of gold, frankincense
and myrrh. They are followed by a retinue with
horses. Saint Joseph holds a gift, presumably from
the kneeling king who points to himself. New
Testament (Matthew 2: 11).

The painting may have formed part of the
predella of an altarpiece, although it is unusually
large. The costumes, particularly of the figures at
the right, reflect Venetian fashions of about 1506–7.
Bought as by Giovanni Bellini; the painting was
widely regarded as by Giorgione in the early part of
this century as it is today, but other artists have
been proposed, notably Catena and Bonifazio.

Underdrawing is visible, especially on the body of
the Christ Child.

Philip John Miles collection, Leigh Court, near Bristol,
by 1822; bought, 1884.

Lilli and Zampetti 1968, p. 88; Pignatti 1969, pp.
97–8; Gould 1975, pp. 104–5.

GIORGIONE
active 1506; died 1510

Giorgio (Zorzi or Zorzo in local dialect), called
Giorgione, was from Castelfranco in the mainland
provinces of Venice. He is documented as an
important artist in Venice by 1507 and by 1510
great collectors were hunting for his pictures.
There is little certainty as to what he painted, but
he was certainly responsible for portraiture,
landscapes and genre subjects of a novel and
poetic type.

GIORGIONE
Il Tramonto (The Sunset)
1506–10

Follower of GIORGIONE
Homage to a Poet
early 16th century

Imitator of GIORGIONE
Nymphs and Children in a Landscape with Shepherds, probably 1575–1625

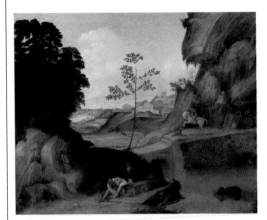

NG 6307
Oil on canvas, 73.3 x 91.4 cm

NG 1173
Oil on wood, 59.7 x 48.9 cm

NG 1695
Oil on wood, 46.6 x 87.6 cm

The figure in the foreground having his leg bound may be Saint Roch; if this identification is correct his attendant is Gothardus. In the right middle ground Saint George on a rearing horse attacks a dragon. At the extreme right Saint Anthony peers from his cave. Monstrous creatures appear in the water below: one like a giant bird, another similar to a huge boar. Anthony was tormented by such beasts. No convincing interpretation of the juxtaposition of these figures has been proposed. Roberto Longhi coined the title *Il Tramonto* (Italian for sunset) in 1934.

The painting was rediscovered in 1933 in poor condition with large losses. Large parts of the painting are, in fact, reconstruction and this includes most of the group of Saint George and the dragon and the island, sometimes mistaken for a creature in the water.

Engravings by Giulio Campagnola (about 1482–about 1515/18) such as *The Astrologer* and *The Young Shepherd* can be related to the figures in this work. Elements of the landscape are comparable to those in paintings by Titian (see NG 270).

Villa Garzone at Ponte Casale, 1933; bought from the dealer and art historian Vitale Bloch, 1961.

Lilli and Zampetti 1968, p. 91; Pignatti 1969, pp. 106–7; Gould 1975, p. 106.

A man, seated on a throne, is crowned with a wreath of laurels. The laurels and the books on the steps before him suggest that he is a poet, but neither his identity nor an explanation for the other elements of the scene has been found. A man plays a lute in the foreground, another makes an offering to the enthroned figure while a child attends. A fourth kneeling figure is depicted at the top of the cliff (top left). The landscape is filled with birds and animals including a peacock, a cheetah and deer. A town can be seen in the middle distance, with mountains beyond. NG 1173 was formerly entitled 'The Golden Age', a reference to a mythical period when all the world was at peace and all creatures in harmony.

It has been suggested that this is a product of Giorgione's studio, but it is probably the work of an early follower of the artist.

Probably Cardinal Pietro Aldobrandini's collection by 1603; bought, 1885.

Lilli and Zampetti 1968, pp. 96–7; Gould 1975, pp. 109–10.

Two nymphs with attendant children dominate the right foreground. A flock with shepherds is in the middle distance, and a river and buildings lie beyond. There is nothing to intimate that this arcadian scene derives from a specific literary source, or has any narrative content.

NG 1695 has previously been attributed to various artists, including Dossi, Cariani and Titian. It is now considered either a copy of a lost Giorgione or, more probably, an imitation dating from the late sixteenth or early seventeenth century. Details of the figures appear to be pastiches of elements of known works by the artist; for example, the features and head-dress of the nymph who is lying down can be compared with those of Giorgione's *Judith* (St Petersburg, Hermitage).

Bequeathed by George Mitchell to the South Kensington (Victoria and Albert) Museum, 1878; on loan since 1900.

Gould 1975, pp. 110–11.

Imitator of GIORGIONE
A Man in Armour
probably 17th century

NG 269
Oil on wood, 39.7 x 27 cm

This figure seems to derive from the soldier saint at the left of the *Madonna and Saints* (Castelfranco, Duomo) – generally regarded as the only surviving altarpiece by Giorgione – who, however, wears a helmet. Alternatively, it could be derived from a fresco of a saint (S. Daniele, Friuli, church of S. Antonio) by Pellegrino da San Daniele (1467–1547), which was possibly inspired by Giorgione. According to a third theory (which does not exclude the first), it records a lost work by Giorgione.

The painting, which is first certainly recorded in the early nineteenth century, was for a long time considered to be by Giorgione, but is now thought to be the work of a seventeenth-century imitator of the artist.

The figure appears to have been used as the model for Philippe de Champaigne's depiction of Gaston de Foix (Versailles). He was also engraved, with a halo, by the French artist Michel Lasne, and described as being after Raphael.

Collection of the Duc de Saint Simon (1675–1755); Benjamin West collection by 1816; bequeathed by Samuel Rogers, 1855.

Lilli and Zampetti 1968, p. 89; Pignatti 1969, p. 144; Gould 1975, pp. 107–9; Jones 1990, pp. 51–2.

Attributed to GIOTTO di Bondone
Pentecost
about 1306–12

NG 5360
Tempera on poplar, 45.5 x 44 cm

The twelve apostles gathered together after Christ's Ascension into Heaven. The Holy Spirit descended on them in the form of a dove and tongues of fire, granting them the power to speak in many languages. New Testament (Acts 2: 1–13). In the foreground of NG 5360 people from different nations marvel at hearing the apostles preach the Gospels in their own language.

NG 5360 was the last of seven scenes in a long rectangular altarpiece probably executed by Giotto and his workshop in about 1306–12. All the scenes were originally painted on one long poplar plank. The other scenes are the *Nativity* (New York, Metropolitan Museum of Art), the *Presentation* (Boston, Isabella Stewart Gardner Museum), the *Last Supper*, the *Crucifixion* (both Munich, Alte Pinakothek), the *Entombment* (Settignano, Berenson collection), and the *Descent into Limbo* (Munich, Alte Pinakothek). The altarpiece may have come from the church of S. Francesco, Rimini.

The lip of gesso on the right-hand side of NG 5360 confirms that it abutted the frame and was, therefore, the last in the series.

Collection of Prince Poniatowski, Florence, by 1839; collection of William Coningham; bequeathed by Geraldine Emily Coningham in memory of Mrs Coningham of Brighton and of her husband, Major Henry Coningham, 1942.

Gordon 1988, pp. 29–34; Bomford 1989, pp. 64–71; Dunkerton 1991, pp. 214, 399.

GIOTTO di Bondone
1266/7; died 1337

Giotto was a Florentine painter and an inspiration to later Florentine artists. He was praised in his lifetime for his novel naturalism, and frescoes by him survive in the Arena Chapel, Padua, and the Bardi and Peruzzi Chapels in S. Croce, Florence; others, in Rome, Naples and Rimini, have been destroyed. Whether he was in any way involved in the decoration of S. Francesco at Assisi is debatable.

GIOVANNI Battista da Faenza
The Incredulity of Saint Thomas
probably about 1500–15

NG 1051
Oil on wood, painted surface 103.5 x 166.4 cm

Saint Thomas, who had doubted that Jesus Christ had risen from the dead, was convinced when Christ (here holding the banner traditionally associated with his victory over death) invited him to touch the wound in his side. New Testament (John 20: 20–9). On the right Saint Anthony of Padua (1195–1231), one of the foremost Franciscan saints) presents a donor; in the left background, Saint Jerome (about 342–420, the chief inspiration for Christian penitents and hermits) is shown in the wilderness. Other saints may be intended in the right background.

In the Hercolani collection, Bologna, before 1777 (and formerly in the sacristy of the church of the PP. Minori Conventuali, Faenza); bequeathed by Miss Sarah Solly, 1879.

Davies 1961, pp. 236–7.

GIOVANNI Battista da Faenza
probably active 1495–1516

Giovanni Battista Bertucci the Elder (or da Faenza) was active in Faenza, where he signed and dated a triptych in 1506. His work appears to have been much influenced by Costa and Perugino.

GIOVANNI Battista da Faenza
The Virgin and Child in Glory
perhaps 1512–16

GIOVANNI Francesco da Rimini
The Virgin and Child with Two Angels
1461

Attributed to GIOVANNI Martini da Udine
The Virgin and Child with Saints George, James the Greater and a Donor, probably about 1500–25

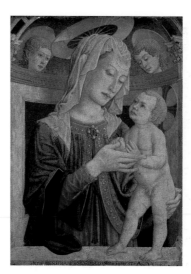

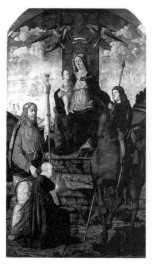

NG 282
Oil on wood, painted surface 179.1 x 81.3 cm

The Virgin (who holds a lily, symbol of her purity) and the Child Jesus are seated on a cloud above two angels.

NG 282 appears to have been the central part of an altarpiece in five compartments that was in the Hercolani collection in Bologna in 1770. Two other panels (Saints John the Evangelist and Thomas Aquinas) from this altarpiece survive. The altarpiece in the Hercolani collection may have been the one painted by Giovanni Battista da Faenza between 1512 and 1516 for the chapel of St Thomas Aquinas in S. Andrea, Faenza.

First recorded with certainty in the collection of Lord Orford, 1854; bought, 1856.

Davies 1961, pp. 233–6.

NG 2118
Tempera on wood, 64.8 x 47 cm

Signed and dated: . IOVANES . FRANCISCVS . DE . RIMINO . FECIT . MCCCCLXI.

The Virgin and Child are shown in a marble niche or throne. Christ stands naked on a parapet. Two angels look on from behind. The pilasters have Corinthian capitals.

It has been suggested that NG 2118, which is dated 1461, was painted in Bologna where the artist settled in about 1459.

A picture attributed to Giovanni Francesco da Rimini in the Walker Art Gallery (Liverpool) is related to this composition. The solid forms, their volume and resemblance to carved marble reliefs may be indebted to the sculpture of Agostino di Duccio, who was active in Rimini in the 1450s and in Bologna in the 1460s.

Hercolani collection, Bologna, by 1777; George Salting by 1905; by whom presented, 1907.

Davies 1961, pp. 237–8; Padovani 1971, p. 3.

NG 778
Oil on wood, painted surface 247.7 x 144.8 cm

Saint James the Greater (left), with a pilgrim staff, presents a donor; Saint George (right), the legendary third-century Cappadocian knight, is shown on horseback, the dragon at his feet.

Formerly considered to be by Martino da Udine (Pellegrino da San Daniele), NG 778 reflects the style of Carpaccio, and a date in the early years of the sixteenth century is probable.

NG 778 was probably square topped, but is framed with a rounded top.

Once in the collection of Conte Ugo Valentinis; bought, 1867.

Davies 1961, pp. 238–9.

GIOVANNI Francesco da Rimini
active 1441; died 1470 or earlier

The artist is recorded in Padua in 1441/4 and was subsequently in Bologna in 1459 and the early 1460s. He is known to have painted altarpieces, frescoes and devotional images.

GIOVANNI Martini da Udine
about 1453–1535

The son of Martino da Tolmezzo, this artist is generally known as Giovanni Martini da Udine. He was influenced by Alvise Vivarini and painted altarpieces on panel, and also decorated altarpieces of carved wood.

GIOVANNI da Milano
Christ of the Apocalypse, the Virgin and Saint John the Baptist, about 1364–6

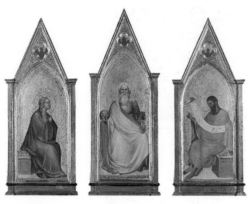

NG 579.6–8
Tempera on wood, centre panel 94 x 37.5;
side panels each 89.5 x 37.5 cm

Inscribed on the Baptist's scroll: ECCO VIRGO CO[N]CIPIET (Behold a Virgin shall conceive Old Testament, Isaiah 7: 14). The typography of this inscription is modern; the original probably read, ECCE AGNUS DEI (Behold the Lamb of God), as usually carried by the Baptist.

Christ is depicted enthroned as Christ of the Apocalypse (New Testament, Revelation 1: 13ff.). He has hair 'as white as snow' and wears a long cloak with a golden girdle; in his right hand he holds a globe with seven stars and in his left two golden keys (those of death and hell). A two-edged sword is just visible in his mouth. Above each of the three figures is a seraph in a quatrefoil.

These three pinnacles are thought to be from an altarpiece which included in the main tier: *Christ Enthroned* (Milan, Pinacoteca di Brera), inscribed with texts from the Apocalypse, and *Eleven Saints* (Turin, Galleria Sabauda). The right panel of the main tier is missing. Two predella panels (Paris, Bacri collection) have also been associated with the altarpiece. The dimensions of NG 579.6–8, and the apocalyptic theme, link them with the Milan and Turin panels. The work is datable to about 1364–6. The site it was originally commissioned for remains unknown. When acquired, the pinnacles were incorrectly associated with the altarpiece attributed to Niccolò di Pietro Gerini (NG 579.1–5).

Bought from the Lombardi–Baldi collection, Florence, 1857.

Gordon 1988, pp. 34–7.

Style of GIOVANNI da Milano
Christ and the Virgin with Saints about 1364–6

NG 1108
Tempera on wood, including frame, 45 x 34 cm

In the upper register Christ and the crowned Virgin are enthroned; they both hold orbs and sceptres (it is unusual for the Virgin to be placed on Christ's left). Below them the saints are, from left to right: John the Baptist, a bishop with a book, Lawrence, Catherine of Alexandria, Clare (?) and Lucy. The back and outer mouldings of the frame which are original are gessoed and covered in reddish-black paint.

There are no traces of hinges, excluding the possibility that the panel originally formed part of a larger work.

Bought from Alessandro Castellani, Rome, 1881.

Gordon 1988, pp. 37–8.

GIOVANNI di Nicola
Saint Anthony Abbot probably about 1350

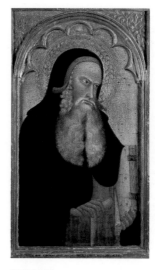

NG 3896
Tempera on poplar, including all the framing 61.5 x 36 cm

Saint Anthony Abbot (about 251–356) is shown in a monastic habit and has a Tau-shaped cross and carries a book.

Once attributed to Bartolo di Fredi, this picture has now been convincingly attributed to Giovanni di Nicola, on the basis of its style and technique (especially the punchwork). NG 3896 is likely to have formed part of a polyptych (it was presumably to the left of a central panel showing the Virgin and Child).

The clasps on Saint Anthony's book were drawn in, but seem never to have been painted. The inner moulding of the frame is original. The *pastiglia* is original but regilded.

Collection of Henry Willet by 1893–4; presented by Henry Wagner, 1924.

Gordon 1988, pp. 39–40.

GIOVANNI da Milano
active 1346–1369?

The artist was from Caversaccio, near Uggiate, in the region of Como. From 1346 he was a member of the artists' guild in Florence, the Arte dei Medici e Speziali. In 1365 he was working on frescoes in the Guidalotti (later Rinuccini) Chapel, S. Croce. Giovanni is probably the 'Iohannes de Mediolano' who worked in the Vatican in 1369.

GIOVANNI di Nicola
active 1326–1360

Giovanni di Nicola was a Pisan artist who was a pupil of Lippo Memmi in Siena in 1326. He seems to have been principally active in Pisa, where he is known to have painted altarpieces. A signed altarpiece in Pisa, possibly dated 1350, is the basis for all attributions.

GIOVANNI da Oriolo
Lionello d'Este
probably about 1447

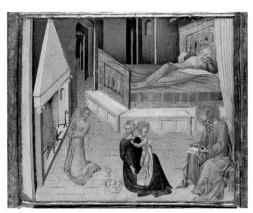

NG 770
Egg (identified) on wood, painted surface
54.6 x 39.4 cm

Inscribed, across the top: LEONELLVS. MARCHIO. ESTE[N]SIS. (Lionello Marquis of Este).
Signed across the bottom: OPVS IOHA[N]NIS ORIOLI. (Work of Giovanni da Oriolo).

Lionello d'Este (1407–50) was the Marquess of Ferrara from 1441 until his death. His portrait likeness can be compared with that in medals by Pisanello.

NG 770 is the only signed work of Giovanni da Oriolo. It is possible that the picture was the subject of a recorded payment for a portrait of 21 June 1447.

Sir Charles Eastlake collection, about 1855–65; bought from Lady Eastlake, 1867.

Davies 1961, pp. 241–2; Dunkerton 1991, p. 90.

GIOVANNI di Paolo
The Birth of Saint John the Baptist
probably about 1453

NG 5453
Tempera on poplar, 30.5 x 36.5 cm

Saint Elizabeth, the mother of Saint John the Baptist, lies in a bed decorated with paintings. A midwife holds the infant saint in the foreground, while another dries a towel by the fire. At the right Saint Zacharias is seated; Elizabeth insisted that the child be called John, and because Zacharias was mute he showed his agreement by writing 'His name is John'. From that moment on he could speak. New Testament (Luke 1: 57–64).

NG 5453 is part of the predella of an altarpiece; three other panels in the Collection come from the same predella (NG 5451, 5452, 5454). They have been associated with an altarpiece dated 1453 of the *Virgin and Child with Saints* (New York, Metropolitan Museum of Art) which includes Saint John the Baptist. Giovanni di Paolo repeated the composition of these scenes in a series of vertical panels showing episodes from the life of Saint John the Baptist which formed shutters closing possibly around a statue of the Baptist or perhaps a reliquary cupboard.

Charles Butler, 1887; J. Pierpoint Morgan by 1909; bought with a contribution from the NACF, 1944.

Davies 1961, pp. 243–5; Christiansen 1988, p. 218; Dunkerton 1991, pp. 278–80.

GIOVANNI di Paolo
Saint John the Baptist retiring to the Desert
probably about 1453

NG 5454
Tempera on poplar, 31.1 x 38.8 cm

The young saint is depicted twice: leaving the home of his parents and walking into the wilderness. The narrative is framed by depictions of roses seen from below. New Testament (Luke 1: 80).

NG 5454 is part of a predella of an altarpiece, showing scenes from the life of Saint John the Baptist; three other panels in the collection come from the same predella (NG 5451–3). For further discussion see the entry for NG 5453.

Charles Butler, 1887; J. Pierpoint Morgan, by 1909; bought with a contribution from the NACF, 1944.

Davies 1961, pp. 243–5; Dunkerton 1991, pp. 278–80.

GIOVANNI da Oriolo
active 1439; died 1480/8

Giovanni di Giuliano came from Oriolo, near Faenza, where he was active from 1439. He was employed by Lionello d'Este in about 1447. His only signed picture is NG 770.

GIOVANNI di Paolo
active by 1417; died 1482

Giovanni di Paolo (sometimes known as Giovanni dal Poggio) was one of the leading painters in Siena in the fifteenth century. His earliest surviving signed and dated work is of 1426. Thereafter a considerable number of authenticated panels by him exist. He may have painted little in the last years of his life when his work deteriorated.

GIOVANNI di Paolo
The Baptism of Christ
probably about 1453

GIOVANNI di Paolo
The Feast of Herod
probably about 1453

GIOVANNI di Paolo
Saints Fabian and Sebastian
about 1475–82

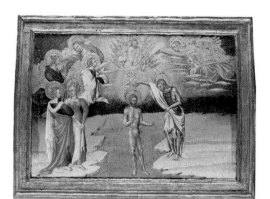

NG 5451
Tempera on poplar, 31 x 44.5 cm

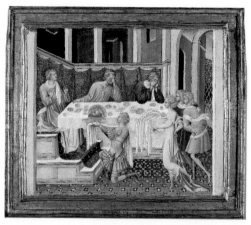

NG 5452
Tempera on poplar, 31 x 37 cm

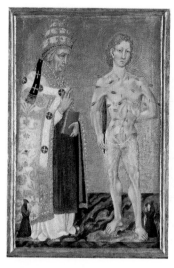

NG 3402
Egg (identified) on wood, probably poplar, bottom edge cut 84.5 x 54.5 cm

Saint John baptises Christ in the river Jordan. God the Father and the Holy Ghost in the form of a dove are depicted above; angels attend on either side. New Testament (all Gospels, e.g. Matthew 3: 13–17).

NG 5451 is probably the central part of the predella of an altarpiece with scenes from the life of Saint John the Baptist; three other panels in the Collection (NG 5452, 5453, 5454) come from the same predella. For further discussion see the entry for NG 5453.

The composition of NG 5451 follows that of Ghiberti's *Baptism* on the font of the Baptistery, Siena (1425–7).

Charles Butler, 1887; J. Pierpoint Morgan by 1909; bought with a contribution from the NACF, 1944.

Davies 1961, pp. 243–5; Dunkerton 1991, pp. 278–80.

Herod's step-daughter, Salome, dances before him on the right, at a banquet. He promised to grant her any request and her mother Herodias told her to ask for the head of Saint John the Baptist on a dish; it is here delivered at the table, to the dismay of Herod and the guests. New Testament (Mark 6: 1–12).

NG 5452 is part of a predella of an altarpiece showing scenes from the life of Saint John the Baptist; three other panels in the Collection come from the same predella (NG 5451, 5453, 5454). For further discussion see the entry for NG 5453.

The composition of NG 5452 derives from Donatello's gilt bronze panel of the same subject on the font of the Baptistery, Siena (1423–7).

Charles Butler, 1887; J. Pierpoint Morgan by 1909; bought with a contribution from the NACF, 1944.

Davies 1961, pp. 243–5; Dunkerton 1991, pp. 278–80.

The sainted pope on the left is Fabian, whose feast falls on the same day as that of Saint Sebastian. At each bottom corner is a kneeling Brother of the Confraternity of the Misericordia; they wear black with a white veil over their face and hold what may be a spoon for collecting alms.

NG 3402 is apparently a votive picture. It is probably one of the artist's late works.

Recent cleaning revealed the original upraised position of Sebastian's hand and arm, and some twenty arrows on the saint, most of which had been painted out.

Charles Butler sale, 26 May 1911 (lot 138); presented through the NACF in memory of Robert Ross, 1919.

Davies 1961, pp. 242–3; Bomford 1978, pp. 56–63.

GIOVANNI del Ponte
The Ascension of Saint John the Evangelist, with Saints, probably about 1410–20

Gerolamo GIOVENONE
The Virgin and Child with Saints and Donors
perhaps about 1520

GIROLAMO da Carpi
The Adoration of the Kings
probably about 1545–50

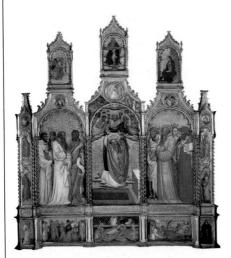

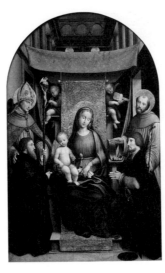

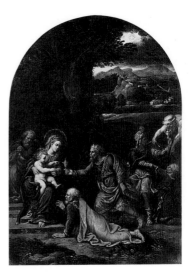

NG 580
Tempera on wood, total size, excluding the predella and pinnacles, 166.4 x 249.6 cm; predella including frame, 39.4 x 249.6 cm

Inscribed identifying the saints: (left wing, left to right) 1/ .S. BER[NARDUS] (Saint Bernard) 2/ .S. SCOLASTICA 3/ .B. (Saint Benedict) 4/ .ECCE. AGNVS. DEI. QVI TO(LLIT PECC)A(TA MUNDI) (Behold the Lamb of God who takes away the sin [of the World]); (right wing, left to right) 1/ Saint Peter (holding the keys) 2/ .S. RVMV[ALDUS] (Saint Romuald) 3/ Saint Catherine of Alexandria 4/ PENITENCIA[M]. / AGGERE. EST./ PERPETRAT/A. MALA. PR/A[N]GERE. (=PLANGERE) ET. / PRA[N]GENDO. (=PLANGENDO) / NON. PER/PETRARE (Saint Jerome?). (To do penance is to repent sins that have been committed and in repenting to sin no more.); (left pilaster, top to bottom) 1/ a male saint with a staff and a book inscribed AI 2/ .COSMO. (Saint Cosmas) 3/ Saint Francis 4/ S. APO/LONIA (Saint Apollonia); (right pilaster, top to bottom) 1/ Saint Nicholas of Bari 2/ S. DAMIAN[US] (Saint Damian) 3/ Saint Margaret 4/ [S] VERDI/ANA (Saint Viridiana).

The Ascension of John the Evangelist is shown in the central panel; in the roundel above is the Descent into Hell, with (left) the broken gates of Hell with the Devil, and (right) possibly Adam and Eve. In the left roundel is Saint Michael and in the right Saint Raphael with Tobias; in the pinnacles are the Trinity (centre), the Angel Gabriel (left) and the Virgin Annunciate (right). The predella shows three scenes from the life of Saint John the Evangelist. (See Appendix B for a larger reproduction.)

NG 580 was probably the high altarpiece for the Camaldolese church of S. Giovanni Evangelista at Pratovecchio.

Bought from the Lombardi–Baldi collection, Florence, 1857.

Davies 1961, pp. 246–9.

GIOVANNI del Ponte
about 1385–1437/42?

Giovanni di Marco had a studio near S. Stefano a Ponte, Florence. He was active in the early 1430s in S. Trinità, Florence (painting frescoes in collaboration with his partner Smeraldo di Giovanni); panel pictures have also been attributed to him.

NG 1295
Tempera and oil on poplar, original painted surface 205.7 x 123.2 cm

The Virgin and Child are flanked by two Franciscan saints who present two unidentified male donors. The saint on the left is Saint Bonaventure (1221–74; a theologian who joined the Franciscan Order, became its head in 1257 and the Cardinal Bishop of Albano); the saint on the right is Saint Francis of Assisi (about 1181–1226, founder of the Order). Both saints hold crucifixes, Saint Bonaventure's is unusually surmounted by a pelican to symbolise Christ's sacrifice for mankind, based on the tradition that the pelican feeds its young with blood from its breast.

NG 1295, which has been compared to Defendente Ferrari's style, was possibly painted in about 1520.

Bought from Antonio Carrer, Venice, 1889.

Davies 1961, pp. 250–1.

Gerolamo GIOVENONE
active 1513; died 1555

Giovenone was active as a painter in Vercelli and Turin. His early style depends upon that of Defendente Ferrari, with whom he may have trained. His later work is strongly under the influence of Gaudenzio Ferrari.

NG 640
Oil on wood, 44.2 x 32.1 cm

Guided by a star, the Three Kings journeyed to Bethlehem to honour the new-born Jesus. They brought gifts of gold, frankincense and myrrh. New Testament (Matthew 2: 2–12).

NG 640 has been catalogued as North Italian School and, before that, as probably Ferrarese and as by Dosso Dossi.

A copy and another version are known.

Bought with the Edmond Beaucousin collection, Paris, 1860.

Gould 1975, pp. 176–7; Mezzetti 1977, pp. 90–1; Russell 1983, p. 359.

GIROLAMO da Carpi
about 1501–1556

According to Vasari, Girolamo da Carpi was trained by Garofalo at Ferrara and then established himself in Bologna. An altarpiece by him in S. Martino is dated 1532. He was employed by Cardinal Ippolito d'Este in Ferrara in the 1530s and Pope Julius III at the Vatican in 1550. His work combines the influences of sixteenth-century Ferrarese and Venetian painting with those of Giulio Romano, Raphael and Correggio.

Attributed to GIROLAMO da Carpi
Cardinal Ippolito de' Medici and Monsignor Mario Bracci, after 1532

GIROLAMO da Treviso
The Madonna and Child with Angels, Saints and a Donor, 1520–30

Attributed to GIROLAMO da Treviso
The Adoration of the Kings
probably 1525–30

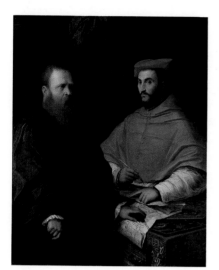

NG 20
Oil on wood, 138.4 x 111.8 cm

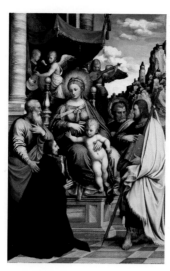

NG 623
Oil (identified) on wood, 225.4 x 147.3 cm

NG 218
Oil on wood, 144.2 x 125.7 cm

Inscribed on a paper: Hyppol . . . Vice cancell (Ippolito... Vice Chancellor); the words at the base of the scroll apparently read: M de Braccijs (possibly Monsignor Mario Bracci, see below). At the bottom left: 4.

Ippolito de' Medici was appointed Vice Chancellor of the Church on 3 July 1532. Monsignor Mario Bracci had been an official at Charles V's coronation in Bologna in 1530. The document depicted is a papal bull.

In the past NG 20 has been attributed to Raphael, Titian and Sebastiano del Piombo. The painting looks as if it has been composed from two separate portraits.

Mentioned as in the Palazzo Borghese, 1687–8; collection of Alexander Day by 1816; bought by the Revd William Holwell by 1819; Holwell Carr Bequest, 1831.

Gould 1975, pp. 111–13.

Signed on the plinth: IERONIMVS. TREVISIVS. P.[INXIT].

The man kneeling in profile is probably a member of the Boccaferri family; he may have been painted from a deathmask. He is presented to the Virgin and Child by an unidentified male saint (once said to be Saint Paul). The saint on the right is Saint James, identified by his pilgrim's staff. The saint behind Saint James may be Saint Joseph.

NG 623 is evidently the picture glowingly described by Vasari in 1550 as being in the church of S. Domenico in Bologna. It was in a chapel identified in 1666 as the chapel of the Boccaferri family, which was also said to contain representations in fresco of the four patron saints of Bologna.

Church of S. Domenico, Bologna, until about 1728–32; Solly collection by 1835; Lord Northwick collection, 1847–59; bought, 1859.

Gould 1975, pp. 114–15.

The Three Kings journeyed to Bethlehem to honour the new-born Jesus. They brought gifts of gold, frankincense and myrrh. New Testament (Matthew 2: 2–12).

NG 218 derives from a cartoon (formerly in the National Gallery but now transferred to the British Museum) drawn by Baldassare Peruzzi (1481–1536). In 1550 Vasari stated that Girolamo da Treviso made such a painting for the cartoon's owner, Count Giovan Battista Bentivoglio, but NG 218 may be another version and is not certainly by Girolamo. The cartoon is datable to 1522–3, and Girolamo da Treviso's copy of the composition probably dates from the later 1520s.

Lapeyrière sale, Paris, by 1825; presented by Edmund Higginson, 1849.

Gould 1975, pp. 115–17; Fagiolo 1987, pp. 95–6.

GIROLAMO da Treviso
active 1524; died 1544

Girolamo da Treviso worked as a painter and to a lesser extent as a sculptor. Frescoes and altarpieces by him survive in and near Bologna. He also worked in Faenza, Genoa, Mantua and Venice. By 1538 he was working for Henry VIII in England, principally as an engineer. His painting was much influenced by Giulio Romano.

GIULIO Romano and Gianfrancesco PENNI
Saint Mary Magdalene borne by Angels
possibly about 1520–1

Workshop of GIULIO Romano
The Birth of Jupiter
probably 1530–9

Follower of GIULIO Romano
The Attack on Cartagena
about 1555–75

NG 225
Fresco transferred and mounted on canvas,
165.1 x 236.2 cm

NG 624
Oil on wood, 106.4 x 175.5 cm

NG 643.1
Oil on canvas, transferred from wood, 35.6 x 153 cm

Mary Magdalene , clothed only by her hair, is being carried to heaven by angels.

NG 225 is one of the four lunette frescoes of the life of Mary Magdalene from the Massimi chapel in the church of SS. Trinità de' Monti, Rome. Giulio Romano, assisted by Gianfrancesco Penni (1496?–1528), painted the four evangelists in the vault, the lunettes, and the altarpiece in the chapel. Two drawings (Chatsworth, Devonshire collection; New York, Pierpont Morgan Library) are thought to relate to two of the other narratives in the lunettes. The rest of the decoration was completed by Perino del Vaga (1500–47). The lunettes must have been completed before Giulio's departure for Mantua in 1524, and a date of about 1520–1 has been suggested.

Recorded in the church of the SS. Trinità de' Monti, Rome, 1550; probably removed from the church in about 1811; presented by Lord Overstone, 1852.

Gould 1975, pp. 120–1; Albers 1988, pp. 91–2; Ferino 1989, pp. 252–3.

The exact text which NG 624 illustrates has not been identified; the picture seems to derive from the accounts of Callimachus, Diodorus Siculus and Ovid (*Fasti*). The nine figures in the background – variously styled the Corybantes or the Curetes according to the different versions – are shown making music so that the noise would distract Jupiter's father, Saturn, from devouring his offspring.

NG 624 was part of a large series of mythological pictures from Giulio's workshop. These can be traced to the Gonzaga collections in Mantua, and may have come from the Palazzo Ducale or another palace in the city or the surrounding area. A date in the 1530s (by when Giulio had long been established in Mantua) has been suggested.

A drawing at Chatsworth (Devonshire collection) has been identified as a preparatory modello for NG 624.

Recorded in the collection of King Charles I (as from Mantua), 1639; collection of the Duke of Orléans by 1727; bought, 1859.

Gould 1975, pp. 118–20; Shearman 1983, pp. 126–7, 129–31.

It is not clear that the attack on Cartagena is in fact the subject depicted but the companion painting (NG 643.2) does relate to Carthaginian history.

NG 643.1 comes from a series of paintings, which also includes NG 643.2, 644.1 and 644.2. Two other pictures from the same series are known, a *Coriolanus* and a *Scipio rewarding the Soldiers* (present locations unknown). Their format suggests that they were made for the panelling of a room, perhaps for the dado below windows. All of them are now thought to be the work of a minor Italian painter, active in the third quarter of the sixteenth century, who was familiar with the work of Giulio Romano and Raphael, upon which they depend. (See Appendix B for a larger reproduction.)

NG 643.1 and the related paintings mentioned above were in the collection of the Emperor Rudolph III of Prague; subsequently they passed through the Queen Christina of Sweden, Odescalchi and Orléans collections; bought with the Edmond Beaucousin collection, Paris, 1860.

Gould 1975, pp. 121–2.

GIULIO Romano
1499?–1546

Giulio Pippi was born in Rome; he was known as Giulio Romano after he had moved to the Gonzaga court at Mantua in 1524. He became Raphael's principal pupil and assistant in Rome, and, together with Gianfrancesco Penni, inherited his workshop in 1520. He was a painter, an architect and a draughtsman who designed theatrical sets and tapestries.

Follower of GIULIO Romano
The Continence of Scipio
about 1555–75

NG 643.2
Oil on canvas, transferred from wood, 35.6 x 153 cm

Follower of GIULIO Romano
The Rape of the Sabines
about 1555–75

NG 644.1
Oil on canvas, transferred from wood, 35.6 x 153 cm

Follower of GIULIO Romano
The Intervention of the Sabine Women
about 1555–75

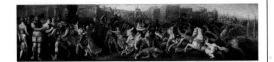

NG 644.2
Oil on canvas, transferred from wood, 35.6 x 153 cm

The warrior Scipio was offered a beautiful Carthaginian woman who had been taken prisoner, but he returned her to the young man she was pledged to marry. The story is taken from Livy (Book XXVI). The painting is a companion piece to 643.1 which also relates to Carthage.

NG 643.2 comes from a series of paintings, which also includes NG 643.1, 644.1 and 644.2. See under NG 643.1 for further discussion and see Appendix B for a larger reproduction.

NG 643.2 and the related paintings mentioned above were in the collection of the Emperor Rudolph III of Prague; subsequently they passed through the Queen Christina of Sweden, Odescalchi and Orléans collections; bought with the Edmond Beaucousin collection, Paris, 1860.

Gould 1975, pp. 121–2.

Romulus held games in Rome at which the Romans competed with the Sabines. He gave a prearranged signal and the Roman men carried off the Sabine women. The episode is taken from Plutarch's *Lives* (II, 14 and 19).

NG 644.1 comes from a series of paintings, which also includes NG 643.1, 643.2 and 644.2. See under NG 643.1 for further discussion and see Appendix B for a larger reproduction.

NG 644.1 and the related paintings mentioned above were in the collection of the Emperor Rudolph III of Prague; subsequently they passed through the Queen Christina of Sweden, Odescalchi and Orléans collections; bought with the Edmond Beaucousin collection, Paris, 1860.

Gould 1975, pp. 121–2.

The Sabines waged war on the Romans to retrieve their women and revenge their abduction. The women, however, threw themselves between the fighting warriors and thus forced a reconciliation. The story is taken from Plutarch's *Lives* (II, 14 and 19).

NG 644.2 comes from a series of paintings, which also includes NG 643.1, 643.2 and 644.1. See under NG 643.1 for further discussion and see Appendix B for a larger reproduction.

NG 644.2 and the related paintings mentioned above were in the collection of the Emperor Rudolph III of Prague; subsequently they passed through the Queen Christina of Sweden, Odescalchi and Orléans collections; bought with the Edmond Beaucousin collection, Paris, 1860.

Gould 1975, pp. 121–2.

GIUSTO de' Menabuoi
The Coronation of the Virgin, and Other Scenes
1367

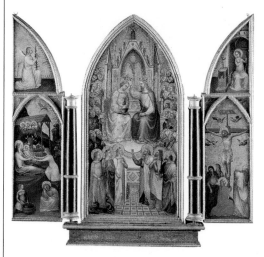

NG 701
Tempera on poplar, central panel 48 x 25 cm

NG 701, detail

Follower of Hugo van der GOES
The Virgin and Child
about 1500

NG 3066
Oil on oak, 48.3 x 38.1 cm

Signed on the reverse: (ju)stus pinxit in mediol
(Giusto painted this in Milan). Dated on the front of
the base: an[n]o. d[omi]ni.m./.ccc.lxvii. (The year of
Our Lord 1367). The cross in the right wing is
marked: . Y. N. R. I. (for I.N.R.I.) The right spandrel in
the left wing is inscribed: MATEUS (Matthew). The
spandrels in the left wing are inscribed: daniel,
(d)avit (Daniel, David).

 Central panel: the Virgin crowned by Christ, with,
in the foreground (left to right), Saint Margaret, an
unknown saint, Saints Catherine, Peter, John the
Baptist and Paul. At the sides are other saints and
angels, including Saints Ambrose, Francis, Dominic,
Benedict (?), Anthony Abbot (?), Stephen (?) and
Lawrence (?). Left wing: the Nativity and the
Annunciation to the Shepherds; above, in the
spandrels, are figures in gold under glass; at the
top, the Angel of the Annunciation. Right wing:
Christ crucified, with the Holy Women and Saint
John; above in the spandrels (again in gold under
glass), Daniel and David; at the top, the Virgin
Annunciate. Reverse of the wings (left to right and
top to bottom): the Expulsion of Joachim, the Angel
appearing to Joachim, the Meeting at the Golden
Gate, the Birth of the Virgin, the Presentation of the
Virgin, and the Marriage of the Virgin.

 NG 701 is a triptych painted for private devotions
and one of only two works by the artist known to
have been made in Lombardy. It is not known for
whom it was commissioned.

 The inclusion of gilded glass (*verre eglomisé*) in the
spandrels of a panel is unusual. All the frame
mouldings and columns are modern.

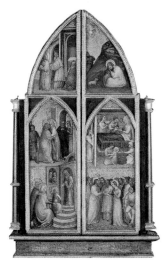

NG 701, with wings closed

*Collection of Prince Ludwig Kraft Ernst von Oettingen-
Wallerstein by 1816; acquired by the Prince Consort,
1851; presented by Queen Victoria at the Prince
Consort's wish, 1863.*

Gordon 1988, pp. 41–4.

Inscribed on the wings: Ave/ Sanctissima/ Maria
m[ate]r/ Dei Regina/ Celi porta/ Paradisi/
Domina/ Mu[n]di pura/ Singularis/ tu es Virgo/
Tu sine pec[cat]o/ Concepta/ concepisti/ J[e]h[su]m
sine/ o[m]ni macula. Tu/ Peperisti,/ Creatorem/ et
salvatore[m]/ Mundi/ In quo non/ Dubito/ libera
me/ Ab omni/ malo Et/ Ora pro/ Peccato/ Meo/
Amen. (Hail, Most holy Mary, Mother of God,
Queen of Heaven, Gate of Paradise, Mistress of the
World, you are the one pure virgin; yourself
conceived without sin you conceived Jesus without
any stain. You have borne the Creator and Saviour
of the World in whom I firmly believe. Deliver me
from all evil, and pray for my sins. Amen.)

 The Christ Child toys with a rosary to which is
linked a small piece of coral. (Traditionally coral
was worn by children as a means of protection from
evil.) The wings are inscribed with a prayer
addressed to the Virgin Immaculate and written in
gothic script (see Abbé V. Leroquais, *Les Livres
d'Heures manuscrits de la Bibliothèque Nationale*, Paris,
1927, Vol.I, pp. 299, 336; Vol.II, pp. 32, 190).

 The frame is original. A nineteenth-century dealer
has set it into another old frame to which the wing
panels, in their original frames, have been attached.
The composition comes from a Campinesque
prototype: the carpentry of the frame suggests that
it was made in Brussels.

*Acquired in Madrid by Sir A.H. Layard, 1872; Layard
Bequest, 1916.*

Davies 1953, pp. 108–11; Davies 1968, pp. 47–8.

GIUSTO de' Menabuoi
active 1349; died 1387/91

**Giusto de' Menabuoi was born in Florence, but
is first documented in Padua in 1373. It has been
suggested that he may have trained in Florence
with Bernardo Daddi or Maso di Banco, and that
he left the city because of the Black Death in
1348. Works from his period of activity in
Lombardy include NG 701.**

Hugo van der GOES
active 1467; died 1482

**Van der Goes was probably born in Ghent, where
he became a master in 1467. His patrons included
Tommaso Portinari and he painted altarpieces and
other religious works. He entered the monastery
of the Rode Klooster near Brussels in about 1475,
where he continued to live and paint until his
death.**

Follower of Hugo van der GOES
The Death of the Virgin
probably after 1500

After Hugo van der GOES (?)
The Nativity, at Night
about 1500

Vincent van GOGH
Van Gogh's Chair
1888

NG 658
Oil (identified) on oak, top corners cut, originally with an arched top, 38.1 x 34.9 cm

The Virgin is seen on her deathbed, surrounded by the twelve apostles. God (or Jesus Christ) appears with four angels above her head.

There was originally a tester over the bed instead of the gloriole with God (or Christ) and four angels. Another version of the composition (Berlin, Staatliche Museen) has this tester as well as a window on the left subsequently altered in NG 658. The style has been related to that of Robert Campin, and it has been suggested that NG 658 is a pastiche of diverse elements, painted in the early sixteenth century.

Collection of Sir Thomas Lawrence by 1830; collection of King William II of Holland, The Hague, by 1843; Edmond Beaucousin collection, Paris, by 1857; bought with the Beaucousin collection, 1860.

Davies 1953, pp. 52–60; Davies 1968, pp. 29–32; Dunkerton 1983, pp. 21–9.

NG 2159
Oil on oak, 62.2 x 46.4 cm

The Virgin Mary, Saint Joseph (with a candle) and angels surround the radiant child Jesus. The Annunciation to the Shepherds is visible in the left background. The two women behind Saint Joseph are presumably the midwives of the Virgin, Zelomi (Zebel) and Salome; the hand of the latter withered on account of her lack of faith in Mary's virginity.

NG 2159 is related to several similar paintings which it has been argued have a common source in a lost painting by Hugo Van der Goes.

Krüger collection by 1848; bought, 1854.

Davies 1954, pp. 139–41; Winkler 1964, pp. 134–41; Davies 1968, pp. 58–9.

NG 3862
Oil on canvas, 91.8 x 73 cm

Signed on the box at the upper left: Vincent.

NG 3862 was painted at Arles in November 1888 when Van Gogh was working in the company of Gauguin. Van Gogh painted a pendant, *Gauguin's Chair* (Amsterdam, Rijksmusuem Vincent Van Gogh), and the pictures were apparently intended to represent the contrasting personalities of the two artists. In a letter to his brother Theo, Van Gogh wrote that one gives the effect by day, the other by night. Van Gogh's own rustic chair, shown in natural light with his pipe, tobacco and the sprouting onions in the background, evokes an image of simplicity and directness. By contrast, Gauguin's more elaborate chair is shown in artificial light with a candle and books to suggest an artist who works from his imagination.

Van Gogh retouched NG 3862 in January 1889 after Gauguin's departure.

Mrs J. van Gogh-Bonger (the artist's sister-in-law); bought from V.W. van Gogh through the Leicester Galleries by the Trustees of the Courtauld Fund, 1924.

Davies 1970, p. 137; Uitert 1990, p. 184, no. 76.

Vincent van GOGH
1853–1890

Van Gogh was born in Holland. He worked as an art dealer in The Hague, London and Paris until 1876. After a brief period as a preacher he moved to Paris in 1886, where he was influenced by Impressionism. He evolved his mature style at Arles in 1888. Gauguin's visit precipitated his first mental crisis. He attended the asylum at St-Rémy before moving to Auvers-sur-Oise where he committed suicide.

Vincent van GOGH
Sunflowers
1888

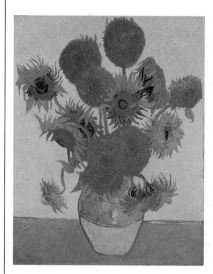

NG 3863
Oil on canvas, 92.1 x 73 cm

Signed on the vase: Vincent
Van Gogh painted a group of four canvases of sunflowers in the late summer of 1888 as decorations for his home at Arles (the so-called 'Yellow House').

NG 3863 dates from August 1888 and was hung in the guest bedroom at Arles in anticipation of the arrival of Gauguin, who came to stay between October and December of that year. Gauguin painted a portrait of Van Gogh painting sunflowers (Rijksmuseum Vincent Van Gogh, Amsterdam).

Van Gogh to some extent became obsessed with the subject. In a letter to his brother Theo he enthused about his plan for painting the sunflowers 'in which the raw or broken chrome yellows will blaze forth'. He also wrote to Theo after having started on the series: 'I am hard at it, painting with the enthusiasm of a Marseillais eating bouillabaisse...'

Mrs J. van Gogh-Bonger (the artist's sister-in-law); bought by the Trustees of the Courtauld Fund from the Leicester Galleries, 1924.

Davies 1970, p. 138; Uitert 1990, pp. 191ff.

Vincent van GOGH
A Wheatfield, with Cypresses
1889

NG 3861
Oil (identified) on canvas, 72.1 x 90.9 cm

The artist was particularly fascinated by cypress trees which he described as being 'as beautiful in line and proportion as an Egyptian obelisk. And the green has a quality of such distinction. It is a splash of black in a sunny landscape.'

NG 3861 was painted in September 1889 at the mental asylum at St-Rémy, near Arles, where Van Gogh was a patient from May 1889 until May 1890. Another version of this composition (New York, Metropolitan Museum of Art) painted earlier, in July 1889, was probably executed directly in front of the motif.

Octave Mirbeau, Paris; bought by the Trustees of the Courtauld Fund through the Independent Gallery, 1923.

Davies 1970, pp. 136–7; Leighton 1987a, pp. 42–59; Uitert 1990, p. 205, no. 89.

Vincent van GOGH
Long Grass with Butterflies
1890

NG 4169
Oil on canvas, 64.5 x 80.7 cm

During his prolonged illness Van Gogh was often restricted to working in the grounds surrounding the asylum at St-Rémy, near Arles, where he was a patient from May 1889 until May 1890. Shortly after his arrival there he described the 'abandoned gardens' in which 'the grass grows tall and unkempt, mixed with all kinds of weeds'.

Painted in May 1890, this picture and another work (Otterlo, Rijksmusuem Kröller-Müller) were his last views of the asylum garden.

Mrs J. van Gogh-Bonger (the artist's sister-in-law) until about 1924; bought by the Trustees of the Courtauld Fund from the French Gallery, London, 1926.

Davies 1970, pp. 138–9; Pickvance 1986–7, p. 183.

Jan GOSSAERT
The Adoration of the Kings
1500–15

Jan GOSSAERT
An Elderly Couple
1510–28

Jan GOSSAERT
A Little Girl
about 1520

NG 2790
Oil (identified) on wood, 177.2 x 161.3 cm

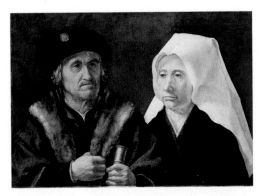

NG 1689
Oil on vellum (?), 45.7 x 67.3 cm

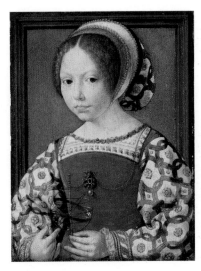

NG 2211
Oil on oak, 38.1 x 28.9 cm

Inscribed on the lid of the chalice presented by Caspar: (L)EROII IASPAR; on the crown of Balthazar: BALTAZAR; and lower down: IENNI / GOSSART: / DEMABV... (?); by the hem of the cloth that Balthazar holds: SALV(E) / REGINA, MIS and VIT (from the Salve Regina, a prayer to the Virgin); around the neck of one of Balthazar's followers another signature: IENNIN / GOS; on the angel's scroll: Gloria : in : excelsis : deo :

Caspar kneels before the Virgin. Behind him stands Melchior with a retinue of attendants. Balthazar is on the left. Further back an onlooker, seen through a doorway, may be a self portrait of the artist. Before the city in the central distance is the Annunciation to the Shepherds. The brilliant star at the top of the panel may represent God; the dove of the Holy Ghost appears below, and so all three members of the Trinity are present.

NG 2790 is first recorded as the altarpiece of the Lady Chapel in the church of the abbey of St Adrian at Geraardsbergen. It is universally regarded as an early work by the artist, but the question of whether it dates from before or after his trip to Italy (about 1508–9) has not been settled.

The dogs are copied from engravings: Schongauer's *Adoration of the Kings* and Dürer's *Saint Eustace* of about 1500/1.

Bought from the abbot of St Adrian's by Albert and Isabella, the Governors of the Netherlands, 1601; bought from Rosalind, Countess of Carlisle, with a special grant and contributions from the NACF, Lord Glenconner, Lord Iveagh and Alfred de Rothschild, 1911.

Davies 1968, pp. 63–6.

Jan GOSSAERT

active 1503; died 1532

Gossaert was a painter and engraver of religious and mythological subjects as well as portraits. His family came from Maubeuge. He joined the guild in Antwerp in 1503 and in 1507/8 entered the service of Philip of Burgundy, afterwards Bishop of Utrecht. In 1508 he travelled to Rome with Philip. His later patrons included Adolf of Burgundy, the Countess of Nassau, Margaret of Austria and Christian II of Denmark.

The sitters in this, the artist's only known double portrait, have not been identified. On the badge on the man's hat a young naked couple with a cornucopia are depicted, clearly providing a contrast with the age of the subjects. The engraved head of the man's cane is decorated with antique grotesques.

NG 1689 has been variously dated between 1510 and 1528.

Possibly (C. Burrell) sale, 21 May 1808 (lot 120); bought, 1900.

Davies 1968, pp. 61–2.

Inscribed on the armillary sphere: I-I-I-A-A-N-N-R-R-R-P ... G-T-Y-.

The young girl, who is richly dressed in a costume encrusted with pearls and jewels, is posed in front of a fictive picture frame. She has traditionally been regarded as Jacqueline (born 1523), daughter of Adolf of Burgundy and Anne of Bergen, but such an identification is no longer accepted. The object she holds and spins is not a toy, although she appears to be using it as such – it is a sophisticated astronomical instrument called an armillary sphere which was used to represent the movements of the planets. She holds it upside down; the letters engraved on the central band are inverted.

NG 2211 has been dated on stylistic grounds to about 1520.

Collection of Sir E.A.H. Lechmere, The Rhydd, by 1882; bought from Agnew (Clarke Fund), 1908.

Davies 1968, pp. 62–3.

Jan GOSSAERT
Adam and Eve
about 1520

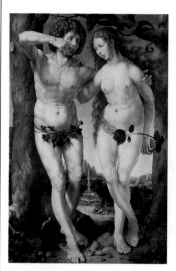

L14
Oil on wood, 168.9 x 111.4 cm

Adam, who already wears his apron of leaves, has just tasted the apple that Eve holds, while the serpent watches from above. Old Testament (Genesis 3: 1–7). On the left and right are two trees, probably the Tree of Life and the Tree of the Knowledge of Good and Evil. In the background is the Garden of Eden; the fountain in the centre of the garden is presumed to be the Fountain of Life. It is carved with figures, including two which may be intended as Adam and Eve. In the foreground are a columbine and a sea holly, probably symbolising respectively fear of God and lust.

Gossaert treated the subject of Adam and Eve many times in paintings and drawings. The depiction of the two figures reflects his interest in painting large-scale nudes. Eve's pose is based on Dürer's engraving of the *Temptation of the Idler*, and Gossaert probably also took inspiration from Marcantonio Raimondi's engraving of *Adam and Eve*.

L14 probably inspired Milton's description of Adam and Eve in his *Paradise Lost* (Book IV, 11: 300–18).

Probably in the monastery of the Knights of St John of Jerusalem, Haarlem; one of four pictures given by the Dutch States-General to King Charles I of England, 1636; sold at the Interregnum, but recovered for the Royal Collection at the Restoration; on loan from Her Majesty The Queen since 1975.

Campbell 1985, pp. 51–3, no. 33.

Jan GOSSAERT
Virgin and Child
about 1520

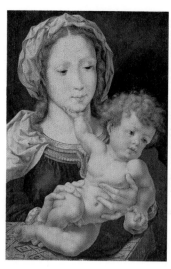

L650
Oil on oak, 38.9 x 26.5 cm

The figures of the Virgin and Child are extremely tightly compressed and thrust towards the viewer; the Virgin's head is off-centre. The Christ Child, often described as a second Adam who will redeem mankind from the sin of the first, holds an apple. His pose appears to have been inspired by Michelangelo and reflects Gossaert's preoccupation with Italian art and the antique, particularly in the depiction of the nude figure. The background of the picture is, characteristically, a dark red marbled stone. This arrestingly intimate and slightly uncomfortable impression must have been intentional: none of the edges of the picture seems to have been cut down.

L650 probably dates from about 1520, the same period as the *Adam and Eve* (L14).

In its subject and in the essential elements of the composition, the painting shows Gossaert's affinities with Netherlandish painting of the fifteenth century.

On loan from a private collection since 1993.

Friedlander 1972, p. 94, no. 30; National Gallery Report 1993–4, pp. 20–1.

Jan GOSSAERT
Man with a Rosary
about 1525–30

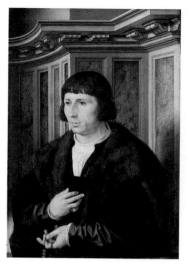

NG 656
Oil on oak, 68.6 x 48.9 cm

The man has not been identified. He is set before a classicising marble interior and toys with a string of rosary beads. He wears a fur-lined garment and jewelled rings.

NG 656 is thought to be the right wing of a diptych. To the left, probably joined by a hinge, may originally have been a panel depicting the Virgin and Child – their presence would make sense of the direction of the sitter's glance and the nature of his pose. The panel with the Virgin and Child seems not to survive, but its composition may be recorded in a number of variants associated with Gossaert (e.g. Madrid, Prado). On stylistic grounds NG 656 is regarded as a late work.

Bought with the Edmond Beaucousin collection, Paris, 1860.

Davies 1968, pp. 60–1.

Jan GOSSAERT
Damião de Goes (?)
about 1530–2

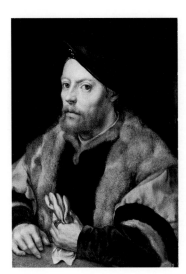

NG 946
Oil on oak, 24.4 x 16.8 cm

It has been suggested that the sitter may be the Portuguese humanist and collector Damião de Goes (1502–74) who resided for a long period in the Low Countries. This identification has been made as a result of a comparison between the painting and the sculpted head of Damião on the stone with his epitaph in the church of S. Maria de Varzea, Alenquer.

NG 946 is regarded as a very late work by the artist; it has been suggested that it was executed in about 1530–2. The back of the panel is branded with the letters CR surmounted by a crown, which signifies that the work belonged to King Charles I .

Acquired from Mantua by Charles I; collection of William Wells, Redleaf; Wynn Ellis Bequest, 1876.

Davies 1968, p. 61.

Follower of GOSSAERT
The Magdalen
early 16th century

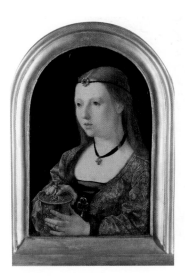

NG 2163
Oil on oak, including the original frame 29.2 x 22.2 cm

The Magdalen holds the jar which contained the ointment with which she anointed Christ.

NG 2163 has been considered to be by Gossaert, but it is now thought to be possibly the youthful work of a pupil.

Bought from Thomas H. Mack (Lewis Fund), 1907.

Davies 1968, p. 66.

After GOSSAERT
The Virgin and Child
17th century?

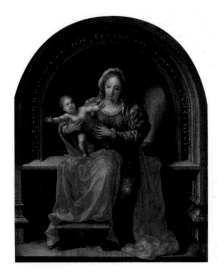

NG 1888
Oil on oak, 30.5 x 23.5 cm

Inscribed: GE. 3. MVLIERIS SEMEN IHS. SERPENTIS CAPVT CONTRIVIT. A reference to the words of God to the serpent after the Fall: 'I will put enmity between thee and the woman, and between thy seed and her seed; it shall bruise thy head ...' Old Testament (Genesis 3: 15).

The Virgin is enthroned; the Christ Child on her lap adopts a cruciform stance.

NG 1888 is a copy, perhaps of the seventeenth century, of a Gossaert design of 1527.

Bought with the Edmond Beaucousin collection, Paris, 1860.

Davies 1968, p. 67.

Francisco de GOYA
A Picnic
1785–90

Francisco de GOYA
Don Andrés del Peral
before 1798

Francisco de GOYA
A Scene from El Hechizado por Fuerza ('The Forcibly Bewitched'), 1798

NG 1471
Oil on canvas, 41.3 x 25.8 cm

NG 1951
Oil on poplar, 95 x 65.7 cm

NG 1472
Oil on canvas, 42.5 x 30.8 cm

NG 1471 is thought to probably be a sketch, dating from the late 1780s, for one of a series of cartoons for tapestries ordered by Charles III to decorate the Bedchamber of the Infantas at the Palace of El Pardo. Only one of the cartoons (*Blind Man's Buff*, now Prado, Madrid) seems to have been used to make a tapestry. The king died in 1788 and this may be why the project was abandoned.

Sold by Goya to the 9th Duke of Osuna, about 1799; bought at the Osuna sale, Madrid, 1896.

MacLaren/Braham 1970, pp. 9–11; Braham 1981, p. 103.

The sitter is probably the Andrés del Peral who worked as a craftsman-painter and gilder at the court of Madrid from the late 1770s to the early 1820s, and is recorded in 1838 as having formed a large collection of small paintings by Goya. The traditional title of the painting 'Dr Peral' derives from a label on the reverse which refers to Juan del Peral who died in Paris in 1888 and was the son of Andrés.

NG 1951 is almost certainly identical with the portrait of Don Andrés del Peral which Goya exhibited at the Real Academia de San Fernando in Madrid in the summer of 1798. It was highly praised by contemporaries.

Bought from the granddaughter of 'Dr Peral' in Seville by the Marqués de la Vega-Inclán in the late nineteenth century; presented by Sir George Donaldson, 1904.

MacLaren/Braham 1970, pp. 14–16; Braham 1981, p. 106.

Inscribed on the book (?) in the lower right corner: LAM/DESCO (see below for translation).

The subject comes from a comedy called *El Hechizado por Fuerza* ('The Forcibly Bewitched') by Antonio de Zamora, which was first performed in 1698. In order to frighten the timorous Don Claudio into marriage with Doña Leonora, he has been made to believe that her slave, Lucía, has bewitched him and that his life will last only as long as the lamp in her room remains alight. Here he replenishes the lamp with oil. To frighten him further a grotesque painting of a 'dance of donkeys' has been hung on the wall behind. He describes the lamp, which is fashioned in the form of a ram as 'lampara descomunal' ('monstrous lamp'); the first parts of these two words are inscribed at the lower right.

NG 1472 is one of six scenes of witchcraft and sorcery painted for the Duke of Osuna and paid for in 1798. They are probably identifiable as the six 'Caprichos raros' which were exhibited at the Real Academia in Madrid in the following year. Of the other works in the series two are in Madrid (Museo Lázaro Galdiano) and three in private collections.

Bought at the Osuna sale, Madrid, 1896.

MacLaren/Braham 1970, pp. 11–12; Braham 1981, pp. 103–4.

Francisco de GOYA
1746–1828

Francisco José de Goya y Lucientes was born in Fuendetodos, near Zaragoza. He had settled in Madrid by 1775 and from 1776 worked on designs for the royal tapestry works. The artist was appointed Painter to the King in 1786. In 1792 he suffered a severe illness and became deaf. He painted portraits, subject pictures and frescoes and also made numerous etchings. From 1824 he lived in Bordeaux.

Francisco de GOYA
Doña Isabel de Porcel
before 1805

Francisco de GOYA
The Duke of Wellington
1812–14

Jan van GOYEN
A Cottage on a Heath
about 1629

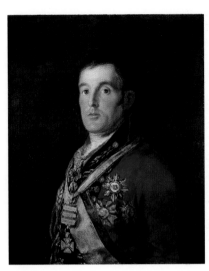

NG 1473
Oil (identified) on canvas, 82 x 54.6 cm

NG 6322
Oil on mahogany, 64.3 x 52.4 cm

NG 137
Oil on oak, 39.7 x 60.5 cm

The identification of the sitter is based upon an inscription on the lining of the canvas. She wears the popular costume of a *maja*, which was very fashionable in Spain in the late eighteenth and early nineteenth centuries.

NG 1473 is almost certainly the portrait exhibited by Goya at the Real Academia de San Fernando in Madrid in 1805. A portrait of Doña Isabel's husband, Don Antonio de Porcel, by Goya was dated 1806 (formerly Buenos Aires, Jockey Club, destroyed).

X-radiographs of NG 1473 reveal that it is painted over a portrait of an unidentified man in uniform.

With the portrait of Antonio de Porcel in the collection of the Porcel y Zayas family until about 1887; bought from the heirs of Don Isidoro Urzaiz, 1896.

MacLaren/Braham 1970, pp. 12–14; Braham 1981, pp. 106–7; Wyld 1981, pp. 38–43.

Arthur Wellesley, 1st Duke of Wellington (1769–1852), is shown wearing the Order of the Golden Fleece and the Peninsula Gold Cross. On his chest are the pink sash and star of the Order of the Bath; below left is the star of the Order of the Tower and Sword of Portugal, and right the star of the Order of San Fernando of Spain.

NG 6322 was executed in August 1812 when Wellington first entered Madrid, after winning the battle of Salamanca. When originally painted, the portrait closely resembled a drawing (London, British Museum) in which the subject was shown wearing a plain crimson jacket with the stars of the three orders and around his neck the Peninsula Medallion. Goya made several revisions and additions: the Golden Fleece was probably added in late August 1812, and then in 1814, when Wellington returned to Madrid, he painted the Peninsula Cross and clasps, which the sitter had received the previous year, over the Peninsula Medallion.

Painted almost certainly for Wellington, 1812; apparently passed to Louisa Catherine Caton, wife of the 7th Duke of Leeds; bought at the Duke of Leeds sale, with aid from the Wolfson Foundation, 1961.

MacLaren/Braham 1970, pp. 16–23; Braham 1981, pp. 109–10.

Signed in the foreground: VG
In the past the attribution to van Goyen has been questioned. The painting is, however, almost certainly an authentic work of about 1629. The monogram appears to be integral to the painting.

Bequeathed by Lt.-Col. J.H. Ollney, 1837.

MacLaren/Brown 1991, pp. 148–9.

Jan van GOYEN
1596–1656

The prolific landscape painter Jan Josephsz. van Goyen was born in Leiden. He is recorded as a pupil of several masters, but was most influenced by the last, Esaias van de Velde. According to the biographer Orlers he visited France. He painted in Leiden, from about 1632 in The Hague, and travelled widely in the Netherlands and Germany.

Jan van GOYEN
A River Scene, with Fishermen laying a Net
1638

Jan van GOYEN
A River Scene, with a Hut on an Island
1640–5

Jan van GOYEN
Fishermen hauling a Net
1640–5

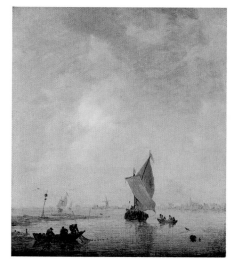

NG 2580
Oil on oak, 31.1 x 25.8 cm

NG 6154
Oil on oak, 37 x 33 cm

NG 6155
Oil on oak, 37 x 33 cm

Signed and dated on the rowing boat: VG 1638 (VG linked).

The church with a square tower on the horizon may be the Grote Kerk, Dordrecht (compare with Cuyp NG 961).

Robert Prioleau Roupell sale, London, 1887; Salting Bequest, 1910.

Beck 1972, II, p. 83, no. 168; MacLaren/Brown 1991, p. 146.

Signed in the left foreground: VG (linked).

This is the companion piece to NG 6155.

The style of the work suggests that it was probably painted in the early 1640s.

Robert Prioleau Roupell sale, London, 1887; bequeathed by Mrs Elizabeth Carstairs, 1952.

Beck 1972, II, p. 101, no. 208; MacLaren/Brown 1991, pp. 146–7.

Signed in the left foreground: VG (linked).

This is the companion piece to NG 6154.

The style of the work suggests that it was probably executed in the early 1640s.

Robert Prioleau Roupell sale, London, 1887; bequeathed by Mrs Elizabeth Carstairs, 1952.

Beck 1972, II, p. 101, no. 209; MacLaren/Brown 1991, p. 147.

Jan van GOYEN
A Scene on the Ice near Dordrecht
1642

Jan van GOYEN
A Windmill by a River
1642

Jan van GOYEN
A River Landscape
1645

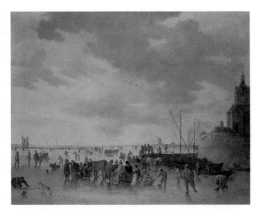

NG 1327
Oil on canvas, 117.5 x 151 cm

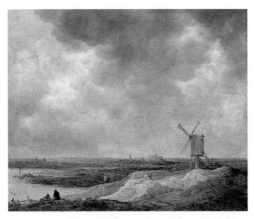

NG 2578
Oil on oak, 29.4 x 36.3 cm

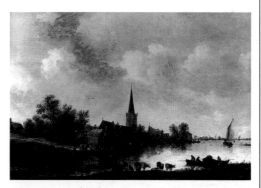

NG 151
Oil on oak, 66 x 96.5 cm

Signed and dated on the sleigh in the foreground: VGOYEN 1642 (VG linked).

In the right foreground is the Rietdijk water-gate (*Rietdijksche Poort*), which stood at the eastern end of Dordrecht: it was built in 1590 and demolished in about 1830. In the left distance, across the frozen Merwede river, are the remains of Merwede castle which was built in the thirteenth century and ruined in the early fifteenth century. The ruins were also depicted in a number of works by Cuyp, see NG 1289.

Baron Haldon sale, London, 1891; bought (Lewis Fund), 1891.

Beck 1972, II, pp. 31–2, no. 63; MacLaren/Brown 1991, p. 145.

Signed and dated bottom left: VG 1642 (VG linked).

Although NG 2578 was probably painted in The Hague, this is an outstanding example of the 'tonal phase' of Dutch landscape painting associated with the town of Haarlem. Van Goyen shows a flat landscape, featureless except for the windmill, small figures and distant buildings, as if from the top of a low hill. The sky occupies three-quarters of the picture space in this panoramic view; it is painted in a deliberately restricted palette of grey, brown, black and white enlivened only by a few strokes of yellow and green.

Robert Prioleau Roupell sale, London, 1887; Salting Bequest, 1910.

Beck 1972, II, p. 439, no. 975; MacLaren/Brown 1991, pp. 145–6.

Signed and dated right foreground: VGOYEN 1645 (VG linked).

It has been suggested that this is a depiction of Overschie in the Province of South Holland, but this identification is now rejected because the church there had on top of it a small open cupola with a weather vane which gave it a bulbous appearance. The cupola does not appear in NG 151.

A number of similar scenes by the artist are known (e.g. the painting of 1651 in the Corcoran Gallery, Washington).

Bequeathed by Mrs S.F. Hodges, 1852.

Beck 1972, II, p. 239, no. 509; MacLaren/Brown 1991, pp. 144–5.

Jan van GOYEN

A Scene on the Ice by a Drinking Booth; A Village in the Distance, 1645

Jan van GOYEN

The Mouth of an Estuary with a Gateway 1649

Jan van GOYEN

An Estuary with Fishing Boats and Two Frigates about 1650–6

NG 2579
Oil on oak, 25.2 x 34 cm

NG 6464
Oil on oak, 33.2 x 47.6 cm

NG 6423
Oil on oak, 49.5 x 69.1 cm

Signed and dated bottom left: VG 1645 (VG linked).
 The village on the horizon has not been identified, and the scene may not be intended as a depiction of a particular site.

Robert Prioleau Roupell sale, London, 1887; Salting Bequest, 1910.

Beck 1972, II, p. 36, no. 71; MacLaren/Brown 1991, p. 146.

Signed and dated centre left: VG 1649
 The building at the left appears to be a water-gate, of a type which appeared at the entrance of many Dutch towns. The specific location has not been identified.

Rudolph Ernst Brandt (died 1962) collection; presented by Mrs Alice Bleecker, 1981.

MacLaren/Brown 1991, p. 148.

The frigate in the middle distance has just fired a salute.
 NG 6423 was probably painted towards the end of van Goyen's life: he died in 1656. A comparable painting by him (Frankfurt, Städelsches Kunstinstitut) is dated that year.

Possibly the Erbstein and Montfoort sale, Paris, 1835; Sir Herbert Cook collection, Doughty House, Richmond; bequeathed by Sir John Heathcoat-Amory, Bt, 1972; entered the Collection in 1973.

Beck 1972, II, p. 413, no. 920; MacLaren/Brown 1991, pp. 147–8.

Imitator of van GOYEN
Sailing Vessels on a River in a Breeze
1650s

Attributed to Francesco GRANACCI
Portrait of a Man in Armour
about 1510

El GRECO
The Adoration of the Name of Jesus
about 1578

NG 2577
Oil on oak, 37.1 x 53.1 cm

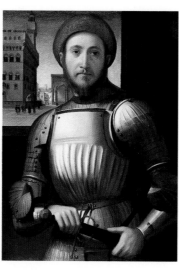

NG 895
Oil on wood, 70.5 x 51.5 cm

NG 6260
Oil and tempera on pine, 57.8 x 34.2 cm

Formerly signed falsely at bottom right: 1651./J. Van Goyen ft.; since cleaning in 1958, only traces of the date remain.

NG 2577 has in the past been attributed to van Goyen, but it is now considered to be an imitation of his late style.

Salting Bequest, 1910.

MacLaren/Brown 1991, p. 149.

The view of the Palazzo Vecchio and the Loggia dei Lanzi in Florence in the background is in general accurate. The street between is now quite different, with buildings housing the Uffizi Gallery. To the left of it is the church of S. Piero Scheraggio. The sitter has not been convincingly identified.

In the past NG 895 has been catalogued as ascribed to Piero di Cosimo. It presumably dates from after the setting up of Michelangelo's *David*, visible in the background, which was unveiled on 8 September 1504, and before the installation of Bandinelli's *Hercules and Cacus* in 1534, which does not appear. A date of about 1510 suits the style of the armour.

Presented by wish of the late Sir Anthony Coningham Stirling, KCB, 1871.

Davies 1961, pp. 424–5.

A monogram representing the name of Jesus is painted at the top: IHS; signed in Greek capitals on a rock in the left foreground (Made by Domenikos Theotokopoulos the Cretan); an old inventory number is in the lower right corner: 76.

The figures in the foreground who kneel to adore the monogram include Philip II of Spain, dressed in black, a doge of Venice and a pope. On the right the damned are inside the mouth of hell which is conceived as that of a giant animal (Leviathan). The saved are on the left. The painting combines a Last Judgement with a votive theme, interpreted as an allegory of the Holy League, a union of Spain (Philip II), the Holy See (the pope) and Venice (the doge) which resulted in the victory over the Turks at Lepanto in 1571.

NG 6260 is an autograph version of a larger painting by El Greco, known as *The Dream of Philip II* (now Monastery of El Escorial, near Madrid). This picture may have been commissioned by Philip II to mark the death in 1578 of Don Juan, his illegitimate brother who led the forces at Lepanto. The style of NG 6260 is of the late 1570s. It is first recorded with a pendant, a reduced replica of the artist's *Disrobing of Christ* (larger version, National Trust, Warwickshire, Upton House).

With its pendant in the collection of Don Luis Méndez de Haro y Guzmán, II Conde-Duque de Olivares (died 1675); bought from Lt.-Col. W.J. Stirling of Keir, 1955.

MacLaren/Braham 1970, pp. 27–34; Braham 1981, pp. 47–8.

Francesco GRANACCI
1469/70–1543

Granacci was a pupil of Domenico Ghirlandaio in Florence, at the same time as Michelangelo. He was established as a painter of the second rank in Florence during the first decades of the sixteenth century; thereafter his reputation declined.

El GRECO
1541–1614

Domenikos Theotokopoulos, known as El Greco, was born in Crete and trained as a Byzantine icon-painter. He travelled to Venice and is recorded in Rome by 1570. He was notably influenced by Tintoretto and Michelangelo. By 1577 he had settled in Toledo where he painted mainly for religious institutions.

El GRECO
Christ driving the Traders from the Temple
about 1600

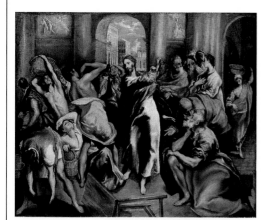

NG 1457
Oil on canvas, 106.3 x 129.7 cm

Attributed to El GRECO
Saint Jerome as Cardinal
1590–1600

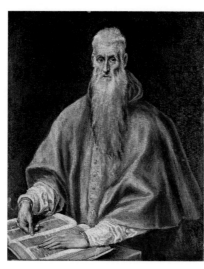

NG 1122
Oil on canvas, 59 x 48 cm

Studio of El GRECO
The Agony in the Garden of Gethsemane
late 16th century

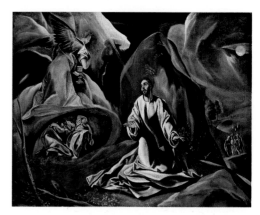

NG 3476
Oil on canvas, 102 x 131 cm

Jesus entered the Temple and drove out the traders declaring: 'My house shall be called a house of prayer: but ye have made it a den of thieves.' New Testament (Matthew 21: 12–13). On the right is a group of the apostles. The reliefs in the background represent on the left, 'The Expulsion of Adam and Eve from Paradise', and on the right 'The Sacrifice of Isaac'. In this context the latter, which is an Old Testament prototype of the Crucifixion, symbolises redemption and perhaps refers to the 'redeemed' figures of the apostles, whereas 'The Expulsion' relief probably refers to the 'unredeemed' traders on the left side of the picture. The overall theme may be intended to symbolise the Counter Reformation movement to purge the church of heresy and abuses. The architecture in the background recalls that of Venice.

There appear to be at least five autograph versions of this subject by the artist (e.g. Washington, National Gallery of Art; Minneapolis, Institute of Arts; New York, Frick Collection; Madrid, S. Gines). The Frick version is closest to NG 1457; on stylistic grounds the National Gallery picture can be dated to about 1600.

Possibly one of the pictures listed in El Greco's inventory, 1614; presented by Sir J.C. Robinson, 1895.

MacLaren/Braham 1970, pp. 24–7; Braham 1981, pp. 50–1.

Damaged signature in Greek at the bottom of the right edge of the canvas.

Saint Jerome (about 342–420) translated the Bible from Greek and Hebrew into Latin. His version, the Vulgate, was in use throughout the Catholic Church for many centuries. Here he is depicted half-length with the text before him. He was often represented, as in this instance, in the clothes of a cardinal, although the office did not exist in his lifetime.

Several versions of this composition exist (e.g. New York, Frick Collection, and Lehmann Collection [both of these are larger]; Madrid, Conde de Adanero Collection; Bayonne, Musée Bonnat). NG 1122 is considered a weaker example from this group which is usually dated to the 1590s.

Possibly one of the two paintings of this subject listed in El Greco's inventory, 1614; collection of Lord Northwick by 1858; bought at the Hamilton sale, 1882.

MacLaren/Braham 1970, pp. 34–6.

Christ kneels in the centre; at the upper left an angel appears to him with a cup, a reference to his forthcoming Passion. In the background on the left are the sleeping apostles – Peter, James the Greater and John; on the right Judas approaches with soldiers. New Testament (Matthew 26: 37; Mark 14: 43; Luke 22: 43; John 18: 3).

NG 3476 is probably a workshop replica of a painting by El Greco (Toledo, Ohio, Museum of Art). There are several versions in a vertical format, of the Toledo (Ohio) picture.

Possibly one of the pictures of this subject listed in El Greco's inventory, 1614; bought (Lewis and other Funds), 1919.

MacLaren/Braham 1970, pp. 37–9; Davies 1989, p. 67.

After El GRECO
Saint Peter
perhaps early 17th century

NG 3131
Oil on vellum (?), 20.3 x 15.9 cm

This head repeats with slight variations a detail of
an El Greco composition known as *The Penitence of
Saint Peter*, of which there are many variants by El
Greco and his school dating from the late 1580s
onwards. (See the autograph version in the Bowes
Museum, Barnard Castle, which is probably the
earliest.)
 NG 3131 is possibly a fragment from a larger
composition.

*Perhaps bought in Spain by Sir A.H. Layard between
1869 and 1877; Layard Bequest, 1916.*

MacLaren/Braham 1970, pp. 39–41.

GRECO-ROMAN
A Young Woman
probably 2nd–3rd century

NG 3931
Probably encaustic on wood, 42 x 22 cm

The woman wears a necklace of alternating green
stone and gold, and gold earrings.
 NG 3931 is from the case of a mummy. It was
found near the village of Er-Rubiyat, north-east of
Medînet-el-Faiyûm.

*Bought from a Greek dealer by Th. Graf of Vienna; from
whom bought by Ludwig Mond, 1839; Mond Bequest,
1924.*

Gordon 1988, p. 44.

GRECO-ROMAN
A Man with a Wreath
probably 2nd–3rd century

NG 3932
Probably encaustic on wood, 42 x 22 cm

The man's white tunic is trimmed with gold. His
wreath and the background are gold.
 NG 3932 is from the case of a mummy. It was
found near the village of Er-Rubiyat, north-east of
Medînet-el-Faiyûm.

*Bought from a Greek dealer by Th. Graf of Vienna; from
whom bought by Ludwig Mond, 1839; Mond Bequest,
1924.*

Gordon 1988, p. 44.

Jean-Baptiste GREUZE
Portrait of a Man
1763

Jean-Baptiste GREUZE
A Girl
1765–80

Jean-Baptiste GREUZE
A Child with an Apple
late 18th century

NG 6500
Oil (identified) on canvas, 64.7 x 54.8 cm

NG 1019
Oil on canvas, 47 x 39.4 cm

NG 1020
Oil on canvas, 40.6 x 32.1 cm

Signed and dated: 1763.
 The identity of the sitter is not known for certain. In 1763, the year NG 6500 was painted, Greuze exhibited at the Paris Salon a portrait of the Comte de Lupé; and on 11 November of that year a Monsieur Bacherach, 'negotiant à Saint Pétersbourg', paid for a portrait that was a 'buste sans mains'. This work could be, but is not necessarily, either of these pictures.

Bought, 1985.

National Gallery Report 1985–7, p. 17.

NG 1019 may be a fragment from, or study for, a larger work.
 It probably dates from the later 1760s or the 1770s.

Wynn Ellis Bequest, 1876.

Davies 1957, p. 109; Wilson 1985, p. 108.

Another version of this work is in the Detroit Institute of Arts.
 NG 1020 may be unfinished. It is probably one of the artist's later works.

Recorded as from Lord Coventry's collection; Wynn Ellis collection by 1854; Wynn Ellis Bequest, 1876.

Davies 1957, p. 109.

Jean-Baptiste GREUZE
1725–1805

Greuze was born in Tournus, trained under Charles Grandon at Lyon, and moved to Paris. He exhibited at the Paris Salon of 1755 to considerable acclaim, but his attempt to be admitted to the Académie as a history painter in 1769 failed. He mainly produced moralistic genre scenes, portraits and studies of adolescent girls.

Jean-Baptiste GREUZE
A Girl with a Lamb
late 18th century

NG 1154
Oil on canvas, 54.6 x 44.5 cm

This work may be unfinished. There is a pentimento by the hand of the girl.
 NG 1154 is probably one of the artist's later works.

Presumably in the collection of Caulet d'Hauteville (died about 1775); presented at the wish of Madame Mary Mohl, 1884.

Davies 1957, p. 109.

Follower of GREUZE
A Girl
late 18th century

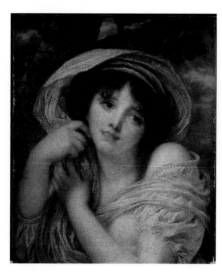

NG 206
Oil on wood, probably mahogany, 45.7 x 38.1 cm

The girl appears to be before a skyscape.
 NG 206 has in the past been attributed to Greuze, but it is now considered to be by a follower of the artist.

Bought by Smith, Paris, 1830; in the collection of Richard Simmons by 1837; by whom bequeathed, 1846/7.

Davies 1957, pp. 109–10.

Francesco GUARDI
Venice: The Arsenal
1755–60

NG 3538
Oil on canvas, 62.3 x 96.9 cm

Signed on the pedestal of the lion statue to the left of the gateway: Franco Guardi
 The gateway to the Arsenal is on the left. The building in the distance is the chapel of the Madonna dell'Arsenale.
 NG 3538 may date from around 1755–60, which would place it among the earliest of Guardi's view paintings. The dating is suggested by comparison with other works of this period by the artist, such as a group in the collection of the Duke of Buccleuch.
 The composition is based on an etching of 1741 by Marieschi which in its turn is derived from an etching by Carlevaris.

Messrs P. & D. Colnaghi; presented by Alfred A. de Pass, 1920.

Levey 1971, pp. 134–7; Morassi 1973, p. 423.

Francesco GUARDI
1712–1793

Guardi was a member of a family of Venetian painters; his brother and collaborator was Gian Antonio Guardi. They worked in many genres, but are mainly known for *vedute* (topographical views of the city) influenced notably by Canaletto, and *capricci* (imaginary views). The artist was elected to the Venetian Academy in 1784.

Francesco GUARDI
Venice: The Grand Canal with Palazzo Pesaro
about 1755–60

Francesco GUARDI
Venice: Piazza San Marco
about 1760

Francesco GUARDI
Venice: The Punta della Dogana with S. Maria della Salute, about 1770

NG 210
Oil on canvas, 72.4 x 119.1 cm

NG 4457
Oil on canvas, 92.7 x 130.9 cm

NG 2098
Oil on canvas, 56.2 x 75.9 cm

The seventeenth-century Palazzo Pesaro, designed by Longhena, is depicted in the centre. On the right a funeral boat can be seen before the façade of the church of S. Stae (Sant'Eustachio). The Palazzo Corner della Regina is at the extreme left.

NG 4457 is tentatively dated to around 1755–60.

The composition is based on an etching by Marieschi, no. 7 in the *Magnificentiores Selectioresque Urbis Venetiarum Prospectus* of 1741.

Said to have been one of a series painted for the 'Palazzo Comello-Montalban', Venice; bequeathed by Lord Revelstoke, 1929.

Levey 1971, pp. 137–8; Morassi 1973, p. 415.

Signed on the plank (?) carried by the man on the right: FRANCᶜᴼ(?) GUARDI

This view shows the main piazza of Venice from the west, looking towards the façade of the basilica of S. Marco and its campanile. On the left are the Procuratie Vecchie and the Torre dell'Orologio, while on the right are the Procuratie Nuove. The tent-like constructions near the basilica are vendors' booths. The scale of figures in the foreground seems incompatible with that of the buildings.

NG 210 illustrates a degree of influence from Canaletto. It is considered stylistically mature and dated to about 1760.

A number of versions of this view by Guardi are known; see NG 2525.

John Webb sale, London, 1821; bequeathed by Richard Simmons, 1846.

Levey 1971, pp. 118–20; Morassi 1973, pp. 371–2.

The dome of S. Maria della Salute dominates this view. To the left are the Seminario and the Dogana da Mar; S. Gregorio and the campanile of S. Vio are on the right.

There are several versions of this view by Guardi. NG 2098 with its pendant, NG 2099, can be dated to about 1770.

A drawing for the composition survives (Vienna, Albertina).

John Samuel collection by 1868; bequeathed by the Misses Cohen as part of the John Samuel collection, 1906.

Levey 1971, pp. 121–2; Morassi 1973, p. 400.

Francesco GUARDI
Venice: The Doge's Palace and the Molo from the Basin of San Marco, about 1770

NG 2099
Oil on canvas, 58.1 x 76.4 cm

Francesco GUARDI
An Architectural Caprice
1770–8

NG 2523
Oil on canvas, 54.2 x 36.2 cm

Francesco GUARDI
An Architectural Caprice with a Palladian Style Building, 1770–80

NG 2517
Oil on canvas, 22.3 x 17 cm

To the right of the Doge's Palace are the state prisons, while to the left are the Library, Zecca, and the State Granaries (now destroyed), before which is moored the ducal galley. It was used by the doge for all state occasions except the Ascension Day ceremony.

NG 2099 is the pendant to NG 2098; both works are dated to about 1770.

A drawing (Venice, Museo Correr) includes some studies of figures and boats which are used in NG 2099.

John Samuel collection by 1868; bequeathed by the Misses Cohen as part of the John Samuel collection, 1906.

Levey 1971, pp. 122–3; Morassi 1973, p. 387.

Signed at the lower left corner: F.G.P. (inxit) (Francesco Guardi painted this).

Various features of the scene are drawn from Venetian architecture. The arch itself recalls that of the Torre dell'Orologio and the building in the middle distance, with the staircase, is a free adaptation of the internal façade of the Doge's Palace and the Scala dei Giganti.

A drawing of the composition, which probably formed the basis of the painting, is extant (New York, Metropolitan Museum of Art). The view was engraved by Dionigi Valesi in Venice, in about 1778. It may be related as a pendant to some other similar picture by Guardi.

George Salting collection by 1900; Salting Bequest, 1910.

Levey 1971, pp. 130–2; Morassi 1973, p. 456.

This invented architectural setting includes a domed building, possibly a temple set on a podium, and a semi-circular colonnade which concludes in the right foreground. The domed construction is derived in part from Palladio's unexecuted design for the Rialto Bridge.

The overall composition is based upon a drawing by Guardi (London, Victoria and Albert Museum). Studies by Guardi, after Palladio's design for the Rialto Bridge, also survive (Venice, Museo Correr).

Possibly Samuel Rogers sale, London, 1856; Salting Bequest, 1910.

Levey 1971, pp. 123–4; Morassi 1973, p. 450.

Francesco GUARDI
An Architectural Caprice
probably 1770s

NG 2519
Oil on canvas, 22.1 x 17.2 cm

This picture is a caprice embodying motifs from the courtyard of the Doge's Palace, as seen from the south. The staircase recalls the Scala dei Giganti, and the building on the left the Arco Foscari.

Three drawings by Guardi related to this composition survive (New York, Metropolitan Museum of Art).

George Salting collection by 1885; Salting Bequest, 1910.

Levey 1971, pp. 125–6; Morassi 1973, p. 457.

Francesco GUARDI
View of the Venetian Lagoon with the Tower of Malghera, probably 1770s

NG 2524
Oil on wood, 21.3 x 41.3 cm

Inscribed on the reverse: *la Tore di Mestre/ Guardi Veneziano.* (The Tower of Mestre/ the Venetian Guardi.)

The building on the right has been identified as the tower of Malghera (or Marghera) near Mestre, a relic of the ancient Venetian fortifications. It was demolished in the nineteenth century.

Datable on comparison with other works by the artist to the 1770s.

Although not derived directly from it, NG 2524 may have been inspired by an etching of the same subject by Canaletto.

Possibly bought by Seguier in anon. sale, London, 1808; Salting Bequest, 1910.

Levey 1971, pp. 132–3; Morassi 1973, pp. 433–4.

Francesco GUARDI
A Caprice with a Ruined Arch
about 1775

NG 2518
Oil on wood, 20.1 x 15.5 cm

Inscribed on the reverse (not in the artist's hand): *di Franᶜᵒ Guardi Veniziano* (by the Venetian Francesco Guardi).

This invented ruined arch, with a suspended lantern, may be derived from those which form the arcade of the Doge's Palace in Venice.

The arch appears in other works by Guardi. A drawing of this composition was formerly in the collection of Sir Robert Witt.

Acquired from Giacomo Guardi by a priest from Ancona; bought by Lord Farnham in Rome; Salting Bequest, 1910.

Levey 1971, pp. 124–5; Morassi 1973, pp. 488–9..

Francesco GUARDI
A View near Venice (?)
probably 1775–80

NG 2520
Oil on canvas, 20.7 x 30.8 cm

Francesco GUARDI
A Caprice with Ruins on the Seashore
about 1775–80

NG 2522
Oil on canvas, 36.8 x 26.1 cm

Francesco GUARDI
A Gondola on the Lagoon near Mestre
after 1780

NG 1454
Oil on canvas, 29.5 x 44.5 cm

It is thought that this is not an invented caprice, but rather a topographical view, the subject of which has not as yet been identified. It has been suggested that it may be a view from the Giudecca, or at Chioggia, but neither idea is entirely convincing.

NG 2520 was probably painted between 1775 and 1780. Its early provenance is the same as that for Guardi NG 2518.

Acquired from Giacomo Guardi by a priest from Ancona; bought by Lord Farnham in Rome; Salting Bequest, 1910.

Levey 1971, pp. 126–7; Morassi 1973, pp. 453–4.

An invented ruined arch dominates this view. Two men are depicted digging in the foreground. The architecture may have been inspired by ruins found on one of the islands in the Venetian lagoon.

A larger painting by Guardi of the same period (London, Victoria and Albert Museum) also includes the ruined arch.

Probably John Henderson collection by 1857; Salting Bequest, 1910.

Levey 1971, pp. 129–30; Morassi 1973, p. 484.

Two gondoliers wearing festival costumes propel their boat across part of the Venetian lagoon. On the horizon is the tower of Malghera, near Mestre on the mainland (see also Guardi NG 2524).

NG 1454 is probably a late work (after 1780) and comparable with a work of higher quality but similar in style and date (Milan, Museo Poldi Pezzoli).

Probably Giacomo Tarma, Venice; bought in Venice by the Hon. Agar Ellis, 1828; bought, 1895.

Levey 1971, pp. 120–1; Morassi 1973, p. 434.

Francesco GUARDI
Caprice View with Ruins
after 1780

NG 2521.1
Oil on wood, 10.2 x 6.1 cm

NG 2521.1 is framed with NG 2521.2 and 2521.3. All include invented picturesque ruins with figures; none is based on known buildings.

The style of the three pictures suggests a similar date of execution, probably after 1780. They seem to have been together since first recorded in the early nineteenth century.

All three works are known in other versions by the artist.

Probably Giacomo Tarma, Venice; bought in Venice by the Hon. Agar Ellis, 1828; Salting Bequest, 1910.

Levey 1971, pp. 127–9; Morassi 1973, pp. 496–7.

Francesco GUARDI
Caprice View with Ruins
after 1780

NG 2521.2
Oil on wood, 10.1 x 6.1 cm

NG 2521.2 is framed with NG 2521.1 and 2521.3. For discussion see entry for NG 2521.1.

Probably Giacomo Tarma, Venice; bought in Venice by the Hon. Agar Ellis, 1828; Salting Bequest, 1910.

Levey 1971, pp. 127–9; Morassi 1973, pp. 496–7.

Francesco GUARDI
Caprice View with Ruins
after 1780

NG 2521.3
Oil on wood, 10.4 x 6 cm

NG 2521.3 is framed with NG 2521.1 and 2521.2. For discussion see entry for NG 2521.1.

Probably Giacomo Tarma, Venice; bought in Venice by the Hon. Agar Ellis, 1828; Salting Bequest, 1910.

Levey 1971, pp. 127–9; Morassi 1973, pp. 496–7.

Francesco GUARDI
Venice: Piazza San Marco
after 1780

Francesco GUARDI
Venice: The Punta della Dogana
1780s

Francesco GUARDI
Venice: The Giudecca with the Zitelle
1780s

NG 2525
Oil on canvas, 34.9 x 53.4 cm

NG 6156
Oil on canvas, 18.7 x 23.8 cm

NG 6157
Oil on canvas, 18.7 x 23.8 cm

The Piazza San Marco is shown from the west. In the centre of the composition are the façade of the basilica of S. Marco and the campanile. On the left are the Procuratie Vecchie and the Torre dell'Orologio; the Procuratie Nuove are on the right.

The style of NG 2525 and the costumes of the figures suggest a date of execution after 1780.

This is a version of a composition the artist treated on a number of occasions, see also Guardi NG 210.

Charles Spencer Ricketts collection before 1895; Salting Bequest, 1910.

Levey 1971, pp. 133–4; Morassi 1973, p. 372.

The Dogana da Mar, or Customs House of Venice, was built by Benoni in about 1677. Compare with Guardi NG 2098.

NG 6156 was probably painted in the 1780s. It is a pendant to NG 6157.

Bought in Venice by Henry Woodward before May 1808; bequeathed by Mrs Elizabeth Carstairs, 1952.

Levey 1971, p. 139; Morassi 1973, p. 404.

S. Maria della Presentazione, called the Zitelle, originally a foundling hospital for girls, was built in the sixteenth century.

This is the pendant to NG 6156. Both pictures are thought to have been painted in the 1780s.

Bought in Venice by Henry Woodward before May 1808; bequeathed by Mrs Elizabeth Carstairs, 1952.

Levey 1971, p. 139; Morassi 1973, p. 428.

Imitator of GUARDI

Venice: Entrance to the Cannaregio

after 1804

Imitator of GUARDI

A Ruin Caprice

19th century

Imitator of GUARDI

A Ruin Caprice

19th century

NG 1054
Oil on canvas, 36.2 x 53.7 cm

NG 2904
Oil on canvas, 13.4 x 19.4 cm

NG 2905
Oil on canvas, 13.4 x 19.4 cm

This is not an accurate topographical record of the view. On the left are the campanile of S. Geremia and the Palazzo Labia. In the centre is the Ponte di Cannaregio and beyond it are the buildings of the Ghetto Vecchio. The Palazzo Querini detti Papozze is on the right.

Microchemical analysis has revealed the presence of a blue pigment called 'Thénards blue', which was not in use until 1804. NG 1054 therefore must be considered the work of a nineteenth-century imitator of Guardi.

The composition is derived in part from Visentini's engraving after Canaletto's 1735 version of the same scene.

Bequeathed by John Henderson, 1879.

Levey 1971, p. 140.

It is assumed that this is an invented ruin set as though it existed in the Venetian Lagoon.

The work is the pendant of NG 2905. Both are thought to be by a nineteenth-century imitator.

Bequeathed by Lady Lindsay, 1912.

Levey 1971, pp. 140–1.

It is assumed that this is an invented ruin set as though it existed in the Venetian Lagoon.

The work is the pendant of NG 2904. Both are thought to be by a nineteenth-century imitator.

Bequeathed by Lady Lindsay, 1912.

Levey 1971, p. 141.

GUERCINO
The Dead Christ mourned by Two Angels
about 1617–18

NG 22
Oil on copper, 36.8 x 44.4 cm

GUERCINO
Elijah fed by Ravens
1620

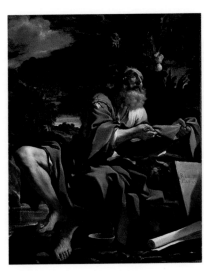

L273
Oil on canvas, 195 x 156.5 cm

GUERCINO
The Incredulity of Saint Thomas
1621

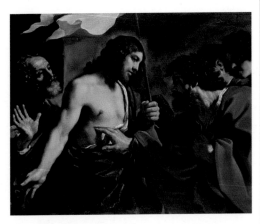

NG 3216
Oil (identified) on canvas, 115.6 x 142.5 cm

There is no New Testament source for an image of Christ mourned by two angels, but two angels are described as emerging from his tomb on the morning after the Resurrection (John 20: 11–17). NG 22 seems to be set in the open air and may be meant to suggest instead the Lamentation over the body of Christ after the Deposition.

NG 22 has been dated to about 1617–18 by Mahon who compared the picture with the *Saint Sebastian succoured by Angels* dated 1617 (Sudeley Castle, Winchcombe, Gloucestershire, Basildon Pictures Settlement). The composition was frequently copied, and two other versions seem to have existed with an attribution to Guercino in the seventeenth century.

Two drawings have been directly connected with this composition (Windsor, Royal Collection; Copenhagen, Museum). NG 22 was engraved in reverse by N. Pitau the Elder.

Collection of Giovanni Battista Borghese, Rome, by 1693; Holwell Carr Bequest, 1831.

Levey 1971, pp. 141–3; Helston 1991, p. 16; Mahon 1991, p. 80.

Inscribed on the stone slab with the biblical reference to the subject: REG. III/CAP. XVII (Kings 3, chapter 17).

The prophet Elijah prophesied a drought and was told by God to hide by a brook (the Cherith, seen in the left foreground), and that ravens (seen top right) would bring him 'bread and flesh' twice a day. Old Testament (1 Kings 17: 6; the first Book of Kings is called the third in the Vulgate edition of the Bible).

L273 was painted for Cardinal Jacopo Serra (1570–1623), the papal legate in Ferrara, in 1620. Serra was one of Guercino's most important patrons during the artist's early years and commissioned at least five pictures from him.

Although the inscription correctly identifies the subject, when the painting was in the Barberini collection, Rome, it was for a long time called 'Saint Paul the Hermit'.

Cardinal Jacopo Serra, Ferrara, 1620; recorded in the Barberini collection, Rome, from 1655; acquired from the Principessa Donna Maria Barberini by (Sir) Denis Mahon, 1936; on loan from Sir Denis Mahon since 1987.

Helston 1991, p. 27; Mahon 1991, pp. 122–4.

Saint Thomas, who had doubted that Jesus Christ had risen from the dead, was convinced when Christ (holding the banner traditionally associated with his victory over death) invited him to touch the wound in his side. New Testament (John 20: 20–9).

Malvasia stated that NG 3216 was painted in Cento in 1621 for Bartolomeo Fabri as a pendant to *The Taking of Christ* (Cambridge, Fitzwilliam). Guercino left Cento for Rome in 1621 and NG 3216 was presumably completed by the time of his departure.

NG 3216 is a good example of Guercino's horizontal compositions with half-length figures, a format he used to strikingly dramatic effect. NG 3216 was engraved in Rome in 1621 by Giovanni Battista Pasqualini. A number of high quality copies are known (e.g. Vatican, Pinacoteca, sometimes attributed to Giovanni Maria Crespi).

Acquired by Thomas Hope of Deepdene, Surrey, before 1818; from whose heirs bought, 1917.

Levey 1971, pp. 143–4; Helston 1991, pp. 28–30.

GUERCINO
1591–1666

Giovanni Francesco Barbieri, called Guercino (the 'squint-eyed'), was born in Cento. He worked principally in Cento until settling in Bologna in 1644, though he was in Rome for Pope Gregory XV's pontificate (1621–3). He painted literary subjects, altarpieces, ceiling paintings, portraits and small religious works. After Guido Reni's death, Guercino was the foremost artist of seventeenth-century Bologna.

GUERCINO
The Presentation of Jesus in the Temple
1623

GUERCINO
Saint Gregory the Great with Saints Ignatius Loyola and Francis Xavier, about 1625–6

GUERCINO
The Cumaean Sibyl with a Putto
1651

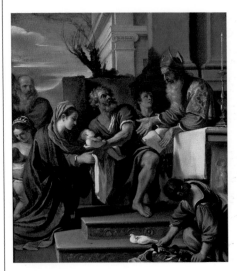

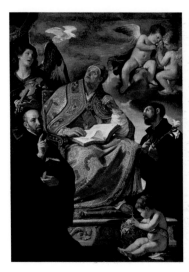

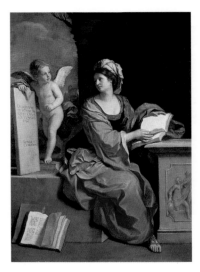

L34
Oil on copper, 72.5 x 65 cm

L603
Oil on canvas, 296 x 211 cm

L592
Oil on canvas, 222 x 168.5 cm

The child Jesus was taken by his parents to the temple according to Jewish law. New Testament (Luke 2: 22–35). Traditionally two doves were presented by the parents (seen here at the foot of the altar). Simeon, who had prayed that he might live long enough to see the Messiah, holds out his arms to receive the child from the Virgin Mary.

L34 was painted in Guercino's hometown of Cento in 1623 (immediately after his return from Rome). It was painted for Bartolomeo Fabri but returned to Guercino's possession in discharge of a debt. The picture was kept in the artist's bedroom until sold to Raphael Dufresne in 1660.

Collection of the Duc d'Orléans (who had received it from the Abbé François de Camps) by 1727; collection of the Earl Gower until 1802 when bought by the 2nd Earl of Ashburnham; acquired by (Sir) Denis Mahon, 1953; transferred to the Mahon Trust, 1977; on loan from the Mahon Trust since 1977.

Helston 1991, p. 34; Mahon 1991, pp. 170–2.

Saint Gregory (about 540–604), one of the four doctors of the Western church, is shown with the dove of the Holy Spirit which inspired his writings. In the foreground a putto holds the papal tiara. To the left is Saint Ignatius Loyola and to the right Saint Francis Xavier, the principal saints of the Jesuit Order.

Both Ignatius and Francis were canonised on 12 March 1622 (the feast day of Saint Gregory the Great), during the pontificate of Gregory XV (Alessandro Ludovisi). After the pope's death, members of his family promoted the foundation of a church (1626) dedicated to Saint Ignatius, and it is probable that L603 was intended for this new church (Sant'Ignazio). Stylistically it is datable to about 1625–6, but it was apparently never placed in the new church, which took more than fifty years to complete. Several drawings for L603 exist.

Given by Niccolò Ludovisi to the Spanish envoy, Don Juan Alfonso Enríquez de Cabrera, 1646; recorded in the church of San Pascual, Madrid, 1776; bought in Paris by the 2nd Duke of Sutherland, 1837; bought from the Sutherland collection by Sir George Faudel-Phillips, 1908; from whom bought by (Sir) Denis Mahon, 1941; on loan since 1992.

Helston 1991, pp. 40–2; Mahon 1991, pp. 188–90; National Gallery Report 1992–3, pp. 22–3.

Inscribed on the stone slab to which the putto is pointing: O LIGNVM / BEATVM IN / QVO DEVS / EXTENSVS / EST / SYBILLA / CVMANA. (O blessed wood on which God was stretched out; Cumaean Sibyl).

The Cumaean Sibyl, historically one of Apollo's priestesses at Delphi, was held by Christians to have predicted that Jesus would be born in Bethlehem. The inscription refers to the wooden cross on which he would be crucified.

Guercino painted this picture in 1651 as a pendant to a painting of King David (Althorp, collection of the Earl Spencer), but was persuaded to sell it to Prince Mattias de' Medici, and to paint a replacement (the *Samian Sibyl*, also at Althorp) for the original patron, Gioseffo Locatelli.

Acquired by Sir John Forbes for Fintray House (near Aberdeen) between 1830 and 1840; acquired from the family by (Sir) Denis Mahon, 1954; on loan from Sir Denis Mahon since 1992.

Helston 1991, p. 58; Mahon 1991, pp. 348–50; National Gallery Report 1991–2, pp. 22–3.

GUERCINO
The Angel appearing to Hagar and Ishmael
1652–3

L612
Oil on canvas, 193 x 229 cm

After GUERCINO
A Bearded Man holding a Lamp
1617–64

NG 5537
Oil on canvas, 119.7 x 85.1 cm

Joris van der HAAGEN
A River Landscape
probably about 1650–60

NG 901
Oil on canvas, 109 x 129 cm

Hagar was the Egyptian servant of Sara, Abraham's wife. Abraham had a child, Ishmael, by Hagar, and when Sara miraculously gave birth to Isaac, she asked Abraham to banish Hagar and her son. Abraham duly sent them into the wilderness. Their supply of food and water ran out and Hagar sat down and turned away from Ishmael so as not to watch him die. An angel appeared and told her not to be afraid and to pick up her child who would become father of a great nation (the Ishmaelites). She then saw a source of water (shown at the extreme left) from which she could fill her water bottle. Old Testament (Genesis 16: 1–16; 21: 1–21).

L612 was painted for Pandolfo Saccini of Siena. It is considered one of Guercino's most lyrical late works.

Collection of Adriano Salimbene, Siena, 1714; acquired by the 2nd Marquess of Rockingham, 1751; inherited on his death (1782) by his sister Lady Anne Watson-Wentworth; from whose descendants the picture was acquired by (Sir) Denis Mahon, 1948; on loan since 1992.

Helston 1991, p. 66; Mahon 1991, p. 362; National Gallery Report 1992–3, pp. 22–3.

NG 5537 is a copy of a foreground figure in Guercino's *Susanna and the Elders* (Madrid, Prado), painted in 1617 for Cardinal Alessandro Ludovisi. It varies from the original only in showing the figure with a lamp in place of a staff. A number of other copies are known. NG 5537 appears to be by an Italian artist (which suggests that it was probably painted before Guercino's original was sent to Spain in 1664).

The number LXXXI painted on the reverse corresponds with the entry in the manuscript list of pictures from the Turner Bequest (1856) that describes NG 5537 as after Guercino.

Collection of J.M.W. Turner by 1856; Turner Bequest, 1856.

Levey 1971, pp. 144–5.

NG 901 is unsigned and has in the past been attributed to Jan Looten (about 1618–about 1680?). Van der Haagen painted wooded landscapes as well as his better-known topographical views and this picture can be compared to similar signed works by him.

Bequeathed by Mrs Jewer Henry Jewer, 1873.

MacLaren/Brown 1991, p. 150.

Joris van der HAAGEN
about 1615–1669

Van der Haagen was presumably trained by his father, the painter Abraham van der Haagen, in Arnhem. He was recorded in The Hague by 1640 where he was active in the painters' guild and was one of the founder members of the painters' confraternity, *Pictura*. He painted landscapes and topographical views, and travelled widely in the Netherlands.

Jan Cornelis HACCOU
A Road by a Cottage
1819

NG 3683
Oil on oak, 23.8 x 32.9 cm

Signed and dated bottom right: J.C.H 1819 (the last letter of the signature may be intended for HC in monogram).

This is an early work by Haccou.

Bequeathed by William Thomas Blinco, 1922.

MacLaren/Brown 1991, p. 151.

Jan HACKAERT and Nicolaes BERCHEM
A Stag Hunt in a Forest
probably about 1660

NG 829
Oil on canvas, 99.7 x 120 cm

Signed at the bottom towards the left: NBerchem f. (NB in monogram). Inscribed above the signature: MonSeron.

A stag is surrounded by hounds and by hunters on foot and on horseback in a river in a forest.

Berchem painted the figures and the animals and Hackaert the landscape. The inscription above the signature does not seem to be by Berchem, but is probably contemporary. It may be the name of the patron for whom the picture was painted but a Monsieur Seron has not been identified.

Collection of the Prince of Wales by 1806; bought for Sir Robert Peel, Bt, 1845; bought with the Peel collection, 1871.

MacLaren/Brown 1991, p. 152.

Dirck HALS
A Party at Table
1626

NG 1074
Oil on oak, 28 x 38.8 cm

Signed and dated on the door lintel: DHALS · ANo 1626 (DH in monogram). The back of the panel is inscribed with the name: T.V. Crimpen.

Merry company scenes (*geselschapjes*) of this sort derive from depictions of biblical subjects, such as the Prodigal Son Feasting. They were often engraved with verses which condemned foolish and extravagant behaviour. It is likely that this painting would have been viewed by at least some contemporaries in that sense. In the left background is a map; on the wall to the right is a painting of the Taking of Christ.

Hals painted two similar compositions, also dated 1626 (San Francisco, Palace of the Legion of Honour; St Petersburg, Hermitage).

Bought from Edward C. Hill, 1879.

MacLaren/Brown 1991, p. 153.

Jan Cornelis HACCOU
1798–1839

The artist was born in Middelburg where he was a pupil of Johannes Hermanus Koekkoek. He travelled to Switzerland, France and Germany and then settled in London, where he exhibited at the Royal Academy in 1836. Haccou painted in oil and watercolour, mainly winter landscapes and river views.

Jan HACKAERT
1628/9–after 1685

Hackaert was born in Amsterdam. He travelled in Switzerland and possibly also in Italy. He worked in Amsterdam where he painted Italianate landscapes that seem to be derived from those of Jan Both. He was a friend of Adriaen van de Velde, who sometimes painted the figures and animals in his pictures. He also made landscape etchings.

Dirck HALS
1591–1656

The artist was the younger brother of Frans Hals. He was born in Haarlem where he spent most of his life, although he is also recorded in Leiden (1641–2 and 1648–9). The style of Dirck Hals's work is based upon that of his brother, with whom he is likely to have studied. He specialised in 'merry company' scenes, such as NG 1074.

Frans HALS
Young Man holding a Skull (Vanitas)
1626–8

Frans HALS
Portrait of a Man in his Thirties
1633

Frans HALS
Portrait of a Woman (Marie Larp?)
about 1635–8

NG 6458
Oil on canvas, 92.2 x 88.0 cm

NG 1251
Oil on canvas, 64.8 x 50.2 cm

NG 6413
Oil on canvas, 83.4 x 68.1 cm

The skull held by the boy is a reminder of the transience of life and the certainty of death. Such a subject is known as a *vanitas* (Latin for vanity), a name derived from a verse in the Old Testament (Ecclesiastes 12: 8), 'Vanity of vanities, saith the preacher, all is vanity'. The tradition of showing young boys holding skulls can be traced back to an engraving by Lucas van Leyden of 1516. The exotic clothing of the youth recalls that used by the Dutch Caravaggisti in allegorical and genre subjects. The subject has traditionally and incorrectly been identified as Hamlet.

NG 6458 is dated 1626–8 on stylistic grounds.

Apparently bought for Sir James Stuart by Andrew Geddes; passed to his daughter, Mrs Woodcock, 1849; bought from the Trustees of the Elton Heirloom Settlement by private treaty, 1980.

Slive 1970–4, III, pp. 37–8, no. 61; Slive 1989–90, pp. 208–11, no. 29; MacLaren/Brown 1991, pp. 160–1.

Inscribed: AETAT SVAE 3 (·) / ANo 1633. Signed at right centre: FH (in monogram).

It was once thought that this work might be a pendant to NG 1021, but that is a later picture. It has also been suggested that this is a self portrait, but this theory is also untenable.

NG 1251 has been cut down on the right, where the present edge of the canvas runs through the first figure of the sitter's age.

Collection of Decimus Burton by 1875; presented by Miss Emily Jane Wood at the wish of her uncle, Decimus Burton, 1888.

Slive 1970–4, III, p. 50, no. 81; MacLaren/Brown 1991, pp. 155–6.

The sitter has been identified as Marie Larp on the basis of an inscription on a label pasted to the stretcher of the painting, which is probably written in an eighteenth-century hand. A woman with this name is mentioned in the Haarlem archives: she seems to have married twice and to have died in 1675. There is, however, no documented portrait of her which can be compared with NG 6413.

Collection of the Comte d'Oultremont; Comte d'Oultremont sale, Brussels, 1889; Arnold and Tripp, Paris; bought by W.C. Alexander, 1891; presented by the Misses Rachel F. and Jean I. Alexander; entered the Collection in 1972.

Slive 1970–4, III, pp. 61–2, no. 112; MacLaren/Brown 1991, pp. 159–60.

Frans HALS
about 1580?–1666

Hals was probably born in Antwerp, but moved as a child to Haarlem where he lived and worked. He was a pupil of Carel van Mander, and in 1610 joined the painters' guild in Haarlem as a master. Famed for the virtuosity of his technique, the artist painted single and group portraits, some genre scenes and a few religious works.

Frans HALS
Portrait of a Middle-Aged Woman with Hands Folded, about 1635–40

Frans HALS
Portrait of Jean de la Chambre at the Age of 33 about 1638

Frans HALS
Portrait of a Woman with a Fan about 1640

NG 1021
Oil on canvas, 61.4 x 47 cm

NG 6411
Oil on wood, 20.6 x 16.8 cm

NG 2529
Oil on canvas, 79.8 x 59 cm

Signed at left: FH (in monogram).
 The sitter has in the past been identified as the wife of the man in *Portrait of a Man in his Thirties* (NG 1215), but the two works do not appear to be pendants. Alternatively, it has been suggested that this portrait is a companion to Hals's *Portrait of a Man holding a Book* (New York, Saul Steinberg collection), but that picture is larger and possibly later in date.
 The costume of the sitter is of the early 1630s, but may have been worn later by older women. NG 1021 has been dated to the latter part of the decade, by comparison with works such as *Portrait of a Woman* of 1639 (Ghent, Museum voor Schone Kunsten).
 The work is probably cut down at the sides and bottom.

Bought (Lewis Fund) from F.A. Keogh, 1876.

Slive 1970–4, III, p. 70, no. 131; MacLaren/Brown 1991, p. 155.

Inscribed upper left: 1638 / aet. 33.
 Jean de la Chambre (1605/6–68), who is shown holding a quill, was a distinguished calligrapher and Master of the French School in the Ursulasteeg, Haarlem.
 NG 6411 was used as the modello for an engraving of Jean de la Chambre by Jonas Suyderhoef, dated 1638, which served as the frontispiece to a collection of six of his own engraved examples of his calligraphic skill.

Sale, Amsterdam, 1883; C. Wertheimer, London; P. and D. Colnaghi, London; bought by W.C. Alexander, 1892; presented by the Misses Rachel F. and Jean I. Alexander; entered the collection in 1972.

Slive 1970–4, III, p. 65, no. 122; Slive 1989–90, p. 273, no. 50; MacLaren/Brown 1991, pp. 158–9.

The sitter has not been identified. Similar clothes are worn by the woman depicted by Codde in NG 2576, which is dated 1640, and in the *Portrait of a Woman* by Johannes Cornelisz. Verspronck (Enschede, Rijksmuseum Twenthe), which was painted in the same year.

With Hals NG 2528, said to have been in the possession of the dealer Joseph Flack, London, mid–1860s; Revd Robert Gwilt sale, London, 1889; Salting Bequest, 1910.

Slive 1970–4, III, p. 74, no. 141; Slive 1989–90, p. 282, no. 53; MacLaren/Brown 1991, pp. 157–8.

Frans HALS
Portrait of a Man holding Gloves
about 1645

NG 2528
Oil on canvas, 78.5 x 67.3 cm

The sitter has not been identified. His clothes appear to date from the mid-1640s.

The handling of the light passages are similar to those in Hals's *Portrait of an Artist* of 1644 (Art Institute of Chicago).

With Hals NG 2529, said to have been in the possession of the dealer Joseph Flack, London, mid–1860s; H.W. Cholmley sale, London, 1902; Salting Bequest, 1910.

Slive 1970–4, III, p. 83, no. 163; MacLaren/Brown 1991, p. 157.

Frans HALS
A Family Group in a Landscape
about 1647–50

NG 2285
Oil on canvas, 148.5 x 251 cm

The identity of the family has not been established. The costumes of most of the figures date from the second half of the 1640s, although that of the older woman is earlier (about 1630–5).

The style of the painting suggests it was executed in the late 1640s. The landscape is by another artist; it may have been painted by either Pieter de Molijn (1595–1661), or Reyer Claesz. Suycker (about 1590–1653/5).

Comparison with the *Family Portrait* in the Thyssen-Bornemisza collection, which is of a similar date, and the absence of stretcher marks, suggest that a strip of about 15 cm has been cut from the top edge.

Perhaps in the Buckingham House sale, London, 1763; bought from Lord Talbot of Malahide, Malahide Castle, near Dublin, 1908.

Slive 1970–4, III, pp. 91–2, no. 176; MacLaren/Brown 1991, pp. 156–7.

Henri-Joseph HARPIGNIES
A River Scene
about 1850–70

NG 2256
Oil on canvas, 21 x 23.2 cm

Signed: hy harpignies.

This river view has not been identified.

Presented by Miss E. Ponsonby McGhee, 1908.

Davies 1970, p. 70.

Henri-Joseph HARPIGNIES
1819–1916

Harpignies was born in Valenciennes. He trained with Jean-Alexis Achard from 1846 to 1850, and was in Italy from 1850 to 1852 and again from 1863 to 1865. He was a landscape painter, influenced by Corot, and exhibited at the Salon from 1853.

Henri-Joseph HARPIGNIES
River and Hills
about 1850–60

Henri-Joseph HARPIGNIES
The Painter's Garden at Saint-Privé
1886

Henri-Joseph HARPIGNIES
Autumn Evening
1894

NG 4582
Oil on canvas, 27.3 x 44.5 cm

NG 1358
Oil on canvas, 59.7 x 81.3 cm

NG 6325
Oil on canvas, 116.8 x 160 cm

Signed: hy harpignies.
 The site has not been identified.
 The evidence of style suggests that this is an early work, perhaps painted in the 1850s.

Collection of Hans Velten by 1926; by whom bequeathed to the Tate Gallery, 1931; transferred, 1956.

Davies 1970, pp. 70–1.

Signed and dated: h/ harpignies 86.
 In about 1879, Harpignies retired to his house, La Trémellerie, at Saint-Privé on the banks of the Yonne river. The garden there became a favourite subject for the painter.

Presented to the Tate Gallery by H. Arthur Robinson in memory of Mrs R.H. Tripp, 1923; transferred from the Tate, 1956.

Davies 1970, pp. 69–70.

Signed and dated: H Harpignies. 94
 The site depicted has not been identified.

Collection of George McCulloch by 1913; bequeathed by Pandeli Ralli, 1928.

Davies 1970, p. 71.

Henri-Joseph HARPIGNIES
Olive Trees at Menton
1907

NG 3808
Oil on canvas, 99.7 x 81.3 cm

Attributed to Gerrit Willemsz. HEDA
Still Life with a Nautilus Cup
probably about 1645

NG 6336
Oil on oak, 84.6 x 99.5 cm

Willem Claesz. HEDA
Still Life: Pewter and Silver Vessels and a Crab
probably about 1633–7

NG 1469
Oil (identified) on oak, 54.2 x 73.8 cm

Signed and dated: h/ harpignies. 1907.
 The specific site has not been identified.
 NG 3808 was exhibited at the Salon of the Société des Artistes Français in 1907.
 An inscription on the back of the canvas, 'Janvier 1906' (January 1906), may not refer to the painting, but to the delivery of the canvas.

Presented by H. Arthur Robinson to the Tate Gallery in memory of R.H. Tripp, 1923; transferred, 1956.

Davies 1970, p. 700.

A nautilus cup, glasses, books and food are seen on a table in front of a curtain (on the right).
 Gerrit Heda, about whom little is known, imitated his father but his technique was cruder and his compositions more cluttered. NG 6336 can be compared to a signed and dated picture of 1644 and probably dates from about the same time.

Bequeathed by Claude Dickason Rotch, 1962.

MacLaren/Brown 1991, pp. 161–2.

Pewter and silver vessels, a crab, a lemon, a knife and a glass are seen on a table.
 NG 1469 was previously attributed to Gerrit Willemsz. Heda but has now been given to Willem Claesz. Heda on the strength of comparison with a signed picture by him of the mid-1630s (Sweden, Oppenheimer collection).

Apparently in the collection of Arthur Kay, Glasgow, by 1893; presented by Henry J. Pfungst, 1896.

MacLaren/Brown 1991, p. 162.

Gerrit Willemsz. HEDA
active 1637; died before 1702

Gerrit Willemsz. Heda, son of the painter Willem Claesz. Heda, was in his father's studio in Haarlem in 1642. He was a still-life painter like his father, whose work he closely imitated.

Willem Claesz. HEDA
1593/4–1680/2

Willem Claesz. Heda entered the Haarlem guild as a master in 1631. He was a painter of still life and together with Pieter Claesz. developed the 'monochromatic' style of still-life painting. His son Gerrit Willemsz. imitated his work.

Willem Claesz. HEDA
Still Life with a Lobster
1650–9

Attributed to David Davidsz. de HEEM
Still Life
probably late 1660s

Martin van HEEMSKERCK
The Virgin and Saint John the Evangelist
about 1540

NG 5787
Oil on canvas, 114 x 103 cm

NG 2582
Oil on oak, 33.7 x 24.2 cm

NG 6508.1
Oil (identified) on oak, painted surface 123 x 46 cm

Signed and dated in the centre: . HEDA . F . 165().
On the left is a *pas-glas* (a tall thick glass); in the centre a *roemer* (a bulbous beer glass). The other objects include bread, a lemon, plates and a knife. There is a merchant's or guild cipher on the hanging corner of the cloth (in the centre).

NG 5787 was previously attributed to Gerrit Heda, but is closely comparable with signed pictures of 1656 by Willem Heda in the museums of Houston and Budapest.

Collection of J. Scully before 1919; presented by Frederick John Nettlefold, 1947.

MacLaren/Brown 1991, p. 163.

Signed bottom right: D. DE HEEM (DE in monogram).
The arrangement includes oranges, cherries, sheaves of wheat and a snail on the ledge in the left foreground.

The painting seems closely to resemble work by Cornelis de Heem rather than the little-known David de Heem. However, the signature appears to be genuine and so the traditional attribution has been retained.

William Theobald sale, London, May 1851; Salting Bequest, 1910.

MacLaren/Brown 1991, p. 165.

The Virgin is supported by Saint John the Evangelist; the focus of her anguish was presumably a figure of Jesus Christ on the right. On the reverse of the panel there is a bishop saint standing in a niche below which is an unidentified coat of arms.

NG 6508.1 and 6508.2 were the wings of an altarpiece, possibly flanking an 'Ecce Homo among Clouds'. The classical elements of their style strongly suggest that the altarpiece was painted after van Heemskerck's return from Italy, probably in about 1540.

Collection of the 4th Marquess of Bath by 1880; bought, 1986.

National Gallery Report 1985–7, pp. 28–31; Dunkerton 1988, pp. 16–35.

David Davidsz. de HEEM
active 1668

The artist was recorded in the painters' college in Utrecht in 1668. No other documentation about his life survives. He was probably the author of a small group of pictures signed D.De Heem and D.D. Heem. The style of these works is close to that of Jan Davidsz. de Heem, who may have been related to him.

Martin van HEEMSKERCK
1498–1574

Born in Heemskerck, he was in Haarlem in 1527–30, working in collaboration with Jan van Scorel. From 1532 to 1536 he was in Rome, where he made drawings of architecture, sculpture and other antique works. On his return to Haarlem his style became strongly influenced by classical antiquity and contemporary Italian work. He painted a number of large altarpieces, and was also active as a draughtsman and designer of prints.

Martin van HEEMSKERCK
The Donor and Saint Mary Magdalene
about 1540

Wolfgang HEIMBACH
Portrait of a Young Man
1662

Bartholomeus van der HELST
Portrait of a Man in Black holding a Glove
1641

NG 6508.2
Oil (identified) on oak, painted surface 123 x 46 cm

A male donor, probably a canon, is presented by
Mary Magdalene (who holds her traditional
attribute of a pot of the balm with which she
anointed Jesus). On the reverse of the panel there
is a bishop saint standing in a niche, below which
is an unidentified coat of arms.
 NG 6508.1 and 6508.2 were the wings of an
altarpiece; see further under NG 6508.1.

Collection of the 4th Marquess of Bath by 1880; bought,
1986.

National Gallery Report 1985–7, pp. 28–31;
Dunkerton 1988, pp. 16–35.

NG 1243
Oil on oak, 49.5 x 35.9 cm

Signed and dated on the balustrade, bottom right:
Cop, CH J(?) Fe. 166 / 2. (Copenhagen: The portraitist
Wolfgang Johann Heimbach made this, 1662.)
 The sitter has not been identified, but may be a
Danish merchant. The background view is probably
intended to show Copenhagen.
 NG 1243 provides the last known date for
Heimbach's first visit to Copenhagen.

Collection of Meredith Roberts, London, by 1888; bought,
1888.

Göttsche 1935, p. 76; Levey 1959, p. 46.

NG 4691
Oil on canvas, 113.5 x 80.2 cm

Inscribed bottom left: Ano 1641.
 The sitter has not been identified.
 Van der Helst had a number of assistants even at
this early stage of his career and this portrait may
include some studio participation.

Possibly in the collection of George Salting, London,
1889; bequeathed by Sir Edward Stern, 1933, with a life
interest to Lady Stern; entered the Collection in 1946.

MacLaren/Brown 1991, p. 167.

Wolfgang HEIMBACH
active 1636–1678

Heimbach was probably born in Ovelgönne, near
Oldenburg. He is said to have studied in Holland,
and was subsequently in Italy, probably from
about 1640 to 1650. By 1653 he was in Copenhagen,
where he became court painter, and stayed until
about 1662 or later. He was a painter of portraits,
genre scenes and a few religious pictures.

Bartholomeus van der HELST
1613–1670

Van der Helst was born in Haarlem, but may have
been taught by Nicolaes Eliasz. in Amsterdam,
where he is recorded in 1636 and where he settled.
The artist was a very fashionable and influential
portrait painter from the mid-1640s. He employed
a number of assistants, among them his son
Lodewijk, who worked in his style.

Bartholomeus van der HELST
Portrait of a Lady in Black Satin with a Fan
1644

Bartholomeus van der HELST
Portrait of a Girl in Pale Blue with an Ostrich Feather Fan, 1645

Catharina van HEMESSEN
Portrait of a Lady
1551

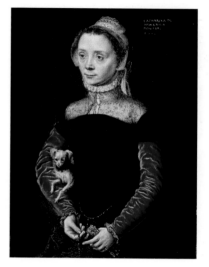

NG 1937
Oil on oak, 104.6 x 76 cm

NG 1248
Oil on canvas, 75.4 x 65.3 cm

NG 4732
Oil on oak, 22.9 x 17.8 cm

Signed and dated top right: b van der helst f1644
 The sitter has not been identified.
 Van der Helst was one of the most successful portrait painters in Amsterdam from the mid-1640s onwards. His Flemish-influenced style and careful depiction of fabrics brought him many commissions for single and family portraits, as well as for guild and militia group portraits.

Collection of Louisa, Lady Ashburton, by 1871; bought from her executor, the Marquess of Northampton, 1904.

MacLaren/Brown 1991, pp. 166–7.

Signed and dated top left: B. vander · helst /1645
 An early nineteenth-century label on the back of the lining identifies the girl as a member of the Braganza family, but there are no other clues to her identity.

Said to have been in the William Beckford collection, Fonthill Abbey, before 1823; bought, 1888.

MacLaren/Brown 1991, p. 166.

Signed and dated upper right: CATHARINA DE / HEMESSEN / PINGEBAT / 1551.
 The sitter, who carries a small dog, is unidentified.

Lady Brooke of Norton Priory, Cheshire, 1901; presented by her daughter Mrs D.E. Knollys, 1934.

Davies 1968, p. 68.

Catharina van HEMESSEN
1527/8–after 1566?

Catharina was the daughter of the Antwerp painter Jan van Hemessen. She married in 1554 and is described as having gone to Spain with Mary of Hungary, who went there in 1556. Most of her surviving works, a number of which are signed, are small portraits of women.

Catharina van HEMESSEN
Portrait of a Man
1552

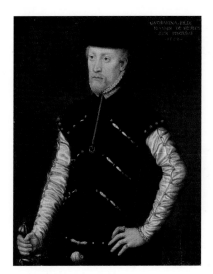

NG 1042
Oil on oak, 36.2 x 29.2 cm

Signed and dated upper right over another similar inscription or signature: CATHARINA. FILIA / IOANNIS DE HEMES / SEN PINGEBAT / .1552. (Catharina, daughter of Jan van Hemessen, painted this. 1552).
The sitter holds a sword.

Bought from James C. Wallace, Holloway (Lewis Fund), 1878.

Davies 1968, pp. 67–8.

Attributed to van HEMESSEN
A Lady with a Rosary
about 1550

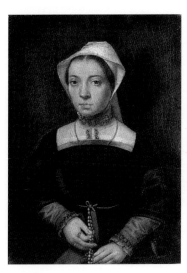

NG 1860
Oil on oak, 23.8 x 17.5 cm

The sitter has not been identified.
Her costume can be dated to about 1550 (compare that in Hemessen NG 4732). The attribution is not certain. The work has been attributed to Catharina's father, Jan, but may be by another unidentified Antwerp artist.

According to a label on the reverse, given by her mother to Miss Julia E. Gordon, who bequeathed the work, 1896.

Davies 1968, p. 68.

Wybrand HENDRIKS
Fruit, Flowers and Dead Birds
about 1780

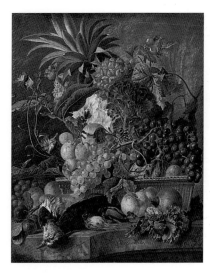

NG 1015
Oil on canvas, 67.7 x 54.6 cm

Signed at the bottom in the centre of the marble slab: W^d Hendriks.
Grapes, peaches, plums, a pineapple and flowers are arranged on a slab, together with three dead birds, including a lapwing.
NG 1015 was painted in imitation of the style of Jan van Os and was once falsely inscribed as his work.

Wynn Ellis Bequest, 1876.

MacLaren/Brown 1991, p. 168.

Wybrand HENDRIKS
1744–1831

Hendriks was born in Amsterdam, but was active as a painter chiefly in Haarlem. He painted portraits, landscapes, genre scenes, topographical views and still lifes. Hendriks was director of the Drawing Academy in Haarlem and curator of the Teylers Foundation there from 1785.

Willem van HERP the Elder
Saint Anthony of Padua (?) distributing Bread
probably 1662

Jan van der HEYDEN
A View in Cologne
about 1660–5

Jan van der HEYDEN
View of the Westerkerk, Amsterdam
probably 1660

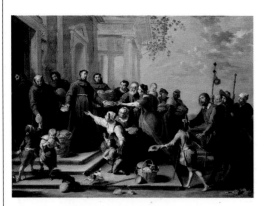

NG 203
Oil on copper, 80 x 114.3 cm

NG 866
Oil on oak, 33.1 x 42.9 cm

NG 6526
Oil on oak, 90.7 x 114.5 cm

Signed: G.V. HERP

The friars on the left are Franciscan, and the one in the centre has a Glory, and is probably Saint Anthony of Padua (1191–1231). The poor on the right, who receive bread from the Franciscans, include two pilgrims.

In 1662 van Herp was paid 95 guilders for a painting of Saint Anthony of Padua distributing bread. This may have been NG 203; the documented picture was subsequently sent to Spain by the Antwerp dealer, Musson.

Perhaps exported from Antwerp to Spain by May 1662; collection of Richard Simmons, 1821; by whom bequeathed, 1846.

Martin 1970, pp. 83–4.

Signed, lower left: J V.D.H.

The construction of Cologne Cathedral began in the middle of the thirteenth century, continued through the fourteenth and fifteenth centuries and was discontinued in the mid-sixteenth century; it was only completed in 1842–80. In this view the cathedral is seen from the west. In the centre distance is the choir, completed in about 1320; across the west end is the enclosing wall with a balustrade that was erected on its completion. To the right, closer to the viewer, is the southern tower of the west front. It had reached this stage by about 1450 and remained in the same state until 1868. The large crane on top of it was in position by the second half of the fifteenth century and was a Cologne landmark until its removal in 1868. The buildings in front of the tower are the deanery and cathedral vicarage which like many of the other structures and the roads do not survive.

NG 866 is the earliest and best of a group of versions of this view (see also: St Petersburg, Hermitage; London, Wallace Collection; Manchester, City Art Gallery). The figures are probably by Adriaen van de Velde; the costumes suggest a date in the first half of the 1660s.

Possibly Petronella de la Court sale, Amsterdam, 1707; collection of Sir Robert Peel, Bt, by 1834; bought with the Peel collection, 1871.

MacLaren/Brown 1991, pp. 169–71.

The building of the Westerkerk was completed by 1631; it is shown here from across the Keizersgracht. On the wooden palings in the foreground are a number of posters, including a torn advertisement for the sale of paintings at auction. The Westerkerk, in which Rembrandt was buried, is the subject of other paintings by van der Heyden, such as a similar, but smaller, composition (London, Wallace Collection).

NG 6526 is unusually large when compared with van der Heyden's many other town views. It was a commission from the governing body of the Westerkerk (the Kerkmeesters), and was hung in their meeting room, the Kerkmeesterscamer, where it is recorded in 1790.

Sold by the Kerkmeesters to B.A. Hopman, an Amsterdam dealer, 1864; collection of Edmond de Rothschild, Paris; bought from the estate of Mrs James de Rothschild, by her wish, through the acceptance-in-lieu procedure, 1990.

MacLaren/Brown 1991, p. 557.

Willem van HERP the Elder
about 1614–1677

Herp was probably born in Antwerp, where he was recorded as a pupil of Damiaen Wortlemans in 1625/6. He became a master in the Antwerp guild in 1637/8. He was a figure painter and is known to have retouched copies after Rubens for the Antwerp dealer Musson.

Jan van der HEYDEN
1637–1712

Jan Jansz. van der Heyden was born in Gorinchem and probably trained as a glass painter. By 1650 he was in Amsterdam where he principally worked. He also visited various parts of Holland, Flanders and the Rhineland. The artist painted city views, landscapes and still lifes. From the late 1660s he was also involved in projects to improve street lighting and fire-fighting in Amsterdam.

Jan van der HEYDEN
An Architectural Fantasy
probably 1665–70

NG 992
Oil (identified) on oak, 51.8 x 64.5 cm

Signed in the right foreground on a block of stone to the left of the tree: I · vd. Heijde.

This is an imaginary view which combines architectural elements of different styles and periods, some of which may be based on actual buildings. The arch in the centre background could be intended as a reminiscence of one of the seventeenth-century gates of Amsterdam, although it does not resemble any of them closely.

The figures in NG 992 are probably by Adriaen van de Velde.

Possibly in the collection of the Elector Palatine Johann Wilhelm, Düsseldorf, 1716; Jan Gildemeester Jansz. sale, Amsterdam, 1800; collection of Wynn Ellis by 1850 or 1851; Wynn Ellis Bequest, 1876.

MacLaren/Brown 1991, p. 171.

Jan van der HEYDEN
An Imaginary View of Nijenrode Castle and the Sacristy of Utrecht Cathedral, probably 1665–70

NG 994
Oil on oak, 52.9 x 41.4 cm

Signed left centre: VHeijde. (VH in monogram).

Van der Heyden has combined a view of part of Utrecht Cathedral, at the left, with a depiction of Nijenrode Castle which is at Breukelen, about seven miles outside of the city. Both the sacristy of the cathedral, which can be seen here, and the castle, were subsequently altered, but van der Heyden's view of the cathedral as it was in his day is largely accurate, as can be seen by comparing it with an eighteenth-century drawing in the Utrecht municipal archives. The painter has, however, shown the sacristy as built of brick rather than stone.

Possibly in the Isack Clockener sale, Amsterdam, 1759; collection of Wynn Ellis before 1864; Wynn Ellis Bequest, 1876.

MacLaren/Brown 1991, p. 172.

Jan van der HEYDEN
The Huis ten Bosch at The Hague
1665–75

NG 1914
Oil on oak, 21.6 x 28.6 cm

Signed on the stone at the bottom left: IVDH.

This is a view of the south or garden front of the Huis ten Bosch (The House in the Wood) which is in the Haagse Bos about one and a half miles east of The Hague. The building, designed by Pieter Post, was constructed in 1645–52 for Amalia van Solms, wife of the Stadholder, Prince Frederik Hendrik of Orange. The building is seen here in its original state: it has been substantially altered – an outer staircase has been built on this side, the dome changed and wings added. The statues and lattice obelisks are no longer in the garden.

NG 1914 was probably painted in the late 1660s or early 1670s. The figures seem almost certainly to be by van der Heyden himself. He painted a number of views of the house, including a larger version from the same angle (New York, Metropolitan Museum of Art).

Possibly anon. sale, Amsterdam, 1764; said to have come from the collection of the dealer Noel Joseph Desenfans (died 1807); bequeathed by Sir James Morse Carmichael, Bt, 1902.

MacLaren/Brown 1991, pp. 173–4.

Jan van der HEYDEN
A Farm among Trees
about 1670

NG 993
Oil on oak, 22.1 x 28.8 cm

Jan van der HEYDEN
A Square before a Church
1678

NG 1915
Oil on oak, 21.8 x 28.9 cm

Meindert HOBBEMA
Cottages in a Wood
about 1660

NG 2570
Oil on wood, 52.1 x 68 cm

The farm is beside a river; two figures sit outside it on the far bank. Although he specialised in town views, van der Heyden painted a few delicate landscapes, of which this is an outstanding example.

Wynn Ellis Bequest, 1876.

MacLaren/Brown 1991, p. 172.

Signed and dated bottom left on the base of the round tower: JVH.1678. (VH in monogram).

The different architectural elements in this townscape suggest that it is an invented view composed of buildings in Germany and Holland. The architecture of the church is typical of the mid-sixteenth-century flamboyant Gothic of Franconia, Braunschweig and the area surrounding Cologne. The building at the left seems Dutch in character. The artist combined buildings from various locations in a number of other paintings (e.g. NG 994).

The figures are probably by van der Heyden himself.

Said to have come from the collection of the dealer Noel Joseph Desenfans (died 1807); bequeathed by Sir James Morse Carmichael, Bt, 1902.

MacLaren/Brown 1991, p. 174.

Signed bottom left: m.hobbema

A characteristic wooded landscape, which was probably painted in about 1660.

Possibly in the Jonkheer Menno Baron van Coehoorn sale, Amsterdam, 1801; collection of Henry Philip Hope, London, by 1835; Salting Bequest, 1910.

MacLaren/Brown 1991, pp. 182–3.

Meindert HOBBEMA
1638–1709

Meyndert (also Meindert) Lubbertsz. was born and spent his life in Amsterdam. As a young man he adopted the surname Hobbema. He was apprenticed to Jacob van Ruisdael in the years around 1660. He specialised in wooded landscapes with sun-lit clearings. In 1668 he became one of the city's wine-gaugers, and was less active as a painter. However, a number of important works (e.g. NG 830) date from after 1668.

Meindert HOBBEMA
A Stream by a Wood
about 1663

NG 833
Oil on oak, 31.4 x 40.1 cm

Meindert HOBBEMA
The Haarlem Lock, Amsterdam
about 1663–5

NG 6138
Oil on canvas, 77 x 98 cm

Meindert HOBBEMA
A Woody Landscape
about 1665

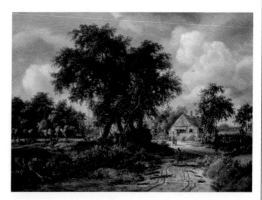

NG 685
Oil on oak, 60.4 x 84.3 cm

NG 833 is a study for a composition elaborated in a larger picture (Rotterdam, Museum Boymans-van Beuningen), which follows this design fairly closely but also includes a road with figures and a horizon at the left.

This landscape is similar in composition and technique to paintings by the artist dated 1663 (Russborough, Beit Collection; Washington, National Gallery of Art), and both this picture and the larger version in Rotterdam can be dated to about the same time.

[Joseph Barchard] sale, London, 1826; bought for Sir Robert Peel, Bt; bought with the Peel collection, 1871.

MacLaren/Brown 1991, p. 181.

Signed near the foreground boat, towards the left: m hobb()ma

The Haarlem Lock (Haarlemmersluis) and the Herring-Packers' Tower (Haaringpakkerstoren), which was named after the adjoining herring-packery, are seen from the west side of the Singel Canal, at its junction with the Brouwersgracht. In the left background is the corner of the Haarlemmerdijk where Hobbema was living late in 1668. In the centre background masts of ships can be seen in what was the open harbour of the Ij; some of them bear Dutch flags. The drawbridge of the lock has now been replaced by a permanent bridge and none of the other buildings has survived.

NG 6138 shows the view before alterations to the buildings made in 1661–2. It cannot be assumed that the picture was painted before these dates; it may have been based upon drawings made earlier. The problem of dating is complicated by the lack of comparable works: this is Hobbema's only townscape.

Possibly in the Catharina Backer sale, Leiden, 1766; Pieter de Smeth van Alphen sale, Amsterdam, 1810; collection of Baron J.G. Verstolk van Soelen, The Hague, by 1834; bequeathed by Miss Beatrice Mildmay, 1953.

MacLaren/Brown 1991, pp. 183–6.

Signed centre bottom: M · hobbema.

Another version of this composition (Zurich, Kunsthaus, Ruzicka collection) is dated 1665; NG 685 was probably painted shortly before. The third and most fully developed version of the composition was formerly in the Meyer collection, London.

J.M. Raikes sale, London, 1829; collection of Comte Perregaux, Paris, by 1835; bought, 1862.

MacLaren/Brown 1991, pp. 175–6.

Meindert HOBBEMA
A Woody Landscape with a Cottage
about 1665

Meindert HOBBEMA
The Watermills at Singraven near Denekamp
probably 1665–70

Meindert HOBBEMA
A Road winding past Cottages
about 1667–8

NG 995
Oil on canvas, 99.5 x 130.5 cm

NG 832
Oil on oak, 60 x 84.5 cm

NG 2571
Oil on oak, 61.3 x 84.5 cm

There are three other versions of this design. The earliest seems to be the picture in the National Gallery of Art, Washington. Probably a little later is the version in the Mauritshuis, The Hague. Next is NG 995 and a final development is the large landscape formerly in the Robarts Collection, England.

All four versions are similar to the artist's *Village among Trees* (New York, Frick Collection), which is dated 1665, and so can be dated at about that time.

Collection of Wynn Ellis by 1850 or 1851; Wynn Ellis Bequest, 1876.

MacLaren/Brown 1991, p. 182.

Signed bottom right: m hobb(·)ma.

These watermills, which still survive, belonged to the manor house in Singraven, near Denekamp, north-east of Enschede, close to the border between Overijssel and Germany. The buildings and the river Dinkel are here seen from the south-south-east.

NG 832 has been dated to 1665–70 by comparison with Hobbema's *Woody Landscape with a Large Pool* of 1668 (Oberlin, Allen Memorial Art Museum).

The artist painted at least one other view of these watermills (Paris, Louvre), which had earlier been painted by Jacob van Ruisdael.

Acquired at the Vaillant sale, Amsterdam, by John Smith, 1824; bought with the Peel Collection, 1871.

MacLaren/Brown 1991, pp. 180–1.

This landscape was probably painted at about the same time as Hobbema's *Woody Landscape with a Lady and a Gentleman on Horseback* of 1667 (Cambridge, Fitzwilliam Museum) and *Woody Landscape with Travellers and Beggars* of 1668 (London, Royal Collection).

Collection of the Hon. William Pole-Tylney-Long-Wellesley, Brussels, 1842; collection of Joseph Barchard by 1847; Salting Bequest, 1910.

MacLaren/Brown 1991, p. 183.

Meindert HOBBEMA
The Ruins of Brederode Castle
1671

Meindert HOBBEMA
The Avenue at Middelharnis
1689

William HOGARTH
The Graham Children
1742

NG 831
Oil on canvas, 82 × 106 cm

NG 830
Oil (identified) on canvas, 103.5 × 141 cm

NG 4756
Oil on canvas, 160.5 × 181 cm

Signed and dated bottom right below a fallen tree: m · Hobbema. / f · 1671·

Brederode Castle in Santpoort is about three miles north of Haarlem. It was built in the thirteenth century and destroyed in 1573. This view remains largely unchanged; the ruins and moat still exist in much the same state, though restored.

The ducks in the foreground of NG 831 are by another artist, possibly Dirck Wijntrack (before 1625–78).

Collection of W. Kops or H. Kopps, Haarlem; in the S.J. Stinstra (of Harlingen) sale, Amsterdam, 1822; collection of Sir Robert Peel, Bt, by 1834; bought with the Peel collection, 1871.

MacLaren/Brown 1991, pp. 179–80.

Signed and dated bottom right: M: hobbema/f 1689.

The village of Middelharnis is on the north coast of the island of Over Flakee in the mouth of the Maas (Province of South Holland). It is here seen from the south-east. The view has changed little and Hobbema's painting is remarkably accurate. To the right of the avenue in the distance are the masts of ships and a beacon (erected in 1682). The church (St Michael's) was built in the fifteenth century; its spire was removed in 1811 by the French to make room for a semaphore.

The signature and date, which have been doubted in the past, are authentic. The fact that the painting is first recorded in a collection in Sommelsdijk (see below), a neighbouring village of Middelharnis, suggests that it may have been painted for a local patron.

X-radiographs reveal that the artist initially placed two additional trees at the entrance to the avenue and subsequently painted them out. These may have begun to show by the early nineteenth century, and it is possible that a restorer then attempted to remove them. This would account for the severe wearing in the sky.

Collection of Theodorus Kruislander (died 1782), clerk of the Council of Sommelsdijk, near Middelharnis; hung in the town hall of Middelharnis from 1782 until sold in 1822; collection of Sir Robert Peel, Bt, by 1834; bought with the Peel collection, 1871.

MacLaren/Brown 1991, pp. 176–9.

Signed and dated: W. Hogarth/Pinxt. 1742

The sitters are the children of Daniel Graham, a prosperous apothecary, and his wife: Henrietta Catherine (born 1733), in a blue dress, Richard Robert (born 1734), winding a sérinette, or bird organ, Anna Maria (born 1738), dancing, and Thomas (born 1740), who died before the painting was finished. The setting is probably the Grahams' house in Pall Mall. Hogarth includes many allusions to the brevity of childhood.

Seen at Mr Graham's in Chelsea by Farrington, 1805; presented by Lord Duveen through the NACF, 1934.

Davies 1946, p. 74; Gordon 1986, p. 8.

William HOGARTH
1697–1764

Hogarth was born and worked in London. He was initially apprenticed to a goldsmith and then entered the Academy in St Martin's Lane in 1720. He painted portraits and conversation-pieces, as well as satirical works and modern moral histories which were engraved. He visited Paris in 1743 and 1748, published his *Analysis of Beauty* in 1753, and in 1757 was appointed Serjeant Painter to George II.

William HOGARTH
Marriage à la Mode: I, The Marriage Contract
before 1743

William HOGARTH
Marriage à la Mode: II, Shortly after the Marriage
before 1743

William HOGARTH
Marriage à la Mode: III, The Visit to the Quack Doctor, before 1743

NG 113
Oil on canvas, 69.9 x 90.8 cm

NG 114
Oil on canvas, 69.9 x 90.8 cm

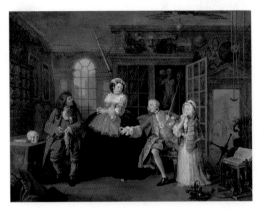

NG 115
Oil on canvas, 69.9 x 90.8 cm

Inscribed on the family tree: *William Duke of Normandye*; on the papers in front of the Earl: *One thousand (?) £25...(?) £200...(?)*; on the paper being brought to his attention: *Mortgage*; on the contract: *Marriage/ Settlem^t of The/ R^t Hon^ble The/ Lord Viscount, Lord...*; and on the plan held by the man at the window: *A Plan of the New/ Building of y^e Right Hon/ (Earl ?; cancelled).*

This is the first in a series of six paintings which explore the themes of marriage, money and vanity among the wealthier classes. The seated, gouty Earl points to his family tree. His vain son, who is to marry an alderman's daughter, admires himself in a mirror. The alderman, seated at the table, holds the contract of marriage, and is attended by a servant; while his daughter talks to the lawyer, Silvertongue, her future lover. The paintings on the walls all depict scenes of horror or violence.

Hogarth designed the series to be engraved, painting the scenes in the reverse direction to that in which they would appear when the engraved plates were printed. The series was completed by April 1743 (see also NG 114–18).

Auctioned as a series, 1751; bought by John Lane and passed to his nephew, Col. John Fenton Cawthorne; bought by J.J. Angerstein, 1797; bought with the J.J. Angerstein collection, 1824.

Davies 1959, pp. 48–68; Gordon 1986, p. 10; Paulson 1989, pp. 115–17; Paulson 1991, pp. 203–45.

Inscribed on the book on the floor: *Hoyle/ on/ Whist*; on the papers held by the steward: *Ledger, Bill* (twice) and *Rec^d... 1743 of...*; on a book in his pocket: *Regeneration*; on a picture over the mantelpiece: *O Happy/ Groves.*

After a night of debauchery, the Viscount has returned from a brothel; a dog sniffs a prostitute's cap hanging from his pocket. His wife yawns after a night of playing cards; the remains of the party are strewn across the room. The household steward departs at the left holding unpaid bills. In his pocket is a copy of a sermon called *Regeneration* by the Methodist preacher George Whitefield.

NG 114 is one of a series of six paintings (see also NG 113 and 115–18).

Auctioned by Hogarth with the other five paintings in the series, 1751; bought by John Lane and passed to his nephew, Col. John Fenton Cawthorne; bought by J.J. Angerstein, 1797; bought with the J.J. Angerstein collection, 1824.

Davies 1959, pp. 50–68; Gordon 1986, p. 12; Paulson 1989, pp. 117–18; Paulson 1991, pp. 203–45.

Inscriptions: tattooed on the woman's left breast: F C; on the title page of the book at the right: EXPLICATION/ DE DEUX/ MACHINES SUPERBES:/ L'UN POUR REMETTRE/ L'EPAULES/ L'AUTRE POUR SERVIR DE/ TIRE-BOUCHON/ INVENTES PAR MONS^R/ DE LA PILLULE/ VUES ET APROUVEÉS PAR/ L'ACADEMIE ROYAL/ DES SCIENCES/ A PARIS. (Explanation of two superb machines: one to reset shoulders, the other to serve as a corkscrew, invented by Monsieur de la Pillule, seen and approved by the Royal Academy of Sciences in Paris.)

The Viscount appears to have brought his child mistress to the doctor either to be cured of venereal disease or to have an abortion. Her bonnet may be the one sniffed by the dog in NG 144. The Quack, M. de la Pillule, cleans his glasses. His rooms are filled with pseudo-medical objects and curios which include a skeleton in the cupboard that appears to be making amorous advances to an *écorché* (flayed figure).

NG 115 is one of a series of six paintings (see also NG 113–14 and 116–18).

Auctioned by Hogarth with the other five paintings in the series, 1751; bought by John Lane and passed to his nephew, Col. John Fenton Cawthorne; bought by J.J. Angerstein, 1797; bought with the J.J. Angerstein collection, 1824.

Davies 1959, pp. 51–68; Gordon 1986, p. 14; Paulson 1989, pp. 119–20; Paulson 1991, pp. 203–45.

William HOGARTH
Marriage à la Mode: IV, The Countess's Morning Levée, before 1743

William HOGARTH
Marriage à la Mode: V, The Killing of the Earl before 1743

William HOGARTH
Marriage à la Mode: VI, The Suicide of the Countess, before 1743

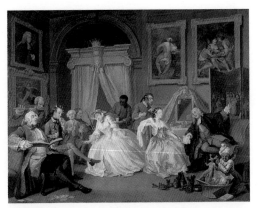

NG 116
Oil on canvas, 70.5 x 90.8 cm

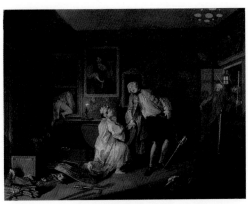

NG 117
Oil on canvas, 70.5 x 90.8 cm

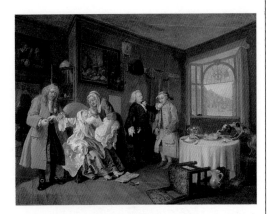

NG 118
Oil on canvas, 69.9 x 90.8 cm

Inscriptions: on the masquerade ticket: *I Door 2d Door 3d Do (or)*; on the book on the sofa: SOPHA; on the cards on the floor: *Count Basset beg/ to no how Lade/ Squander Sleapt/ last nite; Lady Squander's/ compy is desir'd at/ Lady Heathans/ Drum major on/ next Sunday; Lady Squand/ compers(an)y is desir'd at/ (Miss ?) Hairbrain's Rout; Ldy. Squa(nders) Comp/ is desi (r)d at Lady/ Townly(s) Drum/ munday Next*; on the sale catalogue at the lower right: A/ CATALOGUE/ *of the/ Entire Collection/ of the Late Sr/ Timy Babyhouse/ to be sold/ by Auction*; the objects above are numbered: *Lot/ 4, Lot/ 8, Lot 7 and Lot 1000*; on the dish with Leda and the Swan: *Iulio Romano (a ?)*.

On the left an Italian singer, accompanied by a flautist, is serenading the assembled company. The Countess, seated at her dressing table, is involved in an intrigue with the lawyer, Silvertongue, who offers her a ticket to a masquerade. The child's coral hanging from the Countess's chair implies she is now a mother. On the wall pictures after Old Masters have amorous subjects. A copy of *La Sopha*, a licentious novel by Crébillon Fils, is on the sofa.

NG 116 is one of a series of six paintings (see also NG 113–15 and 117–18).

Auctioned by Hogarth with the other five paintings in the series, 1751; bought by John Lane and passed to his nephew, Col. John Fenton Cawthorne; bought by J.J. Angerstein, 1797; bought with the J.J. Angerstein collection, 1824.

Davies 1959, pp. 53–68; Gordon 1986, p. 16; Paulson 1989, pp. 120–1; Paulson 1991, pp. 203–45.

Inscribed on a paper at the lower left: THE/ BAGNIO.

The scene is in a bagnio where the Countess and lawyer Silvertongue have gone after the masquerade referred to in NG 116; part of the costumes they wore lie in the left foreground. The Viscount (now Earl) followed them, and is fatally wounded by the lawyer, who escapes through a window. The master of the bagnio arrives with the night watch, as the Countess begs her husband for forgiveness.

NG 117 is one of a series of six paintings (see also NG 113–16 and 118).

Auctioned by Hogarth with the other five paintings in the series, 1751; bought by John Lane and passed to his nephew, Col. John Fenton Cawthorne; bought by J.J. Angerstein, 1797; bought with the J.J. Angerstein collection, 1824.

Davies 1959, pp. 54–68; Gordon 1986, p. 18; Paulson 1989, pp. 121–2; Paulson 1991, pp. 203–45.

Inscribed on the broadsheet: *Counseller Silvertou/ last dying Speech/ (made... ?)*; on the bottle: *Laudanum*; on the wall: ALMANCK.

The scene is the house of the alderman, the Countess's father; a view of old London Bridge can be seen through the window. The lawyer Silvertongue, the Countess's lover, has been hanged for the Earl's murder; a printed broadsheet of his dying speech lies on the floor. In desperation she has taken poison. Her crippled and diseased child kisses her for the last time, while the idiot servant who brought her the poison is scolded. Her miserly father removes her ring.

NG 118 is one of a series of six paintings (see also NG 113–17).

Auctioned by Hogarth with the other five paintings in the series, 1751; bought by John Lane and passed to his nephew, Col. John Fenton Cawthorne; bought by J.J. Angerstein, 1797; bought with the J.J. Angerstein collection, 1824.

Davies 1959, pp. 55–68; Gordon 1986, p. 20; Paulson 1989, pp. 122–4; Paulson 1991, pp. 203–45.

William HOGARTH
The Shrimp Girl
about 1745

Hans HOLBEIN the Younger
Lady with a Squirrel and a Starling
about 1526–8

Hans HOLBEIN the Younger
Jean de Dinteville and Georges de Selve
('The Ambassadors'), 1533

NG 1162
Oil on canvas, 63.5 x 50.8 cm

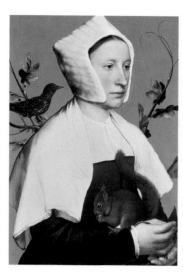

NG 6540
Oil on oak, 56 x 38.8 cm

NG 1314
Oil on oak, 207 x 209.5 cm

The first engraving of this picture was entitled 'Shrimps!'; the girl does indeed appear to be crying her fish for sale. Hogarth may have observed her in action as a street vendor, and made this brilliant, spontaneous, unfinished sketch, which he kept for the remainder of his life.

Mentioned as in Mrs Hogarth's possession by J. Nichols, 1781; bought (Wheeler Fund) at the Leigh Court (Sir Philip Miles) sale, 1884.

Davies 1959, p. 68; Gordon 1986, p. 22.

The sitter is shown against a background of vine leaves, which frequently recurs in Holbein's paintings. On the left is perched a starling, while a squirrel eating a nut crouches on the sitter's arm; she holds it by a chain, indicating it is her pet. Squirrels were common pets in sixteenth-century England. The half-length format is characteristic of Holbein's portraits.

The painting probably dates from the years of Holbein's first brief visit to England, 1526–8, as it is most closely comparable to the portraits of those years and the sitter's dress appears to be English in style. The sitter has not been identified, although it is possible that both the squirrel and starling were intended to allude to a family name or coat of arms. She wears a fur hat similar to that worn by the step-daughter of Sir Thomas More, Margaret Giggs, in a drawing by Holbein (Windsor, Royal Collection), but their features are quite distinct.

Willem Six sale, Amsterdam, 1734 (lot 11); Sir William Hamilton sale, 20 February 1761 (lot 75); 3rd Earl of Cholmondeley; bought by private treaty sale, 1993.

Ganz 1925, pp. 113–15; Rowlands 1985, p. 134, no. 28; National Gallery Report 1992–3, pp. 10–11; Foister 1994, pp. 6–19.

Signed and dated lower left: IOANNES/HOLBEIN/PINGEBAT/1533; Dinteville's dagger is inscribed: AET. SVAE/29 (aged 29). De Selve leans on a book inscribed: AE TAT/IS SVAE. 25 (aged 25). The hymnbook, globes, quadrant and torquetum are further inscribed; for full transcriptions see Levey 1959.

NG 1314 combines portraiture with a complex array of religious and secular objects that relate to the interests of the sitters and may have a *vanitas* significance. At the left is Jean de Dinteville (1504–55), Seigneur de Polisy, Bailly de Troyes, who was French ambassador to England in 1533. To the right stands his friend Georges de Selve (1508/9–41), Bishop of Lavaur in 1526, who acted on several occasions as ambassador to the Emperor, the Venetian Republic and the Holy See. Dinteville wears the Order of St Michel. On his cap is a brooch ornamented with a skull. On the lower shelf is a lute with a broken string, a case of flutes, a hymn-book with music to Martin Luther's version of *Veni Creator Spiritus* and his Ten Commandments, a book of arithmetic, a terrestrial globe, dividers and books. The objects on the upper shelf include a celestial globe, a portable cylindrical sundial, a quadrant, a kind of table quadrant, a polyhedral sundial and a torquetum. In the top left corner a crucifix is partly visible. The mosaic floor is a copy of Abbot Ware's in Westminster Abbey. In the foreground is a skull in distorted perspective (anamorphosis); when seen from the right or through a cylindrical piece of glass the distortion is corrected.

De Selve visited London in mid-April of 1533, the year inscribed on NG 1314.

Hans HOLBEIN the Younger
1497/8–1543

Born in Augsburg, Holbein was working in Basel by 1516. He worked in London from 1526 to 1528 and, after returning to Basel, settled in England in 1532 and entered the service of King Henry VIII in 1536 (or before). In England he painted mostly portraits, but he was also a notable painter of religious subjects, as well as a printmaker and designer.

Hans HOLBEIN the Younger
Christina of Denmark, Duchess of Milan
probably 1538

Melchior d'HONDECOETER
Birds, Butterflies and a Frog among Plants and Fungi, 1668

NG 1314, detail

NG 2475
Oil on oak, 179.1 x 82.6 cm

NG 1222
Oil on canvas, irregular edges 68.3 x 56.8 cm

NG 1314 was removed to Paris from Polisy (Jean de Dinteville's château), by his great-great nephew François de Cazillac, Marquis de Cessac, 1653; bought from the 5th Earl of Radnor with a special grant and contributions from Charles Cotes, Lord Iveagh and Lord Rothschild, 1890.

Davies 1946, pp. 75–9; Levey 1959, pp. 46–54; Rowlands 1985, pp. 139–40.

Christina (1522–90) was the younger daughter of Christian II of Denmark and Isabella of Austria, sister of Charles V. In 1533 she married by proxy Francesco Maria Sforza, Duke of Milan, who died in 1535. She is depicted dressed in mourning clothes, aged 16.

NG 2475 was apparently commissioned by Henry VIII, King of England (1509–47) who planned to make her his fourth bride. Holbein visited Brussels in 1538, and on 12 March is recorded as having made a portrait (probably a drawing) of Christina in a three-hour sitting. NG 2475 is likely to have been painted soon after the Brussels visit. The marriage did not take place and Henry wed Anne of Cleves instead. Christina later married François, Duc de Bar, who became Duc de Lorraine, and died in 1545, leaving her Regent of Lorraine.

Apparently in the inventory of Henry VIII, 24 April 1542; in the inventory of the Lumley collection, about 1590; in the inventory of the Arundel collection, 1654; sold by the 15th Duke of Norfolk to Colnaghi's, 1909; bought from them by the NACF with the aid of an anonymous donation, and presented, 1909.

Levey 1959, pp. 54–7; Levey 1968.

Signed and dated above centre: M . ()/ 1668.

Four bullfinches are identifiable, one above centre, the other three below.

The attribution of NG 1222 to Hondecoeter is confirmed by a signed painting (Amsterdam, Rijksmuseum) in which the birds, trees and most of the butterflies and fungi are repeated. The signature of NG 1222 is damaged, but the M and the following single dot are very like Hondecoeter's usual signature.

Possibly in the collection of Willem Lormier, The Hague, by 1752; presented by J. Whitworth Shaw, 1886.

MacLaren/Brown 1991, pp. 187–8.

Melchior d'HONDECOETER
1636–1695

Hondecoeter was born in Utrecht and studied with his father, the landscape and bird painter Gysbrecht (Gysbert) de Hondecoeter, and his uncle, J.B. Weenix. By 1659 he was active in The Hague and he subsequently settled in Amsterdam. He was a painter of birds.

Melchior d'HONDECOETER
A Cock, Hens and Chicks
about 1668–70

NG 202
Oil on canvas, 85.5 x 110 cm

Gerrit van HONTHORST
Christ before the High Priest
about 1617

NG 3679
Oil on canvas, 272 x 183 cm

Gerrit van HONTHORST
Saint Sebastian
about 1623

NG 4503
Oil on canvas, 101 x 117 cm

As well as a cock, hens and chicks, there is a pigeon and a finch (above left).

Hondecoeter specialised in large-scale decorative canvases of birds. NG 202 can be compared to a similar picture (Karlsruhe, Kunsthalle) which is signed and dated 1668, and was probably painted at about the same time. The chick in the left foreground appears in both pictures.

Bequeathed by Richard Simmons, 1847.

MacLaren/Brown 1991, p. 187.

Christ was brought before the High Priest (probably Caiaphas) by Roman soldiers. He was questioned about his teachings and false testimony was called against him. New Testament (all Gospels, e.g. Matthew 26: 57–66). The two figures behind the High Priest may be the false witnesses mentioned in Matthew's Gospel.

NG 3679 was probably painted in about 1617. Sandrart, who was Honthorst's pupil, stated that it was painted in Rome for Marchese Vincenzo Giustiniani, in whose house Honthorst was living. It became one of the most celebrated paintings in Rome, and numerous copies were made of it.

In the Giustiniani Palace, Rome, until 1804; bought by Lucien Bonaparte, 1804; bought by the Duchess of Lucca, 1820; collection of the 2nd Duke of Sutherland by about 1840; bought, 1922.

MacLaren/Brown 1991, pp. 190–2.

Signed below left: GvHonthorst. fe (GvH in monogram).

Sebastian was a Roman centurion, who was discovered to be a Christian and was sentenced to death by Diocletian. He was bound to a stake (often represented as a tree) and shot with arrows. He was left for dead, although the arrows had not killed him and he was eventually stoned to death. The story is taken from *The Golden Legend*.

NG 4503 was probably painted in about 1623 in Utrecht. The composition was adapted by other Utrecht Caravaggisti: for example, by Jan van Bijlert in 1624 and Hendrick ter Brugghen in 1625.

Possibly in an anon. sale, London, 1832; bought from Mrs Mabel Berryman, 1930.

MacLaren/Brown 1991, pp. 192–3.

Gerrit van HONTHORST
1592–1656

Honthorst was born in Utrecht, where he was a pupil of Abraham Bloemaert. He went to Rome (perhaps as early as 1610), where he established a considerable reputation and was influenced by Caravaggio (whose innovations he popularised in Holland on his return to Utrecht in about 1620). He later worked for the royal courts of England and Denmark, painting large allegories.

Gerrit van HONTHORST

Elizabeth Stuart, Queen of Bohemia

1642

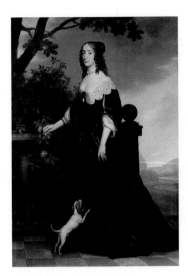

NG 6362
Oil on canvas, 205.1 x 130.8 cm

Signed and dated centre right on the balustrade, below the finial: G Honthorst 1642 (GH in monogram). Inscribed centre left on the balustrade (by a later hand): Queen of Bohemia.

Elizabeth Stuart (1596–1662), known as the 'Winter Queen', was the eldest daughter of James I of England. She married Frederick V, Elector Palatine, in 1613. He was elected King of Bohemia in 1619, but was expelled and they lived in exile in Holland from 1621 onwards. She returned to England in 1661, and died the following year in London in the house of the 1st Earl Craven.

The picture was painted in Holland, ten years after Elizabeth had been widowed, and may have been commissioned to mark this anniversary. She is shown as a still grieving widow. She wears black with very few pieces of jewellery, notably the pearl earrings which had been given to her by her husband, and holds a stem on which there are two roses, one healthy and one wilted, a symbol of her widowed state. The black ribbon on her right arm also refers to her widowhood. The dog refers to fidelity.

Probably bequeathed by the sitter to her son, Prince Rupert, and then (on his death in 1681) to her supporter William Craven, the 1st Earl Craven; bequeathed by his descendant, Cornelia, Lady Craven, 1965.

MacLaren/Brown 1991, pp. 193–5.

Pieter de HOOCH

A Man with Dead Birds, and Other Figures, in a Stable, about 1655

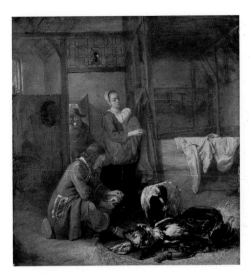

NG 3881
Oil on oak, 53.5 x 49.7 cm

NG 3881 appears to have originally depicted a man tending his wounded colleague. Infra-red and X-ray photographs reveal that the dog and dead game have been painted over the figure of a man lying on the ground. These alterations must have been made after 1825 because the picture was described in that year as showing 'a wounded man who is being bandaged by a surgeon'. It is first described in its present state in 1900.

NG 3881 is an early work, probably painted in the mid-1650s.

Probably in the collection of O.W.J. Berg by 1825; presented by F.N. and O.S. Ashcroft in memory of their parents, on the occasion of the National Gallery Centenary, 1924.

Sutton 1980, pp. 77–8, no. 14; MacLaren/Brown 1991, pp. 202–3.

Pieter de HOOCH

The Courtyard of a House in Delft

1658

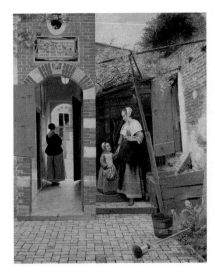

NG 835
Oil on canvas, 73.5 x 60 cm

Signed and dated at the base of the archway on the left: P.D.H. / An[n]o 1658. Inscribed in Dutch above the arch: (dit.is.in.sin)te.hyronimusdale / wil(dt.v.tot.patie)ntie[en.lijdt] tsamhey(t) / begheven w(and)t.w(ij).mu(ette)n / eerst dalle / willen wijlle wy w(o)rden / verheven anno 1614. (This is in Saint Jerome's vale, if you wish to repair to patience and meekness. For we must first descend if we wish to be raised.)

The stone tablet above the arch was originally over the entrance to the Hieronymusdale Cloister on the Oude Delft canal in Delft. When the cloister was suppressed this tablet was removed and set into the wall of a garden behind the canal.

Another signed and dated version of the same view (private collection) probably preceded NG 835. In NG 835 the inscription has been further abbreviated from the original and the figure groups are more confidently disposed.

Pieter de Smeth van Alphen collection by 1810; collection of Sir Robert Peel, Bt, by 1833; bought with the Peel collection, 1871.

Sutton 1980, pp. 84–5, no. 34; MacLaren/Brown 1991, pp. 199–201.

Pieter de HOOCH

1629–1684

Pieter de Hooch was born in Rotterdam, trained with Nicolaes Berchem in Haarlem and was recorded in Delft from 1652 until about 1661 when he had moved to Amsterdam. He was a genre and portrait painter, who developed the Delft style of the 1650s; his pictures became more elaborate and his technique coarser later in his career.

Pieter de HOOCH

An Interior, with a Woman drinking with Two Men; and a Maidservant, probably 1658

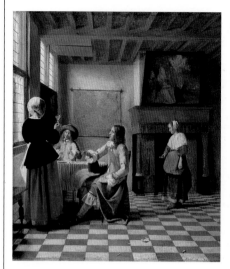

NG 834
Oil on canvas, 73.7 x 64.6 cm

Signed on the side of the table at the extreme left: P D H.

Inscribed on the map in the left background: OCEANUS.

The painting above the fireplace probably shows the Education of the Virgin, and is similar to a picture (Ering, Esterhazy Chapel) which appears to have been painted in Flanders in the early seventeenth century. The map of Holland and Flanders in the left background may have been published by Huyck Allart.

NG 834 was painted in Delft, probably in 1658. It is very close in style to NG 835 which is dated in that year.

Van Leyden collection by 1804; bought with the Peel collection, 1871.

Sutton 1980, p. 82, no. 29; MacLaren/Brown 1991, pp. 198–9.

Pieter de HOOCH

A Woman and her Maid in a Courtyard about 1660/1

NG 794
Oil on canvas, 73.7 x 62.6 cm

Signed and dated bottom right: P.D.H. /166()

The view is probably fanciful, but made up of elements well known to de Hooch. The wall at the end of the garden is almost certainly the old town wall of Delft; it bounded the gardens on the west side of the Oude Delft canal.

The last digit of the date is illegible, but NG 794 was probably painted at the end of de Hooch's years in Delft in 1660 or 1661.

Apparently on the Amsterdam art market in 1833; collection of Comte Perregaux, Paris, by 1841; bought, 1869.

Sutton 1980, p. 89, no. 44; MacLaren/Brown 1991, pp. 197–8.

Pieter de HOOCH

A Musical Party in a Courtyard 1677

NG 3047
Oil on canvas, irregular edges 83.5 x 68.5 cm

Signed and dated above the arch: P: d Hoogh . 1677 .

Inscribed on the left-hand house seen through the arch: 1620.

The woman on the left is playing a viola da gamba. The houses seen across the canal are similar to those on the Keizersgracht in Amsterdam and the one on the left is built in the style of Hendrick de Keyser (1565–1621).

Collection of Jonkheer Johan Steengracht van Oostkappelle, The Hague, by 1833; bought, 1916.

Sutton 1980, p. 113, no. 134; MacLaren/Brown 1991, pp. 201–2.

Samuel van HOOGSTRATEN
A Peepshow with Views of the Interior of a Dutch House, about 1655–60

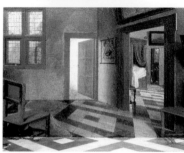

NG 3832
Oil and egg (identified) on wood, exterior measurements 58 x 88 x 60.5 cm

John HOPPNER
Sir George Beaumont
1803

NG 6333
Oil on canvas, 77.5 x 63.9 cm

Sir George Beaumont (1753–1827), collector, amateur artist and admirer of Sir Joshua Reynolds, had long advocated the creation of a National Gallery. His offer in 1823 to present sixteen paintings from his collection to the nation 'whenever the Gallery about to be created is ready to receive them' at last impelled Lord Liverpool's government into buying the J.J. Angerstein Collection and establishing a National Gallery.

NG 6333 was exhibited at the Royal Academy in 1809.

Bequeathed by Claude Dickason Rotch, 1962.

A letter painted on the floor of the interior is inscribed: A Monsieur/Mon(s?) S: Hoogstraten/a/...d...[ordr]echt.

The exterior of the box is painted with illustrations of the three incentives of the painter mentioned by Seneca: Love of Art, Wealth and Fame. On one short side is an artist drawing the Muse Urania, with a cartellino inscribed: Amoris Causa (For the sake of Love). On one long side is a putto pouring bags of gold and silver coins from a cornucopia, and a painter before an easel, with a cartellino inscribed: Lucri Causa (For the sake of Wealth). On the opposite short side is a putto placing a gold chain around a painter's neck and crowning him with a laurel wreath, with a cartellino inscribed: Gloriae Causa (For the sake of Fame). On

the top Venus and Cupid can be seen in bed, painted in an anamorphic projection. The interior is painted with two views of the interior of a house, intended to be viewed through the peepholes at each end of the box. Originally light would have entered the box from the sixth, open side.

Only six boxes of this type are known to survive. The interior of NG 3832 is similar in style to the *Perspective View in a House* of 1662 (Dyrham Park, near Bath).

Possibly in the [F. Halford] sale, London, 6 July 1861; presented by Sir Robert and Lady Witt (through the NACF), 1924.

Brown 1987a, pp. 66–85; MacLaren/Brown 1991, pp. 204–6.

Samuel van HOOGSTRATEN
1627–1678

Samuel Dircksz. van Hoogstraten was born in Dordrecht. He was a pupil of his father, and then, after 1640, of Rembrandt in Amsterdam. He visited Vienna and Rome, as well as London (1662–6), and lived in The Hague before finally settling in Dordrecht. He painted genre scenes, portraits, architectural fantasies and religious subjects, and was interested in *trompe-l'oeil* effects. He was also a poet and an art theorist.

John HOPPNER
1758?–1810

Hoppner was born in London of German parents. He worked as a portraitist throughout his life. The artist entered the Royal Academy Schools and was elected ARA in 1792 and RA in 1795.

Jan van HUCHTENBURGH
A Battle
about 1680

Jan-Baptist HUYSMANS
A Cowherd in a Woody Landscape
about 1697

Jan van HUYSUM
Hollyhocks and Other Flowers in a Vase
1702–20

NG 211
Oil on canvas, stuck on an oak panel, 42.8 x 58.3 cm

NG 954
Oil on canvas, 66.5 x 85.5 cm

NG 1001
Oil on canvas, 62.1 x 52.3 cm

This is probably not intended to represent a specific battle but belongs to a category of paintings based on the French campaigns in the Netherlands in the 1670s.

NG 211 has been attributed to van Huchtenburgh on the basis of a stylistic comparison with signed works, for example the *Cavalry Attack* (Amsterdam, Rijksmuseum).

Sold in London, 1801–2; collection of Richard Simmons, 1821; by whom bequeathed, 1847.

MacLaren/Brown 1991, p. 207.

NG 954 has sometimes been attributed to Jan-Baptist Huysmans's brother, Cornelis. However, it can be compared with a landscape that is signed and dated by Jan-Baptist in 1697 (Brussels, Musées Royaux).

Wynn Ellis Bequest, 1876.

Martin 1970, pp. 84–5.

Signed bottom right: Jan Van Huijsum fe.

The arrangement includes carnations. Snails are depicted on the ledge at the right and on a leaf in the lower part of the composition.

This picture dates from the earlier part of van Huysum's career, that is, before the early 1720s when he began to paint more elaborate and artificial flower-pieces, light in tone and set against light backgrounds, such as NG 796.

A repetition of this composition with slight variations is known (Vienna, Akademie).

Possibly in the William Wells sale, London, May 1848; Wynn Ellis Bequest, 1876.

MacLaren/Brown 1991, pp. 209–10.

Jan van HUCHTENBURGH
1647–1733

Van Huchtenburgh was born in Haarlem and was probably a pupil of Thomas Wijck. He worked for the Gobelins tapestry factory under van der Meulen from 1667, but was back in Haarlem by 1670. He subsequently worked in Amsterdam and The Hague. He was a painter of battle scenes.

Jan-Baptist HUYSMANS
1654–1716

Huysmans was a landscape painter who was born and active in Antwerp. He is said to have been a pupil of his elder brother, Cornelis, and their styles are very close. He is recorded as a master in the Antwerp guild in 1676/7.

Jan van HUYSUM
1682–1749

The artist was born in Amsterdam, and trained by his father, Justus van Huysum the Elder, who was a flower painter. He seems to have spent most of his life in the city, painting landscapes and flower and fruit pieces. These works brought van Huysum considerable fame and were widely imitated by later painters.

Jan van HUYSUM
Flowers in a Terracotta Vase
1736

Style of van HUYSUM
Flowers in a Stone Vase
1710–20

Jean-Auguste-Dominique INGRES
Monsieur de Norvins
1811–12

NG 796
Oil on canvas, 133.5 x 91.5 cm

Signed on the ledge: Jan Van Huijsum / fecit 1736 / en. 1737.

The flowers are of different seasons and most of them are depicted larger than natural size. The arrangement includes peonies, poppies, blue iris, African marigolds, apple blossom, narcissi, marigolds, tulips, jacinths, roses, ranunculuses and auriculas. The vase is decorated with putti in low relief. At the base of the vase are more roses, carnations, convolvulus, grapes, peaches and a chaffinch's nest.

The two dates on the inscription may be explained because van Huysum delayed completing his work until particular flowers were in bloom. This is one of the most complex and largest paintings by the artist of this type. The perspective of the vase suggests that the painting was intended to be hung high.

Possibly in the Gerret Braamcamp collection, Amsterdam, 1752; bought from C.J. Nieuwenhuys, 1869.

MacLaren/Brown 1991, pp. 208–9.

NG 3165
Oil on canvas, octagonal, the four corners are later additions, 88.3 x 77.2 cm

Falsely signed on the pedestal towards the right: Jan. Van Huijsum.

The arrangement includes roses, poppies and convolvulus.

NG 3165 is too weak to be the work of van Huysum himself. It is stylistically dependent upon paintings of 1710–20 by the artist. The handling suggests a connection with the followers of Willem van Aelst (1626–about 1683).

Probably in the collection of a Mr Saunders before 1874; bequeathed by Dr W.D. Wilkes, 1917.

MacLaren/Brown 1991, p. 210.

NG 3291
Oil (identified) on canvas, laid down on panel, 97.2 x 78.7 cm

Inscribed on the pedestal of the bust: ROM[A?] (Rome). Signed: Ingres P[inxit]. Ro[ma] (Ingres painted this in Rome).

The sitter is Jacques Marquet de Montbreton de Norvins (1769–1854). He is identified by comparison with a lithograph after a drawn portrait of de Norvins by Ingres.

NG 3291 was painted in Rome in 1811–12, and was probably exhibited at the Paris Salon in 1814. The sitter had a varied career as a government official, soldier and diplomat, and was in Rome as the Chief of Police of the Roman State from 1810 to 1814.

The background includes a bronze figure of *Athena* (now Rome, Vatican, Museo Chiarimonti) which – together with the inscriptions – probably allude to de Norvins's residence in Rome. An infrared photograph reveals that Ingres originally included a bust in the top left-hand corner, perhaps a representation of Napoleon's son, the King of Rome. This was painted out, presumably after the fall of Napoleon in 1814.

Recorded in the collection of the heirs of Monsieur de Norvins; Degas collection, Paris, by 1911; bought with a special grant, 1918.

Wildenstein 1954, p. 175, no. 81; Davies 1970, pp. 76–7; Naef 1977–80, I, pp. 237ff.

Jean-Auguste-Dominique INGRES
1780–1867

Ingres trained with his father in Montauban, in Toulouse, and then in Paris under Jacques-Louis David. He won the Prix de Rome in 1801 and was in Italy from 1806 to 1824, and again from 1834 to 1841. The rest of his career was spent in Paris. He painted mythological, religious and historical subjects as well as numerous portraits.

Jean-Auguste-Dominique INGRES
Angelica saved by Ruggiero
1819–39

Jean-Auguste-Dominique INGRES
Oedipus and the Sphinx
about 1826

Jean-Auguste-Dominique INGRES
Pindar and Ictinus
probably 1830–67

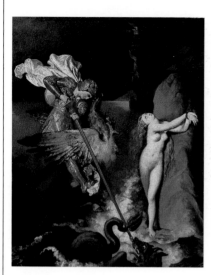

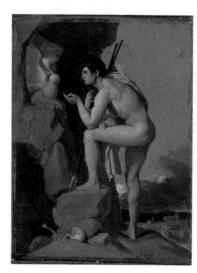

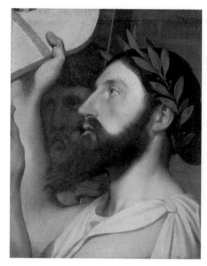

NG 3292
Oil on canvas, 47.6 x 39.4 cm

NG 3290
Oil on canvas, 17.5 x 13.7 cm

NG 3293
Oil on canvas, laid down on panel, 34.9 x 27.9 cm

Signed on the rock on the left at the bottom: *ingres P*it.

The subject is from Ariosto's epic poem *Orlando Furioso* (10: 92f), and represents the hero, Ruggiero, mounted on a hippogriff (a mythological creature that was half horse, half griffin), saving the captive Angelica from a sea monster.

Medieval romance was newly fashionable in nineteenth-century France and Ingres painted a large composition of this subject for Louis XVIII in 1819 (Paris, Louvre); this was destined for the throne room at the Palace of Versailles. NG 3292 is one of several variants of the composition that Ingres painted in subsequent years. It is first recorded in a lithograph of 1839, but may have been painted shortly after Ingres's return to Paris from Italy in 1824.

Probably in the collection of Comte Henri de Mortemart by 1857; Degas collection, Paris, by 1917; bought with a special grant, 1918.

Wildenstein 1954, p. 210, no. 227; Davies 1970, pp. 77–9; Condon 1983–4, pp. 94ff.

Signed near the bottom on the right: Ingres

According to classical myth, Oedipus correctly answered the riddle of the Sphinx, and thereby obtained for himself the kingdom of Thebes, and married Jocasta, who was later revealed to be his mother.

Ingres first painted this subject in Rome in 1808 (now Paris, Louvre). He enlarged and reworked this picture in 1826/7 and NG 3290 is a smaller variant that may be a study made in about 1826 in connection with the changes to the Louvre composition.

A third version of this subject, completed in 1864, is in the Walters Art Gallery, Baltimore.

Probably Didot collection, Paris, by 1828; bought with a special grant from the Degas collection, Paris, 1918.

Wildenstein 1954, p. 171, no. 61; Davies 1970, pp. 74–6; Condon 1983–4, p. 38.

Signed at the bottom on the right: Ingres

Pindar, the lyric poet (518–438 BC), raises his lyre; Ictinus (seen behind Pindar), the fifth century BC architect of the Parthenon, holds an architect's rule.

NG 3293 is loosely connected to Ingres's *Apotheosis of Homer* painted for a ceiling in the Louvre in Paris. This monumental figure composition, painted in 1826–7, remains in the Louvre picture gallery and is a study of the classical tradition in art and literature. Ingres later worked on a drawing (*Homer Deified*, Paris, Louvre) in which he modified the earlier composition, and NG 3293 is one of several paintings that relate to different details of the drawing. It was, however, probably painted as an independent work of art.

Haro collection, Paris, by 1867; bought by Degas, 1898; bought with a special grant, 1918.

Wildenstein 1954, p. 202, no. 187; Davies 1970, pp. 79–83.

Jean-Auguste-Dominique INGRES
Madame Moitessier
1856

NG 4821
Oil on canvas, 120 x 92.1 cm

Inscribed in French on the mirror: Mᵉ, INÈS MOITESSIER / NÉE DE FOUCAULD. Signed and dated on the frame of the mirror: J. Ingres 1856 / AET LXXVI. (J[ean] Ingres 1856 / Age 76).

The sitter, Marie-Clotilde-Inès de Foucauld, was born in 1821 and married Sigisbert Moitessier, a wealthy banker, in 1842.

Ingres worked on NG 4821 from 1844 to 1856. The picture underwent numerous changes and at one time included the sitter's young daughter Catherine (1843–1914). The pose is probably based on an ancient Roman wall-painting of Arcadia from Herculaneum (now Naples, Museo Archeologico Nazionale). Ingres may have seen this wall-painting on his visit to Naples in 1814.

In 1851 Ingres painted another portrait of the sitter. This picture (Washington, National Gallery of Art) shows Madame Moitessier standing in a black dress.

Moitessier collection by 1867; bought (Champney, Florence, Hornby-Lewis, Lewis-Publications and Temple West Funds), 1936.

Davies 1936, pp. 257ff.; Wildenstein 1954, p. 222, no. 280; Duclaux 1967–8, pp. 324ff, no. 251; Davies 1970, pp. 83–5.

INGRES and Studio
The Duc d'Orléans
after 1842

NG 3252
Oil on canvas, 54.3 x 45.1 cm

Signed on the right: Ingres
Ferdinand-Philippe, Duc d'Orléans (1810–42), the eldest son of King Louis-Philippe of France, was a friend and important patron of Ingres.

NG 3252 is a reduced version of a three-quarter-length portrait that Ingres completed by April 1842. When the Duc d'Orléans was killed in a carriage accident that July, a number of copies of the portrait were ordered from the artist. Most of these were painted by Ingres's pupils, under his supervision.

Toupet collection by 1900; collection of Sir Hugh Lane by 1913; Lane Bequest, 1917.

Wildenstein 1954, p. 214, no. 241; Davies 1970, pp. 72–4; Toussaint 1985, p. 97.

George INNESS the Elder
Delaware Water Gap
about 1857

NG 4998
Oil on canvas, 90.2 x 138.4 cm

A locomotive on the Delaware, Lackawanna and Western railroad, completed in 1855, steams towards us, in contrast to the raft moving slowly upstream.

The view is from the Pennsylvania shore of the Delaware river; the further shore is in New Jersey. In the distance is the Gap, cut by the Delaware in the Kittatinny Mountains.

This picture, the first of several different versions, was probably painted in 1857.

Bequeathed by J. Sanders Slater to the Tate Gallery, 1939; transferred, 1956.

George INNESS the Elder
1825–1894

Inness was born in the Hudson River Valley, near Newburgh, New York State; he grew up in New York city, and spent most of his life there. Chiefly a landscape painter, he made several visits to Italy and France in the 1850s, and was influenced by the Barbizon School. His later work was infused by the spiritualism of his Swedenborgian faith.

Louis-Gabriel-Eugène ISABEY
The Fish Market, Dieppe
1845

NG 2715
Oil on wood, probably oak, 35.6 x 53 cm

Louis-Gabriel-Eugène ISABEY
Grandfather's Birthday
1866

NG 2714
Oil on oak, Painted surface 24.1 x 28.9 cm

Jozef ISRAËLS
Fishermen carrying a Drowned Man
probably 1861

NG 2732
Oil on canvas, 129 x 244 cm

Signed and dated: E. Isabey. / 45.
 Isabey was among the first French nineteenth-century painters to derive inspiration from the Normandy coast. His views of quaint harbour towns look back to Dutch and Flemish traditions and, as in this picture, he often included figures in historical costume.

Eugène Miller by 1876; presented by J.C.J. Drucker, 1910.

Davies 1970, p. 86; Miquel 1980, p. 143, no. 591.

Signed and dated: E. Isabey. 66.
 NG 2714 was described as 'La Fête du Grandpère' in 1889; an alternative title, inscribed on the cradling, is 'Le Nouveau Né'.
 NG 2714 is signed and dated 1866.

Presumably collection of Col. McMurdo by 1889; presented by J.C.J. Drucker 1910.

Davies 1970, pp. 85–6; Miquel 1980, p. 285, no. XI.

Signed: Jozef Israëls.
 A disconsolate widow with her two children heads a procession of fishermen as they carry the body of their drowned colleague away from the sea. NG 2732 was entitled 'Le naufragé' when exhibited at the Salon in Paris in 1861 and 'The Shipwrecked' when shown in London in 1862, where it enjoyed great success and helped to establish the artist's reputation in this country.
 Israëls made several studies for this picture during his stay at Zandvoort, a fishing village on the North Sea coast, although the final composition was painted in Amsterdam, probably in 1861. A signed wash drawing (Aberdeen, Art Gallery) was perhaps one of the preparatory studies.

Bought in 1862 by the dealer Gambart and sold to Arthur J. Lewis; presented by Mrs Alexander Young at her husband's wish, 1910.

Sillevis 1983, p. 189, no. 29; MacLaren/Brown 1991, pp. 211–12.

Louis-Gabriel-Eugène ISABEY
1803–1886

The son of a miniature painter, Isabey was a successful painter of seascapes and history paintings. He exhibited at the Salon from 1824 and was one of the official painters at the court of Louis-Philippe. He visited England in 1825.

Jozef ISRAËLS
1824–1911

Israëls was born in Groningen and trained first there, then at the Amsterdam Academy and finally in Paris. He travelled widely in Europe and received numerous honours. He was a painter of peasant life (especially fishermen) and of aspects of Jewish life.

Jozef ISRAËLS
An Old Man writing by Candlelight
about 1885–99

NG 2713
Oil on canvas, 65 x 54.6 cm

Signed bottom left: Jozef Israels.
 NG 2713 was entitled 'The Philosopher' in the artist's lifetime.

Presented by J.C.J. Drucker, 1910.

MacLaren/Brown 1991, p. 211.

ITALIAN
Portrait of an Old Man
early 16th century

NG 3130
Oil on canvas, 76.2 x 62.9 cm

The sitter has not been identified. The dress suggests a date in the early sixteenth century.
 NG 3130 in the past has been attributed to Giovanni Bellini, Gentile Bellini, School of Gentile Bellini, Titian, Giorgione, and Domenico Morone (?).

Bequeathed by Sir William Boxall (died 1879) to Sir A.H. Layard; Layard Bequest, 1916.

Davies 1961, p. 255.

ITALIAN
The Holy Family
16th century

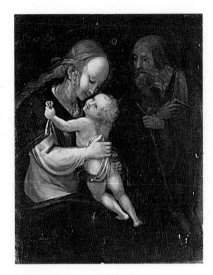

NG 3125
Oil on wood, 49.5 x 38.4 cm

The Christ Child embraces the Virgin, while Saint Joseph, who holds a carpenter's square, looks on at the right.
 NG 3125 is one of a group of paintings by an as yet unidentified artist, whose style was influenced to some extent by that of Sodoma, to whom the panel was at one time attributed.

Manfrin collection, Venice; bought by Sir A.H. Layard, 1880; Layard Bequest, 1916.

Gould 1975, pp. 124–5.

ITALIAN
The Head of Saint John the Baptist
1511

ITALIAN
Portrait of a Young Man
about 1518

ITALIAN
A Concert
mid-1520s

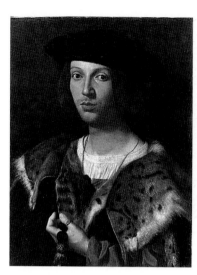

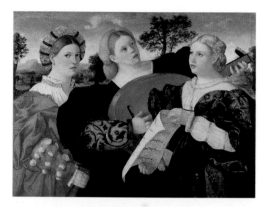

NG 2903
Oil on canvas, transferred from wood,
90.8 x 122.2 cm

NG 1438
Oil on walnut, original painted surface
45.7 x 38.7 cm

NG 1052
Oil on wood, 64.5 x 49.2 cm

Inscribed: MDXI / II.K[A]L.FEB (1511, two days before the Kalends of February, i.e. 31 January).

Saint John the Baptist was beheaded at Herodias' request, and his head presented to Salome on a charger. New Testament (Matthew 14: 1–12).

Leonardo appears to have painted a Head of Saint John the Baptist on a Charger during one of his stays in Milan. Several early sixteenth-century Milanese pictures seem to have been derived from this work. Andrea Solario painted a version of the design, similar to NG 1438, in 1507 (Paris, Louvre).

Said to be from the collection of Cardinal Giovanni Francesco Stoppani, Rome, by 1774; Professor Geromini, Cremona, by 1858; bought, 1895.

Davies 1961, pp. 282–3.

The costume of the unidentified sitter has been dated to about 1518.

In the past NG 1052 has been attributed to Raphael, to the Milanese School and (less appropriately) to Bartolommeo Veneto.

Northwick collection, Thirlestaine House, Cheltenham, by 1858; bequeathed by Miss Sarah Solly, 1879.

Gould 1975, p. 123.

As the woman in the centre plays a lute, her companions sing; the figure at the right holds the score.

In the past NG 2903 has been attributed to the School of Palma Vecchio, Lotto, Pordenone and Bonifazio. The treatment of the subject is close to Palma Vecchio's *Three Sisters* (Dresden, Gemäldegalerie), but the style of the work suggests that it may be by an artist from Friuli. The dress indicates a date in the mid-1520s.

In St Petersburg, 1868; the collection of Sir Coutts Lindsay by 1872; bequeathed by Lady Lindsay, 1912.

Gould 1975, pp. 312–13.

ITALIAN
A Man and his Wife
mid-1540s

ITALIAN
Portrait of a Man
probably 1585–95

ITALIAN
The Dead Christ supported by Angels
late 16th century

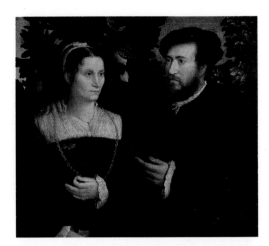

NG 3117
Oil on canvas, perhaps transferred from wood
65.4 x 73.7 cm

NG 173
Oil on canvas, 119.4 x 97.7 cm

NG 219
Oil on wood, 62.2 x 46.7 cm

The costumes of these unidentified sitters have been dated to the mid-1540s. The woman stands before a lemon tree.

NG 3117 is badly damaged and so difficult to attribute with any certainty. It is probably North Italian although, judging by the costumes, not Venetian.

Costabili collection, Ferrara, by 1841; Sir A.H. Layard collection by 1869; Layard Bequest, 1916.

Gould 1975, pp. 123–4.

The costume of the unidentified sitter suggests a dating of about 1585–95.

The condition of the picture makes a precise attribution difficult.

Collection of Alleyne FitzHerbert, first Baron St Helens (1753–1839); presented by his nephew Henry Gally Knight, 1839.

Gould 1975, pp. 306–7.

The dead Christ, wearing the crown of thorns and displaying his wounds, is supported by two angels.

NG 219 has in the past been attributed to the Sienese and Lombard Schools; it was once given to Sodoma but is clearly later in date; then it was proposed as a very early work by Giulio Cesare Procaccini (1574–1625) of Milan. Most recently, and with more conviction, it has been attributed to the little known Fra Paolo Piazza da Castelfranco who worked in the Veneto in the late sixteenth century.

Presented by Sir Walter Calverley Trevelyan, Bt, 1849.

Gould 1975, pp. 205–6.

ITALIAN
Portrait of a Lady with a Dog
late 16th century

ITALIAN
Portrait of a Cardinal
probably late 16th century or early 17th century

ITALIAN
Portrait of a Man
early 17th century

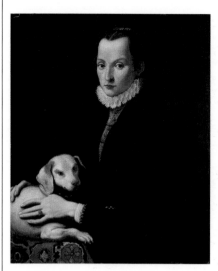

NG 3817
Oil on wood, 83.8 x 70.5 cm

NG 2147
Oil on canvas, 64.1 x 53.3 cm

NG 2149
Oil on canvas, 64.7 x 53.3 cm

The fashion of the unidentified sitter's clothes suggests a date in the late sixteenth century.

NG 3817, which is probably North Italian, was once attributed to Sofonisba Anguisciola (1527–1625). It displays some stylistic similarities with the work of Bartolomeo Passarotti (1529–92).

Presented by Sir Henry Howorth through the NACF, 1923.

Gould 1975, p. 125.

The sitter has not been identified.

NG 2147 remains unrecorded prior to its acquisition. It is thought to be a work of the late sixteenth or early seventeenth century; the condition of the picture prevents a more specific appraisal of authorship or quality. It has previously been catalogued as a work in the style of Tintoretto.

X-ray photographs reveal that the portrait is painted over an earlier painting of a beardless man wearing a ruff.

Bought from the Galvagna collection, Venice, 1855.

Gould 1975, p. 263; Plesters 1984, pp. 29–31.

Inscribed: HIC SATVS EST/ CVLTOR PHAE(BI) /ORPH(EO) /GRATVS PRINC(IPI?) /PROMPTVS IN/ (?SERVIENDO) (A Man born a devotee of Apollo, pleasing to Orpheus, a ready [?servant] of his prince).

This bust-length portrait of an unidentified sitter has probably been cut down at the right. The inscription, which is truncated, may be part of a couplet of unknown origin, and presumably refers to the subject.

NG 2149 has in the past been catalogued as School of Leandro Bassano.

Bought with the Galvagna collection, Venice, 1855.

Gould 1975, pp. 22–3.

ITALIAN
A Dead Soldier
17th century

NG 741
Oil on canvas, 104.8 x 167 cm

ITALIAN
Bust of a Bearded Man
17th century

NG 2105
Oil on walnut, 25.7 x 18.7 cm

ITALIAN
Bust of a Man
17th century

NG 3589
Fresco on terracotta tile, 50.7 x 35.5 cm

What appears to be a letter A is inscribed on the extreme right, midway up the canvas.

A young soldier wearing armour lies on the ground. A skull and bones are to the left and a smoking lamp hangs above. The work is probably intended as a *vanitas* – a reminder of the brevity of life and the inconsequential nature of human achievement.

NG 741 has in the past been thought of as a Spanish picture but is now considered more likely to be Italian, and perhaps Neapolitan, in origin.

The composition inspired Manet's *Dead Toreador* (Washington, National Gallery of Art).

In the anon. (Duparc de le Rue and Veuve Laforest) sale, Paris, 20 August 1821 (lot 104); bought at the Pourtalès-Gorgier sale, Paris, 27 March, 1865 (lot 205).

Levey 1971, pp. 148–9.

The costume of the unidentified sitter can be dated to the early seventeenth century.

NG 2105 has in the past been attributed to Annibale Carracci and to the Flemish School. It is currently considered Italian, and possibly Bolognese. The reverse is inscribed 1661, but this is unlikely to be the date of execution.

John Samuel collection, 1895; bequeathed by the Misses Cohen as part of the John Samuel collection, 1906.

Levey 1971, p. 145.

The sitter has not been identified.

NG 3589 has in the past been attributed to Guido Reni, Franceschini (Il Volterrano) and Giovanni da San Giovanni. The first is untenable and neither of the others wholly convincing. However, a Florentine origin is plausible. The work is first recorded with a now untraced pendant female portrait.

Sir William Hamilton sale, 1809; bought (Lewis Fund), 1921.

Levey 1971, pp. 145–6.

ITALIAN
Portrait of a Man
1630–70

NG 2104
Oil on paper (?) on wood, 17.8 x 12.7 cm

Formerly attributed to the Flemish painter Enrico Fiammingo (Hendrick van Somer, 1607/15–84), the picture is now thought to be by an Italian painter.

The costume suggests a date in the mid-seventeenth century.

Bequeathed by the Misses Cohen as part of the John Samuel collection, 1906.

ITALIAN
Saint John the Baptist
probably 1640–60

NG 6455
Oil on canvas, 77.8 x 62.3 cm

The saint, who wears animal skins and carries a reed cross, drinks in the wilderness.

NG 6455 was at one time attributed to Caravaggio or one of his followers. It may have been painted in the mid-seventeenth century, probably in Rome.

Bequeathed by Dame Joan Evans, 1979.

National Gallery Report 1978–9, pp. 40–1.

ITALIAN
An Old Man holding a Pilgrim-Bottle
probably 1650s

NG 5595
Oil on canvas, 112.5 x 91.5 cm

NG 5595 was once thought to be Spanish. The style of the work has been associated with that of the painters Cipper and Ceruti. An attribution to Pietro Bellotti (1627–1700) and a suggested date in the 1650s has also been recently proposed.

Recorded as belonging to General Montbrun (1770–1812), and to have come from Spain; bought by John Stedman in Genoa, 1817; bought from the Trustees of the Cook collection, 1945.

Levey 1971, pp. 146–7.

ITALIAN

A Female Figure resting on a Sword (Saint Catherine of Alexandria?), probably 18th century

ITALIAN

Portrait of a Woman
19th century

ITALIAN

Portrait of a Young Man
19th century

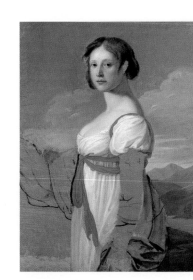

NG 4177
Oil on wood, 53.3 x 45.7 cm

The figure rests on a sword and may be Saint Catherine of Alexandria who was tortured on a wheel and then beheaded with a sword.

NG 4177 has in the past been attributed to Solimena, but it may be Roman rather than Neapolitan.

Possibly in the Gerard Vandergucht sale, London, 8 March 1777 (lot 14); presented by F.D. Lycett Green through the NACF, 1926.

Levey 1971, pp. 147–8.

NG 2217
Oil on canvas, 95.3 x 76.2 cm

The sitter has not been identified; the portrait is unfinished.

NG 2217 was once attributed to Jacques-Louis David and has been claimed as both French and Italian. It would seem to date from the early nineteenth century. The canvas was first used to sketch the figure of a naked man, possibly as part of a larger composition.

Bought (Lewis Fund), 1908.

Levey 1983, p. 24, no. 25.

NG 2084
Tempera on wood, 55.9 x 43.8 cm

A half-length depiction of an unidentified youth; the reverse of the support is marbled.

NG 2084 is almost certainly a forgery, made in Italy in the second half of the nineteenth century, of an Italian painting of the late fifteenth century. When bequeathed it was described as by Pietro Pollaiuolo but in 1929 it was catalogued as Florentine.

John Samuel collection; bequeathed by the Misses Cohen as part of the John Samuel collection, 1906.

Davies 1961, pp. 254–5.

ITALIAN
Portrait Group
early 20th century

NG 3831
Oil and tempera on wood, 40.6 x 36.5 cm

A depiction of Federigo da Montefeltro, Duke of Urbino (1422–82), with two of his children.

NG 3831 is a forgery of the early twentieth century, perhaps by the celebrated forger Icilio Federico Joni, cleverly designed to attract students of Renaissance portraiture.

Bought from Hanson Walker (Florence Fund), 1923.

Davies 1961, p. 256.

ITALIAN, NORTH
Portrait of a Musician
probably about 1500–75

NG 2511
Oil on wood, 66.7 x 55.9 cm

This musician – seen in front of an instrument and holding a pair of dividers – has not been identified.

NG 2511 has sometimes been attributed to Giulio Campi of Cremona (after 1500–72).

Collection of George Salting by 1894; Salting Bequest, 1910.

Gould 1975, pp. 177–8.

ITALIAN, NORTH
Woman at a Window
probably 1510–30

NG 2146
Oil on wood, 51.4 x 41.6 cm

The provocative character of her dress and her sly look out of the window (and the picture) suggest that the subject is a prostitute, but not necessarily a specific individual.

In the past NG 2146 has been attributed to Pordenone. The costume is comparable to that in other Italian works of about 1515.

Bought with the Galvagna collection, Venice, 1855.

Gould 1975, pp. 204–5.

ITALIAN, NORTH

Portrait of a Man in a Large Black Hat

probably about 1510–60

NG 3945

Oil on wood, painted surface 60.7 x 49.2 cm

The sitter, who was once described as Baldassare Castiglione, has not been identified.

NG 3945 was attributed to Savoldo at one time. This has now been rejected and connections with the work of Basaiti in the 1520s have been suggested.

Collection of the Marquess of Exeter before 1888; bought by Ludwig Mond, 1888; Mond Bequest, 1924.

Gould 1975, pp. 178–9.

ITALIAN, NORTH

The Protonotary Apostolic, Giovanni Giuliano

probably about 1520–30

NG 1105

Oil on canvas, 94 x 71.4 cm

Inscribed on the two letters in front of the sitter: Al R[everen]do monsig[nore] Juliano proton[otario] ap[os]t[ol]ico / d[e]g[nissi]mo S[e ascriva?] / a Padua / al borgo dogni santj (To the most reverend Monsignor Giuliano, Apostolic Notary, most noble [Lord, who one addresses] at Padua, at the town of Ogni Santi).

The sitter identified in the inscription is Giovanni Giuliano. There are records of his activity in Venice between 1504 and 1518. His features can be compared with a medal at Brescia (Museo Civico) inscribed: IOANNES. IVLIANVS. PROTONOTARIVS. APOSTOLICVS. There were twelve 'Protonotaries Apostolic', consisting of senior prelates who registered papal legislation and directed the process of the canonisation of saints.

NG 1105 was probably painted about 1520–30, perhaps in Padua or possibly in Bergamo.

Bought from M. Guggenheim, Venice, 1881.

Gould 1975, pp. 135–6.

ITALIAN, NORTH

Saint Hugh

about 1525–1600

NG 692

Oil on wood, painted surface 41.3 x 32 cm

Inscribed either side of the sitter's head: \mathcal{S} VG (sometimes read as Saint Hugh).

The inscription may be a later addition and it is not certain whether Saint Hugh of Grenoble or Saint Hugh of Lincoln is represented.

NG 692 has been attributed to Mansueti and to Lodovico da Parma who were both active in the sixteenth century, but neither identification is convincing.

Both the proposed saints were Carthusians (who wore white habits). However, the habit may have been underpainted only and left unfinished.

Bequeathed by Lt.-General Sir William George Moore, 1862.

Gould 1975, p. 177.

ITALIAN, NORTH
A Battle
probably 1530s

NG 1062
Oil on wood, 71.1 x 94.6 cm

An unidentified battle rages before a mountainous landscape. A figure on a white horse in the foreground would appear to be playing a leading part.

The costumes suggest a date in the 1530s. It has been suggested that NG 1062 may derive from a lost work by Piero della Francesca.

W. Benoni White by 1863; bought, 1879.

Davies 1961, pp. 434–5.

ITALIAN, NORTH
Portrait of a Lady in a Plumed Hat
probably 1565–75

NG 4033
Oil on paper, mounted on canvas, 44.8 x 34 cm

This woman has not been identified.

NG 4033 has sometimes been attributed to Salviati and to Niccolò dell'Abate. The costume would seem to indicate a date in the second half of the 1560s or the early 1570s.

In an anonymous British collection by 1903; Sir Claude Phillips Bequest, 1924.

Gould 1975, p. 179.

ITALIAN, NORTH
The Adoration of the Shepherds
probably about 1600–25

NG 1887
Oil on copper, 31.4 x 24.7 cm

Inscribed on the angel's scroll: GLORIA IN EXCELSIS DEO (Glory to God in the highest).

Shepherds came to adore the Child Jesus lying in a manger. The inscription on the scroll refers to the words of the angels who appeared to the shepherds, singing the Lord's praises. New Testament (Luke 2: 8–17).

NG 1887, which has previously been attributed to Scarsellino (about 1550–1620), was probably painted in Northern Italy, perhaps in Ferrara. The orbit of Donducci (Il Mastelletta, 1575–1655) has also been suggested. It was probably painted quite early in the seventeenth century.

Bought with the Edmond Beaucousin collection, Paris, 1860.

ITALIAN, NORTH
A Man holding an Armless Statuette
before 1640

NG 4459
Oil on canvas, 75.8 x 63.5 cm

The sitter, who has not been identified, is probably a collector or connoisseur.

NG 4459 was formerly catalogued as Bernardo Strozzi. It is probably a Genoese work, and a date before 1640 is likely.

Collection of Harry Kent before 1922; presented by F.D. Lycett Green through the NACF, 1929.

Levey 1971, pp. 167–8.

ITALIAN, NORTH
The Interior of a Theatre
probably 1700–50

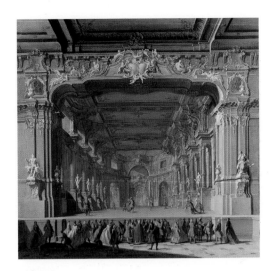

NG 936
Oil on canvas, 104.8 x 112.4 cm

NG 936 is possibly a project for a theatre rather than a view of one actually in existence (it was formerly described as the Teatro Farnese, Parma). The proscenium arch is decorated with various statues and two historiated reliefs of Apollo flaying Marsyas and Pan pursuing Syrinx. The performance has sometimes been identified as *Othello*, but this is not sustainable.

Formerly attributed to the School of Ferdinando Bibiena (1657–1743), NG 936 is now thought to be the work of an anonymous north Italian artist. The stage setting may derive loosely from Bibiena designs which were widely disseminated through prints. The costumes of the foreground figures seem to suggest the first half of the eighteenth century.

Wynn Ellis Bequest, 1876.

Levey 1971, pp. 168–9; Lenzi 1979, p. 177; Gaskell 1990, p. 7.

ITALIAN, EMILIAN
A Mathematician (?)
1600–50

NG 2294
Oil on canvas, 113.7 x 83.8 cm

Inscribed on the book on the left: Ef[?]eme

The sitter (who was incorrectly identified as Galileo in the nineteenth century) is not known. He holds a pair of dividers and an astrolabe is seen behind him; he has been called 'A Mathematician (?)', but might be an astrologer. It is likely that the inscription has been incorrectly repainted and its reading is uncertain. The paper beneath the book may be meant to imply astronomical study (infra-red examination of this area of the picture revealed an inscription, subsequently painted out, suggesting the words: 'Ephemerides Sacra').

NG 2294 is likely to be by a north Italian painter, possibly active in Bologna (NG 2294 entered the Collection as by the Florentine artist Passignano (1558–1638), an idea that has now been rejected). It presumably dates from the period 1600–50.

Collection of George Fielder by 1884; by whom bequeathed, 1908.

Levey 1971, pp. 106–7.

ITALIAN, EMILIAN
Portrait of a Painter
about 1650

ITALIAN, FERRARESE
The Conversion of Saint Paul
1520–50

ITALIAN, FLORENTINE
The Dead Christ and the Virgin
about 1340–55

NG 2106
Oil on canvas, 64.1 x 51.4 cm

NG 73
Oil on wood, 58.1 x 69.8 cm

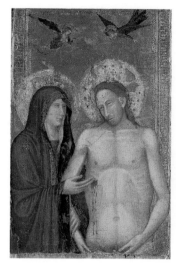

NG 3895
Tempera on wood, painted surface 58.5 x 38.5 cm

The sitter has not been identified. He holds a palette and brushes, and is thus almost certainly a painter.

NG 2106 was previously attributed to Benedetto Gennari (1633–1715), but there seems no reason for this attribution. It has subsequently been catalogued as Emilian School, but even this is tentative. A date of about 1650 seems likely.

Bequeathed by the Misses Cohen as part of the John Samuel collection, 1906.

Levey 1971, p. 106.

Christ appearing in the clouds (upper right) strikes his persecutor Saul blind. Saul (henceforth Paul) is the prominent figure who has fallen on the ground beside his horse. This is the moment of his conversion. New Testament (Acts 9: 1–9).

NG 73 is related in style to the work of Ferrarese artists such as Garofalo, Dosso and Mazzolino. It also includes recollections of fifteenth-century paintings.

Possibly Cardinal Pietro Aldobrandini inventory (no. 23), 1603; imported by Alexander Day by 1800–1; Holwell Carr Bequest, 1831.

Gould 1975, p. 84.

The Virgin Mary touches the wound in the side of the dead Christ; two mourning angels appear above. The reverse shows a cross and some of the instruments of the Passion (a lance, sponge on the end of a pole, a hammer and nails and a 'vessel full of vinegar' as described in the New Testament, John 19: 29).

NG 3895 is one wing of a diptych. The other wing is in the Lehman Collection (New York, Metropolitan Museum of Art). It shows Saint John the Evangelist and presumably the Magdalen. This combination of half-length figures in a diptych appears to be unique. The pictures seem to be by a Florentine artist, although Roberto d'Odorisio (a Neapolitan, documented in 1382) has also been suggested.

The panel has suffered considerable damage.

Collection of Thomas Watson Jackson by 1915; presented by Henry Wagner, 1924.

Pope-Hennessy 1987, pp. 93–5; Gordon 1988, pp. 25–7.

NG 3895, reverse

ITALIAN, FLORENTINE

Head of a Male Saint
after 1365

NG 3120
Fresco, irregular shape 42 x 33 cm

The saint has not been identified.

NG 3120 is from the chapel of S. Andrea in S. Maria del Carmine, Florence; it is a concave fragment, which suggests that it came from the vault. This chapel was founded by Ugolino di Bonsi after 1365. The damaged state of the fragment precludes an attribution, and it is not known who was responsible for the frescoes in this chapel.

Collection of Sir A.H. Layard by 1864; Layard Bequest, 1916.

Gordon 1988, p. 25.

ITALIAN, FLORENTINE

The Baptism of Christ
late 14th century/early 15th century

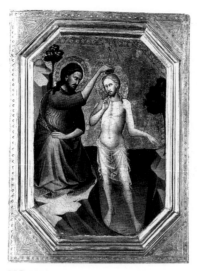

NG 4208
Tempera on wood, painted surface, including frame 38.5 x 28.5 cm

Saint John baptises Jesus Christ in the river Jordan. New Testament (all Gospels, e.g. Matthew 3: 13–17).

NG 4208 may be the end section from a predella panel or supporting pilaster. The rest of the altarpiece has not definitely been identified, although it has been suggested that together with scenes from the lives of Saints James and John the Baptist and the Crucifixion (Paris, Louvre) NG 4208 could have been part of an altarpiece for the Nobili family chapel of S. Jacopo and S. Giovanni Decollato in S. Maria degli Angeli, Florence. An attribution to Lorenzo Monaco on the basis of stylistic comparison has been suggested, but not widely accepted; it has also been attributed to Agnolo Gaddi.

Warner Ottley collection by 1847; presented by Viscount Rothermere, 1926.

Davies 1961, p. 192; Cole 1977 pp. 84ff.; Eisenberg 1989, pp. 197–8.

ITALIAN, FLORENTINE

God the Father
probably about 1420–50

NG 3627
Tempera on wood, diameter excluding frame 10.5 cm

God the Father is shown with an orb and with his hand raised in blessing.

NG 3627 was almost certainly part of a frame. It was formerly catalogued as by Masaccio, and said to be probably from the frame of his Pisa polyptych (NG 3046), although there is no evidence for this. NG 3627 is probably Florentine, and most likely datable to about 1420–50, although recently it has been attributed to the circle of Piero della Francesca.

Collection of Charles Ricketts and Charles Haslewood Shannon by about 1508; by whom presented through the NACF, 1922.

Davies 1961, p. 189; Joannides 1993, p. 463.

ITALIAN, FLORENTINE
The Virgin and Child
probably about 1450–75

NG 6266
Tempera on wood, painted surface 49.5 x 33.5 cm

This composition occurs in several Florentine pictures of the mid-fifteenth century. It has been described as 'one of the stand-bys of Florentine shops of the time'. Two of the other versions (Boston, Isabella Stewart Gardner Museum; Esztergon) have been attributed to Pesellino, who may have invented the composition.

NG 6266 has been attributed to Piero di Lorenzo (1412–80), and also to Don Diamante (1430–98); it was probably painted by a Florentine artist in the third quarter of the fifteenth century.

Said to have come from Florence; collection of Sir Thomas Carmichael by 1902; bequeathed by Lord Carmichael (died 1926); entered the Collection, 1956.

Davies 1961, pp. 194–5.

ITALIAN, FLORENTINE
The Virgin and Child with Two Angels
probably 1450–80

NG 2508
Tempera on wood, painted surface 69.2 x 49.8 cm

Inscribed on the Virgin's collar: ave. regi(na). celi. (Hail Queen of Heaven).

The wall enclosing the Virgin and Child may be meant to suggest the *hortus conclusus* or enclosed garden of the Old Testament (Song of Solomon 4: 12), an image much favoured in litanies of the Virgin Mary.

NG 2508 is related to compositions by Botticelli and Verrocchio, which ultimately derive from a picture by Fra Filippo Lippi (Florence, Uffizi). The painting seems to be near in style to works attributed to Verrocchio, but it is not of high quality.

Another work in the Collection which derives from the same basic prototype is by an imitator of Fra Filippo Lippi (NG 589).

Collection of Sir Augustus Callcott; collection of the Revd W. Davenport Bromley by 1857; collection of Fairfax Murray, 1895; collection of George Salting by 1904; Salting Bequest, 1910.

Davies 1961, pp. 187–8; Lightbown 1978, II, pp. 12–13.

ITALIAN, FLORENTINE
The Virgin and Child with Saint John the Baptist and an Angel, probably 1450–1500

NG 1199
Tempera on wood, painted surface diameter 69.9 cm

This design of the Virgin and Child was one of the most popular in fifteenth-century Florence. The angel holds a lily, a symbol of the Virgin's purity, and the young Saint John the Baptist is shown dressed in a camel skin and with a reed cross.

Pictures such as NG 1199 were the stock-in-trade of several Florentine workshops in the second half of the fifteenth century. Many in the same style and technique as NG 1199 have been grouped together as the work of Pier Francesco Fiorentino who was active in this period.

The frame of this tondo is integral and original.

Bought from Baslini, Milan, 1885.

Davies 1961, p. 186; Dunkerton 1991, p. 156.

ITALIAN, FLORENTINE
Portrait of a Lady in Red
probably 1460–70

ITALIAN, FLORENTINE
Portrait of a Young Man
probably 1475–1500

ITALIAN, FLORENTINE
The Holy Family with Angels
probably 1475–1500

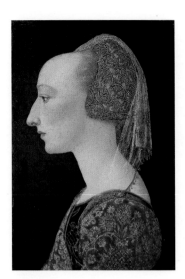

NG 585
Oil and tempera on wood, painted surface
42 x 29 cm

Acquired as a portrait of Isotta da Rimini, this identification has been rejected and the sitter is not known.

NG 585 has been attributed to Piero della Francesca, Uccello and a number of other Florentine artists. It was probably painted in Florence in the third quarter of the fifteenth century, perhaps in the 1460s by an artist close to Antonio del Pollaiuolo.

Guicciardini collection, Florence, probably by 1833; bought from the Lombardi–Baldi collection, Florence, 1857.

Davies 1961, pp. 183–4; Wohl 1980, p. 182.

NG 1299
Tempera on wood, painted surface 56 x 37 cm

The sitter has not been identified.
NG 1299 was formerly attributed to the School of Domenico Ghirlandaio.

Collection of Stefano Bardini by 1889; bought, 1889.

Davies 1961, pp. 195–6.

NG 2492
Tempera on wood, diameter within an incised line 126 cm

Inscribed on the Virgin's collar: (RE)GI/N/A.
NG 2492 is possibly intended as a Nativity scene, depicting the Virgin in Adoration of the Christ Child, with Saint Joseph nearby. The antique ruins may suggest the passing of the old pagan order with the birth of the Christian era.

This tondo was formerly ascribed to Jacopo del Sellaio (about 1441–93). It is somewhat eclectic and shows some influence of Andrea del Verrocchio and Domenico Ghirlandaio.

Collection of George Salting, 1889; Salting Bequest, 1910.

Davies 1961, p. 187.

ITALIAN, FLORENTINE
Portrait of Savonarola
perhaps about 1500–40

ITALIAN, FLORENTINE
A Bearded Man
about 1527–8

ITALIAN, FLORENTINE
Portrait of a Lady
about 1535–50

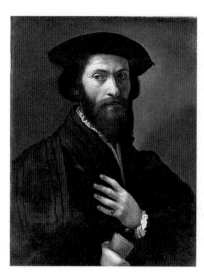

NG 1301
Oil on wood, painted surface 21.2 x 16.5 cm

NG 1150
Oil on wood, 63.2 x 50.1 cm

NG 21
Oil on wood, 59.1 x 48.5 cm

The identification of the sitter as the Dominican friar Girolamo Savonarola (1452–98) is confirmed by the depiction – on the reverse of the panel – of his execution, and that of his two companions Domenico da Pescia and Silvestro Maruffi, in May 1498 in Piazza della Signoria, Florence.

NG 1301 may have been painted about 1500–40 after Savonarola's death, for there was a continuing interest in his moral and political preaching in Florence.

Said (by Walter Savage Landor) to have entered the Tornaquinci collection in Florence from the Medici; given to Robert Southey by Walter Savage Landor, 1839; presented by Dr William Radford, 1890.

Gould 1975, pp. 89–90.

This sitter, who holds a paper in his right hand, has not been identified.

Formerly ascribed to Pontormo and to Lotto. The costume accords best with a dating of about 1527–8.

Collection of Charles Fairfax Murray by 1883; bought, 1883.

Gould 1975, p. 89.

The sitter has not been identified.

This portrait was formerly attributed to Bronzino, and then to Cristofano Allori (1577–1621). It was probably, but not certainly, painted in Florence.

Holwell Carr collection by 1828 (as from the collection of the Duca di S. Vitale, Parma); Holwell Carr Bequest, 1831.

Gould 1975, p. 88.

NG 1301, reverse

ITALIAN, FLORENTINE
Portrait of a Boy
about 1545

ITALIAN, FLORENTINE
Portrait of a Lady
probably 1555–65

ITALIAN, FLORENTINE
A Knight of S. Stefano
after 1561

NG 649
Oil on wood, 129 x 61 cm

NG 650
Oil on canvas, 113 x 80 cm

NG 670
Oil on wood, 209.5 x 121.2 cm

The youthful sitter has not been identified.
 Formerly attributed to Pontormo, Bronzino and Francesco Salviati. The dress suggests a date in the mid-1540s and is plainly that of a wealthy family; the full-length format also suggests an aristocratic sitter.

Edmond Beaucousin collection, Paris, by 1860 (and said to have come form the collection of the Duke of Brunswick); bought, 1860.

Gould 1975, pp. 88–9.

The sitter has not been identified.
 NG 650 was formerly attributed to Bronzino and to Alessandro Allori; neither of which seems acceptable. The costume has been said to accord best with a dating in the late 1550s or early 1560s.

Probably in the collection of Lord Shrewsbury by 1854; bought with the Edmond Beaucousin collection, Paris, 1860.

Gould 1975, pp. 85–6.

The sitter wears the cross of the military order of S. Stefano, founded in Pisa in 1561 by the Grand Duke of Tuscany, Cosimo I de' Medici. The letters and inkstand on the table, and the books and statue above, allude to his status and learned interests.
 Independent life-size and full-length portraits are very rare in Tuscan sixteenth-century art. The painting has been attributed to Alessandro Allori (1535–1607), successor to Bronzino as painter to the Medici Court, but it is closer in style to the work of Maso da San Friano (Tommaso Manzuoli, 1531–71).

Presented by G.F. Watts RA, 1861.

Gould 1975, pp. 7–8.

ITALIAN, MILANESE
Bona of Savoy (?)
about 1475–1500

NG 2251
Tempera on canvas, 139.7 x 60.5 cm

The sitter, who holds columbines, may be Bona of Savoy (1449–1503), the wife of Galeazzo Maria Sforza. This identification finds some support by comparison with a representation of her on a medal.

If NG 2251 is indeed a portrait of Bona of Savoy it may date from the period when she was Regent of Milan (1476–80) and must date from the last quarter of the fifteenth century (for she is represented as a mature woman).

This picture is very damaged.

Acquired from the Ravaisson collection, Paris, by Sir George Donaldson, 1889; by whom presented, 1908.

Davies 1961, p. 374.

ITALIAN, MILANESE
Francesco di Bartolomeo Archinto
1494

NG 1665
Oil (identified) on wood, painted surface
53.3 x 38.1 cm

Inscribed on the scroll held by the sitter: 1494 ET[ATI]S AN[N]O. 20 (1494 Aged 20 years) AMPRF (a monogram with letters interlaced).

The identification of the sitter was traditional before the painting left the Archinto collection in Milan. Francesco was alive in 1507 and died in 1551, and there is no reason why he should not have been twenty in 1494. The identification has not, however, been independently verified.

NG 1665 is greatly influenced by Leonardo da Vinci and may be by one of the artists recorded in his Milanese workshop in the 1490s. The cryptic monogram, apparently composed of the letters AMPRF, has been taken to mean Am[brosius] Pr[eda] F[ecit] (Ambrogio de Predis made this).

Palazzo Archinto, Milan, by 1842; bought from W. Fuller Maitland, 1898.

Davies 1961, pp. 448–9.

ITALIAN, MILANESE
Male Members of a Confraternity
about 1500

NG 779
Oil on silk or linen, mounted on wood, painted surface 64.5 x 41.9 cm

Nine men are shown in profile, probably at prayer, at the foot of a patron saint (unidentified, probably male).

NG 779 and 780 were probably painted as parts of a confraternity banner or standard; another fragment (God the Father) was in Milan in the nineteenth century. All three fragments are thought to have been part of a standard, once in the Certosa di Pavia. Female members of the confraternity (and part of the patron saint) are seen in NG 780. The groups of both men and women probably include portraits, but none has been identified.

Molteni collection, Milan; bought, 1867.

Davies 1961, pp. 82–3; Dunkerton 1991, p. 64.

ITALIAN, MILANESE
Female Members of a Confraternity
about 1500

ITALIAN, MILANESE
The Virgin and Child
perhaps about 1500–25

ITALIAN, NEAPOLITAN
The Adoration of the Shepherds
probably 1630s

NG 780
Oil on silk or canvas, mounted on wood, painted
surface 64.5 x 41.9 cm

Fourteen women are shown at prayer, probably
kneeling and at the foot of a patron saint.
 NG 780 was said to have been cut from the same
confraternity banner or standard as NG 779. See
under NG 779 for further discussion.

Molteni collection, Milan; bought, 1867.

Davies 1961, pp. 82–3; Dunkerton 1991, pp. 64–5.

NG 2089
Fresco, painted surface 73.5 x 45.1 cm

NG 2089 is a fragment of a fresco. It is close in style
to Boltraffio, while also resembling the work by the
Master of the Pala Sforzesca; it was presumably
painted by a Milanese follower of Leonardo. It is
badly damaged.

*Collection of William Graham before 1885; bequeathed by
the Misses Cohen as part of the John Samuel collection,
1906.*

Davies 1961, p. 374.

NG 232
Oil on canvas, 228 x 164.5 cm

The Virgin kneels, supporting the Christ Child.
Behind them Saint Joseph rests on his staff. On the
right are the shepherds. New Testament (Luke: 2).
The two bound lambs in the foreground are
probably intended as an allusion to the future
sacrifice of Christ. In the right background the
Annunciation to the shepherds is depicted.
 NG 232 was formerly attributed to Murillo, but it
has also been thought to be a work by Velázquez,
Zurbarán, Francesco Fracanzano and Giovanni Do,
the last two of whom were active in Naples. The
style and technique of the picture would indeed
seem to indicate a Neapolitan origin, but at present
it is not possible to attribute it to a particular artist.
The picture is recorded in Seville from 1777,
although it was certainly there from much earlier,
and several copies and variants were made in Spain.
There are some pentimenti.

*Collection of Don Miguel Espinosa y Maldonado
Saavedra, Conde del Agulia, Seville, 1777; King Louis-
Philippe, Paris, 1832/3; bought in London, 1853.*

MacLaren/Braham 1970, pp. 74–7.

ITALIAN, NEAPOLITAN
Christ disputing with the Doctors
1675–1700

NG 1676
Oil on canvas, 120 x 161.9 cm

ITALIAN, NEAPOLITAN
Portrait of a Lady
18th century

NG 6254
Oil on canvas, 92.7 x 75 cm

ITALIAN, ROMAN
Crane, Python and Lizard
probably 18th century

NG 2980
Mosaic, 23.5 x 29.2 cm

At the age of twelve Jesus went with his parents to Jerusalem for the Passover. On their return they found he was not with them, and after searching they discovered him in the Temple involved in a learned debate with the Jewish scribes. New Testament (Luke 2: 41–51).

NG 1676 has in past been variously attributed to the Spaniard Francisco Herrera (1627–83), Preti, an imitator of Preti and Juan Rizi (1600–81). It certainly appears to be Neapolitan and can probably be dated to the later part of the seventeenth century.

Edward Stephens by 1857; bequeathed by Mrs Alexander Lang Elder, 1899.

Levey 1971, p. 166.

A three-quarter-length portrait of an unidentified sitter.

NG 6254 has been attributed to Solimena and described as one of his very late works. It reflects the style of his paintings, but appears to be inferior in quality to portraits by the artist.

Galitzin collection, Naples; presented by Mrs E. Antal in memory of Frederick Antal, 1955.

Levey 1971, pp. 166–7.

The mosaic seems to be an imitation of ancient Roman work.

Bequeathed by Lt.-Col. J.H. Ollney, 1836.

Davies 1961, pp. 462–3.

ITALIAN, ROMAN
The Water of Life
probably 19th century

NG 3403
Mosaic, 50 x 51 cm

The mosaic is an imitation of a medieval work.

Presented by Henry Wagner through the NACF, 1919.

Davies 1961, p. 463.

ITALIAN, SIENESE
The Marriage of the Virgin
probably 1400–25

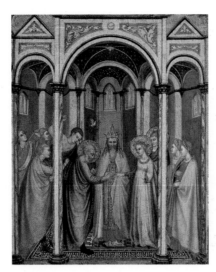

NG 1317
Tempera on wood, 41 x 33 cm

The Virgin's marriage to Saint Joseph is not described in the Gospels, but appears in the New Testament Apocrypha and the thirteenth-century *Golden Legend*. According to these sources Joseph was chosen because of a miraculous sign – the flowering of his rod. Here he holds the rod, surmounted by a dove (symbol of the Holy Ghost), while placing a ring on the Virgin's hand. The ceremony takes place in a temple; at the right stands the Virgin's mother, Saint Anne, and two other women, and at the left disappointed suitors break their rods.

NG 1317 is thought probably to come from a predella. A panel depicting the *Birth of the Virgin* (Rome, Vatican Museums) almost certainly formed part of the same ensemble. A third painting, the *Crucifixion* (Siena, Museo dell'Opera del Duomo), may be by the same artist, but does not necessarily derive from the same work. NG 1317 has speculatively and variously been attributed to Gualtieri di Giovanni da Pisa (active 1389–1445), the Master of the Life of Mary, and Gregorio di Cecco di Luca (active 1389–1423).

Bought from A. Borgen, London, 1890.

Davies 1961, pp. 470–1.

ITALIAN, TUSCAN
The Virgin and Child with Two Angels
13th century

NG 4741
Tempera on wood, 36.5 x 26.7 cm

Inscribed on the background: MP ΘY. (=MHTHP ΘEOY. – Mother of God).

The Virgin and Child embrace. On the reverse is a cross painted with triangles and circles at the ends of its four arms; such a design may distantly derive from Byzantine ivories.

It has been suggested that NG 4741 formed one half of a diptych, with a *Christ on the Cross* (Budapest, Szépmüvészeti Museum) attached to it on the right. It has in the past been variously attributed to Giunta Pisano (active early to mid-thirteenth century), the Master of San Martino, a follower of Coppo di Marcovaldo (documented 1261–75) and the circle of Guido da Siena (documented 1262–about 1271). At present it appears impossible to attribute such a work with precision.

NG 4741 was stolen from the Gallery in 1970.

Bought in Assisi by W.B. Chamberlin, about 1890; by whom presented, 1934.

Gordon 1988, pp. 98–9.

NG 4741, reverse

ITALIAN, TUSCAN
Heads of Angels
15th century

NG 1842
Fresco, irregular shape, 28 x 38 cm

The subject of the fresco from which this fragment comes remains unidentified.

NG 1842 has been attributed to Sassetta and to Sano di Pietro (1405–81), both of whom were active in Siena, but it is by no means clear whether it can, on stylistic grounds, be associated with works produced in that city. An undated letter stuck to the reverse of the fresco suggests that it was acquired in Florence at the 'Convento delle Poverine, Via della Scala'. However, this may be misleading because the Convent of S. Gerolamo delle Poverine is on the Via Tripoli, which is a long way from the Via della Scala.

Henry Vaughan Bequest, 1900.

Davies 1961, pp. 524–5.

ITALIAN, TUSCAN
Saints Michael and John the Baptist
about 1450–60

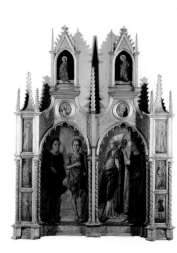

NG 584
Tempera on wood, painted surfaces of large panels 94 x 49.5 cm

The fragments of this altarpiece are mounted in a nineteenth-century frame. In the main panels are, at the left, Saints Michael and John the Baptist, and at the right, a bishop and a female martyr. The Archangel Gabriel and the Annunciate Virgin are depicted in the medallions, while in the pinnacles above are the Virgin and Saint John the Evangelist. The pilasters contain saints both on the front and sides. Left front: Saint Benedict; a pope; a monk. Left side: Saint Ansanus(?); a bishop; Saint Peter. Right front: Saints Romuald(?); Catherine of Alexandria; Sebastian(?). Right side: Saints Jerome; Paul; Mary Magdalene(?).

The presence of Saint Romuald and of Saint Benedict, in white, suggests that NG 584 comes from an altarpiece painted for a Camaldolese institution; it is recorded as being from the Camaldolese nunnery of S. Giovanni Evangelista, Pratovecchio. A painting representing the *Virgin of the Assumption* in that church may have been the central panel of the altarpiece. The whole work was probably painted in the 1450s. It has in the past been attributed to the Master of Pratovecchio, to Andrea dal Castagno and been associated with the work of Giovanni di Francesco. (See Appendix B for a larger reproduction of this work.)

Bought from the Lombardi–Baldi collection, Florence, 1857.

Davies 1961, pp. 521–4.

ITALIAN, UMBRIAN
A Saint
about 1350–1400

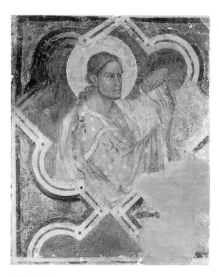

NG 4143
Fresco transferred to canvas, 80 x 64.8 cm

This male saint has not been identified; he turns the pages of a book and is probably meant to be one of the evangelists.

NG 4143, 4144 and 4145 are fresco fragments said to be from the walls of the Palazzo del Capitano del Popolo, Assisi. They were probably painted by an Umbrian artist in the mid- or late fourteenth century. Two other fragments are known.

Bought, 1926.

Gordon 1988, pp. 116–17.

ITALIAN, UMBRIAN
A Saint
about 1350–1400

ITALIAN, UMBRIAN
A Bishop Saint
about 1350–1400

ITALIAN, VENETIAN
The Dead Christ
1350–1400

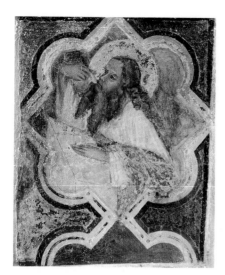

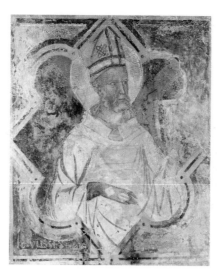

NG 4144
Fresco transferred to canvas, 77.5 x 62.2 cm

NG 4145
Fresco transferred to canvas, 78.1 x 64.8 cm

NG 3893
Tempera on poplar, 52.3 x 30 cm

This male saint has not been identified; he is seated at a desk, with a pen, and is probably meant to be one of the evangelists, perhaps Luke.

NG 4143, 4144 and 4145 are fresco fragments said to be from the walls of the Palazzo del Capitano del Popolo, Assisi; see under NG 4143 for further comment.

Bought, 1926.

Gordon 1988, pp. 116–17.

This bishop saint has not been identified; he holds a book.

NG 4143, 4144 and 4145 are fresco fragments said to be from the walls of the Palazzo del Capitano del Popolo, Assisi; see under NG 4143 for further comment.

Bought, 1926.

Gordon 1988, pp. 116–17.

Inscribed above the cross: I. N. R. I.

Christ stands within the tomb before the cross. Two angels with censers are depicted at either side of his head. This representation derives from the legend of Cristo di San Gregorio, according to which Christ appeared to Saint Gregory the Great at Mass in S. Croce in Gerusalemme, Rome. The prototype in the church was engraved by Israel von Meckenem, and essentially corresponds with NG 3893.

It is thought to be a product of the Venetian School.

Charles Butler sale, London, 25 May 1911 (lot 15); bought by Henry Wagner; by whom presented, 1924.

Gordon 1988, p. 118.

ITALIAN, VENETIAN

The Virgin and Child with Saints Christopher and John the Baptist, and Doge Giovanni Mocenigo
1478–85

NG 750
Oil on canvas, 184.2 x 295.9 cm

ITALIAN, VENETIAN

A Man in Black
about 1500

NG 2095
Oil on wood, 31.1 x 25.4 cm

ITALIAN, VENETIAN

Augustus and the Sibyl
about 1500

NG 3086
Oil on poplar, 17.5 x 38.5 cm

Inscribed on the scroll held by Saint John: ECCE AG(NUS DEI) (Behold the Lamb of God). Inscribed on the banner which the Doge holds that also bears the lion of Venice: PAX/ TIBI/ MAR/CE /EVA/NGEL/ISTA/ MEVS (Peace be with you Mark, my Evangelist). Inscribed on the altar: VRBEM REM VE/NETAM SERVA/ VENETVMQ[UE]/ SENATVM/ ET MIHI SI ME/REOR VIRGO/ SVPERNA (F)AVE (Protect the city, the Venetian State and the Venetian Senate/government and, if I merit it, look down with favour on me, Virgin).

The Virgin and Child are enthroned left of centre; Christ is blessing and has a chaffinch, symbolic of the Passion, by him. Giovanni Mocenigo (Doge, from 1478 to 1485) kneels holding a banner in homage to them. He is identified by his family coat of arms which appears on the banner and against the altar; his features can be compared with those depicted on a contemporary medal. John the Baptist, who presents him, is his name saint. At the left stands Saint Christopher carrying the infant Christ.

Documentation in the Mocenigo archives, and the reading of an old false inscription on the painting, suggest that the painting may have been commissioned in relation to an outbreak of plague in Venice, but this remains unproven. NG 750 has been traditionally ascribed to Carpaccio; it has also been attributed to members of the Bellini family and to Bastiani. It is evidently a votive painting: such paintings were found it seems both in palaces and chapels.

Collection of the Mocenigo di S. Polo, Venice, about 1840; bought from the Conte Alvise Mocenigo di S. Eustachio, Venice, 1865.

Davies 1961, pp. 544–7.

The sitter has not been identified.

In the past NG 2095 has been attributed to Antonello da Messina, Alvise Vivarini, Andrea da Murano (active 1462–1507), Marco Marziale and Giovanni Bellini.

Collection of John Samuel by 1893; bequeathed by the Misses Cohen as part of the John Samuel collection, 1906.

Davies 1961, p. 72; Heinemann 1962, p. 126.

According to tradition, the Virgin and Child appeared to the Roman Emperor Augustus and one of the Sibyls and pointed out the site of the church of S. Maria d'Aracoeli, Rome. The Virgin and Child are in the sky at the upper left.

It is possible that NG 3086 originally formed part of a piece of furniture. In the past the work has been attributed to numerous Venetian painters active in the early fifteenth century, but its condition makes firm attribution difficult. A part of the landscape derives from that in Giovanni Bellini's *Resurrection* (Berlin, Gemäldegalerie), and the town and bridge recur in the background of Busati NG 3084.

Bought from Richetti by Sir A.H. Layard; Layard Bequest, 1916.

Davies 1961, pp. 547–8.

ITALIAN, VENETIAN
Portrait of a Lady
about 1510–20

ITALIAN, VENETIAN
Portrait of a Lady
about 1515–20

ITALIAN, VENETIAN
The Virgin and Child with Saint Joseph, Saint Lucy and a Woman and Child at Prayer
probably about 1540–7

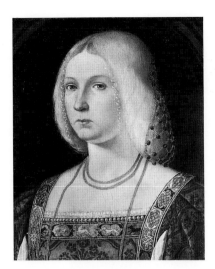

NG 631
Oil on wood, 36.8 x 29.8 cm

NG 595
Oil on canvas, 73 x 57.8 cm

NG 1203
Oil on canvas, 85.7 x 118.1 cm

The unidentified sitter is framed by spandrels.
 The clothes she wears appear to date from the period 1510–20. The work has been variously attributed to Gentile Bellini, Bissolo, Bartolommeo Veneto (active 1502–about 1531), Francesco Rizzo da Santacroce (before 1490–after 1548), a pupil of Palma Vecchio and Pietro degli Ingannati (active 1529–48); none of these attributions is regarded as satisfactory.

Collection of Col. Bourgeois, Paris; bought with the Edmond Beaucousin collection, Paris, 1860.

Davies 1961, p. 543.

The unidentified richly dressed sitter is depicted behind a parapet.
 The clothes of the subject are thought to date from the period around 1516–17. Attributions to Palma Vecchio and Licinio have been suggested, but the condition of the picture precludes a firm attribution.

Bought in Rome from 'Signor Menchetti', 1858.

Gould 1975, pp. 307–8.

Saint Joseph is identified by his rod that burst into flower; Saint Lucy (whose name means light) holds a burning light. The woman and the child in the foreground have sometimes been said to be saints, but are more probably a mother and her child, the donors of the picture, although the mother's head has been given a radiance.
 NG 1203, which is very damaged, has previously been catalogued as by Cariani.

Andreossi collection, Milan, by 1886; bought, 1886.

Gould 1975, p. 48; Pallucchini 1983, pp. 122–3, no. 41.

ITALIAN, VENETIAN
A Naval Battle
16th century

NG 3108
Oil on wood, 17.1 x 38.7 cm

ITALIAN, VENETIAN
The Story of Cimon and Efigenia
16th century

NG 4037
Oil on wood, 67.9 x 120 cm

ITALIAN, VENETIAN
A Colossal Male Spandrel Figure
probably late 16th century

NG 272
Oil on canvas, 152.1 x 115.9 cm

The battle depicted here has not been associated with a literary or historical source.

NG 3108 is one of a series of panels of similar sizes which treats comparable subjects. It was first recorded with three other works from the series (two of which are now in the Szeben collection, Bucharest; the other was on the London art market, 1949). A fifth panel also appeared on the art market earlier this century. It is surmised that the works all formed part of the decoration of the panelling of a dado or perhaps a suite of furniture. They were once attributed to Andrea Schiavone.

Manfrin collection, Venice; bought by Sir A.H. Layard, 1880; Layard Bequest, 1916.

Gould 1975, pp. 308–9.

Cimon was the son of a rich man from Cyprus. He worked on his father's country estate and one day came across a young woman asleep with three servants, and immediately fell in love with her. The story is from Boccaccio's *Decameron* (5: 1). The painting has been cut at the left. The missing portion may have shown the other two servants.

The original shape of NG 4037 suggests that the picture was designed for the decoration of a piece of furniture. Attributions to Palma Vecchio and Domenico Mancini (active about 1511) have been suggested. The latter seems more likely, but the condition of the work prevents a more specific appraisal.

Acquired by Sir Claude Phillips before June 1907; Sir Claude Phillips Bequest, 1924.

Gould 1975, p. 309.

The unidentified figure looking down from the spandrel of a painted arch is probably a fragment of a mural decoration. Such a figure is likely to represent a prophet or ancestor of Christ who prefigured the New Testament subject matter in the chapel below.

NG 272 has in the past been attributed to Pordenone and described as Italian School, sixteenth century. It is now suggested that it may derive from the Veneto; spandrel figures of this type are not uncommon among the works of followers of Paolo Veronese.

Said to have come from 'a church in the territory of Venice'; presented by Cavaliere Vallati, 1855.

Gould 1975, p. 307.

ITALIAN, VENETIAN
A Young Woman with Carnations
probably about 1590–1600

NG 2097
Oil on canvas, 97.8 x 74.3 cm

This unidentified woman is seen with one breast exposed, and with carnations tucked into her chemise.

NG 2097 appears to have been painted in the late sixteenth century.

John Samuel collection by 1894; bequeathed by the Misses Cohen as part of the John Samuel collection, 1906.

Gould 1975, pp. 39–40.

ITALIAN, VENETIAN (?)
The Nativity
17th century

NG 3647
Oil on canvas, 92.4 x 116.3 cm

NG 3647 has in the past been variously attributed. It is currently considered to be probably North Italian and possibly Venetian in origin. The composition is known in several versions, one of which has been attributed to Tintoretto.

Thomas Emmerson sale, London, 22 May 1858 (lot 198); presented by Sir Henry Howorth through the NACF, in memory of Lady Howorth, 1922.

Levey 1971, p. 242.

ITALIAN, VENETIAN (?)
Portrait of a Man
about 1750

NG 4041
Oil on canvas, 75 x 64.5 cm

The sitter has not been identified.

It is not certain that NG 4041 is by a Venetian artist. It may be the work of a painter active in the city, but trained elsewhere. It probably dates from the mid-eighteenth century.

Sir Claude Phillips Bequest, 1924.

Levey 1971, p. 243.

ITALIAN, VERONESE
Trajan and the Widow I
probably about 1475–1500

ITALIAN, VERONESE
Trajan and the Widow II
probably about 1475–1500

John JACKSON
The Reverend William Holwell Carr
probably 1820–30

NG 1135
Tempera on spruce, painted surface 34 x 31.5 cm

NG 1136
Tempera on wood, painted surface 33.5 x 33 cm

NG 124
Oil on canvas, 75.6 x 62.9 cm

The Roman Emperor Trajan halted his military campaign in order to deliver justice to a widow whose child (right foreground) had been killed. The story is taken from Dante's *Purgatorio* (X, 76ff). It was often depicted on *cassoni* (wedding chests).

NG 1135 and 1136 are presumably from a piece of furniture but their frames, although engaged, may not be original. An eighteenth-century inscription (made in Venice by 'Signaroli', probably the painter Giambettino Cignaroli, 1706–70) on the reverse of NG 1135 attributes the two pictures to Vittore Carpaccio. This attribution is untenable (as is the later idea that they are the work of Domenico Morone); they were probably painted in Verona by an unknown artist active in the last quarter of the fifteenth century.

Collection of Caterina Locatelli Terzi before 1756; bought, Venice, 1883.

Davies 1961, pp. 552–3.

The Emperor Trajan is seen dispensing justice to the widow from a throne on the right. The story is taken from Dante's *Purgatorio* (X, 76ff).

NG 1135 and 1136 are presumably from a *cassone*; see under NG 1135 for further discussion.

Collection of Caterina Locatelli Terzi before 1756; bought, Venice, 1883.

Davies 1961, pp. 552–3.

Born William Holwell in 1758, ordained in 1790 and given the rich living of Menheniot in Cornwall in 1792, Holwell took the additional name of Carr on inheriting his late wife's estates in 1798. As the Revd William Holwell Carr, he employed a curate to undertake his parish duties, devoting his time to collecting pictures. He died in 1830, having bequeathed 29 paintings to the National Gallery, including Rembrandt NG 54 and Tintoretto NG 16.

Holwell Carr Bequest, 1831.

Davies 1959, pp. 70–1.

John JACKSON
1778–1831

Jackson was born in Lastingham in Yorkshire. He travelled to London in 1804 and entered the Royal Academy Schools. The artist was elected ARA in 1815 and RA two years later. He was chiefly a portrait painter.

John JACKSON
William Seguier
1830

NG 6022
Oil on canvas, 78.7 x 65.4 cm

Inscribed on the reverse: Portrait of William Seguier Esq.ʳ/by John Jackson Esq.ʳ R.A./painted for George Watson Taylor Esq.ʳ/1830.

William Seguier (1771–1843) was appointed in 1824 as the first Keeper of the National Gallery (see the Introduction to the catalogue). He was also a painter and picture restorer and an adviser to collectors.

Presented by Charles H. Seguier-Brown, great-grandson of the sitter, 1950.

JACOMETTO
Portrait of a Boy
probably about 1475–98

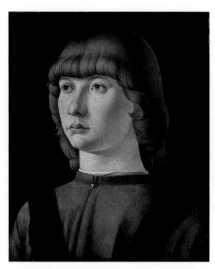

NG 2509
Tempera and oil on wood, 22.9 x 19.7 cm

The sitter has not been identified; in a damaged version in the Museo Correr, Venice, the figure has a halo and a palm and is inscribed S.F.

Jacometto's style is close to that of Antonello da Messina but also resembles that of the followers of Mantegna, such as Zoppo. NG 2509 was associated with NG 3121 by Bernard Berenson.

Duchâtel collection, Paris, by 1860; bought by George Salting, 1889; Salting Bequest, 1910.

Davies 1961, pp. 258–9.

JACOMETTO
active about 1472; died before 1498

Jacometto (also known as Jacometto Veneziano) is primarily known through documentary references to his miniatures and small portraits. He was active in Venice and was evidently patronised by Venetian patricians. Attributions depend upon a pair of portraits (New York, Metropolitan Museum of Art, Robert Lehman Collection) which appear to be the pictures by Jacometto described by Michiel when in the Contarini collection in Venice.

JACOMETTO
Portrait of a Man
probably about 1475–1500

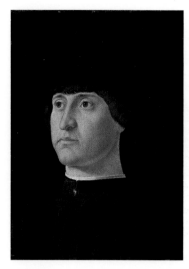

NG 3121
Tempera and oil on wood, painted surface 26 x 19 cm

Inscribed on the reverse: FELICES TER ET AMPLIVS / QVOS / IRRVPTA TENET COPVLA (More than triple happiness comes to the couple bound together as one).

The reverse shows two crossed sprays of myrtle and is inscribed with lines from Horace (*Odes* I: 13, lines 17–18). The sitter has not been identified.

NG 3121 was attributed to Jacometto on the basis of comparison with portraits by him (New York, Metropolitan Museum of Art, Robert Lehman Collection); it was formerly attributed to various artists active in Venice, including Antonello da Messina, Giovanni Bellini, Carpaccio and Alvise Vivarini.

Bought from the Manfrin collection, Venice, by Sir A.H. Layard, 1871; Layard Bequest, 1916.

Davies 1961, pp. 259–60.

NG 3121, reverse

Follower of Hieronymous JANSSENS
Ladies and Gentlemen playing La Main Chaude
probably 1655–65

Thomas JONES
A Wall in Naples
about 1782

Johan Barthold JONGKIND
River Scene
1860–80

NG 4976
Oil on oak, 26.8 x 39 cm

NG 6544
Oil on paper laid down on canvas, 11.4 x 16 cm

NG 4583
Oil on canvas, 52.1 x 80 cm

The game which the figures are playing involves one person hiding his face on the lap of another, and then guessing who has hit his hand which is behind his back.

NG 4976 was formerly attributed to Janssens, but is now considered to be the work of a follower. It can probably be dated by the clothes to about 1655–65.

Bought, possibly in Paris, by Albert Kingsley; presented by his son, George Kingsley, 1939.

Martin 1970, pp. 85–6.

The subject is a wall, pitted with scaffolding holes and apparently stained with the passage of water to the left of the balcony.

It is one of a series of remarkable and original *plein-air* oil sketches on paper, produced by Jones while living in Naples. Like other of his views, it has the appearance of an image observed and recorded from the window or roof of his lodgings. Although the French artist Claude-Joseph Vernet advocated making direct compositional sketches in the open air, for an eighteenth-century artist so entirely to dispense with the usual compositional props of the conventional classical landscape was highly unusual. In doing so, Jones introduced new possibilities for landscape depiction, which would be thoroughly explored and developed in the following century.

Captain John Dale, and thence by descent through his daughter Rose to the Adams family; sold Christie's, 28 July 1955 (lot 6); bought Agnew's; Lady Ashton; sold Christie's, 23 March 1979 (lot 88); private collection; bought, 1993.

Gowing 1985, pp. 47, 63, pl. 42; Hawcroft 1988, p. 92, no. 105; National Gallery Report 1993–4, pp. 10–11.

Signed: Jongkind
This view is traditionally described as a depiction of the river Seine; the specific site has not been identified.

Sir George A. Drummond (died 1910) collection, Montreal; bequeathed by Hans Velten to the Tate Gallery, 1931; transferred, 1956.

Davies 1970, p. 87.

Hieronymus JANSSENS
1624–1693

Janssens was born and worked in Antwerp. In 1636/7 he is listed in the records of the city's guild of St Luke as a pupil of C.J. van der Lamen; in 1643/4 he became a master. He was a painter of conversation pieces.

Thomas JONES
1742–1803

Born in Radnorshire, Wales, Jones attended Oxford University before studying with Richard Wilson, the leading British landscape painter of the time, from 1763 to 1765. Jones later spent the years 1776 to 1783 in Italy, chiefly painting landscapes and topographical watercolours. After returning from Italy and succeeding to Pencerrig, his father's Radnorshire estate, his artistic output was small.

Johan Barthold JONGKIND
1819–1891

Jongkind was born at Latrop in the Netherlands, but spent much of his artistic career in France. He trained at the Drawing Academy in The Hague, and in Paris he worked in the studios of Eugène Isabey and F.E. Picot. He painted mainly in Paris and Normandy, where he met Monet in 1862; the latter declared that it was to Jongkind that he owed 'the final education of my eye'.

Johan Barthold JONGKIND
The Boulevard de Port-Royal, Paris
1877

NG 6529
Oil on canvas, 28 x 45 cm

Imitator of JONGKIND
Skating in Holland
about 1890–1900?

NG 3253
Oil on canvas, 31.8 x 46.4 cm

Cornelius JONSON
Portrait of a Lady
1655

NG 6280
Oil on canvas, 99.7 x 81.3 cm

Signed and dated lower right: Jongkind 1877
 Jongkind produced a number of views in the 1870s of this newly constructed boulevard near his studio in Paris. On a watercolour of 1874 showing a similar scene the artist recorded that the view was taken from a vantage point close to the place de l'Observatoire, looking east along the boulevard, with the Maison d'Accouchement on the right. Further down is the Hôpital Cochin.

Bernheim-Jeune, Paris (by 1902?); M.L. Tauber, Paris, 1921; Kenneth Levy; Kenneth and Helena Levy Bequest, 1990.

Hefting 1975, p. 269, no. 683; National Gallery Report 1990–1, p. 19.

Signed bottom right: Jongkind.
 Jongkind painted a number of similar compositions in the early 1860s, but the authenticity of NG 3253 has been doubted and it seems likely to be a late nineteenth-century forgery.

Sir Hugh Lane Bequest, 1917; on loan to the Hugh Lane Municipal Gallery of Modern Art, Dublin, since 1979.

Davies 1970, p. 86.

Signed and dated: Cornelius Jonson / van Ceulen / fecit / 1655.
 The sitter has not been identified.
 NG 6280 may have been painted in Utrecht.

Collection of the Marquess of Exeter by 1888 (and presumed to have been at Burghley House by 1815); bequeathed by Robert Wylie Lloyd, 1958.

Davies 1959, pp. 71–2.

Cornelius JONSON
1593–1661

Cornelius Jonson (Johnson, Janson, Janssen van Ceulen [Cologne]) was born in London of parents from Antwerp. His training is obscure but he was active as a portraitist in England from 1617 to 1643. After the start of the Civil War he went to Holland, where he died.

JOOS van Cleve
The Holy Family
about 1515–20

Follower of JOOS van Cleve
The Crucifixion
probably 1525–35

After JOOS van Cleve
The Adoration of the Kings
probably 1525–50

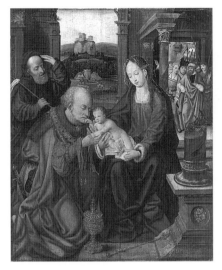

NG 2603
Oil on oak, painted surface 50.2 x 36.5 cm

NG 1088.1–3
Oil on canvas, transferred from oak, central part
72.2 x 49.8 cm; wings, each 75.6 x 21.6 cm

NG 2155
Oil on oak, 66.7 x 55.2 cm

Saint Joseph, in spectacles and reading from a book on a lectern, appears behind the Virgin Mary and the Child Jesus. The Virgin fingers three cherries (sometimes known as the fruit of paradise and a symbol of heaven); the lily in a glass symbolises her purity. The presence of a knife and a cut lemon has been said to indicate that the subject is the weaning of Christ.

NG 2603 is generally considered an early work by Joos van Cleve. Numerous versions of the composition are known.

The figure of Jesus was originally painted in a seated position.

Collection of George Salting by 1890; Salting Bequest, 1910.

Davies 1968, pp. 101–2; Hand 1982, pp. 159–60, 299.

Inscribed on the cross: INRI. Inscribed above the arms of the donor: WB.

The Virgin Mary and John the Evangelist are shown on either side of the Crucified Christ. The donor and donatrix on the wings have unidentified coats of arms. The Way to Calvary can be seen in the background of the left wing, the Resurrection in the background of the right wing.

These panels have been associated with the work of a remote follower of Joos van Cleve, and have been tentatively dated (on the basis of style and costume) to about 1525–35.

The Archangel Gabriel (NG 1088.4) was originally on the reverse of the left wing, and the Virgin Annunciate (NG 1088.5) on the reverse of the right wing.

Collection of Karl Aders, London, by 1832; bequeathed by Mrs Joseph H. Green, 1880.

Davies 1968, pp. 103–4; Martens 1990, pp. 237–70.

The Three Kings journeyed to Bethlehem to honour the new-born Jesus. They followed a star (to which one of the figures in the background was probably pointing), and brought gifts of gold, frankincense and myrrh. New Testament (Matthew 2: 2–12). The figures in the right background form the kings' retinue.

NG 2155 is the central panel of a triptych, and has been cut at the top and at both sides. Only one of the kings is seen in NG 2155; the other two are presumed to have been on the missing wings of the triptych. There are several versions of the complete composition, one of which (Detroit, Institute of Art) bears the initials J.B. (a supposed signature of Joos van Cleve). NG 2155 seems to be a copy of the sixteenth century, but it was not necessarily painted in the workshop of the master.

Krüger collection, Minden, by 1848; from where bought, 1854.

Davies 1968, pp. 102–3.

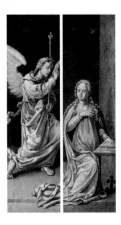

NG 1088.4–5

JOOS van Cleve
active about 1511; died 1540/1

Previously known as the Master of the Death of the Virgin after two altarpieces in Cologne and Munich, this painter is probably to be identified as Joos van Cleve (also known as Joos van der Beke) who became a master in Antwerp in 1511 and died in the winter of 1540–1. He also painted at the French court.

Attributed to JOOS van Wassenhove
Music
about 1480

NG 756
Oil on poplar, painted surface 155.6 x 97.2 cm

Inscribed on the entablature behind the throne: I (?)ECLESIE CONFALONERIVS (a reference to the patron's office as Standard Bearer (Commander in Chief) of the papal armies).

The figure, who has been identified as Music (one of the Seven Liberal Arts), is enthroned and points to an organ. The kneeling youth may be Costanzo Sforza (born 1447), one of whose *imprese* may have been a spray of laurel (seen hanging behind him).

NG 756 and 755 are parts of a series which probably represented the Seven Liberal Arts; see further under NG 755.

On the reverse are drawings of nude figures, a horseman, heads, etc.

Possibly from the ducal palace at Gubbio; Cosimo Conti, Principe di Trevignano (1809–55), Florence; subsequently William Spence, Florence; from whom bought, 1866.

Davies 1954, pp. 142–57; Davies 1968, pp. 72–8; Dunkerton 1991, pp. 115–16; Reynaud and Ressort 1991, pp. 82–116.

Workshop of JOOS van Wassenhove
Rhetoric (?)
about 1480

NG 755
Oil on poplar, painted surface 156.8 x 105.4 cm

Inscribed on the entablature behind the throne: DVX VRBINI MONTIS FERETRI AC (Duke of Urbino, [Count of] Montefeltro and ...).

The enthroned figure, pointing to a book, is thought to represent Rhetoric (one of the Seven Liberal Arts).

NG 755 and 756 are parts of a series which probably represented the Seven Liberal Arts of which two others (formerly Berlin, destroyed 1945) represented *Astronomy* and *Dialectic (?)* (with a portrait of Federico da Montefeltro). The series may have been made for Federico's palace in Gubbio: they were perhaps intended to go above the intarsia panelling (now New York, Metropolitan Museum of Art) in his *studiolo* there. The attribution to Joos depends on comparison with the series of Famous Men painted for the *studiolo* in the ducal palace at Urbino which appears to have been completed in 1476.

Drawings including a male torso and a horse are on the reverse.

Possibly from the ducal palace at Gubbio; Cosimo Conti, Principe di Trevignano (1809–55), Florence, subsequently William Spence, Florence; from whom bought, 1866.

Davies 1954, pp. 142–57; Davies 1968, pp. 71–8; Dunkerton 1991, pp. 115–16; Reynaud and Ressort 1991, pp. 82–116.

Jacob JORDAENS
The Virgin and Child with Saints Zacharias, Elizabeth and John the Baptist, about 1620

NG 3215
Oil on canvas, 114 x 153 cm

The visit of the Virgin and Child to Saint John and his parents, Saints Zacharias and Elizabeth, is described in the *Meditations* of the Pseudo-Bonaventura. Christ points to the goldfinch (a symbol of the Passion) released from the cage held by the Baptist, who leans over his emblem, the lamb. Christ's gesture may be intended to signal his longing for the Passion, which had been prophesied by Saint John.

NG 3215 is probably an autograph variant, executed around 1620, of a signed picture (Raleigh, North Carolina Museum of Art).

Perhaps bought by Mr Greenwood and sold by him at Christie's, 1773; Lord [Henry] Francis Pelham-Clinton-Hope sale, Christie's, 1917; bought (Clarke Fund), 1917.

Martin 1970, pp. 89–91.

JOOS van Wassenhove
active 1460–about 1480/5?

Known during his activity in Italy as 'Giusto da Guanto' (Justus of Ghent) Joos was active in Antwerp by 1460 and was subsequently in Ghent (1464–9). By 1473/4 he was active at the ducal court in Urbino, where the altarpiece of the *Communion of the Apostles* is documented as his work. A number of works painted for Federico da Montefeltro, Duke of Urbino, have been associated with him.

Jacob JORDAENS
1593–1678

Jordaens, who was a portrait and figure painter, was born in Antwerp and taught by Adam van Noort. After the death of Rubens he became a leading artist in the Southern Netherlands, and worked for the monarchs of Spain, England and Sweden. He also worked for the house of Orange and the burgomasters of Amsterdam. He was a Protestant.

Jacob JORDAENS
The Holy Family and Saint John the Baptist
probably 1620–5

NG 164
Oil on oak, 123 x 93.9 cm

The Christ Child stands in front of the Virgin
holding rosary beads, while Saint Joseph looks on
from behind, and the infant Baptist at the left holds
a cross.

NG 164 was probably painted about 1620–5,
possibly under the influence of Caravaggio's
Madonna of the Rosary (now Vienna,
Kunsthistorisches Museum), which at that time was
in the Dominican church in Antwerp.

Presented by the 5th Duke of Northumberland, 1838.

Martin 1970, pp. 87–9.

Jacob JORDAENS
Portrait of Govaert van Surpele (?) and his Wife
probably 1636–8

NG 6293
Oil on canvas, 213.3 x 189 cm

Govaert van Surpele (1593–1674) held important
posts in the government of his native city of Diest in
south Brabant. He was married twice: first to
Catharina Cools (died 1629) and in 1636 to
Catharina Coninckx (died 1639). The style of the
costumes is of about 1635 and it is likely that Van
Surpele (whose coat of arms is in the background) is
shown with his second wife shortly after their
marriage.

*Collection of the 4th Duke of Devonshire by 1743;
acquired from the 11th Duke of Devonshire by
application of the 1956 Finance Act, 1958.*

Martin 1970, pp. 91–4.

Workshop of JUAN de Flandes
*Christ appearing to the Virgin with the Redeemed
of the Old Testament,* before 1505

NG 1280
Oil on chestnut, 20.9 x 15.3 cm

The scroll issuing from Christ's mouth is inscribed:
Mater.mea: dulci(ss?)ima (ego?) (sum?) . resvrrexi/
(adhuc?)/(m?)...../...../. (mse ?)...(Sweetest
mother I have risen...); on the Virgin's scroll:
Gaud(eo ?).... (tio?) et exultabo. .(ote ?) . (o ?).. /
Jhu.meo: . /.(I rejoice and exult in ... my Jesus...).; on
the scroll of the Redeemed: G(au) dium ... redempti
... precioso (NB) sanguin(e) (Filii?) tui... (Joy ...
redeemed by the precious blood of your son...)

Christ's descent into Hell or Limbo in order to
liberate the righteous of the Old Testament and his
subsequent appearance to the Virgin is not
described in the Gospels. But it is described in
apocryphal sources, such as the Acts of Pilate and
the Gospel of Saint Bartholomew.

NG 1280 is one of a series of 47 panels of about
the same size which belonged to Queen Isabella of
Castille and are first recorded in 1505. Most of them
show scenes from the life of Christ and the Virgin.
Of the surviving pictures from the series, the
majority are attributable to Juan de Flandes or his
studio. Originally the panels may have been
intended for an altarpiece with many
compartments.

On the verso are extensive remains of marbled
paint.

*Listed with the other panels in the series in the inventory
of the possessions of Queen Isabella at the castle of Toro
(Zamora province), 25 February 1505; bought from the
Henry Attwell Barnes collection, London, 1889.*

MacLaren/Braham 1970, pp. 41–7.

JUAN de Flandes
active from 1496; died before 1519

The artist was a painter of Flemish origin, called
Juan de Flandes (John of Flanders), who worked
in the service of Queen Isabella of Castille in 1496,
and from 1498 until her death in 1504. His real
name remains unknown, but he is almost certainly
identifiable with the Juan de Flandes who was
later active in Salamanca and Palencia.

Jens JUEL
Joseph Greenway
1788

Willem KALF
Still Life with the Drinking-Horn of the Saint Sebastian Archers' Guild, Lobster and Glasses
about 1653

Thomas de KEYSER
Portrait of Constantijn Huygens and his (?) Clerk
1627

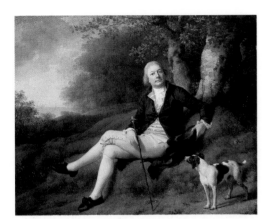

NG 6341
Oil on canvas, 79.8 x 99.1 cm

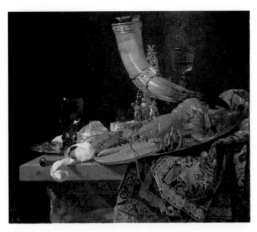

NG 6444
Oil on canvas, 86.4 x 102.2 cm

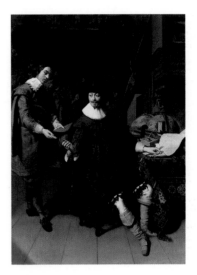

NG 212
Oil on oak, 92.4 x 69.3 cm

Signed and dated as if incised in the bark of the tree: Juel pinxit/ Hafniæ 1788.

Joseph Greenway was born in Devon. He amassed a fortune as a captain of a Danish East Indiaman and acquired Danish citizenship in 1785. He became Sheriff of Exeter in 1802–3, and Mayor in 1804–5, but is recorded as having died bankrupted, by 1821.

The background is said to represent an estate north of Copenhagen which belonged to a friend of the sitter.

In the possession of the sitter's descendants; presented according to the wish of Mrs Maud M. Greenway, 1963.

Feldeck 1966, pp. 193–4; Poulsen 1991, I, p. 134, no. 438.

Signed lower left: W.Kalf
The drinking-horn of the Amsterdam Guild of Archers was made in 1565; it is now in the city's Historisch Museum. Kalf's depiction varies slightly from the original, but generally follows its appearance. It is made from a buffalo horn set in a silver mount, the foot of which shows Saint Sebastian bound to a tree. The horn also appears in paintings by Metsu and van der Helst.

NG 6444 was presumably commissioned by a member of the guild. It was painted at about the same time as the *Still Life with Porcelain Jug, Roemer and Fruit* of 1653 (Munich, Alte Pinakothek).

Kalf also painted a variant in an upright format in which the composition is extended at the bottom (formerly New York, collection of K. Lilienfeld). Comparable arrangements of glasses, lobsters and fruit can be found in other works by the artist.

Possibly recorded in the inventory of the Amsterdam wine dealer Arnout Stevens, 1706; bequeathed by R.S. Newall, 1978.

MacLaren/Brown 1991, pp. 213–14.

Signed and dated on the front of the chimney-piece: TDK AN 1627. (TDK in monogram)
Constantijn Huygens the Elder (1596–1687), Lord of Zuylichem, served in the Dutch embassies in Venice and London and was knighted by James I in 1622. He became secretary to the Stadholder, Prince Frederik Hendrik of Orange in 1625, held the same post with his successor, Willem II, advised Frederik Hendrik's widow, Amalia van Solms, and served King William III until his death. Huygens was particularly interested in the arts: he wrote about painting (praising the young Rembrandt, among others), composed music and songs and was a poet. With his friend, the architect Pieter Post, he built his own house in The Hague. Behind Huygens hangs a tapestry showing Saint Francis before the Sultan; in the centre of its upper border is the sitter's coat of arms. Above the fireplace is a seascape in the style of Jan Porcellis (about 1584–1632), and beneath it a small bust portrait. The objects on the table refer to Huygens's interests in astronomy, music and architecture. They include a pair of terrestrial and celestial globes, a *chittarone* and architectural drawings.

Huygens is recorded in Amsterdam, where NG 212 was probably painted, between 22 February and 27 April 1627. It may be the work which he later described as having been painted shortly before his wedding (on 6 April 1627).

Probably collection of Susanna Louisa Huygens (died 1785); bequeathed by Richard Simmons, 1847.

MacLaren/Brown 1991, pp. 215–17.

Jens JUEL
1745–1802

Juel initially studied painting in Hamburg and then, from 1765, at the Academy in Copenhagen. He travelled to Italy and painted in Rome (1772–6). The artist then visited Paris and Geneva, before returning to Copenhagen in 1780. He was appointed court painter in the city, and later became director of its Academy.

Willem KALF
1619–1693

Kalf was born in Rotterdam. He may have been taught by Hendrick Pot in Haarlem or by François Ryckhals in Middelburg; he is recorded in Paris in 1641 but was back in Rotterdam in 1646. By 1653 he had settled in Amsterdam with his wife, Cornelia Pluvier, a distinguished poet and musician. Kalf first painted farm interiors, and later specialised in still lifes of an elaborate type known as *pronkstilleven*.

Thomas de KEYSER
1596/7–1667

Thomas Hendricksz. de Keyser was born in Amsterdam. He was the son and pupil of the architect and sculptor Hendrick de Keyser. He painted single and group portraits, popularising small full-length portraits and small equestrian portraits. He also painted some history pictures. Later he entered the Amsterdam stonemasons' guild, and in 1662 was appointed stonemason to the city.

Gustav KLIMT
Portrait of Hermine Gallia
1904

Christen KØBKE
Portrait of Wilhelm Bendz
about 1830

Christen KØBKE
The Northern Drawbridge to the Citadel in Copenhagen, 1837

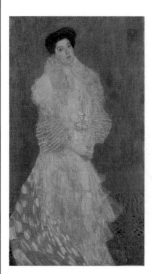

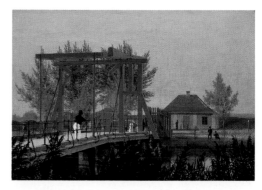

NG 6507
Oil (identified) on canvas, 44.2 x 65.1 cm

NG 6434
Oil on canvas, 170.5 x 96.5 cm

NG 6542
Oil on canvas, 22 x 19 cm

Signed and dated upper right in a cartouche: GUSTAV KLIMT 1904

Hermine Gallia (1870–1936), née Hamburger, married her uncle, Moritz Gallia, in 1893. A government adviser, he was a significant patron of the arts. In the portrait Hermine Gallia wears a dress designed by Klimt himself.

NG 6434 was exhibited unfinished at the Klimt-Kollektive exhibition at the Secession in November – December 1903.

There are numerous drawings for the composition and several pentimenti are visible, much of the figure's contour having been altered. The floor originally terminated nearer the level of the sitter's clasped hands. The pattern of the floor perhaps reflects the influence of Klimt's two visits to Ravenna in 1903.

Dr and Mrs Moritz Gallia; Professor Hans Jahre, Vienna; sale Christie's, London, 1971; bought, 1976.

Novotny 1975, p. 334, no. 138; National Gallery Report 1975–7, pp. 28–9; Strobl 1980–4, pp. 292–9; Smith 1985, p. 116.

The sitter Wilhelm Bendz (1804–32) was, like Købke, a pupil of C.W. Eckersberg at the Royal Academy of Fine Arts in Copenhagen. By 1830, although he was still receiving tuition and advice from Eckersberg, Bendz had apparently established a considerable reputation among younger artists. His portraits and interiors demonstrate that he was an accomplished artist with a preference for unusual and dramatic light effects. In 1831 Bendz set out on a Grand Tour to Germany and Italy but only got as far as Vicenza, where he died, apparently of typhoid fever. Bendz is shown holding his painter's maulstick, as if he has just been interrupted at his work. Within the small format, Købke projects a strong sense of the sitter's personality, describing his features in a lively yet precise, realist style.

NG 6542 was probably painted shortly before Bendz left Copenhagen.

Bendz is known to have exerted an important influence on Købke and the portrait records their close association. It was copied several times after the untimely death of the sitter and Købke himself made another version of it, perhaps as a souvenir for Eckersberg.

After the death of the sitter the portrait is recorded in the collection of his nephew, Dr Viggo Bendz; bought through Christie's from a private collection in Denmark, 1993.

Hannover 1893, p. 131, no. 25A; Krohn 1915, p. 6, no. 27; National Gallery Report 1992–3, pp. 16–17.

Signed and dated on the reverse: C.Købke Sept:1837

The view is taken from the citadel – a fort and barracks – overlooking Copenhagen harbour across one of the bridges over the surrounding moat. Although the citadel still exists, this drawbridge has been replaced and the exact site depicted in NG 6507 cannot be identified with certainty.

Købke lived with his family in the citadel until 1833 and it has been suggested that this work was painted as a gift for his mother. An oil sketch (Copenhagen, Statens Museum) and a detailed drawing (Copenhagen, Vejle Kunstmuseum) were made in preparation for the painting. Both have a grid of squares for transferring the design onto the final canvas, although Købke made a number of changes to the composition while working on NG 6507, adding extra figures and omitting a tree at the right.

Possibly given to the artist's mother, about 1837; collection of the artist's brother Kommandør Waldemar Hjartvar Købke by 1884; bought, 1986.

National Gallery Report 1985–7, pp. 26–7; Schwartz 1992, pp. 50–1.

Gustav KLIMT
1862–1918

Born in Baumgarten, near Vienna, Klimt studied at the Vienna Kunstgewerbeschule from 1876 to 1883. He collaborated on decorative compositions for numerous buildings in Vienna and in 1897 was a founding member and first president of the Vienna Secession. He resigned from the movement in 1905. As a painter Klimt influenced Kokoschka and Schiele, but he was also an important influence on the design of costume, furniture and architecture.

Christen KØBKE
1810–1848

Købke was born in Copenhagen, where he trained at the Royal Academy of Fine Arts from 1822 to 1832. In 1838 he travelled to Italy via Germany, visiting Rome, Pompeii and Naples, and sketching outdoors on Capri. Købke painted landscapes, mainly of the area around Copenhagen, and portraits, generally of relatives or close friends.

Willem KOEKKOEK
View of Oudewater
about 1867

Philips KONINCK
An Extensive Landscape with a Road by a River
1655

Philips KONINCK
An Extensive Landscape with a Town in the Middle Distance, about 1665–8

NG 6472
Oil on canvas, 64.8 x 84.4 cm

NG 6398
Oil on canvas, 137.4 x 167.7 cm

NG 6408
Oil on canvas, 43.7 x 53.5 cm

Signed lower left: W Koekkoek (WK in monogram).
 The clock tower to the left of centre in the distance is that of the Grote Kerk (church of St Michael) in the town of Oudewater. Much of the rest of the scene is probably intended to be picturesque rather than topographically accurate. Oudewater is on the river Ijssel between Gouda and Utrecht.
 NG 6427 is dated by comparison with other works by the artist.

Bequeathed by Miss J.M. Hawkins Turner, 1982.

MacLaren/Brown 1991, p. 218.

Signed lower right: P Koninck 1655
 The site has not been identified, and may be imaginary.
 NG 6398 is one of a pair of landscapes by Koninck (the other is at Firle Place, Sussex). The figures are by Koninck himself (unlike the figures in NG 836 and 4251).

Collection of E. Hooft by 1796; collection of Earl Granville by 1845; bought by W.H. Grenfell, 1845; by descent to the Viscountess Gage; from whom acquired under the terms of the 1956 Finance Act, 1971.

MacLaren/Brown 1991, p. 221.

Signed bottom right: PK (in monogram).
 The landscape setting has not been identified and is probably imaginary.
 This is probably a late work, painted in about 1665–8.

Mansfield collection by 1806; collection of W.C. Alexander, 1905; presented by the Misses Rachel F. and Jean I. Alexander; entered the collection in 1972.

MacLaren/Brown 1991, p. 222.

Willem KOEKKOEK
1839–1895

Koekkoek was born into a family of painters in Amsterdam and was taught by his father, Hermanus Koekkoek. After stays in The Hague and Utrecht, Willem returned to Amsterdam and then in 1885 settled in Nieuwer-Amstel (Amstelveen). He specialised in painting town views and street scenes based on those of the seventeenth-century painter Jan van der Heyden. He preferred picturesque effects to topographical accuracy.

Philips KONINCK
1619–1688

Philips Koninck was born in Amsterdam where he worked, having been trained in Rotterdam by his elder brother, Jacob. He is also said to have been taught by Rembrandt, whose influence is apparent in his landscapes. In his own time he was best known as a painter of portraits and genre subjects.

Philips KONINCK
An Extensive Landscape with a Hawking Party
probably about 1670

NG 836
Oil on canvas, 132.5 x 160.5 cm

Philips KONINCK
*An Extensive Landscape with Houses in a Wood
and a Distant Town,* about 1670

NG 4251
Oil on canvas, 101.5 x 146.5 cm

Paulus Constantijn LA FARGUE
The Grote Markt at The Hague
1760

NG 1918
Oil on mahogany, 57.6 x 75.9 cm

The canvas has been cut down on the right, where a right arm with a stick and the right leg of a man are visible.

The figures may be by Jan Lingelbach, who frequently painted figures in Koninck's and other artists' landscapes. If they are by him, NG 836 must have been painted before 1674, when Lingelbach died.

Bought by Lerouge in Paris, 1811; collection of Edmund Higginson, Saltmarsh Castle, 1838; collection of Sir Robert Peel, Bt, 1846; bought with the Peel collection, 1871.

MacLaren/Brown 1991, pp. 219–20.

NG 4251 was previously described as a view of Gelderland, but is probably an imaginary landscape.

The figures and animals are probably by Adriaen van de Velde. If they are, NG 4251 must have been painted before 1672, when van de Velde died.

There are two other versions of this composition by van de Velde (Moscow, Pushkin Museum; Cape Town, Michaelis collection).

Collection of Sir Charles Bagot by 1834; collection of Baron J.G. Verstolk van Soelen, The Hague; collection of Thomas Baring by 1846; by descent to the Earls of Northbrook, from whom bought with contributions from the Benson family and the NACF, 1927.

MacLaren/Brown 1991, pp. 220–1.

Signed and dated bottom centre: P.C. la Fargue Pinx 1760.

The market square (Grote Markt) is shown here from the Prinsengracht. On the extreme left is the Groot Boterhuis (the former butter market) on the wall of which are various sale bills. In the centre, beyond the houses (most of which have now been rebuilt), are the tower and roof of the choir of the Grote Kerk (St Jacob). The spire was built in the sixteenth century. The street leading to the church is the Schoolstraat.

Bought from the Hon. C. Sclater–Booth (Lewis Fund), 1903.

MacLaren/Brown 1991, pp. 222–3.

Paulus Constantijn LA FARGUE
1729–1782

The artist was born and worked chiefly in The Hague. He entered the painters' confraternity, *Pictura,* in the city in 1761. In 1768 he is recorded as a pupil of The Hague Academy. The artist mainly made topographical paintings in oil and watercolour of cities and villages in South Holland. He also made etchings and book illustrations. He was the most prolific member of a family of topographical artists.

Jan de LAGOOR
A Woody Landscape with a Stag Hunt
probably 1645–50

NG 1008
Oil on canvas, 112 x 148.5 cm

Laurent de LA HYRE
Allegorical Figure of Grammar
1650

NG 6329
Oil on canvas, 102.9 x 113 cm

Nicolas LANCRET
The Four Ages of Man: Childhood
1730–5

NG 101
Oil on canvas, 33 x 44.5 cm

Signed bottom left: Jᴰ Lag. . .f. (Jᴰ in monogram).
NG 1008 once had a false signature of Paulus Potter. There is no reason to doubt the damaged signature of Lagoor, and the picture is comparable to other signed works by him. Lagoor was a close follower of Jacob van Ruisdael.

Wynn Ellis collection by 1851; Wynn Ellis Bequest, 1876.

MacLaren/Brown 1991, pp. 223–4.

Signed bottom left: L. DE LA HIRE in. X F.1650.
Inscribed on the ribbon: VOX LITTERATA ET ARTICVLATA DEBITO MODO PRONVNCIATA (A meaningful and literate word spoken in a correct manner).
Grammar, one of the Liberal Arts, is here personified as a woman. The essence of this art is explained in the inscription. She waters plants (primulas and anemones). In an edition of Ripa's *Iconologia* (Paris, 1644) which may have been known to the artist it was said that: 'Like tender plants, by means of cultivation young brains carry the fruits of exquisite doctrine for the common utility of the public.'
NG 6329 is from a series of seven paintings representing the Liberal Arts (Grammar, Rhetoric, Dialectic, Arithmetic, Music, Geometry and Astronomy) that La Hyre executed in 1649–50 for Gédéon Tallemant (1613–68), one of Louis XIII's councillors. The paintings were intended for his house in the Marais district of Paris. The other six allegories survive: *Astronomy*, 1649 (Orléans, Musée des Beaux-Arts); *Music*, 1649 (New York, Metropolitan Museum of Art); *Geometry*, 1649 (France, private collection); *Arithmetic*, 1650 (Holland, Heino, Foundation Hannema-De Stuers); *Rhetoric*, 1650, *Dialectic*, 1650 (both Switzerland, Bürgenstock Castle). Other versions of *Grammar* and *Arithmetic* (both Baltimore, Walters Art Gallery) and a second version of *Geometry* (Ohio, Toledo Art Museum) are also known.

Hôtel Tallemant, Paris, probably until 1760; Cardinal Fesch collection, 1844; bequeathed by Francis Falconer Madan, 1961.

Wilson 1985, pp. 50–1; Rosenberg 1988, pp. 292–302; Wine 1992, pp. 84–7; Wine 1993, pp. 23–33.

Children play within a loggia, pulling along a girl on a toy cart, while a nurse who holds an infant looks on.
NG 101 is the first of a series of four canvases by Lancret (see also NG 102, 103, 104) which represent the Four Ages of Man – Childhood, Youth, Maturity, and Old Age. The series was engraved by Nicolas de Larmessin IV. The production of these prints was announced in the *Mercure de France* in July 1735. It is reasonable to assume that the paintings were executed a little before that date.

Collection of the Marquis of Bute; Beckford (Fonthill Abbey) sale, 1823; bequeathed by Lt.-Col. J.H. Ollney, 1836/7.

Wildenstein 1924, p. 73, no. 30; Davies 1957, pp. 127–8.

Jan de LAGOOR
active 1645–1659

Lagoor entered the Haarlem guild in 1645, and was a *hoofdman* (senior official) in 1649. In 1659 he was declared insolvent in Amsterdam. He was a landscape painter, and an etcher, who was influenced by Cornelis Vroom and subsequently by Jacob van Ruisdael.

Laurent de LA HYRE
1606–1656

Born in Paris and initially taught by his father, La Hyre worked at Fontainebleau in about 1623, and briefly in the studio of Georges Lallement in Paris in about 1625, before becoming an independent painter. He painted altarpieces, works of interior decoration and easel pictures. He was a founder of the Académie in 1648.

Nicolas LANCRET
1690–1743

Lancret was born in Paris where he worked throughout his life. He studied as a pupil of Pierre Dulin, and then probably after 1711 under Gillot. He was elected to the Académie in 1719, and became a very successful painter of *fêtes galantes* inspired by Watteau, and genre scenes influenced by Detroy.

Nicolas LANCRET
The Four Ages of Man: Youth
1730–5

Nicolas LANCRET
The Four Ages of Man: Maturity
1730–5

Nicolas LANCRET
The Four Ages of Man: Old Age
1730–5

NG 102
Oil on canvas, 33 x 44.5 cm

NG 103
Oil on canvas, 33 x 44.5 cm

NG 104
Oil on canvas, 33 x 44.5 cm

A girl pulling on a stocking at the right is attended by a young man standing by her. The centre of attention in the room is another girl bedecked in flowers who admires herself in a mirror.

NG 102 is the second in a series of four canvases by Lancret (see also NG 101, 103, 104) which represent the Four Ages of Man. For further comment see NG 101.

A preparatory drawing for this composition survives (London, British Museum).

Collection of the Marquis of Bute; Beckford (Fonthill Abbey) sale, 1823; bequeathed by Lt.-Col. J.H. Ollney, 1836/7.

Wildenstein 1924, p. 73, no. 31; Davies 1957, pp. 127–8.

In the foreground stand two archers, one of whom shoots into the air. Behind them are men and women engaged in amorous pursuits.

NG 103 is the third in a series of four canvases by Lancret (see also NG 101, 102, 104) which represent the Four Ages of Man. For further comment see NG 101.

Collection of the Marquis of Bute; Beckford (Fonthill Abbey) sale, 1823; bequeathed by Lt.-Col. J.H. Ollney, 1836/7.

Wildenstein 1924, p. 73, no. 32; Davies 1957, pp. 127–8.

A young girl rejects the advances of an old man at the left. At the right two elderly women are seated, one spinning and the other asleep.

NG 104 is the last in a series of four canvases by Lancret (see also NG 101, 102, 103) which represent the Four Ages of Man. For further comment see NG 101.

Collection of the Marquis of Bute; Beckford (Fonthill Abbey) sale, 1823; bequeathed by Lt.-Col. J.H. Ollney, 1836/7.

Wildenstein 1924, p. 73, no. 33; Davies 1957, pp. 127–8.

Nicolas LANCRET
The Four Times of the Day: Morning
1739

Nicolas LANCRET
The Four Times of the Day: Midday
1739–41

Nicolas LANCRET
The Four Times of the Day: Afternoon
1739–41

NG 5867
Oil on copper, 28.6 x 36.5 cm

NG 5868
Oil on copper, 28.9 x 36.8 cm

NG 5869
Oil on copper, 28.6 x 36.8 cm

A commentator at the Salon of 1739 at which NG 5867 was exhibited wrote: 'This young person, with her bodice nonchalantly open and her dressing gown thrown back ... pours tea into the cup that M. l'Abbé holds out to her with a distracted air; because he is attentive only to this beauty's disarray. A maid takes it all in, smiling slyly.' The time on the clock is about eight minutes past nine.

This is the first in a series of four works by Lancret (see also NG 5868, 5869, 5870) which illustrate the Four Times of the Day – Morning, Midday, Afternoon, and Evening. The series was engraved by Nicolas Larmessin IV; he presented the prints to the Académie in Paris in 1741, so all the paintings must have been completed before then. As mentioned above, this work was exhibited at the Salon in 1739.

Compositions such as NG 5867 were satirised by Hogarth (see Hogarth NG 116).

Probably Marquess of Bute sale, 1822; Sir Godfrey Macdonald of the Isles (from Thorpe Hall, Rudston) sale, 1935; bequeathed by Sir Bernard Eckstein, 1948.

Wildenstein 1924, p. 74, no. 34; Davies 1957, pp. 128–9; Wilson 1985, p. 86; Holmes 1991, pp. 90–1, no. 16.

The four figures who have been picking flowers in a garden stop by a sundial to check their watches; the time shown on it is midday.

This is the second in a series of four works by Lancret (see also NG 5867, 5869, 5870) which illustrate the Four Times of the Day. For further discussion see NG 5867.

Probably Marquess of Bute sale, 1822; Sir Godfrey Macdonald of the Isles (from Thorpe Hall, Rudston) sale, 1935; bequeathed by Sir Bernard Eckstein, 1948.

Wildenstein 1924, p. 74, no. 35; Davies 1957, pp. 128–9; Holmes 1991, pp. 90–1, no. 16.

Four figures, who appear to be the same as those depicted by Lancret in NG 5868, play a game of backgammon outdoors.

This is the third in a series of four works by Lancret (see also NG 5867, 5868, 5870) which illustrate the Four Times of the Day. For further discussion see NG 5867.

Probably Marquess of Bute sale, 1822; Sir Godfrey Macdonald of the Isles (from Thorpe Hall, Rudston) sale, 1935; bequeathed by Sir Bernard Eckstein, 1948.

Wildenstein 1924, p. 74, no. 36; Davies 1957, pp. 128–9; Holmes 1991, pp. 90–1, no. 16.

Nicolas LANCRET
The Four Times of the Day: Evening
1739–41

NG 5870
Oil on copper, 28.9 x 36.8 cm

Nicolas LANCRET
A Lady in a Garden taking Coffee with some Children, probably 1742

NG 6422
Oil on canvas, 88.9 x 97.8 cm

Bernardino LANINO
The Madonna and Child with Saint Mary Magdalene, a Sainted Pope, Saint Joseph (?) and Saint Paul, 1543

NG 700
Oil on wood, 205.7 x 133.4 cm

Five women bathe and dry themselves by moonlight.

This is the last in a series of four works by Lancret (see also NG 5867, 5868, 5869) which illustrate the Four Times of Day. For further discussion see NG 5867.

Probably Marquess of Bute sale, 1822; Sir Godfrey Macdonald of the Isles (from Thorpe Hall, Rudston) sale, 1935; bequeathed by Sir Bernard Eckstein, 1948.

Wildenstein 1924, p. 74, no. 37; Davies 1957, pp. 128–9; Holmes 1991, pp. 90–1, no. 16.

The traditional title of the work is *La Tasse de Chocolat* (The Cup of Chocolate), but when it was first exhibited (see below) it was called *Une dame dans un Jardin prenant du Caffé avec des Enfans*, and the utensil the servant holds is actually a coffee pot. Honeysuckle grows around the urn. A toy doll lies on the ground behind the dog. The group probably represents a family and their manservant, but there is no evidence that the figures were portraits.

NG 6422 was exhibited at the Salon in 1742 (no. 50). It is thought it was probably executed in that year.

Bequeathed by Sir John Heathcoat Amory, Bt, with life interest to Lady Amory, by whom presented, 1973.

Wildenstein 1924, p. 112, no. 621; Wilson 1985, p. 88; Holmes 1991, p. 96, no. 18.

Signed and dated on a cartellino bottom left: Bernardinus / Effigiabat 1543 (Bernardino made this likeness 1543); and inscribed on the paper held by Saint Paul: Justificati / ex fide / ergo / ad (Therefore being justified by faith [we have peace with God through our Lord Jesus Christ]).

Saint Paul holds a paper with an inscription from his Letter to the Romans (New Testament, Romans 5: 1). In the background Christ appears (as a gardener) to the Magdalen on the morning after the Resurrection, but tells her not to touch him ('noli me tangere') (New Testament, John 20: 14–18).

NG 700 was painted as an altarpiece for the chapel, dedicated to the Magdalen, in the church of S. Paolo in Vercelli. It was commissioned in 1540 by Francesco de Strata. The altarpiece originally had a predella depicting six events from the life and conversion of the Magdalen; this has not been traced.

A cartoon survives for the top half of the composition (Birmingham, Barber Institute) and a preparatory drawing in Turin (Biblioteca Reale) may also be related to this altarpiece.

Recorded in the church of S. Paolo in Vercelli, 1759; bought, 1863.

Gould 1975, pp. 127–8; Romano 1986, p. 252.

Bernardino LANINO
about 1512; died 1583

Bernardino Lanino was a member of a family of painters from Vercelli. He seems to have worked with Gaudenzio Ferrari. Documented works (frescoes and altarpieces) date from 1534.

Nicolas de LARGILLIERRE
Portrait of a Man
probably 1710

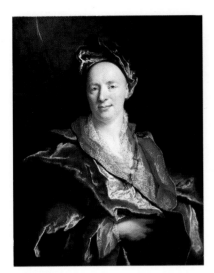

NG 5585
Oil on canvas, 91.4 x 71.1 cm

Several identifications have been made for the sitter, none entirely satisfactory. The most likely is based on a version of the painting in the Uffizi, Florence, which is said to represent the poet Jean-Baptiste Rousseau (1670–1741) and which is dated 1710 on a label on the back. This identification might be correct, but there seem to be no other portrayals of the poet at a similar age which can be compared with NG 5585 to prove it, and the type of frogging on the sitter's jacket would have been unusual in 1710.

According to a label on the back from the Comte de Chabert, but not in the Vicomte G. Chabert sale, Paris, 1909; probably passed from the Duchess of Manchester (died 1909) to her sister, Emilie Yznaga: by whom bequeathed, 1945.

Davies 1957, pp. 129–31; Rosenfeld 1981, pp. 233–4.

Attributed to LARGILLIERRE
Princess Rákóczi
probably 1720

NG 3883
Oil on canvas, 136.5 x 104.1 cm

The identification of the sitter is traditional. The princess was Charlotte Amelia (1679–1722), daughter of the Landgrave of Hesse-Rheinfels. In 1694 she married the Hungarian patriot Francis Rákóczi II, Prince of Transylvania. From 1713 until her death she lived in Paris. Another version of NG 3883 (New York, private collection) is signed and dated 1720 on the back of the canvas. The sitter in the New York version, possibly the original, is said to be the Marquise de Soucarière.

NG 3883 is perhaps by a close follower of Largillierre.

Clifford Waterman Chaplin sale, 1910; bought, 1924.

Davies 1957, p. 131.

Pieter LASTMAN
Juno discovering Jupiter with Io
1618

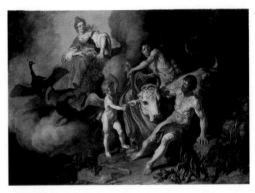

NG 6272
Oil on oak, 54.3 x 77.8 cm

Signed and dated, top right: Pietro Laſtman / fecit Aº 1618.

There are numerous versions of the story of Io. The account best known in later times is that in Ovid's *Metamorphoses* (I, 583ff.). Io was seduced by Jupiter. He spread a dark cloud to trap her and Juno, looking down from the sky, saw it and descended to earth to look for him. She appears with her attributes, the peacocks, at the upper left. Jupiter, hoping to deceive Juno, turned Io into a heifer, but Juno asked for the animal and gave it to the hundred-eyed Argus to guard. Jupiter ordered Mercury to kill Argus, and Io, still as the heifer, wandered in Egypt. Eventually Juno allowed Jupiter to transform her back to human form. Lastman shows the moment in the story when Juno asks Jupiter for the heifer as a gift. The actions and gestures of the principal figures are so close to Ovid's text that Lastman was presumably following it in detail. He adds, however, two figures not mentioned by Ovid – a winged child, who is Love, and Deceit, wearing a mask and a fox's skin. After the death of Argus, Juno took his eyes to decorate the tail of the peacock; Lastman correctly shows the birds here without the 'eyes'.

Anon. sale, London, 1957; presented by Julius Weitzner, 1957.

MacLaren/Brown 1991, p. 225.

Nicolas de LARGILLIERRE
1656–1746

Largillierre, who specialised as a portraitist, was born in Paris. He was a pupil of Antoni Goubau in Antwerp from 1668 to 1673. In 1675 he came to England and was assisting Antonio Verrio at Windsor Castle in 1679; after an interlude in Paris, he briefly returned to England in 1686–7, before settling in Paris, where he flourished. He became director of the Académie in Paris (1738–42).

Pieter LASTMAN
1583–1633

Pieter Pietersz. Lastman was probably born in Amsterdam. He may have studied with Gerrit Pietersz. Sweelinck, before leaving for Italy. From 1604 he was in Rome. He returned to Amsterdam by 1607 and painted religious and mythological works which were inspired by Elsheimer and Caravaggio. He was the leading history painter in Amsterdam; among his pupils were Jan Lievens and Rembrandt.

Pieter LASTMAN
The Rest on the Flight into Egypt
1620

L162
Oil on wood, 61.8 x 98.5 cm

Inscribed and dated lower right: P Lastman (PL in monogram) fecit. 1620.

The Holy Family fled to Egypt because Saint Joseph had been warned in a dream that Herod wanted to kill the Christ Child. New Testament (Matthew 2: 13–15). Here they are shown resting on the journey, close to a waterfall. The apple Joseph holds refers to the Fall, from which Christ as the new saviour will redeem mankind.

Lastman was the leading painter of biblical and mythological subjects in Amsterdam in the early seventeenth century and the teacher of Rembrandt and Jan Lievens. In this important dated work the landscape is more extensive than is usual in his biblical scenes: it displays his study of the landscapes of Elsheimer during his stay in Italy and familiarity with the work of the contemporary Dutch landscape painter, Jacob Pynas.

On loan from the Master Governor of Trinity Hospital, Retford, since 1986.

Brown 1986, p. 192, no. 85.

Maurice-Quentin de LA TOUR
Henry Dawkins
about 1750

NG 5118
Pastel on paper, mounted on canvas, 66.7 x 53.3 cm

NG 5118 was identified as Henry Dawkins when sold by the Dawkins family in 1913. This identification may be confirmed by a label on the reverse, although this could also refer to ownership.

Henry Dawkins (1728–1814) was MP for Southampton. La Tour probably painted this pastel portrait in Paris in about 1750, although a date in the 1760s has also been suggested.

Collection of Revd. E.H. Dawkins by 1913; bequeathed by C.B.O. Clarke, 1940.

Besnard 1928, p. 138; Davies 1957, pp. 131–2; Bury 1971, pl. 63.

Maurice-Quentin de LA TOUR
1704–1788

Maurice-Quentin de La Tour was born in St-Quentin, Picardy, and was principally active as a pastel portraitist in Paris where he regularly exhibited at the Salons. He was popular with male and female sitters from a wide range of society.Sir

Thomas LAWRENCE
Queen Charlotte
1789–90

NG 4257
Oil on canvas, 239.4 x 147.3 cm

Charlotte Sophia of Mecklenburg-Strelitz (1744–1818) married George III of England in 1761. She sat to Lawrence in the autumn of 1789, but did so unwillingly, still feeling the strain of the king's recent mental illness. The pearl bracelets on Queen Charlotte's wrists were part of the king's wedding gift to her; one clasp contains his portrait miniature, the other his royal monogram. Mrs Papendiek, one of her household, thought the likeness 'stronger than any I can recollect'; but the portrait failed to please the king and queen, and remained on Lawrence's hands.

In Lawrence's studio sale, 1831, bought by Sir Matthew White Ridley; offered unsuccessfully at Christie's, 8 July 1927; bought shortly afterwards from the Trustees of the late 2nd Viscount Ridley (Temple–West, Lewis and Florence Funds), 1927.

Davies 1959, pp. 74–5; Levey 1979, pp. 25–6; Garlick 1989, p. 168, no. 186.

Sir Thomas LAWRENCE
1769–1830

Lawrence was born in Bristol and entered the Royal Academy Schools in 1787, although he was almost entirely self-taught. He succeeded Reynolds in 1792 as King's Painter and was knighted in 1815; he was president of the Royal Academy from 1820. A highly successful painter with steady royal patronage, the vast majority of his work was portraiture.

Sir Thomas LAWRENCE
John Julius Angerstein
probably about 1790–5

NG 6370
Oil on canvas (sight), 76.2 x 64.8 cm

John Julius Angerstein (1735–1823) was a banker and collector who was instrumental in the development of Lloyds as a great insurance house. He was of German origin, but lived in England from about 1750. His collection was bought for the nation in 1824 by the government of Lord Liverpool and formed the original nucleus of the National Gallery.

Unlike NG 129, another portrait of the sitter by Lawrence, NG 6370 was painted from life. Lawrence used a canvas on which he had already painted an unknown sitter.

Bequeathed by Miss May Rowley, a descendant of the sitter's daughter, 1965.

Garlick 1989, pp. 136–7, no. 29c.

Sir Thomas LAWRENCE
John Julius Angerstein
about 1823–8

NG 129
Oil on canvas, 91.4 x 71.1 cm

John Julius Angerstein (1735–1823) is also the subject of NG 6370 where further details of the sitter are given.

NG 129 is a replica, commissioned by George IV a few months after Angerstein's death, of a portrait which Lawrence had painted for Angerstein in 1816. Angerstein had been a patron of Lawrence since the early 1790s and the artist painted his likeness on several occasions (including NG 6370). NG 129 was paid for in 1824 but was not delivered until 1828.

Commissioned by George IV; presented by William IV, 1836.

Davies 1959, pp. 72–4; Garlick 1989, pp. 136–7, no. 29d.

Gregorio LAZZARINI
Portrait of Antonio (?) Correr
1685

NG 3933
Oil on canvas, 125.7 x 97.2 cm

Inscribed on the pilaster: ANTONIO CORARIUS/ figlio di/ VETOR. PROCURATOR/ DI/ S.MARCO/ 1685/ Gº LAZZARINI/ fece. (Antonio Correr, son of Vittore, Procurator of S. Marco, 1685, made by Gregorio Lazzarini.) On the letter: A Sua Eccellenza/ Il N.H. Sò Antonio Corer/Venezia. (To his Excellency, the Noble and Honourable Signore Antonio Correr, Venice.)

On the left is the Correr coat of arms. The identification of the sitter, however, is problematic since no Antonio Correr, son of Vittore, is known to have been a Procurator of S. Marco. It is not improbable that the inscription on the pilaster has been tampered with and that the sitter could actually be Vittore Correr (1658–1714), who became a Procurator of S. Marco in 1685. The portrait is of a type commonly made to mark an official appointment in the Venetian state administration. The sitter wears the winter costume of a Venetian nobleman.

Tanara collection, Verona; bought by J.P. Richter for the Mond collection, 1888; Mond Bequest, 1924.

Levey 1971, pp. 149–50.

Gregorio LAZZARINI
1655–1730

Lazzarini was born in Venice. He first studied under Francesco Rosa and then with Forabosco and Pietro della Vecchia. The artist painted religious and mythological works, as well as portraits, and enjoyed the patronage of the Venetian nobility. Giambattista Tiepolo was among his pupils. He died in Villabona (Polesine).

Frederic, Baron LEIGHTON of Stretton
Cimabue's Celebrated Madonna is carried in Procession through the Streets of Florence, 1853–5

The LE NAIN Brothers
Four Figures at Table
perhaps 1630s

The LE NAIN Brothers
The Adoration of the Shepherds
probably late 1630s

L275
Oil on canvas, 222 x 521 cm

NG 3879
Oil on canvas, 44.7 x 54.9 cm

NG 6331
Oil on canvas, 109.5 x 137.4 cm

The picture illustrates the account in Vasari's *Lives of the Artists* of how, in the thirteenth century, the newly completed painting of the Madonna and Child was carried from the painter Cimabue's house to the church of S. Maria Novella in Florence; the painting (the *Rucellai Madonna*, Florence, Uffizi) is now attributed to Duccio. In the centre walks Cimabue with his boy pupil Giotto; behind are other painters, and in the corner the poet Dante watches. Vasari also describes the earlier viewing of the painting by Charles of Anjou, King of Naples, and Leighton includes him in the picture, on horseback, at the extreme right.

L275 was painted in Rome, and exhibited at the Royal Academy in 1855. It was greatly admired, and ensured the success of Leighton's career as a painter.

Bought by Queen Victoria, 1855; on loan from Her Majesty The Queen since 1988.

Ormond 1975, pp. 26–31, 150, no. 25; National Gallery Report 1988–9, pp. 20–1.

This work (of which a number of copies are known) has in the past been called 'Saying Grace' (because of the attitude of the small girl), and 'The Three Ages' (because of the states of childhood, youth and maturity represented by the figures). Neither description seems entirely satisfactory, hence the title above. The older woman and youngest child also appear in another painting attributed to the brothers, *Landscape with Chapel* (Hartford, Connecticut, Wadsworth Atheneum).

X-radiographs reveal that the composition is painted over a bust-length portrait of a man who is bearded and wears a ruff. The man's costume can be dated to around the 1620s; the portrait may also have been the work of the brothers Le Nain. A strip at the bottom of the canvas is an addition.

P.M. Turner, 1922; presented by F. Hindley Smith, 1924.

Davies 1957, p. 135; Thuillier 1978, pp. 162–4, no. 23; Wilson 1978, pp. 530–3; Wine 1992, pp. 98–101, no. 5; Rosenberg 1993, pp. 78–9, no. 29.

Before classical ruins (symbolic of the old order, now superseded by Christianity) shepherds and angels with Joseph and Mary adore the Christ Child. New Testament (Luke 2: 7–20). An angel and one of the shepherds look away to the left; they might be distracted by the approaching Magi. That the boy wears a hat may signify he is a non-believer, outside of the circle of the faithful, or he may be simply a genre figure.

On stylistic grounds NG 6331 can be dated to the late 1630s. A related, although more crowded, depiction of the same subject by the Le Nains or a copyist (Dublin, National Gallery of Ireland) is dated to 1644. The kneeling shepherd recalls comparable figures by Caravaggio; while the Virgin seems akin to the creations of Orazio Gentileschi.

The painting was executed over an earlier composition in which the head of the Virgin, turned towards the right, can be seen between those of Joseph and the boy shepherd.

Possibly Duke of Chartres sale, 1834; said to have been acquired by one of the Dukes of Norfolk, 19th century; acquired from the 16th Duke of Norfolk, through Leggatt Bros, 1962.

Thuillier 1978, no. 9, pp. 117–18; Wilson 1985, p. 48; Wine 1992, no. 6, pp. 102–5; Rosenberg 1993, p. 86, no. 50.

Frederic, Baron LEIGHTON of Stretton
1830–1896

One of the most successful painters of Queen Victoria's reign, Leighton studied in Italy and Germany, and was strongly influenced by German painting. He was elected president of the Royal Academy in 1878, and was active in organising exhibitions of Old Master paintings. His own work included portraits, landscapes and, especially, evocations of the classical past.

The LE NAIN Brothers
Antoine (about 1600–48), Louis (about 1603–48) and Mathieu (about 1607–77)

These three artist brothers were born in Laon. The traditional dates of birth for Antoine (1588) and Louis (1593) are almost certainly wrong. In 1629 Antoine entered the painters' guild of St-Germain-des-Prés, Paris. He established a studio in the city in which the three brothers painted peasant scenes, portraits and religious works. There are problems in distinguishing their respective contributions. The brothers were admitted to the Académie in 1648.

The LE NAIN Brothers
A Woman and Five Children
1642

The LE NAIN Brothers
Three Men and a Boy
probably 1640s

Attributed to Ignacio de LEON y Escosura
A Man in 17th-Century Spanish Costume
1850–90

NG 1425
Oil on copper, 25.5 x 32 cm

NG 4857
Oil on canvas, 53.3 x 63.5 cm

NG 1308
Oil on canvas, 92.7 x 69.9 cm

Signed and dated bottom right: Lenain, fecit 1642.

This work has been known by various titles in the past, including 'A Family Group', 'Le Goûter' and 'The Tasting'. It is one of a number of domestic genre scenes by the Le Nain brothers set before a neutral backdrop. Strips of wood extend the support beyond the copper on all sides.

Probably Pierre-Maximilien De la Fontaine sale, 1807; presented by Lesser Lesser, 1894.

Davies 1957, pp. 134–5; Thuillier 1978, pp. 148–50, no. 18; Rosenberg 1993, p. 74, no. 13.

It has been suggested that the three principal figures in this work may be portraits of the Le Nain brothers (see biography). The head of the boy at the right was revealed from beneath overpaint when the picture was cleaned in 1968. The work has in the past been given the title 'A Trio of Geometers (?)' because the overpaint included in the foreground geometrical instruments and a globe.

Apparently in the collection of John Walter (1776–1847) or his son, also John, in 1846; A.F. Walter of Bearwood sale, 1913; presented by Mrs N. Clark Neill in memory of her husband, 1936.

Davies 1957, pp. 135–6; Thuillier 1978, p. 248, no. 46; Wilson 1978, pp. 530–3.

NG 1308 is a nineteenth-century imitation of a seventeenth-century painting. It is based on a life-size picture of a dwarf in the manner of Velázquez (Madrid, Prado). Infra-red photographs have demonstrated that NG 1308 was painted over a seventeenth- or eighteenth-century flower piece. The attribution depends on Charles Terry, who wrote in 1897 that he had been told by Ignacio de León that the painting was a pastiche León had painted after Velázquez and given to a dealer in London.

Presented by Charles Henry Crompton-Roberts, 1890.

MacLaren/Braham 1970, pp. 47–8.

Ignacio de LEON y Escosura
1834–1901

León was born at Oviedo and studied in Madrid and Paris. He spent much of his life in Paris, and is known for his historical and costume pictures in the style of Meissonnier.

LEONARDO da Vinci
The Virgin and Child with Saint Anne and Saint John the Baptist, perhaps about 1499–1500

LEONARDO da Vinci
The Virgin of the Rocks (The Virgin with the Infant Saint John adoring the Infant Christ accompanied by an Angel), about 1508

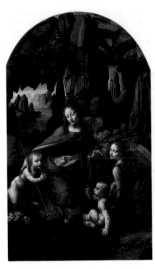

Associate of LEONARDO
An Angel in Red with a Lute
probably about 1490–9

NG 6337
Charcoal, black and white chalk on tinted paper, 141.5 x 104.6 cm

The Virgin Mary sits on the lap of her mother, Saint Anne, who was often represented in this way. The Christ Child blesses Saint John the Baptist (on the right).

The dating and original purpose of NG 6337 are controversial. As a cartoon NG 6337 was certainly made in preparation for a painting of the same scale, but it has not been pricked or incised for transfer onto another support. Leonardo made another cartoon (now lost) of the Virgin and Child with Saint Anne, Saint John (and a lamb – not included in NG 6337), about 1500–1, and a later painting of the subject is in Paris (Louvre). His approach to the theme is also developed in several smaller drawings. The argument has recently been revived that NG 6337 originated as a commission for Louis XII of France in about 1499–1500; alternatively the cartoon is often dated about 1507–8.

A painted variant of NG 6337, by Andrea del Brescianino, is in Milan (Ambrosiana).

Inherited by Francesco da Melzi, and apparently in Milan until its appearance in the Sagredo collection, Venice, before 1726; subsequently in the collection of Robert Udny; in the collection of the Royal Academy, London, by 1779; presented by the NACF following a public appeal, 1962.

Marani 1989, pp. 103–4; Harding 1989, pp. 5–27; Dunkerton 1991, p. 378; Keynes 1991, pp. 147–58.

NG 1093
Oil on wood, 189.5 x 120 cm

Inscribed on the scroll held by Saint John the Baptist: ECCE A[G]/NVS [DEI] (Behold the lamb of God).

On the left the infant John the Baptist, Christ's cousin, joins the Virgin in adoring Christ. Since the Baptist is so close to the Virgin and is not wearing his usual camel skin he could be mistaken for Christ. The cross and scroll (inscribed with words from the New Testament, John 1: 29) have been added by a later artist to avoid confusion.

NG 1093 was probably painted in 1508 as the central panel of an elaborate sculptural altarpiece for the chapel of the Confraternity of the Immaculate Conception in S. Francesco, Milan. It was almost certainly intended to replace an earlier panel which had been commissioned from Leonardo in 1483 (now Paris, Louvre). This sequence of events has been deduced from the provenance of NG 1093, and the surviving documentation (discussed by Cannell 1984). There are numerous differences between the two versions, and NG 1093 may be in part the work of Leonardo's assistants. NG 1661 and 1662 were parts of the same altarpiece.

Probably the picture seen by Lomazzo in the church of S. Francesco, Milan, before 1571; bought by Gavin Hamilton from the hospital of S. Caterina alla Ruota, Milan (to which it had probably been transferred in about 1781) in 1785; Lansdowne collection, 1786; possibly in the collection of Lord Suffolk by 1818; bought from the Earl of Suffolk, 1880.

Davies 1961, pp. 261–81; Glasser 1977, pp. 209–77, 308–92; Sironi 1981; Cannell 1984, pp. 99–108; Dunkerton 1991, pp. 382–5.

NG 1662
Oil (identified) on poplar, 118.8 x 61 cm

NG 1661 and 1662 came from the same altarpiece as Leonardo NG 1093 (see under NG 1093 for further information; for the relationship of NG 1662 to this commission see under NG 1661). NG 1662 was probably the outside face of the right-hand shutter and was thus visible when the shutters were closed.

NG 1662 may have been painted by one or both of the de Predis brothers; it seems to reflect Leonardo's style of before 1500.

Probably installed in the church of S. Francesco, Milan, about 1508, and still recorded there about 1787; subsequently in the Melzi d'Eril collection, Milan; bought from Giovanni Melzi, 1898.

Davies 1961, pp. 261–81; Cannell 1984, p. 104; Dunkerton 1991, p. 385.

LEONARDO da Vinci
1452–1519

Leonardo trained in Florence with Verrocchio. He moved to Milan in 1482, but returned to Florence in 1499 or 1500, where he remained for much of the time until 1506. He was then in Milan until 1513 and subsequently in Rome. In 1517 he went to France; he died at Amboise. His interests included painting, sculpture, architecture, and most branches of scientific discovery.

Associate of LEONARDO
An Angel in Green with a Vielle
about 1506

Follower of LEONARDO
Narcissus
about 1490–9

Follower of LEONARDO
The Virgin and Child
after 1510

NG 1661
Oil on poplar, 116 x 61 cm

NG 2673
Oil on wood, painted surface 23.2 x 26.4 cm

NG 1300
Oil on wood, painted surface 59.7 x 43.8 cm

NG 1661 and 1662 came from the same altarpiece as Leonardo NG 1093 (see under NG 1093 for further information). According to the contract of 1483 in which Leonardo was commissioned to paint *The Virgin of the Rocks*, he was to be assisted by Ambrogio and Evangelista de Predis (or Preda), who were not only to help with painting and gilding the sculpture but also to paint 'side panels' with angels, some playing instruments, some singing. NG 1661 and 1662 are both cut down at the top, and probably made up the right-hand shutter (with NG 1661 as the inside face, visible when the shutters were open).

NG 1661 seems to reflect Leonardo's later style and influence, and probably dates from about 1506. Leonardo is likely to have retained responsibility for the design but left the execution to an associate, possibly one of the de Predis brothers (probably Ambrogio; Evangelista died before 1503).

Probably installed in the church of S. Francesco, Milan, about 1508, and still recorded there about 1787; subsequently in the Melzi d'Eril collection, Milan; bought from Giovanni Melzi, 1898.

Davies 1961, pp. 261–81; Cannell 1984, p. 104; Dunkerton 1991, p. 385.

In Greek mythology, Narcissus fell in love with his own reflection in a pool of water. It is unusual for him to be given modern dress and for the pool to be a raised basin.

The painting may be a poetic portrait and the pool an afterthought. The type of effeminate male beauty, the loose curls and the distant lake are all derived from Leonardo da Vinci, and the work is probably by one of the Milanese painters associated with him in the 1490s. A version of this painting, of similar quality with minor variations, is in the Uffizi (Florence).

Possibly in the Aldobrandini collection, Rome, before 1769; certainly in the collection of Lady Taunton by 1870; Salting Bequest, 1910.

Davies 1961, pp. 91–2.

The Virgin and Child are seen in a landscape. The composition is a variant of two compositions by Leonardo: the so-called *Litta Madonna* (St Petersburg, Hermitage) and the *Madonna of the Yarnwinder* (known in several versions).

The motif of the Christ Child reappears in Boltraffio NG 728.

Bought with the Edmond Beaucousin collection, Paris, 1860.

Davies 1961, pp. 281–2.

Stanislas-Victor-Edmond LEPINE
The Pont de la Tournelle, Paris
1862–4

NG 2727
Oil on canvas, 13.7 x 24.4 cm

Stanislas-Victor-Edmond LEPINE
*Nuns and Schoolgirls in the Tuileries Gardens,
Paris,* 1871–83

NG 6346
Oil on wood, 15.7 x 23.7 cm

Attributed to LEPINE
A Gateway behind Trees
1870–92

NG 1361
Oil on canvas, 32.7 x 21.6 cm

Signed: S. Lepine. [sic].
The Pont de la Tournelle is in the middle distance. To the right is the apse of Notre-Dame.

Lépine painted this view many times and at different stages in his career. This picture has been dated to 1862–4. However, it has been suggested that the Eiffel tower is represented in the horizon, in which case this picture must have been painted after 1889.

Alexander Young sale, 1910; presented by J.C.J. Drucker, 1910.

Davies 1970, pp. 87–8; Schmit 1993, p. 54, no. 122.

Signed: S. Lépine.
The building in the background is the ruined shell of the Tuileries palace.

The palace was burnt in the Commune in 1871, and demolished in 1883, hence the dating of NG 6346.

Presented by Mrs H.W. Rawlinson, 1963.

Davies 1970, pp. 88–9; Schmit 1993, p. 80, no. 199.

Signed (faintly): S. Lépine
The influence of Corot is often discernible in Lépine's work. In NG 1361, which is attributed to Lépine, the tonal harmonies of Corot are readily apparent.

Presumably Denys Hague Sale, 1923; presented by Victor Rienaecker through the NACF to the Tate Gallery, 1923; transferred, 1956.

Davies 1970, p. 87.

Stanislas-Victor-Edmond LEPINE
1835–1892

The landscape painter Stanislas Lépine was born in Caen. He took up painting around 1853 and exhibited at the Salon for the first time in 1859. In the same year he met Corot, who was an important influence on his work.

Jean-Baptiste LE PRINCE
The Necromancer
probably 1775

NG 5848
Oil (identified) on canvas, 76.8 x 63.5 cm

Signed: L Prince.

Le Prince exhibited a picture of 'Un Négromantien' at the Salon of 1775 (no. 36). The design of this work, which was then in the collection of the Marquis de Poyanne, is known through Helman's engraving of 1785 and accords with three known versions of which NG 5848 is one.

NG 5848, together with a picture in the Hermitage, St Petersburg, and another in a private collection in New York, has a claim to be the original exhibited in 1775. This picture was, according to Helman's engraving, painted in that year.

Possibly in the collection of the Marquis de Poyanne in 1775; Arthur James collection, by 1908; bequeathed by Mrs M.V. James from the Arthur James collection, 1948.

Davies 1957, pp. 137–8.

Eustache LE SUEUR
Christ on the Cross with the Magdalen, the Virgin Mary and Saint John the Evangelist, about 1642

NG 6548
Oil on canvas, 109.5 x 73.8 cm

The pallor of the Virgin Mary, the gesture of Saint John clutching his cloak, and the yearning posture of the kneeling Magdalen, express the agony of their grief. The direction of their gazes, together with the composition of the painting and its dramatic light, combine to concentrate attention on the dying Christ.

NG 6548 is a variant of a larger picture in the Louvre, Paris.

Acquired by the Institute of the Blessed Virgin Mary, the Bar Convent, York, before 1900; bought at Christie's, 10 June 1994 (lot 7).

Mérot 1987, p. 178, under no. 29.

Eustache LE SUEUR
Saint Paul preaching at Ephesus
1648–9

NG 6299
Oil on canvas, 102.9 x 86.4 cm

During Saint Paul's mission to Ephesus (in modern Turkey), he succeeded in converting many of the inhabitants of the city to Christianity. Some of the converts, who had previously practised the 'magical arts' publicly burnt their books and manuscripts. New Testament (Acts 19: 18–20). Saint Paul stands centrally, while the other disciples on the platform are carrying out various actions, including giving thanks, dispensing alms, hearing confession and blessing the converts.

NG 6299 is a modello for a painting that Le Sueur executed in 1649 for the cathedral of Notre-Dame, Paris (now Paris, Louvre). This work was a so-called 'May' painting, a votive picture given annually (1630–1707) to the cathedral by the Paris goldsmiths. Another identical modello (Algiers, Musée National des Beaux-Arts) and several preparatory drawings (e.g. Paris, Louvre) are known. In the final painting there were numerous changes from the modello: the kneeling man being blessed to the right of the saint was omitted; the confessing figure at the extreme right was transformed, and the disciple behind him instead of dispensing charity points to where the books were to be burnt.

Possibly sold by Christie's, March 1774; bought, 1959.

Mérot 1987, p. 236, no. 83; Wine 1992, pp. 108–11.

Jean-Baptiste LE PRINCE
1734–1781

Le Prince was born in Metz; he later became a pupil of Boucher in Paris. He visited Russia from about 1758 to 1763, and was admitted as a member of the Académie in Paris in 1765. He was principally a painter of genre scenes, often with a Russian subject matter.

Eustache LE SUEUR
1616–1655

Le Sueur was born in Paris and entered the studio of Simon Vouet in about 1631, where he painted a number of decorative and religious schemes. He became an independent artist in about 1643. Influenced by Vouet and Raphael he notably executed a series of works on the life of Saint Bruno (1645–8) for the Paris Carthusians, and was a founder member of the Académie in 1648.

Judith LEYSTER
A Boy and a Girl with a Cat and an Eel
about 1635

LIBERALE da Verona
The Virgin and Child with Two Angels
probably about 1490–1510

LIBERALE da Verona
Dido's Suicide
early 16th century

NG 5417
Oil on oak, 59.4 x 48.8 cm

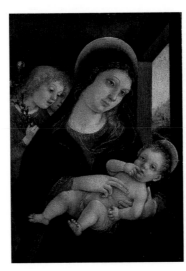

NG 1134
Oil on wood, 61 x 45.1 cm

NG 1336
Oil on poplar, 42.5 x 123.2 cm

Signed right: iudiyh, followed by a star. (Leyster often signed her pictures with a J or L followed by a star, as a punning reference to her surname; in seventeenth-century Dutch *leyster* = lodestar.)

The boy holds up an eel while the girl pulls the cat's tail and gestures to the spectator. This probably refers to a Dutch proverb, either 'To hold an eel by the tail' (meaning that because you have something you cannot necessarily hold onto it) or 'He is as happy as an eel' (meaning he is uncontrollable). In Dutch painting of this period children are often used to point up the foolishness of adults and this may be the case here.

[John Hotchkis] sale, London, July 1910; bequeathed by C.F. Leach, 1943.

MacLaren/Brown 1991, pp. 227–8.

NG 1134 is usually accepted as a work by Liberale da Verona. It probably dates from the late fifteenth or early sixteenth century.

Bought from Paolo Fabris, Venice, 1883.

Davies 1961, p. 283.

Dido, having been abandoned by Aeneas, commits suicide on a pyre composed of his armour and his gifts to her, in her palace in Carthage. Virgil, *Aeneid* (IV, 504ff).

NG 1336 is probably a panel from a *cassone*. The attribution was made in the nineteenth century and has not been challenged.

Some figures come from a Dürer print (*Five Lansquenets and an Oriental on Horseback*) which probably dates from the mid-1490s, and the influence of Mantegna is also evident.

Anon. sale, 1851, where acquired by Lord Northwick; collection of Cecil Dunn-Gardner; collection of Edward Habich; from whom bought, 1891.

Davies 1961, pp. 283–4.

Judith LEYSTER
1609–1660

Judith Jansdr. Leyster was baptised in Haarlem. She may have been a pupil of Frans de Grebber; she joined the Haarlem painters' guild as a master in 1633, establishing her own independent workshop. In 1636 she married the painter Jan Molenaer: they moved to Amsterdam where they lived until 1648, subsequently moving to Heemstede and Haarlem. She was a genre, portrait and still-life painter.

LIBERALE da Verona
about 1445–1527/9

Liberale was first documented working for the church of S. Maria in Organo, Verona, but is most famous for his work as a miniaturist in Monte Oliveto and Siena from 1467 until 1476. By 1492 he had settled in Verona. He was influenced by various artists, including Francesco di Giorgio and Mantegna.

Bernardino LICINIO
The Madonna and Child with Saint Joseph and a Female Martyr, about 1510–30

Bernardino LICINIO
Portrait of Stefano Nani
1528

Jan LIEVENS
Self Portrait
about 1638

NG 3075
Oil on wood, 48.6 x 68.6 cm

NG 1309
Oil on canvas, 91.4 x 77 cm

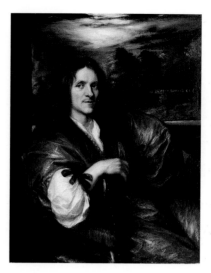

NG 2864
Oil on canvas, 96.2 x 77 cm

Saint Joseph, at the right, plays with the Christ Child. The unidentified saint at the left holds a martyr's palm and banner.
 NG 3075 is related in terms of style to several other paintings by Licinio (e.g. Uffizi, Florence).

Tanara collection, Verona; bought by Sir A.H. Layard before 1869; Layard Bequest, 1916.

Gould 1975, p. 130.

Signed and dated: STEPHANVS/ NANI. ABAVRO/ XVII. MDXXVIII/. LYCINIVS. P. (Stephano Nani, aged 17 (?), 1528, painted by Licinio).
 The sitter is recorded as having held the post of *Scrivan delle Rason vecchie* in 1542 and to have been *Scrivan of the Scuola della Trinità* in Venice.
 Another version of the portrait is known (Rome, Accademia dei Lincei).

Possibly in the Algarotti collection, Venice, in the eighteenth century; F. Perkins collection by 1857; bought at the George Perkins sale, 1890.

Gould 1975, p. 129.

Signed centre left: IL
 The identification of the painting as a self portrait is based on the inscription on a watercolour copy made of the work in 1792 by Aert Schouman (Amsterdam, van Regteren Altena collection) who owned NG 2864, and on comparison with Lucas Vorsterman's engraved portrait of Lievens after Van Dyck.
 The picture shows Lievens working under the powerful influence of Van Dyck. It probably dates from about 1638 when Lievens was in his early thirties and living in Antwerp.

Possibly in the collection of Susanna van Sonnervelt, The Hague, 1696; presented by Charles Fairfax Murray, 1912.

MacLaren/Brown 1991, pp. 232–3.

Bernardino LICINIO
before 1491?–after 1549

Licinio was from a family of artists who came from Poscante (Bergamo). Members of the family moved to Murano and Venice, and Bernardino is first recorded as a painter in the latter city in 1511. His portraits are notably influenced by the early works of Titian, and his religious works by the paintings of Palma Vecchio.

Jan LIEVENS
1607–1674

Lievens was born in Leiden, where he was pupil of Joris van Schooten before training in Amsterdam with Pieter Lastman. During the 1620s he painted in Leiden and was closely associated with Rembrandt. After visiting England (1631–3), he worked in Antwerp, Amsterdam and The Hague. The artist was a portrait, history and landscape painter, as well as being a printmaker.

Jan LIEVENS
A Landscape with Tobias and the Angel
1640–4

NG 72
Oil on oak, 56.9 x 88.5 cm

Jan LIEVENS
Portrait of Anna Maria van Schurman
1649

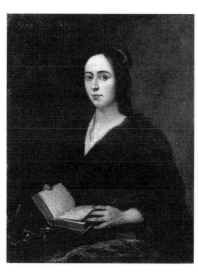

NG 1095
Oil on canvas, 87 x 68.6 cm

Jan LINGELBACH
Peasants loading a Hay Cart
1664

NG 837
Oil on canvas, 70 x 88.7 cm

Tobias was sent by his blind father Tobit to collect a debt. He was escorted by the Archangel Raphael and when a fish attacked him as they crossed the river Tigris, Raphael told the boy to kill it and remove the heart, liver and gall, which could be used to restore his father's eyesight. Book of Tobit 6: 1–3.

NG 72 belongs to a small group of painted landscapes showing the influence of Rubens and, more particularly, of Brouwer; they can be attributed with some confidence to Lievens on the basis of comparison with the landscape in the background of NG 2864 and a landscape in Berlin with a contemporary inscription (or signature) on the back. This panel bears on the reverse the brand of the Antwerp panelmakers' guild. Lievens was in Antwerp from 1635 to 1644, and the picture was probably painted during his last years in the city.

[Dr Robert] Bragge sale, London, 1749 (as Rembrandt); Holwell Carr Bequest, 1831.

MacLaren/Brown 1991, pp. 230–1.

Inscribed in a later hand: Anna Maria Schurman. Signed and dated left: I.L. / 1649
Anna Maria van Schurman (1607–78) was a Dutch poet and scholar. She was born in Cologne, but early in life moved to Utrecht and died in Wierwerd. She was celebrated during her lifetime for her learning and accomplishments and she also drew, etched and engraved on glass. She is identified by the inscription and this is confirmed by comparison with other portraits of her such as the self portrait in pastel (Franeker, Museum).

Brought from Holland by Sir Hans Sloane; Sir Hans Sloane Bequest to the Nation, 1753; presented by the Trustees of the British Museum, 1880.

MacLaren/Brown 1991, p. 231.

Signed and dated bottom left: J: lingelbach / 1664.
After his return to Holland from Italy, Lingelbach was increasingly influenced by the successful and prolific Philips Wouwermans, especially by his landscapes containing figures at work or on horseback. This picture was painted in imitation of works by Wouwermans.

Probably at one time owned by John Smith, London; collection of the Marquess of Bute; bought by (Sir) Robert Peel (Bt), 1822; bought with the Peel collection, 1871.

MacLaren/Brown 1991, p. 234.

Jan LINGELBACH
1622–1674

Lingelbach was born in Frankfurt, brought up in Amsterdam, and was in Rome in the late 1640s, where he was influenced by the genre scenes of the *Bamboccianti* (the association of Northern artists in Rome), especially Pieter van Laer. In 1650 he returned to Amsterdam, where he painted landscapes and genre subjects.

John LINNELL
Samuel Rogers
1846

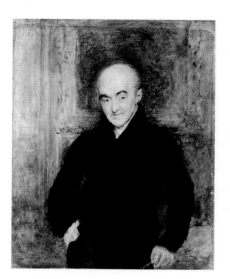

NG 4142
Oil on mahogany, 44.1 x 36.8 cm

Samuel Rogers (1763–1855), banker, collector and poet, was a Trustee and benefactor of the National Gallery. He bequeathed to the Gallery Reni NG 271 and Titian NG 270.

Painted in 1846, NG 4142 is a replica of a portrait painted from the life in 1833–5. Linnell hoped (vainly) that it would be engraved, and produce income. When he was persuaded in 1846 to sell the original version, he painted a replica which he kept; it was finally sold by his executors. The original version was bequeathed to the National Gallery in 1940, but transferred to the Tate Gallery in the same year.

Linnell sale, 1918; bought from J. Leger (Mackerell Fund), 1926.

Davies 1959, p. 76.

Hendrik Frans van LINT
A Landscape with an Italian Hill Town
1700–26

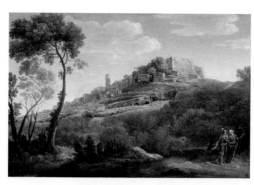

NG 2909
Oil on canvas, 22.7 x 34.6 cm

The town has not been identified. The two figures in classical dress in the lower right-hand corner may be Aeneas and the Sibyl.

NG 2909 was formerly attributed to Cornelis van Poelenburgh, but van Lint painted a number of Italian views of this type to which it is closely related in style and subject matter.

Apparently in the collection of Lady Lindsay by 1885; by whom bequeathed, 1912.

Jean-Etienne LIOTARD
Portrait of a Grand Vizir (?)
about 1738–43

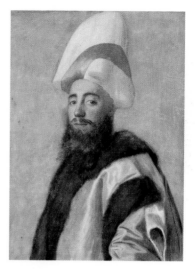

NG 4460
Pastel on paper, 61.6 x 47.6 cm

The sitter was once identified as Edward Wortley Montagu (1713–76), and again as a self portrait, but may be an unidentified Turkish Grand Vizir.

The costume is that of a Grand Vizir and NG 4460 was probably painted during Liotard's visit to Constantinople from about 1738 to 1743. Alternatively the sitter may be a European in Turkish costume.

Collection of J.P. Heseltine, London, by 1911; presented by Mrs John P. Heseltine in memory of her husband, 1929.

Davies 1957, pp. 139–40; Loche 1978, p. 91, no. 38.

John LINNELL
1792–1882

Linnell entered the Royal Academy Schools in 1805; he was also a pupil of the watercolourist John Varley in 1805–6. He exhibited regularly at the Royal Academy from 1807, chiefly portraits and landscapes. Linnell was a friend and patron of William Blake, and of Samuel Palmer, who became his son-in-law.

Hendrik Frans van LINT
1684–1726

Lint was born in Antwerp, the son of the painter Peter van Lint. He became a pupil there of Peter van Bredael in 1697, and then travelled to Rome, where he joined the society of Netherlandish painters, the *Schildersbent*, and was given the nickname 'Studio'. He painted landscapes and town views.

Jean-Etienne LIOTARD
1702–1789

Liotard was born in Geneva and trained there (with Daniel Gardelle) and in Paris (with the miniaturist J.-B. Massé). He travelled widely and visited Rome, Constantinople, Vienna, Paris, London and Holland. From 1758 he lived in Geneva, where he specialised in pastels, mainly portraits and genre subjects.

Filippino LIPPI
The Adoration of the Kings
about 1480

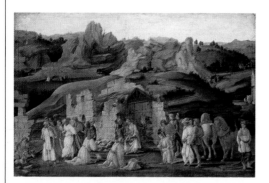

NG 1124
Tempera on wood, 57.5 x 85.7 cm

Filippino LIPPI
The Virgin and Child with Saint John
about 1480

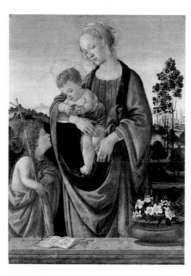

NG 1412
Tempera on poplar, 59.1 x 43.8 cm

Filippino LIPPI
The Virgin and Child with Saints Jerome and Dominic, about 1485

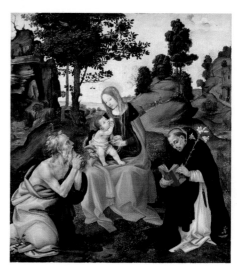

NG 293
Oil and tempera on poplar, main panel, excluding predella 203.2 x 186.1 cm

The Three Kings had followed a star (visible immediately above the group of the Virgin and Child) to the stable in which Jesus had been born. New Testament (Matthew 2: 9–12). They are seen on their knees in front of the Holy Family, holding their gifts of gold, frankincense and myrrh. In the landscape background there are episodes from the lives of the saints, including: Saint Jerome kneeling in penitence before a crucifix, Saint Francis receiving the stigmata, Mary Magdalene (or possibly Mary of Egypt) in the wilderness, and Tobias and the Archangel Raphael.

NG 1124 is an early work which shows the influence of Botticelli (with whom Filippino studied).

The setting of tiny scenes from the lives of saints has parallels with a tradition in Florentine painting: the so-called Thebaïd pictures which represent hermit saints in a landscape setting.

Perhaps in the Capponi collection, Florence, in the early eighteenth century; first recorded in the William Beckford collection, 1833; bought at the Hamilton sale, 1882.

Davies 1961, pp. 287–8; Berti 1991, pp. 155–8; Dunkerton 1991, pp. 75–6.

The Christ Child holds a pomegranate, a symbol of the Passion. The young Saint John the Baptist wears a camel skin tunic and holds a reed cross. The book on the parapet is inscribed with imitations of letters, which do not form a meaningful text.

NG 1412 is generally considered an early work by Filippino, painted while he was strongly under the influence of Botticelli.

Bought in Florence by Sir Charles Eastlake, probably between 1855 and 1865; bought, 1894.

Davies 1961, p. 288; Berti 1991, p. 166.

The Virgin Mary, seated in a landscape, feeds Jesus (this is echoed in the tree above by a bird carrying a worm to its young). If the figure in the background with an ass is meant for Saint Joseph, there may be an allusion to the Rest of the Holy Family on the Flight into Egypt. Saint Jerome is shown twice, in penitence on the left, and in the background with his lion. Saint Dominic holds a lily; the building behind him may be a Dominican hospital. The predella includes Saint Francis and Saint Mary Magdalene lamenting on either side of the dead body of Christ supported by Joseph of Arimathea. The coat of arms of a branch of the Rucellai family is at either end. (See Appendix B for a larger reproduction.)

NG 293 was painted for the burial chapel founded by Filippo di Vanni Rucellai in the new church of S. Pancrazio, Florence, belonging to the Vallombrosans, an order of reformed Benedictine monks dedicated to penitence. His sons (commemorated in an inscription in the chapel) Girolamo (died 1516) and Domenico (died 1484) were probably responsible for the commission and for the choice of their name saints Jerome and Dominic.

A number of workshop derivations are known; that recorded at Todiano di Preci (Davies 1961) is now in the Museo Diocesano, Spoleto.

First mentioned in S. Pancrazio by Vasari (1550); bought from the Rucellai collection, 1857.

Davies 1961, pp. 285–6; Berti 1991, p. 190; Dunkerton 1991, p. 338.

NG 293, predella

Filippino LIPPI
about 1457–1504

Filippino ('little Filippo') Lippi was born in Prato, and probably trained with his father Fra Filippo. From the early 1470s he was in Florence with Botticelli. From 1480 until his death he worked on major commissions in Rome, Florence and throughout the Italian peninsular. Rafaellino del Garbo trained in his workshop.

Filippino LIPPI
An Angel Adoring
probably about 1495

Follower of Filippino LIPPI
Moses brings forth Water out of the Rock
about 1500

Follower of Filippino LIPPI
The Worship of the Egyptian Bull God, Apis
about 1500

NG 927
Tempera on wood, 55.9 x 25.4 cm

NG 4904
Oil and egg (identified) on canvas, transferred from wood, 78.1 x 137.8 cm

NG 4905
Oil and egg (identified) on wood, painted surface 78.1 x 137.2 cm

This angel was probably adoring the Child Jesus. At the bottom of the panel the top of a head is visible, presumably that of the infant Christ or the young Saint John the Baptist.

This panel is a fragment of a larger picture. Another angel fragment (Strasbourg, Musée des Beaux-Arts) may be from the same picture as NG 927, and the appearance of the whole might be echoed in a tondo of the *Virgin and Child with two Angels* (sold at Christie's, 24 February 1939). Neither the date nor the association of the two angels has been unanimously accepted, but a date of about 1495 is probable.

Callcott sale 1845; bought by Wynn Ellis; by whom bequeathed, 1876.

Davies 1961, pp. 286–7; Berti 1991, p. 210.

After Moses had led the Israelites out of Egypt (represented background right) they lacked water and were murmuring against him. At God's command Moses struck a rock with his rod and water flowed forth (the Israelites and their flocks are seen drinking in the right foreground). Old Testament (Exodus 17: 1–7; Numbers 20: 7–13). The elders behind Moses gesture with astonishment.

NG 4904 is a pendant to NG 4905. Other paintings may have continued the series, which might have been designed for the wainscoting of a room.

Once in the collection of William Spence, Florence; collection of Sir Bernhard Samuelson, Bt, by 1873; bequeathed by Sir Henry Bernhard Samuelson, Bt, in memory of his father, 1937.

Davies 1961, pp. 288–9; Berti 1991, pp. 215–18.

The bull in the sky is the Egyptian Bull God Apis, one of whose distinguishing features was a crescent moon on his shoulder. Traditionally the Golden Calf made by the Israelites (Old Testament, Exodus 32: 1–8) was thought to have been an image of the Egyptian God Apis, and some connection is likely as the pendant to NG 4905 is also an episode from the story of Moses.

See under NG 4904 for further information.

Possibly once in the collection of William Spence, Florence; collection of Sir Bernhard Samuelson, Bt, by 1873; bequeathed by Sir Henry Bernhard Samuelson, Bt, in memory of his father, 1937.

Davies 1961, pp. 289–91; Berti 1991, p. 218.

Fra Filippo LIPPI
Saint Bernard's Vision of the Virgin
probably 1447

NG 248
Egg (identified) on wood, irregular hexagon
98 x 106 cm

Fra Filippo LIPPI
The Annunciation
late 1450s?

NG 666
Tempera on wood, 68.5 x 152 cm

Fra Filippo LIPPI
Seven Saints
late 1450s?

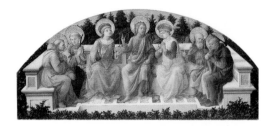

NG 667
Tempera on wood, 68 x 151.5 cm

Saint Bernard (1090–1153; often called Bernard of Clairvaux) was one of the founders of the Cistercian Order. He wrote a number of books, sermons and letters. The exact episode depicted in NG 248 has not been identified. One possibility is that it is intended to illustrate the dialogue between the Virgin and Saint Bernard about Christ's Passion that is meant to form the basis of his *Liber de Passione Christi et doloribus et planctibus matris ejus* (Book of the Passion of Christ and the Sorrows and Lamentations of his Mother). Two Cistercians look on from the background.

The shape of NG 248 would be suitable for a position above a door, and the picture may be an overdoor by Lippi from the Palazzo Vecchio, Florence, for which a payment in May 1447 is recorded, and which was seen in the Palazzo Vecchio by Vasari in 1550. This overdoor was placed outside the chapel (dedicated to Saint Bernard) at the same time as an *Annunciation* (perhaps that in Washington, National Gallery of Art, Kress collection). NG 248 was acquired as the work of Masaccio, and has occasionally been attributed to other artists. Despite its damaged condition it is probably acceptable as the work of Filippo Lippi.

Collection of E. Joly de Bammeville, Paris, by 1850; from where bought, 1854.

Davies 1961, pp. 291–3; Marchini 1975, pp. 25, 26, 207, 232; Ruda 1993, pp. 421–2.

The Archangel Gabriel announces to the Virgin Mary (who has been at prayer in her bedchamber) that she is to bear Jesus, the Son of God. New Testament (Luke 1: 26–35). The Holy Spirit descends from Heaven in the form of a dove and light is shown around an opening in the front of the Virgin's dress. Lilies in a vase symbolise the Virgin's purity, and the *hortus conclusus* (walled garden) is a reference to the Song of Solomon (4: 12) and relates to the Virgin's purity.

On the parapet (below the vase) is a device in grisaille of three feathers and a ring. This was associated with the Medici family and NG 666 was probably painted for a Medici palace, possibly in the late 1450s, and intended for a related, but perhaps separate room, to NG 667. The patron is not certain. See under NG 667 for further comment.

Acquired from the Palazzo Riccardi (formerly Palazzo Medici) by the Metzger brothers shortly before 1848; acquired by Sir Charles Eastlake about 1855; by whom presented, 1861.

Davies 1961, pp. 293–6; Marchini 1975, pp. 206–7; Dunkerton 1991, p. 274; Ruda 1993, pp. 199–203, 445–6.

The seven saints were name saints of the Medici family. NG 667 may have been commissioned by Piero de'Medici (1414–69) or by Pierfrancesco di Lorenzo di Giovanni di Bicci de' Medici (1430–77), whose name saints, Peter Martyr and Francis, are on the far right and left respectively. Another name saint, John the Baptist, patron saint of Florence, is in the centre. He is flanked by Saints Damian and Cosmas, the two patron saints of the Medici because they were physicians (*medici* in Italian). Saints Lawrence and Anthony Abbot are beside Cosmas and Damian.

NG 666 and 667 are companion pieces and were probably set into the furniture of the Palazzo Medici in the Via Larga in Florence (perhaps as overdoors or bedheads; a painted bedhead can be seen in Giovanni di Paolo NG 5453). A date after 1456 has been proposed for these two pictures.

Uccello NG 583 was also painted for the Medici family at about this time.

Acquired from the Palazzo Riccardi (formerly Palazzo Medici) by the Metzger brothers shortly before 1848; bought by Alexander Barker before 1855; bought, 1861.

Davies 1961, pp. 293–6; Marchini 1975, p. 207; Dunkerton 1991, p. 274; Ruda 1993, pp. 199–203, 444–6.

Fra Filippo LIPPI
born about 1406; died 1469

Fra Filippo Lippi spent his youth in the Carmelite friary in Florence, where he took his vows in 1421. He is first mentioned as a painter in 1431, and was much employed by the Medici family. He also worked in Padua (1434), Prato (intermittently from 1452), and Spoleto where he died. He painted frescoes, altarpieces, small devotional works and decorative panels. His son was Filippino Lippi.

Attributed to the Workshop of Fra Filippo LIPPI
The Virgin and Child
probably about 1450–60

NG 3424
Egg (identified) on poplar, 76.5 x 61 cm

The Christ Child holds a goldfinch, often a symbol of the Passion; the Virgin Mary appears to be standing which is relatively unusual. The coats of arms on either side (that of the Ruggieri family of Padua combined with that of an unidentifiable family on the right and that of the Strozzi family on the left) have been repainted and may not have been copied accurately. However, it is possible that NG 3424 might at one time have been owned by a member of the Strozzi family.

NG 3424 is derived from models and painted in the style of Filippo Lippi; it is probably a workshop production of the 1450s, but much repainting at a later date has obscured the evidence of authorship.

Bought by Lord Brownlow, Florence, 1874; by whom presented, 1919.

Davies 1961, pp. 296–7; Marchini 1975, pp. 103, 168, 214; Ruda 1993, pp. 434–5.

Imitator of Fra Filippo LIPPI
The Virgin and Child with an Angel
about 1480

NG 589
Egg (identified) on poplar, painted surface 69.9 x 48.3 cm

This composition of the Virgin and Child with an angel is derived from a picture by Fra Filippo Lippi (Florence, Uffizi). (Another variant based on the same prototype is NG 2508 by an unknown painter of the Italian School.)

NG 589 has sometimes been claimed as an early work by Botticelli (who trained with Fra Filippo Lippi). The strong drawing of the angel's features is close to Botticelli, but colouristically, as well as in the decoration of the Virgin's dress, the picture is closer to Lippi.

Said to have come from Sig. Zambrini of Imola; bought from the Lombardi–Baldi collection, Florence, 1857.

Davies 1961, pp. 113–15; Lightbown 1978, II, p. 115; Dunkerton 1991, p. 156.

LIPPO di Dalmasio
The Madonna of Humility
probably about 1390–1400

NG 752
Tempera (very repainted) on canvas, 110 x 87 cm

Signed along the bottom: .lippus dalmasii pinxit.

The Virgin Mary, who is seated in a flowery meadow, has a crown of twelve stars and the moon at her feet as described in the Book of Revelation (12: 1); the glory behind her represents her as 'clothed with the sun'.

NG 752 was probably painted in Bologna; it may have been a confraternity banner and appears always to have been on canvas. It is damaged by tears and later repaint.

In the Malvezzi collection, Bologna, in 1773 (and presumably by 1678); subsequently in the Hercolani collection, Bologna, by 1816 and until 1861 at least; bought from Michelangelo Gualandi, 1866.

Gordon 1988, pp. 57–8; Dunkerton 1991, p. 44.

LIPPO di Dalmasio
about 1352?–1410/21

Lippo was the son of a Bolognese painter called Dalmasio. Their family name was Scannabecchi. Lippo was first recorded in 1373 and is said to have been born in about 1352. Between 1377 and 1389 he was living in Pistoia. Thereafter he is documented in Bologna.

Johann LISS
Judith in the Tent of Holofernes
about 1622

NG 4597
Oil (identified) on canvas, 128.5 x 99 cm

For the subject see the Apocryphal Book of Judith (13: 8–10). The Jewish heroine Judith insinuated herself into the camp of the enemy Assyrians and attracted the attention of the commander Holofernes. Later, as he slept, she cut off his head with his own sword. Here she is shown handing it to her maidservant.

A picture by Pordenone (Rome, Galleria Borghese) may be the source of the composition of NG 4597. It probably dates from about 1622, after Liss's return from Rome to Venice.

Several versions of the composition are known, some of which are probably autograph works.

In the collection of Prof. Naager, Munich, by 1914; presented by James W. Dollar, 1931.

Levey 1959, pp. 58–9.

Stephan LOCHNER
Saints Matthew, Catherine of Alexandria and John the Evangelist, about 1445

NG 705
Oil on oak, 68.6 x 58.1 cm

Inscribed on the reverse, on the book held by Saint Gregory the Great: OM/N/I/A/Q (and everything?)

The angel beside Matthew, at the left, dictated the Gospel he writes. Catherine, wearing the crown of a princess and with a Tau-cross and bell around her neck, was saved from the wheel upon which she was tortured (fragments of it lie at her feet), but finally beheaded, hence the sword she carries. The eagle by John, at the right, symbolises the inspiration for his Book of Revelations (a pen case and inkwell hang from his waist), while the snake and chalice refer to his survival after having drunk poison. On the damaged reverse (see Appendix A) are Saint Jerome, a female martyr holding a palm (Saint Cordula?), Saint Gregory the Great, and a donor in the cloak of the Order of Saint John of Jerusalem.

NG 705 is the left-hand shutter of an altarpiece. The right-hand shutter survives (Cologne, Wallraf-Richartz Museum), but the central section, which may conceivably have been sculpted, is lost. On the reverse of the Cologne panel is a second donor, identified in an inscription as Heinrich Zeuwelgyn, wearing the dress of the Order of Saint John. The church of the order in Cologne was that of Saints John and Cordula, and it is surmised that the altarpiece came from there.

Acquired from the Cologne dealer Dethier by Sulpiz and Melchior Boisserée, and exchanged by them in 1814; presented by Queen Victoria at the Prince Consort's wish, 1863.

Levey 1959, pp. 60–2; Levey 1977, pp. 42–3; Dunkerton 1991, pp. 266–7.

Alessandro LONGHI
Caterina Penza
about 1760

NG 3934
Oil on canvas, 60.4 x 48.3 cm

Inscribed on the stretcher, probably in a nineteenth-century hand: Temanza moglie del depinta dal Longhi (The wife of Temanza painted by Longhi).

Caterina Giovanna Penza (or Pensa) was born in or about 1721. She married the architect Tommaso Temanza in 1739 and was still living in 1789.

NG 3934 is a pendant to a portrait of the sitter's husband (Venice, Accademia). Both pictures can probably be dated to about 1760 on the basis of the apparent ages of the sitters.

Rawdon Brown sale, London, 1884; bought from J.P. Richter by Ludwig Mond, 1886; Mond Bequest, 1924.

Levey 1971, pp. 151–2.

Johann LISS
about 1595–1629/30

Liss (sometimes called Lys) was, according to inscriptions on his works, from Holstein; Sandrart states that he came from the region of Oldenburg, and that he visited Amsterdam, Paris, Venice and Rome. He was a member of the society of Netherlandish artists in Rome, and is recorded in Venice from 1629. He painted chiefly religious and genre pictures.

Stephan LOCHNER
active 1442; died 1451

Active at Cologne, but probably from the region of Lake Constance, Lochner is first documented at Cologne as making decorations for the arrival of Emperor Frederick III in 1442. The *Adoration of the Kings* (now in Cologne Cathedral) is usually identified as the work by 'Master Steffan' shown to Dürer in 1520.

Alessandro LONGHI
1733–1813

The artist, who was the son of Pietro Longhi, was born and worked in Venice. He was a pupil of Nogari, and worked as a portrait painter and engraver. In 1762 he published the *Compendio*, a series of biographies of the more esteemed Venetian painters of his day. His own life is included.

Pietro LONGHI
A Nobleman kissing a Lady's Hand
about 1746

Pietro LONGHI
A Lady receiving a Cavalier
1750s

Pietro LONGHI
An Interior with Three Women and a Seated Man
probably 1750–5

NG 5852
Oil on canvas, 61.3 x 49.5 cm

NG 5841
Oil on canvas, 61.5 x 50.7 cm

NG 1100
Oil on canvas, 61.3 x 49.5 cm

The man who kisses the lady wears the formal black robes and wig of a Venetian noble. He has been described as a Procurator of S. Marco, but there is no firm evidence for this.

NG 5852 may date from about 1746. It is comparable to another work by the artist of that year called *The Visit* (New York, Metropolitan Museum of Art).

Drawn studies on a single sheet for the manservant and maid survive (Venice, Museo Correr).

G.A.F. Cavendish Bentinck sale, London, 1891; bequeathed by Mrs M.V. James from the Arthur James collection, 1948.

Levey 1971, pp. 158–9.

On the left two maids work at an embroidery frame. The painting on the wall shows the goddess Diana with cupids, two of whom decorate a term of a god, probably Pan.

NG 5841 has been variously dated to around 1746 and to the 1750s.

The pose of the maid on the left is related to one of the figures in a drawing of two girls at an embroidery frame (Venice, Museo Correr).

G.A.F. Cavendish Bentinck sale, London, 1891; bequeathed by Mrs M.V. James from the Arthur James collection, 1948.

Levey 1971, p. 158.

The portrait on the wall is inscribed: Gerardo Sagredo D. Marci/ Procurator.

Gerardo Sagredo (1692–1738), the subject of the engraved portrait in the background, was elected Procurator of S. Marco in 1718. This depiction is a variant of an engraving by Andrea Zucchi after a full-length portrait of Sagredo by Uberti. The scene is perhaps set in the Sagredo Palace, Venice. The picture has been thought to represent a family group or a scene from a play but conclusive evidence is lacking.

It seems likely that NG 1100 dates from the first half of the 1750s.

A drawing for the two women on the left is in the Museo Correr, Venice.

Collection of Count Oldofredi, Milan, before 1880; bought from G. Baslini, Milan, 1881.

Levey 1971, pp. 153–4.

Pietro LONGHI
1702?–1785

Pietro Falca, called Longhi, was born in Venice and became a pupil of Balestra before studying under Crespi in Bologna. By 1732 he had returned to Venice where he mainly painted small genre scenes. He was elected a member of the Venetian Academy in 1766.

Pietro LONGHI
Exhibition of a Rhinoceros at Venice
probably 1751

NG 1101
Oil on canvas, 60.4 x 47 cm

Inscribed on the reverse: . . . per commissione del Nobile Uomo Sier/Girolamo Mocenigo/ Patrizio Veneto.(... commissioned by the noble gentleman, Girolamo Mocenigo, Venetian patrician.)

The rhinoceros was brought to Europe in 1741 and taken to Venice ten years later for the carnival. Exotic creatures were often exhibited in the city as a spectacle on such occasions. The keeper behind the barrier holds the animal's horn in the air; the masked figures beside him wear the *bauta* (a white mask commonly worn in Venice at the carnival). The smaller, dark, oval mask worn by the woman behind is called a *moreta*.

NG 1101 is a version of a picture by Longhi commissioned by Giovanni Grimani (Venice, Ca' Rezzonico). The inscription (see above) records that it was commissioned by Girolamo Mocenigo. Both works were probably painted in about 1751, the year the rhinoceros was exhibited.

Count Oldofredi collection, Milan, before 1880; bought from G. Baslini, Milan, 1881.

Levey 1971, pp. 154–6.

Pietro LONGHI
A Fortune Teller at Venice
about 1756

NG 1334
Oil on canvas, 59.1 x 48.6 cm

Signed lower right: Petrus Longhi. Inscribed on the pillar at the right: Per Doge/ Sier/ Francesco Loredan/ Padre de Poveri/ 1753 (Ser Francesco Loredan, Father of the Poor, for Doge 1753). Above, the ducal cap, flanked by two W (Evviva) symbols. Inscribed on the back wall: Per Piovan/ in San Trovaso/ D. Zuanne Farinato/ de (?) anni XXX/ 1756 (enclosed within a wreath above a biretta) (D. Zuanne Farinato, thirty years old, 1756, for Parish Priest of San Trovaso).

The scene is set under the lower outside arcade of the Doge's Palace, Venice. Showmen and quacks erected booths on this site, especially during the carnival. That it is carnival time is suggested by the masks which two of the figures wear. The object which lies on the chair is a speaking tube, of a type used to convey information to the client. The inscription on the pillar is election propaganda for Doge Francesco Loredan (1685–1762) who became doge in 1752. The other inscription relates to the vacancy for a parish priest at S. Trovaso in 1752.

NG 1334 was probably painted in about 1756. Its style is close to Longhi's *The Quack* (Venice, Ca' Rezzonico) which is signed and dated to 1757.

Bought (Clarke Fund) at the G.A.F. Cavendish Bentinck sale, 1891.

Levey 1971, pp. 156–8.

Ambrogio LORENZETTI
A Group of Poor Clares
about 1329

NG 1147
Fresco, irregular shape, maximum dimensions 58.5 x 52 cm

The Poor Clares were the followers of Saint Clare of Assisi (about 1194–1253) who established an order of nuns who followed the rule of Saint Francis.

This fragment was probably once part of a large fresco, perhaps of *The Body of Saint Francis halted at S. Damiano and mourned by Saint Clare and her Companions*. It probably comes from the Chapter House of the church of S. Francesco, Siena. Two other frescoes datable to about 1329 by Ambrogio Lorenzetti from the Chapter House survive (*Saint Boniface receiving Saint Louis as a Novice* and the *Martyrdom of Franciscans*); they are now in the church of S. Francesco, Siena. Ambrogio Lorenzetti is recorded by Ghiberti and other writers as having painted frescoes in the cloister of the convent. Fragments of these have recently been discovered and it now appears that Ambrogio was involved in two fresco projects at the church.

Ambrogio collaborated with his brother Pietro (see under Pietro Lorenzetti NG 3072) on the Chapter House frescoes.

Bought, 1878.

Gordon 1988, pp. 59–60.

Ambrogio LORENZETTI
active 1319; died 1348/9

Ambrogio, probably the younger brother of Pietro Lorenzetti, was – with Simone Martini – the leading painter in Siena after Duccio's death. His frescoes of Good and Bad Government of 1338–40 in the Palazzo Pubblico, Siena, were his most important work. He also worked in Florence in the 1320s and painted altarpieces as well as frescoes.

Attributed to Pietro LORENZETTI

Saint Sabinus before the Governor of Tuscany (?)
about 1335–42

Workshop of Pietro LORENZETTI

*A Crowned Female Figure (Saint Elizabeth of
Hungary?),* about 1330–9

Workshop of Pietro LORENZETTI

A Female Saint in Yellow
probably 1330–9

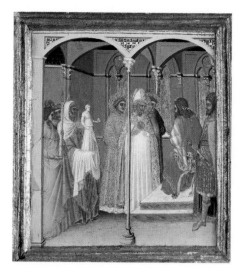

NG 1113
Tempera on poplar, including the original frame
37.5 x 33 cm

Saint Sabinus, one of the four patron saints of Siena,
appears with two deacons (Saints Marcellus and
Exuperantius) before Venustianus, the Roman
Governor of Tuscany, and refuses to worship an
idol. Sabinus' hands were cut off on the order of
Venustianus, who was later converted to
Christianity. The idol was said to be an image of
Jupiter, but appears to be Venus, holding the golden
apple given to her by Paris. This change may be
intended to allude to Venustianus' name.

 NG 1113, which retains its original frame, may
have been part of the predella from Pietro
Lorenzetti's altarpiece of the *Birth of the Virgin*,
signed and dated 1342, for the chapel of S. Savino
(St Sabinus) in Siena Cathedral. Pietro Lorenzetti
received his first payment for this altarpiece in
November 1335, at the same time as someone was
paid to translate the legend of Saint Sabinus from
Latin into Italian so that the story could be painted.

Presented by Charles Fairfax Murray, 1882.

Gordon 1988, pp. 60–3; Volpe 1989, p. 155;
Dunkerton 1991, p. 226.

NG 3071
Fresco, maximum dimensions 38.1 x 33 cm

This female saint probably represents Saint
Elizabeth of Hungary (1207–31), a Hungarian
princess who followed the rule of Saint Francis and
joined his third order.

 This fragment, which originally showed the saint
framed in a hexagon, was part of a decorative
border surrounding a large fresco; see under Pietro
Lorenzetti NG 3072 for further comment.

*Bought by Sir A.H. Layard 'from a man who had cut
them out of the wall' before 1864; Layard Bequest, 1916.*

Gordon 1988, pp. 63–5; Volpe 1989, pp. 150–1.

NG 3072
Fresco, maximum dimensions 39.4 x 27.9 cm

The saint has not been identified.

 This fragment was part of a decorative border
surrounding a large fresco. Together with NG 3071
it probably comes from the Chapter House of the
church of S. Francesco, Siena. Two other frescoes by
Pietro Lorenzetti from the Chapter House survive
(the *Crucifixion* and the *Resurrection*; now in the
church of S. Francesco, Siena, and probably painted
around 1336). Such subordinate elements were
frequently painted by assistants, and these two
fragments have been attributed to the workshop of
Pietro Lorenzetti.

 Ambrogio Lorenzetti was also involved in this
fresco cycle for the Chapter House of the church of
S. Francesco, Siena: a fragment from his frescoes is
in the Collection (see NG 1147).

*Bought by Sir A.H. Layard 'from a man who had cut
them out of the wall' before 1864; Layard Bequest, 1916.*

Gordon 1988, pp. 63–5; Volpe 1989, pp. 150–1.

Pietro LORENZETTI
active 1320; died 1348?

Pietro Lorenzetti, brother of Ambrogio Lorenzetti,
painted a number of important altarpieces, and
was also a fresco painter. He collaborated with his
brother on occasions, and worked in the Lower
Church of S. Francesco, Assisi, and in Arezzo in
1320 as well as in his native Siena.

LORENZO d'Alessandro da Sanseverino
The Marriage of Saint Catherine of Siena
probably about 1481–1500

LORENZO di Credi
The Virgin and Child
1480–1500

LORENZO di Credi
The Virgin adoring the Child
1490–1500

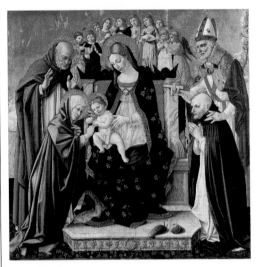

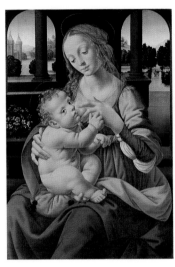

NG 249
Tempera and oil on wood, painted surface
144.8 x 145.4 cm

Inscribed on the Virgin's halo: .AVE. (MARIA) GRATIA. PLENA. DO.(MINUS TECUM) (Hail Mary, full of Grace, the Lord [is with you]); and on the Christ Child's halo: (EGO) SVM LVX (MVNDI) (I am the Light of the World). The haloes of the saints are inscribed with their names: SANTA. K[A]TERINA. DE SEN[IS]; .SANCTVS. DOMINICVS.; S. AVGVSTINVS. Signed on the centre of the throne's base: LAVR/ENTIVS.I.I. / SEVERINAS / PI[N]SIT (Lorenzo da Sanseverino the second painted this).

Saint Dominic (1170–1221, the founder of the Dominican Order of Preachers), left, raises his hands in amazement as his follower, the Dominican tertiary Saint Catherine of Siena (1347?–80), has a ring placed on her finger by the Christ Child – a reference to her vision in which she received this token of his love – in imitation of the divine favour conferred on Saint Catherine of Alexandria. Saint Augustine (354–430), right, stands behind an unnamed Dominican beatus, probably the Blessed Costanzo da Fabriano (died 1481/2).

NG 249 was painted as an altarpiece, possibly for the Dominican church of S. Lucia, Fabriano. In 1502/3 a relic of the Blessed Costanzo was transferred to the church of S. Sebastiano, Fabriano; this is another possible original location for the picture.

In the sacristy of the Dominican church of S. Lucia, Fabriano, by 1839; bought, 1854.

Davies 1961, p. 315.

NG 593
Oil and tempera on wood, 71.1 x 49.5 cm

The Virgin is seated before an arcade with a landscape beyond. The Christ Child suckles at her breast. In the background at the right are Tobias and the Angel.

The composition recalls that of certain works by Leonardo, such as his *Madonna and Child with a Vase of Flowers* (Munich, Alte Pinakothek), of 1475.

Collection of Cav. Mancini, Florence; bought from the Lombardi–Baldi collection, Florence, 1857.

Davies 1961, pp. 303–4.

NG 648
Oil on wood, 86.4 x 60.3 cm

The Virgin kneels, adoring the Christ Child who lies before her. In the background at the right is the Annunciation to the Shepherds.

Collection of Karl Aders; Foster's sale, London, 1835; Lord Northwick's collection by 1846; bought with the Edmond Beaucousin collection, Paris, 1860.

Davies 1961, p. 304.

LORENZO d'Alessandro da Sanseverino
active 1468; died 1503

Lorenzo d'Alessandro was active in the Marches, especially in his native Sanseverino. A painter of altarpieces and frescoes (dated works exist from the period 1481 to 1496), he was principally influenced by Niccolò di Liberatore and Carlo Crivelli.

LORENZO di Credi
about 1458–1537

The artist was the son of a goldsmith. He is recorded in the Florentine workshop of Verrocchio in 1480/1, and seems to have remained there until 1488 when the latter died. His mature work was much influenced by Leonardo da Vinci, who had also worked for Verrocchio.

LORENZO MONACO
Adoring Saints
probably 1407–9

NG 215
Tempera on poplar, painted surface 181.5 x 105 cm

Inscribed on Saint Benedict's book: PASSI/ONIB[US] / XPI (=Christi) P ER / PATIE[N]TIA(M) / PA[R]TICIP/PEMUR /U/T / R/E/G/NI EI(US)/ MERE(AMUR ESSE CONSORTES) (Let us through patience share in the sufferings of Christ that we may deserve to partake of his kingdom.) Inscribed on Saint Matthew's book: CUM N/ATUS /ESSET / YHS (=Iesus) I[N] BE/THLEM / IUDE (=Iuda?) IN / DIEBUS / H/ER/ODI/S RE/GIS (Now when Jesus was born in Bethlehem of Judea in the days of Herod the King.) Inscribed on Saint Paul's book: ad galathas [The letter of Paul] (to the Galatians).

Saints Benedict (in white), with a book inscribed with the Prologue of his Rule, John the Baptist, Matthew, with a book inscribed with words from his Gospel (2: 1), Catherine, Stephen, with the stones of his martyrdom on his head, Paul, with a book inscribed as his Letter to the Galatians, Francis and Augustine or Ambrose assist at the Coronation of the Virgin (see NG 1897).

NG 215 was part of an altarpiece said by Vasari to have been made for the Camaldolese monastery (now destroyed) of S. Benedetto fuori della Porta a Pinti, Florence. A lost Angel of the Annunciation may originally have been the pinnacle above NG 215. See further commentary under NG 1897, with which NG 215 formed a single unified surface.

Transferred to S. Maria degli Angeli, Florence; collection of Cardinal Fesch by 1841; presented by William Coningham, 1848.

Davies 1961, pp. 305–12; Eisenberg 1989, pp. 138–45; Dunkerton 1991, p. 240.

LORENZO MONACO
before 1372–1422 or later

Piero di Giovanni, known as Lorenzo Monaco (Lorenzo the monk), took his vows at the Camaldolese monastery of S. Maria degli Angeli, Florence, in 1391. He painted four altarpieces for the Camaldolese Order, notably the altarpiece for the high altar of S. Maria degli Angeli in 1414. His activity as a painter can be traced back to the 1390s.

LORENZO MONACO
The Coronation of the Virgin
probably 1407–9

NG 1897
Tempera on poplar, painted surface 217 x 115 cm

At the bottom are the fragmentary remains of an inscription: ... S. FLORENT ... (PE?)R .. ME. SUE. ET SU -.

The Coronation of the Virgin shows Mary being crowned Queen of Heaven by her son Jesus Christ, in the presence of saints and choirs of angels with musical instruments. It was one of the most popular subjects in religious art, especially in fourteenth-century Florence.

NG 1897 was the centre of an altarpiece which was made, according to Vasari, for the Camaldolese monastery (now destroyed) of S. Benedetto fuori della Porta a Pinti, Florence. NG 215 and 216 were originally part of the same altarpiece; scenes from the life of Saint Benedict – NG 2862, 4062 and L2 – probably formed its predella and it probably had pinnacle panels. The altarpiece is a smaller version of the same subject painted in 1414 for the main church of the Camaldolese Order in Florence, S. Maria degli Angeli (now Florence, Uffizi), where Lorenzo was a monk. NG 1897 differs from the Uffizi version in having fewer figures, a less elaborate canopy and a tiled floor instead of a starred rainbow. A drawing (Florence, Uffizi) suggests that originally Saint Benedict was to be shown enthroned in the main scene instead of the Coronation of the Virgin.

The robe of the Virgin has almost entirely faded from a deep pinkish mauve to white.

Transferred to S. Maria degli Angeli, Florence; Landi collection, Cerreto, by 1864; bought, 1902.

Davies 1961, pp. 305–12; Burnstock 1988, pp. 58–65; Eisenberg 1989, pp. 138–45; Dunkerton 1991, p. 240.

LORENZO MONACO
Adoring Saints
probably 1407–9

NG 216
Tempera on poplar, painted surface 179 x 101.5 cm

Inscribed on Saint John the Evangelist's book: IN PRIN/CIPIO ER/AT VE[R]B/UM. ET / VERB/UM E/RAT / APUD / DEUM. /ET DE/US ER/AT VER/BUM. HO/C ERAT (In the beginning was the Word, and the Word was with God, and the Word was God). (New Testament, John 1: 1).

Saints Peter, holding keys, Romuald, founder of the Camaldolese Order (in white), Lawrence, Gregory, Dominic and two unidentified male saints (one of whom may be Philip) assist at the Coronation of the Virgin (see NG 1897).

NG 216 was part of an altarpiece said by Vasari to have been made for the Camaldolese monastery (now destroyed) of S. Benedetto fuori della Porta a Pinti, Florence. A possible pinnacle is the *Virgin Annunciate* (Pasadena, Norton Simon collection) which may have been above NG 216. See further commentary under NG 1897, with which NG 216 formed a single unified surface.

Transferred to S. Maria degli Angeli, Florence; presented by William Coningham, 1848.

Davies 1961, pp. 305–12; Eisenberg 1989, pp. 138–45; Dunkerton 1991, p. 240.

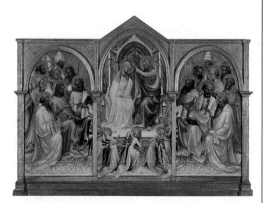

NG 215, **1897** and **216**, in modern frame

LORENZO MONACO
Saint Benedict admitting Saints Maurus and
Placidus into the Benedictine Order, probably 1407–9

LORENZO MONACO
Incidents in the Life of Saint Benedict
probably 1407–9

LORENZO MONACO
The Death of Saint Benedict
probably 1407–9

NG 2862
Tempera on poplar, painted surface 28.5 x 38.5 cm

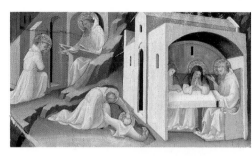

NG 4062
Tempera on poplar, painted surface 28.5 x 52 cm

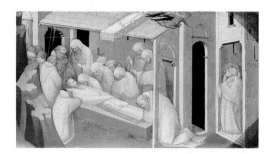

L2
Egg tempera on poplar, painted surface 28.5 x 52 cm

NG 2862 illustrates an episode from the life of Saint Benedict (about 480–547), whose rule was followed by the Camaldolese monks for whom NG 2862 was made. Saints Maurus and Placidus were among Saint Benedict's first followers.

NG 2862, 4062 and L2 are from a predella with scenes from the life of Saint Benedict, probably part of an altarpiece made for the Camaldolese monastery (now destroyed) of S. Benedetto fuori della Porta a Pinti, Florence. The predella comprised three compartments of two scenes each. NG 2862 was paired with *A Monk of Subiaco being drawn from his Prayers by the Devil and Saint Benedict resuscitating a Monk killed by a Fall of Masonry during the Building of Monte Cassino* (Rome, Vatican Museums). The central predella scene which could have shown an Adoration of the Magi, as in a similar altarpiece painted in 1414 by Lorenzo Monaco (Florence, Uffizi), has not been securely identified. See under NG 1897 for further comment.

Collection of Captain James Stirling by 1854; presented by Henry Wagner, 1912.

Davies 1961, pp. 305–12; Eisenberg 1989, pp. 138–45; Dunkerton 1991, p. 240.

Saint Benedict tells Maurus to save Placidus from drowning; Maurus, miraculously walking on the water, seizes Placidus by the hair; and Saint Benedict visits his sister, Saint Scholastica. She prays that he will remain all night: a rainstorm begins and he is unable to depart.

NG 4062, together with NG 2862 and L2, is from a predella with scenes from the life of Saint Benedict, which was part of an altarpiece from S. Benedetto fuori della Porta a Pinti (see NG 2862, where the predella is discussed). NG 4062 was paired with (and is framed with) a fragment showing *The Death of Saint Benedict* on permanent loan to the Collection (L2).

Bought from Canon A.F. Sutton, 1925.

Davies 1961, pp. 305–12; Eisenberg 1989, pp. 138–45; Dunkerton 1991, p. 240.

Saint Benedict is seen lying on his deathbed or funeral bier. At the top of the panel his soul is being taken up to Heaven.

L2 is from a predella with scenes from the life of Saint Benedict which was probably part of an altarpiece from S. Benedetto fuori della Porta a Pinti. Two other panels from this predella by Lorenzo Monaco are in the National Gallery (see NG 4062 and 2862 where the predella is discussed further). L2 was paired, and is framed, with a fragment showing *Incidents in the Life of Saint Benedict* (NG 4062).

On loan from a private collection since 1912.

Davies 1961, pp. 305–12; Eisenberg 1989, pp. 138–45; Dunkerton 1991, p. 240.

Attributed to LORENZO MONACO
Illuminated Letter B (Abraham and the Angels)
1396

NG 3089
Tempera on vellum, 37 x 33 cm

Abraham had a vision of three angels and was told that his wife would bear him a son. Old Testament (Genesis 18: 1–5).

NG 3089 is a fragment from an illuminated choral book (Biblioteca Laurenziana Cod. Cor. 1). It has recently been proposed that this illumination is the work of Don Silvestro dei Gherarducci, another Camaldolese monk working at S. Maria degli Angeli, Florence at the same time as Lorenzo Monaco.

Music and fragments of words appear on the reverse.

Collection of J.G. von Quandt by 1860; Layard Bequest, 1916.

Davies 1961, pp. 312–13; Eisenberg 1989, p. 197.

Attributed to LORENZO MONACO
Saint Benedict in the Sacro Speco at Subiaco
probably about 1415–20

NG 5224
Tempera on wood, including frame 36 x 28 cm

Inscribed on the false frame: ME DUCE (Under my leadership).

This episode from the life of Saint Benedict is related in *The Golden Legend*. The young saint in a cave is receiving food being let down in a basket at the end of a rope attached to a bell by Saint Romanus.

NG 5224 has a false frame with a false coat of arms. It has occasionally been related to the predella of the altarpiece discussed under NG 1897. This is highly unlikely, although stylistically NG 5224 seems to date from the same period.

The composition is related to Taddeo Gaddi's fresco in the refectory at S. Croce, Florence, and the angel (top right) was probably part of another scene: *The Priest at the Easter Meal receiving Word from an Angel of Saint Benedict's Hunger in the Wilderness*.

Collection of Lord Rothermere, 1927; presented by Viscount Rothermere, 1940.

Davies 1961, pp. 313–14; Eisenberg 1989, pp. 145–6.

Attributed to LORENZO Veneziano
The Madonna of Humility with Saints Mark and John the Baptist, about 1359–66

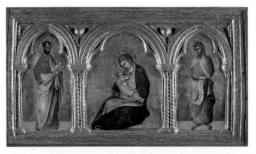

NG 3897
Tempera on poplar, 31.1 x 57.5 cm

Inscribed on the central section: SCA/ MARIA d' LAUMI/ LITADE (presumably intended for de Humilitate, i.e. Holy Mary of Humility). On the left section: .S./MAR/CHVS (Saint Mark). On the right section: S. /.IOHES/ .BTI. (Saint John the Baptist), and on the scroll held by the saint: ECCE/ A(G?)N'/ DEI/ ECCE/ QVI/ TOLIS/ PECA/ TA/ MVN/ DI./ MIS/ ERE/ RE (Behold the Lamb of God. Behold who takes away the sins of the world. Have mercy).

The Virgin is represented here as the Madonna of Humility, seated on the ground (see also Lippo di Dalmasio NG 752 and Dalmatian School NG 4250). She has a crescent moon at her feet, the remains of a roundel representing the sun on the neckline of her robe, and stars behind. These elements may be linked with the subject of the Immaculate Conception, a common theme in Venetian painting of this period. Saint Mark at the left is identified by the inscription, and at the right Saint John the Baptist, dressed in skins, points to the Christ Child. The cusped arches and twisted columns of the frame are typical of the Venetian Gothic.

NG 3897 is most probably an independent work intended for private devotion. It is placed in the artist's output between the two signed works mentioned in the biography (i.e. about 1359–66). The inclusion of Saint Mark may mean the panel was intended for the Venetian market.

A similar work, likewise attributed to Lorenzo Veneziano, also survives (The Hague, Dienst Verspreide Rijkscollecties).

Revd J. Fuller Russell collection; presented by Henry Wagner, 1924.

Gordon 1988, pp. 66–7; Dunkerton 1991, p. 228.

LORENZO Veneziano
active 1356 to 1372

Lorenzo Veneziano was a Venetian whose period of activity is based upon inscriptions on his surviving works. He painted in Venice itself, and in the surrounding Veneto, and is recorded in Bologna (1368) and Verona. The artist's most important signed works are the Lion polyptych of 1357–9 (Venice, Accademia) and the De' Proti polyptych of 1366 (Vicenza, Cathedral).

Attributed to Bernardino LOSCHI
Portrait of Alberto Pio
1512

Johann Carl LOTH
Mercury piping to Argus
1655–60

Lorenzo LOTTO
The Physician Giovanni Agostino della Torre and his Son, Niccolò, 1515

NG 3940
Oil on wood, 58.4 x 49.5 cm

NG 3571
Oil (identified) on canvas, 116.9 x 99.7 cm

NG 699
Oil on canvas, 84.5 x 67.9 cm

Inscribed (now scarcely legible) on the black tunic: ALBERTUS PIUS CARPENSIS MDXII (Alberto Pio of Carpi 1512). Inscribed on the open book with Virgil's *Aeneid*, VI, 724–47. Damaged inscriptions in Greek appear elsewhere in the picture.

There seems to be no reason to doubt the identification of the sitter as Alberto Pio (1475–1531), Lord of Carpi and a humanist prince. The copy of Virgil's *Aeneid* that he holds is open at the prophecy of the future glory of Rome. The landscape background contains figures of the Muses, Silenus on his ass, fauns and a fountain; their exact significance has not been established.

Although Pio was mainly in Rome in about 1512, it is likely that NG 3940 was painted on a visit to Carpi in that year. The portrait has been attributed to Bernardino Loschi on the basis of comparison with an altarpiece of 1515 (Modena, Galleria Estense).

Collection of Sir J.C. Robinson; bought by Ludwig Mond, 1890; Mond Bequest, 1924.

Gould 1975, pp. 130–2.

The god Jupiter fell in love with Io; he protected her from the jealousy of his wife Juno by transforming her into a heifer, depicted at the left. Juno discovered the heifer's identity, and had it guarded by Argus Panoptes. Then Jupiter sent Mercury to kill Argus, which he did after piping him to sleep. Ovid, *Metamorphoses*, I.

NG 3571 is thought to date from the late 1650s, and be among Loth's earliest Venetian works.

Presented by A.G.H. Ward through the NACF, 1920.

Levey 1959, p. 63.

Signed and dated on the chair, bottom right: L. LOTVS. P.[INXIT] /1515 (Lorenzo Lotto painted this, 1515). Inscribed on the scroll held by the foreground figure: Medicorum Esculapio / Joanni Augustino Ber / gomatj (Doctor Giovanni Agostino from Bergamo); and on the letter on the table: D[omi]no Nicolao de la tur / re nobili bergom ... / ... amico sing[ulisissi]mo / Bg.mj (Master Niccolò della Torre, nobles of Bergamo, most particular friend). The book is inscribed: Galienus (Galen).

Giovanni Agostino della Torre, renowned physician of Bergamo, is known to have died in 1535, aged 81. He was therefore 61 at the time this portrait was painted; the likeness of his son Niccolò, a prominent citizen of Bergamo, may have been added later.

Collection of General Teodoro Lechi, Brescia, by 1812 (later said to have been acquired by Lechi from the della Torre family of Bergamo); bought from Morelli, 1862.

Gould 1975, pp. 133–4.

Bernardino LOSCHI
active 1500; died 1540

Bernardino Loschi was from Parma, and worked as court painter to Alberto Pio in Carpi from about 1500 to about 1522. He is known to have painted portraits and altarpieces.

Johann Carl LOTH
1632–1698

Loth was born in Munich. He was the son of the painter Johann Ulrich Loth, by whom he was probably trained. He is thought to have worked in Rome, before settling in Venice by 1660. In Italy he is often referred to as Carlotto. He painted altarpieces, mythologies and historical pictures.

Lorenzo LOTTO
about 1480–after 1556

Lotto was born in Venice, and was active in Treviso (possibly about 1498, and certainly 1503–6), Bergamo (1512–27), Rome (1509), Venice and the Marches. He painted numerous altarpieces, as well as small devotional works, allegories and portraits. He made designs for intarsia choir stalls and sometimes worked in fresco. Lotto's painting, which was influenced by both leading Venetian and German artists, was highly original in style.

Lorenzo LOTTO
The Virgin and Child with Saint Jerome and Saint Nicholas of Tolentino, probably 1522

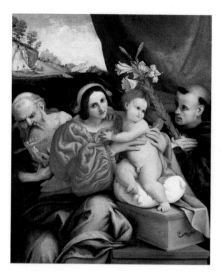

NG 2281
Oil (identified) on canvas, 89.5 x 74.3 cm

Signed and dated on the side of the coffin, right: Laurentius Lotus 1522.

Saint Jerome (about 342–420), the chief inspiration for Christian penitents and hermits, is shown on the left with a crucifix. Saint Nicholas of Tolentino (about 1245–1305) is on the right with a lily, and dressed in black as a member of the Augustinian Order. By depicting Christ standing on the coffin the artist perhaps indicates his future conquest over death.

An unsigned and undated version of the composition is in the Museum of Fine Arts, Boston. A variant of the composition – substituting Saints John the Baptist and Catherine of Alexandria for Saints Jerome and Nicholas – is similarly signed and dated (private collection).

Collection of Martin Colnaghi by 1895; by whom bequeathed, 1908.

Gould 1975, pp. 136–7; Ekserdjian 1991, pp. 87–91.

Lorenzo LOTTO
A Lady with a Drawing of Lucretia
about 1530–3

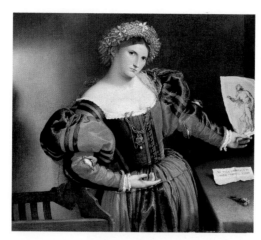

NG 4256
Oil on canvas, transferred from wood, cut down 95.9 x 110.5 cm

Inscribed on the piece of paper on the table: NEC VLLA IMPVDICA LV/CRETIAE EXEMPLO VIVET ('Nor shall ever unchaste woman live through the example of Lucretia').

The sitter has not been conclusively identified. On the basis of the provenance it has been suggested that she might be Lucrezia Valier, who married Benedetto Francesco Giuseppe di Gerolamo Pesaro in 1533. However, Lucretia was a common name and it has been argued that the dress is not noble but that of a wealthy provincial, perhaps from Brescia or Bergamo. The inscription comes from Livy's *History of Rome* (I, 58) and complements the drawing held by the sitter; this shows Lucretia committing suicide after she had been raped by Tarquin. Her words indicate that she accepts the argument of her friends that she was not to blame for the loss of her honour, but that she would not wish to furnish any woman who was to blame with an excuse for living.

NG 4256 is said to have been painted in about 1530–3 on the basis of the style of dress and the supposed identification of the sitter as Lucrezia Valier.

In the collection of the Pesaro family, Venice, by 1797; bought by James Irvine; in British private collections until bought with contributions from the Benson family and the NACF, 1927.

Gould 1975, pp. 137–8.

Lorenzo LOTTO
Portrait of Giovanni della Volta and his Family (?)
probably 1547

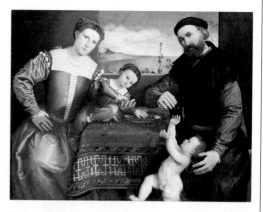

NG 1047
Oil (identified) on canvas, 114.9 x 139.7 cm

Signed: .L. Lotto.

NG 1047 can probably be identified with a portrait described by Lotto in his account book kept between 1538 and 1547. In 1547 (20 March and 23 September) he recorded painting a portrait of his landlord Giovanni della Volta, his wife and two children. No other portrait of a man, woman and two children by Lotto is known, and the costumes of NG 1047 have been dated to the late 1540s.

Lotto asked 50 ducats for his portrait of Giovanni della Volta and his family on the basis of high quality and fine colours (*per bontà e per colori finissimi*). He finally accepted 20 ducats. The portrait was provided with a cover.

Collection of Lucien Bonaparte by 1812; collection of Edward Solly by 1847; bequeathed by Miss Sarah Solly, 1879.

Zampetti 1969, p. 98; Gould 1975, pp. 134–5.

LUCAS van Leyden
A Man aged 38
about 1521

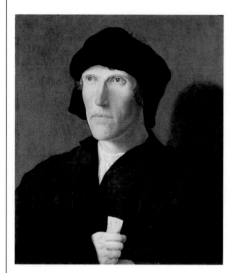

NG 3604
Oil on oak, 47.6 x 40.6 cm

Inscribed on a paper in the sitter's hand: 38.
 The inscription probably refers to the age of the unidentified sitter.
 NG 3604 is dated to about 1521 by comparison with inscribed drawings by the artist.

Claes Adriaensz., Leiden, by 1604; collection of Lewis Fry, Bristol; presented by his children in his memory through the NACF, 1921.

Davies 1968, pp. 79–80; Smith 1992, pp. 151–3.

Style of LUCAS van Leyden
Lot's Daughters make their Father drink Wine
about 1508–15

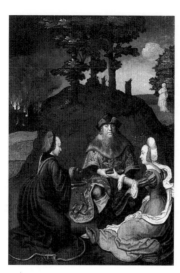

NG 3459
Oil on oak, 32.4 x 22.9 cm

After having left the city of Sodom which was destroyed by God with brimstone and fire, Lot went to live in a cave with his daughters. They thought they might never see another man, and so planned to get their father drunk so that they could seduce him. In the background at the left the burning city of Sodom is depicted, while at the right Lot's wife is shown as a pillar of salt; she was thus transformed when she looked back at the city during their escape. Old Testament (Genesis 19).
 NG 3459 appears to be to be comparable in style to the artist's early engravings. Other engraved and painted treatments of the same subject by, or close to the work of, Lucas are known. Although the painting has been thought to be an early work by Lucas himself, it is probably the work of a follower.

Mrs J.D. Farr; sale, Christie's, 1902; bought from T. Blake Wirgman, 1919.

Davies 1968, pp. 80–1.

Lodewijck van LUDICK
A River between Rocky Cliffs, with a Waterfall on the left, about 1670

NG 1007
Oil on canvas, 53.5 x 66.4 cm

Falsely signed lower right: P(.)W
 The false signature is in imitation of the usual one of Philips Wouwermans. This painting was previously attributed to Abraham Begeijn but in fact is closer in composition and style to signed paintings by van Ludick, especially a landscape in Warsaw (National Museum).

Probably in the Niewenhuys collection; Wynn Ellis Bequest, 1876.

MacLaren/Brown 1991, pp. 234–5.

LUCAS van Leyden
active 1508; died 1533

The artist was an engraver, a painter and a designer of stained glass. He worked in Leyden (Leiden), and according to van Mander was a pupil of Cornelis Engelbrechtsz (or Engelbrechtsz). Dürer was an important influence, especially on his engravings, but his later paintings are more Italianate in style.

Lodewijck van LUDICK
1629–before 1697

Van Ludick was born and worked in Amsterdam. His father was an Amsterdam merchant and art dealer who was acquainted with many of the city's artists, including Rembrandt. Van Ludick was a landscape painter in the manner of Jan Both.

Bernardino LUINI
The Virgin and Child with Saint John
perhaps about 1510

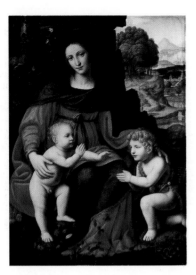

NG 3935
Oil on poplar, painted surface 88.3 x 66 cm

The composition seems to have been influenced by Leonardo's *Virgin of the Rocks* (NG 1093).

Stylistically NG 3935 is probably an early work, possibly of about 1510.

Unidentified seal on the back; acquired by Ludwig Mond, 1893; Mond Bequest, 1924.

Ottino della Chiesa 1956, pp. 83–4; Davies 1961, p. 320.

Bernardino LUINI
Christ among the Doctors
probably about 1515–30

NG 18
Oil on poplar, painted surface 72.4 x 85.7 cm

The twelve-year-old Jesus remained in the Temple disputing with the Doctors. They were astounded by his wisdom. New Testament (Luke 2: 41–8). NG 18 is sometimes said to be Christ disputing with the Pharisees (on the grounds that he seems more than twelve years old), but the subject of his dispute with the doctors was much more common.

NG 18 was formerly attributed to Leonardo and highly praised in the eighteenth and early nineteenth centuries. The composition probably derives from a lost cartoon by Leonardo, who had been asked in 1504 (by Isabella d'Este) for a painting showing Christ as a youth. There are numerous other versions of NG 18, some of similar, but none of higher, quality (e.g. After Luini NG 2088).

Collection of Olimpia Aldobrandini, Rome, by 1626; Palazzo Borghese, Rome, by 1776; collection of Alexander Day by 1800; collection of Lord Northwick by about 1808; from whom bought by the Revd Holwell Carr, 1824; Holwell Carr Bequest, 1831.

Ottino della Chiesa 1956, p. 84; Davies 1961, pp. 317–20.

Workshop of LUINI
The Virgin and Child
early 16th century

NG 3090
Oil on poplar, 48.9 x 43.8 cm

NG 3090 is sometimes accepted as an autograph work by Luini, but is probably a workshop piece (or even an early copy).

Collection of Conte Giberto Borromeo, Genoa, by 1857; bought by Sir A.H. Layard from Baslini, Milan, about 1863; Layard Bequest, 1916.

Ottino della Chiesa 1956, p. 83; Davies 1961, pp. 320–1.

Bernardino LUINI
active 1512; died 1532

Luini, the most famous Milanese painter of the early sixteenth century, was active as a fresco and panel painter in Milan and other towns in Lombardy (Chiaravalle, Saronno, Lugano). He painted in a style first influenced by the fifteenth-century Lombard tradition and then by Leonardo's work in Milan.

After LUINI
Saint Catherine
early 16th century

After LUINI
Christ
probably after 1530

Gerrit LUNDENS (after Rembrandt)
The Company of Captain Banning Cocq and Lieutenant Willem van Ruytenburch ('The Nightwatch'), after 1642

NG 3936
Oil on poplar, painted surface 71.1 x 59.7 cm

NG 2088
Oil on poplar, painted surface 73.7 x 57.8 cm

NG 289
Oil on oak, 66.8 x 85.4 cm

Saint Catherine of Alexandria is shown between two angels. The one on the left holds a martyr's palm; the one on the right holds Catherine's traditional attribute of the wheel on which she was tortured.

Other versions of this composition are known; both NG 3936 and the version in the Hermitage, St Petersburg, have been thought to be the original.

Corsi collection, Florence; Howard collection, Corby Castle, by 1825; Mond Bequest, 1924.

Ottino della Chiesa 1956, p. 84; Davies 1961, p. 322.

NG 2088 is a copy of the central figure of Christ in Luini NG 18 (*Christ among the Doctors*).

Although possibly sixteenth century, NG 2088 does not seem to be contemporary with NG 18.

Said to have come from the Strozzi collection, Ferrara; John Samuel collection by 1871; bequeathed by the Misses Cohen as part of the John Samuel collection, 1906.

Ottino della Chiesa 1956, p. 85; Davies 1961, p. 321.

In the foreground are the company's captain, Frans Banning Cocq, in black, and his lieutenant, Willem van Ruytenburch. Behind them the company's colours are carried by the ensign, Jan Visscher Cornelisen.

NG 289 is a greatly reduced copy of Rembrandt's so-called *Nightwatch* of 1642 (on loan from the city of Amsterdam to the Rijksmuseum, Amsterdam). It records the composition before the original was cut down on all sides, presumably in 1715, when it was moved from the room in the Kloveniersdoelen for which it was painted to the town hall in Amsterdam.

The attribution to Lundens is confirmed by comparison with three signed and dated miniature portraits of 1650 by the artist (Amsterdam, Rijksmuseum). It is likely that the commission came from Banning Cocq because of the picture's provenance (see below), and because a watercolour copy that the captain had made for his family album (on loan to the Rijksmuseum, Amsterdam) was based on the Lundens copy rather than the Rembrandt original.

Possibly included in the inventory of the estate of Catharina Hooft, widow of Cornelis de Graeff, 1691 (Banning Cocq was related to the Hooft and de Graeff families); bequeathed by the Revd Thomas Halford, 1857; on loan to the Rijksmuseum, Amsterdam, since 1963.

MacLaren/Brown 1991, pp. 235–9.

Gerrit LUNDENS
1622–1683?

Lundens was born and worked in Amsterdam, where he is frequently recorded between 1643 and 1683. He is last mentioned on 27 September 1683. The artist painted genre scenes, miniature portraits and small-scale copies of militia company portraits, such as NG 289.

Zanobi MACHIAVELLI
The Virgin and Child
probably about 1470

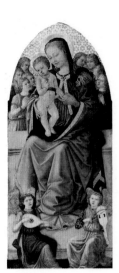

NG 586.1
Tempera on wood, painted surface 163.8 x 70.5 cm

The Virgin and Child are shown enthroned and surrounded by angels. Christ touches a piece of coral that hangs around his neck.

NG 586.1–3 is said to have come from the Augustinian church of S. Spirito, Florence, possibly from the Capponi da S. Frediano family chapel, which contains Augustinian saints (e.g. Saint Nicholas of Tolentino). The altarpiece was probably a triptych with NG 586.2 on the left and NG 586.3 on the right. It has been suggested that NG 587 and NG 588 might have formed part of the same ensemble.

Lombardi–Baldi collection, Florence, by 1845; from where bought, 1857.

Davies 1961, pp. 323–4.

Zanobi MACHIAVELLI
A Bishop Saint and Saint Nicholas of Tolentino
probably about 1470

NG 586.2
Tempera on wood, painted surface 143 x 59.5 cm

Saint Nicholas of Tolentino (about 1245–1305) is on the left dressed in black as a member of the Augustinian Order, and holding a book and a lily. The bishop saint has not been identified.

NG 586.2 was the left wing of a triptych, the central panel of which is NG 586.1. It is discussed under NG 586.1.

A predella panel showing a miracle of Saint Nicholas of Tolentino (Amsterdam, Rijksmuseum) may come from this altarpiece, and would probably have been placed below the figure of Saint Nicholas.

Said to have been in the church of S. Spirito, Florence; Lombardi–Baldi collection, Florence, by 1845; from where bought, 1857.

Davies 1961, pp. 323–4.

Zanobi MACHIAVELLI
Saint Bartholomew and Saint Monica
probably about 1470

NG 586.3
Tempera on wood, painted surface 142.5 x 59.5 cm

Saint Bartholomew is shown with his traditional attribute of the knife with which he was flayed. Saint Monica was a fourth-century saint, whose cult seems to have been developed after her relics were taken to Rome (from Ostia where she died) in 1430.

NG 586.3 was the right wing of a triptych, the central panel of which is NG 586.1. It is discussed under NG 586.1.

Said to have been in the church of S. Spirito, Florence; Lombardi–Baldi collection, Florence, by 1845; from where bought, 1857.

Davies 1961, pp. 323–4.

NG 586.1-3

Zanobi MACHIAVELLI
about 1418–1479

Zanobi Machiavelli was first recorded as a painter in 1464. He was said to have been a pupil of Benozzo Gozzoli, with whom he seems to have worked in San Gimignano and in the Campo Santo at Pisa from 1475 to 1476.

Zanobi MACHIAVELLI
Saint John the Baptist and Saint John the Evangelist, probably about 1470

Zanobi MACHIAVELLI
Saint Mark and Saint Augustine
probably about 1470

Raimundo de MADRAZO
Portrait of a Lady
1885–95

NG 587
Tempera on wood, painted surface 128.9 x 50.1 cm

NG 588
Tempera on wood, painted surface 129.5 x 52.1 cm

NG 3254
Oil on canvas, 49.5 x 40 cm

Inscribed on Saint John the Baptist's scroll: ECCE AGN[US DEI ECCE QUI TOLLIT] / PE[CCATUM MUNDI] (Behold the lamb of God who takes away the sins of the world).

Saint John the Baptist is identified by the camel skin he wore in the desert and the inscription on his scroll from the New Testament (John 1: 29). Saint John the Evangelist is accompanied by his traditional attribute of an eagle, and is shown with a book as is conventional for an evangelist.

NG 587 was the left wing of an altarpiece, of which NG 588 was the right wing. Both panels were once thought to have come from the same ensemble as NG 586.1–3. However, they are slightly smaller than the wings of NG 586, have a different figure scale and rounded tops (whereas the wings of NG 586 have pointed tops). Moreover, pentaptychs were uncommon in Florence around 1470, and would have been particularly unlikely on the small lateral altars of S. Spirito, Florence. On the other hand, it has been observed that – as in NG 586, which may come from the Augustinian church of S. Spirito, Florence – the saints include Augustinians, and the step on which the saints stand is similar in both sets of wings.

Possibly in the church of S. Spirito, Florence; Lombardi–Baldi collection, Florence, by 1845; from where bought, 1857.

Davies 1961, pp. 324–5.

Saint Mark is accompanied by his traditional attribute, a winged lion. Saint Augustine (354–430) is shown as Bishop of Hippo.

NG 588 was the right wing of an altarpiece, of which NG 587 was the left wing. See under NG 587 for further information.

There is a profile sketch of a woman on the unprimed wood of the reverse of NG 588.

Possibly in the church of S. Spirito, Florence; Lombardi–Baldi collection, Florence, by 1845; from where bought, 1857.

Davies 1961, pp. 324–5.

Signed bottom right: R. Madrazo.
The sitter has not been identified.
Her costume has been dated to either the late 1880s or the early 1890s.
It has been suggested that NG 3254 is a study for a larger portrait.

Sir Hugh Lane Bequest, 1917; on loan to the Hugh Lane Municipal Gallery of Modern Art, Dublin, since 1979.

Davies 1970, p. 89.

Raimundo de MADRAZO
1841–1920

Raimundo de Madrazo came from a Spanish family, but was born in Rome. He studied under his father and at the Madrid Academy, and in Paris under Cogniet. He lived and worked mainly in Paris, where he specialised in portrait painting.

Nicolaes MAES
Christ blessing the Children
1652–3

NG 757
Oil on canvas, 206 x 154 cm

The scribbles on the slate that the central child holds are unintelligible.

The subject of Christ blessing the children from the New Testament (Matthew 19; Mark 10: 'Suffer the little children to come unto Me'; etc) was treated by Rembrandt in *The Hundred Guilden Print* of about 1624–5, and by a number of his pupils in addition to Maes. Here the figure at the extreme left appears to be a portrait, and may be a self portrait by Maes.

NG 757 was, until 1880, catalogued as a painting by Rembrandt. Since then it has been attributed to various pupils of his, but recently there has been agreement on the attribution to Maes. The work is thought to date from when he was still in Rembrandt's studio, or just after he left it (i.e. 1652–3), and before his return to Dordrecht late in 1653. It has similarities with other works by Maes of this decade, such as *The Sacrifice of Isaac* (private collection).

Two drawn compositional studies by Maes are known (London, British Museum; Amsterdam, Rijksmuseum).

Possibly recorded in an inventory of pictures belonging to Maria van Rommerswael, Dordrecht, 1674; bought, 1866.

MacLaren/Brown 1991, pp. 242–5.

Nicolaes MAES
A Woman scraping Parsnips, with a Child standing by her, 1655

NG 159
Oil on oak, 35.6 x 29.8 cm

Signed and dated bottom right: N MAES 1655 (MAE in monogram).

The artist painted a number of interiors of this type, showing humble domestic tasks.

Two preparatory drawings for the seated woman are known (Paris, Institut Néerlandais; New York, Woodner Family collection).

[Juriaans] sale, Amsterdam, 1817; bequeathed by Lord Farnborough, 1838.

MacLaren/Brown 1991, pp. 240–1.

Nicolaes MAES
Interior with a Sleeping Maid and her Mistress ('The Idle Servant'), 1655

NG 207
Oil on oak, 70 x 53.3 cm

Signed and dated: N. MAES. 1655. (MAE in monogram).

The housewife points to the sleeping maid, who has allowed a cat to steal a bird. The maid's pose is the traditional one for the sin of Acedia (idleness). However, rather than condemning the girl, the housewife seems to be amused by her fallibility; the scene may refer to a popular Dutch saying: 'A kitchenmaid must keep one eye on the pan and the other on the cat.'

Bought in Leiden by Dr Sanderus; from whom bought by C.J. Nieuwenhuys, Amsterdam, 1823; bequeathed by Richard Simmons, 1847.

MacLaren/Brown 1991, pp. 241–2.

Nicolaes MAES
1634–1693

Maes was born in Dordrecht, and in about 1650 became a pupil of Rembrandt in Amsterdam. He returned to Dordrecht (1653–73), visited Antwerp, and then settled in Amsterdam, where he died. Maes's earliest works are religious scenes in Rembrandt's style but he soon began to paint domestic interiors and small-scale portraits in an original style.

Nicolaes MAES
A Little Girl rocking a Cradle
about 1655

Nicolaes MAES
Portrait of an Elderly Man in a Black Robe
1666

Nicolaes MAES
Portrait of Jan de Reus
1670s

NG 153
Oil on oak, 40.4 x 32.6 cm

NG 1277
Oil on canvas, 89.5 x 71.4 cm

NG 2581
Oil on canvas, 79 x 62.5 cm

Signed bottom right: N. MAE (MAE in monogram).
 NG 153 is one of a group of genre pictures painted by Maes in Dordrecht during the period 1654–9. The right side of the panel has been cut down by at least 5mm. The section which was removed may have been inscribed with the date 1655; such an inscription is described when the work was first recorded.

Possibly collection of François Tronchin, Geneva, by 1780; bequeathed by Lord Farnborough, 1838.

MacLaren/Brown 1991, p. 240.

Signed and dated right centre: .N: MAES. Ao.1666.
 The sitter has not been identified.
 There is another portrait by Maes of the same sitter, signed and dated 1665 (formerly Washington, Johnson collection).

Presented by Sir Theodore Martin, KCB, 1888.

MacLaren/Brown 1991, p. 245.

Jan de Reus (about 1600–85) was a Rotterdam silk merchant. He was a member of the town council and burgomaster eight times, as well as being a director of the Dutch East India Company from 1658. The identification of the sitter is made by comparison with a copy of the portrait by Pieter van der Werff (Amsterdam, Rijksmuseum; on loan to Rotterdam, Historisch Museum), which was one of a series of portraits of directors of the Dutch East India Company.
 NG 2581 was probably painted in the 1670s; it appears to be later than NG 1277.

Sir Hugh Hume Campbell, Bt, sale, London, 1894; Salting Bequest, 1910.

MacLaren/Brown 1991, p. 246.

Nicolaes MAES
Portrait of a Man in a Black Wig
about 1680

Antonio MANCINI
The Customs
1877

Antonio MANCINI
The Marquis del Grillo
1889

NG 2954
Oil on canvas, 47.6 x 38.7 cm

NG 3255
Oil on canvas, 73.7 x 59.1 cm

NG 3257
Oil on canvas, 205.7 x 109.2 cm

The sitter has not been identified.
 NG 2954 was formerly attributed to Caspar Netscher, but is now recognised as the work of Maes, who painted a number of portraits of this type in his later years.

Bequeathed by Mrs Sarah Austen (died about 1891), London, to Sir A.H. Layard; Layard Bequest, 1913.

MacLaren/Brown 1991, p. 247.

Signed bottom right: A. Mancini
 A woman sits surrounded by luggage apparently waiting to have it inspected by customs officials.
 According to Mancini (in a handwritten note made in a copy of the 1908 catalogue of the Municipal Gallery of Modern Art, Dublin) NG 3255 was painted in Paris in 1877, sold to Goupil and subsequently to Hugh Lane.

Sir Hugh Lane Bequest, 1917; on loan to the Hugh Lane Municipal Gallery of Modern Art, Dublin, since 1979.

Alley 1959, pp. 132–3.

Signed and dated bottom right: A. Mancini / 1899
 The Marquis Giorgio Capranica del Grillo (1849–1922) was a gentleman of the court of Queen Margherita of Italy, the Queen Mother. He was a good friend of Mancini's.
 NG 3257 was painted in Rome in 1889 and was apparently post-dated 1899 in 1904. With its bold handling and thick impasto, it is a typical example of the exuberant style of portrait developed by Mancini in the 1880s.

Sir Hugh Lane Bequest, 1917; on loan to the Hugh Lane Municipal Gallery of Modern Art, Dublin, since 1979.

Alley 1959, pp. 133–4.

Antonio MANCINI
1852–1930

Born in Rome, Mancini studied in Naples and worked in Paris in the late 1870s. He was subsequently in Naples until 1883, when he moved to Rome. He painted genre subjects and portraits, which were especially popular in England.

Antonio MANCINI
On a Journey
about 1903

Antonio MANCINI
Aurelia
about 1906

Edouard MANET
Music in the Tuileries Gardens
1862

NG 3260
Oil (identified) on canvas, 76.2 x 118.1 cm

NG 3256
Oil on canvas, 96.5 x 57.8 cm

NG 3258
Oil on canvas, 94 x 59.7 cm

Signed top right: A. Mancini / Roma
 NG 3256 is a portrait of Mancini's father. It was painted in Rome in about 1903 and probably sold directly by the artist to Hugh Lane.

Sir Hugh Lane Bequest, 1917; on loan to the Hugh Lane Municipal Gallery of Modern Art, Dublin, since 1979.

Alley 1959, p. 133.

Signed bottom left: A. Mancini
 The sitter, Aurelia, was a noted model in Rome; she was nicknamed 'La Cornacchia' ('The Crow'). On the reverse of the picture is another oil sketch of the sitter in a different pose.
 NG 3258 was painted in about 1906 and was probably sold directly to Hugh Lane by Mancini, around 1907.

Sir Hugh Lane Bequest, 1917; on loan to the Hugh Lane Municipal Gallery of Modern Art, Dublin, since 1979.

Alley 1959, pp. 134–5.

Signed and dated: éd Manet 1862
 This is Manet's first major painting of modern city life. A crowd of fashionable Parisians has gathered to listen to a concert in the Tuileries gardens. The spectators include many of the artist's friends and family. Manet himself appears at the far left; next to him is the painter Albert de Balleroy; seated to their right is the poet and sculptor Zacharie Astruc; further back, the three men in conversation are the poet Charles Baudelaire, the critic Théophile Gautier and Baron Taylor. Immediately to their left is the painter Henri Fantin-Latour. In the right-hand section of the painting, the standing man leaning forward slightly is probably the artist's brother, Eugène, and behind him, seated against a tree, is Jacques Offenbach, the composer of popular operettas.
 Manet made several studies in the gardens, but the final picture was probably painted in the studio, and he used photographs for some of the portraits.

Collection of J.B. Faure by 1884; acquired by Sir Hugh Lane, 1906; Lane Bequest, 1917.

Davies 1970, pp. 91–4; Cachin 1983, pp. 122–6; Bomford 1990, pp. 112–19.

Edouard MANET
1832–1883

Manet was born in Paris, where he was taught by Couture (1850–6) and studied the Old Masters in the Louvre. His exhibits at the Salon (from 1861) and the Salon des Refusés (1863) achieved much critical attention and he became a leading figure in the Paris avant-garde. During the 1870s he painted open-air figure scenes and in 1874 worked with Monet and Renoir.

Edouard MANET
The Execution of Maximilian
about 1867–8

NG 3294
Oil (identified) on canvas (four fragments laid down on a single support), total dimensions 193 x 284 cm

Edouard MANET
Eva Gonzalès
1870

NG 3259
Oil on canvas, 191.1 x 133.4 cm

Edouard MANET
Corner of a Café-Concert
probably 1878–80

NG 3858
Oil (identified) on canvas, 97.1 x 77.5 cm

The Austrian Archduke Ferdinand Maximilian (1832–67) was installed in Mexico as a puppet emperor by Napoleon III in 1863. He was dependent on the support of an occupying French army and when Napoleon withdrew his troops Maximilian was captured by Mexican forces loyal to their legitimate republican government. He was executed alongside two of his generals, Mejía and Miramón, on 19 June 1867.

Manet's first version of this subject (Boston, Museum of Fine Arts) was painted in 1867. NG 3294 was probably begun later that year. His third and final large-scale version is in the Städtische Kunsthalle, Mannheim. Soldiers from a local barracks posed for the firing squad and Manet used photographs for the likenesses of the victims.

The left-hand section of the canvas showing General Mejía was probably cut off by Manet himself. After the artist's death the canvas was cut up into smaller fragments, some of which were sold separately. Edgar Degas eventually purchased all the surviving fragments and reassembled them on a single canvas. A sketch for a group of four soldiers, formerly in the Gallery and now in the British Museum, was once thought to have been made in preparation for NG 3294, but its attribution to Manet is no longer certain.

In Manet's studio until his death; subsequently sold to Edgar Degas; bought with a special grant at the sale of the Degas collection, 1918.

Davies 1970, pp. 94–8; Wilson Bareau 1992, pp. 35–113.

Signed and dated: manet 1870.
 Eva Gonzalès (1849–83) was the daughter of the novelist Emmanuel Gonzalès and a former pupil of the fashionable painter Charles Chaplin. She entered Manet's studio as his pupil in February 1869. This portrait was completed by March 1870, in time to be exhibited at the Salon of that year. According to Berthe Morisot, the portrait took numerous sittings.

Collection of Eva Gonzalès and then of her widower, Henri Guérard; Sir Hugh Lane Bequest, 1917.

Davies 1970, pp. 89–91; Wilson 1978, p. 41.

Signed and dated: Manet/78 (or 79?).
 NG 3858 was originally the right-hand part of a painting of the Brasserie de Reichshoffen, begun in about 1877, that Manet cut into two pieces. The left half of the composition is now in Winterthur (Oskar Reinhart Collection). NG 3858 was enlarged on the right and a new background (of a dancer on a stage and musicians) was added. The Brasserie de Reichshoffen was apparently in the boulevard Rochechouart, Paris.

The transformation of the café scene into a *café-concert* was completed by the spring of 1880 when the picture was shown under its present title.

Bought at the Manet sale, 1884, for Charles Haviland; bought by the Trustees of the Courtauld Fund, 1924.

Davies 1970, pp. 98–101; Bomford 1983, pp. 3–19; Cachin 1983, pp. 418–21; Wilson Bareau 1986, pp. 65ff.

Giovanni MANSUETI
Symbolic Representation of the Crucifixion
probably 1492

Andrea MANTEGNA
The Agony in the Garden
about 1460

Andrea MANTEGNA
The Virgin and Child with the Magdalen and Saint John the Baptist, probably 1490–1505

NG 1478
Oil on canvas, 129.5 x 123.8 cm

NG 1417
Tempera on wood, 62.9 x 80 cm

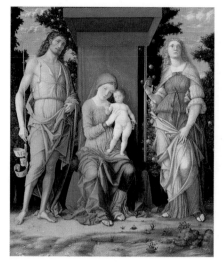

NG 274
Tempera on canvas, 139.1 x 116.8 cm

Signed and dated, possibly falsely: J de mansuet(is?). 1492

The Trinity is represented with Christ crucified, the Dove of the Holy Ghost and, behind, the enthroned figure of God the Father. The Virgin Mary and Saints James the Greater, John the Evangelist and Peter stand at the foot of the cross. The Magdalen, Saints Joseph of Arimathea and Nicodemus kneel in front. Two angels above and to either side hold the spear and the sponge (both instruments of the Passion).

Although the signature and date are retouched and possibly false, they may record the original inscription as the picture is acceptable as the work of Mansueti at this date.

Possibly mentioned by Sansovino in S.M. de' Crocicchieri (now Gesuiti), Venice, 1581; probably in the Manfrin collection, Venice, by 1856; bought, 1896.

Davies 1961, pp. 327–8.

Signed on rocks above the apostles: OPVS ANDREAE MANTEGNA (Work of Andrea Mantegna).

Jesus prays in the Garden of Gethsemane, near Jerusalem (represented here as a walled city filled with Roman monuments), while three of his disciples sleep. Angels reveal to Jesus the instruments of his Passion. Judas approaches with the Roman soldiers. New Testament (Mark 14: 32–43).

This undocumented picture is clearly related to Mantegna's other version of the subject (Tours, Musée des Beaux-Arts), which can be dated 1457–9. The reversal of the composition and the rearrangement of the disciples in NG 1417 suggest that it was made later than the version in Tours. It might be the unidentified picture made in Padua in 1459 for Giacomo Antonio Marcello, or, as has recently been suggested, it might have been painted for the Este of Ferrara.

The composition may owe something to a drawing (London, British Museum) by Jacopo Bellini. Giovanni Bellini treated the subject in a way reminiscent of Mantegna (Bellini NG 726 was probably painted later than NG 1417). An illuminated manuscript which copies the figure of Christ, formerly in the National Gallery, has now been transferred to the British Museum.

Aldobrandini collection, Rome, by 1603 (perhaps previously in the Este collection, Ferrara, 1586); collection of Cardinal Fesch by 1841; collection of W. Coningham by 1845/6; collection of Thomas Baring by 1853; bought, 1894.

Davies 1961, pp. 335–8; Lightbown 1986, pp. 60–2, 404; Dunkerton 1991, p. 292; Christiansen 1992, pp. 126–7.

Inscribed on Saint John's scroll: [EC]CE AGNV[S DEI EC]CE Q[UI TOLLIT PEC]CATA M[UN]DI Andreas Mantinia C.P. F.[ecit] (Behold the lamb of God who takes away the sins of the world; Andrea Mantegna Count Palatine [or Citizen of Padua] made this).

The Virgin and Child are seated beneath a canopy; Jesus' gesture may be one of blessing. Saint John the Baptist wears the camel skin he wore in the desert and the inscription on his scroll is from the New Testament (John 1: 29). Mary Magdalene holds a pot of ointment.

The commission and original location of this altarpiece are not documented; as it is on canvas it could have been dispatched from Mantua to a church elsewhere in northern Italy. Mantegna's signature probably indicates a date after 1469, when Mantegna was made a Count Palatine (*Comes Palatinus*) by the Holy Roman Emperor. Stylistically, the picture is usually dated to the 1490s.

Palazzo Andreani, Milan, by 1796; bought, 1855.

Davies 1961, pp. 329–30; Lightbown 1986, pp. 436–7.

Giovanni MANSUETI
active 1484–died 1526/7

Mansueti signed a large canvas as a pupil of Gentile Bellini; he was probably in the Bellini workshop in the 1480s. NG 1478 is his first dated work and shows him to be a mature artist by 1492. He was active in Venice and painted numerous altarpieces, small devotional works and large narrative canvases (e.g. for the Scuola di San Giovanni Evangelista).

Andrea MANTEGNA
about 1430/1–1506

Born in Padua, Mantegna was apprenticed with Francesco Squarcione. He received commissions for altarpieces and frescoes from 1448. He worked in Padua, Verona and Venice before moving permanently in 1459 to Mantua, where he became painter to the Gonzaga court. He married Giovanni Bellini's sister in 1453. Mantegna was one of the most admired and influential artists in Italy in the second half of the fifteenth century.

Andrea MANTEGNA
The Vestal Virgin Tuccia with a sieve
about 1495–1506

Andrea MANTEGNA
A Woman Drinking
about 1495–1506

Andrea MANTEGNA
Samson and Delilah
about 1500

NG 1125.1
Tempera on poplar, 72.5 x 23 cm

NG 1125.2
Tempera on poplar, 71.2 x 19.8 cm

NG 1145
Glue size on linen, 47 x 36.8 cm

Tuccia was a Vestal Virgin. When her chastity was questioned she proved her innocence by carrying a sieve full of water from the Tiber to the Temple of Vesta. She was celebrated in Pliny's *Natural History* (28: 12) and Petrarch's *Triumph of Chastity*.

Previously catalogued as by a follower of Mantegna this painting and NG 1125.2 are now generally thought to be by the artist himself. They probably date from the last decade of his life. Depictions of exemplary and eminent women of antiquity were often incorporated into domestic decorative settings.

NG 1125.1 and 1125.2 are obviously related, but they are lit from different directions and more ground is shown in this panel than in NG 1125.2. Mantegna relished representing *trompe l'oeil* statues in active poses before a backdrop of coloured marble (e.g. NG 902 and 1145). Isabella d'Este had a 'feigned bronze' picture by Mantegna in her study and these paintings are probably meant to simulate gilt bronze.

Collection of Duke of Hamilton by 1854; bought, 1882.

Davies 1961, pp. 340–1; Lightbown 1986, p. 450; Christiansen 1992, pp. 399, 412.

The woman drinking is likely to be Sophonisba, a Carthaginian whose husband sent poison to her so that she would be able to kill herself rather than be taken into slavery. She was celebrated in Livy's *History of Rome* (30:15) and Petrarch's *Triumph of Love*. Alternatively the woman might be Artemisia, the devoted wife and sister of Mausolus, Prince of Caria in the fourth century BC, who, after his death, drank his ashes mingled with wine.

See the discussion of the companion painting, NG 1125.1.

Collection of Duke of Hamilton by 1854; bought, 1882.

Davies 1961, pp. 340–1; Lightbown 1986, p. 450; Christiansen 1992, pp. 399, 412.

Inscribed on the tree trunk: FOEMINA / DIABOLO TRIBUS / ASSIBUS EST / MALA PEIOR (A woman when bad is three pence worse than the devil(?)).

Delilah cuts Samson's hair, the source of his supernatural strength, as he sleeps in her lap. Old Testament (Judges 16: 17–20). The story was sometimes interpreted as a warning against women, as suggested by the inscription here. Mantegna has departed from the biblical story in a number of ways: normally a man cuts Samson's hair and Philistines are hiding nearby, waiting to blind him. The vine implies that Samson's slumber was induced by wine.

Mantegna painted several small pictures with this format, colour range and theme (e.g. *Judith and Holofernes*, Dublin, National Gallery, which in 1992 was again suggested to have been the companion to NG 1145). Though they may be related, it has not been proved that these paintings ever formed one series.

Perhaps Buonfiglioli collection, Bologna, until 1728; bought Sunderland Sale, 1883.

Davies 1961, pp. 334–5; Lightbown 1986, p. 449; Christiansen 1992, pp. 397, 405.

Andrea MANTEGNA
The Holy Family with Saint John
about 1500

Andrea MANTEGNA
The Introduction of the Cult of Cybele at Rome
1505–6

Imitator of MANTEGNA
Noli me Tangere
perhaps 1460–1550

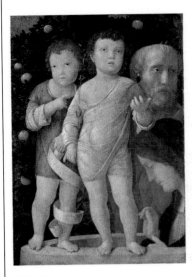

NG 902
Glue (identified) on linen, 73.7 x 268 cm

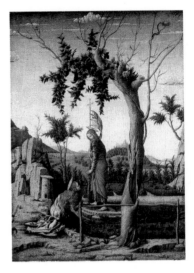

NG 5641
Glue on canvas, 71.1 x 50.8 cm

NG 639
Oil on wood, 42.5 x 31.1 cm

Apparently once inscribed on Baptist's scroll: [ECCE AGNUS] DEI, (Behold the Lamb of God).

The Christ Child holds an olive branch, sceptre and orb, to symbolise his role as Prince of Peace and Saviour of the World. Saint Joseph appears on his left and the young Baptist on his right. The Virgin Mary (in profile) appears to be sewing and this is confirmed by a version of this composition (Paris, Petit Palais) in which her needle and thread are visible. The main difference between NG 5641 and the version in Paris is that Saint Joseph is replaced by a female saint (probably Saint Elizabeth). The subject matter and composition of both pictures are unusual.

NG 5641 is recognisable as by Mantegna on the basis of its style.

Collection of Andrea Monga, Verona, 1856; acquired by Ludwig Mond from J.P. Richter; Mond Bequest, 1924; entered the Collection in 1946.

Davies 1961, pp. 338–9; Lightbown 1986, pp. 448–9.

Inscribed below the figures: S[ENATUS] HOSPES NUMINIS IDAEI C[ONSULTO] (By decree of the Senate [appointed] host to the Idaean deity) (Juvenal, *Satires*, III, 138). And on the tombs: S[ENATUS] P[OPULUS] Q[UE] R[OMANUS] / GN[AEO] SCYPIO/NI CORNELI/US F[ILIUS] P[OSUIT] ([By order of] the Senate and the People of Rome. Cornelius his son raised [this monument] to Gnaeus Scipio), and P[UBLII] SCYPIONIS / EX HYSPANENSI / BELLO / RELIQUIAE (The remains of Publius Scipio from the war in Spain).

And on the drummer boy's collar: S[ENATUS] P[OPULUS] Q[UE] R[OMANUS] (The Senate and the People of Rome).

In 204 BC the Romans brought the cult of Cybele, the Eastern goddess of victory, from Pessina (Asia Minor) to Rome. Mantegna has combined the accounts of Ovid (*Fasti*, 4: 179–349), Livy (29: 10, 11, 14) and Appian (7: 9, 56). Cybele is represented by her sacred stone – she fell to earth as a meteor – and as a bust with a mural crown (associating her with a city state). According to Juvenal, Publius Cornelius Scipio Nasica (probably in profile, gesturing with his right hand) was the most worthy Roman to receive Cybele.

NG 902 is one of four pictures commissioned in 1505 by Francesco Cornaro, a Venetian nobleman who claimed descent from the ancient Cornelii family (who are prominent in NG 902). Mantegna only completed this picture shortly before his death and Bellini supplied another (Washington, National Gallery).

The artist has represented the scene like a sculpted frieze of plain marble figures in relief against a background veneered with coloured marble. NG 902 was intended to decorate a room as a high frieze, as can be deduced from the low viewing-point (clearly visible in the step). See Appendix B for a larger reproduction.

Palazzo Mocenigo (once Cornaro), Venice, 1815 (probably since 1507); Vivian collection by 1835; bought, 1873.

Davies 1961, pp. 330–4; Lightbown 1986, pp. 214–18, 451–2; Dunkerton 1991, pp. 372–4; Christiansen 1992, pp. 412–16.

Christ appears to the Magdalen on the morning after the Resurrection, but tells her not to touch him ('noli me tangere') 'for I am not yet ascended to my Father'. New Testament (John 20: 14–18).

NG 639 is from the same series as NG 1106 and 1381. These panels have been demonstrated by technical examination in 1982 to have been painted no later than the first half of the sixteenth century. All three reflect Mantegna's style of about 1460 and it has been suggested that they either record lost paintings, or, perhaps more likely, lost drawings or engravings by Mantegna.

Collection of Francis Duroveray by 1850; bought with Edmond Beaucousin collection, Paris, 1860.

Davies 1961, p. 341; Lightbown 1986, p. 473.

Imitator of MANTEGNA
The Resurrection
perhaps 1460–1550

Imitator of MANTEGNA
The Maries at the Sepulchre
perhaps 1460–1550

After MANTEGNA
Illuminated Initial D
perhaps about 1500–30

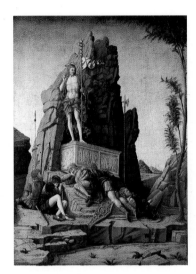

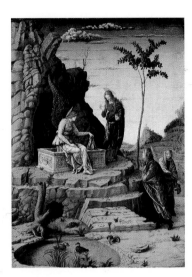

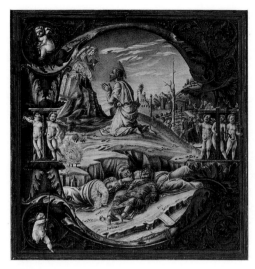

NG 1106
Oil on wood, 42.5 x 31.1 cm

NG 1381
Oil on wood, 42.5 x 31.1 cm

NG 1417.1
Vellum, 19.1 x 19.1 cm

Christ rises from his tomb, while the Roman soldiers sleep. New Testament (all Gospels, e.g. John 20: 1–10).

NG 1106 is from the same series as NG 639 and 1381; these panels are discussed under NG 639.

Capponi Palace, Florence, by 1832; collection of the Revd John Sanford, 1832–9; collection of W. Coningham by 1849; bought, 1881.

Davies 1961, p. 341; Lightbown 1986, pp. 472–3.

On the morning of the Resurrection the three Maries (Mary Magdalene with her ointment pot, Mary the wife of Cleophas, and Mary the mother of James) went to Christ's tomb and there encountered an angel who explained that Christ had risen from the dead. New Testament (Mark 16: 1–8).

NG 1381 is from the same series as NG 639 and 1106; these panels are discussed under NG 639.

Capponi Palace, Florence, by 1832; collection of the Revd John Sanford, 1832–9; collection of W. Coningham by 1849; bequeathed by Lady Taunton, 1892.

Davies 1961, p. 341; Lightbown 1986, p. 473.

Jesus prays in the Garden of Gethsemane while three of his disciples sleep. An angel reveals a chalice to Jesus, and further angels are entwined in the vine decoration of the border with the instruments of his Passion (a cross, hammer, pincers, spear, the column and whip of the Flagellation, etc.). Judas approaches with the Roman soldiers who will arrest Jesus. New Testament (Mark 14: 32–43).

The origin of this illuminated letter D is not documented, but it is likely to have been cut from a manuscript, perhaps a large choral book of the early sixteenth century. It is clearly related to Mantegna's version of the subject (NG 1417) for which a date of about 1460 has been suggested.

Collection of Earl of Northbrook by 1889; by whom presented in 1894.

Davies 1961, pp. 339–40.

MARCO d'Oggiono
The Virgin and Child
probably about 1500–25.

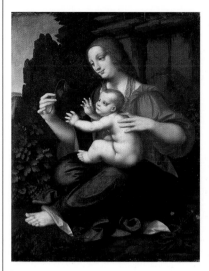

NG 1149
Oil on wood, painted surface 66.7 x 53.3 cm

The Virgin seated on the ground reflects the tradition of the Madonna of Humility. The rocky setting is similar to those which Leonardo favoured for his paintings.

A pricked drawing, apparently for the head of the Virgin, is in the Victoria and Albert Museum, London.

Manfrin collection, Venice, by 1856; bought, 1883.

Davies 1961, p. 343; Marcora 1976, p. 134.

MARGARITO of Arezzo
The Virgin and Child Enthroned, with Scenes of the Nativity and the Lives of the Saints, 1260s

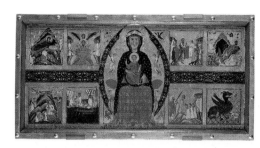

NG 564
Tempera on wood, including frame 92.5 x 183 cm

NG 564, detail

Signed below the Virgin: MARGARIT[US] DE ARITIO ME FECIT (Margarito of Arezzo made me). The narrative scenes are inscribed: 1: DE PARTV VIRGINIS MARIE & ADNV[N]TIATIO[N]E PASTORVM (On the childbirth of the Virgin Mary (i.e. the Nativity) and the Annunciation to the shepherds); 2: HIC BEAT[US] JOH[ANN]ES EV[AN]G[ELISTA] A FERVORE OLEI LIBERATVR (Here Blessed John the Evangelist is rescued from the heat of the oil); 3: HI[C] S[AN]C[TU]S JOH[ANN]ES EV[AN]G[ELISTA] SVSCITAT DELVSIANAM (Here Saint John the Evangelist raises Druisiana); 4: HI[C] .S[ANCTUS] B[E]NEDICT(US) P[RO]IECIT SE I[N] SPINAS FVGIE[N]S DIABOLI TE[N]TATIOE(M) (Here Saint Benedict flings himself among thorns fleeing the temptation of the devil); 5: HI[C] S[AN]C[T]A CATTARINA SVSCEPIT MA(R)TIRIV[M] & I[N] MO[N]TE(M) SINJ AB A[N]G[E]LIS E[ST] D(E)LATA (Here Saint Catherine undergoes martyrdom and is transported by angels to Mount Sinai); 6: HI[C] S[AN]C[TU]S NICOLAVS PRECEPIT NAVTIS VT VAS COL/TVM A DIABULO I[N] MARI P[RO]ICERE[N]T (Here Saint Nicholas instructs the sailors to throw into the sea the jar filled by the devil); 7: HI[C] S[AN]C[TU]S NICOLAVS LIBERAT CO[N]DE[M]NATOS (Here Saint Nicholas frees the condemned men); 8: HI[C] S[AN]C[T]A MARGARITA ... ORE ERVPTIS/ VISCERIBVS ... (Here Saint Margaret ... in the mouth [of the dragon, escapes] when his entrails burst).

In the centre are the Virgin and Christ Child. The Virgin wears a Byzantine crown and is seated on a lion-headed throne. Angels swing censers on either side; outside the mandorla which contains this group are the symbols of the evangelists (Matthew, Mark, Luke and John) and the eight scenes from lives of the saints described in the inscriptions (see above).

NG 564 was probably an altarpiece, rather than an altar frontal. The prominent inclusion of Saints John the Evangelist and Nicholas may suggest that it originally stood on an altar, or came from a church dedicated to these saints. The iconography of the Virgin and Child is very similar to that of the *Virgin and Child* from S. Maria, Montelungo, near Arezzo and the *Virgin and Child* in the National Gallery of Art, Washington, both of which bear the same signature as NG 564.

Bought by Lombardi and Baldi of Florence, in the neighbourhood of Arezzo, before 1845; bought from their collection, 1857.

Gordon 1988, pp. 67–9; Dunkerton 1991, p. 212.

MARCO d'Oggiono
active about 1490; died about 1529

Marco d'Oggiono was possibly among Leonardo da Vinci's pupils in 1490. He collaborated with Boltraffio in 1491 and was subsequently given altarpiece and fresco commissions on his own account. Several authenticated works show that his style was strongly influenced by Leonardo's.

MARGARITO of Arezzo
active 1262?

The artist was called Margaritone by Vasari. Several signed paintings by him have survived. His pictures are most probably of the second half of the thirteenth century. They are mainly dossals showing the enthroned Virgin and Child, and sometimes with lateral scenes, and dossals with Saint Francis.

Michiel Giovanni MARIESCHI
Buildings and Figures near a River with Shipping
1735–43

Michiel Giovanni MARIESCHI
Buildings and Figures near a River with Rapids
1735–43

MARINUS van Reymerswaele
Two Tax Gatherers
probably about 1540

NG 2102
Oil on canvas, 60.7 x 91.8 cm

NG 2103
Oil on canvas, 61 x 92.1 cm

NG 944
Oil on oak, 92.1 x 74.3 cm

The scene appears to be an entirely fanciful invention.

NG 2102 is a pendant to NG 2103. Both pictures are dated towards the end of the artist's brief life.

C.L. Parker sale, London, 1874; bought by Lesser; John Samuel collection; bequeathed by the Misses Cohen as part of the John Samuel collection, 1906.

Levey 1971, p. 160.

The scene appears to be an entirely fanciful invention.

NG 2103 is the pendant to NG 2102. Both pictures are dated towards the end of the artist's brief life.

C.L. Parker sale, London, 1874; bought by Lesser; John Samuel collection; bequeathed by the Misses Cohen as part of the John Samuel collection, 1906.

Levey 1971, p. 160.

Inscribed on the book in the foreground: Dits den ontfanck vander stede (i.e. municipal revenues) ... Another page is also partly visible, headed: Rantsoene (i.e. emoluments from the farming of municipal revenues). The document above the second man's head begins: Cornelis Danielsz. Schepenen in Rey(merswae)le/.

The man at the left appears to be a municipal treasurer. He is composing an account of the municipal revenues from the imposts on wine, beer, fish, etc., let out to farm. The figures are not thought to be portraits; their archaic costumes appear to be fanciful. Some of the coins have been identified: a few of the gold ones at the lower right are *écus d'or au soleil* of François I, and two of the larger silver coins are Joachimsthalers.

NG 944 is one of a large group of pictures with related subjects and designs; their intention was probably satirical, the point of the attack perhaps varying from covetousness to usury or extortion. The town of Reimerswaal (Zeeland, but now under the sea) is mentioned in the inscription; the Cornelis Danielsz. referred to may be a man with this name recorded there in 1524.

From the van Ravenstein collection; Wynn Ellis Bequest, 1876.

Davies 1968, pp. 83–5.

Michiel Giovanni MARIESCHI
1710–1743

Marieschi was born in Venice. He may have been trained by Gaspare Diziani, who probably helped him find work at the court of Saxony. He returned to Italy before 1735. He painted and etched landscape caprices and topographical views of Venice, which were influenced by Canaletto, and probably inspired Guardi.

MARINUS van Reymerswaele
active 1509?; died after 1567?

Signed works by this Netherlandish artist date from 1535(?) to 1551(?). The Reymerswaele of his name appears to refer to Reimerswaal, a place once in Zeeland but now under the sea. Marinus seems to have mainly produced three types of picture (Saint Jerome, Two Tax Gatherers, the Banker and his Wife) which he repeated, and which were replicated by others.

Jacob MARIS
A Girl seated outside a House
1867

Jacob MARIS
A Girl feeding a Bird in a Cage
about 1867

Jacob MARIS
A Young Woman nursing a Baby
1868

NG 5568
Oil on mahogany, 32.7 x 20.9 cm

NG 3261
Oil on mahogany, 32.6 x 20.8 cm

NG 2709
Oil on mahogany, 29.1 x 22.8 cm

Signed and dated bottom right: J. Maris fc [or ft]/67

The church seen in the background is in Montigny-sur-Loing. It appears in a view of that town painted by Maris in 1870 (Rotterdam, Museum Boymans-van Beuningen). The model for the girl is perhaps the same as in NG 3261.

NG 5568 was painted when Maris was living in Paris. It was bequeathed as a painting of 'Vespers' (although the girl appears to be trimming her hat with flowers rather than praying), and it may be the picture of that subject exhibited at the Obach and Co. Gallery in London in 1906.

Bequeathed by Mrs Mary James Mathews to the Tate Gallery in memory of her husband, Frank Claughton Mathews, 1944; transferred, 1956.

MacLaren/Brown 1991, p. 251.

Signed bottom right: J Maris f.

The model for the girl may be the same model as the one in NG 5568, which is dated 1867.

NG 3261 was presumably painted when Maris was living in Paris. It may be the picture that was exhibited at the French Gallery in London in 1868 as 'The Pet Bird' by J. Maris.

Collection of James Staats Forbes, London, by 1898; collection of (Sir) Hugh Lane by about 1905; Lane Bequest, 1917; on loan to the Hugh Lane Municipal Gallery of Modern Art, Dublin, since 1979.

MacLaren/Brown 1991, p. 249.

Signed and dated bottom left: J. Maris ft 1868

The woman in NG 2709 is said to be Maris's wife, Catharina Hendrika Horn, whom he married in 1867. Their first child was born in April 1868 (and died in March 1869).

The picture was painted when the artist was living in Paris. The woman's right breast was originally uncovered and was painted over later, probably not by Maris. A pencil study for the picture, squared for transfer, was in the possession of the Maris family in about 1908.

Presented by J.C.J. Drucker, 1910.

MacLaren/Brown 1991, p. 248.

Jacob MARIS
1837–1899

Jacob Maris was born in The Hague. He studied in The Hague and in Antwerp, where he subsequently set up a studio with his brother Willem, painting pictures for the American market. From 1865 to 1871 he was in Paris; he then settled in The Hague and concentrated on landscape. He died on a visit to Carlsbad.

Jacob MARIS
A Drawbridge in a Dutch Town
about 1875

NG 2710
Oil on canvas, 30.2 x 22.7 cm

Signed bottom right: J Maris
 The town has not been identified. There is a watercolour version of the same view, dated 1875, in Amsterdam (Rijksmuseum).

In the collection of R.T. Hamilton Bruce, Edinburgh, by 1903; presented by J.C.J. Drucker, 1910.

MacLaren/Brown 1991, pp. 248–9; Bailey 1992, p. 13, no. 51.

Jacob MARIS
A Beach
about 1875–90

NG 4262
Oil on canvas, 42.5 x 54.5 cm

Signed bottom left: J Maris
 A woman and two boats are seen on an unidentified beach.
 NG 4262 was probably painted in the late 1870s or 1880s.

In the possession of E.J. van Wisselingh and Co., Amsterdam, by 1898; presented by Mrs R.M. Dunlop to the Tate Gallery, 1927; transferred, 1956.

MacLaren/Brown 1991, p. 250.

Jacob MARIS
Three Windmills
1880

NG 4399
Oil on canvas, 33.7 x 41.3 cm

Signed and dated bottom right: J Maris 80
 NG 4399 was etched by Philippe Zilcken some time before 1890.

In the possession of the Goupil Gallery probably by 1888; presented by C. Frank Stoop to the Tate Gallery, 1928; transferred, 1956.

MacLaren/Brown 1991, p. 250.

Jacob MARIS
A Windmill and Houses beside Water: Stormy Sky
probably 1880–90

NG 4269
Oil on canvas, 48.3 x 59.5 cm

Signed bottom right: J Maris

In the Ch.L. de Hèle collection, Brussels, by 1911; presented by Mrs R.M. Dunlop to the Tate Gallery, 1927; transferred, 1956.

MacLaren/Brown 1991, p. 250.

Matthijs MARIS
Men unloading Carts, Montmartre
1870

NG 2874
Oil on canvas, 23.2 x 30.5 cm

Signed and dated bottom right: M. M. 70.
 During his years in Paris (1869–77) Maris painted a number of views of the Montmartre quarry: another, dated 1872, is in Glasgow (Burrell Collection).

Messrs Murrieta sale, London, 1892; presented by J.C.J. Drucker, 1912.

MacLaren/Brown 1991, p. 252.

Willem MARIS
Ducks alighting on a Pool
about 1885

NG 2875
Oil on canvas, 32.4 x 20.3 cm

Signed bottom right: W.Maris.fc (or fe).
 There was a duck pond near to the artist's home at Voorburg, where he drew and painted the birds in oil and watercolour.

Presented by J.C.J. Drucker, 1912.

MacLaren/Brown 1991, p. 253.

Matthijs MARIS
1839–1917

The artist was born in The Hague. He was the brother of the painters Jacob and Willem Maris. He trained in The Hague and Antwerp. He moved to Paris in 1869 and to London in 1877, where he died. He painted landscapes and town views; after his move to London he produced dream-like grey landscapes and veiled figures which show the influence of the Pre-Raphaelites and Burne-Jones.

Willem MARIS
1844–1910

Willem Maris, the younger brother of the painters Jacob and Matthijs Maris, was born in The Hague. After training in the city, he travelled along the Rhine in 1865, visited Paris in 1867, and Norway in 1871, but was mainly active, as a painter of cattle and birds, in The Hague. He was a founder of the Dutch Drawing Society with Anton Mauve and Hendrick Mesdag in 1876.

Simon MARMION
The Soul of Saint Bertin carried up to God
about 1459

Simon MARMION
A Choir of Angels
about 1459

Style of MARMION
The Virgin and Child with Saints and Donor
probably 1475–1500

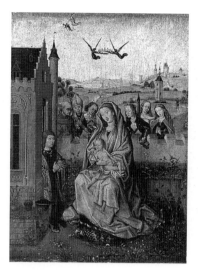

NG 1302
Oil on oak, painted surface 57.5 x 20.5 cm

NG 1303
Oil on oak, 57.5 x 20.5 cm

NG 1939
Oil on oak, 27.3 x 20.3 cm

The tiled roof at the bottom is the continuation of the church in a panel now in Berlin (discussed below) which depicts – *inter alia* – the death of Saint Bertin. Saint Bertin's soul is shown in NG 1302. The reverse, which is painted in grisaille, depicts a Gothic canopy and spire. This originally appeared above an image of the Virgin Annunciate.

NG 1302 and 1303 are fragments from the tops of the shutters of the precious metalwork altarpiece placed on the high altar of the abbey church of St Bertin in St-Omer, northern France. The altarpiece itself, which is now lost, was made between 1455 and 1459 when it was dedicated by its patron, Guillaume Fillastre (appointed abbot, 1442; buried in St Bertin, 1473). The shutters (Berlin, Staatliche Museen) were probably painted in about 1459 and depict episodes from the life of Saint Bertin, a local saint who founded a monastery in what is now St-Omer.

Recorded in the abbey church of St Bertin, St-Omer, 1695; the altarpiece remained in situ until 1783; Edmond Beaucousin collection, Paris, by 1847; bought with the Beaucousin collection, 1860.

Davies 1968, pp. 85–7; Davies 1970, pp. 18–26; Dunkerton 1991, pp. 34–5; Grosshans 1991, pp. 63–98.

The terminal of the gable seen at the bottom is the continuation of a building seen in a panel which depicts – *inter alia* – the patron of the altarpiece, Guillaume Fillastre. The reverse, which is painted in grisaille, depicts a Gothic canopy and spire. This originally appeared above an image of the Archangel Gabriel.

NG 1303 was part of the left shutter of an altarpiece. For further discussion see under NG 1302.

Recorded in the abbey church of St Bertin, St-Omer, 1695; the altarpiece remained in situ until 1783; Edmond Beaucousin collection, Paris, by 1847; bought with the Beaucousin collection, 1860.

Davies 1968, pp. 86–7; Davies 1970, pp. 18–26; Dunkerton 1991, pp. 34–5; Grosshans 1991, pp. 63–98.

In the sky the Archangel Michael casts down Satan (New Testament, Revelation 12: 7–9). The saints behind the parapet are Francis, Lazarus(?), John the Evangelist, Catherine, Barbara and Margaret. The donor, who wears the Order of the Golden Fleece, has not been securely identified, but the design above the window (left) is a device of the Dukes of Burgundy (as well as of the Order of the Golden Fleece).

The figures of the Virgin and Child are based on a design by Rogier van der Weyden (compare the drawing attributed to him in the Museum Boymans-van Beuningen, Rotterdam) which was also used by other artists.

NG 1939 has been cut at the top, which was arched, and on the right.

Collection of Karl Aders, London, by 1831; bought (Lewis Fund), 1904.

Davies 1968, pp. 87–8; Davies 1970, pp. 27–32.

Simon MARMION
active 1449; died 1489

Simon Marmion was active in Amiens from 1449 to 1454. He was subsequently in Valenciennes from 1458, and was recorded in the Tournai Guild in 1468. No paintings are securely documented as by Marmion, but the Saint Bertin altarpiece shutters are generally accepted works. He was celebrated both as an illuminator and as a painter.

Style of MARMION
Saint Clement and a Donor
probably 1480–90

Marco MARZIALE
The Circumcision
1500

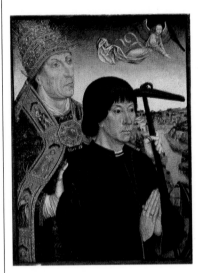

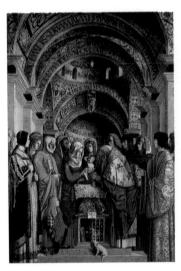

NG 2669
Oil on oak, painted surface 50.2 x 36.8 cm

Inscribed on the frame: credendo se[n]cia[mus]
q[uo]d p[ro] nob[is] dep[re]ceris (May our faith let
us feel that you are pleading our cause).

Saint Clement was a first-century pope. He holds
the anchor to which, according to legend, he was
lashed and then thrown into the sea off the Crimea.
The donor has not been identified.

NG 2669 is the left wing of a triptych; the other
panels from this triptych – *The Virgin and Child* and
A Donatrix with Saint Elisabeth – were formerly in
the Thyssen-Bornemisza collection. The costume
suggests a date in the 1480s.

The frame is original.

*Collection of Léon Somzée by 1900; collection of George
Salting by 1904; Salting Bequest, 1910.*

Davies 1968, pp. 88–9; Davies 1970, pp. 33–7.

NG 803
Oil on canvas, 222.3 x 151.1 cm

The arches on the vaulting are inscribed with verses
from the New Testament (Luke 2: 29ff): NVNC
DIMITTIS SERVVM TVVM DOMINE SECVNDVM VERBVM
TVVM/ IN PACE QVIA VIDERVNT OCVLI MEI SALVTARE TVVM
QVOD/ PARASTI ANTE FATIEM OMNIVM POPVLORVM/
LVMEN AD REVELATIONEM GE(nti)VM ET GLORIAM PLEBIS
TVE ISRAEL (Lord, now lettest thou thy servant depart
in peace, according to thy word. For mine eyes have
seen thy salvation, Which thou hast prepared before
the face of all people; a light to lighten the Gentiles,
and the glory of thy people Israel). Signed and
dated on the cartellino: MARCVS MARTIALIS VENE/TVS
IVSSV M^ci EQVITIS/ ET IVR[I]CON. D. THOME/ .R. OPVS HOC .P.
AN. / M° CCCCC° (Marco Marziale the Venetian. This
work was set up here by the Knight and Justice
Tommaso R in the year 1500); followed by a
monogram, consisting of an M with a horizontal bar
through it and a cross above.

The Circumcision of Christ is described in the
New Testament (Luke 2: 21). Jesus received his
name when this rite was performed. Such a subject
in an altarpiece could be associated with the
veneration of Christ's blood or with veneration for
the Name of Jesus. The architecture and mosaic
ceiling of the temple recalls Veneto-Byzantine
precedents. The Virgin holds the infant while a
priest performs the circumcision beneath a
sanctuary lamp. The woman behind the Virgin may
be the prophetess Anna. Beside her Saint Joseph
stands holding two doves, necessary offerings at the
temple. The woman in profile further to the left is
the donatrix Doralice Cambiago. Standing opposite
her is her husband, the donor Tommaso Raimondi
(died 1510), a jurist and poet; the kneeling boy

NG 803, detail

between them is presumably their son Marco (died
1568). It has been suggested that the man with the
book by the donor is Tommaso's brother, Eliseo,
and the woman behind Saint Joseph, Lorenza degli
Osi, his wife. In the cupboard behind the dog in the
foreground are a book, an incense boat and a jar.

NG 803 was painted for the high altarpiece of S.
Silvestro, Cremona.

*Apparently still in S. Silvestro, Cremona, 1794; bought
from Baslini, Milan, 1869.*

Davies 1961, pp. 345–6.

Marco MARZIALE

active about 1492–about 1507

**Marziale signed his paintings as a pupil of Gentile
Bellini and the work of the Bellini family greatly
influenced his style. From January 1493 the artist
is recorded as working for the Venetian state, but
in about 1500 he moved to Cremona and the two
altarpieces catalogued here were painted for
churches in that city.**

Marco MARZIALE
The Virgin and Child with Saints
1507

MASACCIO
The Virgin and Child
1426

Follower of MASACCIO
The Nativity
perhaps about 1460

NG 3648
Tempera on wood, 21.5 x 65.5 cm

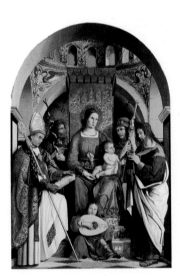

NG 804
Oil on wood, 221 x 142.2 cm

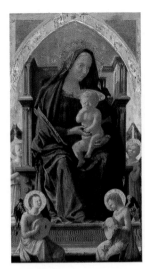

NG 3046
Tempera on poplar, painted surface 135.5 x 73 cm

Inscribed on the vaulting of the apse: (Regi)NA. CELI. LET(a)RE. ALEIVIA.O[?] (Rejoice, Queen of Heaven, Halleluiah). The scroll of Saint John the Baptist is inscribed: ECCE AGNVS (Behold the Lamb). Signed and dated on the cartellino attached to the steps of the throne: MARCVS MARCI/ ALIS VENETVS. P/.M.D.VII (Marco Marziale of Venice painted this, 1507).

The Virgin is enthroned before a cloth of honour with the Christ Child upon her lap, beneath a mosaic-encrusted dome. The saints are from left to right: Saint Gall (on whose crozier the Baptism of Christ and Saint Paul are depicted), Saint John the Baptist, Saint James the Greater (who wears pilgrim badges on his hat which may specifically refer to Rome) and Saint Bartholomew (who holds his attribute, the butcher's knife by which he was flayed in his martyrdom). Before the throne a child plays a lute.

Described by Pannini as the high altarpiece of S. Gallo, Cremona, 1762; acquired from the church by Conte Giovanni Battista Biffi, 1791; collection of Marchese Sommi–Picenardi, Cremona, by 1818; bought from Baslini, Milan, 1869.

Davies 1961, pp. 346–7.

Punched very approximately on the Virgin Mary's halo: AVE GRATIA PLENA (Hail [Mary] full of Grace).

The Virgin is seated on a stone throne. Jesus is eating grapes, a eucharistic symbol. Two angels with lutes are seated at the base of the throne (the bottom edge has been cut), and two kneel beside the throne, set slightly back.

NG 3046 was the centre of an altarpiece commissioned from Masaccio in 1426 by the notary Ser Giuliano degli Scarsi for the chapel of St Julian (Giuliano) in S. Maria del Carmine, Pisa, where it was seen by Vasari in 1550. The side panels with standing saints are now lost, although the predella and some pinnacle panels survive (Berlin, Staatliche Museen; Naples, Capodimonte; Pisa, Museo Nazionale; Malibu, J. Paul Getty Museum). It is debated whether this was the centre of a polyptych or a unified pala.

In NG 3046 the influence of sculpture, especially that of Donatello, is pervasive. Masaccio employed a rational lighting system with cast shadows and linear perspective. The capitals of the throne are of the Corinthian, Ionic and Composite orders, reflecting the interest of Florentine artists in the 1420s in classical architecture. The paint surface has suffered considerable losses and old retouchings have discoloured. The Virgin's red dress is painted over silver leaf.

Collection of Miss Woodburn, 1855; bought with a contribution from the NACF, 1916.

Davies 1961, pp. 348–51; Dunkerton 1991, pp. 248–50, 399; Joannides 1993, pp. 152–72, 382–98.

The Virgin and Child and Saint Joseph are shown with an ox and an ass outside a simple building (probably a stable) in which a midwife sits by a fire. In the right background the Annunciation to the Shepherds can be seen. New Testament (Luke 2: 8–17).

It has been suggested that NG 3648 was the central predella panel of an altarpiece attributed to the Master of the Castello Nativity in Prato (Museo del Duomo). Two other predella panels have been identified: *Saints Giusto and Clemente multiplying the Grain of Volterra* and *Saints Giusto and Clemente praying for the Delivery of Volterra from Barbarians* (Philadelphia, Johnson collection). This altarpiece came from the church of SS. Giusto e Clemente at Faltugnano.

Collection of Sir Henry Howorth by 1907; by whom presented through the NACF in memory of Lady Howorth, 1922.

Salmi 1935, pp. 416–21; Davies 1961, pp. 351–2; Sweeny 1966, pp. 51–2.

MASACCIO
1401–probably 1428

Born in San Giovanni da Valdarno, Tuscany, Tommaso di Ser Giovanni di Mone, called Masaccio, was inscribed with the artists' guild in Florence by 1422 and died in Rome, probably in 1428. He was the leading painter of the Early Renaissance, painting the *Trinity* fresco in S. Maria Novella, Florence, and collaborating with Masolino in the 1420s in the Brancacci Chapel frescoes in S. Maria del Carmine, Florence.

Attributed to MASACCIO and MASOLINO
Saints Jerome and John the Baptist
probably between 1423 and 1428

Attributed to MASOLINO and MASACCIO
Saints Liberius (?) and Matthias
probably between 1423 and 1428

Quinten MASSYS
The Virgin and Child Enthroned, with Four Angels, probably 1490–5

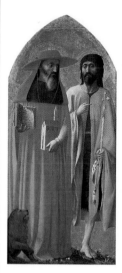

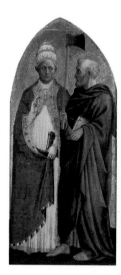

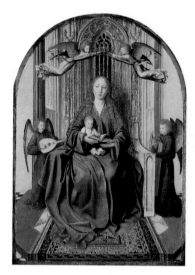

NG 5962
Tempera on poplar, 114 x 55 cm

Inscribed on the book held by Saint Jerome: IN PRINCIPIO. C/REAVIT. DEVM / CELVM. ETTERRA' / TERRA. AVTEM / EIAT. INNANIS / ET VACVA. ET SPIRITVS. DOM/MINI. FEREBA / TVR. SVPER / AQVAS. ECETE/RA (In the beginning God created the heaven and the earth. And the earth was without form and void. And the Spirit of God moved upon the face of the waters) Old Testament, Genesis 1: 1–2; and on the scroll held by Saint John the Baptist: ECCE [AGN]VS. DEI. (Behold the Lamb of God) New Testament, John 1: 29 and 36.

On the left is Saint Jerome (about 342–420), the translator of the Vulgate Bible, who is accompanied by a lion, from whose paw, according to legend, he had removed a thorn. On the right is Saint John the Baptist.

NG 5962 was one side of a single panel, of which the other was NG 5963, and formed part of a double-sided triptych. The reconstruction is discussed further under NG 5963. The altarpiece was originally in S. Maria Maggiore, Rome, where it was seen by Vasari in 1568 and to which the relics of Saint Jerome (here shown as a cardinal) had been transferred. A member of the Colonna family probably commissioned the altarpiece, possibly Pope Martin V (died 1431). Saint John's cross is unusual in being attached to a column, a reference to the Colonna arms. Stylistic differences between the two panels indicate a collaboration between Masaccio and Masolino. This panel appears to be largely by Masaccio.

See NG 5963 for the provenance and bibliography.

NG 5963
Tempera on synthetic support, transferred from poplar, 114.5 x 55 cm

Saint Matthias, who was buried in S. Maria Maggiore, holds the axe with which he was martyred. The other saint, wearing a papal tiara, may be Saint Liberius (pope from 352–66) who is seen founding the church in the *Miracle of the Snow* (see below), or possibly Saint Gregory.

NG 5963 was one side of a single panel, of which the other side was NG 5962, and formed part of a double-sided triptych originally in S. Maria Maggiore, Rome, where it was seen by Vasari. The front of the triptych probably showed the *Assumption of the Virgin* (Naples, Museo di Capodimonte) with *Saints Jerome and John the Baptist* (NG 5962) on the left, and *Saints Martin and John the Evangelist* (Philadelphia, Johnson collection) on the right. The back probably showed the *Miracle of the Snow* (Naples, Museo di Capodimonte) and *Saints Paul and Peter* (Philadelphia, Johnson collection) on the left, and *Saints Liberius and Matthias* on the right. NG 5963 may have been begun in about 1427–8 by Masaccio (who died in Rome around 1428) and completed by Masolino, or painted about 1423–5, probably in Florence, with Masolino directing Masaccio; it appears to be largely the work of Masolino.

In the Palazzo Farnese by 1653; in the collection of Cardinal Fesch, by 1841; bought with a contribution from the NACF from the Adair collection at Flixton Hall, 1950.

Davies 1961, pp. 353–61; Lee Roberts 1985, pp. 295–6; Dunkerton 1991, pp. 252–4, 399; Joannides 1993, pp. 72–9, 414–22.

NG 6282
Oil on oak, painted surface 62.2 x 43.2 cm

The Virgin is seated on an elaborate Gothic throne. Two angels crown the Virgin, while another two play musical instruments. The Child Jesus plays with the Virgin's bookmark.

NG 6282, a small devotional picture, is an early work by Massys and was probably painted in Antwerp in the 1490s. Massys was clearly influenced by van Eyck and Robert Campin (the composition may be related to that reflected in a picture after Campin, NG 2608). The gold of the Virgin's throne is created with gold leaf overlaid with black and brown lines.

Sneyd collection by 1899; collection of C.W. Dyson Perrins by 1927; by whom bequeathed, 1958.

Davies 1968, p. 90; Dunkerton 1991, p. 346.

MASOLINO
about 1383–after 1432

Tommaso di Cristoforo Fini da Panicale, called Masolino, may have assisted Ghiberti from 1403 to 1407. He was inscribed in the Florentine painters' guild in 1423, and was in Hungary between 1425 and 1427. There are documented works in Castiglione d'Olona, Empoli and Todi, and he collaborated with Masaccio on the frescoes of the Brancacci Chapel in S. Maria del Carmine, Florence.

Quinten MASSYS
1465–1530

Massys was born in Louvain, but was in Antwerp by 1491, when he became a master in the guild. There are two documented altarpieces (Brussels and Antwerp) and several signed and dated paintings. Massys was the leading painter in Antwerp in the early sixteenth century.

Quinten MASSYS
The Virgin and Child with Saints Barbara and Catherine, probably about 1515–25

Attributed to MASSYS
A Grotesque Old Woman
about 1525–30

Workshop of MASSYS
The Crucifixion
probably after about 1515

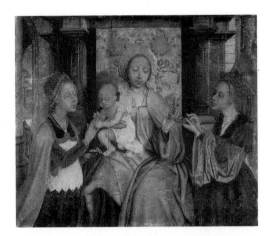

NG 3664
Glue on linen, 92.7 x 110 cm

NG 5769
Oil on oak, original painted surface 64.1 x 45.4 cm

NG 715
Oil (identified) on oak, painted surface
90.2 x 58.4 cm

Saint Catherine of Alexandria is shown on the left with her attribute of the wheel leaning against the column behind her. The Christ Child places a ring on her finger, a reference to her vision in which she received this token of his love – the so-called 'mystic marriage of Saint Catherine'. Saint Barbara is shown in front of her attribute of the tower in which she was confined. She receives a crown from the Virgin.

NG 3664 is one of the rare surviving examples of the many cloth paintings produced in the Netherlands in the fifteenth and sixteenth centuries.

Linnell collection by 1882; presented by Charles Bridger Orme Clarke, 1922.

Davies 1968, pp. 89–90; Roy 1988, pp. 36–43.

Various identities have been proposed for the woman depicted here, but the painting is unlikely to be a portrait. It may be connected with a Leonardesque drawing (Windsor, Royal Collection).

NG 5769 might be intended as a social satire and it has been related to Erasmus's *Praise of Folly* (published 1512). A related portrait of an old man is in a private collection (New York) and another, similar, signed portrait of an old man is in the Musée Jacquemart-André, Paris.

Collection of H.D. Seymour by 1854; bequeathed by Miss Jenny Louisa Roberta Blaker, 1947.

Davies 1968, pp. 92–5; Silver 1984, pp. 220–1.

Inscribed on the cross: INRI.

The Virgin and Saint John the Evangelist mourn, and Saint Mary Magdalene clutches the foot of the cross; two other Maries are on the left. Joseph of Arimathea and Nicodemus can be seen in the background with a man carrying a ladder to take down the body of Christ, while on the right soldiers return to Jerusalem.

NG 715 was probably painted in Massys's workshop after about 1515.

Acquired by Prince Ludwig Kraft Ernst von Oettingen-Wallerstein from Galerie-Inspektor Huber, Munich, 1815; acquired by the Prince Consort, 1851; presented by Queen Victoria at the Prince Consort's wish, 1863.

Davies 1968, pp. 90–1.

Follower of MASSYS
A Female Figure standing in a Niche
probably about 1500–50

NG 3901
Oil on oak, painted surface 114.6 x 34.9 cm

This female figure may represent the Virgin Mary or another holy woman.

NG 3901 was probably the outside of the right shutter of an altarpiece; it could not have been the outside of NG 3902 as was once proposed. See further under NG 3902.

Apparently acquired in Madrid between 1810 and 1822 by Lord Cowley; presented by Henry Wagner, 1924.

Davies 1968, pp. 96–7.

Follower of MASSYS
A Donor
about 1520?

NG 1081
Oil on oak, painted surface 68.6 x 33 cm

The identity of this donor, who is shown at prayer before a devotional book, is not known.

NG 1081 was presumably the left wing of a triptych. The right wing was probably of a donatrix, and may have been a panel once in a private collection in Germany. The central part of the triptych has not been identified.

The landscape is in the style of Patenier, who collaborated with Massys.

Collection of Karl Aders, London, by 1831; bequeathed by Mrs Joseph H. Green, 1880.

Davies 1968, p. 96.

Follower of MASSYS
Saint Luke painting the Virgin and Child
about 1520?

NG 3902
Oil on oak, 113.7 x 34.9 cm

Saint Luke is often depicted as the patron saint of painters because, according to legend, he painted the Virgin and Child. NG 3902 is an interesting representation of an artist's workshop and working practices in the early sixteenth century. Saint Luke holds a wooden palette, brushes and a maulstick. His attribute, an ox, is also included.

This panel was probably the inside of the right shutter of an altarpiece, but NG 3901 could not have been the outside of this shutter as has been surmised. No other elements of this altarpiece are known.

Apparently acquired in Madrid between 1810 and 1822 by Lord Cowley; presented by Henry Wagner, 1924.

Davies 1968, pp. 96–7; King 1985, pp. 249–55; Dunkerton 1991, p. 139.

After MASSYS
Christ
probably about 1500–50

After MASSYS
The Virgin
probably about 1500–50

MASTER of the AACHEN ALTARPIECE
The Crucifixion
about 1495–1505

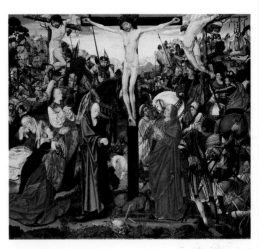

NG 1049
Oil on oak, 107.3 x 120.3 cm

NG 295.1
Oil on oak, painted surface 58.2 x 33 cm

Christ is shown with an orb as ruler of the world.
A companion panel (NG 295.2) shows the Virgin at
prayer. The pairing of images of Christ and the
Virgin was widespread. See, for example, Bouts
NG 711 and 712.

Many versions exist (e.g. Antwerp, Koninklijk
Museum voor Schone Kunsten). The composition
presumably derives from the Ghent altarpiece by
Hubert and Jan van Eyck.

*Brought to the Netherlands from Madrid, 1816; bought
from the Royal Collection in The Hague, 1857.*

Davies 1968, p. 92.

NG 295.2
Oil on oak, painted surface 58.4 x 33 cm

The Virgin is shown at prayer. See also under NG
295.1.

Many versions exist (e.g. Antwerp, Koninklijk
Museum voor Schone Kunsten). The composition
presumably derives from the Ghent altarpiece by
Hubert and Jan van Eyck.

*Brought to the Netherlands from Madrid, 1816; bought
from the Royal Collection in The Hague, 1857.*

Davies 1968, p. 92.

Inscribed on the edges of the Virgin's robe, at her
head: STABAT MATER; on her skirt: QVIS EST HOM[O] [Q]VI
NON FLERE[T] MATREM CRISTI S[I] VIDERE[T] IN TANTO
SUPPLICIO (From the *Stabat Mater,* a popular hymn to
the Virgin, attributed to Jacopone da Todi: 'Who is
the man who would not weep if he saw the mother
of Christ in such torment').

In the centre is the crucified Christ. On the left the
Virgin and three holy women mourn; Saint John
stands on the right. In the left background Christ
falls under the cross on his way to Calvary, while in
the right background he is being taken down from
the cross.

NG 1049 is the central panel of a triptych formerly
in the church of St Columba, Cologne, the shutters
of which are in the Walker Art Gallery, Liverpool;
they show *Christ before Pilate* and *The Deposition.*
When the triptych is closed it shows two donors
kneeling (on the right) and observing the *Mass of
Saint Gregory* (on the left panel). Coats of arms
identify the donors as Hermann Rinck (Mayor of
Cologne in 1480 and 1488, died 1496) and his wife
Gertrud von Dallem.

*Recorded as having been brought from Flanders to
England at the time of the French Revolution; presented
by Edward Shipperdson, 1847.*

Levey 1959, pp. 64–5; Walker Art Gallery 1977,
pp. 115–17.

MASTER of the AACHEN ALTARPIECE
active late 15th to early 16th century

**The master is named after a large Crucifixion
triptych (now in the Treasury of Aachen
Cathedral) which appears to have been painted
for a church in Cologne. He seems to have been
active in the latter city. Pictures associated with
the Aachen Altarpiece also show affinities with
paintings attributed to the Master of the Holy
Kindred, the Master of Saint Severin and the
Master of Saint Ursula.**

MASTER of the BLESSED CLARE
Vision of the Blessed Clare of Rimini
about 1340

MASTER of the BRUGES PASSION SCENES
Christ presented to the People
about 1510

MASTER of CAPPENBERG (Jan Baegert?)
The Coronation of the Virgin
about 1520

NG 6503
Tempera on wood, transferred from the original support, painted surface 55.9 x 61 cm

NG 1087
Oil on oak, 93.3 x 41.3 cm

NG 263
Oil on oak, painted surface 97.2 x 70.5 cm

The book held by Saint John the Evangelist is inscribed: [Pax] mea[m] do v[obis]. Pax [meam]. relinquo vobi[s]. (My peace I give you. My peace I leave you.)

Christ, accompanied by the apostles and Saint John the Baptist, appears to the kneeling Blessed Clare of Rimini (died 1326?), showing her his wounds. Saint John the Evangelist hands her a book which Christ has given to him. This vision is loosely based on a fourteenth-century Life of the Blessed Clare of Rimini.

NG 6503 was probably painted in Rimini in about 1340. It was originally the right-hand panel of an altarpiece, probably a plain horizontal dossal. Another part of the same altarpiece is in Florida (Coral Gables, Lowe Art Museum, University of Miami) and depicts the Adoration of the Magi. It has been suggested that the central panel showed the Virgin and Child with two angels and Saint Mary Magdalene. An almost identical altarpiece exists (now in Ajaccio, Musée Fesch). This has the same two lateral scenes but has a Crucifixion at the centre instead of an image of the Virgin and Child.

In the Monastero degli Angeli, Rimini, by 1755; Ashburnham collection by 1953 (and probably by 1878); bought from a private collector, 1985.

Gordon 1988, pp. 69–73; Pasini 1990, p. 147.

Inscribed on one of the medallions in the background: CE/ZAR (Caesar).

Pilate debates with the Jewish elders below. Christ stands beside him, wearing the crown of thorns. These two figures are taken from an engraving by Schongauer. The background scenes of the Flagellation and the Mocking of Christ correspond, with slight variations, to those in a painting by Memlinc (Turin, Galleria Sabauda). The statue above the central column is of Moses, and one of the medallions above is presumably intended as a representation of Caesar. Above is an *all'antica* relief of nudes and monsters.

Collection of Karl Aders, London, 1831; bequeathed by Mrs Joseph H. Green, 1880.

Davies 1954, pp. 199–202; Davies 1968, p. 100.

Inscribed on the halo: sancta. maria. (Holy Mary).

The Coronation of the Virgin does not have a biblical source. The three persons of the Trinity are represented: God the Father (right), Jesus Christ (left) and the dove of the Holy Ghost (centre).

NG 263 and 2154 are two panels from a group of eight which formed two wings of an altarpiece and depicted scenes from, during and after Christ's Passion. The other panels (which were originally on two panels that have subsequently been cut into fragments) are in the Westfälisches Landesmuseum, Münster. NG 263 was at the lower right of the right wing. It has sometimes been suggested that these panels came from the Kloster-Kirche in Liesborn and that they formed the shutters to the Liesborn altarpiece; hence the Master of Cappenberg could be identified as Jan Baegert (who was paid for painting the shutters of the high altarpiece at Liesborn in 1520). Although the provenance of the panels does not confirm this, the suggestion seems very plausible.

From the abbey church at Liesborn or Marienfeld; in the Krüger collection, Aachen, by 1833; from where bought, 1854.

Levey 1959, pp. 66–70; Tschira van Oyen 1972, pp. 98–104; Brough 1985, pp. 63–6; Brandl 1993, pp. 184–9.

MASTER of the BLESSED CLARE
active mid-14th century

This Riminese painter is named after his painting of the Blessed Clare of Rimini (NG 6503 in the Collection). He painted altarpieces and it has been suggested that some frescoes in Ferrara might be by his hand.

MASTER of the BRUGES PASSION SCENES
active early 16th century

This artist is named after an altarpiece with scenes from the Passion which is in the cathedral of St Salvator, Bruges, and which includes borrowings from two woodcuts by Dürer of about 1498. He has often been called the Bruges Master of 1500.

MASTER of CAPPENBERG (Jan Baegert?)
active about 1500–about 1525

The Master of Cappenberg is named after the Crucifixion altarpiece in Cappenberg (Westphalia). None of the paintings associated with him is signed or dated, but all seem to date from about 1500 to 1525. He is probably identifiable with Jan Baegert who was recorded as a painter in 1520.

MASTER of CAPPENBERG (Jan Baegert?)
Christ before Pilate
about 1520

NG 2154
Oil on oak, painted surface 99.1 x 69.2 cm

Jesus stands before Pilate, who was reluctantly
persuaded to have him crucified and is shown
washing his hands of the deed. His wife Claudia
Procula is at his shoulder. New Testament
(Matthew 27: 11–24).

NG 2154 and 263 are two panels of an altarpiece
(see further under NG 263). NG 2154 was at the
lower left of the left wing.

The dog and Christ's hands are taken from an
engraving of the same subject by Schongauer.

*From the abbey church at Liesborn or Marienfeld; in the
Krüger collection, Aachen, by 1833; from where bought,
1854.*

Levey 1959, pp. 66–70; Tschira van Oyen 1972, pp.
98–104; Brough 1985, pp. 63–6; Brandl 1993, pp.
184–9.

MASTER of the CASOLE FRESCO
The Virgin and Child with Six Angels
perhaps about 1315–20

NG 565
Tempera on canvas, transferred from wood
188 x 165 cm

The angels and Virgin were originally full length;
the painting has been cut down at its base, probably
because it was damaged. The picture may be the one
seen by Vasari in the church of S. Croce, Florence,
before 1550 and attributed by him to Cimabue. It has
recently been attributed to the Master of the Casole
Fresco and a date of about 1315–20 has been
proposed. A date of about 1325 has also been
suggested; dates for the works of the Master of the
Casole Fresco are scarce, all revolving around the
probable date of his fresco in Casole, Val d'Elsa, of
about 1317.

Bought from the Lombardi–Baldi collection, 1857.

Stubblebine 1979, pp. 114–15; Gordon 1988, pp. 74–5.

MASTER of the CASSONI
The Triumph of Love
probably 1440–60

NG 3898
Tempera on wood, twelve-sided; diameter
including frame 68.5 x 68.5 cm

The subject is loosely derived from Petrarch's
Triumphs. Love stands, naked and winged, on a
richly decorated chariot. In the foreground Phyllis
rides on Aristotle's back (an incident not found in
Petrarch); and Delilah shears Samson of his hair as
he sleeps in her lap (Old Testament, Judges 16:
17–20). The reverse shows two unidentified coats of
arms suspended from a lemon and an orange tree,
and a bird (probably an egret).

NG 3898 is a *desco da parto* (birth plate). These
were originally used in Florence for bringing food
to women in labour, and seem to have become
traditional gifts at birth.

Collection of Henry Wagner; by whom presented, 1924.

Davies 1961, pp. 363–5; Dunkerton 1991, pp. 110–11.

MASTER of the CASOLE FRESCO
active about 1300–30

The Master of the Casole Fresco was a Sienese
artist named after a fresco of about 1317 in the
Collegiata at Casole in Val d'Elsa (near Siena). He
shows the influence of Duccio and to a lesser
extent of Pietro Lorenzetti; he painted panel
paintings as well as frescoes.

MASTER of the CASSONI
probably active about 1440–70

The Master of the Cassoni was named in the early
twentieth century and various *cassoni* and *deschi
da parto* have been attributed to him. The panels
in this group are generally dated from the 1440s to
the 1460s. They may or may not have been
produced by one Florentine workshop.

MASTER of DELFT
Scenes from the Passion: The Crucifixion
about 1500–10

MASTER of DELFT
Christ presented to the People
about 1500–10

MASTER of DELFT
The Deposition
about 1500–10

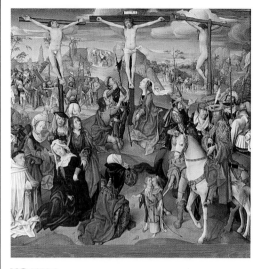

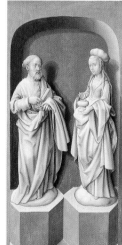

NG 2922.1
Oil (identified) on oak, central panel 97.8 x 105.4 cm; wings each 102.2 x 49.5 cm

The cross is inscribed: I.N.R.I., and the harness on the white horse at the right is inscribed: E/LANT(?)/M/AR.

This triptych of scenes from the Passion shows the *Crucifixion* (NG 2922.1) in the centre, *Christ presented to the People* (NG 2922.2) on the left, and *The Deposition* (NG 2922.3) on the right. In this panel the Magdalen is at the foot of the cross, while in the foreground at the left are Saint John and the other Holy Women. A figure on the right who carries a lance may be Longinus; in the background are the procession to Calvary with Pilate (?), Judas hanging from a withered tree, the Virgin swooning with Saint John and three Holy Women, and the Agony and preparation for the Arrest.

The donor may have been a Carthusian, from the Charterhouse of St Bartholomew in Jerusalem, near Delft, but he could have been a Premonstratensian. The tower in the left background is that of the New Church, Delft, which was completed as shown here in 1496, and altered in 1536.

Possibly in the collection of Lord Northwick, Thirlestaine House, Cheltenham, by 1846; presented by Earl Brownlow, 1913.

Davies 1968, pp. 105–7.

NG 2922.2
Oil (identified) on oak, 102.2 x 49.5 cm

The belt of a man is inscribed: ANE.

Pilate may be the figure with the reed at the extreme left; in the background the two thieves have set out for Calvary. On the reverse are the Virgin and Child with Saint Augustine in grisaille,

For further discussion see NG 2922.1.

Possibly in the collection of Lord Northwick, Thirlestaine House, Cheltenham, by 1846; presented by Earl Brownlow, 1913.

Davies 1968, pp. 105–7.

NG 2922.3
Oil (identified) on oak, 102.2 x 49.5 cm

In the foreground are the Virgin, Saint John and the Magdalen with two Holy Women, and set further back Joseph of Arimathaea and Nicodemus. On the reverse are Saint Peter and the Magdalen in grisaille.

For further discussion see NG 2922.1.

Possibly in the collection of Lord Northwick, Thirlestaine House, Cheltenham, by 1846; presented by Earl Brownlow, 1913.

Davies 1968, pp. 105–7.

 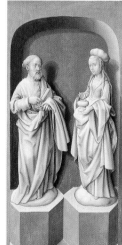

NG 2922.2, reverse NG 2922.3, reverse

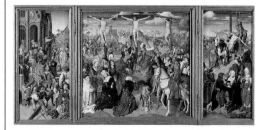

NG 2922.1-3

MASTER of DELFT

active early 16th century

The wings of a composite altarpiece (private collection) indicate that the painter was working in Delft in about 1510. His principal picture is the triptych showing scenes of the Passion (NG 2922.1–2). There appears to be some stylistic connection between his work and that of the Master of the Virgo inter Virgines; both artists may have been employed on woodcuts for book illustrations.

Workshop of the MASTER of the FEMALE HALF-LENGTHS
Saint John on Patmos, about 1525–50

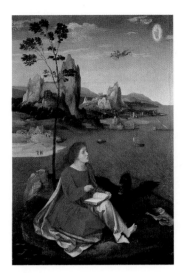

NG 717
Oil on oak, 36.2 x 24.1 cm

It was on the island of Patmos that Saint John wrote the Book of Revelation. Beside him rests his symbol, the eagle, who holds the saint's ink pot. In the sky above there appears a vision of a woman and child ('the Woman clothed with the Sun') and the seven-headed dragon of the Apocalypse. On the ground near John is a small devil who may be attempting to prevent him from writing.

The approach to the subject appears to derive from the work of Patenier, but the landscape and figure seem consistent with other studio products of the Master of the Female Half-Lengths.

From the Count Joseph von Rechberg collection, Mindelheim; acquired by Prince Ludwig Kraft Ernst von Oettingen-Wallerstein, 1815; acquired by the Prince Consort, 1851; presented by Queen Victoria at the Prince Consort's wish, 1863.

Davies 1968, pp. 115–16.

Workshop of the MASTER of the FEMALE HALF-LENGTHS
The Rest on the Flight into Egypt, about 1525–50

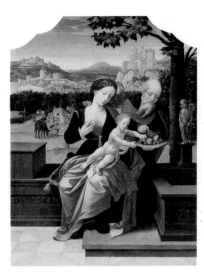

NG 720
Oil on oak, 81.9 x 62.2 cm

The Virgin and Child with Saint Joseph, who holds a dish of fruit, rest by a fountain bearing a figure similar to the one on the *Manneken Pis* fountain in Brussels. In the background is the Miracle of the Corn. According to this story the Holy Family came across a man sowing corn; the next day he was questioned by officers of Herod seeking Christ. The man said he had seen the fugitives when he was sowing, but miraculously the crop had grown overnight to its full height and the pursuers were deceived.

NG 720 is considered a workshop product. There is a similar although inverted composition in Philadelphia (Museum of Art).

Prince Ludwig Kraft Ernst von Oettingen-Wallerstein; acquired by the Prince Consort, 1851; presented by Queen Victoria at the Prince Consort's wish, 1863.

Davies 1968, pp. 116–17.

Attributed to the Workshop of the MASTER of the FEMALE HALF-LENGTHS
A Female Head, about 1525–50

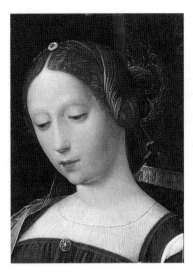

NG 721
Oil on oak, 26 x 18.7 cm

This fragment appears to be the head of a female saint, possibly the Magdalen.

NG 721 has in the past been attributed to Bernaert van Orley, but is now considered loosely related to the output of the Master of the Female Half-Lengths.

Acquired in Paris in 1815 by Count Joseph von Rechberg, Mindelheim; acquired by Prince Ludwig Kraft Ernst von Oettingen-Wallerstein, 1815; acquired by the Prince Consort, 1851; presented by Queen Victoria at the Prince Consort's wish, 1863.

Davies 1968, p. 117.

MASTER of the FEMALE HALF-LENGTHS
active second quarter of the 16th century

This artist is named after *A Concert of Three Female Figures* in Austria (Rohrau, Harrach collection). A large number of paintings of varying quality are associated with this painter. They may have been produced in Antwerp and display close associations with Patenier, but are also influenced by the work of Benson and Ysenbrandt who were active in Bruges.

Style of the MASTER of the FEMALE HALF-LENGTHS
Saint Christopher carrying the Infant Christ
about 1525–50

NG 716
Oil on oak, 24.8 x 54.6 cm

According to legend Saint Christopher was a huge man who carried travellers across a ford. He carried a child who became so heavy that the saint could hardly bear his weight; the child then declared that he was Jesus Christ and that the saint had been carrying the whole world. A hermit is depicted in the landscape at the right. On the reverse of the panel is the lay-in of another landscape with some figures drawn in brush.

The figures of the saint and the Christ Child may be by a different hand, perhaps a follower of Massys. The work as a whole has in the past been considered to be by a follower of Patenier, but the landscape seems closer to the style of the Master of the Female Half-Lengths.

From the Count Joseph von Rechberg collection, Mindelheim; acquired by Prince Ludwig Kraft Ernst von Oettingen-Wallerstein, 1815; acquired by the Prince Consort, 1851; presented by Queen Victoria at the Prince Consort's wish, 1863.

Davies 1968, pp. 117–18.

Circle of the MASTER of the LEGEND of SAINT URSULA
Saint Lawrence showing the Prefect the Treasures of the Church, about 1510

NG 3665
Oil on canvas, 130.2 x 92.7 cm

The Roman Prefect Decius demanded that Saint Lawrence reveal to him the treasures of the Church, and so the saint assembled the poor of Rome declaring that they were the treasures.

NG 3665 is from a series, which probably originally consisted of eight pictures of the life of Saint Lawrence. Five other parts of the cycle are known (three in Cologne, Wallraf-Richartz Museum; one in Berlin, Neisser collection; and one was recorded on the Berlin art market in the 1920s).

Schwarzschild collection, Warsaw; collection of Charles Roberts, London, by 1892; presented by Sir Henry Howorth, through the NACF, in memory of Lady Howorth, 1922.

Levey 1959, pp. 94–5.

MASTER of the LEHMAN CRUCIFIXION
Noli me Tangere
probably about 1370–5

NG 3894
Tempera on poplar, 55.5 x 38 cm

Christ appears to the Magdalen on the morning after the Resurrection, urging her not to touch him ('noli me tangere') before the time of the Ascension. Mary Magdalene is wearing her traditional red dress. Mary mistook Christ for a gardener, and he is shown here with a hoe. New Testament (John 20: 14–18).

NG 3894 is a pinnacle panel from an altarpiece attributed to the Master of the Lehman Crucifixion. Other parts of this altarpiece (see Gordon 1988, fig. 15 for a reconstruction) survive (New York, Metropolitan Museum of Art; Rome, private collection; Luxembourg, Musée d'Histoire et d'Art; and Denver, Colorado, Art Museum).

Nothing of the original frame survives.

Said to be from the collection of Abate Casali, Florence; collection of Edward Granville Harcourt Vernon by 1857; presented by Henry Wagner, 1924.

Pope-Hennessy 1987, pp. 68–70; Gordon 1988, pp. 76–7.

MASTER of the LEGEND OF SAINT URSULA
active late 15th/early 16th century

This artist is named after a scattered series of paintings with scenes from the life of Saint Ursula which in the past have been associated with the Master of Saint Severin. The painter appears to have been active in Cologne, but Dutch influences on his work suggest that he may have been trained in Holland. The earliest work attributed to him probably dates from about 1480.

MASTER of the LEHMAN CRUCIFIXION
active about 1352–99?

The Master of the Lehman Crucifixion was a Florentine painter who is named after a Crucifixion in the Lehman Collection (New York, Metropolitan Museum of Art). His style is close to Jacopo di Cione. It has been suggested that the painter may be identifiable with the Camaldolese monk Don Silvestro dei Gherarducci, who probably trained in the circle of Jacopo di Cione and died in 1399.

MASTER of LIESBORN
The Annunciation
probably 1470–80

NG 256
Oil on oak, 98.7 x 70.5 cm

The angel's scroll is inscribed: ave/ gracia/ plen[a]/ dominus/ tecu[m] (Hail [Mary], full of Grace, the Lord is with you).

The Archangel Gabriel announces to the Virgin that she will bear the Son of God. New Testament (Luke 1: 26–38). The scene is framed by fictive columns surmounted by sculptures of Old Testament prophets who foretold the birth of Christ. Within the room there is a statue of God the Father between the windows. On the panes and the cushions are coats of arms and heraldic devices which may indicate the identity of the patrons. A framed prayer is hung on the wall above the bench.

NG 256 is one of several surviving fragments of the high altarpiece in the Benedictine Abbey of Liesborn. The subject of the central panel was the Crucifixion (see NG 259-261). Apart from NG 256, 257 and 258, fragments of a *Nativity with Angels* (Münster, Westfälisches Landesmuseum) also survive. Older reconstructions of the altarpiece have suggested that these four panels made up a fixed left-hand shutter, but recently it has plausibly been suggested that the four panels flanked the *Crucifixion* in two pairs, a common Westphalian arrangement.

The high altar was dedicated in 1465 by Abbot Heinrich von Cleve (died 1490), and the altarpiece has been dated to the mid-1470s.

Still in situ, 1803; dismembered and dispersed, apparently 1807; bought from the Krüger collection, 1854.

Levey 1959, pp. 71–2; Dunkerton 1991, pp. 322–4.

MASTER of LIESBORN
The Presentation in the Temple
probably 1470–80

NG 257
Oil (identified) on canvas, transferred from oak, 98.4 x 70.2 cm

The Purification of the Virgin and the Presentation of the Child to Simeon are here combined. New Testament (Luke 2: 24–5). Above the pillars are three statues of, from left to right, the prophet Malachi(?), some of whose texts are linked with the principal subjects; David, who represents Christ's royal lineage; and Moses, whose presence refers to the Mosaic law of Purification, according to which it was necessary to make an offering of turtle doves or pigeons (held in a cage by the woman at the left). The omission of Saint Joseph is unusual, although he is absent from some other Westphalian pictures of the period.

NG 257 formed part of the Liesborn Altarpiece, which may be dated to the mid-1470s (see discussion of NG 256).

Still in situ, 1803; dismembered and dispersed, apparently 1807; bought from the Krüger collection, 1854.

Levey 1959, pp. 72–3; Dunkerton 1991, pp. 322–4.

MASTER of LIESBORN
The Adoration of the Kings
probably 1470–80

NG 258
Oil on oak, 23.2 x 38.7 cm

This fragment shows two kneeling kings, one of whom offers a golden cup, paying homage to the Christ Child who rests on his mother's lap. The scene appears to be set in a ruined stable before a landscape; the wall and a stream can be seen at the left.

NG 258 is one of three surviving fragments from the *Adoration*, one of the panels of the Liesborn Altarpiece (see discussion of NG 256). The other two fragments, showing a third king before a landscape and another male figure (Joseph?), are in the Westfälisches Landesmuseum, Münster.

Still in situ, 1803; dismembered and dispersed, apparently 1807; bought from the Krüger collection, 1854.

Levey 1959, p. 73; Dunkerton 1991, pp. 322–4.

MASTER of LIESBORN

active second half of the 15th century

Named after the dismembered high altarpiece of the Benedictine Abbey at Liesborn, Westphalia (dedicated 1465), from which fragments catalogued here derive, the artist appears to have been influenced by the style of painting practised in Cologne; he was active in various Westphalian centres.

MASTER of LIESBORN
Head of Christ Crucified
probably 1470–80

MASTER of LIESBORN
Saints John the Evangelist, Scholastica and Benedict, probably 1470–80

MASTER of LIESBORN
Saints Cosmas and Damian and the Virgin
probably 1470–80

NG 259
Oil on oak, 32.7 x 29.8 cm

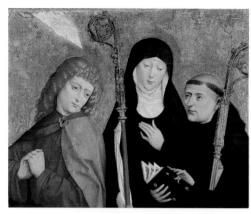

NG 260
Oil on canvas, transferred from oak, 55.9 x 70.8 cm

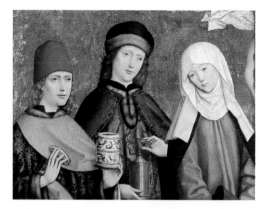

NG 261
Oil on canvas, transferred from oak, 54.9 x 72.1 cm

Inscribed on a paper attached to the cross: I.N.R.I (Jesus Nazarenus Rex Judaeorum: Jesus of Nazareth, King of the Jews).

This fragment shows Christ crowned with thorns upon the cross. At the lower left corner is the wing of an angel.

NG 259 is from the dismembered central panel of the Liesborn Altarpiece which may be dated to the mid-1470s (see discussion of NG 256). Six other fragments from this scene survive: NG 260 and 261 and four depictions of angels (Münster, Westfälisches Landesmuseum); some of the angels hold chalices to catch the blood of Christ.

Still in situ, 1803; dismembered and dispersed, apparently 1807; bought from the Krüger collection, 1854.

Levey 1959, pp. 73–4; Dunkerton 1991, pp. 322–4.

The haloes were once inscribed, but are now illegible.

The saints are, from left to right, John the Evangelist, Scholastica (who is dressed as a Benedictine abbess) and her brother Benedict, the founder of the Benedictine Order, who is dressed as an abbot. This fragment originally formed part of a Crucifixion scene (part of Christ's loin cloth can be seen at the upper left), the central panel of the altarpiece from the Benedictine Abbey of Liesborn. On the crook of Scholastica's crozier is a depiction of the Sacrifice of Isaac, perceived as a prefiguration of the Crucifixion.

For further fragments from this scene see NG 259 and 261.

Still in situ, 1803; dismembered and dispersed, apparently 1807; bought from the Krüger collection, 1854.

Levey 1959, p. 260; Dunkerton 1991, pp. 322–4.

Inscribed on the haloes with the original names (damaged), left to right: ... M..; ..MIA.; MA....S (Cosmas; Damian; the Virgin Mary).

Saints Cosmas and Damian, protectors of the Abbey of Liesborn, were twins, and doctors, who were martyred for their faith in the year 303. They both carry containers for medicines; the blue and white earthenware pot that Cosmas holds has a dragon pattern. NG 261 comes from a depiction of the Crucifixion, the central panel of the Liesborn Altarpiece; part of Christ's loin cloth and leg can be seen at the upper right.

Six other fragments of the scene survive: NG 259 and 260 and four depictions of angels (Münster, Westfälisches Landesmuseum).

Still in situ, 1803; dismembered and dispersed, apparently 1807; bought from the Krüger collection, 1854.

Levey 1959, pp. 74–6; Dunkerton 1991, pp. 322–4.

Attributed to the MASTER of LIESBORN
The Crucifixion with Saints
about 1465–90

Circle of the MASTER of LIESBORN
Saints Ambrose, Exuperius and Jerome
about 1465–90

Circle of the MASTER of LIESBORN
Saints Gregory, Maurice and Augustine
about 1465–90

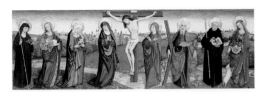

NG 262
Oil on oak, 38.4 x 118.4 cm

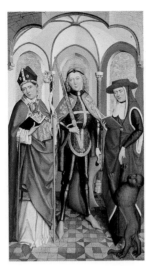

NG 254
Oil (identified) on canvas, transferred from wood,
120 x 67.9 cm

NG 255
Oil on canvas, transferred from wood,
120 x 67.9 cm

Inscribed on the cross: INRI.

The figures are, from left to right, Saints Scholastica, Mary Magdalene, Anne, the Virgin, Christ Crucified, John the Evangelist, Andrew, Benedict and Agnes. Saint Anne is depicted with the Madonna and Child in her arms, while Saint Andrew carries the X-shaped cross upon which he was martyred, and Saint Agnes is accompanied by a lamb.

NG 262 is from the Benedictine Abbey at Liesborn, and may have formed the predella to an altarpiece there. Although it was not part of the high altarpiece from which NG 256–261 derive, the composition was probably inspired by the Crucifixion which was the central panel of that work.

The abbey church at Liesborn; the Krüger collection, Minden, by 1848; from where bought, 1854.

Levey 1959, pp. 78–9.

The haloes of the saints are inscribed: (.) Ambrosius. eps.; .S'. exuperius. martir.& miles; .S'. Jheronim'.

Saint Ambrose on the left is dressed as a bishop; he was one of the Doctors of the Church. Saint Exuperius, identified on his halo as a knight and a martyr, carries a sword and shield, while Saint Jerome is dressed as a cardinal and attended by his lion.

NG 254 and 255 are evidently shutters from the same altarpiece from the Abbey of Liesborn, but are not part of the high altarpiece (see NG 256–261).

The abbey church at Liesborn; the Krüger collection, Minden, by 1840; from where bought, 1854.

Levey 1959, pp. 76–7.

Inscribed on the haloes: .S.' gregorius.; .S.' m (...). martir.; S.'au (...).

Saint Gregory is dressed as a Pope; he has a depiction of the Annunciation on his morse. Saint Maurice wears the armour of a knight, and Saint Augustine carries the Sacred Heart.

NG 255 and 254 are thought to come from the same altarpiece.

The abbey church at Liesborn; the Krüger collection, Minden, by 1840; from where bought, 1854.

Levey 1959, pp. 77–8.

Circle of the MASTER of LIESBORN
The Virgin and Child with a Donor
about 1475–90

Circle of the MASTER of LIESBORN
Saint Dorothy
late 15th century

Circle of the MASTER of LIESBORN
Saint Margaret
late 15th century

NG 2151
Oil on oak, 118.8 x 51.5 cm

NG 2152
Oil on oak, 80.4 x 48.3 cm

NG 2153
Oil on oak, 80.7 x 47.9 cm

Inscribed on the donor's scroll with a shortened version of the text 'miserere mei clementissime . . . misericordiam tuam et per intercessionem dulcissime genetricis tue lucem mihi concede perpetuam' (Have mercy on me, most clement [Lord Jesus Christ, in accordance with] your merciful goodness (literally: '[great] mercy') and through the intercession of your most sweet mother grant me eternal light).

The Virgin stands holding the Christ Child; she is about to be crowned by two angels. This is an early example of the Madonna of the Rosary. At the right is a diminutive donor who wears the black habit of a Benedictine monk. The monk's head is on a piece of wood inserted and painted in the nineteenth-century; the original fragment survives in the Westfälisches Landesmuseum, Münster.

NG 2151 is the central panel of an altarpiece from the Benedictine monastery of Herzebrock (Westphalia). Other portions of the work survive in Münster (Westfälisches Landesmuseum). The work was probably painted late in the fifteenth century.

From the Benedictine Convent at Herzebrock, near Rheda; Krüger collection, Minden, 1848; from where bought, 1854.

Levey 1959, pp. 79–82.

Inscribed on the halo: Scta dorotea (repainted).

Saint Dorothy was a virgin who is said to have suffered her martyrdom under the emperor Diocletian. She wears a wreath of roses and holds a rose and a basket of roses; these flowers are said to have been miraculously sent by her from Paradise after she was mocked on the way to her death.

NG 2152 and 2153 are fragments from the same painting; see the entry for the latter picture.

Recorded as from a chapel at Lippstadt; in the Krüger collection, Minden, by 1848; from where bought, 1854.

Levey 1959, p. 82.

Inscribed on the halo: Sancta. Margarit (repainted).

Saint Margaret is wearing a head-dress of pearls. She carries a cross and holds a chain which secures a dragon upon which she rests. According to one of the various legends about the saint she overcame this creature by making the sign of the cross.

NG 2153 and 2152 are fragments from a larger work which probably depicted the Virgin and Child seated in a garden (the *hortus conclusus*) with Saints Dorothy, Catherine, Agnes and Margaret. Parts of other figures are visible in the background of NG 2153. Other fragments were recorded, but are now lost. The picture was probably an altarpiece for the Augustinian convent of St Anna Rosengarten, Lippstadt, Westphalia.

Recorded as from a chapel at Lippstadt; in the Krüger collection, Minden, by 1848; from where bought, 1854.

Levey 1959, pp. 82–4.

MASTER of the LIFE of the VIRGIN
The Presentation in the Temple
probably about 1460–75

Workshop of the MASTER of the LIFE of the VIRGIN
The Conversion of Saint Hubert
probably about 1480–5

Workshop of the MASTER of the LIFE of the VIRGIN
The Mass of Saint Hubert
probably 1480–5

NG 706
Oil on oak, 83.8 x 108.6 cm

NG 252
Oil (identified) on oak, 123 x 83.2 cm

NG 253
Oil (identified) on canvas, transferred from wood, 123.2 x 83.2 cm

Traces of the Virgin's name on her halo. The altarpiece is inscribed: ANGLAE (perhaps for *Angularis*, a reference to the cornerstone of the Temple, *Lapis Angularis*, used typologically by Saint Paul to describe Christ, New Testament, Ephesians 2: 19–20).

Simeon receives the Infant Christ from the Virgin, who has come to the Temple for purification after having given birth. Saint Joseph, his candle unlit, stands behind her. New Testament (Luke 2: 24–5). On the right is probably the prophetess Anna and her husband. The stone altarpiece shows (left to right) the Offering of Cain and Abel and the Murder of Abel; the Sacrifice of Isaac; the Drunkenness of Noah. All three scenes are Old Testament prototypes for Christ's Passion. On the dorsal of Simeon's cape is the Vision of Augustus and the Tiburtine Sibyl. The figure on the edge of his cope can be identified as Moses.

NG 706 is one of a series of panels which formed an altarpiece with scenes from the Life of the Virgin. The others are in the Alte Pinakothek, Munich. Dr Johann von Schwartz-Hirtz (Counsellor at Cologne, 1439–67) has been identified as a donor on one of the panels. A member of his family is said to have restored a chapel in St Ursula's, Cologne, for which this altarpiece was presumably commissioned.

Bought by the brothers Sulpiz and Melchior Boisserée, 1812; passed into the collection of Prince Ludwig Kraft Ernst von Oettingen-Wallerstein, 1815; acquired by the Prince Consort, 1851; presented by Queen Victoria at the Prince Consort's wish, 1863.

Levey 1959, pp. 85–7; Dunkerton 1991, pp. 308–10.

MASTER of the LIFE of the VIRGIN
Active second half of the 15th century

The artist is named after a series of eight panels of the Life of the Virgin, of which NG 706 is one. None of his works is dated. Although he was active in Cologne, the style of some of the works associated with his name suggest that he may have been trained in the Netherlands.

The cross is inscribed: INRI.
Saint Hubert (about 656–727) was the first bishop of Liège. According to legend he was hunting in the forest of Ardennes on a holy day when he saw a stag with a crucifix between its antlers. He dismounted, fell to his knees, adored the cross and promised to give up his worldly ways. In the background are scenes of hunting and hawking.

NG 252 is the inside left-hand wing of the so-called Werden Altarpiece. For further discussion see the entry for NG 250.

From the abbey at Werden, suppressed 1803; Krüger collection, Minden, by 1847; from where bought, 1854.

Levey 1959, pp. 88–90.

An angel appears with a stole for Saint Hubert as he celebrates Mass. On the altarpiece is God the Father with Saints Peter and Paul to either side. The dog's presence may allude to the fact that Saint Hubert was a protector against hydrophobia (rabies).

NG 253 is the inner right-hand wing of the so-called Werden Altarpiece. For further discussion see the entry for NG 250.

From the abbey at Werden, suppressed 1803; Krüger collection, Minden, by 1847; from where bought, 1854.

Levey 1959, pp. 88–90.

Workshop of the MASTER of the LIFE of the VIRGIN

Saints Jerome, Bernard (?), Giles and Benedict (?)
probably 1485–90

NG 250
Oil (identified) on canvas, transferred from wood,
123.8 x 82.5 cm

Saint Jerome is accompanied by his lion, and Saint
Giles, who is dressed as a Benedictine abbot, by a
hind.

NG 250 is the outside right-hand wing of an
altarpiece that was presumably made for the Abbey
at Werden where it was first recorded along with
NG 251, 252 and 253, which must have formed part
of the same altarpiece. No other surviving parts of
the altarpiece are known. The costumes suggest a
date of about 1485–90. The outside wings are of
lower quality than the inner ones, which are very
close in handling to works definitely attributed to
the Master of the Life of the Virgin.

*From the abbey at Werden, suppressed 1803; Krüger
collection, Minden, by 1847; from where bought, 1854.*

Levey 1959, pp. 87–90.

Workshop of the MASTER of the LIFE of the VIRGIN

Saints Augustine, Hubert, Ludger (?) and Gereon (?)
probably 1485–90

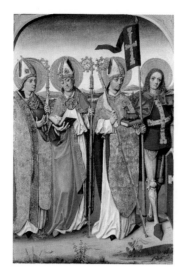

NG 251
Oil on oak, 123.8 x 83.2 cm

Saint Augustine holds a heart pierced by an arrow,
and Saint Hubert has a book with a stag seated on
it. On the morse of the cope of the saint who may be
Ludger is a depiction of the Virgin and Child
enthroned adored by angels.

NG 251 is the outside left-hand wing of the so-
called Werden Altarpiece. Ludger was the founder
of the abbey of Werden in about 800. For further
discussion see the entry for NG 250.

*From the abbey at Werden, suppressed 1803; Krüger
collection, Minden, by 1847; from where bought, 1854.*

Levey 1959, pp. 87–90.

Workshop of the MASTER of the MAGDALEN LEGEND

The Magdalen, about 1520

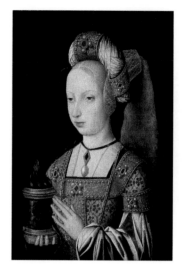

NG 2614
Oil on oak, total painted surface 37.5 x 27.3 cm

The Magdalen holds a jar of the balm with which
she anointed Christ's body. The saint was once held
to be the portrait of a lady, but this is unlikely.

Several versions of this composition exist; in some
there is a halo. NG 2614 was probably painted in
about 1520.

*Collection of William Spread by 1892; Salting Bequest,
1910.*

Davies 1954, pp. 207–10; Davies 1968, pp. 119–20.

MASTER of the MAGDALEN LEGEND
active about 1483–1527

**Named after a large dismembered triptych
thought to date from about 1515–20. The Master
is supposed to have been active in Brussels,
partly as a court painter. Dates on paintings
attributed to him range between 1483 and 1527.**

MASTER of the MANSI MAGDALEN
Judith and the Infant Hercules
probably about 1525–30

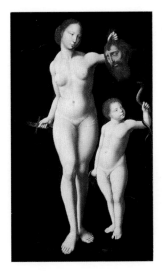

NG 4891
Oil on oak, painted surface 89.5 x 52.7 cm

Judith holds the head of Holofernes and his sword, alluding to the narrative in the Apocrypha of the Old Testament (Judith 13: 6–10) in which this virtuous Jewish heroine cut off the head of the Assyrian general with his sword as he slept. It is unusual for Judith to be represented nude. Hercules, the god of strength and courage, holds two serpents. The snakes have peacock crowns, a reference to the goddess Juno who tried to kill the infant Hercules and his brother by sending them two snakes. Juno's attribute was a peacock. The reason for the association of an Old Testament heroine with a hero from Greek mythology is obscure; it may be related to the theme of virtue.

Bequeathed by Charles Haslewood Shannon, 1937.

Davies 1968, p. 120; Taylor 1984, pp. 101–15.

Attributed to the MASTER of MARRADI
The Story of the Schoolmaster of Falerii
probably about 1450–75

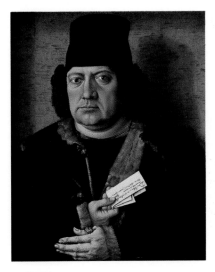

NG 3826
Carved and gilded wood, 97 x 200 x 75 cm;
main panel, tempera on wood, 38.4 x 127.6 cm

Inscribed on a flag to the left: S.[enatus] P.[opulus] Q.[ue] [Romanus] (By Order of the Senate and the People of Rome).
 Rome was besieging Falerii when the schoolmaster of Falerii took his pupils to the Roman camp offering them, and with them the city, to the Roman general Camillus (on a white horse to the right). He refused to take the besieged city by treachery and answered: 'There are rights of war as of peace and we have learnt to use them justly no less than bravely,' and the traitor was duly bound and given to the children to return to their city (where he is seen to be punished). The Falerians were so impressed by this fair dealing that they surrendered their city to Camillus (left foreground). Plutarch, *Lives*, I, 198–9. Figures of nude children appear on either end of the *cassone*.
 NG 3826 is a wedding chest or *cassone. Cassoni* were part of the furnishing of the Italian bedchamber, and they were commonly painted. This chest was probably extensively rebuilt in the nineteenth century, and it has been entirely regilded. The inside of the lid is painted with the same decorative design as appears on a wedding chest which has been dated about 1472 (London, Courtauld Institute of Art).

From the collection of Lady Lindsay; presented by the Misses Lindsay, 1912.

Davies 1961, pp. 189–90.

MASTER of the MORNAUER PORTRAIT
Portrait of Alexander Mornauer
about 1464–88

NG 6532
Oil (identified) on wood, probably pine or fir, original painted area 45.2 x 38.7 cm

Inscribed in German on the letter held by the sitter: Dem ehrsamen und weisen alle[x]/ander Mornauer [stadt]schr[eiber] /zu lanzhut m[ein]em gutren günner (To the honourable and wise Alexander Mornauer, town clerk of Landshut, my good patron).
 Alexander Mornauer was town clerk of Landshut in Bavaria from 1464 until 1488. He is identified on the letter, which is addressed to him. His ring depicts the punning device of a moor's head (alluding to his name).
 NG 6532 was certainly painted between 1464 and 1488, probably in the 1470s.
 The original top edge of the painting has been cut slightly. In the eighteenth century the background was overpainted with Prussian blue; this was removed in 1991. The present background depicts woodgrain.

Collection of the 1st Marquess of Buckingham, Stowe House, by 1797; collection of the Earl of Clare; collection of Lord Overstone; bought from the Loyd collection, 1990.

Buchner 1953, pp. 105–7, 203; National Gallery Report 1990–1, pp. 12–13; Foister 1991, pp. 613–18.

MASTER of the MANSI MAGDALEN
active early 16th century

This artist is named from the Mansi *Magdalen* (Berlin, Staatliche Museen), perhaps of about 1525 or later. He was a follower of Quinten Massys.

MASTER of MARRADI
late fifteenth century

The Master of Marradi is the name given to a prolific artist active in Tuscany in the late fifteenth century whose work owes much to Domenico Ghirlandaio.

MASTER of the MORNAUER PORTRAIT
probably active about 1460–1480

Various identities and nationalities have been proposed for the Master of the Mornauer Portrait. It has been suggested that he may be identical with Ulrich Fuetrer of Landshut in Bavaria but he is more probably a Tyrolean painter. A portrait of Archduke Sigismund of the Tyrol (Munich, Alte Pinakothek) appears to be by the same artist.

MASTER of MOULINS (Jean Hey)
Charlemagne, and the Meeting of Saints Joachim and Anne at the Golden Gate, about 1500

NG 4092
Oil on oak, 72 x 59 cm

According to apocryphal writings, Saint Anne was the wife of Saint Joachim and mother of the Virgin Mary. It was widely believed that the Virgin was conceived when Joachim, returned from guarding his flocks, met and embraced Saint Anne at the Golden Gate of the Temple of Jerusalem, here depicted as a medieval walled city. At the right is the Emperor Charlemagne (died 814). He was never canonised but often appears in paintings represented as a saint. Charlemagne's surcoat bears 'per pale' the eagle of the Holy Roman Empire, and France ancient. His crown has the imperial eagle on the top and the fleurs-de-lis on the rim.

NG 4092 is a fragment from the left side of an altarpiece. An *Annunciation* (Art Institute of Chicago) is the right-hand portion; that picture shows signs of having been cut at the left. The central scene probably showed the Virgin and Child. It has been suggested that the overall theme of the altarpiece would have been the mysteries of the conceptions of the Virgin and Christ. The altarpiece may have been displayed in the chapel of the Immaculate Conception in Moulins Cathedral. The present picture has been catalogued as studio work, but recent cleaning shows it to be almost certainly the work of the master himself.

Sold from a private collection, France, 1903; bought (Temple–West Fund), 1925.

Davies 1957, pp. 153–5; Dunkerton 1991, p. 358.

MASTER of the OSSERVANZA
The Birth of the Virgin
about 1430–50

NG 5114
Tempera on wood, approximate total area
28 x 45 cm

Saint Anne is shown in bed in the central panel of the triptych. The Virgin Mary is being washed by midwives in the foreground. In the right wing Saint Joachim is told the news of the birth; in the left wing two women are seen in a domestic setting. The source is *The Golden Legend.*

This small triptych, made for private devotion, was formerly attributed to Sano di Pietro and to Sassetta, but the attribution to the Master of the Osservanza is probably acceptable and NG 5114 can be related to a larger picture of the same subject (also attributed to him) at Asciano.

Trivulzio collection by 1858; bequeathed by Viscount Rothermere, 1940.

Davies 1961, pp. 367–8; Van Os 1990, p. 113.

Attributed to the MASTER of the PALA SFORZESCA
The Virgin and Child with Saints and Donors
probably about 1490

NG 4444
Oil on wood, 55.9 x 48.9 cm

The saints are, from left to right: James the Greater; a deacon who may be either Saint Lawrence or Stephen; a saint who is probably Bernardino; and an unidentified male saint. The donors have not been identified, but presumably represent the members of a single family, the men on one side, the women on the other, ranged behind the married couple facing each other in the foreground.

NG 4444 may be dated slightly earlier than the Pala Sforzesca (see biography) to about 1490.

Prince Jérome Napoleon sale, Christie's, 11 May 1872 (lot 234); presented by Lady Margaret Watney in memory of her husband, Vernon J.Watney, 1929.

Davies 1961, p. 369.

MASTER of MOULINS (Jean Hey)
active 1483 or earlier–about 1500

The artist is named after a triptych in Moulins Cathedral, which is usually dated to about 1498. It is now generally accepted that he is the painter Jean Hey. Several paintings have been associated with the triptych.

MASTER of the OSSERVANZA
active about 1425–about 1450

Named after a triptych dated 1436 that was once in the church of the Osservanza near Siena (now Siena, Pinacoteca), the Master was one of the leading painters in fifteenth-century Siena. He was influenced by Sassetta and has sometimes been identified as the young Sano di Pietro, and (more recently) as Vico di Lucca. The works attributed to him include large altarpieces and small devotional works.

MASTER of the PALA SFORZESCA
active about 1495

This artist is named after an altarpiece called the Pala Sforzesca which is dated 1494/5 and is now in the Brera, Milan. It includes portraits of Lodovico il Moro and his family as donors, and shows a combination of the style of Leonardo da Vinci with that of leading Lombard painters such as Foppa.

Attributed to the MASTER of the PALA SFORZESCA
Saint Paul, about 1495

MASTER of the PALAZZO VENEZIA MADONNA
Saint Mary Magdalene, about 1330–50

MASTER of the PALAZZO VENEZIA MADONNA
Saint Peter, about 1330–50

NG 3899
Oil on walnut, 23.8 x 13.3 cm

NG 4491
Tempera on poplar, 59.5 x 33.5 cm

NG 4492
Tempera on poplar, 59.5 x 33.5 cm

This is a panel from an altarpiece. Saint Paul is depicted before a niche, with his usual attributes, a book and a sword.

When NG 3899 entered the Gallery it was catalogued as School of Verrocchio and from 1929 as of the Milanese School. On grounds of style it is linked with NG 4444 and so with the Pala Sforzesca (see biography).

Presented by Henry Wagner, 1924.

Davies 1961, pp. 368–9.

Mary Magdalene is represented traditionally with blond hair, a red dress, and holding a pot of balm with which she anointed Jesus' feet.

NG 4491 and 4492 were painted by an unidentified Sienese painter. They originally formed the right side of a polyptych (see Gordon 1988, fig.15, for a reconstruction). A third panel of Saint Paul (private collection) is related to these two pictures and probably came from the left-hand side of the polyptych. It has been suggested that the central panel was the Virgin and Child once in the Palazzo Venezia (hence the painter's name) and now in the Galleria Nazionale, Rome.

Cumming collection by the mid-nineteenth century; presented by the Misses Cumming in memory of their father, Charles D. Cumming, 1930.

Gordon 1988, pp. 78–80.

Saint Peter holds two keys, one in silver leaf, the other in gold leaf. These are the keys of the Kingdom of Heaven (New Testament, Matthew 16: 18–19) which were his emblem and were subsequently adopted by the popes, his successors as bishops of Rome.

NG 4492 and 4491 formed part of a polyptych. See under NG 4491 for further commentary.

Cumming collection by the mid-nineteenth century; presented by the Misses Cumming in memory of their father, Charles D. Cumming, 1930.

Gordon 1988, pp. 78–80.

MASTER of the PALAZZO VENEZIA MADONNA
active mid-14th century

The Master of the Palazzo Venezia Madonna (so called after a Madonna once in the Palazzo Venezia and now in the Galleria Nazionale, Rome) was a Sienese follower of Simone Martini.

Workshop of the MASTER of the PRODIGAL SON
The Dead Christ supported by the Virgin and Saint John, about 1550

NG 266
Oil on oak, 108 x 68.5 cm

The body of Christ is supported by the Virgin Mary and Saint John. The dove of the Holy Ghost appears above the figures.

NG 266 was probably painted to encourage meditation on Christ's Passion. The format of the picture may derive from Venetian tradition (see for comparison Bellini NG 3912). NG 266 was perhaps painted in about 1550; many versions are known.

Krüger collection, Aachen, by 1833; from where bought, 1854.

Davies 1968, pp. 122–3.

MASTER of RIGLOS
The Crucifixion
about 1450–60

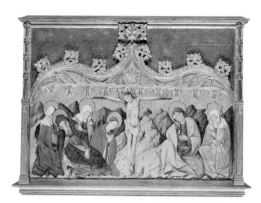

NG 6360
Egg (identified) on pine, 43 x 102.5 cm

In the central compartment formed by the tracery a scroll is inscribed: INRI.

At the centre Christ is on the cross. On the left are the Magdalen and the Virgin supported by two Holy Women. On the right are Saint John and a figure with a scalloped halo who may be Saint Anne. The tracery and ornament around the picture are original.

NG 6360 is recorded in a photograph as being the pinnacle of the retable of Saint Martin in the church of St Martin in Riglos (Huesca province). The central panel of the altarpiece was the *Saint Martin and the Beggar* (Barcelona, Museo de Arte de Cataluña). NG 6360 was placed above this. Three small scenes of events in the life of Saint Martin were set vertically at either side of the altarpiece; the lowest at the left was *Saint Martin's Vision of the Virgin and Saints* (Merion, Pennsylvania, Barnes Foundation), and the lowest at the right, the *Death of Saint Martin* (Bologna, Pinacoteca). The altarpiece also had a predella, of which five panels are recorded.

Remained in the church for which it was painted (see above) until about 1916; bequeathed by Sir Ronald Storrs, 1964.

MacLaren/Braham 1970, pp. 49–51.

MASTER of the SAINT BARTHOLOMEW ALTARPIECE
The Virgin and Child with Musical Angels
probably mid-1480s

NG 6499
Oil on oak, 52 x 38 cm

Inscribed on the angel's scroll at the top: regi[n]a.celi.letare (the beginning of an antiphon: Rejoice, the Queen of Heaven).

The Virgin is seated before a cloth of honour surrounded by music-making angels. The group is framed at the top with fictive gilt carving. Among the instruments played are a portative organ, bells and a harp. On the left is a columbine, so called because of its appearance (i.e. 'like a dove'), which may allude to the Holy Ghost.

Ralph Bernal sale, 1855; bought from Andrew Christie-Miller, 1985.

National Gallery Report 1985–7, pp. 16–17.

MASTER of the PRODIGAL SON
active 1535?–about 1560?

The Master of the Prodigal Son is named after a painting in Vienna (*Prodigal Son,* Kunst-historisches Museum). He is thought to have headed a workshop that produced many replicas of his pictures. He seems to have been active in Antwerp, and to have known something of Italian art. Attempts to associate him with documented painters have not been conclusive.

MASTER of RIGLOS
active mid-15th century

This artist, who was active in Aragón, is named after an altarpiece which was formerly in the church of St Martin in Riglos (Huesca). NG 6360 formed the pinnacle of the work.

MASTER of the SAINT BARTHOLOMEW ALTARPIECE
active about 1470 to about 1510

The artist is named after the Saint Bartholomew Altarpiece which was made for the church of St Columba, Cologne (now Munich, Alte Pinakothek). He was the most accomplished Cologne painter of the later fifteenth and early sixteenth century; his work was influenced by that of Netherlandish artists, notably Rogier van der Weyden.

MASTER of the SAINT BARTHOLOMEW ALTARPIECE

The Deposition, about 1500–5

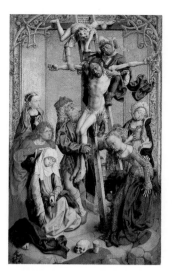

NG 6470
Oil on oak, 74.9 x 47.3 cm

Inscribed at the top of the cross in Hebrew and Greek, rather than the more usual Latin: Jesus of Nazareth King of the Jews.

After the crucifixion, Christ, his body stiffened by *rigor mortis,* is brought down from the cross. He is lowered by Nicodemus into the arms of Joseph of Arimathea. New Testament (Matthew 27: 37). At the left the swooning Virgin is held by Saint John the Evangelist. The Magdalen, whose pot of ointment is on the ground before her, leans on the ladder. Behind her one of the three Maries holds the crown of thorns. The skull on the ground marks the place as Golgotha. The scene is set in a fictive gilt shrine, framed by tracery, as though in imitation of a sculpted polychrome group – a device used in Rogier van der Weyden's famous *Descent from the Cross* (Madrid, Prado).

It is not known if NG 6470 was part of an altarpiece for a church, or intended for domestic devotions, although the latter seems more likely. It is thought to date from the first years of the sixteenth century.

Another much larger version of the subject by the artist, dated to about 1510, also survives (Paris, Louvre).

Ingram family collection, Temple Newsam, 1714; bought from the Earl of Halifax, 1981.

National Gallery Report 1980–1, pp. 50–1; Smith 1985, p. 82; Dunkerton 1991, p. 368.

MASTER of the SAINT BARTHOLOMEW ALTARPIECE

Saints Peter and Dorothy, probably 1505–10

NG 707
Oil (identified) on oak, 125.7 x 71.1 cm

Saint Peter holds the keys to Heaven, and spectacles which appear to have a latticed window reflected in them. Saint Dorothy holds a basket of flowers which includes roses. According to her legend she promised an unbeliever to send roses and apples to him from Heaven. The reverse is painted with the Virgin and Child by another artist and is not necessarily contemporary with the front.

NG 707 is the left wing of an altarpiece; the right wing of which (Mainz, Mittelrheinisches Landesmuseum) shows Saints Andrew and Columba and, on the reverse, two kings apparently adoring the Virgin and Child on the National Gallery panel. These panels may be the outer ones from the Saint Bartholomew Altarpiece, after which the artist is named, which was painted for St Columba's, Cologne (now Munich, Alte Pinakothek), but they may be from another work made for this church.

Apparently separated from the rest of the altar by 1688, when valued; Count Joseph von Rechberg collection, Middelheim; acquired by the Prince Consort from Prince Ludwig Kraft Ernst von Oettingen-Wallerstein, 1851; presented by Queen Victoria at the Prince Consort's wish, 1863.

Levey 1959, pp. 92–3; Smith 1989, p. 80; Dunkerton 1991, p. 380.

NG 707, reverse

Workshop of the MASTER of the SAINT BARTHOLOMEW ALTARPIECE

The Virgin and Child in Glory with Saint James the Great and Saint Cecilia, about 1480

NG 6497
Oil on wood, 36 x 59.2 cm

The frame of the central panel (interior) is inscribed: Ave.regia.celor (Behold the Queen of Heaven); the frame of the left shutter (interior): SANCTVS. IACOBVS; the frame of the right shutter (interior): SANCTA. CECILIA.; the scroll the Angel of the Annunciation holds on the right panel (exterior): Ave Gratia Plena Dominus Tecum (Hail (Mary) full of Grace, the Lord be with you); her cloak is decorated with the sign: IHS.

The Virgin holds the Christ Child and is surrounded by rays of the sun in the central panel; she is crowned as the Queen of Heaven by two angels (see inscription). The orb symbolises temporal power. On the interior of the panel at the right Saint Cecilia stands beside her attribute, a portative organ, and – most unusually – holds a bird. In the left panel Saint James the Great is dressed as a pilgrim; he carries a staff and cockle shells are attached to the hat at his neck. On the exterior of the two shutters the Annunciation to the Virgin in her bedroom is depicted. Some traces of the original finish of the frames remain, apparently mainly red in colour.

NG 6497 is similar in scale and style to the Holzhausen Triptych (Cologne, Wallraf-Richartz Museum), which may be dated as early as 1480 and is attributed to the workshop of the Master of the Saint Bartholomew Altarpiece.

Bought, 1984.

National Gallery Report 1985–7, pp. 14–15.

NG 6497, with shutters closed

Attributed to the MASTER of SAINT FRANCIS
Crucifix
probably about 1272–85

NG 6361
Egg (identified) on poplar, 92.1 x 71.0 cm

Inscribed in the top terminal: ECCE. HIC. EST. CHRISTUS. IESUS / REX. IVDEORUM. SERVATOR (sic) MV/NDI. SALVUS. NOSTRE. QUI. PRO. N/OBIS. PEPENDIT IN LIGNO VITAS (sic).(Behold, this is Jesus Christ, King of the Jews, Saviour of the World and our Salvation, who for us hung on the Tree of Life); and on the arms of the cross, either side of Christ's head: REX GL[ORI]E (King of Glory [from Psalm 23, 24]).

Jesus Christ is shown on the cross. The Virgin Mary is supported by two Holy Women on the left; Saint John the Evangelist and the Centurion are on the right. The inscription in the top terminal is not original but may follow the lost original; the Latin is not entirely accurate.

NG 6361 may originally have been one side of a double-sided Crucifix. It was designed to be portable but it may also have been placed on an altar. It postdates the larger *Crucifix* of 1272 painted by the same artist (Perugia, Galleria Nazionale).

The *Crucifix* is cut from a single plank of poplar. The hollowed-out roundel at the top may once have contained a relic, perhaps of the True Cross. The side terminal panels of the cross are original.

Stoclet collection by 1925; bought with contributions from the NACF and an anonymous donor, 1965.

Gordon 1988, pp. 81–3; Bomford 1989, pp. 54–63; Todini 1989, pp. 184–5.

MASTER of SAINT FRANCIS

active about 1260–72 or later

The Master of Saint Francis (Maestro di San Francesco), who was active in Umbria, is named after a picture of Saint Francis in S. Maria degli Angeli near Assisi. His only dated work is a crucifix of 1272 (Perugia, Galleria Nazionale); he also painted frescoes in the Lower Church of S. Francesco at Assisi (probably about 1247–60/3).

MASTER of SAINT GILES
Saint Giles and the Hind
about 1500

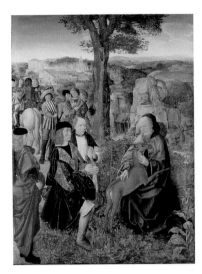

NG 1419
Oil (identified) on oak, painted surface
61.6 x 46.4 cm

The King of France kneels with a bishop to ask forgiveness of Saint Giles. A member of the royal hunt had injured the saint while shooting at the hind which was his companion in the wilderness. The tower in the background is probably that of the town of Pontoise. On the reverse of the panel (see below) is a damaged grisaille showing a bishop saint in a niche.

NG 1419 and 4681 are generally thought to date from about 1500 and to have come from the same series as two panels in Washington (National Gallery of Art) which depict *Episodes from the Life of a Bishop Saint* and *The Baptism of Clovis*. Numerous reconstructions of the panels as part of an altarpiece have been suggested. They may have been painted for a church in Paris.

Collection of Thomas Emmerson by 1854; collection of Thomas Baring; bequeathed to the Earl of Northbrook, 1873; bought with other pictures from the Northbrook collection, 1894.

Davies 1968, pp. 107–9; Bomford 1977a, pp. 49–56; Hand and Wolff 1986, pp. 169–76; Sterling 1990, II, pp. 258–85.

NG 1419, reverse **NG 4681**, reverse

MASTER of SAINT GILES
The Mass of Saint Giles
about 1500

NG 4681
Oil and egg (identified) on oak, painted surface
61.6 x 45.7 cm

Inscribed on a paper held by an angel: Egidi me/rito re/missa sunt / peccata / karolo. (By the merit of Giles, sins are remitted for Charles). Inscribed on the retable: SANCTV/S DEVS / DOMINV / SABAOTH (Holy, Lord God of Saboath); and on the reliquary at the foot of the cross: de crv / ce d[omi]ni (From the Cross of Our Lord); and on the statue: [SANC]IVS LVDOVICVS. REX. (Saint Louis the King).

According to *The Golden Legend*, King Charles Martel (kneeling left) could not bring himself to confess a sin. He asked Saint Giles to pray for him. While Giles was celebrating Mass, an angel appeared above the altar with a paper on which was written the king's sin and his pardon, dependent on his repentance. The miracle is said to have taken place in Orléans in 719, but has been represented here as occurring before the high altar of the abbey church of St-Denis near Paris. Many of the objects shown (e.g. the gold altarpiece) can be proved to have existed in the church. On the reverse of the panel is a grisaille showing Saint Peter in a niche (see below); it may the work of an assistant of the master.

NG 4681 comes from the same series as NG 1419 (see further under NG 1419).

NG 4681 is the only extant representation of the abbey church of St-Denis as it was in about 1500.

Duc de Tallard collection by 1752; collection of Richard Cosway by 1791; collection of the Earl of Dudley by 1831; by descent until sold in 1892; presented by the NACF, 1933.

Davies 1968, pp. 109–13; Bomford 1977a, pp. 49–56; Dunkerton 1991, pp. 27–8.

MASTER of SAINT GILES

active about 1500

The Master of Saint Giles is named from the two paintings in the National Gallery. He appears to have had a Netherlandish training and to have worked in Paris, views of which appear in some of his paintings.

MASTER of SAINT VERONICA
Saint Veronica with the Sudarium
about 1420

MASTER of the STORY of GRISELDA
The Story of Patient Griselda, Part I
probably about 1493–1500

MASTER of the STORY of GRISELDA
The Story of Patient Griselda, Part II
probably about 1493–1500

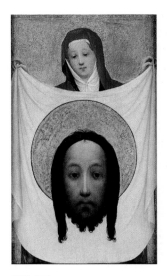

NG 687
Oil on walnut, 44.2 x 33.7 cm

NG 912
Tempera and oil on wood, painted surface
61.6 x 154.3 cm

NG 913
Tempera and oil on wood, painted surface
61.6 x 154.3 cm

Punched on Veronica's halo: sancta. veronica; and on Christ's halo: ihs.xps.ihs.x (an abbreviation of Iesus Christus).

Saint Veronica (whose name *vera icon* means true image) wiped Christ's face with her veil while he was carrying the cross to Calvary, and an impression of his features was miraculously transferred to the cloth, or *sudarium*.

NG 687 is similar in style to the painting in Munich (see biography) which gives the artist his name. They are both datable to about 1420. Cleaning has suggested that NG 687 is comparable in quality to the Munich picture, and therefore by the artist himself. It is said to have been in the church of St Lawrence, Cologne, in the early nineteenth century. The church was demolished in 1817.

Bought at the Weyer sale, 1862.

Levey 1959, pp. 95–6; Dunkerton 1991, p. 242.

NG 912, 913 and 914 illustrate the last story in Boccaccio's *Decameron* (10:10). The Marquis Gualtieri di Saluzzo goes stag-hunting (left background); and he decides to marry a poor girl whom he had seen in the neighbourhood (here carrying water in the left foreground). The Marquis goes to her father's house (right background) and announces that he will marry Griselda on the condition of her absolute obedience. He leads her away (right middle ground), and orders her in front of all his courtiers to exchange her old clothes for rich ones. Originally she was shown naked (as in the story) before the various attendants, but drapery has been added at a later date. The Marquis marries Griselda (centre) in front of a triumphal arch.

The story of Patient Griselda was an appropriate subject with which to commemorate a wedding, and these panels were probably intended to be part of a piece of domestic furniture, or to be set into the wainscoting of a bedchamber. It has been suggested that they may have been commissioned in about 1493 to decorate a room in the Palazzo Spannocchi, Siena; the costumes have been said to make a date of about 1500 likely.

Collection of Alexander Barker by about 1854; bought, 1874.

Davies 1961, pp. 365–7; Tátrai 1979, pp. 50–66.

NG 921, 913 and 914 illustrate the last story in Boccaccio's *Decameron* (10: 10). Several years after their marriage the Marquis decides to put his wife's obedience to the test by having her give first her daughter and then her son to a servant. She wrongly believes that the Marquis has ordered them to be put to death (left background, in three episodes). Underneath a loggia (centre) the Marquis pretends to receive papal permission to dissolve the marriage; he then instructs her to return to her father's house; Griselda returns her ring, and strips off her rich clothes. She leaves to the right, to return to her father's house (right background).

See under NG 912 for further discussion.

Collection of Alexander Barker by about 1854; bought, 1874.

Davies 1961, pp. 366–7; Tátrai 1979, pp. 50–66.

MASTER of SAINT VERONICA
active early 15th century

The artist is named after the *Saint Veronica with the Sudarium* (Munich, Alte Pinakothek), which comes from the church of St Severin, Cologne. Other paintings have been grouped under the name of this painter, who presumably worked in Cologne.

MASTER of the STORY of GRISELDA
active about 1490–1500

This master is named after NG 912–14. He seems to have worked in Siena, and shows the influence of both Signorelli and Pintoricchio. Secular decorative panels have been attributed to him.

MASTER of the STORY of GRISELDA
The Story of Patient Griselda, Part III
probably about 1493–1500

NG 914
Tempera and oil on wood, painted surface
61.6 x 154.3 cm

NG 912, 913 and 914 illustrate the last story of
Boccaccio's *Decameron* (10: 10). The Marquis goes to
find Griselda at her father's house (right
background), and instructs her to prepare his house
for the arrival of his new bride. Griselda obeys and
is seen sweeping in the left background. The
supposed bride's cortège (in fact Griselda's
daughter and son who had been brought up in
Bologna) is seen beyond the loggia, and welcomed
by Griselda. The Marquis finally reveals to Griselda
that the whole story has been a test of obedience
(left foreground) 'to show you how to be a wife',
and he reunites her with her children and restores
Griselda to her position and to her home.
 See under NG 912 for further discussion.

*Collection of Alexander Barker by about 1854; bought,
1874.*

Davies 1961, pp. 366–7; Tátrai 1979, pp. 50–66.

MASTER of the VIEW of SAINTE GUDULE
Portrait of a Young Man
about 1480

NG 2612
Oil on oak, 22.5 x 14.3 cm

The sitter holds a heart-shaped book. An inkpot and
pencase rest on the ledge in front of him. In the
background are the portal and rose window of the
south transept of Notre Dame du Sablon, Brussels.
 NG 2612 may have formed the right wing of a
diptych. The costume suggests a date of about 1480.
 A closely related portrait, although with a
different background, is in the Metropolitan
Museum of Art, New York.

*Horace Walpole's collection, Strawberry Hill, by 1784;
Salting Bequest, 1910.*

Davies 1954, pp. 202–7; Davies 1968, pp. 113–15.

Workshop of the MASTER of 1518
The Visitation of the Virgin to Saint Elizabeth
about 1515

NG 1082
Oil on oak, 80 x 69.5 cm

After the Annunciation of Christ's birth, the Virgin
Mary visited her cousin Saint Elizabeth, who was
expecting the birth of Saint John the Baptist. In the
background at the right is a figure who could be
either Saint Zacharias or Saint Joseph. New
Testament (Luke 1: 36–56).
 NG 1082 came from the same altarpiece as NG
1084. It has been suggested that two further panels
from the ensemble can be identified: an *Adoration of
the Kings*, now in Honolulu, and a *Christ among the
Doctors* (Antwerp, Museum Mayer van der Bergh).
On grounds of style the altarpiece is dated to about
1515.

*Said to have been in the Noble sale with NG 1084,
Christie's, 7 April 1796; collection of Karl Aders,
London, by 1817; bequeathed by Mrs Joseph H. Green,
1880.*

Davies 1968, pp. 98–9.

MASTER of the VIEW of SAINTE GUDULE
active later 15th century

This artist is named after a painting with a view
of the façade of the church of Ste Gudule,
Brussels (Paris, Louvre). He was probably active
in Brussels, and the style of his work appears to
be a debased imitation of that of Rogier van der
Weyden. None of his pictures is dated, but the
costumes in them suggest that he painted during
the period 1470–90.

MASTER of 1518
active early 16th century

This artist takes his name from an altarpiece of
1518 in the church of St Mary, Lübeck. A large
group of works produced in or near Antwerp in
the early sixteenth century have been linked with
him. Some of the compositions were repeated by
Pieter Coecke van Aalst, and the master has
therefore sometimes been identified as van Aalst's
father-in-law, Jan van Dornicke.

Workshop of the MASTER of 1518
The Flight into Egypt
about 1515

Workshop of the MASTER of 1518
The Crucifixion
about 1518

Henri MATISSE
Portrait of Greta Moll
1908

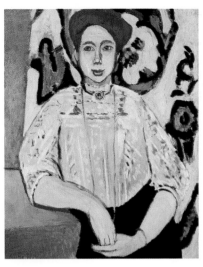

NG 1084
Oil on oak, 80 x 69.5 cm

NG 718
Oil on oak, 94.6 x 67.3 cm

NG 6450
Oil on canvas, 93 x 73.5 cm

The Virgin suckles the Christ Child as Saint Joseph leads her donkey towards the town in the distance. In the background are the Miracles of the Corn and the Statue – two legends associated with the Flight into Egypt – and the Massacre of the Innocents.

NG 1084 came from the same altarpiece as NG 1082. For further discussion see under NG 1082.

Said to have been in the Noble sale with NG 1082, Christie's, 7 April 1796; collection of Karl Aders, London, by 1817; bequeathed by Mrs Joseph H. Green, 1880.

Davies 1968, pp. 98–9.

A label on the top of the cross is inscribed: .I.N.R.I.

Angels collect blood in chalices from the wounds of Christ. The Magdalen embraces the foot of the Cross. To the left stand the Virgin and Saint John; to the right, Longinus and another soldier. The skull and bone in the foreground indicate that the site is Golgotha.

The style of NG 718 is close to that of NG 1082 and 1084.

Bought from Johann Georg Günther of Augsburg by Prince Ludwig Kraft Ernst von Oettingen-Wallerstein, 1814; acquired by the Prince Consort, 1851; presented by Queen Victoria at the Prince Consort's wish, 1863.

Davies 1968, p. 98.

Signed and dated bottom left: Henri Matisse 1908

Greta Moll was born in Mulhouse in 1884. She was a sculptress and painter and, like her husband, the painter Oskar Moll, a pupil of Matisse. Both were early collectors of his work.

In her account of how NG 6450 was executed, Greta recalled that she had to sit ten times for the artist early in 1908.

The flowered cotton print against which the sitter is placed reappears in a number of works of these years, including *Harmony in Red* (St Petersburg, Hermitage).

Possession of the sitter; private collection, Texas; private collection, Switzerland; bought from the Lefevre Gallery, 1979.

National Gallery Report 1978–9, pp. 32–3; Fourcade 1993, p. 240, no. 59.

Henri MATISSE
1869–1954

Born in Cateau-Cambrésis, Matisse trained first as a lawyer. He took up painting in 1890, studying under Gustave Moreau at the Ecole des Beaux-Arts from 1895 to 1897, and at the Académie Carrière (where he met Derain). He worked in the south of France from 1904, and after 1914 on the Riviera. His later works include a number of designs in cut-and-pasted paper and several mural decorations.

MATTEO di Giovanni
The Assumption of the Virgin
probably 1474

MATTEO di Giovanni
Christ Crowned with Thorns
1480–95

MATTEO di Giovanni
Saint Sebastian
probably 1480–95

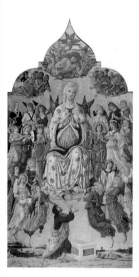

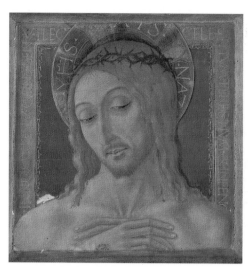

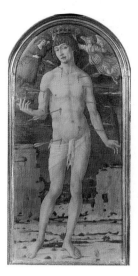

NG 1155
Tempera on wood, 331.5 x 174 cm

NG 247
Tempera on wood, painted surface 21.6 x 21.6 cm

NG 1461
Tempera on wood, painted surface 126.4 x 59.7 cm

Inscribed on the Virgin's halo: REGINA. CELI. LETARE (Rejoice, Queen of Heaven).

The Assumption of the Virgin does not occur in the Bible, but is described in various early medieval sources, including *The Golden Legend*. As the Virgin rises up to Heaven, surrounded by music-making angels, her girdle falls from her waist and Saint Thomas, the disciple who doubted that Christ had risen from the dead, catches it. Christ, accompanied by prophets and ancestors, among them David and John the Baptist, welcomes his mother.

In 1863 NG 1155 was said to have been dated 1474 and to have been the central panel of an altarpiece in S. Agostino, Asciano, near Siena. It was discovered in the wood store of the monastery of S. Agostino at Asciano in 1800. Side panels representing Saint Michael and Saint Augustine survive in Asciano (both these panels were apparently from the left-hand side of the polyptych, which may also have comprised a second tier containing the Annunciation and other saints).

S. Agostino, Asciano, 1800; bought, 1884.

Davies 1961, p. 370.

Inscribed on the halo: .YHS. / XPS. / .NAZA. (Jesus Christ of Nazareth); and around the edge: .IN NOMINE. IHV . OMNE . GEN/V. FLECT CELES/TIVM. TERESTIVM & INFENO. (That at the name of Jesus every knee should bow, of things in heaven, and things in earth, and things under the earth).

The inscription around the edge is from the New Testament (Philippians, 2: 10). Christ is shown after (or during) the Mocking of Christ when he was crowned with thorns. New Testament (all the Gospels, e.g. John 19: 1–3).

Collection of E. Joly de Bammeville by 1854; bought 1854.

Davies 1961, p. 371.

Sebastian was a third-century Roman centurion, who was discovered to be a Christian and was sentenced to death by Diocletian. He was bound to a stake (often represented as a tree, but here excluded entirely) and shot with arrows. The arrows did not kill him, however, and he was eventually stoned to death. The story is taken from *The Golden Legend*. In NG 1461 Sebastian is shown holding a martyr's palm and a crown; another crown is held above his head by two angels.

NG 1461 was presumably a private devotional picture. It appears not to have been part of any kind of polyptych, and is probably a complete picture.

Bought, 1895.

Davies 1961, pp. 370–1.

MATTEO di Giovanni
active 1452; died 1495

Probably born in Sansepolcro, Matteo di Giovanni was in Siena in partnership with Giovanni di Pietro in 1452 and still there in 1457. He may have trained with Domenico di Bartolo, and was later active in Sansepolcro and the area between there and Siena.

Juan Bautista Martinez del MAZO
Queen Mariana of Spain in Mourning
1666

Attributed to MAZO
Don Adrián Pulido Pareja
after 1647

Attributed to Damiano MAZZA
The Rape of Ganymede
probably about 1570–90

NG 2926
Oil on canvas, 196.8 x 146 cm

NG 1315
Oil on canvas, 203.8 x 114.3 cm

NG 32
Oil on canvas, dimensions of the present rectangle
177 x 186.6 cm

The paper in the queen's hand is inscribed: *Señora /
Juan Bap*(ta?) *de*(l?) *Mazo 1666.* (The signature is
damaged and has been gone over.) At the bottom
left corner there is a second inscription in an
eighteenth(?)-century hand: LA REINA. NᴬS/ Dᴬ
MARIANA. DE. (in monogram)/ AVSTRIA MADRE/ DE. (in
monogram) EL REI. DN. CARLOS II./ Q. DE (in
monogram) DˢGOZA. (Queen Mariana of Austria,
mother of King Carlos II, who is in heaven).
 Queen Mariana of Spain (1634–96) was the
daughter of Emperor Ferdinand III and the Infanta
María. She married her uncle Philip IV of Spain in
1649, and was widowed in 1665, acting as Regent
until 1677. In this portrait she wears the habit of a
nun, the traditional dress of a noblewoman in
mourning. In the background at the left courtiers
attend her son, Charles II, who assumed full
kingship in 1677. The fair-haired woman behind the
boy may be Maribárbola, the dwarf who is also
depicted in Velázquez's *Las Meninas* (Madrid,
Prado). The room has been identified as the Pieza
Ochavada, an octagonal chamber in the Alcázar
(destroyed 1734). The statue of Venus is now in the
Royal Palace in Madrid.
 NG 2926 is one of only two signed works by the
artist. The composition was used as a prototype for
portraits of the queen in mourning painted in the
studio of Juan Carreño (1614–85).

*In the collection of the Earl of Carlisle by 1848; presented
by Rosalind, the Countess of Carlisle, 1913.*

MacLaren/Braham 1970, pp. 52–4.

Inscribed later, at the left: Did. Velasq.ᶻ Philip. IV.
acubiculo./eiusq.ᶻ pictor. 1639 (Diego Velázquez,
gentleman of the bedchamber and painter of Philip
IV 1639); and at the bottom: ADRIAN/PVLIDO-PAREJA
(Adrián Pulido Pareja).
 Don Adrián Pulido Pareja (1606–60) was captain
general of the Spanish forces in the New World. In
1647 he was made a knight of the Order of Santiago.
In this portrait he wears the badge of the Order on a
ribbon around his neck and holds a commander's
baton in his right hand.
 NG 1315 was once attributed to Velázquez, who
according to Palomino painted a portrait of Pareja
in 1639 with a similar inscription. But the signature
is false and the painting is now considered to be by
Mazo, although no signed or documented painting
by him is directly comparable. NG 1315 may be
either a copy of the now-lost Velázquez portrait, or
a work wrongly attributed by Palomino. The latter
seems more likely, and a date of execution shortly
after 1647 is suggested by the badge of the Order of
Santiago.

*Probably seen by Palomino in the collection of the Duke
of Arcos before 1724; bought from the 5th Earl of Radnor,
with the aid of gifts from Charles Cotes, Lord Iveagh and
Lord Rothschild, 1890.*

MacLaren/Braham 1970, pp. 54–8.

While guarding his father's flock near Troy the
beautiful shepherd boy Ganymede was taken by
Zeus, in the guise of an eagle, to Mount Olympus,
where he served as cup bearer to the gods.
 NG 32 is probably the ceiling painting of this
subject described by Ridolfi in 1648 as the work of
Damiano Mazza and as formerly at Casa Assonica,
Padua. It was subsequently described (and
engraved) as the work of Titian, but Ridolfi's
attribution is probably correct. The canvas was
originally an octagon but has been enlarged to a
rectangle.

*Probably once in a pavilion at the Casa Assonica, Padua;
recorded in the collection of Duca Iacopo di Lorenzo
Salviati, Rome, 1668 (and previously described there in
1664); Palazzo Colonna, Rome, by 1783; in the
possession of Alexander Day, London, 1800–1; bought by
J.J. Angerstein, 1801; bought with the J.J. Angerstein
collection, 1824.*

Gould 1975, pp. 139–40.

Juan Bautista Martinez del MAZO
about 1612/16–1667

Mazo was probably born at Beteta in the diocese
of Cuenca, Spain. He is the most important pupil
of Velázquez, whose style he adopted and whose
daughter he married in 1633. The artist principally
painted in Madrid, becoming painter to Prince
Baltasar Carlos. He visited Naples in 1657 and in
1661 was appointed Painter to the Royal Chamber.

Damiano MAZZA
active 1573

Mazza was apparently born in Padua. He was
active there and in Venice. In 1573 he provided an
altarpiece for the church at Noale in the Veneto,
the style of which confirms the later statements
that he was a follower of Titian.

Filippo MAZZOLA
The Virgin and Child with Saint Jerome and the
Blessed Bernardino da Feltre, after 1494–1505

Lodovico MAZZOLINO
The Nativity
probably 1504–10

Lodovico MAZZOLINO
The Holy Family with Saint Nicholas of Tolentino
probably about 1515–30

NG 1416
Oil on wood, 55.9 x 74.3 cm

NG 3114
Oil on wood, 39.4 x 34.3 cm

NG 169
Oil on wood, 80.6 x 62.2 cm

Signed bottom centre: .PHILIPPVS.MAZOL(L?)A.
P. P.

The Virgin is seated with the Christ Child upon
her lap behind a parapet; at the left is Saint Jerome.
Bernardino da Feltre (1439–94), who was not
formally beatified until 1653, was responsible for
the establishment and development of the Monte di
Pietà (an institution for monetary loans) in many
North Italian towns. He is shown at the right
holding a staff, a book and a model of the Holy
Sepulchre with Christ in the tomb against a cross
inscribed INRI.

NG 1416 can probably be dated to between 1494
(the date of Bernardino's death) and 1505 when
Mazzola died.

Bought (Lewis Fund), 1894.

Davies 1961, pp. 372–3.

The Virgin Mary is seen at prayer over her new-
born son outside the stable where he was born.
Saint Joseph is on the right; a shepherd is on the left.
New Testament (Luke 2: 6–16).

NG 3114 has been compared with a triptych of
1509 that has been attributed to Mazzolino (Berlin,
Gemäldegalerie).

Costabili collection, Ferrara, by 1838; Sir A.H. Layard
collection by 1869; Layard Bequest, 1916.

Gould 1975, p. 143.

A picture of the Holy Family is combined with a
representation of the Trinity: the Father, Son and
Holy Ghost (traditionally represented as a dove).
In the left foreground is Saint Nicholas of Tolentino
(about 1245–1305) in the habit of the Augustinian
Order (Saint Augustine was particularly devoted to
the Trinity).

Said to be from the Lercari Palace, Genoa, before 1807;
bought, 1839.

Gould 1975, pp. 141–2.

Filippo MAZZOLA
active 1490; died 1505

Mazzola worked in Parma. He may have been a
pupil of Francesco Tacconi and, in terms of the
style of his works, he particularly imitated the
work of Giovanni Bellini. His son was
Parmigianino.

Lodovico MAZZOLINO
active 1504–about 1528/30

Ludovico Mazzolino, son of the painter Giovanni,
was documented as Ferrarese but may have
studied in Bologna, perhaps with Lorenzo Costa,
whose influence is seen in his works. Mazzolino
specialised in small-scale religious paintings, but
his work for the Este family in Ferrara also
included frescoes. In 1524 he was working in
Bologna.

Lodovico MAZZOLINO
Christ disputing with the Doctors
probably about 1520–5

Lodovico MAZZOLINO
The Holy Family with Saint Francis
probably about 1520–9

Lodovico MAZZOLINO
Christ and the Woman taken in Adultery
probably 1522

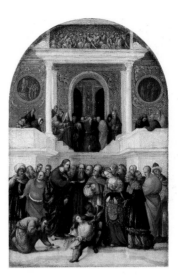

NG 1495
Oil on wood, 31.1 x 22.2 cm

NG 82
Oil on wood, 53 x 39.4 cm

NG 641
Oil on wood, 46 x 30.8 cm

The Hebrew inscription is said to read: The House which Solomon built unto the Lord.

Unknown to his parents, the twelve-year-old Christ remained behind in Jerusalem after they had left and disputed with the Doctors in the Temple, who were amazed by his understanding of the Scriptures. New Testament (Luke 2: 41–8).

Mazzolino painted this subject several times (e.g. Rome, Capitoline collection). NG 1495 is closely related to an altarpiece, completed for a church in Bologna in 1524 and now in Berlin. It might be the version painted for Sigismondo d'Este in January 1520. Drawings of the subject by Mazzolino are also known.

The Hebrew inscription is probably intended to recall the temple in Jerusalem where this event took place.

Said to have come from the Bardini collection, Florence; bought, 1897.

Gould 1975, pp. 142–3.

The Holy Family shown with the infant Saint John the Baptist (identified by his traditional attribute of a lamb) and his mother Saint Elizabeth. They are accompanied by Saint Francis of Assisi (about 1181–1226, founder of the Franciscan Order). The monkey probably symbolises evil, and takes fright at the lamb, a symbol of the Passion.

NG 82 is a typical small work by Mazzolino.

Said to be from the Gentile collection, Genoa, 1809; Holwell Carr Bequest, 1831.

Gould 1975, p. 141.

Dated on the step on the right: 15XXII (1522).

The Pharisees and Scribes brought an adulterous woman before Christ in the temple in order to test him. They asked whether he thought she should be stoned. Christ rose from writing on the ground, and replied: 'He that is without sin among you, let him first cast a stone at her.' New Testament (John 8: 2–9). This episode is located in the temple of Jerusalem which is decorated by a relief showing Moses giving the Ten Commandments, to one of which the woman's accusers appealed.

The date on NG 641 is worn, but is probably of 1522. The later provenance in the Aldobrandini collection may suggest that the picture was once in the Este collections in Ferrara; Mazzolino worked for the Este on numerous occasions.

Aldobrandini collection, Rome, by 1603; bought, 1860.

Gould 1975, p. 142.

Jean-Louis-Ernest MEISSONIER
A Man in Black smoking a Pipe
1854

NG 6468
Oil on oak, 32.4 x 23.5 cm

Signed and dated bottom right: J Meissonier 1854.
 Meissonier painted numerous genre scenes with individuals in period costume. NG 6468 is a typical example with the smoker shown in a modest interior with a tankard and a glass of beer. The wall behind is decorated with some unframed popular prints.

Collection of Rudolph Ernst Brandt; presented by Mrs Alice Bleecker, 1981.

National Gallery Report 1980–1, pp. 44–5; Hungerford 1993, p. 113, no. 31.

Luis MELENDEZ
Still Life with Oranges and Walnuts
1772

NG 6505
Oil on canvas, 61 x 81.3 cm

Inscribed on a box-end: L E M D ANO 1772.
 The arrangement includes chestnuts, walnuts, oranges, a melon, two earthenware jugs with paper covers, a small wooden barrel, and some circular and oblong boxes. The jugs may contain oil, wine or water, while the barrel possibly has olives in it. The oblong boxes probably hold *dulce de membrillo*, a quince jelly which is still eaten in Spain.
 NG 6505 is an example of the larger type of still life painted by the artist. It can be associated with three other works of identical size (two, Boston, Museum of Fine Arts; one, private collection). Of these pictures only this one is dated.

Private collection, Lausanne; bought, 1986.

National Gallery Report 1985–7, pp. 24–5; Helston 1989, pp. 82–3.

Altobello MELONE
The Walk to Emmaus
about 1516–20

NG 753
Oil (identified) on wood, 145.4 x 144.1 cm

On the day after Christ's tomb had been found empty he appeared to two disciples, but they remained unaware of his true identity until they invited him to dine with them in the village of Emmaus, when he broke bread as he had at the Last Supper. New Testament (Luke 24: 13–35). Here he is depicted as a pilgrim with a hat, staff and shell, encountering them on the road. In the background he appears again, this time between the disciples, approaching the village.
 The style of NG 753 accords with that of the frescoes in Cremona by the artist (see biography).

Carmelite church of S. Bartolomeo, Cremona, by 1627; Gioseppe Aglio (1794) states that when the church was suppressed the painting entered the Fraganechi collection, Villa Rocca, Cremona; a label on the back bears this family name; seen by Otto Mündler in the possession of Conte Castelbarco, Milan, 1856; from whom bought, 1864.

Gould 1975, pp. 144–5.

Jean-Louis-Ernest MEISSONIER
1815–1891

Meissonier was born in Lyon. He trained under Jules Potier and Cogniet, and exhibited his paintings at the Salon in Paris from 1834. He was widely admired as a painter and in 1889 was the first artist to receive the Grand Croix de la Légion d'Honneur. He is mainly known for his pastiches of Dutch seventeenth-century genre paintings and for his military scenes, often depicting Napoleonic subjects.

Luis MELENDEZ
1716–1780

Luis Egidio Meléndez de Rivera Durazo y Santo Padre was born in Naples and moved with his family in 1717 to Madrid. In 1748 he was expelled from the new Real Academia there. Luis then travelled back to Italy. He twice requested to become a court painter, but died in poverty in Madrid. The still lifes for which he is most famous date from the late 1750s onwards.

Altobello MELONE
active from 1516; died before 1543

'Altobellus de Melonibus' signed a fresco of the *Flight into Egypt* in Cremona Cathedral which is dated 1517. He is recorded as a pupil of Romanino and was obviously much influenced by him, and also, to a lesser extent, by Boccaccio Boccaccino.

Altobello MELONE
Christ carrying the Cross
about 1520–5

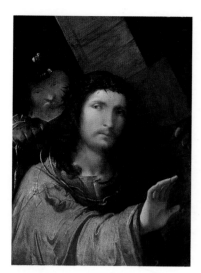

NG 6546
Oil on poplar, 49 x 63.5 cm

Christ is depicted turning, as if to his mother or to Saint Veronica, on his way to Calvary. The faces of two soldiers are also included in the composition.

NG 6546 is exceptionally well preserved and probably dates from the early 1520s.

Sold by Mrs S. Isepp, Sotheby's, 26 June 1957; Mr and Mrs Philip Pouncey; bought from Mrs Pouncey, 1993.

National Gallery Report 1993–4, pp. 14–15.

Hans MEMLINC
The Virgin and Child with an Angel, Saint George and a Donor, about 1470–80

NG 686
Oil on oak, painted surface 54 x 37.5 cm

The unidentified donor kneels on the right of the Virgin and Child. He is accompanied by Saint George, the legendary third-century Cappadocian knight who rescued a princess by slaying a dragon, here shown at his feet.

The group of the Virgin and Child often appears, with slight variations, in Memlinc's work (e.g. NG 6275.1 where the action of the child is similar).

Collection of Christian Geerling, Cologne, by 1847; bought, Cologne, 1862.

Davies 1954, pp. 157–61; Davies 1968, pp. 128–9; Dunkerton 1991, p. 70.

Hans MEMLINC
Saints John the Baptist and Lawrence
probably about 1475

NG 747
Oil on oak, each panel 57.2 x 17.1 cm

Saint John the Baptist (left) holds a lamb, a reference to his New Testament identification of Christ as the Lamb of God (John 1: 29, 36). Saint Lawrence (right), a third-century deacon of the church, is shown with the gridiron on which he was martyred by being roasted.

On the reverse of each panel is a landscape and four cranes. On the reverse of the Saint John the Baptist panel there is also the coat of arms of the Florentine family of Pagagnotti. The panels are wings of a folding triptych; the centre panel is the *Virgin and Child with Angels* in the Uffizi, Florence. Painted for a Florentine patron, the triptych was in Florence by about 1480 and the landscapes were copied by several Florentine painters.

Bought from Emmanuel Sano, Paris, 1865.

Davies 1954, pp. 166–9; Davies 1968, p. 124; Rohlmann 1993, pp. 237, 244–5.

NG 747, reverses

Hans MEMLINC
active 1465; died 1494

Born at Seligenstadt (near Frankfurt-am-Main), Memlinc was active in Bruges from 1465 to 1494. Profoundly influenced by Rogier van der Weyden, he was the leading painter in Bruges, with a large workshop and patrons in Italy as well as in the Netherlands.

Hans MEMLINC
A Young Man at Prayer
probably about 1475

Hans MEMLINC
*The Virgin and Child with Saints and Donors
(The Donne Triptych),* probably about 1475

Hans MEMLINC
Saint John the Baptist
probably about 1475

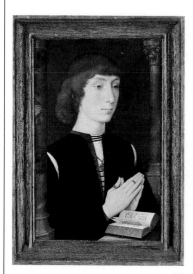

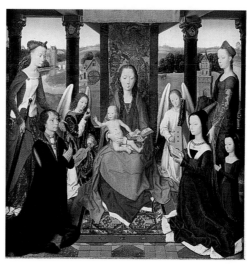

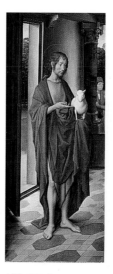

NG 2594
Oil on oak, painted surface 38.7 x 25.4 cm

NG 6275.1
Oil on oak, central panel 70.7 x 70.5 cm

NG 6275.2
Oil on oak, painted surface 71.1 x 30 cm

The man has not been identified.

NG 2594 was probably the left wing of a diptych or triptych commissioned for domestic devotional use. The Virgin and Child may have appeared in another panel. A date of about 1475 has been suggested.

The frame may be original.

Collection of Eugen Felix by 1889; acquired by George Salting, 1900; Salting Bequest, 1910.

Davies 1954, pp. 170–2; Davies 1968, p. 124; Dunkerton 1991, p. 103.

Sir John Donne of Kidwelly (died 1503) is presented to the Virgin and Child by Saint Catherine, who is shown with her attributes – the sword with which she was decapitated and the wheel on which she was tortured. Elizabeth, Lady Donne (right), and her daughter (thought to be Anne, probably born about 1470) are presented by Saint Barbara, who holds the tower in which she was confined. Sir John and Lady Donne wear Yorkist collars of roses and suns, with King Edward IV's pendant, the Lion of March. They are identified by their coats of arms.

NG 6275.1 is the central panel of a triptych, of which NG 6275.2 and 6275.3 are the wings. Sir John Donne was occasionally in the Netherlands and often in Calais, and could have commissioned the triptych from Memlinc at various times.

Collection of the 3rd Earl of Burlington, Chiswick, by about 1744 (probably by descent from Sir John Donne); acquired from the Duke of Devonshire (a descendant of the Earl of Burlington), 1957.

Davies 1968, pp. 125–8; Davies 1970, pp. 38–51; Dunkerton 1991, p. 320.

Saint John the Baptist is holding the Lamb of God. The figure in the background is often identified as Memlinc's self portrait. Saint Christopher carrying the Christ Child is painted in grisaille on the reverse of the panel.

NG 6275.2 was the left wing of a triptych of which NG 6275.1 was the central part. It is discussed under NG 6275.1.

Collection of the 3rd Earl of Burlington, Chiswick, by about 1744 (probably by descent from Sir John Donne); acquired from the Duke of Devonshire (a descendant of the Earl of Burlington), 1957.

Davies 1968, pp. 125–8; Davies 1970, pp. 38–51; Dunkerton 1991, p. 320.

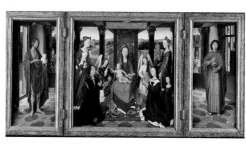

NG 6275.1-3

Hans MEMLINC
Saint John the Evangelist
probably about 1475

NG 6275.3
Oil on oak, painted surface 71 x 30.5 cm

Saint John the Evangelist is seen casting the poison (in the form of a snake) out of a cup that he has been given to drink. Saint Anthony Abbot is painted in grisaille on the reverse of the panel.

NG 6275.3 was the right wing of a triptych of which NG 6275.1 was the central part. It is discussed under NG 6275.1.

Collection of the 3rd Earl of Burlington, Chiswick, by about 1744 (probably by descent from Sir John Donne); acquired from the Duke of Devonshire (a descendant of the Earl of Burlington), 1957.

Davies 1968, pp. 125–8; Davies 1970, pp. 38–51; Dunkerton 1991, p. 320.

NG **6275.2**, reverse NG **6275.3**, reverse

Hans MEMLINC
The Virgin and Child
about 1480

NG 709
Oil on oak, painted surface 37.5 x 27.9 cm

The Virgin and Child are very similar – although on a larger scale – to the same figures in the Donne Triptych (NG 6275). Varying opinions have been expressed over the extent of Memlinc's participation in NG 709; he may have contributed to the execution as well as being responsible for the original figure composition. The painting was probably intended as a private devotional picture.

Jean Baptiste de Vichy, Graf von Vichy (born 1758); acquired by Prince Ludwig Kraft Ernst von Oettingen-Wallerstein, Munich, 1817; acquired by the Prince Consort, 1851; presented by Queen Victoria at the Prince Consort's wish, 1863.

Davies 1954, pp. 162–6; Davies 1968, pp. 129–30; Dunkerton 1991, pp. 72, 74.

Philippe MERCIER
Portrait of a Man
1740

NG 4036
Oil on canvas, 81.3 x 65.4 cm

Dated 1740, and apparently signed: . . .erc. ..

It has been suggested that the sitter is Dr Richard Mead, the famous physician and collector. This identification has not been verified.

The date of NG 4036 would suggest that the picture was painted in Britain and the sitter is likely to be British.

Sir Claude Phillips Bequest, 1924.

Davies 1957, p. 155.

Philippe MERCIER
1689–1760

Mercier was born in Berlin, where he was a pupil of Antoine Pesne. He was influenced by Watteau. He seems to have settled in London sometime before 1720, and from 1739 was in Yorkshire. He returned to London in 1751. Numerous portraits by him exist.

Gabriel METSU
Two Men with a Sleeping Woman
about 1655–60

NG 970
Oil on oak, 37.1 x 32.4 cm

Signed on the slate on the table: G M(et?)(..).

An inn-keeper's slate, playing cards and a pipe are among the objects on the table. The setting is probably a tavern and the woman (probably the inn-keeper's wife or a serving maid) has been drinking and smoking.

Female drunkenness was a subject of amusement and of moral admonition in seventeenth-century Dutch genre painting.

Probably in the collection of the Greffiers Fagel by 1752; in the collection of Wynn Ellis by 1851; Wynn Ellis Bequest, 1876.

MacLaren/Brown 1991, pp. 256–7.

Gabriel METSU
A Young Woman seated drawing
about 1655–60

NG 5225
Oil on oak, 36.3 x 30.7 cm

On the table beneath the bust of a woman (which is being sketched by the seated woman) is part of the engraving of *Christ at the Column before the Flagellation* by Lucas Vorsterman after a painting by Gerard Seghers (Ghent, St Michael's).

NG 5225 was probably painted in the late 1650s. The same engraving and bust appear in Metsu's *Self Portrait standing at a Window* (London, Royal Collection) and the bust appears on its own in *The Letter Writer* (London, Wallace Collection) and *The Artist painting a Woman playing a Cello* (private collection).

Collection of Petronella de La Court by 1707; collection of Alexander Baring (later 1st Baron Ashburton) by 1833; collection of Alfred Charles de Rothschild by 1918; collection of the 1st Viscount Rothermere by 1932; by whom presented, 1940.

MacLaren/Brown 1991, pp. 259–61.

Gabriel METSU
The Interior of a Smithy
about 1657

NG 2591
Oil on canvas, 65.4 x 73.3 cm

Signed on the window frame on the right: GMetsu (GM in monogram).

NG 2591 meticulously depicts the tools of the blacksmith's trade.

There was a tradition in Dutch painting of depicting trades and occupations. Brekelenkam, Quast and Wouwermans all painted such scenes, and Metsu painted several pictures of smithies in the early 1650s. NG 2591 seems to be in a more developed style and was probably painted in about 1657.

Abraham Delfos et al. sale, The Hague, 1807; bought by George Salting, 1886; Salting Bequest, 1910.

MacLaren/Brown 1991, pp. 258–9.

Gabriel METSU
1629–1667

Metsu was born in Leiden, where he worked until about 1657 when he settled in Amsterdam. He was probably a pupil of Gerrit Dou but his early works show little relationship to Dou's style. Metsu was an eclectic artist, principally painting genre and religious scenes but also portraits and still lifes.

Gabriel METSU

A Woman seated at a Table and a Man tuning a Violin, about 1658

NG 838
Oil on canvas, 43 x 37.5 cm

Signed below the window: G. Metsu
The woman holds a sheet of music; a viola da gamba is on the table. A carved figure of Atlas is beside the fireplace.
NG 838 has been dated to about 1658 on the basis of comparison with an interior of 1658 by ter Borch (Schwerin, Staatliches Museum) by which it is clearly influenced. The picture was engraved in 1771 when in the Choiseul collection.

Collection of the Duc de Choiseul by 1771; collection of Prince de Talleyrand, Paris, by 1814; brought to England by William Buchanan; collection of Sir Robert Peel, Bt, by 1833 (and possibly by 1823); bought with the Peel collection, 1871.

MacLaren/Brown 1991, pp. 254–5.

Gabriel METSU

An Old Woman with a Book about 1660

NG 2590
Oil on canvas, 31.6 x 27.3 cm

Signed below in the centre: G. Metsu
The inscription on the paper hanging over the ledge is so damaged as to be illegible, although the initial D beneath the inscription can be made out.
This type of subject is derived from Dou's so-called 'niche' paintings. NG 2590 has been dated to about 1660 on the basis of a comparison with the *Hunter in a Niche* of 1661 (The Hague, Mauritshuis). It has been suggested that NG 2590 was painted as a pair to *The Apothecary* (Paris, Louvre). Both were in the Braamcamp collection, but the dimensions and a description of 1766 make it clear that the pictures were not pendants.

Probably in the collection of Pieter van Lip by 1712; collection of Gerret Braamcamp, Amsterdam, by 1752; collection of the 2nd Baron Ashburton, London, by 1851; Salting Bequest, 1910.

MacLaren/Brown 1991, pp. 257–8.

Gabriel METSU

A Man and a Woman seated by a Virginal about 1665

NG 839
Oil on oak, 38.4 x 32.2 cm

Signed top right: G. Metsu. Inscribed on the lid of the virginal: IN . TE . D[O]MINE . SPERAVI . NON . CONF[UN]DAR . I[N] . AETERNV[M]. (In thee, O Lord, do I put my trust; never let me be put to confusion.) Inscribed on the inside of the keyboard cover: OMNIS . [SPIRITUS LAUDE]T . DOMINVM. (Let every thing that hath breath praise the Lord.)
The inscriptions are from the Old Testament (Psalms 31: 1 or 71: 1 on the lid of the virginal; Psalms 150: 6 on the inside of the keyboard cover); they occur on virginals in other pictures by Metsu (e.g. Rotterdam, Museum Boymans-van Beuningen); the second inscription appears on a virginal of 1620 in the Musée Instrumental du Conservatoire in Brussels. In the left background is a painting of a Twelfth Night feast; Metsu painted this subject in a similar composition (though reversed) in the early 1650s (Munich, Alte Pinakothek). In the centre background is a landscape in the style of Ruisdael.

Collection of Michael Bryan by 1798; collection of Sir Robert Peel, Bt, by 1833 (and possibly by 1823); bought with the Peel collection, 1871.

MacLaren/Brown 1991, pp. 255–6.

Adam-François van der MEULEN
Philippe-François d'Arenberg saluted by the Leader of a Troop of Horsemen, 1662

Attributed to Georges MICHEL
Landscape with Trees, Buildings and a Road
1785–1843

Attributed to Georges MICHEL
Stormy Landscape with Ruins on a Plain
1785–1843

NG 1447
Oil on canvas, 58.5 x 81 cm

NG 2258
Oil on paper mounted on canvas, 44.5 x 68.6 cm

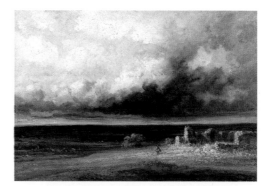

NG 2759
Oil on paper mounted on canvas, 55.6 x 80.6 cm

Signed and dated lower right: A. F. V. MEVLEN . FEC: 1662. BRVXEL.

Philippe-François, 1st Duke of Arenberg and Duke of Arschot and Croy (1625–74), was an important figure at the court of Brussels. He served in the army of the Southern Netherlands and distinguished himself at the Siege of Arras in 1654. He was made captain general of the Flemish fleet in 1660 and governor of Hainault in 1663. He is seen here in his coach, taking the salute from the leader of a troop of horsemen. The outrider wears Arenberg's colours of yellow and red.

Collection of Prince Lothar Franz of Schönborn, Pommersfelden, by 1719; Pommersfelden sale, Paris, 17ff. May 1867 (lot 194); Mrs Lyne Stephens sale, Christie's, 11 May 1895; bought at the sale.

Martin 1970, pp. 95–6.

This work has in the past been entitled 'Woodland Scene'.

NG 2258 imitates the style of Dutch seventeenth-century painters such as van Goyen, but does not seem to be a direct copy.

Bought from A. Foinard, Paris (Lewis Fund), 1908.

Davies 1970, p. 102.

Landscapes of this type, inspired by Dutch seventeenth-century precedents, were often painted by Michel.

Bought from Shepherd Bros by T.W. Bacon, 1909; by whom presented through the NACF, 1910.

Davies 1970, p. 102.

Adam-François van der MEULEN
1632–1690

Van der Meulen was born in Brussels where he was taught by Pieter Snayers. He was active in Brussels until 1664, when he entered the service of Louis XIV of France. A painter of views, travel scenes and battles, van der Meulen designed tapestries for the Gobelins factory and was also a printmaker. He died in Paris.

Georges MICHEL
1763–1843

Michel was born in Paris. He studied briefly as a pupil of Leduc from about 1775, and exhibited paintings at the Salon from 1791 to 1814. He worked principally as a landscape painter, but was also employed as a restorer and copyist. His late landscapes are mainly of the Paris region, in a style derived from seventeenth-century Dutch and Flemish precedents.

MICHELANGELO
The Virgin and Child with Saint John and Angels
('The Manchester Madonna'), probably about 1495

MICHELANGELO
The Entombment
about 1500–1

After MICHELANGELO
Leda and the Swan
after 1530

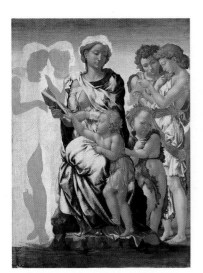

NG 809
Tempera on wood, 104.5 x 77 cm

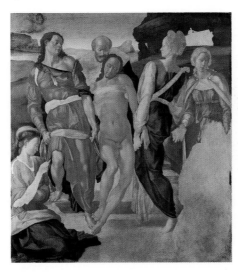

NG 790
Oil (identified) on wood, 161.7 x 149.9 cm

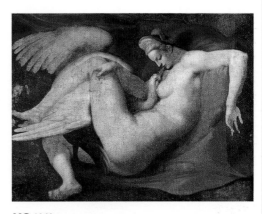

NG 1868
Oil on canvas, 105.4 x 141 cm

Christ indicates a passage in the book held by the Virgin which one pair of angels contemplates. The other angels study a scroll perhaps given to them by the young John the Baptist. Both book and scroll may carry prophecies of Christ's future sacrifice.

NG 809 is unfinished, especially on the left. The picture has been known as 'The Manchester Madonna' since its inclusion in the 1857 exhibition at Manchester. It was attributed to Michelangelo by about 1700, and it is now widely accepted as an autograph – if very early – work by him. The style of the drapery folds, the compositional arrangement and the rock plinth all have parallels in his earliest sculpture.

Almost certainly the picture described at the Villa Borghese, Rome, 1700; collection of Alexander Day by 1833 (and probably from about 1798/9); collection of H. Labouchère, 1849; bought from Labouchère's executors, 1870.

Gould 1975, pp. 148–50; Hirst 1994, pp. 37–46, 83–106.

Christ's dead body is supported by John the Evangelist, Joseph of Arimathea and Nicodemus after he has been taken down from the cross. He is about to be carried up some steps to a tomb visible in the right background. Mary Magdalene, a Holy Woman (Mary Salome) and the outline of the Virgin Mary (on the right) are also shown. New Testament (all Gospels, e.g. John 19: 38–42).

NG 790 is unfinished, and has been connected with payments to Michelangelo for an altarpiece for the church of S. Agostino, Rome. It seems that the altarpiece for which these payments were made in 1500–1 was not delivered and it is therefore probable that Michelangelo did not complete his commission.

Two drawings for NG 790 are known (both Paris, Louvre). One is a rejected idea for the figure of Saint John. The other is for the Mary on the left, and shows her with a crown of thorns and the nails with which Christ had been crucified.

Farnese collection, Rome, by 1649; bought in Rome by Robert Macpherson, 1846; from whom bought, 1868.

Gould 1975, pp. 145–8; Hirst 1981a, pp. 581–93; Hirst 1988, p. 12; Butterfield 1989, pp. 390–3; Hirst 1994, pp. 57–71, 107–27.

In Greek mythology, Leda coupled with Zeus in the form of a swan and conceived her children Castor, Clytemnestra, Helen and Pollux.

NG 1868 is probably an old copy after a painting of this subject by Michelangelo. This was painted (after several preparatory drawings had been made) for Alfonso d'Este, Duke of Ferrara, in about 1529–30, but was not delivered and was given instead – together with a full-size cartoon – to Antonio Mini, who took these gifts to France. They are now lost and the composition is only known through copies, especially an engraving by Cornelis Bos. There is some evidence that Rosso Fiorentino made a copy of Michelangelo's *Leda*, and NG 1868 has sometimes been tentatively identified as Rosso's copy, although the circumstantial evidence is weak and the stylistic evidence inconclusive (and obscured by the damaged condition of NG 1868).

Possibly in the collection of Sir Joshua Reynolds by 1795; presented by the Duke of Northumberland, 1838.

Wilde 1957, pp. 270–80; Gould 1975, pp. 150–2; Hirst 1988, p. 92.

MICHELANGELO
1475–1564

Michelangelo Buonarroti was the greatest sculptor and one of the greatest painters and architects of the sixteenth century in Italy. He trained as a painter with Domenico Ghirlandaio from about 1487, and several panel paintings by him survive. The frescoes of the Sistine Chapel are his most celebrated work. He worked in his native Florence, in Bologna and Siena, but mainly in Rome, where his patrons included seven successive popes.

After MICHELANGELO
The Dream
after 1533

After MICHELANGELO
The Purification of the Temple
after 1550

After MICHELANGELO
The Holy Family (Il Silenzio)
probably about 1560–70

NG 8
Oil on slate, 65.4 x 55.9 cm

NG 1194
Oil on wood, 61 x 40 cm

NG 1227
Oil on wood, 43.2 x 28.6 cm

The scenes in the clouds in the background
represent six of the seven Deadly Sins. The male
nude in the centre is probably the human soul
reawakened by an angelic trumpeter. The masks
below the globe represent worldly illusions and
deceits. No contemporary explanation of the
allegory has survived, but the composition was
described by Vasari in 1568 as *Il Sogno* (*The Dream*).
The picture has been explained as a Neoplatonic
allegory of how the mind is haunted on earth by sin
and deceit, and is only exposed to virtue in Heaven.

NG 8 was painted after a drawing by
Michelangelo (London, Courtauld Institute, Princes
Gate collection). This drawing, which has been
dated to about 1533, was made as a presentation
drawing and is highly finished. NG 8 has
sometimes been attributed to Battista Franco
(1498–1561), but this is not certain and copies of
Michelangelo's drawings by other artists are also
recorded.

The pose of the male nude repeats an earlier
design by Michelangelo, used by Sebastiano del
Piombo for the figure of Lazarus in the *Raising of
Lazarus* (NG 1).

Holwell Carr Bequest, 1831.

Gould 1975, pp. 153–4; Farr 1987, p. 132.

Christ visited the temple in Jerusalem and found it
full of traders and money-lenders. Angered by this
he expelled them saying: 'My house shall be called
the house of prayer; but ye have made it a den of
thieves.' New Testament (Matthew 21: 12–13). The
temple has been represented with a Jewish
candelabra and with four twisted columns like
those in St Peter's, Rome, that were believed to
come from Solomon's temple.

Small sketches for the composition by
Michelangelo are known (Oxford, Ashmolean
Museum; London, British Museum), but no finished
drawing has survived. Michelangelo is known to
have provided compositional drawings to other
artists on occasion, and his finished drawings were
also copied by later painters. The execution of NG
1194 has sometimes been attributed to Marcello
Venusti (active 1548; died before 1579) but this is
not certain. Michelangelo's drawings probably date
from about 1550.

*Recorded in the Villa Borghese, Rome, by 1650;
subsequently in the collection of Samuel Woodburn, and
then of the Duke of Hamilton; bought, 1885.*

Gould 1975, pp. 154–5.

The Christ Child sleeps across his mother's lap in an
attitude suggestive of the *Pietà* when his dead body
was placed in a similar position. Saint Joseph and
the youthful Saint John the Baptist look on. Saint
John is unusually dressed in a wolf's skin rather
than a camel skin.

A presentation drawing by Michelangelo of this
composition is at Welbeck Abbey. Various painted
versions and an engraving dated 1561 by Bonasone
(active 1531–74) are known. The execution of NG
1227 has sometimes been attributed to Marcello
Venusti (active 1548; died before 1579).

*Collection of the Duke of Hamilton by 1882; bought,
1887.*

Gould 1975, p. 155.

MICHELE da Verona
Coriolanus persuaded by his Family to spare Rome
probably about 1495–1510

NG 1214
Oil on canvas, 93.3 x 120 cm

The Volscians are besieging Rome (left background).
Coriolanus, after being exiled from the city, is acting
as their general and is preparing to attack. He was
persuaded to desist by Valeria, his mother Volumnia,
his wife Virgilia and his children. Plutarch, *Life of
Coriolanus*.
 Richter acquired NG 1214 as the work of
Carpaccio, but the attribution to Michele da Verona
(which can also be traced to a guidebook of 1820/1)
is probably correct. The picture is close in style to
his *Crucifixion* (dated 1501) in the Brera, Milan.

*Apparently in the collection of Francesco Caldana,
Verona, 1820; bought from J.P. Richter, 1886.*

Davies 1961, pp. 373–4.

Michiel van MIEREVELD
Portrait of a Woman
1618

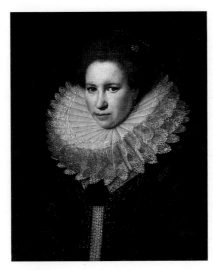

NG 2292
Oil on oak, 61.6 x 50.5 cm

Signed and dated above the sitter's left shoulder:
F[?] 1618 / M Mierevelt
 The female sitter in this portrait has not been
identified. There is a fragment of paper on the back
with the remains of an inscription: Cad(..) rello /
...rta (.) (p?)rello.

*Collection of George Fielder by 1878; by whom
bequeathed, 1908.*

MacLaren/Brown 1991, p. 261.

Frans van MIERIS the Elder
Portrait of the Artist's Wife, Cunera van der Cock
about 1657–8

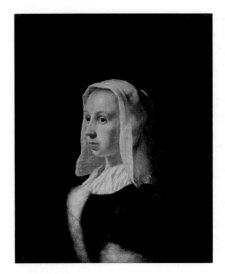

NG 1415
Oil on vellum, inlaid on oak at a later date
16 x 13.3 cm

Cunera Cornelisdr. van der Cock (1629/30–1700)
married Frans van Mieris in 1657. A small oval bust
portrait in Munich of 1662, clearly of the same
woman, is the companion to the self portrait of the
artist in the same collection. There is another van
Mieris self portrait in Berlin (Gemäldegalerie) which
may be a pair to NG 1415.
 NG 1415 is dated by comparison to other works
by the artist, such as the *Doctor's Visit* of 1657 in
Glasgow (Museum and Art Gallery).

*Possibly in the Josua van Belle sale, Rotterdam, 1730;
Cornelis Ploos van Amstel sale, Amsterdam, 1800;
bought from Horace Buttery, 1894.*

MacLaren/Brown 1991, pp. 265–6.

MICHELE da Verona
about 1470–1536/44

Michele da Verona was active as a painter of
altarpieces and smaller works in northern Italy.
Several signed works exist, including a large
Crucifixion (Milan, Brera).

Michiel van MIEREVELD
1567–1641

Michiel Jansz. van Miereveld (or Mierevelt) was
born in Delft, where he lived for most of his life.
He was taught by Anthonie van Blocklandt in
Utrecht, and was subsequently patronised by the
Stadholder's court in The Hague. He was a very
successful portrait painter, and had a number of
pupils, among them his sons Pieter and Jan.

Frans van MIERIS the Elder
1635–1681

Frans Jansz. van Mieris was born in Leiden, the
son of a goldsmith. He was initially trained as a
goldsmith, but subsequently was apprenticed to
Gerrit Dou. He entered the Leiden guild in 1658.
He had a successful career in Leiden and was
patronised by many of the town's leading citizens.
He painted small-scale genre scenes and portraits,
and also religious, classical and literary subjects,
in a precise style.

Frans van MIERIS the Elder
A Woman in a Red Jacket feeding a Parrot
about 1663

Frans van MIERIS the Elder
Self Portrait of the Artist, with a Cittern
1674

After Frans van MIERIS
An Old Fiddler
probably 18th century

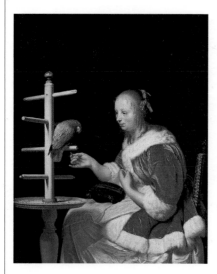

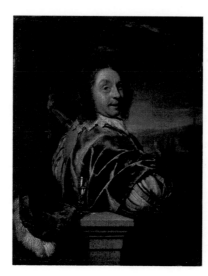

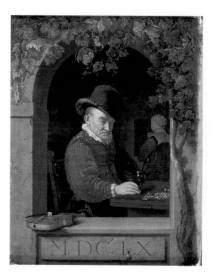

NG 840
Oil on copper, 22.5 x 17.3 cm

NG 1874
Oil on canvas, 17.5 x 14 cm

NG 2952
Oil on oak, 28.9 x 22.9 cm

Behind the woman are, barely visible, a bed with curtains at the left, and an open door surrounded by foliage at the right.

NG 840 is one of a large number of copies of this composition. The best and probably the original version of the design is the picture, signed and dated 1663, in a private collection in England.

Probably in the collection of L.J. Gaignat by 1760; possibly in the collection of the Prince de Talleyrand; collection of William Beckford, Fonthill Abbey; collection of Sir Robert Peel, Bt, by 1829; bought with the Peel collection, 1871.

MacLaren/Brown 1991, pp. 262–4.

Inscribed on the stonework: AEtat 38 4/13 / Ao Dom 1674 (see below).

The identity of the subject is confirmed by comparison with a self-portrait drawing which is signed and dated 1667 (London, British Museum). The artist wears an archaic form of dress, of a type quite often seen in the works of Leiden painters, which may be based on the theatrical costumes of the *Commedia dell'Arte*.

The inscription dates the painting to 13 April 1674, which was three days before van Mieris's 39th birthday.

Possibly the self portrait of van Mieris in 'Italian' costume, playing the lute, in the collection of Diego Duarte, Antwerp, 1682; collection of Sir John May by 1847; May Bequest, 1854.

MacLaren/Brown 1991, pp. 266–8.

Inscribed: M. D C. LX (1660).

In the background at the right a woman writes on a slate. The man wears late sixteenth-century dress (compare with NG 1874).

NG 2952 is a copy, perhaps of a much later date, of a picture by van Mieris, signed and dated 1660, which was last recorded with Knoedler and Co., New York, in 1946. It differs from the original in having a vine rather than ivy trailing over the arch. There are many other copies and versions of this composition.

Layard Bequest, 1913.

MacLaren/Brown 1991, pp. 268–9.

Willem van MIERIS	Pierre MIGNARD	Francisque MILLET
A Woman and a Fish-pedlar in a Kitchen	*The Marquise de Seignelay and Two of her Children*	*Mountain Landscape, with Lightning*
1713	1691	1659–79

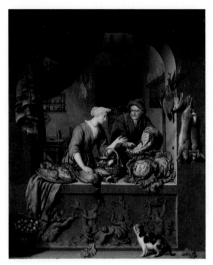

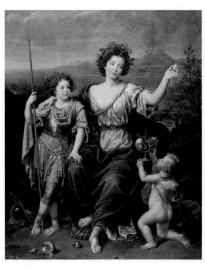

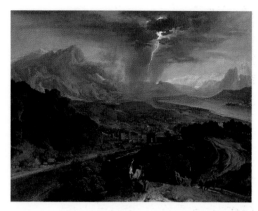

NG 5593
Oil on canvas, 97.2 x 127 cm

NG 841
Oil on oak, 49.5 x 41 cm

NG 2967
Oil on canvas, 194.3 x 154.9 cm

Signed and dated top left: W. van Mieris. Fc Anno 1713.

The bas-relief of tritons and nereids in the foreground is a variant of a Triumph of Galatea relief which appears in several of van Mieris's paintings (e.g. *Joseph and Potiphar's Wife*, Karlsruhe, Staatliche Kunsthalle). In the left background porcelain is displayed on a wooden *theerak* (a rack used to support teacups and teapots).

NG 841 is a typical example of the artist's genre scenes set in niches.

Probably in the Graaf van Wassenaar Obdam sale, The Hague, 1750; collection of John Dent by 1815; bought for (Sir) Robert Peel (Bt), 1827; bought with the Peel collection, 1871.

MacLaren/Brown 1991, pp. 270–1.

Signed and dated: P. MIGNard/ PINxIT. 1691.

Catherine-Thérèse de Matignon, Marquise de Lonray (1662–99), married Jean-Baptiste Colbert de Seignelay in 1679. He was the eldest son of the Prime Minister, Jean-Baptiste Colbert, and headed the Admiralty as Ministre de la Marine; he died in 1690. She is here depicted, a year after her husband's death, in a *portrait historié*, which includes numerous maritime references. The marquise is represented in the guise of the sea-nymph Thetis. She is apparently accompanied by two of her sons, the elder of whom is shown as Achilles, the son of Thetis, and the younger as Cupid, the god of love. The couple had five sons, but it is not clear which of them are represented in the painting; they may be the eldest, Marie-Jean-Baptiste (1683–1712), and the youngest, Théodore-Alexandre (1690–95). Details such as the coral, pearls and seascape expand on the maritime theme.

Collection of Sir Richard Wallace, Paris, by 1874; inherited by Sir John Murray Scott; by whom bequeathed, 1914.

Davies 1957, p. 157; Rosenfeld 1981, pp. 76–8, no. 7; Nikolenko 1982–3, pp. 94–5; Wilson 1985, p. 74.

The picture has in the past been entitled the 'Flight of Ahab' and the 'Destruction of Sodom and Gomorrah', but neither of these Old Testament subjects appears to fit the image.

The attribution of NG 5593 is confirmed by comparison with an engraving which is inscribed as being after Francisque (i.e. Millet).

Possibly anon. sale, Christie and Ansell, April 1777; collection of Sir J.C. Robinson; Cook collection; bought (Clarke Fund), 1945.

Davies 1957, p. 159.

Willem van MIERIS
1662–1747

Willem van Mieris was born in Leiden, the second son and pupil of Frans van Mieris the Elder, whose style he imitated throughout his life, which was spent entirely in his native city. He painted genre, religious, mythological and literary subjects, as well as portraits and copies of his father's work.

Pierre MIGNARD
1612–1695

Mignard was born in Troyes. He trained under Jean Boucher in Bourges and studied at Fontainebleau, before working with Vouet in Paris in 1627. He spent from 1636 to 1657 in Italy (mostly Rome). He then had a successful career in Paris, notably as a portraitist. In 1690 he was made director of the Académie.

Francisque MILLET
1642–1679

The artist's real name was Jean-François Millet. He was born in Antwerp, moved to Paris in 1659 and apart from possible trips to Holland and England, remained there for the rest of his life. No signed pictures survive, but several are authenticated by early engravings. Millet chiefly painted landscapes, loosely linked to the style of Poussin.

Jean-François MILLET
The Whisper
about 1846

NG 2636
Oil on canvas, 45.7 x 38.1 cm

Signed: J. F. Millet
The title is traditional; in the nineteenth century the picture was called 'Peasant and Child'.

NG 2636 was probably painted in about 1846, and is one of a number of pastoral subjects painted by Millet in his early years in his so-called *manière fleurie*.

Collection of Alfred Sensier by 1883; Salting Bequest, 1910.

Davies 1970, p. 103.

Jean-François MILLET
The Winnower
about 1847–8

NG 6447
Oil on canvas, 100.5 x 71 cm

Signed bottom left: J. F. Millet
NG 6447 was Millet's first major peasant subject, and was exhibited to great acclaim at the Salon of 1848.

It was purchased in 1848 by Ledru-Rollin, a Republican politician, but the picture disappeared from view when Ledru-Rollin went into exile shortly afterwards. Two later variants are in Paris (Louvre and Musée d'Orsay).

NG 6447 was thought to have been destroyed until it was rediscovered in an attic in America in 1972. There are several areas of damage on the figure. The frame is probably original.

Collection of Ledru-Rollin; bought, 1978.

Lindsay 1974, pp. 239–45; Herbert 1976, pp. 62–4, no. 26; National Gallery Report 1978–9, pp. 26–7.

Follower of Jean-François MILLET
Landscape with Buildings
after 1860

NG 6253
Oil on canvas, 36.8 x 44.5 cm

An inscription on the reverse of the canvas identifies the site as '*environs de Fontainebleau*' (surroundings of Fontainebleau), although it seems more likely to be a scene in Normandy.

Traditionally, NG 6253 has been attributed to Millet and it has been compared to his *Church at Gréville* (Paris, Musée d'Orsay). However, it is probably the work of a follower and may possibly be by the artist's son, François.

With the Fine Art Society, London, 1938; bequeathed by Sir Victor Wellesley, 1954.

Davies 1970, p. 103.

Jean-François MILLET
1814–1875

Millet was born at Grouchy and studied under Delaroche in Paris in 1837. The delicate, mannered style of his early idylls gave way around 1847 to a more robust realist approach, based on peasant subjects that seem in tune with the mood of the 1848 revolution. In 1849 he moved to Barbizon, where he painted rustic scenes, often with sentimental and moralising overtones.

Gerolamo MOCETTO
The Massacre of the Innocents
about 1500–25

Gerolamo MOCETTO
The Massacre of the Innocents
about 1500–25

Pier Francesco MOLA
The Rest on the Flight into Egypt
about 1630–5

NG 160
Oil on canvas, 30.5 x 45.7 cm

NG 1239
Oil on canvas, presumably transferred from wood,
67.9 x 44.5 cm

Signed on the pedestal, left of centre: HEROL/EMO
/ MOCETO / P.[INXIT].

Herod had been told of the birth of Jesus; when
the Child was not delivered to him he resolved to
have all children under the age of two killed. New
Testament (Matthew 2: 16). The Massacre of the
Innocents is depicted continuously in NG 1239 and
1240. Herod, who is seen seated in NG 1239, directs
the slaughter in both scenes.

These two pictures were probably cut from a
single composition – the architectural elements of
one are continued in the other – the balustrade
across the top of NG 1239 repeating the balustrade
which recedes in NG 1240 and the paving having
the same pattern.

A number of the figures in NG 1239 recur in
Mocetto's engraving of *The Killing of the Sow*.

*First recorded in the collection of John Strange, Venice,
before 1786; bought from J.P. Richter, Florence, 1888.*

Davies 1961, pp. 375–6.

NG 1240
Oil on canvas, presumably transferred from wood,
67.9 x 44.5 cm

For the subject, date and form of NG 1240, see
under NG 1239.

The distraught mother who flings wide her arms
in NG 1240 is copied from Andrea Mantegna's
engraving of the *Entombment*. The children at her
feet are copied from another popular engraving by
Mantegna, the *Bacchanal with a Wine Vat*.

*First recorded in the collection of John Strange, Venice,
before 1786; bought from J.P. Richter, Florence, 1888.*

Davies 1961, pp. 375–6; Christiansen 1992, pp.
199–200, 279–80.

Joseph had been warned in a dream that Herod was
searching for the Christ Child, so he took him and
the Virgin to safety in Egypt. New Testament
(Matthew 2: 13–15).

The artist treated this subject on several occasions;
NG 160 is likely to be among the earliest of these
pictures. It may have been painted in the early 1630s.

Stylistically the work illustrates the influence of
Albani.

*Duc d'Orléans collection, Palais Royal, 1727; sale of
Orléans pictures, 1798; bought by Charles Long; by
whom bequeathed, as Lord Farnborough, 1838.*

Levey 1971, pp. 162–3.

Gerolamo MOCETTO
about 1458–1531

Gerolamo Mocetto came from Murano and was
principally active in Venice. He also worked in
Verona (probably about 1517). Greatly influenced
by Mantegna and Giovanni Bellini, Mocetto was
an engraver as well as a painter.

Pier Francesco MOLA
1612–1666

Mola was baptised in Coldrerio, near Como. He
went with his family to Rome, and studied there
with Prospero Orsi and Cesare d'Arpino. Then he
worked under Albani in Bologna, and is
documented in Lucca and Venice. The artist was
notably influenced by Guercino, and painted
frescoes in Rome (Gesù), and at Valmontone
(Palazzo Pamphili).

Pier Francesco MOLA
Saint John the Baptist preaching in the Wilderness
about 1640

Style of MOLA
Leda and the Swan
probably 1650–66

Jan MOLENAER
Two Boys and a Girl making Music
1629

NG 69
Oil on canvas, 54 x 70 cm

NG 151.1
Oil on canvas, 38.6 x 50.1 cm

NG 5416
Oil on canvas, 68.3 x 84.5 cm

Saint John the Baptist, wearing furs, with his reed cross lying beside him, points to the figure of Christ in the background at the extreme right. New Testament (Luke 3: 1–17).

Mola treated this subject, with variations, several times (e.g. Paris, Louvre). NG 69 was probably painted at the beginning of the 1640s.

Possibly from the Robit collection, Paris; collection of the Rev Holwell Carr by 1818; Holwell Carr Bequest, 1831.

Levey 1971, pp. 161–2.

The story of Leda and the Swan is a Greek myth which is told in various versions. Leda, the wife of the king of Sparta, was loved by the god Jupiter. He transformed himself into a swan and came to lie with her. As a consequence of their union she bore the twins Castor and Pollux, who were hatched from eggs.

The poor condition of the picture, which has suffered damage in the past, makes it difficult to attribute it to Mola with certainty, but stylistically it lies close to his mature works and may be autograph.

M. de Ménars sale, Paris, 1782; Comte de Vaudreuil sale, Paris, 1784; bequeathed by Lord Farnborough, 1838.

Levey 1971, p. 163.

Signed and dated on the end of the box: I MR / 1629 (MR in monogram).

The boy on the right plays a *rommelpot*, the one on the left a violin. The girl wears a gorget and beats an accompaniment with spoons on a helmet.

Molenaer often painted children playing musical instruments; these genre subjects were presumably meant to evoke the carefree time of childhood.

NG 5416 was once attributed to the Le Nain brothers on the basis of a false inscription on the reverse of the stretcher.

Collection of H. Phillips by 1826; bequeathed by C.F. Leach, 1943.

MacLaren/Brown 1991, pp. 272–3.

Jan MOLENAER
about 1610–1668

Jan Miense Molenaer was born in Haarlem and lived chiefly there or in nearby Heemstede (with the exception of periods in Amsterdam, about 1637–48 and 1655–6). In 1636 he married the painter Judith Leyster. Apart from a few portraits and religious pictures, his work largely consists of genre subjects.

Jan MOLENAER
A Young Man playing a Theorbo and a Young Woman playing a Cittern, probably 1630–2

Follower of Joos de MOMPER the Younger
A Music Party before a Village
1640–60

Claude-Oscar MONET
Bathers at La Grenouillère
1869

NG 1293
Oil on canvas, 68 x 84 cm

NG 1017
Oil on canvas, 142.7 x 182.3 cm

NG 6456
Oil (identified) on canvas, 73 x 92 cm

Signed on the foot-warmer: (I?) MR (in monogram; faint).

The portrait in the right background of a bearded man in armour with an orange sash is in the style of Michiel van Miereveld, and probably shows Prince Frederik Hendrik of Orange (1584–1647) who became Stadholder in 1625.

NG 1293 was probably painted in the early 1630s on the basis of comparison with, for example, *The Dentist* of 1630 (Braunschweig, Herzog Anton Ulrich-Museum). It is typical of Dutch genre scenes in which music-making is often a means of representing love or courtship.

Bought (Clarke Fund), 1889.

MacLaren/Brown 1991, pp. 271–2.

Inscribed: D:D:V:/ 1633
The view has not been identified.

This landscape appears to be the work of an unidentified follower of de Momper. The inscription was probably added later in an attempt to attribute the picture to David Vinckboons (1576–1632/3). The figures and the landscape seem to be by different artists.

Wynn Ellis Bequest, 1876.

Martin 1970, pp. 97–8.

Signed and dated bottom right: Claude Monet 1869
La Grenouillère was a floating café and bathing place on the banks of the Seine near Bougival, west of Paris. It was popular with locals and day trippers in the late 1860s.

Monet worked alongside Renoir at La Grenouillère in the summer of 1869. The works that they produced there are often celebrated as important documents in the history of Impressionism, introducing the qualities of immediacy and directness that became the basis of their subsequent work. It is possible that NG 6456 and a related composition in the Metropolitan Museum of Art, New York, were painted as sketches for a more ambitious and finished composition that Monet may have intended to execute back in his studio.

Bought by Bruno Cassirer from Durand-Ruel, 1901; bequeathed by Mrs M.S. Walzer as part of the Richard and Sophie Walzer Bequest, 1979.

Wildenstein 1974–93, I, p. 178, no. 135; House 1986, pp. 114–15; Bomford 1990, pp. 120–5.

Joos de MOMPER the Younger
1564–1634/5

The artist, who was a landscape painter, was born in Antwerp. He was probably taught by his father, Bartholomeus, and is recorded as a member of the guild in the city in 1581. He may have travelled to Italy, but if so, had certainly returned to Antwerp by 1590. De Momper worked for the Regents of the Southern Netherlands at the court in Brussels.

Claude-Oscar MONET
1840–1926

Monet grew up in Le Havre, where he was influenced by Boudin and Jongkind. He moved to Paris in 1859 and entered the studio of Gleyre in 1862. He settled in Giverny in 1883 where he constructed the famous water garden that was to inspire much of his later work. He exhibited first at the Salon (1865), and then in the Impressionist exhibitions (1872–4). He travelled widely in Europe.

Claude-Oscar MONET
The Beach at Trouville
1870

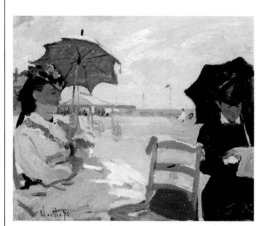

NG 3951
Oil (identified) on canvas, 37.5 x 45.7 cm

Claude-Oscar MONET
The Thames below Westminster
about 1871

NG 6399
Oil on canvas, 47 x 72.5 cm

Claude-Oscar MONET
The Petit Bras of the Seine at Argenteuil
1872

NG 6395
Oil (identified) on canvas, 52.6 x 71.8 cm

Signed and dated bottom left: Cl. M. 70.

The sitters in this view of the beach at Trouville are probably Monet's first wife Camille (left) and Madame Boudin (right), wife of the painter Eugène Boudin.

Monet painted NG 3951 in 1870, soon after his marriage to Camille. Boudin had previously painted views of the beach at Trouville (see NG 6309, 6310, 6312, 2758), and the area was also familiar to Monet. NG 3951 was almost certainly painted entirely in the open air: the surface is covered in sand that blew onto both his palette and his canvas.

Said to have been in the collection of Alphonse Kann before 1924; bought by the Trustees of the Courtauld Fund, 1924.

Davies 1970, p. 105; Wildenstein 1974–93, I, p. 188, no. 158; Bomford 1990, pp. 126–31.

Signed and dated: Claude Monet 71.

The Houses of Parliament and Westminster Bridge are seen from further down the newly constructed Victoria Embankment. Monet's fascination with London's mists and fogs is frequently related to his admiration for Turner, although the possible influence of Whistler and Japanese prints seem more relevant to this particular picture.

NG 6399 dates from Monet's first visit to London in 1870–1. He came to England – like Pissarro and Daubigny – to avoid the Franco-Prussian War.

Bought by J.J. Astor, 1936 (said to have been previously in the collection of Alfred Gold, Berlin); bequeathed by Lord Astor of Hever, 1971.

Wildenstein 1974–93, I, p. 192, no. 166; House 1986, p. 113; House 1987, pp. 73ff.

Signed bottom right: Claude Monet

Monet settled in Argenteuil, about nine kilometres from Paris, in 1871. He painted numerous views of the Seine at this point: NG 6395 shows a stretch of the river separated from the main flow by the Ile Marante.

Durand-Ruel by about 1881; bequeathed by Sir Robert Hart Bt, 1971.

Wildenstein 1974–93, I, p. 202, no. 196; Hayes Tucker 1982, pp. 92–7; Bomford 1990, pp. 142–7.

Claude-Oscar MONET
The Museum at Le Havre
1872–3

NG 6527
Oil on canvas, 75 x 100 cm

Claude-Oscar MONET
The Gare St-Lazare
1877

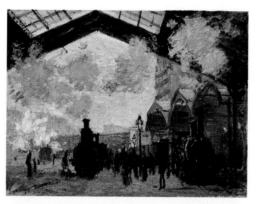

NG 6479
Oil (identified) on canvas, 54.3 x 73.6 cm

Claude-Oscar MONET
Lavacourt under Snow
about 1878–81

NG 3262
Oil (identified) on canvas, 59.7 x 80.6 cm

Signed and dated: Claude Monet 73

NG 6527 shows Le Havre from one of the walls of the inner harbour looking across the basin to the Musée des Beaux-Arts. This museum was destroyed during World War II and has been replaced by a modern structure.

Monet was living at Argenteuil during the early 1870s but made frequent trips to his home town of Le Havre, on the Normandy coast. In 1872 and 1873 he painted several views of the harbour at Le Havre including his famous *Impression: Sunrise* (Paris, Musée Marmottan), the picture which provoked the term 'Impressionism'.

Bought from Monet by Giuseppe de Nittis, Paris, 1876; bought by Kenneth Levy, 1936; bequeathed by Helena and Kenneth Levy, 1990.

Wildenstein 1974–93, I, p. 224, no. 261; National Gallery Report 1990–1, pp. 16–17.

Signed bottom right: Claude Monet.

The view is taken from the terminus of one of the main lines, looking along the *quais* and tracks to the Pont de l'Europe in the middle distance. Monet painted twelve paintings of the railway station of St-Lazare in Paris in a burst of activity early in 1877. It would have been familiar to him as the main station for trains to Normandy as well as to nearer Impressionist haunts such as Bougival and Argenteuil. The paintings of the Gare St-Lazare were apparently executed on the spot.

Other versions of the station interior include those in Paris (Musée d'Orsay) and Chicago (Art Institute).

Lazare Weiller, Paris, before 1901; Samuel Courtauld by 1936; bought by private treaty, 1982.

Cooper 1954, pp. 104–5, no. 42; Wildenstein 1974–93, I, p. 306, no. 441; Bomford 1990, pp. 166–71.

Signed and dated: Claude Monet 1881

Lavacourt is a hamlet on the other side of the Seine from Vétheuil where Monet had settled in 1878. NG 3262 is one of a group of similar views taken from the river banks looking upstream, with the tumbledown cottages of Lavacourt on the right.

NG 3262 is signed and dated 1881, although Daniel Wildenstein has suggested that it was painted in the winter of 1878–9 and stylistically it is close to Monet's earliest works painted at Vétheuil. Monet frequently added his signature long after the completion of a picture, sometimes when it was sold or if it left his studio for exhibition, and his dating was often inaccurate.

Durand-Ruel collection, 1891; acquired by Sir Hugh Lane, 1905; Lane Bequest, 1917.

Davies 1970, p. 104; Wildenstein 1974–93, I, p. 336, no. 511; House 1986, p. 121; Bomford 1990, pp. 182–7.

Claude-Oscar MONET
Flood Waters
1896

NG 6278
Oil on canvas, 71 x 91.5 cm

Stamped: Claude Monet

NG 6278 probably depicts the river Epte, a tributary of the Seine that passes through Giverny where Monet lived in his later years. The river is known to have been in flood in the autumn of 1896.

NG 6278 is unsigned, and was probably a study relating to a similar picture dated 1896 (private collection).

Sold by Monet's son to a private collector; bought from Messrs Tooth & Sons, 1958.

Davies 1970, p. 106; Wildenstein 1974–93, III, p. 198, no. 1439.

Claude-Oscar MONET
The Water-Lily Pond
1899

NG 4240
Oil on canvas, 88.3 x 93.1 cm

Signed and dated: Claude Monet 99.

In the 1890s Monet extended his garden at Giverny, developing a water-lily pond over which he constructed an arched bridge. In 1899–1900 he painted a series of at least seventeen views of the pond and the Japanese bridge. The simple, frontal composition of NG 4240, with the close-up view of the bridge, is repeated with variations in several canvases. NG 4240 was among a group of these pictures shown at Durand-Ruel's gallery in 1900.

Bought from Monet by the dealers, Petit, Bernheim-Jeune and Petit and sold by them to Georges Kohn, March 1900; bought 1927.

Davies 1970, pp. 105–6; Wildenstein 1974–93, IV, p. 156, no. 1516.

Claude-Oscar MONET
Irises
about 1914–17

NG 6383
Oil on canvas, 200.7 x 149.9 cm

Irises grew near the pool of water-lilies in Monet's garden at Giverny.

Although NG 6383 is the same height as the large water-lily paintings, there is no evidence to suggest that it was originally conceived as part of this series. The unusual perspective of the view might suggest that Monet was looking down on the irises and a winding path, perhaps from the Japanese bridge.

Bought from Monet's son by Katia Granoff, about 1950; from whom bought, 1967.

Davies 1970, pp. 107–8; Wildenstein 1974–93, IV, p. 266, no. 1829.

Claude-Oscar MONET
Water-Lilies
after 1916

NG 6343
Oil (identified) on canvas, 200.7 x 426.7 cm

Stamped: Claude Monet.

In the 1900s Monet continued to expand his garden at Giverny and, after the enlargement of the pond, the surface of the water with its floating water-lilies became his principal motif. He began to evolve plans for a large ensemble of water-lily pictures and in 1916 he moved into a specially constructed studio that could accommodate his huge canvases.

Nineteen of these canvases were installed in the Orangerie in Paris one year after Monet's death, in two special rooms constructed to his design. NG 6343 is one of a number of canvases which evolved simultaneously but which were not included in his final scheme.

Bought from Monet's son by Katia Granoff; bought with a special grant, 1963.

Davies 1970, pp. 106–7; Wildenstein 1974–93, IV, no. 1978, p. 323.

Bartolomeo MONTAGNA
The Virgin and Child
probably about 1485–7

NG 802
Tempera with oil on wood, painted surface 64.8 x 54.6 cm

The Virgin and Child are seen in front of a landscape with a church and some covered boats (right). The Child sits on a book (presumably a religious book) and holds cherries – sometimes symbolic of Heaven.

Collection of Conte Carlo Castelbarco, Milan, before 1862; bought, 1869.

Davies 1961, pp. 376–7; Puppi 1962, pp. 104–5.

Bartolomeo MONTAGNA
Saint Zeno, Saint John the Baptist and a Female Martyr, probably about 1495

NG 3074
Oil on canvas, transferred from wood, 102.9 x 141 cm

Signed (much retouched) top left: Bart(b?)olomeus mo[n] / tanea pinxit; and inscribed on Saint John's scroll: ECCE AGNVS (Behold the Lamb).

Saint Zeno, the fourth-century Bishop of Verona, is on the left. Saint John the Baptist, who holds a reed cross around which is a scroll inscribed with words from his Gospel (New Testament, John 1: 29, 36), is in the centre. The female saint on the right with a book and a martyr's palm may be Saint Catherine of Alexandria.

NG 3074 has been transferred to canvas, and may have been cut down at this time (it has been suggested that originally the saints were full-length, and that the signature may have been moved from the lost lower section of the picture).

Said to be from a chapel belonging to the Tanara family, S. Giovanni Ilarione (between Verona and Vicenza); bought from the Tanara family, Verona, by Sir A.H. Layard, 1856; Layard Bequest, 1916.

Davies 1961, pp. 377–8; Puppi 1962, p. 106.

Bartolomeo MONTAGNA
living 1459; died 1523

Montagna was born in Vicenza. He may have trained in Venice in the late 1460s, and he worked both there (painting two large canvases for the Scuola Grande di San Marco in 1482) and in Verona, but he was principally active in Vicenza. He painted panel altarpieces, small canvases and in fresco, and also made designs for intarsia choirstalls.

Attributed to MONTAGNA
The Virgin and Child
probably 1481

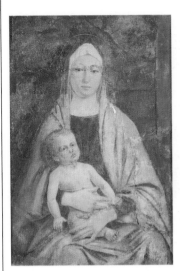

NG 1696
Fresco, 83.8 x 57.8 cm

NG 1696 is a fragment from a larger fresco traditionally thought to come from the choir of a church at Magrè, near Schio, Vicenza, and to date from 1481. This information is recorded on an inscription on the frame which appears to have been made for the painting when it belonged to Layard and may reflect some evidence which is now no longer extant (or known). The attribution to Montagna has not been confirmed.

Said to be from the church of Magrè (near Schio and Vicenza); Sir A.H. Layard collection; presented by Lady Layard, 1900.

Davies 1961, pp. 378–9; Puppi 1962, pp. 105–6.

Attributed to MONTAGNA
The Virgin and Child
perhaps about 1504–6

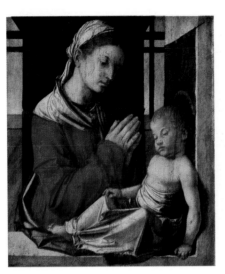

NG 1098
Oil on canvas, transferred from wood, 59 x 51 cm

NG 1098 is badly damaged and it is therefore difficult to be certain about the attribution. It has been suggested that it was painted in Verona around 1504–6.

Bought from Baslini, Milan, 1881.

Davies 1961, p. 378; Puppi 1962, p. 105.

Adolphe MONTICELLI
The Hayfield
probably 1860–80

NG 3263
Oil on wood, probably mahogany, 21.6 x 43.8 cm

Signed bottom left: Monticelli
A number of figures and a haycart dominate this summer composition.

Collection of Albert Pontremoli by 1906; Sir Hugh Lane Bequest, 1917; on loan to the Hugh Lane Municipal Gallery of Modern Art, Dublin, since 1979.

Davies 1970, p. 108.

Adolphe MONTICELLI
1824–1886

Monticelli was born in Marseilles, where he studied with Félix Ziem and then at the Ecole de Dessin. He studied in Paris with Paul Delaroche in 1847 but spent most of his career in Provence, with occasional visits to Paris. He was an influence upon the art of Cézanne and Van Gogh.

Adolphe MONTICELLI
Subject Composition
probably 1870–90

Adolphe MONTICELLI
Conversation Piece
probably 1870–90

Adolphe MONTICELLI
Subject Composition
probably 1870–90

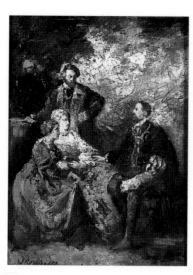

NG 5016
Oil on wood, 42 x 29.5 cm

Signed lower right: Monticelli
 Two standing women and a seated dog are seen in what may be a park. No specific subject has been identified.

Presented as part of the 'Harry Wearne Collection of Twelve Paintings by Monticelli' to the Tate Gallery, 1939; transferred, 1956.

Davies 1970, pp. 109–10.

NG 5017
Oil on wood, 33 x 25.4 cm

Signed lower left: Monticelli
 NG 5017 depicts four figures in historical costume, but the subject of the picture has not been identified.

Presented as part of the 'Harry Wearne Collection of Twelve Paintings by Monticelli' to the Tate Gallery, 1939; transferred, 1956.

Davies 1970, pp. 109–10.

NG 5018
Oil on wood, 21 x 15.9 cm

Signed: Monticelli
 Four female figures, two seated and two standing, are shown. There is a close variant of the composition in the Musée du Petit Palais, Paris.

Presented as part of the 'Harry Wearne Collection of Twelve Paintings by Monticelli' to the Tate Gallery, 1939; transferred, 1956.

Davies 1970, pp. 109–10.

Adolphe MONTICELLI
A Vase of Wild Flowers
probably 1870–80

NG 5015
Oil on wood, probably mahogany, 61 x 47 cm

Signed bottom right: Monticelli
 A vase of flowers is seen on a table.

Presented as part of the 'Harry Wearne Collection of Twelve Paintings by Monticelli' to the Tate Gallery, 1939; transferred, 1956.

Davies 1970, pp. 109–10.

Adolphe MONTICELLI
Torchlight Procession
probably 1870–86

NG 5009
Oil on wood, 30.5 x 48.9 cm

Signed bottom left: Monticelli
 The occasion of the procession has not been identified.

Presented as part of the 'Harry Wearne Collection of Twelve Paintings by Monticelli' to the Tate Gallery, 1939; transferred, 1956.

Davies 1970, pp. 108–10.

Adolphe MONTICELLI
Subject Composition
probably 1870–86

NG 5010
Oil on wood, probably mahogany, 19.1 x 42.5 cm

Signed bottom right: Monticelli
 The subject has not been identified. Four women are shown, perhaps below a vine. Another image, depicting the standing figure of a woman, is painted on the reverse (in the opposite sense).

Presented as part of the 'Harry Wearne Collection of Twelve Paintings by Monticelli' to the Tate Gallery, 1939; transferred, 1956.

Davies 1970, pp. 109–10.

NG 5010, reverse

Adolphe MONTICELLI
Fountain in a Park
about 1875–80

NG 5011
Oil on wood, probably mahogany, 19.1 x 47 cm

Adolphe MONTICELLI
Meeting Place of the Hunt
about 1875–80

NG 5012
Oil on wood, probably mahogany, 19.1 x 47 cm

Adolphe MONTICELLI
Still Life: Oysters, Fish
about 1878–82

NG 5013
Oil on wood, probably mahogany, 46.4 x 61.6 cm

Signed lower left: Monticelli
A number of figures, on horseback and on foot, are seen beside a fountain.

NG 5011 may have been painted as a pendant to NG 5012. Both have been dated stylistically to about 1875–80.

Presented as part of the 'Harry Wearne Collection of Twelve Paintings by Monticelli' to the Tate Gallery, 1939; transferred, 1956.

Davies 1970, pp. 109–10.

Signed lower left: Monticelli
A number of figures, on horseback and on foot, and a dog are seen beside a fountain.

NG 5012 may have been painted as a pendant to NG 5011. Both have been dated stylistically to about 1875–80.

Presented as part of the 'Harry Wearne Collection of Twelve Paintings by Monticelli' to the Tate Gallery, 1939; transferred, 1956.

Davies 1970, pp. 109–10.

Signed: Monticelli
A lemon, a plate of oysters, several fish and a glass are seen on a table.

Presented as part of the 'Harry Wearne Collection of Twelve Paintings by Monticelli' to the Tate Gallery, 1939; transferred, 1956.

Davies 1970, pp. 109–10; Sheon 1979, p. 210.

Adolphe MONTICELLI
Still Life: Fruit
about 1878–82

Adolphe MONTICELLI
Sunrise
about 1882–4

Adolphe MONTICELLI
Sunset
about 1882–4

NG 5014
Oil on wood, probably mahogany, 45.7 x 61 cm

NG 5007
Oil on wood, 27.9 x 41.3 cm

NG 5008
Oil on wood, 31.8 x 44.8 cm

Signed bottom left: Monticelli
 A glass, a bottle (or carafe), a knife and a plate of fruit are seen on a table.

Presented as part of the 'Harry Wearne Collection of Twelve Paintings by Monticelli' to the Tate Gallery, 1939; transferred, 1956.

Davies 1970, pp. 109–10; Sheon 1979, p. 210.

Signed bottom right: Monticelli
 The sun rises in the centre.
 NG 5007 and its pendant NG 5008 have been dated on the basis of style to about 1882–4.

Presented as part of the 'Harry Wearne Collection of Twelve Paintings by Monticelli' to the Tate Gallery, 1939; transferred, 1956.

Davies 1970, pp. 108–10; Sheon 1979, p. 205; Garibaldi 1991, p. 163.

Signed: Monticelli
 The sun sets in the centre behind two trees.
 NG 5008 and its pendant NG 5007 have been dated on the basis of style to about 1882–4.

Presented as part of the 'Harry Wearne Collection of Twelve Paintings by Monticelli' to the Tate Gallery, 1939; transferred, 1956.

Davies 1970, pp. 108–10; Sheon 1979, p. 205; Garibaldi 1991, p. 163.

Anthonis MOR van Dashorst
Portrait of a Man
probably 1560–77

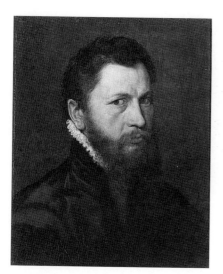

NG 1231
Oil on oak, 49.5 x 40.6 cm

Inscribed falsely: A. Morro f.
The sitter has not been identified. Portraits of less than half-length, such as this, are rare in Mor's work, but NG 1231 is not thought to be a fragment from a larger painting.
It is probably one of the artist's later pictures.

Collection of James Whatman, Maidstone, by 1856; bought at the Whatman sale (Walker Fund), 1887.

Davies 1968, p. 131.

Luis de MORALES
The Virgin and Child
probably 1565–70

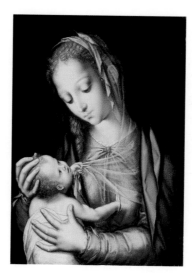

NG 1229
Oil on oak, 28.5 x 19.6 cm

The Christ Child holds the Virgin's breast and tugs at her veil.
Several versions of this design by Morales and his studio are known (e.g. Madrid, Prado).

S. Herman de Zoete sale, London, 1885; bought by Colnaghi; presented by Gerard F. de Zoete, 1887.

MacLaren/Braham 1970, pp. 59–60.

Paolo MORANDO
The Virgin and Child, Saint John the Baptist and an Angel, probably about 1514–18

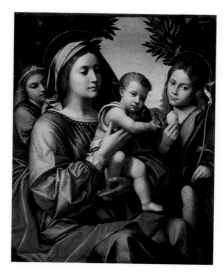

NG 777
Oil on canvas, 75.6 x 64.8 cm

Signed: PAVLVS. / V[ERONENSIS] .P.[INXIT]. (Paolo of Verona painted this).
The Virgin and Child are flanked by an angel (left) and Saint John the Baptist (right). Saint John presents his younger cousin Christ with an emblem of his future sacrifice – a wooden cross and also a lemon (which is sometimes said to allude to the weaning of Christ).
NG 777 appears to be a work by Morando despite the uncertainty in the signature.

Portalupi collection, Verona, before 1836; from where bought, 1867.

Davies 1961, pp. 380–1.

Anthonis MOR van Dashorst
active 1544; died 1576/7

Mor was from Utrecht. (His name was often given in the Spanish form: Antonio Moro.) The artist studied there under Jan van Scorel, and became a master in Antwerp in 1547. He was the Habsburg court portraitist and worked in Brussels, Antwerp, Lisbon, Madrid, London and Rome.

Luis de MORALES
active 1546; died 1586?

Morales was probably born in Badajoz. He painted in and around the city, and it is surmised that he travelled to Seville and the Spanish court, possibly in the late 1550s. Influences on his work include German and Italianising Flemish painters such as Massys from whom the Leonardesque elements in his style are probably derived.

Paolo MORANDO
about 1486/8–1522

Morando is also known as Il Cavazzola. He seems to have trained in Verona with Francesco Bonsignori and Francesco Morone, and he was subsequently active there (in a short career), painting altarpieces and small devotional works. There are dated works from 1508 onwards.

NG 735
Oil on canvas, presumably cut down, 156.8 x 55.2 cm

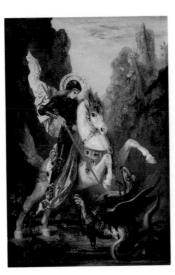

NG 6436
Oil on canvas, 141 x 96.5 cm

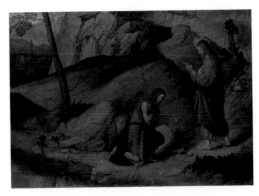

NG 3096
Oil on canvas, 65.4 x 94 cm

Signed and dated: PAVLVS / MORA[N]DVS / .V[ERONENSIS] .P[INXIT]. M.D.[XVIII]. (Paolo Morando of Verona painted this 1518).

Saint Roch, who was particularly associated with pilgrimages and with the plague, is traditionally depicted with an open wound on his thigh and with a pilgrim's staff. He was expelled from Piacenza, but his dog (bottom right) brought him a loaf every day and an angel (top left) tended his wound. The story is taken from *The Golden Legend*.

NG 735 was the left wing of a triptych formerly in S. Maria della Scala, Verona, of which the other wing was a panel of *Saint Sebastian* (now lost) by Francesco Torbido (about 1482–after 1562). The central canvas was Gerolamo dai Libri's *Virgin and Child with Saint Anne*, which is also in the Gallery. See under Gerolamo NG 748 for further information.

S. Maria della Scala, Verona, by 1568; private collections in Verona, 1742–1864; bought from Cesare Bernasconi, Verona, 1864.

Davies 1961, pp. 379–80.

Signed bottom left: -Gustave Moreau-

NG 6436 is one of Moreau's rare completed oils. It was commissioned by Louis Mante in 1889 and completed in 1890. However, the picture was probably begun much earlier since the design refers back to a watercolour of 1869 (private collection) and is listed in a studio inventory of about 1870–5. There are five preparatory drawings for the painting in the Musée Gustave Moreau, Paris. Its composition relates to the work by Raphael of the same subject in the Louvre, and to Carpaccio's murals, which Moreau studied, in the Scuola di San Giorgio degli Schiavoni, Venice.

Private collection; bought from Arthur Tooth and Sons Ltd, 1976.

National Gallery Report 1975–7, pp. 32–3; Mathieu 1976, p. 352, no. 361.

Although the narrative incident of Christ blessing Saint John is not included in the Gospels, it is presumably based on Matthew: 'Then cometh Jesus from Galilee to Jordan unto John, to be baptised of him. But John forbad him, saying, I have need to be baptised of thee, and comest thou to me? And Jesus answering said unto him, Suffer it to be so now: for thus it becometh us to fulfil all righteousness.' New Testament (Matthew 3: 13–15).

It has been a source of controversy whether NG 3096 is a fragment of a larger work, or a complete picture. The stylistic arguments against NG 3096 being an independent work do not seem valid, although the picture does have an unusual composition.

Possibly in the collection of Rodolfo Vantini, Brescia, in 1826; bought in Brescia by Morelli for Sir A.H. Layard before 1869; Layard Bequest, 1916.

Gould 1975, pp. 164–5; Begni Redona 1988, p. 80; Begni Redona 1988a, pp. 55–6.

Gustave MOREAU
1826–1898

Moreau, a leading Symbolist painter, was born in Paris. He studied from 1846 under François Picot at the Ecole des Beaux-Arts, and then travelled in Italy from 1857 to 1859. He exhibited intermittently at the Salon from 1852 to 1880 and became a member of the Académie in 1888. From 1892 until his death, he taught at the Ecole des Beaux-Arts, where his pupils included Matisse and Rouault.

MORETTO da Brescia
about 1498–1554

Alessandro Bonvicino, called Il Moretto da Brescia, was active throughout his career in and around Brescia. He was strongly influenced by Titian, and painted numerous portraits and large altarpieces. He also painted smaller religious works. Moroni was his pupil and some works have been attributed to both Moretto and Moroni.

MORETTO da Brescia
The Madonna and Child with Saint Nicholas of Tolentino and Saint Anthony of Padua, about 1520

MORETTO da Brescia
Portrait of a Gentleman
1526

MORETTO da Brescia
The Madonna and Child with Saints Hippolytus and Catherine of Alexandria, about 1538–40

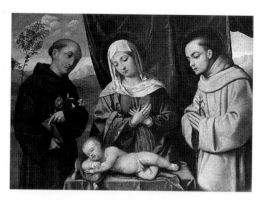

NG 3094
Oil on wood, 44.8 x 62.9 cm

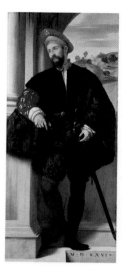

NG 1025
Oil on canvas, 201.3 x 92.1 cm

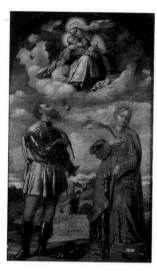

NG 1165
Oil on canvas, painted surface 229.2 x 135.8 cm

Saint Nicholas of Tolentino (about 1245–1305), on the left, wears the black habit of the Augustinian Order and holds a lily and a book. Saint Anthony of Padua (1195–1231) was one of the foremost Franciscan saints. Portuguese by birth, he spent his later years in Padua, where he is said to have had a vision of the Infant Christ when preaching on the Incarnation.

Bought from Count Averoldi of Brescia by Morelli for Sir A.H. Layard, before 1868; Layard Bequest, 1916.

Gould 1975, pp. 162–3; Begni Redona 1988, p. 108.

Dated bottom right: M.D.XXVI (1526).
The sitter, who wears a badge of Saint Christopher in his hat, has not been securely identified. He may be Gerolamo II Avogadro (died 1534), whose descendants married into the Fenaroli family from whose collections NG 1025 was acquired.

NG 1025 is the earliest known example of an independent life-size full-length portrait in Italy.

In the collection of Conte Fenaroli, Brescia, before 1832 (and probably identifiable in the inventory of 1734); bought from Baslini, Milan, 1876.

Gould 1975, pp. 160–1; Begni Redona 1988, pp. 185–7.

Inscribed on illusionistic labels (*cartellini*) at the saints' feet with their names: S. HIPPOLYTVS, S. AECATERINA; and on the broken slab between the saints: ME[M]BRIS DISSOLV(I) / VOLVERUNT / NE VINCULIS / DIVELLERE[N]TUR / AETERNIS (They chose to be parted from their limbs so as not to be torn asunder in everlasting chains).

Saint Catherine of Alexandria is shown with her attribute the wheel and with the sword of her martyrdom; she holds a martyr's palm. Saint Hippolytus, the gaoler of Saint Lawrence (who converted him), is shown in armour.

In an inventory of the late eighteenth century NG 1165 was said to have been commissioned by Canon Conte Tommaso Caprioli for his church at Flero, just south of Brescia. Canon Caprioli died in 1538, but the style and costumes point to a slightly later date and the picture was probably painted after his death.

The Virgin's pose derives from an engraving after a design by Mantegna.

First recorded in an inventory of about 1780–90 (then in the possession of Conte Faustino Lechi of Brescia); subsequently in the collections of Edward Solly and then of William Coningham; presented by Francis Palgrave, 1884.

Gould 1975, pp. 161–2; Begni Redona 1988, pp. 320–1.

MORETTO da Brescia
The Madonna and Child with Saint Bernardino and other Saints, about 1540–54

MORETTO da Brescia
Portrait of a Young Man
about 1542

MORETTO da Brescia
Portrait of a Man at Prayer
about 1545

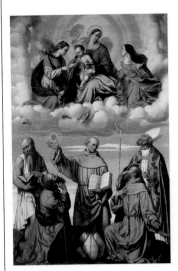

NG 625
Oil on canvas, 355.6 x 232.4 cm

NG 299
Oil on canvas, 113.7 x 94 cm

NG 3095
Oil on canvas, 102.9 x 89.4 cm

Inscribed on the book held by Saint Bernardino: PATER / MANI/FESTA/VI NO/MEN /TVVM / HOMI/NI/BVS (Father, I have broadcast your name - i.e. the name of Jesus - among men); and on the mitres at his feet: VRBINI, SIENE, FERRARIAE (Urbino, Siena, Ferrara).

Saint Bernardino holds his monogram of the name of Jesus (IHS) and a book inscribed with a verse from the New Testament (John 17: 6). The three mitres at his feet allude to the bishoprics which he refused to accept. He is flanked – left to right – by Saints Jerome (identifiable by his lion), Joseph (with his flowering staff), Francis (with the stigmata) and Nicholas of Bari (with the three golden spheres in his left hand). Above are the Virgin and Child between Saint Catherine of Alexandria (on whose finger Christ is placing a ring, a reference to the saint's vision of her 'mystic marriage' to Christ) and Saint Clare (with the monstrance beside her).

The original destination of this altarpiece is not known. It was probably painted for a chapel, or a Franciscan church, dedicated to Saint Bernardino (died 1444). The artist's workshop played a large part in the execution.

Said in 1860 to have been taken from Brescia to Cremona in the late eighteenth century, and to have been bought in 1852 by Lord Northwick from Dr Faccioli of Verona; bought at the sale of Lord Northwick's collection in 1859.

Gould 1975, pp. 158–60; Begni Redona 1988, pp. 357–9.

Inscribed in Greek on the sitter's cap: Alas I desire too much.

The sitter has been identified since the picture's arrival in the National Gallery as a member of the Martinengo family; he may be the accomplished humanist Fortunato Martinengo Cesaresco, who was born in 1512 and married Livia d'Arco in 1542.

It has been suggested that NG 299 was painted at about the time of Fortunato Martinengo's marriage. The costume is apparently datable to the period between the mid-1530s and the mid-1540s.

Sold by Contessa Marzia Martinengo to Conte Teodoro Lechi of Brescia in 1843; from whom bought by Charles Henfrey, Turin, 1854; bought from his collection, 1858.

Gould 1975, pp. 156–8; Begni Redona 1988, pp. 378–81; Begni Redona 1988a, pp. 146–7.

NG 3095 shows a man at prayer; he has tentatively been identified as a member of the Averoldi family on the basis of the picture's provenance from this important Brescian family.

The function of the picture remains unclear. It may be a memorial for a family burial chapel. A copy showing a composition including a table and a crucifix may record the original appearance of NG 3095, but the additions might be those of the copyist.

Bought by Morelli for Sir A.H. Layard from Conte Ettore Averoldi, 1864/5; Layard Bequest, 1916.

Gould 1975, pp. 163–4; Begni Redona 1988, pp. 420–2.

Berthe MORISOT
Summer's Day
about 1879

Domenico MORONE
The Rape of the Sabines (before the signal)
about 1490

Domenico MORONE
The Rape of the Sabines (after the signal)
about 1490

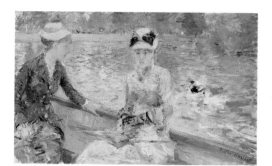

NG 3264
Oil (identified) on canvas, 45.7 x 75.2 cm

NG 1211
Tempera on spruce, 45.4 x 49.2 cm

NG 1212
Tempera on spruce, 45.4 x 49.2 cm

Two models are posed in a boat. The setting has been identified as the northern end of the Lac Inférieur in the Bois de Boulogne, Paris, which was then a fashionable attraction, with its parkland, lakes, racetrack and zoo.

NG 3264 is thought to be the painting Morisot exhibited at the fifth Impressionist exhibition of 1880 with the title 'The Lake in the Bois de Boulogne'. There is a watercolour of the same composition (present whereabouts unknown).

The same models, in identical clothes, also appear in a work by Morisot entitled *In the Bois de Boulogne* (Stockholm, Nationalmuseum) which was exhibited in the same year.

Collection of Bernheim-Jeune, Paris; Durand-Ruel, 1910; bought by Sir Hugh Lane, 1912; Lane Bequest, 1917.

Davies 1970, pp. 110–11; Bomford 1991, pp. 176–81.

Inscribed on a banneret hanging from a trumpet: S.[enatus] P.[opulus] Q.[ue] [Romanus] (By Order of the Senate and the People of Rome).

Four months after the founding of Rome, a chronic shortage of women was threatening the future of the city. Romulus resolved to remedy this situation by announcing the discovery of a buried deity and staging games to celebrate this event. Neighbouring peoples were invited, and the games designed to provide the opportunity for carrying off sufficient young women to give the Romans brides (and children). Plutarch's *Lives* (II, 14). Plutarch specified that the deity was discovered in the Circus Maximus, and that it was normally hidden except during equestrian games. Romulus is enthroned, surrounded by young Roman men. To either side, on a decorated platform and beneath a temporary awning, are the Sabine women who have come to watch the spectacle.

The setting of NG 1211 and 1212 is the same. The walls of the newly founded city of Rome can be seen in the background of both pictures. For the subsequent events and information on the attribution and dating of NG 1211 see NG 1212.

Possibly in the Monga collection, Verona; bought from Guggenheim in Venice by J.P. Richter before 1885; from whom bought, 1886.

Davies 1961, pp. 381–2; Henry 1994, pp. 21–2.

The signal for the rape of the Sabine women to begin was when Romulus stood up and gathered his cloak around him. Plutarch's *Lives* (II, 14). Romulus' entourage of young men have shed their gay cloaks (seen in two piles to either side of him) and are in the act of taking the Sabine women by force. Romulus is also shown (standing) with a Sabine woman (presumably Hersilia) at his side. The action in the foreground is harder to interpret. Some figures seem to be rushing to join the action (probably Romans hoping to find themselves a wife); while a white-haired commander on horseback looks on. On the left a knight, with his sword drawn, charges away from the action, perhaps in pursuit of the rest of the Sabines who were said to have fled when the trap was sprung.

The Rape of the Sabine Women was a subject commonly painted on *cassoni* (or marriage chests), and NG 1211 and 1212 were probably part of such a chest. The attribution to Morone of these two panels is now generally accepted. They have been dated about 1490 on the basis of the fifteenth-century costumes worn.

Possibly in the Monga collection, Verona; bought from Guggenheim in Venice by J.P. Richter before 1885; from whom bought, 1886.

Davies 1961, pp. 381–2; Henry 1994, pp. 21–2.

Berthe MORISOT
1841–1895

Morisot was born in Bourges. She moved with her family to Paris in about 1852. She studied under Guichard who introduced her to Corot, her most important mentor. She first exhibited at the Salon in 1864. Morisot knew a number of the Impressionists, and later participated in their exhibitions. Working in oils, pastels and watercolours, she depicted landscapes and scenes of modern life.

Domenico MORONE
about 1442–after 1518

Domenico Morone was principally active in Verona from 1471 onwards. His works are rare, and include small devotional works, frescoes and an important picture of the *Fight between the Gonzaga and the Buonaccolsi* of 1494 (Mantua, Palazzo Ducale). Francesco Morone was his son and pupil.

Francesco MORONE
The Virgin and Child
probably 1520–9

Giovanni Battista MORONI
Portrait of a Gentleman (Il Cavaliere dal Piede Ferito), probably about 1555–60

Giovanni Battista MORONI
Portrait of a Lady (La Dama in Rosso)
probably about 1555–60

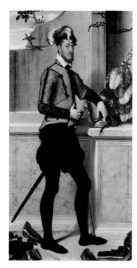

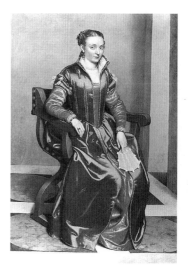

NG 285
Tempera? on spruce, painted surface 62.2 x 43.2 cm

NG 285 has been considered a very late work and has also been associated with a painting of 1503 in S. Maria in Organo, Verona. A date in the 1520s seems most probable. The painting is a fragment of an altarpiece – the foreshortened arms of the Virgin's throne (partly cut) indicate that the Virgin was placed quite high above the viewer.

Elements of the composition recur in other works by Francesco Morone.

Collection of Baron Francesco Galvagna, Venice, by 1844; from where bought, 1855.

Davies 1961, p. 382.

NG 1022
Oil on canvas, 202.2 x 106 cm

NG 1022 has a provenance from the Avogadro-Fenaroli family of Brescia, and the sitter may have been a sixteenth-century member of this family, possibly Pietro or Faustino Avogadro. He wears a brace on his left leg, hence the reference to his 'wounded foot' (*piede ferito*) in the traditional title.

Collection of the Avogadro-Fenaroli family, Brescia, before 1876; bought from Baslini, Milan, 1876.

Gould 1975, pp. 167–8; Braham 1978, p. 30.

NG 1023
Oil on canvas, 154.6 x 106.7 cm

The sitter may have been a member of the Avogadro family of Brescia. She holds an early form of fan in her left hand.

Collection of the Avogadro-Fenaroli family, Brescia, before 1876; bought from Baslini, Milan, 1876.

Gould 1975, p. 168; Braham 1978, p. 30.

Francesco MORONE
about 1471–1529

Francesco Morone, the son and pupil of Domenico Morone, was an important painter of frescoes and altarpieces in Verona. He collaborated with his father from 1496 and was subsequently an associate of Gerolamo dai Libri. He painted important pictures for the church of S. Maria in Organo, near Verona.

Giovanni Battista MORONI
about 1520/4–1578

Moroni was from Albino, near Bergamo. He trained with Moretto in Brescia, and subsequently worked there and later in Bergamo. He is best known as a portraitist (an aspect of his work particularly well represented in the National Gallery), but also painted altarpieces and at least one allegorical picture. Although Moroni appears never to have visited Venice, his work was apparently admired there.

Giovanni Battista MORONI
Portrait of a Gentleman
probably about 1555–60

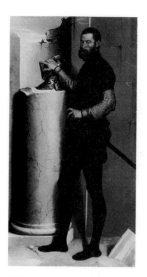

NG 1316
Oil on canvas, 185.4 x 99.7 cm

The man in this portrait has not been identified. The tunic is the kind worn beneath armour, and he rests his hand against a helmet on a broken column. The column shaft may symbolise the sitter's fortitude or, since it is broken, his misfortunes; but slightly ruinous marble settings were common in Moroni's portraiture.

NG 1316 was previously thought to be by Titian, until attributed to Moroni by Sir Charles Eastlake.

Collection of the Earl of Radnor, Longford Castle, by 1853; bought with contributions from Lord Rothschild, Lord Iveagh and Charles Cotes, 1890.

Gould 1975, p. 169; Braham 1978, p. 30.

Giovanni Battista MORONI
Chastity
probably about 1555–60

NG 3123
Oil on canvas, 153.3 x 87 cm

Inscribed on the tablet below the figure's right foot: CASTITAS / INFAMIAE / NVBE / OBSCVRATA / EMERGIT ([Her] Chastity, obscured by a cloud of infamy, shines forth).

NG 3123 either represents the Roman Vestal Virgin Tuccia, or alludes to her example in a generalised allegory of Chastity. When Tuccia's chastity was questioned she proved her innocence by carrying a sieve full of water from the Tiber to the Temple of Vesta as recorded in Pliny's *Natural History* (28: 12), and Petrarch's *Triumph of Chastity*.

NG 3123 is the only known single-figure allegory by Moroni.

Tuccia is also the subject of Mantegna NG 1125.1.

Manfrin collection, Venice, before 1856; from where bought by Sir A.H. Layard, 1880; Layard Bequest, 1916.

Gould 1975, pp. 170–1; Braham 1978, p. 30.

Giovanni Battista MORONI
Canon Ludovico di Terzi
probably about 1560–5

NG 1024
Oil on canvas, 100.2 x 81.3 cm

Inscribed on the letter: Al Molto R.[everen]do M[esser] Lud.[ovi]co di Terzi / Can.[oni]co. di B[er]gomo Dig.[nissim]o et Proth.[onotari]o / ap.[ostoli]co Sig.[no]r mio osser.[visi]mo / B[er]gomo. (To the Most Reverend Master Ludovico di Terzi, Worthy Canon of Bergamo and Apostolic Protonotary, my most highly regarded lord, Bergamo).

Ludovico di Terzi was a prominent churchman in Bergamo. The Terzi family came from Sforzatica, near Bergamo. Having studied law (probably at Padua from before 1537 until 1540) Ludovico was appointed apostolic protonotary at an unknown date, and was recorded as a canon of the cathedral in Bergamo from 1539 to 1582. He probably died in 1583.

NG 1024 would appear to show a man in his mid-40s and has accordingly been dated in the early 1560s.

Probably in the Terzi collection, Bergamo, by 1648; subsequently in the Avogadro collection, Bergamo; bought from Baslini, Milan, 1876.

Gould 1975, p. 168; Braham 1978, pp. 16, 18–19, 35; Bomford 1979, pp. 34–42; Gregori 1979, pp. 126–8.

Giovanni Battista MORONI
Portrait of a Man
probably about 1560–5

Giovanni Battista MORONI
Portrait of a Gentleman ('Il Gentile Cavaliere')
probably about 1565–70

Giovanni Battista MORONI
Portrait of a Man
probably about 1565–70

NG 3129
Oil on canvas, 47 x 39.7 cm

Inscribed along the parapet at the bottom of the canvas: DVM SPIRITVS / HOS REGET ARTVS (So long as breath commands by being...); below is another, possibly later, inscription: ANNOR / XXX (Year 30 – indicating the sitter's age).

The sitter was described, when the picture was sold to Sir A.H. Layard (see provenance), as a member of the Lupi family. The Lupi were a leading family in Bergamo. The inscription is from Virgil's *Aeneid* (IV, 336) and the words are spoken by the hero Aeneas when he parts from Queen Dido, claiming that he will never forget her.

Bought from Count Lupi of Bergamo by Sir A.H. Layard before 1868; Layard Bequest, 1916.

Gould 1975, pp. 171–2; Braham 1978, p. 36.

NG 2094
Oil on canvas, 99 x 80 cm

Inscribed (largely illegibly) on the letter, lower right: Al . . . Sg Berg[amo] (To Lord ... Bergamo).

The sitter is unidentified; he wears fashionable costume, which apparently shows French and Spanish influence.

Collection of John Samuel by 1868; bequeathed by the Misses Cohen as part of the John Samuel collection, 1906.

Gould 1975, p. 169; Braham 1978, p. 37.

NG 3128
Oil on canvas, 42.6 x 37.5 cm

This unidentified sitter is wearing chain-mail sleeves and a tunic of a type worn under a breast plate.

NG 3128 is probably not a fragment, but an independent portrait.

Bought by Morelli (from Mündler) for Sir A.H. Layard before 1869; Layard Bequest, 1916.

Gould 1975, p. 171; Braham 1978, p. 37.

Giovanni Battista MORONI
Portrait of a Man ('The Tailor')
about 1570

Giovanni Battista MORONI
Leonardo Salvagno (?)
1570s

Giovanni Battista MORONI
Portrait of a Man holding a Letter ('The Lawyer')
probably 1570–5

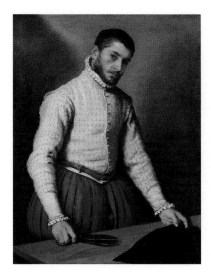

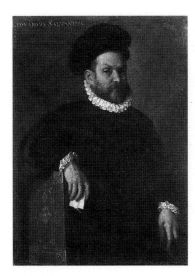

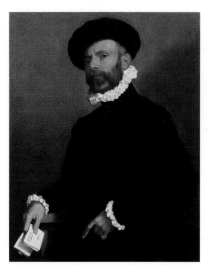

NG 697
Oil on canvas, 97.8 x 74.9 cm

NG 3124
Oil on canvas, 98.5 x 71.4 cm

NG 742
Oil on canvas, 81.3 x 64.8 cm

NG 697 has been described as 'The Tailor' (*un Sartor*) since the mid-seventeenth century and it does seem to be a portrait of a tailor at work. The black cloth (as worn by Moroni's more fashionable sitters at this time) is marked in white for cutting, and the tailor holds his shears ready to cut the cloth.

Described in the Palazzo Grimani, Venice, 1660; bought from Federigo Frizzoni, Bergamo, 1862.

Gould 1975, pp. 165–6; Braham 1978, p. 37; Campbell 1990, pp. 90, 98.

Inscribed top left (perhaps not original): LEONARDVS SALVANEVS (Leonardo Salvagno); and on the book: AC CIVITATIS / BERGOMI / PRIVILEGIA (The privileges of the City of Bergamo).

There is some doubt as to whether the inscription identifying the sitter can be relied upon. Another inscription may be below the present one.

NG 3124 is probably datable from the costume to the early 1570s, and was presumably painted in Bergamo. It is damaged and partly repainted.

Thieni collection, Vicenza, before 1865; purchased by Sir A.H. Layard before 1869; Layard Bequest, 1916.

Gould 1975, pp. 170–1; Braham 1978, p. 38.

Inscribed on the letter: Al Mag° Sig.ʳ Juli-. . . . / Sp... / R..... (To the most honourable Lord Julius ...).

The sitter has not been identified. He was once described as a lawyer on the basis that the contraction 'Mag°ʳ' should be read as *Magistrato* (Magistrate). Suggestions for the place name at the end of the inscription have included the following north Italian towns: Rovato, Rovetta, Roncola, Rancia and Romano.

Possibly from the Tomini collection, Bergamo; collection of Conte Teodoro Lechi, Brescia, by 1814; bought by James Irvine, 1827; bought from the collection of Charles-Edouard de Portalès, 1865.

Gould 1975, pp. 166–7; Braham 1978, p. 38; Gregori 1979, p. 210.

Attributed to MORONI
An Angel
possibly about 1545–55

NG 2091
Oil on wood, 151.1 x 53.3 cm

Inscribed at the bottom: AVE REGINA (Hail Queen).
 NG 2091 was the outside face of a shutter, probably from a triptych. It faced NG 2090, and was on the reverse of NG 2092.
 See commentary under NG 2093.

Apparently in the collection of G. Morelli by 1894; bequeathed by the Misses Cohen as part of the John Samuel collection, 1906.

Gould 1975, pp. 172–4; Braham 1978, p. 38; Begni Redona 1988, pp. 531–2.

Attributed to MORONI
An Angel
perhaps about 1545–55

NG 2090
Oil on wood, 151.1 x 53.3 cm

Inscribed at the bottom: COELORVM (of Heaven)
 NG 2090 was the outside face of a shutter, probably from a triptych. It faced NG 2091, and was on the reverse of NG 2093.
 See commentary under NG 2093.

Apparently in the collection of G. Morelli by 1894; bequeathed by the Misses Cohen as part of the John Samuel collection, 1906.

Gould 1975, pp. 172–4; Braham 1978, p. 38; Begni Redona 1988, pp. 531–2.

Attributed to MORONI
Saint Joseph
perhaps about 1545–55

NG 2092
Oil on wood, 151.1 x 53.3 cm

Inscribed at the bottom: S. IOSEPH.
 NG 2092 was the inside face of a shutter, probably from a triptych. It was on the reverse of NG 2091, and would have been on the left of the missing central image of the Virgin Mary, when the triptych was open. Joseph holds the staff which miraculously broke into blossom demonstrating that he (among the Virgin Mary's many suitors) was chosen to be her husband.
 See commentary under NG 2093.

Apparently in the collection of G. Morelli by 1894; bequeathed by the Misses Cohen as part of the John Samuel collection, 1906.

Gould 1975, pp. 172–4; Braham 1978, p. 38; Begni Redona 1988, pp. 531–2.

Attributed to MORONI
Saint Jerome
perhaps about 1545–55

NG 2093
Oil on wood, 151.1 x 53.3 cm

Inscribed at the bottom: S. HIERONIMVS.
 NG 2093 was the inside face of a shutter, probably from a triptych. It was on the reverse of NG 2090, and would have been on the right of the missing central image of the Virgin Mary, when the triptych was open. A similar triptych attributed (to Moretto or Moroni) shows the *Assumption of the Virgin* as the central image (Milan, Brera).
 It has recently been maintained that NG 2090–93 are in fact works from Moretto's studio, probably dating from about 1545–55. The attribution to Moroni relies on the fact that Moroni was the leading artist in Moretto's studio at this time.

Apparently in the collection of G. Morelli by 1894; bequeathed by the Misses Cohen as part of the John Samuel collection, 1906.

Gould 1975, pp. 173–4; Braham 1978, p. 38; Begni Redona 1988, pp. 531–2.

Jan MOSTAERT
The Head of Saint John the Baptist, with Mourning Angels and Putti, early 16th century

NG 1080
Oil on oak, 26 x 17.1 cm

Saint John the Baptist was decapitated at the request of Salome, whose dancing so pleased Herod. New Testament (Mark 6: 21–8). She appears receiving the head in the medallion at the right. In the medallion at the left, Saint John is shown baptising Christ. The lower scenes appear to show Saint John preaching, the calling of Saint Andrew, and at the right Saint John again, with two figures, one of whom may be a donor. The clothes of some of the angels above are decorated with white crosses which recall the Maltese cross of the Order of Saint John of Jerusalem.

Collection of Karl Aders, London, 1831; bequeathed by Mrs Joseph H. Green, 1880.

Davies 1968, pp. 132–3.

Style of MOSTAERT
Christ Crowned with Thorns
after 1510

NG 3900
Oil on oak, 30.5 x 21 cm

Christ has his hands tied, wears the crown of thorns, and carries instruments of his Flagellation – a stick and a bundle of twigs.
 NG 3900 is one of several versions of this composition, all connected with, and perhaps derived from, the figure on the left wing of the Oultremont Triptych of about 1510 (Brussels). It may be a later copy.

Collection of Henry Willett, Brighton, by 1892; bought by Henry Wagner, 1905; by whom presented, 1924.

Davies 1968, pp. 133–4.

Jan MOSTAERT
about 1472/3–1555/6

Mostaert worked from 1498 in Haarlem. He was in the service of Margaret of Austria in 1519. The artist returned to Haarlem and was in Hoorn in 1549; his works are related stylistically to those of Geertgen tot Sint Jans.

Frederick de MOUCHERON
A Landscape with Classical Ruins
about 1660

NG 1352
Oil on canvas, 71 x 65.2 cm

Signed on the architrave: F DE MOUCHERON.
A herdsman converses with a woman who holds a child in the left foreground.
Similarities between this work and paintings by de Moucheron's master Jan Asselijn (died 1652), such as his *Shepherd and Shepherdess amidst Ruins* (Dresden) are striking. NG 1352 is probably a relatively early work by the artist, painted in about 1660.

Charles William Harrison Pickering sale, London, 1881; bequeathed by Richard W. Cooper, 1892.

MacLaren/Brown 1991, p. 274.

Frederick de MOUCHERON
Figures in an Italian Garden with Fountains and Statuary, probably 1665–70

NG 842
Oil on canvas, 73.7 x 93.2 cm

Signed bottom left: Moucheron.f.
This Italianate garden appears not to be based on a particular site.
NG 842 can be dated by comparison with de Moucheron's *Landscape with Narcissus* of 1668 (The Hague, Thurkow collection). Houbraken records that Adriaen van de Velde often painted the figures in de Moucheron's landscapes; the figures here are almost certainly by him (compare Adriaen van de Velde NG 869).

Collection of Sir Robert Peel, Bt, by 1845; bought with the Peel collection, 1871.

MacLaren/Brown 1991, p. 274.

Bartolomé Esteban MURILLO
The Infant Saint John with the Lamb
1660–5

NG 176
Oil on canvas, 165 x 106 cm

Inscribed on the scroll of the cross on the ground: ECCE AGNVS DEI ('Behold the Lamb of God').
The infant Baptist stands in the wilderness embracing the lamb, a symbol of Christ. New Testament (John 1: 29 and 36).
NG 176 is the companion to the *Infant Christ as the Good Shepherd* (private collection, on loan to the Birmingham Museum and Art Gallery); the two pictures were together until 1840. They decorated the altar erected in the Plaza de S. Maria la Blanca in Seville in 1665 during the festivities for the church's inauguration, and were presumably painted shortly before.

Collection of the Comte de Lassay (died 1750); bought from Lord Ashburton, 1840.

MacLaren/Braham 1970, pp. 65–7; Marqués 1982–3, pp. 175–6, no. 35.

Frederick de MOUCHERON
1633–1686

The artist was born in Emden. He was probably a pupil of Jan Asselijn in Amsterdam, and travelled to Paris, Lyon and Antwerp before returning to Amsterdam, where he died. De Moucheron was a painter of Italianate landscapes which are related to the work of Jan Both and Adam Pynacker.

Bartolomé Esteban MURILLO
1617–1682

Murillo was the leading artist in Seville in the later seventeenth century. His first dated work is of 1646; the artist is recorded in Madrid in 1658. Influenced by Zurbarán, Velázquez, Rubens and Van Dyck, he painted many works for religious foundations in and around Seville. He also painted some influential genre pictures of children.

Bartolomé Esteban MURILLO
Portrait of Don Justino de Neve
1665

NG 6448
Oil on canvas, 206 x 129.5 cm

Inscribed beneath the coat of arms: ETATIS SVAE. 40/ Bartholome Murillo Romulensis/ Praecirca obsequium desiderio pingebat/ A.M. (D.) C.L.X.V. (Bartolomé Murillo of Seville (Romulensis)/was painting [this] at the request [of the sitter while] in [his] service. 1665.)

The sitter was a canon and prebendary of Seville Cathedral. He was a friend and patron of the artist, and one of the executors of his will. His arms appear above the inscription; this area may be an early addition.

The inscription apparently refers to work carried out by Murillo at Don Justino's instigation – probably the series of canvases he painted for S. Maria la Blanca in Seville. This commission was completed in 1665, the date recorded on the portrait.

Left in Don Justino's will to the Hospital of the Venerables Sacerdotes, Seville – there from 1685; confiscated during the French occupation of Seville, reached England before 1818; George Watson Taylor sale, 24 July 1832; Lord Lansdowne; bought from the Trustees of the Bowood collection through Agnew's, 1979.

Braham 1981, pp. 86–7.

Bartolomé Esteban MURILLO
Christ healing the Paralytic at the Pool of Bethesda
1667–70

NG 5931
Oil on canvas, 237 x 261 cm

Jesus stands to the left with Saints Peter and John and a third apostle; the paralysed man is on the ground before him by the Pool of Bethesda, seen on the right. Christ said to him, 'Rise, take up thy bed, and walk.' New Testament (John 5: 2–8). The encounter is used here as an illustration of visiting the sick.

This is one of a series of paintings by Murillo for the church of the hospital of La Caridad (Charity) in Seville, commissioned by Miguel de Mañara. Murillo became a member of the confraternity of the Caridad in 1665. His six largest pictures in the church (two of which are still *in situ*) represent, together with the sculpted altarpiece showing the Entombment of Christ, the seven cardinal Acts of Charity. Murillo was paid for the six canvases between 1670 and 1674; NG 5931 was one of the four for which he received 8,000 reales each in 1674. It was painted between 1667 and 1670, when it is recorded as installed in the church.

Church of the Hermandad de la Caridad, Seville, until 1810; Marshal Soult collection, Paris, until 1835; presented through the NACF in memory of W. Graham Robertson, 1950.

MacLaren/Braham 1970, pp. 67–70; Marqués 1982–3, pp. 181–2, no. 45.

Bartolomé Esteban MURILLO
Self Portrait
probably 1670–3

NG 6153
Oil on canvas, 122 x 107 cm

Inscribed on a tablet: Bart.us Murillo seipsum depin/gens pro filiorum votis acpreci/bus explendis (Bart(olo)mé Murillo portraying himself to fulfil the wishes and prayers of his children/sons).

The artist has depicted himself in an oval frame, upon which he rests his hand. On the ledge are attributes of his profession: at the right a palette with brushes, and at the left a drawing, red chalk, a compass and a ruler.

As the inscription declares, NG 6153 was painted for Murillo's children. It can probably be dated to the early 1670s, when the artist was in his fifties. It is one of two self portraits by Murillo recorded by Palomino, his first biographer, in 1724. Another self portrait by him is in an American private collection. NG 6153 was engraved (in reverse) by Richard Collin in Brussels in 1682, the year of Murillo's death, at the instigation of Nicolas Omazur, a poet and silk merchant from Antwerp who sat for a portrait by Murillo in about 1672.

The composition was probably suggested by the engraved portraits on the frontispieces of many books of the time.

Presumed to have been inherited by the artist's son Gaspar, and taken to Brussels, 1682; Frederick, Prince of Wales by 1747; Lord Ashburnham, 1794; Earl Spencer, Althorp House, 1851; bought, 1953.

MacLaren/Braham 1970, pp. 71–4; Marqués 1982–3, p. 188, no. 61; Iñiguez 1982, pp. 322–4.

Bartolomé Esteban MURILLO
A Peasant Boy leaning on a Sill
1670–80

Bartolomé Esteban MURILLO
The Two Trinities ('The Pedroso Murillo')
about 1675–82

Attributed to MURILLO
Saint John the Baptist in the Wilderness
1660–70

NG 74
Oil on canvas, 52 x 38.5 cm

NG 13
Oil on canvas, 293 x 207 cm

NG 3938
Oil (identified) on canvas, 120 x 105.5 cm

This depiction of a smiling boy is a genre study rather than a portrait.

The style of NG 74, with its lively brushstrokes, is of Murillo's later years.

This work may be a pendant to *A Girl raising her Veil* (London, Carras collection). The two pictures were perhaps the ones recorded together in 1737, but it is possible that the painting of the girl was cut down in order to relate to this picture.

Possibly Comtesse de Verrue sale, Paris, 1737; presented by M.M. Zachary, 1826.

MacLaren/Braham 1970, pp. 64–5; Marqués 1982–3, p. 193, no. 71; Iñiguez 1982, pp. 297–8.

The subject is the Heavenly and Earthly Trinities. The Holy Family is shown as a counterpart on earth to the Heavenly Trinity. God the Father dominates the top half of the composition, attended by angels. Below him hovers the dove, symbolising the Holy Ghost. The Christ Child stands below the dove, between the Virgin and Saint Joseph, who holds a flowering rod. The composition is based on a print by Hieronymus Wienix (1553–1619).

According to Palomino, Murillo's eighteenth-century biographer, the artist painted a number of works for Cadiz, where he died in 1682. NG 13 is first recorded in the Marqués del Pedroso collection in Cadiz, in the early eighteenth century. The style of the work suggests that it is one of Murillo's last pictures.

The artist also treated the subject earlier in about 1640 (Stockholm, Nationalmuseum).

Collection of Don Carlos Francisco Colarte, 2nd Marqués del Pedroso, Cadiz, 1708; bought in London, 1837.

MacLaren/Braham 1970, pp. 61–3; Iñiguez 1982, pp. 174–5.

Inscribed on the scroll on the saint's reed cross: ECCE AGN [US] (Behold the Lamb).

The saint is here shown in the wilderness and dressed in camel hair. New Testament (Matthew 3: 1–4; Mark 1: 4–6). (For another depiction of the saint by Murillo see NG 176.)

This painting achieved some fame as a devotional image in the eighteenth century, and it was briefly in the collection of Thomas Gainsborough (1787–9). NG 3938 was formerly considered the work of a follower of Murillo; it is now attributed to the artist himself.

Said to be the picture bought from Don Juan del Castillo by Don Francisco Eminente for Charles II of Spain, about 1670; Mond Bequest, 1924.

MacLaren/Braham 1970, pp. 80–1.

MURILLO and Studio
The Immaculate Conception of the Virgin
17th century

Style of MURILLO
A Young Man Drinking
1700–50

After MURILLO
The Birth of the Virgin
after 1804

NG 1257
Oil on canvas, 26.6 x 45.2 cm

NG 3910
Oil on canvas, 211 x 126 cm

NG 1286
Oil on canvas, 62.8 x 47.9 cm

The Immaculate Conception (the belief that the Virgin was conceived without Original Sin) was a subject which became very popular in Spain, and especially in Seville in the seventeenth century. She is identified with the Woman of the Apocalypse, hence her appearance in the sky 'clothed with the sun, and the moon under her feet', New Testament (Revelation 12: 1). In 1618 a Papal Bull encouraging the cult of the Immaculate Conception was published in Seville but it was only in 1854 that the Church defined it as dogma. Murillo painted the image on a number of occasions (for examples by other artists in the Collection see Valdes Leal NG 1291, Velázquez NG 6264, and Crivelli NG 906).

NG 3910 was once thought to be by an imitator of the artist, but cleaning has revealed the participation of Murillo himself.

The figure of the Virgin repeats with slight variations that in Murillo's picture in the church of S. Catalina, Capuchin monastery, Cadiz.

Possibly acquired from the convent at Córdoba for King Louis-Philippe, about 1835–7; bequeathed by Joseph Trueman Mills, 1924.

MacLaren/Braham 1970, pp. 78–80.

This genre study shows a youth with vine leaves wrapped around his head clasping a wine bottle and drinking from a glass.

NG 1286 may be a copy of a lost original by Murillo, or an imitation of his work, perhaps by a French painter of the first half of the eighteenth century.

Possibly Duc de Tallard sale, Paris, 1756; possibly collection of the Prince de Talleyrand; certainly collection of Lord Charles Townsend before 1835; bequeathed by John Staniforth Beckett, 1889.

MacLaren/Braham 1970, pp. 81–3.

In the centre of the composition is the infant Virgin, surrounded by women and angels. In the left background, Saint Anne lies in bed, and Saint Joachim is seated near her.

NG 1257 is a reduced copy of the work painted by Murillo in 1655 for Seville Cathedral (now Paris, Louvre). It can be dated to after 1804 because it has been found by technical analysis to include the use of a blue pigment, called 'Thénard's blue', which was not available until that year.

Said to have been in the collection of the Duchesse de Berry; presented by Lord Savile, 1888.

MacLaren/Braham 1970, p. 77.

Jean-Marc NATTIER
Portrait of a Man in Armour
about 1750

Jean-Marc NATTIER
Manon Balletti
1757

Nazario NAZARI
Andrea Tron
before 1773

NG 5587
Oil on canvas, 54 x 44.5 cm

NG 5586
Oil on canvas, 54 x 47.5 cm

NG 1102
Oil (identified) on canvas, 249.6 x 165.9 cm

A bust-length portrait of an unidentified sitter who wears the insignia of a knight of the military Order of Saint-Louis (instituted 1693).

The portrait may have been cut down from a larger picture.

Bequeathed by Miss Emilie Yznaga, 1945.

Davies 1957, pp. 164–5.

Signed and dated right: Nattier. p.x./ 1757. (Nattier painted this 1757.)

Marie-Madeleine, called Manon (1740–76), was the daughter of a well-known actress, Sylvia Balleti, who was in the Italian company in Paris. Manon was romantically linked with Casanova, but in 1760 married the architect Jacques-François Blondel (1705–74). The identification is based on family tradition (see provenance), and the artist exhibited a portrait called *Mlle Balety* (no. 25) at the 1757 Salon.

Acquired from the descendants of the sitter by the Duchess of Manchester, 1907; passed to her sister Miss Emilie Yznaga; by whom bequeathed, 1945.

Davies 1957, p. 164; Wilson 1985, p. 102.

Andrea Tron (1712–85) was Venetian ambassador to Paris (1745–8) and Vienna (1748–51). He was elected a Procurator of S. Marco in February 1773 and became a notable figure in Venetian politics. He narrowly missed being elected doge. Here he is depicted as a *Cavaliere della stola d'oro* – he wears the insignia across his left shoulder. This honour was usually bestowed by the Senate when an ambassador returned to Venice, and Tron may have received it after returning from Paris in 1748 (see also Tintoretto NG 4004). The identity of the sitter is confirmed by the Tron coat of arms on the surmount of the original frame (the only part of it which survives), and by an engraving by Felice Zuliani after the picture giving the subject's name.

This engraving was issued in 1773, and so NG 1102 must pre-date that year.

At the death of the sitter passed to Caterina Dolfin-Tron; bought from Guggenheim in Venice, 1881.

Levey 1971, pp. 164–5.

Jean-Marc NATTIER
1685–1766

The son of the portraitist Marc Nattier and the miniaturist Marie Courtois, Nattier was born and worked all of his life in Paris. He studied at the Académie of which he became a member in 1718. He became a fashionable portrait painter, patronised especially by the women of Louis XV's court.

Nazario NAZARI
1724–after 1793

The artist was probably born in Venice. He was trained by his father Bartolomeo Nazari, who specialised in portraiture in oil and pastel. Nazari is recorded in Bergamo in 1750–5, but otherwise worked in Venice, where he painted mostly portraits of notable figures, including the doge.

Pieter NEEFFS the Elder
View of a Chapel at Evening
about 1640–5

NG 2207
Oil on oak, 28.6 x 21.6 cm

Pieter NEEFFS the Elder and Bonaventura PEETERS the Elder
An Evening Service in a Church 1649

NG 2206
Oil on oak, 26.8 x 38.2 cm

Aert van der NEER
A River near a Town, by Moonlight
about 1645

NG 239
Oil on oak, 30.3 x 48.4 cm

The church has not been identified, and may be an invention of the artist. Candles are being lit on the altar and a service (probably Benediction if it is evening) is about to begin. The painting on the high altar is a Holy Family.

NG 2207 is a variant of the left half of NG 2206 by Pieter Neeffs and Bonaventura Peeters. The figures are by a different hand, perhaps in the style of Pieter Snayers (1582–1667). The costumes suggest a date in the early 1640s. In the eighteenth and nineteenth centuries NG 2207 was attributed to Hendrick van Steenwyck.

In the collection of the 4th Duke of Marlborough, perhaps by 1777 and certainly by 1862; Blenheim Palace sale, Christie's, 24 July 1886, (lot 49); bequeathed by Henry Calcott Brunning, 1907.

Martin 1970, pp. 99–101.

Signed and dated: PEETER. NEEFFS. / 1649
The church has not been identified, and may be an invention of Pieter Neeffs. A service (probably Benediction if it is evening) is about to begin.

NG 2206 is one of a series of church interiors by Pieter Neeffs the Elder (or his studio) in which the figures are by other artists. Here the figures and the statues are by Bonaventura Peeters the Elder (1614–52). There are numerous variants by Neeffs of NG 2206. This type of composition was first developed by Hendrick van Steenwyck the Younger.

Sir William W. Knighton sale, Christie's, 23 May 1885; bequeathed by Henry Calcott Brunning, 1907.

Martin 1970, pp. 101–3.

Signed bottom left: AV DN (in two monograms).
A vessel on the left flies a flag with the Dutch colours.

Van der Neer's work is difficult to date with any precision but this picture was probably painted in the mid-1640s. There are a number of other versions of this composition by him.

Collection of Robert Heathcote by 1805; bequeathed by Lord Colborne, 1854.

MacLaren/Brown 1991, p. 276.

Pieter NEEFFS the Elder
active 1605–1656/61

Pieter Neeffs the Elder was probably born in Antwerp, where he worked. He may have been taught there by Hendrick van Steenwyck the Elder. He painted church interiors, in which the figures were normally executed by other artists. Two of his sons, Lodewijk and Peeter, were also painters: they worked in his style and were his assistants.

Aert van der NEER
1603/4–1677

Aert– or Aernout – van der Neer was first recorded in Gorinchem, and only devoted himself to painting when he moved to Amsterdam in about 1630. His earliest dated picture is of 1632. He was a painter of moonlit landscapes, winter scenes, landscapes at dawn and dusk, and nocturnal fires.

Aert van der NEER
A Village by a River in Moonlight
about 1645

Aert van der NEER
An Evening Landscape with a Horse and Cart by a Stream, about 1645–55

Aert van der NEER
A River Landscape with a Village
probably about 1645

NG 2536
Oil on oak, 19.7 x 28.3 cm

NG 2537
Oil on canvas, 52.3 x 63.5 cm

NG 2534
Oil on oak, 28.4 x 43.2 cm

Signed (probably falsely) bottom left: AV DN (in two monograms).

This moonlight scene has not been identified and is probably not intended to be topographically accurate.

Van der Neer's early work was influenced by the landscape painters Joachim (1602–59) and Raphael (1598–1657) Camphuysen whom he knew in Gorinchem.

Collection of George Salting, London; Salting Bequest, 1910.

MacLaren/Brown 1991, pp. 279–80.

Another cart can be seen in the background.

Collection of Alexis-Joseph Febvre by 1882; collection of George Salting, London; Salting Bequest, 1910.

MacLaren/Brown 1991, p. 280.

Signed (perhaps falsely) bottom right: AV N (AV in monogram).

A man on horseback can be seen riding along the towpath of the river.

Probably bought from Sulley by George Salting, 1904; Salting Bequest, 1910.

MacLaren/Brown 1991, p. 279.

Aert van der NEER
A Frozen River near a Village, with Golfers and Skaters, about 1648

Aert van der NEER
An Evening View near a Village
about 1650

Aert van der NEER
A Landscape with a River at Evening
about 1650

NG 1288
Oil on canvas, 39.5 x 53 cm

NG 152
Oil on canvas, 121.5 x 162.5 cm

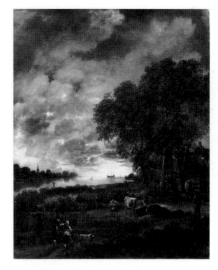

NG 2283
Oil on canvas, 79 x 65.1 cm

Signed on a rock bottom left: AV DN (in two monograms).

The site has not been identified and the painting was probably not intended to be topographically accurate.

Sold by Rutley to John Staniforth Beckett, 1853; by whom bequeathed, 1889.

MacLaren/Brown 1991, p. 278.

Signed bottom left on a tree trunk: AV DN f in two monograms).

A milkmaid carrying pails of milk has stopped to talk to a man who also has a yolk on his shoulders. The time of day appears to be early evening.

NG 152 once bore a false Cuyp signature.

Collection of Lucien Bonaparte by 1812; in England in 1815, and subsequently in the collections of Chevalier Erard, Passy and, by 1834, Lord Farnborough; by whom bequeathed, 1838.

MacLaren/Brown 1991, pp. 275–6.

Signed bottom centre: AV DN (in two monograms).

The sun appears to set beyond a river and its last rays are reflected on the figures and cattle.

NG 2283 was probably painted in the late 1640s or early 1650s.

Collection of Ramsay Richard Reinagle by 1832; bought by R.C.L. Bevan, 1832; purchased by Martin H. Colnaghi, 1892 (probably from the heirs of R.C.L. Bevan); bequeathed by Martin H. Colnaghi, 1908.

MacLaren/Brown 1991, pp. 278–9.

Aert van der NEER
A View along a River near a Village at Evening
1660s

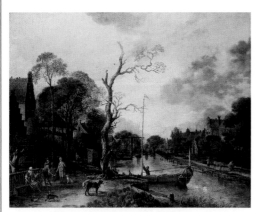

NG 732
Oil on canvas, 133.5 x 167.5 cm

Aert van der NEER
A Frozen River by a Town at Evening
about 1665

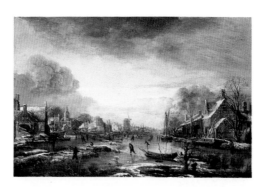

NG 969
Oil on oak, 26.4 x 40.5 cm

Eglon Hendrik van der NEER
Judith
about 1678

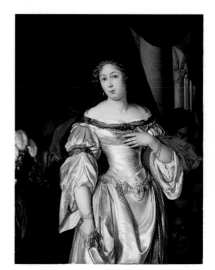

NG 2535
Oil on oak, 32 x 24.6 cm

Signed on the barge in the right foreground: AV DN (in two monograms).

NG 732 may show a view along the river Vecht, but the site has not been securely identified, and the view may not be topographically accurate. The *trekjacht* (a yacht which travelled along the canals between the main towns of the United Provinces drawn by a horse) in the foreground, which flies a Dutch flag, has the arms of Amsterdam on its stern.

NG 732 is one of van der Neer's largest paintings.

Perhaps in the [van Haeften] sale, Leiden, 1764; collection of the Earl of Shaftesbury, London, by 1857; from whom bought, 1864.

MacLaren/Brown 1991, p. 277.

Signed at the bottom, left of centre: AV DN (in two monograms).

Van der Neer specialised in landscapes seen by moonlight or evening light. This example was probably painted in the mid-1660s.

Wynn Ellis Bequest, 1876.

MacLaren/Brown 1991, p. 278.

Signed on the blade of the sword: E. Vander Neer fe [or fc]

Nebuchadnezzar's general Holofernes and the Assyrian army were besieging the town of Bethulia in Judah. Judith, a widow of Bethulia, realised that the town would fall, and went out to the Assyrian camp to save her people. She was left alone with Holofernes in his tent after he had consumed large quantities of wine. As he slept Judith took down his sword and cut off his head. Apocryphal Book of Judith (13: 6–10). In NG 2535 the body of Holofernes is on the bed, and Judith's maid is putting his head into a sack. The prominence of the figure of Judith and the portrait character of her face make it likely that this is a portrait of a young woman in the guise of the Jewish heroine.

The figure of Judith can be compared with a female lute player in a picture of 1678 (Munich, Alte Pinakothek). NG 2535 was probably painted at about that time.

Possibly Destouches collection by 1794; collection of George Salting, 1880; Salting Bequest, 1910.

MacLaren/Brown 1991, p. 281.

Eglon Hendrik van der NEER
1634?–1703

Eglon Hendrik van der Neer trained with his father Aert van der Neer and Jacob van Loo. He was active in Rotterdam until 1679, and then in Brussels (1679–89) and Düsseldorf (1690–1703) where he became court painter to the Elector Palatine. He painted genre and history paintings, as well as portraits and landscapes.

NETHERLANDISH
A Young Man holding a Ring
probably 1450–60

NETHERLANDISH
Philip the Fair
about 1493–5

NETHERLANDISH
Margaret of Austria
about 1493–5

NG 2602
Oil on oak, 17.8 x 12.4 cm

NG 2613.1
Oil on oak, painted surface, 22.6 x 15.5 cm

NG 2613.2
Oil on oak, painted surface, 23.2 x 15.2 cm

In the background is a repeating design of rain falling from clouds; beneath each repeat is an inscription: har. las. uber. gan (Lord, let [them] pass over).

The sitter has not been identified.

NG 2602 was perhaps painted in about 1450–60. The dialect of the inscription is perhaps from the frontiers of Holland and Germany.

Anon. (Salter?) sale, Christie's, 1905; bought by Fairfax Murray; Salting Bequest, 1910.

Davies 1953, pp. 7–9; Davies 1968, p. 146.

Inscribed above and beside Philip's head: Ph[ilippu]s dei gra[tia] archi/ dux austrie/ dux (b)urg[und]ie. The coats of arms are inscribed: (Au)stria, Stiri (a),/ (Carn)iole (i.e. Krain), Carintie, Tirole, Cili (i.e. Cilli, Celje), / Habsbu(r)g, Schelckli[n]gen, Alsatie, / Slauonice (i.e. Slavonia), Burgou (i.e. Burgau, near Günzburg), / Kiburg (i.e. Kyburg), Phirt (ie. Pfirt, Ferrette), / Terraentia (i.e. Upper Austria), Port[us] Nauonis (i.e. Pordenone), / Nelle[n]burg, Orte[n]burg.

Philip the Fair (1478–1506) became Philip I of Castile; he wears the collar of the Golden Fleece. His sister, Margaret of Austria (1480–1530), depicted in NG 2613.2, became Regent of the Netherlands. The arms at the top of his panel are his; those at the top of hers show on one side the same arms and on the other a blank area, signifying that she is an unmarried woman. The other coats of arms are of territories which belonged to the House of Austria.

From the arms and inscriptions, it can be established that NG 2613.1-2 was painted in about 1493–5. This is confirmed by a diptych of the same sitters at Schloss Ambras, on the frame of which their ages are written as 16 and 14, so dating it to about 1494. The commission of the Schloss Ambras picture and the present painting was perhaps connected with a proposed double marriage into the Spanish royal house.

Chigi Collection, Rome; Salting Bequest, 1910.

Davies 1953, pp. 10–15; Davies 1968, pp. 146–50.

Inscribed above and beside Margaret's head: Margareta filia/ Regis/ Romanoru. The coats of arms are inscribed: B(o)urgu[n]dia (i.e. the Duchy), Lotheringia (i.e. Lorraine), / Braba[n]tia, Limburgia, Luxe[m]burgia, Gheldres (i.e. Guelders). / Flandria, Bourgu[n]dia (i.e. Franche Comté), Artesium (i.e. Artois)/ Ha[n]nonia (i.e. Hainault), Namurcu[m], / Holla[n]dia, Zeela[n]dia, / Zutphania (ie. Zutphen), Frisia, / Salins, Malins (i.e. Malines). Some of the inscriptions are inaccurate: the arms labelled Schelklingen are really those of Upper Austria, and those labelled Terraentia are those of Ehingen.

See NG 2613.1 for discussion.

Chigi collection, Rome; Salting Bequest, 1910.

Davies 1953, pp. 10–15; Davies 1968, pp. 146–50.

NETHERLANDISH

The Virgin and Child with Saints and Angels in a Garden, about 1500

NETHERLANDISH

The Virgin and Child with Two Angels about 1500

NETHERLANDISH

The Virgin and Child early 16th century

NG 1085
Oil on oak, central panel 67.7 x 45 cm, left wing 67.8 x 18.8 cm, right wing 67.9 x 18.7 cm

NG 3379
Oil on oak, 47 x 34.3 cm

NG 265
Oil on oak, 69.9 x 51.4 cm

In the central panel is a mystic treatment of the Marriage of Saint Catherine, related to the type of picture known as the 'Virgo inter Virgines'. The building in the background may be intended to represent the gateway into Heaven. The statue in front of the window could be of Saint Michael. In the left wing Saint John the Baptist kneels with the lamb; in the background are Saints Agnes and Agatha. In the right wing is Saint John the Evangelist with angels(?) in the background.

NG 1085 has not been satisfactorily attributed; its style suggests the influence of a number of artists, including Geertgen tot Sint Jans, who was active in Haarlem.

The central panel has been cut at the top, and both the wings at the top and bottom.

Inscribed on the reverse: 'Ex Coll: Henrici Hamal Leod:1812(?)', i.e. Henri Hamal of Liège (1744–1820); seen at Godesberg in the collection of Karl Aders, 1828; bequeathed by Mrs Joseph H. Green, 1880.

Davies 1953, pp. 1–7; Davies 1968, pp. 138–40.

The Virgin is seated before a cloth of honour. The angels look on from behind a curtain.

NG 3379 has in the past been attributed to the Bruges Master of the Legend of Saint Ursula.

Murray Marks sale, 1918; bought by Brown and Phillips; from whom bought (Lewis Fund), 1918.

Davies 1968, p. 153.

The Christ Child rests on the lap of the Virgin; she holds a book and he has just blown a soap bubble. This action probably relates to the saying 'Man is a bubble' (*Homo Bulla*) which held some currency in the sixteenth century; it means that human life is transient, unlike the eternal truths of religion.

It has been suggested in the past that NG 265 is related to the work of Bellegambe (about 1470/80–about 1535). A more general attribution is at present favoured.

Bought from a Münster collection by Krüger, before 1848; from whom bought, 1854.

Davies 1968, pp. 135–6.

NETHERLANDISH
Acts of Charity (?)
early 16th century

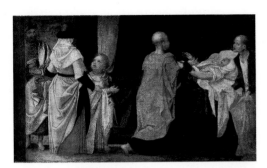

NG 4573
Oil on oak, 25.4 x 42.5 cm

The subject is unclear. It has been suggested that it may be the Clothing of the Naked, combined with one or two of the other Acts of Charity – Comforting the Dying, and possibly Feeding the Hungry. If this is the case, then the other acts would have occupied one or two other similar panels.

NG 4573 has been attributed to the Master of 1518, but the picture is too damaged to make an attribution beyond a general association with the Netherlandish School.

Anon. sale, Foster's, 6 December 1911 (lot 209); presented by Sir Michael Sadler through the NACF in memory of Lady Sadler, 1931.

Davies 1968, pp. 154–5.

NETHERLANDISH
Portrait of a Man
16th century

NG 1094
Oil on oak, 60 x 49.6 cm

The sitter is unidentified.
Apparently a sixteenth-century picture.

On the back of the support is a label inscribed: Anthony More/ Painter given/ Dr. Gifford 1758; presented by the Trustees of the British Museum, 1880.

Davies 1968, p. 141.

NETHERLANDISH
Portrait of Andreas (?) Boulengier
16th century

NG 6412
Oil on wood, 74.5 x 57.2 cm

Inscribed top left: D. ANDREAS; top right above the coat of arms: AETATIS SUA 42 (Aged 42) ; bottom centre in a late hand: H. Holbein(?).

The inscription and arms at the top right may be false, but the name and age could be copied over original inscriptions. The arms on the man's ring are those of the Boulengier family of Bruges.

Arthur Sanderson, Edinburgh; sold Christie's, 3 July 1908 (lot 90); presented by the Misses Rachel F. and Jean I. Alexander; entered the Collection in 1972.

NETHERLANDISH

Saint Ambrose with Ambrosius van Engelen (?)

probably 1520

NG 264
Oil on oak, 72.4 x 65 cm

Reverse: on a black background, a crozier with a scroll inscribed: NE QVID NIMIS (Nothing in excess). The cross on the mitre beside the donor is inscribed: III R II (for INRI).

Saint Ambrose stands behind a donor who is at prayer. The saint holds a scourge and a cross; Moses is depicted on his morse. The appearance of the donor suggests that he is a Premonstratensian monk; on the mitre in front of him Christ is represented on the cross with Mary and John on either side.

NG 264 is apparently the right wing of a triptych of 1520 which in the seventeenth century was in the Premonstratensian Abbey of Parc, near Louvain. It showed the Virgin in the centre panel; Saint Augustine in one wing; and in the other wing Abbot Ambrose and, behind him, Saint Ambrose. The donor would in that case be Ambrosius van Engelen (born 1481, abbot 1515, died 1543), who used the device 'ne quid nimis', which was also employed (after his death) by the abbey.

Krüger collection, Minden, by 1848; from where bought, 1854.

Davies 1968, pp. 134–5.

NETHERLANDISH

A Girl Writing

about 1520

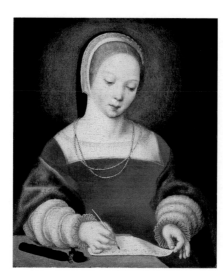

NG 622
Oil on oak, 27.3 x 23.5 cm

Subjects of this type are sometimes entitled 'The Magdalen Writing', but the lightening of the background around the head of the figure would appear not to be intended as a halo. Her costume is of about 1520; it is also depicted in two paintings, *Woman weighing Gold* (Berlin, Staatliche Museen) and *Woman playing a Spinet* (Massachusetts, Worcester Art Museum), sometimes attributed to Jan van Hemessen.

No satisfactory attribution for NG 622 has been found. Figures of this sort were often painted by the Master of the Female Half-Lengths. The picture may have been painted in Antwerp.

Count Joseph von Rechberg; from whom acquired by Prince Ludwig Kraft Ernst von Oettingen-Wallerstein, 1815; acquired by the Prince Consort, 1851; presumably one of the group of paintings presented by Queen Victoria at the Prince Consort's wish, 1863, but no official record exists.

Davies 1968, pp. 136–7.

NETHERLANDISH

The Magdalen (?)

about 1520

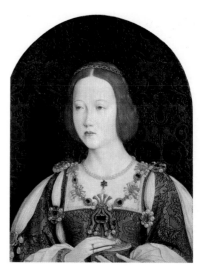

NG 2615
Oil on oak, 41.3 x 32.4 cm

The ointment jar is the attribute of the Magdalen, but NG 2615 may be a portrait of a woman represented in the guise of the saint. Her necklace appears to be ornamented with scourges, and her bracelets suggest manacles. According to a nineteenth-century label on the back of the panel the 'sitter' is 'Mary Tudor, Queen of France' (1496?–1533), the daughter of Henry VII. Other suggested identifications include Eleanor of Austria and her younger sister Catherine. None of these theories has been convincingly confirmed.

NG 2615 appears not to have been painted in a purely Netherlandish style. It may be Portuguese or French in origin.

In the collection of Hollingworth Magniac, Colworth, by 1862; Salting Bequest, 1910.

Davies 1968, pp. 150–2.

NETHERLANDISH

The Virgin and Child Enthroned
about 1520

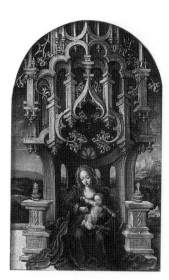

NG 3045
Oil on oak, 22.9 x 14.6 cm

The Virgin and Child are enthroned before a landscape; the Christ Child holds a cross.

NG 3045 is thought to come from either Brussels or Antwerp.

The regilded frame fixed to the painting seems to be original.

The Revd H.E. Richards, Claygate (died 1885); presented by Sir Charles Archer Cook, 1916.

Davies 1968, p. 152.

NETHERLANDISH

The Magdalen Weeping
about 1520

NG 3116
Oil on oak, 52.1 x 38.1 cm

A later inscription top left: No. 511.

The Magdalen holds the jar of ointment with which she anointed Christ.

It has been suggested that the style of the artist who painted NG 3116 is related to that of the Master of the Magdalen Legend.

Bought by Sir A.H. Layard in Madrid, 1871; Layard Bequest, 1916.

Davies 1968, p. 153.

NETHERLANDISH

The Birth of the Virgin (?)
about 1520

NG 3650
Oil on oak, 71.1 x 45.1 cm

Inscribed left: Gēn.8°.; right: .nūr. 24°.

At the left Noah is depicted with the dove in the ark (Old Testament, Genesis 8: 7–8), while at the right is the Parable of Balaam (Old Testament, Numbers 24: 17). The ark is sometimes represented allegorically as a symbol of redemption, and Balaam's star can be a symbol of the birth of the Virgin. The combination of these elements would suggest that the central scene is the Birth of the Virgin.

NG 3650 was probably one panel of a series. It was probably painted in Brussels.

Ralph Bernal sale, London, 13 March 1855 (lot 965); presented in memory of Lady Howorth through the NACF, 1922.

Davies 1968, pp. 153–4.

NETHERLANDISH

The Virgin and Child in a Landscape

about 1520–30

NETHERLANDISH

A Young Man Praying

probably 1525–30

NETHERLANDISH

The Virgin and Child with Saint Anne

about 1525

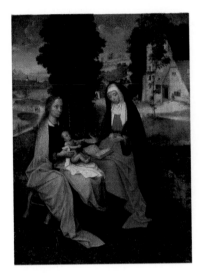

NG 1864
Oil on oak, 81.3 x 80 cm

NG 1063
Oil on oak, 24.1 x 18.4 cm

NG 1089
Oil on oak, 40 x 30.5 cm

In the background at the right is Saint John the Baptist, carrying a lantern and preceded by the Lamb of God. The main towers of the town in the background suggest those of Bruges.

NG 1864 has been associated with the style of Ysenbrandt.

Acquired from Count Joseph von Rechberg by Prince Ludwig Kraft Ernst von Oettingen-Wallerstein; acquired by the Prince Consort, 1851; presented by Queen Victoria at the Prince Consort's wish, 1863.

Davies 1968, p. 144.

The costume can be dated to the later 1520s. The painting may be the left wing of a triptych or diptych.

Bought by J.H. Anderdon in Bath, 1845; bought at the Anderdon sale, 30 May 1879.

Davies 1968, p. 138.

The Christ Child reaches across to Saint Anne who has an open book on her lap.

NG 1089 is possibly of the School of Bruges. Several versions are known.

Collection of Karl Aders, London, by 1835; bequeathed by Mrs Joseph H. Green, 1880.

Davies 1968, pp. 140–1.

NETHERLANDISH
Landscape: A River among Mountains
about 1525–50

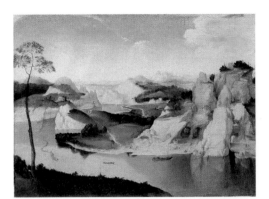

NG 1298
Oil on poplar(?), 50.8 x 68.6 cm

NETHERLANDISH
The Magdalen
about 1530

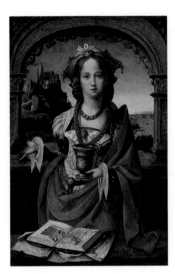

NG 719
Oil on oak, 52.7 x 34.9 cm

NETHERLANDISH
A Man with a Pansy and a Skull
about 1535

NG 1036
Oil on oak, 27.3 x 21.6 cm

At the lower left an artist sketches in the open air. It appears that logs are being transported along the river. This is probably a fragment of a larger work.

NG 1298 is connected with an engraving by Hoefnagel after a design made by Pieter Bruegel the Elder in Rome in 1553. In the engraving a mythological subject is indicated by the presence of two small figures of Mercury and Psyche in the sky. They do not, however, appear in the painting. It is unclear if the engraving derives from the picture, or if both are after a common source. Since the panel is not oak, and since the ground is gesso and not chalk, it was probably painted in Italy by a Netherlandish artist.

Bought by Conte Teodoro Lechi of Milan, then Brescia, at Milan before 1814; bought from Stefano Bardini, Florence, 1889.

Davies 1968, pp. 141–3.

The figures on the jar the Magdalen holds may be Cain and Abel. The rocks in the background represent La Sainte-Baume in Provence, where she is said to have spent many years in penitence.

NG 719 has in the past been ascribed to the Master of 1518.

Bought from Count Joseph von Rechberg, Mindelheim, by Prince Ludwig Kraft Ernst von Oettingen-Wallerstein, 1816; acquired by the Prince Consort, 1851; presented by Queen Victoria at the Prince Consort's wish, 1863.

Davies 1968, p. 137.

The skull is probably intended as a *memento mori*, and the pansy stands for thought (from the French *pensée*). The costume, which appears to be Dutch, suggests the date given above.

Bought by W. Fuller Maitland from Farrer, 1849; bought from W. Fuller Maitland (Lewis Fund), 1878.

Davies 1968, pp. 137–8.

NETHERLANDISH
Anna van Spangen, Wife of Adriaen van der Goes
1543

NETHERLANDISH
A Little Girl with a Basket of Cherries
1570s

NETHERLANDISH
Portrait of a Bearded Man
about 1570–80

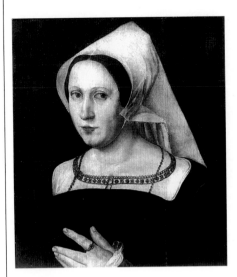

NG 1652
Oil on oak, 46.4 x 41.3 cm

NG 6161
Oil on canvas, 79.4 x 52.1 cm

NG 2295
Oil on paper, mounted on a walnut panel,
41.9 x 30.5 cm

Dated: 1543
 The coat of arms (top right) shows the sitter to be Anna van Spangen (died 1548), who married Adriaen van der Goes, Advocate of Holland (1505–60). They lived in Delft and The Hague.
 An engraving by Houbraken of her husband exists, which (if inverted) may record the pendant to the work; the original appears to have been dated 1543. Another pair of portraits of these sitters were still with the van der Goes family in 1970.

Bequeathed by Miss Martha Brown, 1897.

Davies 1968, p. 143.

The costume of the sitter is datable to the 1570s.
 When NG 6161 entered the Gallery it was attributed to Martin de Vos (about 1531–1603).

Bequeathed by Mrs Elizabeth Carstairs, 1952.

Davies 1968, p. 155.

The subject has formerly been called a 'Spanish General', and then a 'Military Commander'. The dress and background have been left unfinished. This is possibly a study for a sitter in a group.
 The costume suggests the dating given above.

George Fielder collection by 1884; bequeathed by George Fielder and received on the death of his widow, 1908.

Davies 1968, pp. 145–6.

NETHERLANDISH
Portrait of a Girl with a Parrot
about 1640

NG 6498
Oil on canvas, 112 x 79 cm

The child has not been identified; her costume has been dated to about 1640.

NG 6498 was formerly attributed to Jacob Gerritsz. Cuyp (1612–52), who painted a number of full-length children's portraits. Cuyp's style, however, is rather flatter and more two dimensional than this painting. It has also been associated with the work of Pieter Soutman (about 1580–1657) and Cornelis de Vos (about 1585–1651), but its attribution remains in doubt. It is in a poor state of preservation.

Bequeathed by Lady Colman, 1985.

National Gallery Report 1985–7, pp. 15–16.

NETHERLANDISH
Edzard the Great, Count of East Friesland
18th century

NG 2209
Oil on oak, 48.9 x 36.2 cm

Inscribed, possibly in a modern hand, on the sword: victor est qvi in/nomen domini pvgnavit (the victor is he who has fought in the Name of the Lord).

On the sitter's hat is a brooch with what may be an eagle on it. NG 2209 is a bust copy in armour of a portrait of a man in robes and with hands, of which the original is purported to be a version in Oldenburg. The identification of the sitter as Edzard the Great, Count of East Friesland (1462–1528), who visited the Netherlands in 1516/17, is due to a tradition attached to the Oldenburg picture.

Bought by C.L. Eastlake in London; presented by Mrs C.L. Eastlake in memory of her husband, Keeper of the National Gallery, 1907.

Davies 1968, p. 145.

NETHERLANDISH (?)
Three Men and a Little Girl
about 1540

NG 2597
Oil on canvas, 83.8 x 69.9 cm

The subjects have not been identified, but it is thought that the dress of the men may be Venetian in style.

NG 2597 is probably by a Netherlandish painter working in Venice or the Veneto. It was once attributed to Dirck Barendsz. (1534–92). The child's costume, which is recognisably that of a girl, can be dated to about 1540.

Given by Pope Urban VIII to the Barberini Collection, Rome, where included in an inventory of 1629; Salting Bequest, 1910.

Davies 1968, pp. 9–10.

Caspar NETSCHER
A Lady at a Spinning-wheel
1665

Caspar NETSCHER
Two Boys blowing Bubbles
about 1670

Caspar NETSCHER
A Lady teaching a Child to read, and a Child playing with a Dog ('La Maîtresse d'école')
probably 1670s

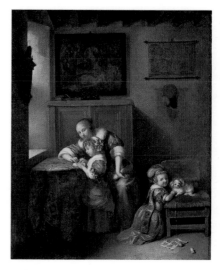

NG 845
Oil on oak, 22.5 x 17.7 cm

NG 843
Oil on oak, 31.2 x 24.6 cm

NG 844
Oil on oak, 45.1 x 37 cm

Signed and dated on the spinning-wheel: CNetscher/1665 (CN in monogram).

Before he devoted himself exclusively to portraiture, Netscher painted a number of genre scenes. His indebtedness to his master Gerard ter Borch can be seen in the careful depiction of texture, in this case of the fur and satin of the woman's clothes.

Possibly in the collection of the Comte de la Motte; the collection of Blondel de Gagny by 1760; the collection of Sir Robert Peel, Bt, by 1833; bought with the Peel collection, 1871.

MacLaren/Brown 1991, pp. 285–6.

Inscribed below the swag of fruit carved in the stone at the bottom: Aº 1670. G. Netʃcher (a clumsy and almost certainly later addition, possibly copied from a genuine inscription formerly on the painting).

The boy in the background at the right blows bubbles in a shell he holds, while his companion is about to burst one which has drifted towards him. On the ledge are shells and a silver dish decorated with a nude man and woman embracing: it repeats the design of a bowl of a small *tazza* of 1618 by Adam van Vianen (Amsterdam, Rijksmuseum). Children blowing bubbles are often a symbol of the transience of human life; the subject, which has a classical origin, is known as the *homo bulla* (man is a bubble). In this context the silver *tazza* and the rare shells, which were enthusiastically collected in Holland in the seventeenth century, represent the futility of worldly possessions.

In spite of the false inscription, NG 843 is securely attributed to Netscher on stylistic grounds. The costumes of the figures and the style of the picture (as well as the inscription) suggest a date of about 1670.

Probably in the Adriaan Bout sale, The Hague, 1733; Randon de Boisset sale, Paris, 1777; collection of the Duchesse de Berry, Paris, by 1833; bought with the Peel collection, 1871.

MacLaren/Brown 1991, pp. 283–4.

This genre scene intentionally juxtaposes the industry of the girl who is being taught to read at the window, with the idleness of the boy who prefers to play with the dog. The broadsheet on the floor with its large, brightly coloured and crudely printed illustrations contrasts with the girl's book. At the upper left hangs a mirror, while behind the woman is a reduced version of Rubens's *Brazen Serpent* (NG 59).

A picture of a related subject by Netscher with the same dimensions as NG 844, called *Maternal Care* (Amsterdam, Rijksmuseum), may have been a pendant to the work catalogued here. The style of the two paintings, and of the costumes, suggests a date in the 1670s.

Collection of Philippe, Duc d'Orléans, which was formed in the quarter century before his death in 1723; sold by his great-grandson ('Philippe-Egalité') to Thomas Moore Slade, 1791 or 1792; collection of Sir Robert Peel, Bt, by 1824; bought with the Peel collection, 1871.

MacLaren/Brown 1991, pp. 284–5.

Caspar NETSCHER
1635/6?–1684

Netscher was probably born in Prague and taken as a child to Arnhem, where he was a pupil of Hermen Coster. Later he studied with Gerard ter Borch in Deventer. He had settled in The Hague by 1662. In his early years there he painted portraits, genre pictures and some religious and classical subjects, but later he devoted himself to small-scale portraits strongly influenced in style by Van Dyck.

Caspar NETSCHER
Portrait of a Lady and a Girl
1679

Caspar NETSCHER
Portrait of a Lady
1683

Studio of NETSCHER
Portrait of a Young Man
1679

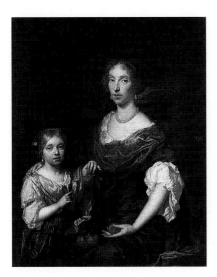

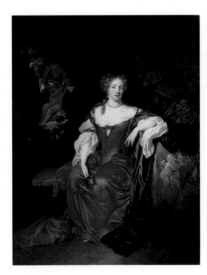

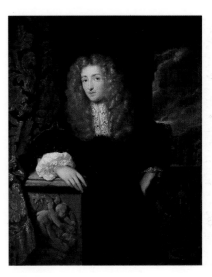

NG 2953
Oil on canvas, 47.5 x 38.5 cm

NG 4790
Oil on canvas, 78.5 x 62 cm

NG 1332
Oil on canvas, 47.5 x 38.5 cm

Signed and dated at the lower right: CNetscher. fec /1679. (CN in monogram).

The oranges held by both the girl and the woman, and pointed to deliberately by the girl, may well refer to the family's adherence to the cause of the House of Orange.

There is also an orange tree in the background.

Collection of Mrs Sara Austen (died about 1891), London, and bequeathed by her to Sir A.H. Layard; Layard Bequest, 1913.

MacLaren/Brown 1991, p. 286.

Signed and dated at the bottom of the stonework: CNetscher. Fec./1683. (CN in monogram).

The unidentified woman is seated in a garden in front of a fountain in the shape of a putto holding up a ewer; she rests her left arm on a pedestal decorated with a bas-relief showing two embracing putti. In her right hand she holds orange blossoms.

This is a characteristic example of Netscher's many small-scale portraits painted in The Hague in the 1670s and early 1680s.

Private collection, London, before 1860–5; presented by J.J. Humphrey Johnstone on the occasion of the Silver Jubilee of King George V, 1935.

MacLaren/Brown 1991, pp. 286–7.

Signed and dated on the relief at the bottom left: CN/1679.

The man stands in front of a formal garden at the right, and rests his arm on a pedestal decorated with a relief representing a cupid overcoming Pan. The sitter was formerly identified as 'Admiral Lord Berkeley', but none of the admirals who were members of the Berkeley family was of the age of this sitter in 1679. If he is one of the Earls of Berkeley, the only reasonable candidate is Charles, the 2nd Earl (1649–1710), who was envoy to the States of Holland (1689–94). The only other portrait that claims to represent him, however, shows a different man.

In the past NG 1332 has been attributed to Caspar Netscher, but it is now considered a studio replica of a painting (Amsterdam, Rijksmuseum) dated 1678 which is described as a portrait of a member of the Citters family. (The reason for this identification is unclear.)

The signature and date are not in Netscher's hand and were presumably added later.

Presented by Baron Savile, 1891.

MacLaren/Brown 1991, pp. 287–8.

After NETSCHER
A Musical Party
after 1665

Nicolas de NEUFCHATEL
Portrait of a Young Lady
probably 1561

Style of NEUFCHATEL
A Man with a Skull
16th century

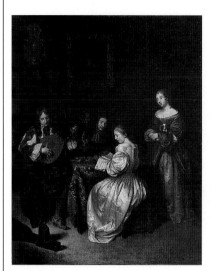

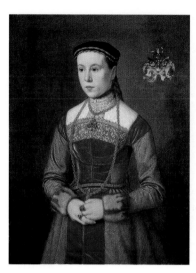

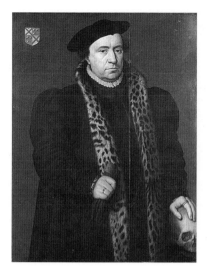

NG 1879
Oil on canvas, 55.5 x 45 cm

NG 184
Oil on canvas, 80.6 x 65.4 cm

NG 195
Oil on oak, 97.2 x 75.6 cm

The man seated on the left plays a theorbo; in front of him on the floor is its case. In the centre of the wall behind the figures is a landscape with a carved gilt frame and, on the left, a wall-sconce.

NG 1879 is a copy of a composition by Caspar Netscher, the original (or best version) of which is signed and dated 1665 (Munich, Alte Pinakothek). There are a number of other replicas or copies of this design.

Collection of Sir John May by 1847; May Bequest, 1854.

MacLaren/Brown 1991, p. 289.

Inscribed and dated top right: AETAT[I]S SVAE·I (?) (·)/ ANNO DOM. 15(61?) (Aged (?). In the year of Our Lord 15(61?).

The coats of arms in the upper right corner, revealed during cleaning in 1968, identify the sitter as Susanna Stefan (died 1594), wife of Wolff Furter (1538?–94) of Nuremberg.

William Beckford collection, Fonthill, by 1812; bought from Nieuwenhuys, 1858.

Davies 1968, pp. 156–7.

The sitter and the coat of arms at the upper left have not been identified. In the past the portrait has been described as being of a 'Medical Professor', presumably because of the presence of the skull. But in a sixteenth-century work this is more likely to be intended as a *memento mori*.

When it was acquired by the Gallery NG 195 was attributed to Holbein. Subsequently it has been described as German, Netherlandish and as a work by Neufchâtel. It is not, however, an early nineteenth-century fake, as has also been suggested.

Imported from Paris by S.J. Rochard; from whom bought, 1845.

Davies 1968, pp. 157–8.

Nicolas de NEUFCHATEL
active 1561 to 1567

Neufchâtel was a portraitist who is documented as having worked in Nuremberg. Little is known of his life, although Sandrart says that he was born near Mons, and that he learnt to paint there. The artist has been identified with Colyn van Nieucasteel, a pupil of Pieter Coecke in Antwerp in 1539.

NICCOLO dell'Abate
The Death of Eurydice
about 1552–71

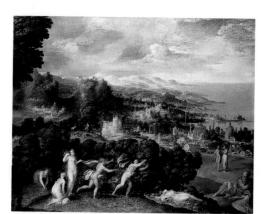

NG 5283
Oil on canvas, 189.2 x 237.5 cm

Aristaeus (distant right) consults his mother Cyrene concerning the death of his bees. She suggests that he speaks to the sea-god Proteus (reclining on the right) who tells Aristaeus that the death of his bees was punishment for causing the death of Eurydice. Aristaeus' attack on Eurydice (centre foreground) provoked her flight during which she was bitten by a snake and died (right of centre). In the middle distance Eurydice's husband Orpheus charms wild animals with his lyre. Virgil, *Georgics* (IV, 315–558).

NG 5283 was probably painted by Niccolò dell'Abate during his years in France, perhaps as part of a series of mythologies (a picture in the Louvre, Paris, may be related).

Probably in the collection of W. Buchanan by 1827; in the Talbot collection before 1941; presented by the NACF, 1941.

Gould 1975, pp. 174–6.

NICCOLO di Buonaccorso
The Marriage of the Virgin
about 1380

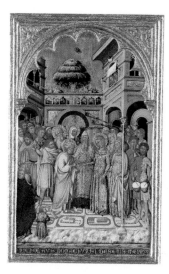

NG 1109
Egg (identified) on wood, 51 x 33 cm

Signed: NICHOLAUS: BONACHVRSI: DE SENIS: ME P[I]NX[I]T (Niccolò di Buonaccorso of Siena painted me).

Saint Joseph places a ring on the Virgin's finger. According to apocryphal lives of the Virgin her suitors had to present rods at the temple, and the rod which flowered signified the chosen one; Saint Joseph's blossoms in the form of a dove. At the left are the unsuccessful suitors, while in the background are the Virgin's parents – Saints Joachim and Anna. The palm tree may be a reference to the Song of Songs (7: 7), where the beloved is compared to the tree. At the top of the composition a swallow returns to its nest. On the reverse is a geometric design, painted and punched.

NG 1109 was probably the central panel of a folding triptych, with the *Presentation of the Virgin* (Florence, Uffizi) on the left and the *Coronation of the Virgin* (New York, Metropolitan Museum of Art, Lehman Collection) on the right. All three panels share a geometric pattern on the reverse. The Uffizi *Presentation* was recorded in the nineteenth century in the Hospital of S. Maria Nuova, Florence, but a number of paintings from churches throughout Tuscany were being stored there at the time so this is no evidence of original location.

Bought from Fairfax Murray, 1881.

Pope-Hennessy 1987, pp. 33–5; Gordon 1988, pp. 86–8; Dunkerton 1991, p. 230.

NICCOLO di Liberatore
Christ on the Cross, and Other Scenes
1487

NG 1107
Tempera and oil on wood, central panel 92.1 x 57.8 cm; wings, each painted surface 43 x 25 cm

Inscribed on the central panel above the cross: .I.N.R.I.; signed and dated on a cartellino: .NicolAi fulginatis. / .Mº .cccº Lxxxvij (Niccolò from Foligno. 1487); the cross in the lower section of the right wing is inscribed: .I.N.R.I.; inscribed on the sun in the frame: yhs (the monogram of Christ).

In the central panel angels catch the blood from Christ's wounds in cups. Below, the Virgin swoons and is supported by two Holy Women; at the other side of the cross stands Saint John the Evangelist; Saint Francis clasps its base. In the upper part of the left wing is the Agony in the Garden. Saints Peter, James and John are asleep in the foreground, while behind Judas approaches with the soldiers. In the lower part of the left wing is the Way to Calvary. The Virgin and two Holy Women help Christ to carry the cross. In the upper section of the right wing is the Resurrection, while in the lower is the Mourning over the Dead Christ. In the gable of the frame is the monogram of Christ in glory – a device made popular by the great Franciscan preacher Saint Bernardino. The reverses of the wings are painted with red and green marbling.

The triptych is presumed to have been painted for the convent of S. Chiara at Aquila, where it is first recorded. The framing appears to be original, although much restored and given a new base for the central panel.

Convent of S. Chiara at Aquila, 1848; bought from Signora Maria Gianzana, through Alessandro Castellani, Rome, 1881.

Davies 1961, pp. 385–6.

NICCOLO dell'Abate
about 1509/12–1571

Niccolò was born in Modena and died in France. He worked in Bologna from 1547/8, and had moved to Fontainebleau by 1552 (where he worked with Primaticcio). He was an important decorative painter, who left several frescoed rooms in Italy, before moving to France. He was noted for his landscapes but he also painted heroic and romantic narratives.

NICCOLO di Buonaccorso
active about 1370; died 1388

The artist belonged to the guild of painters in Siena. A signed polyptych by him, dated to 1387, survives in fragments and a book cover, dated 1385, has been attributed to him. NG 1109 is the only other known signed work.

NICCOLO di Liberatore
active about 1456; died 1502

The artist was from Foligno. He was wrongly referred to as Alunno by Vasari. He may have been a pupil of his father-in-law, Pietro di Giovanni Mazzaforte. A number of signed and dated pictures by him exist. Niccolò worked much in Foligno, but also elsewhere in Umbria and the Marches.

Attributed to NICCOLO di Pietro Gerini
Triptych: The Baptism of Christ
probably 1387

NG 579.1–5
Tempera on wood, 238 x 200 cm

Saint John baptises Christ in the river Jordan. Above are God the Father, and the Holy Ghost represented as a dove. New Testament (all four Gospels, e.g. Matthew 3: 13–17). At the top an angel is depicted in a medallion. In the left wing is Saint Peter, and in the right Saint Paul. The subjects of the predella are, from left to right: Saint Benedict; the Angel Gabriel appearing to Zacharias; the Birth of Saint John the Baptist; Saint John the Baptist decapitated; the Feast of Herod; Salome bringing the Baptist's head to Herodias; Saint Romuald.

When NG 579 entered the gallery three pinnacles (see Giovanni da Milano NG 579.6–8) were attached to it. It is possible that the altarpiece is missing pinnacles and pilasters at either side, and it has been suggested that a pinnacle with the Blessing Redeemer (Munich, Alte Pinakothek) originally formed part of it. An inscription (now obliterated) was recorded below the central compartment stating that the work was painted for Filippo Neroni in 1337(?). The style of the work suggests the date was probably 1387. It is possibly the altarpiece commissioned for the Stoldi Chapel in S. Maria degli Angeli, Florence, by the family of Don Filippo Neroni, which was completed in that year.

NG 579 appears to be the first known altarpiece to isolate the Baptism of Christ as the central narrative scene. As such it may have influenced Piero della Francesca's *Baptism* (see NG 665).

Bought from the Lombardi–Baldi collection, 1857.

Gordon 1988, pp. 89–93.

NICCOLO di Pietro Gerini
active 1368; died 1415

The artist is first recorded in 1368 as a member of the painters' guild, the Arte dei Medici e Speziali, in Florence. He appears to have worked principally in Florence, but also in Prato and Pisa. He collaborated with other painters, such as Jacopo di Cione (see NG 569).

François de NOME
Fantastic Ruins with Saint Augustine and the Child, 1623

NG 3811
Oil on canvas, 45.1 x 66 cm

Dated: 1623

In the foreground Saint Augustine (about 354–430) speaks with a child trying to empty the sea into a hole dug in the sand. When Saint Augustine told him that this was impossible, the child, either a messenger from God or the Christ Child himself, replied that Augustine, trying to explain the Trinity, was engaged on an even more impossible task.

De Nomé was a painter of architectural and nocturnal caprices. Although the subject of the saint and the child is apparently secondary, the crumbling city may represent the Città Vecchia (Old City [of Rome], and Rome's port on the Tyrrhenian Sea), where Augustine was said to have encountered the child, or evoke the collapse of Roman civilisation in contrast to the perfection of God's city (the theme of Augustine's most influential book, *De Civitate Dei – Of the City of God*).

Presented (as by Jacques Callot) by Sir Philip Sassoon Bt, GBE, through the NACF, 1923.

Letts 1991, p. 100; Rosaria Nappi 1991, p. 180.

François de NOME
about 1593–after 1630

François de Nomé was one of two French-speaking artists called in Italy Monsù (for 'Monsieur') Desiderio. He came from Metz and worked mainly in Naples, where he is documented in 1613 and 1621. He was probably apprenticed in Rome to Balthasar Lauwers; his last dated work is of 1630.

Attributed to Michiel NOUTS
A Family Group
about 1655

NG 1699
Oil on canvas, 178 x 235 cm

It has been suggested that this portrait shows the family of Vincent Laurensz. van der Vinne (born 1629) on the basis of comparison with a drawing of van der Vinne by Leendert van der Cooghen (1610–81) in Berlin. But the resemblance is only slight, and the painting is quite unlike the work of Cooghen.

The costumes of the sitters appear to be typical of the early 1650s. NG 1699 has in the past been attributed to Vermeer and to Michiel Sweerts (1618–62/4). Neither suggestion is tenable, but the work does appear to be by an artist familiar with painting in Delft in the 1650s, and perhaps slightly predates, stylistically, Nouts's portrait in the Rijksmuseum (see biography) of 1656.

Before 1900 the picture was cut in half. In 1915, after both halves had entered the collection, they were rejoined, and replacements of missing portions were added at the top, bottom and centre between the two sections.

The left half presented by Charles Fairfax Murray, 1900; the right half bought, 1910.

MacLaren/Brown 1991, pp. 290–1.

Michiel NOUTS
active 1656

The only certain record of this painter is a portrait by him of 1656 (Amsterdam, Rijksmuseum). He may be identified as Michiel Servaesz. Nouts (later Nuyts) who was baptised in Delft and settled in Amsterdam, but this Nouts is only ever recorded as a musician. A small group of portraits has been linked with the Rijksmuseum picture.

Jacob OCHTERVELT
A Young Lady trimming her Fingernails, attended by a Maidservant, probably 1670–5

NG 2553
Oil on canvas, 74.6 x 59 cm

In seventeenth-century Holland it was usual to drape tables with Turkish carpets, as here. The tapestry hanging on the back wall appears to show Hagar in the Wilderness.

NG 2553 belongs to a group of works by the artist from the early 1670s, in which the same costumes are worn and the same basin and ewer appear.

Probably Dr [Robert] Bragge sale, London, 1756; Sir John Chapman; Salting Bequest, 1910.

Kuretsky 1979, p. 85, no. 76; MacLaren/Brown 1991, p. 293.

Jacob OCHTERVELT
A Woman standing at a Harpsichord, a Man seated by her, probably 1675–80

NG 2143
Oil on canvas, 79.7 x 65.4 cm

Behind the couple hangs a painting of a wooded landscape, and above the doorway there is a bust. The woman's dress is the same as the one depicted in Ochtervelt NG 3864.

The style of the dress suggests a date in the late 1670s.

Collection of Fürstin Carolath-Beuthen, Berlin, 1883; Huldschinsky sale, Berlin, 1900; presented by Henry J. Pfungst, 1907.

Kuretsky 1979, p. 93, no. 95; MacLaren/Brown 1991, p. 292.

Jacob OCHTERVELT
A Woman playing a Virginal, Another singing and a Man playing a Violin, probably 1675–80

NG 3864
Oil on canvas, 84.5 x 75 cm

Inscribed on the underside of the virginal's lid: S? D?E?. Signed over the door: Jac : Ocht(. .)velt : f.

The map on the wall is based on one of North and South America called *Americae nova descriptio* which was published by Dancker Danckerts in Amsterdam in 1661. The dress and coiffure of the woman at the virginal are identical to those in Ochtervelt NG 2143.

The style of the woman's dress suggests a date in the late 1670s.

Bought, 1924.

Kuretsky 1979, pp. 92–3, no. 94; MacLaren/Brown 1991, pp. 293–4.

Jacob OCHTERVELT
1634–1682

Jacob Lucasz. Ochtervelt was born in Rotterdam. He is said to have been a pupil of Nicolaes Berchem in Haarlem at the same time as Pieter de Hooch (about 1650). He worked in Rotterdam but by 1674 had moved to Amsterdam. Most of his paintings are of genre subjects, usually set in prosperous households.

Jan OLIS
A Musical Party
1633

Johann Heinrich Ferdinand OLIVIER
Abraham and Isaac
1817

Attributed to Crescenzio ONOFRI
Landscape with Figures
probably 1670–1712

NG 3548
Oil on oak, 36.7 x 52.8 cm

NG 6541
Oil on wood, 21.5 x 30.5 cm

NG 2723
Oil on canvas, 171.5 x 246.4 cm

Signed and dated on the chair-back: JOLIS · 1633 (JO in monogram).

The woman plays a viola da gamba; the man with his back to the viewer, a lute; the man on the right, a flute; and the standing man, a violin.

A figure of a boy in the background was painted out when the painting was cleaned in 1969–70, because it was then considered of inferior quality. It is, however, probably by Olis himself.

Presented by Alfred A. de Pass, 1920.

MacLaren/Brown 1991, pp. 294–5.

Abraham has left his donkey in the care of two servants and leads his son to the place of sacrifice. Old Testament (Genesis 22: 1–14).

When Olivier first visited Salzburg in 1815 he was overwhelmed by the beauty of the surrounding countryside. This experience may have influenced his painting of NG 6541, which dates from 1817. The setting provides a dramatic view past cliffs and valleys towards a distant mountain peak which might well be a recollection of the Watzmann (a mountain to the south of Salzburg) with its distinctive broken silhouette.

In style, the picture seems deliberately archaic, with precise outlines, elaborate detail and odd disparities of scale. The work seems indebted to traditional German art, and the simplified, flattened forms of the figures also recall medieval German woodcuts. However, the most direct source for the subject and its treatment would appear to be the work of Olivier's friend and mentor, Joseph Anton Koch (1768–1839). The two artists were in close contact during Koch's stay in Vienna (1812–15) and Koch illustrated the same biblical episode in a drawing of 1798.

Sent for sale to the artist and picture dealer Johan Jakob Kirchner, Nuremberg, 1817; next recorded in a private collection, Berlin; by descent to Dr Hans-Georg Urban, Berlin, 1966; sale, Sotheby's, Munich, 12 June 1991 (lot 23); presented by Mr Bruno Meissner, 1992.

Grote 1938, p. 188; National Gallery Report 1992–3, pp. 12–13.

NG 2723 does not appear to have a specific subject.

Formerly attributed to an unidentified pupil of Gaspard Dughet, NG 2723 is now attributed to his pupil Crescenzio Onofri, with the figures by an anonymous collaborator (perhaps F. Petrucci, 1660–1719).

Probably Poli collection, Rome, by 1825; presented by Philip Pusey, 1849.

Davies 1957, p. 89; Boisclair 1986, p. 309.

Jan OLIS
about 1610–1676

The artist was born in Gorinchem, east of Dordrecht. He may have been in Rome in 1631. In the following year he entered the Dordrecht guild. He later moved to Heusden. The few known works by Olis are mostly genre scenes in the manner of such 'guardroom' painters as Anthonie Palamedesz. of Delft, but he also painted portraits, history paintings and still lifes.

Johann Heinrich Ferdinand OLIVIER
1785–1841

Olivier was born in Dessau. He trained in Dessau and Berlin and completed his artistic education in Dresden (1804–6) and Paris (1807–10). In 1811 he settled in Vienna and became part of a circle of Romantic writers and artists. In 1817 he joined the Brotherhood of Saint Luke (later known as the Nazarenes). Olivier painted many biblical subjects and was particularly attracted to landscape as a vehicle for expressing Christian iconography.

Crescenzio ONOFRI
1640s–after 1712

Onofri was a pupil of Gaspard Dughet and painted principally landscapes. In 1671 he was working in the Doria Pamphili Palace in Rome and he later produced canvas paintings and frescoes of landscapes for prominent Roman families, including the Colonna, Pallavicini and Theodoli. The figures in his pictures are sometimes by other artists.

Attributed to Crescenzio ONOFRI
Landscape with Fishermen
probably 1670–1712

NG 2724
Oil on canvas, 171.5 x 243.8 cm

Jacob van OOST the Elder
Portrait of a Boy aged 11
1650

NG 1137
Oil on canvas, 80.5 x 63 cm

Attributed to van OOST
Two Boys before an Easel
about 1645

NG 3649
Oil on canvas, 56.5 x 58.7 cm

NG 2724 does not appear to have a specific subject.
Formerly attributed to an unidentified pupil of Gaspard Dughet, NG 2724 is now attributed to his pupil Crescenzio Onofri, with the figures by an anonymous collaborator (perhaps F. Petrucci, 1660–1719).

Probably Poli collection, Rome, by 1825; presented by Philip Pusey, 1849.

Davies 1957, p. 89; Boisclair 1986, p. 309.

Signed, inscribed and dated: AETAT (AE in monogram): SVAE (AE in monogram) ii 1650 . IVO . (VO in monogram).
The inscription informs us that the sitter, who wears a muff and fur cap, is eleven years old. He has not been identified.

Collection of Miss M.A. Thomas by 1883; bought, 1883.

Martin 1970, p. 103; Meulemeester 1984, p. 278.

On the easel is a grisaille of the story of Gideon (Old Testament, Judges 6: 36–40 and 7: 5–6).
NG 3649 has been attributed to Jacob van Oost on the basis of comparison with a signed painting in Bruges and dated to about 1645 on the grounds of the costumes the boys are wearing.

Presented by Sir Henry H. Howorth through the NACF in memory of Lady Howorth, 1922.

Martin 1970, p. 104; Meulemeester 1984, p. 367.

Jacob van OOST the Elder
1601–1671

Van Oost was born in Bruges and was taught there by his elder brother, Frans. He joined the Bruges guild as a master in 1621 and subsequently travelled to Italy. He was back by 1628 and for the rest of his life worked as a portrait and figure painter in his native city.

Pietro ORIOLI
The Nativity with Saints
probably about 1485–95

Pietro ORIOLI
The Adoration of the Shepherds
probably about 1490–6

Style of Bernaert van ORLEY
The Virgin and Child in a Landscape
1515–41

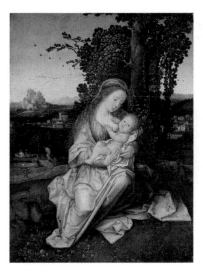

NG 1849
Tempera on wood, painted surface 187.5 x 155 cm

L471
Tempera on wood, 66.5 x 49.5 cm

NG 714
Oil on oak, 34.6 x 26.7 cm

Saint John the Baptist's scroll is inscribed: ECCE [A]GN[VS] DEI (Behold the Lamb of God). The cross in the centre panel of the predella is inscribed: INRI.

The Virgin and Child and Saint Joseph are flanked by Saints Stephen, John the Baptist (left), Jerome and Nicholas of Bari (right). God the Father appears above between two angels. The figure behind Saint Stephen is probably a shepherd. Each pilaster is painted with three saints – on either side at the top are the Angel Gabriel and the Virgin Mary (forming the Annunciation); in the centre are Saint Peter and Saint Paul; and below are Saint Francis and Saint Lucy.

The predella depicts the Agony in the Garden with Saints Peter, James and John; the Betrayal of Christ, with Saint Peter cutting off the ear of Malchus; the Crucifixion with the Virgin Mary, Saint John the Evangelist and Mary Magdalene; the Deposition with the Virgin Mary, Saint John the Evangelist, Mary Magdalene, and probably Joseph of Arimathea; and the Resurrection. At either end of the predella are the coats of arms of the Cerretani family and of a relation of the Piccolomini of Siena. The intended location of the altarpiece has not been identified, perhaps in part because it was previously attributed to Pacchiarotto (1474–1540 or later), but Orioli was active at the end of the fifteenth century. (See Appendix B for a larger reproduction of this work.)

The frame is original but has been restored and regilded.

Cerretani collection, Siena, before 1858; bought, 1901.

Davies 1961, pp. 399–401.

The principal narrative in the foreground is the Adoration of the Child Jesus by his parents, Mary and Joseph, and two shepherds. The Annunciation to the Shepherds is shown in the right background. New Testament (Luke 2: 1–16).

L471 seems to have been a small independent devotional painting, but Orioli employed a similar composition for a predella panel and for his altarpiece in the National Gallery (see NG 1849).

On loan from a private collection since 1989.

National GalleryReport 1989–90, pp.26–7; Kanter 1992, pp. 337–9.

NG 714 has in the past been attributed to van Orley, but it appears not to be by him or a member of his studio, although there is a stylistic association with his work. The landscape is vaguely reminiscent of the style of Patenier.

Count Joseph von Rechberg; bought by Prince Ludwig Kraft Ernst von Oettingen-Wallerstein, 1815; acquired by the Prince Consort, 1851; presented by Queen Victoria at the Prince Consort's wish, 1863.

Davies 1968, pp. 158–9.

Pietro ORIOLI
1458–1496

Pietro di Francesco degli Orioli was probably trained in the workshop of Matteo di Giovanni. His first independent works probably date from the early 1480s, and he painted religious subjects, on panel and in fresco. His works were previously attributed to Giacomo Pacchiarotto.

Bernaert van ORLEY
active 1515; died 1541

By 1515 van Orley was employed by Margaret of Austria, Regent of the Netherlands. In 1518 he was appointed her painter; he also served her successor, Mary of Hungary. Van Orley executed many altarpieces and portraits, as well as designing tapestries and stained glass. He was strongly influenced by Italian art, and by Raphael in particular.

Lelio ORSI
The Walk to Emmaus
about 1565–75

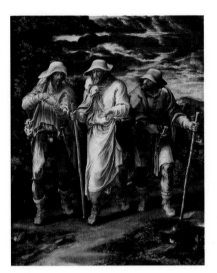

NG 1466
Oil on canvas, 71.1 x 57.1 cm

After the Crucifixion, two of Jesus' disciples set out for Emmaus. They were joined by Christ himself, disguised as a pilgrim, who explained the prophecies concerning his death and resurrection. As they broke bread together at an inn in Emmaus the disciples recognised the risen Christ. New Testament (Luke 24: 13–29). A goldfinch in the foreground probably symbolises Christ's Passion.

NG 1466 is dated to after Orsi's trip to Rome (and probably to the period about 1565–75) on the basis of a general debt to Michelangelo and an interest in the exaggerated proportions of Michelangelo's figures.

A number of drawings by Orsi are directly related to NG 1466. The hats and alpine walking sticks of the three figures may derive from Northern European prints which circulated widely in Italy.

Collection of Antonio Scarpa, Motta di Livenza, by 1874 (previously said to have been in the collection of Luigi Ceretti, Modena); bought at the Scarpa sale, Milan, 1895.

Gould 1975, pp. 180–1; Monducci 1987, pp. 212–15; Letts 1991, p. 96.

ORTOLANO
Saints Sebastian, Roch and Demetrius
after 1516

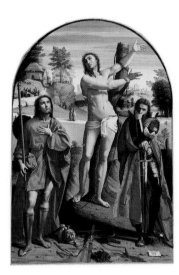

NG 669
Oil on wood, 230.4 x 154.9 cm

Inscribed on the cartellino at the lower right: .S. DEMET/ RIVS. (Saint Demetrius).

Demetrius, a proconsul of Achaia, was stabbed to death with a lance by order of Emperor Maximinianus because he converted many people to Christianity. Sebastian and Roch were saints popularly invoked against the plague. Demetrius is named on the paper at his feet, presumably because he would otherwise be hard to identify.

The composition of NG 669 shows the influence of Raphael's *Saint Cecilia* altarpiece in Bologna, which was finished not later than 1516. The costumes also accord with such a date.

Recorded as in the church of S. Maria at Bondeno near Ferrara in 1621; still to be seen there in 1844; Alexander Barker, London, by 1857; from whom bought, 1861.

Gould 1975, pp. 181–2.

Georgius Jacobus Johannes van OS
Fruit, Flowers and Game
about 1820

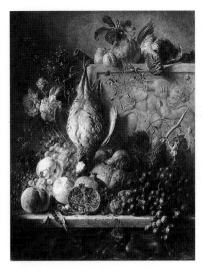

NG 3226
Oil on mahogany, 80.5 x 61.6 cm

Signed left: G J J Van Os
The fruit includes grapes, peaches and pomegranates. A partridge hangs from the barrel of a gun, and a snipe lies at the upper right. Below it the design on the bas-relief shows a Bacchante and a satyr, and two putti are depicted on the relief at the bottom.

In the possession of Nieuwenhuys, Brussels; said to have been in the Scarisbrick collection; William Benoni White sale, London, 1879; bequeathed by W.W. Aston, 1919.

MacLaren/Brown 1991, pp. 295–6.

Lelio ORSI
about 1511–1587

Orsi was born and died in Novellara, where he was a painter of frescoes and small canvases and an architect. Orsi's painting shows the influence of Giulio Romano and Correggio. He was also fascinated by the art of Michelangelo, whose works in Rome he studied at first hand in 1555.

ORTOLANO
before 1487–after 1524

Giovanni Battista Benvenuti, called Ortolano (Kitchen-gardener), is recorded in Ferrara in 1512, 1520 and 1524. There are no signed or documented works by the artist, but NG 669 was attributed to him as early as 1621. Both NG 669, and a group of pictures which can be associated with it on grounds of style, show that the painter's work is close to that of Garofalo.

Georgius Jacobus Johannes van OS
1782–1861

The artist was born in The Hague. He was the son of the painter Jan van Os, upon whose style his own still lifes were based. Georgius van Os also painted landscapes and made lithographs. He worked in Paris, Amsterdam and The Hague, and then settled in Paris in 1826 and worked for the Sèvres porcelain factory.

Jan van OS
Dutch Vessels in Calm Water
probably 1770–85

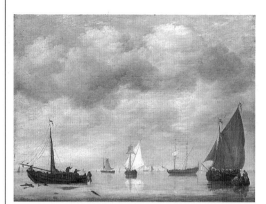

NG 1462
Oil on oak, 32.1 x 42.4 cm

Jan van OS
Fruit, Flowers and a Fish
1772

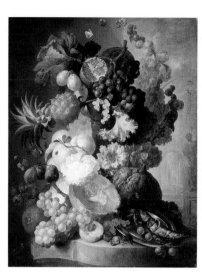

NG 1380
Oil on mahogany, 72.2 x 56.7 cm

Jan van OS
Fruit and Flowers in a Terracotta Vase
1777–8

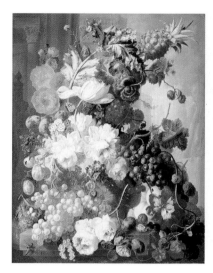

NG 6520
Oil on mahogany, 89.1 x 71 cm

Signed on the flag of the passenger vessel on the right: IVO. On a spar in the foreground left of centre are the worn remains of some letters, apparently a spurious signature of Willem van de Velde.

The vessel on the right, which is carrying passengers, is called a *tjalk*. It has two Dutch vanes flying from it. The boat in the right middle distance is a brigantine.

NG 1462 has in the past been catalogued as by Hendrick Dubbels owing to a misreading of the signature. Van Os painted a number of works of this type during the earlier part of his career.

Presented by Arthur Kay, Glasgow, 1895.

MacLaren/Brown 1991, p. 296.

Signed and dated on the marble slab: J. Van Os. fecit 1772.

A view of a statue with a formal garden beyond can be seen on the right. The fruit includes grapes, melons, peaches, plums, a pineapple and a pomegranate, while the principal flowers are roses and hollyhocks.

Presented by George Holt of Liverpool, 1892.

MacLaren/Brown 1991, p. 296.

Signed lower left: I. VAN OS fecit; and dated 1777 and 1778.

The still life is arranged before an imposing classical building set in a park. The arrangement includes grapes, plums, peaches, a pineapple, roses and carnations.

It is not unusual for still-life paintings of this type to be dated in two successive years, as the artist waited for particular flowers to bloom in different seasons.

Collection of Sir William Churchman, Bt (died 1947); presented by Miss V. Churchman in memory of her sister I.N. Churchman, 1988.

MacLaren/Brown 1991, p. 558.

Jan van OS
1744–1808

Jan van Os was baptised in Middelharnis. The artist was a pupil of Aert Schouman in The Hague and joined the painters' confraternity there in 1773. He painted still lifes of fruit and flowers in the tradition of Jan van Huysum, and some seascapes in the manner of Willem van de Velde the Younger.

Adriaen van OSTADE
A Peasant holding a Jug and a Pipe
about 1650–5

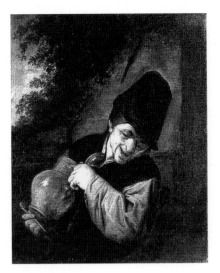

NG 2543
Oil on oak, 26.8 x 22 cm

Signed bottom left: AV . ostade. (AV in monogram).
It is possible that this inscription has been
reinforced.

Van Ostade painted a number of such individual
half-length studies of peasants: this man clasps a
stoneware jug and a clay pipe.

Probably in the Comte de Vaudreuil sale, Paris, 1784;
collection of George Salting; Salting Bequest, 1910.

MacLaren/Brown 1991, p. 301.

Adriaen van OSTADE
The Interior of an Inn with Nine Peasants and a
Hurdy-Gurdy Player, 1653

NG 2540
Oil on oak, 39.9 x 55.7 cm

Signed and dated bottom left: Av. Ostade . 1653 (Av
in monogram).

The artist painted many tavern scenes of this type
showing peasants drinking, smoking and listening
to itinerant musicians.

Johan van der Marck (of Leiden) sale, Amsterdam, 1773;
Earl of Dudley sale, London, 1892; collection of George
Salting by 1894; Salting Bequest, 1910.

MacLaren/Brown 1991, pp. 299–300.

Adriaen van OSTADE
A Peasant courting an Elderly Woman
1653

NG 2542
Oil on oak, 27.3 x 22.1 cm

Signed and dated bottom left: Av. Ostade./1653
The tall wine glass the man holds is a pas-glas.
In the eighteenth century the painting, or the
contemporary print after it by Cornelis Visscher
(1619/29–62), was known by the humorous title
Het schollenmannetje (literally, the little plaice man),
which refers to the salt plaice lying on the table.
In addition to the etching by Visscher, the
composition was engraved in mezzotint by Jacob
Gole (about 1660–about 1737) and Peter Schenk
(1660–about 1718/19).

The [Hendrick de Wacker van Son (Zon)] sale,
Amsterdam, 1761; Jan Maurits Quinkhard sale,
Amsterdam, 1773; collection of William Wells, Redleaf,
by 1819; collection of George Salting by 1886; Salting
Bequest, 1910.

MacLaren/Brown 1991, pp. 300–1.

Adriaen van OSTADE
1610–1685

Adriaen Jansz. van Ostade was born and worked
in Haarlem. He was a pupil of Frans Hals at the
same time as Adriaen Brouwer, who influenced
him. He had joined the guild by 1634. He painted
and etched peasant scenes; he also painted a few
biblical subjects and small portraits. Among his
pupils were his younger brother Isack, Cornelis
Bega, Jan Steen, and his close imitator Cornelis
Dusart.

Adriaen van OSTADE
An Alchemist
1661

NG 846
Oil on oak, 34 x 45.2 cm

Inscribed on a paper under the stool in the foreground: oleum et / operam / perdis (to lose one's time and trouble). Signed and dated on a shovel hanging by the fireplace: Av. Ostade./1661 (Av in monogram).

With its dark interior and figures illuminated by shafts of light, this painting shares formal similarities with Ostade's many scenes of peasant life (e.g. NG 2540), but the artist has introduced into this setting the figure of an alchemist, which is taken from an earlier pictorial tradition, of which the best-known example is Pieter Bruegel the Elder's drawing of 1558 (Berlin, Kupferstichkabinett). Alchemists, who believed that base metals could be transformed into gold, were satirised in the sixteenth and seventeenth centuries: their search for wealth was an illustration of human folly. The moral of the futility of the alchemist's endeavour is explained in the Latin inscription: it is from the Roman comic dramatist Plautus and was quoted by the German humanist Agricola in 1556.

Samuel van Huls sale, The Hague, 1737; collection of La Livre de Jolly, Paris, by 1764; bought with the Peel collection, 1871.

MacLaren/Brown 1991, pp. 298–9.

After Adriaen van OSTADE
A Cobbler
about 1680–about 1720

NG 2541
Oil on oak, 22.6 x 18.2 cm

Falsely signed and dated: Av. Ostade· 1671· (AV in monogram).

The cobbler repairs shoes while his companion smokes. A water pump is against the wall on the right.

NG 2541 has in the past been considered a work by Ostade, but it is now recognised that it is a slightly enlarged copy after an etching by him. Although other copies are recorded, no original painting of the composition is known.

Salting Bequest, 1910.

MacLaren/Brown 1991, p. 302.

Isack van OSTADE
A Farmyard
about 1640

NG 1347
Oil on oak, 40 x 41 cm

Signed bottom right: Isack Ostade
NG 1347 is probably one of the artist's earlier works, painted in about 1640, although the precise sequence of his work is difficult to establish.

Heinrich Moll sale, Cologne, 1886; bought from Edward Habich, Cassel, 1891.

MacLaren/Brown 1991, p. 304.

Isack van OSTADE
1621–1649

Isack Jansz. van Ostade was born and lived in Haarlem; he was a pupil of his brother Adriaen and entered the painters' guild in 1643. Isack was a painter of peasant life and landscape. His early work was influenced by his brother's interior peasant scenes, but later he painted outdoor scenes often set in winter.

Isack van OSTADE
The Outskirts of a Village, with a Horseman
1640s

Isack van OSTADE
A Winter Scene
1640s

Isack van OSTADE
A Landscape with Peasants and a Cart
1645

NG 847
Oil on oak, 56.8 x 49.7 cm

NG 848
Oil on oak, 48.8 x 40 cm

NG 2544
Oil on oak, 52.9 x 45.4 cm

This characteristic scene by the artist was engraved in reverse by B.A. Dunker in 1770 while in the collection of the Duc de Choiseul.

Duc de Choiseul sale, Paris, 1772; bought with the Peel collection, 1871.

MacLaren/Brown 1991, p. 303.

Signed bottom left: Isack·van·Ostade
 Isack van Ostade specialised in depictions of winter scenes. This outstanding example is, like NG 847, difficult to date with any certainty within the artist's short working life.

Possibly Baron Nagel sale, London, 1795; collection of Sir Robert Peel, Bt, by 1842; bought with the Peel Collection, 1871.

MacLaren/Brown 1991, p. 303.

Signed and dated bottom right: Isack · van · Ostade/ 1645
 A rare example of a dated landscape by Isack van Ostade.

Salting Bequest, 1910.

MacLaren/Brown 1991, p. 304.

Isack van OSTADE
The Interior of a Barn with Two Peasants
about 1645

Follower of Isack van OSTADE
An Inn by a Frozen River
about 1640s

Attributed to Michael PACHER
The Virgin and Child Enthroned with Angels and Saints, about 1475

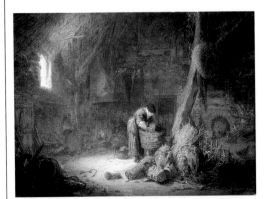

NG 6404
Oil on oak, 30.2 x 40.2 cm

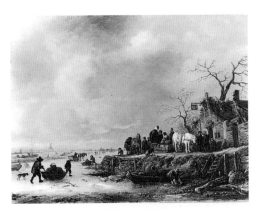

NG 963
Oil on oak, 41.6 x 55.7 cm

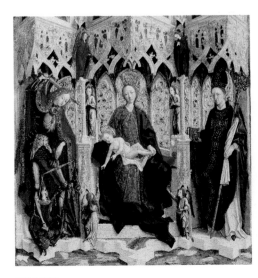

NG 5786
Oil on silver fir, 40.3 x 39.4 cm

An early work, dependent in style and subject matter on the peasant interiors of Isack's elder brother, Adriaen.

When it was sold in 1777, NG 6404 apparently had a pendant, showing an interior with an old man seated by a fireside and a woman washing a child.

Prince de Conti sale, Paris, 1777; bought by W.C. Alexander, 1886; presented by the Misses Rachel F. and Jean I. Alexander; entered the Collection, 1972.

MacLaren/Brown 1991, p. 304.

When NG 963 was cleaned in 1969 a false signature in the lower right was removed. The work is not by Ostade himself, but is a mid-seventeenth-century painting, and may well be by a close imitator in Haarlem such as Claes Molenaer (before 1630–1676).

In the collection of Wynn Ellis by 1850 or 1851; Wynn Ellis Bequest, 1876.

MacLaren/Brown 1991, p. 305.

At the left Saint Michael weighs human souls, while at the right stands an unidentified bishop saint. On the pillars of the throne are the Angel Gabriel and the Virgin Annunciate. The two angels at the base of the throne offer the Christ Child fruit, which he reaches down to receive.

The small size of NG 5786 suggests that it was intended as a private devotional painting. The Gothic canopies over the figures are comparable to those in the larger *Altarpiece of the Four Fathers of the Church* by Pacher (Munich, Alte Pinakothek), of about 1480. The figure of Saint Michael is similar to carvings of the saint from the artist's workshop. The style of his armour suggests a date of about 1475 or later.

Bought by George A. Simonson from an old family near Bolzano, about 1913–14; bequeathed by Miss Anna S.H. Simonson, 1947.

Levey 1959, pp. 99–100; Dunkerton 1991, pp. 330–1.

Michael PACHER
active 1465?; died 1498

A painter and sculptor, Pacher was a citizen of Bruneck (Brunico) in the Tyrol (1467–96), where he ran a large workshop. In 1471 he is documented as undertaking altarpieces at Gries, near Bolzano, and at St Wolfgang. Pacher was active in Salzburg in 1484 and from 1496 to 1498, where he painted the high altarpiece for the parish church.

After PADOVANINO
Cornelia and her Sons
17th century

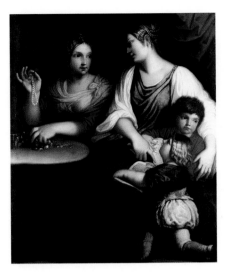

PALMA Giovane
Mars and Venus
probably 1585–90

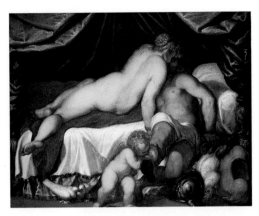

NG 1866
Oil (identified) on canvas, 130.9 x 165.6 cm

PALMA Vecchio
Portrait of a Poet (Ariosto?)
about 1516

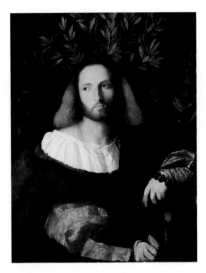

NG 636
Oil (identified) on canvas, transferred from wood,
1857, remounted on wood, 1916, 83.8 x 63.5 cm

NG 70
Oil on canvas, 142.5 x 118.1 cm

Cornelia, a Roman matron and mother of the
Gracchi, declared that her sons were her jewels
after a female friend boasted of the jewels she
owned. The subject comes from Valerius Maximus,
Factorum ac dictorum memorabilium, Libri IX (IV, 4).

NG 70 has previously been catalogued as by
Padovanino, but most of it, with the exception of
the lower portion, is of the quality of an old copy.
The lower portion could, however, conceivably be
by Padovanino.

Bequeathed by Lt.-Col. J.H. Ollney, 1837.

Levey 1971, p. 170.

Venus was the goddess of Love and Mars the god
of War. Venus was the wife of Vulcan and her
adultery with Mars was notorious.

Mythological pictures by Palma are rare. Ridolfi
mentioned in his catalogue of the artist's works a
Mars and Venus painted for the poet Cavaliere
Marino. But Venus' hairstyle suggests the late
1580s, which is somewhat early if the picture was
painted for Marino (born 1569).

When NG 1866 was presented to the Gallery the
donor stated that it was not suitable for public
exhibition, and so it hung for many years in the
Director's Office; it was first catalogued in 1929.

*Almost certainly the picture seen by Richard Symonds
in the possession of the Earl of Northumberland, 1652;
presented by the Duke of Northumberland, 1838.*

Gould 1975, pp. 183–4.

The painting has been supposed to represent a poet
for the figure has a book in his hands and there are
laurels (with which poets were crowned) behind
him. It probably dates from about 1516 when the
poem *Orlando Furioso* was published and achieved
instantaneous fame, and so has been proposed as a
portrait of the author, Lodovico Ariosto (1474–1533).

For an example of a subject from Ariosto's work
see Ingres NG 3292, and for another portrait which
was once thought to be a depiction of the poet, see
Titian NG 1944.

NG 636 has in the past been attributed to Titian; it
is now generally accepted as a work by Palma
Vecchio.

*In the Tomline collection, probably after 1850; bought
with the Edmond Beaucousin collection, Paris, 1860.*

Gould 1975, pp. 185–7.

PADOVANINO
1588–1648

Alessandro Varotari was called Padovanino after
his birthplace, Padua. He was probably trained by
Damiano Mazza, and settled in Venice in 1614. He
was called to Rome to copy Titian's *Bacchanals*,
but had apparently returned to Venice by 1620.
Titian's paintings strongly influenced his work.

PALMA Giovane
1554–1628

Iacopo Palma was called Palma Giovane to
distinguish him from his great-uncle, Palma
Vecchio. In his youth he apparently served the
Duke of Urbino, who sent him to Rome, and he
worked in Titian's studio. He principally painted
religious and historical subjects in Venice, but also
received commissions from Rudolph II and King
Sigismond III of Poland. After Tintoretto's death
(1594), he became the leading painter in the city.

PALMA Vecchio
active 1510; died 1528

Iacomo Negreti, called Palma Vecchio, came from
the neighbourhood of Bergamo. He was first
mentioned in 1510 in Venice, where he appears to
have worked for the rest of his life. He mainly
painted devotional works and portraits, including
ideal portraits of women. His work is close in style
to that of Titian.

PALMA Vecchio
A Blonde Woman
about 1520

Attributed to PALMA Vecchio
Saint George and a Female Saint
early 16th century

Marco PALMEZZANO
The Dead Christ in the Tomb, with the Virgin Mary and Saints, 1506

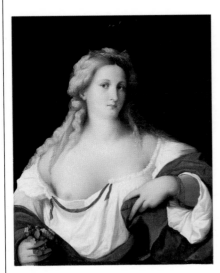

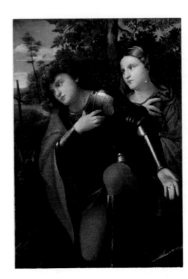

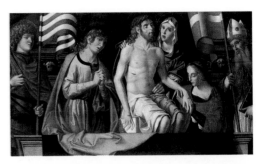

NG 596
Oil on wood, 98.5 x 167.6 cm

NG 3939
Oil (identified) on wood, 77.5 x 64.1 cm

NG 3079
Oil on canvas, transferred from wood, 102.9 x 73 cm

The painting, and others like it by Palma and Titian, is unlikely to have been regarded as the portrait of a specific individual, but rather as a type of sensuous beauty loosely associated with Flora (a pagan nymph, but also a famous Roman courtesan) – hence the flowers.

The dating to about 1520 is suggested by comparison of the style of the figure's hair with similar hairstyles in contemporary Venetian work, notably the dated paintings of Lotto.

A strip of wood 2.54 cm high has been added along the top.

William Delafield sale, Christie's, 30 April, 1870 (lot 53); bought by Mond, 1889; Mond Bequest, 1924.

Gould 1975, pp. 187–8.

The soldier is identified as Saint George because the dragon he vanquished lies at the lower left and his shattered lance lies at the lower right. His companion is likely to be a female saint, but has not been identified.

NG 3079 is a fragment and probably had a Madonna and Child to the left. A complete work of this type by Palma Vecchio is in the Alte Pinakothek, Munich. The present picture is damaged and heavily repainted; its condition precludes a firm attribution to the artist.

Bought by Sir A.H. Layard by 1869; Layard Bequest, 1916.

Gould 1975, pp. 188–9.

Christ is shown seated on the lid of his open tomb after the Crucifixion. The Virgin Mary, Saint John the Evangelist and Mary Magdalene appear to be inside the tomb. On the left is Saint Valeriano, the patron saint of Forlì (he holds the town's blue and white standard). On the right is Saint Mercuriale, the first bishop of Forlì, who holds the red and white banner of the Guelphs.

NG 596 was the lunette above an altarpiece of *The Institution of the Eucharist* (Forlì, Pinacoteca). This altarpiece was placed on the high altar of the Duomo in Forlì by October 1506. NG 596 is said originally to have been semicircular and has been cut down to its present shape; the top corners are additions.

Forlì Cathedral by October 1506 and until 1840; bought, 1858.

Gould 1975, pp. 189–90.

Marco PALMEZZANO
1458/63–1539

Palmezzano was born in Forlì and was active there. He may have been a pupil of Melozzo da Forlì, and worked alongside him in 1493. He painted altarpieces, frescoes and small devotional images. He seems to have visited Venice and to have been influenced by Bellini's altarpieces.

Giovanni Paolo PANINI
Roman Ruins with Figures
about 1730

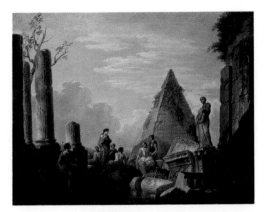

NG 138
Oil on canvas, 49.5 x 63.5 cm

Giovanni Paolo PANINI
Rome: The Interior of St Peter's
before 1742

NG 5362
Oil on canvas, 149.8 x 222.7 cm

PAOLO da San Leocadio
The Virgin and Child with Saints
about 1495

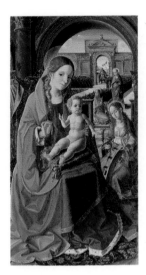

NG 4786
Oil on oak, 43.5 x 23.3 cm

Signed lower left: G.P.P.

The artist painted a number of *capricci* of this sort in which a known monument is set within a fanciful arrangement of ruins. The pyramid is based upon that of Caius Cestius in Rome, while all of the other elements are invented.

It has been suggested that NG 138 is one of the artist's earlier works and can be dated to about 1730. It may include some intervention by a member of his studio.

Bequeathed by Lt.-Col. J.H. Ollney, 1837.

Levey 1971, p. 171.

Inscribed around the cupola: Caelorum Tu Es Petrus Et S. (This is part of a text from the Gospel of Matthew, chapter 16: 17–18). On the ceiling of the nave: PAVLVS V PONTIF. MAX.A.MDCXV (Pope Paul V, 1615). On the sarcophagus above the first doorway at the right: Innocentius XIII/ PONTIFEX MAX (Pope Innocent XIII). On the sarcophagus above the second doorway: Innocen: XI (?)/P.M. (Pope Innocent IX). Inscribed on the base of the pillar at the extreme left: Julio Paulo/Pannini.

This interior view of the basilica shows its appearance from the left of the main entrance, looking towards the high altar. At the right of centre in the nave are a cardinal and other figures.

NG 5362 appears to be one of the derivations the artist executed from a commission he received from Cardinal de Polignac to depict the cardinal visiting the basilica (this painting is in the Louvre, Paris). The cardinal and surrounding figures in NG 5362 are not portraits. In later versions of the view the artist included changes that were made to the church, and so its appearance here helps suggest a date of execution, certainly before 1742, and possibly at some point in the previous decade. The signature is not autograph, and the work may have been executed with studio assistance.

Du Cane Estates (Braxted Park, Essex) sale, London, 1942; bought from F.A. Drey, 1942.

Levey 1971, pp. 172–5.

Signed in the centre of the border of the Virgin's robe: PAVLVS [the letters AV in monogram].

Christ, who is seated on the Virgin's lap, blesses with his right hand. To the right is Saint Catherine of Alexandria, with her attribute, a broken wheel. In the walled garden (*hortus conclusus*) in the background is Saint Agatha, seated, and another female saint who bears a martyr's palm and a short sword. Saint Joseph enters the garden through the archway with a joiner's saw in his hand. In the pediment above the archway is a carving of God the Father. The border of the Virgin's robe is ornamented with imitation Cufic script.

NG 4786 possibly originally formed the left wing of a diptych or a leaf of a small polyptych.

Said to have been from the Palazzo Cerretani, Florence; bought from the executors of Sir Guy Sebright, Bt, 1935

MacLaren/Braham 1970, pp. 83–6.

Giovanni Paolo PANINI
1691–1765

Giovanni Paolo Panini or Pannini was born in Piacenza where he probably studied architectural drawing. In 1711 he travelled to Rome, worked as a pupil of Luti and in 1719 was elected to the Accademia di San Luca, eventually becoming its president (1754–5). He decorated palaces in the city and specialised in painting architectural views.

PAOLO da San Leocadio
active 1472 to 1520

Paulo de Regio or de Sent Leocadio came from San Leocadio, near Reggio d'Emilia. In 1472 he travelled to Valencia to paint frescoes for the cathedral, and remained working in the city and its vicinity. The style of his mature works is indebted both to contemporary Bolognese and Ferrarese painting and to the local Hispano-Flemish manner.

Abraham de PAPE
Tobit and Anna
about 1658

Luis PARET
View of El Arenal de Bilbao
1784

PARMIGIANINO
Portrait of a Man
probably before 1524

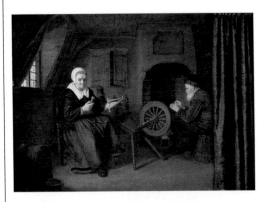

NG 1221
Oil on oak, 40.7 x 56 cm

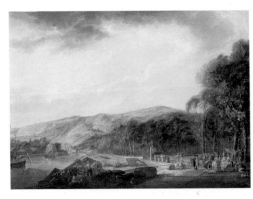

NG 6489
Oil on wood, 60.3 x 83.2 cm

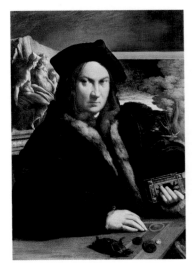

NG 6441
Oil on wood, 89.5 x 63.8 cm

Signed and dated on the wall-cupboard: A · DE · PAPE 165(8 or 9?).

Tobit and Anna were the parents of Tobias who saved his father's sight with the help of the Archangel Raphael. Tobit had been reduced to poverty by God as a test: Anna supported them with her spinning-wheel and the bare cupboard refers to their hardship. Book of Tobit (2: 11 and 4: 21). The painting was formerly described as a Cottage Interior but its real subject was identified by comparison with a similar painting by Rembrandt (NG 4189), which also might have been thought to be a genre scene were it not for the inscription on a contemporary engraving after it. A map hangs on the wall above the fireplace, and the whole scene is set behind an illusionistic representation of curtains that are drawn back. Pictures were often protected by such curtains in the seventeenth century, and Dutch paintings not infrequently include depictions of them after the mid-1640s.

The third number of the date inscribed on NG 1221 can be read as a 5, so the work is thought to have been executed in the late 1650s.

Duke of Marlborough (Blenheim Palace) sale, London, 1886; bought (Walker Fund), 1886.

MacLaren/Brown 1991, pp. 305–6.

Signed and dated three times lower left: Luis Paret, año de 1784; L. Paret pingebat aº 84; L. Paret pinxit anno 1784.

The small quayside of El Arenal on the river Nervión, which is now in the centre of modern Bilbao, was used as an elegant promenade and for unloading cargoes from ships. In the distance at the left is the convent of Saint Agustín.

NG 6489 is very probably one of a series of at least six views of northern Spanish ports commissioned from Paret by King Charles III. They were made during the artist's exile (see biography), and in handling and figure style appear to emulate contemporary French painting.

Probably Royal Palace, Madrid; collection of the Hon. Bertram Bell, Ireland; bought at Christie's, December 1983.

National Gallery Report 1982–4, p. 30; Helston 1989, p. 102.

The sitter has not been identified, but may have been a collector of note. The sculpted relief on the left probably represents Mars and Venus with Cupid, and the statuette on the table may be a figure of Ceres, and is probably antique, as are the coins.

NG 6441 was probably painted in Parma before 1524, although a later date is also possible.

Recorded in the Farnese collection, Parma, probably before 1600; in the collection of William Young Ottley by 1801; subsequently in the collection of Lord Radstock and then the Byng family; bought, 1977.

National Gallery Report 1975–7, pp. 42–3.

Abraham de PAPE
before 1621–1666

Abraham Isaacksz. de Pape was probably born in Leiden, and taught there by Gerrit Dou. The artist is mentioned in guild documents in the city from 1644. He was principally a genre painter, but also executed a few portraits.

Luis PARET
1746–1799

Paret was born in Madrid. In the early 1760s he visited Rome, and early in his career enjoyed royal patronage. Back in Madrid in 1775 he was exiled from the court because of a suspected involvement in a scandal concerning his patron Don Luis de Borbón. The artist lived in Puerto Rico and northern Spain; in 1780 he was elected to the Academia de San Fernando.

PARMIGIANINO
1503–1540

Girolamo Francesco Maria Mazzola, called Il Parmigianino from his native Parma where he principally worked. He also worked in Rome (1524–7) and in Bologna (1527–31). His surviving works are mainly religious paintings (altarpieces and small devotional works) and portraits; he also painted in fresco.

PARMIGIANINO
The Madonna and Child with Saints John the Baptist and Jerome, 1526–7

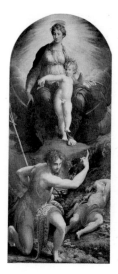

NG 33
Oil on poplar, 342.9 x 148.6 cm

Traditionally called 'The Vision of Saint Jerome' in acknowledgement of the unusual fact that the saint is depicted asleep, this image of the Madonna and Child with Saints also contains imagery associated with the Immaculate Conception (e.g. the crescent moon on which the Virgin Mary is seated). In the foreground is Saint John the Baptist, pointing to the Christ Child.

NG 33 was commissioned in January 1526 by Maria Bufalini for a chapel in the church of S. Salvatore in Lauro, Rome. While Parmigianino was working on the altarpiece Rome was sacked by Imperial troops (in 1527) and he fled the city. The altarpiece remained in Rome (at one time it was in the refectory at S. Maria della Pace) until removedin about 1558 to the Bufalini chapel in the church of S. Agostino in Città di Castello. Vasari's revised account of these events has been substantiated by recent archival discoveries.

Numerous drawings made in preparation for NG 33 survive.

Bought by James Durno probably about 1789; presented by the Directors of the British Institution, 1826.

Popham 1971, pp. 7–9, 90; Gould 1975, pp. 191–6; Corradini 1993, pp. 27–9; Vaccaro 1993, pp. 22–7.

PARMIGIANINO
The Mystic Marriage of Saint Catherine
about 1527–31

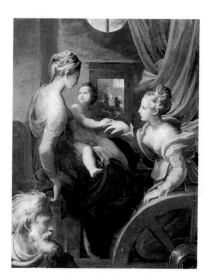

NG 6427
Oil on wood, 74.2 x 57.2 cm

Saint Catherine of Alexandria is shown on the right with the wheel on which she was tortured and a martyr's palm. The Christ Child places a ring on her finger, a reference to her vision in which she received this token of his love – the so-called 'mystic marriage of Saint Catherine'. The figure in the foreground may be the hermit who converted her. Two unidentified figures are seen at a doorway beyond.

NG 6427 may be the picture of the 'Virgin and several other figures' that Vasari stated Parmigianino painted for a close friend in Bologna. It is generally dated to his period in Bologna from 1527 to 1531.

Several drawings by Parmigianino have been related to NG 6427. The composition was engraved by Giulio Bonasone (active 1531–74), and copies after the picture are also known, some dating from the sixteenth century. There is another unfinished small painting of the subject of the same date (Paris, Louvre).

First recorded in the Villa Borghese, Rome, 1650; bought by William Ottley, about 1799–1800; in the collection of William Morland by 1814; bought for the 2nd Earl of Normanton, 1832; Normanton collection, Somerley, until bought, 1974.

Popham 1971, pp. 49, 114, 136, 143, 227; National Gallery Report 1973–5, pp. 30–1; Gould 1975a, pp. 230–3.

Joseph PARROCEL
The Boar Hunt
about 1700

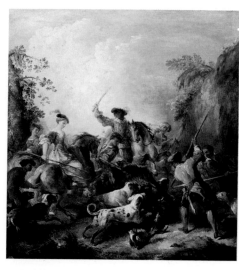

NG 6473
Oil on canvas, 110.5 x 106 cm

NG 6473 has been regarded as one of five paintings commissioned in about 1699 for Louis XIV and given by him to his son, the Comte de Toulouse, but the only certain survivor of this group, all of which were described in 1762 as large, is *La Foire de Bezons* (Tours, Musée des Beaux-Arts) which is more than twice the size of NG 6473. More probably it is one of a pendant pair of which the other is NG 6474.

Possibly with Pierre-Joseph Titon de Cogny before 1758; André-Louis, Marquis de Sinety, about 1800; bought, 1982.

National Gallery Report 1982–4, pp. 14–15; Wilson 1985, p. 76; Lavergne-Durey 1989, p. 80.

Joseph PARROCEL
1646–1704

Parrocel was born in the south of France into a family of painters. He trained partly in Rome under the battle painter Jacques Courtois before settling in Paris in 1675. He was received into the Académie in 1676, and executed works for the châteaux of Versailles and Marly, the Hôtel de Soubise and Notre-Dame, Paris.

Joseph PARROCEL
The Return from the Hunt
about 1700

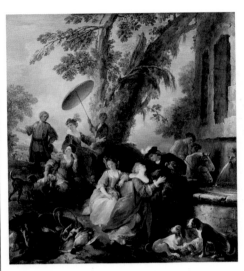

NG 6474
Oil on canvas, 110.5 x 106 cm

NG 6474 has been regarded as one of five paintings commissioned in about 1699 for Louis XIV and given by him to his son, the Comte de Toulouse, but the only certain survivor of this group, all of which were described as large, is *La Foire de Bezons* (Tours, Musée des Beaux-Arts) which is more than twice the size of NG 6474. More probably NG 6474 is one of a pendant pair of which the other is NG 6473.

Possibly with Pierre-Joseph Titon de Cogny before 1758; André-Louis, Marquis de Sinety, about 1800; bought, 1982.

National Gallery Report 1982–4, pp. 14–15; Wilson 1985, p. 76; Lavergne-Durey 1989, p. 80.

Pierre PATEL
The Rest on the Flight into Egypt
1652

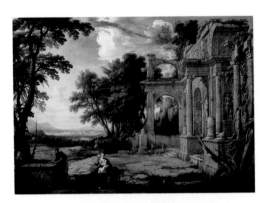

NG 6513
Oil on canvas, 97 x 194.5 cm

Signed and dated at the bottom : P. PATEL INVE-PIN/.1652 (Pierre Patel invented and painted this, 1652).

Joseph was warned in a dream that King Herod was searching for the Christ Child and so took Mary and the infant to Egypt for safety. New Testament (Matthew 2: 13–15). Their rest during the journey is a frequently depicted incident which is not actually described in the Bible. In NG 6513 they have paused beside a derelict temple covered with picturesque (but almost certainly fantastic) antique bas-reliefs.

Patel's landscape demonstrates the impact on Parisian taste of French classical landscapes arriving from Rome. In NG 6513 Patel, who had probably never visited Italy, represents the Roman campagna in the manner of Claude. There is a related drawing in the Ecole Nationale Supérieure des Beaux-Arts, Paris.

Bought, 1988.

National Gallery Report 1985–7, pp. 35–6.

Attributed to Joachim PATENIER
Saint Jerome in a Rocky Landscape
probably 1515–24

NG 4826
Oil on oak, 36.2 x 34.3 cm

In the foreground Saint Jerome is seated with his lion. The lion had been given the task of looking after an ass that belonged to a monastery. He fell asleep and passing merchants with camels took the ass. When they were next in the district the lion recognised the ass and returned him to the monastery. The merchants can be seen in the middle distance in front of the monastery, kneeling before the abbot and asking to be pardoned. The subject is recounted in *The Golden Legend*.

NG 4826 is the left part of a Patenier composition known in several versions, the best of which is a signed painting in Madrid (Prado). The National Gallery's picture has been cut down.

Collection of Rodolphe Kann, Paris; sold to Duveen; bought by Mrs Henry Oppenheimer, a niece of Rodolphe Kann, by 1916; by whom bequeathed, 1936.

Davies 1968, pp. 160–1.

Pierre PATEL
about 1605–1676

Pierre Patel was probably born in Picardy. By 1635 he was in Paris and a member of the painters' guild there. He was known as a landscapist and worked on decorative schemes at the Hôtel Lambert in 1646–7. He seems never to have travelled to Italy.

Joachim PATENIER
active 1515; died not later than 1524

The artist's name is also sometimes given as Patinir and Patinier. He was from either Bouvignes or Dinant. In 1515 he became a master in Antwerp, where he worked. Patenier specialised as a landscape painter.

Workshop of Joachim PATENIER
Landscape with the Rest on the Flight into Egypt
probably 1515–24

Style of Joachim PATENIER
The Virgin and Child with a Cistercian (?) Nun
perhaps about 1525

Imitator of Jean-Baptiste PATER
The Dance
18th century

NG 3115
Oil on oak, 33 x 54.6 cm

NG 945
Oil on oak, 33.3 x 24.1 cm

NG 4079
Oil on canvas, 74.9 x 114.9 cm

In the left background is the Miracle of the Corn, according to which corn sprang up to deceive Herod's officers during the Flight into Egypt. The Massacre of the Innocents is also shown. The figure at the right may be Saint Joseph.

NG 3115 has in the past been catalogued as ascribed to Patenier, but it appears to be inferior in quality to works such as NG 4826 which can be associated with his hand.

Bought by Sir A.H. Layard, Madrid, 1871; Layard Bequest, 1916.

Davies 1968, pp. 161–2.

The kneeling figure has in the past been identified as Saint Catherine of Siena or Saint Agnes, but is more likely to be a donatrix.

NG 945 has previously been catalogued as Flemish. It is somewhat reminiscent of the style of Patenier.

Wynn Ellis Bequest, 1876.

Davies 1968, p. 162.

Parkland idylls of this sort populated by elegantly dressed figures were developed by Watteau and adopted by Pater.

NG 4079 is considered an eighteenth-century imitation of Pater's work which can be related to other compositions by Pater, including one of his *Fêtes Galantes* at Kenwood. A number of the figures are derived from the paintings of Watteau.

Passed from John Webb to his daughter Edith Cragg; by whom bequeathed, as part of the John Webb Bequest, 1924.

Davies 1957, pp. 165–6.

Jean-Baptiste PATER
1695–1736

Pater was born in Valenciennes where he studied under Jean-Baptiste Guidé. He was briefly a pupil in Paris of Watteau, whose style and subject matter he adopted, and was elected a member of the Académie in 1728.

Giovanni Antonio PELLEGRINI
Rebecca at the Well
1708–13

Giovanni Antonio PELLEGRINI
An Allegory of the Marriage of the Elector Palatine, about 1713

Jean-Baptiste PERRONNEAU
A Girl with a Kitten
1745

NG 6328
Oil on canvas, 43.2 x 63.5 cm

NG 6332
Oil (identified) on canvas, 127.3 x 104.5 cm

Abraham sent his servant to find a bride for his son Isaac. The servant came to a well and waited for a woman who would provide both him and his camels with water. Whoever did so would be the ideal bride for Isaac. Rebecca did both, and in return he gave her a bracelet. She later married Isaac. Old Testament (Genesis 24: 22ff.).

NG 6332 appears to have been painted while Pellegrini was in England between 1708 and July 1713.

Claude Dickason Rotch collection by 1951; by whom bequeathed, 1962.

Levey 1971, p. 177.

The Elector Palatine, Johann Wilhelm, married Anna Maria Luisa de' Medici, daughter of the Grand Duke Cosimo III of Tuscany, in 1691. In July 1713 Pellegrini travelled from England to Düsseldorf to work for him.

NG 6328 is a preparatory sketch for a large composition which was one of a series of 14 paintings by the artist that dealt with aspects of the life and reign of the Elector Johann Wilhelm. The pictures were made for Schloss Bensberg, near Düsseldorf, during the period July 1713–August 1714. The fluid handling of this sketch is akin to that of other surviving preparatory works from the project; it may predate the artist's departure from England.

Bought at Sotheby's, 4 April 1962.

Levey 1971, pp. 175–7.

NG 3588
Pastel on paper, 59.1 x 49.8 cm

Signed and dated: Perronneau. pin. / aoust 1745. (Perronneau painted this August 1745).

NG 3588 is probably a portrait but the sitter has not been identified.

NG 3588 is sometimes said to be a fake, but technical examination has not confirmed this view.

Collection of Lady Dorothy Nevill by 1902; presented by Sir Joseph Duveen, 1921.

Vaillat 1923, pp. 10, 209, 245; Davies 1957, pp. 166–7.

Giovanni Antonio PELLEGRINI
1675–1741

Pellegrini was born in Venice and studied under Pagani. He was influenced by the work of Giordano and Sebastiano Ricci. In 1704 he married the sister of Rosalba Carriera. The artist visited England with Marco Ricci in 1708 and worked there until 1713. He also travelled to Düsseldorf (where he served the ELECTOR Johann Wilhelm, see NG 6328), the Low Countries and Paris, before returning to Venice where he died.

Jean-Baptiste PERRONNEAU
1715?–1783

Perronneau was born in Paris. He worked as an engraver before specialising as a portrait painter (in oil and particularly in pastel). He became a member of the Académie in 1753, and visited Italy in 1759 and Russia in 1781. He died in Amsterdam.

Jean-Baptiste PERRONNEAU
Jacques Cazotte
about 1760–5

NG 6435
Oil on canvas, 92.1 x 73 cm

Signed upper right: Perronneau.

Jacques Cazotte was a writer of romantic novels and verse. He was born in Dijon in 1719 and guillotined in 1792. Cazotte was out of France from 1747 to 1752 and again from 1754 to 1759.

NG 6435 was probably painted in the early 1760s. It has been suggested that the costume dates from this period which would also accord with the likely age of the sitter.

A copy of NG 6435 is in the museum at Châlons-sur-Marne.

In a private collection in England in 1918; bought, 1976.

Constable 1933, no. 223.

Jean-Baptiste PERRONNEAU
Portrait of a Woman
perhaps about 1760–9

NG 4063
Pastel on paper, 61 x 48.9 cm

Inscribed in French in a modern hand on the reverse: Mme Legrix née d'Hégar

One of several pictures, variously dated between 1757 and 1769, acquired from the descendants of the Journu family, who lived in and around Bordeaux. The sitter may be connected with that family or, alternatively, the inscription may be correct. Perhaps painted in the 1760s.

Journu collection, Bordeaux, before 1923; presented by F.D. Lycett Green through the NACF, 1925.

Vaillat 1923, pp. 69, 218; Davies 1957, p. 167.

Pietro PERUGINO
The Virgin and Child with an Angel
about 1496–1500

NG 288.1
Oil (identified) on poplar, painted surface
113 x 64 cm

The Virgin and Child with an Angel was the central panel of a polyptych and was flanked by the Archangel Raphael with Tobias (right, NG 288.3) and the Archangel Michael (left, NG 288.2).

These three panels come from the Certosa at Pavia (seen in Bergognone NG 1410), where they formed the lower tier of a six-panel altarpiece, probably commissioned in 1496 by (or on behalf of) Lodovico il Moro, Duke of Milan. Perugino's signature can be seen on NG 288.2. The upper tier comprised *God the Father* (by Perugino; Pavia, Certosa) flanked by the *Virgin Annunciate* and the *Angel Gabriel* (by Fra Bartolommeo; Geneva, Musée d'Art et d'Histoire).

Copies in the Certosa, Pavia, record the appearance of the panels before they were cut down between 1784 and 1856. The composition of NG 288.1 is repeated in Perugino's *Madonna del Sacco* (Florence, Pitti). See NG 288.2 for the provenance and bibliography.

Pietro PERUGINO
living 1469; died 1523

Pietro Vannucci, called il Perugino ('the Perugian'), trained with Andrea del Verrocchio in Florence. He married a Florentine, and seems to have worked equally in Perugia and Florence but also in Rome and elsewhere. His reputation was at its height between 1490 and 1505 when there was no more admired or sought-after painter in Italy, but in his later years his work was regarded as outmoded.

Pietro PERUGINO
The Archangel Michael
about 1496–1500

Pietro PERUGINO
The Archangel Raphael with Tobias
about 1496–1500

Pietro PERUGINO
The Virgin and Child with Saint John
after 1500

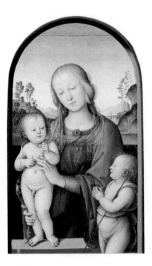

NG 288.2
Oil (identified) on poplar, painted surface
114 x 56 cm

Signed below the tree supporting Michael's scales:
PETRVS PERVSINV(S) / PINXIT.

The Archangel Michael tramples on Satan (whom he cast to the ground in aerial combat). This story occurs in the Bible and in *The Golden Legend*.

NG 288.2 was part of a polyptych and is discussed under NG 288.1.

Copies in the Certosa, Pavia, record the appearance of the panels before they were cut down between 1784 and 1856. The figure of Satan, which is cut off at the bottom of the panel, is seen more clearly in a copy in the Certosa, Pavia. A metalpoint drawing for Michael's armour is in the Royal Library, Windsor.

Recorded in the Certosa, Pavia, until 1784 (mentioned by Vasari in 1550); bought in Milan, Melzi collection, 1856.

Davies 1961, pp. 403–7; Bomford 1980, pp. 3–31; Scarpellini 1984, pp. 100–1; Dunkerton 1991, pp. 360–2.

NG 288.3
Oil (identified) on poplar, painted surface
113 x 56 cm

The Archangel Raphael accompanied Tobias on a journey for his father Tobit. Tobias holds the fish whose gall would cure his father's blindness. The story is told in the apocryphal Book of Tobit.

NG 288.3 was part of a polyptych and is discussed under NG 288.1.

Copies of the altarpiece in the Certosa, Pavia, record the appearance of the panels before they were cut down between 1784 and 1856. Tobias's dog, who appears at the base of the panel, is seen more clearly in the copy. A metalpoint drawing of these figures is in the Ashmolean Museum, Oxford.

Recorded in the Certosa, Pavia, until 1784 (mentioned by Vasari in 1550); bought in Milan, Melzi collection, 1856.

Davies 1961, pp. 403–7; Bomford 1980, pp. 3–31; Scarpellini 1984, pp. 100–1; Dunkerton 1991, pp. 360–2.

NG 181
Tempera on poplar, 68.5 x 44.5 cm

Signed on the Virgin's mantle: PETRUS . PERUGINUS.

NG 181 shows Perugino's awareness of Verrocchio's marble *Virgin and Child* (Florence, Bargello), and must therefore date from after 1472 when he joined Verrocchio's workshop in Florence; a date of soon after 1500 is probable and some degree of workshop participation is also likely.

NG 181 was originally round-topped and it is now displayed with a re-created addition at the top. The Virgin's robe is painted in ultramarine, the most expensive and intense blue pigment and one often reserved for the Virgin's drapery.

Apparently bought in Perugia; collection of William Beckford by 1820; from whom bought, 1841.

Davies 1961, pp. 401–2; Bomford 1977, pp. 29–34; Scarpellini 1984, p. 80.

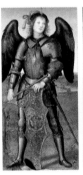

NG 288.1–3

Pietro PERUGINO
The Virgin and Child with Saints Jerome and Francis, probably about 1507–15

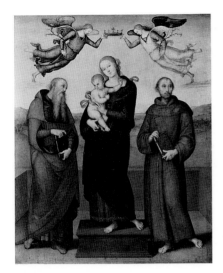

NG 1075
Oil on wood, 185.5 x 152.5 cm

The Virgin with the Child stands on a plinth with Saint Jerome (left) and Saint Francis (right). Above, two angels hold a crown over the Virgin's head.

An altarpiece depicting the Madonna of Loreto (according to tradition the Virgin's house had been miraculously moved to Loreto) and Saints Francis and Jerome was commissioned from Perugino (and perhaps painted by him and his workshop) in 1507. This altarpiece was intended for the chapel built on behalf of Giovanni di Matteo Schiavone (died June 1507) in the church of S. Maria de' Servi, Perugia. NG 1075 can be linked to this commission by its subject and by its provenance.

Despite the contractual clause that Perugino should paint the panel himself, recent opinion favours significant workshop involvement in this picture. The original frame for this altarpiece is now in the Pinacoteca Nazionale, Perugia. This does not appear to allow for a predella as specified in the contract. The two angels may have been reversed from the same cartoon.

Moved from S. Maria de' Servi to S. Maria Nuova, about 1542; removed from that church in 1821 and bought from Baron Fabrizio della Penna, 1879.

Davies 1961, pp. 407–10; Scarpellini 1984, pp. 115–16.

Follower of PERUGINO
The Virgin and Child in a Mandorla with Cherubim, probably about 1500–50

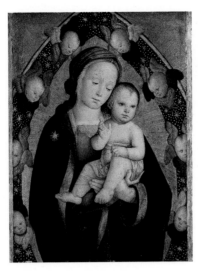

NG 702
Tempera on wood, 46 x 32 cm

The Virgin and Child are seen in an almond-shaped aureole or *mandorla* (from the Italian for 'almond') of cherubim, the second of the highest order of angels representing Divine Wisdom.

NG 702 is one of many versions of a popular composition. These may reflect a lost original by Perugino, or perhaps a design by him. Some versions have been ascribed to Antonio da Viterbo (called Il Pastura, active from 1450), including a picture recently offered for sale at Phillips (15 May 1984). NG 702 probably dates from the first half of the sixteenth century.

Bought by Count Joseph von Rechberg, Paris, 1815; collection of the Prince Consort by 1854; presented by Queen Victoria at the Prince Consort's wish, 1863.

Davies 1961, pp. 411–12.

Follower of PERUGINO
The Virgin and Child with Saints Dominic and Catherine of Siena, and Two Donors
perhaps about 1500–50

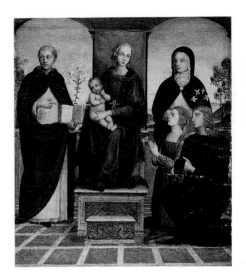

NG 2484
Oil on wood, 35.5 x 31.5 cm

The Virgin and Child are shown with Saint Dominic (1170–1221), the founder of the Dominican Order of Preachers, who commonly holds a lily, and Saint Catherine of Siena (about 1347–80), a Dominican tertiary, canonised in 1461. Saint Catherine stands behind two donors, a man and a woman.

NG 2484 has not been attributed and is generally held to be the work of an early sixteenth-century follower of Perugino.

Conte Guido di Bisenzo Collection, Rome, by 1836; Salting Collection by 1892; Salting Bequest, 1910.

Davies 1961, p. 413.

After PERUGINO
The Baptism of Christ
probably 1810–60

Francesco PESELLINO
David and Goliath
about 1440–50

Francesco PESELLINO
The Triumph of David
about 1440–50

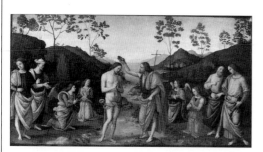

NG 1431
Oil on canvas, 32.5 x 59 cm

L7
Egg tempera on wood, 43.2 x 177.8 cm

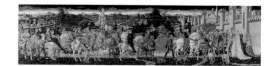

L8
Egg tempera on wood, 43.2 x 177.8 cm

Saint John the Baptist baptises Jesus in the river Jordan. New Testament (all Gospels, e.g. Matthew 3: 13–17). Four angels and four other figures are also present.

NG 1431 is a modern copy of a predella panel by Perugino (Rouen, Musée des Beaux-Arts). Within five years of its acquisition, the authenticity of this picture was doubted.

Bought, Rome, 1894.

Davies 1961, p. 411.

David is seen with his flock in the left background; again in the foreground, gathering stones for his sling; and towards the centre he stands before Saul and refuses to put on the armour which he is being offered. The right half of the panel shows David facing Goliath with a stone in his sling; and (in the centre) David is shown cutting off the giant's head. Old Testament (I Samuel 17: 20–51).

L7 is a panel from a *cassone* or marriage chest; see further under L8 and see Appendix B for a larger reproduction.

Acquired from the Pazzi collection (Florence) by Marchese Luigi Torregiani in the early nineteenth century; bought from the Palazzo Torregiani, Florence, 1896, by Agnew, and from him in the same year by Lord Wantage; on loan from the Loyd Trustees since 1974.

Parris 1967, pp. 34–5; Dunkerton 1991, p. 109.

Saul leads a triumphal procession from the battlefield at Gath back to Jerusalem. David stands with Goliath's head on the second chariot. Old Testament (I Samuel 17: 53–4). A marriage ceremony is seen before the walls of Jerusalem, and it has been suggested that this was intended to allude to the marriage of Elenora Pazzi (from whose family the pair of *cassoni* panels is said to have been acquired).

L7 and L8 are panels from a pair of *cassoni* (painted marriage chests), and it is possible that two smaller panels in the Musée des Arts at Le Mans came from the short ends of these chests.

The Triumph of David was a popular subject in Florence, where there was a special interest in David as an Old Testament republican hero. See Appendix B for a larger reproduction.

Acquired from the Pazzi collection (Florence) by Marchese Luigi Torregiani in the early nineteenth century; bought from the Palazzo Torregiani, Florence, 1896, by Agnew, and from him in the same year by Lord Wantage; on loan from the Loyd Trustees since 1974.

Parris 1967, pp. 34–5; Dunkerton 1991, p. 109.

Francesco PESELLINO
about 1422–1457

Francesco di Stefano, known as Pesellino, was probably a pupil of Fra Filippo Lippi. His only documented work is the altarpiece catalogued here, but he ran a successful workshop in the Corso degli Adimari, Florence, where in 1453 he entered into a partnership with two other painters, Piero di Lorenzo and Zanobi di Migliore.

Francesco PESELLINO
The Trinity with Saints
1455-60

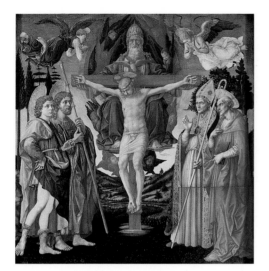

NG 727, 3162, 3230, 4428 and L15
Egg and oil (identified) on wood, painted surface
184 x 181.5 cm

The altarpiece was divided into several pieces,
probably in the eighteenth century, and has now
been reassembled. The fragments entered the
Collection at different dates and have different
Inventory numbers. The main panel shows the
Trinity (NG 727); with an angel on the right (NG
3162); and an angel on the left (NG 3230); Saints
Zeno and Jerome (NG 4428); Saints James the
Great and Mamas (L15, on loan from Her Majesty
The Queen).

The altarpiece was commissioned in 1455 from
Pesellino by the Company of Priests of the Trinity
for their church in Pistoia. Pesellino died in 1457
and the altarpiece, judged to be about half-finished,
was completed in Prato by Fra Filippo Lippi (and
installed in 1460). The division of labour between
the two artists (and their workshops) remains
unclear, but it is likely that Pesellino was
responsible for the design of the altarpiece, and
perhaps the left-hand figures, and that Lippi was
responsible for the right-hand figures, the dove,
God's hands and the landscape.

A drawing for the central group of the Trinity is
in St Petersburg (Hermitage).

*NG 727: Collection of William Young Ottley by 1837
(and probably by about 1791/9); collection of the Revd
Walter Davenport Bromley; bought, 1863. NG 3162 and
3230: apparently in the Lombardi–Baldi collection,
Florence, by about 1845; collection of Lord Somers by
1866; from whom bought, 1917. NG 4428: Collection of
William Young Ottley by 1837 (and probably by about
1791/9); Emperor William II of Germany by 1906;
presented by the NACF in association with and by the
generosity of Sir Joseph Duveen, Bt, 1929.*

Davies 1961, pp. 414–19; Dunkerton 1991, pp. 54, 57,
147; Ruda 1993, pp. 449–52.

Francesco PESELLINO
Predella of the Trinity with Saints Altarpiece
1455-60

NG 4868.1-2
Tempera on wood 27 x 39.5 cm

NG 4868.1-2 were predella panels of the altarpiece
of the *Trinty with Saints*. They show: Saint Mamas in
Prison thrown to the Lions (NG 4868.1); and the
Beheading of Saint James the Great (NG 4868.2).

Saint Mamas was an obscure martyr and was the
specific choice for this altarpiece of the treasurer of
the Company of the Trinity, Piero ser Landi, who
supervised the commission. In NG 4868.1 lions – the
saint's attribute in the main panel – are released
into Mamas's prison-cell, but gently lick him
instead of devouring him.

The altarpiece was completed in 1460, after
Pesellino's death in 1457, by Fra Filippo Lippi, and
the four predella panels were probably painted by
someone in his workshop in Prato.

For further discussion of the altarpiece see the
main entry.

*Found in some buildings attached to S. Desiderio,
Pistoia, before 1879; presented by Mr and Mrs Felix M.
Warburg through the NACF, 1937.*

Davies 1961, pp. 414–19.

Francesco PESELLINO
Predella of the Trinity with Saints Altarpiece
1455-60

NG 4868.3–4
Tempera on wood 27 x 39.5 cm

NG 4868.3–4 were predella panels of the altarpiece
of the *Trinity with Saints*. They show: Saint Zeno
exorcising the Daughter of the Emperor Gallienus
(NG 4868.3); and Saint Jerome and the Lion
(NG 4868.4).

The altarpiece was completed in 1460, after
Pesellino's death in 1457, by Fra Filippo Lippi, and
the four predella panels were probably painted by
someone in his workshop in Prato.

For further discussion of the altarpiece see the
main entry.

*Found in some buildings attached to S. Desiderio,
Pistoia, before 1879; presented by Mr and Mrs Felix M.
Warburg through the NACF, 1937.*

Davies 1961, pp. 414–19.

Attributed to Calisto PIAZZA
Portrait of a Man
probably about 1528–9

Attributed to Martino PIAZZA
Saint John the Baptist in the Desert
1513–22

Giovanni Battista PIAZZETTA
The Sacrifice of Isaac
probably after 1735

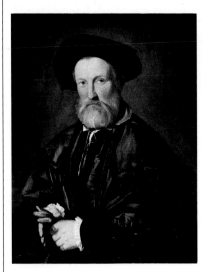

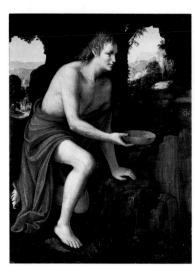

NG 2096
Oil on wood, 75.6 x 58.9 cm

NG 1152
Oil on wood, 69.2 x 52.1 cm

NG 3163
Oil on canvas, 201.2 x 133.4 cm

The sitter may be Ghirardo Averoldi; a portrait of Ghirardo was described as being in the Averoldi collection, Brescia, in 1826, and has been thought to correspond with NG 2096.

Formerly attributed to Romanino, NG 2096 has now been given to Calisto Piazza on the basis of comparison with his style of portraiture. NG 2096 is markedly Brescian in character and it has been stated that the costume can be dated about 1528–9.

Apparently in the Averoldi collection, Brescia, by 1865 (and perhaps by 1826); bequeathed by the Misses Cohen as part of the John Samuel collection, 1906.

Gould 1975, p. 198.

Signed at the right with a monogram: MPP surmounted by a T.

This painting is unlikely to be a devotional work; the subject, involving an attractive under-dressed young male in romantic scenery, is one which Leonardo made popular.

Seen by Mündler in the possession of Sr. Bozzi, Milan; bought from Pietro Vergani, Milan, 1883.

Davies 1961, pp. 419–20.

God tested Abraham's faith by requesting that he sacrifice his son Isaac. Just as he was about to kill the boy an angel intervened to prevent him. Old Testament (Genesis 22: 10–11).

NG 3163 is unfinished and in poor condition. Piazzetta treated the subject in a number of compositions. This work appears to have been intended as an altarpiece. It is likely to post-date the artist's *Assumption of the Virgin* of about 1735 (Lille, Musée des Beaux-Arts), but a more precise dating is problematic because of its state.

Chiericati collection, Vicenza; bought by Roger Fry before 1911; presented by Sir Robert Witt through the NACF, 1917.

Levey 1971, pp. 177–80.

Calisto PIAZZA
active 1514; died 1562?

Calisto Piazza was a member of a family of artists active in Lodi. He appears to have worked in Brescia until 1529 when he moved to Lodi. A number of signed altarpieces show him to have been a follower of Romanino.

Martino PIAZZA
active about 1513–1522

Martino de' Toccagni, generally known by the surname Piazza, worked in Lodi with his brother Albertino. One documented picture by the brothers survives. Three other paintings, including NG 1152, are recorded with monograms; it is not certain whether this group of works are by the same artist, or whether they can be identified as works by Piazza.

Giovanni Battista PIAZZETTA
1683–1754

Piazzetta was born in Venice. He probably initially trained in the studio of his father, Giacomo Piazzetta, who was a sculptor. He then trained under Antonio Molinari and later with Crespi in Bologna. In Venice the artist worked on religious commissions, portraits and book illustrations. He was elected a member of the Accademia Clementina in Bologna in 1727, and became director of the Venetian Academy in 1750.

Pablo PICASSO
Child with a Dove
1901

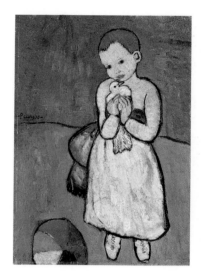

L9
Oil on canvas, 73 x 54 cm

Signed: Picasso.
The child clasps the dove and stands beside a multi-coloured ball. The whole canvas is heavily worked in thick impasto and may have been painted over an earlier picture.
L9 was painted by Picasso in Paris in 1901, and is one of his most important pictures from this period.

Samuel Courtauld by 1928; private collection, on loan since 1974.

Zervos 1957, p. 41, no. 83.

Pablo PICASSO
Fruit Dish, Bottle and Violin
1914

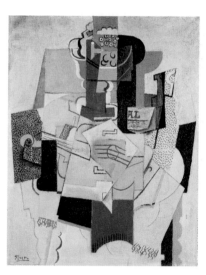

NG 6449
Oil on canvas, 92 x 73 cm

Signed bottom left: Picasso
The fragmented forms of a table, a bowl of fruit, a bottle, a newspaper and a violin are recognisable. The combination of areas of strong flat colour, spotted textures, bare canvas and sand is characteristic of Picasso's synthetic Cubism.
NG 6449 was painted in the autumn of 1914.

Collection of Count Etienne de Beaumont; bought from Marlborough Fine Art, 1979.

National Gallery Report 1978–9, pp. 30–1.

PIERO di Cosimo
A Satyr mourning over a Nymph
about 1495

NG 698
Oil on poplar, 65.4 x 184.2 cm

A nymph lies on the grass, displaying wounds on her hand, wrist and throat. A satyr kneels, apparently mourning over her, while a dog sits at her feet. In the background other creatures, including a pelican, are depicted. The subject may be linked with the Death of Procris: in Ovid's *Metamorphoses* (VII, 752–65) Procris is described as being killed in error by her husband, Cephalus, to whom she had given a magical dog and spear. Ovid does not mention a satyr, but one appears in a play of this subject in 1486, entitled *Cefalu*, by Niccolò da Coreggio (see also Claude NG 2). On the reverse of the panel is a drawing which may be of a frame pilaster.
The painting probably served as a *spalliera* (a backboard for a bench or chest), or as part of the panelling in a Florentine palace.
Underdrawing is visible notably on the bodies of the figures. Revisions include the readjustment of the position of the dog's head.

Collection of Conte Ferdinando Guicciardini (1782–1833), Florence; bought, 1862.

Davies 1961, pp. 421–2; Dunkerton 1991, pp. 350–1.

Pablo PICASSO
1881–1973

Picasso was born in Málaga and brought up in Barcelona. He first visited Paris in 1900 and settled there in 1904. He met Braque in 1907 and together they evolved Cubism. Renowned for his versatility, Picasso worked in a great variety of styles and diverse media. He lived mainly in France, visiting Spain frequently until Franco came to power in 1936.

PIERO di Cosimo
about 1462–after 1515

The son of a Florentine goldsmith, Piero entered the studio of Cosimo Roselli in 1480; he later adopted his master's name. By the late 1480s he was esteemed in his own right, especially for designing processions and pageants in Florence.

PIERO di Cosimo
The Fight between the Lapiths and the Centaurs
probably 1500–15

NG 4890
Oil on wood, 71 x 260 cm

PIERO della Francesca
The Baptism of Christ
1450s

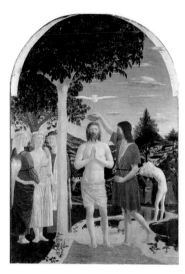

NG 665
Egg (identified) on poplar, 167 x 116 cm

PIERO della Francesca
Saint Michael
completed 1469

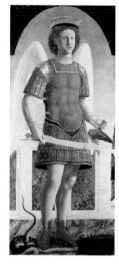

NG 769
Oil (identified) on poplar, 133 x 59.5 cm

Hesiod and Homer relate this story, but the artist has closely followed the version given by Ovid in the *Metamorphoses* (XII, 210ff.). Pirithous, the king of the Lapiths, was to marry Hippodame. At their marriage feast one of the centaur guests, Eurytus, attempted to carry off the bride; this sparked off the battle Piero has depicted. Eurytus is depicted in the right foreground with Hippodame. In the centre foreground are two lovers, Cyllarus and Hylonome; he lies by the javelin which killed him. Many of the other figures, such as Hercules at the far left, can also be identified from the text (for a larger reproduction see Appendix B).

NG 4890 probably served as a *spalliera* (the backboard of a chest or bench), or as part of the panelling in a Florentine palace. Such furniture was often ordered to celebrate a marriage, and the subject would have been regarded as entertaining for such a purpose. The interest in groups in action that the work displays may reflect Piero's awareness of the work of the Pollaiuolo and Signorelli.

Gagliardi, Florence, by 1885; bequeathed by Charles Haslewood Shannon, 1937.

Davies 1961, pp. 422–4.

Christ is baptised by Saint John; a dove, symbol of the Holy Ghost, hovers above. New Testament (all Gospels, e.g. Matthew 3: 13–17). At their feet the transition from transparent to reflective water is depicted. Further back another figure prepares for the rite. The Gospels describe the event as taking place by the river Jordan, but this landscape recalls the scenery around Borgo Sansepolcro, which may be the town to the left. Three angels attend with robes to cover Christ. In the right middle distance are four men wearing priestly robes; one seems to point to the source of divine light above. Its descent and the haloes of the principal figures are finely defined in gold.

NG 665 was either an altarpiece in its own right, or planned as the central part of a larger ensemble; it was probably painted for a chapel dedicated to the Baptist in the Camaldolese Abbey (Badia) of Borgo Sansepolcro in the 1450s. In about 1465 panels by Matteo di Giovanni bearing the Graziani family arms were added, converting it to a triptych with predella – it is possible that such a scheme had always been projected.

For the depiction of the Baptism centrally in an altarpiece see Niccolò di Pietro Gerini NG 579.

The Camaldolese Abbey, Borgo Sansepolcro; bought, 1861.

Clark 1951, pp. 13–14, 204; Davies 1961, pp. 426–8; Paolucci 1989, p. 106; Dunkerton 1991, pp. 198, 286–7.

Inscribed on his armour: *ANGELUS *POTENTIA DEI *MICHA(EL?). (Michael, angel by the power of God).

Saint Michael is one of the seven archangels. He overcame Lucifer (New Testament, Revelation 12: 7–9), who is here symbolically depicted as a decapitated serpent, which the saint tramples under foot. As captain of the heavenly host Michael is conventionally dressed in armour (see Perugino NG 288, Crivelli NG 788), but in this case it is modelled on ancient Roman patterns, although encrusted with jewels. He is crowned with a wreath below his halo and stands before a wall, beyond which is the blue of the sky.

NG 769 was originally placed to the left of the central image in a large single-sided polyptych. Robes which belonged to a figure in the (now lost) principal section encroach at the lower right. The altarpiece was intended for the high altar of Sant' Agostino, Borgo Sansepolcro. The contract for it, from the Augustinian Friars and Angelo di Giovanni di Simone, is dated 4 October 1454; by November 1469 the commission was completed. In addition to NG 769 the most important surviving fragments from the work are: *Saint Augustine* (Lisbon, Museu Nacional de Arte Antiga); *Saint Peter* (New York, Frick Collection); and *Saint Nicholas* (Milan, Museo Poldi Pezzoli).

Fidanza, Milan, 1861; purchased by Sir Charles Eastlake for his private collection; bought, 1867.

Clark 1951, pp. 41–3, 208; Davies 1961, pp. 428–33; Paolucci 1989, p. 212; Dunkerton 1991, pp. 198, 298–9.

PIERO della Francesca
about 1415/20–1492

Piero della Francesca was born in Borgo Sansepolcro in Tuscany. By 1439 he was working with Domenico Veneziano in Florence. He continued to reside in Borgo Sansepolcro, but also worked in Rimini, Rome, Arezzo and Ferrara. He painted in fresco and on panel, and wrote on perspective and geometry.

PIERO della Francesca
The Nativity
1470-5

PINTORICCHIO
Saint Catherine of Alexandria with a Donor
probably about 1480–1500

PINTORICCHIO
The Virgin and Child
late 15th century

NG908
Oil (identified) on poplar, 124.4 x 122.6 cm

The Virgin kneels to adore Christ who lies upon her cloak. Five angels sing and play lutes, celebrating his birth. Saint Joseph sits on a saddle and two shepherds stand further back, one pointing above, possibly towards the star. The ox and ass are beneath the shelter, upon which a magpie has alighted. The ass appears to be braying, but is probably eating straw (now no longer visible). A goldfinch is identifiable in the left foreground. New Testament (Luke 2: 4–20).

Presumably intended as an altarpiece, and probably a late work by the artist, *The Nativity* illustrates a familiarity with Netherlandish paintings.

The painting may be unfinished; it is also likely to have been damaged by over-cleaning before acquisition by the Gallery.

Descendants of the artist; Giuseppe Marini-Franceschi, Sansepolcro, 1825; Alexander Barker; bought, 1874.

Clark 1951, pp. 44–5, 208–9; Davies 1961, pp. 433–4; Paolucci 1989, p. 230; Dunkerton 1991, pp. 198, 306–7.

NG 693
Oil on wood, painted surface 56.5 x 38.1 cm

Saint Catherine is represented wearing a martyr's crown. She holds a book, to indicate her learning, and the sword by which she was executed; at her side is the wheel upon which she was tortured. The donor on the right is tonsured but is not in an ecclesiastical habit.

NG 693 was possibly painted in Rome.

Bequeathed by Lt.-General Sir William George Moore, 1862.

Davies 1961, p. 436.

NG 703
Tempera on wood, painted surface including painted framing 53.5 x 35.5 cm

The Virgin Mary and the Christ Child are seen through a frame or window. Attached to this in the lower centre is an unidentified coat of arms, presumably that of the original owner of the painting.

Bought in Paris by Count Joseph von Rechberg, 1815; presented by Queen Victoria at the Prince Consort's wish, 1863.

Davies 1961, p. 436.

PINTORICCHIO
active 1481; died 1513

Bernardino di Betto, called Pintoricchio, was the most successful painter in Italy at the close of the fifteenth century. He was active in Perugia, but is best known for his frescoes in Rome, especially those in the Borgia apartments in the Vatican Palace, and for the decoration of the Piccolomini Library in the cathedral at Siena. He painted small devotional panels and altarpieces as well as in fresco.

PINTORICCHIO
Penelope with the Suitors
about 1509

PISANELLO
The Virgin and Child with Saint George and Saint Anthony Abbot, mid-15th century

PISANELLO
The Vision of Saint Eustace
mid-15th century

NG 911
Fresco, detached and mounted on canvas, 125.5 x 152 cm

NG 776
Tempera (very repainted) on poplar, 47 x 29.2 cm

NG 1436
Tempera on wood, 54.5 x 65.5 cm

The woman at the loom is Penelope, wife of Odysseus. During his long absence after the Trojan War she was besieged by suitors but refused to consider their advances until she had finished weaving her father-in-law's shroud (which she unravelled each night). The men are presumably all suitors (although the most prominent among them has been taken for her son, Telemachus), and the man entering the room is probably Odysseus disguised as a beggar. In the distance other episodes from *The Odyssey* are depicted. Odysseus listens to the song of the sirens strapped to the mast of the ship while his crew block their ears. Sailors in a small boat nearby dive in to the water, maddened by the beauty of the singing. On the coast Circe meets Odysseus; around him are the swine into which this sorceress has turned previous visitors. Homer, *The Odyssey* (chapters 10, 12, 15, 17, 19 and 21).

NG 911 was – with Signorelli NG 910 and 3929 – one of a series of frescoes painted by Signorelli, Genga and Pintoricchio for the Palazzo del Magnifico, Siena. See further under Signorelli NG 910.

Palazzo del Magnifico, Siena, by about 1509; removed about 1842/4 for E. Joly de Bammeville; collection of Alexander Barker by 1857; bought, 1874.

Davies 1961, pp. 436–9, 472–9 ; Tátrai 1978, pp. 177–83; Rovik 1988, pp. 65–9; Kanter 1989, pp. 193–5.

Signed in the form of vegetation, bottom centre: pisanus/pi[nxit].

The Virgin and Child appear, as in a vision, before the sun, possibly in reference to the woman and child of the Apocalypse (New Testament, Revelation 12: 1). Saint George, accompanied by two horses, stands by the dragon he vanquished, wearing silver armour and a wide-brimmed straw hat fashionable among fifteenth-century courtiers. Saint Anthony Abbot holds a bell (the Order of the Hospitallers of Anthony rang bells to attract alms) and is accompanied by a boar (the Order's pigs were allowed to roam free).

This private devotional work is the artist's only signed painting and is generally thought to date from late in his career. Pisanello was employed by the d'Este family in Ferrara from 1438, and the face of Saint George shares some similarities with Pisanello's portrait of Lionello d'Este of 1441 (Bergamo, Accademia Carrara); his features have also been compared to those of Ludovico Gonzaga who had a particular devotion to Saint George. A drawing of the Virgin and Child (Paris, Louvre) has been associated with this painting.

NG 776 was heavily restored before acquisition, notably in the sky and the figure of Saint George. The ornate frame was made in Milan in the nineteenth century and contains copies of medals by Pisanello.

Costabili collection, Ferrara, by 1841; presented by Lady Eastlake in memory of Sir Charles Eastlake, 1867.

Davies 1961, pp. 439–40; Dell'Acqua 1972, p. 99, no. 100; Paccagnini 1972 (?), pp. 219–21; Dunkerton 1991, pp. 268–9.

PISANELLO

about 1395–probably 1455

Pisanello was chiefly famed as a medallist, but also painted on panel and in fresco, notably treating chivalric themes. He may have trained in Verona and painted a lost work in Venice either with or immediately after Gentile da Fabriano. From at least 1438 he was employed at the Este court in Ferrara, and the Gonzaga court in Mantua. He also worked in Naples (1449) and Rome (1431/2).

Inscribed above the crucifix: INRI.

This incident is recounted in Jacopo da Voragine's *Golden Legend* of about 1275. Saint Eustace was a general who, while hunting outside Rome, saw a stag with a glowing crucifix between its antlers, and was converted to Christianity. Pisanello has filled the surrounding forest with a decorative arrangement of naturalistically depicted animals and birds. One of the dogs growls at the crucifix, while the hunt continues with another hound chasing a hare. The cartellino or scroll in the foreground is not inscribed.

The work, which is thought to date from late in the artist's career, possibly when he was working at the court of the Gonzaga, is not recorded prior to the nineteenth century. It was probably intended for a domestic setting.

A number of drawings by Pisanello can be associated with NG 1436, including studies of horses, birds, deer, hounds, a hare and a crucifix, many of which are in the Louvre, Paris. The subject is also comparable to a scene on the *recto* of a medal he designed (*Domenico Novello Malatesta*, about 1445, London, Victoria and Albert Museum). The profile of the saint may be a portrayal of a patron. The background has darkened considerably.

Ashburnham collection, London, by 1878; bought, 1895.

Davies 1961, pp. 440–2; Dell'Acqua 1972, p. 95, no. 77; Paccagnini 1972 (?), pp. 222–6; Dunkerton 1991, pp. 276–7.

Camille PISSARRO
View from Louveciennes
1869–70

NG 3265
Oil on canvas, 52.7 x 81.9 cm

Camille PISSARRO
Fox Hill, Upper Norwood
1870

NG 6351
Oil (identified) on canvas, 35.3 x 45.7 cm

Camille PISSARRO
The Avenue, Sydenham
1871

NG 6493
Oil (identified) on canvas, 48 x 73 cm

Signed bottom right: C. Pissarro.

The view is taken from the village of Louveciennes, looking towards the Marly aqueduct (on the horizon). Pissarro lived nearby at Louveciennes, west of Paris, from 1869 until the outbreak of the Franco-Prussian War in 1870.

There is a painting by Renoir of the same view (New York, Metropolitan Museum of Art).

Bought from Pissarro by Durand-Ruel, 1897; Sir Hugh Lane Bequest, 1917.

Pissarro/Venturi 1939, I, p. 90, no. 85; Davies 1970, pp. 111–12.

Signed and dated bottom right: C. Pissarro. 70.

Towards the end of 1870 Pissarro and his family took refuge in England from the Franco-Prussian War. He stayed in Upper Norwood until June 1871, and painted a number of views, including this one, of the suburbs of Norwood and Sydenham (see also NG 6493).

The traditional title of NG 6351 identified it as a view in Lower Norwood, but the site depicted is probably Fox Hill, Upper Norwood. Many of the houses in this street have been rebuilt but the general character of this view and the distinctive bend still correspond with Pissarro's painting.

Although built up in a number of stages, NG 6351 is essentially a rapidly executed work which was probably painted in the open air.

Paul Rosenberg, Paris; presented by Viscount and Viscountess Radcliffe, 1964.

Pissarro/Venturi 1939, I, p. 93, no. 105; Davies 1970, pp. 114–15; Bomford 1991, pp. 132–5.

Signed and dated bottom left: C. Pissarro 1871

This is one of twelve paintings dating from Pissarro's stay in London in 1870–1 (see also NG 6351). The view is still recognisable today in what is now called Lawrie Park Avenue, Sydenham. The church of St Bartholomew, Westwood Hill, is in the background.

NG 6493 was probably painted in April or May of 1871.

The composition may have been inspired by Hobbema's *The Avenue at Middelharnis* (NG 830) which went on show at the National Gallery in the spring of 1871. Although much of this picture was painted in the open air, Pissarro may have reworked it back in the studio, for example painting out the figure of a woman on the right-hand pavement. There is a pencil and watercolour (or gouache) study for this picture in the Louvre, Paris (Cabinet des Dessins).

Bought by Paul Durand–Ruel, London, 1871; bought, 1984.

Pissarro/Venturi 1939, I, p. 94, no. 110; National Gallery Report 1982–4, p. 33; Bomford 1991, pp. 136–41.

Camille PISSARRO
1830–1903

Pissarro was born on St Thomas in the West Indies, but lived and worked mainly in and near Paris. He received advice from Corot and attended the Académie Suisse where he met Monet and Cézanne. He exhibited occasionally at the Salon in the 1860s and participated in all the Impressionist exhibitions (1874–86). In the late 1890s he painted numerous townscapes in Rouen, Paris and Le Havre.

Camille PISSARRO
The Côte des Bœufs at L'Hermitage
1877

NG 4197
Oil (identified) on canvas, 114.9 x 87.6 cm

Signed and dated bottom right: C. Pissarro. 1877
Two figures stand on a path leading to a group of farm buildings. The small touches of broken colour and the heavily textured surface are characteristic of Pissarro's technique during this period. The Côte des Boeufs is a hillside close to Pissarro's home at L'Hermitage near Pontoise. Pissarro lived at Pontoise (about thirty kilometres from Paris) for most of the period between 1866 and 1883.
Painted in 1877 (and probably shown at the Impressionist exhibition of that year), this is one of the largest and most ambitious of Pissarro's works of the mid-1870s.
Cézanne painted a view of the same motif when he stayed with Pissarro at Pontoise in 1877 (private collection).

Mme Pissarro (the artist's mother); presented by C.S. Carstairs to the Tate Gallery through the NACF, 1926; transferred, 1950.

Pissarro/Venturi 1939, I, p. 134, no. 380; Davies 1970, pp. 113–14; Bomford 1991, pp. 158–65.

Camille PISSARRO
The Boulevard Montmartre at Night
1897

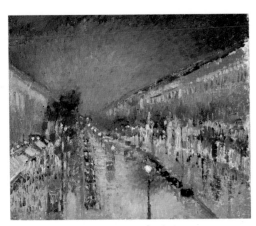

NG 4119
Oil on canvas, 53.3 x 64.8 cm

This view of the boulevard Montmartre in Paris is taken from a room in the Grand Hôtel de Russie on the corner of the boulevard des Italiens and the rue Drouot.
Pissarro stayed in the Grand Hôtel de Russie in February and March 1897, and during this period painted a series of views of the boulevard Montmartre. The canvases vary in format and explore changes in the weather, light and seasons. NG 4119 stands out as the only night scene painted by Pissarro during this period.
The bold, sketchy technique and lack of finish lend an experimental quality to the work, which is unsigned and was never exhibited by the artist.

Collection of Lucien Pissarro; bought by the Trustees of the Courtauld Fund, 1925.

Pissarro/Venturi 1939, I, p. 219, no. 994; Gould 1970, pp. 112–13; Brettell 1993, p. 69, no. 50.

Camille PISSARRO
The Louvre under Snow
1902

NG 4671
Oil on canvas, 65.4 x 87.3 cm

Signed and dated bottom left of centre: C. Pissarro, 1902.
NG 4671 shows the view looking west along the Seine towards the Pont-des-Arts, with the Louvre at the right. The railings and steps in the foreground enclose a nineteenth-century statue of Henri IV, situated further to the left, out of the picture. In 1900 Pissarro took an apartment at 28 place Dauphine on the Ile-de-la-Cité in Paris. Pissarro himself described the 'very beautiful view' from this vantage point which inspired several extensive series of paintings over the following months.

Bought from Lucien Pissarro, 1932.

Pissarro/Venturi 1939, I, p. 250, no. 1215; Davies 1970, p. 114; Brettell 1993, pp. 123ff.

Giovanni Battista PITTONI
The Nativity with God the Father and the Holy Ghost, about 1740

NG 6279
Oil on canvas, 222.7 x 153.5 cm

NG 6279 combines the New Testament episode of the Nativity (Luke 2: 6–16) with the Trinity (God the Father, the Son and the Holy Ghost). This subject is unusual, but not unique and recalls the theme of the Two Trinities depicted by Murillo (NG 13).

NG 6279 is an altarpiece, but its original location is not known. A date of about 1740 has been suggested. Several variants of the composition are known, none of which is directly related to this picture.

When NG 6279 was cleaned it was discovered that the figure of God the Father and the dove of the Holy Ghost had been painted out at a later date (probably in the nineteenth century). A number of drawings have been related to NG 6279 (Venice, Accademia and Correr; private collection).

Collection of Lord Willoughby de Eresby, Grimsthorpe Castle, by 1865; bought with a contribution from the NACF, 1958.

Levey 1971, pp. 180–3.

Pieter van der PLAS
Portrait of a Man
about 1640

NG 175
Oil on wood, 71.5 x 59.5 cm

Signed bottom left: P.V.PLAS F.
In the past this has incorrectly been identified as a portrait of the English poet John Milton. It is a Flemish portrait of a man who has undertaken a pilgrimage: his pilgrim's staff and flask can be seen at the left. A vision of the Resurrected Christ is in the upper right-hand corner.

Presented by C. Lofft, 1839.

Egbert van der POEL
A View of Delft after the Explosion of 1654
1654

NG 1061
Oil on oak, 36.2 x 49.5 cm

Signed and dated bottom left: E vander Poel 12 octob/1654.
A large area of Delft was destroyed by the explosion of a powder magazine at 10.30 am on 12 October 1654. Van der Poel shows an apparently topographically accurate view of the devastation, as seen from the north-east. According to a contemporary account all that was left on the site of the magazine itself was a deep pool of water – which is presumably the one that can be seen on the right. Among those killed was the artist Carel Fabritius. The damaged area was not built over, and much of it remains open space to this day. The prominent buildings on the horizon are, from left to right: the Nieuwe Kerk, the tower of the town hall, the Oude Kerk, and over on the right, the chapel of the hospital of St George in Noordeinde.

NG 1061 records the aftermath of an event the artist may have seen. The date inscribed on the picture is that of the day of the explosion; the picture was painted shortly afterwards.

Van der Poel repeated the composition many times: at least twelve versions survive.

Thomas Farrant sale, London, 2 June 1855 (lot 27), bought by Rutley; John Henderson Bequest, 1879.

MacLaren/Brown 1991, pp. 306–9.

Giovanni Battista PITTONI
1687–1767

Pittoni was apparently born in Venice, where he worked for most of his life and where he died. He painted altarpieces and collectors' pictures, many of which were dispatched to foreign patrons, especially in Germany. In 1758 he succeeded Tiepolo as president of the Accademia, Venice.

Pieter van der PLAS
about 1595–about 1650

Van der Plas was born in Brussels and was a pupil there of Ferdinand de Berdt. He became a master in the Brussels guild in 1619. He was a painter of single and group portraits and painted the burgomasters of Brussels in adoration before the Virgin in 1647 (Brussels, Musées Royaux des Beaux-Arts).

Egbert van der POEL
1621–1664

Egbert Lievensz. van der Poel was born in Delft. He entered the guild there in October 1650. The artist had settled in Rotterdam by 1655. Before 1654 he painted mainly interiors of stables and cottages, and canal, coastal and winter landscapes. Later he produced nocturnal fire and moonlight scenes, as well as numerous views of Delft before and after the explosion of 1654 (see NG 1061).

Cornelis van POELENBURGH
Women bathing in a Landscape
about 1630

Antonio and Piero del POLLAIUOLO
The Martyrdom of Saint Sebastian
completed 1475

Antonio del POLLAIUOLO
Apollo and Daphne
probably 1470–80

NG 955
Oil on canvas, 35 x 43.5 cm

NG 292
Oil (identified) on poplar, 291.5 x 202.6 cm

NG 928
Oil on wood, 29.5 x 20 cm

Signed right foreground: C.P.
 NG 955 has in the past been attributed to Johan van Haensbergen (1642–1705), Poelenburgh's pupil, but recent cleaning confirmed that the monogram was authentic. It also revealed the original tonality of the sky and the detailed handling of the ruins. It is consistent with the mature work of Poelenburgh and can be dated around 1630 on stylistic grounds.

Earl of Waldegrave sale, Strawberry Hill, 1842; Wynn Ellis Bequest, 1876.

MacLaren/Brown 1991, pp. 310–11.

Sebastian was a Roman centurion who was discovered to be a Christian and was sentenced to death by Diocletian. He was bound to a stake (often represented as a tree) and shot with arrows. He was left for dead, although the arrows had not killed him and he was eventually stoned to death. The story is taken from *The Golden Legend*.
 NG 292 was completed in 1475 as the altarpiece of the Oratory of St Sebastian built by the Pucci family in SS. Annunziata, one of the most important churches in Florence. An arm bone of the saint was preserved in the church, and the family took an interest in the chapel from about 1450. Vasari stated that Antonio Pollaiuolo was paid 300 scudi, and that the saint was a portrait of Gino di Ludovico Capponi.
 NG 292 was highly renowned and details were copied by Raphael and Andrea del Sarto.

Recorded in the Oratory of St Sebastian in SS. Annunziata, Florence, 1510; bought from Marchese Roberto Pucci, Florence, 1857.

Davies 1961, pp. 443–6; Byam Shaw 1977, pp. 848–51; Ferino Pagden 1984, pp. 285–6; Dunkerton 1991, p. 316; Wright 1992, pp. 188–219.

The god Apollo pursued the nymph Daphne. She prayed to her father (the river god Peneus) for rescue and was turned into a laurel tree as he touched her. Ovid, *Metamorphoses* (I, 525–655).
 Mythological subjects from antiquity became increasingly popular in the fifteenth century and this small picture was almost certainly designed for a secular setting, possibly for a piece of furniture. NG 928 is usually given to Antonio del Pollaiuolo as an early work.

Acquired by William Coningham, Rome, 1845; Wynn Ellis Bequest, 1876.

Davies 1961, pp. 446–7; Wright 1992, p. 215.

Cornelis van POELENBURGH
about 1593–1667

The artist was born in Utrecht and was a pupil of Abraham Bloemaert. He was in Italy for ten years from about 1617, working for the Grand Duke of Tuscany. He worked in London for Charles I from 1637 until 1641. Poelenburgh's style was formed in Rome under the influence of Elsheimer and his circle. He painted Italianate landscapes with ruins and nymphs: he also painted religious and mythological subjects.

Antonio (about 1432–1498) and Piero (about 1441–before 1496) del POLLAIUOLO

Antonio and Piero are identified with the sons of Jacopo Benci who collaborated on an altarpiece in 1466/7. Antonio trained as a goldsmith and was a sculptor and a designer of prints and embroidery as well as a painter. Piero trained as a painter, perhaps with Andrea del Castagno. They worked in Florence, San Gimignano and Rome. Antonio was the more original and daring artist of the two.

PONTORMO
Joseph sold to Potiphar
probably 1515

PONTORMO
Pharaoh with his Butler and Baker
probably 1515

PONTORMO
Joseph's Brothers beg for Help
probably 1515

NG 6453
Oil on wood, 36.3 x 142.5 cm

NG 6451
Oil on wood, 61 x 51.6 cm

NG 6452
Oil (identified) on wood, 61 x 51.7 cm

Joseph (the boy in the foreground) stands before his new master, Potiphar. The Ishmaelites – who had sold him to Potiphar – are to the left gathering up their payment. Old Testament (Genesis 39: 1).

NG 6451 was painted as part of the decoration of the bedroom of Pierfrancesco Borgherini, who was married in 1515; see under Pontormo NG 6453 for further comment.

In the Borgherini palace, Florence, until about 1584; acquired in Florence by Lord Cowper in the late eighteenth century; subsequently in the Panshanger collection; bought with the aid of the NACF (Eugene Cremetti Fund), 1979.

Braham 1979, pp. 754–65.

Pharaoh had imprisoned his butler and his baker in the same place as Joseph. Joseph foretold that Pharaoh would pardon the butler and execute the baker. The butler appears on the steps being escorted (and not restrained) down from the gaol, and again in the foreground offering a cup to the seated Pharaoh. The baker is shown on the right (and probably struggling above) being led away to his fate. Old Testament (Genesis 41: 1–22).

NG 6452 was painted as part of the decoration of the bedroom of Pierfrancesco Borgherini, who was married in 1515; see under Pontormo NG 6453 for further comment.

In the Borgherini palace, Florence, until about 1584; acquired in Florence by Lord Cowper in the late eighteenth century; subsequently in the Panshanger collection; bought with the aid of the NACF (Eugene Cremetti Fund), 1979.

Braham 1979, pp. 754–65.

Inscribed on the banner to the right: .ECCE. / .SALVATOR. / .MUNDI. (Behold the Saviour of the World); and on the chariot: ECCE / SALUS MU[N]D[I] (Behold the Salvation of the World); and on the pedestal of the statue on the right: MUNITIO ... (The defence ...).

Joseph had predicted that seven years of famine would follow seven years of plenty. When this duly occurred his brothers – without recognising him – came to beg for corn (seen being distributed on the right). Old Testament (Genesis 42: 1–8). The inscriptions identifying Joseph as the Saviour of the World emphasise the parallel commonly made between the lives of Joseph and Christ.

NG 6451–3 together with NG 1131, Bacchiacca NG 1218 and 1219 and panels preserved in Florence (Uffizi and Pitti Palace) and Rome (Borghese Gallery) were parts of a bedroom decorated by Pontormo, Granacci, Andrea del Sarto and Bacchiacca with the story of Joseph for Pierfrancesco Borgherini's home in Florence. The decoration was probably commissioned in connection with his marriage to Margherita Accaiuoli in 1515, and was set into the walnut bed and wainscoting (described in some detail by Vasari and reconstructed by Braham). See Appendix B for a larger reproduction of this panel.

In the Borgherini palace, Florence, until about 1584; acquired in Florence by Lord Cowper in the late eighteenth century; subsequently in the Panshanger collection; bought with the aid of the NACF (Eugene Cremetti Fund), 1979.

Braham 1979, pp. 754–65.

PONTORMO
1494–1557

Jacopo Carucci, called Pontormo from the village – near Empoli – where he was born, was a pupil of Andrea del Sarto (and perhaps of Leonardo, Albertinelli and Piero di Cosimo). He painted altarpieces, portraits and frescoes, and was patronised by the Medici and other leading Florentine families throughout his career.

PONTORMO
Joseph with Jacob in Egypt
probably 1518

NG 1131
Oil (identified) on wood, painted surface
96.5 x 109.5 cm

In the left foreground, Joseph introduces his father Jacob to Pharaoh. In the right foreground, Joseph sits and listens to a spokesman for the people who are clamouring for bread (the boy seated on a step in the centre foreground is probably a portrait of Pontormo's pupil, Bronzino). In the right middle distance, Joseph, with one of his sons, climbs the staircase to visit his dying father. In the right background, Joseph presents his sons (Ephraim and Manasseh) to the dying Jacob. Old Testament (Genesis 47: 13ff. and 48).

NG 1131 was painted as part of the decoration of the bedroom of Pierfrancesco Borgherini, who was married in 1515; see under Pontormo NG 6453 for further comment. This painting was the last one in the series to be completed and was supplementary to those originally planned. It reflects the success of Pontormo's other, earlier, contributions and was itself also especially admired.

Several preparatory drawings are known.

In the Borgherini palace, Florence, until about 1584; possibly in the Aldobrandini collection, Rome, by 1603; collection of the Duke of Hamilton by 1854; bought at the Hamilton sale, 1882.

Gould 1975, pp. 199–201; Braham 1979, pp. 754–65.

PONTORMO
A Discussion
perhaps about 1525–50

NG 3941
Oil on canvas, transferred from wood,
35.2 x 24.8 cm

The subject was once identified as 'Herod and the Three Magi' (New Testament, Matthew 2: 7), but none of the figures is shown with a king's attribute.

Saints and prophets had been depicted in active debate in this manner by Donatello (1368–1466) and other Florentine artists.

Collection of Conte Enrico Costa, Florence; bought by Ludwig Mond, 1892; Mond Bequest, 1924.

Gould 1975, p. 202.

Follower of PONTORMO
The Madonna and Child with the Infant Baptist
probably 1560s

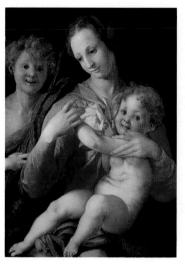

NG 6375
Oil on wood, 81.3 x 58.4 cm

The Infant Baptist, wearing a camel skin, appears behind the Virgin Mary and the child Jesus.

NG 6375 was first recorded with an attribution to Andrea del Sarto but is closer to Pontormo. However, the painting also has some features reminiscent of the work of Maso da San Friano (Tommasso Manzuoli, 1531–71) and is likely to date from the 1560s. Many Florentine painters of the second half of the sixteenth century respectfully imitated the inventions of Sarto and Pontormo. A version of the painting in the Art Institute of Chicago features the same pentimenti and so was presumably worked on simultaneously.

Recorded in the Borghese collection, Rome, 1693 (attributed to Andrea del Sarto); bought with the Camuccini collection by the 4th Duke of Northumberland, 1856; bought, 1966.

Gould 1975, pp. 86–8.

Willem de POORTER
An Allegorical Subject (The Just Ruler)
probably 1636

NG 1294
Oil on oak, 50.2 x 37.5 cm

Signed bottom right: W. D. p.

A figure in a breastplate and rich cloak, and wearing a laurel wreath, lays a sceptre on a globe (or an orb) which stands on a cracked pedestal; beside the globe are two crowns. A pile of weapons is in the left foreground. The subject may be intended as an allegory of merit (*Merito*) and so of the just ruler. This concept was similarly represented in Cesare Ripa's *Iconologia*, which was translated into Dutch in 1644.

De Poorter painted a similar allegory (Rotterdam, Museum Boymans-van Beuningen) which is dated 1636, and NG 1294 probably dates from the same year.

Collection of Mr Chandler by 1857; presented by T. Humphry Ward, 1889.

MacLaren/Brown 1991, pp. 311–12.

Giovanni Antonio PORDENONE
Saint Bonaventure
probably 1530–5

NG 4038
Oil on wood, 29.8 x 29.8 cm

Saint Bonaventure was a thirteenth-century Franciscan bishop and theologian. He was born in Italy and travelled to Paris where he principally taught. He is shown blessing and resting his left hand upon a book.

This work and NG 4039 are from a ceiling decoration in the Scuola di S. Francesco ai Frari, Venice. At the corners of the design were four panels with depictions of the evangelists (now Budapest), while at the sides were the two works in the Collection and two other images of the Franciscan saints Bernardino and Anthony (also Budapest). In the centre of the ceiling was a panel, now lost, of Saint Francis receiving the stigmata. The surviving works are comparable to Pordenone's Beato Lorenzo Giustiniani altarpiece (Venice, Accademia), which was commissioned in 1532, and are thought to date from the same period.

Said to have been bought in Venice by Edward Chaney, mid-nineteenth century; Sir Claude Phillips Bequest, 1924.

Gould 1975, pp. 203–4.

Giovanni Antonio PORDENONE
Saint Louis of Toulouse
probably 1530–5

NG 4039
Oil on wood, 29.8 x 29.8 cm

Saint Louis of Toulouse (1274–97), heir of King Charles II of Naples, gave up the kingdom in favour of his brother Robert of Anjou so he could become a Franciscan friar. Later he was appointed Bishop of Toulouse, and is here depicted as such, with a fleur-de-lis on his vestments.

This work and NG 4038 are from a ceiling decoration in the Scuola di S. Francesco ai Frari, Venice. (See under NG 4038 for a description of the ceiling.) The surviving works are comparable to Pordenone's Beato Lorenzo Giustiniani altarpiece (Venice, Accademia), which was commissioned in 1532, and are thought to date from the same period.

Said to have been bought in Venice by Edward Chaney, mid-nineteenth century; Sir Claude Phillips Bequest, 1924.

Gould 1975, pp. 203–4.

Willem de POORTER
1608–after 1648

Willem de Poorter was apparently born in Haarlem, where he was active between 1630 and 1648. He may have been Rembrandt's pupil in Amsterdam (or possibly in Leiden), and was also influenced by Pieter Lastman and Jan Pynas. He painted biblical scenes and allegorical and mythological subjects, as well as a few portraits and still lifes.

Giovanni Antonio PORDENONE
active 1504; died 1539

Giovanni Antonio de Sacchis was known as Pordenone after the place of that name in Friuli, north-east of Venice, where he was born. He painted altarpieces and frescoes in a number of northern Italian cities, and probably travelled to Rome. Influences on his work include Venetian art, as well as Michelangelo and Raphael. He died in Ferrara.

PORTUGUESE
The Mystic Marriage of Saint Catherine
early 16th century

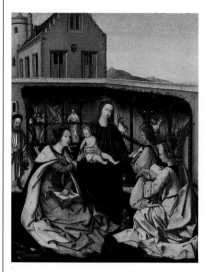

NG 5594
Oil on wood, 33 x 25.7 cm

Saint Catherine had a vision in which she exchanged rings with the Christ Child, and so became mystically 'wed' to him. The Virgin is here shown seated in the *hortus conclusus*, enclosed garden, which is intended as a metaphor for her virginity. Saint Joseph is in the left background, and the woman in the right foreground is probably the Magdalen.

NG 5594 is connected stylistically with a group of works (now mainly in the Lisbon Museum) attributed to Frei Carlos, a painter of Netherlandish extraction who took monastic vows at the Convento do Espinheiro at Evora in 1517. No documentation links the artist with these paintings, but they are generally associated with his name. It has been suggested that he may have been the master of a workshop in the monastery.

Said to have been in the possession of the O'Neil family, Portugal, since the mid-eighteenth century; sent to London for sale by George O'Neil of Lisbon, and bought by Herbert Cook, 1906; bought from the Cook collection, 1945.

MacLaren/Braham 1970, p. 142.

Frans POST
Landscape in Brazil
about 1636–44

L39
Oil on canvas,

Signed lower left.
Some of Post's views of Brazil are topographically accurate while others, like this one, seem to be generalised views.

On loan from the Rijksmuseum, Amsterdam, since 1978.

Frans POST
about 1612–1680

Post was born and trained in Haarlem. In 1636 he travelled to Brazil in the suite of Prince Jan Maurits of Nassau, who was Governor of the country (then a Dutch colony). He returned to Haarlem in 1644, where he had a successful career painting Brazilian landscapes. He also drew designs for prints based on his Brazilian sketches which were published in Caspar van Baerle's description of Brazil in 1647.

Hendrick POT
A Merry Company at Table
1630

NG 1278
Oil on oak, 32.3 x 49.6 cm

Signed top right: HP (in monogram). Scratched into the back of the panel: 1630.
This is a brothel scene or *bordeeltje*. An elderly procuress supervises the proceedings, and makes an obscene gesture with her finger in the bowl of her pipe. Prominent on the table are wine and oysters – both of which are known for their aphrodisiac qualities. The dog licking the man's fingers at the bottom right corner may be intended further to underline the licentiousness of the scene. The age of the procuress is contrasted with the youth and beauty of the girls: this comparison has a *vanitas* intention, stressing the inevitability of age, decay and death.
The date 1630, scratched on the back of the panel, may well be that of the picture: it would agree with the style of the work and the costumes.

Earl of Londesborough sale, London, 7 July 1888 (lot 54); bought by Sir J.C. Robinson; bought from Messrs Lake, Beaumont and Co. (Lewis Fund), 1889.

MacLaren/Brown 1991, p. 313.

Hendrick POT
about 1585 or earlier?–1657

Hendrick Gerritsz. Pot was probably born in Haarlem. He is said to have been a pupil of Carel van Mander. He became dean of the Haarlem guild in 1626, 1630 and 1635, and visited London in 1632. He may have acquired citizenship of Amsterdam in 1640, where he is later recorded on a number of occasions. Pot painted small portraits, and guardroom and festive scenes.

Paulus POTTER
Cattle and Sheep in a Stormy Landscape
1647

NG 2583
Oil on oak, 46.3 x 37.8 cm

Signed and dated bottom left: Paulus. Potter. f. 1647.
 A number of alterations in the outlines of the horns, bodies and legs of the animals were made by the artist during his work on the panel and a third sheep was painted out.
 NG 2583 was once hung as a companion piece to *A Farmyard with Horses and Figures* (present location unknown), also of 1647, when they were both in the Hope collection, but they had different earlier histories and were probably not intended as pendants.

Collection of Jan and Pieter Bisschop, Rotterdam, by 1752; bought with that collection by Adriaen and John Hope of Amsterdam in 1771; John's sons settled in England and the painting remained in the Hope collection until 1898; Salting Bequest, 1910.

MacLaren/Brown 1991, p. 315.

Paulus POTTER
A Landscape with Cows, Sheep and Horses by a Barn, 1651

NG 849
Oil on oak, 57.7 x 52.9 cm

Signed and dated on the tree trunk in the centre foreground: Paulus. Potter. f. i65i
 In NG 849 Potter is very close to the style of Karel Dujardin as can be seen, for example, in a painting of 1656 (Dujardin NG 826). Although Dujardin was the older artist, Potter may well have been the originator of this style.

Private collection, Amsterdam, by 1756; collection of Sir Robert Peel, Bt, by 1834; bought with the Peel collection, 1871.

MacLaren/Brown 1991, p. 314.

Nicolas POUSSIN
The Nurture of Bacchus
about 1627

NG 39
Oil on canvas, 74.9 x 97.2 cm

Bacchus was the son of the god Jove and the mortal Semele. Jove's wife, Juno, brought about the death of Semele and Jove took the child from her womb and sewed it into his thigh, from where it was born. The infant Bacchus before being looked after by the Nysiades was watched over by Semele's sister Ino. Juno sought vengeance on Ino and her husband Athamas, but Venus transformed them into gods, as recounted in Ovid's *Metamorphoses* (III, 259–315 and IV, 416–542). Poussin shows Ino watching the infant Bacchus who is held by Athamas. In the background at the left are the children of Ino and Athamas. The dark clouds and the goat, which is probably intended as a sacrificial animal, may allude to the future vengeance of Juno, and by extension the whole could be a moral allegory which warns against disregard for the gods.
 The painting appears unfinished – this is particularly apparent in the areas of the landscape to the left and right of the central group. Poussin treated the subject in a slightly earlier work of 1626–7 (Paris, Louvre) in which the central group in NG 39 is established. It was also explored by the artist in a quite different composition (Chantilly, Musée Condé).

The Duc de Tallard sale, Paris, March 1756 (lot 161) (?); bequeathed by G.J. Cholmondeley, 1831; entered the Collection, 1836.

Davies 1957, pp. 170–2; Blunt 1966, pp. 93–4; Thuillier 1974, p. 88; Wild 1980, p. 261; Wright 1985, p. 136; Oberhuber 1988, p. 266; Mérot 1990, p. 274; Wine 1992, pp. 162–5.

Paulus POTTER
1625–1654

Potter was born in Enkhuizen, and was probably taught there by his father, Pieter. By 1646 he was living in Delft, and by 1649 in The Hague. In 1652 he settled in Amsterdam. He was principally a painter of animals in landscape, but he also painted a life-size equestrian portrait of Dirk Tulp (Amsterdam, Six Collection) and made etchings of animals.

Nicolas POUSSIN
1594–1665

Poussin was born near Les Andelys, Normandy. He studied in Paris, settled in Rome in 1624 and only once returned to France (1640–2), to work for Louis XIII. Influenced by Venetian and Bolognese paintings, as well as by the Antique and Raphael, he depicted religious and mythological subjects, as well as landscapes. His often erudite art became an exemplar of classicism.

Nicolas POUSSIN
Cephalus and Aurora
1627–30

Nicolas POUSSIN
A Bacchanalian Revel before a Term of Pan
1630–4

Nicolas POUSSIN
The Adoration of the Golden Calf
by 1634

NG 65
Oil on canvas, 96.5 x 130.8 cm

NG 62
Oil on canvas, 99.7 x 142.9 cm

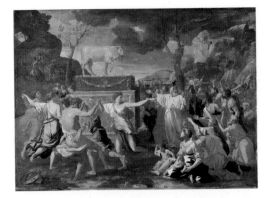

NG 5597
Oil (identified) on canvas laid down on board,
154.3 x 214 cm

Aurora, goddess of the dawn, who is seated, attempts to embrace Cephalus. He rejects her, being reminded of his wife Procris by a cupid who displays her portrait. Ovid describes the rejection of Aurora, but makes no mention of the portrait (*Metamorphoses*, VII, 694ff.). Poussin also embellishes the story by including the figures behind the central group: a river god (Oceanus ?), the winged horse Pegasus, a reclining earth goddess (?) and in the sky Apollo driving his chariot. These figures may be intended to have allegorical significance, representing the four elements, water, air, earth and fire respectively.

No information about a commission survives. The work is dated to 1627–30 on stylistic grounds.

Poussin also treated the principal subject in an earlier work (Hovingham Hall, Yorkshire, Worsley Collection, about 1624–5). The figure of Cephalus in NG 65 is comparable to that of Bacchus in Titian NG 35 – a work which Poussin was able to study in the Aldobrandini collection in Rome. A number of pentimenti are revealed on X-ray photographs: notably, a chariot which may have been Aurora's appears where the earth goddess now is.

Sale of Mme d'Hariague, Paris, 14 sqq. April 1750 (lot 19); G.J, Cholmondely Bequest, 1831.

Davies 1957, pp. 174–6; Blunt 1966, pp. 104–5; Thuillier 1974, pp. 87–8; Wild 1980, p. 14; Wright 1985, p. 145; Oberhuber 1988, p. 278; Mérot 1990, p. 276.

This arcadian celebration does not have a specific literary source. Nymphs, shepherds and a satyr dance before a term of the god Pan which has been draped with garlands. Pan was the ancient Greek deity of gardens and woodlands. He is associated with Bacchus, the god of wine, and this 'Bacchanal' includes appropriate details such as the squeezing of the juice of grapes at the left.

The painting is dated on stylistic grounds to the early 1630s. No information about a patron has survived; the tradition that the picture originally belonged to Cardinal Richelieu appears unfounded.

The central figure group was reused by the artist, in reverse, in the foreground of NG 5597. X-ray photographs reveal that the composition is painted over another inverted one, which is hard to decipher but includes a man in armour.

Collection of Randon de Boisset, before 1777; Comte de Vaudreuil sale, 1787; Calonne sale, 1795; bought, 1826.

Davies 1957, pp. 172–4; Blunt 1966, pp. 101–2; Thuillier 1974, p. 94; Wild 1980, p. 49; Wright 1985, p. 176; Mérot 1990, p. 276.

Moses, with Joshua, returns from Mount Sinai holding the tablets of the Law (upper left). On seeing the Israelites dancing before a pagan statue he smashes the tablets. While Moses had been away the Israelites had asked Aaron (in white, right of centre) for other gods, so he cast the golden calf before which they celebrate. Old Testament (Exodus: 32). The tents the people used in the wilderness are in the landscape at the right. The varying degrees of awareness of the anger of Moses is explored in detail – ranging from the horror of those near to him, to the ignorance of the dancers in the foreground. This subject of destruction was complemented by the theme of salvation in the work's pendant, *The Crossing of the Red Sea* (Melbourne, National Gallery of Victoria).

Both NG 597 and its pendant were painted for Amadeo dal Pozzo, Marchese of Volterra, and are recorded in an inventory of the Pozzo collection of 1634.

The foreground group of dancers is a reversed version of one used earlier by the artist in a painting of a profane subject (NG 62).

Collection of Amadeo del Pozzo by 1634; bought by Sir Jacob Bouverie (later Viscount Folkestone), 1741; bought with a contribution from the NACF, 1945.

Davies 1957, pp. 177–9; Blunt 1966, p. 22; Thuillier 1974, p. 96; Wild 1980, p. 64; Wright 1985, p. 180; Mérot 1990, p. 255.

Nicolas POUSSIN
The Adoration of the Shepherds
about 1634

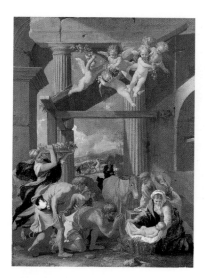

NG 6277
Oil on canvas, 96.5 x 73.7 cm

Nicolas POUSSIN
The Triumph of Pan
1636

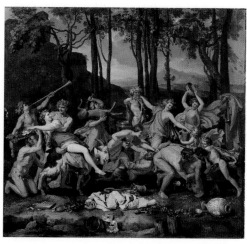

NG 6477
Oil on canvas, 134 x 145 cm

Nicolas POUSSIN
Landscape in the Roman Campagna with a Man scooping Water, about 1637–8

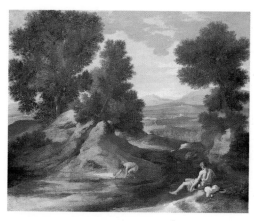

NG 6390
Oil on canvas, 63.1 x 77.8 cm

Signed on the stone in the foreground: N.Pusin. fe[cit]. (Nicolas Poussin made this.)

The shepherds adore the Christ Child, who lies to the right watched over by the Virgin and Joseph. The ox and ass appear behind them. New Testament (Luke 2: 15–16). An earlier event can be seen in the background where the terrified shepherds receive the announcement of the arrival of Christ from a heavenly host (Luke 2: 8–14).

Nothing is known of a commission. NG 6277 is dated to about 1634 by comparison with works such as *The Adoration of the Magi* of 1633 (Dresden, Staatliche Kunstsammlungen). The scale suggests it was intended for private devotion.

The lower half of the composition is recorded in a drawing in the British Museum, while the upper region is found on a sheet in Oxford (Christ Church Picture Gallery). Neither drawing is unquestionably by Poussin. Numerous copies of NG 6277 are known.

Possibly Le Nôtre (1613–1708) collection; Sir Joshua Reynolds, after 1761; bought with a special grant and contribution from the NACF, 1957.

Blunt 1966, pp. 32–3; Thuillier 1974, p. 94; Wild 1980, p. 50; Wright 1985, p. 170; Mérot 1990, p. 262; Verdi 1992, p. 52.

A number of literary and visual references are combined in this pagan celebration. Nymphs and satyrs with goats carouse before a term of the god Pan. His identity may here be combined with that of Priapus. Pan was god of woods and fields, and Priapus a deity of gardens; both are associated with fertility and Bacchic ritual. The instruments played, the sacrificial deer, and the props in the foreground are either attributes of these figures or linked with such rites. They include panpipes, thyrsi, theatrical masks (comedy, tragedy and satire), and a shepherd's staff. The figure with a staff on the side of the urn (bottom, right) may also be Pan.

The painting was executed with *The Triumph of Bacchus* (Kansas City, Nelson-Atkins Museum of Art) for Cardinal Richelieu; both works left Rome in May 1636. They hung in the Cabinet de la Chambre du Roi in Richelieu's château, with pictures by Mantegna, Perugino and Costa. (See also, Attributed to Poussin NG 42.)

A number of preparatory drawings are known. Some figures in the painting were borrowed from an engraving after Giulio Romano of *The Triumph of Priapus*. The trees in the background recall *The Feast of the Gods* by Giovanni Bellini and Titian (Washington, National Gallery of Art).

Cardinal Richelieu; bought by James Morrison, 1850; bought with contributions from the NHMF and the NACF, 1982.

Blunt 1966, p. 97; Thuillier 1974, p. 97; Wild 1980, p. 67; Brigstocke 1981, pp. 44–52; Wright 1985, p. 178; Mérot 1990, p. 275; Wine 1992, pp. 166–73.

A path meanders through trees towards an open landscape with mountains beyond at the right. In the foreground an old man rests; a sack and a gourd lie beside him. He observes a younger figure who kneels to scoop water from a pool. There is no literary source for this landscape which recalls the countryside around Rome (the Campagna) in which Poussin sketched.

Along with NG 6391, this work was executed for Cassiano dal Pozzo, an important friend and patron of the artist. The two works are probably not pendants and were, therefore, not necessarily painted in the same year. NG 6390 is dated on grounds of style to 1637–8. It is among the artist's earliest painted landscapes.

Either Cassiano dal Pozzo or his younger brother, Carlo Antonio dal Pozzo, about 1638; probably Gavin Hamilton, 1779; bought, 1970.

Blunt 1966, p. 146; Thuillier 1974, p. 102; Wild 1980, p. 106; Wright 1985, p. 207; Mérot 1990, p. 295; Verdi 1990, pp. 64–7; Wine 1992, pp. 174–9.

Nicolas POUSSIN
Landscape in the Roman Campagna
about 1639–40

Nicolas POUSSIN
Landscape with a Man killed by a Snake
1648

Nicolas POUSSIN
Landscape with a Man washing his Feet at a Fountain, about 1648

NG 6391
Oil on canvas, 62.8 x 74.4 cm

NG 5763
Oil on canvas, 119.4 x 198.8 cm

NG 40
Oil on canvas, 74.3 x 100.3 cm

A roadway leads between trees, past water into open country. In the foreground a figure rests and looks back to a second traveller who is tying on a sandal. A third figure continues along the road at the left. This lucidly composed study of landscape was probably inspired by aspects of the countryside around Rome (the Campagna) which the artist is known to have travelled through and sketched.

Along with NG 6390, this work was executed for Cassiano dal Pozzo, an important friend and patron of the artist. The two works are probably not pendants and were, therefore, not necessarily painted in the same year. NG 6391 is dated on grounds of style to 1639–40.

Either Cassiano dal Pozzo or his younger brother, Carlo Antonio dal Pozzo, about 1638; probably Gavin Hamilton, 1779; bought, 1970.

Blunt 1966, p. 146; Thuillier 1974, p. 102; Wild 1980, p. 106; Wright 1985, p. 207; Mérot 1990, p. 295; Verdi 1990, pp. 64–7; Wine 1992, pp. 174–9.

NG 5763 is not a depiction of a literary source, instead it appears to be an exploration of a psychological theme – a study of different degrees of fear. The chain of reactions, which diminish in intensity, can be 'read' from the terror of the man running in the foreground who sees the serpent, to the alarm of the woman in the middle distance and the awareness of the figure on the boat. People on the far side of the lake are oblivious to the drama. A town is depicted in the idealised landscape.

In Félibien's *Life of Poussin* (1685) NG 5763 is recorded as being painted with a pendant, showing a fleeing man, for Pointel, a Parisian banker and friend of Poussin. The catalogue of the Strange sale (London 1773) in which it was included suggested a completion date of 1648. This concurs with its style.

Three related drawings by the artist are known (Paris, Louvre; Dijon, Musée des Beaux-Arts; and Bayonne, Musée Bonnat).

Pointel collection, about 1648; Robert Strange, 1773; bought, 1947.

Davies 1957, pp. 179–82; Blunt 1966, pp. 143–4; Thuillier 1974, p. 105; Wild 1980, p. 130; Pace 1981, pp. 125, 146; Mérot 1990, p. 29; Verdi 1990, p. 69.

It has been suggested that NG 40 is a pair to *Landscape with a Roman Road* (London, Dulwich Picture Gallery). The dimensions of the works are comparable, they were engraved as associated in 1684 by Etienne Baudet, and are similarly dated, but their respective compositions suggest that each was conceived independently.

NG 40 is dated to about 1648 on grounds of style.

Sir George Beaumont collection by 1787; his Gift, 1823/8.

Davies 1957, p. 182; Blunt 1966, p. 145; Thuillier 1974, p. 105; Wild 1980, p. 134; Mérot 1990, p. 294; Verdi 1990, pp. 102–3.

Nicolas POUSSIN
The Finding of Moses
1651

NG 6519
Oil (identified) on canvas, 116 x 177.5 cm

Nicolas POUSSIN
The Annunciation
1657

NG 5472
Oil on canvas, 105.8 x 103.9 cm

Nicolas POUSSIN
Sleeping Nymph surprised by Satyrs
1626–7

NG 91
Oil on canvas, 66 x 50.8 cm

To escape Pharaoh's order to kill Israelite boys Moses was placed in an ark of bulrushes upon the Nile. Here he is discovered by Pharaoh's daughter (in yellow), who is attended by her maidens and by the baby's sister Miriam (in white), who cradles the child. Old Testament (Exodus 2: 3–9). The eastern setting includes palms, a sphinx, a god with a cornucopia (the Nile?), and a carob tree, as well as a pagan act of worship at the left. The arrangement of the maids recalls figure groups in works such as Poussin NG 6277.

In Félibien's *Life of Poussin* (1685) this picture is recorded as painted in 1651 for M. Reynon, a silk merchant from Lyon.

Poussin treated the subject three times: in 1638, in 1647 (both Paris, Louvre), and finally in this work. The arc of figures perfected here was formulated in the 1647 version. In 1650 Poussin had painted for Reynon *Christ healing the Blind Man* (Paris, Louvre), an all-male pendant, as it were, to NG 6519. Both works have as their underlying theme the celebration of the sense of sight, a theme emphasised by the unusual brilliance of Poussin's colour.

Acquired by the Duc de Richelieu and then by Lomérie de Brienne before 1662; bought by the Marquis de Seignelay before 1685; bought by the first Lord Clive (1725–74), and thence by descent; acquired jointly by the National Gallery and the National Museum of Wales, Cardiff, 1988.

Blunt 1966, pp. 13–14; Thuillier 1974, p. 107; Wild 1980, p. 153; Wright 1985, pp. 223–4; National Gallery Report 1988–9, pp. 12–15; Mérot 1990, p. 254.

Signed and dated on the plaque: POVSSIN. FACIEBAT./ ANNO. SALVTIS. MDCLVII./ ALEX. SEPT. PONT. MAX. REGNANTE./ .ROMA. (Poussin made this/ in the year of our Saviour 1657/ During the reign of Pope Alexander VII/ Rome.)

The archangel Gabriel announces to the Virgin that she will bear the Son of God. New Testament (Luke 1: 26–38). Above her hovers a dove who represents the Holy Spirit, the medium through whom the Christ Child was conceived. Beside her rests a book, the text of which is not decipherable. The Virgin's pose may have been intended to express her reply to Gabriel: 'Behold the handmaid of the Lord; be it unto me according to thy word.'

NG 5472 was probably meant to hang above the tomb of Poussin's patron Cassiano dal Pozzo (1588–1657) in S. Maria Sopra Minerva, Rome. Poussin wrote in a letter of 24 December 1657 that he was to work on a sepulchre for Pozzo; the date on the inscription is that of the year of Pozzo's death, and the paving and tablet suggest that the painting was intended to be incorporated into an architectural setting.

Another version of the subject from a series by Poussin (Munich, Alte Pinakothek) is dated about 1655.

Possibly Thomas Bladon sale, 1775, or Robert Udny sale, 1804; presented by Christopher Norris, 1944.

Davies 1957, pp. 176–7; Costello 1965, pp. 16–22; Blunt 1966, p. 32; Thuillier 1974, p. 110; Wild 1980, p. 180; Wright 1985, p. 229; Mérot 1990, p. 261; Wine 1992, pp. 194–9.

No literary source can be specifically related to this incident.

Another version of the subject is in the Kunsthaus, Zurich.

Until very recently NG 91 was thought to be a copy of a lost original by Poussin.

Henry Hope sale, 1816 ; Holwell Carr Bequest, 1831.

Davies 1957, pp. 183–5; Blunt 1966, p. 178; Thuillier 1974, p. 114; Wild 1980, p. 265; Wright 1985, p. 246.

Attributed to Nicolas POUSSIN
Bacchanalian Festival with Silenus
1635–6

After Nicolas POUSSIN
The Plague at Ashdod
after 1630

After Nicolas POUSSIN
The Holy Family with Saints Elizabeth and John
after 1640

NG 165
Oil on canvas, 128.9 x 204.5 cm

NG 42
Oil on canvas, 143.5 x 121.3 cm

NG 1422
Oil on canvas, 68.6 x 50.8 cm

There is no specific literary source for this Bacchic celebration in which Silenus is seated at the left astride a tiger.

Recent technical examination suggests that NG 42 is contemporary with Poussin's *Triumph of Pan* (NG 6477). In spite of the questionable quality of NG 42 it may, therefore, be by Poussin or by some unrecorded assistant and part of the same scheme for the château of Cardinal Richelieu that Poussin executed in 1635–6.

The pose of the reclining figure is in part based upon that of the ancient Roman sculpture, the *Barberini Faun*.

John Purling sale, London, 17 February 1801; bought, 1824.

Davies 1957, pp. 187–91; Blunt 1966, p. 99; Thuillier 1974, p. 97; Wild 1980, p. 69; Montagu 1989, p. 165; Mérot 1990, p. 275.

The Philistines captured the Ark of the Covenant and placed it in the temple of the idol Dagon in Ashdod, but the Lord caused the idol to be smashed and its worshippers to be plague-stricken. Old Testament (I Samuel 5: 1–6). At the left are the Ark of the Covenant and the broken idol of Dagon.

This is an old copy of Poussin's original (Paris, Louvre), which was acquired early in 1631 by Fabrizio Valguarnera. NG 165 may be by the Italian artist Angelo Caroselli (1585–1653).

In Cardinal Mazarini's palace, Rome, by 1645; Palazzo Colonna, Rome, probably by 1693; presented by the Duke of Northumberland, 1838.

Davies 1957, p. 185; Blunt 1966, p. 25.

Saint Elizabeth kneels to present the infant Saint John to the Christ Child who is held by the standing Virgin. Saint Joseph watches.

This is an early copy of the painting by Poussin (now Chantilly, Musée Condé) which was probably painted either just before or after his journey to Paris in 1640–2. NG 1422 was for a long time attributed to Le Sueur. It is now thought to be by an unknown, probably French, artist. Two other copies of the composition are recorded.

W.B. Tiffin's sale, May 1877; presented by Francis Turner Palgrave, 1894.

Davies 1957, p. 186; Blunt 1966, p. 38.

Pierre-Charles POUSSIN
Pardon Day in Brittany
1851

Attributed to Ludovico POZZOSERRATO
Landscape with Mythological Figures
1581–1605

Attributed to Ludovico POZZOSERRATO
The Sons of Boreas pursuing the Harpies
1581–1605

NG 810
Oil on canvas, 146 x 327 cm

NG 5466
Oil on canvas, 184.8 x 206.4 cm

NG 5467
Oil on canvas, 184.8 x 205.1 cm

Signed and dated: Charles Poussin. 1851
The subject is associated with the fête held in honour of Notre-Dame-de-Bon-Secours at Guingamp. This event takes place on the first Sunday in July and the preceding Saturday.

Presented by R.E. Lofft, 1870.

Davies 1970, p. 115.

The subject appears to be loosely connected to the Circe story, a version of which appears in the *Argonautica* (Book IV) of Apollonius Rhodius, which seems to be the source for this painting's companion piece NG 5467. One woman, with a wine glass, has the head of a hog, another on the rock above, has the head of a toad, and the one in the foreground has a serpent for a tail.
 NG 5466 and its pendant, NG 5467, have previously been catalogued as Venetian School. Paolo Fiammingo (1540–96) has also been suggested as the artist.

Bought as by Tintoretto by Frederick Cavendish Bentinck from A. Marcato, Venice, 1892; bought from F.C. Bentinck, 1944.

Gould 1975, pp. 310–12.

The subject seems to derive from the *Argonautica* (Book II) of Apollonius Rhodius, or perhaps from some source which itself derived from this. The winged Zetes and Calais, the sons of Boreas, chase the harpies away from the blind Phineas, who stands at the lower right pointing up at the sky. His food had been defiled by the harpies.
 NG 4567 and its pendant, NG 5466, have previously been catalogued as Venetian School. See also under NG 5466.

Bought as by Tintoretto by Frederick Cavendish Bentinck from A. Marcato, Venice, 1892; bought from F.C. Bentinck, 1944.

Gould 1975, pp. 310–12.

Pierre-Charles POUSSIN
1819–1904

Poussin was born in Paris, where he was taught by Léon Cogniet. He exhibited works at the Salon from 1842.

Ludovico POZZOSERRATO
active 1581 or earlier; died 1603/5

Loderwijk Toeput, known as Pozzoserrato, was born in the Netherlands but is recorded in Italy by 1581. He worked chiefly in Treviso, providing local altarpieces and fresco decorations for palaces, but also painting mythologies and scenes of villa life for the art market in Venice.

Attributed to Giovanni Ambrogio de PREDIS
Profile Portrait of a Lady
probably about 1500

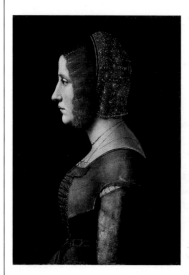

NG 5752
Oil on walnut, painted surface 52.1 x 36.8 cm

The Moor's head and the letters L and O ornamenting the buckle of the belt worn by this unidentified female sitter may allude to Lodovico il Moro (the Moor), Duke of Milan.

NG 5752 has been attributed to Giovanni Ambrogio de Predis, in spite of the problems attached to identifying his individual style. This portrait does seem to be a Milanese work of about 1500, and the attribution has generally been accepted.

In the collection of the Earl of Roden, Tullymore Park, before 1907; presented by Mrs Gutekunst in memory of her husband Otto Gutekunst, 1947.

Davies 1961, pp. 449–50.

Mattia PRETI
The Marriage at Cana
about 1655–60

NG 6372
Oil on canvas, 203.2 x 226 cm

When the wine ran out at the marriage feast at Cana, Jesus (here seated at the right, next to the Virgin Mary) commanded the servants to fill six stone jars with water. This miraculously turned to wine and was the the first of his miracles. New Testament (John 2: 1–11).

Preti is recorded as having painted this subject on several occasions during his years in Naples. He probably painted this version in about 1655–60, perhaps for the Perrelli family (where a version was recorded by De Dominici, the biographer of Neapolitan artists, in 1742–3).

Gerace collection, Naples, by about 1959; bought from the collection of Vitale Bloch, 1966.

Levey 1971, pp. 184–5; Clifton 1989, p. 58.

Andrea PREVITALI
The Virgin and Child with Saint John the Baptist and Saint Catherine, 1504

NG 1409
Oil on wood, 65.4 x 85.7 cm

Inscribed on a cartellino in the centre of the marble parapet: + 1504 / Andreas. cordelle. aghi. discipulus. / iovanis. Bellini. pinxit (followed by a mark) (1504 Andrea Cordelle Aghi [Cordeliaghi] disciple of Giovanni Bellini painted this).

Christ is shown with a piece of coral around his neck and a coral bracelet. Saint Catherine of Alexandria is on the right with a martyr's palm; Christ places a ring over her finger, recalling the saint's vision of her 'mystic marriage' to Christ. Saint John the Baptist is on the left in a camel skin and with a reed cross.

In 1504, the date on this painting, Previtali is thought to have been working in Venice, where he was strongly influenced by the art of Giovanni Bellini. He claims to be Bellini's disciple in the inscription and the figure of Saint John is derived from Bellini. There is a version of NG 1409 in the church of S. Giobbe, Venice, identical in composition but different in every minute detail of the clothing.

Buckingham collection, Stowe, by 1817; acquired by Sir Charles Eastlake, 1848; bought at Lady Eastlake's sale, 1894.

Davies 1961, p. 451; Zampetti 1975, p. 135.

Giovanni Ambrogio de PREDIS
about 1455–after 1508

Giovanni Ambrogio de Predis (or Preda) is recorded from 1482 when in the employment of Lodovico il Moro, Duke of Milan; in 1483 he was named in the contract for the *Virgin of the Rocks* (Leonardo NG 1093; he may have painted NG 1661) with his brother Evangelista (who died in 1490 or soon afterwards). From 1493 Giovanni Ambrogio worked for Emperor Maximilian I, and was strongly influenced by Leonardo.

Mattia PRETI
1613–1699

Preti was born in Taverna, Calabria, and painted in Modena and Rome before settling in Naples in about 1653. He left for Malta in 1660 where he was active until his death. He painted frescoes and altarpieces and other figural compositions. Early in his career he was made a knight of the Order of Saint John.

Andrea PREVITALI
active 1502; died 1528

Previtali probably moved to Venice in about 1495–1502. Before his return to his native Bergamo in about 1511, his work showed the influence of Giovanni Bellini – whose disciple he claimed to be – and Cima. His painting (mainly small devotional works and altarpieces) after about 1511 manifests Lorenzo Lotto's influence. From 1510 he adopted the name Previtali in preference to his family name Cordeliaghi.

Andrea PREVITALI
The Virgin and Child with a Donor
about 1505

Andrea PREVITALI
The Virgin and Child
about 1505–11

Andrea PREVITALI
Salvator Mundi
about 1511–19

NG 695
Oil on wood, 53.3 x 68.6 cm

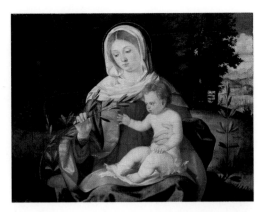

NG 2500
Oil on wood, 50.2 x 66 cm

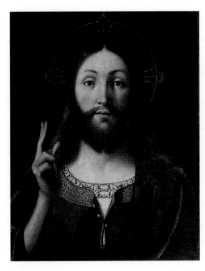

NG 3087
Oil on poplar, 47.6 x 38.1 cm

The Virgin and Child are shown in the foreground with a donor, probably a Franciscan friar, praying on the left. Christ holds a flower and gives a sign of blessing. The donor is tonsured and raises his hands in veneration. Saint Catherine of Alexandria stands amid ruins in the right background with the wheel on which she was tortured.

There is another, signed, version of this composition in the Wadsworth Athenaeum (Hartford, Connecticut).

Manfrin collection by 1856 (perhaps acquired about 1748); bought, 1862.

Davies 1961, pp. 450–1; Zampetti 1975, p. 136.

The Virgin bends a branch (probably an olive branch symbolic of peace) towards Jesus who touches one of its leaves.

The painting may date from Previtali's residence in Venice and certainly reflects Bellini's influence.

Grandi collection, Milan, by 1908; Salting Bequest, 1910.

Davies 1961, p. 451; Zampetti 1975, p. 136.

Christ is shown raising his right hand in a gesture of blessing, as Saviour of the World.

The painting must be earlier than NG 2501 which is inscribed 1519, but it may also date from Previtali's years in Bergamo after his return from Venice in about 1511–12.

Previtali painted a number of other pictures of this traditional subject, including NG 2501. Antonello's painting of the same subject (NG 673) belongs in the same tradition of imagery. Both ultimately derive from Netherlandish prototypes circulating in Italy.

Bergamo by 1863; acquired by Sir A.H. Layard, 1863; Layard Bequest, 1916.

Davies 1961, p. 452; Zampetti 1975, p. 136.

Andrea PREVITALI
Salvator Mundi
1519

Attributed to PREVITALI
Scenes from an Eclogue of Tebaldeo: Damon broods on his Unrequited Love / Damon takes his Life
perhaps about 1505

Attributed to PREVITALI
Scenes from an Eclogue of Tebaldeo: Thyrsis asks Damon the Cause of his Sorrow / Thyrsis finds the Body of Damon, perhaps about 1505

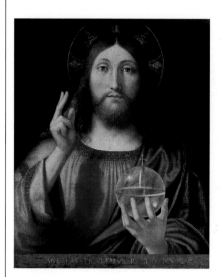

NG 2501
Oil on poplar, 61.6 x 52.7 cm

NG 4884.1
Oil on wood, 45.3 x 20 cm

NG 4884.2
Oil on wood, 45.3 x 20 cm

Inscribed on the marble parapet: ANDREAS. PRIVITALVS. P.[INXIT] M.D. XVIIII.

The image of the Salvator Mundi (Saviour of the World) was popular in Venice and here Christ is shown with a crystal orb, symbolising royal dominion. This orb is surmounted by a cross and Christ raises his right hand in a gesture of blessing.

This picture is signed and dated 1519. By this date Previtali was working in Bergamo and the picture was probably made for a private patron in that city.

Previtali painted a number of other pictures of this traditional subject, including NG 3087. The strength of the tradition in Venice can be appreciated by considering this picture in relation to Antonello's version of the same subject, NG 673. Both ultimately derive from Netherlandish prototypes circulating in Italy.

Salting collection by 1903; Salting Bequest, 1910.

Davies 1961, p. 452; Zampetti 1975, p. 136.

The Arcadian story of the shepherd Damon and his suicide on account of unrequited love for Amaryllis is from the *Eclogues* of the Ferrarese poet Antonio Tebaldeo (Venice, 1502). NG 4884.1 shows episodes one and three of this tale (which is completed by NG 4884.2): at the top Damon (lute in hand) broods on his love; at the bottom Damon takes his life (having first broken his lute).

This is an unusually poetic work for Previtali. He did not often paint secular scenes but here he approaches the subjects and the style of Giorgione. These panels may have been made as decorations for a piece of furniture, perhaps in Venice.

Acquired with an attribution to Giorgione the panels, which are painted on two strips of wood, are now generally given to Previtali.

Da Porto collection, Schio, near Vicenza, by 1937 (and allegedly from the Manfrin collection, Venice); bought (with a contribution from the NACF), 1937.

Davies 1961, pp. 453–4; Zampetti 1975, pp. 135–6.

The Arcadian story of the shepherd Damon and his suicide on account of unrequited love for Amaryllis is from the *Eclogues* of the Ferrarese poet Antonio Tebaldeo (Venice, 1502). NG 4884.2 shows episodes two and four of this tale (see also NG 4884.1): at the top Thyrsis asks Damon the cause of his sorrow; at the bottom Thyrsis finds the body of Damon.

Further comment can be found under NG 4884.1.

Da Porto collection, Schio, near Vicenza, by 1937 (and allegedly from the Manfrin collection, Venice); bought (with a contribution from the NACF), 1937.

Davies 1961, pp. 453–4; Zampetti 1975, pp. 135–6.

Attributed to PREVITALI
The Virgin and Child with Two Angels
about 1512–20

Attributed to Jan PROVOOST
The Virgin and Child in a Landscape
early 16th century

Scipione PULZONE
Portrait of a Cardinal
1575–98

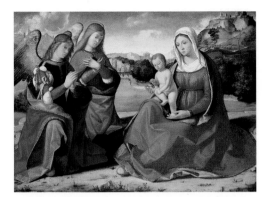

NG 3111
Oil on canvas, transferred from wood,
63.7 x 92.7 cm

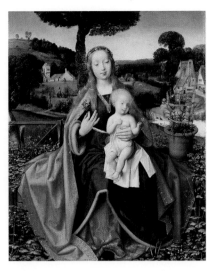

NG 713
Oil on oak, 60.3 x 50.2 cm

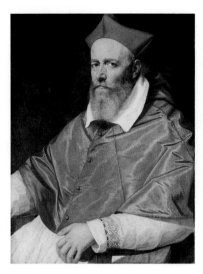

NG 1048
Oil on tin-plated copper, 94.3 x 71.8 cm

The Christ Child is shown with two cherries.

NG 3111 has much in common with the paintings of Boccaccio Boccaccino, but the landscape appears more reminiscent of Previtali. A variant of the composition in the style of Boccaccino exists (Lipphart collection) and NG 3111 is now tentatively thought to be by Previtali but based on a design by Boccaccino. This connection can be explained by the geographical proximity of Bergamo (Previtali's home from about 1512 until his death in 1528) to Cremona (Boccaccino's home from 1506 until his death about 1524–5).

Castellani collection (ex-Arache), Turin, 1856; Layard Bequest, 1916.

Davies 1961, pp. 452–3; Zampetti 1975, p. 136.

The Virgin is seated in a garden before a landscape. The object held by the Christ Child is a toy that could be made to rise into the air and fall.

The distant landscape may be by another hand.

Count Joseph von Rechberg, Mindelheim; bought by Prince Ludwig Kraft Ernst von Oettingen-Wallerstein, 1815; acquired by the Prince Consort, 1851; presented by Queen Victoria at the Prince Consort's wish, 1863.

Davies 1968, pp. 163–4.

A smaller version of this portrait in the Galleria Nazionale, Rome, is traditionally identified as a depiction of Cardinal Savelli – probably Cardinal Giacomo Savelli (died 1587) but possibly Cardinal Silvio Savelli (made cardinal in 1596; died 1599).

The presentation of the sitter – seated and in three-quarter profile and three-quarter length – was a convention for ecclesiastical portraiture established by the mid-sixteenth century.

Bought from W. Campbell Spence, Florence, 1879.

Gould 1975, pp. 206–7.

Jan PROVOOST
living 1491; died 1529

Provoost (in French Prévost) was from Mons. By 1491 he had married the widow of the painter Simon Marmion. In 1494 he settled in Bruges. A *Last Judgement* there is a documented work of 1524–6.

Scipione PULZONE
active 1569; died 1598

Pulzone was born in Gaeta. He was principally active in Rome, but also visited Naples and Florence. He gained a reputation as a portraitist, but executed many religious paintings in which a reaction against the extravagances of Mannerist art is notable.

Pierre-Cécile PUVIS de CHAVANNES
The Beheading of Saint John the Baptist
about 1869

NG 3266
Oil on canvas, 240 x 316.2 cm

Pierre-Cécile PUVIS de CHAVANNES
Death and the Maidens
before 1872

NG 3421
Oil on millboard, 40.6 x 31.4 cm

Pierre-Cécile PUVIS de CHAVANNES
Summer
before 1873

NG 3422
Oil on canvas, 43.2 x 62.2 cm

Herod, King of Israel, entranced by Salome's dancing offers her the object of her wishes. At the prompting of her mother, Heriodias, she requests the head of John the Baptist on a plate. New Testament (Mark 6).

NG 3266 is probably unfinished. The composition relates to a smaller painting, dated 1869 (Birmingham, Barber Institute), which Puvis showed at the Salon of 1870. Puvis made a large number of drawings and studies of the individual figures in this picture. According to tradition, Salome's features are based on those of the Princess Marie Cantacuzène (who later became the artist's wife) and the face of Herod (standing on the right) is said to have been modelled on that of the writer Anatole France.

Acquired from the heirs of the painter by Durand-Ruel, 1898; Sir Hugh Lane Bequest, 1917.

Davies 1970, pp. 116–17; Price 1977, p. 386.

The girls dance in a meadow, apparently unaware of the shrouded figure of death, the reaper, lying in the foreground. The title perhaps recalls Schubert's song *Death and the Maiden* (1817), although the subject was popular in French art and literature of the nineteenth century.

NG 3421 is a study for Puvis's painting of 1872 (Williamstown, Clark Art Institute).

A gift from the painter to Ary Renan; acquired by Arthur Studd, about 1891; bequeathed by Arthur Haythorne Studd, 1919.

Davies 1970, pp. 117–18; Price 1977, p. 414.

NG 3422 is a study with variations for the picture called *Summer* or *The Harvest*, dated 1873. The finished painting was purchased by the French government from the Salon of 1873 and now hangs in the entrance hall of the Musée d'Orsay, Paris.

A gift from the painter to Ary Renan; acquired by Arthur Studd, about 1891; bequeathed by Arthur Haythorne Studd, 1919.

Davies 1970, p. 118; Price 1977, p. 417.

Pierre-Cécile PUVIS de CHAVANNES
1824–1898

Puvis was born in Lyon. He was taught by Henri Scheffer in Paris, then spent a year in Italy, and studied briefly under Delacroix and Couture. He made his debut at the Salon in 1850 and in the 1860s began to specialise in the large decorative projects for which he is now best known.

Pierre-Cécile PUVIS de CHAVANNES
A Maid combing a Woman's Hair
about 1883

Jacob PYNAS
Mountain Landscape with Narcissus
1628

Pieter QUAST
A Man and a Woman in a Stableyard
probably 1630s

NG 3267
Oil on millboard, 32.5 x 24 cm

NG 6460
Oil on wood, 47.6 x 62.8 cm

NG 2856
Oil on oak, 45.4 x 57.5 cm

Inscribed: P. Puvis de Chavann(es).

This painting is usually connected with a larger picture of a similar subject, *Woman at her Toilette*, dated 1883 (Paris, Musée d'Orsay). However, Puvis turned to this intimate type of subject frequently during his career and NG 3267 should probably be regarded as an independent work. Two drawings relating to this picture are recorded.

NG 3267 has been dated variously between 1870 and 1883.

Bought from Dezaunais by Durand-Ruel, 1902; sold to Sir Hugh Lane, 1906; Lane Bequest, 1917; on loan to the Hugh Lane Municipal Gallery of Modern Art, Dublin, since 1979.

Davies 1970, p. 117; Argencourt 1976–7, pp. 183ff.; Price 1977, p. 512.

Signed and dated left: J. Pynas fc 1628.

The subject is derived from Ovid's *Metamorphoses* (III, 345–510). Narcissus spurned the many potential lovers who pursued him because of his beauty. He was condemned to fall in love with his own reflection. The basin is decorated with a bas-relief of the Rape of Europa, a theme loosely appropriate both to a basin and to Narcissus in that it combines the subjects of water and love.

When NG 6460 was first recorded (see provenance) the figure of Narcissus had been painted over and a rider on a white horse had been added in the middle distance. The painting was then known as 'Landscape with Virgil's Tomb'.

Collection of Arthur Kay, Edinburgh, by 1936; bought from S. Nystad with the aid of a fund to commemorate the art historian and critic Keith Roberts (1937–79), 1980.

MacLaren/Brown 1991, p. 316.

Signed on a pilgrim bottle standing on a barrel at the right: P.

It is Quast's intention here to ridicule the soldier. He is a swaggering, over-dressed figure who might have stepped from one of the pages of the many contemporary plays by Coster, Rodenburgh and others that mocked the pretensions of soldiers. The vanity of soldiers is also made fun of by Adriaen van de Venne in his satirical novel *Tafereel van de Belacherende Werelt* (1635); Quast knew van de Venne when he was in The Hague.

In the collection of Charles Lock Eastlake, London (Keeper of the National Gallery, 1878–98; died 1906); bequeathed by Mrs Charles Lock Eastlake, 1911.

MacLaren/Brown 1991, p. 317.

Jacob PYNAS
about 1585; died after 1648

Jacob Symonsz. Pynas was born in Haarlem. He was in Italy in 1605 and in Amsterdam in 1608. He is further recorded in Amsterdam in 1618 and 1643 and in The Hague in 1622, but was principally active in Delft. He belongs to a group of history painters known as the Pre-Rembrandtists, of whom Pieter Lastman is the best known. Like Lastman, Pynas studied the work of Elsheimer in Rome.

Pieter QUAST
1605/6–1647

Pieter Jansz. Quast was born in Amsterdam. In 1634 he became a member of the guild in The Hague, but by 1644 he had returned to Amsterdam. The artist painted mainly genre and satirical subjects with a strongly caricatural element. He also painted some historical and literary scenes and worked as a printmaker and book illustrator.

Pieter QUAST
A Standing Man
probably 1630–5

NG 6410
Oil on oak, 35 x 23.5 cm

Inscribed lower right: PQVAST (PQ and VA in monogram).
 The man is probably a soldier: this is not a portrait but is related to the barrack-room scenes painted by Quast in the mid-1630s.

Lord Haldon sale, Christie's, 28 February 1891 (lot 84); presented by the Misses Rachel F. and Jean I. Alexander; entered the Collection in 1972.

MacLaren/Brown 1991, p. 318.

Attributed to RAFFAELLINO del Garbo
Portrait of a Man
probably 1490s

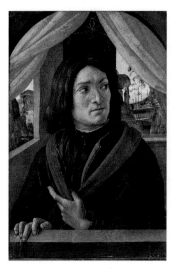

NG 3101
Tempera and oil on wood, 51.5 x 35.2 cm

The sitter has not been identified.
 NG 3101 was painted under the influence of both Botticelli and Filippino Lippi, probably in Florence in the 1490s. The arched format, curtains and ledge reinforce the impression that the sitter is standing at a window – an idea inspired by earlier Netherlandish portraiture.

Bought by Sir A.H. Layard from Arrigoni of Bergamo, not later than 1865; Layard Bequest, 1916.

Davies 1961, pp. 456–7; Dunkerton 1991, pp. 98–9.

Attributed to RAFFAELLINO del Garbo
The Virgin and Child with Two Angels
about 1495–1527

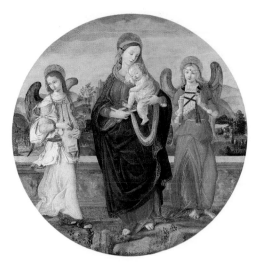

NG 4902
Tempera on canvas, transferred from wood,
84.5 x 84.5 cm

The Christ Child is depicted asleep and the angels have, it seems, ceased to play their instruments.

In the collection of Sir Bernhard Samuelson by 1893/4; passed to his son, Sir Henry Bernhard Samuelson, 1905; by whom bequeathed, in memory of his father, 1937.

Davies 1961, p. 457.

RAFFAELLINO del Garbo
living 1479?; died 1527?

It seems likely that three names, recorded as Raffaellino del Garbo, Raffaelle Carli and Raffaelle dei Capponi, describe the same man. A number of works associated with the foremost of these, form a unified group of Florentine pictures which date from the late fifteenth and early sixteenth century.

Attributed to RAFFAELLINO del Garbo
The Virgin and Child with the Magdalen and Saint Catherine of Alexandria, about 1495–1527

Abraham RAGUINEAU
Portrait of a Young Man in Grey
1657

RAPHAEL
The Procession to Calvary
about 1502–5

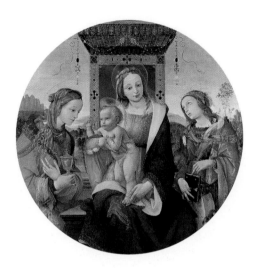

NG 2919
Tempera with oil on wood, 24.1 x 85.1 cm

NG 4903
Tempera on canvas, transferred from wood,
diameter 128.3 cm

Christ blesses the Magdalen at the left, who holds
her attribute, an ointment jar. At the right, Saint
Catherine of Alexandria holds a book and the
wheel on which she was tortured, and from which
she was miraculously saved.
 NG 4903 was formerly attributed to Botticelli or
Filippino Lippi. A drawing in Oxford (Christ
Church Picture Gallery) may be a study for it.

*In the Pucci collection, Florence, by 1849; in the
collection of Sir Henry Bernhard Samuelson by 1907;
by whom bequeathed, in memory of his father, 1937.*

Davies 1961, pp. 457–8.

NG 1848
Oil on oak, 73.8 x 59.8 cm

Inscribed right centre: A Raguineau/pinxit (AR in
monogram), and inscribed top left: Ao 1657/.AEtatis
18. (Year 1657. Age 18.)
 The sitter has not been identified. Raguineau was
probably living in 's Hertogenbosch when this
portrait was painted.

*Said to have been in the collection of Prince Bariatinsky
in Russia and to have been bought at the sale of his
collection by F. Meazza; F. Meazza sale, Milan, 15 April
1884 (lot 164); bought by Aldo Noseda, Milan, from
whom bought, 1901.*

MacLaren/Brown 1991, p. 319.

Christ carries the cross, on his way to Golgotha.
Behind him is Simon of Cyrene, who helps to bear
the weight of the cross. The fainting Virgin is
supported by the three other Maries. Saint John the
Evangelist, beside her, wrings his hands. New
Testament (Matthew 27: 30–3).
 NG 2919 was the central panel of the predella
below an altarpiece of the Virgin and Child with
Saints. (See Appendix B for a larger reproduction.)
This altarpiece was made for the church of S.
Antonio, Perugia, in about 1502, and is now in New
York (Metropolitan Museum of Art). Other parts of
the predella exist in New York (Metropolitan
Museum of Art), Boston (Isabella Stewart Gardner
Museum) and London (Dulwich Picture Gallery).

*Sold by the nuns of S. Antonio, Perugia, to Queen
Christina of Sweden, 1663; bought by the Duc d'Orléans,
1721; subsequently in the Hibbert and Miles collections;
collection of the Earl of Plymouth (Lord Windsor) by
about 1893; from whom bought, 1913.*

Dussler 1971, p. 15; Gould 1975, pp. 220–2;
Oberhuber 1977, pp. 9–55.

Abraham RAGUINEAU
1623–1681 or later

The artist, who was a portraitist, also signed his
name Ragueneau. He was baptised in London, and
by 1640 was living in The Hague. Later he is
recorded in 's Hertogenbosch, Breda, The Hague,
Leiden and Zierikzee. In 1659 he was paid for
teaching the young Prince of Orange, and was
apparently employed in his household until 1671.

RAPHAEL
1483–1520

The son of the painter Giovanni Santi, Raphael
was born in Urbino, and is traditionally said to
have trained with Perugino. He painted altarpieces
for churches in Umbria and Tuscany, before
moving to Rome in 1508. In Rome he worked for
Popes Julius II and Leo X and important private
patrons (painting frescoes, portraits, altarpieces;
and designing tapestries and buildings).

RAPHAEL

The Crucified Christ with the Virgin Mary, Saints and Angels (The Mond Crucifixion), about 1503

RAPHAEL

An Allegory ('Vision of a Knight') about 1504

RAPHAEL

The Madonna and Child with Saint John the Baptist and Saint Nicholas of Bari (The Ansidei Madonna) 1505

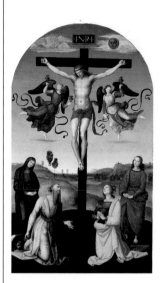

NG 3943
Oil (identified) on poplar, 280.7 x 165.1 cm

NG 213
Tempera on poplar, 17.1 x 17.1 cm

NG 1171
Oil on poplar, 209.6 x 148.6 cm

The cross is inscribed: (top) I.N.R.I.; (bottom) RAPHAEL / VRBIN / AS / .P.[INXIT] (Raphael of Urbino painted this).

Saints John the Evangelist, Jerome and Mary Magdalene stand or kneel at the foot of the cross. Two angels catch Christ's blood in chalices, such as are used for the wine of the Mass.

This altarpiece was painted for an altar in the church of S. Domenico in Città di Castello. The altar was the donation of Domenico Gavari in 1503 and NG 3943 probably dates from about this time. Such a dating corresponds with Raphael's stylistic development and this picture has always been acknowledged as very close in style to Perugino. Two of the three predella panels survive (Raleigh, North Carolina Museum of Art; Lisbon, Gulbenkian Museum); they depict episodes from the life of Saint Jerome.

A drawing (Oxford, Ashmolean Museum) seems to have been a study for the figure of Mary Magdalene.

Described in the church of S. Domenico in Città di Castello by Giorgio Vasari (1550); collection of Cardinal Fesch, 1818; collection of Lord Ward (later Earl of Dudley), 1847; bought by Ludwig Mond at the Dudley sale in 1892; Mond Bequest, 1924.

Dussler 1971, pp. 8–9; Gould 1975, pp. 222–3; Jones and Penny 1983, pp. 11, 13, 16; Dunkerton 1991, p. 366.

NG 213 may illustrate an episode from Silius Italicus' *Punica,* in which case the knight who sleeps beneath a bay tree would be the Roman hero Scipio Africanus (236–184 BC). In a dream he was offered a choice between Virtue, who lived at the end of a steep and rocky path (seen behind her), and Pleasure (at right), who is less soberly dressed. However, the two women are not presented as contestants, and the attributes they hold (a book, a sword and a flower) suggest the ideals of scholar, soldier and lover which a knight should combine.

The panel has been dated stylistically to about 1504. A related panel of identical size and depicting *The Three Graces* exists (Chantilly, Musée Condé) – together these panels may have served as covers for portraits.

A cartoon for NG 213 formerly in the Collection was transferred to the British Museum in 1994.

Borghese collection, Rome, by about 1650; collection of William Young Ottley, 1798; said to have been in the collections of Lady Sykes (1833) and then of Sir Thomas Lawrence (1839); bought from the Revd Thomas Egerton, 1847.

Dussler 1971, p. 6; Gould 1975, pp. 212–15; Jones and Penny 1983, p. 8; Plesters 1990, pp. 16–18; Dunkerton 1991, p. 370.

Inscribed on the frieze: .SALVE.MATER.CHRISTI. (Hail Mother of Christ) and dated on the hem of the Virgin's mantle: MDV (1505).

Saint Nicholas of Bari (the fourth-century Archbishop of Myra; in 1087 his remains were transferred to Bari) is shown on the right with the three golden spheres which he gave to three young women who could not afford a dowry. Saint John the Baptist (on the left) wears the camel skin he wore in the desert and holds a crystal cross.

This altarpiece, commissioned by Bernardino Ansidei for the chapel of St Nicholas of Bari in the church of S. Fiorenzo in Perugia, developed the architectural setting and compositional scheme made popular in Perugia by Perugino. The picture is dated 1505 (although the numerals have sometimes been read as 1506 or 1507), and was probably commissioned in about 1504. One of the predella paintings for the altarpiece is also in the Collection (NG 6480).

Bought by Gavin Hamilton for Lord Robert Spencer, 1764; later given to the 4th Duke of Marlborough; from whose descendants bought, 1885.

Dussler 1971, pp. 13–14; Gould 1975, pp. 216–18; Jones and Penny 1983, pp. 16, 19; Plesters 1990, pp. 31–6; Dunkerton 1991, p. 376.

RAPHAEL
Saint John the Baptist Preaching
1505

RAPHAEL
The Madonna of the Pinks
probably 1507–8

RAPHAEL
Saint Catherine of Alexandria
about 1507–8

NG 6480
Egg (identified) on wood, 23 x 53 cm

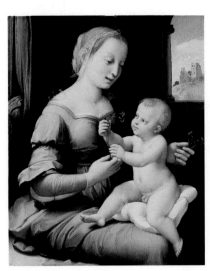

L582
Oil on wood (probably cherry), 29 x 23 cm

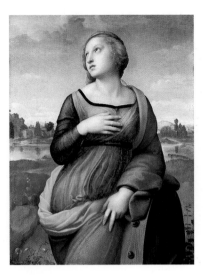

NG 168
Oil on wood, 71.5 x 55.7 cm

Saint John the Baptist was the forerunner of Christ and preached his coming, baptising those who converted. New Testament (John 1: 19–23).

NG 6480 is one of the three paintings which formed the predella for Raphael's *Ansidei Madonna* (NG 1171) in the church of S. Fiorenzo, Perugia. For further details on the commission, see under NG 1171. The panel would have originally appeared beneath the figure of Saint John the Baptist in the main altarpiece; the Baptist wears the same clothes in both panels.

Bought by Gavin Hamilton for Lord Robert Spencer, 1764; subsequently in the Lansdowne collection; bought (Morton Fund), 1983.

Dussler 1971, p. 14; National Gallery Report 1982–4, p. 21; Braham 1984, pp. 15–23; Dunkerton 1991, pp. 204, 376.

The flowers held by the Virgin Mary are carnations, or pinks (in Italian *garofani*).

L582 was probably painted in Florence about 1507–8, and can be compared with other paintings of the Virgin and Child of about this date (e.g. *Large Cowper Madonna*, Washington, National Gallery of Art). The picture was famous in the mid-nineteenth century, but was subsequently considered to be one of many copies of the composition until rediscovered and published in 1992.

Apparently in a French collection since the seventeenth century; bought in Paris by Vincenzo Camuccini, probably in 1828; bought with the Camuccini collection in Rome by the 4th Duke of Northumberland, 1853; on loan from the the Trustees of the 10th Duke of Northumberland Wills Trust since 1991.

National Gallery Report 1991–2, pp. 18–19; Penny 1992, pp. 67–81.

Saint Catherine of Alexandria leans against her traditional attribute of the wheel on which she was tortured.

NG 168 was probably painted just before Raphael left Florence and went to Rome. The pose of the saint reflects his study of the dynamic compositions of Leonardo and Michelangelo.

A full-size and pricked drawing for NG 168 is in Paris (Louvre); infra-red examination reveals free-hand underdrawing on the panel of NG 168.

Recorded in the Villa Borghese, Rome, 1650; acquired by Alexander Day, before 1800; bought from William Beckford, 1839.

Dussler 1971, pp. 25–6; Gould 1975, pp. 210–12; Jones and Penny 1983, pp. 44, 46; Dunkerton 1993, p. 11.

RAPHAEL

The Madonna and Child with the Infant Baptist (The Garvagh Madonna), probably 1509–10

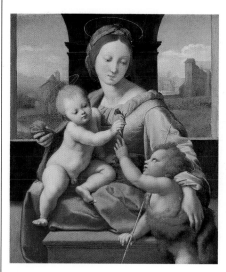

NG 744
Oil on wood, 38.7 x 32.7 cm

This painting of the Virgin and Child with Saint John has traditionally been entitled 'The Aldobrandini Madonna' or 'The Garvagh Madonna' (after families who owned it in the eighteenth and nineteenth centuries).

NG 744 was probably painted when Raphael was working in the Stanza della Segnatura in the Vatican Palace, Rome. Raphael made numerous studies of the Virgin and Child in his drawings of this period, but none corresponds exactly with the composition in NG 744. There is however a detailed underdrawing (visible in infra-red); this seems to be both in metalpoint and in black chalk.

Described in 1787 in the collection of Prince Aldobrandini in the Palazzo Borghese, Rome (and possibly identifiable with a picture described at the Villa Borghese in 1650); acquired by Alexander Day before 1800; bought by Lord Garvagh in 1818; bought from his widow and heirs, 1865.

Dussler 1971, pp. 26–7; Gould 1975, pp. 215–16; Dunkerton 1993, pp. 7–21.

RAPHAEL

The Madonna and Child (The Mackintosh Madonna), probably about 1510–12

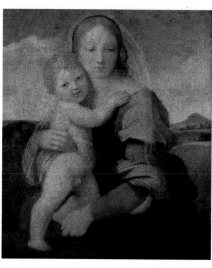

NG 2069
Oil (almost entirely repaint) on canvas, transferred from wood, painted area 78.8 x 64.2 cm

This painting is also known as 'The Madonna of the Tower' (visible in the left background) and 'The Mackintosh Madonna' (after its last owners).

NG 2069 is extremely damaged. The original cartoon for NG 2069 (London, British Museum) may have been used later by Domenico Alfani (1479/80–after 1553) as the basis for a picture dated 1518 (Perugia, Galleria Nazionale). Raphael is known to have supplied Alfani with drawings on other occasions.

Orléans collection by 1729; apparently acquired by Mr Hibbert, 1798; subsequently in the collections of Henry Hope and then Samuel Rogers; bought by R.J. Mackintosh, 1856; presented by Miss Eva Mackintosh, 1906.

Dussler 1971, p. 31; Gould 1975, pp. 218–20.

RAPHAEL

Pope Julius II
1511–12

NG 27
Oil (identified) on wood, 108 x 80.7 cm

Giuliano della Rovere (1443–1513) was elected pope in 1503. He took the name of Julius II and was active both in defence of the church and as a patron of the arts until his death.

NG 27 can be dated to the period from June 1511 until March 1512, when Pope Julius grew a beard as a token of mortification at having lost the city of Bologna, in imitation of ancient practices of mourning. The picture was probably set up in 1513 (after his death) in his favoured church of S. Maria del Popolo, Rome. This portrait was considered by contemporaries to be one of the greatest of Raphael's portraits, but NG 27 was not recognised as Raphael's original until 1970. Before then it had usually been considered an old copy, and the copy attributed to Titian (Florence, Palazzo Pitti) was sometimes claimed as the original.

Papal cross-keys are faintly visible on the green background; these appear to have been Raphael's original idea for the background. He changed his mind in favour of the green curtain.

Probably in the church of S. Maria del Popolo, Rome, until 1591, and then in the collection of Cardinal Sfrondati; certainly in the Borghese collection by 1693; J.J. Angerstein collection by 1823; bought, 1824.

Dussler 1971, pp. 29–30; Gould 1975, pp. 208–10; Partridge 1980, pp. 1–151; Jones and Penny 1983, pp. 157–60.

Imitator of RAPHAEL
Portrait of a Young Man
early 16th century; repainted in the 19th century

NG 2510
Oil on wood, 26.6 x 21.6 cm

The painting has in the past been described as a portrait of Raphael and the sitter does indeed resemble him. Recent examination suggests that the picture is an old one but the face is entirely repainted and the painting seems artificially aged.

NG 2510 was previously described as Umbrian and possibly Bolognese. It also appears at one time to have been attributed to Raphael's associate, Timoteo Viti (1469–1523). It was probably purchased by George Salting (at a high price) as a self portrait by Raphael.

Salting Bequest, 1910.

Gould 1975, p. 123.

After RAPHAEL
The Madonna and Child
probably before 1600

NG 929
Oil on wood, 87 x 61.3 cm

NG 929 is a copy of Raphael's *Bridgewater Madonna* of about 1508 (Sutherland collection, on loan to the National Gallery of Scotland).

The picture appears to be an old copy, possibly dating from the sixteenth century.

Collection of 'M. le Prince Charles', 1722; Wynn Ellis collection by 1854; Wynn Ellis Bequest, 1876.

Odilon REDON
Ophelia among the Flowers
about 1905–8

NG 6438
Pastel on paper, 64 x 91 cm

Signed bottom right: Odilon Redon
Redon produced numerous drawings and pastels of this subject taken from Shakespeare's *Hamlet* in the period from about 1900 to 1908. This pastel is purged of any literary detail or explanation and Ophelia floats in a detached, imaginary world.

NG 6438 was once thought to have started as a vertical picture of flowers in a vase which was then turned around and transformed into the present composition.

Albert D. Lasker collection, USA; bought from Marlborough Fine Art, with a contribution from the NACF, 1977.

National Gallery Report 1975–7, pp. 36–7.

Odilon REDON
1840–1916

Redon was born in Bordeaux. He went to Paris in 1859 where he trained first as an architect and then as a painter under Gérôme. Back in Bordeaux by about 1864, he learnt the techniques of etching and engraving from Rodolphe Bresdin. He produced mainly drawings and prints until the 1890s when colour began to play a more important role in his art.

REMBRANDT
Anna and the Blind Tobit
about 1630

REMBRANDT
Portrait of Aechje Claesdr. Presser
1634

REMBRANDT
Ecce Homo
1634

NG 4189
Oil on oak, 63.8 x 47.7 cm

Traces of a false signature, which are now no longer visible, were recorded on the varnish at the left: Re.bra.

Tobit, who was a devout Jew, lived with his wife Anna and their son Tobias. He was blinded when sparrows' droppings fell into his eyes, a misfortune which he endured with great fortitude. Tobit sent his son on a journey to collect a debt. Tobias was accompanied by the Archangel Raphael, who told him to save the heart, liver and gall of a large fish, the gall of which he used to cure his father's blindness. Old Testament Apocrypha (The Book of Tobit 2).

NG 4189 was engraved as the work of Rembrandt during his lifetime, but it has subsequently been argued that its meticulous detail suggests that it was either a collaboration between Rembrandt and his Leiden pupil Gerrit Dou, or by Dou alone. Comparisons with the work of Rembrandt and Dou have made it clear that the picture is, in fact, an authentic work by Rembrandt painted in about 1630 in Leiden before his move to Amsterdam. Recent cleaning has revealed areas of the background and skilful treatment of detail (formerly obscured by discoloured varnish), which also support the attribution to Rembrandt himself.

Possibly in the collection of the Unshod Carmelites at the Convent of San Hermenegildo, Madrid, by 1776; certainly in the John Bell sale, North Park, Glasgow, 1881; bought from Denis Elliot Watson, 1926.

Bruyn 1982–9, I, pp. 461–6, no. C3; MacLaren/Brown 1991, pp. 109–12.

NG 775
Oil (identified) on oak, 71.1 x 55.9 cm

Inscribed left centre: AE·S VE. 83. Signed and dated right centre: Rembrandt·f /1634.

This 83-year-old woman has recently been identified as Aechje Claesdr. Presser, mother of the Rotterdam brewer Dirck Jansz. Presser, whose portrait, with that of his wife, Rembrandt painted in a similar format in 1634. She wears a black overdress called a *vlieger*, which is shaped by rounded shoulder coils, or *bragoenen*. Three gold pins hold together her linen cap.

The oval format of NG 775, which is also used in the other early portraits by the artist in the National Gallery (e.g. NG 850), was fashionable in Amsterdam at the time.

Probably in the Klaas van Winkel sale, Rotterdam, 1791; bought from Lady Eastlake, 1867.

Bredius 1969, p. 576, no. 343; Bruyn 1982–9, II, pp. 571–7, no. A104; Bomford 1988, pp. 48–51, no. 3; MacLaren/Brown 1991, pp. 341–3; Brown 1991–2, p. 176, no. 19.

NG 1400
Oil on paper stuck on canvas, 54.5 x 44.5 cm

Signed and dated in the right background beneath the clock: Rembrandt·f·/1634. On the edge of the head-dress of the high priest with the rod in Hebrew letters is the name of God (JHWH) followed by AL or EL which may be the beginning of the word Elohim, or God.

'Ecce Homo' (Behold the Man) were Pilate's words to the people when he presented Christ to them before the Crucifixion. Jesus stands with his hands bound, crowned with thorns. Pilate rises from his seat, rejecting the rod of justice the Jewish elders offer him. The hand of the clock points to six in accordance with the Gospel (John 19: 4–5, 13–16): '[at] about the sixth hour … he saith unto the Jews, Behold your King!' The priests declared, 'We have no King but Caesar'. The bust at the right is a symbol of temporal Roman power.

NG 1400 is painted in grisaille and was used as a preparatory study for an etching by Rembrandt known in two states (1635, unfinished, and 1636). It was laid onto the etching plate and the outlines of the design transferred onto the plate with a stylus: the indentations of this transfer can be clearly seen.

Possibly mentioned in the inventory of Rembrandt's possessions, 1656; collection of Valerius Röver, Amsterdam, 1738; bought from the executors of Lady Eastlake, widow of Sir Charles Eastlake, 1894.

Bredius 1969, p. 605, no. 546; Bruyn 1982–9, II, pp. 459–68, no. A89; Royalton-Kisch 1984, pp. 130–2; Bomford 1988, pp. 42–7, no. 2; MacLaren/Brown 1991, pp. 346–9; Brown 1991–2, pp. 164–6, no. 15.

REMBRANDT

1606–1669

Rembrandt Harmensz. van Rijn was born in Leiden and taught there by Jacob van Swanenburgh. He became a pupil of Pieter Lastman in Amsterdam, and subsequently worked in Leiden (about 1624–31) and Amsterdam (1632–69). The best-known and most influential Dutch artist of the seventeenth century, he painted and etched portraits, biblical and mythological subjects, genre scenes, still life and landscapes. He had many pupils, followers and imitators.

REMBRANDT
Portrait of Philips Lucasz.
1635

REMBRANDT
Saskia van Uylenburgh in Arcadian Costume
1635

REMBRANDT
The Lamentation over the Dead Christ
about 1635

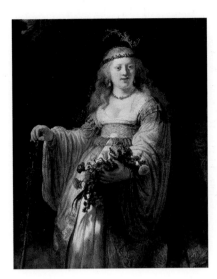

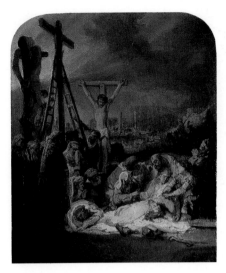

NG 850
Oil on oak, 79.5 x 58.9 cm

NG 4930
Oil (identified) on canvas, 123.5 x 97.5 cm

NG 43
Oil (identified) on irregularly shaped paper and pieces of canvas, stuck on oak, 31.9 x 26.7 cm

Signed and dated lower right: Rembrandt/1635

Lucasz. had a very successful career with the East India Company; he was appointed Councillor General Extraordinary of the Dutch East Indies in 1631. In 1633 he returned to the Netherlands as the commander of a trading fleet and in the following year married Petronella Buys whose family came from The Hague. This portrait is one of a pair; its companion shows the sitter's wife Petronella Buys (private collection).

The portraits were painted early in 1635 just before Lucasz. returned to the East Indies with his new wife. He died at sea in 1641 on his way to Ceylon; she returned to Amsterdam, remarried and died in 1670. The first recorded owner of the pictures, Jacques Specx, was Petronella's brother-in-law and an important patron of Rembrandt in the 1630s; he may have commissioned the pendants, or they might have been a gift to him from the sitters before their departure for the Indies.

The format of NG 850 was originally rectangular. X-radiographs reveal that Rembrandt included the sitter's left hand which rested on the gold chain. The hand was painted out when the portrait was changed from a rectangular to an oval format, probably after Rembrandt's death.

Jacques Specx collection before 1655; bought with the Peel collection, 1871.

Bredius 1969, p. 564, no. 202; Bruyn 1982–9, III, pp. 175–82, no. A115; Bomford 1988, pp. 52–7, no. 4; MacLaren/Brown 1991, pp. 343–6.

Traces of a false signature and date:Rem(··)a(·)/1635

Rembrandt married Saskia van Uylenburgh (1612–42) in 1634. She is shown here in arcadian costume, either in the guise of a shepherdess, or as Flora, the Roman goddess of spring. Such pastoral themes can also be found in contemporary poems, plays and paintings. The identification of Saskia is based on a drawing that Rembrandt made at the time of their betrothal in 1633 (*Saskia in a Straw Hat*, Berlin, Kupferstichkabinett). X-radiographs reveal that Rembrandt began the painting with a different subject and composition, probably a *Judith and Holofernes* based on a design by Rubens.

The false signature and date may have been copied from a genuine inscription that has been removed, since 1635 is compatible with the style of the painting. At the end of 1635, Rombertus, the couple's first child, was born; Saskia was probably carrying him when she posed for this work. He died in February 1636.

The artist had painted another version of Saskia as Flora (St Petersburg, Hermitage) in 1634. Titian's *Flora* (Florence, Uffizi) which was in the collection of Alfonso Lopez in Amsterdam (see NG 672) may have influenced Rembrandt's pictures of this type.

Duc de Tallard sale, Paris, 1765; in the collection of the Duke of Montagu, London, by about 1780; his daughter married the 3rd Duke of Buccleuch; bought from the 8th Duke of Buccleuch with contributions from the NACF, 1938.

Bredius 1969, p. 556, no. 103; Bruyn 1982–9, III, pp. 148–60, no. A112; Bomford 1988, pp. 58–65, no. 5; MacLaren/Brown 1991, pp. 353–8; Brown 1991–2, pp. 188–91, no. 23.

An inscription by Jonathan Richardson the Younger on the reverse of the British Museum drawing (see below) was copied by Sir Joshua Reynolds and pasted on the back of NG 43.

Christ's body, taken down from the cross, is laid across the Virgin's lap; the weeping Magdalen clasps his feet. The good thief (right) and the bad thief (left) are still on their crosses.

NG 43 is painted in grisaille. Rembrandt treated a number of biblical subjects in this manner in the 1630s (see NG 1400). They may have been intended to be used for a series of prints.

Initially the composition was painted in oil on paper, which was then mounted on a slightly larger piece of canvas over which the design was continued. It was then pasted to a larger panel, probably in the artist's studio. The composition was then extended at the top and bottom by painting up to the edge of the panel, probably by an artist working under Rembrandt's supervision. A drawing in which Rembrandt worked out the composition, making a number of changes, is in the British Museum, London. Another drawing by Ferdinand Bol (private collection) shows the composition before the final alterations. (See Giovanni Domenico Tiepolo NG 1333 and 5589.)

J. Barij collection, Amsterdam, by 1730; Joseph (Consul) Smith collection, Venice, by 1738; Richard Dalton sale, London, 1791; Sir Joshua Reynolds sale, London, 1795; Sir George Beaumont Gift, 1823/8.

Bredius 1969, p. 608, no. 565; Bruyn 1982–9, III, pp. 89–100, no. A107; Owen 1988, p. 48, no. 9; Bomford 1988, pp. 66–73, no. 6; MacLaren/Brown 1991, pp. 321–8.

REMBRANDT
Belshazzar's Feast
about 1636–8

REMBRANDT
Self Portrait at the Age of 34
1640

REMBRANDT
The Woman taken in Adultery
1644

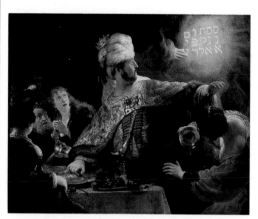

NG 6350
Oil (identified) on canvas, 167.6 x 209.2 cm

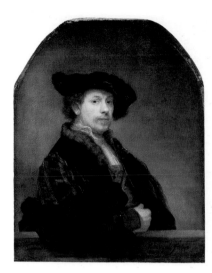

NG 672
Oil (identified) on canvas, 102 x 80 cm

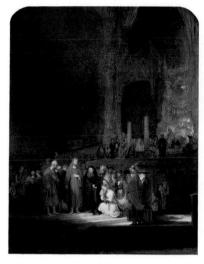

NG 45
Oil (identified) on oak, 83.8 x 65.4 cm

Signed and dated lower right: Rembrand./f 163(?). There is damage in the area of the signature and date and the final digit is lost. Rembrandt probably obtained the formula for the Hebrew inscription from Mennaseh ben Israel, a Jewish scholar who published it in his *De Termino Vitae* (Amsterdam 1639), and whose portrait the artist had etched in 1636. When transliterated it reads: Mene, Mene, Tekel, Upharsin ('God hath numbered thy kingdom and finished it... Thou art weighed in the balances, and art found wanting... Thy kingdom is divided...').

Belshazzar's father Nebuchadnezzar had stolen gold and silver vessels from the temple in Jerusalem. Belshazzar used them at a feast, during which a hand appeared and inscribed a message on the wall of the palace. Only Daniel was able to interpret it (Daniel 5: 1–5; 25–8).

NG 6350 is dated on stylistic grounds to about 1636–8. During this period the artist executed a group of large-scale paintings that employ similarly sharply contrasted lighting and arrested movement to capture a moment of drama.

Thin wedge-shaped pieces of canvas have been cut from each side; consequently the whole picture is tilted slightly anti-clockwise.

Collection of the Earl of Derby, Knowsley Hall, by 1736; bought from the Earl of Derby with a contribution from the NACF, 1964.

Bredius 1969, p. 598, no. 497; Bruyn 1982–9, III, pp. 124–33, no. A110; Bomford 1988, pp. 74–9; MacLaren/Brown 1991, pp. 362–4; Brown 1991–2, pp. 184–6, no. 22.

Signed and dated bottom right: Rembrandt. f 1640. Inscribed below: Conterfeycel (portrait).

The painting is closely related to a self-portrait etching made by Rembrandt in the previous year, 1639. In both the print and the painting the composition is influenced by Raphael's *Portrait of Baldassare Castiglione* (Paris, Louvre) and Titian's *Portrait of a Man* (NG 1944), which in the seventeenth century was thought to show the Italian poet Ariosto. Rembrandt certainly knew the *Castiglione*, of which he made a rough sketch at or after the sale of Lucas van Uffelen's pictures in Amsterdam in April 1639, when it was bought by Alfonso Lopez. He could also have seen the Titian 'Ariosto' in Amsterdam since it (or a copy) was in Lopez's collection at some time between 1637 and 1641.

The support of NG 672 may originally have been rectangular and the top corners subsequently removed to give an arched shape. X-radiographs reveal two significant pentimenti: the artist's left hand was shown with his fingers resting on the parapet, and initially his collar was more rounded and extended towards the right.

General Dupont collection, Paris; bought, 1861.

Bredius 1969, p. 549, no. 34; Bruyn 1982–9, III, pp. 375–81, no. A139; Bomford 1988, pp. 80–5, no. 8; MacLaren/Brown 1991, pp. 339–41; Brown 1991–2, pp. 218–21, no. 32.

Signed and dated bottom right: Rembrandt· f· 1644.

The figures are dwarfed by the cavernous interior of a huge temple. At the right is an altar with a high priest seated before it, while in the foreground the Pharisees and Scribes have brought an adulterous woman before Christ. They ask him whether she should be stoned to death, the punishment for adultery in the Mosaic law. They were hoping to trick him into denying the Mosaic law. The woman kneels, tearful, on the steps, and Christ, whose height emphasises his importance in the composition, looks down at her. His reply to the Pharisees was, 'He that is without sin among you, let him first cast a stone at her.' New Testament (John 8: 3).

NG 45 displays some characteristics of the artist's works from the previous decade; the elaborate setting for example recalls *Simeon and the Infant Christ in the Temple* of 1631 (The Hague, Mauritshuis). The freely drawn foreground figures, however, are entirely consistent with Rembrandt's style in the mid-1640s.

Probably in the inventory of the dealer Johannes de Renialme, Amsterdam, 1657; Willem Six (nephew of Jan) collection, Amsterdam, by 1718; bought with the J.J. Angerstein collection, 1824.

Bredius 1969, p. 608, no. 566; Brown 1976, p. 72, no. 87; Bomford 1988, pp. 86–91, no. 9; MacLaren/Brown 1991, pp. 328–30.

REMBRANDT
The Adoration of the Shepherds
1646

REMBRANDT
A Bearded Man in a Cap
1650s

REMBRANDT
A Woman bathing in a Stream (Hendrickje Stoffels?), 1654

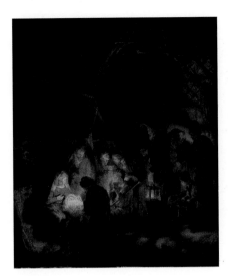

NG 47
Oil (identified) on canvas, 65.5 x 55 cm

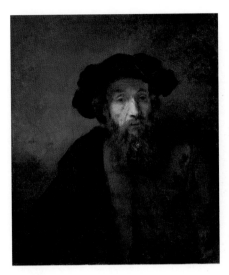

NG 190
Oil (identified) on canvas, 78 x 66.7 cm

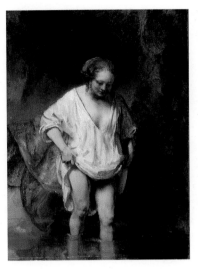

NG 54
Oil (identified) on oak, 61.8 x 47 cm

Signed and dated bottom left: Rembrandt.f.1646.

Joseph stands behind the Virgin. Two shepherds kneel before the crib. Behind, two women hold up a small child so that it can see Jesus. In the shadows at the right stand a group of five other figures, among them a boy with a dog. New Testament (Luke 2: 16).

There is another, larger version of this subject by Rembrandt, which is also dated 1646 (Munich, Alte Pinakothek). That picture was painted for the Stadholder Frederik Hendrik, Prince of Orange, and hung as part of a series showing the Life and Passion of Christ in his palace in The Hague. The commission is documented in a series of letters between Rembrandt and the prince's secretary, Constantijn Huygens. Comparison of that painting with NG 47 suggests that the London painting is later. In the Munich picture the Holy Family is on the right, but the composition is not simply reversed in NG 47. There are numerous differences which make it clear that it is a variation on the same theme. An attribution to Nicolaes Maes has been suggested for NG 47 but there are few stylistic analogies with Maes's early work.

Maréchal de Noailles sale, Paris, 1767; collection of J.J. Angerstein by 1807; bought with the J.J. Angerstein collection, 1824.

Bredius 1969, p. 608, no. 575; Bomford 1988, pp. 92–5, no. 10; MacLaren/Brown 1991, pp. 330–2.

Signed and dated: Rembrandt.f. / 165(7?)

In the past various titles have been given to this painting, among them 'An Old Man's Head' and 'A Jewish Rabbi'. The identification as a Jew can be traced back only to the early nineteenth century.

NG 190 is signed and dated, but the last digit of the date is hard to read; it may be read as a 7. 1657 would be acceptable on stylistic grounds.

The same man seems to have been used by Rembrandt as a model in a number of other works of the 1650s and 1660s, including *Aristotle contemplating the Bust of Homer*, 1653 (New York, Metropolitan Museum of Art); the so-called *Portrait of a Rabbi*, 1657 (San Francisco, Palace of the Legion of Honor); and *A Bearded Man*, 1661 (St Petersburg, Hermitage). A copy of NG 190 was painted by Gainsborough in about 1770 (London, Royal Collection).

Collection of the Duke of Argyll before 1781; collection of Jeremiah Harman by 1836; bought, 1844.

Bredius 1969, p. 571, no. 283; Bomford 1988, pp. 112–15, no. 14; MacLaren/Brown 1991, pp. 335–6.

Signed and dated bottom right: Rembrandt f 1654

A young woman, apparently unaware that she is being observed, wades into the water. On the bank beside her is a rich robe. The model for the woman is probably Hendrickje Stoffels (about 1625–63) who in 1654 was admonished by the Reformed Church in Amsterdam for living with the artist 'like a whore', and bore him a daughter called Cornelia in October that year. The identification cannot be confirmed as there is no documented portrait of Hendrickje, but the same woman appears in a group of works of this period (see NG 6432). The robe suggests that she might here be in the guise of an Old Testament heroine, such as Susanna or Bathsheba, or the goddess Diana, who were spied upon by men while bathing.

NG 54 displays remarkable spontaneity and freedom in the handling of the paint. It appears unfinished in some parts but was clearly finished to Rembrandt's satisfaction as he signed and dated it. Its size and support might suggest that it was a sketch for a larger history painting but, unlike Rubens, Rembrandt did not usually make preliminary oil sketches for larger projects.

Possibly in the Andrew Hale sale, London, 1739; Holwell Carr Bequest, 1831.

Bredius 1969, p. 589, no. 437; Bomford 1988, pp. 96–101, no. 11; MacLaren/Brown 1991, pp. 332–3; Brown 1991–2, pp. 246–9, no. 40.

REMBRANDT
Portrait of Hendrickje Stoffels
probably 1654–6

REMBRANDT
A Franciscan Friar
about 1655

REMBRANDT
An Elderly Man as Saint Paul
probably 1659

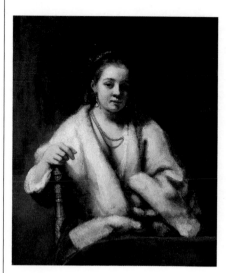

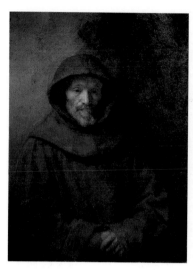

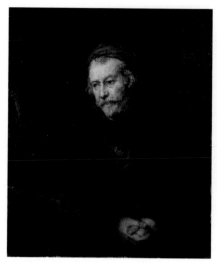

NG 6432
Oil (identified) on canvas, 101.9 x 83.7 cm

NG 166
Oil (identified) on canvas, 89 x 66.5 cm

NG 243
Oil (identified) on canvas, 102 x 85.5 cm

Signed and dated (falsely ?) lower left: Rembrandt f 16(?5 or 6)9.

This is probably a portrait of Hendrickje Stoffels (about 1625–63) who is first mentioned as a member of the artist's household in 1649 and bore him a child, Cornelia, in 1654. In that year the artist seems to have used her as a model in *A Woman bathing in a Stream* (NG 54). The identification cannot be confirmed as there is no documented portrait of Hendrickje, but the same woman appears in a number of informal portraits at this time and has usually been thought to be the artist's mistress.

NG 6432 probably dates from 1654–6 when Hendrickje was about 32 years old. It belongs to a group of portraits of the 1650s, painted and etched, in which Rembrandt explores the three-quarter-length portrait type (see, for example, his etching *Clement de Jonghe*, 1651).

A drawing (London, British Museum) may record an early stage of the composition seen in the X-radiograph of the painting, in which the sitter's hands are clasped together on her lap.

Bought by the art dealer William Buchanan in Amsterdam, 1817; collection of Edward Grey, Haringey House, Hornsey; collection of James Morrison, Basildon Park, Berkshire; bought by private treaty from the Trustees of the Walter Morrison Settlement with a contribution from the NACF, 1976.

Bredius 1969, p. 557, no. 113; Brown 1976, pp. 74–5, no. 91; Bomford 1988, pp. 106–11, no. 13; MacLaren/Brown 1991, pp. 364–7.

Signed and dated centre right: Rembrandt. f. 165(?)

An unidentified man is dressed in the habit of the Franciscan Order. This is a damaged painting which at some stage was transferred to a new canvas. During this process part of the original ground was removed and the paint surface has shrunk and been flattened. However, despite this damage, there is enough of the painting in good or reliable condition to sustain the traditional attribution to Rembrandt.

The last digit of the date on the inscription is illegible; the right edge of the painting, which has been reduced slightly, runs through it. The style suggests a date of about 1655.

Rembrandt painted his son, Titus, in a Franciscan habit in 1660 (Amsterdam, Rijksmuseum) and there is a third study of a Franciscan, dated 1661, in Helsinki (Atheneum). It has been suggested that the Rijksmuseum painting shows Titus in the guise of Saint Francis (who was the subject of an etching by Rembrandt of about 1657) and it is possible that NG 166 is also meant to show Saint Francis.

Possibly Richard Cosway RA sale, London, 1821; presented by the Duke of Northumberland, 1838.

Bredius 1969, p. 573, no. 308; Bomford 1988, pp. 102–5, no. 12; MacLaren/Brown 1991, pp. 334–5.

Signed and dated: Rembrandt / 165(9?)

Saint Paul's attributes, which he has here, are a book and the sword, symbolising the word of God and the nature of his martyrdom. The roundel in the upper left corner shows the Sacrifice of Isaac: in Paul's Epistle to the Hebrews (11: 17) Abraham's sacrifice of his son is cited as an example of Faith. The composition repeats in reverse (with slight variations) that of an etching of 1655 by Rembrandt.

The last digit of the date on the inscription is difficult to read but is probably a 9.

NG 243 belongs to a group of half-length apostles and saints painted in the years around 1660.

N.W. Ridley (later Lord Colborne) collection by 1815; by whom bequeathed, 1854.

Bredius 1969, p. 573, no. 297; Bomford 1988, pp. 116–19, no. 15; MacLaren/Brown 1991, pp. 337–9.

REMBRANDT
Portrait of Jacob Trip
about 1661

REMBRANDT
Portrait of Margaretha de Geer, Wife of Jacob Trip
about 1661

REMBRANDT
Portrait of Frederick Rihel on Horseback
probably 1663

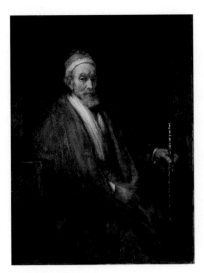

NG 1674
Oil (identified) on canvas, 130.5 x 97 cm

NG 1675
Oil (identified) on canvas, 130.5 x 97.5 cm

NG 6300
Oil (identified) on canvas, 294.5 x 241 cm

Signed right: Rembr. . .

Jacob Jacobsz. Trip (1575–1661) was a wealthy Dordrecht merchant. In 1603 he had married Margaretha de Geer and went into business with her brother Louis de Geer, one of the greatest ironmakers and armament manufacturers of the day. This portrait is a pendant to Rembrandt's portrait *Margaretha de Geer* (NG 1675). The couple were also painted by other artists; their identity is confirmed by comparison with a pair of portraits by Jacob Gerritsz. Cuyp which were in the collection of the de Geer family.

Two of their sons, Louis and Hendrick, who also dealt in armaments, built the palatial Trippenhuis on the Kloveniersburgwal in Amsterdam in 1660–2, and these two portraits may have been commissioned by Rembrandt to hang there. Jacob Trip died in 1661 and this portrait may have been painted not from life, but from another portrait, perhaps by J.G. Cuyp.

The signature, just above the sitter's left hand, is fully visible only in ultra-violet light. It is cut off by the edge of the canvas: this would suggest that the painting has been reduced in size, perhaps by as much as 5 cm on the right-hand side. X-radiographs reveal that Trip's right hand was originally slightly higher and that he sat in a simple, round-backed chair.

With NG 1675 probably in the Lee Family collection in the eighteenth century; bought, 1899.

Bredius 1969, p. 574, no. 314; Brown 1976, p. 77, no. 94; Bomford 1988, pp. 120–5, no. 16; MacLaren/ Brown 1991, pp. 350–2.

This portrait of Margaretha de Geer (1583–1672) is a pendant to *Portrait of Jacob Trip* (NG 1674); the couple had married in 1603. Margaretha wears a large ruff and gown that were fashionable about 40 years earlier. She continued to live in Dordrecht after her husband's death in 1661 and died there in 1672, aged 89.

For discussion of the circumstances of the commission of these pendant portraits, see NG 1674. On stylistic grounds the pair are dated to about 1661.

The canvas appears to have been cut down on all four sides, particularly at the right, and presumably at the same time as its pendant. The artist made a number of changes to the sitter's position and the details of her costume, which can be seen on the X-radiograph. Her left hand was originally placed in her lap and then to the right of its present position. The shape of the ruff around her neck would also seem to have been altered more than once; initially it was tilted more towards the viewer. Finally, her white cuffs seem originally to have been trimmed with lace.

With NG 1674 probably in the Lee Family collection in the eighteenth century; bought, 1899.

Bredius 1969, p. 581, no. 394; Brown 1976, p. 77, no. 95; Bomford 1988, pp. 126–9, no. 17; MacLaren/ Brown 1991, pp. 352–3.

Signed left: R. .brandt 166(3?)

Frederick Rihel (1621–81) came from a Strasbourg family of paper manufacturers and printers. He is first mentioned in Amsterdam in 1642 and he remained there as a successful merchant. A portrait of him on horseback is recorded in the inventory taken after his death, which includes many items of dress and accoutrements worn by the rider in the portrait. The horse performs a *levade*, taking part in a procession that winds around a stretch of water in the lower left where the prow of a boat can be seen. On the left is the façade of a building. In front of it is a coach containing three men, and a groom on the running board. On the right are two (or three) riders on horseback.

The date seems to read 1663. The picture probably commemorates the part Rihel played in the entry of the Prince of Orange into Amsterdam in 1660. The building on the left would then be the Heiligewegspoort, by which the Prince entered the city. Rihel, a keen horseman, was a member of the Amsterdam civic guard which accompanied the Prince into the city.

Count Ferdinand of Plettenberg and Witten sale, Amsterdam, 1738; collection of the 2nd Earl Cowper by about 1750; collection of the Earls Cowper, Panshanger; bought with a special grant and contributions from the NACF and the Pilgrim Trust, 1959.

Bredius 1969, pp. 568–9, no. 255; Brown 1976, pp. 78–9, no. 96; Bomford 1988, pp. 134–9, no. 19; MacLaren/Brown 1991, pp. 358–62.

REMBRANDT
Self Portrait at the Age of 63
1669

Attributed to REMBRANDT
Portrait of Margaretha de Geer, Wife of Jacob Trip
1661

Follower of REMBRANDT
Diana bathing surprised by a Satyr
17th century

NG 221
Oil (identified) on canvas, 86 x 70.5 cm

NG 5282
Oil (identified) on canvas, 75.3 x 63.8 cm

NG 2538
Oil on oak, 46.3 x 35.4 cm

Signed and dated lower left: [....] t: f/1669.

The picture was painted in the final year of Rembrandt's life, 1669, and is one of his last works. He died on 4 October and was buried on 8 October in the Westerkerk, Amsterdam. Another *Self Portrait* of the same year is in the Mauritshuis, The Hague.

The fact that only the last letter of the signature remains makes it likely that the canvas has been cut down by about 3 cm on the left side. X-radiographs reveal two significant pentimenti: originally the turban was higher and fuller and entirely white (as in the *Self Portrait* in Kenwood House, London), and the hands were depicted open with a brush or maulstick being held in the painter's right hand.

William van Huls collection, London, before 1722; bought, 1851.

Bredius 1969, p. 551, no. 55; Bomford 1988, pp. 140–3, no. 20; MacLaren/Brown 1991, pp. 336–7.

Signed and dated left: Rembrandt.f / 1661

Margaretha de Geer (1583–1672) was the wife of the wealthy Dordrecht merchant Jacob Trip (1575–1661). The couple were depicted by Rembrandt in a pair of portraits in the National Gallery (NG 1674 and 1675). In the present portrait the sitter wears the same peaked head-dress and millstone ruff as in NG 1675 but is shown closer to half-length and with her body turned slightly to the left (compared to the frontal, more formal pose of the other portrait).

The exact relationship between the two portraits of Margaretha de Geer is unclear because certain technical features of this work make it impossible to be certain that it was painted by Rembrandt himself, rather than by a follower. It is either a more freely painted variant by Rembrandt of the larger picture, based upon the same series of sittings and intended for another member of the Trip family, or a skilful imitation of the artist's work painted before 1818 when it was in the collection of Lord Townsend.

Lord Charles Townsend collection by 1818; presented by the NACF, 1941.

Bredius 1969, p. 581, no. 395; Bomford 1988, pp. 130–3, no. 18; MacLaren/Brown 1991, pp. 367–9.

Traces of a false signature bottom left: Rembran(· ·)

The presence of the hounds suggest that the woman may be the goddess and huntress Diana. The scarcely visible figure looking at her from behind a tree may be a satyr, or, less probably, Actaeon.

NG 2538 was thought to be by Rembrandt until 1960, but both the composition and execution are too weak for him, and it is clearly the work of a pupil or follower. Attributions to Gerbrand van der Eeckhout and (more convincingly) Govert Flinck have been suggested. The style is loosely based on that of Rembrandt in the late 1630s (e.g. *Christ appearing to the Magdalen*, 1638, London, Royal Collection).

Sold by R. Langton Douglas to George Salting, 1909; Salting Bequest, 1910.

Bredius 1969, pp. 592–3, no. 473; MacLaren/Brown 1991, pp. 372–3.

Follower of REMBRANDT
An Old Man in an Armchair
17th century

NG 6274
Oil (identified) on canvas, 111 x 88 cm

Signed and dated falsely top right: Rembrandt.f. /1652

This painting entered the Collection as a Rembrandt. Subsequently it was noted that the overall structure, and in particular the loose treatment of the beard, fur coat and right hand, was weak. Such a lack of stylistic coherence is not found in Rembrandt's autograph portraits of the early 1650s, which is an outstanding period for his portraiture (e.g. *Nicolaes Bruyningh*, 1652, Cassel; *Jan Six*, 1654, Amsterdam, Six Foundation).

NG 6274, which displays a debt to Venetian, and in particular Tintorettesque portraiture (e.g. Tintoretto NG 4004), is now attributed to an unidentified pupil or early follower of Rembrandt.

Almost certainly among the pictures at Chiswick House collected by the 3rd Earl of Burlington (died 1753); bought from the Duke of Devonshire, 1957.

Bredius 1969, p. 570, no. 267; MacLaren/Brown 1991, pp. 376–7.

Follower of REMBRANDT
A Man seated reading at a Table in a Lofty Room
about 1631–50

NG 3214
Oil on oak, 55.1 x 46.5 cm

Traces of a false signature along the handrail of the stairs at right: Rem(·)randt.

The painting was entitled 'Philosopher in his Study' in two auction sales in the eighteenth century. Astrologers, alchemists and philosophers were popular subjects in Dutch art of the seventeenth century (see Ostade NG 846, Bol NG 679 and van Deuren NG 2589). Above the shelves of books at the right are a pair of globes.

NG 3214 was until relatively recently considered to be a painting by Rembrandt from about 1628–9. Owing to stylistic weaknesses – the fussy, literal-minded way in which details are incised in the paint, the clumsy drawing of the arch on the back wall, the contrast between the detailed draughtsmanship of the globes and books and the loose, almost careless treatment of the figure – it is now considered to be the work of an early or contemporary follower of the artist, who imitated the style of Rembrandt's Leiden period (1625–31). It has been suggested that it is by the same artist as the *Rest on the Flight to Egypt* (The Hague, Mauritshuis).

Possibly David Ietswaard sale, Amsterdam, 1749; bought from John Davies of Elmley Castle (Temple–West Fund), 1917.

Bruyn 1982–9, I, pp. 529–32, no. C14; MacLaren/Brown 1991, pp. 373–6.

Follower of REMBRANDT
A Young Man and a Girl playing Cards
perhaps about 1645–50

NG 1247
Oil on canvas, 123.5 x 104 cm

The painting is not by Rembrandt but its style derives from Rembrandt's work of about 1645–50 and suggests that the painter was either a pupil of Rembrandt, or in direct contact with him. It has been attributed to Nicolaes Maes, Barent Fabritius and Cornelis Bisschop (1630–74). The last is the most likely but no signed painting by Bisschop shows the broad handling that characterises this picture.

Possibly Thomas Bladen sale, London, 1775; bought, 1888.

MacLaren/Brown 1991, pp. 371–2.

Follower of REMBRANDT
A Seated Man with a Stick
perhaps 1675–1725

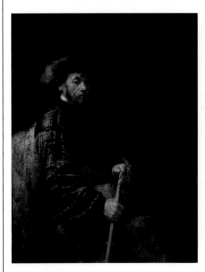

NG 51
Oil on canvas, 137.5 x 104.8 cm

Signed, probably falsely, bottom left: R(·)mbrandt / (·)6(··)

The painting was formerly known as 'A Jew Merchant', a title apparently given to it for the first time in 1832.

NG 51 was presented to the National Gallery as a Rembrandt and considered to be by him until 1960. Subsequently weaknesses – notably the meaningless brushstrokes on the nose, the clumsy drawing of the right shoulder and the over-elaborate treatment of the right sleeve – have been noted and it has been argued that it is the work of a pupil or later imitator of Rembrandt. An attribution to Samuel van Hoogstraten has been suggested, but it could well be a late seventeenth- or early eighteenth-century invention.

Probably sold by Sir Thomas Lawrence to Sir George Beaumont, 1797; Sir George Beaumont Gift, 1823/8.

Bredius 1969, p. 569, no. 257; Owen 1988, p. 51, no. 10; MacLaren/Brown 1991, pp. 370–1.

Imitator of REMBRANDT
A Study of an Elderly Man in a Cap
17th century

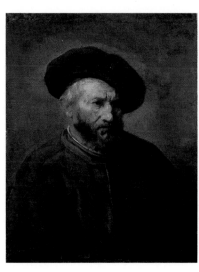

NG 2539
Oil on canvas, 67 x 53 cm

Falsely signed and dated centre right: Rembrandt.f./ 164(8?)

From 1929 onwards doubts were raised about the attribution of this picture to Rembrandt. It was cleaned in 1952 and discovered to be a substantially worn work by an imitator. Analysis of paint samples suggest that it is a seventeenth-century painting by an artist familiar with Rembrandt's techniques rather than a later imitation.

Probably in the collection of the Dukes of Sutherland before 1846; Salting Bequest, 1910.

Jones 1990, pp. 129–32, no. 136; MacLaren/Brown 1991, pp. 377–8.

Guido RENI
The Coronation of the Virgin
about 1607

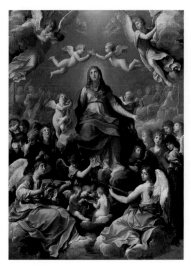

NG 214
Oil on copper, 66.6 x 48.8 cm

The Virgin is crowned by angels, possibly as 'Regina angelorum' (Queen of the angels), and elements of her Assumption are mingled with those of the Coronation of the Virgin, in which she is usually shown crowned by God the Father and Jesus Christ.

Reni painted variants on the Glorification of the Virgin from the beginning of his career, and NG 214 is generally considered to be the culmination of his interest in the theme, and is dated to about 1607.

NG 214 clearly develops from Reni's *Glorification of the Virgin* of about 1602–3 (Madrid, Prado), and there are a number of drawings that, while not directly related to NG 214, show Reni's evolving approach to this subject. The composition was copied in 1626 by Domenichino (Bayonne, Musée Bonnat).

Collection of William Wells by 1831 (when said to have been acquired from Sir Thomas Lawrence, and to have come from the Royal Collection in Madrid); bequeathed by William Wells, 1847.

Levey 1971, pp. 187–9; Pepper 1984, p. 222.

Guido RENI
1575–1642

Reni, one of the foremost Italian painters of the early seventeenth century, was born in Bologna, where he probably trained with Ludovico Carracci in 1594/5. He was subsequently active in Rome, Bologna, Mantua, Naples, Modena and other cities, painting altarpieces, devotional works and mythologies for his patrons. He had many pupils and an active workshop.

Guido RENI
Lot and his Daughters leaving Sodom
about 1615–16

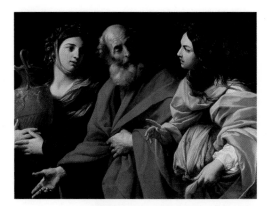

NG 193
Oil on canvas, 111.2 x 149.2 cm

Guido RENI
Susannah and the Elders
1620–5

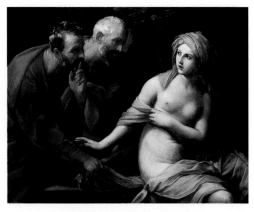

NG 196
Oil on canvas, 116.6 x 150.5 cm

Guido RENI
Saint Jerome
about 1624–5

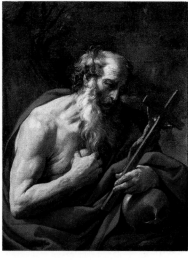

NG 11
Oil on canvas, 111.8 x 86.4 cm

The only just man in Sodom, Lot was warned by a divine messenger that the city was about to be destroyed for its sins. He fled with his wife and daughters; his wife was turned to a pillar of salt when she looked back upon Sodom. The incestuous union of Lot and his daughters gave rise to two tribes, enemies of Israel. Old Testament (Genesis 19: 30).

A preparatory drawing survives for the head of the daughter on the left (Windsor, Royal Collection).

NG 193 was engraved as in the Palazzo Lancellotti, Rome, by D. Cunego for Gavin Hamilton's *Schola Italica Picturae* (1771). In 1787 it was described in that collection together with another picture by Reni, *Susannah and the Elders* (NG 196), and they have been considered pendants ever since, though they were not necessarily painted as such.

Palazzo Lancellotti, Rome, by 1771; bought, 1844.

Levey 1971, pp. 186–7; Pepper 1984, pp. 231–2; degli Esposti 1988, p. 208.

Susannah was bathing in a garden when two elders, who lusted after her, emerged from hiding and threatened to denounce her as unchaste if she would not 'lie with' them. She refused and despite being falsely accused, she was subsequently vindicated. Old Testament Apocrypha (Susannah 15–24).

After recent cleaning (1984) it seems probable that NG 196 is largely by Guido Reni.

NG 196 was described in the Palazzo Lancellotti, Rome, in 1787. At that time it was a pendant of *Lot and his Daughters* (NG 193), an earlier picture by Guido Reni. They were not necessarily painted as a pair. Another painting by Guido Reni of the same subject and composition as NG 196 was in the Imperial collection, Vienna, in 1660, when it was engraved in the *Theatrum Pictorium*. This picture has not been traced. Several copies of the composition are known.

Palazzo Lancellotti, Rome, by 1787; bought, 1844.

Levey 1971, pp. 192–3; Pepper 1984, pp. 240–1; Ebert-Schifferer 1988, pp. 142–4.

Saint Jerome (about 342–420), the chief inspiration for Christian penitents and hermits, is shown in the desert, beating his chest with a stone and holding a crucifix, his hand resting on a skull.

Formerly thought to be an old copy, NG 11 appears (after its recent cleaning, 1984–5) to be an autograph painting by Reni. It was probably executed for a private collector about 1624–5, and it appears in Barberini inventories from 1644 to 1740. Malvasia (1678) described a half-length Saint Jerome in the Barberini palace, and it has been shown that this picture was acquired by the Barberini family from Carlo Ganotto in 1634.

NG 11 was engraved by D. Cunego in the collection of Gavin Hamilton in Rome in 1769; the engraving was made in preparation for Hamilton's *Schola Italica Picturae* (1771). There exist several poor copies of the composition.

Collection of Cardinal Antonio Barberini, Rome, by 1644; collection of Gavin Hamilton, Rome, by 1769; Holwell Carr Bequest, 1831.

Levey 1971, pp. 191–2; Pepper 1984, p. 248; Ebert-Schifferer 1988, pp. 151–2.

Guido RENI
Saint Mary Magdalene
about 1634–5

Guido RENI
Christ embracing Saint John the Baptist
about 1640

Guido RENI
The Adoration of the Shepherds
about 1640

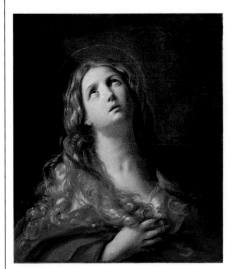

NG 177
Oil (identified) on canvas, 79.3 x 68.5 cm

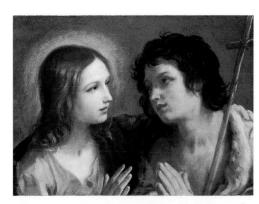

NG 191
Oil (identified) on canvas, 48.5 x 68.5 cm

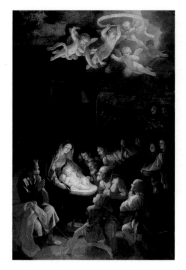

NG 6270
Oil on canvas, 480 x 321 cm

There are versions of this subject by Reni in a number of other collections (Paris, Louvre; Madrid, Prado) and the Magdalen's head in NG 177 seems to derive from a full-length painting of *Mary Magdalene* (Rome, Galleria Nazionale). A date in the mid-1630s has been suggested for NG 177. This period was one in which Reni's style took a new direction with a generally paler palette.

NG 177 was engraved by Bouilliard in 1786.

Apparently in the collection of the Marquis de Seignelay (died 1690); subsequently in the Orléans collection; bought, 1840.

Levey 1971, pp. 194–5; Pepper 1984, p. 271.

John the Baptist (on the right, with a reed cross) was miraculously born of barren parents, shortly before Jesus (on the left) was born of the Virgin Mary. The two were often shown as youths, prior to the later moment when John would baptise Jesus.

NG 191 is likely to be a late work by Guido Reni (though it has also been attributed to his studio), perhaps of about 1640. It was probably made for private devotion, and in it Reni returned to a theme he had painted in a larger full-length picture for the church of the Gerolamini, Naples (about 1621).

Collection of Vincenzo Camuccini, Rome, by 1804; bought, 1844.

Levey 1971, pp. 185–6; Pepper 1984, p. 243.

Inscribed on the angels' scroll: GLORIA IN ECCELSIS DEO (Glory to God in the highest).

An angel appeared to the shepherds (left background) and they came to adore the Child Jesus lying in a manger. The inscription on the angels' scroll quotes the words sung by the multitude of angels that appeared to the shepherds. New Testament (Luke 2: 8–17).

NG 6270 is one of two large-scale treatments of the Adoration of the Shepherds, painted by Reni late in his career (about 1640). The other version was painted for the Certosa di S. Martino in Naples (where it remains) and shows some differences (there is no agreement on which version was painted first). Malvasia mentioned both pictures in 1678, and said that one version was made 'per germania' (for Germany). NG 6270 was probably commissioned or acquired by Prince Karl Eusebius of Liechtenstein (1611–84).

Reni may have had some studio assistance in the execution of NG 6270.

Collection of Prince Johann Adam of Liechtenstein, Feldsberg, by 1706; bought from his descendants, 1957.

Levey 1971, pp. 189–90; Pepper 1984, pp. 289–90.

RENI and Studio
The Toilet of Venus
about 1620–5

After RENI
Perseus and Andromeda
1635–1700

After RENI
Head of Christ Crowned with Thorns
1640–1749

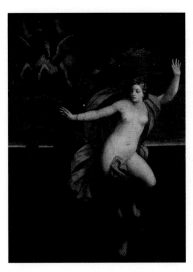

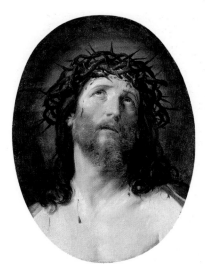

NG 90
Oil on canvas, 281.9 x 205.7 cm

NG 87
Oil on canvas, 280 x 205.7 cm

NG 271
Oil on wood, 56 x 42.8 cm

Venus is shown attended by the Three Graces, Aglaia, Euphrosyne and Thalia (the daughters of Zeus who personified beauty, charm and grace). Two Cupids are also included.

NG 90 appears to be based on Guido Reni's design, and in part executed by him (he is generally thought to have painted the figure of Venus). In 1678 Malvasia described a picture of this subject painted by Reni for the Duke of Savoy; it has also been identified as a picture mentioned in a letter of 1622 as recently completed (together with its large pendant *The Judgement of Paris*) for the Duke of Mantua. This picture then passed to the collection of Charles I of England, and was sold following his execution.

A number of other versions, and partial copies, are known.

Perhaps in the collection of the Duke of Mantua, 1622; acquired from John Law(s) by George I, 1723; presented by William IV, 1836.

Levey 1971, pp. 190–1; Pepper 1984, p. 244.

Andromeda was chained to a rock as a sacrifice to placate the sea monster sent by Poseidon to destroy her native country. She was rescued by Perseus. Ovid, *Metamorphoses* (IV, 783–960).

NG 87 is an old copy or a studio version with slight variations of Reni's *Perseus and Andromeda* (Rome, Palazzo Rospigliosi-Pallavicini), which is dated to about 1635–6.

Acquired from John Law(s) by George I, 1723; presented by William IV, 1836.

Levey 1971, p. 192; Pepper 1984, pp. 273–4.

Jesus is shown after the Mocking of Christ when he was crowned with thorns. New Testament (e.g. John 19: 1–3).

NG 271 was inspired by one of the numerous versions of this subject painted by Guido Reni (e.g. Paris, Louvre). NG 271, which may have been painted as late as the early eighteenth century, has a provenance from the collection of Cardinal Valenti Gonzaga in Rome. It can be seen in a painting by Giovanni Paolo Panini which shows a view of Valenti's gallery, painted in 1749 (Hartford, Wadsworth Atheneum).

Collection of Cardinal Valenti Gonzaga, Rome, by 1749; Benjamin West by 1787; bequeathed by Samuel Rogers, 1855.

Levey 1971, pp. 193–4.

Pierre-Auguste RENOIR
A Nymph by a Stream
1869–70

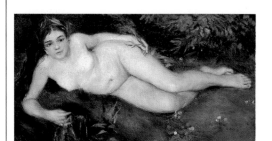

NG 5982
Oil on canvas, 66.7 x 122.9 cm

Pierre-Auguste RENOIR
At the Theatre (La Première Sortie)
1876–7

NG 3859
Oil (identified) on canvas, 65 x 49.5 cm

Pierre-Auguste RENOIR
Boating on the Seine
about 1879–80

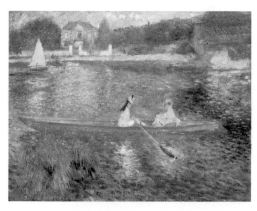

NG 6478
Oil (identified) on canvas, 71 x 92 cm

Signed lower right: A. Renoir
 The model was Lise Tréhot who posed for several works by Renoir, including his *Woman of Algiers* of 1870 (Washington, National Gallery of Art). The latter is almost identical in size to NG 5982 and these two pictures were probably pendants. The Washington picture shows a clothed woman in a harem setting. By contrast, the woman in NG 5982 is naked, surrounded by vegetation and wearing a wreath of leaves in her hair.

Acquired by Prosper Garny from Renoir; acquired by Paul Rosenberg, 1917; bought, 1951.

Davies 1970, p. 121; White 1988, p. 37.

Signed top left: Renoir
 A young girl is seated in a box, looking down at an audience in a theatre. She wears a bonnet, clasps a bouquet and has a companion seated beside her at the right. The picture has been given various titles, including 'Le Café-Concert', 'Au Théâtre', and 'La Première Sortie' (The First Outing).
 Renoir usually painted his subjects in contemporary clothes, and those of this figure indicate a date at the end of 1876 or 1877.
 Themes of 'modern' urban entertainment were popular among Impressionist painters and the subject of a theatre box had been treated earlier by the artist, notably in *La Loge* of 1874 (London, Courtauld Institute Galleries). X-ray photographs indicate that initially Renoir established a different composition for NG 3859, with two figures sitting in front of the girl.

Armand Doria sale, 1899; bought by the Trustees of the Courtauld Fund, 1923.

Davies 1970, pp. 120–1; Bomford 1991, pp. 152–7.

Signed: Renoir.
 The exact site has yet to be identified. Traditionally, the picture is known as a view on the Seine near Asnières but it seems more likely to be Chatou, an area associated with boating and frequented by Renoir in the late 1870s.
 The high-keyed colour and bold brushwork may be compared to works such as the *Oarsmen at Chatou* of 1879 (Washington, National Gallery of Art). The detail of the train passing over the iron bridge in the background recalls some of Monet's pictures of Argenteuil dating from the early 1870s.

Victor Chocquet before 1899; bought by Samuel Courtauld, 1929; bought by private treaty, 1982.

National Gallery Report 1982–4, p. 19; Bomford 1991, pp. 172–5.

Pierre-Auguste RENOIR
1841–1919

Born in Limoges, Renoir initially worked in Paris as a painter of porcelain. He entered Charles Gleyre's studio in 1861 where he met Monet and Sisley. In the 1860s and 1870s he painted mainly landscapes and modern-life subjects, but after a trip to Italy in 1881 he moved away from Impressionism and began to concentrate on figure painting. He spent his last years at Cagnes in the south of France.

Pierre-Auguste RENOIR
The Umbrellas
about 1881–6

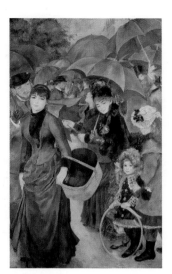

NG 3268
Oil (identified) on canvas, 180.3 x 114.9 cm

Pierre-Auguste RENOIR
Moulin Huet Bay, Guernsey
about 1883

NG 6204
Oil on canvas, 29.2 x 54 cm

Pierre-Auguste RENOIR
Lakeside Landscape
1885–90

NG 6528
Oil on canvas, 66.2 x 76 cm

Signed bottom right: Renoir
 Renoir worked on this painting over a period of years in the 1880s. The two little girls and the woman at the right are painted in an earlier, softer style than the figures at the left and the umbrellas. Renoir probably reworked the picture after a trip to Italy in 1881–2, using harder contours and more severe colours.
 Analysis of the differing fashions in this work confirms that the right-hand group dates from about 1880–1, while the woman with a band-box wears a dress fashionable in about 1885–6. It is not known why Renoir chose to rework only parts of the picture in a later style but this was his last large-scale picture of a contemporary urban subject.

Bought by Durand-Ruel, 1892; Sir Hugh Lane Bequest, 1917.

Davies 1970, pp. 119–20; House 1985, pp. 194–7; Bomford 1991, pp. 188–95.

Signed bottom left : Renoir
 This view shows Moulin Huet Bay on the Channel Island of Guernsey with three figures in the foreground. The rocks have been identified: those at the left are 'Les Tas de Pois d'Amont', and those on the right are probably 'La Surtaut' (Cradle Rock).
 Renoir was in Guernsey in September 1883, and NG 6204 is one of a group of studies dating from that stay.

Acquired from Renoir by Vollard; bought, 1954.

Davies 1970, p. 121.

Signed lower right: Renoir.
 A pencil inscription on the stretcher identifies this as a landscape near Annecy and in the past it has been described as a view near Talloires and the Lac d'Annecy in the Haute Savoie. However, the scenery depicted here bears little resemblance to the Lac d'Annecy and it is not known whether Renoir visited this region in the 1880s or 1890s.
 The picture is undated but seems close in style to Renoir's landscapes of the second half of the 1880s. In some areas of the painting, including the sky, the brushstrokes are arranged in parallel patterns that are reminiscent of works by Cézanne. Renoir stayed with Cézanne at Aix-en-Provence in 1888 and was again in that area in 1889.

Lefevre Galleries, 1936; bequeathed by Helena and Kenneth Levy, 1990.

National Gallery Report 1990–1, p. 18.

Pierre-Auguste RENOIR
A Bather
probably 1885–90

NG 6319
Oil on canvas, 39.4 x 29.2 cm

Signed: Renoir

In the 1880s Renoir gradually moved away from the contemporary subjects favoured by the Impressionists and turned to more timeless subjects, often inspired by classical mythology. NG 6319 is one of numerous paintings of nudes in generalised landscape settings that he painted in the late 1880s and 1890s.

Probably on the London art market in 1934; presented by Sir Antony and Lady Hornby, 1961.

Davies 1970, p. 124.

Pierre-Auguste RENOIR
Misia Sert
1904

NG 6306
Oil on canvas, 92.1 x 73 cm

Signed and dated: Renoir '04.

The subject of this portrait, Misia, née Godebska (1872–1950), was a notable figure in the circle of avant-garde artists who worked in Paris at the turn of the century. She sat for a number of painters, notably Vuillard, Bonnard and Toulouse-Lautrec, was an early patron of Diaghilev and published her memoirs (English translation, *Two or Three Muses*, 1953). She married Thadée Natanson (a director of the famous literary and artistic review, the *Revue Blanche*) and appears as Misia Nathanson in Vuillard's *Lunch at Vasouy* (NG 6373). She later married the Spanish painter José Maria Sert; it is as Misia Sert that she is chiefly remembered.

According to the sitter's memoirs Renoir painted seven or eight portraits of her; each of which required three day-long sittings per week for a month.

In the possession of the sitter; in the collection of Walter P. Chrysler after 1945; bought, 1960.

Davies 1970, p. 122.

Pierre-Auguste RENOIR
Dancing Girl with Tambourine
1909

NG 6317
Oil on canvas, 155 x 64.8 cm

Signed and dated bottom left: Renoir. 09

A girl wearing an exotic pseudo-oriental costume plays the tambourine. The model was Georgette Pigeot. Part of the costume is preserved at Renoir's house at Cagnes.

This work and its pendant, NG 6318, were painted in 1909 to form part of the decoration of the dining room of 24 avenue de Friedland in Paris, the home of Maurice Gangnat. The paintings were intended to be placed either side of a fireplace which was surmounted by a mirror (with this picture at the right). According to Madame Pigeot the original plan was to have the girls carrying bowls of fruit.

Renoir considered these pictures to be among his more important later works. Their format and subjects can in part be compared with Renoir's *Caryatids* (Merion, Pennsylvania, Barnes Foundation).

Maurice Gangnat collection, Paris; bought with a special grant, 1961.

Davies 1970, pp. 122–3.

Pierre-Auguste RENOIR
Dancing Girl with Castanets
1909

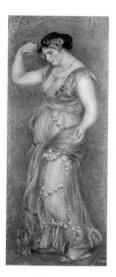

NG 6318
Oil on canvas, 155 x 64.8 cm

Signed and dated bottom left: Renoir. 09
 This is the pendant composition to NG 6317. The model was Georgette Pigeot, except for the head which was modelled by Gabrielle Renard, Renoir's maid.

Maurice Gangnat collection, Paris; bought with a special grant, 1961.

Davies 1970, pp. 122–3.

Attributed to Gabriel REVEL
Portrait of a Man
about 1675

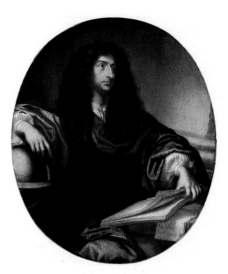

NG 2929
Oil on canvas, 111.8 x 96.5 cm

Inscribed: René Descartes/Peint par Mignard. 1647; and on the ring round the globe: MAIUS, IUNIUS.
 On the basis of the inscription NG 2929 has in the past been considered a portrait of the philosopher Descartes by Pierre Mignard, but it is quite unlike the authenticated likenesses of Descartes and the hand is not that of Mignard. A recent attribution of NG 2929 to the portraitist Gabriel Revel seems probable.
 The costume of the sitter accords with a date of about 1675.

Possibly anon. sale, Christie's, 6 May 1796 (lot 33); at Castle Howard by 1805; presented by Rosalind, Countess of Carlisle, 1913.

Davies 1957, p. 158.

Sir Joshua REYNOLDS
Captain Robert Orme
1756

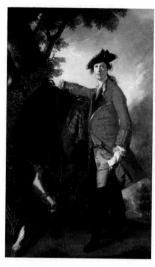

NG 681
Oil on canvas, 240 x 147.3 cm

Signed and dated: J. Reynolds pinxit 1756
 Robert Orme (1725?–90) had entered the army as an ensign in the 34th Foot, but transferred to the Coldstream Guards in 1745 and was promoted to lieutenant in 1751. He was aide-de-camp to General Braddock and was wounded when Braddock was killed by the French near Fort Duquesne (Pittsburgh) in 1755. He returned to England and resigned from the army in 1756.
 NG 681 was evidently not commissioned by the sitter, and remained in the artist's studio until 1777 (see provenance). The composition is based on a sketch of 1752 (London, British Museum) by Reynolds after Jacopo Ligozzi's *Saint Francis embracing a Sick Man* in the cloister of the church of Ognissanti in Florence.

Bought from Reynolds by the 5th Earl of Inchiquin, 1777; by descent to the 5th Earl of Orkney; bought, 1862.

Davies 1959, pp. 81–2; Penny 1986, pp. 187–8.

Gabriel REVEL
1643–1712

Revel was born in Château-Thierry, some forty miles from Paris. He was a pupil of Charles Le Brun in Paris by 1671, and was admitted to the Académie as a portraitist in 1683. He painted portraits of the lesser nobility and the bourgeoisie, as well as large religious pictures for his home town and Dijon, where he spent the last twenty years of his life.

Sir Joshua REYNOLDS
1723–1792

Reynolds was born in Plympton, near Plymouth. He was apprenticed to Thomas Hudson in London from 1740 to 1743, and later studied in Italy (1749–52). He was in London from 1753, and was appointed president of the Royal Academy on its foundation in 1768. He was above all a portrait painter and the leading Academic theorist. His *Discourses on Art* were widely studied.

Sir Joshua REYNOLDS
Anne, Countess of Albemarle
probably 1759–60

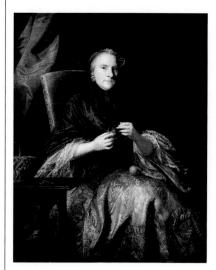

NG 1259
Oil on canvas, 126.9 x 101 cm

Anne (1703–89), daughter of Charles Lennox, 1st Duke of Richmond, married the 2nd Earl of Albemarle in 1722. He died in 1754.

Reynolds's pocket-books record eleven appointments for Lady Albemarle to sit to him, in September 1757 and in April, May and June 1759. Although there are enough recorded sittings for two different portraits, NG 1259 is the only known portrait by Reynolds of Lady Albemarle. She is engaged in the fashionable pastime of 'knotting' (making a linen braid with a small shuttle). Reynolds noted in November 1760 that 40 guineas was owing to him for her portrait, a bill eventually settled by the executors of her son, the 3rd Earl of Albemarle (died 1772).

Collection of the Earls of Albemarle until 1888; bought, 1888–90.

Davies 1959, pp. 83–4; Penny 1986, pp. 194–5.

Sir Joshua REYNOLDS
Lady Cockburn and her Three Eldest Sons
1773

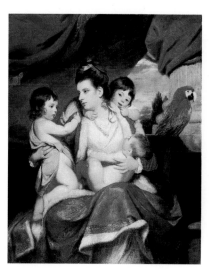

NG 2077
Oil (identified) on canvas, 141.6 x 113 cm

Signed and dated on the hem of her dress: 1773 / J REYNOLDS: PINX[IT] .

Augusta Anne, Lady Cockburn (1749–1837), was the daughter of the Revd Francis Ayscough, later Dean of Bristol. In 1769 she married Sir James Cockburn, 8th Bt, as his second wife. Her three eldest children were James, later General Sir James Cockburn, 9th Bt (1771–1852), kneeling on the left; George, later Admiral Sir George Cockburn, 10th Bt (1772–1853), behind his mother; and William, later the Revd Sir William Cockburn, 11th Bt, Dean of York (1773–1858), on his mother's knee. The macaw was a pet in Reynolds's household, and was apparently added as an afterthought.

The composition of NG 2077 recalls sixteenth- and seventeenth-century paintings of Charity (e.g. Van Dyck NG 6494). NG 2077 was engraved by C. Wilkin (1750–1814) and published in 1791 as *Cornelia and her Children*. It was exhibited at the Royal Academy in 1774.

In the collections of descendants until about 1900; bequeathed by Alfred Beit, 1906.

Davies 1959, pp. 84–5; Penny 1986, pp. 259–60.

Sir Joshua REYNOLDS
Colonel Banastre Tarleton
1782

NG 5985
Oil (identified) on canvas, 236.2 x 145.4 cm

Banastre Tarleton (1754–1833) distinguished himself fighting against the Americans in the American War of Independence, and returned to England as a lieutenant-colonel in 1782. Later he was Member of Parliament for Liverpool, a general and a baronet.

NG 5985 was painted in 1782. Sittings with Reynolds are recorded from January to April, and the portrait was exhibited that year at the Royal Academy. Tarleton wears the uniform of a cavalry troop raised during the American campaign and which he commanded; it was known as Tarleton's Green Horse (part of the British Legion, whose flag seems to fly overhead). In 1781 Tarleton lost two fingers of his right hand, as Reynolds discreetly shows. His pose is based on an antique Hermes, casts of which were known in London (e.g. at the Royal Academy).

A mezzotint after NG 5985 by John Raphael Smith was published in 1782.

Collection of Wynn Ellis by 1865; bequeathed to Admiral Sir J.W. Tarleton; bequeathed by Mrs Henrietta Charlotte Tarleton, 1951.

Davies 1959, pp. 88–9; Penny 1986, pp. 300–1.

Sir Joshua REYNOLDS
Lord Heathfield
1787

NG 111
Oil on canvas, 142.2 x 113.7 cm

George Augustus Eliott (1717–90) was appointed Governor of Gibraltar in 1775. During the siege of 1779–83 he held the British fortress against Spanish attack, and was made Baron Heathfield in 1787. He is represented at Gibraltar during the siege, with a smoking mortar in the background, holding the key to the fortress, and wearing what is presumably the ribbon and star of the Order of the Bath.

Lord Heathfield sat for NG 111 in August and September 1787. The portrait was commissioned by the print publisher John Boydell who paid for it in October of that year.

Collection of Alderman John Boydell, probably from October 1787; collection of Sir Thomas Lawrence, 1809; collection of J.J. Angerstein; bought with the rest of the J.J. Angerstein collection, 1824.

Davies 1959, pp. 80–1.

Francisco RIBALTA
The Vision of Father Simón
1612

NG 2930
Oil on canvas, 210.8 x 110.5 cm

Signed and dated on a cartellino at the lower left: FRANCISCᵒ RIBALTA. / FECIT . ANNO. 1612 . (Francisco Ribalta made this in 1612.)

Father Simón (1578–1612) who kneels at the right was the priest of S. Andrés, Valencia. He was venerated for his piety and famed for the visions he had of Christ carrying the cross, as depicted here. He initially saw such apparitions on the Calle de Caballeros in Valencia, accompanied by the sound of trumpets. In the right background are Saint John the Evangelist and the Virgin. Attempts were made by the Inquisition to suppress the popular cult of Simón, who was never beatified, although widely revered and frequently depicted.

NG 2930 was probably the picture commissioned for the chapel in S. Andrés where Simón's body was laid to rest. The date on the inscription concurs with that of his death.

The figure of Father Simón was painted out, probably in the nineteenth century, and uncovered again when the picture was cleaned in 1945/6.

Bought from the Pescuera collection, Valencia, by Richard Ford, 1831; bought from Capt. Richard Ford, 1913.

Hendy 1947, pp. 45–7; MacLaren/Braham 1970, pp. 87–91; Braham 1981, p. 56.

Jusepe de RIBERA
The Lamentation over the Dead Christ
before 1626

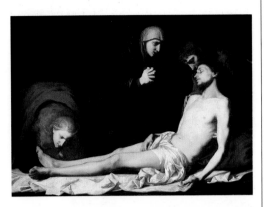

NG 235
Oil on canvas, 129.5 x 181 cm

The dead Christ is supported by Saint John the Evangelist. The Virgin laments by his side while the Magdalen leans forward to kiss his feet. This incident is not described in the Gospels, but forms part of a long pictorial tradition.

Ribera painted several Lamentations and Depositions (e.g. Naples, S. Martino, and Paris, Louvre) although this appears to be his earliest surviving picture of the subject. It has been suggested that NG 235 is the picture painted in 1623 for the Genoese nobleman Marcantonio Doria.

Said to have been in the Royal Gallery, Naples, and removed by Eugène de Beauharnais (died 1824); probably bought from Hogarth by David Barclay, by whom presented, 1853.

MacLaren/Braham 1970, pp. 92–4.

Francisco RIBALTA
1565–1628

Ribalta was born in Solsona, Catalonia. His biographer Palomino says the artist trained in Italy; this remains unproven, but he was influenced by the work of Italians, especially Caravaggio and Sebastiano del Piombo, which reached Spain. He lived in Barcelona (1571/3–81), Madrid and Valencia (by 1599–1628), painting principally religious pictures.

Jusepe de RIBERA
1591–1652

Ribera was born in Játiva near Valencia. He is described as having been trained by Ribalta, and when young travelled to Italy where he was known as Lo Spagnoletto. He was in Parma in 1610–11 and is recorded in Rome in 1615–16; by 1616 the artist had settled in Naples where he died. He painted religious, mythological and genre works, often for the Spanish viceroys.

Jusepe de RIBERA
Girl with a Tambourine
1637

L583
Oil on canvas, 59 x 45 cm

Inscribed to the right of the girl's head: Jusepe de Ribera/ español F. 1637 (Jusepe de Ribera, Spaniard, made this, 1637).

The girl, a vivacious portrayal from life, sings and plays her tambourine. She has been identified as a personification of the sense of Hearing.

L583 was almost certainly part of a series of Five Senses to which a complementary painting by Ribera, *The Drinker* (private collection), also belongs. The latter is of the same size, is similarly inscribed and symbolises the sense of Taste. A third painting *A Boy with a Vase of Flowers* (Oslo, Nasjonalgaleriet), representing the sense of Smell, may also be part of the series.

Private collection, Paris, 1930s; private collection, London; on loan since 1991.

Pérez Sánchez-Spinosa 1992, p. 127, no. 46.

Jusepe de RIBERA
Jacob with the Flock of Laban
probably 1638

NG 244
Oil on canvas, 132 x 118 cm

Signed and dated on the rock: Jusepe de Ribera español/academico Romano/F 1638 (?) (Jusepe de Ribera the Spaniard, Roman academician painted this, 1638).

Jacob rests beneath a tree with sheep around him. In the water are sticks of wood peeled of their bark. According to the Old Testament (Genesis 30: 37–8) the sheep that drank from this water conceived spotted lambs and Jacob was later able to claim these as his own from his father-in-law, Laban.

NG 244 is a fragment of a larger painting which is recorded in two old copies (Madrid, Museo Cerralbo; Genoa, Villa Rocca at Chiavari). These works show that the Gallery's picture originally formed part of a horizontal composition, notably extended at the left of its present format. The manner in which the copies vary from each other suggests that the painting may have been cut down in two stages.

Anon. sale, London, 1806; Lord Colbourne Bequest, 1854.

MacLaren/Braham 1970, pp. 94–6.

Louis-Gustave RICARD
Portrait of a Man
probably 1866

NG 3297
Oil on canvas, 64.1 x 54.6 cm

The unidentified sitter seems to be wearing the ribbon of the Légion d'Honneur.

NG 3297 was recorded in the Degas sale as bearing the date 1866 on the reverse but this is no longer visible.

Bought with a special grant at the Edgar Degas sale, Paris, 1918.

Davies 1970, p. 124.

Louis-Gustave RICARD
1823–1873

Ricard was principally a portrait painter. He was born in Marseilles, and studied under Raymond Aubert (1838–40) and under Pierre Bronzet (1840–2), and then in Paris with Léon Cogniet. He exhibited at the Salon from 1850, often visited Italy, and spent several years in England (1848–50 and 1870–1).

Louis-Gustave RICARD
The Countess of Desart as a Child
probably 1870–1

Sebastiano RICCI
Bacchus and Ariadne
probably 1700–10

Sebastiano RICCI
Esther before Ahasuerus
probably 1730–4

NG 5573
Oil on mahogany, 54.6 x 45.7 cm

NG 851
Oil on canvas, 75.9 x 63.2 cm

NG 2101
Oil on canvas, 47 x 33 cm

Signed: GR
The sitter was Ellen Odette Bischoffsheim (1857–1933). She married the 4th Earl of Desart in 1881 as his second wife, and from 1922 was a Senator of the Irish Free State.
It is suggested that NG 5573 may have been painted in 1870–1 when the artist was in England, which would suit the age of the sitter.

Mrs Bischoffsheim; presented by the sitter's sister, Lady FitzGerald, to the Tate Gallery, 1944; transferred, 1956.

Davies 1970, pp. 124–5.

Ariadne was abandoned on the island of Naxos by Theseus, and there discovered by Bacchus. As she sleeps he approaches from the right, crowned with roses. Cupids descend bearing a hymeneal torch to celebrate the union of the couple. For the subject see Ovid's *Metamorphoses* (Book VIII), and Philostratus' *Imagines* (I, 15).
NG 851 probably dates from the first decade of the eighteenth century. This has been established by comparison of its handling with Ricci's *Aurora* of about 1705 (London, Royal Collection). The composition is based on a painting by Carpioni (died 1674).

Bought with the Peel collection, 1871.

Levey 1971, pp. 195–6.

Those who entered the inner court of King Ahasuerus without being asked were punishable by death unless he extended his golden sceptre to them. Ahasuerus here holds out his sceptre to Esther. The figure at the far right may be intended for Haman. Old Testament (Esther 5: 1–2).
NG 2101 is probably the picture recorded in the eighteenth century in an engraving by Pietro Monaco as belonging to Anton Maria Zanetti, the Venetian engraver and connoisseur. Comparison between its handling and that of Ricci's modello of the *Assumption* in Budapest for the Vienna altarpiece of 1733–4, suggests that it can be similarly dated.

Possibly in an anon. (Thomas Hamlet) sale, London, 29 July 1833 (lot 186); John Samuel collection catalogue (as by G.B. Tiepolo), 1895; bequeathed by the Misses Cohen as part of the John Samuel collection, 1906.

Levey 1971, pp. 196–8.

Sebastiano RICCI
1659–1734

Ricci, who was a leading decorative painter of the period, was born in Belluno. He studied under Mazzoni and Federico Cevelli in Venice, and then under Giovanni del Sole in Bologna. Although mainly active in Venice, he also visited Parma, Florence, Modena, Milan and Bergamo. The artist was in England from 1712 to 1716, and returned to Venice via France and possibly Holland.

Hyacinthe RIGAUD
Antoine Pâris
1724

Studio of RIGAUD
Cardinal Fleury
after 1728

Attributed to Marten RIJCKAERT
Landscape with Satyrs
about 1626

NG 1353
Oil on oak, 10.3 x 20.4 cm

NG 6428
Oil on canvas, 144.7 x 110.5 cm

NG 903
Oil on canvas, 80 x 64.8 cm

Traces of signature at the left.

Antoine Pâris (1668–1733) was the eldest of four brothers, all of whom were famous financiers at the outset of the eighteenth century.

In Rigaud's account book, *Le Livre de raison*, there is a record of two portraits of Antoine Pâris having been painted 'en grand' in 1724. NG 6428 is clearly one of these works. The other may be a very similar painting in the Norton Simon Foundation, California.

The Pâris family and by descent until after 1917; bought, 1975.

National Gallery Report 1973–5, pp. 31–2; Wilson 1985, p. 80.

André-Hercule de Fleury (1653–1743) was tutor to the young Louis XV. He was made a cardinal in 1726, and became in effect Prime Minister of France.

NG 903 appears to be a partial repetition of a three-quarter portrait of Fleury by Rigaud which the artist noted in his account book as having been painted in 1728. The original version of this work is sometimes thought to be a painting at Versailles. Many copies were made in Rigaud's studio. Other copies exist which are not contemporary.

Collection of the 1st Lord Holland (1705–74); presented by the widow of General Charles Richard Fox, son of the 3rd Lord Holland, 1874.

Davies 1957, pp. 200–1.

It has been suggested that NG 1353 may originally have formed part of the decoration of a cabinet. This would explain a groove in the top left corner of the support which runs just beneath and parallel to the top edge.

The painting is comparable to two panels (Weimar, Staatliche Kunstsammlungen) signed in monogram by Rijckaert and dated 1626.

Anon. [Mrs Edgar Disney] sale, Christie's, 3 May 1884 (lot 110); Richard W. Cooper Bequest, 1892.

Martin 1970, pp. 234–5.

Hyacinthe RIGAUD
1659–1743

Hyacinthe-François-Honoré-Mathias-Pierre Martyr-André-Jean Rigau y Ros, called Rigaud, born in Perpignan, was a pupil of Paul Pézet and Antoine Ranc in Montpellier. He was awarded the Prix de Rome in 1682, but did not go to Italy. Rigaud worked in Paris as a successful court portraitist. In 1733 he became director of the Académie.

Marten RIJCKAERT
1587–1631

Rijckaert was a landscape painter. He was born in Antwerp, where he was probably taught by his father. It has been suggested that he may also have been a pupil of Tobias Verhaecht and that he visited Italy. The artist was admitted as a master in the Antwerp guild of St Luke in 1611.

Ercole de' ROBERTI
The Adoration of the Shepherds
about 1490

Ercole de' ROBERTI
The Dead Christ
about 1490

Ercole de' ROBERTI
The Institution of the Eucharist
probably 1490s

NG 1411.1
Tempera on wood, 17.8 x 13.5 cm

NG 1411.2
Tempera on wood, 17.8 x 13.5 cm

NG 1127
Egg (identified) on wood, 29.8 x 21 cm

In this panel the shepherds have come to adore the Christ Child. The ox and ass are stabled behind the manger. In the background to the right can be seen the Annunciation to the Shepherds.

The landscape and the light connect this painting with NG 1411.2. The two paintings clearly belong together, but how they were originally displayed is unknown.

Costabili collection, Ferrara, 1838; bought at the Lady Eastlake sale, 2 June 1894.

Davies 1961, p. 462.

The cover of the tomb is inscribed: I⊃.

This panel depicts two events from Christ's Passion, each of which is depicted as the subject of visionary contemplation by a saint, who thus participates in Christ's suffering. In the foreground the dead Christ, supported by grieving angels, appears before Saint Jerome, who beats his breast with a stone in penitence. In the left background is the earlier scene of the Deposition of Christ on Golgotha, and to the right Saint Francis receives the stigmata – the marks of the wounds which Christ suffered on the cross.

NG 1411.2 is related to NG 1411.1. See under NG 1411.1 for further discussion.

Costabili collection, Ferrara, 1838; bought at the Lady Eastlake sale, 2 June 1894.

Davies 1961, p. 462.

Christ blesses the host he holds in his left hand. To the right sits Saint John, while at the left is Saint Peter. Judas, who will betray Christ, sits at the end of the table at the right, dressed in dark blue, looking away from the company, frowning. The ceiling and walls are decorated with low relief ornament of antique character; three narrative scenes are also included: above Christ, in a lunette, a scene of sacrifice; at the left, an Adoration of the infant Christ; and at the far right, the Flight into Egypt.

An X-radiograph of the panel reveals that a key hole was cut at the left but was then plugged before the panel was painted. This, in conjunction with the sacramental subject, suggest that it was intended as the door of a tabernacle within which the host would have been kept (for a painting which probably served a similar function, see Giovanni Bellini NG 1233). It has been suggested that this work would have been placed at the centre of a predella, possibly with Roberti NG 1217 to one side. It was not unusual for predellas to incorporate a tabernacle as a central feature.

Apparently bought from the Villa Aldobrandini, Rome, by W.Y. Ottley, 1798; bought at the Hamilton sale, 1 July 1882.

Davies 1961, pp. 460–1; Dunkerton 1986, pp. 33–7.

Ercole de' ROBERTI
active 1479; died 1496

Ercole d'Antonio de' Roberti has also been referred to as Ercole de' Grandi. He is recorded in Bologna, before moving to Ferrara in 1479. From 1486 he worked for the Este family in the city. An altarpiece by him of 1480 is in the Brera, Milan. His work shows the influence of Cossa, whose pupil he probably was. Few of his works survive but his reputation was very great.

Ercole de' ROBERTI
The Israelites gathering Manna
probably 1490s

NG 1217
Tempera on canvas, transferred from wood,
28.9 x 63.5 cm

The children of Israel complained to Moses and
Aaron, who had led them into the wilderness, about
their lack of food. God promised Moses that bread
would daily fall from heaven to feed them: 'And
when the dew that lay was gone up, behold, upon
the face of the wilderness there lay a small round
thing, as small as the hoar frost on the ground ...
And Moses said unto them, This is the bread
[manna] which the Lord hath given you to eat.'
Moses and Aaron stand at the left. Old Testament
(Exodus 16: 14–36).

It has recently been suggested that NG 1217
formed part of a predella which constituted the base
of an altarpiece the artist may have executed for the
church of S. Domenico, Ferrara, in about 1490–5.
See commentary under NG 1127. If NG 1217 does
indeed come from this altarpiece then the subject
can be related to its overall theme, i.e. the
Sacrament, with the manna being analogous to
the Host – a medium for salvation. (See also Costa
NG 3103.)

*Perhaps collection of Lucrezia d'Este, Duchess of Urbino,
and bequeathed to Cardinal Piero Aldobrandini; Cardinal
Fesch after 1829; Lord Ward (later Earl of Dudley) by
1859; bought (Clarke Fund), 1886.*

Davies 1961, pp. 459–60; Manca 1985, pp. 521–2.

Roelant ROGHMAN
A Mountainous Landscape
about 1665

NG 1340
Oil on canvas, 63.5 x 74.3 cm

The site is not identifiable.
NG 1340 is attributed to Roghman on the basis of
comparison with a signed painting by the artist, the
Mountainous Landscape with Fisherman (Amsterdam,
Rijksmuseum).

Edward Habich collection, Cassel; bought, 1891.

MacLaren/Brown 1991, pp. 378–9.

Roelant ROGHMAN
1627–1692

**The artist was born and worked in Amsterdam.
He was a landscape and topographical artist and
was said to be a 'great friend' of Rembrandt.
Roghman drew and etched views of castles and
manor houses in the Northern Netherlands. Jan
Griffer is said to have been his pupil.**

Gerolamo ROMANINO
The Nativity
probably 1525

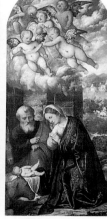

NG 297. 1–5
Oil and egg (identified) on wood, centre panel
260.8 x 115.6 cm; lower side panels 158.8 x 64.8 cm;
upper side panels 74.3 x 64.8 cm

The central panel of the Nativity (with shepherds in
the right background) is flanked by panels with
Saint Alessandro (lower left) and Saint Jerome in
penitence (lower right) with his lion, a stone and a
crucifix. Above these lateral panels are Saint
Gaudioso (upper left) and Saint Filippo Benizzi
(upper right).
NG 297 was painted as the high altarpiece of the
church of S. Alessandro, Brescia. Saint Alessandro
was included as the titular saint; Saint Gaudioso, the
fifth-century bishop of Brescia, was buried in the
church, and Saint Filippo Benizzi was included as
the fifth general of the Servites, the order to whom
the church belonged. Originally a *Saint John and the
Magdalen lamenting the Dead Christ* was at the top of
the altarpiece, and an *Annunciation* and *Adoration of
the Kings* were on shutters that covered the
altarpiece. A seventeenth-century description of the
altarpiece states that the frame bore the date 1525, a
date which is borne out by the style of NG 297.
NG 297 was said (in 1700) to have been painted in
competition with Titian's altarpiece for the church
of SS. Nazaro e Celso in Brescia (dated 1522). It
certainly reflects a knowledge of Titian's work in
both Brescia and Venice.

*Recorded by Ridolfi in the church of S. Alessandro,
Brescia, 1648; Averoldi collection, Brescia, by 1826;
bought, 1857.*

Panazza 1965, pp. 71–2; Gould 1975, pp. 226–8.

Gerolamo ROMANINO
about 1484/7–after 1559

**Romanino was principally active in Brescia, but
also worked at an early date in Padua and for a
large area of north Italy (Cremona, Asola, Trento).
He was a prolific painter of altarpieces and
pictures of religious subjects and he also worked
in fresco.**

Attributed to ROMANINO
Pegasus and the Muses
probably 1546

NG 3093
Oil on wood, 38.1 x 115.6 cm

Salvator ROSA
Self Portrait
about 1645

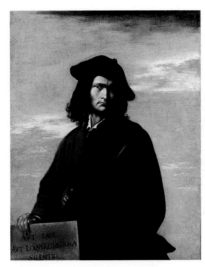

NG 4680
Oil on canvas, 116.3 x 94 cm

Salvator ROSA
Witches at their Incantations
about 1646

NG 6491
Oil on canvas, 72 x 132 cm

The nine female figures singing and playing music are the Muses; Pegasus, the winged horse, kicks the ground and causes the fountain of Hippocrene to flow. Ovid, *Metamorphoses* (V, 312–36, 374–430). In the background are the daughters of Pierus who sang in contest with the Muses.

NG 3093 is a furniture picture, or perhaps made to be incorporated into the wainscot of a room. An inscription on the reverse is now illegible except for the date – it was previously recorded as 'Girolo Romanino Bresciano V., 1546'. The date of this inscription is unknown but it appears to be consistent with the appearance and style of the picture, and with the date of the costumes.

Given by Morelli to Sir A.H. Layard before 1869; Layard Bequest, 1916.

Gould 1975, p. 228.

Inscription painted on the tablet, bottom left: AVT TACE/ AVT LOQVERE MELIORA/SILENTIO. (a Latin epigram: Keep silent unless your speech is better than silence).

The artist is portrayed silhouetted against the sky. He wears a scholar's cap and gown. The brown cloak may relate to Ariosto's verses on *Silence* in which a 'mantel bruno' is described. The painter may have depicted himself as a personification of Silence. This quality was associated with philosophers of antiquity and is referred to in one of Rosa's late satires.

The reverse bears an old inscription describing the picture as a self portrait painted for the Casa Niccolini, Florence. This identification is supported by the dating of the painting on stylistic grounds to the mid-1640s, when Rosa was in Tuscany. NG 4680 was almost certainly intended as a pendant to the artist's *Lucretia as Poetry* (Hartford, Wadsworth Atheneum). The sitter was Rosa's mistress and her guise as poetic eloquence complements his own personification in the National Gallery's picture.

This is one of several self portraits by the artist (see also New York, Metropolitan Museum of Art; Siena, Chigi-Saraceni). NG 4680 recalls the half-length philosophers by Ribera.

Casa Niccolini, Florence; Revd. John Sanford by 1832; presented by the 6th Marquis of Lansdowne in memory of his father, the 5th Marquis, 1933.

Salerno 1963, p. 108; Levey 1971, pp. 200–2; Arts Council 1973, p. 22; Salerno 1975, pp. 86–7.

Signed on the stone seat of the naked witch beneath the hanged man: ROSA.

This macabre invention is a pictorial anthology of witchcraft practices, drawing on a variety of literary and visual sources. It includes, from left to right: a parody of the rites of the church; forms of divination; illicit use of corpses; acts of incantation; and demonic monsters.

NG 6491 seems to be referred to by the artist in a letter of 15 December 1666, where it is described as having been painted twenty years earlier, in 1646. Such a dating accords with the style of the work.

This is the most accomplished of a group of paintings of witches by Rosa executed for his Florentine patrons. Elements of it recall Rosa's contemporary poem *La Strega* (The Witch) as well as the prints of Hans Baldung, Marcantonio Raimondi and Agostino Veneziano. A drawing for the man impaling a heart survives (Princeton, University Museum of Art).

Sir William Hamilton sale, 1761; Althorp, the Spencer collection; bought, 1984.

Arts Council 1973, p. 24; Salerno 1975, p. 90.

Salvator ROSA
1615–1673

Rosa was born in Naples. He was a satirist and poet, as well as an etcher and painter of altarpieces, portraits, scenes of witchcraft and landscapes. He worked under Domenico Greco and was influenced by Ribera and Aniello Falcone. Rosa was active in Rome in the 1630s. From 1640 to 1649 he was in Tuscany, after which he settled in Rome.

Salvator ROSA
Landscape with Mercury and the Dishonest Woodman, after 1649

NG 84
Oil (identified) on canvas, 125.7 x 202.1 cm

Salvator ROSA
Landscape with Tobias and the Angel
probably 1660–73

NG 6298
Oil on canvas, 147.4 x 224 cm

Style of ROSA
Tobias and the Angel
17th century

NG 811
Oil on canvas, 236.7 x 339.3 cm

An honest woodman lost an axe in some water and was rewarded by the god Mercury with a golden one when he denied that his own had been made of precious metal. Subsequently a dishonest woodman declared that he had lost a golden axe. Mercury proved that he was lying by recovering an iron one. The subject is from Aesop's *Fables*.

NG 84 is has been variously dated on grounds of style between 1649 and the artist's death. When first recorded the picture was hung with another similarly sized work by Rosa, *The Finding of Moses* (Detroit, Museum of Fine Arts).

Palazzo Colonna, Rome, 1783; bought, 1837.

Salerno 1963, p. 113; Levey 1971, pp. 199–200; Arts Council 1973, p. 46; Salerno 1975, p. 96.

Tobias was sent to a distant city by his blind father Tobit to collect a debt. While carrying out his errand he was escorted by the Archangel Raphael. A fish tried to devour him in the river Tigris, but the angel told the boy to remove its heart, liver and gall, which would later be used to restore his father's eyesight. Book of Tobit 6: 1–4.

As a result of comparison with other paintings by the artist NG 6298 is considered a late work.

The artist depicted this subject on other occasions (see for example *Landscape with Tobias and the Angel*, Hartford, Wadsworth Atheneum, and Style of Rosa, NG 811).

Hon. James Ansell sale, London, 6–7 April 1773; bought, 1959.

Salerno 1963, p. 144; Levey 1971, p. 202; Salerno 1975, p. 103.

For the subject see NG 6298.

It has variously been suggested that NG 811 is a work by Rosa, a work in the 'Style of Rosa', or a work by an English imitator of the artist. It is generally considered unlikely to have been actually executed by him. Another version of the composition is known (Rome, Blumenstil Collection).

Collection of W.G. Coesvelt, London, 1836; Wynn Ellis Bequest, 1870.

Salerno 1963, p. 144; Levey 1971, pp. 203–4; Salerno 1975, p. 103.

Style of ROSA
Mountainous Landscape with Figures
after 17th century

Style of ROSA
A Coastal Scene
probably 18th century

After ROSA
An Angel appears to Hagar and Ishmael in the Desert, 17th century

NG 1206
Oil on canvas, 76.5 x 111.5 cm

NG 935
Oil on canvas, 88.9 x 118.8 cm

NG 2107
Oil on canvas, 132.7 x 95.3 cm

The figures have not been related to a particular literary source. They appear to derive from a work by Rosa entitled *Crucifixion of Polycrates* (Chicago, Art Institute).

When bequeathed to the Gallery NG 1206 was considered to be a work by Rosa. It is now thought to be an old pastiche. An attribution to Filippo d'Angeli (about 1600–about 1640) has been suggested.

Mrs F.L. Ricketts bequest, 1886.

Salerno 1963, p. 154; Levey 1971, pp. 204–5.

Inscribed on a rock to the right of the figure group in the foreground: SR (monogram).

Imaginary coastal scenes of this type recall the works of Claude Lorraine. Rosa painted such works in the 1640s.

In spite of the signature and past attributions to the artist, NG 935 is no longer considered to be by Rosa, but rather a pastiche of the artist's work, perhaps of the eighteenth century. An attribution to Martoriello (1670–1720) has been suggested.

Wynn Ellis Bequest, 1876.

Salerno 1963, p. 144; Levey 1971, p. 204; Salerno 1975, p. 88.

When his wife Sarah gave birth to Isaac, Abraham banished his servant and concubine Hagar and their son Ishmael to the wilderness with a supply of water. When the water was used up Hagar despaired, but God heard the voice of the child crying and his angel called to her from heaven, saying '... Fear not ... for I will make him a great nation.' She then discovered a well of water, from which she gave her son to drink. Old Testament (Genesis 21: 17).

NG 2107 has been variously attributed to Rosa, Style of Rosa and to Testa (1612–50). The link with Testa is now considered unfounded. It is a copy of a work signed by Rosa (Toledo, Hospital de Tavera).

Melli collection, Milan; collection of Giovanni Morelli, until 1874–5; John Samuel collection by 1895; bequeathed by the Misses Cohen as part of the John Samuel collection, 1906.

Levey 1971, p. 203.

After ROSA
The Philosophers' Wood
after 1645

Alexandre ROSLIN
The Dauphin, Louis de France
1760s

William Charles ROSS
Prince Albert
1840

NG 1892
Oil on canvas, 148.3 x 220.5 cm

NG 5588
Oil on canvas, 80 x 64.1 cm

NG 6537
Watercolour on ivory, 5.5 x 4.5 cm

This is a copy of a signed work by the artist of about 1645 (Florence, Pitti Palace). The focus of the original is the Cynic philosopher Diogenes. He reduced his possessions to a drinking bowl and cloak, but after having seen a boy drinking with his hands threw the bowl away.

The picture in the Pitti Palace was painted for Marchese Carlo Gerini; it remained in the Gerini collection until 1818. NG 1892 is first recorded in the eighteenth century.

Acquired in Florence by William Henry, Duke of Gloucester, 1777; bequeathed by his daughter, Princess Sophia Matilda, 1843.

Levey 1971, p. 202.

The sitter, Louis de France (1729–65), was the son of Louis XV (whom he predeceased) and Marie Leczinska. He was the father of Louis XVI, Louis XVIII and Charles X. He is shown in the uniform of colonel of dragoons, wearing the Order of the Saint-Esprit.

NG 5588 seems to be a version of a work by Roslin (Versailles) painted about 1765. It may not be entirely autograph.

Probably passed from the Duchess of Manchester (died 1909) to her sister, Emilie Yznaga; by whom bequeathed, 1945.

Davies 1957, pp. 201–2.

Albert, the Prince Consort (1819–61), had a keen appreciation of painting and was one of the first collectors in Britain to buy so-called primitive Italian and German painting. In 1847 he acquired a substantial collection of early German, Netherlandish and Italian paintings belonging to Prince Ludwig Kraft Ernst von Oettingen-Wallerstein. In 1863, after the death of the Prince Consort, Queen Victoria presented a number of these paintings to the National Gallery, in accordance with the Prince Consort's wishes. These included some of the first fifteenth-century German paintings to enter the Gallery's collection.

One of several portrait miniatures of the Prince Consort painted by Ross, this image was apparently produced in 1840, the year of Queen Victoria's marriage to Prince Albert.

Presented by Mr Edwin Bucher, 1991.

National Gallery Report 1991–2, pp. 12–13.

Alexandre ROSLIN
1718–1793

Roslin was a portrait painter, born in Malmö, Sweden. He travelled in Germany and Italy and was in Paris from 1752. He revisited Sweden in 1774 and went on to St Petersburg, before going to Warsaw and Vienna in 1777. In 1779 he returned to Paris where he remained.

William Charles ROSS
1794–1860

Ross trained at the Royal Academy Schools. In 1814 he became assistant to the miniaturist Andrew Robertson and abandoned large-scale painting. He was the leading painter of portrait miniatures in mid-nineteenth-century England, and his clients included members of European royal families as well as Queen Victoria and Prince Albert. Many of his portrait miniatures are on a large scale and reflect the compositions of full-scale portraiture.

ROSSO FIORENTINO
A Knight of Saint John
about 1520–3

NG 932
Oil on poplar, 96.8 x 76.2 cm

The sitter has not been identified. He wears the cross of the Order of St John, and displays the hilt of his sword.

NG 932 has recently been attributed to Rosso on the basis of stylistic comparisons with works of the early 1520s (e.g. the *Deposition*, Volterra, Pinacoteca). A similar date has been suggested for this portrait.

The Order of St John was expelled from Rhodes in 1522–3 and established itself in Malta in 1530.

Collection of King Louis-Philippe, Paris, by 1838; Wynn Ellis Bequest, 1876.

Gould 1975, p. 86; Franklin 1989, pp. 839–42; Franklin 1994, pp. 215–16.

Johann ROTTENHAMMER
The Coronation of the Virgin
probably 1596–1606

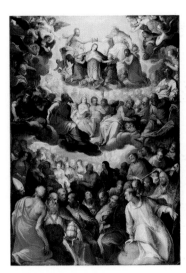

NG 6481
Oil on copper, 92.7 x 63.5 cm

At the top of the composition the Virgin is crowned by the Trinity – God the Father, Christ and the Holy Ghost in the form of a dove. Beneath are Adam and Eve, and to the left on this level Saint Peter, Abraham and Isaac, and David. Opposite are Saint Paul (?), Moses, Jonah and probably Aaron. In the background of the lower part of the composition are various saints and martyrs, including Justina, Lucy, Catherine of Alexandria, Ursula, Mary Magdalene, Sebastian, Clare, Peter Martyr, Luke and John the Evangelist. In the foreground are the Fathers of the Church, including Jerome, along with Saints Stephen, Francis and Lawrence. The bearded figure in a cape has been identified as Camillo Borghese, who became Pope Paul V in 1605.

The inclusion of Paul V might suggest that NG 6481 was painted in Rome, but stylistically the work is Venetian in character and was probably executed during the artist's stay in Venice.

A squared-up preparatory drawing of the composition, which varies in some details from NG 6481, survives (Florence, Uffizi).

Probably collection of the Earl of Arundel, 1655; Spencer collection, Althorp, by 1822; bought, 1983.

National Gallery Report 1982–4, pp. 22–3.

Henri ROUSSEAU
Tiger in a Tropical Storm (Surprised!)
1891

NG 6421
Oil on canvas, 129.8 x 161.9 cm

Signed and dated lower left: Henri Rousseau, 1891.

NG 6421 is the first of Rousseau's many jungle pictures. The scene is imaginary, although the trees and plants were probably inspired by flora in the Jardin des Plantes in Paris. The tiger may have been based on a pastel by Delacroix.

NG 6421 was first exhibited at the Salon des Indépendants in Paris in 1891 with the title 'Surprised!' The exotic subject and the apparently primitive technique attracted much attention.

G. Bernheim, Paris, 1933; bought with a contribution from the Hon. Walter H. Annenberg, 1972.

National Gallery Report 1971–2, pp. 41–2; Béhar 1985, pp. 109–10.

ROSSO FIORENTINO
1494–1540

Giovanni Battista di Jacopo, called Rosso, was born and trained in Florence. He painted altarpieces and a few portraits in Florence and Volterra before moving to Rome in 1524. He fled from Rome in 1527 and worked in Sansepolcro and Arezzo before travelling to the court of Francis I at Fontainebleau in 1530.

Johann ROTTENHAMMER
1564–1625

Born in Munich, where he studied until 1588, Rottenhammer travelled to Italy, and stayed in Rome in about 1595 to 1596. He was in Venice in 1606, where he established a reputation for small works on copper of mythological and religious subjects. From 1606 he worked in Augsburg and Munich, receiving important commissions for decorative schemes and altarpieces.

Henri ROUSSEAU
1844–1910

Rousseau was born in Laval. In 1871 he joined the Paris municipal toll service and later began painting in his spare time. He exhibited at the Salon des Indépendants from 1886. His work influenced numerous modern artists, including Picasso, and later the Surrealists, who appreciated his poetic imagination and his direct, expressive style.

Philippe ROUSSEAU
The Fish Market
probably about 1834–50

NG 2480
Oil on wood, 23.8 x 34.6 cm

Philippe ROUSSEAU
A Valley
possibly about 1860

NG 4849
Oil (identified) on canvas, 81 x 99.4 cm

Philippe ROUSSEAU
Still Life with Oysters
probably 1875–87

NG 3829
Oil on canvas, 42.2 x 62.2 cm

Signed: Ph. Rousseau

NG 2480 combines a still life of dead fish with a genre scene of figures in the background.

NG 2480 was presented as the work of Eugène Isabey and Philippe Rousseau. The background figures are possibly by Eugène Isabey, although there is no record of a collaboration between these two artists. Certainly, the subject and its treatment seem indebted to similar scenes by Isabey (e.g. NG 2715). It is probably an early work.

Thomas McLean Gallery before 1909; presented by Henry L. Florence, 1909.

Davies 1970, p. 125; Weisberg 1981, p. 144.

Signed: Ph. Rousseau

Rousseau is best known as a still-life painter but his earliest submissions to the Salon were all landscapes. This picture was probably based on the direct observation of an actual landscape, although the site has not been identified.

NG 4849 has a trader's stamp (J. Bovard, 15 rue de Buci, Paris) on the back of the canvas, and was possibly painted in the artist's middle period.

Van Wisselingh collection by 1928; presented by Francis Howard to the Tate Gallery, 1936; transferred, 1956.

Davies 1970, p. 126; Weisberg 1981, pp. 183–4; Clarke 1986, p. 52, no. 49.

Signed: Ph. Rousseau

NG 3829 is typical of Rousseau's still-life style, and was probably a late work.

Presented by Lt.-Col. R.H. Whitwell to the Tate Gallery, 1923; transferred, 1956.

Davies 1970, pp. 125–6.

Philippe ROUSSEAU
1816–1887

Philippe Rousseau is said to have been taught by Gros and to have studied with Victor Bertin. He exhibited at the Salon from 1834, and specialised in landscape and later in still life.

Pierre-Etienne-Théodore ROUSSEAU
Sunset in the Auvergne
1830

Pierre-Etienne-Théodore ROUSSEAU
The Valley of St-Vincent
probably 1830

Pierre-Etienne-Théodore ROUSSEAU
A Rocky Landscape
about 1836–40

NG 2635
Oil on wood, 20.3 x 23.8 cm

NG 3296
Oil on paper laid down on canvas, 18 x 34.9 cm

NG 4170
Oil on millboard, 27.9 x 43.5 cm

Signed lower left: TH. Rousseau
Rousseau was in the Auvergne in 1830, and NG 2635 was probably painted on this trip. It is one of a group of small studies painted in the open air which are remarkable for their freedom and accuracy of observation.

Collection of George Salting by 1909; Salting Bequest, 1910.

Davies 1970, p. 127; Green 1982, pp. 54–5.

Probably stamped lower left: TH. R.
St-Vincent is in the valley of Le Falgoux which extends up to Puy Mary, one of the principal summits of the Cantal region in the Auvergne.
NG 3296 has been dated to 1830, when Rousseau travelled in the Auvergne.
The composition was extended along the top edge with a narrow strip; this was probably added by Rousseau.

Alfred Sensier collection by 1877; collection of Comte Doria by 1899; bought by Edgar Degas, 1899; bought with a special grant, 1918.

Davies 1970, pp. 127–8; Green 1982, p. 38.

NG 4170 is a study from nature, perhaps in the Forest of Fontainebleau, although a precise site has not been identified.

Barye collection by 1876; presented by A.E. Anderson to the Tate Gallery through the NACF, 1926; transferred, 1956.

Davies 1970, p. 128; Green 1982, p. 49.

Pierre-Etienne-Théodore ROUSSEAU
1812–1867

Théodore Rousseau was born in Paris and studied under J.-C.-J. Rémond and Guillon Lethière. He exhibited at the Salon from 1831, and specialised in landscape (e.g. views in the Forest of Fontainebleau at Barbizon, where he settled in 1844).

Pierre-Etienne-Théodore ROUSSEAU
River Scene
about 1840–60

NG 2439
Oil on wood, probably oak, 31.4 x 40.3 cm

Signed: TH. Rousseau
 The title is traditional; the sea can be seen in the background.

Said to be from the Pecarère collection; collection of Sir J.C. Day by 1902; presented, 1909.

Davies 1970, p. 126.

Pierre-Etienne-Théodore ROUSSEAU
Landscape
probably 1860–5

NG 5781
Oil on millboard, 49.8 x 67 cm

Signed lower left: TH. Rousseau
 Rousseau frequently began his works in front of the motif and finished them in his studio. NG 5781 may represent the initial stages of the picture, perhaps sketched out in the open air.

Collection of Alexandre Dumas by 1882; collection of Alexis Rouart by 1882; presented to the Tate Gallery by Mrs Julian Lousada, 1926; transferred, 1956.

Davies 1970, pp. 128–9; Green 1982, pp. 57–8.

Pierre-Etienne-Théodore ROUSSEAU
Moonlight: The Bathers
perhaps 1860s

NG 3269
Oil on canvas, 52.1 x 67.3 cm

Figures are seen bathing in a river at night.

Collection of James Staats Forbes by 1904; Sir Hugh Lane Bequest, 1917; on loan to the Hugh Lane Municipal Gallery of Modern Art, Dublin, since 1979.

Davies 1970, p. 127.

Peter Paul RUBENS
'The Judgement of Paris'
about 1600

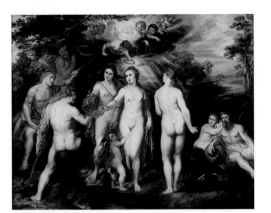

NG 6379
Oil on oak, 133.9 x 174.5 cm

Peter Paul RUBENS
Samson and Delilah
about 1609

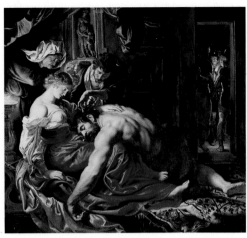

NG 6461
Oil (identified) on wood, 185 x 205 cm

Peter Paul RUBENS
Saint Bavo about to receive the Monastic Habit at Ghent, before 1612

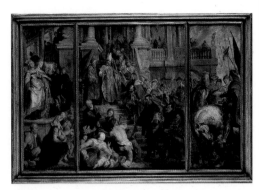

NG 57
Oil on oak, central panel, 106.7 x 82.1 cm;
side panels, each 107.6 x 41.1 cm

The Judgement of the Goddesses by Lucian (died AD 180) is the literary source probably used by Rubens. Paris, seated with his back to the viewer, gives the prize of a golden apple to Venus, the central standing goddess, whom he judged to be the most beautiful of the three. To the left stands Juno who is angered by the choice, and to the right, turned away, Minerva, identifiable by the armour at her feet. Venus is accompanied by Cupid and crowned by a putto; another putto holds two doves . Paris is accompanied by Mercury at the left, and in the background two satyrs watch the contest. At the right a water god and a nymph recline on the ground.

This work was probably painted shortly before Rubens's departure for Italy in 1600.

Two drawings (Paris, Louvre; New York, Metropolitan Museum of Art) and an oil sketch (Vienna, Akademie der bildenden Künste) illustrate the evolution of the composition, which is based in part on Raphael's *Judgement of Paris*, as engraved by Marcantonio Raimondi. The putti in the sky recall the work of Rubens's master Otto van Veen (1556–1629). (See also Rubens NG 194.)

Probably anon. sale, Christie's, 1815; bought, 1966

Jaffé 1968, pp. 174ff.; Martin 1970, pp. 213–15; Brown 1987, p. 16; Jaffé 1989, pp. 147–8.

Samson, the Jewish hero, fell in love with Delilah. She was bribed by the Philistines, and discovered that his strength came from his hair which had never been cut. While he was asleep it was cut, Samson was drained of his strength and the Philistines were able to capture him. Old Testament (Judges 16: 17–20). Rubens depicts a candlelit interior; the Philistines wait at the door, one of their number cuts Samson's hair, while an elderly woman provides extra light. In a niche behind is a statue of the goddess of love, Venus, with Cupid – a reference to the cause of Samson's fate.

NG 6461 was painted in about 1609 for Nicolaas Rockox, a wealthy and important patron of the artist who became burgomaster of the city of Antwerp. It was intended for the 'Great Salon' in his home in the Keizerstraat (today a museum). Frans Francken the Younger (1581–1642) shows it *in situ* in his painting of the room (Munich, Alte Pinakothek).

Rubens's evolution of the design can be seen in a drawing (private collection) and an oil sketch (Cincinnati, Art Museum), in which the composition of the principal group is refined. It was engraved by Jacob Matham about 1613. The painting inspired a version of the subject by Van Dyck (London, Dulwich Picture Gallery).

Liechtenstein collection by 1700; sold, 1880, and rediscovered in Paris, 1929; bought, 1980.

Rooses 1886–92, I, pp. 143–4, no. 115; Brown 1983; Plesters 1983, pp. 30–49; Brown 1987, p. 18; D'Hulst 1989, pp. 107–13; Jaffé 1989, pp. 165–6, no. 90.

Saint Bavo was a knight who gave up his worldly concerns to enter the Benedictine monastery of St Peter's, Ghent. The main literary source is J. Molanus, *Indiculus Sanctorum Belgii* (Louvain 1573). In the central panel Saint Bavo stands in armour, being greeted by Saint Amandus and Saint Floribert, who bend towards him, while his wealth is being distributed at the lower left. In the right panel Kings Clothar and Dagobert reject an imperial edict that forbade knights to enter the Church, and in the left panel two relatives of Saint Bavo, Saints Gertrude and Begga, are shown.

NG 57 is a modello (oil sketch) for a triptych intended for the high altar of St Bavo, Ghent. The altarpiece was commissioned by Bishop Maes of Ghent in 1611 or 1612, but the patron died in May 1612 and the project was abandoned. In 1623 Rubens was given a new commission for a different work for the site, which remains in the church and incorporates some features from this composition.

Holwell Carr Bequest, 1831.

Rooses 1886–92, II, pp. 230–1, no. 396(1); Martin 1968, pp. 434ff.; Martin 1970, pp. 126–33; Jaffé 1989, pp. 180–1, no. 174.

Peter Paul RUBENS
1577–1640

Rubens was born in Siegen (Germany), and trained by Otto van Veen in his parents' native city, Antwerp. He travelled to Italy (1600–8), before establishing a busy studio in Antwerp. A collector, scholar and diplomat, the artist served Philip IV, Charles I, Marie de Médicis and the Regents of the Netherlands. His paintings – histories, mythologies, religious works, allegories, landscapes, hunts and portraits – were influential throughout Europe.

Peter Paul RUBENS
A Shepherd with his Flock in a Woody Landscape
probably 1615–22

Peter Paul RUBENS
Peasants with Cattle by a Stream in a Woody Landscape ('The Watering Place'), about 1615–22

Peter Paul RUBENS
A Lion Hunt
about 1616–17

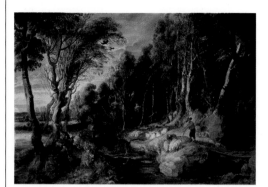

NG 2924
Oil on oak, 64.4 x 94.3 cm

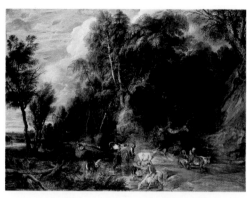

NG 4815
Oil (identified) on oak, 99.4 x 135 cm

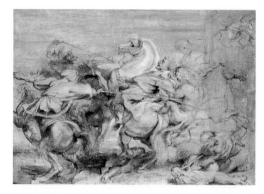

NG 853.1
Oil on oak, 73.6 x 105.4

Parts of the general scheme of this composition were also used by Rubens in NG 4815. In that work the right half of the composition of NG 2924 is reused on a smaller scale, left of centre.

NG 2924 evolved in two main stages: initially the main central scene was worked on and then the support was enlarged all round. The central part of the composition was altered; X-radiographs reveal a group of cottages which was subsequently painted out.

Possibly Rubens sale, Antwerp, 1640; presented by Rosalind, Countess of Carlisle, 1913.

Rooses 1886–92, IV, pp. 368–9, no. 1177; Martin 1966, pp. 180ff.; Martin 1970, pp. 200–3; Brown 1982, pp. 27–39; Brown 1987, p. 30; Jaffé 1989, p. 239.

The left middle ground of this work is a slightly altered and reduced version of another landscape of comparable date – Rubens NG 2924. The support of NG 4185 is made up of eleven panels; it appears that the artist started with the composition of the right half of NG 2924 and then had the support expanded all around and to the right, consequently enlarging and transforming the landscape.

Gainsborough paid homage to Rubens's work in his own landscape painting of this title (see Gainsborough NG 109).

M. d'Armagnac (?Charles Comte d'Armagnac, 1684–1758) collection; bought with a contribution from the NACF, 1936.

Rooses 1886–92, IV, pp. 380–1, no. 1196; Martin 1966, pp. 180–3; Martin 1970, pp. 205–13; Brown 1982, pp. 27–39; Adler 1982, pp. 95–6, no. 25; Brown 1987, p. 28; Jaffé 1989, p. 239, no. 486.

In this grisaille sketch eastern hunters on horseback attempt to fight off a lion who tries to drag one of them to the ground. Another figure kills a lion on the ground and a corpse lies beneath the horses. A slightly altered arrangement of the central group appears in the upper right. There is no literary source for this violent study, but there are a number of visual precedents, notably by Leonardo.

The sketch has been dated on stylistic grounds to 1616–17.

The central group of the rider being pulled from his horse was reused by Rubens with variations in a finished painting of a lion hunt (Munich, Alte Pinakothek). Three other works of this type by the artist are known (Musée de Bordeaux, destroyed; Dresden; Rennes). A number of Rubens's sketches were executed as grisailles (see also Rubens NG 1865). The central group in NG 853.1 derives in part from Rubens's study of works after Leonardo's fresco of *The Battle of Anghiari* which was destroyed in 1557. A drawn version of it by the artist (Paris, Louvre) was based upon Lorenzo Zacchia's engraving of the work of 1558. Additionally, Rubens may have been inspired by Stradanus's *Lion Hunt*, published by Cock in 1570.

Johann Engelbert von Jabach collection, Cologne, before 1754; bought with the Peel collection, 1871.

Rooses 1886–92, IV, pp. 338–9, no. 1154; Martin 1970, pp. 182–77; Rowlands 1977, p. 82, no. 88; Held 1980, pp. 406–8, no. 298; Balis 1986, pp. 107–10; Brown 1987, p. 22.

Peter Paul RUBENS
The Miraculous Draught of Fishes
1618–19

NG 680
Pencil, pen and oil on paper stuck on canvas,
55 x 85 cm

Peter Paul RUBENS
The Coup de Lance
before 1620

NG 1865
Oil on oak, 64.8 x 49.9 cm

Peter Paul RUBENS
The Nativity
about 1628

L396
Oil on canvas, 289.5 x 219.7 cm

Jesus accompanied Simon Peter when he went fishing on Lake Gennesaret. When Christ told him to cast his nets Simon Peter protested that nothing had been caught the previous night. In the event the nets broke because they were so full of fish and the apostle was ashamed for having doubted Jesus, who replied: 'Fear not: from henceforth thou shalt catch men.' New Testament (Luke 5: 1–10). This is the moment shown by Rubens.

This modello is a preparation for an engraving by Schelte à Bolswert. It records with variations part of a composition used in the central panel of a triptych that Rubens had been commissioned by the Corporation of Fishmongers to paint for the church of Nôtre Dame au delà de la Dyle, Malines, in October 1617. The altarpiece was completed in August 1619. The engraving is undated, but inscribed as bearing the privilege of (i.e. being authorised by) the Regents of the Spanish Netherlands. Archduke Albert died in 1621 and the engraving and modello must have been made before his death.

The composition in part recalls Raphael's tapestry cartoon of the subject (Royal Collection, on loan to the Victoria & Albert Museum, London).

Possibly Cav. Gizzi collection, Naples, 1815; bought, 1861.

Martin 1966a, pp. 239ff.; Martin 1970, pp. 170–4; Renger 1974, pp. 122–75; Rowlands 1977, pp. 121–2, no. 163; Held 1980, pp. 463–4, no. 336; Brown 1987, p. 24; Jaffé 1989, p. 348, no. 1201.

Longinus drives his spear into the side of the crucified Christ, hence the title of the work, *Coup de Lance*. Saint John the Evangelist, Saint Mary Magdalene and Mary Cleophas stand at the right, while the Virgin swoons at the base of the cross. New Testament (John 19: 31–4). On the right is the bad thief, and on the left the good thief.

This grisaille sketch is a preparatory work for the high altarpiece of the church of the Récollets, Antwerp, which was installed in 1620 (now Antwerp, Museum voor Schone Kunsten). The sketch is thought to date from the previous year. The donor of the altarpiece was Nicolaas Rockox, an important early patron of the artist (see also Rubens NG 6461).

This modello constitutes an early stage in the evolution of the design of the altarpiece; there are a number of significant differences between it and the finished work. The reverse is branded with the coat of arms of the city of Antwerp.

Monastery of the Récollets, 1753; on loan from the Victoria & Albert Museum since 1895.

Martin 1970, pp. 193–7; Rowlands 1977, p. 119, no. 160; Held 1980, pp. 484–5, no. 352; Brown 1987, p. 26; Jaffé 1989, p. 250, no. 543.

The Child is warmed by the breath of the ox, while the ass can be glimpsed behind. In the sky above three angels carry a banderole which in the engraving after the painting by Schelte à Bolswert, an Antwerp engraver who often worked for Rubens, bears the words: Gloria in excelsis Deo et in terra pax hominibus bonae voluntatis (Glory to God in the highest, and on earth peace, good will toward men). New Testament (Luke 2: 14).

L396 is dated on stylistic grounds to about 1620.

On loan from the Trustees of the First Lord Moyne since 1988.

Jaffé 1989, p. 263, no. 660.

Peter Paul RUBENS
Portrait of Susanna Lunden (?)
('Le Chapeau de Paille'), probably 1622–5

Peter Paul RUBENS
Minerva and Mercury conduct the Duke of Buckingham to the Temple of Virtue, before 1625

Peter Paul RUBENS
A Wagon fording a Stream
probably 1625–40

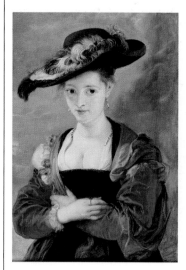

NG 948
Black chalk and oil on paper stuck on canvas,
47 x 70.5 cm

NG 852
Oil on oak, 79 x 54.6 cm

NG 187
Oil on oak, 64 x 63.7 cm

The sitter is thought to be Rubens's sister-in-law, Susanna Lunden (1599–1643). She was born Susanna Fourment and the artist knew her father, Daniel Fourment, an Antwerp silk and tapestry merchant, for whom he worked. She married Raymond del Monte in 1617, but was soon widowed and in 1622 married Arnold Lunden. In 1630 Rubens married her younger sister Hélène. As there is no securely identified portrait of Susanna, the identification must remain speculative. The traditional title of the painting – *Le Chapeau de Paille* (The Straw Hat) – inaccurately describes what is actually a felt hat of a type worn by both sexes in the Netherlands in the 1620s. The same sitter was, however, depicted by Rubens on another occasion wearing a straw hat (private collection).

The ring worn by the sitter and her apparent age suggest that this portrait dates from shortly after her second marriage, i.e. 1622–5. It is possibly first recorded in the possession of the family of her second husband.

A life drawing that is probably preparatory to NG 825 survives (Vienna, Albertina). The painting influenced later portraits (notably Lawrence's *Lady Peel* (New York, Frick Collection), and Vigée Le Brun's *Self Portrait* NG 1653).

Possibly Lunden collection by 1639; bought with the Peel collection, 1871.

Rooses 1886–92, IV, pp. 175–9, no. 949; Martin 1970, pp. 174–82; Brown 1987, p. 32; Vlieghe 1987, pp. 107–9, no. 102; Jaffé 1989, p. 279, no. 756.

This allegory glorifies George Villiers, Duke of Buckingham (1592–1628), the favourite of both James I and Charles I. He is carried upwards by Minerva, the goddess of wisdom, and, on the right, by Mercury, god of eloquence, who holds a laurel wreath above the duke's head. The figure of Virtue waits for the duke outside her palace at the top of the composition, with Abundance seated at her side. At the bottom he is pulled down by Envy who is pawed by a lion symbolising anger. At the left the Three Graces offer Buckingham another crown.

NG 187 is a preparatory sketch for a ceiling painting that hung in the duke's London home, York House (it was destroyed in a fire in 1949). It was probably commissioned from the artist when Buckingham first met him in 1625 in Paris, or a little later. The ceiling apparently arrived from Antwerp a few months before the duke's assassination.

The composition is in part based on Correggio's *Ascent of Christ* (Parma, S. Giovanni Evangelista), and certain ideas were reused again by the artist (e.g. *Apotheosis of James I*, London, Whitehall, Banqueting House).

Hon. John Clerk of Elden (Lord Eldin) sale, Edinburgh, 14 March 1833; bought, 1843.

Martin 1966, pp. 613ff.; Martin 1970, pp. 147–53; Held 1980, pp. 390–3, no. 291; Brown 1987, p. 34; Jaffé 1989, p. 285, no. 794.

The painting is unfinished; areas of foliage have not been completed.

The attribution of this work to Rubens has in the past been doubted, but NG 948 is now considered to be by the artist. The dating of Rubens's landscapes is problematic because they were not commissioned and so relatively few documents concerning them survive.

This view also appears with slight variations in another landscape by the artist (Rotterdam, Museum Boymans-van Beuningen). It has also been related to a drawing in St Petersburg (Hermitage).

Lord Camden sale, 1809; Wynn Ellis Bequest, 1876.

Rooses 1886–92, IV, pp. 393–4, no. 1205; Martin 1970, pp. 215–17; Adler 1982, pp. 166–7, no. 57; Jaffé 1989, p. 346, no. 1190.

Peter Paul RUBENS
Portrait of Ludovicus Nonnius
about 1627

NG 6393
Oil on wood, 124.4 x 92.2 cm

Inscribed on the bust: HIPPOCRATES (in Greek letters).

This three-quarter-length seated portrait is of Ludovicus Nonnius (about 1553–1645/6), a doctor from a Portuguese family who worked in Antwerp. The book he holds and the objects surrounding him refer to his accomplishments. The sitter wrote a number of works, including the *Diaeteticon* (1627), a study of diet as an important factor for good health, which was based upon the eating habits of the ancient Romans. The presence of the bust of Hippocrates (the Greek founder of medicine) identifies his profession and his respect for Antiquity – a vital aspect of contemporary learning.

The portrait is dated to the late 1620s on grounds of style. It was probably painted shortly before Rubens's diplomatic journeys of 1628–30, and may date from the year of publication of the *Diaeteticon*, which could be the book the sitter holds.

The bust is based upon a drawing after the antique by the artist which was the subject of an engraving by Schelte à Bolswert of 1638.

Anon. sale [Edward Davis (1687–8)], bought by the Earl of Kent; Cowper collection, Panshanger; bought, 1970.

National Gallery Report 1969–70, pp. 33–6; Brown 1987, p. 36; Vlieghe 1987, pp. 137–9; Jaffé 1989, p. 306, no. 923.

Peter Paul RUBENS
Apotheosis of King James I
1629–30

L79
Oil on wood, 95 x 63.1 cm

Sketches for seven compositions are shown here, all for the commission given to Rubens to provide paintings for the ceiling of the Great Hall in the Banqueting House of Whitehall Palace, London. In the centre is an oval showing the apotheosis of James I, a sketch for the painting occupying the middle of the ceiling. The King is flanked by Piety, on the left, and Justice, whom he embraces, and is about to be crowned with a wreath. Above and below are friezes of putti and animals. To either side of the central oval are sketches of four triumphs, above Liberality overcoming Avarice and Discipline overcoming Impudence, below Knowledge vanquishing Ignorance and Heroic Force vanquishing Envy. Like the upper frieze, the lower triumphs are depicted upside down in order to indicate their relative positions on the ceiling.

These sketches were probably painted in London in 1629–30, while Rubens was discussing the Whitehall project. The apotheosis, the friezes symbolising the union of England and Scotland, and two of the triumphs, are mentioned in written programmes apparently drawn up before the death of James I in 1625, but the themes underwent much subsequent modification, in which Rubens must have played an important role.

On loan from a private collection since 1981.

Held 1980, pp. 199–201, no. 133; Martin 1994, pp. 29–34.

Peter Paul RUBENS
Minerva protects Pax from Mars ('Peace and War')
1629–30

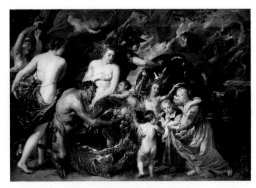

NG 46
Oil (identified) on canvas, 203.5 x 298 cm

Minerva, the goddess of wisdom, drives away the god of war, Mars, from Pax (Peace), who is shown naked. She feeds Plutus, the god of wealth. Below, a satyr offers the fruits of peace in a cornucopia to two girls, one of whom is crowned by Hymen, the god of marriage. To the right of Mars is the Fury Alecto, and beyond in the sky a phantom who spits fire, representing the destructive nature of war. By contrast Pax is crowned with an olive wreath, and two women to the left of her stand for the benefits of peace – prosperity and the arts.

Rubens was in England in 1629–30 as an envoy for Philip IV of Spain. He sought an exchange of ambassadors to negotiate peace between the two countries. NG 46 was a gift to Charles I, whose cipher is on the back of the canvas. The themes of this allegory – the benefits of peace and the destructiveness of war – reflect the aims of his successful political mission.

Drawn studies of the children survive (e.g. Rotterdam, Museum Boymans-van Beuningen; Weimar, Staatliche Kunstsammlungen; Vienna, Albertina). They are probably portraits of the children of Sir Balthasar Gerbier, with whom Rubens stayed in London.

Gift to Charles I, 1629–30; presented by the Duke of Sutherland, 1828.

Rooses 1886–92, IV, pp. 45–6, no. 825; Martin 1970, pp. 116–25; Brown 1979; Hughes 1980, pp. 157–65; Brown 1987, p. 40; Jaffé 1989, p. 314, no. 969.

Peter Paul RUBENS
Portrait of Thomas Howard, 2nd Earl of Arundel
1629–30

NG 2968
Oil on canvas, 67 x 54 cm

Peter Paul RUBENS
A Roman Triumph
about 1630

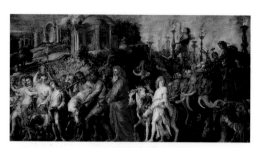

NG 278
Oil on canvas stuck down on oak panels,
86.8 x 163.9 cm

Peter Paul RUBENS
'The Judgement of Paris'
probably 1632–5

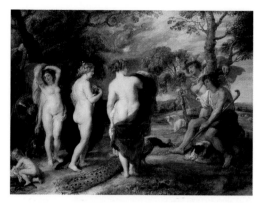

NG 194
Oil on oak, 144.8 x 193.7 cm

Thomas Howard (1585–1646), 2nd Earl of Arundel and Surrey, became Earl Marshal of England in 1621. He was an important patron of the arts, a collector and a connoisseur whom Rubens met in England in 1629/30. He wears a fur-lined coat and the Lesser George (an insignia of the Order of the Garter) hung from a blue ribbon. There are a number of other portraits of him by Rubens (e.g. London, National Portrait Gallery; Boston, Isabella Stewart Gardner Museum).

The style of NG 2968 suggests that it dates from Rubens's stay in England; there is no record of the artist and sitter meeting after then.

It has been suggested that the portrait may recall Dürer's engraving of his friend, the humanist Willibald Pirckheimer, the original copper plate of which Arundel acquired.

Possibly Rubens sale, Antwerp, 1640; presented by Rosalind, Countess of Carlisle, 1914.

Rooses 1886–92, IV, p. 127, no. 889; Martin 1970, pp. 203–5; Huemer 1977, pp. 105–7, no. 4; Howarth 1985, p. 155; Howarth 1985–6, p. 10, no. 2; Brown 1987, p. 38; Jaffé 1989, p. 314, no. 971.

This procession is based on Mantegna's *Triumphs of Caesar*. The figure group includes (from left to right): maidens who could serve at sacred rites; animals for sacrifice; trumpeters and pipe players; slaughterers; in the centre, dressed in red, a *pontifex* (priest), with above him a soothsayer; and elephants bearing fruit and incense burners.

NG 278 is dated on grounds of style to about 1630.

The figures are chiefly drawn from *Triumphs IV* and *V* of the series by Mantegna (London, Hampton Court, Royal Collection). Rubens had access to these works when he worked for the Gonzaga in Mantua during his Italian trip (1600–8). The *Triumphs* were bought by Charles I as part of the Mantua collection and shipped to England in about 1630. It is unclear whether or not Rubens saw them during his visit to England in 1629–30. Their arrival was certainly being anticipated during his stay. He would also have been able to refer to the woodcuts of them by Andrea Andreani. NG 278 has a complex support; the right section, which recalls *Triumph V*, was probably painted first. The left is a free interpretation of *Triumph IV*, while the central area of the picture and the landscape are unifying elements invented by the artist.

Possibly Forchoudt collection, Antwerp, before 1673; bought, 1856.

Rooses 1886–92, III, pp. 208–9, 715–17; Martin 1970, pp. 163–70; Martindale 1979, p. 106; Brown 1987, p. 42; Jaffé 1989, p. 314, no. 970.

The Judgement of the Goddesses by Lucian (died AD 180) is the literary source probably used by Rubens. Jupiter asked Paris, a prince of Troy, to decide which of three goddesses – Juno, Minerva and Venus – was the most beautiful and award a golden apple marked 'to the fairest'. He sits on the right, offering the apple to Venus, who promised him the most beautiful woman in the world as his wife. Juno (identified by the peacock) offered riches, while Minerva (with the head of the Medusa and the owl beside her) offered victory in war. Paris, who is accompanied by Jupiter's messenger, Mercury, later abducted the most beautiful woman, Helen, an action that precipitated the Trojan war. The Fury of war, Alecto, appears in the sky (see also Rubens NG 46).

The painting is dated on grounds of style to 1632–5.

Venus may be based on Rubens's second wife Hélène Fourment. Six other versions of the subject, by or deriving from Rubens, are known (see also Rubens NG 6379). One of these (Dresden, Gemäldegalerie Alte Meister) slightly precedes and is closely related to NG 194. X-radiographs reveal that Paris and Mercury may have been altered after the artist finished the work, and that originally a putto disrobed Venus.

Possibly Diego Duarte collection, Antwerp, before 1649; bought, 1844.

Rooses 1886–92, III, pp. 141–2, no. 663; Martin 1970, pp. 153–63; Jaffé 1989, p. 332, no. 1084.

Peter Paul RUBENS
The Birth of Venus
about 1632–3

NG 1195
Black chalk and oil on oak, 61 x 78 cm

Peter Paul RUBENS
The Rape of the Sabine Women
probably 1635–40

NG 38
Oil on oak, 169.9 x 236.2 cm

Peter Paul RUBENS
The Brazen Serpent
probably 1635–40

NG 59
Oil on canvas, 186.4 x 264.5 cm

This is a sketch for an ornate silver basin. The central subject is the Birth of Venus, which is described in Hesiod's *Theogony* and in the *Homeric Hymns*. She steps from a shell, wringing foam from her hair, assisted by three women who may be Nereids, Horae or Graces, on to the island of Cyprus. A cupid and a figure who may be Persuasion crown her, while a personification of Desire rides a Triton at the right. In the sky above, Zephyrus blows the main group ashore. In the rim around the central group, are Neptune and his wife Amphitrite, at the bottom Cupid and Psyche, and on the sides swans, putti riding seahorses and nymphs adorned with pearls riding dolphins.

This design, with one for a ewer, was made for Charles I and cast by Theodore Rogiers, a silversmith from Antwerp. The sketch is dated to about 1632–5. The basin and ewer are recorded in a print by Jacob Neeffs (1660), but the objects themselves no longer survive. The main subject on the ewer, for which no oil sketch is known, was the Judgement of Paris.

Collection of the Duke of Hamilton by 1830; bought (Clarke Fund), 1885.

Rooses 1886–92, III, pp. 172–3, no. 688; Martin 1970, pp. 187–93; Held 1980, pp. 355–8, no. 265; Brown 1987, p. 44; Jaffé 1989, p. 319, no. 1000.

Romulus, seated at the upper left, held games in Rome at which the Romans competed with the Sabines. He gave a prearranged signal and the Roman men carried off the Sabine women. A later attempt by the Sabines to recapture them was defeated. Plutarch's *Lives* (II, 14 and 19). The Romans and Sabines fight in the background beyond the rail that separates the audience from the games. The abduction is set before classical architecture, but the women wear seventeenth-century Flemish dress.

A sketch by Rubens of the same subject, which was probably executed a little earlier but is not strictly preparatory to this painting, survives (Antwerp, Banque de Paris et des Pays-Bas, Huis Osterrieth).

Possibly Guilliam van Hamme collection, Antwerp, 1668; bought with the J.J. Angerstein collection, 1824.

Rooses 1886–92, IV, pp. 18–19, no. 803; Martin 1970, pp. 109–16; Held 1980, pp. 379–82, no. 283; Jaffé 1989, pp. 344–5, no. 1181.

Moses at the left, with the hooded Eleazar beside him, calls to the people of Israel who are being attacked by a plague of serpents that God sent them because of their sinfulness. He tells them to look at a bronze serpent he has set up on a pole, upper left, because 'everyone that is bitten, when he looketh upon it shall live'. Old Testament (Numbers 21: 6–9).

This work was probably executed with some studio assistance during the second half of the 1630s. The painting may have been blocked in by a member of the studio on the basis of a modello by Rubens, and then worked up by the master.

It has been suggested that the woman at the right of centre in black may be based on the artist's second wife Hélène Fourment. The composition was first engraved by Schelte à Bolswert.

Collection of Lorenzo Marana, Genoa, before 1805; bought, 1837.

Rooses 1886–92, I, pp. 139–40, no. 112; Martin 1970, pp. 133–7; Jaffé 1989, p. 370, no. 1373.

Peter Paul RUBENS
An Autumn Landscape with a View of Het Steen in the Early Morning, probably 1636

NG 66
Oil on oak, 131.2 x 229.2 cm

Peter Paul RUBENS
Aurora abducting Cephalus
about 1636–7

NG 2598
Oil on oak, 30.8 x 48.5 cm

Peter Paul RUBENS
A Landscape with a Shepherd and his Flock
about 1638

NG 157
Oil on oak, 49.4 x 83.5 cm

Het Steen is the sixteenth-century house at the left of this expansive landscape, which Rubens bought in 1635 for his growing family. It is near Elewijt, between Vilvoorde and Malines. The house survives, although in a substantially altered state. The direction of the view is towards the north; the city on the horizon may be Antwerp and the town in front of it may be Malines. The light and the types of vegetation suggest that it is an autumn morning. In the foreground a hunter with dogs stalks partridge resting on the far side of a blackberry hedge. On the left a wagon leaves the house, while in the right middle distance women milk a herd of cows.

NG 66 was probably painted in about 1636. It may have been intended as a pendant to Rubens's *Landscape with a Rainbow* (London, Wallace Collection); both paintings are of similar size and date, and came from the Balbi collection in the eighteenth century.

As with many of Rubens's landscapes, the support is complex. In this case it is made up of seventeen oak panels.

Rubens's family, Antwerp, 1640; Sir George Beaumont Gift, 1823/8.

Rooses 1886–92, IV, pp. 392–3, no. 1204; Martin 1970, pp. 137–42; Adler 1982, pp. 160–2; Brown 1987, p. 48; Jaffé 1989, p. 352, no. 1227.

Aurora, goddess of the dawn, attempted unsuccessfully to seduce Cephalus, the husband of Procris. Ovid, *Metamorphoses* (I, 849–54). She steps from her chariot on mount Hymettus to embrace Cephalus, who in this depiction does not seem to reject her. This may be explained if Rubens is also referring to an alternative version of the story (Hesiod's *Theogony*, 985) in which the pair become lovers.

In 1636 Rubens was commissioned by King Philip IV of Spain to decorate his hunting lodge, the *Torre de la Parada*, nine miles outside Madrid. The decoration was to take the form of a huge series of canvases painted with hunting scenes based on mythological stories; this is one of the sketches for the paintings in the scheme. Most of the large canvases were carried out by other Flemish artists.

The coat of arms of the city of Antwerp is branded on the reverse of the panel.

Infantado collection, Madrid, by 1776; George Salting Bequest, 1910.

Rooses 1886–92, III, pp. 15–16, no. 516; Martin 1970, pp. 197–200; Held 1980, pp. 261–2, no. 173; Jaffé 1989, p. 354, no. 1247; Alpers 1971, pp. 184–5; Brown 1987, p. 52.

The view has not been identified, and is probably not intended to be topographically accurate. It may be based upon the landscape around Het Steen, the country home the artist bought in 1635 (see Rubens NG 66).

The painting is considered a late work, probably of about 1638.

Rubens's *Landscape with Farm Buildings: Sunset* (Oxford, Ashmolean Museum) may be related to NG 157.

Possibly Rubens sale, Antwerp (lot 112), 1640; bequeathed by Lord Farnborough, 1839.

Rooses 1886–92, IV, pp. 378–9, no. 1193; Martin 1970, pp. 142–7; Adler 1982, pp. 181–2, no. 68; Brown 1987, p. 54; Jaffé 1989, p. 347, no. 1193.

Studio of RUBENS
Drunken Silenus supported by Satyrs
about 1620

NG 853
Oil on canvas, 133.5 x 197 cm

Attributed to the Studio of RUBENS
Portrait of the Archduke Albert
before 1615

NG 3818
Oil on canvas, 122 x 89 cm

Attributed to the Studio of RUBENS
Portrait of the Infanta Isabella
before 1615

NG 3819
Oil on canvas, 120.5 x 88.8 cm

Silenus, the old bloated and drunken figure supported by satyrs at the centre of the composition, was the teacher and companion of Bacchus, the god of wine. At the lower right two putti offer him grapes, while above them an old Bacchante carries a torch. On the left a figure plays pipes, and a young Bacchante squeezes grapes over Silenus.

The painting has been variously attributed to Rubens himself and to Van Dyck. It is now considered to be a product of Rubens's studio that can be dated to about 1620 when Van Dyck was a member. The figures may have been painted largely by a member of the studio, perhaps Van Dyck, and then reworked by the master. The sky and landscape are probably by Jan Wildens (1586–1653) and the foliage and fruit by Frans Snijders (1579–1657).

The composition derives in part from a work of a similar subject by Rubens – *The March of Silenus* (Munich, Alte Pinakothek). Van Dyck painted two related compositions (Dresden, Gemäldegalerie Alte Meister; Brussels, Musées Royaux des Beaux-Arts).

Probably Lucas van Uffel collection, Venice, 1637; bought, 1871.

Martin 1970, pp. 217–25; Wheelock 1991, p. 106.

The sitter is Archduke Albert of Austria (1559–1621). He was appointed Governor of the Netherlands by the Spanish monarch in 1595, and later, in 1598, became joint sovereign with his wife, the Infanta Isabella, of the Seventeen Provinces. In 1599 he was made a knight of the Order of the Golden Fleece, and is shown here wearing the badge of that order.

A portrait of his wife (NG 3819) forms a pendant to this work. Both compositions were engraved in 1615 as after Rubens. The artist was appointed painter to the court of the sitters in 1609. These portraits were probably painted in the artist's studio after prototypes by the master that no longer survive.

With pendant in the Bonomi Cereda sale, Milan, 1896; bequeathed by Richard J. Jackson, 1923.

Rooses 1886–92, IV, pp. 115–16, no. 875; Martin 1970, pp. 227–8; Vlieghe 1987, p. 38, no. 875.

The subject is Isabella Clara Eugenia (1566–1633), Archduchess of Austria, who was the daughter of Philip II of Spain. In 1598 her father appointed her joint sovereign of the Seventeen Provinces of the Netherlands with her husband, the Archduke Albert.

A portrait of Albert (NG 3818) forms a pendant to this work. Both compositions were engraved in 1615 as after Rubens. The artist was appointed painter to the court of the sitters in 1609. After the archduke's death in 1621 Rubens became a close adviser to Isabella. These portraits were probably painted in the artist's studio after prototypes by the master that no longer survive.

With pendant in the Bonomi Cereda sale, Milan, 1896; bequeathed by Richard J. Jackson, 1923.

Rooses 1886–92, IV, pp. 193–4, no. 967; Martin 1970, pp. 228–9; Vlieghe 1987, pp. 38–9, no. 61.

Attributed to the Studio of RUBENS
The Holy Family with Saints in a Landscape
after 1635

After RUBENS
An Allegory showing the Effects of War
('The Horrors of War'), after 1638

Jacob van RUISDAEL
A Bleaching Ground in a Hollow by a Cottage
probably 1645–50

NG 67
Oil on canvas, 119 x 158.5 cm

NG 279
Oil on paper stuck down on canvas, 47.6 x 76.2 cm

NG 44
Oil on oak, 52.5 x 67.8 cm

The Virgin and Child are shown in front of a classical building. Further to the left is a female saint and Saint George with the princess he saved from the dragon. On the right the infant John the Baptist with two angels pulls a lamb towards the sleeping Christ Child. In the landscape behind this group Saint Joseph sleeps.

The composition is based on a painting by the artist (Madrid, Prado) that probably dates from the period 1630–5, and a woodcut after that picture, produced under Rubens's supervision, which excludes the saints. The painting may also have been made in Rubens's studio.

J.J. Angerstein collection; bought, 1824.

Martin 1970, pp. 225–7.

Mars, the god of War, leaves the Temple of Janus at the left and marches away to the right encouraged by the Fury Alecto, but is restrained by the goddess of Love, Venus. The woman at the left, distraught, with her hands in the air, is a personification of Europe. At the right Alecto is accompanied by monsters who symbolise Plague and Famine. They are about to overcome personifications of Harmony, Fecundity, Maternity and Charity whom Mars tramples. In the distance a battle and a burning town can be seen.

This is a reduced copy of a painting by Rubens (Florence, Palazzo Pitti), which is thought to date from about 1637–8. It may have been executed while the Pitti painting was still in Rubens's studio.

The themes of the allegory are a later reworking of those explored by the artist in NG 46. An explanation of it was provided by Rubens in a letter of 12 March 1638 to the artist Sustermans in which he states 'That grief-stricken woman clothed in black, with torn veil, robbed of all her jewels and other ornaments, is the unfortunate Europe who, for so many years now, has suffered plunder, outrage, and misery.'

Genoese collection, 1803; bought, 1856.

Rooses 1886–92, IV, p. 51, no. 827(1); Martin 1970, pp. 230–3.

Signed bottom right: JvRuisdael (JvR in monogram).

The bleaching of linen was one of the main industries of Haarlem in the seventeenth century, and the city's bleaching grounds were considered the best in Europe.

NG 44 was probably painted in the late 1640s, before Ruisdael left Haarlem for Amsterdam.

Collection of Sir John May by 1847; by whom bequeathed, 1854.

Rosenberg 1928, p. 76, no. 63; MacLaren/Brown 1991, p. 380.

Jacob van RUISDAEL
1628/9?–1682

Born in Haarlem, Jacob van Ruisdael was the greatest of all Dutch landscape painters. Having trained with his father, Isaack, and probably also with his uncle, Salomon, he remained in his native city until 1657 when he moved permanently to Amsterdam. Ruisdael had a number of pupils, notably Meindert Hobbema, and also many followers and imitators, among them Cornelis Decker and Roelof van Vries.

Jacob van RUISDAEL
A Road winding between Trees towards a Distant Cottage, probably 1645–50

NG 988
Oil on oak, 32.6 x 30.4 cm

Signed bottom left: JvR (in monogram).
This is an early work, probably painted at the end of the 1640s.

Collection of Graf Carl von Rechberg, Stuttgart, about 1820; Wynn Ellis Bequest, 1876.

Rosenberg 1928, p. 91, no. 321; MacLaren/Brown 1991, p. 386.

Jacob van RUISDAEL
A Cottage and a Hayrick by a River
about 1646–50

NG 2565
Oil on oak, 26 x 33.4 cm

Signed in the water bottom right: JvR (in monogram).
In the late eighteenth century, and in the nineteenth, NG 2565 had a companion piece, *A Cornfield,* the present location of which is unknown.
NG 2565, which shows the influence of Salomon van Ruysdael, was probably painted in the period 1646–50.
A related drawing is known, and a variant is in Detroit (Institute of Arts).

In the Chevalier Lambert collection by 1787; collection of Samuel Woodburn by 1854; Salting Bequest, 1910.

Rosenberg 1928, p. 99, no. 434; MacLaren/Brown 1991, pp. 396–7.

Jacob van RUISDAEL
Two Watermills and an Open Sluice at Singraven
about 1650–2

NG 986
Oil on canvas, 87.3 x 111.5 cm

Signed bottom left: Ruil̸dael.
The watermills belonged to the manor house of Singraven near Denekamp, a village close to Bentheim in the eastern part of the Dutch province of Overijssel. The setting is Ruisdael's invention: there are no hills near Denekamp.
Ruisdael travelled to Bentheim in about 1650 and it was presumably on that trip that he visited Singraven. He painted a number of variants of this composition and used the Singraven watermills as prototypes for his many paintings of watermills. They were later painted by his pupil Hobbema (NG 832).

Probably in the collection of Thomas Emmerson by 1832; collection of Wynn Ellis by 1845; Wynn Ellis Bequest, 1876.

Rosenberg 1928, p. 78, no. 100; MacLaren/Brown 1991, pp. 383–5.

Jacob van RUISDAEL
Ruins in a Dune Landscape
probably 1650–5

NG 746
Oil on oak, excluding false additions on all sides
43.2 x 58.5 cm

Signed and dated, probably falsely, bottom right:
JvRuiſdael 1673 (JvR in monogram).

The ruins have not been identified. The high
dunes in the background recall the landscape
around Haarlem.

NG 746 probably dates from the early 1650s,
when Ruisdael was still living in Haarlem.

Apparently in an anon. sale, London, 1835; bought, 1865.

Rosenberg 1928, p. 101, no. 472; MacLaren/Brown
1991, p. 382.

Jacob van RUISDAEL
A Ruined Castle Gateway
about 1650–5

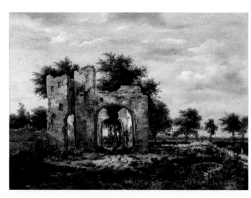

NG 2562
Oil on oak stuck on to millboard, remounted on an
oak panel, 46.7 x 64.5 cm

Signed lower left: vRuiſdael (vR in monogram).

The view, once incorrectly described as the castle
of Burgvliet near Bergen-op-Zoom, has not been
identified. It may not be topographically accurate.

*Morel et al. sale, Paris, 1786; collection of Admiral Lord
Radstock by 1822; Salting Bequest, 1910.*

Rosenberg 1928, p. 102, no. 473; MacLaren/Brown
1991, pp. 393–4.

Jacob van RUISDAEL
*A Rocky Hill with Three Cottages, a Stream at its
Foot,* probably 1650–60

NG 2564
Oil on canvas, 55 x 66 cm

Signed bottom right: vR (in monogram).

The attribution to Ruisdael has been doubted in
the past, but the painting is an autograph work of
the 1650s. The monogram, although it may have
been strengthened, is characteristic.

*Apparently in the collection of Frederick Perkins by
1835; Salting Bequest, 1910.*

Rosenberg 1928, p. 92, no. 323; MacLaren/Brown
1991, pp. 395–6.

Jacob van RUISDAEL

A Landscape with a Ruined Building at the Foot of a Hill by a River, about 1655

NG 991
Oil on oak, 22.8 x 29.3 cm

Jacob van RUISDAEL

A Road leading into a Wood
about 1655–60

NG 2563
Oil on canvas, 54.5 x 71 cm

Jacob van RUISDAEL

Vessels in a Fresh Breeze
probably about 1660–5

NG 2567
Oil on canvas, 44.5 x 54.6 cm

Signed bottom right: JR (in monogram).
There are two larger versions of the composition (Berlin, Staatliche Museen, and Dresden, Gemäldegalerie).
The attribution of NG 991 to Jacob van Ruisdael has in the past been questioned.

Perhaps in the collection of Wynn Ellis by 1850/1; Wynn Ellis Bequest, 1876.

Rosenberg 1928, p. 98, no. 411; MacLaren/Brown 1991, pp. 390–1.

Signed bottom left: vR (in monogram).
Formerly catalogued as by a follower of Jacob van Ruisdael, NG 2563 is now considered to be autograph. The figures were painted on top of the landscape and have been attributed to another artist, but are probably the work of Ruisdael himself.

Collection of the Duc de Choiseul by 1770; collection of William Theobald by 1842; Salting Bequest, 1910.

Rosenberg 1928, p. 92, no. 322; MacLaren/Brown 1991, pp. 394–5.

Signed bottom right: JvRuiſdael (JvR in monogram).
None of Ruisdael's seascapes is dated and there is little agreement about their chronology, but NG 2567 was probably painted in the early 1660s. It can be compared with a *View of the IJ on a Stormy Day* (Worcester, Mass., Museum of Fine Arts).

Sold by Gritten in 1841 and in the collection of William Theobald by 1842; collection of George Salting, 1876; Salting Bequest, 1910.

Rosenberg 1928, p. 109, no. 590; MacLaren/Brown 1991, p. 397.

Jacob van RUISDAEL
A Waterfall in a Rocky Landscape
probably 1660–70

NG 627
Oil on canvas, 98.5 x 85 cm

Falsely signed left: J Ruysdael f (JR in monogram).

Although the signature was apparently added later, NG 627 is by Jacob van Ruisdael. Ruisdael painted many waterfalls from the late 1650s onwards: they were inspired by those painted by the Amsterdam landscape painter Allart van Everdingen, who had visited Scandinavia in 1644 and made a number of drawings of rocky mountainous scenes with torrents and waterfalls.

In the collection of Graf Friedrich Moritz von Brabeck in Söder, near Hildesheim, by 1792; bought, 1859.

Rosenberg 1928, p. 83, no. 182; MacLaren/Brown 1991, pp. 380–1.

Jacob van RUISDAEL
A Landscape with a Waterfall and a Castle on a Hill, probably 1660–70

NG 737
Oil on canvas, 101 x 86 cm

Signed bottom left: vRuiſdael (vR in monogram).

This picture probably dates from the 1660s when Ruisdael was living in Amsterdam. It was first recorded in an Amsterdam collection in the nineteenth century.

Collection of Joannes Meynders, Amsterdam, by 1838; collection of Johann Moritz Oppenheim, London, by 1842; by whom bequeathed, 1864.

Rosenberg 1928, p. 83, no. 183; MacLaren/Brown 1991, p. 381.

Jacob van RUISDAEL
A Pool surrounded by Trees, and Two Sportsmen coursing a Hare, about 1665

NG 854
Oil on canvas, 107.5 x 143 cm

Signed bottom left: JvRuiſdael (JvR in monogram).

Two huntsmen and their dogs can be seen coursing a hare in the centre of this forest landscape. Two silver birches, one fallen and one upright, dominate the right foreground.

There are a number of forest landscapes of this type by Jacob van Ruisdael. One of these (*Wooded Landscape with a Pool*, Ashbourne, Derbyshire, Clowes collection) has the first three digits of a date in the 1660s ('166'), and because of its similarity to that painting NG 854 has been dated about 1665.

Many works of Ruisdael's maturity strike a melancholy note, which might be apparent here in the mood of gradual death and decay. It has been suggested that this theme might reflect the views on human mortality held by the Mennonites, a Calvinist sect of which Ruisdael was a member.

Miss Fanshaw sale, London, 1835; bought by Sir Robert Peel, Bt, 1843; bought with the Peel collection, 1871.

Rosenberg 1928, p. 91, no. 320; MacLaren/Brown 1991, pp. 382–3.

Jacob van RUISDAEL
A Waterfall at the Foot of a Hill, near a Village
probably 1665–70

Jacob van RUISDAEL
A Torrent in a Mountainous Landscape
about 1665–70

Jacob van RUISDAEL
A Landscape with a Ruined Castle and a Church
about 1665–70

NG 855
Oil on canvas, 84.8 x 100 cm

NG 987
Oil on canvas, 122 x 130 cm

NG 990
Oil (identified) on canvas, 109 x 146 cm

On the hill is the spire of a village church, and other buildings. To the left sheep are being herded across a wooden bridge over a ravine.

NG 855 has been dated on grounds of style to the second half of the 1660s, when Jacob van Ruisdael was living in Amsterdam.

Josephus Augustinus Brentano sale, Amsterdam, 1822; collection of Lord Charles Townshend by 1824; collection of Sir Robert Peel, Bt, by 1835; bought with the Peel collection, 1871.

Rosenberg 1928, p. 83, no. 184; MacLaren/Brown 1991, p. 383.

Signed bottom left: JvR (JvR in monogram).

Although signed and traditionally ascribed to Ruisdael, NG 987 has also been attributed to Johan van Kessel (1641/2 - 1680), who was probably a pupil of Ruisdael. The painting is in fact by Ruisdael himself, and the signature authentic. It is very similar to other waterfalls by Ruisdael of the late 1660s.

Collection of J.A.A. de Lelie, Amsterdam, by 1842; collection of Wynn Ellis by 1859; Wynn Ellis Bequest, 1876.

Rosenberg 1928, p. 83, no. 185; MacLaren/Brown 1991, pp. 385–6.

Signed in the water bottom right: JvRuiJdael (JvR in monogram).

There are at least four other landscapes by Ruisdael that show the same view or part of it. They were said in nineteenth-century catalogues to be views near Haarlem – and one was described in this way as early as 1761. It has been suggested that the church in the centre is that of Beverwijk (St Agatha), about seven miles north of Haarlem. In fact that church had a differently shaped tower, and it seems that, although the view is loosely based on the area around Haarlem, Ruisdael is not attempting topographical accuracy.

The two shepherds and their flock in the left foreground were painted by Adriaen van de Velde. This picture has been dated on the basis of style to the late 1660s; it must have been painted before Adriaen van de Velde's death in 1672. NG 2561 is a variant of NG 990.

Probably in the Jan Gildemeester Jansz. sale, Amsterdam, 1800; collection of Richard Abraham, 1828; Wynn Ellis collection by 1854 (apparently by 1851); Wynn Ellis Bequest, 1876.

Rosenberg 1928, p. 74, no. 24; MacLaren/Brown 1991, pp. 387–90.

Jacob van RUISDAEL
An Extensive Landscape with Ruins
probably 1665–75

NG 2561
Oil on canvas, excluding the false additions on either side 34 x 40 cm

Jacob van RUISDAEL
Three Watermills with Washerwomen
about 1670

NG 989
Oil on canvas, 60 x 74 cm

Jacob van RUISDAEL
The Shore at Egmond-aan-Zee
about 1675

NG 1390
Oil on canvas, 53.7 x 66.2 cm

Signed in the centre foreground: JvR (in monogram).
NG 2561 is a smaller variant of NG 990. Three other pictures by Jacob van Ruisdael show the same view and these were described in the nineteenth century (and in one instance in 1761) as showing a view near Haarlem. In fact, although the composition was loosely based on the countryside near Haarlem, Ruisdael was not attempting topographical accuracy.

Probably in the collection of Edward Wright Anderson by 1864; in the collection of George Salting by 1904; Salting Bequest, 1910.

Rosenberg 1928, p. 74, nos. 25 and 26; MacLaren/Brown 1991, pp. 392–3.

Signed, probably falsely, bottom right: J R.
The same watermills occur in another picture by Jacob van Ruisdael (formerly New York, S. Borchard collection). The attribution of NG 989 to Ruisdael has been doubted but it is an autograph, rather worn painting that dates from about 1670.

Coclers sale, Paris, 1789; imported into Britain by Chaplin, 1836; Wynn Ellis Bequest, 1876.

Rosenberg 1928, p. 78, no. 101; MacLaren/Brown 1991, p. 387.

Signed bottom right: JvRui∫dael (JvR in monogram).
Egmond-aan-Zee is on the North Sea, to the west of Alkmaar. In the distance on the right is the tower of the church at Egmond (which was engulfed by the sea in 1743 but can be identified from old engravings).
NG 1390 was probably painted in about 1675, and may have been the companion piece of the *Coast near Muiden* (Sussex, Polesden Lacey). The figures in NG 1390 were probably painted by Gerrit van Battem (1636–84).

Collection of the Duc de Choiseul by 1772; bought at the Choiseul sale, Paris, April 1772 by Boileau; Prince de Conti sale, Paris, April 1777; collection of the Marquis de Marigny by 1781; collection of Baron J.G. Verstolk van Soelen, The Hague, by 1835; bought in 1846 by Humphrey St John Mildmay; bought at the Henry Bingham Mildmay sale, London, 24 June 1893.

Rosenberg 1928, p. 108, no. 570; MacLaren/Brown 1991, p. 391–2.

Follower of van RUISDAEL
The Skirts of a Forest
probably 1650–1700

NG 2566
Oil on canvas, 57.5 x 70.5 cm

Falsely signed bottom right: JRuysdael f. (JR in monogram).

NG 2566 was painted by a contemporary, or near contemporary, follower or imitator of Jacob van Ruisdael.

Possibly in the collection of the 3rd Duke of Dorset by 1770; Salting Bequest, 1910.

Rosenberg 1928, p. 92, no. 324; MacLaren/Brown 1991, p. 398.

Imitator of van RUISDAEL
A Castle on a Hill by a River
probably 1650–1700

NG 996
Oil on canvas, 140 x 176 cm

Falsely signed and dated bottom right: MHobbem() 16() (MH linked; the third figure of the date is possibly a 5).

NG 996 may be based on a lost work by Ruisdael showing Bentheim Castle on the German/ Netherlandish border. The viewpoint is different from any of the known paintings of this subject by Ruisdael.

NG 996 is by a seventeenth-century Dutch imitator of Ruisdael. It has recently been suggested that it is an early work by Ruisdael's follower, Johan van Kessel (1641–80).

Collection of Edmund Higginson by 1842; Wynn Ellis bequest, 1876.

MacLaren/Brown 1991, pp. 398–9; Davies 1992, pp. 120–1, no. 12.

Rachel RUYSCH
Flowers in a Vase
about 1685

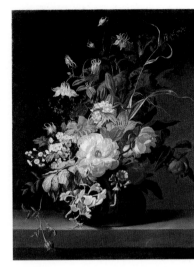

NG 6425
Oil on canvas, 57 x 43.5 cm

Signed on the ledge lower right: Rachel Ruysch.
Caterpillars and other insects are depicted on the flowers, vase and ledge.

NG 6425 is thought to be a relatively early work by the artist.

Bequeathed by Alan Evans, 1974.

MacLaren/Brown 1991, p. 399.

Rachel RUYSCH
1664–1750

Ruysch, who specialised in painting flower still lifes, was born in Amsterdam. She was a pupil of the Delft painter Willem van Aelst. She married the portraitist Juriaan Pool in 1693 and they both joined The Hague guild in 1701. She became court painter to the Elector Palatine Johan Wilhelm (1708–16), and visited his court in Düsseldorf (1710–13).

Jacob Salomonsz. van RUYSDAEL
A Waterfall by a Cottage in a Hilly Landscape
about 1650–81

Salomon van RUYSDAEL
A River with Fishermen drawing a Net
1630–5

Salomon van RUYSDAEL
A River Landscape with Fishermen
1631

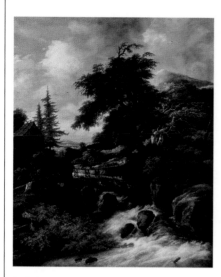

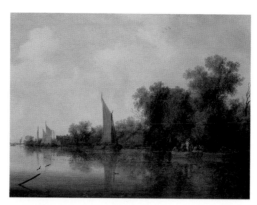

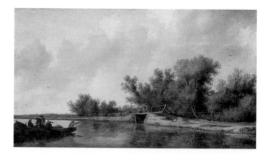

NG 1439
Oil on oak, 36.6 x 65.5 cm

NG 5846
Oil on oak, 46.3 x 62.8 cm

NG 628
Oil on canvas, 103.5 x 86.9 cm

Signed below the cottage at the left: Ruyſdael (the first letter is possibly intended for vR in monogram).
　Cattle are herded across the bridge towards the cottage.
　NG 628 has in the past been attributed to Jacob Isaacksz. van Ruisdael, but its quality suggested that it could not be his. It can, however, be linked with works by Jacob Salomonsz., and the signature is comparable to documents signed by the latter.

Graf Friedrich Mortitz von Brabek in Söder, near Hildesheim (Hanover), by 1792; passed to Graf Andreas von Stolberg after 1814; bought, 1859.

MacLaren/Brown 1991, pp. 400–1.

The painting is dated to the early 1630s owing to its similarity to pictures such as *A River Landscape with Fishermen* (NG 1439), which is dated 1631.

Collection of Arthur James by 1908; bequeathed by Mrs Mary Venetia James, 1948.

Stechow 1975, p. 145; MacLaren/Brown 1991, p. 403.

Signed and dated bottom left below the boat: S. vR 1631 (vR in monogram).
　Examination by infra-red reflectography has revealed extensive underdrawing in charcoal or black chalk beneath the trees, cottage and footbridge. The boat and figures were not drawn at this stage.

Collection of the Revd Chauncey Hare Townsend by 1857; on loan from the Victoria and Albert Museum since 1895.

Stechow 1975, pp. 135–6; Brown 1988, p. 156; MacLaren/Brown 1991, pp. 402–3.

Jacob Salomonsz. van RUYSDAEL
1629/30–1681

The artist, who was born in Haarlem, was the son of Salomon van Ruysdael and cousin of Jacob Isaacksz. van Ruisdael. He first worked in Haarlem, but by 1666 had settled in Amsterdam. Later he returned to Haarlem, where he died insane. His woody landscapes are dependent stylistically on the later works of his father and his waterfalls were painted in imitation of his cousin Jacob.

Salomon van RUYSDAEL
1600/3?–1670

Born in Naarden in Gooiland, the artist joined the guild in Haarlem in 1623. He worked there throughout his life, and was influenced by Esaias van de Velde and Jan van Goyen. He painted landscapes, seascapes and still lifes. He was the father of Jacob Salomonsz. van Ruysdael and uncle of Jacob Isaacsz. van Ruisdael.

Salomon van RUYSDAEL
River Scene
1632

NG 6419
Oil on wood, 51.5 x 96.5 cm

Salomon van RUYSDAEL
A View of Rhenen seen from the West
1648

NG 6348
Oil on wood, 30.5 x 41.3 cm

Salomon van RUYSDAEL
A View of Deventer seen from the North-West
1657

NG 6338
Oil on wood, 51.8 x 76.5 cm

Signed and dated, on a barrel, bottom left: SvR/1632 (vR in monogram).

The site is unidentified.

Salomon van Ruysdael painted a number of river landscapes in the early 1630s that display the influence of Jan van Goyen. NG 1439 is another example of this early phase of his work.

Collection of Miss I.E.H. Cuming Butler before 1929; by whom bequeathed, 1972.

Stechow 1975, p. 136; MacLaren/Brown 1991, p. 405.

Signed and dated left foreground: S.VR. 1648 (VR linked).

The river in the foreground is the Rhine. On the left bank cattle stand and drink, while on the right are close-hauled sailing vessels. On the horizon can be seen the town of Rhenen in the province of Utrecht, dominated by the tower of the Cunerakerk, in front of which is the Koningshuis.

Some of the architectural details such as the tower of the Cunerakerk are imprecisely defined. The artist painted Rhenen on two other occasions (Malibu, Getty Museum; Merion, Pennsylvania, Barnes Foundation Museum of Art).

Collection of David Hart, about 1850; bequeathed by Nicholas A. Argenti with a life interest to Mrs Argenti, 1963.

Stechow 1975, p. 149; MacLaren/Brown 1991, pp. 404–5.

Signed and dated on the boat nearest the viewer in the foreground: SVR. 1657 (VR linked).

The town of Deventer in the province of Overijssel can be seen in the distance, across the river Ijssel. Although this depiction is not topographically accurate, a number of the buildings on the skyline can be identified: (from left to right) the Noordenbergtoren, the double-spired Bergh Kerk (St Nicholas), the Grote Kerk (St Lebuinus) with the Maria Kerk in front of it, and the Vispoort. At the right Dutch sailing vessels navigate the river, while at the left five men in two rowing boats draw up a net. Behind them cattle can be seen drinking at the water's edge.

Two other views of Deventer by Ruysdael are recorded. In this work a pentimento is visible by the spire of the Grote Kerk.

Collection of F. Kleinberger before 1910; presented by William Edward Brandt, Henry Augustus Brandt, Walter Augustus Brandt and Alice Mary Bleecker in memory of Rudolph Ernst Brandt, 1962.

Stechow 1975, p. 112; MacLaren/Brown 1991, pp. 403–4.

Salomon van RUYSDAEL
A Landscape with a Carriage and Horsemen at a Pool, 1659

NG 1344
Oil on oak, 49.9 x 63.3 cm

Andrea SACCHI
Saints Anthony Abbot and Francis of Assisi
before 1627

NG 6382
Oil on canvas, 61 x 78 cm

Pier Francesco SACCHI
Saint Paul Writing
early 16th century

NG 3944
Oil on poplar, 106 x 81.9 cm

Signed and dated at the bottom edge, right of centre: SVRvySDAEL/1659 (SVR in monogram).

This is a relatively late work by Salomon van Ruysdael, painted in the fluent and assured style of his maturity. Unlike *A River Landscape with Fishermen* (NG 1439) it contains no preparatory underdrawing.

Collection of Edward Habich, Cassel, by 1881; bought, 1891.

Stechow 1975, p. 106; MacLaren/Brown 1991, p. 402.

Lower left: 40. Bottom right: 18(?)9. (remains of old inventory numbers).

Saint Anthony on the left reads a book and in his right hand holds his tau-shaped stick. Saint Francis crosses his hands before him and looks heavenwards. The stigmata can be seen on his hands.

The painting is dated early by comparison with other works by Sacchi such as an altarpiece of 1623–4 (Nettuno, S. Francesco). A picture answering its description is recorded in a Barberini inventory of about 1738. The picture may have been executed as a pendant to Bernini's *Saints Andrew and Thomas* (NG 6381) which was in the Barberini collection by 1627. However, the fact that a painting of Saints Francis and Anthony was described in Sacchi's possession at his death, suggests that it was acquired later by the Barberini.

Possibly collection of Cardinal Carlo Barberini, 1692; presented by Messrs P. and D. Colnaghi, 1967.

Levey 1971, pp. 205–6; Harris 1977, pp. 51–2.

The words written by the saint, inscribed in Greek, are: 'Charity suffereth long, and is kind; charity envieth not; charity vaunteth not itself, is not puffed up.' New Testament (I Corinthians 13: 4).

Saint Paul's attribute, the sword, rests by his desk, as he contemplates the crucifix and writes.

NG 3944 is very similar in style and character to the *Four Doctors of the Church* (Paris, Louvre), which is signed by the artist and dated to 1516.

In the possession of Domenico Odone, Genoa, 1857; Mond Bequest, 1924.

Gould 1975, pp. 229–30.

Andrea SACCHI
1599/1600–1661

Sacchi was probably born in Nettuno, near Rome; he studied under Albani in Bologna and settled in Rome in about 1621. From 1629 he worked for Cardinal Antonio Barberini. He travelled to northern Italy in the late 1630s and to Paris in 1640. In Rome he was a member of the Accademia di San Luca and taught Carlo Maratta.

Pier Francesco SACCHI
about 1485–1528

Sacchi had settled in Genoa by 1501 when he was apprenticed to Pantaleo Berengerio. He was then said to be about sixteen. Few works can confidently be attributed to him. Several of his paintings are inscribed 'de Papia' in addition to his name, indicating that he came from Pavia.

Pieter SAENREDAM
The Interior of the Grote Kerk at Haarlem
1636–7

NG 2531
Oil on oak, 59.5 x 81.7 cm

Pieter SAENREDAM
The Interior of the Buurkerk at Utrecht
1644

NG 1896
Oil on oak, 60.1 x 50.1 cm

Herman SAFTLEVEN
Christ teaching from Saint Peter's Boat on the Lake of Gennesaret, 1667

NG 2062
Oil on oak, 46.7 x 62.8 cm

The Grote Kerk is here seen from the north side of the choir, a little to the east of the north transept. In the distance on the right is part of the south aisle, on the wall of which, between the pew and a column, can be seen part of a painting of the exterior of the church, which is still there (see Berckheyde NG 1451). The artist has taken some liberties with the architecture, but the interior is seen more or less in the state in which it remains.

A preliminary drawing for NG 2531 in the Haarlem municipal archives is inscribed by Saenredam: '29 May 1636, this drawing finished by me ... in the Grote Kerk at Haarlem, from the life.' The cartoon from which the design was transferred to the panel, which is in the same collection, is inscribed: 'This composition was drawn in the Grote Kerk at Haarlem and finished on 21 November 1636 and finished painting, the same size, at the beginning of May, 1637.' Saenredam did not make replicas of his paintings, so the picture referred to in the second inscription must be NG 2531.

The collection of Arthur Kay, Glasgow; in the sale of pictures belonging to Revon (Château de Dampierre), F.E. Lintz (The Hague) and others, Amsterdam, 27 April 1909 (lot 143); Salting Bequest, 1910.

MacLaren/Brown 1991, pp. 408–9.

Inscribed on the right pier: de buer kerck binnen utrecht/aldus geſchildert int iaer 1644 /van/ Pieter Saenredam.

This view shows the interior of the Buurkerk from the door in the north side, looking south-west. Hanging on a column in the centre background is a guild board. In the recess of the pier on the right are the Tables of the Commandments, above which appear the head and shoulders of Moses. Higher on the same pier are a sword and shield, and at the bottom of it a drawing in red of an episode from the popular thirteenth-century French story of the four sons of Aymon of Dordogne. They are shown escaping on their magic horse Bayard, after one of them, Renaud, killed Charlemagne's nephew. To the right of this is a sketch of a woman.

A drawing by Saenredam (Utrecht, Municipal Archives) dated 16 August 1636 shows the interior from the same viewpoint. NG 1896 corresponds with the right half of it. A painting corresponding to the left half of the drawing, which is the same size as NG 1896, is in Fort Worth (Kimbell Art Museum). It is signed and dated 1645.

Said to have been in the 'van der Pott' (Pot ?) collection, Rotterdam; all or part of this collection was bought in 1824 or 1825 by Charles Galli and taken to Edinburgh; bought by Arthur Kay, Glasgow, probably 1896; by whom presented, 1902.

MacLaren/Brown 1991, pp. 406–8.

Inscribed bottom left on a rock: HS/1667 (HS in monogram).

'And he entered into one of the ships, which was Simon's, and prayed him that he would thrust out a little from the land. And he sat down, and taught the people out of the ship.' New Testament (Luke 5: 1–3).

The same subject was treated by the artist in a work of the previous year (Edinburgh, National Gallery of Scotland).

Lt.-Col. Walter R. Tyrell sale, 1892; presented by Charles Lock Eastlake, 1906.

Schulz 1982, no. 149; MacLaren/Brown 1991, p. 410.

Pieter SAENREDAM
1597–1665

Saenredam was a painter of church interiors and topographical views. He was born in Assendelft and in 1622 became a pupil of Frans Pietersz. de Grebber in Haarlem, entering the guild there in 1623. Saenredam's earliest dated painting is *The Expulsion from the Temple* (Copenhagen, Statens Museum for Kunst) of 1626. He made detailed drawings of churches which he then used as the basis for his precise and luminous paintings.

Herman SAFTLEVEN
1609–1685

Herman Hermansz. Saftleven was born in Rotterdam. By 1633 he had settled in Utrecht, where he was to remain, apart from travels in the Rhineland. The artist, who worked for the House of Orange, developed a landscape painting technique based upon the precise, miniaturistic handling of the Flemish followers of Jan Brueghel the Elder.

Gabriel-Jacques de SAINT-AUBIN
A Street Show in Paris
1760

Giuseppe SALVIATI
Justice
probably about 1559

Giovanni SANTI
The Virgin and Child
perhaps about 1488

NG 3942
Oil on canvas, excluding later additions
87 x 104.8 cm

NG 2129
Oil on canvas, 80 x 64.1 cm

NG 751
Egg and oil (identified) on wood, 68 x 49.8 cm

A mock duel is enacted on the stage.
 An etching by Duclos of NG 2129 gives the painter and the date, 1760. A picture of approximately the same size, *La Réunion du Boulevard* in Perpignan, may have been intended as a pendant.

In the collection of Francis Baring; his sale, 1907; bought (Lewis Fund), 1907.

Davies 1957, p. 206; Wilson 1985, p. 114.

An allegorical figure of Justice is shown with her traditional attributes of a sword and scales. She holds the coat of arms of the Contarini family (see below), and is accompanied by two lions, symbolising Venice.
 NG 3942 was said to have come from the Zecca (Mint) in Venice, and there is circumstantial evidence to support the claim, although it is not mentioned in early guidebooks. The coat of arms on the left has been identified as that of a branch of the Contarini family, who were prominent in Venetian government circles. Two members of the Contarini family held the post of *Provveditore in Zecca* (Officer for the Mint) in 1542–3 and 1558–9. Stylistically the later date is more probable and NG 3942 may therefore have been commissioned by Paolo Contarini to commemorate his period in office.
 NG 3942 was extended all round prior to 1808. The extension includes most of the lion on the left and the darker area either end of the crescent moon.

Sent to Milan, 1808; Cavendish Bentinck collection before 1891; bought by Richter for Ludwig Mond; Mond Bequest, 1924.

Gould 1975, pp. 231–2; McTavish 1981, pp. 272–3.

The Virgin supports the Child Jesus who is sleeping on a parapet in the foreground. He wears a coral necklace. Curtains appear to have been drawn back to reveal a cloth of honour and a distant landscape.
 The attribution of NG 751 to Giovanni Santi is generally accepted, and the picture has been tentatively dated to about 1488, relatively late in his career.
 Fischel noticed that the sleeping Child seems to derive from a *Virgin and Child* of Giovanni Bellini's middle period (Boston, Isabella Stewart Gardner Museum) and that the motif was also drawn from memory by Giovanni Santi's son Raphael (Oxford, Ashmolean).

Collection of Count Mazza, Ferrara, by 1864; bought, 1865.

Fischel 1939, p. 51; Davies 1961, pp. 463–4; Dubos 1971, p. 118.

Gabriel-Jacques de SAINT-AUBIN
1724–1780

Saint-Aubin lived and died in Paris. He studied at the Académie under Jeaurat and Boucher. He made relatively few paintings and is best known for engravings, and for drawings, especially those he made on the catalogues of the Salon exhibitions which he visited.

Giuseppe SALVIATI
active 1535 to 1573

Giuseppe Porta took the name Salviati from his master, Francesco Salviati, whose pupil he became in 1535 in Rome. He settled in Venice in 1539 and was famous for his paintings on the façades of numerous buildings (now destroyed). He also painted altarpieces for many churches and canvases for several civic buildings in Venice.

Giovanni SANTI
active 1469–1494

Giovanni Santi was active mainly in Urbino, partly for the Montefeltro court, and he also worked in Perugia, Fano and perhaps in Mantua (he painted Isabella d'Este's portrait). He was influenced by Melozzo, and admired Mantegna. He was a poet and chronicler as well as a painter. He was the father of Raphael.

Dirck SANTVOORT
Portrait of Geertruyt Spiegel with a Finch
1639

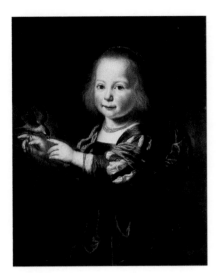

NG 3154
Oil on oak, 62.7 x 50 cm

Signed and dated, top right: D. D. Santvoort fe / 1639. (There is some damage in the area of the date but the last digit can be read in infra-red photographs as a 9.)

The girl has recently been identified as Geertruyt Spiegel, who was born in Amsterdam in October 1635, the daughter of Elbert Dircksz. Spiegel and Petronella Roeters. The couple had five daughters and commissioned portraits of them in the guise of the five senses from Santvoort. Geertruyt is shown with a finch on her hand as a representation of the sense of Touch.

The portraits of the other four daughters are in museums in Cleveland and Rodez and in private collections.

Presented by Tilson Lee, 1916.

Ekkart 1990, pp. 249–55; MacLaren/Brown 1991, p. 411.

Philip van SANTVOORT
The Rape of Tamar by Amnon
after 1718

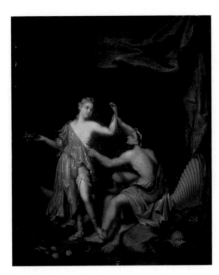

NG 3404
Oil on oak, 59.8 x 49.4 cm

Signed and dated: P V Santvoirt[?].fc[?]:17[?] (.) (.) (PV and fc(?) in monogram).

Amnon, one of King David's sons, fell in love with his sister, Tamar. He pretended to be ill and insisted that she be brought to him to prepare food, and then raped her. Old Testament (2 Samuel 13: 1–14).

NG 3404 has in the past been attributed to the Dutch sculptor Jan van Santvort, but a correct reading of the signature now means that the work is recognised as a painting by Philip van Santvoort. The last two digits of the date are obliterated.

Presented by Augustine Sargent, 1919.

Martin 1970, pp. 235–6.

Carlo SARACENI
Moses defending the Daughters of Jethro
1609–10

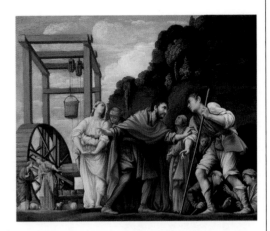

NG 6446
Oil on copper, 28.5 x 35.3 cm

Having fled from Egypt Moses rested by a well in the land of Midian. As he sat there the daughters of Jethro, priest of Midian, came to water their sheep. Shepherds approached to drive the women away but Moses rose to their defence and watered their sheep himself. Old Testament (Exodus 2: 16–19).

NG 6446 is thought to have been painted when the artist was in Rome and particularly influenced by the works of Elsheimer.

Bequeathed by Benedict Nicolson, 1978.

Helston 1983, p. 78.

Dirck SANTVOORT
1610/11–1680

Dirck Santvoort was born in Amsterdam, where he was active as a portrait painter and where he died. His portraits sometimes show the influence of Rembrandt, but are predominantly influenced by Cornelis van der Voort and Nicolaes Eliasz.

Philip van SANTVOORT
active from about 1711/12

Philip van Santvoort was a history painter, and is recorded as a pupil of G. J. van Opstal in the records of the Antwerp Guild of St Luke for 1711/12. He became an independent master in the city in 1720/1, and it has been suggested that he may have travelled to Poland.

Carlo SARACENI
1579–1620

Saraceni was a Venetian who was resident in Rome from 1598 until 1613. While there he was particularly influenced by the works of Elsheimer and Caravaggio. He was associated with French artists and at the end of his life was assisted by Jean Le Clerc, a painter from Nancy.

John Singer SARGENT
Lord Ribblesdale
1902

Andrea del SARTO
The Madonna and Child with Saint Elizabeth and Saint John the Baptist, about 1513

Andrea del SARTO
Portrait of a Young Man
about 1517–18

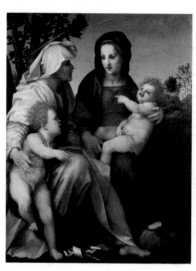

NG 3044
Oil on canvas, 258.5 x 143.5 cm

NG 17
Oil on wood, 106 x 81.3 cm

NG 690
Oil on linen, 72.4 x 57.2 cm

Signed and dated bottom right: John Sargent 1902
Thomas Lister (1854–1925), 4th Baron Ribblesdale, is shown in hunting clothes. He had been Master of the Buckhounds from 1892 to 1895, and was a Trustee of the National Gallery from 1909 until his death.

Presented by Lord Ribblesdale in memory of Lady Ribblesdale and his sons, Captain the Hon. Thomas Lister and Lieutenant the Hon. Charles Lister, 1916.

Chamot 1964, II, p. 590.

Inscribed on the scroll lower centre: EC[CE] [A]GN[US DEI] (Behold the Lamb of God).
NG 17 appears to be a variant of a signed picture in St Petersburg (Hermitage), which differs by the inclusion on the right of Saint Catherine. Dating of both pictures has fluctuated, but a date of about 1513 is probable.
The pentimenti in NG 17 (e.g. Saint Elizabeth's hand) have led to the suggestion that the picture preceded the St Petersburg version. However, they are more explicable as changes made on a workshop variant of that picture produced under the supervision, and possibly with the involvement, of Sarto. There is a sixteenth-century copy of the St Petersburg picture in the Royal Collection.

Villa Aldobrandini, Rome, by 1626 (and probably by 1603); bought from the Aldobrandini collection, 1805, by Irvine, for Buchanan; Holwell Carr collection by 1816; Holwell Carr Bequest, 1831.

Shearman 1965, II, pp. 214–15; Gould 1975, pp. 233–4; Cecchi 1989, p. 56.

Signed top left with the artist's monogram of two entwined As (for Andrea d'Agnolo).
The sitter in NG 690 has not been securely identified. He was formerly thought to represent a sculptor, holding a block of stone, but the object in his hands is much more likely to be a book. It has been suggested on the basis of the provenance (see below) that it might be a portrait of Giovan Battista Puccini (born 1463), who is known to have been a patron of Andrea del Sarto on other occasions. However, Puccini would have been 54 in 1517, and the sitter appears to be a younger man. More recently he has tentatively been identified as Paolo da Terrarossa, another patron of Sarto, whose family was involved in the manufacture of bricks (a novel identification of the object held by this man).
NG 690 has been dated on grounds of style to about 1517–18. It has been suggested that two red chalk drawings (Florence, Uffizi) were made in preparation for the portrait.
It has sometimes been suggested that NG 690 has probably been transferred from panel, but there is no technical evidence to support this claim.

Palazzo Puccini, Pistoia, by 1821; bought, 1862.

Shearman 1965, II, pp. 237–8; Gould 1975, pp. 234–5; Chiarini 1986, pp. 221–3; Cecchi 1989, p. 78; Campbell 1990, pp. 80, 105.

John Singer SARGENT
1856–1925

Born in Florence of American parents, Sargent spent most of his life in Europe. He studied painting in Italy and then from 1874 with Carolus-Duran in Paris. He later became a friend of Monet and was a landscape painter as well as a society portraitist and mural painter.

Andrea del SARTO
1486–1530

Andrea d'Agnolo (called del Sarto from his father who was a tailor) was one of the leading Florentine painters of the early sixteenth century. His work, consisting of altarpieces, frescoes, small religious paintings and occasional portraits, was largely produced in Florence, but the artist also worked briefly for Francis I at Fontainebleau in 1518/19, and visited Rome in 1520.

SASSETTA
Saint Francis giving away his Clothes and Saint Francis Dreaming, 1437–44

SASSETTA
Saint Francis renounces his Earthly Father
1437–44

SASSETTA
The Pope accords Recognition to the Franciscan Order (?), 1437–44

NG 4757
Egg (identified) on poplar, 87 x 52.5 cm

On the left Saint Francis gives his clothes to an impoverished knight. That night he dreamt of a palace adorned with military banners, and thought that he would follow a military career, until a voice explained that the vision concerned a spiritual army (i.e. the order which Francis was to found). This episode from the Life of Saint Francis of Assisi (about 1181–1226, founder of the Franciscan Order) probably follows the account in Saint Bonaventure's life of Saint Francis called the *Legenda Maior*.

NG 4757–63 are parts of the high altarpiece of S. Francesco, Borgo Sansepolcro, commissioned from Sassetta in 1437 for 510 florins, painted in Siena, and delivered in 1444. The altarpiece was a double-sided polyptych. Other panels survive (principally Paris, Louvre; Settignano, Berenson Collection; Chantilly, Musée Condé) and tentative reconstructions have been advanced. *The Virgin and Child with Saints* was painted on the front, while eight panels with stories from the life of Saint Francis were arranged in two tiers on the reverse on either side of *Saint Francis in Glory* (facing the friars who sat in the choir). NG 4757 was on the reverse, probably in the top-left corner, with the narrative sequence continuing to the bottom right (NG 4763).

Collection of Abate Angelucci, Arezzo, by 1819; bought with contributions from the NACF, Benjamin Guinness and Lord Bearsted, 1934.

Davies 1961, pp. 502–12, 568–70; Banker 1991, pp. 11–58; Dunkerton 1991, pp. 262–4, 400.

NG 4758
Tempera on poplar, 87.5 x 52.5 cm

Saint Francis throws off his clothes, and accepts the protection of a bishop, rejecting his inheritance to be received naked by the Church. His father displays his anger outside. This episode from the life of Saint Francis of Assisi (about 1181–1226, founder of the Franciscan Order) probably follows Saint Bonaventure's *Legenda Maior*.

NG 4757–63 come from the back of the double-sided high altarpiece of S. Francesco, Borgo Sansepolcro, showing eight scenes from the life of Saint Francis tiered in pairs on either side of *Saint Francis in Glory* (Settignano, Berenson Collection). NG 4758 was probably second from the left in the top tier of the reverse immediately adjacent to NG 4757; for further details on the altarpiece see under NG 4757.

The commission is unusually fully documented from the first contract to the delivery of the altarpiece in 1444, particularly the extent to which the friars controlled the subject matter, details of which were agreed with the painter in 1439.

Collection of Abate Angelucci, Arezzo, by 1819; bought with contributions from the NACF, Benjamin Guinness and Lord Bearsted, 1934.

Davies 1961, pp. 503–12, 568–70; Banker 1991, pp. 11–58; Dunkerton 1991, pp. 262–4, 400.

NG 4759
Tempera on poplar, 87.5 x 52 cm

Pope Innocent III blesses Saint Francis and grants his order the right to preach. The saint is now dressed in his characteristic habit and wears the narrow tonsure sanctioned by Pope Innocent. This episode from the life of Saint Francis of Assisi (about 1181–1226, founder of the Franciscan Order) probably follows Saint Bonaventure's *Legenda Maior*. It is also possible that this scene represents the Granting of Indulgence of the Portiuncula as requested by the friars in a document of 1439.

NG 4757–63 come from the back of the double-sided high altarpiece of S. Francesco, Borgo Sansepolcro, showing eight scenes from the life of Saint Francis tiered in pairs on either side of *Saint Francis in Glory* (Settignano, Berenson Collection). NG 4759 was probably in the bottom left corner of the reverse. It is debated whether, in the scheme accepted here, the next panel was the *Stigmatisation* (NG 4760) or *Saint Francis' Mystic Marriage with Poverty* (Chantilly, Musée Condé). For further details on the altarpiece see under NG 4757.

Collection of Abate Angelucci, Arezzo, by 1819; bought with contributions from the NACF, Benjamin Guinness and Lord Bearsted, 1934.

Davies 1961, pp. 503–12, 568–70; Banker 1991, pp. 11–58; Dunkerton 1991, pp. 262–4, 400.

SASSETTA
1392?–1450

Known as Sassetta since the eighteenth century, Stefano di Giovanni was the most important artist in fifteenth-century Siena, where he probably trained with Benedetto di Bindo and where he was inscribed with the guild of painters before 1428. He designed stained glass and inlaid floors, as well as painting banners, frescoes and panel paintings, including an outstanding altarpiece for the Arte della Lana (guild of wool merchants) in 1423–6.

SASSETTA
The Stigmatisation of Saint Francis
1437–44

SASSETTA
Saint Francis bears Witness to the Christian Faith before the Sultan, 1437–44

SASSETTA
The Legend of the Wolf of Gubbio
1437–44

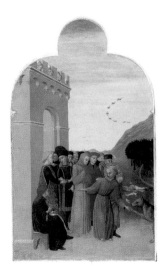

NG 4760
Tempera on poplar, 87.5 x 52.5 cm

NG 4761
Tempera on poplar, 86.5 x 53.5 cm

NG 4762
Tempera on poplar, 86.5 x 52 cm

While in a retreat at La Verna in 1224, Saint Francis saw 'a Seraph [one of the orders of angels] with six wings, flaming and resplendent, descending from Heaven. There appeared between his wings the image of a Crucified Man ... [and] immediately the marks of the nails began to appear in his hands and his feet.' Saint Francis receives the stigmata, the marks of Christ's wounds which remained with him until his death. This was perhaps the most important episode from the life of Saint Francis of Assisi (about 1181–1226, founder of the Franciscan Order). NG 4760 probably follows the account in Saint Bonaventure's *Legenda Maior*. Saint Francis was sometimes considered a 'second Christ'. Brother Leo was not in fact present although, as here, he is often shown. In the niche the crucifix has miraculously begun to bleed.

NG 4757–63 are parts of the double-sided high altarpiece of S. Francesco, Borgo Sansepolcro. NG 4760 was probably second from the right in the bottom tier of the reverse; for further details on the altarpiece see under NG 4757.

Collection of Abate Angelucci, Arezzo, by 1819; bought with contributions from the NACF, Benjamin Guinness and Lord Bearsted, 1934.

Davies 1961, pp. 504–12, 568–70; Banker 1991, pp. 11–58; Dunkerton 1991, pp. 262–4, 400.

Saint Francis, who had travelled to the Orient in order to convert the Sultan to Christianity, offered to walk through fire with one of the Sultan's priests, at which they fled. This episode from the life of Saint Francis of Assisi (about 1181–1226, founder of the Franciscan Order) probably follows Saint Bonaventure's *Legenda Maior*.

NG 4757–63 are parts of the double-sided high altarpiece of S. Francesco, Borgo Sansepolcro. NG 4761 was probably second from the right in the top tier of the reverse; for further details on the altarpiece see under NG 4757.

Collection of Abate Angelucci, Arezzo, by 1819; bought with contributions from the NACF, Benjamin Guinness and Lord Bearsted, 1934.

Davies 1961, pp. 504–12, 568–70; Banker 1991, pp. 11–58; Dunkerton 1991, pp. 262–4, 400.

Saint Francis makes a pact with the wolf, who had been preying on the people of Gubbio, that in return for giving up its habits it would be fed at public expense. This was written down by a notary and the wolf places his right paw in the hand of the saint. This episode from the life of Saint Francis of Assisi (about 1181–1226, founder of the Franciscan Order) is probably taken from the fourteenth-century *Little Flowers of Saint Francis* (the *Fioretti*).

NG 4757–63 are parts of the double-sided high altarpiece of S. Francesco, Borgo Sansepolcro. NG 4762 was probably in the top-right corner of the reverse; for further details on the altarpiece see under NG 4757.

This episode does not occur in every Franciscan source and may have been added because Gubbio is near Sansepolcro and the legend had local significance, or possibly because one of the friars at Borgo Sansepolcro came from Gubbio and asked for this episode to be included.

Collection of Abate Angelucci, Arezzo, by 1819; bought with contributions from the NACF, Benjamin Guinness and Lord Bearsted, 1934.

Davies 1961, pp. 505–12, 568–70; Banker 1991, pp. 11–58; Dunkerton 1991, pp. 262–4, 400.

SASSETTA
The Funeral of Saint Francis and the Verification of the Stigmata, 1437–44

NG 4763
Tempera on poplar, 88 x 53 cm

NG 4763 shows the funeral of Saint Francis of Assisi, founder of the Franciscan Order who died in 1226, and probably follows Saint Bonaventure's *Legenda Maior*. A knight who had previously doubted the authenticity of the stigmata is convinced by the wound in the saint's side; the story continued the parallels between Saint Francis and Christ, in whose Resurrection Saint Thomas would not believe until he thrust his hand into the wound in Christ's side. The woman in the foreground is presumably the Blessed Jacopa (a Franciscan tertiary, who died at Assisi), the only woman present at Saint Francis's death.

NG 4757–63 are parts of the back of the high altarpiece of S. Francesco, Borgo Sansepolcro, showing scenes from the life of Saint Francis tiered in two groups of four panels on either side of *Saint Francis in Glory* (Settignano, Berenson Collection). NG 4763 was probably in the bottom-right corner of the reverse immediately adjacent to the panel showing the saint receiving the stigmata (NG 4760); for further details on the altarpiece see under NG 4757.

Collection of Abate Angelucci, Arezzo, by 1819; bought with contributions from the NACF, Benjamin Guinness and Lord Bearsted, 1934.

Davies 1961, pp. 505–12, 568–70; Banker 1991, pp. 11–58; Dunkerton 1991, pp. 262–4, 400.

SASSOFERRATO
The Virgin in Prayer
1640–50

NG 200
Oil (identified) on canvas, 73 x 57.7 cm

The Virgin in Prayer was not a common subject, but was developed in the fifteenth century and popularised during the Counter Reformation. The composition of NG 200 derives from a painting (known in engravings) by Guido Reni, who was a major influence on Sassoferrato throughout his career.

The engraving after Guido Reni is inscribed 'Virgo Modestis Ora Pro Nobis' (Virgin of Modesty, Pray for us), and NG 200 was probably made for private devotion.

NG 200 is one of many versions of this popular Sassoferrato design. It is of high quality and likely to be a mature work. It was probably painted several years after the *Virgin in Prayer* in the Galleria Doria, Rome.

Bequeathed by Richard Simmons, 1846.

Levey 1971, pp. 207–8; Macé de Lepinay 1990, p. 86.

SASSOFERRATO
The Virgin and Child Embracing
1660–85

NG 740
Oil on canvas, 97.2 x 74 cm

Saint Joseph is visible in the landscape seen in the left background, beyond the Virgin and Child.

The design of NG 740 is based on an etching by Guido Reni, who was a major influence on Sassoferrato. NG 740 is likely to be a late work and it may have been among a group of pictures in Sassoferrato's studio at his death. Other versions of the composition are known.

Apparently in the collection of the artist's heirs until the early nineteenth century; Pope Gregory XVI by 1846; bought in Venice, 1864.

Levey 1971, pp. 208–9.

SASSOFERRATO
1609–1685

Giovanni Battista Salvi is called Sassoferrato after his birthplace in the Marches. He was active in Rome (altarpiece for S. Sabina), where he died, and Umbria. He adapted compositions by Raphael, Guido Reni and others, and painted principally devotional images of the Virgin and Child; he occasionally painted portraits and altarpieces.

Roelandt SAVERY
Orpheus
1628

NG 920
Oil on oak, 53 x 81.5 cm

Gian Girolamo SAVOLDO
Saint Jerome
perhaps 1527

NG 3092
Oil on canvas, 120.4 x 158.8 cm

Gian Girolamo SAVOLDO
Saint Mary Magdalene approaching the Sepulchre
probably 1530–48

NG 1031
Oil on canvas, 86.4 x 79.4 cm

Signed and dated bottom left: ·ROELANDT · / SAVERY · Ft/1628.

Orpheus had the power to enchant with his music all living creatures, as well as the trees and rocks. Ovid, *Metamorphoses* (X, 180–2; XI, 1–3). Here he is shown playing a violin, although he should be depicted with a lyre. The animals around him include at the left, lions, a pelican, an ostrich and a buffalo, and at the right an elephant, a camel and parrots.

NG 920 is one of a number of works of this subject by the artist that gave him the opportunity to explore variations on the theme of a landscape with animals.

Bequeathed by S.J. Ainsley, 1874.

MacLaren/Brown 1991, p. 413.

Signed on the rock in the right foreground, under the book: jouanes jeron/imus de brisio/de sauoldis/faciebat (Giovanni Girolamo of Brescia, of the Savoldo family, made this).

Saint Jerome (about 342–420), translator of the Vulgate Bible and the chief inspiration for Christian penitents and hermits, is shown in the desert beating his chest in penitential prayer in front of a crucifix. Venice is seen in the background; the large church may represent SS. Giovanni e Paolo, Savoldo's parish church in 1532.

It has been suggested that the picture might be the 'Saint Jerome' commissioned by Giovan Paolo Averoldi of Brescia in 1527, but another painting by Savoldo of the same subject is known, and has a Lombard provenance.

There is a drawing for the head of Saint Jerome (Paris, Louvre). This shows the head as it is painted, and not clean-shaven and short-haired as it appears in infra-red photographs. The drawing was presumably made at the same time as the change to the painting.

Perhaps d'Ardier collection, 1648; Bruschetti collection, Milan, by 1855; Layard Bequest 1916.

Gould 1975, pp. 237–9; Stradiotti 1990, pp. 156–8.

Mary Magdalene is identified by the pot of ointment with which she anointed Christ's body, and by the glimpse of her traditional red dress underneath a silver-grey cloak. She was present at the Crucifixion and was the first to find Christ's tomb empty on the morning after the Resurrection. New Testament (John 20: 1 and perhaps 11–16). Her right hand is raised in a conventional gesture of lamentation, and the line below her left eye might suggest that she has been weeping.

NG 1031 is presumed to have been painted when Savoldo was living in Venice. In 1611 the painting was in the collection of a descendant of Giovan Paolo Averoldi, who may have commissioned Savoldo NG 3092.

The sun rises over an unidentified view, presumed to be Venice. Versions of this composition survive in Berlin (Staatliche Museen), Florence (Contini-Bonacossi) and a private collection.

Collection of Lorenzo Averoldi, Brescia, 1611; bought (with a Brescian provenance), 1878.

Gould 1975, pp. 236–7; Stradiotti 1990, pp. 150–2.

Roelandt SAVERY
1576–1639

Roelandt Jacobsz. Savery was a landscape, flower and animal painter. He was born in Courtrai (Flanders), then settled with his family in Amsterdam, where he was probably taught by his brother Jacob. The artist painted in Amsterdam, Prague (for Emperor Rudolph II in 1604–12), Vienna and Utrecht (1619–39).

Gian Girolamo SAVOLDO
born about 1480/5; active 1508–48

Savoldo, who described himself as a native of Brescia, is recorded as a painter in Parma in 1506 and in Florence in 1508. From about 1520 he worked predominantly in Venice and the Veneto. Strongly influenced by Giorgione, he seems mostly to have painted figure groups (both religious and secular) for wealthy collectors.

Cornelis van der SCHALCKE
An Extensive River Landscape, with Two Sportsmen and their Greyhounds, about 1659

NG 974
Oil on canvas, 100.5 x 149.5 cm

Godfried SCHALCKEN
An Old Woman scouring a Pot
1660s

NG 997
Oil on oak, 28.5 x 22.8 cm

Godfried SCHALCKEN
A Woman singing and a Man with a Cittern
about 1665–70

NG 998
Oil on oak, 26.6 x 20.4 cm

This landscape has in the past been described as a view of the river Scheldt with Antwerp cathedral in the distance; the tower may be intended for the cathedral, but the identification is not certain.

NG 974 has been attributed to Philips Koninck and subsequently to Jacob Koninck. It is, however, by the same hand as a picture signed by van der Schalcke and formerly in the A. Singer collection in Vienna, which was probably painted in 1659. NG 974 should be dated at about the same time.

Apparently in the [Dr Reichel, of Dresden] sale, London, 1847; Wynn Ellis Bequest, 1876.

MacLaren/Brown 1991, pp. 414–15.

Signed bottom right: G · Schalcken ·
 The old woman, the broken pot, empty candle-holder and butterfly are all elements that identify the painting as a *vanitas*, an allegory of the transience of life. The artist painted several works of this type.
 NG 997 is an early work in the style of Dou; it was probably painted in the 1660s.

In the collection of Wynn Ellis by 1861; Wynn Ellis Bequest, 1876.

MacLaren/Brown 1991, p. 417.

Signed bottom left: G · Schalcken·
 The association between music and courtship, familiar in Dutch genre painting, is here underlined by the presence of the rose, a symbol of love, on the table. There is a painting in the background, the only visible part of which shows two bare legs.
 Both style and costumes suggest that the picture was painted in about 1665–70. In early sales NG 998 is described as having a pendant of a child playing with a doll, but this subject makes it unlikely that they originally formed a pair.
 Recent cleaning revealed that the painting, which is on a rectangular panel, has an arched top.

In the collection of the Comte de Vence by 1759; Prince de Conti sale, Paris, 1777; Wynn Ellis Bequest, 1876.

MacLaren/Brown 1991, pp. 417–18.

Cornelis van der SCHALCKE
1611–1671

Cornelis Symonsz. van der Schalcke was born and worked in Haarlem, succeeding his father as verger of St Bavo in 1636. His few surviving works are all landscapes of the period 1640–65. He was formerly considered to be a follower of Jan van Goyen, but his work also appears to show the influence of Pieter de Molijn, Salomon van Ruysdael, Isack van Ostade and, in his later years, Philips Koninck.

Godfried SCHALCKEN
1643–1706

Godfried (or Godefried) Cornelisz. Schalcken was born in Made, near Dordrecht. As a child he moved to Dordrecht, where he was a pupil of Samuel van Hoogstraten and, afterwards, in Leiden, of Dou. He worked in Dordrecht, London (1692–4) and The Hague. Among his patrons were King William III and the Elector Palatine, Johann Wilhelm. He also painted religious, mythological and literary subjects, but enjoyed particular success with his genre scenes and portraits.

Godfried SCHALCKEN
A Candlelight Scene: A Man offering a Gold Chain and Coins to a Girl seated on a Bed, about 1665–70

NG 999
Oil on copper, 15.5 x 18.9 cm

Signed top left: G · Schalcken·
 On the lower part of the bedpost in this scene of seduction is a carved cupid. Schalcken specialised in painting interiors lit by candlelight.

Wynn Ellis Bequest, 1876.

MacLaren/Brown 1991, p. 418.

Godfried SCHALCKEN
Allegory of Virtue and Riches
about 1667

NG 199
Oil on copper, 17.1 x 13.1 cm

This scene was once identified as 'Lesbia weighing her sparrow against jewels', the subject of two poems by Catullus, but in fact it is an allegory of virtue and riches. The bird represents virtue and true love (as do the embracing putti on the bas-relief), which the woman is attempting to outweigh with the piled-up jewels. She grieves, as does the sculpted cupid in the background at the left, because her virtue has been sacrificed for riches.
 When in the Fagel collection (1752), there was a companion painting by Frans van Mieris the Elder showing a woman releasing a sparrow from a box (now Amsterdam, Rijksmuseum), which is an allegory of the loss of virginity. That painting is dated 1667, and Schalcken's painting is presumably of the same date.

In the collection of Greffiers Fagel, 1752; collection of Richard Simmons by 1833; bequeathed by Richard Simmons, 1847.

MacLaren/Brown 1991, p. 416.

Ary SCHEFFER
Mrs Robert Hollond
1851

NG 1169
Oil on canvas, 81.9 x 60.3 cm

Signed and dated: Ary Scheffer/Paris décembre 1851.
 The sitter, Ellen Julia Tweed (1822–84), married Robert Hollond, MP for Hastings, in 1840. An authoress and philanthropist, she held a salon in Paris which attracted the leading Liberals of the day.
 She presented Boucher NG 1090 to the National Gallery in 1880.

Bequeathed by Robert Hollond and the sitter; entered the Collection, 1885.

Davies 1970, p. 129.

Ary SCHEFFER
1795–1858

The artist was a portrait and history painter. He was born in Dordrecht and taught by his father, J.B. Scheffer. He was in Paris in 1811, where he studied under Guérin, and exhibited works at the Salon from 1812.

Ary SCHEFFER
Saints Augustine and Monica
1854

Attributed to Andrea SCHIAVONE
A Mythological Figure
probably about 1548–50

Attributed to Andrea SCHIAVONE
Two Mythological Figures
probably about 1548–50

NG 1170
Oil on canvas, 135.2 x 104.8 cm

NG 1883
Oil on canvas, 18.7 x 18.7 cm

NG 1884
Oil on canvas, 18.7 x 18.7 cm

Signed and dated: Arÿ Scheffer/1854.

Saint Augustine and his mother, Saint Monica, held a discussion at Ostia about the Kingdom of Heaven. Shortly afterwards Saint Monica fell ill and died. The subject is taken from Saint Augustine's *Confessions* (10: 10).

NG 1170 is one of several replicas of Scheffer's most popular picture. The original (private collection) was finished in about 1845 and showed the painter's own mother as the model for Saint Monica. In NG 1170, however, the model used for the saint is said to have been Mrs Hollond whose husband bequeathed the picture to the Gallery (see Scheffer NG 1169).

Richard Holland by 1857; by whom bequeathed; entered the Collection, 1885.

Davies 1970, pp. 129–30.

NG 1883 was formerly catalogued as 'Apollo killing the Python', but the subject has not been identified for certain.

This picture, together with NG 1884, has been attributed to Schiavone (but with reservations about the attribution because of the picture's condition). Recently these doubts have been rejected (Richardson) and a date in the late 1540s proposed.

Probably in the Algarotti collection in the eighteenth century; collection of Baron V. Denon, Paris, 1826; bought with the Edmond Beaucousin collection, Paris, 1860.

Gould 1975, pp. 240–1; Richardson 1980, pp. 165–6.

The subject, presumed to be mythological, is not precisely indicated and has not been identified.

Probably in the Algarotti collection in the eighteenth century; collection of Baron V. Denon, Paris, 1826; bought with the Edmond Beaucousin collection, Paris, 1860.

Gould 1975, pp. 240–1; Richardson 1980, pp. 165–6.

Andrea SCHIAVONE
active about 1540; died 1563

Andrea Meldolla was called Schiavone (the Slav) because he came from Zara on the Dalmatian coast. He is recorded in various civic commissions in Venice in the 1540s and 1550s but the majority of his work is unsigned and was painted for private patrons. He also made etchings.

Giorgio SCHIAVONE
The Virgin and Child
about 1456–60

Giorgio SCHIAVONE
The Virgin and Child Enthroned, with Saints
probably about 1456–61

Jakob SCHLESINGER (after RAPHAEL)
The Sistine Madonna
probably 1822

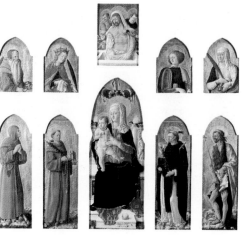

NG 630
Tempera on wood, painted surface 92 x 120 cm

NG 904
Tempera on wood, painted surface 55.9 x 41.3 cm

Inscribed on the left pilaster: A / E(?); on the right pilaster: P /Ω (the Greek letter Omega).

The letters of the inscription are probably the abbreviated form of 'Alpha et Omega, Principium et Finis' ([I am] Alpha and Omega, the beginning and the end) from the New Testament (Revelation 1: 8).

NG 904 was probably painted in about 1456–60, around the time of Giorgio Schiavone's training in the Squarcione workshop in Padua (1456–9). A number of the motifs in the picture are drawn from works by or after Donatello: e.g. the pose and modelling of the Christ Child can be related to a plaquette in the style of Donatello (Washington, National Gallery of Art), and the architectural background has parallels in terracotta casts attributed to Donatello's collaborator in Padua, Giovanni da Pisa (e.g. Berlin, Staatliche Museen).

Collection of Alexander Barker, London, by 1871; bought, 1874.

Davies 1961, pp. 467–8; Kokole 1990, pp. 50–6.

Signed on a cartellino on the Virgin's throne: .OPVS. SCLAVONI. DISIPVLI. / SQVARCIONI. S. (Work of Schiavone, disciple of Squarcione). The third word of the inscription originally read DISIPVLVS, but Schiavone changed this to DISIPVLI. Inscribed on Saint John the Baptist's scroll: EC[CE] AG/N[VS] / DEI (Behold the Lamb of God).

The ten panels of this polyptych show, centre: the Virgin and Child enthroned; lower row, left to right: Saints Bernardino, Anthony of Padua, Peter Martyr, John the Baptist; upper row, left to right: Saints Jerome, Catherine, Saint Sebastian, a female saint; the *Pietà* appears in the centre of the upper row.

NG 630 was probably painted for the church of S. Niccolò, Padua, on the commission of a member of the Frigimelica family. The polyptych is likely to date from the period about 1456–61, and certainly from after 1450 (when Bernardino of Siena – who is identified here by holding a monogram of Jesus' name in Greek (IHS) – was canonised).

Palazzo Frigimelica, Padua, by 1765 (and said to have come from the Frigimelica altar in the church of S. Niccolò, Padua); collection of James Johnston, Edinburgh, by 1835; collection of James Dennistoun by 1854; bought with the Edmond Beaucousin collection, Paris, 1860.

Davies 1961, pp. 464–7.

NG 661
Pencil on paper mounted on canvas, 257.8 x 203.2 cm

Raphael's *Sistine Madonna* (about 1512–14) was painted as an altarpiece for the church of S. Sisto, Piacenza. It is now in the Gemäldegalerie in Dresden.

NG 661 is a tracing, apparently made in 1822, by Jakob Schlesinger from Raphael's altarpiece in Dresden.

Sold by Schlesinger's son to Messrs P. & D. Colnaghi, Scott & Co, about 1855–6; by whom presented, 1860.

Gould 1975, p. 224.

Giorgio SCHIAVONE
1436/7–1504

Giorgio Culinovic was born in Dalmatia and was known in Italy as Schiavone (the Slav). He was apprenticed to Squarcione about 1456–9 and returned to Zara in 1462. He was in Padua again in 1476, but spent much of the rest of his life in Sebenico. He was a member of the circle of artists working in Padua under the influence of Donatello and the direction of Squarcione.

Jakob SCHLESINGER
1792–1855

Schlesinger was a painter and a restorer, and was active in Dresden from 1820 to 1823.

Otto Franz SCHOLDERER
Lilac
about 1860–1902

NG 6401
Oil on canvas, 50 x 37 cm

Signed: Otto Scholderer
 This still life is characteristic of the artist: sprays of lilac are depicted in a glass vase.

Bequeathed by Dr J.V. Scholderer, son of the painter, 1971.

Otto Franz SCHOLDERER
Portrait of the Artist's Wife
probably 1872-3

NG 6400
Oil on canvas, 31.6 x 40 cm

Signed: O.S.
 Scholderer married Luise Steurwaldt in February 1872. He painted her several times.
 NG 6400 is related to a larger painting (Frankfurt, Städelsches Kunstinstitut) where the sitter wears the same costume, but holds a European fan, rather than the Japanese one shown here. The Frankfurt painting, for which NG 6400 may be a study, is dated 1873 and was exhibited at the Royal Academy in 1875.

Bequeathed by Dr J.V. Scholderer, son of the painter, 1971.

Herbst 1934, no. 80.

Style of Martin SCHONGAUER
The Virgin and Child in a Garden
1469–91

NG 723
Oil (identified) on lime, 30.2 x 21.9 cm

The Virgin and Child are shown in a closed garden (the *hortus conclusus*), which is intended as a metaphor for the chastity of the Virgin. The iris at the right may symbolise Christ's Passion.
 The composition of NG 723 is close to that of an engraving signed with Schongauer's initials (Bartsch 30), but it is not a copy of that work. It may conceivably be a workshop piece.

Collection of Prince Ludwig Kraft Ernst von Oettingen-Wallerstein, before 1847; acquired by the Prince Consort, 1851; presented by Queen Victoria at the Prince Consort's wish, 1863.

Levey 1959, p. 101.

Otto Franz SCHOLDERER
1834–1902

Scholderer was born and died in Frankfurt; he studied at the Städelsches Kunstinstitut there with J.D. Passavant and Jacob Becker. He made frequent trips to Paris where he became acquainted with Fantin-Latour, Manet and Courbet. He was in London from 1871 to 1899 and was a painter of still lifes and portraits.

Martin SCHONGAUER
active 1469; died 1491

The son of a goldsmith from Colmar, Schongauer matriculated at Leipzig University in 1465 and is mentioned as living at Colmar in 1469. By the summer of 1489 he was established as a citizen of Breisach. Famous for his engravings, which are initialled, no paintings by or attributed to him are signed; *The Madonna of the Rose Bower* (St Martin's, Colmar) is dated 1473.

Heinrich Wilhelm SCHWEICKHARDT
Cattle
1794

SEBASTIANO del Piombo
The Daughter of Herodias
1510

SEBASTIANO del Piombo
The Raising of Lazarus
about 1517–19

NG 1878
Oil on mahogany, 46.4 x 61 cm

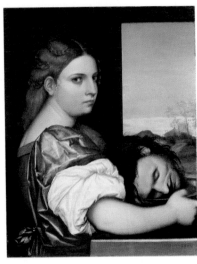

NG 2493
Oil on wood, 54.9 x 44.5 cm

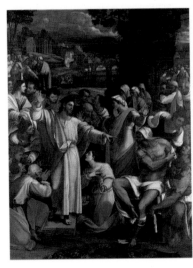

NG 1
Oil (identified) on canvas, transferred from wood,
381 x 289.6 cm

Signed and dated at the bottom right: H. W. Schweickhardt f. 1794.

This is a typical example of Schweickhardt's work in the manner of Cuyp and Potter.

It may be the painting entitled *Cattle*, exhibited by the artist at the Royal Academy in 1794 (no. 316).

Possibly in the Schweickhardt sale, 8 June 1799 (lot 81); bequeathed by Mrs S.F. Hodges, 1852.

Levey 1959, p. 102.

Dated bottom right: 1510
Saint John the Baptist was beheaded at Herodias' request, and his head presented to her daughter Salome on a charger. Salome then brought the head to her mother. New Testament (Matthew 14: 1–11). An alternative identification as Judith with the head of Holofernes has recently been suggested.

NG 2493 dates from Sebastiano's period in Venice. The influence of Giorgione and the young Titian can be observed.

In the collection of George Salting by 1900; Salting Bequest, 1910.

Gould 1975, p. 249; Hirst 1981, pp. 4, 30–1, 93; Joannides 1992, pp. 167–8.

Signed lower left (below Christ's foot): SEBASTIANVS. VENETVS. FACIE/BAT (Sebastiano of Venice made this).

Lazarus (right) had lain in his tomb for four days when – at the behest of his sisters Martha and Mary Magdalene (seen between the figure of Christ and Lazarus) – Jesus (left) went to his grave and 'cried with a loud voice, Lazarus, come forth. And he that was dead came forth, bound hand and foot with graveclothes'. New Testament (John 11: 1–46). In the distance the Jews report the miracle to the Pharisees.

NG 1 was painted in competition with Raphael's *Transfiguration* (Rome, Vatican) for Cardinal Giulio de' Medici in Rome in 1517–19. The painting was subsequently taken to the cardinal's archiepiscopal church (now the cathedral, where a fragment of the original frame remains) in Narbonne. As an ambitious depiction of divine healing and a multi-figure narrative the painting formed both an appropriate pendant to Raphael's picture and was appropriate in subject matter for the Medici.

Some of the main figures are based on drawings which Michelangelo (according to Vasari and Dolce) supplied for Sebastiano. Three red chalk drawings survive (Bayonne, Musée Bonnat; London, British Museum). A drawing by Sebastiano for the figure of Martha is in Frankfurt, Staedel Institute.

Orléans collection by 1723 (catalogued 1727); bought by J.J. Angerstein at the Orléans sale in London, 1798; bought, 1824.

Gould 1975, pp. 241–6; Hirst 1981, pp. 66–75; Gardner von Teuffel 1984, pp. 765–6; Gardner von Teuffel 1987, pp. 185–6; Hirst 1988, pp. 55–6.

Heinrich Wilhelm SCHWEICKHARDT
1746–1797

Schweickhardt (or Schweickardt) was born in Brandenburg. By June 1774 he was active in The Hague where he remained until settling in England in 1787. From then on he exhibited regularly at the Royal Academy. He mainly painted landscapes with cattle and ice scenes, usually in imitation of the work of Dutch seventeenth-century artists.

SEBASTIANO del Piombo
about 1485–1547

Born in Venice, Sebastiano Luciano probably trained with Giorgione, and was an established painter before moving to Rome with Agostino Chigi in 1511. He soon became a friend of Michelangelo, and from 1520 was considered the leading painter in Rome. In 1531 he was nominated to the office of the Piombo (Keeper of the Papal Seal), hence Sebastiano del Piombo.

SEBASTIANO del Piombo
The Madonna and Child with Saints Joseph and John the Baptist and a Donor, about 1519–20

SEBASTIANO del Piombo
A Lady as Saint Agatha
about 1540

Imitator of Hercules SEGERS
A Mountainous Landscape
early 17th century

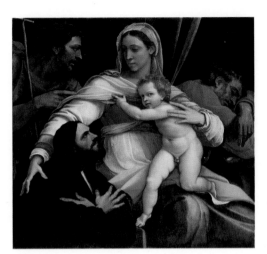

NG 1450
Oil on wood, 97.8 x 106.7 cm

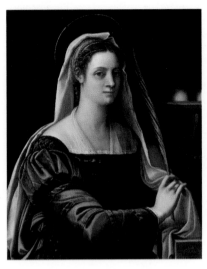

NG 24
Oil on canvas, painted area 92.4 x 75.3 cm

NG 4383
Oil on oak, 57.8 x 82.2 cm

The Virgin and Child are flanked by Saints Joseph (sleeping, right) and John the Baptist (left). The donor may be Pierfrancesco Borgherini (born 1480), who was a wealthy merchant and a friend of both Michelangelo and Sebastiano. It is rare for the Virgin to put an arm around the donor.

Sebastiano was working for Pierfrancesco Borgherini in S. Pietro in Montorio, Rome, in the later 1510s and a figure in his chapel there may also be his portrait (which would support the identification of the donor in NG 1450 as Pierfrancesco Borgherini). A further portrait by Sebastiano in San Diego (Museum of Fine Art) may also be of Pierfrancesco. It is possible that a drawing by Michelangelo (Rotterdam, Museum Boymans-van Beuningen) was – as in the case of the *Raising of Lazarus* (NG 1) – provided for Sebastiano, although the essential format is typically Venetian.

Probably in the Palazzo Brignole (Cambiaso collection), Genoa, 1780; bought from 'sénateur Cambiaso', Genoa, by J.B.P. Le Brun, 1807–8; collection of Sir Thomas Baring by 1816; bought by William Coningham, 1843; bought from the Earl of Northbrook, 1895.

Gould 1975, pp. 247–9; Hirst 1981, pp. 82–4; Haskell 1991, pp. 677–8, 681.

Signed bottom right: .F. SEBASTIANV[S] / .VEN. / .FACIEBAT / .ROMAE. (Frate Sebastiano of Venice made this. Rome.)

Saint Agatha was a third-century martyr who was reputed to have been tortured for resisting the advances of the Roman governor; among the tortures she endured was the severing of her breasts (seen with shears in the right background). She holds a martyr's palm. NG 24 is possibly a portrait of a woman in the guise of Saint Agatha.

The letter 'F' before the name 'Sebastianus' in the inscription shows that the picture was painted after 1531, the year Sebastiano was appointed to the office of the Piombo which carried the honorific 'Frate' (friar).

Said to be 'from the Borghese collection'; Holwell Carr Bequest, 1831.

Gould 1975, p. 247.

NG 4383 was traditionally thought to be by Rembrandt, and then until 1960 was attributed to Hercules Segers. It is now considered to be the work of an imitator of Segers' etchings (rather than of his few paintings). The artist responsible also appears to have painted the *Mountainous Landscape* in the Bredius Museum in The Hague. Other pictures can be attributed to the same hand.

Probably bought by Charles Peers (died 1853); bought from his descendant (Sir) Charles Peers, 1928.

MacLaren/Brown 1991, pp. 420–1.

Hercules SEGERS
1589/90–1633 or later

Hercules Pietersz. Segers was born in Haarlem. By 1596 his family had moved to Amsterdam and he is thought to have been taught there by Gillis van Coninxloo. He lived in Haarlem, Amsterdam, Utrecht and The Hague. Segers was principally a landscape painter and a remarkably original etcher of landscape. He made very few impressions of his etchings, regarding each one as a unique work of art.

Style of SEGNA di Bonaventura
Crucifix
early 14th century

NG 567
Tempera on wood, 213.5 x 184 cm

Inscribed (renewed): IHS NAZARENUS/ R.E.X./ IUDEORUM (Jesus of Nazareth King of the Jews).

The Virgin and Saint John are shown at either side. In other contemporary Crucifixes, a roundel of God the Father surmounts the cross; one may originally have been included here. The panel is extensively damaged: Christ's arms have been largely repainted.

NG 567 has in the past been attributed to Segna. It appears to be related to his work, but the precise nature of the link is difficult to define because of its condition. It can be compared, for example, with his signed Crucifix in the Pushkin Museum of Fine Arts, Moscow, and appears to pre-date another work by him of this type in Arezzo (Badia of SS. Flora e Lucilla), which can probably be dated to about 1319.

Bought from the Lombardi–Baldi collection, 1857.

Stubblebine 1979, p. 132; Gordon 1988, pp. 93–4.

Jakob SEISENEGGER
Portrait of a Girl
about 1545–50

NG 4206
Oil (identified) on wood, 28.9 x 21.6 cm

The rich costume of this unidentified sitter would suggest that she came from a wealthy and possibly aristocratic family; a Habsburg identification has been proposed. It is likely that this bust-length portrait has been cut from a larger work.

The style of the clothes suggests a date of about 1545–50.

X-radiographs reveal a fake Cranach device at the left.

Abel collection, Stuttgart, by 1855; bought by the King of Württemburg, 1859; catalogued as in the Stuttgart Museum from 1891; exchanged with Böhler, Munich, 1925; bought and presented by the NACF, 1926.

Levey 1959, pp. 103–4; Löcher 1963, p. 94.

Georges-Pierre SEURAT
Bathers at Asnières
1884

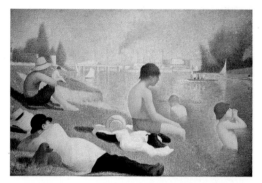

NG 3908
Oil (identified) on canvas, 201 x 300 cm

The setting is the left bank of the Seine at Asnières, a suburb to the north-west of central Paris. The tip of the island called La Grande Jatte is on the right. It was the subject of Seurat's next large composition (Art Institute of Chicago), which shows the same stretch of water from the other side.

NG 3908 was Seurat's first large-scale composition, and the only one executed before he had fully evolved the technique of 'pointillism'. It combines relatively academically defined forms, in the figure groups, with areas such as the water, painted in an 'Impressionist' technique. It was rejected by the Salon of 1884, but was shown at the Salon des Indépendants in that year. Parts of the canvas, including the hat of the boy in the water at the right, were reworked in 1887 using small dots of colour.

A number of surviving studies – oil sketches and drawings in conté crayon – make it possible to plot the genesis of NG 3908. The drawings are essentially preparations for the figures, while the oil sketches are mainly plein-air studies of the landscape.

Assigned to the painter's family after his death, 1891; Félix Féneon by about 1900; bought from Féneon through the Independent Gallery by the Trustees of the Courtauld Fund, 1924.

Russell 1965, pp. 115–38; Davies 1970, pp. 131–3; Herbert 1991, pp. 147ff.

SEGNA di Bonaventura
active 1298; died 1326/31

This Sienese painter was apparently a nephew of Duccio. He is recorded at Arezzo in 1319. Only four signed works by him are known.

Jakob SEISENEGGER
1504/5–1567

Seisenegger was probably born in Austria. He was appointed court painter to Emperor Ferdinand I in Augsburg in 1531, and in the following year executed a full-length portrait of Charles V (now in Vienna). From 1535 to 1545 he travelled to Vienna, Prague, Augsburg, Spain and the Netherlands. He painted a few religious pictures, but mainly portraits, frequently of members of the Habsburg family.

Georges-Pierre SEURAT
1859–1891

Seurat was born in Paris and spent most of his short life there. In 1877 he entered the Ecole des Beaux-Arts and studied under Henri Lehmann. Influenced by Ingres, Delacroix and the scientific theoreticians of colour, Seurat developed the approach to painting called divisionism or pointillism.

Sir Martin Archer SHEE
W.T. Lewis as the Marquis in 'The Midnight Hour'
before 1792

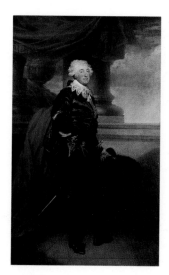

NG 677
Oil on canvas, 238.8 x 147.3 cm

The actor William Thomas Lewis (1748–1811) was known as 'Gentleman Lewis'. He is here shown as the Marquis in Mrs Inchbald's play *The Midnight Hour*. He first took this part in a production at Covent Garden on 22 May 1787.

NG 677 was exhibited at the Royal Academy in 1792. It was engraved in the same year by J. Jones.

The sitter's son, who left NG 677 to the Gallery, also bequeathed a sum of money which continues as the Lewis Fund.

Bequeathed by Thomas Denison Lewis, the sitter's son, 1849; entered the Collection, 1863.

Davies 1959, p. 91.

Jan SIBERECHTS
A Cowherd passing a Horse and Cart in a Stream
probably 1658

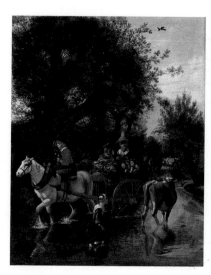

NG 2130
Oil on canvas, 63.8 x 54.3 cm

Signed and dated on the shaft of the cart: J. Siberechts. A . anvers. 165(?)8(?).

Siberechts specialised in genre scenes set in the countryside, such as this, during the first part of his career.

The date may tentatively be read as 1658. What is certain is that the work derives from the artist's Antwerp period, that is, before 1672–6.

Dr Franck sale, Christie's, 1843; presented by John P. Heseltine, 1907.

Martin 1970, p. 237; Brown 1987, p. 114.

Luca SIGNORELLI
The Holy Family
probably about 1490–5

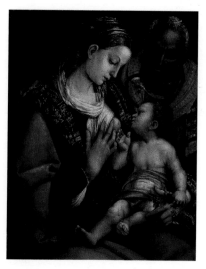

NG 2488
Oil on wood, 80.6 x 64.8 cm

The Holy Family of Mary, Joseph and the Child Jesus is here associated with the image of the 'Virgo Lactans', for the Virgin is preparing to suckle the child. The strawberries held by Jesus probably refer to the fruitful and righteous life of Christ.

Bought by George Salting, 1904; Salting Bequest, 1910.

Davies 1961, pp. 484–5.

Sir Martin Archer SHEE
1769–1850

The portraitist Shee was born in Dublin, where he studied under F.R. West. He moved to London in 1788, entered the Royal Academy Schools in 1790, was elected in 1800 and president in 1830. Shee also wrote plays and poems, including a long poem entitled *Elements of Art*.

Jan SIBERECHTS
1627–1700/3

Siberechts was a landscape painter, who depicted scenes with peasants and topographical views of country houses. He was born in Antwerp where he is recorded as a master in 1648/9; he may have already visited Italy by then. Between 1672 and 1676 Siberechts settled in England, where he travelled extensively and remained until his death.

Luca SIGNORELLI
about 1440/50–1523

Born in Cortona, Signorelli was a pupil of Piero della Francesca and became one of the major artists active in central Italy from about 1480 until his death. He was famous as a painter of frescoes (e.g. in the Sistine Chapel, Rome, and in the cathedral of Orvieto) and altarpieces. He also painted portraits and small religious works.

Luca SIGNORELLI
The Adoration of the Shepherds
probably about 1490–1510

NG 1776
Oil on wood, painted surface 17.1 x 64.8 cm

An angel appeared to the shepherds and they came to adore the Child Jesus. The Virgin Mary and Saint Joseph are to the right of the Child. New Testament (Luke 2: 8–17).

NG 1776 is a predella panel from an (unidentified) altarpiece. It is clearly the work of Luca Signorelli. The Nativity and Adoration were common subjects for the central panel of a predella.

The narrative scene is surrounded by painted framing elements.

First recorded in the collection of Agostino Castellani, Cortona, 1856; bought, 1900.

Davies 1961, p. 483.

Luca SIGNORELLI
The Circumcision
about 1491

NG 1128
Oil on wood, painted surface 258.5 x 180 cm

Inscribed at the bottom: LVCAS / CORTONENSIS / PINXIT (Luca from Cortona painted this).

Jesus was circumcised according to Jewish tradition. Here the High Priest prepares to perform the act while Mary, Joseph (with a staff) and other figures look on. In the centre, raising his hands, is Simeon who seems to be shown at the moment when he says: 'Lord, now lettest thou thy servant depart in peace, according to thy word. For mine eyes have seen thy salvation.' New Testament (Luke 2: 21–31). The naming of Jesus, his Presentation and his Circumcision are described together in Saint Luke's Gospel.

NG 1128 was recorded in 1756 in the chapel of the Circumcision belonging to the Compagnia del Santissimo Nome di Gesù (Company of the Holy Name of Jesus) in S. Francesco, Volterra, and is identifiable with the picture mentioned by Vasari in 1568 as having been partially repainted by Sodoma. It was probably painted when Signorelli was working in Volterra. The circular reliefs in the spandrels of the arch seem to represent a prophet and a sibyl.

A compositional study for NG 1128 and a cartoon for the head of Simeon survive on a pricked drawing in Rotterdam (Museum Boymans-van Beuningen). X-radiographs show several changes of pose centring on the Christ Child; Sodoma's repaint is evident in this area.

Recorded in S. Francesco, Volterra, until 1782; probably in the Lansdowne collection by 1806; collection of the Duke of Hamilton by 1854; bought, 1882.

Davies 1961, pp. 479–81.

Luca SIGNORELLI
The Adoration of the Shepherds
about 1496

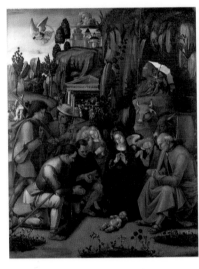

NG 1133
Oil on wood, painted surface 215 x 170.2 cm

Signed on the portico: .LVCE . DE CORTONA. P.[ICTORIS] O.[PUS] (Work of Luca of Cortona, painter); above, a monogram probably LS (for Luca Signorelli).

The Nativity story starts with the decree of taxation by Augustus. This is rarely depicted by artists, but in NG 1133 Signorelli shows (centre background) people gathering under a portico to pay their tax. The Annunciation to the Shepherds is in the left background, and their Adoration of the Child Jesus (together with the Holy Family, and angels) is represented in the foreground. New Testament (Luke 2: 1–16).

NG 1133 is probably the altarpiece referred to by Vasari in 1550 in the church of S. Francesco, Città di Castello. Signorelli was active in Città di Castello for much of the 1490s, and early sources (the earliest of 1627) state that the picture was painted in 1496. The altarpiece may have been commissioned by a member of the Tiberti family, who apparently had rights over the altar in S. Francesco for which NG 1133 was made.

A squared drawing for the three shepherds and an angel is in the British Museum (London); some of the figures recur in an altarpiece of the same subject at Cortona (Museo Diocesano).

Probably recorded in S. Francesco, Città di Castello, 1550; certainly recorded in the Mancini collection, Città di Castello, 1826; bought (Lewis Fund), 1882.

Davies 1961, pp. 481–3.

Luca SIGNORELLI
The Triumph of Chastity: Love Disarmed and Bound, about 1509

Luca SIGNORELLI
Coriolanus persuaded by his Family to spare Rome about 1509

The Virgin and Child with Saints 1515

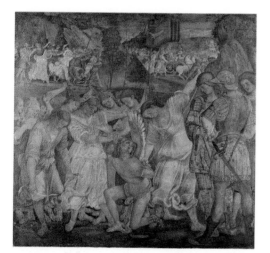

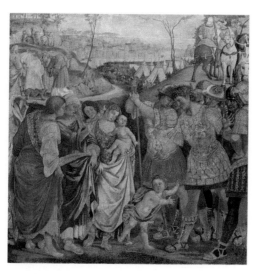

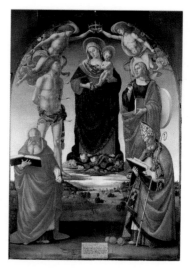

NG 910
Fresco, detached and mounted on canvas, 125.7 x 133.4 cm

NG 3929
Fresco, detached and mounted on canvas, 125.7 x 125.7 cm

NG 1847
Oil on wood, painted surface 265 x 193 cm

Inscribed on the cartellino in the foreground: LVCAS CORITIVS (Luca from Cortona).

The god of Love is bound by Laura, the ideal chaste woman of Petrarch's poetry. She is assisted by Lucretia and Penelope, chaste heroines of antiquity, who pluck his wings and break his bow. The Roman heroes Caesar and Scipio Africanus look on. In the distance, Chastity exhibits her prisoner in her triumphal car. The theme is taken from Petrarch's *Trionfi* (Triumphs).

NG 910 and 3929 by Signorelli, and NG 911 by Pintoricchio, are three from a series of eight frescoes which decorated a room in the Palazzo del Magnifico, Siena. Two other frescoes and their wooden encasement are in Siena (Pinacoteca Nazionale; attributed to Girolamo Genga) and the floor tiles are now in Paris (Louvre), Berlin (Kunstgewerbe Museum) and London (Victoria and Albert Museum). The original ceiling frescoes are in New York (Metropolitan Museum of Art). The room was commissioned by Pandolfo Petrucci, the ruler of Siena from 1503. The frescoes probably date from the time of his marriage in 1509 as the date 1509 and the combined arms of the Petrucci and the Piccolomini families occur on some of the floor tiles. It is possible that the theme was the virtues of women. The frescoes were damaged when detached from the wall.

Removed from the Palazzo del Magnifico, Siena, about 1842/4 for E. Joly de Bammeville; collection of Alexander Barker by 1857; bought, 1874.

Davies 1961, pp. 472–9; Tátrai 1978, pp. 177–83; Agosti 1982, pp. 70–7; Kanter 1989, pp. 180–93.

Signed on a scroll by the standing children's feet: LVCAS CORITIV[S] (Luca from Cortona).

The Volscians are besieging Rome. Coriolanus (on the right, crowned with a wreath), after being exiled from the city, is acting as their general and is preparing to attack. He was begged (and persuaded) to spare the city by Valeria, his mother Volumnia, his wife Virgilia and his children, one of whom runs to greet him. Plutarch, *Life of Coriolanus*.

NG 3929 was – with NG 910 and Pintoricchio NG 911 – one of a series of frescoes painted by Signorelli, Genga and Pintoricchio. For further discussion see under NG 910.

Removed from the Palazzo del Magnifico, Siena, by about 1842/4 for E. Joly de Bammeville; collection of Alexander Barker by 1857; collection of Ludwig Mond by 1893; Mond Bequest, 1924.

Davies 1961, pp. 485–6; Tátrai 1978, pp. 177–83; Kanter 1989, pp. 180–93.

Inscribed on the piece of paper painted at the bottom: EGREGIVM. QVOD. CERNIS. OPVS. MAGISTER. / ALOYSIVS. PHYSICVS. EXGALLIA. ET. TOMAS/INA. EIVS. VXOR. EXDEVOTIONE. SVIS. / SVMPTIBVS. PONI. CVRAVERVNT. LVCA. SI/GNORELLO. DECORTONA. PICTORE. INSI/GNI. FORMAS. INDVCENTE. AN[N]O. D[OMIN]I. M.D.XV. (This fine work which you see Master Aloysius, doctor from France, and Tomasina his wife, have caused to be set up to express their devotion [and] at their own expense, and Luca Signorelli of Cortona, the distinguished painter, painted the figures in the year of the Lord 1515.)

Saints Sebastian and Jerome are shown on the left; Saints Christina and Nicholas of Bari are on the right. Two angels with lilies crown the Virgin Mary, and the Christ Child appears to hold a globe (symbol of world dominion).

NG 1847 was painted as an altarpiece for the chapel dedicated to Saint Christina in the church of S. Francesco, Montone (near present day Umbertide). It was commissioned (as confirmed in the surviving copy of the contract for NG 1847) by a physician, Luigi de Rutenis (i.e. from Rodez) who had founded this chapel. The predella (with scenes from the life of Saint Christina) is now in the Museo del Brera, Milan.

Acquired, not long before 1826, by Giacomo Mancini; bought, 1901.

Davies 1961, p. 484; Kanter 1989, pp. 242–4.

Luca SIGNORELLI
Esther before Ahasuerus, and Three Episodes from the Life of Saint Jerome, about 1519–22

NG 3946
Oil on wood, painted surface 29.5 x 212.5 cm

Attributed to Francesco SIMONINI
A Campaign Scene
1610–53

NG 5465
Oil on canvas, 37.7 x 65.5 cm

Alfred SISLEY
The Watering Place at Marly-le-Roi
probably 1875

NG 4138
Oil (identified) on canvas, 49.5 x 65.4 cm

The subject of Esther before Ahasuerus is told in the apocryphal additions to the Book of Esther (15: 2ff.); the three episodes from the life of Saint Jerome are related in the *Divoto Transito del Glorioso Sancto Hieronymo* (1490, chapters 22, 26 and 27). From left to right: the Apparition of Saints John the Baptist and Jerome to Augustine; the Apparition of Christ and Jerome to Sulpicius Severus and two monks; Esther's intercession with Ahasuerus on behalf of the Jews; and the Apparition of Christ and Jerome to Cyril.

NG 3946 was the predella to an altarpiece commissioned jointly by Niccolò Gamurrini and the Compagnia di S. Gerolamo (Company of Saint Jerome) in 1519 for their church in Arezzo. The main panel is now in the Museo Civico, Arezzo, and includes the Virgin and Child with various prophets and saints (holding texts and attributes that allude to the Immaculate Conception). The touching of Esther by Ahasuerus was believed to foretell or parallel the distinction of Mary explicit in the doctrine of the Immaculate Conception; Jerome (also included in the main panel) is sometimes associated with this doctrine. (See Appendix B for a larger reproduction.)

The delivery of this altarpiece (probably in 1522) was described by Giorgio Vasari, who was born and brought up in Arezzo.

Collection of E. Joly de Bammeville by 1854; Mond collection by 1887; Mond Bequest, 1924.

Davies 1961, pp. 486–9; Kanter 1989, pp. 269–73.

The figures at the left, who look out over the battlefield, appear to be officers.

NG 5465 has previously attributed to J.M. Laroon, and catalogued as British School.

Presented by the NACF, 1944.

Signed and dated: Sisley.7(5?)

The watering place is one of the few remains of the château at Marly-le-Roi, constructed for Louis XIV in the late seventeenth century and destroyed in the 1790s, after the Revolution. Sisley lived at Marly (west of Paris) from 1875 until 1877 and often painted this site. Here the watering place is shown in the foreground with its surface frozen and covered with snow except for a small corner at the right beneath an outlet. Beyond is the boundary wall of the gardens and a road leading south towards Versailles (see Pissarro NG 3265 for another view of this area).

Anon. (Depeaux) sale, Paris, 25 April, 1901 (lot 48); bought from the Independent Gallery, London, by the Trustees of the Courtauld Fund, 1926.

Daulte 1959, no. 152; Davies 1970, pp. 133–4; Bomford 1991, pp. 148–51.

Francesco SIMONINI
1686–1753

Simonini was born in Parma. He was taught by Spolverini and travelled to Florence where he studied the work of Jacques Courtois. The artist visited Rome, Bologna and, towards the end of his life, Venice, where he remained. He specialised in paintings and engravings of battle scenes.

Alfred SISLEY
1839–1899

Sisley had British parents, but was born in Paris and lived mainly in France. He entered the studio of Gleyre in 1862, where he met Monet, Bazille and Renoir. A landscape painter, he remained loyal to the basic tenets of Impressionism for much of his career.

Follower of Frans SNIJDERS
Still Life of Fruit and Vegetables with Two Monkeys, 1650–1700

NG 1252
Oil on canvas, 102.9 x 135.5 cm

The composition seems to derive from the work of Snijders, but it may be a copy after a lost painting by him or by an artist working in his style during the second half of the seventeenth century.

B.R. Haydon (1786–1846) sale, London, 1823; possibly bought then by Decimus Burton (1800–81); presented by Miss Emily Jane Wood by the wish of her uncle, Decimus Burton, 1888.

Martin 1970, p. 239.

Pieter SNIJERS
A Still Life with Fruit, Vegetables, Dead Chickens and a Lobster, 1707–52

NG 1401
Oil on canvas, 118.8 x 99.7 cm

Signed: P. Snijers
Snijers worked in Antwerp in the first half of the eighteenth century. Few of his paintings are dated and it is very difficult to construct a chronology of his works.

Bought from Richard Stephens, 1894.

Martin 1970, p. 240.

SODOMA
Saint Jerome in Penitence
probably about 1535–45

NG 3947
Oil on poplar, 141 x 111.8 cm

Saint Jerome is shown in his penitential retreat in the wilderness, where he retired in about 374–6. A blood-stained rock rests beside his cardinal's hat. The Bible, which he translated into Latin from the original Greek and Hebrew, is propped up on a skull in front of him and he is accompanied by the lion (left) from whose paw, according to legend, he drew out a thorn.

Monte di Pietà, Rome, by 1858; Mond Collection, 1890; Mond Bequest, 1924.

Gould 1975, pp. 250–1.

Frans SNIJDERS
1597–1657

The artist, who was a painter of animals, hunts and still lifes, was born in Antwerp, where he was taught by Pieter Bruegel the Younger. He visited Italy, but had returned to Antwerp by 1609. Snijders was employed by Philip IV of Spain and Archduke Leopold Wilhelm, and collaborated with Rubens (see Rubens NG 853).

Pieter SNIJERS
1681–1752

Snijers was a landscape, still-life and portrait painter, and a collector. He was born in Antwerp where he is documented as a pupil of Alexander van Bredael in 1694/5. The artist is recorded as a master of the guild of St Luke in 1707–8, and as one of the directors of the Académie Royale in the city in 1741.

SODOMA
1477–1549

Giovanni Antonio Bazzi, known as Il Sodoma, was born in Vercelli in northern Italy, but was principally active in Siena from about 1506. He also worked in Rome, Florence and other towns in central Italy, painting frescoes, altarpieces and processional banners. He was also a sculptor.

SODOMA

The Madonna and Child with Saints Peter and Catherine of Siena and a Carthusian Donor
probably about 1540–9

Attributed to SODOMA

The Madonna and Child
probably about 1520–30

Attributed to SODOMA

Head of Christ
probably about 1525–50

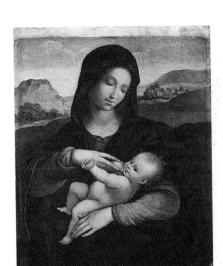

NG 1144
Oil on poplar, 48.9 x 37.8 cm

Saint Catherine of Siena (1347?–80; canonised in 1461) wears the habit of a Dominican tertiary. Saint Peter presents a donor who wears the habit of the Carthusian Order.

NG 1144 was possibly executed with some workshop assistance.

Collection of Giovanni Rosini, Pisa, by 1845; bought from Charles Fairfax Murray, 1883.

Gould 1975, p. 250.

NG 246
Oil on wood, 79.7 x 65.1 cm

Another version of this composition is also attributed to Sodoma.

Collection of E. Joly de Bammeville by 1854; bought, 1854.

Gould 1975, pp. 251–2.

NG 1337
Oil on wood, 38.7 x 31.7 cm

Christ is shown with the crown of thorns and bearing the cross on the way to Calvary where he was taken to be crucified. New Testament (Matthew 27: 31).

NG 1337 is probably not a fragment, but an independent devotional work. It probably dates from the mid-sixteenth century.

Habich collection, Cassel; bought, 1891.

Gould 1975, p. 251.

Follower of SODOMA
The Nativity with the Infant Baptist and Shepherds, probably about 1540–60

NG 4647
Oil on poplar, 119.7 x 96.5 cm

An angel appeared to the shepherds (right background) and they came to adore the Child Jesus (foreground). The Three Kings (centre background), guided by a star, are seen on their journey to Bethlehem to honour the new-born Jesus. The angels hold scrolls. New Testament (Luke 2: 8–17 and Matthew 2: 2–12).

NG 4647 was probably painted by a follower of Sodoma, perhaps from his design.

Bought in Florence by Ernest Hartland, 1875; presented by his widow in accordance with his wish, 1932.

Gould 1975, p. 252.

Giovanni Antonio SOGLIANI
The Madonna and Child
probably about 1520–40

NG 645
Oil on wood, 17.3 x 10.4 cm

Formerly catalogued as by Albertinelli (1474–1515), NG 645 has now been attributed to Sogliani.

Bought with the Edmond Beaucousin collection, Paris, 1860.

Gould 1975, p. 253.

Andrea SOLARIO
A Man with a Pink
about 1495

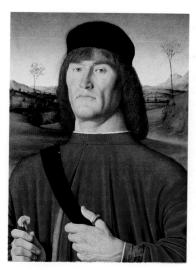

NG 923
Oil and egg (identified) on poplar, 49.5 x 38.5 cm

This portrait has in the past been given the title 'A Venetian Senator'. The costume may be that of a Venetian magistrate. The flower the sitter holds is probably intended as a symbolic reference to his betrothal.

NG 923 is dated to about 1495, when Solario was probably working in Venice.

Palazzo Grillo-Cattaneo (or Palazzo Gavotto), near the Piazzo del Portello, Genoa, by 1842; Villa (Frederico) Mylius, Genoa, 1872; bought by Baslini, Milan, 1873; from whom bought, 1875.

Davies 1961, pp. 490–1; Dunkerton 1991, p. 99.

Giovanni Antonio SOGLIANI
1492–1544

Sogliani was a pupil of Lorenzo di Credi in Florence. He seems to have remained with Lorenzo di Credi for many years, but he was also influenced by Fra Bartolommeo. He was an independent artist in Florence by about 1515 and was engaged on paintings for Pisa Cathedral between 1528 and 1533.

Andrea SOLARIO
about 1465–1524

Solario was from Milan. The painter's earliest signed work (now Milan, Brera) is of 1495 and from Murano. It is thought probable that he visited Venice. He was certainly influenced by Venetian painting, and also by Leonardo's work in Milan. The artist is later recorded as working for Cardinal d'Amboise in Normandy from 1507 to 1509 or later.

Andrea SOLARIO
Giovanni Cristoforo Longoni
1505

Workshop of Andrea SOLARIO
The Virgin and Child
early 16th century

Antonio de SOLARIO
The Virgin and Child with Saint John
perhaps about 1500–10

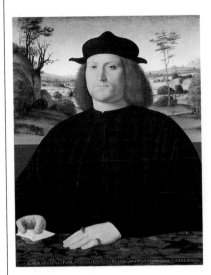

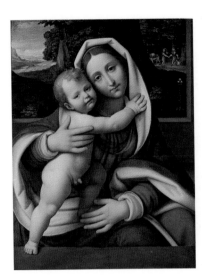

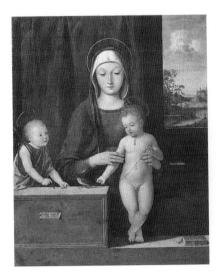

NG 734
Oil on poplar, 79 x 60.5 cm

Inscribed on a letter: Nobili Joanni Christophoro/ Longono Amico (Noble Joanni Christophoro/ Longono friend). Inscribed on the parapet: IGNORAN QVALIS FVERIS . QVALISQVE FVTVRVS . SIS QVALIS . STVDEAS POSSE VIDERE DIV. (You know not what sort of person you were or will be; devote much time to an earnest effort to see what sort of person you are), and inscribed on the wall: ANDREAS. / .SOLARIO. / .F. / . 1505. (Andrea Solario made this 1505).

The sitter appears to be identified by the inscription on the letter. He is presumed to be a figure who is documented elsewhere in 1494 and 1498, although not otherwise described as a noble.

Bought from Baslini, Milan, 1863.

Davies 1961, pp. 489–90.

NG 2504
Oil on wood, 61 x 46.4 cm

NG 2504 is possibly an old copy of a lost Solario. It has in the past been attributed to a Milanese follower of Leonardo (such as Cesare da Sesto).

The composition seems to be related to that of Raphael's *Mackintosh Madonna* (NG 2069).

Presumably in the Pourtalés-Gorgier collection, Paris; catalogued by J.-J. Dubois, 1841; Salting Bequest, 1910.

Davies 1961, p. 491.

NG 2503
Oil on canvas, transferred from wood, 36.5 x 29.8 cm

Inscribed on Saint John's scroll: EC[C]E A[GNUS] (Behold the Lamb). Signed on a cartellino attached to the parapet: Antonius desolario / venetus f.[ecit] (Antono de Solario, Venetian, made this).

The Virgin and Child and the young Saint John the Baptist are seen in a domestic interior. Saint John holds a reed cross and a scroll inscribed with words from his Gospel (New Testament, John 1: 29 and 36). The Christ Child holds a bird on a string.

NG 2503 reveals Solario's Venetian training, and is probably an early work.

Collection of the Abate Luigi Celotti, Venice, by 1828; Leuchtenberg collection, Munich, by 1840; Salting Bequest, 1910.

Davies 1961, p. 494.

Antonio de SOLARIO
probably active 1502–1518

Antonio de Solario (Lo Zingaro) was probably trained, and perhaps born, in Venice. He was commissioned to finish a polyptych (commenced by Vittorio Crivelli) in Fermo in 1502, and was probably active in the Marches for several years. He appears to have worked in Naples (painting frescoes), and may have visited England.

Antonio de SOLARIO
Saint Catherine of Alexandria
1514

Antonio de SOLARIO
Saint Ursula
1514

Francesco SOLIMENA
An Allegory of Louis XIV
about 1700

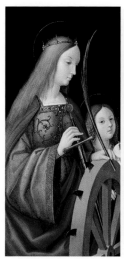

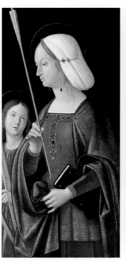

NG 646
Oil on wood, 84 x 40 cm

NG 647
Oil on wood, 84 x 40 cm

NG 6521
Oil on canvas, 47 x 58.5 cm

Inscribed on the reverse: / AVE GRACIA PLENA / DOMINVS TECUM (Hail [Mary] full of Grace, the Lord be with you); and on Saint John's scroll: ECCE AGNVS DEI (Behold the Lamb of God).

Saint Catherine of Alexandria is shown with the wheel and sword of her martyrdom, and with a martyr's palm. She is accompanied by an angel. The reverse shows Saint John the Baptist in a medallion. He has a reed cross, and a scroll inscribed with words from his Gospel (New Testament, John 1: 29 and 36), and points at a lamb which he holds in his left hand. The reverse is also inscribed with part of the Archangel Gabriel's salutation at the Annunciation (New Testament, Luke 1: 28).

NG 646 was on the left of a panel of the Virgin and Child with Saint Joseph, an angel and a donor (Bristol, City Art Gallery). The donor is identified as Paul Withypoll and the central panel is signed and dated 1514. Paul Withypoll (died 1547) was a member of the Merchant Taylors' Guild, whose patron saint was John the Baptist.

Bought with the Edmond Beaucousin collection, Paris, 1860.

Davies 1961, pp. 492–4.

Inscribed on the reverse: BENEDICTA TV INTER / MVLIERES ET. B[ENEDICTVS] F.[RVCTVS] V.[ENTRIS] T[VI] (Blessed art thou amongst women, and blessed is the fruit of thy womb).

Saint Ursula was the daughter of King Maurus of Brittany. She married the son of a British king and was martyred at Cologne after returning there from a pilgrimage to Rome, along with 11,000 virgin companions, her husband and the pope. She holds an arrow, the specific emblem of her martyrdom. She is accompanied by an angel. The reverse shows Saint Paul in a medallion. He holds a book and a sword. The reverse is also inscribed with part of the Archangel Gabriel's salutation at the Annunciation (New Testament, Luke 1: 42).

NG 647 was on the right of a panel of the Virgin and Child with Saint Joseph, an angel and a donor (Bristol, City Art Gallery). The donor is identified as Paul Withypoll and Saint Paul is probably painted on the reverse of NG 647 as his patron saint. See further under NG 646.

Bought with the Edmond Beaucousin collection, Paris, 1860.

Davies 1961, pp. 492–4.

Seated on a lion at the left is the figure of Minerva, representing wisdom. She points to a shield held up by putti, on which no image has yet been painted. The figure of Time, whose hourglass and scythe lie beside him, supports a book in which the winged figure of History is recording the great deeds of the unpainted protagonist.

NG 6521 is related to a large painting (now St Petersburg, Hermitage) and may be a preparatory sketch for it. Before being repainted with an image of Catherine the Great, the medallion in the Hermitage painting bore an image of Louis XIV. Solimena painted this work for Cardinal Gualtieri (1660–1728), Papal Nuncio in France, who presented it to Louis XIV. A variant of NG 6521, of higher quality and on copper (private collection), shows Charles Bourbon, King of Naples and future Charles III of Spain, on the medallion.

Philip Hendy, Director of the National Gallery (1945–67), 1964; bequeathed by him and entered the Collection, 1989.

National Gallery Report 1988–9, pp. 18–19.

Francesco SOLIMENA
1657–1747

Solimena was probably born in Canale di Serino, near Avellino. He settled in Naples in 1674, and was the leading painter there after the death of Giordano. He painted large canvases and fresco cycles, becoming very wealthy and enjoying an international reputation.

Francesco SOLIMENA
Dido receiving Aeneas and Cupid disguised as Ascanius, probably 1720s

Hendrick SORGH
A Woman playing Cards with Two Peasants
1644

Hendrick SORGH
Two Lovers at Table
1644

NG 6397
Oil on canvas, 207.2 x 310.2 cm

NG 1055
Oil on oak, 26.3 x 36.1 cm

NG 1056
Oil on oak, 26.4 x 36.4 cm

Aeneas arrived in Carthage which was ruled by Dido, an ally of his enemy Juno. In order to protect him, his mother Venus disguised her son Cupid as Aeneas' son Ascanius. Cupid then made Dido fall in love with Aeneas, so Juno could not persuade her to oppose him. The winged Cupid with his quiver and bows approaches Dido; both she and Aeneas are unaware of his true identity. Virgil, *Aeneid* (Book I).

The head in profile with a helmet on the extreme right may well be a self portrait.

Bought, 1971.

Helston 1983, p. 94.

Signed and dated on the lintel above the door at the right: H. Sorgh 1644.

This is the companion picture to NG 1056. Both paintings illustrate ways in which women can make fools of men. Here, the woman has cheated the peasant of his hard-earned money. The eggs and duck suggest that he was on his way to market. The third figure mocks his foolishness.

The panel was probably cut down to an oval after it was painted.

Bequeathed by John Henderson, 1879.

MacLaren/Brown 1991, pp. 421–2.

Signed and dated upper right: H. Sorgh 1644.

This is the companion picture to NG 1055. Both paintings illustrate ways in which women can make fools of men. In this instance, the man holding a wineglass and embracing the girl is going to lose his money: the procuress at the door will make him pay dearly for the young woman's favours.

The panel was probably cut down to an oval after it was painted.

Bequeathed by John Henderson, 1879.

MacLaren/Brown 1991, p. 422.

Hendrick SORGH
1610 or 1611–1670

Hendrick Maertensz. Sorgh was born and worked in Rotterdam. He is said to have been a pupil of David Teniers, but his early works recall the paintings of Adriaen Brouwer. Sorgh was chiefly a genre painter of peasant interiors and, later, market scenes. He developed a distinctive style, related to that of his Rotterdam contemporaries Cornelis and Herman Saftleven.

Attributed to Lo SPAGNA
The Agony in the Garden
perhaps 1500–5

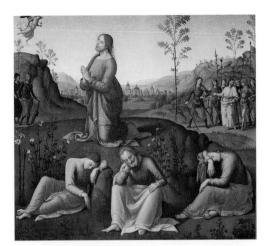

NG 1032
Oil on wood, 60.3 x 67.3 cm

Attributed to Lo SPAGNA
Christ at Gethsemane
perhaps about 1500–5

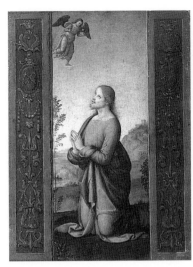

NG 1812
Oil on wood, 34 x 26 cm

Attributed to Lo SPAGNA
Christ Crowned with Thorns
perhaps 1500–25

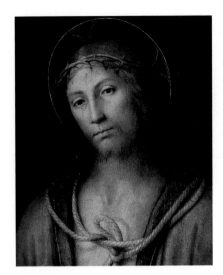

NG 691
Oil on wood, 40.3 x 32.4 cm

Jesus prays in the Garden of Gethsemane while three of his disciples sleep. An angel reveals a chalice to him. Judas – who holds a money bag – approaches with the Roman soldiers who will arrest Jesus. New Testament (Mark 14: 32–43).

Once thought to be by the young Raphael this panel has in recent years been attributed to Lo Spagna or a follower of Perugino. The composition is based on Perugino's *Agony in the Garden* (Florence, Uffizi), painted in Florence in the 1490s for San Giusto. Individual figures also derive from works by Perugino (e.g. *The Transfiguration*, Rome, Vatican). On the basis of its relation to these works the panel is generally dated to the period 1500–5.

There are four pricked preparatory drawings attributed to Lo Spagna in the Gabinetto dei Disegni (Florence). These are said to correspond in size with the figures of NG 1032 and are fragments of one cartoon. The composition was reversed in a picture of 1530 by Giannicola di Paola for a church in Perugia (now Galleria Nazionale).

Collection of Prince Gabrielli, Rome, by 1829; brought to Britain by Woodburn; collection of W. Coningham by 1849; bought from W. Fuller Maitland, 1878.

Davies 1961, pp. 495–6; Ferino Pagden 1982, pp. 65-7; Gualdi-Sabatini 1984, pp. 106–15, 304–5, 397–9.

Jesus prays in the Garden of Gethsemane as an angel reveals a chalice to him, foreshadowing the Passion. New Testament (Mark 14: 32–43). The panel is painted with a decorative framing border which includes the nails, the crown of thorns and two scourges, all instruments of the Passion.

The figure of Christ is closely related to that in NG 1032. The attribution of NG 1812 to Lo Spagna has not been unanimously accepted, but if it is correct this small panel can probably be dated to the beginning of the sixteenth century, perhaps about 1500–5.

There is a companion panel in the collection of the Duke of Sutherland. This is *Christ carrying the Cross* and has a similar painted border. It is said to have come from the Palazzo Medici-Riccardi, Florence, which would, if proven, add to our knowledge of the provenance of NG 1812.

Probably in the Niccolini collection, Rome, about 1575–1600; collection of Henry Farrer by 1850; bequeathed by Henry Vaughan, 1900.

Davies 1961, pp. 496–7; Gualdi-Sabatini 1984, pp. 115–16.

Jesus is shown with the crown of thorns which was placed on his head during the Mocking. The image is not necessarily intended as a narrative but suggests both the moment in the New Testament (John 19: 5) when Christ was presented to the people by Pilate, who said 'Behold the man' (Ecce Homo), and Christ on the way to Calvary where he was taken to be crucified (Matthew 27: 31).

Images of this type seem ultimately to be derived from German or Netherlandish art.

Bequeathed by Lt.-General Sir William George Moore, 1862.

Davies 1961, p. 495; Gualdi-Sabatini 1984, p. 342.

Lo SPAGNA

active 1504; died 1528

Giovanni di Pietro, known as Lo Spagna (the Spaniard), was one of Perugino's principal followers. He is recorded in Perugia in 1504, and also worked in Todi, Trevi, Spoleto, and probably (with Perugino) in Florence.

SPANISH
Landscape with Figures
17th century

SPANISH
A Man and a Child eating Grapes
probably 19th century

Giovanni Battista SPINELLI
The Adoration of the Shepherds
before 1660

NG 1376
Oil on canvas, 91.2 x 126 cm

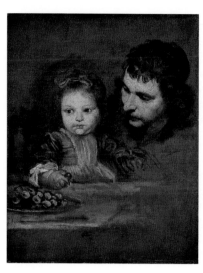

NG 2526
Oil on canvas, 73 x 57.8 cm

NG 1157
Oil on canvas, 153.3 x 134 cm

The men and mule in the foreground are copied from Velázquez NG 197, *Philip IV hunting Wild Boar*.

NG 1376 has in the past been attributed to Velázquez and Mazo, but neither suggestion is tenable.

John Watkins Brett sale, London, 1864; bequeathed by Sir William H. Gregory, 1892.

MacLaren/Braham 1970, p. 97.

The composition is unfinished; areas such as the body of the man have not been established and the table top has only been sketched in.

NG 2526 has been attributed to Velázquez and to Pedro Núñez de Villavicencio (1644–1700), but is probably nineteenth century, and may have been intended as a Velázquez imitation.

Earl of Clare sale, London, 1864; J.C. Robinson sale, Paris, 1868; apparently in the collection of George Salting by 1883; Salting Bequest, 1910.

MacLaren/Braham 1970, pp. 97–8.

The Christ Child has been laid in a manger and is surrounded by the shepherds who have come to worship him. New Testament (Luke 2: 1–20).

NG 1157 is damaged and largely repainted. It has in the past been described as Italian (?) School, seventeenth century, and attributed to José Sarabia (1608–69) and Cavallino. In spite of its condition, the attribution to Spinelli is convincing. The provenance supports a Neapolitan origin for the picture.

Recorded as bought from a monastery in Naples by Woodford Pilkington, 1860s; by whom presented, 1884.

Levey 1971, p. 209.

Giovanni Battista SPINELLI
active from about 1630–about 1660

Spinelli was the son of a grain merchant from Bergamo. He is first recorded in Chieti (Abbruzzo) in 1640 and he was active in Naples in the 1650s. His work is influenced by northern Mannerist prints and by the work of Caracciolo.

SPINELLO Aretino
Saint Michael and Other Angels
about 1373–1410

SPINELLO Aretino
Decorative Border
about 1373–1410

SPINELLO Aretino
Decorative Border
about 1373–1410

NG 1216.1
Fresco transferred to canvas, 116.2 x 170.2 cm

NG 1216.2
Fresco transferred to canvas, 55.9 x 153.7 cm

NG 1216.3
Fresco transferred to canvas, 55.9 x 127

This fragment, together with NG 1216.2–3, is from a large fresco of the *Fall of Lucifer*. NG 2616.1 shows Saint Michael and other angels from a scene depicting the war in heaven. The battle took place before God who was shown enthroned above, while Lucifer's agents plunge to earth below. New Testament (Revelation 12: 7–9).

The composition of the entire work is recorded in an engraving of 1821 by Carlo Lasinio. It was painted for the Compagnia di Sant' Angelo or S. Michele Arcangelo in Arezzo. According to Vasari, Spinello made the figure of Lucifer so horrible that he had bad dreams and soon died. This might suggest a dating of about 1405–10, but it is also surmised that the work was executed earlier. The Saint Michael is similar to the same figure in Spinello's fresco in San Francesco, Arezzo.

The Confraternity from which the fragment comes was suppressed in 1785; the three fragments were removed in 1855; presented by Sir A.H. Layard, 1886.

Gordon 1988, pp. 97–8.

Inscribed:+HOC.OPUS.FECIT.FIERI.XPO-FANUS.HU. (Christofano Hu... had this work made)

This fragment comes from the border of a fresco of the *Fall of Lucifer*. Between medallions which contain a saint and an angel, a donor kneels. He wears a white religious habit.

It appears that NG 1216.3 was originally joined to the right side of NG 1216.2. For comment on the work from which these fragments come see NG 1216.1.

The Confraternity from which the fragment comes was suppressed in 1785; the three fragments were removed in 1855; presented by Sir A.H. Layard, 1886.

Gordon 1988, pp. 97–8.

Inscribed: .UCII.c....ANNO (?) DNI...., III (... the year of Our Lord ... III...).

This fragment comes from a fresco of the *Fall of Lucifer*. An angel and an unidentified saint are depicted with medallions.

It appears that NG 1216.3 was originally joined to the right side of NG 1216.2. For comment on the work from which these fragments derive see NG 1216.1.

The Confraternity from which the fragment comes was suppressed in 1785; the three fragments were removed in 1855; presented by Sir A.H. Layard, 1886.

Gordon 1988, pp. 97–8.

SPINELLO Aretino
active 1373; died 1410/11

The artist, who came from Arezzo, was probably born after 1345. He is recorded as a member of the artists' guild, the Arte dei Medici e Speziali, in Florence in 1386. Spinello settled for a while in the city, but also worked in Arezzo, Lucca, Monte Oliveto Maggiore, the Camposanto, Pisa, from 1391 to 1392 and at the Palazzo Pubblico, Siena. Several authenticated works by him survive.

SPINELLO Aretino
Two Haloed Mourners
about 1387–95

Bartholomaeus SPRANGER
The Adoration of the Kings
about 1595

Johannes SPRUYT
Geese and Ducks
probably about 1660

NG 1013
Oil on canvas, 119.5 x 155.5 cm

NG 276
Fresco, 50 x 50 cm

NG 6392
Oil on canvas, 199.8 x 143.7 cm

These two mourners are a fragment from a scene showing the Burial of Saint John the Baptist. New Testament (Mark 6: 29). According to the Gospels the saint was buried by his disciples, some of whom were the apostles, but it is not clear which of them, or which other saints, took part in the burial.

NG 276 was one of six scenes from the Baptist's life which formerly decorated the chapel of Vanni Manetti in S. Maria del Carmine, Florence, that have been variously dated between 1387 and 1395. The compositions of the frescoes are recorded, after a fire in the church in 1771, in engravings of 1772 by Thomas Patch, who removed some of the fragments. The rest of the work was presumably destroyed when the church was reconstructed. The other fragments which survive are in Pisa (Camposanto, Ammanati Chapel), Rotterdam (Museum Boymans-van Beuningen), Liverpool (Walker Art Gallery); there may also be a fragment in Pavia and one is on the US art market.

Bought from Thomas Patch by Charles Towneley, 1772; Greville collection sale, 1810; bought at the Samuel Rogers sale, 1856.

Gordon 1988, pp. 95–6.

Signed lower left: B/SPRANGERS,ANT .VS S./C.M,/TIS A CUBI.LO PICTOR/F. (B Sprangers of Antwerp, court painter to His Majesty the Holy Emperor made this).

The star above Bethlehem, which the kings followed, is depicted at the top of the composition. The first king's offering of gold lies in a bowl on the ground. New Testament (Matthew 2: 1–12). Saint Joseph stands behind the Virgin, and further back are the ox and ass. The procession in the distance appears to be the retinue of the kings.

The scale and format of NG 6392 suggest that it was intended as an altarpiece. It may have been painted for the chapel of the castle in Geyerswörth (Bamberg), which was renovated in the years 1583–97.

Bought, 1970.

Smith 1985, p. 104.

This painting was formerly thought to be by d'Hondecoeter but has recently been reattributed to Spruyt on the basis of comparison with signed pictures by him (e.g. The Hague, Bredius Museum, and Ayrshire, Culzean Castle).

Wynn Ellis Bequest, 1876.

MacLaren/Brown 1991, p. 423.

Bartholomaeus SPRANGER
1546–1611

Bartholomaeus Spranger was born and trained in Antwerp. In 1565 he travelled to Italy where he worked for ten years. He was then employed in the service of the Habsburg Emperors as court painter in Prague from 1581 until his death in the city. As well as being a painter he worked as a printmaker, sculptor and designer of the applied arts.

Johannes SPRUYT
1627/8–1671

Spruyt was born and worked in Amsterdam, where he may have trained in the studio of Jan Baptist Weenix. He was first described as a painter in 1659 and specialised in pictures of birds and fowl, similar to those painted by Melchior d'Hondecoeter.

After Massimo STANZIONE
Monks and Holy Women mourning over the Dead Christ, 18th century or earlier

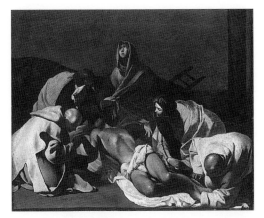

NG 3401
Oil on slate, 43.7 x 52.4 cm

Gherardo STARNINA (The Master of the Bambino Vispo)
The Beheading of a Female Saint, about 1400–13

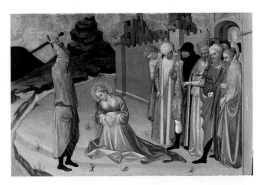

NG 3926
Tempera on poplar, 40.5 x 63 cm

Jan STEEN
Peasants merry-making outside an Inn, and a Seated Woman taking the Hand of an Old Man about 1645–50

NG 2557
Oil on oak, 24.3 x 20.3 cm

This is a copy with minor variations of Stanzione's large-scale *Deposition* of about 1638 (Naples, Certosa di S. Martino).

NG 3401 may be by a French artist, and is probably at least as old as the eighteenth century.

Probably bought by Gibbs Crawford Antrobus, British Minister in Naples, 1824; bought from the Eldar Gallery, 1919.

Levey 1971, p. 210.

The saint may be Catherine of Alexandria, or possibly Saint Margaret, although several female saints were decapitated.

NG 3926 was painted on the same plank of wood as the *Death of the Virgin* (Chicago, Art Institute). It has been suggested that these two panels formed part of the predella for an altarpiece showing the *Virgin and Child with Saints Margaret, Andrew, Peter and Mary Magdalene* (Würzburg, Martin-von-Wagner Museum). A third panel showing *The Last Communion of Mary Magdalene* (present whereabouts unknown) may also have formed part of the predella.

Collection of Conte Guido di Bisenzo, Rome, by 1838; collection of Lord Ward (later Earl of Dudley) by 1847; bought by Richter for Ludwig Mond, 1892; Mond Bequest, 1924

Davies 1961, pp. 362–3; Van Waadenoijen 1974, p. 86; Syre 1979, pp. 111–13.

Signed bottom right: JSteen (JS in monogram).
NG 2557 was probably painted in the late 1640s. The influence of Joost Droochsloot (1586–1666), who worked in Utrecht, is evident, especially in the large number of small figures.

Salting Bequest, 1910.

MacLaren/Brown 1991, p. 427.

Massimo STANZIONE
about 1585?–1656

Stanzione was born in Orta di Atella. He travelled to Rome and studied there under Santafede. His work displays the influence of Caracciolo, Ribera and Artemisia Gentileschi. The artist mainly painted for churches in the Naples area, but also produced secular pictures for private patrons, including Don Antonio Ruffo of Messina. He died in Naples of the plague.

Gherardo STARNINA (The Master of the Bambino Vispo)
about 1354; died about 1413

After being inscribed in the Florentine artists' guild in 1387 Starnina is documented in Spain (Valencia) in 1395, 1398 and 1401. He seems to have returned to Florence by 1404 and is generally identified with the Master of the Bambino Vispo (Master of the Lively Child), a name invented in 1904.

Jan STEEN
1625/6–1679

Jan Steen was born in Leiden and is said to have studied with Nicolaus Knüpfer, Adriaen van Ostade and Jan van Goyen. He was active in Leiden, The Hague, Delft, Warmond and Haarlem, and was a prolific painter of genre subjects, portraits, religious and mythological pictures. He also painted a few landscapes.

Jan STEEN
A Pedlar selling Spectacles outside a Cottage
about 1650–3

Jan STEEN
A Young Woman playing a Harpsichord to a Young Man, probably 1659

Jan STEEN
Skittle Players outside an Inn
probably 1660–3

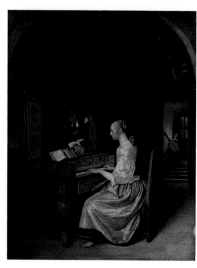

NG 2556
Oil on oak, 24.6 x 20.3 cm

NG 856
Oil on oak, 42.3 x 33 cm

NG 2560
Oil on oak, 33.5 x 27 cm

Signed on the lintel of the cottage door: JSteen. (JS in monogram).

NG 2556 had a companion picture showing a fortune teller when it was sold in the Netherlands in 1771, 1778 and 1800.

The picture was probably painted in the early 1650s, when Steen was living in The Hague.

Johan Balthasar Krauht et al. sale, The Hague, 7–8 October 1771 (lot 8); Anon. sale, Amsterdam, 1 October 1778 (lot 144); G.C. Blanken sale, The Hague, 4–5 June 1800 (lot 17); Salting Bequest, 1910.

MacLaren/Brown 1991, p. 426.

Signed and dated above the keyboard: IOHANIS STeeN FECIT 16(.)(9?). Inscribed on the inner side of the top of the harpsichord: ACTA VIRUM / PROBANT (Actions prove the man); and on the inner side of the keyboard: Soli Deo Gloria (Glory to God alone).

The design of seahorses and arabesques above the keyboard can also be seen on the instrument in Vermeer's *Lady at a Virginal* (London, Royal Collection), and there is a very similar printed paper decoration on an Antwerp virginal of about 1620 (Brussels, Musée Instrumental du Conservatoire). Biblical quotations and proverbs are often found on virginals and harpsichords (compare Metsu NG 839). The coat of arms above the door is now illegible. The boy in page's dress in the background carries a theorbo.

The date has been damaged, but is probably 1659, which would be appropriate for the style of NG 856.

Bought by A. Smit, 1802; collection of (Sir) Robert Peel (Bt) by 1823; purchased with the Peel collection, 1871.

MacLaren/Brown 1991, pp. 424–5.

On the left is the sign-board (a white swan) of an inn. NG 2560 may be the picture described as a 'Landscape with Skittle-players in the Haarlemmer Hout' in the Cornelis van Dyck sale of 1713.

NG 2560 was probably painted in 1660–3, when Steen was living in Haarlem.

Possibly in the Jacob Cromhout and Jasper Loskart sale, Amsterdam, 1709 and/or the Cornelis van Dyck sale, The Hague, 1713; certainly in the collection of Pieter Testas by 1757; Randon de Boisset collection by 1777; Talleyrand collection by 1814; collection of Alexander Baring (later 1st Baron Ashburton) by 1829; Salting Bequest, 1910.

MacLaren/Brown 1991, pp. 429–30.

Jan STEEN
An Interior with a Man offering an Oyster to a Woman, probably 1660–5

NG 2559
Oil on oak, 38.1 x 31.5 cm

Signed top left: JSteen (JS in monogram).
 In the right background is an engraved view, probably of Antwerp. In the seventeenth century oysters were thought to be an aphrodisiac and the man's offer can be interpreted as a sexual advance.
 NG 2559 was probably painted in the early 1660s. A signed variant is known (Oslo, Museum), and another is said to have existed.

Perhaps in the collection of Robert de Neufville by 1736; collection of Sir Hugh Hume Campbell, Bt, by 1856; Salting Bequest, 1910.

MacLaren/Brown 1991, pp. 428–9.

Jan STEEN
A Man blowing Smoke at a Drunken Woman, Another Man with a Wine-pot, about 1660–5

NG 2555
Oil on oak, 30.2 x 24.8 cm

Signed top left: JSteen. (JS in monogram).
 The woman has fallen asleep with a glass in one hand and a pipe in the other. The two men seem to mock her state, and the picture may be intended to illustrate the saying 'De Wijn is een spotter' (Wine is a mocker).
 NG 2555 was probably painted in the early 1660s. Steen often painted pictures on the theme of female drunkenness (e.g. NG 6442).

Salting Bequest, 1910.

MacLaren/Brown 1991, p. 426.

Jan STEEN
The Effects of Intemperance
about 1663–5

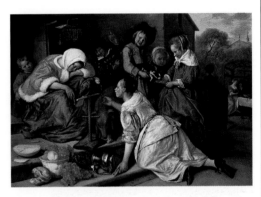

NG 6442
Oil on wood, 76 x 106.5 cm

Signed on the step lower centre: JSteen (JS in monogram).
 There is a later inscription above the round window of the building in the right background: HOSPITAL.
 The woman slumped on the left, whose purse is being picked by a child on the extreme left, is sleeping off the effects of alcohol. She illustrates the proverb 'De Wijn is een spotter' (Wine is a mocker). As in many other paintings by Steen, it is the foolishness of their elders that encourages the children to misbehave. Here the child throwing roses in front of the pig illustrates a popular saying about foolish behaviour. In the background an old man is seducing a young girl, another of the pitfalls of alcohol. Above the head of the drunken woman hangs a basket in which can be seen reminders of the fate of those who lack self-discipline – the crutch and clapper of the beggar (*Lazarusklep*) and the birch of judicial punishment. Steen's moralistic message is that it is only by actively resisting the temptations of excessive indulgence in sensual pleasures that poverty and degradation can be avoided.
 Steen often painted pictures on the theme of female drunkenness (e.g. NG 2555).

Bought in Amsterdam, 1829; purchased for W.B. Beaumont (later Lord Allendale), 1878; bought from the Trustees of the Allendale Settlement with anonymous contributions, 1977.

MacLaren/Brown 1991, pp. 431–2.

Jan STEEN
A Peasant Family at Meal-time ('Grace before Meat'), about 1665

Jan STEEN
The Interior of an Inn ('The Broken Eggs') about 1665–70

Jan STEEN
Two Men and a Young Woman making Music on a Terrace, about 1670–5

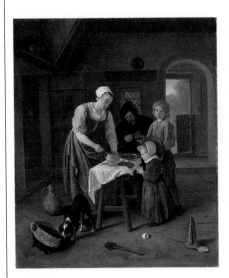

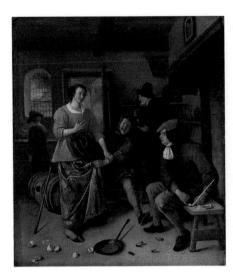

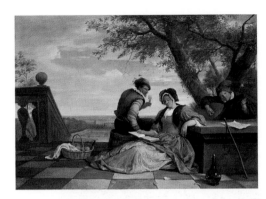

NG 1421
Oil on canvas, 43.8 x 60.7 cm

NG 2558
Oil on canvas, 44.8 x 37.5 cm

NG 5637
Oil on canvas, 43.3 x 38.1 cm

Signed bottom left: JSteen. (JS in monogram).
 The little girl on the right of the table is saying grace. This type of picture, which was frequently painted by Jan Steen, is known as 'Grace before Meat'.

Van Tol collection by 1779; collection of Prince Eugène [de Beauharnais], Duke of Leuchterberg, by 1825; by descent to Duke Georgi Nicolaievitch of Leuchtenberg, St Petersburg, 1904; collection of George Salting by 1906; Salting Bequest, 1910.

MacLaren/Brown 1991, pp. 427–8.

Signed on the side of the bench bottom right: JSteen. (JS in monogram).
 In this raucous tavern scene, the man who lifts a woman's skirt has the features of the artist himself.

E. de Boursault collection, Paris, by 1833; collection of (Sir) Otto Beit by 1909; by whom bequeathed, 1941.

MacLaren/Brown 1991, pp. 430–1.

Signed on the parapet right: JSteen (JS in monogram).
 The man on the right is playing a lute. The dress of the two men is archaic and may be based on theatrical costumes. The old man seated in the centre may be intended to be the Pantalone of the *commedia dell'arte.*

Collection of the Hon. William Pole-Tylney-Long-Wellesley, Brussels, by 1842; bought for the National Gallery, 1894.

MacLaren/Brown 1991, p. 425.

After STEEN
An Itinerant Musician saluting Two Women in a Kitchen, probably about 1770

NG 1378
Oil on thick paper, stuck on canvas, 46 x 36.8 cm

Inscribed on the side of the fireplace at the right: JSt 1670 (JS in monogram; the t has been repainted and the letters 'een' added above the date.)

NG 1378 is a copy after Steen's picture in an English private collection. The old man has a flute in his breeches pocket; the room is clearly the kitchen.

NG 1378, which is painted in grisaille, was probably made by (or for) Samuel de Wilde (1748–1832) in preparation for his print (dated 1771). Steen's picture was probably painted in about 1670, which is the date inscribed on this copy but not on the original.

Presumably in the Samuel Woodburn collection by 1854 (and possibly in the van Loon collection, Amsterdam, by 1833); bequeathed by Sir William H. Gregory, 1892.

MacLaren/Brown 1991, pp. 432–4.

Harmen STEENWYCK
Still Life: An Allegory of the Vanities of Human Life, about 1640

NG 1256
Oil on oak, 39.2 x 50.7 cm

Signed on the box: H· Steenwyck

This arrangement of objects is intended to refer symbolically to aspects of human life and temporal pursuits that were thought to be vain and futile by comparison with the lasting truths of religion. Such a subject is known as a *vanitas*, a title derived from the Old Testament (Ecclesiastes 1: 2): 'Vanitas vanitatum . . . et omnia vanitas' (Vanity of vanities... all is vanity). The books symbolise human knowledge, and the musical instruments (a recorder, part of a shawn, a lute) the pleasures of the senses. The Japanese sword and the shell, which in the seventeenth century would have been collectors' rarities, symbolise wealth. The skull, chronometer and expiring lamp allude to the transience and frailty of human life.

X-radiographs reveal that the bust of a man in profile wearing a wreath was once painted where the bottle is now. This was probably intended to show a Roman emperor – a symbol of earthly power related to the themes explored elsewhere in the picture.

Sir John Savile Lumley (later Baron Savile) collection by 1882; presented by Lord Savile, 1888.

MacLaren/Brown 1991, pp. 434–5.

Hendrick van STEENWYCK the Younger and Jan BRUEGHEL the Elder
The Interior of a Gothic Church looking East
1604–15

NG 1443
Oil on copper, 36.7 x 55 cm

Signed on the base of the column in the right foreground: H. W/ ST(?) E(?)INWICK. The reverse of the support is engraved with the name: HANS GOYVAERTS (see below). The bottom right of the tombstone in the left foreground is inscribed: MONCOV...IOM...NFT/...OYN. The tombstone in the foreground to the right of centre bears the date: 1603. There may also be traces of another date on the tombstone at the right before the column.

The building has not been identified. A christening party enters from the right, while behind them a priest celebrates Mass in a side chapel. In the main aisle mourners sit around a catafalque in front of the screen. The paintings hanging in the church show the Adoration of the Magi and the Raising of Lazarus.

The architecture of NG 1443 was painted by Steenwyck, but the figures appear to be by another artist, probably Jan Brueghel the Elder (see Steenwyck NG 2204, where comparable figures are depicted). The name Hans Goyvaerts, which is on the back of the copper support, may have been that of the Antwerp art dealer from whom Brueghel bought the picture before adding the figures.

Possibly in the collection of the dealer Hans Goyvaerts; collection of Jan Brueghel the Elder, Antwerp, about 1615; G.A. Morland sale, Christie's, 1863; bequeathed by George Mitchell to the South Kensington (now Victoria & Albert) Museum, 1878; on loan since 1895.

Martin 1970, pp. 243–6.

Harmen STEENWYCK
1612–after 1655

Harmen Evertsz. Steenwyck was born in Delft. He studied in Leiden from 1628 for about five years with his uncle, David Bailly. The artist was back in Delft by 1644. In 1654 he was in the East Indies, but by the following year had returned to Delft. Steenwyck specialised in meticulous still lifes.

Hendrick van STEENWYCK the Younger
active by 1604; died 1649

The artist, who was probably taught by his father, specialised in painting church interiors and architectural scenes. According to van Mander, he was active as a painter by 1604. He worked in London from 1617 to 1637 and was employed by Charles I and members of his court. By 1645 Steenwyck was back in the Northern Netherlands; his widow is recorded as living in Leiden in 1649.

Hendrick van STEENWYCK the Younger
The Interior of a Gothic Church looking East
after 1609

Hendrick van STEENWYCK the Younger
A Man kneels before a Woman in the Courtyard of a Renaissance Palace, 1610

Hendrick van STEENWYCK the Younger
Croesus and Solon
about 1610

NG 4040
Oil on copper, 10.5 x 15.3 cm

NG 141
Oil on copper, 40.2 x 69.8 cm

NG 1132
Oil on copper, 31.1 x 22.9 cm

The tombstone in the foreground bears the date: 1609.

The church depicted here has not been identified. It has been suggested that the figures are taking part in a wedding ceremony. The date 1609 on the tombstone in the foreground is not necessarily that of the painting, merely a date after which the picture was painted.

Sir Claude Phillips Bequest, 1924.

Martin 1970, p. 243.

Signed and dated: H. V. STEINWY (?) CK. 1610.

The subject has been identified as Aeneas in the palace of Dido, but this is uncertain. The architecture may have been inspired by a design in Hans Vredeman de Vries's *Perspectiva*, which was published in Antwerp in 1602.

Recent cleaning of the painting has shown it to be in an excellent state of preservation.

Probably Philip van Dijk sale, The Hague, 1753; William Beckford collection by 1822; bequeathed Lt-Col. J.H. Ollney, 1837.

Martin 1970, pp. 241–2.

Signed: TEENW.. K[?].

Herodotus and Plutarch both recount the story of the visit of the Athenian legislator Solon to King Croesus at Sardis. Croesus considered himself the happiest of men because of his immense wealth, and here he is shown surrounded by riches.

Although the architectural setting in NG 1132 is by Steenwyck the Younger, the figures and flowers may be by another artist. Such collaborations were common in architectural scenes of this type. Steenwyck's collaborator worked in the style of Jan Brueghel the Elder. The architecture is similar to that in NG 141 which is dated 1610.

Bought at the 12th Duke of Hamilton sale, Christie's, July 1882 (lot 1019) (Clarke Fund).

Martin 1970, pp. 247–8.

Hendrick van STEENWYCK the Younger and Jan BRUEGHEL the Elder
The Interior of a Gothic Church looking East, 1615

Imitator of van STEENWYCK
Interior of a Church at Night
1632

Alfred STEVENS
The Present
about 1866–71

NG 2204
Oil on copper, 25.6 x 40.2 cm

NG 2205
Oil on oak, 47.1 x 65.7 cm

NG 3270
Oil on canvas, 37 x 46 cm

Signed and dated : H. V. STEEIN/ 1615.
 The church has not been identified. A christening party enters from the right. Beyond them a priest celebrates Mass and a funeral procession approaches the high altar. The paintings hanging in the church depict the Walk to Emmaus and Christ and the Woman of Samaria.
 The figures are probably by Jan Brueghel the Elder.

Christopher Beckett Denison sale, Christie's, 6 June 1885 (lot 84); bequeathed by Henry Calcott Brunning, 1907.

Martin 1970, pp. 246–7.

The tombstone at the centre bears the inscription: 632/ HIER LEYT BEGRAVEN HENRY STEENWYCK. (Here lies buried Henry Steenwyck).
 The paintings hanging in the church depict, from left to right, Christ carrying the Cross, the Virgin and Child, the Crucifixion and Saint Jerome. The object in the centre is a font crane which supports a font cover.
 The numbers 632 in the inscription are presumably the last digits of the date 1632. The style of the costumes of the figures supports this dating. NG 2205 has in the past been attributed to Hendrick van Steenwyck the Younger and Peeter Neeffs the Elder. It is probably by a follower of the former.

Possibly in the Fonthill Abbey sale, 1823; Sir William W. Knighton sale, Christie's, 23 May 1885 (lot 494); bequeathed by Henry Calcott Brunning, 1907.

Martin 1970, pp. 248–9.

Signed top left: A. Stevens
 On the reverse: AS (in monogram).
 Stevens specialised in paintings of fashionably dressed young women and this picture, with its modest scale and intimate subject, is typical of his work.
 Stevens painted this subject on at least five occasions. One version was exhibited in 1866; NG 3270 appears to be later. It was first recorded in 1871.

Collection of J. Staats Forbes by 1871; collection of (Sir) Hugh Lane, 1904; Lane Bequest, 1917; on loan to the Hugh Lane Municipal Gallery of Modern Art, Dublin, since 1979.

Martin 1970, pp. 249–50.

Alfred STEVENS
1823–1906

Stevens was born in Brussels where he was trained by F.J. Navez. At the age of 21 he went to Paris and, with the exception of the years 1849–52, stayed there for the rest of his life. He exhibited regularly at the Paris and Brussels Salons and enjoyed official and court patronage, yet also maintained contacts with numerous avant-garde artists, including Manet and his circle.

Alfred STEVENS
Storm at Honfleur
probably 1890–1

Abraham STORCK
A River View
about 1690–1700

Bernardo STROZZI
A Personification of Fame
probably 1635–6

NG 3966
Oil on canvas, 66 x 81 cm

NG 146
Oil on canvas, 58.4 x 73.7 cm

NG 6321
Oil on canvas, 106.7 x 151.7 cm

Signed: A. Stevens. (AS in monogram)
The subject of NG 3966 was recorded on a photograph in the artist's possession as 'Bad Weather at Honfleur'. In 1880 Stevens began to make regular trips to the Normandy coast to relieve a bronchial condition. His later landscapes and marines are painted in a bold, spontaneous style that perhaps reveals Stevens's interest in Impressionism.

Collection of Félix Gérard by 1893; bought by the Tate Gallery, 1924; transferred, 1956.

Martin 1970, p. 249.

Signed bottom left: A: Storck Fecit.
In the centre is a *boeier* yacht (a round type of Dutch vessel, usually sprit-rigged, with a deep rail and a curved spoon bow), to the right a *tjalk* (a Dutch sprit-sail barge); and beyond a *statenjacht* (States yacht used for transporting members or guests of the States General), with the arms of the Province of Holland on her stern and a Dutch flag. The church in the centre distance recalls the Sint Laurens Kerk, Rotterdam, but the view is probably not topographically accurate.
NG 146 was probably painted in the 1690s.

Bequeathed by Lt-Col. J.H. Ollney, 1837.

MacLaren/Brown 1991, p. 436.

Fame is here personified as a winged woman who holds two instruments which probably refer symbolically to the different forms of Fame. They are a golden trumpet and a wooden recorder, or tenor shawm. The trumpet is probably intended as a reference to honourable fame, while the shawm symbolises that which is dishonourable.
NG 6321 appears to date from Strozzi's Venetian period. Stylistically it particularly displays affinities with his S. Benedetto altarpiece of 1635–6.

Possibly in the collection of Ferdinando Carlo Gonzaga, last Duke of Mantua, Venice, 1709; bought from Malcolm Waddingham, 1961.

Levey 1971, pp. 211–12.

Abraham STORCK
1644–1708

Abraham Sturckenburg (he later called himself Storck) was born in Amsterdam, the son of a painter. He worked in Amsterdam, painting seascapes in the manner of Ludolf Bakhuizen, harbour scenes and imaginary views of Italian harbours in the style of Jan Baptist Weenix, and some topographical views, principally of Amsterdam.

Bernardo STROZZI
1581–1644

Strozzi was born in Genoa where he is said to have studied under Pietro Sorri and Cesare Corte. In about 1597 he became a Capuchin friar, but left the Order in about 1610, although remaining a priest. The artist had settled in Venice by 1631 where he was made a monsignor in 1635, and remained there until his death.

George STUBBS
The Milbanke and Melbourne Families
about 1769

George STUBBS
A Lady and a Gentleman in a Phaeton
1787

After Pierre SUBLEYRAS
The Barque of Charon
about 1770

NG 6429
Oil on canvas, 97.2 x 149.3 cm

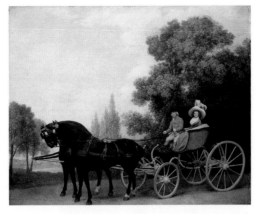

NG 3529
Oil (identified) on oak, 82.5 x 101.6 cm

NG 4133
Oil on canvas, 134.6 x 83.8 cm

The sitters are from left to right: Lady Melbourne, née Elizabeth Milbanke (1751–1818); her father, Sir Ralph Milbanke (1722–98), 5th Bt; her brother, John Milbanke (died 1800); and her husband, Sir Peniston Lamb, later 1st Viscount Melbourne (1748–1828).

Elizabeth Milbanke married Sir Peniston Lamb in April 1769. She is shown in a timwhisky (a type of carriage), perhaps because she was pregnant (her first child was born in May 1770). NG 6429 was probably exhibited at the Society of Artists exhibition in May 1770.

Presumably commissioned by Peniston Lamb; by descent through the collection of the 5th Earl Cowper; bought, 1975.

Egerton 1984, pp. 150–1.

Signed and dated by the nearside front wheel of the carriage: Geo: Stubbs / p[inxi]t. 1787

The sitters have not been identified but it has been suggested that they might be members of the Hope family who were bankers in Liverpool. The phaeton is carefully observed.

Perhaps painted for a member of the Hope family in Liverpool; probably in the collection of Charles Coates by 1888; presented by his niece, Miss H.S. Hope, 1920.

Davies 1959, p. 94; White 1980, p. 64; Egerton 1984, p. 175.

In Greek myth Charon was the boatman who took the souls of the dead across the river Styx to Hades. This composition repeats that of a painting by Subleyras of around 1735 (Paris, Louvre), which also appears (obscured) in the picture by Subleyras of his studio (Vienna, Akademie).

NG 4133 has in the past been attributed to Fuseli (1741–1825); it may be contemporary with him.

Revd. Alfred Thornton, Ashford; presented by Frederick B. Lucas, 1925.

Davies 1957, pp. 208–9; Michel 1987, pp. 162–3.

George STUBBS
1724–1806

Stubbs was born in Liverpool, and was largely self-taught as an artist. From an early age he studied anatomy and he is principally renowned as a painter of horses. He was also a portraitist and painted open-air conversation pieces. He moved to London in about 1759 and was elected ARA in 1780.

Pierre SUBLEYRAS
1699–1749

Subleyras was born in Saint-Gilles-du-Gard. He was a pupil of his father, and later of Antoine Rivalz in Toulouse. He studied at the Académie in Paris and won the Prix de Rome in 1727. The following year he went to Rome, where he settled. He painted mainly altarpieces and portraits.

Justus SUSTERMANS
Double Portrait of the Grand Duke Ferdinand II of Tuscany and his Wife Vittoria della Rovere
probably 1660s

NG 89
Oil on canvas, 161 x 147 cm

Ferdinand II de' Medici (1610–70), who wears a commander's sash and the military Order of San Stefano, and carries a commander's baton, succeeded his father as Grand Duke of Tuscany in 1621, assuming power in 1627. In 1634 he married Vittoria della Rovere (1621–94).

In the early nineteenth century NG 89 was attributed to Velázquez. It is in fact by Sustermans, but may also include the participation of members of his studio. The costumes of the sitters seem to date from the 1660s. The poses of the two figures correspond with two single portraits of them by Sustermans (Florence, Uffizi). It is possible that earlier drawings were used for NG 89 and that it was not painted directly from life.

Bought from F.L.J. Laborde-Méréville (1761–1802) by J.J. Angerstein; bought with the J.J. Angerstein collection, 1824.

Martin 1970, pp. 251–3.

Attributed to SUSTERMANS
Portrait of a Man
probably 1649

NG 3227
Oil on canvas, 120 x 93.5 cm

The sitter has been described as a Florentine nobleman, but the red costume suggests that he may have been Genoese and have held office in the government of that Republic.

The artist worked in Genoa in 1649. NG 3227 may be an old copy after a work by Sustermans. A better version of the portrait was recorded on the Vienna art market in 1968.

Bequeathed by W.W. Aston, 1917, with a life interest to his widow; acquired, 1919.

Martin 1970, p. 253.

Lambert SUSTRIS
Solomon and the Queen of Sheba
1550–70

NG 3107
Oil on canvas, 78.8 x 185.4 cm

The Queen came to Solomon to see if what she had heard of his wisdom and wealth was true. Old Testament (I Kings 10: 1–13). In NG 3107 she is depicted with her followers kneeling before him on the steps, left of centre.

NG 3107 has been attributed in the past to Bonifazio, Andrea Schiavone and Bordone.

The main concern of the painter may have been the classical buildings which recall sources such as Serlio's architectural books, and are redolent of contemporary stage designs. The figures are sketched lightly on top of the architecture and have become transparent with age and wear.

Bought by Sir A.H. Layard in Madrid, 1872; Layard Bequest, 1916.

Gould 1975, pp. 313–14.

Justus SUSTERMANS
1597–1681

The portraitist Sustermans was born in Antwerp, where he was a pupil of Willem de Vos in 1609. He went to Paris in about 1616 and joined the studio of Frans Pourbus the Younger, before travelling to Florence where he became court painter to the Grand Dukes of Tuscany. The artist also worked in Vienna, Innsbruck and various Italian cities.

Lambert SUSTRIS
about 1515/20–about 1570

Sustris was born in Amsterdam and may have been a pupil of Jan van Scorel or of Heemskerck in Utrecht. He worked in oil and fresco and was noted for his portraits and landscapes. He arrived in Venice between 1534 and 1538, and worked as an associate of Titian both in Venice and at the Imperial court at Augsburg in 1548 and 1550–2. He later worked in Padua and Venice.

SWABIAN
Portrait of a Woman of the Hofer Family
about 1470

Francesco TACCONI
The Virgin and Child
1489

Jean-Joseph TAILLASSON
Virgil reading the Aeneid to Augustus and Octavia
1787

NG 722
Oil on silver fir, 53.7 x 40.8 cm

NG 286
Oil on lime, 99.7 x 52.7 cm

NG 6426
Oil on canvas, 147.2 x 166.9 cm

Inscribed top left: GEBORNE HOFERIN (Born a Hofer).

Although the inscription provides the name of the family of the sitter, her identity has not been established. She holds a sprig of forget-me-not, which is probably intended as a symbol of remembrance. The fly on her head-dress might, because of its short life, be intended as a symbol of mortality, but may also be a reminder of the fictive nature of the illusion the artist has created (see also Crivelli NG 907.1).

The costume of the sitter dates NG 722 to about 1470. Its style has been associated with that of the work of the Master of the Sterzing Wings who was active in about 1456–8 in Ulm.

Collection of Prince Ludwig Kraft Ernst von Oettingen-Wallerstein; at Schloss Wallerstein, 1826; acquired by the Prince Consort, 1851; presented by Queen Victoria at the Prince Consort's wish, 1863.

Levey 1959, pp. 106–7; Dunkerton 1991, p. 300.

Inscribed on the step of the throne: .OP.FRANCISI. / .TACHONI.1489. / .OCTV. (Work of Francesco Tacconi October 1489).

The Virgin and Child are seated in front of a cloth of honour.

The composition is derived from an altarpiece – in which the Virgin was depicted full-length on a throne – by Giovanni Bellini. This altarpiece is now known only through replicas and copies, including NG 286. A variant by Bellini, truncated in format but probably of the original figure size, is also in the Collection (NG 280).

Probably Savorgnan collection, Venice, before 1824; collection of Baron Francesco Galvagna, Venice, by 1824; bought with the Galvagna collection, 1855.

Davies 1961, p. 512.

Signed and dated bottom left: Taillasson. 1787.

For the subject see the *Life of Virgil* by Donatus. The poet Virgil reads to the Emperor Augustus and his sister Octavia a passage from the *Aeneid* (Book VI), which includes praise for her son, Marcellus, who had recently died.

NG 6426 was exhibited at the Paris Salon of 1787, as the property of M. Dufresnoy.

A careful drawing after the painting, possibly preparatory to an engraving, exists (Cambridge, Massachusetts, Fogg Art Museum). No engraving, however, is known.

Collection of the notary Duclos-Dufresnoy, 1787; bought, 1974.

National Gallery Report 1973–5, p. 29; Wilson 1985, p. 120.

Francesco TACCONI
active about 1458–about 1500

Francesco di Giacomo Tacconi was born in Cremona where he became an important local artist. He was in Venice for several years (at least 1489–91) with notable commissions (e.g. the organ doors in St Mark's) and was influenced by Giovanni Bellini. He painted altarpieces and frescoes.

Jean-Joseph TAILLASSON
1745–1809

Taillasson was born in Bordeaux and died in Paris. He was a pupil of J.-M. Vien in Paris and became a member of the Académie in 1782. He regularly exhibited works at the Salon, usually of classical and historical subjects. In 1785 he published *Le Danger des règles dans les arts.*

Attributed to Agostino TASSI
Diana and Callisto
after 1626

David TENIERS the Younger
Two Men playing Cards in the Kitchen of an Inn
probably 1635–40

David TENIERS the Younger
Spring
about 1644

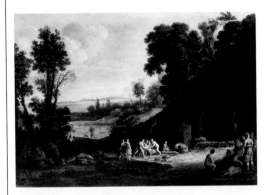

NG 4029
Oil on wood, 49.5 x 72.4 cm

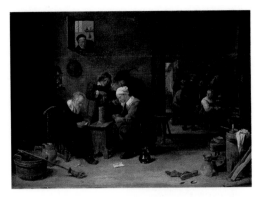

NG 2600
Oil on oak, 55.5 x 76.5 cm

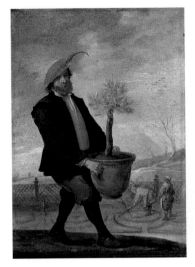

NG 857
Oil on copper, 22.1 x 16.5 cm

Callisto was one of the chaste goddess Diana's nymphs. When Diana discovered Callisto was pregnant by Jupiter, she transformed Callisto into a bear and set her dogs on her, but Jupiter saved her at the last moment. Ovid, *Metamorphoses* (II, 422–53).

NG 4029 has been ascribed to Paul Brill (1554–1626), but it is now considered to be by Tassi, although strongly influenced by Brill and perhaps executed shortly after his death.

Mrs Pine Coffin sale, London, 1917; Sir Claude Phillips Bequest, 1924.

Levey 1971, pp. 212–13.

Signed: DAVID TENIERS F

A man deals cards at the table; a woman looks down from an opening in the wall above. On the left a man urinates, while in the right background a woman cooks over the fire, surrounded by four men.

The panel has on the reverse the monogram of the Antwerp panel-maker Michiel Vriendt, who died in 1636. The picture was probably painted at about that time.

Perhaps anon. sale, Amsterdam, 21 October 1739; collection of M. Bellanger, Substitut de M. le Procureur du Roi, by 1747; Salting Bequest, 1910.

Martin 1970, pp. 269–71.

Signed: DT.F (DT in monogram).

In the foreground a gardener wearing a plumed hat carries a potted tree. Behind him two figures with spades are starting to lay out a formal garden. Beyond the fence the land is uncultivated. This work is the first in a series of four paintings by Teniers in the National Gallery that depict activities intended to symbolise the four seasons (see also NG 858, 859, 860). The growth of the tree and the creation of the garden in this case allude to spring.

NG 857, along with the others in the series, is dated by comparison with the artist's *Prodigal Son* (Paris, Louvre) of 1644.

In sixteenth-century Flanders seasons were usually represented by female personifications. Representing them naturalistically in a male guise, as in this case, was an innovation of the seventeenth century. Teniers painted at least four other comparable series. He may have been influenced by the engravings of such subjects by J. Matham and A. Tempesta.

Perhaps Comtesse de Verrue sale, Paris, 27–28 March 1737; Prince Talleyrand sale, Paris, 7–8 July 1817; bought by Buchanan; bought with the Peel collection, 1871.

Martin 1970, pp. 259–61.

Agostino TASSI
about 1580–1644

Tassi was born and spent most of his life in Rome, although he is recorded in Florence and Genoa. From 1610 he worked on various decorative schemes in the city. In 1612 he was imprisoned as a result of a law suit with Artemisia Gentileschi. For a period in the early 1620s Claude may have been his pupil.

David TENIERS the Younger
1610–1690

The son and pupil of David Teniers the Elder, the artist was born in Antwerp. He entered the Guild of St Luke there in 1632/3. He painted and etched landscapes and genre scenes. Later (probably by 1651) he settled in Brussels where he worked for the Governors of the Netherlands. Teniers visited England in the 1650s to buy paintings. He helped establish the Académie Royale in Antwerp in 1663.

David TENIERS the Younger
Summer
about 1644

David TENIERS the Younger
Autumn
about 1644

David TENIERS the Younger
Winter
about 1644

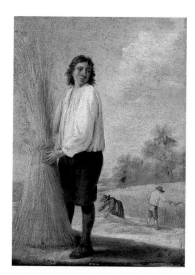

NG 858
Oil on copper, 21.9 x 16 cm

NG 859
Oil on copper, 22.1 x 16.4 cm

NG 860
Oil on copper, 22.2 x 16.2 cm

Signed: DT.F (DT in monogram).
The labourer in the foreground holds upright a sheaf of ripe corn. Behind him to the right two men continue the harvest, one working with a scythe and the other piling up the sheaves.
This picture is the second in a series of four paintings by Teniers that symbolise the seasons (see also Teniers NG 857, 859, 860). See Teniers NG 857 for further discussion.

Perhaps the Comtesse de Verrue sale, Paris, 27–28 March 1737; Prince Talleyrand sale, Paris, 7–8 July, 1817; bought by Buchanan; bought with the Peel collection, 1871.

Martin 1970, pp. 259–61.

Signed: DT.F (DT in monogram)
The man in the foreground raises a glass of wine and holds a jug. Behind him to the right beneath a shelter two men tread grapes, another empties a barrel and a third seals one.
NG 859 is the third in a series of four paintings by Teniers that symbolise the seasons (see also Teniers NG 857, 858, 860). See Teniers NG 857 for further discussion.

Perhaps the Comtesse de Verrue sale, Paris, 27–28 March 1737; Prince Talleyrand sale, Paris, 7–8 July, 1817; bought by Buchanan; bought with the Peel collection, 1871.

Martin 1970, pp. 259–61.

Signed: DT (in monogram)
An elderly man, dressed in furs, is seated at a table in the open air. He warms his hands on a brazier. A jug and glass are also on the table. Behind him at the left figures can be seen skating and sledging.
NG 860 is the fourth in a series of four paintings by Teniers that symbolise the seasons (see also Teniers NG 857, 858, 859). See Teniers NG 857 for further discussion.

Perhaps the Comtesse de Verrue sale, Paris, 27–28 March 1737; Prince Talleyrand sale, Paris, 7–8 July, 1817; bought by Buchanan; bought with the Peel collection, 1871.

Martin 1970, pp. 259–61.

David TENIERS the Younger
*A Man holding a Glass and an Old Woman
lighting a Pipe,* about 1645

David TENIERS the Younger
*A View of a Village with Three Peasants talking in
the Foreground,* about 1645

David TENIERS the Younger
Peasants at Archery
about 1645

NG 5851
Oil on canvas, 119.4 x 289.6 cm

NG 158
Oil on oak, 23.8 x 34.3 cm

NG 950
Oil on canvas, 112.5 x 166.7 cm

Signed: D. TENIERS. F
 This work is not recorded before the mid-eighteenth century. It has been suggested that the signature may not be authentic, but there is no reason to doubt the attribution to Teniers. The handling of the paint is comparable to that in his *Boors Carousing* (London, Wallace Collection) which is dated 1644. NG 158 may have been painted a little later.
 Scenes of this sort, and more specifically the pose of the peasant raising his glass, probably derive from the work of Brouwer.

Perhaps Jacomo de Wit sale, Antwerp, 15 May 1741 (lot 109); bequeathed by Lord Farnborough, 1838.

Martin 1970, pp. 256–7.

Signed: DT.F (DT in monogram).
 The village in the distance has not been identified.
 A pentimento is visible on the nearside of the stream; it would appear that a wooden structure has been painted out.

Collection of the dealer Remy, Paris, 1742; collection of the Marquess of Buckingham at Stowe by 1801; probably bought by Wynn Ellis after 1850/1; Wynn Ellis Bequest, 1876.

Martin 1970, pp. 266–7.

Signed: D: TENIERS .F
 The view has not been identified.
 NG 5851 was probably painted at about the same time as Teniers NG 950.

Collection of James, 2nd Earl of Bandon (1785–1856), by 1831; bequeathed by Mrs M.V. James from the Arthur James Collection, 1948.

Martin 1970, p. 271.

David TENIERS the Younger
A View of Het Sterckshof near Antwerp
about 1646

NG 817
Oil on canvas, 82 x 118 cm

David TENIERS the Younger
The Rich Man being led to Hell
about 1647

NG 863
Oil on oak, 48 x 69 cm

David TENIERS the Younger
The Covetous Man
about 1648

NG 155
Oil on canvas, 62.5 x 85 cm

Signed: D · TENIERS · F

The large house partially hidden by trees has been identified as Het Sterckshof in Duerne near Antwerp. It has been suggested that the figures in the foreground are the artist, his wife, Anna Brueghel (1620–56), and their eldest son, David, who was born in 1638. The identification is not certain. The house in the painting was not the Teniers family home. The figure who offers the fish may be paying a seignorial due.

The dating of NG 817 is dependent upon comparison with two works of 1646 by the artist which illustrate similar handling, and in which figures wear similar clothes (*Village Fête*, Woburn Abbey, collection of the Duke of Bedford; *Village Fête*, St Petersburg, Hermitage).

The woman in the foreground also appears in Teniers NG 952, a studio version of the Bedford painting referred to above.

Possibly anon. (Séréville) sale, Paris, 22 January 1812 (lot 12); bought from Nieuwenhuys, 1871.

Martin 1970, pp. 257–9.

Signed : D TENIERS · F

Christ told the parable of the rich man. At his gate lay a poor man called Lazarus who was ill and hoped for charity. The poor man died and was carried to heaven, but at the rich man's death he was sent to hell. New Testament (Luke 16: 19–23). The rich man standing at the entrance to hell is not actually described in the Bible. Teniers conceived it as a cave mouth surrounded by demons and monsters.

It has been suggested that there was a pendant to NG 863 showing the rich man at table, but no such picture is now known. NG 863 is dated to about 1647, the date of Teniers's *Temptation of Saint Anthony* (Berlin) in which comparable monsters appear. The Antwerp coat of arms is branded on the reverse of the panel.

Monsters such as these ultimately derive from the creations of Bosch. Teniers may have been influenced more directly by Cornelis Saftleven (e.g. *The Rich Man being led to Hell*, 1631, Warsaw, National Museum).

Le Comte de Merle sale, Paris, 1 March 1784 (no. 48); entered the collection of (Sir) Robert Peel (Bt), 1822; bought with the Peel collection, 1871.

Martin 1970, pp. 264–6.

Signed: DAVID. TENIERS. The papers on the table are inscribed: Lan... ge... geheeten/Loquor.

'But God said unto him, Thou fool, this night thy soul shall be required of thee: then whose shall those things be, which thou has provided? So is he that layeth up treasure for himself, and is not rich toward God.' New Testament (Luke 12: 20–1). The fool who would not be parted from his money holds it in a bag on his lap and stares towards the light. The old woman weighs gold. On the table are sacks of coins, deeds and an hourglass.

The figures in NG 155 are based on the same models used for the artist's *Soldiers plundering a Village* of 1648 (Vienna, Kunsthistorisches Museum).

Subjects of this type are in part derived from the prototype of Massys's *Money Changers* (Paris, Louvre) which was in Antwerp in the seventeenth century. (See also Marinus van Reymerswaele NG 944.)

Possibly anon. sale, Christie's, 28 June 1814 (lot 81); bequeathed by Lord Farnborough, 1838.

Martin 1970, pp. 254–6.

David TENIERS the Younger

A Cottage by a River with a Distant View of a Castle, about 1650

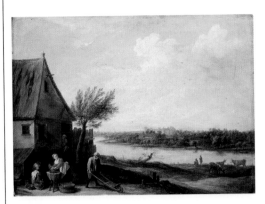

NG 861
Oil on oak, 48.9 x 66.7 cm

David TENIERS the Younger

An Old Peasant caresses a Kitchen Maid in a Stable about 1650

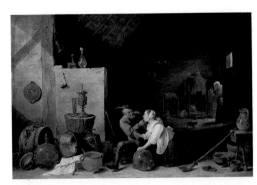

NG 862
Oil on oak, 43.2 x 64.9 cm

David TENIERS the Younger

Peasants playing Bowls outside a Village Inn about 1660

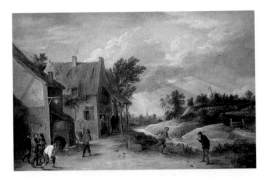

NG 951
Oil on canvas, 120.2 x 191 cm

Signed: D · TENIERS · F
 The castle has not yet been identified, but the view is almost certainly not imaginary.
 NG 861 is thought slightly to predate a painting by Teniers in the Prado, Madrid (no. 1794), which is signed and dated 1654.

The dealers Remy and Hele by 1751; entered the collection of (Sir) Robert Peel (Bt), 1822; bought with the Peel collection, 1871.

Martin 1970, pp. 261–2.

Signed: D · TENIERS · F
 The reverse of the panel is branded with the coat of arms of the city of Antwerp.
 NG 862 was probably painted in about 1650 and can be compared with the so-called *Marriage of the Artist* of 1651 (private collection).

Collection of Landgraf Wilhelm VIII (1682–1760) of Hesse at Cassel, by 1749; looted by General Lagrange, 1806; given by Napoleon to the Empress Josephine, and perhaps recorded at Malmaison, 1811; entered the collection of (Sir) Robert Peel (Bt), 1822; bought with the Peel collection, 1871.

Martin 1970, pp. 262–4.

Signed: DTf (DT in monogram).
 One of the participants runs to join his partner at the target, while their opponent is about to bowl. Spectators watch the game and a woman brings out drinks from an inn. The sign outside the inn is a crescent moon.

Perhaps in the Dr Bearcroft sale, Langford, 12 February 1762; Wynn Ellis Bequest, 1876.

Martin 1970, pp. 267–9.

Attributed to TENIERS
Peasants making Music in an Inn
about 1635

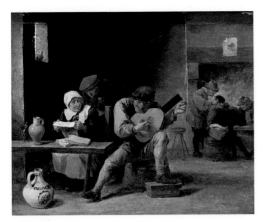

NG 154
Oil on oak, 29.1 x 36.2 cm

Attributed to TENIERS
A Gipsy telling a Peasant his Fortune in a Hilly Landscape, about 1640

NG 949
Oil on canvas, 163.2 x 215.3 cm

Attributed to TENIERS
Backgammon Players
probably 1640–5

NG 242
Oil on oak, 37.5 x 56.7 cm

Inscribed: D·TENIERS·F· ; on the book (of songs): BASO.

The man plays a lute. The owl on the window ledge may be a reference to sinfulness.

NG 154 has been generally accepted as a work of David Teniers the Younger, but it displays weaknesses of handling. It is painted in his style of the mid-1630s and may be a copy of a lost original.

The initials F/ DB on the reverse of the panel may be those of the panel-maker François de Bout who became a master in the Antwerp guild of St Luke in 1637/8.

Perhaps in the W. van Huls sale (lot 114), London, 6ff. August 1722; Lord Farnborough collection by 1818; by whom bequeathed, 1838.

Martin 1970, pp. 271–2.

Inscribed: DT (in monogram).

Travellers rest on a road before a mountainous landscape with a castle in the middle distance.

The foreground figures, in reverse and with others, recur in a tapestry woven by J. van Bortch after a design by Teniers.

Perhaps in the Richard Morgan sale, Christie's, 9 March 1850 (lot 16); Wynn Ellis Bequest, 1876.

Martin 1970, pp. 274–5.

Inscribed: D. TENIERS . F

The older player throws the dice, while his opponent moves a piece. Two other figures watch the game. In the right background three men warm themselves by a fire.

The reverse of the support bears the brand of the coat of arms of the city of Antwerp.

Collection of N.W. Ridley Colborne (later Lord Colborne) by 1838; by whom bequeathed, 1854.

Martin 1970, pp. 273–4.

Follower of TENIERS
An Old Woman peeling Pears
after 1640s

Imitator of TENIERS
Personification of Autumn (?)
after 1644

Imitator of TENIERS
A Doctor tending a Patient's Foot in his Surgery
17th century

NG 805
Oil on canvas, 48.6 x 66.5 cm

NG 953
Oil on oak, 16.4 x 12.4 cm

NG 2599
Oil on oak, 39 x 61.1 cm

Inscribed: D. TENIERS. F; and on the wall above the carafe: XXVIII

To the right of the woman is a greyhound, and to the left objects that include earthenware and brass pots and cauliflowers. The furniture in the background recurs in Teniers NG 862.

NG 805 was probably inspired by Teniers's style of the 1640s. It is reminiscent of a work by the artist's brother, Juliaen Teniers the Younger (1616– about 1676), in Copenhagen.

Perhaps in the collection of Count d'Astorg (1787–1853); bought from G.H. Phillips, 1870.

Martin 1970, pp. 277–9.

Inscribed: DT (in monogram).

The painting has been called 'The Toper', but it may well be intended as a personification of Autumn, and as such could derive from Teniers NG 859 of about 1644.

NG 953 has been attributed to David Teniers the Younger, but its quality suggests that it is the work of an imitator.

Wynn Ellis Bequest, 1876.

Martin 1970, p. 279.

Inscribed: D TENIERS F (possibly originally PD in monogram); and on the wall, the remains of a date: 16.

An assistant warms a plaster at the right, while the patient is treated.

NG 2599 has been attributed to David Teniers the Younger, but seems to be a copy after a lost original by the artist.

Possibly in the Willem Lormier sale, The Hague, 4 July 1763; Salting Bequest, 1910.

Martin 1970, pp. 279–82.

Imitator of TENIERS
An Old Woman Reading
17th century

NG 2601
Oil on oak, 17.8 x 14.3 cm

Inscribed: DT· (in monogram).
 Probably an old imitation of Teniers's manner.

George Salting collection after 1900; Salting Bequest, 1910.

Martin 1970, p. 282.

After TENIERS
A Country Festival near Antwerp
after 1646

NG 952
Oil on canvas, 89.7 x 125 cm

Inscribed: D.TENE[?]I[?]RS. F. 1643.
 The city on the horizon is Antwerp. On the rise at the right is a carved and festooned cross, which seems to have a Virgin and Child at the top. The group in the left foreground is traditionally thought to represent Teniers and his family (see Teniers NG 817).
 NG 952 is probably a studio replica of a painting of 1646 by Teniers (Woburn Abbey, collection of the Duke of Bedford).

Perhaps in the D. Potter sale, The Hague, 19 May 1723; probably Wynn Ellis collection, 1836; Wynn Ellis Bequest, 1876.

Martin 1970, pp. 276–7.

Giovanni Battista TIEPOLO
The Virgin and Child appearing to a Group of Saints, about 1735

NG 2513
Oil on canvas, 52.7 x 31.8 cm

Saint Francis of Assisi (about 1181–1226) stands on the left. The female martyr may be either Saint Agnes or Saint Lucy. The kneeling priest is probably a saint, and resembles depictions of Saint Philip Neri (1515–95). The pope on the right is also probably a saint, but is not securely identified.
 NG 2513 may be an independent sketch and does not appear to be related to any known Tiepolo altarpiece. It was probably painted in the mid-1730s.
 The group of the Virgin and Child with angels is repeated in a picture of *The Virgin and Child appearing to Saint Catherine of Siena* (Cremona, Pinacoteca).

Collection of Noel Desenfans, 1801; Salting Bequest, 1910.

Levey 1971, pp. 221–3.

Giovanni Battista TIEPOLO
1696–1770

Born in Venice, Tiepolo was active there and in other cities of Northern Italy. He was working in Würzburg from 1750 to 1753, with his sons Domenico and Lorenzo; in 1762 he was invited by Charles III to Madrid, where he painted frescoes in the Royal Palace. He died in Madrid.

Giovanni Battista TIEPOLO
A Vision of the Trinity appearing to Pope Saint Clement (?), about 1735–9

NG 6273
Oil on canvas, 69.2 x 55.2 cm

Although there are no identifying attributes, Saint Clement, the first pope of that name and a first-century martyr, is probably the pope shown here experiencing a vision of the Trinity. This identification is suggested by the circumstances of the picture's creation, see below.

NG 6273 is a highly finished modello for an altarpiece (Munich, Alte Pinakothek) that was probably commissioned by Clemens August, Archbishop-Elector of Cologne (died 1761). This altarpiece was installed in the chapel of Schloss Nymphenburg by 1739, and NG 6273 probably dates from a few years earlier. Clemens August commissioned a number of other works that related to his name, including a Martyrdom of Saint Clement from Pittoni (destroyed).

There are several copies of NG 6273.

Collection of Julius Weitzner by 1957; bought with the aid of the NACF, 1957.

Levey 1971, pp. 223–5.

Giovanni Battista TIEPOLO
Saints Augustine, Louis of France, John the Evangelist and a Bishop Saint, before 1737

NG 1193
Oil on canvas, 58.1 x 33.3 cm

In the centre, Saint Augustine (354–430), Doctor of the Church, holds his symbol, a flaming heart; on the left is Saint Louis (1215–70), King of France; and on the right is Saint John the Evangelist, identified by his attribute, the eagle. An unidentified bishop saint stands behind Saint John.

NG 1193 is a preliminary modello for an altarpiece (now destroyed) painted in 1737–8 for the Augustinian church of S. Salvatore, Venice. The composition of the lost altarpiece was copied in a drawing in 1746 by Franz Martin Kuen (1719–71), and is closely related to NG 1193.

Other versions of the subject (both by and after Tiepolo) are known.

Probably in the collection of Lord Ward by 1854 (and certainly by 1868); bought (Lewis Fund), 1885.

Levey 1971, pp. 218–21.

Giovanni Battista TIEPOLO
The Banquet of Cleopatra
1740s

NG 6409
Oil on canvas, 46.3 x 66.7 cm

Cleopatra owned the two largest pearls known. Contemptuous of the banquets of Mark Anthony, she was determined to spend ten million sesterces on a single feast. During the feast, she dropped one of her pearls into a vessel containing vinegar, where it dissolved; she then drank the liquid. Here, Cleopatra is about to release the pearl and Anthony starts back in surprise. The story is told by Pliny (*Natural History*, Book IX).

Tiepolo painted this subject on several occasions, most famously as a fresco in the Palazzo Labia, Venice. NG 6409 may be a sketch for this work, done at a time when a horizontal treatment was envisaged. An alternative suggestion is that the sketch was made in preparation for a canvas of 1747 now at Archangelskoye (near Moscow).

Cavendish–Bentinck collection by 1891; presented by the Misses Rachel F. and Jean I. Alexander; entered the Collection, 1972.

Morassi 1962, p. 18; Knox 1980, pp. 35–55.

Giovanni Battista TIEPOLO
Saints Maximus and Oswald (?)
about 1745

NG 1192
Oil on canvas, 58.4 x 32.4 cm

On the left is Saint Maximus Vitalianus, the second bishop of Padua who died in about 195. The saint on the right is probably Saint Oswald (about 603–642), King of Northumbria. His cult was popular in the Veneto where he was invoked as a protector against the plague.

Tiepolo painted an altarpiece of these saints in about 1742 for the church of Sts Maximus and Oswald in Padua. A preparatory sketch for the altarpiece (which was commissioned by Don Cogolo di Thiene) survives (Zurich, Kunsthaus). NG 1192 differs from both the finished altarpiece and this sketch (Saint Oswald's raven is not included in NG 1192), and it is unlikely to be a preparatory sketch. It probably derives from the finished altarpiece, and another very similar derivation exists (Bergamo, Accademia Carrara). The altarpiece was probably finished by 1745, which would seem a reasonable date for NG 1192 (which, for stylistic reasons, could not be significantly later).

Other versions of NG 1192 are known.

Collection of Lord Ward by 1868 (and possibly by 1854); bought (Lewis Fund), 1885.

Levey 1971, pp. 214–18.

Giovanni Battista TIEPOLO
An Allegory with Venus and Time
about 1754–8

NG 6387
Oil (identified) on canvas, 292 x 190.4 cm

NG 6387 was first described as 'Il Parto di Venere' ('Venus giving Birth'). Venus appears to have given birth to a boy, probably Aeneas and not Cupid, as he has no wings. The boy is held by Time, who is represented with his attributes of scythe and hourglass. A winged Cupid with a quiver of arrows appears below Time. The Three Graces appear above on Venus' chariot; they seem to be dropping flowers onto the figures below.

NG 6387 was painted for a ceiling, almost certainly in the Ca' Contarini, Venice (where the picture is recorded in June 1758). NG 6387 was etched in reverse by Giovanni Domenico Tiepolo as the work of his father. The ceiling picture may have been painted to celebrate a birth in the Contarini family; the boy has strongly individualised features and may be a portrait in the guise of the classical hero Aeneas. In 1876 NG 6387 was recorded together with four allegorical roundels which may represent the virtues and qualities to be hoped for in an heir.

A drawing probably related to NG 6387 exists in New York (Metropolitan Museum of Art).

Ca' Contarini, Venice, by 1758; bought with a special grant and a contribution from the Pilgrim Trust, 1969.

Levey 1971, pp. 228–31.

Giovanni Battista TIEPOLO
Two Men in Oriental Costume
about 1757

NG 6302
Oil on canvas, 159.1 x 53.3 cm

Two men in oriental costume are shown in a landscape which includes a shield. This may relate to an episode in Torquato Tasso's *Gerusalemme Liberata* (Canto 14: 77), when Rinaldo, who had been enchanted by the sorceress Armida, recognised himself in the reflection of a magic shield. See also NG 6303.

NG 6302 is part of a series of canvases by Tiepolo. This series includes NG 6303–5, and there may also have been other canvases. Stylistically a date of about 1757 is plausible since the series bears comparison with the contemporary frescoes by Tiepolo at the Villa Valmarana, Vicenza. NG 6302–5 were presumably painted to decorate a specific room, perhaps dedicated to subject matter drawn from Tasso. NG 6302 and 6304 were engraved by Giovanni Battista Tiepolo's son, Giovanni Domenico, as the work of his father.

A drawing exists (Florence, Uffizi) for the head of the man on the left.

Collection of Friedrich von Rosenberg, Vienna, by 1883 (possibly collection of Samuel, Graf von Festetits, Vienna, by 1859); bought, 1960.

Levey 1971, pp. 225–8; Knox 1978, pp. 49–95.

Giovanni Battista TIEPOLO
Rinaldo turning in Shame from the Magic Shield
about 1757

Giovanni Battista TIEPOLO
Seated Man, Woman with Jar, and Boy
about 1757

Giovanni Battista TIEPOLO
Two Orientals seated under a Tree
about 1757

NG 6303
Oil on canvas, 161.3 x 53.5 cm

NG 6304
Oil on canvas, 160.4 x 53.5 cm

NG 6305
Oil on canvas, 158.8 x 53 cm

Rinaldo, who had been enchanted by the sorceress Armida, recognises himself in the reflection of a magic shield and turns away in shame, throwing down the crown of flowers which he had put on while under Armida's spell. Torquato Tasso, *Gerusalemme Liberata* (Canto 16: 30). Though a shield is seen in NG 6303, Rinaldo appears to look out of the picture, possibly at the shield in another picture from the same series, NG 6302.

NG 6303 is part of a series of canvases by Tiepolo. This series includes NG 6302 and 6304–5; for further detail see under NG 6302. NG 6303 was engraved by Giovanni Battista Tiepolo's son, Lorenzo, as the work of his father.

Collection of Friedrich von Rosenberg, Vienna, by 1883 (possibly collection of Samuel, Graf von Festetits, Vienna, by 1859); bought, 1960.

Levey 1971, pp. 225–8; Knox 1978, pp. 49–95.

A seated man looks over his shoulder at a standing woman who carries a jar and is accompanied by a boy. Though part of a series that seems to derive from Torquato Tasso's *Gerusalemme Liberata*, the subject of NG 6304 (if it has a specific subject) has not been identified.

NG 6304 is part of a series of canvases by Tiepolo. This series includes NG 6302–3 and 6305; for further detail see under NG 6302. NG 6302 and 6304 were engraved by Giovanni Battista Tiepolo's son, Giovanni Domenico, as the work of his father.

Collection of Friedrich von Rosenberg, Vienna, by 1883 (possibly collection of Samuel, Graf von Festetits, Vienna, by 1859); bought, 1960.

Levey 1971, pp. 225–8; Knox 1978, pp. 49–95.

Two men in turbans are seated under a tree. One holds a jar. Though part of a series that seems to derive from Torquato Tasso's *Gerusalemme Liberata*, the subject of NG 6304 (if it has a specific subject) has not been identified.

NG 6305 is part of a series of canvases by Tiepolo which includes NG 6302–4; for further detail see under NG 6302. NG 6305 is of inferior quality to the rest of the series and may be a studio production.

Collection of Friedrich von Rosenberg, Vienna, by 1883 (possibly collection of Samuel, Graf von Festetits, Vienna, by 1859); bought, 1960.

Levey 1971, pp. 226–8; Knox 1978, pp. 49–95.

Giovanni Domenico TIEPOLO
The Deposition from the Cross
probably 1750–60

NG 5589
Oil on canvas, 80 x 89.2 cm

Giovanni Domenico TIEPOLO
The Marriage of Frederick Barbarossa and Beatrice of Burgundy, about 1752–3

NG 2100
Oil on canvas, 72.4 x 52.7 cm

Giovanni Domenico TIEPOLO
The Deposition from the Cross
1755–60

NG 1333
Oil on canvas, 64.2 x 42.5 cm

Inscribed on the cross: INRI.

Christ's dead body is mourned at the foot of the cross by the Virgin Mary, Mary Magdalene (identified by her blond hair), Saint John the Evangelist (in red), and probably Nicodemus and Saint Joseph of Arimathea. New Testament (e.g. John 19: 38–42).

The composition of NG 5589 is similar to Rembrandt's *Deposition from the Cross* in the National Gallery (NG 43), which was in the possession of Consul Joseph Smith in Venice between 1738 and 1762. NG 5589 was once attributed to Giovanni Battista Tiepolo or to Giovanni Domenico in collaboration with Giovanni Battista, but it was probably painted by Giovanni Domenico in the 1750s.

Giovanni Domenico Tiepolo painted the same subject on other occasions, see for example NG 1333. NG 5589 may be one of a series of pictures on themes from the Passion that were painted in the studio of Giovanni Battista Tiepolo.

Collection of E. Secerétan by 1889; bequeathed by Miss Emilie Yznaga 1945.

Mariuz 1971, p. 121; Levey 1971, pp. 240–1.

The marriage of the Emperor Frederick I Barbarossa (1150–90) to Beatrice, daughter of the Count of Burgundy, was celebrated in Würzburg in 1156.

NG 2100 is related compositionally to the fresco of *The Marriage of Frederick Barbarossa and Beatrice of Burgundy* by Giovanni Battista Tiepolo, painted in 1752 in the Kaisersaal of the Residenz, Würzburg. These frescoes were commissioned about 1750 by Prince-Bishop Karl Philipp von Greiffenklau. His likeness (as Frederick Barbarossa) on the steps of the altar suggests that NG 2100 was painted in Würzburg. NG 2100 had been thought to be a modello for the fresco, but it seems likely to have been done by Giovanni Domenico Tiepolo after his father's fresco.

Bequeathed by the Misses Cohen as part of the John Samuel collection, 1906.

Levey 1971, pp. 234–8; Fahy 1978, p. 29; Levey 1986, pp. 185–7.

Christ's dead body is mourned at the foot of the cross by the Virgin Mary (in blue), Mary Magdalene (identified by her blond hair) and Saint John the Evangelist (in red). Nicodemus and Joseph of Arimathea are on the right. New Testament (e.g. John, 19: 38–42).

The composition of NG 1333 is similar to Rembrandt's *Lamentation over the Dead Christ* in the National Gallery (NG 43), which was in the possession of Consul Joseph Smith in Venice between 1738 and 1762. NG 1333 was once attributed to Giovanni Battista Tiepolo or to Giovanni Domenico in collaboration with Giovanni Battista, but it was probably painted by Giovanni Domenico in the late 1750s.

Giovanni Domenico Tiepolo painted the same subject on other occasions, see for example NG 5589. The figure of Saint John occurs in a drawing by Giovanni Domenico (Paris, Louvre).

Cavendish Bentinck collection by 1891 (apparently bought in Venice); bought, 1891.

Mariuz 1971, p. 121; Levey 1971, pp. 232–4.

Giovanni Domenico TIEPOLO
1727–1804

Born in Venice, Giovanni Domenico Tiepolo was the eldest surviving son of Giovanni Battista Tiepolo, whose assistant he became. He was active in Venice, Würzburg and Vicenza. In 1762 he accompanied his father to Madrid, returning to Venice after Giovanni Battista's death in 1770.

Giovanni Domenico TIEPOLO
The Building of the Trojan Horse
about 1760

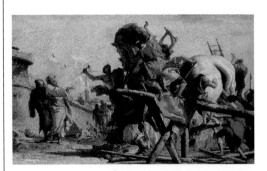

NG 3318
Oil on canvas, 38.8 x 66.7 cm

Giovanni Domenico TIEPOLO
The Procession of the Trojan Horse into Troy
about 1760

NG 3319
Oil on canvas, 38.8 x 66.7 cm

Jacopo TINTORETTO
Christ washing his Disciples' Feet
about 1556

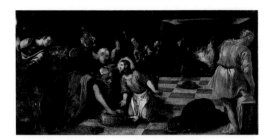

NG 1130
Oil (identified) on canvas, 200.6 x 408.3 cm

The Greeks had laid siege to Troy. In order to penetrate the walls, seen in the background, they built a wooden horse in which they concealed troops. The two men on the left may be Agamemnon and Odysseus. Virgil, *Aeneid* (Book II) and Homer, *Odyssey* (Books IV and VIII).

NG 3318 was probably painted as a sketch in preparation for a larger composition of the same subject (Hartford, Wadsworth Atheneum). A date of about 1760 is generally suggested for NG 3318, but it could date from a slightly later period.

NG 3318 is one of a group of three sketches (including NG 3319, *The Procession of the Trojan Horse into Troy*, and a picture in a private collection in Paris, *The Greeks descending from the Horse inside the Walls of Troy*) which were probably made in preparation for a series of larger compositions depicting the Fall of Troy (of which only the picture at Hartford is known).

Probably in an English collection by 1833; bought, 1918.

Mariuz 1971, p. 121; Levey 1971, pp. 238–9.

Inscribed on the body of the horse: PALADI / VOTUM (An offering to Pallas [Athene]).

The Greeks left the wooden horse in which troops were concealed as a gift to the Trojans, feigning a votive offering to Pallas. The Trojans promptly pulled the horse into the city. Priam's daughter Cassandra, who prophesied disaster if the wooden horse was admitted, is shown being seized by soldiers in the centre background. Virgil, *Aeneid* (Book II) and Homer, *Odyssey* (Books IV and VIII).

NG 3319 was probably painted as a sketch made in preparation for a larger composition of the same subject. This is not known, but two other sketches exist (NG 3318, *The Building of the Trojan Horse*, and a picture in a private collection in Paris, *The Greeks descending from the Horse inside the Walls of Troy*) and all three were probably made in preparation for a series of larger compositions depicting the Fall of Troy (of which only the picture related to NG 3318 is known today). A date of about 1760 is generally suggested for NG 3319, but it could date from a slightly later period.

Probably in an English collection by 1833; bought, 1918.

Mariuz 1971, p. 121; Levey 1971, pp. 239–40.

The disciples gathered for the feast of the Passover. During the meal Jesus illustrated his humility by washing their feet. New Testament (John 13). Peter protested, but Jesus replied: 'If I do not wash you, you have no part in me.' Peter then said, 'Lord, not my feet only, but also my hands and my head', and this seems to be the moment depicted.

This work is from the Cappella del Sacramento (Chapel of the Sacrament) in the church of S. Trovaso (SS. Gervasio e Protasio), Venice. A replica now replaces it *in situ*, opposite Tintoretto's *Last Supper*. The subjects of the paintings were appropriate to the chapel, which was dedicated to the Eucharist. The chapel architecture is inscribed 1556; the paintings are likely to be of this date or slightly later. They are first referred to in Borghini's *Riposo* in 1584.

The artist painted other versions of the subject (e.g. Gateshead, Shipley Art Gallery).

Bought from Hamilton Palace (Clarke Fund), 1882.

De Vecchi 1970, p. 110; Gould 1975, pp. 256–9; Plesters 1979, pp. 3–24; Plesters 1980, pp. 32–47; Pallucchini 1982, pp. 187–8.

Jacopo TINTORETTO
1518–1594

The artist's family name was Robusti; Jacopo took the name 'Tintoretto' from his father's profession of dyer (*tintore*). He worked almost exclusively in Venice, with the exception of a visit to Mantua in 1580, and was chiefly famed for his large religious paintings on canvas for the Doge's Palace, *scuole* and churches of the city.

Jacopo TINTORETTO
Saint George and the Dragon
probably 1560–80

NG 16
Oil on canvas, 157.5 x 100.3 cm

Jacopo TINTORETTO
The Origin of the Milky Way
probably 1575–80

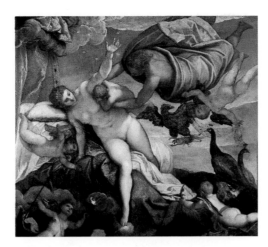

NG 1313
Oil (identified) on canvas, 148 x 165.1 cm

Jacopo TINTORETTO
Portrait of Vincenzo Morosini
probably 1580–5

NG 4004
Oil on canvas, 84.5 x 51.5 cm

The legend of Saint George is told in *The Golden Legend* and elsewhere. The princess on her knees in the foreground was sacrificed by a terrorised city to a dragon. As she flees from the conflict the saint charges the beast on his white horse. An earlier victim lies in the middle distance.

The relatively small scale and the format of NG 16 suggest that it was painted for domestic devotions. It was recorded in 1648 by Ridolfi in the Palazzo Correr in Venice. Whether it had been commissioned by a member of the Correr family remains unknown. On grounds of style the work is dated to the 1560s or 1570s.

The presence of God blessing in the sky and the unmolested corpse are unusual, perhaps unprecedented, in representations of this subject. A preparatory drawing for the corpse survives (Paris, Louvre).

Holwell Carr collection, 1821; Holwell Carr Bequest, 1831.

De Vecchi 1970, p. 100; Gould 1975, pp. 254–6; Plesters 1979, pp. 3–24; Plesters 1980, pp. 32–47; Pallucchini 1982, p. 175.

Jupiter wishing to immortalise the infant Hercules, whose mother was a mortal, held him to the breasts of the sleeping goddess Juno. After the child had suckled, the milk continued to spurt upwards – creating the Milky Way – and down to earth, where it was transformed into lilies. The story is told in *Geoponica* (Book 11, Chapter 20), a Byzantine botanical text translated in Venice (1542 and 1549). Putti carry torches and arrows, symbols of passion and love. The peacocks are emblems associated with Juno, while the eagle and the thunderbolt in its claws are attributes of Jupiter. The net as a device for trapping may symbolise deceit, or the trick played on Juno.

The lower part of the canvas featuring the lilies has been cut. The whole composition is recorded in drawings and in a painted copy. The painting was probably one of four made for the Emperor Rudolph II in the later 1570s.

Collection of the Marquis de Seignelay by 1727; bought, 1890

De Vecchi 1970, pp. 125–6; Gould 1975, pp. 259–61; Plesters 1979, pp. 3–24; Plesters 1980, pp. 32–47; Pallucchini 1982, pp. 212–13.

The sitter is identifiable because a similar portrait is included by Tintoretto in the *Resurrection* he painted on the altarpiece of the Morosini funerary chapel in the church of S. Giorgio Maggiore, Venice. Additionally, NG 4004 can be compared with another inscribed portrait of Morosini of 1580 (Venice, Doge's Palace). Morosini (1511–88) held a number of important public posts in and around Venice; he had been Prefect of Bergamo, Procurator of St Mark's, and in 1584 became president of the University of Padua. He wears over his right shoulder the *Stola d'Oro* (stole of gold), the insignia of an order of knighthood.

Approximate dating is possible because of the age of the sitter, and the close relationship with the *Resurrection,* which is dated to about 1585.

Presented by the NACF in commemoration of the Fund's coming of age and the National Gallery centenary, 1924.

De Vecchi 1970, p. 124; Gould 1975, p. 262; Plesters 1980, pp. 32–47.

Attributed to TINTORETTO
Jupiter and Semele
1540s

NG 1476
Oil on spruce, 22.9 x 65.4 cm

Follower of TINTORETTO
Portrait of a Lady
about 1550

NG 2161
Oil on canvas, 98.4 x 80.7 cm

After TINTORETTO
The Miracle of Saint Mark
1800–50

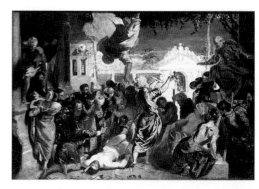

NG 2900
Oil on paper stuck down on canvas, 40.6 x 59.7 cm

The god Jupiter descends at the centre of the composition. Semele, who reclines at the right, expects immortality from his embraces, but is in fact destroyed by them. Ovid, *Metamorphoses* (Book III).

The Ovidian theme, as well as the style, size and format, suggest that NG 1476 belongs to a series which includes: *Latona changing the Lycian Peasants into Frogs* and *Apollo and Diana killing the Children of Niobe* (both London, Courtauld Institute), and *Argus and Mercury* (New York, Suida Manning collection). All of these could have formed part of the decoration of a *cassone* (chest), or of the panelling of a room. The Gallery's panel is an early work which was previously attributed to Andrea Schiavone.

Collection of Frederic (Lord) Leighton by 1876; bought, 1896.

De Vecchi 1970, p. 89; Gould 1975, p. 263; Pallucchini 1982, p. 139; Plesters 1984, pp. 24–9.

The picture was bought from the Capello family as a depiction of Pellegrina Morosini, who married Bartolommeo Capello in 1544, but no evidence for this identification has been adduced.

Past attributions to Pordenone and the sixteenth-century Veronese School, are now dismissed in favour of an association with the work of Tintoretto and a later date (which technical analysis also suggests is likely).

Bought from the heirs of the Signori Capello, 1855.

Gould 1975, p. 264; Plesters 1984, pp. 32–3.

Saint Mark descends from heaven to save from torture a slave who had disobeyed his master in order to venerate the saint's relics. This is a sketch copy of *The Miracle of Saint Mark* painted by Tintoretto for the Scuola Grande de San Marco (now Venice, Accademia) in 1548.

NG 2900 may be by William Etty (1787–1849), who was in Venice in 1832–3. He copied a number of works there, and became known as the 'English Tintoretto'. Other painters also studied Tintoretto, however. The work must date from after 1704 because the pigment Prussian blue has been detected, but no pigments new to the nineteenth century were found, and so it may have been executed in the early part of the last century.

Bequeathed by Lady Lindsay, 1912.

Gould 1975, pp. 263–4; Plesters 1984, pp. 31–2.

TITIAN
The Holy Family and a Shepherd
about 1510

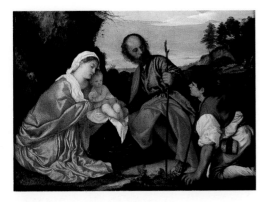

NG 4
Oil on canvas, (probably cut on all sides)
99.1 x 139.1 cm

TITIAN
Noli me Tangere
probably 1510–15

NG 270
Oil on canvas, 108.6 x 90.8 cm

TITIAN
Portrait of a Lady
about 1511

NG 5385
Oil on canvas, 119.4 x 96.5 cm

Though only one shepherd is shown in adoration (right), the subject of NG 4 is probably a variation on the Adoration of the Shepherds. An ox and an ass are seen on the left and the Annunciation to the Shepherds is visible in the right background. New Testament (Luke 2: 8–17).

Nothing is known of the origin of this picture, which is generally thought to be an early work by Titian.

The picture shows the influence of Giorgione, especially in the treatment of the Virgin and Child. This type of horizontal devotional scene set in a landscape was developed by Giovanni Bellini (e.g. NG 599) and was popular in Venice throughout the sixteenth century.

Borghese collection, Rome, by 1693; bought by W.Y. Ottley by 1799; acquired by the Revd Holwell Carr, 1810; Holwell Carr Bequest, 1831.

Wethey 1969, pp. 93–4; Gould 1975, pp. 267–8; Hope 1983, p. 220.

Christ appeared to the Magdalen on the morning after the Resurrection, urging her not to touch him ('noli me tangere') before the time of the Ascension. She is wearing her traditional red dress, and holds the jar of oil with which she anointed Jesus. Mary mistook Christ for a gardener, and he is shown here with a hoe. New Testament (John 20: 14–18).

NG 270 probably dates from the years immediately following Giorgione's death in 1510. The picture was perhaps made for a private collector. Religious subjects in beautiful landscape settings were fashionable in Venice.

Giorgione's influence is evident in the character and prominence of the landscape. Titian – like Giorgione – uses the landscape to further the psychological content of the picture, with the tree and the bush echoing the poses of the figures. In this landscape Titian has re-used buildings from his own *Sacred and Profane Love* (Rome, Borghese Gallery) and from the *Venus* (Dresden, Gemäldegalerie) started by Giorgione.

X-radiographs show that Christ was originally painted wearing a hat and walking away from Mary Magdalene, before Titian decided on the more elegant pose.

Muselli collection, Verona, by 1648; brought to Britain after purchase from the Orléans collection, 1792; bequeathed by Samuel Rogers, 1856.

Gould 1975, pp. 275–8; Hope 1980, pp. 20–2; Laclotte pp. 407–11.

Signed on the parapet: T.V. (probably for TITIANUS VECELLIVS, Tiziano Vecellio).

The traditional identification of this portrait as Catherina Cornaro, a Venetian noblewoman who became Queen of Cyprus and died in 1510, has been abandoned. It has also been known by its seventeenth-century Italian description 'La Schiavona' ('The Slavonian Woman').

NG 5385 has been dated about 1511 as the sitter seems to be represented in Titian's fresco of that year: *The Miracle of the New-born Child* in the Scuola di S. Antonio, Padua.

X-radiographs show that originally there was a circular window at the top right of the picture and that the parapet, which bears the painter's initials and the sitter's profile portrait in the semblance of a carved relief, was only later extended to the right. The profile portrait can be related to the debate over the primacy of sculpture or painting in the sixteenth century (the *paragone*). This unusual addition – with its echoes of ancient Roman portraiture – might suggest a sitter of some status, though it has also been suggested that she was a close acquaintance of the artist.

Collection of Conte Alessandro Martinengo Colleone, Brescia, 1641 (as 'a painting called the Slavonian Woman'); bought by Herbert Cook, 1914; presented in his memory by Sir Francis Cook, Bt., through the NACF, 1942.

Wethey 1971, p. 139; Gould 1975, pp. 287–90; Hope 1980, pp. 30–2.

TITIAN

active about 1506; died 1576

The greatest painter of Renaissance Venice, Titian was the successor to Giovanni Bellini and Giorgione and owed much to both of them. He painted devotional and mythological themes, portraits, allegories and altarpieces, and worked for Francis I of France, the Emperor Charles V and his son Philip II of Spain, as well as the leading families of Venice, Mantua, Ferrara, Urbino and Rome.

TITIAN
Portrait of a Man
about 1512

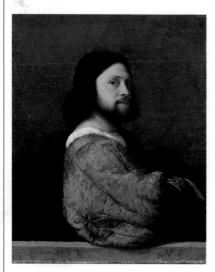

NG 1944
Oil on canvas, 81.2 x 66.3 cm

Inscribed on the parapet: .T.V. (probably for TITIANVS VECELLIVS, Tiziano Vecellio)

The sitter has not been identified. In the seventeenth century the picture was thought to be a portrait of the Italian poet Lodovico Ariosto (1474–1533), author of *Orlando Furioso*. The idea that it is a self portrait has enjoyed some favour in recent years.

NG 1944 was probably painted before 1512 (the date on a portrait in the Hermitage in St Petersburg which is manifestly derived from it). In the late 1630s the painting was in the Lopez collection in Amsterdam, where it was engraved by R. van Persijn (probably after a drawing by Sandrart). Rembrandt must have seen this portrait in that collection, as his self portrait of 1640 (see NG 672) is inspired by it. Van Dyck may have bought the picture in Paris in 1641, but the next certain reference to it is not until 1824.

NG 1944 is significant for the development of the triangular (or pyramidal) composition which had a long currency in European portraiture.

Lopez collection, Amsterdam, by about 1640; first recorded with certainty in 1824 in the collection of the Earl of Darnley; bought with a special grant and contributions from Lord Iveagh Waldorf Astor, Pierpont Morgan, Alfred Beit, Lady Wantage and Lord Burton, 1904.

Wethey 1971, pp. 103–4; Gould 1975, pp. 280–3; Hope 1980, pp. 30–2.

TITIAN
Portrait of a Young Man
about 1515

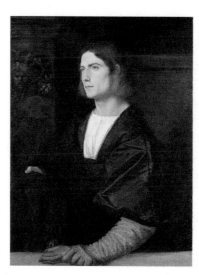

L611
Oil on canvas, 92.7 x 70.7 cm

The sitter has not been identified; he holds a hat with a jewelled badge, and a glove in his other (gloved) hand. The tablet with a letter C, preceded by another illegible character, may be a clue to the identity of the sitter.

Bought in the eighteenth century by the 7th Viscount of Irwing; passed by descent to the Meynell collection by 1808; and by descent to the Halifax collection; on loan from the Trustees of the Halifax collection since 1992.

Wethey 1971, p. 14, 149; National Gallery Report 1992–3, pp. 28–9; Laclotte 1993, pp. 369–70.

TITIAN
Bacchus and Ariadne
1522–3

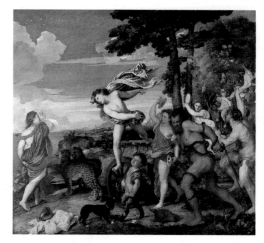

NG 35
Oil (identified) on canvas, 175.2 x 190.5 cm

Signed on the vase on the yellow cloth in the left foreground: TICIANVS F.[ECIT].

NG 35 illustrates celebrated passages from the Latin poets Catullus (*Carmina*, 64: 257–65), Ovid (*Ars Amatoria*, I, 525–66) and Philostratus (*Imagines*, 1: 15 and 19). Bacchus, the god of wine, leaps from a chariot towards Ariadne, who has been searching the horizon for Theseus, the lover who has abandoned her. Bacchus offers himself as her husband and the sky – in which she will be a constellation of stars – as a wedding gift.

NG 35 is one of a famous series by Bellini, Titian and Dosso Dossi commissioned by Alfonso d'Este, Duke of Ferrara, for a small room, the Camerino d'Alabastro, in the Ducal Palace, Ferrara. Titian's *Worship of Venus* and *Bacchanal of the Andrians* (Madrid, Prado) were painted in the years 1518–25. NG 35 was painted in Venice in 1522–3 (and received its finishing touches in Ferrara in 1523). It seems to have been commissioned as a substitute for a painting of a similar subject which Raphael had failed to deliver.

NG 35 is remarkable for its brilliant colour, naturalistic details, and for the man with snakes who seems to derive from the famous classical statue, the *Laocoön*, discovered in Rome in 1506 (now Rome, Vatican).

Collection of Alfonso d'Este, Ferrara, 1523; Aldobrandini collection, Rome, 1598–1797; brought to Britain, 1806, and bought from Thomas Hamlet, 1826.

Gould 1975, pp. 268–74; Holberton 1986, pp. 347–50; Hope 1987, pp. 25–42.

TITIAN
The Virgin and Child with Saint John the Baptist and a Female Saint, probably 1530–5

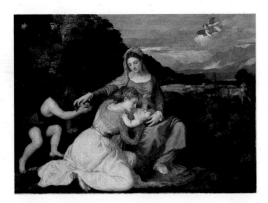

NG 635
Oil on canvas, 100.6 x 142.2 cm

TITIAN
The Vendramin Family
1543–7

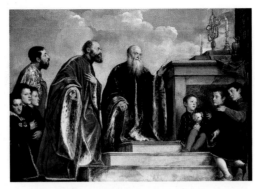

NG 4452
Oil (identified) on canvas, 205.7 x 301 cm

TITIAN
The Tribute Money
1560–8

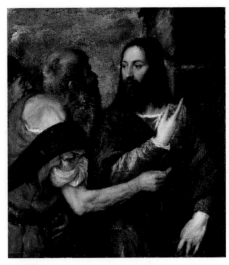

NG 224
Oil on canvas, 109.2 x 101.6 cm

The Virgin and Child with the young Saint John the Baptist was a common subject from the fifteenth century onwards. John the Baptist is identified by his camel skin and reed cross. The young female saint is probably Saint Catherine of Alexandria but she has no attribute. Shepherds can be seen in the background; they – and the angel in the sky – might allude to the Annunciation to the Shepherds (New Testament, Luke 2: 8–17).

The painting was said in the nineteenth century to be signed and dated 1533, but the inscription removed in 1955 ('No. 78 Di. Titio') was not original and added no information as to the picture's date. It did confirm the identification of the picture with one in an Aldobrandini inventory of 1655 (see below). The early 1530s is nevertheless an acceptable date for this picture; it can be compared with other works from that period (e.g. *The Madonna of the Rabbit*, Paris, Louvre). There are versions in Florence (Pitti) and Fort Worth (Kimbell); in the former the female saint is identified as Saint Catherine by her attribute of the wheel.

Aldobrandini collection, Rome, 1603 (and accurately described in the 1655 inventory); bought with the Edmond Beaucousin collection, Paris, 1860.

Wethey 1969, pp. 104–5; Gould 1975, pp. 278–80; Valcanover 1990, pp. 206–8.

This group portrait shows male members of the Venetian Vendramin family before an altar on which a relic of the Holy Cross is displayed. This relic, which survives in the Scuola di San Giovanni Evangelista in Venice, had been given to the family in the fourteenth century and became an object of special devotion to them. The principal figure, who stretches out a hand to indicate his seven sons, is Andrea Vendramin (died 1547). His brother Gabriel Vendramin (died 1552) kneels before the altar.

The death of Andrea Vendramin in 1547 makes it likely that the picture was painted before that date and it is usually placed in the years 1543–7.

There was a tradition in Venice of large-scale family portraiture in religious pictures made for a domestic setting. NG 4452 was made for the Vendramin Palace and fits into this tradition, although unusually it shows the family gathered in front of a reliquary rather than in front of an image of the Virgin and Child. The head of the youngest bearded figure was originally painted towards the left edge of the painting and this first version is now visible through the paint of the sky.

Inventory of Gabriel Vendramin, Venice, 1569; bought after 1636 by Van Dyck, and subsequently in British private collections (including that of Reynolds) until bought with a special grant and contributions from Samuel Courtauld, Sir Joseph Duveen and the NACF, 1929.

Wethey 1971, p. 147; Gould 1975, pp. 284–7.

Signed on the pilaster, right: TITIANVS / .F.[ECIT].

The Pharisees ask Christ whether it is right to pay tax to the Romans. Christ evades a seditious response by asking whose name appears on the coin. 'They say unto him, Caesar's. Then saith he unto them, Render therefore unto Caesar the things that are Caesar's; and unto God the things that are God's.' New Testament (Matthew 22: 17–22, Mark 12: 14–17, Luke 20: 22–5).

NG 224 was probably painted for King Philip II and sent to Spain in 1568; it is probably the painting mentioned as recently finished and dispatched in a letter from Titian to Philip in October 1568. Titian's responsibility for the execution of NG 224 has occasionally been doubted, but major pentimenti support the attribution.

Collection of Philip II, Madrid, 1574; given to Maréchal Soult, about 1810; bought, Soult collection sale, 1852.

Wethey 1969, pp. 164–5; Gould 1975, pp. 274–5.

TITIAN
The Death of Actaeon
about 1565

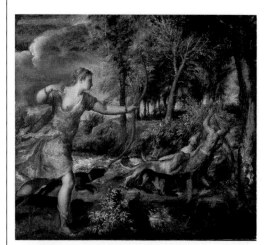

NG 6420
Oil on canvas, 178.4 x 198.1 cm

In revenge for surprising her naked, bathing in the woods, Diana transformed the hunter Actaeon into a stag and he was killed by his own dogs. The female figure who holds a bow (without a string, or an arrow) probably represents the vengeful goddess. Ovid, *Metamorphoses* (III, 192–252).

Among Titian's most famous late works are the mythological paintings (*poesie*) commissioned by Philip II, King of Spain from 1556 to 1598. Titian had already painted the *Discovery of the Pregnancy of Callisto* and *Diana discovered at her Bath by Actaeon* (Edinburgh, National Galleries, Sutherland loan), and the sequel is illustrated in NG 6420. This picture was referred to in 1559 as 'Actaeon attacked by his dogs' and was probably worked on into the mid-1560s. It was apparently never sent to Spain.

Collection of Queen Christina, Rome, by 1662–3; Orléans collection, Paris, by 1721; collection of Sir Abraham Hume by 1800; bought with a special grant and contributions from the NACF, the Pilgrim Trust and through public appeal, 1972.

Wethey 1975, pp. 136–8; Gould 1975, pp. 292–7.

TITIAN
An Allegory of Prudence
about 1565–70

NG 6376
Oil on canvas, 76.2 x 68.6 cm

Inscribed in three parts across the top: EX PRAETE/RITO PRAESENS PRVDEN/TER AGIT NI FVTVRA[M]/ ACTIONE[M] DE/TVRPET (From the past the present acts prudently so as not to spoil future action).

The three human heads allude to the three ages of man – youth, maturity, old age – and the inscription is divided in such a way as to correspond with the heads below. The three animal heads (wolf, lion, dog) form a symbol of prudence and may also be intended to relate to characteristics of the three ages. The emblem has a cryptic and perhaps private meaning.

The heads may be portraits, with Titian himself as the old man, his son, Orazio (?), in the centre, and his cousin and heir, Marco Vecellio (?), on the right. The central head may be meant to recall Saint Mark, whose attribute is a lion.

Prudence was often represented allegorically in the Renaissance (e.g. School of Rossellino relief, London, Victoria and Albert Museum), and the three animal heads featured in a famous Venetian book of 1499, the *Hypnerotomachia Poliphili* (*Dream of Polyphilus*). The specific imagery in NG 6376 is found in Piero Valeriano's *Hieroglyphica* (first published in 1556).

Crozat collection, Paris, 1740; brought to Britain by 1816 and in British collections since; presented by Betty and David Koetser, 1966.

Gould 1975, pp. 290–2; Fletcher 1990, p. 742; Valcanover 1990, pp. 347–8.

TITIAN
The Madonna and Child
probably 1570–6

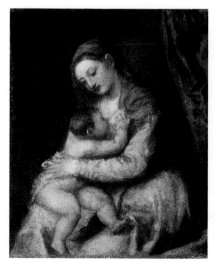

NG 3948
Oil on canvas, 75.6 x 63.2 cm

The Virgin Mary suckling the Child Jesus – the so-called Virgo Lactans – became an increasingly rare image, though it developed from a long and celebrated tradition of Venetian paintings of the Madonna.

Titian's style developed into one of extraordinary freedom in his late period. The image is created on the canvas by a patchwork of different colours that blend when seen from a distance. Although blurred, the underlying structure and design of NG 3948 have not been lost. Such works were painted over a great length of time and only gradually brought to a 'finished' state. This picture may have been among those left in Titian's studio at his death.

Collection of Lord Ward, 1st Earl of Dudley, by 1851; bought at the Dudley sale by Ludwig Mond, 1892; by whom bequeathed, 1924

Wethey 1969, p. 101; Gould 1975, pp. 283–4; Laclotte 1993, pp. 6756.

Studio of TITIAN
Venus and Adonis
probably after 1554

Follower of TITIAN
Mythological Scene
probably 1530–1600

Imitator of TITIAN
A Concert
probably 1600–50

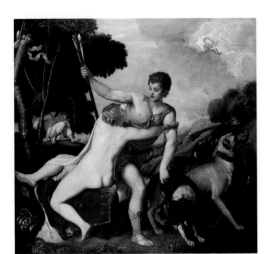

NG 34
Oil (identified) on canvas, 177.1 x 187.2 cm

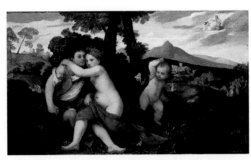

NG 1123
Oil on wood, 76.2 x 132.1 cm

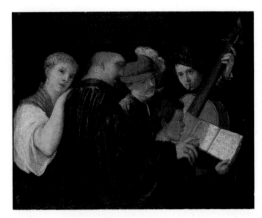

NG 3
Oil on canvas, 99.1 x 125.1 cm

Venus' lover Adonis, famed for his beauty, ignored her plea to abstain from the hunt, and was fatally wounded by a boar. Ovid, *Metamorphoses* (X, 665–740). The moment of his departure is shown in NG 34. Venus' complex pose is derived from a famous antique relief. Cupid, the god of Love, sleeps in the left background.

NG 34 was probably painted in Titian's studio sometime after 1554. Of the many versions of this composition, that in Madrid (Prado) is generally regarded as autograph and seems to have been painted in 1553–4 for Philip II of Spain. Another version at least in part by Titian himself is in Malibu (J. Paul Getty Museum).

Palazzo Colonna, Rome, by 1783; collection of Alexander Day by 1800; bought by J.J. Angerstein; from whom bought, 1824.

Wethey 1975, pp. 190–1; Gould 1975, pp. 297–8.

The central figures may be Hippomenes and Atalanta, whose story Ovid (*Metamorphoses*, X) interrupts to tell the story of Adonis. Incidents of the birth and death of Adonis appear in the background.

NG 1123 was probably painted by a sixteenth-century follower of Titian.

Hamilton Palace collection by 1882; bought, 1882.

Gould 1975, pp. 304–5.

NG 3 was probably painted in imitation of Titian in the early seventeenth century.

This type of composition – a group with suggestions of narrative and sometimes of portraiture – was developed in the late fifteenth century and seems to have been made popular by Giorgione.

Possibly Gonzaga collection, Mantua, by 1627; possibly collection of Charles I by 1640; bought with the J.J. Angerstein collection, 1824.

Gould 1975, pp. 305–6.

After TITIAN
Portrait of a Man (Girolamo Fracastoro?)
probably 16th century

After TITIAN
'The Gloria'
after 1566

After TITIAN
A Boy with a Bird
probably 17th century

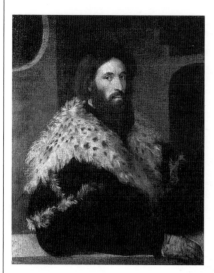

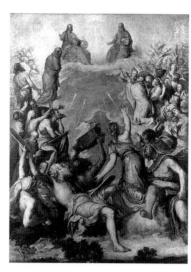

NG 933
Oil on canvas, 34.9 x 48.9 cm

NG 3949
Oil on canvas, 92.4 x 72.4 cm

NG 4222
Oil on canvas, 130.8 x 98.4 cm

The identification of the sitter as Girolamo Fracastoro derives from an inscription on a strip of paper that was once stuck onto the canvas (bottom left); it read: [D]ottore Fracastoro. Nothing else confirms the sitter's identification. Girolamo Fracastoro (born 1472) was famous for his literary and scientific achievements. NG 3949 is not incompatible with known portraits of Fracastoro, but the identification is not conclusive.

Vasari stated that Fracastoro was portrayed by Titian, Torbido and Caroto. NG 3949 is generally said to be after a lost Titian original, perhaps of the years 1515–25.

Collection of T. Lechi, Brescia (as Titian), by 1824; bought by Ludwig Mond, 1895; Mond Bequest, 1924.

Gould 1975, pp. 299–300.

NG 4222 is a reduced copy after Titian's *Gloria* (now Madrid, Prado). God the Father and Son, with the Holy Ghost in the form of a dove, are seen on the clouds. Below are the Virgin, Saint John the Baptist (left), Charles V, the Empress Isabella and Philip II of Spain, together with Maria of Hungary, the Infanta Doña Juana and Titian. Ezekiel (on an eagle), Moses with the tablets, Noah with the Ark, Mary Magdalene(?) and King David, with a harp, are ranged across the bottom from left to right. The subject of the original, though sometimes described as the Trinity, is the Last Judgement.

NG 4222 has been claimed to be Titian's modello for the *Gloria* which was dispatched from Venice to the Emperor Charles V in 1554. It is in fact an old copy, partly made from an engraving of 1566 by Cornelius Cort.

Apparently in Madrid by about 1806; collection of Samuel Rogers, before 1833; bought (Lewis Fund), 1926.

Gould 1975, pp. 300–4.

The boy resembles the figure of Cupid, god of Love, in the versions of Titian's *Venus and Adonis* in Washington (National Gallery of Art) and New York (Metropolitan Museum of Art).

NG 933 was probably painted in the seventeenth century after one of the pictures produced in Titian's studio late in his career.

Collection of Jeremiah Harman by 1844; Wynn Ellis Bequest, 1876.

Gould 1975, pp. 298–9.

Louis TOCQUE
Portrait of a Man
1747

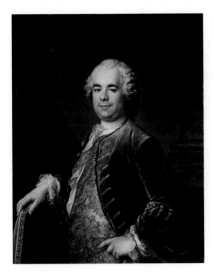

NG 4097
Oil on canvas, 100.3 x 80 cm

Signed and dated: L. Tocqué. pinxit / 1747.
(L. Tocqué painted this / 1747.)
 The sitter has not been identified.

Apparently in a private collection in England before about 1920, when bought at Bridgnorth by E. Peter Jones; by whom presented, 1925.

Doria 1929, p. 154, no. 525; Davies 1957, p. 209.

Louis TOCQUE
Portrait of Mademoiselle de Coislin (?)
probably 1750–9

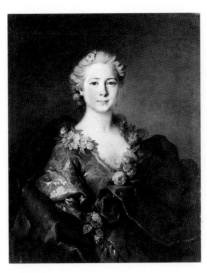

NG 5590
Oil on canvas, 79.4 x 63.5 cm

The identification of the sitter was suggested in a 1907 sale catalogue. She could be either Renée-Marguerite or Marie-Josèphe, daughters of Pierre-Louis Coislin, Marquis du Cambout, or Mademoiselle du Cambout-Coislin, daughter of Pierre-Armand du Cambout, Marquis de Coislin (who married in 1727).
 NG 5590 was probably painted in the 1750s.

Thirion collection, Paris, by 1907; bequeathed by Miss Emilie Yznaga, 1945.

Doria 1929, p. 100, no. 55; Davies 1957, p. 210.

Studio of TOCQUE ?
Jean Michel de Grilleau
probably 1740–6

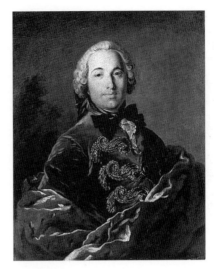

NG 3964
Oil on canvas, 81.3 x 66 cm

NG 3964 is probably a studio copy of Tocqué's likely original which was recorded in the possession of the descendants of Jean Michel de Grilleau (1708–69) in 1939.
 As the sitter is shown without the ribbon of the Order of Saint Michel, which he obtained in 1746, this studio copy was probably painted in the early 1740s. In the probable original Grilleau does wear the ribbon, which was therefore presumably added in 1746 or soon after.

Possibly collection of Madame Jacobs by 1904; bought, 1924.

Doria 1929, p. 154, no. 523; Davies 1957, p. 210.

Louis TOCQUE
1696–1772

Tocqué was born in Paris. A portrait painter, he was a pupil of Nicolas Bertin and then of Jean-Marc Nattier and was influenced by Rigaud and Largillierre. He was admitted to the Académie in 1734 and in 1747 married one of Nattier's daughters. He worked in St Petersburg in 1756–8 and in Copenhagen in 1758–9.

Michele TOSINI
Charity
probably about 1570

Henri de TOULOUSE-LAUTREC
Woman seated in a Garden
1891

Attributed to Robert TOURNIERES
La Barre and other Musicians
about 1710

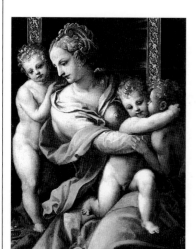

NG 652
Oil on wood, 24.5 x 17.8 cm

NG 4186
Oil on millboard, 66.7 x 52.8 cm

NG 2081
Oil on canvas, 160 x 127 cm

Charity, one of the theological virtues with Faith and Hope (see New Testament, 1 Corinthians 13: 13), is represented as a woman with three children. From the sixteenth century onwards Charity was commonly represented as a woman suckling children. The fire (bottom left) represents the ardour of her virtue that combines the love of God with the love of one's neighbour.

NG 652 derives from Francesco Salviati's larger picture of the subject (Florence, Uffizi), and was previously catalogued as by a follower of Francesco Salviati. There are other versions of this composition and the backcloth appears in other paintings by Tosini.

Said to have been in the Fesch collection; bought with the Edmond Beaucousin collection, Paris, 1860.

Gould 1975, p. 230.

Signed and dated: Lautrec '91 (There may be a 'T' before the word Lautrec.)

NG 4186 was exhibited with the title 'Femme Assise dans un Jardin', during the artist's lifetime. The sitter is said to be Gabrielle the dancer, and the setting Monsieur Forest's garden in Montmartre. The same sitter appears in other works by Lautrec – on the arm of Cha-U-Kao in a painting in the Oskar Reinhart collection in Winterthur, and alone in a painting at Albi.

Murat, Paris; bought from Reid and Lefevre, London, by the Trustees of the Courtauld Fund, 1926.

Davies 1970, p. 134.

Centre, a sheet of music inscribed: TRIO DE M. DE LA BARRE/ SONATES EN TRIO/ POUR LA FLUTE TRAVERS (ière)/ PREMIERE SONATE. (The trio of M. de La Barre/ Sonatas for a Trio/ For the Flute/First Sonata.) Right, music inscribed: LIVRE [III] DES... SONATES EN TRIO/ POUR LA FLUTE TRAVESIE(re)/ PRMIERE SONATE (Book III of, Sonatas for a Trio, for the Flute, First Sonata).

The man standing turning the music is probably Michel de La Barre (about 1674–1743/4), a Parisian flautist and composer. The music is copied exactly from *Troisième livre de trios, pour les violons, flutes et hautbois, mêlés de sonates pour la flute traversière* (Paris 1707). The figure seated at the left holds a bass viol.

The seated musician at the right with a flute, whose costume is richer than those of the others, may have been an amateur who commissioned the portrait as a record of his association with the composer. The clothes can be dated to about 1710.

Probably in the Baron Vivant Denon catalogue, 1826; bought from the Comtesse de Coullanges, 1907.

Davies 1957, pp. 212–13.

Michele TOSINI (called Michele di Ridolfo del Ghirlandaio)
1503–1577

Tosini was trained in the workshop of Lorenzo di Credi but in 1525 became a junior associate of Ridolfo Ghirlandaio. His mature style was influenced by the work of Bronzino, Pontormo, Francesco Salviati and Vasari. Tosini worked on many large decorative commissions with Vasari, including the ceilings of the Palazzo Vecchio, Florence.

Henri de TOULOUSE-LAUTREC
1864–1901

Henri-Marie-Raymond de Toulouse-Lautrec-Monfa was born in Albi, a member of an ancient noble family. He was crippled by accidents in his youth. He moved to Paris in 1881 and entered the Ecole des Beaux-Arts, studying under Bonnat and Cormon. He settled in Montmartre in 1884 and there he painted and made lithographs of figures in dance-halls, cabarets and brothels.

Robert TOURNIERES
1667–1752

Also known as Robert Levrac or Levrac-Tournières, the artist was born in Caen. From about 1685 he studied in Paris under Bon de Boullongne. He worked as a copyist for Rigaud from 1698 to 1699, and in 1702 became a member of the Académie. He specialised in portraits, often of groups depicted less than half life-size.

Jan Jansz. TRECK
Vanitas Still Life
1648

NG 6533
Oil on oak, 90.5 x 78.4 cm

Inscribed on the jug: Treck/1648; and on the title page of a play at the left: TQUAEDT syn Meester loont, Bly eynde spel (Evil Pays Its Master, or Evil is its Own Reward, a comedy).

The objects shown here are intended to make the viewer reflect on the inevitability of death and the transience of human actions. Such a moralising work is called a *vanitas* in reference to the biblical quotation – 'Vanity of vanities, saith the Preacher, vanity of vanities: all is vanity' (Ecclesiastes 1: 2). The painting contains a number of objects often found in such images: skull, hourglass, extinguished pipe and tapers, and shell used for blowing bubbles. Human actions, which in this context are regarded as futile, are referred to by the armour, musical instruments, musical score, drawing, jug and the title page of the play at the left. This work was written by Theodoor Rodenburgh (about 1578–1644), a member of the Amsterdam Chamber of Rhetoric. It was based on a Spanish play and first printed in Dutch in 1618.

NG 6533 predates the other painting by Treck in the National Gallery (NG 4562) by a year.

Bought by Robert Philip Wood (1818–98), a Liverpool merchant; presented by his great-grandson, Anthony N. Sturt, and his wife, Marjorie, 1990.

National Gallery Report 1990–1, pp. 14–15.

Jan Jansz. TRECK
Still Life with a Pewter Flagon and Two Ming Bowls, 1649

NG 4562
Oil (identified) on canvas, 76.5 x 63.8 cm

Signed and dated on the white cloth: JJ Treck/1649 (JJ in monogram).

The bowls are late Ming blue and white, of a type first imported into Holland shortly before the picture was painted.

The same elements are re-arranged in another still life by Treck (Budapest) which is dated 1645.

Robson and Sons, Newcastle-upon-Tyne, 1930; bought (Mackerell and Cockerill Funds), 1931.

MacLaren/Brown 1991, p. 437.

Charles-Philogène TSCHAGGENY
An Episode on the Field of Battle
1848

NG 738
Oil on canvas, 145.5 x 195 cm

Signed and dated: Chs TSCHAGGENY. 1848
NG 738 is probably intended to show a battle in the English Civil War.

The picture was presumably painted during the artist's stay in England and was exhibited at the Royal Academy in 1850.

Bequeathed by Johann Moritz Oppenheim, 1864.

Martin 1970, pp. 282–3.

Jan Jansz. TRECK
1605/6–1652

Treck was born and worked in Amsterdam. He was a pupil of his brother-in-law, Jan Jansz. den Uyl the Elder. He was a still-life painter, whose style is closely related to that of den Uyl and is a development of that of the Haarlem still-life painters, Willem Claesz. Heda and Pieter Claesz.

Charles-Philogène TSCHAGGENY
1815–1894

Tschaggeny was born in Brussels, where he was taught by E. Verboeckhoven. He was active in England in about 1848–50. He was a figure and animal painter, and an engraver.

Cosimo TURA
An Allegorical Figure
probably 1455–60

Cosimo TURA
Saint Jerome
probably about 1470

Cosimo TURA
The Virgin and Child Enthroned
mid-1470s

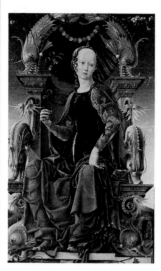

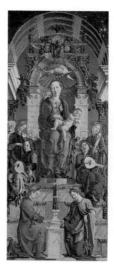

NG 3070
Oil with egg in the first version (identified) on poplar, painted surface 116.2 x 71.1 cm

NG 3070 is now known to be one of a series of Muses and may represent Calliope (who was associated with justice).

Other Muses from the same series are in the Pinacoteca Nazionale, Ferrara; the Museum of Fine Arts, Budapest (signed by Michele Pannonio); the Poldi Pezzoli, Milan; and the Gemäldegalerie, Berlin. They were painted for a room in the Este villa of Belfiore (near Ferrara; destroyed in 1483). It was probably painted in the late 1450s, when Tura was employed at Belfiore by Borso d'Este as 'painter of the *studiolo*' (1458–63). The series would have hung high on the wall of a *studiolo* – hence the low vanishing-point.

Technical examination of NG 3070 (in 1987) has demonstrated radical changes to an earlier picture possibly by the Sienese painter Angelo del Maccagnino which differed in medium and composition and had perhaps been left unfinished on his death (probably about 1456–8). The panel has been cut on all four sides.

S. Domenico, Ferrara, by about 1706; Costabili collection, Ferrara, by 1836; acquired by Sir A.H. Layard, probably in 1866; Layard Bequest, 1916.

Davies 1961, pp. 518–21; Dunkerton 1987, pp. 5–35; Dunkerton 1991, pp. 114–16, 198–9; Mottola Molfino 1991, I, pp. I; 380–425, II, pp. 133–331.

NG 773
Oil and egg (identified) on poplar, painted surface 101 x 57.2 cm

Saint Jerome is represented as though in the wilderness, where he retired in about 374–6. The Bible, which he translated into Latin from the original Greek and Hebrew, lies nearby, and he is accompanied by the lion from whose paw, according to legend, Jerome drew out a thorn.

A vision of the Crucified Christ has been cut from the top of NG 773 and is now in Milan (Brera). In the right background a donor and Saint Francis, or conceivably a friar adopting the saint's pose at the Stigmatisation, appear to look up at where the vision of the Crucified Christ was positioned. An owl (which has caught a frog) and a wall creeper are visible on the tree. On the left friars seem to be involved in a building project. NG 773 could have been placed as the altarpiece in a newly built chapel of Saint Jerome in a Franciscan church or in a private chapel.

NG 773 has a very finished underdrawing that can be seen through the thin layers of flesh paint.

Rizzoni collection, Ferrara, about 1783; bought by Sir Charles Eastlake from the Costabili collection, Ferrara, after 1858; bought from Lady Eastlake, 1867.

Davies 1961, pp. 516–17; Dunkerton 1991, pp. 169, 171; Dunkerton 1994, pp. 42–53.

NG 772
Oil and egg (identified) on poplar, 239 x 101.6 cm

Inscribed on the organ, in the central foreground (extremely damaged but independently recorded): IMAGO VIRGINIS EXCITA[N]TIS FILIU[M]. / SURGE PUER. ROUORELLA FORES GENS PULTAT. APERTUM / REDDE ADITUM. PULSA LEX AIT: INTUS ERIS. (An image of the Virgin waking her son. Arise, child. The Roverella family strikes at the gate. Grant that the way be opened. The law says 'Knock and thou shalt be within'). Inscribed in Hebrew with the Ten Commandments on the sides of the throne.

The Christ Child sleeps in the Virgin's lap on a throne which bears the symbols of the four evangelists (the angel for Matthew; the eagle for John; the winged lion for Mark; the winged ox for Luke) and tablets with the Ten Commandments. Six angels play musical instruments.

Baruffaldi (about 1706) saw the altarpiece *in situ* in the chapel of the Roverella family in S. Giorgio fuori le mura in Ferrara. He described the lost left wing as showing Saints Peter and George and a member of the Roverella family knocking on a door. He also recorded the Latin inscription on the organ which refers to this. The right wing of *Saints Maurelius and Paul and a Member of the Roverella Family*, a *Head of a Saint*, and a *Lamentation* that surmounted the whole ensemble, survive (Rome, Palazzo Colonna; San Diego, Museum of Fine Art; Paris, Louvre). NG 772 was probably painted in the mid-1470s and was dismembered in 1709.

S. Giorgio fuori le mura, Ferrara, by about 1706 (Baruffaldi); acquired by Eastlake in about 1855; bought from Lady Eastlake, 1867.

Davies 1961, pp. 513–16; Dunkerton 1991, pp. 199, 209, 326–9.

Cosimo TURA
before 1431–1495

Cosimo (or Cosmè) Tura was active in Ferrara by 1451. He was employed as court artist by Borso d'Este from 1458, and subsequently worked for his successor Ercole I. He painted secular pictures, altarpieces and frescoes, as well as designing tapestries and tableware. Few of his works survive.

Cosimo TURA
The Virgin Annunciate
probably about 1475–80

NG 905
Oil and egg (identified) on poplar, painted surface
45.1 x 34 cm

The book on the Virgin Mary's knee is presumably a
prayer book from which she had been reading
when the Angel Gabriel appeared and announced
that she would bear the Son of God. New Testament
(Luke 1: 26–38).

NG 905 was probably one of a pair of panels. It
would have been incorporated high up, to the right
of a polyptych altarpiece; the other panel, depicting
the Angel Gabriel, would have been placed to the
left. It is likely to date from the late 1470s. The paint
of the flesh is worn and the painting has been cut on
the top: only the legs and tails of the sphinxes
crowning the Virgin's throne are now visible.

*Possibly in the Costabili collection, Ferrara, by 1838;
bought at the Alexander Barker sale, 1874.*

Davies 1961, pp. 517–18.

Joseph Mallord William TURNER
Dutch Boats in a Gale ('The Bridgewater Sea Piece')
1801

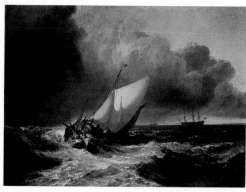

L297
Oil on canvas, 162.5 x 221 cm

Dutch boats are shown in a fierce gale on course for
collision, while fishermen attempt to bring their
catch aboard.

L297 was commissioned by Francis Egerton, third
Duke of Bridgewater, as a pendant to *A Rising Gale*
by William van der Velde the Younger, which he
owned (now Toledo Museum of Art). Turner's
picture, for which he made a number of drawings,
is slightly larger than its pendant, but adopts a
similar composition, in reverse, as befits a pendant
picture. Although Turner greatly admired Dutch
painting, his greater emphasis on light to suggest
movement is characteristic of his own, more
dramatic style. Turner was paid 250 guineas for the
picture, and tried, unsuccessfully, to obtain a
further twenty guineas for the frame, in which the
painting is still displayed. The picture was exhibited
at the Royal Academy in 1801.

*Duke of Bridgewater, 1801; thence by descent; private
collection, 1976; on loan since 1987.*

Butlin 1977, pp. 12–13, no. 14.

Joseph Mallord William TURNER
Calais Pier: An English Packet Arriving
1802–3

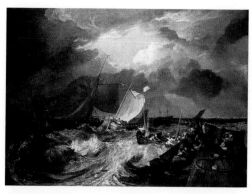

NG 472
Oil on canvas, 172.1 x 240 cm

A packet boat crowded with travellers has crossed
the Channel and is arriving at Calais amid stormy
seas.

NG 472 is partly based on Turner's own
experience during his first crossing to Calais in
1802. NG 472 was exhibited at the Royal Academy
in 1803 with the following title: 'Calais Pier, with
French poissards preparing for sea: an English
packet arriving'.

A drawing related to the composition is in the
Tate Gallery. NG 472 was engraved in 1827 by
T. Lupton.

Turner Bequest, 1856.

Davies 1959, pp. 94–5.

Joseph Mallord William TURNER
1775–1851

Born in Covent Garden, London, Turner studied at
the Royal Academy Schools from 1789 to 1793. He
exhibited at the Royal Academy from 1790 to 1850,
and became the youngest ever Academician in
1802. Most of Turner's pictures and drawings were
bequeathed to the nation, but the will was
disputed and a settlement was reached only in
1856. The majority of the paintings are in the Tate
Gallery, London.

Joseph Mallord William TURNER
Sun rising through Vapour: Fishermen cleaning and selling Fish, before 1807

Joseph Mallord William TURNER
Dido building Carthage, or The Rise of the Carthaginian Empire, 1815

Joseph Mallord William TURNER
Ulysses deriding Polyphemus
1829

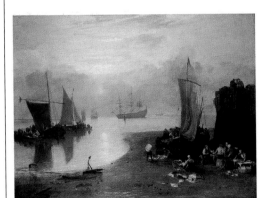

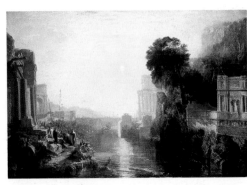

NG 498
Oil on canvas, 155.6 x 231.8 cm

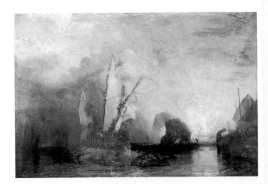

NG 508
Oil on canvas, 132.7 x 203.2 cm

NG 479
Oil on canvas, 134.6 x 179.1 cm

Fishermen unload their catch and prepare it for sale. The boats and the figures reflect Turner's debt to Dutch painting of the seventeenth century.

NG 479 was exhibited at the Royal Academy in 1807. In Turner's second will of 1831 he specified that the picture (along with NG 498) should hang in the National Gallery between two paintings by Claude (NG 14 and 12).

Five sketches at the Tate Gallery can be related to the composition.

Bought by Sir John Leicester, 1818; sold Christie's, 7 July 1827; bought by Turner; Turner Bequest, 1856.

Davies 1959, pp. 95–6; Butlin 1977, pp. 45–6.

The tomb at the right is inscribed: SICHAEO (Sychaeus). At the extreme left is the following inscription: DIDO/ BUILDING/ CARTHAGE/ OR/ THE/ RISE/ of the/ CARTHAGINIAN/ EMPIRE/ J.M.W. Turner/ 1815.

The building on the right is the tomb of Dido's husband, Sychaeus. He was murdered by her brother Pygmalion, and as a result she fled from Tyre to North Africa, where she founded the city of Carthage (Virgil, *Aeneid*, Book I).

NG 498 was exhibited at the Royal Academy in 1815. Two years later Turner exhibited *The Decline of the Carthaginian Empire* (London, Tate Gallery), which he appears to have regarded as a companion for it.

In his will Turner asked that NG 498 hang between Claude's *Seaport with the Embarkation of the Queen of Sheba* (NG 14) and *'The Mill'* (NG 12). The composition and mood of NG 498 were intended as a conscious homage to the work of Claude, which Turner deeply admired.

Turner Bequest, 1856.

Davies 1959, p. 96; Butlin 1977, pp. 84–5.

Inscribed in Greek on the flag of Ulysses' ship, with the beginning of his name.

Ulysses stands on the deck of his ship with his arms in the air mocking the giant Cyclops, Polyphemus, whom he has just blinded. One of the flags displays an image of the Trojan horse, in reference to the hero's part in the Trojan wars. Water nymphs travel before the ship, and Phaeton with his horse-drawn chariot can be seen in the sun rising up over the horizon to the right. The subject is taken from Homer's *Odyssey* (Book IX).

NG 508 was exhibited at the Royal Academy in 1829. The idea appears to have been initially sketched by the artist in about 1807. A preparatory oil study for the painting (London, Tate Gallery) dates from Turner's second visit to Italy in 1828–9. The precipitous rocks appear to have been based on the artist's studies of the scenery around the Bay of Naples.

Turner Bequest, 1856.

Davies 1957, p. 96; Butlin 1977, pp. 166–7.

Joseph Mallord William TURNER
The Evening Star
about 1830–40

Joseph Mallord William TURNER
Margate (?) from the Sea
about 1835–40

Joseph Mallord William TURNER
The Parting of Hero and Leander - from the Greek of Musaeus, before 1837

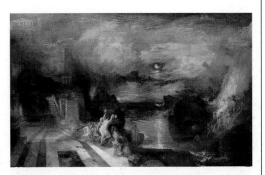

NG 521
Oil on canvas, 146.1 x 236.2 cm

NG 1991
Oil on canvas, 91.1 x 122.6 cm

NG 1984
Oil on canvas, 90.2 x 120.7 cm

The subject may be associated with one of Turner's own draft verses including the line 'The first pale Star of Eve ere Twylight comes', written in a sketchbook of about 1829–30. In his painting, the star is chiefly noticeable by its reflection near the water's edge. As sky and sea darken, a boy who has been netting shellfish sets off for home, searching in his creel for a morsel to throw to his dog; there is no other incident.

Turner Bequest, 1856.

Davies 1959, p. 100; Butlin 1977, p. 255.

This unfinished work illustrates Turner's fascination with atmospheric conditions – the combination of light, air and water. Much of the paint is applied in heavy impasto. There is no certainty that Margate is the location.

Turner Bequest, 1856.

Butlin 1977, p. 257.

The title is Turner's own; he exhibited the picture at the Royal Academy in 1837 with a quotation (in translation) from the ancient Greek poet Musaeus. The night is one of tragedy for the lovers as Leander drowns in the Hellespont after parting from Hero.

Turner Bequest, 1856.

Butlin 1977, pp. 200–1.

Joseph Mallord William TURNER
The Fighting 'Temeraire' tugged to her Last Berth to be broken up, 1838, before 1839

Joseph Mallord William TURNER
Rain, Steam, and Speed – The Great Western Railway, before 1844

TYROLESE
The Death of the Virgin
15th century

NG 524
Oil on canvas, 90.8 x 121.9 cm

NG 538
Oil on canvas, 90.8 x 121.9 cm

NG 4190
Oil and tempera on pine, 88.9 x 71.8 cm

In 1805 the *Temeraire*, a 98-gun ship of the line, had played a distinguished part in Nelson's most famous victory, the Battle of Trafalgar. Years later, she was still in service at Sheerness as a victualling-depot; but on 6 September 1838 she was towed up the Thames to be broken up at a Rotherhithe yard. Turner, on a steamer returning from Margate, is said to have observed and sketched part of the *Temeraire*'s last journey. It has been pointed out that her masts (like anything reusable) would have been removed before she was broken up; Turner has 'restored' them to give the *Temeraire* a majesty which contrasts with the squat tug which leads her to her doom. The painting was believed to represent the decline of Britain's former naval greatness.

NG 524 was exhibited at the Royal Academy in 1839, and engraved by J. Willmore in 1845.

Turner Bequest, 1856.

Davies 1959, p. 97; Butlin 1977, pp. 208–10.

A steam train advances across a bridge in the rain. The bridge, designed by the engineer Brunel and completed in 1839, spans the Thames between Taplow and Maidenhead. The view is to the east, towards London. In front of the train a hare dashes for cover, to the right a ploughman is working in the field, and in the lower left people are boating on the river. It was suggested by a contemporary of the artist that the 'Speed' of the title refers to the hare rather than the train.

NG 538 was exhibited at the Royal Academy in 1844. According to an unverifiable anecdote its subject was inspired by a trip Turner made on the line during a storm. More reliably, the work can be associated with the so-called 'railway mania' which swept across England in the 1840s.

Turner Bequest, 1856.

Davies 1959, pp. 99–100; Butlin 1977, pp. 232–3.

Inscribed on the donor's scroll: trahe me post te asumptio marie (Lead me to heaven after you, Mary); and on the book held by the apostle: laudate pu/eri domi/num laudate nom/en domi/ni excelsus / super om/nes gentes do/minus et / super celos / gloria ei/us asolis / ortu (us) que / ad ocas (um) / laudab (ile nomen Domini). (Praise the Lord, ye children, praise ye the name of the Lord... [The Lord is] high above all nations and his glory above the heavens... From the rising of the sun to the going down of the same [the name of the Lord is] worthy of praise.) (Psalm 112, 1–4 in the Vulgate).

In *The Golden Legend* it is described how the apostles were miraculously summoned together to witness the Dormition of the Virgin. It is probably Saint Peter who holds an incense burner over her. NG 4190 is unusual in that it seems to show thirteen apostles. The donor in the foreground appears to be dressed as a Franciscan.

The panel, which may have originally formed part of an altarpiece, has in the past been catalogued as Spanish, but a more convincing attribution to the Tyrolese School is supported both by the provenance of the work and the species of wood of its support.

Vambianchi collection, Trento; presented by the 1st Viscount Rothermere, 1926.

Levey 1959, pp. 107–8.

Paolo UCCELLO
The Battle of San Romano
probably about 1450–60

NG 583
Tempera on poplar, 182 x 320 cm

Paolo UCCELLO
Saint George and the Dragon
about 1460

NG 6294
Oil on canvas, 56.5 x 74 cm

Lucas van UDEN and David TENIERS the Younger
Peasants merry-making before a Country House
about 1650

NG 5866
Oil on canvas, 178.5 x 264.2 cm

NG 583 shows a skirmish which took place between Florentine and Sienese mercenaries in 1432. The victorious Florentines are led by Niccolò da Tolentino (centre, on a white horse), who is identifiable by the 'Knot of Solomon' on his banner (this device reappears on a monument to Tolentino painted by Andrea dal Castagno in Florence Cathedral).

NG 583 and its two companion panels (Paris, Louvre; Florence, Uffizi) showing incidents from the same battle were probably commissioned by Cosimo de' Medici, who was a close friend of Niccolò da Tolentino (died 1435). Uccello may have worked on the commission for many years: it is possible that the panels were originally intended for the first Medici palace (now Pucci) and were adapted for the Palazzo Medici (now Medici-Riccardi) in the course of its construction (1444–52). Debate continues over the exact arrangement of the three panels but they may have fitted between arched vaults (the top corners of each panel have been added to make the panels rectangular, possibly by Uccello himself).

The armour of the soldiers is of silver leaf, which has tarnished with age.

Palazzo Medici, Florence, by 1492; bought from the Lombardi–Baldi collection, Florence, 1857.

Davies 1961, pp. 525–31; Dunkerton 1991, pp. 282–4; Gebhardt 1991, pp. 179–85.

NG 6294 combines two incidents from the legend of Saint George (as recounted in *The Golden Legend*): his defeat of the dragon that had been terrorising a city and was about to devour a princess; and the rescued princess bringing the dragon to heel (with her girdle as a leash). The gathering storm may be intended to suggest divine assistance – the eye of the storm is in a direct line with the saint's lance.

Uccello is known to have painted the subject several times and a painting in Paris (Musée Jacquemart-André) may be an earlier version. The picture is one of the earliest paintings on canvas in the National Gallery and has a complicated layer of priming below the paint surface.

Lanckoronski collection, Vienna, by 1898; from where bought with a special grant and other contributions, 1959.

Davies 1961, pp. 532–3; Beck 1979, pp. 1–5; Dunkerton 1991, p. 164.

Signed: D TENIERS.
The house has not been identified; a coat of arms which was once to the left of the entrance is no longer legible.

The landscape in NG 5866 is thought to be by Lucas van Uden, but the figures are probably the work of David Teniers II. They can be dated on grounds of style to about 1650, and the landscape was probably painted shortly before then. The two artists also collaborated on other occasions.

Probably in the collection of John Skipp (1742–1811) at Overbury; presented by John Hanbury Martin, 1948.

Martin 1970, pp. 284–5; Brown 1987, p. 68.

Paolo UCCELLO
1397–1475

Paolo Doni, called Uccello, was apprenticed to the sculptor Ghiberti possibly around 1412–16. In 1415 he entered the artists' guild, the Arte dei Medici e Speziale, in Florence, as a painter. Principally active as a painter of frescoes, panels and canvases in Florence, Uccello also designed stained glass and carried out a mosaic in Venice in 1425. He was famously interested in perspective.

Lucas van UDEN
1595–1672

The artist, a landscape painter and etcher, was born in Antwerp, where he was probably taught by his father. He was admitted to the Antwerp Guild of St Luke as a master in 1627/8. In 1644 he travelled along the Rhine and then spent a year in Brussels. He may have worked in Rubens's studio.

UGOLINO di Nerio
The Betrayal of Christ
about 1324–5

UGOLINO di Nerio
The Way to Calvary
about 1324–5

UGOLINO di Nerio
The Deposition
about 1324–5

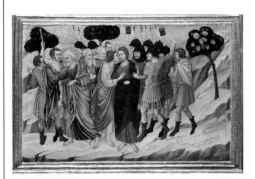

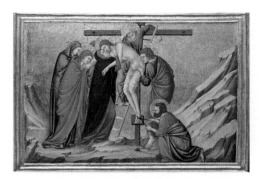

NG 1188
Tempera on poplar, 40.5 x 58.5 cm

NG 1189
Tempera on poplar, 40.5 x 58.5 cm

NG 3375
Tempera on poplar, 40.5 x 58.5 cm

The Roman soldiers have come to arrest Christ. At the centre Judas betrays Christ with a kiss as described in the New Testament (Matthew 26: 47–52). On the left Saint Peter cuts off the ear of Malchus. Only Christ and Peter are depicted with haloes. The scene takes place at night; illumination is provided by the torches held aloft.

This panel formed the second scene after the *Last Supper* (New York, Metropolitan Museum of Art, Lehman Collection) in the predella of the high altarpiece of S. Croce, Florence. It is assumed that the work post-dates the artist's high altarpiece, now lost, for S. Maria Novella in Florence (probably 1320–4). The S. Croce altarpiece was probably paid for by the Alamanni family, whose coat of arms was originally on it. The altarpiece (see Appendix A for a reconstruction) remained complete until the late eighteenth century when an inscription beneath the central panel depicting the Virgin and Child was recorded: *Ugolino de Senis me Pinxit* (Ugolino of Siena painted me). Technical analysis of the surviving fragments dispersed among several collections has confirmed that the arrangement of the panels shown in an eighteenth-century drawing (Rome, Biblioteca Vaticana: Vat. Lat., 9847, f.92r) is correct.

Collection of W. Young Ottley by 1835; bought from the Fuller Russell collection, 1885.

Stubblebine 1979, pp. 164–8; Pope-Hennessy 1987, pp. 8–11; Boskovits 1988, pp. 163–75; Gordon 1988, pp. 100, 108–16; Bomford 1990, pp. 98–123; Dunkerton 1991, pp. 222–5.

UGOLINO di Nerio
active 1317; died 1339/49?

Ugolino is documented in Siena in 1325 and 1327. The style of his work suggests that Duccio may well have taught him there. Ugolino's only autograph painting is the altarpiece, which originally bore a signature, from S. Croce, Florence (about 1324–5), from which all the fragments catalogued here come.

Christ carries the cross on his way to Golgotha. New Testament (Luke 23: 27–31). He is led by a rope tied around his neck. He looks back at his mother, Mary, who is attended by other women.

This panel formed the central scene of the seven scenes of Christ's Passion in the predella of the high altarpiece of S. Croce, Florence. The Crucifixion was omitted from the predella, but placed instead above the main central panel which showed the Virgin and Child.

All the other works catalogued here as by Ugolino are from this altarpiece; for further discussion see under Ugolino NG 1188.

Collection of W. Young Ottley by 1835; bought from the Fuller Russell collection, 1885.

Stubblebine 1979, pp. 164–8; Pope-Hennessy 1987, pp. 8–11; Boskovits 1988, pp. 163–75; Gordon 1988, pp. 100–1, 108–16; Bomford 1990, pp. 98–123; Dunkerton 1991, pp. 222–5.

Inscribed on the cross: (I)C.XC (Jesus Christ).

Joseph of Arimathea (?), on the ladder, lowers the dead Christ from the cross. The Virgin, accompanied by the Maries, embraces him. Saint John the Evangelist supports Christ on the right, while Nicodemus (?) removes a nail from his feet. This incident is not described in the Gospels.

This panel formed the fifth of the seven scenes of Christ's Passion in the predella of the high altarpiece of S. Croce, Florence. All the other works catalogued here as by Ugolino are from this altarpiece; for further discussion see under Ugolino NG 1188.

This composition is similar to that of the same subject in Duccio's *Maestà* (Siena, Museo dell'Opera del Duomo).

Collection of W. Young Ottley by 1835; Fuller Russell collection until 1885; presented by Henry Wagner, 1918.

Stubblebine 1979, pp. 164–8; Pope-Hennessy 1987, pp. 8–11; Boskovits 1988, pp. 163–75; Gordon 1988, pp. 101–2, 108–16; Bomford 1990, pp. 98–123; Dunkerton 1991, pp. 222–5.

UGOLINO di Nerio
The Resurrection
about 1324–5

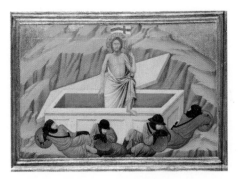

NG 4191
Tempera on poplar, 40.5 x 56.5 cm

UGOLINO di Nerio
Saint Simon and Saint Thaddeus (Jude)
about 1324–5

NG 3377
Tempera on poplar, 70.5 x 62.2 cm

UGOLINO di Nerio
Two Angels
about 1324–5

NG 3378
Tempera on poplar, 28.5 x 57.2 cm

Christ steps triumphant out of the tomb while four soldiers sleep in the foreground. New Testament (Matthew 28: 2–4). He holds a flag with a red cross on a white ground.

This panel formed the last scene in the predella of the high altarpiece of S. Croce, Florence. All the other works catalogued here as by Ugolino are from this altarpiece; for further discussion see under NG 1188.

Collection of W. Young Ottley by 1835; Fuller Russell collection until 1885; presented by Viscount Rothermere, 1926.

Stubblebine 1979, pp. 164–8; Pope-Hennessy 1987, pp. 8–11; Boskovits 1988, pp. 163–75; Gordon 1988, pp. 105, 108–16; Bomford 1990, pp. 98–123; Dunkerton 1991, pp. 222–5.

Inscribed on the background at the left: ...ON.(the remainder of Saint Simon), and at the right: S. THA.(the remainder of Saint Thaddeus).

Saint Simon on the left, holds a book, while Saint Thaddeus, who turns to the right, holds a knife. Three unidentified heads are depicted between decorative motifs in the band of quatrefoils below.

This panel formed the second section from the right of the upper tier, below the pinnacles of the high altarpiece of S. Croce, Florence. It was placed beneath the pinnacle depicting Jeremiah and above Saint Francis in the main tier. The tier from which it came showed mainly apostles. All the other works catalogued here as by Ugolino are from this altarpiece; for further discussion see under NG 1188.

The identification of Simon is accepted because of the inscription and the similarity between the types of apostles in Ugolino's work and those which are identified in Duccio's *Maestà*.

Collection of W. Young Ottley by 1835; Fuller Russell collection until 1885; presented by Henry Wagner, 1919.

Stubblebine 1979, pp. 164–8; Pope-Hennessy 1987, pp. 8–11; Boskovits 1988, pp. 163–75; Gordon 1988, pp. 103, 108–16; Bomford 1990, pp. 98–123; Dunkerton 1991, pp. 222–5.

This fragment showing two angels in the spandrels was originally placed above a figure of Saint Francis, now lost, on the principal tier (second section from the right) of the high altarpiece of S. Croce, Florence. Each of the spandrel angels in the altarpiece was distinctively different. Some of the main tier panels from the altarpiece survive (Berlin, Gemäldegalerie). All the other works catalogued here as by Ugolino are from this altarpiece; for further discussion see under NG 1188.

Beneath the spandrel is part of the main tier, from which the gold and gesso have been scraped, revealing fragments of the layer of linen beneath.

Collection of W. Young Ottley by 1835; Fuller Russell collection until 1885; presented by Henry Wagner, 1919.

Stubblebine 1979, pp. 164–8; Pope-Hennessy 1987, pp. 8–11; Boskovits 1988, pp. 163–75; Gordon 1988, pp. 104, 108–16; Bomford 1990, pp. 98–123; Dunkerton 1991, pp. 222–5.

UGOLINO di Nerio
Saint Bartholomew and Saint Andrew
about 1324–5

UGOLINO di Nerio
Isaiah
about 1324–5

UGOLINO di Nerio
Moses
about 1324–5

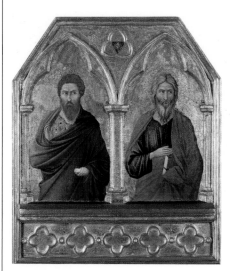

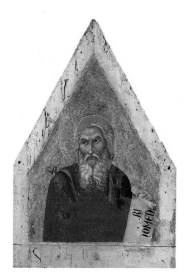

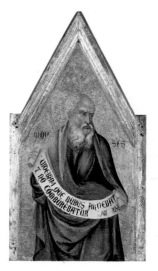

NG 3473
Tempera on poplar, 62 x 70 cm

NG 3376
Tempera on poplar, 46 x 32 cm

NG 6484
Tempera on poplar, 54.4 x 31.4 cm

Inscribed in the background at the left: (Bar) THOLO/MEU, and at the right : S AN/DREAS.

Saint Bartholomew, at the left, holds a scroll in his left hand and blesses (?) with his right, revealing an ornate garment beneath his cloak. Saint Andrew, at the right, holds a book.

This panel formed the third section from the left, below the pinnacles, of the high altarpiece of S. Croce, Florence. It was above a depiction of Saint Paul in the main tier and below *David* (NG 6485). All the other works catalogued here as by Ugolino are from this altarpiece; for further discussion see under NG 1188.

Collection of W. Young Ottley by 1835; Davenport Bromley collection until 1863; presented by the Earl of Crawford and Balcarres through the NACF, 1919.

Stubblebine 1979, pp. 164–8; Pope-Hennessy 1987, pp. 8–11; Boskovits 1988, pp. 163–75; Gordon 1988, pp. 104–5, 108–16; Bomford 1990, pp. 98–123; Dunkerton 1991, pp. 222–5.

Inscribed across the background: YSA/.AS. (Isaiah).

Inscribed on the scroll: (A)RI. NOMEN: [Ecce virgo concipiet, et pariet filium, et voc]abitur nomen [ejus Emmanuel] (Behold the Virgin shall conceive and bear a son and his name will be Emmanuel).

This three-quarter-length depiction of the Old Testament prophet shows him holding a scroll in his left hand and looking to the left. The inscription derives from his prophecy (Isaiah 7: 14), which was interpreted as predicting the birth of Jesus.

NG 3376 formed the second pinnacle from the left of the high altarpiece of S. Croce, Florence. All the other works catalogued here as by Ugolino are from this altarpiece; for further discussion see under NG 1188.

The condition of the panel is poor; there is extensive damage both at the top and bottom, and it has been considerably cut at the bottom.

Collection of W. Young Ottley by 1835; Fuller Russell collection until 1885; presented by Henry Wagner, 1918.

Stubblebine 1979, pp. 164–8; Pope-Hennessy 1987, pp. 8–11; Boskovits 1988, pp. 163–75; Gordon 1988, pp. 102–3, 108–16; Bomford 1990, pp. 98–123; Dunkerton 1991, pp. 222–5.

Inscribed on the background: MOYSES. Inscribed on the scroll: VIDEBAM QUE RUBUS ARDEBAT/ ET NO COMBUREBATUR (['And the angel of the Lord appeared to him in a flame of fire out of the midst of a bush; and] he looked, and lo, the bush was burning, yet it was not consumed').

The Old Testament prophet Moses, looking to the right, displays a scroll inscribed with an extract from the story of the burning bush (Exodus 3: 2).

This panel is a pinnacle (third from the right) from the high altarpiece of S. Croce, Florence. It was situated above *Saint James the Major and Saint Philip* (Berlin, Gemäldegalerie). All the other works catalogued here as by Ugolino are from this altarpiece; for further discussion see under NG 1188.

Collection of W. Young Ottley by 1837; bought by private treaty from the Trustees of the Doughty House Trust, 1983.

Stubblebine 1979, pp. 164–8; Gordon 1984, pp. 36–52; Pope-Hennessy 1987, pp. 8–11; Boskovits 1988, pp. 163–75; Gordon 1988, pp. 106, 108–16; Bomford 1990, pp. 98–123; Dunkerton 1991, pp. 222–5.

UGOLINO di Nerio
David
about 1324–5

UGOLINO di Nerio
Two Angels
about 1324–5

Moses van UYTTENBROECK
Landscape with Mythological Figures
1628

NG 6476
Oil on oak, 56 x 86.4 cm

NG 6486
Tempera on poplar, 27 x 56.5 cm

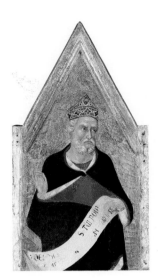

NG 6485
Egg (identified) on poplar, 55.3 x 31.1 cm

Inscribed on the background: DA (David).

Inscribed on the scroll: DE... S... TUI... PON/M (presumably this read originally: De fructe ventris tui ponam [super sedem tuam], which is an extract from the Old Testament (Psalm 132: 11): of the fruit of thy body will I set [upon thy throne]).

The prophet David, who wears a crown to denote his kingship, blesses (?) with his right hand and displays the inscribed scroll with his left.

This panel is a pinnacle (third from the left) from the high altarpiece of S. Croce, Florence. It was situated above *Saint Bartholomew and Saint Andrew* (NG 3473). All the other works catalogued here as by Ugolino are from this altarpiece; for further discussion see under NG 1188.

Collection of W. Young Ottley by 1837; bought by private treaty from the Trustees of the Doughty House Trust, 1983.

Stubblebine 1979, pp. 164–8; Gordon 1984, pp. 36–52; Pope-Hennessy 1987, pp. 8–11; Boskovits 1988, pp. 163–75; Gordon 1988, pp. 106–7, 108–16; Bomford 1990, pp. 98–123; Dunkerton 1991, pp. 222–5.

The angels which fill the spandrels look down towards the image which would originally have appeared beneath them.

This fragment was originally placed above a figure of Saint Louis of Toulouse, now lost, which was on the principal tier (outermost on the right-hand side) of the high altarpiece of S. Croce, Florence. All the other works catalogued here as by Ugolino are from this altarpiece; for further discussion see under NG 1188.

The panel below the spandrel, which is part of the main tier is still covered in its original fabric, and retains the original gilded moulding of the arched frame.

Collection of W. Young Ottley by 1837; bought by private treaty from the Trustees of the Doughty House Trust, 1983.

Stubblebine 1979, pp. 164–8; Gordon 1984, pp. 36–52; Pope-Hennessy 1987, pp. 8–11; Boskovits 1988, pp. 163–75; Gordon 1988, pp. 107–16; Bomford 1990, pp. 98–123.

Signed and dated lower right: MWBR 1628

The subject has not been satisfactorily identified. It has been described as 'The Nurture of Bacchus', but the figure with a crown of leaves is not a child. It could equally well be a pastoral love scene such as that of Daphnis and Chloë. Uyttenbroeck is not known to have visited Italy and the building on the right, in front of which two large Corinthian columns stand, is loosely based on the many engraved views of Roman monuments that would have been available to him.

Bought, anon. sale, Christie's, April 1982.

MacLaren/Brown 1991, p. 438.

Moses van UYTTENBROECK
about 1600–1646/7

Uyttenbroeck was a leading painter in The Hague. He joined the painters' guild there in 1620, and later, in the 1630s and 1640s, worked for the Prince of Orange on the decoration of his palace at Honselaersdijk. Uyttenbroeck was a history painter, specialising in scenes of mythological figures in a landscape. He illustrated episodes from Ovid's *Metamorphoses*, and was profoundly influenced by the work of Adam Elsheimer.

After Wallerant VAILLANT
A Boy seated Drawing
probably 1700–1800

NG 3591
Oil on canvas, 127 x 99.5 cm

Juan de VALDES LEAL
*The Immaculate Conception of the Virgin, with
Two Donors,* probably 1661

NG 1291
Oil on canvas, 189.7 x 204.5 cm

VALENTIN de Boulogne
The Four Ages of Man
about 1626–7

NG 4919
Oil on canvas, 96 x 134 cm

The boy is reading, having put down the book at his feet in which he was drawing the cast of the Christ Child from Michelangelo's *Virgin and Child* (Bruges, Notre Dame). The fig leaf on this cast may be a later addition.

NG 3591 is a copy of a picture attributed to Vaillant (Paris, Louvre). Vaillant also painted a variant of this composition which is signed and dated 1658 (Maastricht, Bonnefantenmuseum), and made a mezzotint of it. Several other copies are known and NG 3591 was probably painted in the eighteenth century.

Collection of Lady Carbery, Co. Cork, by 1921; presented by Mr and Mrs J.G. Lousada through the NACF to the Tate Gallery, 1921; transferred, 1922.

MacLaren/Brown 1991, pp. 439–40.

Signed and dated on a paper lying before the donor: JUAN / BALDES (both in monogram) FAC/A(O?) 1661 (?).

According to the doctrine of the Immaculate Conception, the Virgin Mary was conceived without Original Sin. Here she is surrounded by cherubs who carry emblems associated with her – an olive branch, a palm, a rose, an iris, a mirror and on the left a throne, which is intended as that of Solomon. The identity of the donors is not known, but it has been suggested that the man may be a canon or a city official, and that the woman is in mourning dress.

Bought in Spain by Captain the Hon. Frederick William Charteris before 1862; bought from his widow, Lady Louisa Charteris, 1889.

MacLaren/Braham 1970, pp. 98–9.

The figures around the table are intended to exemplify childhood, youth, maturity and old age. Their attitudes and attributes allude to different aspects of human endeavour and its futility. The child displays, uncomprehending, an open cage from which a bird has flown; the youth is fancifully dressed and plays a lute, but his looks will not last and the music will cease when he lays aside his instrument; the soldier wears a victor's laurel wreath, but his heroics are past; and the old man will soon have no use for the money before him. His drinking signifies pleasure but the flask and glass indicate pleasure's fragility.

NG 4919 was probably painted around 1626–7. The canvas has been cut down on all sides; its probable original appearance is recorded in an engraving of 1786 made when it was in the Orléans collection.

Possibly in the collection of Michel Particelli, Paris, 1650; Orléans collection by about 1700; bought in England by J.J. Angerstein, 1798; Bearsted collection by 1927; presented by the 2nd Viscount Bearsted through the NACF, 1938.

Davies 1957, pp. 214–15; Mojana 1989, pp. 122–3; Wine 1992, pp. 202–5.

Wallerant VAILLANT
1623–1677

Vaillant was born in Lille and is said to have studied under Erasmus Quellinus in Antwerp. He was active as a painter, etcher and mezzotinter in Amsterdam, Frankfurt, Paris and perhaps England. He was chiefly a portraitist, but also painted genre scenes and a few still-life pictures.

Juan de VALDES LEAL
1622–1690

Juan de Nisa y Leal Valdés, who came from a Portuguese family, was born in Seville. He first painted in Córdoba (until at least 1654) where he may have been a pupil of Antonio del Castillo. The artist was perhaps in Carmona in 1653 and by 1656 had resettled in Seville, where he became a rival of Murillo.

VALENTIN de Boulogne
1591–1632

Born in Coulomniers-en-Brie, the artist may have been first taught by his father. Valentin is first recorded in Rome in 1620, where he remained. He received commissions from the family of Pope Urban VIII, and in 1629 painted the *Martyrdom of Saints Processus and Martinian* for St Peter's, Rome (Rome, Pinacoteca Vaticana).

Jacques-Antoine VALLIN
Dr Forlenze
1807

NG 2288
Oil (identified) on canvas, 209.6 x 128.3 cm

Signed and dated on a rock lower left: Vallin / 1807

Joseph-Nicolas-Blaise Forlenze (1751?–1833) was born in Picerno and educated in Naples. In NG 2288 he is depicted in front of Mount Vesuvius, a lighthouse (perhaps one on the Molo in Naples) and a fountain with a statue of Saint Januarius.

Forlenze later became a surgeon and an oculist in Paris, where this portrait was painted. The orders and decorations were probably added after 1807. They include the Légion d'Honneur and the Order of St Michel. Forlenze was a member of these orders, but only after 1807. NG 2288 was exhibited at the Salon of 1808.

The head and shoulders of the sitter were painted on a small canvas that was subsequently fitted in to the full-length portrait.

Presented by Frédéric Mélé, 1908.

Davies 1970, pp. 135–6.

Diego VELAZQUEZ
Kitchen Scene with Christ in the House of Martha and Mary, probably 1618

NG 1375
Oil on canvas, 60 x 103.5 cm

The remains of a date which must have been 1618 are visible on the right below the scene with Christ.

The scene represented on the upper right is from the New Testament (Luke 10: 38–42). As Mary sat at Jesus' feet, listening to him, her sister Martha complained that she should not be left to serve the food alone. Christ replied that 'Mary has taken that good part, which shall not be taken away from her'. The scene appears to be viewed through an aperture in the wall, although it has also been interpreted as a reflection in a mirror and a picture on the wall. Opinions also vary about the relationship of the Gospel scene to the figures in the foreground. They may be intended as a latter-day Martha and Mary.

NG 1375 is one of the artist's early works, and it is related to other genre pictures which Velázquez painted in Seville. Its composition may derive from an engraving after Pieter Aertsen.

Possibly bought in Spain during the Peninsular War by Lt.-Col. Henry Packe; bequeathed by Sir William H. Gregory, 1892.

López-Rey 1963, p. 125; MacLaren/Braham 1970, pp. 121–5; Harris 1982, pp. 44–6; Brown 1986, pp. 16–21.

Diego VELAZQUEZ
Saint John the Evangelist on the Island of Patmos
about 1618

NG 6264
Oil on canvas, 135.5 x 102.2 cm

Saint John is depicted seated writing the Book of Revelation. To the left is his attribute, the eagle. He gazes up to the left at a vision of the Woman of the Apocalypse with the dragon, which is described in the New Testament (Revelation 12: 1–4, and 14).

The picture was painted as a pendant to Velázquez NG 6424, *The Immaculate Conception.* Both paintings are recorded together in Seville, and are thematically linked because John's vision of the Woman of the Apocalypse formed the basis of the iconography of the Immaculate Conception. The pictures were painted in the artist's Sevillian period and are usually dated to about 1618.

Recorded in the Chapter House of the Convent of the Shod Carmelites, Seville, with NG 6424, 1800; bought by Bartholomew Frere, Minister Plenipotentiary at Seville, 1809/10; bought with a special grant and contributions from the Pilgrim Trust and the NACF, 1956.

López-Rey 1963, pp. 131–2; MacLaren/Braham 1970, pp. 129–33; Braham 1981, pp. 60–1; Brown 1986, p. 25.

Jacques-Antoine VALLIN
about 1760–about 1835

Vallin entered the school of the Académie in about 1775. He was taught by Drevet, Callet and Renou. He exhibited at the Salon between 1791 and 1827.

Diego VELAZQUEZ
1599–1660

Diego Rodríguez de Silva Velázquez was born in Seville. He was taught by Francisco Pacheco from 1613 to 1618, and in 1623 was called to Madrid where he became principal painter to Philip IV. The artist visited Italy (1629–31 and 1649–51) and in 1659 was made a Knight of Santiago. Famed for the virtuosity of his technique, Velázquez explored most genres. His chief follower was Mazo.

Diego VELAZQUEZ
The Immaculate Conception
about 1618

Diego VELAZQUEZ
Christ after the Flagellation contemplated by the Christian Soul, probably 1628–9

Diego VELAZQUEZ
Philip IV of Spain in Brown and Silver
about 1631–2

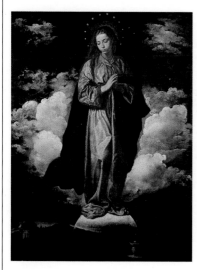

NG 6424
Oil on canvas, 135 x 101.6 cm

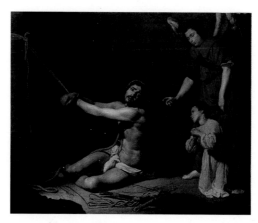

NG 1148
Oil on canvas, 165.1 x 206.4 cm

NG 1129
Oil on canvas, 195 x 110 cm

The young Virgin is depicted in the sky, standing upon the moon, and with a crown of stars around her head. These aspects of the iconography of the Immaculate Conception are based upon Saint John's vision of the Woman of the Apocalypse described in the New Testament (Revelation 12: 1–4, and 14). The Immaculate Conception, the doctrine that the Virgin who bore Christ was herself conceived without sin, was an important element of the cult of the Virgin, particularly in Spain. The various elements of the landscape – the garden, fountain, temple and ship – are derived from the imagery of the litanies of the Virgin.

NG 6426 was commissioned as a pendant to Velázquez NG 6264. Both paintings are first recorded together in the Chapter House of the Convent of the Shod Carmelites in Seville, and are thematically linked, as suggested above. The Carmelites were particularly devoted to belief in the Immaculate Conception.

Recorded in the Chapter House of the Convent of the Shod Carmelites, Seville, with NG 6264, 1800; bought by Bartholomew Frere, Minister Plenipotentiary at Seville, 1809/10; bought with the aid of the NACF, 1974.

López–Rey 1963, pp. 128–9; Braham 1981, pp. 81–2; Harris 1982, pp. 43, 52; Brown 1986, p. 25.

Christ is shown after the Flagellation, tied by his hands to the column. The blood-stained instruments of flagellation lie before him, in the foreground of the composition. On the right, at the bidding of the Guardian Angel, the Christian Soul, personified as a kneeling child, contemplates the suffering Christ. This subject was rarely treated in paintings. One of the few other Spanish examples of the period is by Juan de Roelas (about 1558–1625), a painter who worked in Seville during Velázquez's youth (Madrid, Convento de la Encarnación).

The figure of Christ reflects an acquaintance with Italian, specifically Bolognese, figure-painting which Velázquez would have known from works in the royal collection in Madrid. The style and colouring of the picture suggest a date before the artist's first visit to Italy (1629–31).

Bought in Madrid by John Savile Lumley (later Baron Savile), 1858; presented by him, 1883.

López–Rey 1963, p. 126; MacLaren/Braham 1970, pp. 119–21; Harris 1982, pp. 116–18; Brown 1986, pp. 67–8.

Signed on the paper in his right hand: Señor./Diego Velasqu[e]z. /Pintor de V.Mg (Señor. Diego Velázquez, Painter to Your Majesty, the opening words of a petition from Velázquez to the king.)

The king's dress is of unusual splendour and suggests that this work records a particular occasion; in most other portraits, such as NG 745, he is in more austere dress. The badge of the Order of the Golden Fleece is worn from a gold chain. The type of collar he wears is called a *golilla,*

NG 1129 was probably painted soon after Velázquez's return from Italy in 1631. It is one of the few signed works by the artist and the principal portrait of the king in the 1630s. The picture is first recorded in the monastery of El Escorial, near Madrid, and may have been brought there in the seventeenth century, although it is unlikely that it was made for that site.

Almost certainly in the library of El Escorial by 1764; given by Joseph Bonaparte to General Dessolle, 1810; passed from the collection of William Beckford to his son-in-law the 10th Duke of Hamilton, 1844; bought at the Hamilton sale, 1882.

López–Rey 1963, pp. 211–12; MacLaren/Braham 1970, pp. 114–19; Harris 1982, pp. 88, 91; Brown 1986, p. 85.

Diego VELAZQUEZ
Philip IV hunting Wild Boar (La Tela Real)
probably 1632–7

NG 197
Oil on canvas, 182 x 302 cm

Diego VELAZQUEZ
Portrait of Archbishop Fernando de Valdés
1640–5

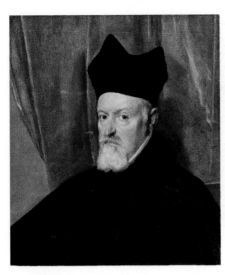

NG 6380
Oil on canvas, 63.5 x 59.6 cm

Diego VELAZQUEZ
The Toilet of Venus ('The Rokeby Venus')
1647–51

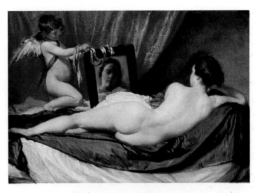

NG 2057
Oil (identified) on canvas, 122.5 x 177 cm

Inscribed on the reverse: *Pardo* (a reference to the palace of El Pardo near Madrid, near where the hunt may have taken place and where the picture hung in the eighteenth century).

In such hunts as this the wild boar were led into a large canvas enclosure. Because of the enormous expense involved in putting them on, only the king could afford them (hence *La Tela Real*: the Royal Enclosure). In the right foreground Philip IV meets the charge of the boar; to his left is the Conde-Duque de Olivares (First Minister) and beyond him a figure possibly identifiable as the Infante Don Carlos, Philip's brother. Queen Isabella watches the spectacle from her coach to the left of the tree in the right foreground. The hunt probably took place near the palace of El Pardo outside Madrid (see inscription). This building was close to the Torre de la Parada, a hunting lodge built for Philip (see Rubens NG 2598).

NG 197 was probably painted in the early or mid-1630s. Another artist may have been responsible for some of the peripheral figures and elements of the landscape. The work was probably originally intended for the Torre de la Parada.

A copy of NG 197 is in the Prado, Madrid.

Painted for Philip IV, probably for the Torre de la Parada; presented by Ferdinand VII to Sir Henry Wellesley (British minister in Spain), 1814–18; bought from Henry Farrer, 1846.

López–Rey 1963, pp. 168–9; MacLaren/Braham 1970, pp. 101–8; Harris 1982, pp. 130–1; Brown 1986, pp. 129–30.

Fernando de Valdés y Llanos was from the family of the Counts of Toreno. He was appointed Bishop of Tereul in 1625, Bishop Elect of León in 1632, and in 1633 Archbishop of Granada and President of the Council of Castille, a post comparable to that of Lord Chancellor. He died in 1639.

NG 6380 is considered to be a fragment of a larger, probably full-length, portrait of the sitter, from which another fragment of a hand which holds a paper signed by the artist also survives (formerly Madrid, Palacio de Oriente, Patrimonio Nacional). It is surmised that this work was a copy made by Velázquez based on a portrait in the Conde de Toreno collection, Madrid. It is thought that it was painted posthumously, perhaps with the aid of a death mask, in the early 1640s.

Probably the painting described by Sir David Wilkie in the collection of José de Madrazo, Madrid, 1828; Sir David Wilkie until 1842; bought with a contribution from the NACF, 1967.

MacLaren/Braham 1970, pp. 133–7; Brown 1986, pp. 273–4.

Venus reclines naked before a mirror held by a winged cupid.

NG 2057 was probably painted for Don Gaspar Méndez de Haro, Marqués del Carpio, son of the First Minister of Spain; it was recorded in an inventory of his possessions in 1651. It was executed shortly before Velázquez's departure for his second visit to Italy in November 1648, or during his stay there, 1649–51, and shows strong Venetian influence, recalling the nudes of Giorgione and Titian. The pose of Venus may have been inspired by classical statuary. It is the only surviving painting of a female nude by Velázquez; works of this type were disapproved of by the Spanish Inquisition, and so it would only have been displayed privately. Its popular title derives from the name of the home of its first English owners (see provenance).

Collection of Don Gaspar Méndez de Haro, 1651; given by the Duchess of Alba to Don Manuel Godoy in 1799/1800; in England in 1813, and bought in the following year by John Bacon Sawrey Morritt of Rokeby Hall, Yorkshire; presented by the NACF, 1906.

López–Rey 1963, pp. 143–4; MacLaren/Braham 1970, pp. 125–9; Braham 1981, pp. 69–70; Harris 1982, pp. 136–40; Brown 1986, pp. 181–3.

Diego VELAZQUEZ
Philip IV of Spain
about 1656

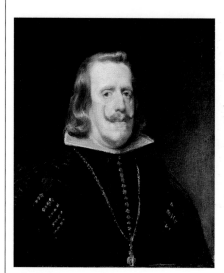

NG 745
Oil on canvas, 64.1 x 53.7 cm

King Philip IV of Spain (1605–65) was the son of
Philip III and Margaret of Austria; he ascended to
the Spanish throne in 1621. He wears the badge of
the Order of the Golden Fleece on a gold chain. The
type of collar depicted is called a *golilla*.

NG 745 was probably painted about 1656; the first
engravings after it by Villafranca date from the
following year. It was one of the last portraits
Velázquez made of his royal patron.

Many copies and versions of this portrait type
exist, notably the comparable autograph work in the
Prado, Madrid.

*Collection of Prince Demidoff, Florence, by 1862 ; bought
from Emanuel Sano, Paris, 1865.*

López–Rey 1963, pp. 219–20; MacLaren/Braham
1970, pp. 108–13; Brown 1986, p. 229; Ortiz 1989, pp.
260–5.

Adriaen van de VELDE
A Goat and a Kid
1655–72

NG 1348
Oil on canvas, 42.5 x 50.5 cm

The background landscape in NG 1348 was painted
after the animals (an unpainted outline around them
is visible); it may be by Frederick de Moucheron.

The goat also appears in NG 983 and in Adriaen
van de Velde's *Jacob departing from Laban* (London,
Wallace Collection). Both animals are also repeated
in his *Mercury and Battus* of 1671 (Prague, Narodni
Galeri).

*Collection of Edward Habich, Cassel, by 1881; bought,
1891.*

MacLaren/Brown 1991, pp. 444–5.

Adriaen van de VELDE
A Farm with a Dead Tree
1658

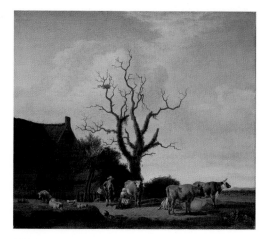

NG 867
Oil on canvas, 54.2 x 62.5 cm

Signed and dated bottom left: A.V. Velde.f/ 1658.
This early work shows van de Velde working in
the style of Paulus Potter.

*Johan Christoph Werther sale, Amsterdam, 25–26 April
1792; Claude-Joseph Clos sale, Paris, 18–19 November
1812; Duc de Dalburg sale, London, 13–14 June 1817;
Varroc and Lafontaine sale, Paris, 28 May 1821;
collection of (Sir) Robert Peel (Bt), 1822; bought with the
Peel collection, 1871.*

MacLaren/Brown 1991, p. 441.

Adriaen van de VELDE
1636–1672

The son of Willem the Elder and brother of
Willem the Younger, Adriaen was born and
worked in Amsterdam. He was probably a pupil
of his father and then of Wijnants in Haarlem. He
painted mostly landscapes, in which figures and
animals are often prominent, at first influenced by
Potter, later by Berchem and Wouwermans. He
often painted figures and animals in landscapes
by other artists.

Adriaen van de VELDE
The Edge of a Wood, with a Sleeping Shepherd, Sheep and Goats, 1658

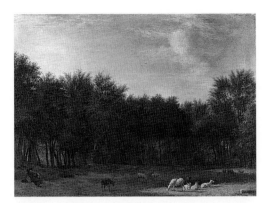

NG 982
Oil on oak, 27.7 x 38.1 cm

Adriaen van de VELDE
A Landscape with a Farm by a Stream
1661

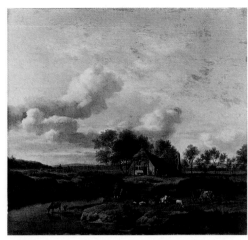

NG 2572
Oil on canvas, 32.3 x 35.4 cm

Adriaen van de VELDE
Peasants with Cattle fording a Stream
about 1662

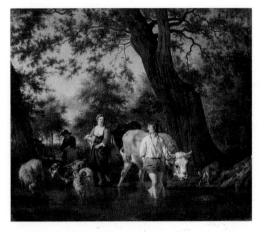

NG 868
Oil on canvas, 32.4 x 37.8 cm

Signed and dated on the log at bottom right: A.V. Velde.f/1658.

The shepherd's spud or houlette, used for rounding up sheep, lies on the grass beside him.

A similar painting by the artist, dated to the same year, entitled *Deer at the Edge of a Wood*, is now in Frankfurt (Städelsches Kunstinstitut).

Wynn Ellis Bequest, 1876.

MacLaren/Brown 1991, p. 443.

Signed and dated bottom centre: A.V. Velde f/1661.

NG 2572 is one of a group of works with similar subjects by the artist of the period about 1658–61.

A preparatory drawing of the cow survives (Amsterdam, Historisch Museum).

Perhaps collection of Frederick Perkins by 1836; Salting Bequest, 1910.

MacLaren/Brown 1991, p. 445.

The painting is not recorded before the eighteenth century; it was then said to have a pendant, *Landscape with a Woman milking a Cow.* It has been suggested that the picture comes from the last years of the artist's life, but a copy of it is said to have been signed and dated 1662 and so this may be the approximate date of NG 868.

Collection of the Prince de Carignan; Selle sale, Paris, 19–28 February 1761 (lot 25 with pendant); Randon de Boisset sale, Paris, 27 February 1777; Choiseul-Praslin sale, Paris, 18 February 1793; Sir Simon H. Clarke sale, London, 8–9 May 1840; collection of Sir Robert Peel, Bt, by 1842; bought with the Peel collection, 1871.

MacLaren/Brown 1991, p. 442.

Adriaen van de VELDE
A Bay Horse, a Cow, a Goat and Three Sheep near a Building, 1663

Adriaen van de VELDE
Golfers on the Ice near Haarlem
1668

Esaias van de VELDE
A Winter Landscape
1623

NG 983
Oil on canvas, 31 x 37 cm

NG 869
Oil on oak, 30.3 x 36.4 cm

NG 6269
Oil on oak, 25.9 x 30.4 cm

Signed and dated bottom left: A. V. Velde/1663.
The goat reappears with very slight variations in NG 1348.
Three drawings for the cow are known (Amsterdam, Historisch Museum; Paris, Louvre; New York, Pierpont Morgan Library), and one for the sheep (Amsterdam, Historisch Museum). The cow was also depicted in another painting of the same year by the artist (Madrid, Thyssen-Bornemisza Collection), and in at least four other pictures by Adriaen van de Velde.

Mennechet, Paris, 1840; Wynn Ellis Bequest, 1876.

MacLaren/Brown 1991, pp. 443–4.

Signed and dated bottom left: A.V.Velde. f/1668.
Men in the right foreground play golf; one is about to strike the ball with his club (*kolf*). On the horizon can be seen a windmill and the skyline of Haarlem, dominated by the Grote Kerk.
Pentimenti in the figure groups are visible: for example in the arm of the man about to play, and in the outline of the man leaning on his club.

Pierre-Jean Mariette sale, Paris, 1775; collection of Sir Robert Peel, Bt, by 1834; bought with the Peel collection, 1871.

MacLaren/Brown 1991, pp. 442–3.

Signed and dated lower centre: E. V. VELDE. 1623.
Two figures play golf in the left foreground.
Infra-red photographs of NG 6269 reveal a very free black chalk underdrawing. There are drawing lines beneath all the main landscape features, the house and the trees on either side. The figures, however, are not drawn but painted directly at a late stage in the composition: the initial drawing lines of the road and foreground can be seen to pass straight through them.

Anon. sale, London, 4 July 1956 (lot 91), bought by Slatter; from whom bought (Colnaghi Fund), 1957.

MacLaren/Brown 1991, p. 446.

Esaias van de VELDE
1587–1630

Esaias was born in Amsterdam, where he was probably taught by Gillis van Coninxloo. He moved to Haarlem in 1609 and joined the artists' guild there in 1612; among his pupils was Jan van Goyen. The artist then settled in The Hague in 1618. He painted and etched genre scenes and landscapes, and played an important role in the development of realism in Dutch landscape painting.

Jan van de VELDE
Still Life: A Goblet of Wine, Oysters and Lemons
1656

Willem van de VELDE the Younger
Calm: A Dutch Ship coming to Anchor and Another under Sail, 1657

Willem van de VELDE the Younger
A Dutch Ship and other Small Vessels in a Strong Breeze, 1658

NG 1255
Oil on oak, 40.3 x 32.2 cm

NG 870
Oil on canvas, 55 x 62 cm

NG 2573
Oil on canvas, 55 x 70 cm

Signed and dated along the edge of the table or ledge: Jan · vande · Velde · fecit · Anº 1656

The green goblet is a Rhenish *roemer*.

The painting is worn and the grain of the panel shows through, particularly in the background.

Collection of John Savile Lumley (later Sir John Savile Lumley and Baron Savile) by 1873; by whom presented, 1888.

MacLaren/Brown 1991, p. 447.

Signed and dated bottom left in the sea: w v velde 1657.

The small boat with her sprit-sail half lowered and her sprit nearly horizontal in the left foreground is a *kaag* – a Dutch vessel with a straight raking stem and clinker-built. Close ahead is a small ship, probably an Indiaman, coming to anchor. There are other ships under sail and becalmed beyond.

The signature is in an unusual position and may not be genuine. Nevertheless NG 870 is an autograph painting by Willem van de Velde the Younger made in his father's studio in Amsterdam.

Collection of George Watson Taylor by 1821; bought by (Sir) Robert Peel (Bt), 1823; bought with the Peel collection, 1871.

Robinson 1990, p. 258, no. 203; MacLaren/Brown 1991, pp. 449–50.

Signed and dated on the orange and white vane of the vessel in the left foreground: W V Velde 1658

In the left foreground is a *kaag* – a Dutch vessel with a straight raking stem and clinker-built. The ship on the right, a man-of-war, has the arms of the Province of Holland (a lion rampant) on her stern and a Dutch flag at the main.

NG 2573 was painted by Willem van de Velde for the van de Velde studio in Amsterdam. It shows the influence of Simon de Vlieger.

In the collection of Corneille-Louis Reynders by 1821; collection of Sir Robert Peel, 2nd Bt, by 1835; sold by Sir Robert Peel, 4th Bt, 1897; Salting Bequest, 1910.

Robinson 1990, pp. 797–8, no. 215; MacLaren/Brown 1991, p. 459.

Jan van de VELDE
1620–1662

Jan Jansz. van de Velde was born in Haarlem, the son of the engraver Jan van de Velde. He is recorded in Amsterdam in 1642 and 1643, and died in Enkhuizen. He was a still-life painter who worked in the tradition of Pieter Claesz. and Willem Heda of Haarlem.

Willem van de VELDE the Younger
1633–1707

He was born in Leiden, the son of Willem the Elder; by 1636 the family had moved to Amsterdam. He was taught by his father and perhaps by Simon de Vlieger. He worked in Amsterdam until 1672 when he and his father moved to England. They were in the service of Charles II and James II. Willem the Younger painted seascapes and later 'portraits' of specific vessels and naval events.

Willem van de VELDE the Younger
Dutch Vessels lying Inshore in a Calm, one Saluting, 1660

NG 6407
Oil on canvas, 54.6 x 69.5 cm

Willem van de VELDE the Younger
Dutch Ships and Small Vessels Offshore in a Breeze, about 1660

NG 872
Oil on oak, 41.5 x 58.6 cm

Willem van de VELDE the Younger
The Shore at Scheveningen
about 1660

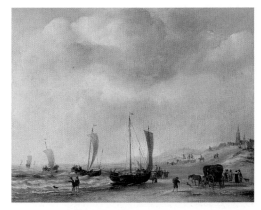

NG 873
Oil on canvas, 44.5 x 56.8 cm

Signed and dated on a piece of wood on the shore at lower left: W. V. Velde 1660.

To the right is a *kaag* – a Dutch vessel with a straight raking stem and clinker-built. On the extreme left is a *weyschuit* – a small Dutch open boat with a straight raking stern, usually rigged with a sprit. A little further out a States yacht (*statenjacht*) and other vessels can be seen.

Painted partly by Willem van de Velde the Younger in the van de Velde studio in 1660. The figures may be the work of Hendrick Dubbels.

Collection of the 4th Earl of Mexborough by 1864; collection of W.C. Alexander, 1904; presented by the Misses Rachel F. and Jean I. Alexander; entered the collection in 1972.

Robinson 1990, pp. 387–8, no. 217; MacLaren/Brown 1991, pp. 460–1.

Signed on a floating spar in the centre: WVV.

In the left foreground is a *kaag* – a Dutch vessel with a straight raking stem and clinker-built – with her white sprit-sail lowered. Anchored inshore in the centre is a *smalschip* – a small sprit-rigged transport vessel. In the right background a ship at anchor is firing a gun to port. Other small vessels are also included. In the catalogue of the Nieuhoff sale (Amsterdam 1777) the coast was identified as the island of Texel.

NG 872 was probably painted in about 1660. The water in the foreground may have been painted by Hendrick Dubbels who was working in the van de Velde studio at that time.

Nicholas Nieuhoff collection by 1777; collection of (Sir) Robert Peel (Bt), by 1823; bought with the Peel collection, 1871.

Robinson 1990, pp. 803–4, no. 205; MacLaren/Brown 1991, pp. 451–2.

On the dunes, right, are the village and church of Scheveningen, which lies on the North Sea coast of the Netherlands, about three miles from The Hague. The late fifteenth-century church still stands. The coach on the shore in the right foreground has the arms of Amsterdam on the back. A number of small fishing boats are coming in to land.

NG 873 may be a collaborative work, deriving from a picture of the same subject by Simon de Vlieger. The figures, coach and horses (and perhaps the church and houses) may be by Adriaen van de Velde, the rest by his elder brother Willem. NG 873 was probably painted in about 1660, and is related to a dated picture of 1659 in the collection of Dr G. Henle, Duisburg.

Juriaans collection by 1817 (and possibly Blackwood collection by 1757); collection of Sir Robert Peel, Bt, by 1835; bought with the Peel collection, 1871.

Robinson 1990, pp. 856–7, no. 206; MacLaren/Brown 1991, p. 452.

Willem van de VELDE the Younger
An English Vessel and Dutch Ships Becalmed
about 1660

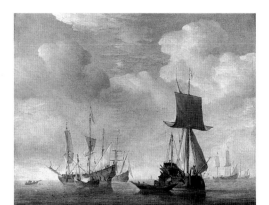

NG 874
Oil on oak, 22.7 x 27.6 cm

Willem van de VELDE the Younger
Two Small Vessels and a Dutch Man-of-War in a Breeze, about 1660

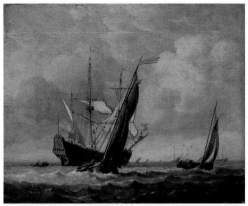

NG 875
Oil on oak, 24.2 x 29.8 cm

Willem van de VELDE the Younger
A Dutch Ship, a Yacht and Smaller Vessels in a Breeze, about 1660

NG 979
Oil on canvas, 33 x 36.5 cm

Signed, probably falsely, in the lower right corner: VV
An English two-masted armed ketch flying a white flag with Saint George's cross is in the right foreground. A small vessel, probably a *weyschuit* (a small Dutch open boat with a straight raking stern, usually rigged with a sprit), is approaching her. There is a small Dutch ship, probably an Indiaman, at anchor in the left middle distance with a *smalschip* (a small sprit-rigged Dutch transport vessel) nearby. Several other vessels are in the right distance.

Collection of the Duc de Choiseul by 1772; collection of Joseph Barchard by 1823; collection of Sir Robert Peel, Bt, by 1835; bought with the Peel collection, 1871.

Robinson 1990, pp. 526–7, no. 207[1]; MacLaren/ Brown 1991, p. 453.

Signed on a floating spar at bottom left: W V V.
In the left foreground is a *kaag* (a Dutch vessel with a straight raking stem and clinker-built); another is nearby on the right. The man-of-war has the arms of the Province of Holland on her stern and flies a Dutch ensign.

Probably in the collection of Sir Robert Peel, Bt, before 1830; bought with the Peel collection, 1871.

Robinson 1990, pp. 804–6, no. 208; MacLaren/Brown 1991, pp. 453–4.

Signed on a floating spar at bottom right: W V V
In the right foreground is a *kaag* – a Dutch vessel with a straight raking stem and clinker-built. In the centre is a States yacht (*statenjacht*) with Dutch colours and the arms of the Province of Holland on her stern. A Dutch ship with a Dutch flag at the main is further away on the left, with a large *weyschuit* (a Dutch open boat with a straight raking stern, usually rigged with a sprit) in front of her. Other vessels are seen beyond.
NG 979 was probably painted, partly by Willem van de Velde the Younger, for the family studio.

Collection of Ralph Fletcher, Gloucester, by 1835; collection of Wynn Ellis by 1858; Wynn Ellis Bequest, 1876.

Robinson 1990, pp. 806–7, no. 212; MacLaren/Brown 1991, pp. 456–7.

Willem van de VELDE the Younger
Small Dutch Vessels Aground at Low Water in a Calm, about 1660

Willem van de VELDE the Younger
Dutch Ships in a Calm
about 1660

Willem van de VELDE the Younger
Dutch Vessels close Inshore at Low Tide, and Men Bathing, 1661

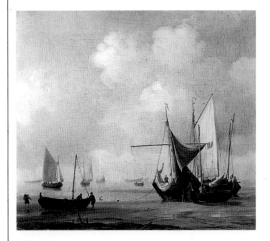

NG 2574
Oil on canvas, 32.9 x 36.9 cm

NG 6465
Oil on wood, 35.7 x 43.3 cm

NG 871
Oil on canvas, 63.2 x 72.2 cm

Signed on a spar in the centre foreground: W.V.V.

A number of vessels are gently run aground in the foreground, and at anchor in the background. Men can be seen walking on the sandbanks.

NG 2574 is probably a production of the van de Velde studio, and only partly by Willem van de Velde the Younger.

Collection of Lord Bateman by 1896; Salting Bequest, 1910.

Robinson 1990, pp. 391–2, no. 216[1]; MacLaren/Brown 1991, pp. 459–60.

Signed on the stern of the fishing buss: WVV.

On the left there is a fishing buss and a *hoeker* – a Dutch fishing vessel. On the right is a *kaag* – a Dutch vessel with a straight raking stem and clinker-built. Other vessels can be seen beyond.

NG 6465 was probably painted by Willem van de Velde for the family studio, around 1660. At least eight versions of the composition are known.

Possibly with J.P.B. Lebrun; collection of Baron Delessert by 1869; presented by Mrs Alice Bleecker, 1981.

Robinson 1990, pp. 533–5, no. 107[1]; MacLaren/Brown 1991, p. 461.

Signed and dated on the cross-piece between two stumps at lower left: W V Velde 1661

On the left are a *kaag* (a Dutch vessel with a straight raking stem and clinker-built), a *wijdschip* (a small Dutch transport vessel) and a small *weyschuit* (a small Dutch open boat with a straight raking stern, usually rigged with a sprit). In the right middle distance is a sprit-rigged fishing boat.

NG 871 is the best of four known versions and was probably painted by Willem van de Velde the Younger without studio assistance.

Collection of the Duc de Berry, Paris, by 1820; collection of Sir Robert Peel, Bt; bought with the Peel collection, 1871.

Robinson 1990, pp. 488–90, no. 204[1]; MacLaren/Brown 1991, pp. 450–1.

Willem van de VELDE the Younger
*A Dutch Yacht surrounded by Many Small Vessels,
saluting as Two Barges pull alongside,* 1661

NG 978
Oil on canvas, 90 x 126 cm

Willem van de VELDE the Younger
Boats pulling out to a Yacht in a Calm
about 1665

NG 980
Oil on canvas, 43 x 50.5 cm

Willem van de VELDE the Younger
A Dutch Vessel in a Strong Breeze
about 1670

NG 150
Oil on canvas, 23.2 x 33.2 cm

Signed inside the wreath on the pennant of the ship in the right foreground: W/VV. Dated on the stern of the row-barge in the left foreground: ANN(O?) 1[6]61

In the centre is a States yacht (*statenjacht*) with a Dutch ensign and, on her stern, the arms of the Province of Holland, and those of Amsterdam above; alongside her is a row-barge with the Amsterdam arms on her stern; in the left foreground is another row-barge with the arms of an admiralty. In the right foreground is a *boeier* yacht (a Dutch vessel with a curved spoon bow), presumably the one used by the van de Veldes (as the pennant is a private one with Willem van de Velde's initials).

NG 978 probably represents the departure of admiralty officials on their way from Amsterdam across the Zuiderzee to visit the fleet. This must have been a fairly common occurrence in about 1660.

Probably Robit collection, Paris, by 1801; collection of the Comte de Pourtalès, Paris; collection of Wynn Ellis by 1871 (and possibly by 1850); Wynn Ellis Bequest, 1876.

Robinson 1990, pp. 357–9, no. 211; MacLaren/ Brown 1991, pp. 455–6.

Signed on a spar in the bottom right corner: W V V.

A *weyschuit* (a small Dutch open boat with a straight raking stern, usually rigged with a sprit) is pushing off from the shore on the right. In the left background there is a States yacht (*statenjacht*) carrying the ensign of the States-General. Beyond are several men-of-war with Dutch colours; one of them, and the yacht, is firing a salute.

NG 980 was probably painted in about 1665. A group of dated pencil and wash drawings has been related to the picture, which is probably a scene on the Dutch coast near Den Helder.

In the collection of Edward Solly by 1835; collection of Wynn Ellis by 1850/1; Wynn Ellis Bequest, 1876.

Robinson 1990, pp. 442–3, no. 213; MacLaren/ Brown 1991, p. 457.

Signed on the rudder of the larger vessel: W.V.V.

The small boat with her mainsail half lowered in the centre is a *kaag* – a Dutch vessel with a straight raking stem and clinker-built. A vane striped blue and yellow is at the masthead and a flag in the same colours is at the peak. A *weyschuit* – a small Dutch open boat with a straight raking stern – approaches across rough seas from the left. In the right distance a *smalschip* – a small Dutch transport vessel – or similar boat can be seen.

There is another signed picture of a similar subject by Willem van de Velde the Younger (Stockholm, Nationalmuseum).

Bequeathed by Lord Farnborough, 1838.

Robinson 1990, pp. 823–4, no. 202; MacLaren/ Brown 1991, p. 449.

Willem van de VELDE the Younger
A Small Dutch Vessel close-hauled in a Strong Breeze, about 1672

Willem van de VELDE the Younger
Three Ships in a Gale
1673

Studio of Willem van de VELDE
Small Dutch Vessels in a Breeze
after 1660

NG 876
Oil on canvas, 32.7 x 40.3 cm

NG 981
Oil on canvas, 74.5 x 94.5 cm

NG 977
Oil on oak, 21 x 29.6 cm

Signed on a floating spar at bottom left: W.V.V.
 In the foreground is a small gaff-rigged vessel, known in Dutch as a *galjoot*. In the left middle distance is a ship with a Dutch pennant.

Collection of Daniel de Jongh by 1810; collection of Sir Robert Peel, Bt, by 1835; bought with the Peel collection, 1871.

Robinson 1990, pp. 914–16, no. 209; MacLaren/Brown 1991, pp. 454–5.

Signed and dated on a floating spar below centre: W.Vande. Velde Londe[n] 1673.
 In the left foreground is a ship, presumably at sea anchor. Behind her is another, much damaged and with a tattered Dutch flag. A third ship is seen in the right distance.
 NG 981 was painted in London (spelt Londe[n] in the inscription) in 1673 and the ships may be from Flushing (Vlissingen).

Collection of Jean-Henri Eberts, Paris, by 1766; collection of Wynn Ellis by 1871; Wynn Ellis Bequest, 1876.

Robinson 1990, pp. 1022–4, no. 214[1]; MacLaren/Brown 1991, pp. 457–9.

Signed (perhaps falsely) on the buoy in the bottom right corner: V V
 On the left is a *kaag* (a Dutch vessel with a straight raking stem and clinker-built) or a similar vessel, with a Dutch vane. On the right is a small sprit-rigged vessel, probably a *weyschuit*. A ship in the background flies the flag of vice-admiral of a fleet, and a plain red ensign.
 NG 977 is probably a studio work painted after an original of the late 1650s by Willem van de Velde the Younger.

Wynn Ellis Bequest, 1876.

Robinson 1990, p. 800, no. 210; MacLaren/Brown 1991, p. 463.

Studio of Willem van de VELDE
Calm: Two Dutch Vessels
probably after 1670

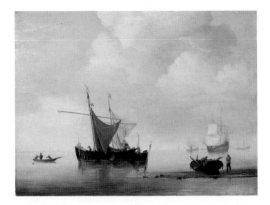

NG 149
Oil on oak, 20.9 x 27.9 cm

Jacob van VELSEN
A Musical Party
1631

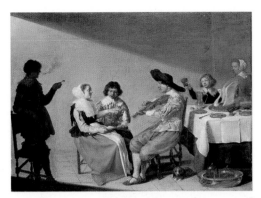

NG 2575
Oil on oak, 40 x 55.8 cm

Pieter VERBEECK
A White Horse standing by a Sleeping Man
about 1652

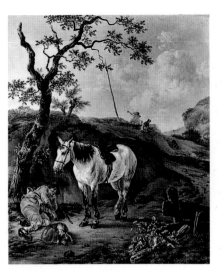

NG 1009
Oil on oak, 31.8 x 27 cm

Signed on the sand bank at right: W.V.V.
 In the centre is a *smalschip* (a small Dutch sprit-rigged transport vessel) with a Dutch ensign. On the right on a spit of sand is a *weyschuit* (a small open boat with a straight raking stern, usually rigged with a sprit).
 NG 149 was probably painted by the van de Velde studio without Willem's involvement. It could also be a late seventeenth or early eighteenth-century copy.

Collection of Gerrit Muller by 1827; bequeathed by Lord Farnborough, 1838.

Robinson 1990, pp. 484–6, no. 201[1]; MacLaren/ Brown 1991, pp. 462–3.

Signed and dated, top right: J v Velsen. 1631 . . .
 The false signature of Anthonie Palamedesz. (1601–73) was previously on this painting. (It was removed before 1895.)

Collection of Henry Doetsch, London, by 1895; Salting Bequest, 1910.

MacLaren/Brown 1991, p. 464.

Signed on the lower plank of the fence at the right: P. Verbeecq.
 The horse's pose may derive from a print by Paulus Potter (dated 1652). NG 1009 was once falsely signed as the work of Potter, but this signature covered Verbeeck's original.
 The main group of NG 1009 was etched, probably by Verbeeck himself, on the same scale but in the opposite direction.

Collection of Colonel Fitzgibbon (later 3rd Earl of Clare) by 1842; Wynn Ellis Bequest, 1876.

MacLaren/Brown 1991, p. 465.

Jacob van VELSEN
active 1625; died 1656

Jacob van Velsen was probably born in Delft and joined the guild there in 1625. He seems to have spent his life in Delft, but died in Amsterdam. He painted genre scenes in the style of Anthonie Palamedesz., who became a master in the Delft guild four years before van Velsen.

Pieter VERBEECK
probably about 1610/15?–1652/4

Pieter Verbeeck was born in Haarlem and worked in Alkmaar and Utrecht before returning to Haarlem in about 1643. After a few early battle pieces, he seems to have painted exclusively landscapes with horses alone or with riders. In Utrecht he was influenced by the Italianate landscape painters and later by Paulus Potter and Isack van Ostade.

Jan VERMEER
A Young Woman standing at a Virginal
about 1670

Jan VERMEER
A Young Woman seated at a Virginal
about 1670

Andries VERMEULEN
A Scene on the Ice
about 1800

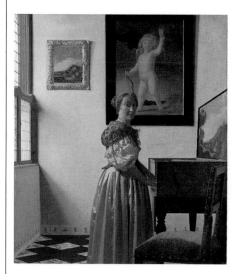

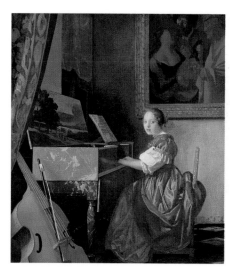

NG 1850
Oil on oak, 39.8 x 49 cm

NG 1383
Oil on canvas, 51.7 x 45.2 cm

NG 2568
Oil on canvas, 51.5 x 45.5 cm

Signed on the side of the virginal: IVMeer (or IMeer; the capitals are in monogram).

The smaller painting on the wall is in the manner of Jan Wijnants (see NG 884). The larger work, which appears in two other paintings by Vermeer (New York, Frick Collection; Metropolitan Museum of Art), is apparently in the style of Cesar van Everdingen, and may be a painting recorded in the possession of the painter's widow in 1676. Its subject may refer to the theme of fidelity. The inside of the virginal is painted with a landscape and there is a skirting of blue and white Delft tiles.

NG 1383 is dated on grounds of style to about 1670.

It has been suggested that NG 1383 is a pair to the National Gallery's other Vermeer, NG 2568. The works are the same size, similarly dated, and thematically can be contrasted because of the subjects of the paintings within them. But they have different provenances before the nineteenth century, and the artist is known to have on other occasions explored variations on a theme, rather than consciously creating pendants. This painting – and NG 2568 – were in the collection of the French art critic Théophile Thoré who wrote two articles in the *Gazette des Beaux-Arts* in 1866 which heralded the 'rediscovery' of Vermeer.

Possibly collection of Diego Duarte, Antwerp, 1682; collection of Etienne-Joseph-Théophile Thoré (Thoré-Bürger), Paris, by 1866; bought, 1892.

MacLaren/Brown 1991, pp. 466–8.

Signed centre: IVMeer (or IMeer; the capitals are in monogram).

The instrument has a landscape painted on the inside of the lid. In the foreground rests a viola da gamba with the bow placed between the strings, and at the back of the room hangs a painting which has been identified as Dirck van Baburen's *The Procuress* (Boston, Museum of Fine Arts). This work was also included in Vermeer's *Concert* (Boston, Isabella Stewart-Gardner Museum). A tapestry frames the scene at the upper left, and the skirting in the lower right is decorated with Delft tiles. Whether or not the subject of the *The Procuress* is intended to have a bearing on the meaning of the whole work is not clear; it is probable that a general association between music and love is intended.

NG 2568 has been dated on grounds of style to about 1670.

It has been suggested that NG 2568 is a pair to Vermeer NG 1383; for discussion of this theory and a note about the ownership of the paintings in the nineteenth century see the entry for the latter painting.

Possibly collection of Diego Duarte, Antwerp, 1682; collection of Etienne-Joseph-Théophile Thoré (Thoré-Bürger), Paris, 1867; Salting Bequest, 1910.

MacLaren/Brown 1991, pp. 468–9.

Signed left: A.Vermeulen
This type of composition is based on the work of Isack van Ostade (see NG 848).

NG 1850 is similar to another work by the artist (Frankfurt, Städelsches Kunstinstitut) which is signed and dated 1800. It was probably painted at about the same time.

Bequeathed by Miss Susannah Caught, 1901.

MacLaren/Brown 1991, p. 470.

Jan VERMEER
1632–1675

Johannes Reyniersz. Vermeer, now one of the most celebrated of all Dutch artists, was born and worked in Delft. He entered the painters' guild there in 1653, and his earliest dated painting, *The Procuress* (Dresden, Staatliche Gemäldegalerie), is of 1656. Vermeer apparently experienced financial difficulties in his last years. About thirty paintings by him – mostly genre scenes showing interiors with one or more figures – are known.

Andries VERMEULEN
1763–1814

The artist was born in Dordrecht where he was taught by his father, Cornelis Vermeulen, a landscape painter. Andries was also a landscape painter. He married in Amsterdam where he worked until his death. His landscapes are based upon seventeenth-century precedents; initially he worked in the manner of Hobbema, and later painted ice scenes based on those of Isack van Ostade.

Style of Jan Cornelisz. VERMEYEN
A Man holding a Coloured Medal
about 1545–50

Claude-Joseph VERNET
A Sporting Contest on the Tiber at Rome
1750

Claude-Joseph VERNET
A River with Fishermen
1751

NG 2607
Oil on oak, painted surface 41.9 x 33.5 cm

NG 236
Oil on canvas, 99.1 x 135.9 cm

NG 1057
Oil on canvas, 59.1 x 74.3 cm

Inscribed on the medal: MERCVRIVS. DE. GATTINARIA. CARLIS () M. CACELLĀR. (Mercurius Gattinaria, Chancellor to the Emperor Charles V).

The sitter holds a portrait medal of Gattinaria (1465–1530) who became Chancellor to the Emperor Charles V in 1518. The sitter may be the medallist who produced the medal, or a protégé of Gattinaria (various specific identifications have been proposed).

The medal is supposed to be of about 1530, and was perhaps struck as a memorial after Gattinaria's death. This might indicate the date of NG 2607, although the sitter's costume has been said to suggest a date of about 1545–50.

Collection of the Hon. Miss Canning before 1905; Salting Bequest, 1910.

Davies 1968, pp. 165–7; Horn 1989, I, p. 12.

Signed and dated: Joseph Vernet. f./Romae. 1750.

The Castel Sant'Angelo is in the background. It has been suggested that the foreground figures show the Marquis de Villette (see below) introducing the artist and his wife to his brother who was Directeur des Postes at Lyon.

NG 236 was commissioned by the Marquis de Villette in 1749, and was exhibited at the Salon in the following year (no. 124). It is one of several pictures by Vernet which the Marquis owned.

The composition was engraved in 1769 by P.-J. Duret.

Marquis de Villette sale, Paris, 1765; bought by the American artist John Trumbull, Paris, 1795; presented by Lady Simpkinson, 1853.

Hendy 1947, p. 81, no. 81; Davies 1957, p. 217; Conisbee 1976–7, pp. 60–1, no. 22.

Signed and dated: Joseph Vernet 1751.

The landscape is imaginary.

The attribution of NG 1057 to Vernet was doubted in earlier catalogues, but cleaning of the work has confirmed its authenticity.

Bequeathed by John Henderson, 1879.

Davies 1957, pp. 217–18.

Jan Cornelisz. VERMEYEN
1500–1559

Jan Vermeyen was probably born near Haarlem, and later worked in Malines and elsewhere. He accompanied the Emperor Charles V on the Tunis campaign of 1535 and designed tapestries of this subject. He was a portraitist for Charles V and also for the Regents of the Netherlands, Margaret of Austria and Mary of Hungary. A number of portraits have been attributed to him.

Claude-Joseph VERNET
1714–1789

Vernet studied under his father in Avignon, and then worked in Aix before going to Rome in 1734 where he remained until 1752. In 1753 he was in Paris and became a member of the Académie. He painted a series on the seaports of France for the French crown, from 1753 to 1762, travelling around the country to do so. His paintings were enthusiastically received at numerous Salons.

Claude-Joseph VERNET
A Sea-Shore
1776

Attributed to Claude-Joseph VERNET
A Seaport
later 18th century

Emile-Jean-Horace VERNET
The Emperor Napoleon I
1815

NG 201
Oil on copper, 62.2 x 85.1 cm

NG 1393
Oil on canvas, 97.2 x 134 cm

NG 1285
Oil on canvas, 72.4 x 59.7 cm

Signed and dated: J. Vernet./f. 1776.

The scene, like many of those by the artist, appears to have as its backdrop a Mediterranean port, perhaps near Naples, but the site is not identifiable, and the setting is probably fanciful.

NG 201 was painted for the Comte de Luc.

Comte de Luc sale, Paris, 1777; bequeathed by Richard Simmons, 1846/7.

Davies 1957, pp. 216–17; Wilson 1985, p. 116.

Inscribed on the wall at the right: SPQ (R or M?)/Divo...
Inscribed on the bale lower down: NW.

The coat of arms on the wall at the right may be intended as that of either Marseilles or Toulon. It has been suggested that the scenery recalls that of Toulon.

NG 1393 was in the past catalogued as by Vernet, but on cleaning doubts were raised about its quality. It has been attributed to Lacroix de Marseille, who closely imitated Vernet, but it is not signed by this artist nor engraved as his.

Presented by Isabel Tarratt, in accordance with the wishes of her mother, Mrs Tarratt of Suffolk Hall, Cheltenham, 1894.

Davies 1957, pp. 218–19.

Signed and dated: Horace Vernet 1815

Napoleon Bonaparte (1769–1821), emperor of the French, is portrayed wearing the cross and plaque of the Légion d'Honneur and the cross of the Order of the Iron Crown (both orders were founded by Napoleon).

NG 1285 is one of three portraits of Napoleon painted by Vernet for Lord Kinnaird in 1815–16. It may have been based on a sketch of Napoleon made from the life by Vernet in 1812.

Collection of Lady Kinnaird by 1815, and by descent to the Dukes of Leinster; presented by the Duke of Leinster, 1889.

Davies 1970, pp. 139–40.

Emile-Jean-Horace VERNET
1789–1863

Horace Vernet was the grandson of Claude-Joseph Vernet. He studied under his father Carle Vernet and his maternal grandfather Moreau le Jeune. He exhibited regularly at the Salon from 1812 and was director of the French Academy in Rome from 1828 to 1835. He painted many battle-pieces for the Duc d'Orléans, later King Louis-Philippe.

Emile-Jean-Horace VERNET
The Battle of Jemappes
1821

Emile-Jean-Horace VERNET
The Battle of Montmirail
1822

Emile-Jean-Horace VERNET
The Battle of Hanau
1824

NG 2963
Oil on canvas, 177.2 x 288.3 cm

NG 2965
Oil on canvas, 178.4 x 290.2 cm

NG 2966
Oil on canvas, 174 x 289.8 cm

Signed and dated: Horace Vernet 1821.

NG 2963 is one of four paintings commissioned from Vernet by the Duc d'Orléans (later King Louis-Philippe) depicting French successes in the Revolutionary and Napoleonic Wars (see also NG 2964, 2965 and 2966). On 6 November 1792 at Jemappes (near Mons in Belgium) the Austrians were defeated by the French Revolutionary army under General Dumouriez. The young duke distinguished himself in battle, and later he frequently referred to his role in this victory as evidence of his republican sympathies.

Dumouriez and his officers are shown at the right. To the left of centre, soldiers attend to the mortally wounded General Drouet. Further to the left, in a patch of light in the far distance, the duke is shown on a white horse, leading his troops into battle.

In 1822, during the Bourbon Restoration, Vernet's picture was rejected from the Salon but it was shown there shortly after the accession of Louis-Philippe, highlighting the political changes following the Revolution of 1830.

Collection of Duc d'Orléans (Louis-Philippe), Palais Royal, Paris, by 1826; bought by Lord Hertford at the Louis-Philippe sale, 1851; by inheritance to Sir Richard Wallace, and subsequently Sir John Murray Scott; by whom bequeathed, 1914.

Davies 1970, pp. 140–2; Durey 1980, pp. 62–4; Marrinan 1988, pp. 78, 244, 254.

Signed and dated: Horace Vernet fecit 1822

The Duc de Dantzig, shown at the right on a white horse, directs the charge of the French infantry.

NG 2965 is one of four paintings commissioned from Vernet by the Duc d'Orléans (later King Louis-Philippe) depicting French victories in the Revolutionary and Napoleonic wars (see also NG 2963, 2964 and 2966). After the Campaign of Leipzig in the autumn of 1813, Napoleon's armies were forced to retreat to France. In 1814 Napoleon scored some successes against the pursuing Allied forces, notably at Montmirail on 11 February 1814 where he defeated the Russians under General Sacken.

Collection of Duc d'Orléans (Louis-Philippe), Palais Royal, Paris, by 1826; bought by Lord Hertford at the Louis-Philippe sale, 1851; by inheritance to Sir Richard Wallace, and subsequently Sir John Murray Scott; by whom bequeathed, 1914.

Davies 1970, pp. 140–2.

Signed and dated: Horace Vernet 1824

French Grenadiers defend their artillery against an attack by Bavarian cavalry. NG 2966 is one of four paintings commissioned from Vernet by the Duc d'Orléans (later King Louis-Philippe) depicting French successes in the Revolutionary and Napoleonic wars (see also NG 2963, 2964 and 2965). In the autumn of 1813 the Campaign of Leipzig forced Napoleon to withdraw west of the Rhine. As they retreated the French defeated a force of Germans under Wrede at Hanau (near Frankfurt) on 30 October 1813.

Collection of Duc d'Orléans (Louis-Philippe), Palais Royal, Paris, by 1826; bought by Lord Hertford at the Louis-Philippe sale, 1851; by inheritance to Sir Richard Wallace, and subsequently Sir John Murray Scott; by whom bequeathed, 1914.

Davies 1970, pp. 140–2.

Emile-Jean-Horace VERNET
The Battle of Valmy
1826

Paolo VERONESE
Christ addressing a Kneeling Woman
about 1546

Paolo VERONESE
The Vision of Saint Helena
about 1560–5

NG 2964
Oil on canvas, 174.6 x 287 cm

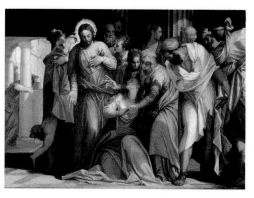

NG 931
Oil (identified) on canvas, 117.5 x 163.5 cm

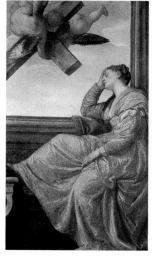

NG 1041
Oil on canvas, 197.5 x 115.6 cm

Signed and dated: H. Vernet 1826.

NG 2964 is one of four paintings commissioned from Vernet by the Duc d'Orléans (later King Louis-Philippe) depicting French successes in the Revolutionary and Napoleonic wars (see also NG 2963, 2965 and 2966). On 20 September 1792 at Valmy (on the main road from Verdun to Paris) the French Revolutionary army under General Kellermann was attacked by an invading Austro-Prussian force led by the Duke of Brunswick. The French withstood a fierce barrage of artillery and Brunswick subsequently retreated. In NG 2964 the future Duc d'Orléans leads the defence of the windmill at the left. General Kellermann is at the centre on the wounded horse.

The four battle pictures were badly damaged by a fire at the Palais Royal during the Revolution of 1848 and were probably restored by Vernet himself. This picture was the least damaged of the group.

Collection of Duc d'Orléans (Louis-Philippe), Palais Royal, Paris, by 1826; bought by Lord Hertford at the Louis-Philippe sale, 1851; by inheritance to Sir Richard Wallace, and subsequently Sir John Murray Scott; by whom bequeathed, 1914.

Davies 1970, pp. 140–2; Marrinan 1988, pp. 78, 244, 254.

The kneeling woman who holds her loosened hair and whose necklace is unfastened has been taken to be Mary Magdalene discarding her jewels or preparing to anoint Christ. The painting has also been thought to represent Christ and the woman taken in adultery. A more likely hypothesis is that it represents 'the woman with an issue of blood' who touched Christ's garment in the hope of a cure while a crowd thronged around him. When Christ asked who had touched him she confessed what she had done and he turned to her, saying: 'Daughter, thy faith hath made thee whole'. New Testament (Mark 5: 24–34).

NG 931 is probably an early work painted in Verona and may date from about 1546. It resembles very closely a composition, also of that period, of Christ raising the daughter of Jairus (a copy of the lost original is in S. Bernardino, Verona), another miracle rarely depicted by painters.

Collection of Sir Gregory Page, Bt, London, by 1761; Wynn Ellis Bequest, 1876.

Gould 1975, pp. 322–3; Pignatti 1976, p. 110.

Saint Helena's vision of the True Cross is represented by two angels with the cross appearing to her as she sleeps. Saint Helena, mother of the Emperor Constantine, is said to have received divine guidance in her quest for the place where the True Cross, on which Christ had been crucified, was buried. The story (but not the specific incident) is told in *The Golden Legend*.

The composition of NG 1041 derives from an engraving by a follower of Marcantonio Raimondi after a drawing by Raphael. The attribution of NG 1041 to Veronese has occasionally been doubted but it is generally accepted as a relatively early work.

Seen by Govaert Bidloo in the collection of Philips de Flines, Amsterdam, by 1681; bought, 1878.

Gould 1975, pp. 324–6; Pignatti 1976, p. 141; Golahny 1981, pp. 25–7.

Paolo VERONESE
probably 1528–1588

Paolo Caliari, called Veronese, worked in his native city of Verona – where he trained with Antonio Badile – before settling in Venice in about 1554. He painted altarpieces, portraits and large-scale decorative works (religious, historical and mythological) for churches, monasteries, villas, palaces and civic buildings throughout Venice and the Veneto.

Paolo VERONESE
The Consecration of Saint Nicholas
1561–2

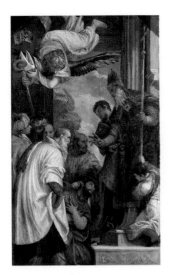

NG 26
Oil on canvas, 282.6 x 170.8 cm

Paolo VERONESE
The Family of Darius before Alexander
1565–70

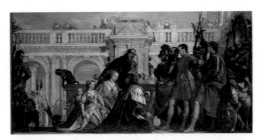

NG 294
Oil (identified) on canvas, 236.2 x 474.9 cm

Paolo VERONESE
Allegory of Love, I ('Unfaithfulness')
probably 1570s

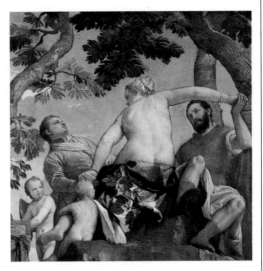

NG 1318
Oil (identified) on canvas, 189.9 x 189.9 cm

On the eve of the election of a new archbishop of Myra in Lycia (Asia Minor) in the fourth century AD, it was revealed to one of the bishops that a young man called Nicholas had been divinely chosen. When Saint Nicholas presented himself at the cathedral the following day he was elected and immediately installed as archbishop. The story is told in *The Golden Legend*. Veronese has shown the moment of Nicholas' recognition – or subsequent consecration – with an angel above bringing his bishop's stole, crozier and mitre. The saint humbly obeys. In 1087 the remains of Saint Nicholas were transferred to Bari.

NG 26 was painted for the altar dedicated to Saint Nicholas of Bari in S. Benedetto Po, near Mantua, where it was probably installed in 1562. In March 1562 Veronese received final payment for three altarpieces commissioned for the church in December 1561 (one of the other two pictures survives in the Chrysler Museum, Norfolk, Virginia).

S. Benedetto Po, near Mantua, by 1568 (and presumably since March 1562); presented by the Governors of the British Institution, 1826.

Gould 1975, pp. 316–18; Pignatti 1976, p. 124.

NG 294 illustrates the episode related in various histories (but especially in Valerius Maximus and Plutarch) of the mistake made by the family of Darius, the defeated Persian king, in identifying Alexander after the battle of Issus (in 333 BC). Alexander and his friend Hephaestion visited Darius' pavilion, and the mother of Darius, misled by Hephaestion's height and splendid attire, offered him the obeisance due to the victorious monarch. Alexander graciously observes that Hephaestion was like another Alexander. Appropriately there is no consensus as to which figure is intended for Alexander, but the figure in red is more likely since he speaks to comfort the queen. The gesture of Darius' mother towards the princess (sister of Darius' wife) doubtless refers to the offer of her as a bride to the conqueror.

NG 294 was probably painted for the Pisani family, perhaps at the time of a matrimonial alliance (for which the subject would be appropriate). The date of NG 294 has caused some debate but probably belongs to the second half of the 1560s.

Veronese studied Alexander and Hephaestion in a drawing (Paris, Louvre), and his underdrawing on the canvas is also visible in places. On occasion Veronese was involved with Palladio and stage designs; his interest in 'staging' his compositions is seen here.

Pisani collection, Venice, by 1648; bought from the Pisani family, 1857.

Gould 1975, pp. 320–2; Pignatti 1976, p. 132; Cocke 1984, p. 325.

Inscribed on the letter: *Che(?) / uno(?) possede...* (That one possesses...).

The title of this allegory ('Unfaithfulness') is traditional. The nude woman receives from, or passes to, the man on the left a note.

NG 1318 and 1324, 1325 and 1326 were probably painted for a ceiling and form a complete series. They may have been commissioned by Emperor Rudolph II (died 1612; a patron of Veronese from 1581) for a ceiling in the castle at Prague. Alternatively the series may have been painted for a location in Venice, as two details from them are recorded in Van Dyck's Italian Sketchbook (London, British Museum), though it has been observed that these might depend on drawings, copies or modelli rather than the original canvases.

Collection of Rudolph II, Prague, by 1637; collection of Queen Christina of Sweden by 1652; collection of the Duc d'Orléans by 1727; collection of Lord Darnley by 1818; bought, 1890.

Gould 1975, pp. 326–30; Pignatti 1976, pp. 145–6; Cocke 1984, pp. 184–5; Rearick 1988, pp. 126–9.

Paolo VERONESE
Allegory of Love, II ('Scorn')
probably 1570s

Paolo VERONESE
Allegory of Love, III ('Respect')
probably 1570s

Paolo VERONESE
Allegory of Love, IV ('Happy Union')
probably 1570s

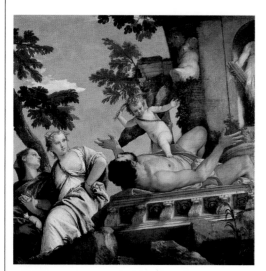

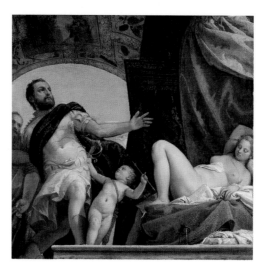

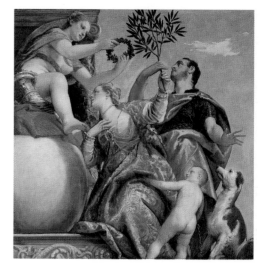

NG 1324
Oil (identified) on canvas, 186.6 x 188.5 cm

NG 1325
Oil (identified) on canvas, 186.1 x 194.3 cm

NG 1326
Oil (identified) on canvas, 187.4 x 186.7 cm

The title of this allegory ('Scorn') is traditional, but is not inappropriate. Cupid is shown in the foreground beating a near-naked man with his bow. The woman on the extreme left holds an ermine, symbolising Chastity; she is escorting the woman with exposed breasts away from the attentions of the man chastised by Cupid.

The four Allegories NG 1318, 1324, 1325 and 1326 were probably painted for a ceiling and form a complete series; for further comment see under NG 1318.

Collection of Rudolph II, Prague, by 1637; collection of Queen Christina of Sweden, by 1652; collection of the Duc d'Orléans by 1727; collection of Lord Darnley by 1818; bought, 1891.

Gould 1975, pp. 326–30; Pignatti 1976, pp. 145–6; Cocke 1984, pp. 184–5; Rearick 1988, pp. 126–9.

Cupid seems to urge the soldier towards the sleeping woman, but he appears to resist Cupid's encouragement, and to be restrained by his companion. The title of this allegory ('Respect') is traditional. The relief on the vault may represent the Continence of Scipio (a classical example of sexual restraint).

NG 1318, 1324, 1325 and 1326 were probably painted for a ceiling and form a complete series; for further comment see under NG 1318.

Collection of Rudolph II, Prague, by 1637; collection of Queen Christina of Sweden by 1652; collection of the Duc d'Orléans by 1727; collection of Lord Darnley by 1818; presented by Lord Darnley, 1891.

Gould 1975, pp. 326–30; Pignatti 1976, pp. 145–6; Cocke 1984, pp. 184–5; Rearick 1988, pp. 126–9.

The title of this allegory ('Happy Union') is traditional. A woman (perhaps Venus, the goddess of Love, or an allegorical figure of Abundance – suggested by the horn of plenty on which she sits) places a crown (probably myrtle) on the head of a woman who is united in peace (symbolised by an olive branch) with the bearded man. The dog may represent fidelity. The scene is likely to be the culmination of the series.

NG 1318, 1324, 1325 and 1326 were probably painted for a ceiling and form a complete series; for further comment see under NG 1318.

Collection of Rudolph II, Prague, by 1637; collection of Queen Christina of Sweden by 1652; collection of the Duc d'Orléans by 1727; collection of Lord Darnley by 1818; bought, 1891.

Gould 1975, pp. 326–30; Pignatti 1976, pp. 145–6; Cocke 1984, pp. 184–5; Rearick 1988, pp. 126–9.

Paolo VERONESE
The Adoration of the Kings
1573

After VERONESE
The Rape of Europa
probably 1575–1625

Attributed to Andrea del VERROCCHIO
Tobias and the Angel
1470–80

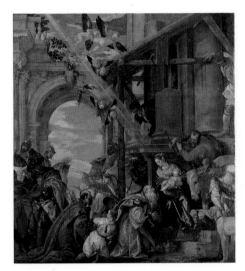

NG 268
Oil on canvas, 355.6 x 320 cm

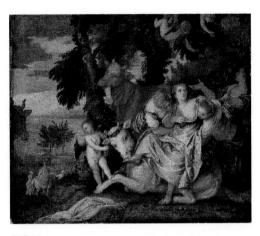

NG 97
Oil on canvas, laid down on wood, 59.4 x 69.9 cm

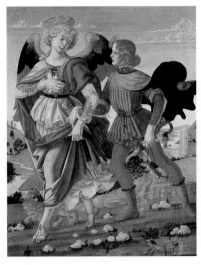

NG 781
Tempera on poplar, painted surface 83.6 x 66 cm

Dated bottom right: M.D.LXXIII. [1573].

The Three Kings have sought out the Child Jesus in the stable where he was born. They bear gifts (gold, frankincense and myrrh) and have journeyed from the East. New Testament (Matthew 2: 10–12). The ruins are intended to suggest that the new Christian order was born out of the decay of the old pagan order.

NG 268 comes from the church of S. Silvestro, Venice, where it was described in 1581. The attribution to Veronese has never been doubted, though varying degrees of studio assistance have been suggested. Given the date on the picture (1573), studio assistance would not be surprising: Veronese was also painting the huge canvas of the *Feast in the House of Levi* (Venice, Accademia) in this year.

Three drawings have been related to NG 268 (Haarlem, Teylers Museum; formerly Haarlem, Koenigs collection; formerly New York, Lehmann Collection). Several copies of the composition are known. The church of S. Silvestro, Venice was altered in 1836–43, and NG 268 was folded and stored at this time.

Bought, 1855.

Gould 1975, pp. 318–20; Pignatti 1976, pp. 136–7; Cocke 1984, pp. 161–5.

Europa was carried away from Tyre by Zeus who had transformed himself into a bull. The unwitting Europa first garlanded the bull in flowers, then sat upon its back, before being carried across the sea from her native land to Crete. Ovid, *Metamorphoses* (II, XIII, 978–1032).

Sometimes described as a modello for the larger picture of this subject in the Doge's Palace, Venice, NG 97 is more likely to be a copy.

Probably in the collection of Rudolph II, Prague, by 1637; Holwell Carr Bequest, 1831.

Gould 1975, pp. 330–1; Pignatti 1976, pp. 188–9.

Inscribed in Italian on the paper held by Tobias: Ricord (for *Ricordo* – a memorandum).

Tobias was sent by his blind father Tobit to collect a debt (hence the paper he carries in one hand) from a distant city. The Archangel Raphael, who escorts him, bade him extract the heart, liver and gall from a fish (that he caught as it tried to devour him in the river Tigris). The gall was to restore his father's eyesight. Raphael was venerated as a protector of travellers and as a healer. Book of Tobit (4: 3–4).

Paintings such as NG 781 were especially popular in Florence among members of a lay association devoted to the Archangel Raphael. This picture has also sometimes been attributed to the young Perugino, and to a follower of Verrocchio.

Collection of Conte Angiolo Galli Tassi, Florence, by 1863; bought from G. Baslini, Milan, 1867.

Davies 1961, pp. 555–7; Gombrich 1972, pp. 28–30; Scarpellini 1984, p. 69; Dunkerton 1991, p. 314.

Andrea del VERROCCHIO
about 1435–1488

Famous as a sculptor and much employed by the Medici family, Andrea di Michele di Francesco Cioni seems to have trained in Florence with Giuliano Verrocchi and Donatello. He is known to have painted an altarpiece for the cathedral of Pistoia and the *Baptism of Christ* (Florence, Uffizi), in which an angel is attributed to Leonardo. Many young artists studied in his workshop.

Attributed to Andrea del VERROCCHIO
The Virgin and Child with Two Angels
probably about 1470–80

Hendrick VERSCHURING
Cavalry attacking a Fortified Place
about 1677

Jan VICTORS
A Village Scene with a Cobbler
about 1650

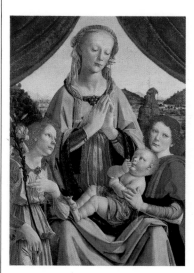

NG 296
Tempera on wood, painted surface 96.5 x 70.5 cm

NG 3134
Oil on canvas, 91 x 113.5 cm

NG 1312
Oil on canvas, 63 x 78.5 cm

Curtains have been parted revealing the Virgin and Child and two angels. One of the angels holds a lily, traditional symbol of the Virgin's purity.

NG 296 has been cut down, probably on all sides. It has sometimes been considered to be by the young Perugino; however, the picture is closer to the works that form the basis of all attributions to Verrocchio.

Verrocchio was a sculptor and goldsmith as well as a painter. His workshop was noted for the careful rendering of expensive fabrics and jewellery, both of which are exceptionally well represented in NG 296.

Contugi collection, Volterra, by 1857; bought, 1857.

Davies 1961, pp. 554–5; Scarpellini 1984, p. 70; Dunkerton 1991, p. 150.

Signed bottom left of centre: H. Verschuring. f(e?).

NG 3134 is not known to represent a specific battle or historical event. The figures are in seventeenth-century dress.

The architecture and the cypress trees show that the scene is a southern one, presumably Italian, and the picture no doubt reflects Verschuring's experience of Italy. However, it is unlikely to date from the artist's Italian years: a very similar battle scene, signed and dated 1677, was in the Czernin collection in Vienna (in 1936) and NG 3134 probably also dates from around 1677.

Hart collection by 1852; presented by Augustine Sargent, 1917.

MacLaren/Brown 1991, pp. 470–1.

Signed on the barrel in the right foreground: Jan Victors.

The costume of the old woman on the left, with its prominent gold braiding on the bodice, was worn in the Province of North Holland. In the right background a quack has set up his stall beneath his distinctive Chinese umbrella.

The model used for the cobbler in the central foreground reappears in Victors's *The Swine Butcher* (Amsterdam, Rijksmuseum) which is signed and dated 1648, and in another picture of 1651 (York, City Art Gallery). NG 1312 was probably painted in about 1650.

Boursault collection, Paris, by 1832; collection of Edmund Higginson by 1841; bought, 1890.

MacLaren/Brown 1991, pp. 471–2.

Hendrick VERSCHURING
1627–1690

Verschuring was born in Gorinchem where he is said to have studied with Dirck Govaertz. He then moved to Utrecht where he was a pupil of Jan Both for six years. He worked in Italy for eight years before returning to Gorinchem by 1657. He painted pictures of cavalry scenes and some Italianate views.

Jan VICTORS
1619–1676 or later

Jan Victors was born and worked in Amsterdam, and may have studied with Rembrandt before 1640. In 1676 he went to the Dutch East Indies and apparently died there. Until the mid-1650s he painted religious subjects and portraits in a strongly Rembrandtesque style; from about 1650 he increasingly painted genre subjects. They are related in style to the genre scenes of Nicolaes Maes.

Elizabeth Louise VIGEE LE BRUN
Self Portrait in a Straw Hat
after 1782

Elizabeth Louise VIGEE LE BRUN
Mademoiselle Brongniart
1788

Alvise VIVARINI
The Virgin and Child
about 1483

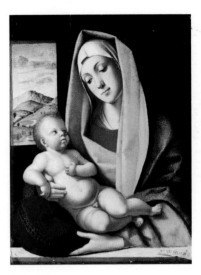

NG 1653
Oil (identified) on canvas, 97.8 x 70.5 cm

NG 5871
Oil on oak, 65.1 x 53.3 cm

NG 1872
Oil on wood, 69.2 x 53.3 cm

The artist has here depicted herself with a loaded palette and brushes.

NG 1653 is an autograph replica of a self portrait on panel (now Switzerland, private collection) which was painted in Brussels in 1782 and exhibited in Paris in the same year at the Salon de la Correspondance. The National Gallery's painting has in the past been catalogued as a copy by another artist, but recent cleaning has shown it to be by Vigée Le Brun herself.

The work appears to have been inspired in part by Rubens's *Chapeau de Paille* (NG 852), which Vigée Le Brun had seen in Antwerp.

A.P. Pickering sale, 1897; bought by S.T. Smith, from whom bought, 1897.

Davies 1957, p. 133; Baillio 1982, pp. 44–6.

Alexandrine-Emilie (1780–1847) was the daughter of the architect Alexandre-Théodore Brongniart. She married Louis-André, Baron Pichon. This information is inscribed on the back of the work. The inscription, which is dated 1870, was made by the sitter's son.

Probably in the Salon of 1789 (no. 83); passed to a son of the sitter, Baron Jérôme Pichon (1812–96); bequeathed by Sir Bernard Eckstein, 1948.

Davies 1957, pp. 132–3; Baillio 1982, p. 35.

Signed on the cartellino at the lower right: ALVVIXI VIVARIN. P (partly damaged).

The Virgin rests a hand on the parapet in the foreground. The view seen through the window is unlikely to be of a specific place.

When NG 1872 was engraved by G.M. Sasso for his *Venezia Pittrice* (Venice, Correr Library) it was depicted with the landscape in a different form. This overpainting has been removed. The work can be dated by comparison with the artist's *Madonna and Child Enthroned* (Barletta, S. Andrea), which is signed and dated 1483.

Passed from the Correr collection at S. Giovanni Decollato, Venice, to the Manfrin collection, Venice, not later than 1803; bought from the Sangiorgi Gallery, Rome, by Charles Loeser of Florence, 1893; by whom presented, 1898.

Davies 1961, p. 558; Pallucchini 1962, no. 247, p. 135; Steer 1982, no. 15, p. 141.

Elizabeth Louise VIGEE LE BRUN
1755–1842

Vigée Le Brun was born in Paris, the daughter of the painter Louis Vigée. She became a member of the Académie de Saint-Luc in 1774 and in 1783 was elected to the Académie. She enjoyed success as a fashionable portraitist and was patronised by Queen Marie-Antoinette. From 1789 to 1805 she travelled in Europe and visited Russia.

Alvise VIVARINI
living 1457; died 1503/5

The artist, who is often called Luigi, was from a family of painters; he was the son of Antonio Vivarini and the nephew (and also probably the pupil) of Bartolomeo. His work was influenced by Antonello da Messina and Giovanni Bellini among others. An altarpiece by Alvise at Montefiorentino is dated 1475. He was employed by the Venetian State from 1488.

Alvise VIVARINI
Portrait of a Man
1497

Antonio VIVARINI and GIOVANNI d'Alemagna
Saints Peter and Jerome
about 1440–6

Antonio VIVARINI and GIOVANNI d'Alemagna
Saints Francis and Mark
about 1440–6

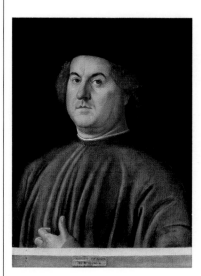

NG 2672
Oil on wood, 62.2 x 47 cm

NG 768
Tempera on poplar, 140.3 x 45.7 cm

NG 1284
Tempera on wood, 135.3 x 45.1 cm

Signed and dated on the cartellino attached to the parapet in the foreground: .ALOVISIV(s). VIVARINVS/ DE MVRIANO.F/.1497. (Alvise Vivarini of Murano made this. 1497.)

The identity of the sitter has not been established.

NG 2672 is the only portrait by the artist which is authenticated by a signature.

With Brison, Milan, May 1857; Bonomi collection, Milan, by 1871; collection of George Salting by 1902; Salting Bequest, 1910.

Davies 1961, pp. 558–9; Pallucchini 1962, no. 262, p. 138; Steer 1982, no. 16, p. 141.

Inscribed on the pedestal: .SAN[C]TVS PETRVS. SA[NC]TVS. GERONIMVS.

The saints are identified both by the inscriptions beneath them and by their attributes. Peter holds the keys to Heaven, and Jerome as one of the Doctors of the Church is dressed in cardinal's robes and holds a model of a church.

NG 768 is from the same altarpiece as NG 1284. These two panels appear originally to have flanked a *Virgin and Child Enthroned* (now Padua, Church of the Filippini, S. Tommaso Cantauriense). The flowers behind the saints and the platform upon which they stand are continued across all three panels. It is not known for which church the altarpiece was originally painted, although a work of the same subject is recorded as once being in the church of S. Moisè, Venice. It is thought to date from the period of collaboration between Antonio Vivarini and Giovanni d'Alemagna (died 1449/50), i.e. the 1440s.

Zambeccari collection, Bologna, by 1857; bought by Sir Charles Eastlake; bought from Lady Eastlake, 1867.

Davies 1961, pp. 559–60; Pallucchini 1962, pp. 19, 103–4, no. 59–61.

Inscribed on the pedestal: SA[NC]T[VS].FRANSISCVS. SANCTVS.MARCVS.

The saints are identified by the inscriptions beneath them and by their attributes. Mark holds a book, while Francis wears the habit of a friar, carries a crucifix and displays the stigmata in his side.

For discussion of the date and the work from which NG 1284 comes see the entry for NG 768.

Bought from J.P. Richter (Clarke Fund), 1889.

Pudelko 1937, pp. 130–3; Pallucchini 1962, pp. 19, 103–4, no. 59–61.

Antonio VIVARINI
probably active 1440; died 1476/84

The artist signed his paintings 'Antonio da Murano'. He collaborated with his brother-in-law Giovanni d'Alemagna in Venice and then in Padua (1447). In 1450 Antonio painted an altarpiece in Bologna with his brother Bartolomeo. The style of his work is dependent on Gentile da Fabriano, Pisanello and the followers of Squarcione.

Bartolomeo VIVARINI
The Virgin and Child with Saints Paul and Jerome
about 1460s

Simon de VLIEGER
A Dutch Man-of-war and Various Vessels in a Breeze, about 1638–45

Simon de VLIEGER
A View of an Estuary, with Dutch Vessels at a Jetty and a Dutch Man-of-War at Anchor
about 1645–50

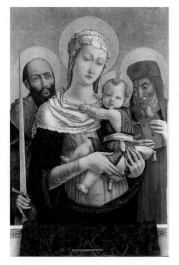

NG 284
Tempera on wood, 95.3 x 63.5 cm

NG 3025
Oil on oak, 41.2 x 54.8 cm

NG 4455
Oil on oak, 88.5 x 122 cm

Signed on the cartellino in the foreground: . OPVS . BARTOLMEI . VIVARINI . DEMVRANO. (The work of Bartolomeo Vivarini of Murano.)

Saint Paul at the left carries his attribute, a sword, while Saint Jerome at the right is dressed in his cardinal's robes and reads a book. Both figures are placed behind rather than beside the Virgin, the composition, which is cramped, was perhaps originally designed without them. The gold background and the haloes are not original.

NG 284 is considered one of the artist's earlier works.

Contarini collection, Venice; collection of Conte Bernardino Cornain degli Algarotti, Venice, by 1816; bought, 1855.

Davies 1961, p. 561; Pallucchini 1962, no. 135, p. 116; Dunkerton 1991, pp. 69–70.

Signed on a spar at the bottom left: VLIEGE(R?).

In the middle distance on the right is a frigate with a Dutch flag at the main; left foreground, a gaff-rigged *wijdschip* (a small Dutch transport vessel).

NG 3025 was probably painted in the late 1630s or early 1640s.

Collection of Baron Huntingfield by 1915; bought, 1915.

MacLaren/Brown 1991, p. 473.

Signed on a floating spar in the right foreground: S DE VLIEGER.

The man-of-war at anchor on the right has the arms of the Province of Holland on her stern and a Dutch flag at the main. The largest ship at the jetty on the left is probably a gaff-rigged *wijdschip* (a small Dutch transport vessel); the smaller vessel nearest the spectator is a *kaag* (a Dutch vessel with a straight raking stem and clinker-built). This view may be of the toll-house at the estuary of the river Maas.

NG 4455 was probably painted in about 1645–50.

Perhaps in the collection of Josué van Belle, Rotterdam, by 1730; Lord Revelstoke Bequest, 1929.

MacLaren/Brown 1991, pp. 473–4.

Bartolomeo VIVARINI
about 1432?–after 1499?

The artist was a member of a family of Venetian painters; his elder brother was Antonio Vivarini. At first Bartolomeo collaborated with Antonio, and then later he worked independently. His altarpieces of 1464 and 1465 in Venice and Naples owe much to the work of Mantegna.

Simon de VLIEGER
about 1601–1653

Simon de Vlieger was born in Rotterdam and subsequently worked in Delft, Amsterdam and Weesp, where he died. He was principally a seascape painter (who influenced the work of van de Cappelle, Hendrick Dubbels and Willem van de Velde the Younger), but he also painted and drew landscapes, and animal and figure subjects. He also made twenty etchings of landscapes and animals.

Willem van der VLIET
Portrait of Suitbertus Purmerent
1631

Jakob Ferdinand VOET
Cardinal Carlo Cerri
1669–79

Attributed to Simon de VOS
The Raising of Lazarus
1625–76

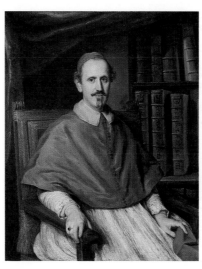

NG 6384
Oil on canvas, 109.2 x 160 cm

NG 1168
Oil on oak, 113.5 x 85.4 cm

NG 174
Oil on canvas, 121.3 x 97.8 cm

Signed and dated, bottom right: Æta:45.aº1631 / w.vander vliet / fecit (AE in monogram). The crucifix on the table is inscribed: INRI.

Suitbertus Hendriksz. Purmerent (1587–1650) was born in The Hague. He was sent to Delft in 1613 and became a Catholic priest at the church in the Begijnhof there two years later. He holds a biretta in his right hand. The identification of the sitter is confirmed by comparison with a portrait of him when older by Hendrik Cornelisz. van der Vliet (Delft, Begijnhof).

NG 1168 may have been painted to mark Purmerent's appointment as archpriest of Delfland in February 1631. In 1631 he was 44 years old, and not 45, as is stated in the inscription.

Collection of William Russell by 1878; bought (Clarke Fund), 1884.

MacLaren/Brown 1991, p. 475.

Inscribed on the books: Decis Rot. Card Cerri/ Decis. Rot. Rom Pena/ Decis. These are the titles of Cardinal Cerri's most important work, the *Decisiones Rotae* (Judgements of the Rota).

Carlo Cerri (1611–90), Dean of the Rota, the supreme ecclesiastical tribunal, was made Cardinal, Bishop of Ferrara and Legate of Urbino on 29 November 1669 by Pope Clement IX.

NG 174 was probably painted soon after 1669, but before 1679, when Clouwet, who made an engraving of the portrait, died.

Presented by Henry Gally Knight, 1839.

Levey 1971, pp. 243–4.

Lazarus, the brother of Mary Magdalene, was dying and Jesus was called to his bedside, but by the time he arrived Lazarus had been dead for four days. Jesus was taken to the grave, gave thanks to God, and 'he that was dead came forth, bound hand and foot with grave clothes.' New Testament (John 11: 1–44).

NG 6384 has in the past been catalogued as simply ascribed to the Flemish School, but has recently been convincingly attributed to de Vos.

Bequeathed by Mrs Marion C. Smith, 1967.

Martin 1970, p. 76; Martin 1985, pp. 204–5.

Willem van der VLIET
1583/84?–1642

Willem Willemsz. van der Vliet was born in Delft where he lived and worked. He had joined the painters' guild by 1615. Few works by the artist are known; they are mainly portraits that date from 1624 to 1640. Vliet's nephew, Hendrik Cornelisz., the painter of church interiors, was his pupil and painted some portraits in his style.

Jakob Ferdinand VOET
1639–1700?

Voet was probably born in Antwerp. He first painted in Paris (up to 1664), and then travelled to Italy. The artist was working in Rome as a portraitist in the late 1660s and was strongly influenced by Carlo Maratta. In 1684 he went via Turin back to Antwerp where he remained for the rest of his life.

Simon de VOS
1603–1676

De Vos was born and worked in Antwerp. In 1615 he entered the workshop of Cornelis de Vos and in 1620 became a master in the Antwerp guild. He painted small-scale biblical, mythological and genre scenes, as well as portraits. He also painted the figures in floral garlands by Daniel Seghers. Among his pupils was Jan van Kessel the Elder.

Studio of Simon VOUET
Ceres and Harvesting Cupids
about 1634

NG 6292
Oil on canvas, 147.6 x 188.7 cm

Roelof van VRIES
A View of a Village
about 1660–5

NG 134
Oil on oak, 64.8 x 49 cm

Cornelis VROOM
A Landscape with a River by a Wood
1626

NG 3475
Oil on oak, 31.2 x 44.2 cm

Ceres was a mythological goddess associated with summer and the fertility of the earth. Here, as a personification of Summer (see Ovid's *Metamorphoses*, II, 28), she is linked with the tradition of representing the seasons by appropriate everyday actions, in this case harvesting corn.

NG 6292 is probably one of three pictures painted in 1634 to decorate a small cabinet in the Hôtel de Bullion, Paris, the house of Claude de Bullion (1570–1640), Surintendant des Finances. There was apparently no specification for the pictures, but there are later references to a depiction of 'Diana and Actaeon' to signify the Hunt, a 'Silenus and Satyrs' to signify the Wine Harvest, and 'Ceres with Cupids' for the Corn Harvest. The first two are lost; the third is likely to be the picture catalogued here. It is likely that all three were executed by a member of Vouet's studio.

Probably Claude de Bullion, Paris, 1634; bought with a contribution from Mr Edgar Ivens, 1958.

Wine 1992, pp. 216–19, no. 25.

NG 134 was previously attributed to Frans or Cornelis Decker, but is in fact a characteristic work by van Vries. It can be compared with landscapes signed by him (e.g. Munich, Alte Pinakothek; Stockholm, Nationalmuseum).

Little is known about the chronology of van Vries's work but this landscape may date from the early 1660s.

Bequeathed by Lt-Col. J.H. Ollney, 1837.

MacLaren/Brown 1991, p. 476.

Signed and dated in the centre: CVROOM / 1626 (CVR in monogram).

The composition is indebted to works by Elsheimer such as *The Small Tobias* (Frankfurt, Historisches Museum) and *The Flight into Egypt* (Munich, Alte Pinakothek), which were available to Vroom in the form of the prints by Hendrick Goudt.

Despite its small size, NG 3475 is a complex and innovatory composition which looks forward to the early work of Jacob van Ruisdael.

Presented by Sir Robert Witt through the NACF, 1919.

MacLaren/Brown 1991, p. 477.

Simon VOUET
1590–1649

Vouet was born in Paris, and travelled to England, Istanbul (1611), and Venice (1612), before settling in Rome from 1614 to 1627. While there he visited other Italian cities and adopted a Caravaggesque style. From 1627 he painted in Paris for the crown and religious institutions, developing a lighter form of classicism. His pupils included Le Sueur and Mignard.

Roelof van VRIES
1630/1–after 1681

Van Vries was born in Haarlem and worked in Leiden and Amsterdam as well as in his native city. He entered the Leiden guild in 1653 and the Haarlem guild in 1657. He was a landscape painter, whose style was based on that of Jacob van Ruisdael. His pictures are often confused with those of two other followers of Ruisdael, Salomon Rombouts and Cornelis Decker.

Cornelis VROOM
1591/2–1661

Cornelis Hendricksz. Vroom. was the son of the marine painter Hendrick Cornelisz. Vroom. His early paintings are marines in the style of his father, but he then turned to landscape: his conception of landscape is original and foreshadows the achievement of Jacob van Ruisdael. Vroom worked in Haarlem, but may have been in London in 1627. Among his patrons were Charles I and the Prince of Orange.

Edouard VUILLARD
Lunch at Vasouy
1901, reworked 1935

Edouard VUILLARD
Lunch at Vasouy
1901, reworked 1935

Edouard VUILLARD
The Mantelpiece (La Cheminée)
1905

NG 3271
Oil on cardboard, 51.4 x 77.5 cm

NG 6388
Distemper on canvas, 218.4 x 190 cm

NG 6373
Distemper on canvas, 218.4 x 190 cm

Signed: E. Vuillard
 NG 6373 and 6388 originally formed a single painting, commissioned by the Swiss-born writer Jean Schopfer (known as Claude Anet). The painting was apparently executed in 1901 when Vuillard spent the summer with his friends Jos and Lucie Hessel at Vasouy near Honfleur. Vuillard had earlier completed two large decorative pictures for Schopfer showing figures in the garden of Misia and Thadée Natanson at Villeneuve-sur-Yonne (1898, private collection).
 After Schopfer's death, his widow (from his second marriage) asked Vuillard to divide the Vasouy painting into two pictures. The artist extensively reworked the two separate halves of the composition at this stage (1935).

Collection of Claude Anet by about 1902; bought, 1970.

Davies 1970, pp. 142–4; Wilson Bareau 1986a, pp. 37–46; Thomson 1988a, pp. 49, 115; Groom 1993, pp. 108ff.

Signed: E. Vuillard
 Various members of the artistic and literary world of Paris have been identified in NG 6373, including (left to right) Pierre Bonnard, Madame and Monsieur Claude Anet, the novelist Romain Coolus, Misia Natanson, Lucie Hessel, Madame and Monsieur Louis Schopfer and the writer Tristan Bernard.
 For further discussion see entry for NG 6388.

Collection of Claude Anet by about 1902; bought, 1966.

Davies 1970, pp. 142–4; Wilson Bareau 1986a, pp. 37–46; Thomson 1988a, pp. 49, 115; Groom 1993, pp. 108ff.

Signed and dated: E. Vuillard, 1905
 The objects on the mantelpiece are painted as a still life.
 NG 3271 was painted during Vuillard's stay at the summer house rented by his friends Jos and Lucie Hessel at Amfréville in Normandy in 1905.
 On the reverse there is a rapid sketch of a woman with two dogs and two children on a bench.

Collection of (Sir) Hugh Lane by 1908; Sir Hugh Lane Bequest, 1917.

Davies 1970, p. 142; Dumas 1990, p. 222; Thomson 1991–2, p. 67.

Edouard VUILLARD
1868–1940

Vuillard was born at Cuiseaux, and studied in Paris at the Académie Julian (with Robert-Fleury and Bouguereau). He was later a founder of the group called the Nabis, through which he also associated with Bonnard. He worked in Paris for most of his life, with frequent visits to Italy, and major European cities.

Edouard VUILLARD
Madame André Wormser and her Children
1926/7

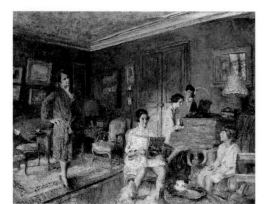

NG 6488
Oil on canvas, 89 x 116.5 cm

Signed bottom right: E. Vuillard

Madame Wormser, née Olga Boris (1884–1972), was the wife of the banker André Wormser. The children, from left to right, are Diane (born 1916), Dominique (born 1910), Olivier (born 1913) and Sabine (born 1920). The room is the drawing room of the Wormsers' Paris house at 27 rue Scheffer. On the walls are pictures by Manet, Monet, Renoir, Degas and Roussel.

NG 6488 was painted in 1926/7 for the Wormser family.

Presented by an Officer of General de Gaulle's Free French Navy in grateful remembrance of the years 1940–5, 1983.

National Gallery Report 1982–4, p. 29; Dumas 1990, p. 225.

Jacob van WALSCAPPELLE
Flowers in a Glass Vase
about 1670

NG 1002
Oil on canvas, stuck on oak, 59.8 x 47.5 cm

Signed bottom right: Jacob: Walscappe (the rest of the signature has been cut off).

The arrangement includes tulips, strawberries, carnations and lilies. Numerous insects are also depicted. A window is reflected in the glass of the vase.

NG 1002 has been cut down at the right, and probably also on the other side.

Wynn Ellis Bequest, 1876.

MacLaren/Brown 1991, p. 478.

Jean-Antoine WATTEAU
The Scale of Love
1715–18

NG 2897
Oil on canvas, 50.8 x 59.7 cm

The French title *La Gamme d'Amour* is from Le Bas's engraving of the painting of 1726–9, which was published by Watteau's friend and patron Jean de Jullienne in 1735. As the title suggests, the harmony of music was probably intended as a metaphor for the union of lovers.

A number of drawings by Watteau can be related to the composition, including one for the guitarist which is in the British Museum, London.

According to the Le Bas engraving, NG 2897 was in the collection of Denys Mariette (died 1741); bequeathed by Sir Julius Wernher Bt, 1912.

Davies 1957, pp. 222–3; Wilson 1985, p. 78.

Jacob van WALSCAPPELLE
1644–1727

The artist was born Jacobus Cruydenier, but adopted the name of his great-grandfather. He came from Dordrecht and travelled to Amsterdam where his brother-in-law Ottmar Ellinger the Elder was a flower painter. He was a pupil of another flower painter, Cornelis Kick, in Amsterdam. Walscappelle specialised in this genre. Later he held various municipal posts in Amsterdam.

Jean-Antoine WATTEAU
1684–1721

Watteau was born in Valenciennes. He went to Paris around 1702 and a year later joined the studio of Gillot, and that of Claude Audran III. He became a member of the Académie in 1717. Save for a visit to London in 1719–20, he remained in Paris or its environs. Watteau invented the genre of the *fête galante*.

After WATTEAU
Perfect Harmony
18th century

NG 2962
Oil on canvas, 27.3 x 22.9 cm

While a musician plays music held by a companion, lovers stroll in the park behind.

NG 2962 is thought to be after an original, stated to have been on panel, that was engraved by B. Baron in 1730. It is now presumed to be the picture in the Iveagh Bequest, London (Kenwood House). Several other copies and versions of the composition exist, some of which have been attributed to Pater.

The collection of Sir Richard and Lady Wallace, Paris (died 1890 and 1897 respectively); bequeathed by Sir John Murray Scott, 1914.

Davies 1957, p. 223.

Jan WEENIX
An Italian Courtyard
probably 1660–5

NG 6462
Oil on canvas, 84.5 x 68.5 cm

Signed and dated lower right: J.Weenix 16(6?) (the rest of this area is damaged).

Two lovers are seated on steps before a tavern. The woman dips a biscuit into the wineglass held by her partner. The couple are attended by a black servant. Behind this group drinkers are seated before the tavern; a woman shows them a tablet. Beyond is the portico of a *palazzo*, with a terrace before it, upon which is a statue inspired by Michelangelo's *Slave* (Paris, Louvre). Musicians play on the steps before the palace, while a man and a dog dance on the terrace.

NG 6462 was painted in the early 1660s when Jan Weenix was collaborating closely with his father Jan Baptist Weenix who devised this type of Italianate genre scene.

Bought by private treaty from Mrs Gifford-Scott, 1980, who bequeathed the equivalent sum to the National Gallery, 1983.

MacLaren/Brown 1991, p. 479.

Jan WEENIX
A Deerhound with Dead Game and Implements of the Chase, 1708

NG 238
Oil on canvas, 173.5 x 157 cm

Signed and dated bottom left: J Weenix f 1708.

On the ground lie a stag and a heron. Two hares, a gun and a horn are hung from the tree at the left. At the right a boy blows a hunting horn, and in the landscape beyond him a stag hunt is in progress.

This painting may have been commissioned by the Elector Palatine for his hunting lodge at Schloss Bensberg. Weenix was his court painter in 1708.

Marquess of Lansdowne sale, London, March 1806; bequeathed by Lord Colborne, 1854.

MacLaren/Brown 1991, p. 478.

Jan WEENIX
1642–1719

Jan Weenix was the son and pupil of Jan Baptist Weenix. He was born in Amsterdam. He is recorded as a member of the Utrecht painters' guild from 1664 until 1668. Later he lived in Amsterdam. He was court painter to the Elector Palatine Johann Wilhelm in Düsseldorf from about 1702 until 1714 (or later). He painted portraits, Italianate genre scenes and still lifes, particularly of dead game.

Jan Baptist WEENIX

A Huntsman cutting up a Dead Deer, with Two Deerhounds, 1647–60

NG 1096
Oil on canvas, 196 x 265 cm

Jacob WEIER

Cavalry attacked by Infantry
1645

NG 1470
Oil on oak, 38.4 x 60.2 cm

Adriaen van der WERFF

A Boy with a Mousetrap
about 1678–9

NG 3049
Oil on oak, 19.2 x 13.3 cm

Signed bottom right: Gio Ba(tt?) Ween(.) (that the final letters are not legible does not mean that the painting has been cut down at the right).

The huntsman is disembowelling the deer in the foreground at the right; his gun lies on the ground beside him. In the background, left of centre, a stag hunt is taking place.

After his return from Italy, Weenix invariably signed his name in its Italian form.

Presented by Henry Reene to the British Museum, 1756; transferred, 1880.

MacLaren/Brown 1991, p. 480.

Signed and dated: I WEIER / 1645
This battle scene is typical of Weier's paintings in the manner of Wouwermans.

NG 1470 is one of the two paintings by Weier that are dated 1645; they provide the earliest evidence of his activity as a painter.

Presented by Sir Augustus Wollaston Franks, 1896.

Levey 1959, p. 109.

Signed bottom: A.Vander. Werff.fe.
In the eighteenth century the painting had a pendant, *A Boy putting a Bird in a Cage* (present location unknown). It has been argued that the two pictures form an iconographically related pair, the subject of which is moderation in love. In classical literature the mouse and mousetrap are employed as symbols of punished intemperance and this imagery is also found in the work of the seventeenth-century Dutch poets Vondel, Cats and Heinsius. In this interpretation the birdcage in the pendant would refer to the idea of love's pleasurable captivity.

NG 3049 belongs to the earliest group of genre pictures painted by van der Werff, in about 1678–9.

With pendant, Duc de Choiseul sale, Paris, 1772; Prince de Conti sale, Paris, 1777; bequeathed by Henry L. Florence, 1916.

MacLaren/Brown 1991, p. 482–3.

Jan Baptist WEENIX
1621–before 1663

Weenix was born in Amsterdam. He was taught by Jan Micker in Amsterdam, Abraham Bloemaert in Utrecht and finally by Nicolaes Moeyaert in Amsterdam. He was in Italy, mostly in Rome, from 1642 or 1643 to 1647, returning to Amsterdam before settling in the Utrecht area. He painted fanciful Italian landscapes and seaports, and still lifes with dead game. His son, Jan Weenix, was a close follower.

Jacob WEIER
active 1645; died 1670

Jacob Weier was probably trained in Holland. He painted imitations of Dutch work, mainly camp or battle scenes, but some genre paintings. His first dated works are of 1645; in 1648 he was appointed official painter in Hamburg (where he died in 1670).

Adriaen van der WERFF
1659–1722

Van der Werff was born in Kralingen, near Rotterdam, and taught there by Cornelis Picolet and Eglon Hendrik van der Neer. He worked in Rotterdam and was among the successful Dutch painters of the seventeenth and eighteenth centuries: his patrons included the Elector Palatine, the King of Poland and the Duke of Brunswick. The artist painted highly finished religious, literary and genre subjects on a small scale, and a few portraits.

Adriaen van der WERFF
Portrait of a Man in a Quilted Gown
1685

NG 1660
Oil on canvas, 47.3 x 38.3 cm

Signed bottom left: Adriaen vander Werff. fec./ an⁰ 1685

The unidentified sitter is seated in a garden at night. The statue in the background at the right is based upon the so-called 'Farnese Flora' (Naples, Museo Nazionale), but the pose is reversed. The artist presumably knew the statue in the form of an engraving.

Presented by Sir Edward Malet, 1898.

MacLaren/Brown 1991, p. 482.

Adriaen van der WERFF
The Rest on the Flight into Egypt
1706

NG 3909
Oil on oak, 54.5 x 43 cm

Signed and dated, bottom right: Chev[alie]ʳ vʳ werff. /Anº 1706

Joseph was warned in a dream that King Herod was searching for the Christ Child and so took Mary and the infant to Egypt for safety. Their rest during the journey is a frequently depicted incident which is not actually described in the Bible. Joseph sleeps in the background to the left of the Virgin and Child.

NG 3909 can probably be identified with a painting of this subject listed under the year 1706 in a manuscript of autobiographical notes written by the artist (Rotterdam, Historisch Museum). It appears to have been commissioned by van de Werff's patron, the Elector Palatine Johann Wilhelm, who had created him a knight (*chevalier*) in 1703.

On the back of the panel are two seals, one with van der Werff's coat of arms and the other with his personal device.

A gift from the Elector Palatine to Cardinal Pietro Ottoboni, apparently in 1707; Dr Robert Bragge sale, London, 1724; Duke of Westminster sale, 1924; bought, 1924.

MacLaren/Brown 1991, pp. 483–5.

Jacob de WET the Elder
A Landscape with a River at the Foot of a Hill
probably about 1646

NG 1342
Oil on oak, 53 x 72.5 cm

Signed bottom right: J.d. Wet

NG 1342 is de Wet's only known landscape without biblical figures. The right half of the composition was repeated – with variations – in the right background of de Wet's *Abraham giving the Shewbread to Melchizedek* (Dublin, National Gallery).

NG 1342 is similar to the signed and dated *Eliezer and Rebecca* of 1646 (St Petersburg, Hermitage) and was probably painted at about the same time.

Collection of Edward Habich, Cassel; bought, 1891.

MacLaren/Brown 1991, p. 486.

Jacob de WET the Elder
active 1632; died after 1675

Jacob de Wet was born in Haarlem, where he worked for most of his life and where he was *hoofdman* (senior official) of the guild in 1645 and 1660, and dean in 1661. He painted religious and mythological subjects, often in a landscape setting, and their style suggests that he may have been a pupil of Rembrandt in the 1630s.

Rogier van der WEYDEN
The Magdalen Reading
probably about 1435

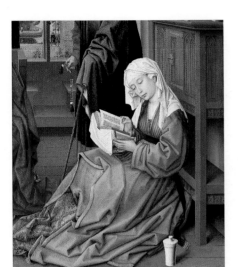

NG 654
Oil on mahogany, transferred from another panel,
painted surface 61.6 x 54.6 cm

Mary Magdalene is identified by the jar of ointment
with which she anointed Christ. The headless figure
behind her is probably Saint Joseph. The figure
kneeling on the left can be identified as Saint John
the Evangelist.

NG 654 is a fragment from the right-hand side of
a large altarpiece. The whole altarpiece probably
showed the Virgin and Child flanked on either side
by three saints. Two other fragments survive, the
head of Saint Joseph(?) and that of a female saint,
perhaps Saint Catherine (Lisbon, Gulbenkian
Foundation). A drawing attributed to the Master of
the Coburg Roundels (Stockholm,
Nationalmuseum) appears to record this altarpiece.
NG 654 may well be an early work, from about
1435. Mary Magdalene, and the domestic interior in
which she is seated, are comparable to similar
figures and settings in works attributed to van der
Weyden's master, Robert Campin (e.g. *Saint Barbara*,
Madrid, Prado).

*Collection of Maria Hoofman (died 1845), Haarlem;
Edmond Beaucousin collection, Paris; bought with the
Beaucousin collection, 1860.*

Davies 1954, pp. 173–9; Davies 1968, pp. 169–70;
Davies 1972, pp. 218–19; Dunkerton 1991, pp. 270–3.

Rogier van der WEYDEN and Workshop
The Exhumation of Saint Hubert
about 1440

NG 783
Oil on oak, 87.9 x 80.6 cm

Saint Hubert was buried in 727 in the church which
he had founded, St Pierre, Liège (here represented
as a Gothic church with a statue of Saint Peter on
the tabernacle above the altar). NG 783 appears to
show the second occasion (in 825) when the saint's
body was exhumed and found to be perfectly
preserved. On the left (in blue with a crown) is
Louis the Pious, Emperor and King of France; on
the right is Walcaudus, Bishop of Liège (810–836).

NG 783 was probably made for the chapel
dedicated to Saint Hubert founded in or about 1437
in the church of St Gudula, Brussels (Saint Gudula
is shown on the extreme right of the painted
altarpiece in the centre of NG 783). It was seen in
this chapel by Dubuisson-Aubenay in about 1623.
At that time NG 783 formed a diptych with *The
Dream of Pope Sergius* (now Malibu, J. Paul Getty
Museum). Van der Weyden himself may have been
responsible for some of the heads.

*St Gudule, Brussels, 1623; Earl of Bessborough collection
by 1792; bought from the Eastlake collection, 1868.*

Davies 1954, pp. 179–93; Davies 1968, pp. 173–6;
Davies 1972, pp. 219–21.

Workshop of van der WEYDEN
Lamentation over the Dead Christ
probably 1440–50

NG 6265
Oil on oak, painted surface 35.6 x 45.1 cm

The Virgin holds the dead body of Christ after his
Crucifixion, a traditional episode not explicitly
related in the New Testament. On the left is Saint
Jerome, the great doctor of the Early Christian
Church and the chief inspiration for Christian
penitents and hermits, and an unidentified donor.
The saint on the right is probably Saint Dominic, the
founder of the Dominican Order of Preachers.

The painting is one of several workshop pictures
(e.g. Brussels, Musées Royaux des Beaux-Arts)
which depend on the central panel of Rogier van
der Weyden's *Miraflores Altarpiece* (Berlin, Staatliche
Museen). The composition has been adapted to
include two different saints and a donor. The donor
presumably commissioned NG 6265 as a small
devotional picture with saints to reflect his own
names or religious affiliations.

*Collection of the Earl of Powis by 1895; acquired from the
Earl of Powis by application of the 1956 Finance Act, 1956.*

Davies 1968, pp. 171–2; Davies 1972, p. 221;
Dunkerton 1991, p. 72.

Rogier van der WEYDEN
about 1399–1464

**Rogier was born in Tournai and was probably the
Rogelet de le Pasture who was apprenticed to
Robert Campin in 1427 and who became a master
in Tournai in 1432. By 1435 he was in Brussels,
where he worked for the town and for the
Burgundian court. His portraits, altarpieces and
religious works were influential throughout
Europe long after his death.**

Workshop of van der WEYDEN
Saint Ivo (?)
about 1450

NG 6394
Oil on oak, 45.1 x 34.8 cm

This painting formerly bore a (later) inscription identifying the subject as Saint Ivo (1253–1303), the patron saint of lawyers and advocate of the poor (S. IVO ADVOCATVS PAVPERVM). The saint was most popular in his native Brittany. The paper held by the sitter resembles a legal document, which would be appropriate for Saint Ivo.

Collection of Sir Richard Sullivan (died 1806); bought from the collection of Lady Baird, 1971.

Davies 1972, p. 222.

Workshop of van der WEYDEN
Portrait of a Lady
about 1460

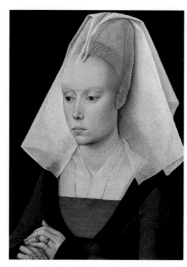

NG 1433
Oil on oak, painted surface 36.2 x 27.6 cm

The sitter has not been identified. The style of her dress, her headband and her veil suggest a date of about 1460. Her forehead has been plucked to give her a high hairline, fashionable at that period.

On the reverse is a painting of the head of Christ crowned with thorns (a popular devotional image). NG 1433 is not of such a high quality as other portraits almost certainly by van der Weyden (e.g. *Portrait of a Lady*, Washington, National Gallery of Art), and it was probably produced in his workshop.

Madame Blanc collection, Paris, by 1876; bequeathed by Mrs Lyne Stephens, 1895.

Davies 1954, pp. 196–9; Davies 1968, pp. 170–1; Davies 1972, pp. 221–2; Dunkerton 1991, p. 290.

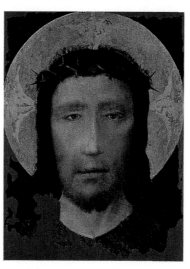

NG 1433, reverse

Follower of van der WEYDEN
Christ appearing to the Virgin
probably about 1450–75

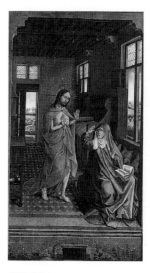

NG 1086
Oil on canvas, transferred from wood,
124.4 x 71.1 cm

Christ appears to the Virgin Mary after the Resurrection and displays his wounds. An angel seated on Christ's empty tomb and two sleeping soldiers can be seen through the window in the left background; through the window on the right the three Holy Women who found the tomb empty on the morning after the Resurrection (New Testament, Mark 16: 1–5) are shown making their way towards it. Christ's appearance to his mother is not described in the Bible, but is found in later writings (e.g. *The Golden Legend*).

The composition is adapted from the right wing of van der Weyden's *Miraflores Altarpiece* (Berlin, Staatliche Museen). NG 1086 may also have been the wing of a triptych (the other elements of which have not been identified) and was probably painted between 1450 and 1475 by a follower of van der Weyden.

Collection of Karl Aders by 1835; bequeathed by Mrs Joseph H. Green, 1880.

Davies 1954, pp. 193–6; Davies 1968, p. 176; Davies 1972, p. 215.

Jan WIJNANTS
A Landscape with a Dead Tree, and a Peasant driving Oxen and Sheep along a Road, 1659

Jan WIJNANTS
A Landscape with a High Dune and Peasants on a Road, probably about 1665

Jan WIJNANTS
A Track by a Dune, with Peasants and a Horseman 1665

NG 883
Oil on canvas, 80 x 99.4 cm

NG 971
Oil on canvas, 40.9 x 53.7 cm

NG 2533
Oil on oak, 29.7 x 36.8 cm

Signed and dated on the end of the felled tree left foreground: J. Wynants/1659.

The landscape is unlikely to depict a specific location.

The figures and animals are apparently by Jan Lingelbach.

Trouard collection, Paris, by 1779; collection of (Sir) Robert Peel (Bt), 1821; bought with the Peel collection, 1871.

MacLaren/Brown 1991, p. 504.

Signed by the side of the track below right: J.W.

The landscape is probably based on the dunes around Haarlem, but is unlikely to represent a specific location.

The figures and animals are in the style of Jan Lingelbach, and the picture probably dates from the 1660s when Wijnants and Lingelbach were both living in Amsterdam.

Fossard collection, Paris, by 1834; collection of Wynn Ellis by 1850/1; Wynn Ellis Bequest, 1876.

MacLaren/Brown 1991, p. 505.

Signed and dated bottom right: J Wijnants / 1665.

NG 2533 may be based on studies of the dunes around Haarlem, but is unlikely to depict a specific location.

The figures in the foreground are in the style of Jan Lingelbach.

Collection of William Wells, Redleaf, by 1835; Salting Bequest, 1910.

MacLaren/Brown 1991, p. 506.

Jan WIJNANTS
active 1643; died 1684

Jan Wijnants was born and worked in Haarlem, painting landscapes, usually scenes in the dunes around Haarlem. In 1660 he moved to Amsterdam, where he died. The figures in his landscapes were frequently by other artists, including Adriaen van de Velde (who is said to have been a pupil of Wijnants), Dirk Wijntrack and Jan Lingelbach.

Jan WIJNANTS
*Peasants driving Cattle and Sheep by a Sandhill,
and Two Sportsmen with Dogs,* probably 1665–70

Jan WIJNANTS
*A Landscape with Two Dead Trees, and Two
Sportsmen with Dogs on a Sandy Road*
probably 1665–75

Jan WIJNANTS
*A Landscape with a Woman driving Sheep through
a Ruined Archway,* 1667

NG 884
Oil on oak, 28.6 x 38.1 cm

NG 972
Oil on oak, 29 x 36.8 cm

NG 2532
Oil on canvas, 35.8 x 43.5 cm

Signed, possibly falsely, bottom left: J W
 The dunes probably recall the dunes around
Haarlem, but NG 884 is unlikely to depict a specific
location.
 The figures are in the style of Adriaen van de
Velde, but are not certainly by him. NG 884 was
probably painted at the end of the 1660s.

*Bought by Peeters at an anon. sale, Antwerp, 1784;
collection of Sir Robert Peel, Bt, by 1835; bought with the
Peel collection, 1871.*

MacLaren/Brown 1991, pp. 504–5.

Signed, probably falsely, bottom right: J Wijnants
 NG 972 is unlikely to depict a specific location.
 The figures are in the style of Adriaen van de
Velde. NG 972 was probably painted in the later
1660s or early 1670s.

*Perhaps in an Amsterdam sale, 1800; Wynn Ellis
collection, probably by 1858; Wynn Ellis Bequest, 1876.*

MacLaren/Brown 1991, p. 505.

Signed and dated bottom left: J Wijnants 1667.
 NG 2532 is unlikely to depict a specific location.
 The figures are probably by Adriaen van de
Velde.

*Van Saceghem collection, Ghent, by 1835; collection of
George Salting, 1894; Salting Bequest, 1910.*

MacLaren/Brown 1991, pp. 505–6.

Richard WILSON
The Valley of the Dee, with Chester in the Distance
probably 1761

Richard WILSON
A View of Holt Bridge, on the River Dee
before 1762

The WILTON DIPTYCH
Richard II presented to the Virgin and Child by his Patron Saint John the Baptist and Saints Edward and Edmund, about 1395–9

NG 6197
Oil on canvas, 148 x 193.5 cm

NG 6196
Oil on canvas, 148.5 x 193 cm

NG 4451
Egg (identified) on oak, each wing 53 x 37 cm

This view is probably taken from further down stream than NG 6196, looking towards Chester, whose distant towers can be seen.

NG 6197 may have been exhibited at the Society of Artists in 1761.

Bought from Agnew (Colnaghi Fund), 1953.

Davies 1959, pp. 108–9.

Holt Bridge links Holt in Denbighshire with Farndon in Cheshire. At the right can be seen the tower of St Chad's church in Farndon, and at the extreme left the outskirts of Holt. Like NG 6197, this is a landscape in the spirit of Claude rather than a topographically accurate view.

NG 6196 was probably exhibited at the Society of Artists in 1762.

Bought from Agnew (Colnaghi Fund), 1953.

Davies 1959, pp. 108–9.

Richard II, King of England from 1377 to 1399, is presented (left) by Saint John the Baptist, with a lamb, and two saintly ancestors – Saint Edward the Confessor (died 1066), holding the ring which he gave to a pilgrim who turned out to be Saint John the Evangelist, and Saint Edmund, the last king of the Angles who was killed by a Viking arrow in 869 – to the Virgin and Child and angels (right). One angel holds a red and white banner which could be either that of Saint George, patron of England, or the banner of Christ's victory over death at the Resurrection. On the reverse is a shield with the arms of France and England, impaled with those of Edward the Confessor, surmounted by a helm, a cap of maintenance and a crowned lion (left); and a White Hart Lodged (right) with a crown collar. The white hart was Richard's personal device, and the broom-cod (collars of which are worn by Richard and the angels) was the device of Charles VI, King of France, although probably also taken over by Richard.

NG 4451, reverse

Richard WILSON
1713/14–1782

Wilson was born in Wales, but moved to London in 1729 and practised as a portraitist. He was in Italy from 1750 to 1756/7 and there started painting landscapes, notably depicting scenes around Rome, which were influenced by the works of Vernet and Claude. Wilson continued to produce such pictures after his return, and was one of the founders of the Royal Academy in 1768.

The WILTON DIPTYCH
Richard II presented to the Virgin and Child by his Patron Saint John the Baptist and Saints Edward and Edmund, about 1395–9

Emanuel de WITTE
The Interior of the Oude Kerk, Amsterdam, during a Sermon, about 1660

Emanuel de WITTE
The Interior of the Oude Kerk, Amsterdam, during a Sermon, about 1660

NG 4451, detail of the orb

NG 1053
Oil on canvas, 51.1 x 56.2 cm

NG 6402
Oil on canvas, 79.1 x 63.1 cm

Painted in the orb at the top of the banner is a green island with a white castle with two turrets. The island is surrounded by blue sky at the top and a silver sea in which there is a boat with masts and a white sail. The orb is probably a symbol of England.

It is not known who painted the diptych; artists from England, France, Italy and Bohemia have been suggested. NG 4451 must have been commissioned by Richard II himself, probably after 1395.

Collection of Charles I by 1639; collection of the Earl of Pembroke, Wilton House (hence 'The Wilton Diptych') by 1718; bought from the Earl of Pembroke with a special grant and contributions from Samuel Courtauld, Viscount Rothermere, C.T. Stoop and the NACF, 1929.

Davies 1957, pp. 92–101; Harvey 1961, pp. 1–24; Dunkerton 1991, pp. 236–8, 399.

This is a largely accurate view of the nave and north aisle of the Oude Kerk (St Nicholas), Amsterdam, taken from near the south entrance. The coat of arms of the city of Amsterdam is in the centre window. A sermon is being delivered from the pulpit. De Witte has made a number of small changes for artistic effect.

NG 1053 shows the organ after the renovation of 1658/9 and was painted in about 1660. The interior of the church is seen from a different angle in NG 6402.

Said to have been in the collection of Edward Solly by 1837; in the William Beckford sale, Bath, 1845; bequeathed by Miss Sarah Solly, 1879.

MacLaren/Brown 1991, pp. 488–9.

Signed lower right: E de Witte.

This is a reasonably accurate view of the nave and south aisle of the Oude Kerk (St Nicholas), Amsterdam, taken from the north aisle. The four evangelists, with their emblems, are in the centre window. A sermon is being delivered from the pulpit.

NG 6402 shows the small organ after the renovation of 1658/9, but here it is in the south aisle rather than the north aisle where it was actually placed. The church is seen from almost exactly opposite the point in the church from which NG 1053 was taken, and – like that picture – NG 6402 has been dated about 1660.

Collection of James Whatman by 1887; presented by the Misses Rachel F. and Jean I. Alexander; entered the Collection in 1972.

MacLaren/Brown 1991, p. 492.

Emanuel de WITTE
1615/17–1691/2

De Witte was born in Alkmaar, where he was active by 1636. He was in Rotterdam by 1639, and in Delft by 1641. By 1652 he had moved to Amsterdam, where he died. He was chiefly a painter of church interiors, but had begun his career as a figure painter and also painted a few portraits, domestic interiors, harbour and market scenes.

Emanuel de WITTE
Adriana van Heusden and her Daughter at the New Fishmarket in Amsterdam, about 1662

Franchoys WOUTERS
Nymphs surprised by Satyrs
about 1650–60

Jan WOUWERMANS
A Landscape with a Farm on the Bank of a River
1650–66

NG 3682
Oil on canvas, 57.1 x 64.1 cm

NG 1871
Oil on oak, 43.3 x 58.1 cm

NG 1345
Oil on oak, 40 x 55.7 cm

The New Fishmarket in Amsterdam was opened in early 1661, and although no identifiable building is visible, the site and the identity of the woman on the left – who is clearly a portrait and is probably Adriana van Heusden – seem to be confirmed by the circumstances in which NG 3682 was painted (see below).

NG 3682 was probably painted when de Witte was living in the home of Joris de Wijs and his wife Adriana van Heusden. A small picture of Adriana with her little daughter in the New Fishmarket near the Haarlem Lock in Amsterdam was the subject of litigation between de Witte and Adriana van Heusden in 1669–71. This picture is the only de Witte fishmarket scene which includes a portrait of a little girl. A replica (formerly E. Hockliffe collection, London) is inscribed 'E. De. Witte (A?) 1662'. The probable date is supported by the style and costume of the painting.

Probably painted for Joris de Wijs, Amsterdam, about 1662; apparently in the Thomas Henry collection, Paris, by 1836; Watson Taylor collection, Erlestoke Park, by about 1863; bought, 1922.

MacLaren/Brown 1991, pp. 489–92.

Signed with initials: WF (probably for 'Wouters fecit').

The reverse of this panel bears the stamp of the coat of arms of Antwerp.

This picture, probably inspired by a composition by Rubens and Jan Brueghel, seems to have been painted in the 1650s.

Presented by M. Forster, 1845.

Martin 1970, pp. 287–8.

Signed bottom centre: Jwouwerman (Jw linked).

Two horsemen have stopped to talk. Behind them are farm buildings. A boat navigates the river on the left.

Jan Wouwermans's landscapes were based on the dune scenery near Haarlem.

Count Potocki sale, Paris, 1884; collection of Edward Habich, Cassel; from whom bought, 1891.

MacLaren/Brown 1991, p. 493.

Franchoys WOUTERS
1612–1659/60

Wouters, who was a landscape and figure painter, was born in Lierre. He trained in Antwerp, where in 1634 he entered Rubens's studio. The artist was appointed painter to the Emperor Ferdinand II. He travelled to England in 1636 in the retinue of the emperor's ambassador, and had returned to Antwerp by 1641. He became dean of the Antwerp Guild of St Luke in 1649/50.

Jan WOUWERMANS
1629–1666

Jan Pauwelsz. Wouwermans was the younger brother of Philips Wouwermans. Born in Haarlem, he entered the painters' guild there in 1665 and remained in the town for the rest of his life. He was a landscape painter, who was influenced by Jan Wijnants, Philips Wouwermans and Jacob van Ruisdael.

Philips WOUWERMANS
A Horse being Shod outside a Village Smithy
probably 1640–50

Philips WOUWERMANS
Cavalry making a Sortie from a Fort on a Hill
1646

Philips WOUWERMANS
A White Horse, and an Old Man binding Faggots
1650s

NG 2554
Oil on oak, 46.1 x 62.2 cm

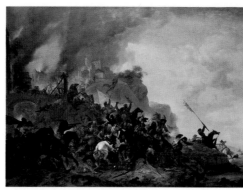

NG 6263
Oil on canvas, 139 x 190.5 cm

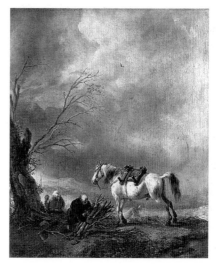

NG 881
Oil on oak, 31.8 x 26.3 cm

Signed bottom right: PHILS. W (PHILS in monogram).
 In the right foreground is a grinding stone.

Possibly in the collection of Dutch paintings bought from Johann Christian Berens by Herzog Peter von Kurland before 1778; Salting Bequest, 1910.

MacLaren/Brown 1991, p. 499.

Signed and dated bottom left: PHIL Wouwermans/ Ao 1646 (PHIL in monogram).
 While a battle rages in the foreground, buildings burn at the upper left. A Gothic church can be seen among them, but the site has not been identified, and the action appears to be imaginary; the colours carried by those fighting do not provide a clue to their identity.
 NG 6263 is one of the largest battle paintings by Wouwermans, and one of his few dated works.

Collection of the Dukes of Marlborough, Blenheim Palace, by about 1783; bought from W.R. Drown, 1956.

MacLaren/Brown 1991, pp. 499–500.

Signed bottom left: W (it is possible that there are the remains of a PHILS monogram in front of the W).
 The faggots (bundles of twigs and sticks) would be used as firewood.
 On grounds of style NG 881 is considered to date from the 1650s.

Randon de Boisset sale, Paris, 1777; bought with the Peel collection, 1871.

MacLaren/Brown 1991, pp. 496–7.

Philips WOUWERMANS
1619–1668

Philips Wouwermans was born in Haarlem. He may have been taught by his father and Frans Hals. He joined the painters' guild in Haarlem in 1640, painting principally landscapes, often with battles or hunts. He was very productive and had great contemporary success.

Philips WOUWERMANS
Two Vedettes on the Watch by a Stream
1650s

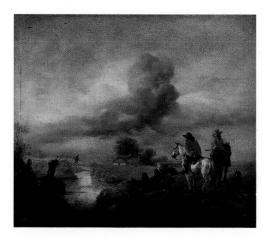

NG 1060
Oil on oak, 31.6 x 35.7 cm

Signed bottom right: PHL W (PHL in monogram).
Vedettes are mounted sentries who were usually placed near an outpost.
NG 1060 is an early work by the artist.
Pentimenti can be seen in the outline of the man behind the woman with the baby.

Aubrey sale, London, July 1855; bequeathed by John Henderson, 1879.

MacLaren/Brown 1991, p. 498.

Philips WOUWERMANS
Cavalrymen halted at a Sutler's Booth
probably 1650s

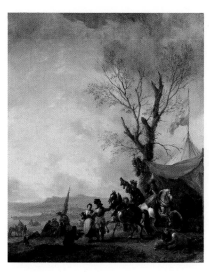

NG 878
Oil on oak, 51.5 x 41.7 cm

Signed bottom left: PHILS · W (PHILS in monogram).
A sutler is a camp follower who sells provisions to soldiers. A group of cavalrymen have stopped before a tent at the right which has a flag flying from it; one of them has dismounted and talks to a woman, while a man begs in front of them.
NG 878 is first recorded in 1740 when the composition was engraved in reverse by Jacques-Philippe Le Bas.

Collection of Duplex de Bacquencourt by 1740; entered the collection of (Sir) Robert Peel (Bt), 1821; bought with the Peel collection, 1871.

MacLaren/Brown 1991, pp. 494–5.

Philips WOUWERMANS
A View on a Seashore with Fishwives offering Fish to a Horseman, 1650–68

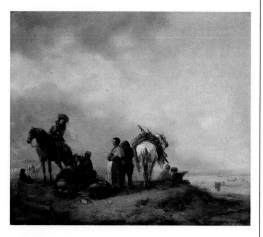

NG 880
Oil on oak, 35.3 x 41.2 cm

Signed bottom right: PHILS · W (PHILS in monogram).
The white horse carries a fishing net on its back; in the distance at the right two boats can be seen by the shore.
When NG 880 was exhibited at the British Institution in 1818 it was stated in the catalogue that it was the last painting made by the artist. There is no stylistic reason for this tradition.
The back of the panel is stamped with the arms of the first recorded owner, Queen Isabella Farnese (wife of Philip V of Spain). She is recorded as having owned eighteen paintings by the artist.

Collection of Queen Isabella Farnese (died 1766); perhaps removed by the French, 1809–13; collection of Lord Charles Townsend by 1818; collection of (Sir) Robert Peel (Bt), by 1824; bought with the Peel collection, 1871.

MacLaren/Brown 1991, p. 496.

Philips WOUWERMANS
A Stream in the Dunes, with Two Bathers
1650–68

Philips WOUWERMANS
Two Horsemen at a Gipsy Encampment, One having his Fortune told, 1650–68

Philips WOUWERMANS
The Interior of a Stable
probably 1655–60

NG 973
Oil on oak, 27 x 35.5 cm

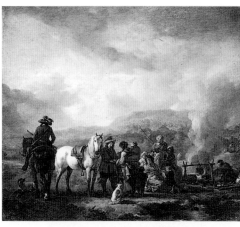

NG 2282
Oil on oak, 32 x 35.9 cm

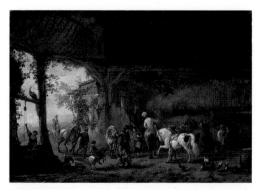

NG 879
Oil on canvas, 47 x 67 cm

The artist painted many scenes set in dune landscapes which recall those near Haarlem.

When the painting was cleaned it was discovered that a fisherman seated in the left foreground was a later addition, and he was removed.

Wynn Ellis sale, London, 1858; Wynn Ellis Bequest, 1876.

MacLaren/Brown 1991, p. 497.

Inscribed bottom left: PHILS · W (PHILS in monogram).

In the past NG 2282 has been catalogued as 'Ascribed to Wouwermans', but it is now considered to be an authentic work by the artist.

Marin sale, Paris, March 1790; bequeathed by Martin Colnaghi, 1908.

MacLaren/Brown 1991, pp. 498–9.

Signed bottom right: PHILS · W (PHILS in monogram).

The artist often treated stable interiors: there are similar scenes by him in Cambridge (Fitzwilliam Museum), Dresden (Staatliche Kunstsammlungen) and Munich (Alte Pinakothek).

Servad sale, Amsterdam, 1778; collection of (Sir) Robert Peel (Bt), by 1829; bought with the Peel collection, 1871.

MacLaren/Brown 1991, p. 495.

Philips WOUWERMANS
A Dune Landscape with a River and Many Figures
probably 1660–68

NG 882
Oil on oak, 23.5 x 30.5 cm

Philips WOUWERMANS
A Stag Hunt
about 1665

NG 975
Oil on canvas, 75 x 104.2 cm

Attributed to Philips WOUWERMANS
Cavalry attacking Infantry
1656–68

NG 976
Oil on oak, 33.4 x 63.1 cm

Signed in the bottom right corner: PHILS W (PHILS in monogram).

Wouwermans lived and worked in Haarlem and his dune landscapes are based on the dune scenery between the town and the sea.

Sold by John Smith, 1823; in the collection of (Sir) Robert Peel (Bt), by 1829; bought with the Peel collection, 1871.

MacLaren/Brown 1991, p. 497.

Signed bottom right: PHLS W (PHLS in monogram). On the hill at the right is a hermit outside his hut. The style is that of the artist's last years.

Bought from the Reynders collection by Buchanan, and in the collection of Edward Gray, Haringay House, by 1824; Lord Northwick's collection; Wynn Ellis Bequest, 1876.

MacLaren/Brown 1991, pp. 497–8.

Signed or inscribed bottom left: PHILS. W (PHILS in monogram).

In the past this battle scene has not been considered to represent an actual historical event. However, a version of the composition (St Petersburg, Hermitage) has been described as a battle between Poles and Swedes. The soldiers' dress and the colours of the banners suggest that this may be the case; the horsemen advancing from the left would be the Poles. The two nations were at war (1655–60), and at this period the Swedes were an enemy of the Dutch.

In spite of the inscription the quality of the execution suggests that NG 976 is probably by a studio assistant. It can be dated a little later than Wouwermans's *Battle between Polish and Turkish Cavalry* of 1656 (also St Petersburg).

Rutland House sale, London, 1827; collection of Wynn Ellis by 1845; Wynn Ellis Bequest, 1876.

MacLaren/Brown 1991, pp. 500–1.

Joseph WRIGHT of Derby
An Experiment on a Bird in the Air Pump
1768

NG 725
Oil on canvas, 182.9 x 243.9 cm

Signed and dated on the reverse: Jos Wright Pinxt 1768.

A lecturer is demonstrating the creation of a vacuum: air is pumped out of the glass bowl in which a white cockatoo has been placed. The bird will expire if the lecturer continues to deprive it of oxygen. The reactions of the onlookers range from the distress of a child to the self-absorption of lovers. The couple on the left may be Thomas Coltman and Mary Barlow, the sitters in NG 6496.

NG 725 was recognised by contemporary viewers as a very remarkable picture, a judgement that has been reiterated ever since. In Wright's account book NG 725 was described in a list of 'Candle Light pictures' as 'The Air Pump'. The verso of a study made in preparation for the picture was later reused for a self portrait (private collection). Air pumps were developed in the seventeenth century and were relatively familiar by Wright's day; the subject of the picture is therefore more of a demonstration than an experiment.

Bought by Dr Bates; presented by Edward Tyrrell, 1863.

Egerton 1990, pp. 58–61.

Joseph WRIGHT of Derby
Mr and Mrs Thomas Coltman
about 1770–2

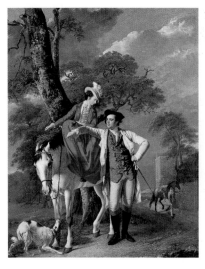

NG 6496
Oil on canvas, 127 x 101.6 cm

Inscribed on the reverse, in a later hand: Thomas Coltman and his first wife Mary / Nat. 1747 Ob. 1826 nee Barlow Ob. 1786 (?) aet 39 / Wright of Derby pinxt

Thomas Coltman (1747–1826) is shown with his first wife, Mary Barlow (1747–86), whom he married in 1769. The house in the background is Gate Burton House in Lincolnshire.

Coltman was a friend of Wright. NG 6496 was recorded in Wright's account book as 'Mr & Mrs Coltman, a Conversation (£63)'. It was probably painted in about 1770–2.

Collection of Thomas Coltman and his descendants; bought with contributions from the National Heritage Memorial Fund and the Pilgrim Trust, 1984.

Egerton 1990, pp. 71–3.

Joachim WTEWAEL
The Judgement of Paris
1615

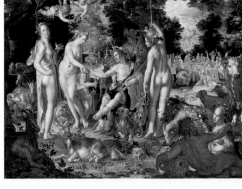

NG 6334
Oil on oak, 59.8 x 79.2 cm

Signed and dated bottom left: Jo wte. wael (Jo in monogram) /fecit /Anº 1615.

The subject derives from Homer's *Iliad* (XXIV, 25–30). Jupiter permitted Eris, the personification of strife, to attend the marriage of Peleus and Thetis. This is the scene in the right background. While there, she provoked a quarrel between the goddesses as to who was the fairest. Mercury brought them to the shepherd Paris on Mount Ida to be judged. In the foreground Paris hands the golden apple marked 'to the fairest' to Venus; Juno is on the left and Minerva on the right. Paris' choice led to the outbreak of the Trojan War.

Wtewael painted a number of versions of the *Judgement of Paris* and the *Marriage of Peleus and Thetis*, but NG 6334 is the only painting that conflates the two scenes into a single composition.

The foreground group includes reminiscences of the *Judgement of Paris* engraved after Raphael by Marcantonio Raimondi. The figure of Minerva is based on that of Ceres in Goltzius's *Wedding of Cupid and Psyche*, an engraving of 1587. The river god at the lower right is derived from the figure of Neptune in that engraving.

Collection of Lord Donegal; collection of Henry Doetsch, London; Doetsch sale, Christie's, 22–25 June 1895 (lot 344); bequeathed by Claude Dickason Rotch, 1962.

MacLaren/Brown 1991, pp. 502–3.

Joseph WRIGHT of Derby
1734–1797

Born in Derby, Wright trained with Thomas Hudson in London, before returning to Derby. He painted landscapes, portraits and night scenes, sometimes of scientific and industrial 'subjects', but principally as investigations of dramatic lighting. Between 1773 and 1775 he was in Italy, then in Bath, returning in 1777 to Derby, where he died.

Joachim WTEWAEL
1566–1638

Joachim Anthonisz. Wtewael was born in Utrecht. He studied with his father, a glass-engraver, and then with the painter Joos de Beer. He spent two years in Italy, and then two in France in the entourage of the bishop of St Malo. Wtewael had returned to Utrecht by 1592 where he became a successful merchant and painter. His refined and complex style is based on that of the Haarlem Mannerists.

Adriaen YSENBRANDT
The Magdalen in a Landscape
perhaps about 1510–25

Style of YSENBRANDT
The Entombment
about 1550

Bernardino ZAGANELLI
Saint Sebastian
about 1505–6

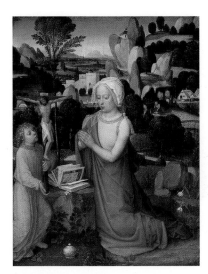

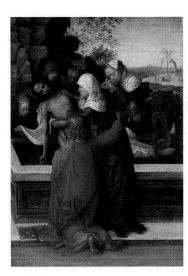

NG 2585
Oil on oak, painted surface 40 x 31.1 cm

The crucifix is inscribed: INRI.
 Mary Magdalene is at prayer before a book and a crucifix which is held by an angel; the jar containing the ointment with which she anointed Christ is in the foreground. She appears again in the right background reading in a cave.
 NG 2585 is said to be an early work, possibly of about 1510–25.

Said to have belonged to Livio Odescalchi (1651– 1713), Rome; collection of Léon Somzée, Brussels, by 1892; Salting Bequest, 1910.

Davies 1968, pp. 177–8.

NG 1151
Oil on paper mounted on oak, painted surface 17.5 x 12.1 cm

Christ's dead body is lowered into a tomb after he has been taken down from the cross (the Deposition is visible in the right background). The Virgin Mary, Saint John the Evangelist, Nicodemus, Joseph of Arimathea, Mary Magdalene and two Holy Women are present. New Testament (all Gospels e.g. John 19: 38–42).
 NG 1151 is painted over an engraving by Schongauer.

Bought from G. Baslini, Milan, 1883.

Davies 1968, pp. 178–9.

NG 1092
Oil on wood, 119.4 x 44.2 cm

Signed on the cartellino, bottom right: B ΔARDINV COTIGLA .P.
 According to the saint's legend he was an officer in the imperial guard of the Roman emperor Diocletian. When it was revealed that he was a Christian he was shot with arrows, but his wounds healed and he was subsequently martyred by being battered to death.
 NG 1092 is the only known work signed by Bernardino without his brother Francesco, although many others have been attributed to him working independently. It is probably the central panel of a polyptych commissioned by the students of the University of Pavia for their chapel in the Carmine, Pavia, which was painted in about 1505–6.
 The panels of Saints Nicholas of Bari and Catherine of Alexandria, which flanked NG 1092, are now in Monza (Collegio della Guastalla).

A signed panel, probably NG 1092, depicting Saint Sebastian is described as being part of the altarpiece for the Carmine, Pavia, until 1856; the collection of Frizzoni at Bellagio, 1871; bought by Sir William Boxall from Baslini, Milan; bought from F. Sacchi, London, 1880.

Gould 1975, pp. 331–2; De Marchi 1990, no. 10.

Adriaen YSENBRANDT
active 1510; died 1551

Ysenbrandt (also Isenbrandt) became a master in Bruges in 1510. The group of works associated with his name show Gerard David's influence. Two of these pictures are dated: a male portrait of 1515 and an altarpiece of 1518 (formerly Lübeck, destroyed in World War II).

Bernardino ZAGANELLI
active 1499; died 1509 or soon after

Bernardino and his brother Francesco were from Cotignola; they collaborated on works dated to 1499, 1504 and 1509. Because Francesco's name precedes that of Bernardino on inscriptions it is surmised that he was the elder. Their paintings were influenced by Palmezzano, Ercole de' Roberti, Costa and Francia among others. Bernardino's independent work also reveals a close study of Giorgione and Perugino.

Francesco ZAGANELLI
The Baptism of Christ
1514

Francesco ZAGANELLI
The Dead Christ with Angels
1514

Giuseppe ZAIS
Landscape with a Ruined Tower
probably 1760–80

NG 3892.1
Oil on wood, 200.7 x 190.5 cm

NG 3892.2
Oil on wood, 98.1 x 202.5 cm

NG 2086
Oil on canvas, 70.2 x 95.9 cm

Inscribed on the angel's scroll: ·HIC·/ ·EST· FILIVS·/ MEVS DILECTVS· (This is my beloved son [in whom I am well pleased]); on the Baptist's scroll: ·ECCE·/ AGNVS·/ ·DEI· (Behold the lamb of God). Signed and dated on the cartellino, lower left: ·xhs· ·1514· /fracischus choti/ gnolensis· ·f· (Francesco of Contignola made this).

Saint John, at the right, baptises Christ in the river Jordan. New Testament (all Gospels, e.g. Matthew 3: 13–17). A dove above Christ signifies the Holy Ghost. A child angel holds a towel to dry Christ. The women at the left may be intended as the Virgin and Saint Anne or Saint Elizabeth, although they are not usually depicted in a representation of the Baptism.

NG 3892.1 is the central part of an altarpiece, of which NG 3892.2 also formed a part. Both panels are recorded, as having come from the Laderchi chapel in S. Domenico, Faenza, and they were probably painted for this site.

Removed from the Laderchi chapel in S. Domenico, Faenza, when the chapel was being restored at the end of the eighteenth century; in Rome by 1847; the Erskine family collection, Linlathen, Forfarshire; bought, 1924.

Gould 1975, pp. 332–3.

Christ, wearing the crown of thorns and displaying the wound inflicted on his side during the Crucifixion, is supported by two angels upon a tomb.

NG 3892.2 is a lunette from an altarpiece, and would originally have been placed above the central panel, NG 3892.1. Both panels are recorded, as having come from the Laderchi chapel in S. Domenico, Faenza, and they were probably painted for this site.

Removed from the Laderchi chapel in S. Domenico, Faenza when the chapel was being restored at the end of the eighteenth century; in Rome by 1847; the Erskine family collection, Linlathen, Forfarshire; bought, 1924.

Gould 1975, pp. 332–3.

The landscape is imaginary.

NG 2086 has in the past been attributed to Zuccarelli, but it is now considered to be by Zais. When first recorded it was described as having a pendant, which is now lost.

John Samuel collection by 1895; bequeathed by the Misses Cohen as part of the John Samuel Collection, 1906.

Levey 1971, p. 245.

Francesco ZAGANELLI
active 1499; died 1531/2

Francesco and his brother Bernardino were from Cotignola; they collaborated on works dated to 1499, 1504 and 1509. As Francesco's name precedes that of Bernardino on inscriptions it is surmised that he was the elder. Their paintings were influenced by Palmezzano, Ercole de' Roberti, Costa and Francia, among other artists. Most co-signed paintings correspond in style with works which Francesco signed alone. From 1513 onwards Francesco worked in Ravenna.

Giuseppe ZAIS
1709–1784

Zais was born in Canale d'Agordo, near Belluno. He was a landscape painter, whose work displays the influence of Marco Ricci and Zuccarelli. The artist was elected to the Venetian Academy in 1774, and died in Treviso.

Giuseppe ZAIS
Landscape with a Group of Figures
probably 1770–80

Giuseppe ZAIS
Landscape with a Group of Figures Fishing
probably 1770–80

Johann ZOFFANY
Mrs Oswald
probably about 1760–5

NG 1296
Oil on canvas, 49.5 x 65.5 cm

NG 1297
Oil on canvas, 49 x 65.5 cm

NG 4931
Oil on canvas, 226.5 x 158.8 cm

Signed on the foreground rock: ZAISE. F.
 The landscape is invented. At the right two women wash clothes.
 NG 1296 is a pendant to NG 1297. Both pictures can be dated to the period of the artist's maturity.

Bought from Ricchetti, Venice, 1889

Levey 1971, p. 244.

NG 1297 is a pendant to NG 1296, and like it dates from the artist's maturity.
 The figures in this work may have been inspired by contemporary French engravings.

Bought from Ricchetti, Venice, 1889.

Levey 1971, pp. 244–5.

The sitter was born Mary Ramsay, daughter of Alexander Ramsay of Jamaica. She married Richard Oswald in 1750.
 Richard Oswald bought the estate of Auchincruive, Ayrshire, where NG 4931 is known to have hung, in 1764. The background may be an attempt to represent Ayrshire, but Zoffany is not known to have visited Scotland. Mrs Oswald died, childless and widowed, in 1788.

By descent from the sitter's nephew until 1922; bought, 1938.

Davies 1959, pp. 111–12; Webster 1976, p. 37.

Johann ZOFFANY
1733?–1810

Johann Joseph Zoffany was born in Frankfurt-am-Main. He came to England in 1761, and exhibited a successful theatrical picture in 1762. He was elected RA in 1769. From 1783 to 1789 he worked in India. His most characteristic works are conversation pieces and theatrical subjects, though he also painted portraits.

Marco ZOPPO
The Dead Christ supported by Saints
about 1465

Marco ZOPPO
A Bishop Saint, perhaps Saint Augustine
probably about 1468

Francesco ZUCCARELLI
Landscape with Cattle and Figures
about 1750–70

NG 590
Egg (identified) on wood, painted surface
26.4 x 21 cm

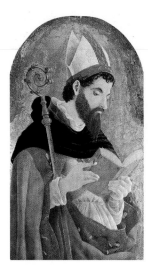

NG 3541
Tempera on wood, painted surface 49.5 x 28.6 cm

NG 2087
Oil on canvas, 92.7 x 132.4 cm

The body of the crucified Christ is propped up in the tomb, on which two extinguished candles are standing. Saint John the Baptist stands behind a parapet with another saint, who may be Saint Jerome, wearing a hermit's cowl over a blue cardinal's cape. This identification finds some confirmation from the fact that Zoppo represented Jerome on other occasions wearing blue and with a long beard (e.g. Baltimore, Walters Art Gallery; Bologna, Pinacoteca; Berlin, Staatliche Museen).

The subject and format would make it likely that NG 590 served as the crowning panel of a polyptych altarpiece, but the reverse is decorated to imitate marble, suggesting that it was painted as an independent work, perhaps for private devotion. It was probably painted in Venice in about 1465.

Collection of Professor Rosini, Pisa, before 1845; bought from the Lombardi-Baldi collection, 1857.

Davies 1961, p. 562; Armstrong 1976, pp. 75–81, 190, 352–3.

This bishop saint has not been securely identified; Saint Augustine (354–430, the Bishop of Hippo) may be intended.

NG 3541 is a panel from an altarpiece, and was probably once part of the upper tier of a polyptych. Three other panels have been identified: *Saint Peter* (Washington, National Gallery of Art), *Saint Paul* (Oxford, Ashmolean Museum) and *Saint Jerome* (Baltimore, Walters Art Gallery). A polyptych that was signed by Zoppo and dated 1468 was described in the church of S. Giustina, Venice, in 1581. It has been suggested that these four panels once formed part of this altarpiece.

The church of S. Giustina had been an Augustinian church since 1448 which might support the identification of NG 3541 as Saint Augustine.

Collection of Alfred de Pass by 1895; by whom presented, 1920.

Davies 1961, pp. 562–3; Armstrong 1976, pp. 83–92, 358–61; Lloyd 1977, pp. 191–3.

This genre scene is set as though in an Italian landscape. The site is not specific.

NG 2087 has been repainted in places and has suffered some damage, but in spite of its condition it is still considered an original by Zuccarelli.

Melli collection, Milan; inherited by Giovanni Morelli by December 1874; sold to John Samuel, 1875; bequeathed by the Misses Cohen as part of the John Samuel Collection, 1906.

Levey 1971, p. 246.

Marco ZOPPO
about 1432–about 1478

Born in Cento, Marco (di Antonio) di Ruggero, Lo Zoppo, signed himself 'Bononensis' (from Bologna). Apprenticed to Squarcione of Padua in about 1453, he moved to Venice in 1455 and to Bologna in 1461–2. He died in Venice. Zoppo painted altarpieces (polyptychs and single-field altarpieces) and small devotional works.

Francesco ZUCCARELLI
1702–1788

Zuccarelli, who was a celebrated and prolific landscape painter, was born in Pitigliano, Tuscany. He is said to have been trained by Paolo Anesi in Florence and by G.B. Morandi in Rome. The artist was in Florence by 1729, then worked in Venice from about 1730, and in England from 1752 to 1762 and from 1765 to 1771. He was a founder member of the Royal Academy in 1768.

Follower of Federico ZUCCARO
The Conversion of the Magdalen
probably 1580–1600?

NG 1241
Oil on pear wood, 29.8 x 58.4 cm

Attributed to Francesco ZUGNO
The Finding of Moses
after 1740

NG 3542
Oil on canvas, 53.7 x 80.7 cm

Francisco de ZURBARAN
Saint Margaret of Antioch
1630–4

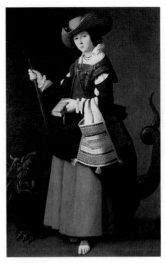

NG 1930
Oil on canvas, 163 x 105 cm

The title is traditional and the subject rarely depicted (it is not described in the Bible). The painting may, in fact, simply represent Christ preaching in the Temple, although one woman among the female portion of the congregation is given special prominence.

Figures in the foreground at the right derive from a design of the same subject by Zuccaro which was for a fresco formerly in the Grimani Chapel in S. Francesco della Vigna, Venice. Vasari describes the fresco which is datable to the early 1560s. The pendant to the *Magdalen* fresco survives, and makes possible the identification of the design of the lost work in engravings and drawings. Some of the figures in NG 1241 may be portraits, and the fashions of their clothes date from the 1580s or 1590s. In the past an attribution to Pedro Campaña (1503–80) has been proposed, but this does not seem tenable. Another version of the composition (Rome, Borghese Gallery) also survives.

Collection of Philip John Miles which had been formed by Richard Hart Davis, Leigh Court, by 1822; Buchanan (1824) said the work came from the Vitturi collection, Venice, and had been sold with it to Thomas Moore Slade who sent it to England, about 1774–6; bought, 1888.

Gould 1975, pp. 333–5.

Pharaoh had commanded that all Hebrew boys be cast into the river. A woman of the house of Levi hid her son (Moses) in a basket of bulrushes at the river's bank. Moses' sister kept watch and saw Pharaoh's daughter discover the boy, at which time she volunteered his mother as a nurse. Old Testament (Exodus 2: 5–10).

The composition of NG 3542 seems to derive from Giovanni Battista Tiepolo's representation of the same scene (Edinburgh, National Gallery). The influence of Paolo Veronese is also evident.

Probably in the collection of Edward Cheney by 1884; presented by Alfred de Pass, 1920.

Levey 1971, p. 247.

Various stories from the life of Saint Margaret, a virgin martyr of Antioch, are recorded. She is supposed to have overcome a dragon, to have been the princess rescued by Saint George, and to have been swallowed by a dragon which burst, so releasing her – hence her role as a patron of women in childbirth. Her rustic clothes and the crook she carries refer to her rural upbringing, but the book implies her faith and learning. Over her arm is a Spanish saddle-bag (*alforjas*).

NG 1930 is thought to date from the early 1630s before the artist left Seville for Madrid in 1634.

Possibly in the collection of Prince Charles (later Charles IV of Spain) by 1789; perhaps given by the King of Spain to the 2nd Baron Ashburton; bought from the 5th Marquess of Northampton who was the executor of Lousia, Lady Ashburton, 1903.

MacLaren/Braham 1970, pp. 138–40; Baticle 1987, pp. 247–8.

Federico ZUCCARO
1540?–1609

Federico was Taddeo Zuccaro's younger brother. He came from the Urbino area, but was partly brought up in Rome, where he painted. The artist also worked in Venice, Florence and elsewhere in Italy. He visited Holland, England and Spain, and was responsible for the foundation of the Accademia di S. Luca in Rome in 1593.

Francesco ZUGNO
1709–1787

Born in Venice, Zugno studied and collaborated with G.B. Tiepolo. Together they painted decorative frescoes at Palazzo Labia (Venice) and Villa Soderini (Nervesa). A number of canvases are attributed to Zugno, including a signed (or inscribed) picture at Vidor, and two works in Munich. By 1762 he seems to have stopped painting.

Francisco de ZURBARAN
1598–1664

Zurbarán was born in Fuente de Cantos (Badajoz). His earliest dated work is of 1627. The artist settled in Seville in 1629, and ran an active workshop, which mainly produced religious works. He was influenced by Italian art, and by Ribera, Velázquez and later perhaps Murillo. Recorded as working in Madrid in 1634, he lived there from 1658 until his death.

Francisco de ZURBARAN
Saint Francis in Meditation
1635–9

Francisco de ZURBARAN
Saint Francis in Meditation
1639

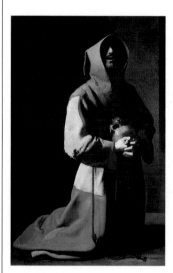

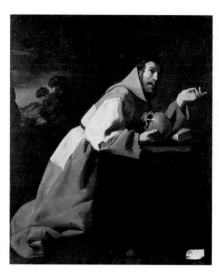

NG 230
Oil (identified) on canvas, 152 x 99 cm

NG 5655
Oil on canvas, 162 x 137 cm

Saint Francis of Assisi was the thirteenth-century founder of the mendicant order of Franciscans. He clasps a skull, symbolic of mortality, upon which he meditates. Evidence of the stigmata he received in emulation of Christ's wounds can be seen on his left hand. According to biographies of the saint he spent the last years of his life meditating on the sufferings of Christ, an activity encouraged by Counter-Reformation writers.

The Capuchin habit the saint wears, made of patches of coarse wool with a pointed hood and tied at the waist with a thick rope, suggests that the work was commissioned for a community of Franciscan Capuchins. On stylistic grounds NG 230 appears to just pre-date NG 5655, which is dated 1639.

Acquired in Spain for King Louis-Philippe, about 1835–7; bought from the Louis-Philippe sale, London, 1853.

MacLaren/Braham 1970, pp. 137–8; Baticle 1987, pp. 271–3.

Signed and dated on a cartellino in the lower right-hand corner: Fran^{co} Dezurbara[n] / faciebat /1639 (Francisco de Zurbaran made this 1639).

Saint Francis of Assisi was the thirteenth-century founder of the mendicant order of Franciscans. He kneels in a landscape, clasping a skull, upon which he meditates. For further discussion of the subject, see NG 230.

Collection of Sir Arthur Aston of Aston Hall, Cheshire (British envoy in Madrid, 1840–3); Aston Hall sale, 1862; bequeathed by Major Charles Edmund Wedgwood Wood, 1946.

MacLaren/Braham 1970, pp. 140–1.

Sir Francis Legatt CHANTREY
Bust Portrait of Charles Long, Lord Farnborough
1834

FRENCH
Fame
19th century?

ITALIAN
Bust Portrait of Leonardo Rinaldi (?)
perhaps about 1620

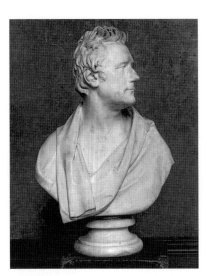

NG 2786
White Carrara marble, 76.2 cm high

NG 4105
Bronze, hollow-cast, 231.5 cm high

NG 6357
White Carrara marble, 60.9 cm high

Charles Long (1761–1838), who was son-in-law to the exceedingly wealthy Sir Abraham Hulme, was a Tory politician and a promoter and patron of the arts, active on the Committee of Taste, the British Institution, and as a Trustee of both the British Museum and National Gallery. He was made Paymaster General and created Baron Farnborough on his retirement in 1826. A notable connoisseur and collector himself, he was also art adviser to George IV – 'the spectacles of the King'.

Commissioned in 1833, completed in 1834, dated 1836 and also chiselled with the sitter's and sculptor's names, this bust was paid for only in 1842 after both had died. It was made from the plaster cast (of the original clay model) which remained in the sculptor's studio and is now in the Ashmolean Museum, Oxford (no. 707). This plaster had earlier served as the model for the marble dated 1820, which is today in the National Portrait Gallery (no. 2090). Chantrey (1781–1841) was the leading portrait sculptor in England in the period 1810 to 1840.

Presented by Mrs Samuel Long, 1911.

Assembled from several separately made units, presumably sand-cast, this bronze, probably made in France in the last century, certainly reflects French sculpture of the late sixteenth and seventeenth centuries. It is especially close to Pierre Biard's bronze of the same subject executed 1597–1609 (Paris, Louvre).

NG 4105 has been proposed as the sculpture of *Fame* commissioned for the entrance gate of the Château de Richelieu in 1639 from Guillaume Bertelot (recorded in Rome in the first two decades of the century, died 1648) and it may be a replica of this work.

Presented by Sir Herbert Cook, Bt, through the NACF in memory of Sir Francis Cook, Bt, 1925.

Chiselled on the reverse: LEONARDUS RINALDIUS/ A. VICTORIA. F/ MDXXXXVI.

Although his name is chiselled on the reverse, the bust is not in the style of Alessandro Vittoria (1525–1608), the leading sculptor working in Venice in the second half of the sixteenth century; nor has a Leonardo Rinaldi been identified among Venetian noblemen of that period. The marble, of which there is also a version in bronze, has therefore been dismissed as a fake probably of the late nineteenth century. However, it is of very high quality and may well be old (perhaps made in Rome in about 1620) but given a spurious inscription to help sell it. Vittoria was especially noted for his male portrait busts.

Presented by the NACF in memory of William Gibson (Keeper of the National Gallery, 1938–60), 1964.

ITALIAN
Bust Portrait of Andrea Mantegna
about 1880

ITALIAN, Florentine (?)
Head of The Dying Alexander
17th–18th century

After Stefano MADERNO
Hercules and Antaeus
19th century?

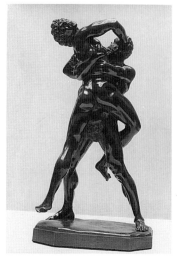

NG 2250
Plaster of Paris with a 'bronzed' finish,
75 cm in diameter

One of an edition of casts made of the high relief
bronze bust of Mantegna and its circular porphyry
background which serves as the artist's memorial in
his burial chapel in S. Andrea, Mantua. The
memorial was probably designed, the bust was
perhaps modelled, and the bronze was possibly
cast, by Mantegna himself, but other artists have
been proposed. The pupils of the eyes were said to
be set with diamonds.

Presented by Henry Vaughan, 1883.

NG 2241
Imperial Egyptian porphyry, 79.7 cm high
(including socle)

NG 2241 is a copy of a heroic Hellenistic head in
white marble (Florence, Uffizi), long celebrated as a
portrait of Alexander the Great, often supposed to
be depicted dying.
 The notoriously hard material of imperial
porphyry was worked by a few craftsmen in
Florence and Rome and also occasionally elsewhere
(most notably Paris) from the late sixteenth century
onwards, using ancient columns, shafts and other
fragments.

Presented by Henry Yates Thompson, 1894.

NG 6271
Hollow-cast bronze, 58.4 cm high (including
integral plinth)

Assembled from several separately made units,
probably sand-cast, this bronze was made perhaps
in Venice and probably in the last century, after a
terracotta model of approximately the same size
then in the Accademia in Venice and now in the Ca
d'Oro there. The model is signed S.M. and must be
the work of Stefano Maderno (1576–1636), a
Lombard sculptor who achieved considerable fame
in Rome in the early sixteenth century. NG 6271
belongs to a series of terracotta groups by him,
many representing Labours of Hercules.

Presented anonymously, 1957.

Robert William SIEVIER
Bust Portrait of Wynn Ellis
about 1843

After Adriaen de VRIES
Girl Bathing
about 1700–50

John Warrington WOOD
Bust Portrait of Sir Austen Henry Layard
completed 1881

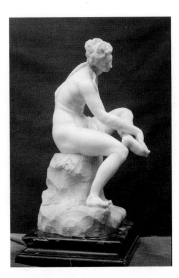

NG 2239
White Carrara marble. 78.1 cm high (including socle)

NG 6378
White Carrara marble, 57.2 cm high (excluding plinth)

NG 5449
White Carrara marble, 62.2 cm high

Presumed to be identical with the bust of Wynn Ellis exhibited by Sievier at the Royal Academy in 1843 (as no. 1438). Wynn Ellis (1790–1875) was a notable benefactor of the Gallery.

Sievier (1794–1865) turned to sculpture in the early 1820s after training as an engraver. He enjoyed considerable success in the ensuing decades but in the 1840s he turned his attention to new inventions and their application in manufacture: india-rubber, elastic fibre, electric telegraphy. NG 2239 is probably one of his latest works.

Presented by H. Churchill, the sitter's nephew, 1878.

De Vries (about 1560–1626) was born in The Hague. He trained in the workshop of Giovanni Bologna in Florence, and worked in Milan, Rome, Turin and Augsburg before settling in Prague from about 1593 as court sculptor to the Holy Roman Emperor Rudolph II. This sculpture is modelled on a bronze (of similar size) by him. It was probably carved in Italy in the first half of the eighteenth century.

Bought, 1966.

Chiselled with the sitter's three names (in capitals) and J.Warrington Wood/Sculpt Roma 1881.

Layard (1817–94) was an explorer, archaeologist, politician and diplomat. He bequeathed his substantial collection of paintings to the National Gallery, where he long served as a Trustee. This portrait may be based on a bust of Layard which Wood exhibited at the Royal Academy in 1870 (no. 1181).

Wood (1839–86), who took his middle name from the Lancashire town where he was born and died, lived and worked for much of his professional life in Rome.

Presented by Vice-Admiral Arthur John Layard Murray, 1943.

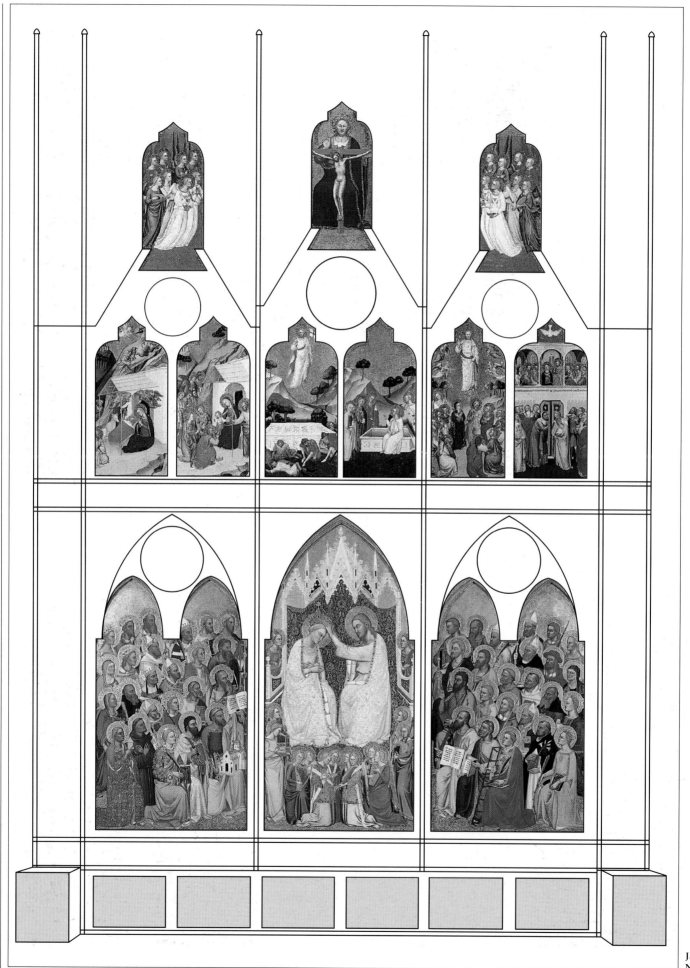

Jacopo di CIONE
NG 569–578

Carlo CRIVELLI
NG 788.1–9
NG 788.10–13

Stephan LOCHNER NG 705, reverse

UGOLINO di Nerio NG 1188–9, 3375–8, 3473, 4191, 6484–6

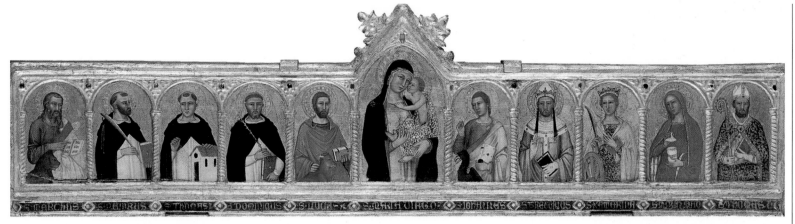

ANDREA di Bonaiuto da Firenze NG 5115

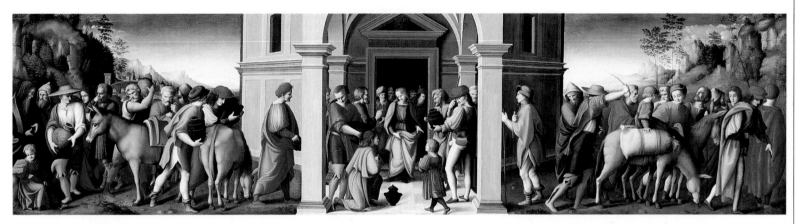

BACCHIACCA NG 1218

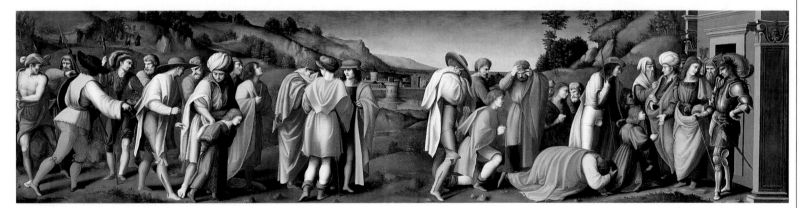

BACCHIACCA NG 1219

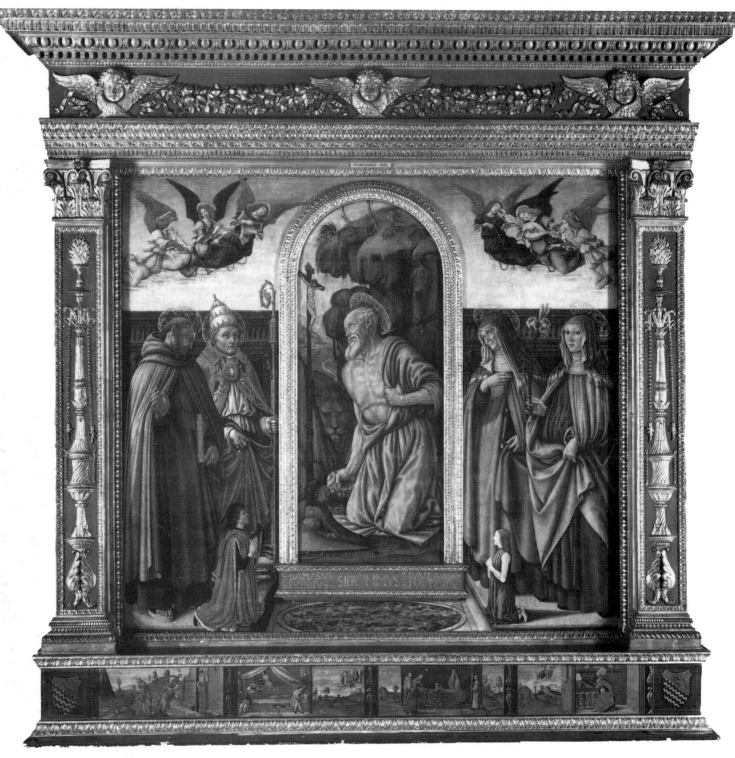

Francesco BOTTICINI NG 227.1–2

After COSSA NG 597.1

Lorenzo COSTA NG 629.1–5

GIOVANNI del Ponte NG 580

Follower of GIULIO Romano NG 643.1

Follower of GIULIO Romano NG 643.2

Follower of GIULIO Romano NG 644.1

Follower of GIULIO Romano NG 644.2

ITALIAN, TUSCAN NG 584

Filippino LIPPI NG 293

Andrea MANTEGNA NG 902

Francesco PESELLINO L7

Francesco PESELLINO L8

PIERO di Cosimo NG 4890

Pietro ORIOLI NG 1849

PONTORMO NG 6453

RAPHAEL NG 2919

Luca SIGNORELLI NG 3946

Bibliography

Ackerman 1986
Gerald Ackerman *The Life and Work of Jean-Léon Gérôme* London 1986

Adler 1982
W. Adler *Corpus Rubenianum, I. Landscapes* London 1982

Adriani 1993
Götz Adriani *Cézanne Gemälde* EXH CAT Kunsthalle Tübingen 1993

Agosti 1982
Giovanni Agosti 'Precisioni su un "Baccanale" perduto del Signorelli' *Prospettiva* 30 1982

Ainsworth 1989
Maryann W. Ainsworth 'Northern Renaissance Drawings and Underdrawings: A Proposed Method of Study' *Master Drawings* 27 1989 pp. 5–38

Albers 1988
Géraldine Albers and Philippe Morel 'Pellegrino Tibaldi e Marco Pino alla Trinità dei Monti' *Bollettino d'arte* March 1988 pp. 69-92

Alley 1959
Ronald Alley *Tate Gallery Catalogues: The foreign paintings, drawings and sculpture* London 1959

Alpers 1971
Svetlana Alpers *Corpus Rubenianum, The Decoration of the Torre de la Parada* London 1971

Ananoff 1976
Alexandre Ananoff *François Boucher* Lausanne and Paris 1976

Ananoff 1980
Alexandre Ananoff *L'opera completa di Boucher* Milan 1980

Andrews 1977
Keith Andrews *Adam Elsheimer* Oxford 1977

Anker 1987
Valentina Anker *Alexandre Calame. Vie et Oeuvre. Catalogue raisonné de l'oeuvre peint* Fribourg 1987

Argencourt 1976–7
L. d'Argencourt, M. C. Boucher, D. Druick and J. Foucart *Puvis de Chavannes* EXH CAT Galeries Nationales du Grand Palais, Paris, and National Gallery of Canada, Ottawa 1976–7

Armstrong 1976
Lilian Armstrong *The Paintings and Drawings of Marco Zoppo* New York 1976

Arts Council 1973
Arts Council *Salvator Rosa* EXH CAT London 1973

Ashton 1981
Dore Ashton *Rosa Bonheur: A Life and a Legend* London 1981

Baccheschi 1973
E. Baccheschi *L'opera completa del Bronzino* Milan 1973

Bailey 1991
Colin B. Bailey *The Loves of the Gods* Paris, Philadelphia and New York 1991

Baillio 1982
Joseph Baillio *Elisabeth Louise Vigée LeBrun 1755–1842* EXH CAT Kimbell Art Museum, Fort Worth 1982

Balis 1986
Arnout Balis *Corpus Rubenianum, Hunting Scenes* London 1986

Banker 1991
J. R. Banker 'The Program for the Sassetta Altarpiece in the Church of S. Francesco in Borgo S. Sepolcro' *I Tatti Studies* IV 1991 pp. 11-58

Barzini 1971
L. Barzini and G. Mandel *L'Opera pittorica completa di Daumier* Milan 1971

Baticle 1987
Jeannine Baticle *Zurbarán* EXH CAT Metropolitan Museum of Art, New York, and Galeries Nationales du Grand Palais, Paris 1987

Bazin 1987
Germain Bazin *Théodore Géricault, étude critique, documents et catalogue raisonné* 3 vols Paris 1987

Beck 1972
H. U. Beck *Jan van Goyen 1596–1656* 3 vols Amsterdam 1972

Beck 1979
James Beck 'Paolo Uccello and the Paris Saint George' *Gazette des Beaux-Arts* XCIII 1979 pp. 1-5

Begni Redona 1988
Begni Redona and Pier Virgilio *Alessandro Bonvicino, Il Moretto da Brescia* Brescia 1988

Begni Redona 1988a
Begni Redona and Pier Virgilio *Moretto* EXH CAT Monastero di S. Giulia, Brescia 1988

Bellosi 1970
Luciano Bellosi 'Un quadro giovanile di Pietro da Cortona' *Paragone* XXI 247 1970 pp. 74-6

Bellosi 1990
Luciano Bellosi *Giovanni di Francesco e l'arte fiorentina di metà Quattrocento* EXH CAT Casa Buonarroti, Florence 1990

Bellosi 1993
Luciano Bellosi *Francesco di Giorgio e il Rinascimento a Siena 1450-1500* EXH CAT S. Agostino and Pinacoteca Nazionale, Siena 1993

Berti 1990
Luciano Berti and Antonio Paolucci (eds) *L'età di Masaccio. Il Primo Quattrocento a Firenze* Milan 1990

Berti 1991
Luciano Berti and Umberto Baldini *Filippino Lippi* Florence 1991

Besnard 1928
Albert Besnard *Maurice Quentin de La Tour* Paris 1928

Blankert 1980
Albert Blankert et al *Gods, Saints and Heroes - Dutch Painting in the Age of Rembrandt* EXH CAT National Gallery of Art, Washington 1980

Blunt 1966
Anthony Blunt *The Paintings of Nicolas Poussin, A Critical Catalogue* London 1966

Boggs 1962
Jean Sutherland Boggs *Portraits by Degas* Berkeley and Los Angeles 1962

Boggs 1988
Jean Sutherland Boggs et al *Degas* EXH CAT Galeries Nationales du Grand Palais, Paris, National Gallery of Canada, Ottawa, and Metropolitan Museum of Art, New York 1988

Boisclair 1986
Marie-Nicole Boisclair *Gaspard Dughet: sa vie et son œuvre* Paris 1986

Bomford 1977
David Bomford 'Perugino's Virgin and Child with Saint John' *National Gallery Technical Bulletin* 1 1977 pp. 29–34

Bomford 1977a
David Bomford and Jo Kirby 'Two Panels by the Master of Saint Giles' *National Gallery Technical Bulletin* 1 1977 pp. 49–56

Bomford 1978
David Bomford and Jo Kirby 'Giovanni di Paolo's SS. Fabian and Sebastian' *National Gallery Technical Bulletin* 2 1978 pp. 56-66

Bomford 1979
David Bomford 'Moroni's Canon Ludovico di Terzi: An Unlined Sixteenth-Century Painting' *National Gallery Technical Bulletin* 3 1979 pp. 34–42

Bomford 1980
David Bomford, Janet Brough and Ashok Roy 'Three Panels from Perugino's Certosa di Pavia Altarpiece' *National Gallery Technical Bulletin* 4 1980 pp. 3-32

Bomford 1982
David Bomford and Ashok Roy 'Canaletto's Venice: The Feast Day of S. Roch' *National Gallery Technical Bulletin* 6 1982 pp. 40-5

Bomford 1983
David Bomford and Ashok Roy 'Manet's The Waitress: An Investigation into its Origin and Development' *National Gallery Technical Bulletin* 7 1983 pp. 3-21

Bomford 1986
David Bomford, Ashok Roy and Alistair Smith 'The Techniques of Dieric Bouts: Two Paintings Contrasted' *National Gallery Technical Bulletin* 10

1986 pp. 39-58

Bomford 1988
David Bomford, Christopher Brown and Ashok Roy *Art in the Making: Rembrandt* EXH CAT National Gallery, London 1988

Bomford 1988a
David Bomford, Ashok Roy and David Saunders 'Gainsborough's Dr Ralph Schomberg' *National Gallery Technical Bulletin* 12 1988 pp. 44-58

Bomford 1989 (1990)
David Bomford, Jill Dunkerton, Dillian Gordon and Ashok Roy *Art in the Making: Italian Painting before 1400* EXH CAT National Gallery, London 1989 (reprinted 1990)

Bomford 1991
David Bomford, Jo Kirby, John Leighton and Ashok Roy *Art in the Making: Impressionism* National Gallery, London 1991

Boskovits 1988
M. Boskovits *Frühe Italienische Malerei. Katalog der Gemälde* Gemäldegalerie, Berlin 1988

Bowness 1978
Alan Bowness, Marie Thérèse de Forges, Michel Laclotte and Hélène Toussaint *Gustave Courbet* EXH CAT Royal Academy of Arts, London 1978

Braham 1978
Allan Braham *Giovanni Battista Moroni* EXH CAT National Gallery, London 1978

Braham 1979
Allan Braham 'The Bed of Pierfrancesco Borgherini' *Burlington Magazine* CXXI no. 921 1979 pp. 754-65

Braham 1981
Allan Braham *El Greco to Goya, The Taste for Spanish Painting in Britain and Ireland* EXH CAT National Gallery, London 1981

Braham 1981a
Allan Braham and Jill Dunkerton 'Fragments of a Ceiling Decoration by Dosso Dossi' *National Gallery Technical Bulletin* 5 1981 pp. 27-38

Braham 1984
Allan Braham and Martin Wyld 'Raphael's S. John the Baptist Preaching' *National Gallery Technical Bulletin* 8 1984 pp. 15-24

Brandl 1993
Rainer Brandl 'The Liesborn altarpiece, a new reconstruction' *Burlington Magazine* CXXXV no. 1080 1993 pp. 180–9

Bredius 1969
A. Bredius *Rembrandt* third edn (revised by H. Gerson) London 1969

Brettell 1993
Richard Brettell and Joachim Pissarro *The Impressionist and the City: Pissarro's Series Paintings* EXH CAT Dallas Museum of Art, Philadelphia Museum of Art and Royal Academy of Arts, London 1993

Brigstocke 1981
Hugh Brigstocke *Poussin, Sacraments and Bacchanals* Edinburgh 1981

Brigstocke 1982
Hugh Brigstocke *William Buchanan and the 19th Century Art Trade: 100 Letters to his Agents in London and Italy* London 1982

Brough 1985
Janet Brough 'The Construction of Panel Trays for Two Paintings by the Master of Cappenberg' *National Gallery Technical Bulletin* 8 1985 pp. 63-71

Brown 1974
Christopher Brown *Painting in Focus: The Abbé Scaglia adoring the Virgin and Child by Van Dyck* EXH CAT National Gallery, London 1974

Brown 1976
Christopher Brown *Art in Seventeenth-Century Holland* EXH CAT National Gallery, London 1976

Brown 1979
Christopher Brown *Painting in Focus: Rubens's 'Peace and War' Minerva protects Pax from Mars* EXH CAT National Gallery, London 1979

Brown 1982
Christopher Brown, Anthony Reeve and Martin Wyld 'Rubens's The Watering Place' *National Gallery Technical Bulletin* 6 1982 pp. 27-40

Brown 1983
Christopher Brown *Acquisition in Focus: Rubens: Samson and Delilah* EXH CAT National Gallery, London 1983

Brown 1986
Christopher Brown *Dutch Landscape: the early years: Haarlem and Amsterdam 1590–1650* EXH CAT National Gallery, London 1986

Brown 1987
Christopher Brown *The National Gallery Schools of Painting: Flemish Paintings* London 1987

Brown 1987a
Christopher Brown, David Bomford, Joyce Plesters and John Mills 'Samuel van Hoogstraten: Perspective and Painting' *National Gallery Technical Bulletin* 11 1987 pp. 66–85

Brown 1991–2
Christopher Brown, Jan Kelch and Pieter Van Thiel *Rembrandt: The Master & his Workshop: Paintings* EXH CAT New Haven and London 1991–2

Bruyn 1982–9
J. Bruyn, B. Haak, S. H. Levie, P. J. J. Van Thiel and E. Van de Wetering *Stichting Foundation Rembrandt Research Project: A Corpus of Rembrandt Paintings* 3 vols: I (1982) *1625–1631*, II (1986) *1631–1634*, III (1989) *1635–1642* Dordrecht, Boston, London and The Hague

Buchner 1953
E. Buchner *Das deutsche Bildnis der Spätgotik und der frühen Dürerzeit* Berlin 1953

Burnstock 1988
Aviva Burnstock 'The Fading of the Virgin's Robe in Lorenzo Monaco's "Coronation of the Virgin"' *National Gallery Technical Bulletin* 12 1988 pp. 58–65

Bury 1971
Adrian Bury *Maurice Quentin de La Tour* London 1971

Bury 1990
Michael Bury 'Bartolomeo Caporali: a new document and its implications' *Burlington Magazine* CXXXII no. 1048 1990 pp. 469-75

Butlin 1977
Martin Butlin *The Paintings of J.M.W. Turner* New Haven and London 1977

Butterfield 1989
Andrew Butterfield 'A source for Michelangelo's National Gallery Entombment' *Mitteilungen der Kunsthistorisches Institut Florenz* 33 1989 pp. 390-3

Byam Shaw 1976
James Byam Shaw *Catalogue of the Drawings by Old Masters at Christ Church, Oxford* Oxford 1976

Byam Shaw 1977
James Byam Shaw 'The Study of a horse by Andrea del Sarto and its origin' *Burlington Magazine* CXIX no. 897 1977 pp. 848-50

Byam Shaw 1984
James Byam Shaw 'Gentile Bellini and Constantinople' *Apollo* CXX 1984 pp. 56-58

Cachin 1983
Françoise Cachin et al *Manet* EXH CAT Grand Palais, Paris, Metropolitan Museum of Art, New York 1983

Callmann 1974
Ellen Callmann *Apollonio di Giovanni* Oxford 1974

Callmann 1984
Ellen Callmann 'Botticelli's Life of Saint Zenobius' *Art Bulletin* LXVI 1984 pp. 492-6

Campbell 1985
Lorne Campbell *The Early Flemish Pictures in the Collection of Her Majesty The Queen* Cambridge 1985

Campbell 1990
Lorne Campbell *Renaissance Portraits, European Portrait-Painting in the 14th, 15th and 16th Centuries* New Haven and London 1990

Campbell 1994
Lorne Campbell, David Bomford, Ashok Roy and Raymond White 'The Virgin and Child before a Firescreen: History, Examination and Treatment' *National Gallery Technical Bulletin* 15 1994 pp. 20–35

Cannell 1984
William S. Cannell 'Leonardo da Vinci "The Virgin of the Rocks" - A Reconsideration of the Documents and a new Interpretation' *Gazette des Beaux-Arts* 104 1984 pp. 99-108

Cantinelli 1930
Richard Cantinelli *Jacques-Louis David, 1748–1825* Paris and Brussels 1930

Cecchi 1989
Alessandro Cecchi and Antonio Natali *Andrea del Sarto* Florence 1989

Chamot 1964
Mary Chamot, Dennis Farr and Martin Butlin *Tate Gallery Catalogues: The Modern British Paintings, Drawings and Sculpture* London 1964

Chiarini 1986
Marco Chiarini (ed.) *Andrea del Sarto* EXH CAT Palazzo Pitti, Florence 1986

Christiansen 1988
K. Christiansen, L. B. Kanter and C. B. Strehlke *Painting in Renaissance Siena 1420–1500* EXH CAT Metropolitan Museum of Art, New York 1988

Christiansen 1992
Keith Christiansen and Jane Martineau (eds) *Andrea Mantegna* EXH CAT Royal Academy of Arts, London 1992

Clark 1951
Kenneth Clark *Piero della Francesca* London 1951

Clark 1985
Anthony Clark *Pompeo Batoni* Oxford 1985

Clarke 1986
Michael Clarke *Lighting up the Landscape* EXH CAT National Gallery of Scotland, Edinburgh 1986

Clarke 1991
Michael Clarke 'Degas and Corot. The Affinity Between Two Artists' Artists' *Apollo* CXXXII 1991 pp. 15–20

Clarke 1991a
Michael Clarke *Corot and the Art of Landscape* London 1991

Clarke 1991b
Michael Clarke and John Leighton *Corot* London 1991

Clifton 1989
James Clifton and John Spike 'Mattia Preti's Passage to Naples: A Documented Chronology, 1650–1660' *Storia dell'Arte* 65 1989 pp. 45–68

Cocke 1984
Richard Cocke *Veronese Drawings* London 1984

Cole 1977
Bruce Cole *Agnolo Gaddi* Oxford 1977

Condon 1983–4
Patricia Condon with Marjorie B. Cohn and Agnes Mongan *In Pursuit of Perfection: The Art of J.-A.-D. Ingres* EXH CAT J.B. Speed Art Museum, Louisville, and Kimbell Art Museum, Fort Worth 1983–4

Conisbee 1976–7
Philip Conisbee *Joseph Vernet, 1714–1789* EXH CAT Musée de la Marine, Paris 1976–7

Constable 1933
W. G. Constable (ed.) *A commemorative catalogue of the Exhibition of French art* no. 223 pl lxvi 1933

Constable/Links 1976
W. G. Constable revised by J. G. Links *Canaletto* Vol. II Oxford 1976

Cooper 1954
D. Cooper *The Courtauld Collection* London 1954

Corradini 1993
Sandro Corradini 'Parmigianino's contract for the Caccialupi Chapel in S. Salvatore in Lauro' *Burlington Magazine* CXXXV no. 1078 1993 pp. 27-29

Costello 1965
Jane Costello 'Poussin's Annunciation in London', *Essays in honour of Walter Friedlander* New York 1965

D'Hulst 1989
R.-A. D'Hulst and M. Vandenven *Corpus Rubenianum, The Old Testament* London 1989

Daulte 1959
F. Daulte *Alfred Sisley, catalogue raisonné de l'oeuvre peint* Lausanne 1959

David 1880
Jules David *Le Peintre Louis David, 1748–1825. Souvenirs et documents inédits* 2 vols Paris 1880

Davies 1936
Martin Davies 'A Portrait by the Aged Ingres' *Burlington Magazine* LXVIII no. 399 1936 pp. 257ff.

Davies 1946
Martin Davies *National Gallery Catalogues: The British School* London 1946

Davies 1953
Martin Davies *Les Primitifs Flamands, Corpus de la Peinture des Anciens Pays-Bas Méridionaux au Quinzième Siècle* Antwerp 1953

Davies 1954
Martin Davies *Les Primitifs Flamands* Antwerp 1954

Davies 1957
Martin Davies *National Gallery Catalogues: French School* London 1957

Davies 1959
Martin Davies *National Gallery Catalogues: The British School* London 1959

Davies 1961
Martin Davies *National Gallery Catalogues: The Earlier Italian Schools* London 1961

Davies 1968
Martin Davies *National Gallery Catalogues: The Early Netherlandish School* London 1968

Davies 1970
Martin Davies, with additions and some revisions by Cecil Gould *National Gallery Catalogues: French School, Early 19th Century, Impressionists, Post-Impressionists etc.* London 1970

Davies 1972
Martin Davies *Rogier van der Weyden* London 1972

Davies 1989
David Davies *El Greco: Mystery and Illumination* EXH CAT National Gallery of Scotland, Edinburgh 1989

Davies 1992
Alice Davies *Johan van Kessel* Doornspijk 1992

De Marchi 1986
Andrea De Marchi 'Sugli Esordi Veneti di Dosso Dossi' *Arte Veneta* XL 1986 pp. 20-8

De Marchi 1990
Andrea De Marchi 'Bernardino Zaganelli, Madonna col Bambino e le Sante Caterina e Maria Maddalena' in G. Romano (ed.), *Da Biduino ad Algardi* EXH CAT Antichi Maestri Pittori di Giancarlo Gallino, Turin 1990

De Vecchi 1970
Pierluigi De Vecchi and Carlo Bernari *L'opera completa del Tintoretto* Milan 1970

degli Esposti 1988
Giovanni degli Esposti *Guido Reni* Los Angeles 1988

Dell'Acqua 1972
Gian Alberto Dell' Acqua and Renzo Chiarelli *L'opera completa del Pisanello* Milan 1972

Doria 1929
Arnauld Doria *Louis Tocqué: biographie et catalogue critiques: l'oeuvre complet de l'artiste reproduite en cent quarante-neuf héliogravures* Paris 1929

Dorival 1976
Bernard Dorival *Philippe de Champaigne 1602–1674: la vie, l'oeuvre, et le catalogue raisonné de l'oeuvre* Paris 1976

Dubos 1971
Renée Dubos *Giovanni Santi: peintre et chroniqueur à Urbin au XVe siècle* Bordeaux 1971

Duclaux 1967–8
Lise Duclaux, Jacques Foucart, Hans Naef,

Maurice Sérullaz and Daniel Ternois *Ingres* EXH CAT Petit Palais, Paris 1967–8

Dumas 1990
Ann Dumas *Vuillard* Lyon 1990

Dunkerton 1982
Jill Dunkerton and Ashok Roy 'Interpretation of the X-Ray of du Jardin's "Portrait of a Young Man"' *National Gallery Technical Bulletin* 6 1982 pp. 19–25

Dunkerton 1983
Jill Dunkerton 'The Death of the Virgin' *National Gallery Technical Bulletin* 7 1983 pp. 21-30

Dunkerton 1985
Jill Dunkerton 'The transfer of Cima's "The Incredulity of S. Thomas"' *National Gallery Technical Bulletin* 9 1985 pp. 38-60

Dunkerton 1986
Jill Dunkerton 'The technique and restoration of Cima's "The Incredulity of S. Thomas"' *National Gallery Technical Bulletin* 10 1986 pp. 4–27

Dunkerton 1987
Jill Dunkerton, Ashok Roy and Alistair Smith 'The Unmasking of Tura's "Allegorical Figure": A Painting and its Concealed Image' *National Gallery Technical Bulletin* 11 1987 pp. 5-36

Dunkerton 1988
Jill Dunkerton, Aviva Burnstock and Alistair Smith 'Two Wings of an Altarpiece by Martin van Heemskerck' *National Gallery Technical Bulletin* 12 1988 pp. 16-36

Dunkerton 1991
Jill Dunkerton, Susan Foister, Dillian Gordon and Nicholas Penny *Giotto to Dürer, Early Renaissance Painting in The National Gallery* London 1991

Dunkerton 1993
Jill Dunkerton and Nicholas Penny 'The Infra-red Examination of Raphael's "Garvagh Madonna"' *National Gallery Technical Bulletin* 14 1993 pp. 6-22

Dunkerton 1993a
Jill Dunkerton 'The Technique and Restoration of Bramantino's "Adoration of the Kings"' *National Gallery Technical Bulletin* 14 1993 pp. 42–61

Dunkerton 1994
Jill Dunkerton 'Cosimo Tura as Painter and Draughtsman: The Cleaning and Examination of his "Saint Jerome"' *National Gallery Technical Bulletin* 15 1994 pp. 42–53

Durey 1980
Philippe Durey *Horace Vernet* EXH CAT Académie de France, Rome 1980

Dussler 1971
Luitpold Dussler *Raphael: A Critical Catalogue* London 1971

Ebert-Schifferer 1988
Sybille Ebert-Schifferer *Guido Reni und Europa* Frankfurt 1988

Egerton 1984
Judy Egerton *George Stubbs* EXH CAT Tate Gallery, London 1984

Egerton 1990
Judy Egerton *Wright of Derby* EXH CAT Tate Gallery, London 1990

Eisenberg 1989
Marvin Eisenberg *Lorenzo Monaco* Princeton 1989

Eitner 1983
L. Eitner *Géricault. His Life and Work* London 1983

Ekkart 1990
R. E. O. Ekkart 'Vijf kinderportretten door Dirck Santvoort' *Oud Holland* 104 1990 pp. 249–55

Ekserdjian 1991
David Ekserdjian 'A Note on Lorenzo Lotto's "Virgin and Child with Saint Jerome and Saint Nicholas of Tolentino"' *Journal of the Museum of Fine Arts* 3 1991 pp. 87-91

Emiliani 1985
Andrea Emiliani *Federico Barocci (Urbino 1535–1612)* Pesaro 1985

Emiliani 1986-7
Andrea Emiliani et al *The Age of Correggio and the Carracci* EXH CAT Pinacoteca Nazionale di Bologna, National Gallery of Art, Washington, and Metropolitan Museum of Art, New York 1986-7

Emiliani 1993–4
Andrea Emiliani *Ludovico Carracci* EXH CAT Museo Civico, Bologna, and Kimbell Art Museum, Fort Worth 1993-4

Enggass 1964
Robert Enggass *The Painting of Baciccio Giovanni Gaulli 1639-1709* University Park, Pennsylvania 1964

Ettlinger 1978
Helen Ettlinger 'The Virgin Snail' *Journal of the Warburg and Courtauld Institutes* XLI 1978 p. 316

Fabjan 1986
Barbara Fabjan *Filippino Lippi e la bottega di San Marco alla Certosa di Pavia, 1495–1511* Milan 1986

Fagiolo 1967
Maurizio Fagiolo dell'Arco and Marcello Fagiolo dell'Arco *Bernini. Una introduzione al gran teatro del barocco* Rome 1967

Fagiolo 1987
Marcello Fagiolo *Baldassarre Peruzzi, pittura scena e architettura nel Cinquecento* Rome 1987

Fahy 1967
Everett Fahy 'Some Early Italian Pictures in the Gambier-Perry Collection' *Burlington Magazine* CIX no. 768 1967 pp. 128–39

Fahy 1969
Everett Fahy 'The Earliest Works of Fra Bartolommeo' *Art Bulletin* LI 1969 pp. 142–54

Fahy 1978
Everett Fahy 'Italian Paintings at Fenway Court and Elsewhere' *The Connoisseur* 198 1978 pp. 28-43

Fantin-Latour 1911
Mme Fantin-Latour *Catalogue de l'oeuvre complet de Fantin-Latour* Paris 1911

Farr 1987
Dennis Farr (ed.) *100 Masterpieces from the Courtauld Collections* London 1987

Faunce 1978
Sarah Faunce and Linda Nochlin *Courbet Reconsidered* EXH CAT Brooklyn Museum, New York 1978

Feldeck 1966
Ole Feldeck 'A Danish Portrait of an East India Captain' *Burlington Magazine* CVIII no. 757 1966 pp. 193–4

Ferino Pagden 1982
Sylvia Ferino Pagden *Disegni umbri del Rinascimento da Perugino a Raffaello* EXH CAT Gabinetto disegni e stampe degli Uffizi, Florence 1982

Ferino Pagden 1984
Sylvia Ferino Pagden *Raffaello a Firenze* EXH CAT Palazzo Pitti, Florence 1984

Ferino Pagden 1989
Sylvia Ferino Pagden et al. *Giulio Romano* EXH CAT Palazzo Te, Mantua, and Palazzo Ducale, Mantua 1989

Fernier 1977
Robert Fernier *La vie et l'oeuvre de Gustave Courbet* 2 vols Geneva 1977

Ferrari and Scavizzi 1992
O. Ferrari and G. Scavizzi *Luca Giordano* 2 vols Naples 1992

Filedt Kok 1986
J. P. Filedt Kok et al *Kunst voor de beeldenstorm: Noord-nederlandse kunst 1525–1580* EXH CAT Rijksmuseum, Amsterdam 1986

Filipczak 1987
Zirka Zaremba Filipczak *Picturing Art in Antwerp* Princeton 1987

Fischel 1939
Oskar Fischel 'A motive of Bellinesque derivation in Raphael' *Old Master Drawings* XIII 1939 pp. 50-1

Fletcher 1981
Jennifer Fletcher 'Marcantonio Michiel: his friends and collection' *Burlington Magazine* CXXIII no. 941 1981 pp. 453–67

Fletcher 1990
Jennifer Fletcher 'Titian' *Burlington Magazine* CXXXII no. 1051 1990 pp. 740-4

Fletcher 1991
Jennifer Fletcher and David Skipsey 'Death in Venice: Giovanni Bellini and the Assassination of St Peter Martyr' *Apollo* CXXXIII 1991 pp.4–9

Foister 1991
Susan Foister 'The portrait of Alexander Mornauer' *Burlington Magazine* CXXXIII no. 1062 1991 pp. 613-18

Foister 1994
Susan Foister, Martin Wyld and Ashok Roy 'Hans Holbein's "A Lady with a Squirrel and a Starling"' *National Gallery Technical Bulletin* 15 1994 pp. 6–19

Fourcade 1993
Dominique Fourcade and Isabelle Monod-Fontaine *Henri Matisse 1904–1917* EXH CAT Centre Georges Pompidou, Paris 1993

Frangi 1987
Francesco Frangi *Giacomo Ceruti* Milan 1987

Franklin 1989
David Franklin 'A portrait by Rosso Fiorentino in the National Gallery' *Burlington Magazine* CXXXI no. 1041 1989 pp. 839-42

Franklin 1994
David Franklin *Rosso in Italy* New Haven and London 1994

Franks 1866
A. W. Franks 'Notes on Edward Grimston' *Archaeologia* XL 1866 pp. 455–60

French 1980
Anne French *Gaspard Dughet called Gaspar Poussin 1615–75: A French Landscape Painter in Seventeenth-Century Rome and his Influence on British Art* EXH CAT The Iveagh Bequest, Kenwood House, London 1980

Friedlander 1972
Max J. Friedlander *Early Netherlandish painting: Jan Gossaert and Bernart van Orley* Vol. 8 Leiden and Brussels 1972

Fry 1918
Roger Fry 'A cassone-panel by Cosimo Roselli (?)' *Burlington Magazine* XXXII no. 182 1918 pp. 200–1

Furlan 1988
Caterina Furlan *Il Pordenone* Milan 1988

Gabillot 1906
C. Gabillot 'Les Trois Drouais' *Gazette des Beaux-Arts* 35 1906 pp. 155-74

Galassi 1991
Peter Galassi *Corot in Italy* New Haven 1991

Ganz 1925
Paul Ganz 'An unknown Portrait by Holbein the Younger' *Burlington Magazine* XLVII no. 270 1925 pp. 113–15

Gardner von Teuffel 1984
Christa Gardner von Teuffel 'Sebastiano del Piombo, Raphael and Narbonne: new evidence' *Burlington Magazine* CXXVI no. 981 1984 pp. 765-6

Gardner von Teuffel 1987
Christa Gardner von Teuffel 'An early description of Sebastiano's "Raising of Lazarus" at Narbonne' *Burlington Magazine* CXXIX no. 108 1987 pp. 185-6

Garibaldi 1991
Charles Garibaldi and Mario Garibaldi *Monticelli* Geneva 1991

Garlick 1989
Kenneth Garlick *Sir Thomas Lawrence* Oxford 1989

Gaskell 1990
Ivan Gaskell *National Gallery Master Paintings from the collection of Wynn Ellis of Whitstable* Canterbury 1990

Gasquet 1926
Joachim Gasquet *Cézanne* Paris 1926 (1988 ed.)

Gaston 1991
Robert Gaston 'Love's Sweet Poison: A New Reading of Bronzino's London Allegory' *I Tatti Studies* 4 1991 pp. 249–88

Gebhardt 1991
Volker Gebhardt 'Some problems in the reconstruction of Uccello's Rout of San Romano cycle' *Burlington Magazine* CXXXIII no. 1056 1991 pp. 179-85

Glasser 1977
Hannelore Glasser *Artists' Contracts of the Early Renaissance* New York 1977

Goffen 1989
Rona Goffen *Giovanni Bellini* New Haven and London 1989

Golahny 1981
Amy Golahny 'Jan de Bisschop's St Helena after Veronese' *Master Drawings* XIX 1981 pp. 25-7

Gombrich 1972
Ernst H. Gombrich *Symbolic Images* London 1972

Gordon 1984
Dillian Gordon and Anthony Reeve 'Three Newly Acquired Panels from the Altarpiece for Santa Croce by Ugolino' *National Gallery Technical Bulletin* 8 1984 pp. 36-53

Gordon 1986
Dillian Gordon *The National Gallery Schools of Painting: British Paintings* London 1986

Gordon 1988
Martin Davies revised by Dillian Gordon *National Gallery Catalogues: The Early Italian Schools before 1400* London 1988

Göttsche 1935
Gertrud Göttsche *Wolfang Heimbach* Berlin 1935

Gould 1968
Cecil Gould 'An Identification for the Sitter of a Bellinesque Portrait' *Burlington Magazine* CX no. 788 1968 pp. 626-9

Gould 1975
Cecil Gould *National Gallery Catalogues: The Sixteenth Century Italian Schools* London 1975

Gould 1975a
Cecil Gould 'Notes on Parmigianino's "Mystic Marriage of St Catherine"' *Burlington Magazine* CXVII no. 865 1975 pp. 230-3

Gould 1976
Cecil Gould *The Paintings of Correggio* London 1976

Gowing 1985
Lawrence Gowing *The Originality of Thomas Jones* London 1985

Gowing 1988
Lawrence Gowing *Cézanne, The Early Years 1859–1872* EXH CAT Royal Academy of Arts, London, Musée d'Orsay, Paris, and National Gallery of Art, Washington 1988–9

Green 1982
Nicholas Green *Théodore Rousseau* London 1982

Gregori 1979
Mina Gregori *Giovanni Battista Moroni* Bergamo 1979

Gregori 1982
Mina Gregori *Giacomo Ceruti* Bergamo 1982

Gregori 1991–2
Mina Gregori (ed.) *Michelangelo Merisi da Caravaggio: Come nascono i capolavori* EXH CAT Palazzo Pitti, Florence, Palazzo Ruspoli, Rome 1991–2

Groom 1993
Gloria Groom *Edouard Vuillard, Painter-Decorator* New Haven and London 1993

Grosshans 1991
Rainald Grosshans 'Simon Marmion: das Retabel von Saint-Bertin zu Saint-Omer: zur Rekonstruktion und Entstehungsgeschichte des Altares' *Jahrbuch der Berliner Museen* 33 1991 pp. 63–98

Grote 1938
Ludwig Grote *Die Brüder Olivier und die Deutsche Romantik* Berlin 1938

Gualdi-Sabatini 1984
Fausta Gualdi-Sabatini *Giovanni di Pietro detto Lo Spagna* Spoleto 1984

Hamilton 1992–3
Vivien Hamilton *Boudin at Trouville* EXH CAT Burrell Collection, Glasgow, and Courtauld Institute Galleries, London 1992–3

Hand 1982
John Hand *Joos van Cleve: The Early and Mature Paintings* Ann Arbor 1982

Hand and Wolff 1986
John Oliver Hand and Martha Wolff *Early Netherlandish Painting* National Gallery of Art, Washington 1986

Hannover 1893
Emil Hannover *Maleren Christen Købke* Copenhagen 1893

Hannover 1898
Emil Hannover *Maleren C.W. Eckersberg* Copenhagen 1898

Harding 1989
Eric Harding, Allan Braham, Martin Ward and Aviva Burnstock 'The Restoration of the Leonardo Cartoon' *National Gallery Technical Bulletin* 13 1989 pp. 5–29

Harris 1977
Anne Sutherland Harris *Andrea Sacchi* Oxford 1977

Harris 1982
Enriqueta Harris *Velázquez* Oxford 1982

Harvey 1961
J. H. Harvey 'The Wilton Diptych - A Re-Examination' *Archaeologia* 98 Oxford 1961

Haskell 1991
Francis Haskell 'William Coningham and his collection of old masters' *Burlington Magazine* CXXXIII no. 1063 1991 pp. 676-81

Hawcroft 1988
Francis W. Hawcroft *Travels in Italy 1776–1783: Based on the Memoirs of Thomas Jones* EXH CAT Whitworth Art Gallery, Manchester 1988

Hayes 1982
John Hayes *The Landscape Paintings of Thomas Gainsborough* New York 1982

Hayes 1991
John Hayes *The Portrait in British Art* EXH CAT National Portrait Gallery, London 1991

Hayes Tucker 1982
Paul Hayes Tucker *Monet at Argenteuil* New Haven and London 1982

Hefting 1975
Victorine Hefting *Jongkind, sa vie, son oeuvre, son époque* Paris 1975

Heinemann 1962
Fritz Heinemann *Giovanni Bellini e i Belliniani* Venice 1962

Held 1980
J. S. Held *The Oil Sketches of Peter Paul Rubens, A Critical Catalogue* 2 vols Princeton 1980

Held 1982
Julius S. Held 'Artis Pictoriae Amator: An Antwerp Art Patron and his Collection', *Rubens and his Circle* Princeton, New Jersey, 1982

Hellebranth 1976
Robert Hellebranth *Charles-François Daubigny* Morges 1976

Helsted 1983
Dyveke Helsted, Eva Henschen and Bjarne Jørnaes *C.W. Eckersberg i Rom 1813–16* EXH CAT Thorvaldsens Museum, Copenhagen 1983

Helston 1982
Michael Helston *Second Sight: Canaletto, Guardi* EXH CAT National Gallery, London 1982

Helston 1983
Michael Helston *National Gallery Schools of Painting: Spanish and Later Italian Paintings* London 1983

Helston 1989
Michael Helston (ed.) *Painting in Spain During the Later Eighteenth Century* EXH CAT National Gallery, London 1989

Helston 1991
Michael Helston and Tom Henry *Guercino in Britain* National Gallery, London 1991

Hendy 1947
P. Hendy *Cleaned Pictures* EXH CAT National Gallery, London 1947

Henry 1994
Tom Henry 'The Subject of Domenico Morone's "Tournament" panels in the National Gallery, London' *Burlington Magazine* CXXXVI no. 1090 1994 pp. 21–2

Herbert 1962–3
Robert Herbert *Barbizon Revisited* EXH CAT Californian Palace of the Legion of Honor, San Francisco, Toledo Museum of Art, Cleveland Museum of Art, and Museum of Fine Arts, Boston 1962–3

Herbert 1976
Robert Herbert *Jean-François Millet* EXH CAT Galeries Nationales du Grand Palais, Paris, and Hayward Gallery, London 1976

Herbert 1991
Robert Herbert *Georges Seurat 1859–1891* New York 1991

Herbst 1934
Friedrich Herbst *Otto Scholderer. Ein Betrag zur Künstler- und Kunstgeschichte des 19. Jahrhunderts* Frankfurt am Main 1934

Hibbard 1983
H. Hibbard *Caravaggio* London 1983

Hirst 1981
Michael Hirst *Sebastiano del Piombo* Oxford 1981

Hirst 1981a
Michael Hirst 'Michelangelo in Rome: an altar-piece and the "Bacchus"' *Burlington Magazine* CXXIII no. 943 1981 pp. 581-93

Hirst 1988
Michael Hirst *Michelangelo Draftsman* Milan 1988

Hirst 1994
Michael Hirst and Jill Dunkerton *Making and Meaning: The Young Michelangelo. The Artist in Rome 1496–1501* EXH CAT National Gallery, London 1994

Hoffman 1978
Edith Warren Hoffman 'A reconstruction and reinterpretation of Guillaume Fillastre's altar-piece of St. Bertin' *Art Bulletin* LX 1978 pp. 634–49

Holberton 1986
Paul Holberton 'Battista Guarino's Catullus and Titian's "Bacchus and Ariadne"' *Burlington Magazine* CXXVII no. 998 1986 pp. 347-50

Holmes 1991-2
Mary Tavener Holmes *Nicolas Lancret 1690–1743* EXH CAT Frick Collection, New York 1991-2

Hood 1993
W. Hood *Fra Angelico at San Marco* New Haven and London 1993

Hope 1980
Charles Hope *Titian* London 1980

Hope 1983
Charles Hope (ed.) *The Genius of Venice 1500–1600* EXH CAT Royal Academy of Arts, London 1983

Hope 1987
Charles Hope 'The Camerino d'Alabastro: A Reconsideration of the Evidence' in Görel Cavalli-Björkman (ed.) *Bacchanals by Titian and Rubens* Stockholm 1987

Horn 1989
Hendrik J. Horn *Jan Cornelisz. Vermeyen* 2 vols Doornspijk 1989

Horster 1980
Marita Horster *Andrea del Castagno* Oxford 1980

House 1979–80
John House and Mary Anne Stevens (eds.) *Post Impressionism: Cross Currents in European Painting* EXH CAT Royal Academy of Arts, London 1979

House 1985
John House, Anne Distel and Lawrence Gowing *Renoir* Galeries Nationales du Grand Palais, Paris, Museum of Fine Arts, Boston, and Arts Council of Great Britain, London 1985

House 1986
John House *Monet: Nature into Art* New Haven and London 1986

House 1987
John House 'London in the Art of Monet and Pissarro' in Malcolm Warner (ed.) *The Image of London: Views by Travellers and Emigrés 1550–1920* EXH CAT Barbican Art Gallery, London 1987

Howarth 1985
David Howarth *Lord Arundel and his Circle* New Haven and London 1985

Howarth 1985–6
David Howarth *Patronage and Collecting in the Seventeenth Century: Thomas Howard, Earl of Arundel* EXH CAT Ashmolean Museum, Oxford 1985-6

Howell Jolly 1982
Penny Howell Jolly *Jan van Eyck & St. Jerome: A Study of Eyckian Influence on Colantonio & Antonello da Messina in Quattrocento Naples* Ph.D. Thesis, University of Pennsylvania, Ann Arbor 1982

Howell Jolly 1982a
Penny Howell Jolly 'Antonello da Messina's "St Jerome in his Study": a disguised portrait?' *Burlington Magazine* CXXIV no. 946 1982 pp. 27-9

Huemer 1977
Francis Huemer *Corpus Rubenianum, Portraits I* London 1977

Hughes 1980
A. Hughes 'Naming the unnamable: an icono-graphical problem in Rubens's "Peace and War"' *Burlington Magazine* CXXII no.924 1980 pp. 157-65

Humfrey 1983
Peter Humfrey *Cima da Conegliano* Cambridge 1983

Hungerford 1993
Constance Cain Hungerford et al *Ernest Meissonier* EXH CAT Musée des Beaux-Arts, Lyon 1993

Iñiguez 1982
Diego Angulo Iñiguez *Murillo, Catálogo critico* Madrid 1982

Ives 1992-3
Colta Ives, Margret Stuffmann and Martin Sonnabend *Daumier Drawings* EXH CAT Städelsche Kunstinstitut and Städtische Galerie, Frankfurt, and the Metropolitan Museum of Art, New York 1992-3

Jaffé 1968
Michael Jaffé 'Rubens in Italy Part II: some rediscovered works of the first phase' *Burlington Magazine* CX no. 781 1968 pp. 174–87

Jaffé 1989
Michael Jaffé *Rubens: Catologo Completo* Milan 1989

Joannides 1992
Paul Joannides 'Titian's "Judith" and its context: the iconography of decapitation' *Apollo* CXXXV 1992 pp. 163–70

Joannides 1993
Paul Joannides *Masaccio and Masolino. A Complete Catalogue* London 1993

Johnson 1981–9
Lee Johnson *The Paintings of Eugène Delacroix: A Critical Catalogue* 6 vols Oxford 1981–9

Jones 1990
Mark Jones (ed.) *Fake?* EXH CAT British Museum, London 1990

Jones and Penny 1983
Roger Jones and Nicholas Penny *Raphael* New Haven and London 1983

Kanter 1983
Laurence B. Kanter 'Trittico di Benvenuto di Giovanni alla National Gallery di Londra' *Arte Cristiana* LXXI 1983

Kanter 1989
Laurence B. Kanter *The Late Works of Luca Signorelli and his followers 1498–1559* Ph.D. Thesis, New York University 1989

Kanter 1992
Laurence B. Kanter *Painting in Renaissance Siena 1420–1500* EXH CAT Metropolitan Museum of Art, New York 1992

Keith 1994
Larry Keith 'Carel Fabritius's "A View in Delft": Some Observations on its Treatment and Display' *National Gallery Technical Bulletin* 15 1994 pp. 54–63

Kendall 1989
Richard Kendall *Degas: Images of Women* EXH CAT Tate Gallery, London 1989

Keyes 1984
G. Keyes *Esaias van den Velde 1587–1630* Doornspijk 1984

Keynes 1991
Milo Keynes 'The iconography of Leonardo's London cartoon' *Gazette des Beaux-Arts* 117 1991 pp. 147-58

King 1985
Catherine King 'NG 3902 and the theme of Luke the Evangelist as artist and physician' *Zeitschrift für Kunstgeschichte* 48 1985 pp. 249-55

King 1987
Catherine King 'The Dowry farms of Niccolosa Serragli and the altarpiece of the Assumption in the National Gallery London (1126) ascribed to Francesco Botticini' *Zeitschrift für Kunstgeschichte* 50 1987 pp. 275-8

Kitson 1978
M. Kitson *Claude Lorrain: Liber Veritatis* London 1978

Knox 1978
George Knox 'The Tasso Cycles of Gianbattista Tiepolo and Gianantonio Guardi' *Art Institute of Chicago Museum Studies* 9 1978 pp. 49–95

Knox 1980
George Knox 'Anthony and Cleopatra: A Problem in the Editing of Tiepolo drawings' in W. Blissett (ed.) *Editing Illustrated Books* New York 1980

Koepplin 1974
D. Koepplin 'Zwei Fürstenbildnisse Cranachs von 1509' *Pantheon* XXXII 1974 pp. 25–34

Koerner 1990
Joseph Koerner *Caspar David Friedrich and the Subject of Landscape* London 1990

Kokole 1990
Stanko Kokole 'Notes on the Sculptural Sources for Giorgio Schiavone's Madonna in London' *Venezia Arti* Venice 1990

Kozakiewicz 1972
Stefan Kozakiewicz *Bernardo Bellotto* London 1972

Krohn 1915
Mario Krohn *Maleren Christen Købke* Copenhagen 1915

Krumrine 1989
Mary Louise Krumrine *Paul Cézanne Die Badenden* EXH CAT Kunstmuseum, Basel 1989

Kuretsky 1979
S. D. Kuretsky *The Paintings of Jacob Ochtervelt (1634–1682): with Catalogue Raisonné* Oxford 1979

Laclotte 1993
M. Laclotte (ed.) *Le siècle de Titien* EXH CAT Galeries Nationales du Grand Palais, Paris 1993

Langdon 1989
Helen Langdon *Claude Lorrain* Oxford 1989

Larsen 1988
Erik Larsen *The Paintings of Anthony van Dyck* Freren 1988

Lauts 1962
Jan Lauts *Carpaccio* London 1962

Laveissière 1991–2
Sylvain Laveissière and Régis Michel *Géricault* EXH CAT Galeries Nationales du Grand Palais, Paris 1991–2

Lavergne-Durey 1989
Valerie Lavergne-Durey 'Les Titon, mécènes et collectionneurs à Paris à la fin du XVIIe et au XVIIIe siècles' *Bulletin de la Société de l'Histoire de l'Art Français* 1989 pp. 77–103

Lee Roberts 1985
Perri Lee Roberts 'St Gregory the Great and the Santa Maria Maggiore altar-piece' *Burlington Magazine* CXXVII no. 986 1985 pp. 295-6

Leighton 1987
John Leighton *Acquisition in Focus: Jacques-Louis David: Portrait of Jacobus Blauw* EXH CAT National Gallery, London 1987

Leighton 1987a
John Leighton, Anthony Reeve, Ashok Roy and Raymond White 'Vincent Van Gogh's "A Cornfield, with Cypresses"' *National Gallery Technical Bulletin* 11 1987 pp. 42–59

Leighton 1990
John Leighton and Colin Bailey *Painting in Focus: Caspar David Friedrich's Winter Landscape* EXH CAT National Gallery, London 1990

Lemoisne 1946-9
P. A. Lemoisne *Degas et son oeuvre* 4 vols Paris 1946–9

Lennon 1987
Madeline Lennon 'Layard's Letters to Morelli' in F. M. Fales and B. J. Hickey (eds) *Austen Henry Layard tra l'Oriente e Venezia* Rome 1987

Lenzi 1979
Deanna Lenzi et al *Architettura, Scenografia Pittura di paesaggio* Bologna 1979

Letts 1991
Rosa Maria Letts (ed.) *Italy by Moonlight: The Night in Italian Painting 1550–1850* EXH CAT Accademia Italiana, London 1991 (second edition)

Levey 1959
Michael Levey *National Gallery Catalogues: The German School* London 1959

Levey 1971
Michael Levey *National Gallery Catalogues: 17th and 18th Century Italian Schools* London 1971

Levey 1977
Michael Levey et al *Late Gothic Art from Cologne* EXH CAT National Gallery, London 1977

Levey 1979
Michael Levey *Sir Thomas Lawrence* National Portrait Gallery, London 1979

Levey 1983
Michael Levey *The Neglected National Gallery* EXH CAT National Gallery, London 1983

Levey 1986
Michael Levey *Tiepolo* London 1986

Lightbown 1978
Ronald Lightbown *Sandro Botticelli* London 1978

Lightbown 1986
Ronald Lightbown *Mantegna* Oxford 1986

Lilli and Zampetti 1968
Virgilio Lilli and Pietro Zampetti *L'opera completa di Giorgione* Milan 1968

Lindsay 1974
Kenneth Lindsay 'Millet's Lost Winnower Rediscovered' *Burlington Magazine* CXVI no. 854 1974 pp. 239–45

Lippincott 1991
Kristin Lippincott 'A Masterpiece of Renaissance Drawing: A Sacrificial Scene by Gian Francesco de'Maineri' *Art Institute of Chicago Museum Studies* 17 1991 pp. 6-21

Lloyd 1977
Christopher Lloyd *The Earlier Italian Paintings in the Ashmolean Museum* Oxford 1977

Loche 1978
Renée Loche *L'opera completa di Liotard* Milan 1978

Löcher 1963
Kurt Löcher *Jakob Seisenegger: Hofmaler Kaiser Ferdinands I* Munich 1963

López-Rey 1963
José López-Rey *Velázquez, A Catalogue Raisonné of his Oeuvre* London 1963

Lyon 1958
Georgette Lyon *Joseph Ducreux* Paris 1958

Macé de Lepinay 1990
Macé de Lepinay *Giovan Battista Salvi "Il Sassoferrato"* EXH CAT Sassoferrato 1990

MacLaren 1970
Neil Maclaren revised by Allan Braham *National Gallery Catalogues: The Spanish School* London 1970

MacLaren/Brown 1991
Neil Maclaren expanded by Christopher Brown *National Gallery Catalogues: The Dutch School 1600–1900* 2 vols London 1991

Mahon 1991
Denis Mahon *Giovanni Francesco Barbieri: Il Guercino, 1591-1666* EXH CAT Museo Civico Archeologico, Bologna, and Museo Civico, Cento 1991

Maison 1968
Karl Eric Maison *Honoré Daumier: Catalogue Raisonné of the Paintings, Watercolours and Drawings* 2 vols Greenwich, Connecticut, 1968

Manca 1985
Joseph Manca 'An altar-piece by Ercole de'Roberti reconstructed' *Burlington Magazine* CXXVI no. 989 1985 pp. 521–2

Marani 1989
Pietro Marani *Leonardo: Catalogo completo dei dipinti* Florence 1989

Marchini 1975
Giuseppe Marchini *Filippo Lippi* Milan 1975

Marcora 1976
Carlo Marcora *Marco d'Oggiono* Oggiono 1976

Mariuz 1971
Adriano Mariuz *Giandomenico Tiepolo* Venice 1971

Marlier 1957
Georges Marlier *Ambrosius Benson et la peinture à Bruges au temps de Charles-Quint* Damme 1957

Marqués 1982–3
Manuela Mena Marqués and Enrique Valdivieso *Bartolomé Esteban Murillo, 1617–1682* EXH CAT Museo del Prado, Madrid, and Royal Academy of Arts, London 1982-3

Marrinan 1988
Michael Marrinan *Painting Politics for Louis-Philippe* New Haven 1988

Martens 1990
D. Martens 'Une Crucifixion flamande et son descendance au XVIe siècle' *Jaarboek van het Koninklijk Museum voor Schone Kunsten, Antwerpen* 1990 pp. 237–70

Martin 1966
Gregory Martin 'Rubens and Buckingham's "fayrie ile"' *Burlington Magazine* CVIII no. 765 1966 pp. 613-18

Martin 1966a
Gregory Martin 'Two working sketches for Engravings produced by Rubens' *Burlington Magazine* CVIII no. 758 1966 pp. 239-42

Martin 1968
Gregory Martin 'Rubens' 'Disegno Colorito' for Bishop Maes reconsidered' *Burlington Magazine* 1968 p. 434

Martin 1970
Gregory Martin *National Gallery Catalogues: The Flemish School circa 1600-circa 1900* London 1970

Martin 1985
Gregory Martin 'Two newly attributed works to Simon de Vos' *Rubens and his World* 1985 pp. 201–5

Martin 1994
Gregory Martin 'The Banqueting House ceiling: Two newly-discovered projects' *Apollo* CXXXIX 1994 pp. 29–34

Martindale 1979
Andrew Martindale *The Triumphs of Caesar by Andrea Mantegna in the collection of Her Majesty The Queen at Hampton Court* London 1979

Martineau 1981
Jane Martineau (ed.) *Splendours of the Gonzaga* EXH CAT Victoria and Albert Museum, London 1981

Martinelli 1950
Valentino Martinelli 'Le Pitture del Bernini' *Commentari* I 1950 pp. 95-104

Mathieu 1976
Pierre-Louis Mathieu *Gustave Moreau* Paris 1976

McConkey 1989
Kenneth McConkey *Corot* Tokyo 1989

McKillop 1974
Susan McKillop *Franciabigio* Berkeley 1974

McTavish 1981
David McTavish *Giuseppe Porta called Giuseppe Salviati* New York and London 1981

Mérot 1987
Alain Mérot *Eustache le Sueur (1616–1655)* Paris 1987

Mérot 1990
Alain Mérot *Nicolas Poussin* London 1990

Meulemeester 1984
Jean Luc Meulemeester *Jacob van Oost de Oudere en het zeventiende-eeuwse Brugge* Bruges 1984

Meyer zur Capellen 1985
Jürg Meyer zur Capellen *Gentile Bellini* Stuttgart 1985

Mezzetti 1977
Amalia Mezzetti *Girolamo da Ferrara detto da Carpi* Ferrara 1977

Michel 1987
Olivier Michel and Pierre Rosenberg *Subleyras 1699–1749* EXH CAT Musée du Luxembourg, Paris, and Accademia da Francia, Villa Medici, Rome 1987

Millar 1982
Oliver Millar *Van Dyck* EXH CAT National Portrait Gallery, London 1982

Milner 1990
Frank Milner *Degas* London 1990

Miquel 1980
Pierre Miquel *Eugène Isabey, 1803–1886. Le Marine au XIXe siècle* Maurs-la-Jolie 1980

Mojana 1989
Marina Mojana *Valentin de Boulogne* Milan 1989

Monducci 1987
E. Monducci and M. Pirondini *Lelio Orsi* Milan 1987

Montagu 1989
Jennifer Montagu *The Industry of Art: Roman Baroque Sculpture* London 1989

Morassi 1962
Antonio Morassi *A Complete Catalogue of the Paintings of G. B. Tiepolo* London 1962

Morassi 1973
Antonio Morassi *Guardi: L'opera completa di Antonio e Francesco Guardi* Venice 1973

Mottola Molfino 1991
Alessandra Mottola Molfino *Le Muse e il Principe* EXH CAT Museo Poldi Pezzoli, Milan 1991

Muller 1989
Jeffrey M. Muller *Rubens: The Artist as Collector* Princeton, New Jersey 1989

Müller Hofstede 1957
Cornelius Müller Hofstede ' Untersuchungen uber Giorgiones Selbstbildnis in Braunschweig' *Mitteilungen des Kunsthistorischen Institutes in Florenz* VIII 1957 pp. 13-34

Naef 1977–80
Hans Naef *Die Bildniszeichnungen von J.-A.-D. Ingres* 5 vols Bern 1977–80

National Gallery Reports
January 1969 – December 1970 London 1971
January 1971 – December 1972 London 1973
January 1973 – June 1975 London 1975
July 1975 – December 1977 London 1978
January 1978 – December 1979 London 1980
January 1980 – December 1981 London 1982
January 1982 – December 1984 London 1985
January 1985 – December 1987 London 1988
January 1988 – March 1989 London 1989
April 1989 – March 1990 London 1990
April 1990 – March 1991 London 1991
April 1991 – March 1992 London 1992
April 1992 – March 1993 London 1993
April 1993 – March 1994 London 1994

Newcome 1992
M. Newcome *Kunst in der Republik Genua* EXH CAT Schirn Kunsthalle, Frankfurt 1992

Nikolenko 1982–3
Lada Nikolenko *Pierre Mignard: The Portrait Painter of the Grand Siècle* Munich 1982–3

Novotny 1975
Fritz Novotny and Johannes Dobai *Gustav Klimt* Salzburg 1975

NPG Annual Report 1967
National Portrait Gallery Annual Report 1965–66 London 1967

Oberhuber 1977
Konrad Oberhuber 'The Colonna altarpiece in

the Metropolitan Museum and problems of the early style of Raphael' *Metropolitan Museum Journal* 12 1977 pp. 55-91

Oberhuber 1988
Konrad Oberhuber *Poussin, The Early Years in Rome, The Origins of French Classicism* Oxford 1988

Ormond 1975
Leonée Ormond and Richard Ormond *Lord Leighton* New Haven 1975

Ortiz 1989
Antonio Dominguez Ortiz et al *Velázquez* EXH CAT Prado, Madrid, Metropolitan Museum of Art, New York 1989

Ottino della Chiesa 1956
Angela Ottino della Chiesa *Bernardino Luini* Novara 1956

Owen 1988
Felicity Owen, David Blayney Brown and John Leighton *'Noble and Patriotic', The Beaumont Gift 1828* EXH CAT National Gallery, London 1988

Paccagnini 1972a
G. Paccagnini *Pisanello e il ciclo cavalleresco di Mantova* Venice [n.d.] 1972

Pace 1981
Claire Pace *Félibien's Life of Poussin* London 1981

Padovani 1971
Serena Padovani 'Un contributo alla cultura Padovana dello primo rinascimento: Giovan Francesco da Rimini' *Paragone* XXII 1971 pp. 3-31

Pallucchini 1962
Rodolfo Pallucchini *I Vivarini (Antonio, Bartolomeo, Alvise)* Venice 1962

Pallucchini 1982
Rodolfo Pallucchini and Paola Rossi *Tintoretto, Le opere sacre e profane* Milan 1982

Pallucchini 1983
Rodolfo Pallucchini and Francesco Rossi *Giovanni Cariani* Milan 1983

Panazza 1965
G. Panazza (ed.) *Mostra di Girolamo Romanino* EXH CAT Brescia 1965

Paolucci 1989
Antonio Paolucci *Piero della Francesca* Florence 1989

Parris 1967
Leslie Parris *The Loyd Collection of Paintings and Drawings* London 1967

Parris 1976
Leslie Parris, Ian Fleming-Williams and Conal Shields *Constable: Paintings, Watercolours and Drawings* EXH CAT Tate Gallery, London 1976

Parris 1991
Leslie Parris and Ian Fleming-Williams *Constable* EXH CAT Tate Gallery, London 1991

Partridge 1980
Loren Partridge and Randolph Starn *A Renaissance Likeness: Art and Culture in Raphael's Julius II* Berkeley and London 1980

Pasini 1990
G. Pasini *La Pittura Riminese del Trecento* Rimini 1990

Paulson 1989
Ronald Paulson *Hogarth: Graphic Works* 3rd revised edition London 1989

Paulson 1991
Ronald Paulson *Hogarth* New Brunswick and London 1991

Penny 1986
Nicholas Penny *Reynolds* EXH CAT Royal Academy of Arts, London 1986

Penny 1992
Nicholas Penny 'Raphael's "Madonna dei garofani" rediscovered' *Burlington Magazine* CXXXIV no. 1067 1992 pp. 67–81

Pepper 1984
Stephen Pepper *Guido Reni* Oxford 1984

Pérez Sánchez-Spinosa 1992
Alfonso E. Pérez Sánchez and Nicola Spinosa *Jusepe de Ribera 1591–1652* EXH CAT Metropolitan Museum of Art, New York 1992

Pickvance 1979
Ronald Pickvance *Degas 1879* EXH CAT

National Gallery of Scotland, Edinburgh 1979

Pickvance 1986–7
Ronald Pickvance *Van Gogh in Saint-Rémy and Auvers* EXH CAT Metropolitan Museum of Art, New York 1986–7

Pignatti 1969
Terisio Pignatti *Giorgione* Venice 1969

Pignatti 1976
Terisio Pignatti *Veronese* Venice 1976

Piper 1963
David Piper *Catalogue of the Seventeenth-Century Portraits in the National Portrait Gallery 1625–1714* Cambridge 1963

Pissarro 1939
Lodovico-Rodo Pissarro and Lionello Venturi *Camille Pissarro: son art et son oeuvre* 2 vols Paris 1939

Plesters 1979
Joyce Plesters 'Tintoretto's Paintings in the National Gallery, part I' *National Gallery Technical Bulletin* 3 1979 pp. 3-25

Plesters 1980
Joyce Plesters 'Tintoretto's Paintings in the National Gallery, part II' *National Gallery Technical Bulletin* 4 1980 pp. 32-49

Plesters 1983
Joyce Plesters '"Samson and Delilah": Rubens and the Art and Craft of Painting on Panel' *National Gallery Technical Bulletin* 7 1983 pp. 30-51

Plesters 1984
Joyce Plesters 'Tintoretto Paintings in the National Gallery, part III' *National Gallery Technical Bulletin* 8 1984 pp. 24-36

Plesters 1990
Joyce Plesters 'Technical Aspects of Some Paintings by Raphael in the National Gallery, London' J. Shearman and M. Hall (eds) *The Princeton Raphael Symposium*, Princeton 1990

Ponsonailhe 1883
Charles Ponsonailhe *Sebastien Bourdon, sa vie et son oeuvre: d'après des documents inédits tirés des archives de Montpellier* Montpellier 1883

Pope-Hennessy 1974
John Pope-Hennessy *Fra Angelico* London 1974

Pope-Hennessy 1987
John Pope-Hennessy *The Robert Lehman Collection, I: Italian Paintings* Metropolitan Museum of Art, New York 1987

Popham 1971
A. E. Popham *Catalogue of the Drawings of Parmigianino* New Haven 1971

Posner 1971
Donald Posner *Annibale Carracci: A Study in the Reform of Italian Painting Around 1590* London 1971

Potterton 1976
Homerton Potterton *The National Gallery Lends: Pictures from Eighteenth-century Venice* EXH CAT Arts Council, London 1976

Poulsen 1991
Ellen Poulsen *Jens Juel* 2 vols Copenhagen 1991

Previtali 1980
Giovanni Previtali 'Da Antonello da Messina a Jacopo di Antonello, i) La data del "Cristo benedicente" della National Gallery di Londra. ii) Il "Cristo Deposto" del Museo del Prado' *Prospettiva* 20 1980

Price 1980
Aimée Brown Price *Puvis de Chavannes: A Study of the Easel Paintings and a Catalogue of the Painted Works* Ph.D. Thesis, University of Michigan, Ann Arbor 1980

Pudelko 1937
Georg Pudelko 'The Altarpiece by Antonio Vivarini and Giovanni d'Alemagna, once at S. Moise at Venice' *Burlington Magazine* LXXI no. 414 1937 pp. 130-3

Puppi 1962
Lionello Puppi *Bartolomeo Montagna* Venice 1962

Rearick 1988
W. R. Rearick *The Art of Paolo Veronese* Washington 1988

Reff 1976
Theodore Reff *The Notebooks of Edgar Degas* 2 vols Oxford 1976

Renger 1974
Konrad Renger 'Dubens Dedit Dedicavitque Rubens' Beschäftigung mit der Druchgraphik, I: Der Kupferstich' *Jarhbuch der Berliner Museen* 16 1974 pp. 122-75

Rewald 1935
John Rewald and L. Marschutz 'Cézanne et le Château Noir', *L'Amour de l'Art* 1935

Rewald 1936
John Rewald *Cézanne et Zola* Paris 1936

Rewald 1939
John Rewald *Cézanne, sa vie, son oeuvre, son amitié pour Zola* Paris 1939

Rewald 1985
John Rewald *Studies in Impressionism* London 1985

Rewald 1986
John Rewald *Cézanne: a biography* New York 1986

Rewald 1989
John Rewald *Cézanne and America* London 1989

Reynaud and Ressort 1991
Nicole Reynaud and Claudie Ressort 'Les portraits d'hommes illustres du Studiolo d'Urbin' *Revue du Louvre* XLI 1991 pp. 82–116

Reynolds 1984
Graham Reynolds *The Later Paintings and Drawings of John Constable* New Haven and London 1984

Rice 1985
Eugene Rice *Saint Jerome in the Renaissance* Baltimore and London 1985

Richardson 1980
Francis L. Richardson *Andrea Schiavone* Oxford 1980

Robaut 1905
Alfred Robaut *L'oeuvre de Corot* 4 vols Paris 1905

Robertson 1954
Giles Robertson *Vincenzo Catena* Edinburgh 1954

Robinson 1990
M. S. Robinson *The Paintings of the Willem van de Veldes* London 1990

Rodinò 1987
Simonetta Prosperi Valenti Rodinò 'Il Cardinal Giuseppe Renato Imperieli committente e collezionista' *Bollettino d'Arte* 1987 pp.17–60

Roethlisberger 1961
Marcel Roethlisberger *Claude Lorrain: The Paintings* 2 vols London 1961

Roethlisberger 1975
Marcel Roethlisberger *L'opera complete di Claude Lorrain* Milan 1975

Rohlmann 1993
Michael Rohlmann 'Zitate flämischer Landschaftsmotive in Florentiner Quattrocento malerei' in J. Poeschke (ed.) *Italienische Frührenaissance und nordeuropäisches Mittelalter* Munich 1993 pp. 235–58

Romano 1986
Giovanni Romano *Bernardino Lanino e il Cinquecento a Vercelli* Turin 1986

Rooses 1886–92
Max Rooses *L'oeuvre de P.P. Rubens: histoire et description de ses tableaux et dessins* 5 vols Antwerp 1886–92

Rosaria Nappi 1991
Maria Rosaria Nappi *François de Nomé e Didier Barra: l'enigma Monsù Desiderio* Rome 1991

Rosenberg 1928
Jakob Rosenberg *Jakob van Ruisdael* Berlin 1928

Rosenberg 1979
Pierre Rosenberg *Chardin 1699–1779* EXH CAT Galeries Nationales du Grand Palais, Paris, and Cleveland Museum of Art 1979

Rosenberg 1988
Pierre Rosenberg and Jacques Thuillier *Laurent de La Hyre 1606–1656* EXH CAT Musées de

Grenoble, Rennes and Bordeaux 1988

Rosenberg 1993
Pierre Rosenberg *Tout l'oeuvre peint des Le Nain* Paris 1993

Rosenfeld 1981
Myra Nan Rosenfeld *Largillière and the Eighteenth-Century Portrait* EXH CAT Montreal Museum of Fine Arts, Montreal 1981

Rosenthal 1989
Lisa Rosenthal 'The Parens Patriae: Familial imagery in Rubens's Minerva Protects Pax from Mars' *Art History* 12 no.1 March 1989 pp. 22-38

Rovik 1988
Patricia Rovik 'The Odyssey Fresco by Pinturicchio' *Australian Journal of Art* VII 1988

Rowlands 1977
John Rowlands *Rubens, Drawings and Sketches* EXH CAT British Museum, London 1977

Rowlands 1985
John Rowlands *The Paintings of Hans Holbein the Younger* Oxford 1985

Roy 1988
Ashok Roy 'The Technique of a "Tüchlein" by Quinten Massys' *National Gallery Technical Bulletin* 12 1988 pp. 36-44

Rubin 1977
W. Rubin *Cézanne The Late Work* London 1977

Ruda 1993
Jeffrey Ruda *Fra Filippo Lippi: Life and Work with a Complete Catalogue* London 1993

Russell 1965
John Russell *Seurat* London 1965

Russell 1982–3
H. Diane Russell and Pierre Rosenberg *Claude Lorrain: 1600–1682* EXH CAT National Gallery of Art, Washington 1982–3

Russell 1983
Francis Russell 'A late work by Girolamo da Carpi' *Burlington Magazine* CXXV no. 963 1983 p. 359

Russell 1984
H. Diane Russell 'Claude's Psyche Pendants: London and Cologne' *Studies in the History of Art* 14 National Gallery of Art, Washington 1984 pp. 67-81

Salerno 1963
Luigi Salerno *Salvator Rosa* Milan 1963

Salerno 1975
Luigi Salerno *L'opera completa di Salvator Rosa* Salerno 1975

Salmi 1935
M. Salmi 'Aggiunte al Tre e al Quattrocento fiorentino' *Rivista d'Arte* XVII 1935 pp. 411-21

Scarpellini 1984
Pietro Scarpellini *Perugino* Milan 1984

Scharf 1866
G. Scharf 'Observations on the Portrait of Edward Grimston' *Archaeologia* XL 1866 pp. 471–82

Schleier 1970
E. Schleier 'An unnoticed early work by Pietro da Cortona' *Burlington Magazine* CXII 1970 pp. 752-9

Schmit 1973
Robert Schmit *Eugène Boudin* Paris 1973

Schmit 1993
Robert and Manuel Schmit *Stanislas Lépine 1835-1892* Paris 1993

Schnapper 1980
Antoine Schnapper *David, témoin de son temps* Fribourg 1980

Schnapper 1989–90
Antoine Schnapper and Arlette Sérullaz *Jacques-Louis David 1748–1825* EXH CAT Louvre, Paris, and Musée national du château, Versailles 1989–90

Schubert 1970
Dietrich Schubert *Die Gemälde des Braunschweig Maugsammisten* Cologne 1970

Schulz 1982
W. Schulz *Herman Saftleven 1609–85 Leben und Werke* Berlin 1982

Schwartz 1992
Sanford Schwartz *Christen Købke* New York 1992

Shakeshaft 1981
Paul Shakeshaft 'Elsheimer and G. B. Crescenzi' *Burlington Magazine* CXXII no. 123 1981 pp. 550–1

Shearman 1965
John Shearman *Andrea del Sarto* Oxford 1965

Shearman 1983
John Shearman *The Early Italian Pictures in the Collection of Her Majesty The Queen* Cambridge 1983

Sheon 1979
Aaron Sheon *Monticelli, His Contemporaries, His Influence* EXH CAT Museum of Art, Carnegie Institute, Pittsburgh 1979

Sillevis 1983
John Sillevis, Ronald De Leeuw and Charles Dumas *L'Ecole de La Haye: Les Maitres Hollandais du 19eme Siècle* EXH CAT Galeries Nationales du Grand Palais, Paris, Royal Academy of Arts, London, and Haags Gemeentemuseum, The Hague 1983

Silver 1984
Larry Silver *The Paintings of Quinten Massys* Oxford 1984

Sironi 1981
Grazioso Sironi *Nuovi documenti riguardanti la "Vergine delle Rocce" di Leonardo da Vinci* Milan n.d. [1981]

Slive 1970–4
Seymour Slive *Frans Hals* 3 vols London and New York 1970–4

Slive 1989–90
Seymour Slive et al *Frans Hals* EXH CAT National Gallery of Art, Washington, Royal Academy of Arts, London, and Frans Halsmuseum, Haarlem 1989-90

Smith 1983
Alistair Smith and Martin Wyld 'Altdorfer's "Christ Taking Leave of his Mother"' *National Gallery Technical Bulletin* 7 1983 pp. 50–64

Smith 1985
Alistair Smith *National Gallery Schools of Paintings: Early Netherlandish and German Paintings* London 1985

Smith 1989
Alistair Smith, Anthony Reeve, Christine Powell and Aviva Burnstock 'An Altarpiece and its Frame: Carlo Crivelli's "Madonna della Rondine"' *National Gallery Technical Bulletin* 13 1989 pp. 29-44

Smith 1992
Elise Lawton Smith *The Paintings of Lucas van Leyden* Columbia, Missouri and London 1992

Spear 1982
Richard E. Spear *Domenichino* London 1982

Sricchia Santoro 1986
Fiorella Sricchia Santoro *Antonello e l'Europa* Milan 1986

Stechow 1975
W. Stechow *Salomon van Ruysdael* Berlin 1975

Steer 1982
John Steer *Alvise Vivarini, His Art and Influence* Cambridge 1982

Sterling 1990
Charles Sterling *La peinture médiévale à Paris 1300–1500* 2 vols Paris 1990

Stradiotti 1990
R. Stradiotti *Savoldo* EXH CAT Monastero di Santa Giulia, Brescia 1990

Strehlke 1987
Carl Strehlke and Mark Tucker 'The Santa Maria Maggiore Altarpiece: New Observations' *Arte Cristiana* 719 1987

Strobl 1980–4
Alice Strobl *Gustav Klimt. Die Zeichnungen 1878–1918* Salzburg 1980–4

Strong 1972
Roy Strong *Van Dyck: Charles I on Horseback* London 1972

Stubblebine 1979
James H. Stubblebine *Duccio di Buoninsegna and his School* Princeton, New Jersey 1979

Sutton 1980
Peter C. Sutton *Pieter de Hooch* Oxford 1980

Sutton 1986
Denys Sutton *Edgar Degas* New York 1986

Sweeny 1966
Barbara Sweeny *John G. Johnson Collection: Catalogue of Italian Painting* Philadelphia 1966

Syre 1979
Cornelia Syre *Studien zum Maestro del Bambino Vispo und Starnina* Bonn 1979

Tanzi 1991
Marco Tanzi 'Boccaccio Boccaccino: il "Dio Padre" del Duomo di Cremona' *Bollettino d'Arte* 1991 pp. 129-36

Tate Gallery 1934
Tate Gallery *Catalogue: Modern Foreign Schools* (revised) London 1934

Tátrai 1978
V. Tátrai 'Gli affreschi del Palazzo Petrucci a Siena, una precisazione iconografica e un ipotesi sul programma' *Acta Historiae Artium* 24 1978 pp. 177–83

Tátrai 1979
V. Tátrai 'Il Maestro della Storia di Griselda e una Famiglia Senese di Mecenati Dimenticata' *Acta Historiae Artium* 25 1979 pp. 27–66

Taylor 1984
Graeme J. Taylor 'Judith and the Infant Hercules: Its Iconography' *American Imago* 41 1984 pp. 101-15

Tazartes 1983
Maurizia Tazartes 'Artisti e committenti ai primi del Cinquecento in San Frediano di Lucca' *Ricerche di Storia dell'arte* 21 1983

Tellini Perina 1970
Chiara Tellini Perina *Giuseppe Bazzani* Florence 1970

Thomson 1988
Belinda Thomson *Vuillard* Oxford 1988

Thomson 1988a
Richard Thomson *Degas: The Nudes* London 1988

Thomson 1991–2
Belinda Thomson *Vuillard* EXH CAT Art Gallery and Museum, Glasgow, Graves Art Gallery, Sheffield, and Van Gogh Museum, Amsterdam 1991–2

Thuillier 1974
Jacques Thuillier *L'opera completa di Poussin* Milan 1974

Thuillier 1978
Jacques Thuillier *Les Frères le Nain* EXH CAT Galeries Nationales du Grand Palais, Paris 1978

Todini 1989
Filippo Todini *La Pittura Umbra dal Duecento al Primo Cinquecento* Milan 1989

Torella 1989
Fabrizio Torella 'L'Ombra della mezzaluna sull'arte italiana. Il polittico Griffoni' *Musei Ferraresi* 15 1989

Torella 1991
Fabrizio Torella 'Ancora sul polittico Griffoni. Smembramento. Ricostruzione. Fortuna (e sfortuna) critica' *Musei Ferraresi* 16 1991 pp. 39-46

Torriti 1990
Piero Torriti (ed.) *Domenico Beccafumi e il suo tempo* EXH CAT S. Agostino and Pinacoteca Nazionale, Siena 1990

Toussaint 1985
Hélène Toussaint *Les Portraits d'Ingres: peintures des musées nationaux* EXH CAT Réunion des musées nationaux, Paris 1985

Tschira van Oyen 1972
Gundula Tschira van Oyen *Jan Baegert der Meister von Cappenberg* Baden-Baden 1972

Tyler 1991–2
David Tyler 'Thomas Gainsborough's Daughters' *Gainsborough's House Society Annual Report* 1991-2

Tyler 1992–3
David Tyler 'Thomas Gainsborough's Days in Hatton Garden' *Gainsborough's House Review* 1992–3 pp. 27–32

Uitert 1990
Evert van Uitert, Louis van Tilborgh and Sjaar van Heugten *Vincent Van Gogh* EXH CAT Rijksmuseum Vincent Van Gogh, Amsterdam, and Rijksmuseum Kröller - Muller, Otterlo, Milan and Rome 1990

Vaccaro 1993
Mary Vaccaro 'Documents for Parmigianino's "Vision of St Jerome"' *Burlington Magazine* CXXXV no. 1078 1993 pp. 22-7

Vaillat 1923
Léandre Vaillat and Paul Ratouis de Limay *J.-B. Perronneau (1715–1783): sa vie et son oeuvre* Paris 1923

Valcanover 1990
Francesco Valcanover (ed.) *Tiziano* EXH CAT Palazzo Ducale, Venice 1990

Van Os 1990
Henk van Os *Sienese Altarpieces 1215–1460* vol 2 Groningen 1990

Van Waadenoijen 1974
Jeanne van Waadenoijen 'A proposal for Starnina: exit the Maestro del Bambino Vispo' *Burlington Magazine* CXVI no. 851 1974 pp. 82–91

Venturi 1936
Lionello Venturi *Cézanne* Paris 1936

Venturini 1970
Giuseppe Venturini 'Giovanni Mario Verdizzotti, pittore e incisore, amico e discepolo del Tiziano' *Bollettino di Museo Civico di Padova* 59 1970 pp. 33–73

Verdi 1990
Richard Verdi *Cézanne and Poussin: The Classical Vision of Landscape* Edinburgh 1990

Verdi 1992
Richard Verdi *Nicolas Poussin: Tancred & Erminia* EXH CAT Birmingham Museum and Art Gallery 1992–3

Vincent 1968
H. P. Vincent *Daumier and his World* Evanston 1968

Viroli 1990
Giordano Viroli in Andrea Emiliani (ed.) *Giuseppe Maria Crespi* EXH CAT Bologna 1990

Vlieghe 1987
Hans Vlieghe *Corpus Rubenianum, Rubens: Portraits of Identified Sitters in Antwerp* London 1987

Vollard 1937
Ambroise Vollard *Degas* New York 1937

Volpe 1989
Carlo Volpe *Pietro Lorenzetti* Milan 1989

Walker Art Gallery 1977
Walker Art Gallery Foreign Catalogue Liverpool 1977

Waterhouse 1958
Ellis Waterhouse *Gainsborough* London 1958

Webster 1976
Mary Webster *Johann Zoffany* EXH CAT National Portrait Gallery, London 1976

Weisberg 1979
Gabriel P. Weisberg *François Bonvin* Paris 1979

Westhoff-Krummacher 1965
Hildegard Westhoff-Krummacher *Barthel Bruyn der Ältere als Bilnismaler* Munich 1965

Wethey 1969
Harold Wethey *The Paintings of Titian: The Religious Paintings* London 1969

Wethey 1971
Harold Wethey *The Paintings of Titian: The Portraits* London 1971

Wethey 1975
Harold Wethey *The Paintings of Titian: The Mythological and Historical Paintings* London 1975

Wettengl 1990
Kurt Wettengl *Caspar David Friedrich: Winterlandschaften* EXH CAT Museum für Kunst und Kulturgeschichte der Stadt, Dortmund 1990

Wheelock 1991
Arthur Wheelock (ed.) *Van Dyck* EXH CAT National Gallery of Art, Washington 1991

White 1979
John White *Duccio, Tuscan Art and the Medieval Workshop* London 1979

White 1980
Raymond White, Ashok Roy, John Mills and Joyce Plesters 'George Stubbs's "Lady and Gentleman in a Carriage": A Preliminary Note on the Technique' *National Gallery Technical Bulletin* 4 1980 p. 64

White 1988
Barbara White *Renoir: His Life, Art and Letters* New York 1988

Whitfield 1982
Clovis Whitfield (ed.) *Painting in Naples 1606–1705: from Caravaggio to Giordano* EXH CAT Royal Academy of Arts, London 1982

Wilde 1957
Johannes Wilde 'Notes on the genesis of Michelangelo's Leda', in D.J. Gordon (ed.) *Fritz Saxl 1890–1948: A volume of Memorial Essays from his friends in England* London 1957

Wildenstein 1921
Georges Wildenstein *Chardin* Paris 1921

Wildenstein 1924
Georges Wildenstein *Lancret* Paris 1924

Wildenstein 1954
Georges Wildenstein *Ingres* London 1954

Wildenstein 1973
Daniel Wildenstein and Guy Wildenstein *Documents complémentaires au catalogue de l'oeuvre de Louis David* Paris 1973

Wildenstein 1974–93
Daniel Wildenstein *Claude Monet: Biographie et catalogue raisonné* 5 vols Lausanne and Paris 1974–93

Wilson 1978
Michael Wilson 'Two Le Nain Paintings in the National Gallery Re-appraised' *Burlington Magazine* CXX no. 905 1978 pp. 530–3

Wilson 1985
Michael Wilson *National Gallery Schools of Painting: French Paintings before 1800* National Gallery, London 1985

Wilson 1992
Nigel Wilson 'Greek Inscriptions on Renaissance Paintings' *Italia Medioevale e Umanista* XXXV 1992 pp. 215-52

Wilson Bareau 1986
Juliet Wilson Bareau *The Hidden Face of Manet* EXH CAT Courtauld Institute Galleries, London 1986

Wilson Bareau 1986a
Juliet Wilson Bareau 'Edouard Vuillard et les princes Bibesco' *Revue de l'Art* 74 1986 pp. 37-46

Wilson Bareau 1992
Juliet Wilson Bareau *Manet: The Execution of Maximilian* EXH CAT National Gallery, London 1992

Wine 1992
Humphrey Wine and Olaf Koester *Poussin and Claude and French Painting of the Seventeenth Century* EXH CAT Statens Museum for Kunst, Copenhagen 1992

Wine 1993
Humphrey Wine, Paul Ackroyd and Aviva Burnstock 'Laurent de La Hyre's "Allegorical Figure of Grammar"' *National Gallery Technical Bulletin* 14 1993 pp. 22-34

Wine 1994
Humphrey Wine *Claude: The Poetic Landscape* EXH CAT National Gallery, London 1994

Winkler 1964
Friedrich Winkler *Das Werk des Hugo van der Goes* Berlin 1964

Wohl 1980
Hellmut Wohl *The Paintings of Domenico Veneziano c.1410–1461* Oxford 1980

Woolf 1988
Felicity Woolf *Myths and Legends: Paintings in the National Gallery* London 1988

Wright 1980
Joanne Wright 'Antonello da Messina. The Origins of his Style and Technique' *Art History* 3 1980 pp. 41-60

Wright 1985
Christopher Wright *Poussin Paintings - A Catalogue Raisonné* London 1985

Wright 1992
Alison Wright *Studies in the Painting of the Pollaiuolo* Ph.D. Thesis, University of London 1992

Wyld 1979
Martin Wyld, Ashok Roy and Alistair Smith 'Gerard David's "The Virgin and Child with Saints and a Donor"' *National Gallery Technical Bulletin* 3 1979 pp. 51-66

Wyld 1981
Martin Wyld 'Goya's Re-use of a Canvas for Doña Isabel' *National Gallery Technical Bulletin* 5 1981 pp. 38–43

Zampetti 1969
Pietro Zampetti (ed.) *Il libro di spese diverse* Venice and Rome 1969

Zampetti 1975
Pietro Zampetti *I Pittori Bergamaschi. Il Cinquecento I* Bergamo 1975

Zampetti 1986
Pietro Zampetti *Carlo Crivelli* Florence 1986

Zehnder 1977
Frank Günter Zehnder, Alistair Smith, Anton Legner and Götz Czymmek *Late Gothic Art from Cologne* EXH CAT National Gallery, London 1977

Zeri 1991
Federico Zeri *Giorno per Giorno: Scritti sull'Arte Toscana dal Trecento al Primo Cinquecento* Turin 1991

Zervos 1957
Christian Zervos *Pablo Picasso, Vol. I, 1895–1906* Paris 1957

Index by Inventory Number

| | | | | | | |
|---|---|---|---|---|---|
| 2250 | ITALIAN | 2543 | A. van OSTADE | 2621 | DAUBIGNY |
| 2251 | ITALIAN | 2544 | I. van OSTADE | 2622 | DAUBIGNY |
| 2256 | HARPIGNIES | 2545 | CUYP | 2623 | DAUBIGNY |
| 2258 | Attributed to MICHEL | 2546 | DUTCH | 2624 | DAUBIGNY |
| 2281 | LOTTO | 2547 | Imitator of CUYP | 2625 | COROT |
| 2282 | P. WOUWERMANS | 2548 | Attributed to van CALRAET | 2626 | COROT |
| 2283 | A. van der NEER | 2549 | BREKELENKAM | 2627 | COROT |
| 2285 | F. HALS | 2550 | BREKELENKAM | 2628 | COROT |
| 2288 | VALLIN | 2551 | Attributed to van den BOSCH | 2629 | COROT |
| 2289 | FRENCH | 2552 | DELFT | 2630 | COROT |
| 2291 | FRENCH | 2553 | OCHTERVELT | 2631 | COROT |
| 2292 | Van MIEREVELD | 2554 | P. WOUWERMANS | 2632 | DIAZ de la Peña |
| 2293 | BAUGIN | 2555 | STEEN | 2633 | DIAZ de la Peña |
| 2294 | ITALIAN | 2556 | STEEN | 2634 | DUPRE |
| 2295 | NETHERLANDISH | 2557 | STEEN | 2635 | T. ROUSSEAU |
| 2439 | T. ROUSSEAU | 2558 | STEEN | 2636 | J.-F. MILLET |
| 2475 | HOLBEIN the Younger | 2559 | STEEN | 2651 | CONSTABLE |
| 2480 | P. ROUSSEAU | 2560 | STEEN | 2652 | CONSTABLE |
| 2482 | BENVENUTO di Giovanni | 2561 | RUISDAEL | 2669 | Style of MARMION |
| 2483 | Attributed to FIORENZO di Lorenzo | 2562 | RUISDAEL | 2670 | COLOGNE |
| 2484 | Follower of PERUGINO | 2563 | RUISDAEL | 2671 | Attributed to FRANCIA |
| 2485 | CESARE da Sesto | 2564 | RUISDAEL | 2672 | Alvise VIVARINI |
| 2486 | COSTA | 2565 | RUISDAEL | 2673 | Follower of LEONARDO |
| 2487 | FRANCIA | 2566 | Follower of RUISDAEL | 2709 | J. MARIS |
| 2488 | SIGNORELLI | 2567 | RUISDAEL | 2710 | J. MARIS |
| 2489 | Domenico GHIRLANDAIO | 2568 | VERMEER | 2712 | BOSBOOM |
| 2490 | Attributed to Fra BARTOLOMMEO | 2569 | Style of BROUWER | 2713 | ISRAELS |
| 2491 | Attributed to R. GHIRLANDAIO | 2570 | HOBBEMA | 2714 | ISABEY |
| 2492 | ITALIAN | 2571 | HOBBEMA | 2715 | ISABEY |
| 2493 | SEBASTIANO del Piombo | 2572 | A. van de VELDE | 2723 | Attributed to ONOFRI |
| 2494 | CARIANI | 2573 | W. van de VELDE | 2724 | Attributed to ONOFRI |
| 2495 | Attributed to CARIANI | 2574 | W. van de VELDE | 2725 | DIANA |
| 2496 | Follower of BOLTRAFFIO | 2575 | Van VELSEN | 2727 | LEPINE |
| 2497 | Workshop of BOTTICELLI | 2576 | CODDE | 2731 | BUYTEWECH |
| 2498 | BASAITI | 2577 | Imitator of van GOYEN | 2732 | ISRAELS |
| 2499 | BASAITI | 2578 | Van GOYEN | 2757 | Attributed to TORO (Transferred to |
| 2500 | PREVITALI | 2579 | Van GOYEN | | The British Museum) |
| 2501 | PREVITALI | 2580 | Van GOYEN | 2758 | BOUDIN |
| 2502 | David GHIRLANDAIO | 2581 | MAES | 2759 | Attributed to MICHEL |
| 2503 | SOLARIO | 2582 | Attributed to de HEEM | 2767 | After COURBET |
| 2504 | Workshop of SOLARIO | 2583 | POTTER | 2786 | CHANTREY |
| 2505 | CIMA da Conegliano | 2584 | CODDE | 2790 | GOSSAERT |
| 2506 | CIMA da Conegliano | 2585 | YSENBRANDT | 2856 | QUAST |
| 2507 | BARTOLOMMEO Veneto | 2586 | Van de CAPPELLE | 2862 | LORENZO MONACO |
| 2508 | ITALIAN | 2587 | DUBBELS | 2863 | After BENOZZO |
| 2509 | JACOMETTO Veneziano | 2588 | Van de CAPPELLE | 2864 | LIEVENS |
| 2510 | Imitator of RAPHAEL | 2589 | Van DEUREN | 2874 | M. MARIS |
| 2511 | ITALIAN | 2590 | METSU | 2875 | W. MARIS |
| 2512 | Attributed to CORREGGIO | 2591 | METSU | 2876 | DAUBIGNY |
| 2513 | G.B. TIEPOLO | 2592 | CLAESZ. | 2897 | WATTEAU |
| 2514 | Follower of CANALETTO | 2593 | CHRISTUS | 2900 | After TINTORETTO |
| 2515 | CANALETTO | 2594 | MEMLINC | 2901 | Workshop of Giovanni BELLINI |
| 2516 | CANALETTO | 2595 | D. BOUTS | 2902 | Domenico GHIRLANDAIO |
| 2516.1 | CANALETTO (Transferred to the British | 2596 | Workshop of G. DAVID | 2903 | ITALIAN |
| | Museum) | 2597 | NETHERLANDISH (?) | 2904 | Imitator of GUARDI |
| 2517 | GUARDI | 2598 | RUBENS | 2905 | Imitator of GUARDI |
| 2518 | GUARDI | 2599 | Imitator of TENIERS | 2906 | Workshop of BOTTICELLI |
| 2519 | GUARDI | 2600 | TENIERS the Younger | 2907 | Attributed to BERNARDINO da Asola |
| 2520 | GUARDI | 2601 | Imitator of TENIERS | 2908 | Attributed to Fra ANGELICO |
| 2521.–3 | GUARDI | 2602 | NETHERLANDISH | 2909 | Van LINT |
| 2522 | GUARDI | 2603 | JOOS van Cleve | 2910 | FRENCH |
| 2523 | GUARDI | 2604 | AUGSBURG | 2911 | CARMONTELLE (Transferred to the British |
| 2524 | GUARDI | 2605 | BRUYN the Elder | | Museum) |
| 2525 | GUARDI | 2606 | Attributed to Workshop of COECKE | 2919 | RAPHAEL |
| 2526 | SPANISH | 2607 | Style of VERMEYEN | 2922.1–3 | MASTER of DELFT |
| 2527 | COQUES | 2608 | After CAMPIN (?) | 2923 | Annibale CARRACCI |
| 2528 | F. HALS | 2609 | Follower of CAMPIN | 2924 | RUBENS |
| 2529 | F. HALS | 2610 | Attributed to CORNEILLE de Lyon | 2925 | CRANACH the Elder |
| 2531 | SAENREDAM | 2611 | Attributed to CORNEILLE de Lyon | 2926 | MAZO |
| 2532 | WIJNANTS | 2612 | MASTER of the View of SAINTE GUDULE | 2927 | BARNABA da Modena |
| 2533 | WIJNANTS | 2613.1–2 | NETHERLANDISH | 2929 | Attributed to REVEL |
| 2534 | A. van der NEER | 2614 | Workshop of MASTER of MAGDALEN | 2930 | RIBALTA |
| 2535 | E. van der NEER | | LEGEND | 2952 | After F. van MIERIS |
| 2536 | A. van der NEER | 2615 | NETHERLANDISH | 2953 | NETSCHER |
| 2537 | A. van der NEER | 2616 | Attributed to CORNEILLE de Lyon | 2954 | MAES |
| 2538 | Follower of REMBRANDT | 2617 | FRENCH | 2962 | After WATTEAU |
| 2539 | Imitator of REMBRANDT | 2618 | Attributed to ANTONELLO da Messina | 2963 | H. VERNET |
| 2540 | A. van OSTADE | 2619 | Attributed to DUGHET | 2964 | H. VERNET |
| 2541 | After A. van OSTADE | 2619 | DUGHET | 2965 | H. VERNET |
| 2542 | A. van OSTADE | 2620 | Attributed to FRAGONARD | 2966 | H. VERNET |

| | | | | | | |
|---|---|---|---|---|---|
| 2967 | MIGNARD | 3138 | FORTUNY | 3421 | PUVIS de CHAVANNES |
| 2968 | RUBENS | 3140 | DUTCH (?) | 3422 | PUVIS de CHAVANNES |
| 2980 | ITALIAN | 3154 | SANTVOORT | 3424 | Attributed to Workshop of Filippo LIPPI |
| 3011 | Van DYCK | 3163 | PIAZZETTA | 3459 | Style of LUCAS van Leyden |
| 3024 | Van CALRAET | 3164 | Van BASSEN | 3473 | UGOLINO di Nerio |
| 3025 | De VLIEGER | 3165 | Style of van HUYSUM | 3475 | VROOM |
| 3044 | SARGENT | 3214 | Follower of REMBRANDT | 3476 | Studio of El GRECO |
| 3045 | NETHERLANDISH | 3215 | JORDAENS | 3511 | FROMENTIN |
| 3046 | MASACCIO | 3216 | GUERCINO | 3529 | STUBBS |
| 3047 | De HOOCH | 3225 | Van BRUSSEL | 3533 | ARENTSZ. |
| 3049 | Van der WERFF | 3226 | G.J.J. van OS | 3534 | DIEPRAEM |
| 3050 | BOUDIN | 3227 | Attributed to SUSTERMANS | 3535 | ELSHEIMER |
| 3066 | Follower of van der GOES | 3233 | BARYE | 3536 | Style of BONIFAZIO |
| 3067 | G. DAVID | 3234 | BONVIN | 3537 | After Van DYCK |
| 3068.1–2 | GAUDENZIO Ferrari | 3235 | BOUDIN | 3538 | GUARDI |
| 3069 | Attributed to CICOGNARA | 3236 | BROWN | 3539 | FRENCH (?) |
| 3070 | TURA | 3237 | COROT | 3540 | Attributed to CATENA |
| 3071 | Workshop of P. LORENZETTI | 3238 | COROT | 3541 | ZOPPO |
| 3072 | Workshop of P. LORENZETTI | 3239 | Follower of COROT | 3542 | Attributed to ZUGNO |
| 3073 | BRAMANTINO | 3240 | COURBET | 3543 | VENETIAN (Transferred to the British Museum) |
| 3074 | MONTAGNA | 3241 | COURBET | | |
| 3075 | LICINIO | 3242 | COURBET | 3547 | J. BRUEGHEL |
| 3076 | BUONCONSIGLIO | 3243 | Studio of COURBET | 3548 | OLIS |
| 3077 | GEROLAMO da Vincenza | 3244 | DAUMIER | 3556 | P. BRUEGEL |
| 3078 | Workshop of Giovanni BELLINI | 3245 | DAUBIGNY | 3571 | LOTH |
| 3079 | Attributed to PALMA | 3246 | DIAZ de la Peña | 3582 | FRENCH (?) |
| 3080 | Style of BERGOGNONE | 3247 | DEGAS | 3587 | Follower of PRUD'HON (Transferred to the British Museum) |
| 3081 | Style of BERGOGNONE | 3248 | FANTIN-LATOUR | | |
| 3082 | Follower of BOTTICELLI | 3249 | FORAIN | 3588 | PERRONNEAU |
| 3083 | BISSOLO | 3250 | FRENCH | 3589 | ITALIAN |
| 3084 | BUSATI | 3251 | GEROME | 3590 | After de GHEYN |
| 3085 | CARPACCIO | 3252 | INGRES and Studio | 3591 | After VAILLANT |
| 3086 | ITALIAN | 3253 | Imitator of JONGKIND | 3604 | LUCAS van Leyden |
| 3087 | PREVITALI | 3254 | MADRAZO | 3605 | Style of Van DYCK |
| 3088 | BARBARI | 3255 | MANCINI | 3627 | ITALIAN |
| 3089 | Attributed to LORENZO MONACO | 3256 | MANCINI | 3647 | ITALIAN, VENETIAN (?) |
| 3090 | Workshop of LUINI | 3257 | MANCINI | 3648 | Follower of MASACCIO |
| 3091 | BONSIGNORI | 3258 | MANCINI | 3649 | Attributed to van OOST |
| 3092 | SAVOLDO | 3259 | MANET | 3650 | NETHERLANDISH |
| 3093 | Attributed to ROMANINO | 3260 | MANET | 3662 | AUSTRIAN |
| 3094 | MORETTO da Brescia | 3261 | J. MARIS | 3663 | BAZZANI |
| 3095 | MORETTO da Brescia | 3262 | MONET | 3664 | MASSYS |
| 3096 | MORETTO da Brescia | 3263 | MONTICELLI | 3665 | Circle of MASTER of LEGEND of SAINT URSULA |
| 3097 | GIAMPIETRINO | 3264 | MORISOT | | |
| 3098 | Attributed to CARPACCIO | 3265 | PISSARRO | 3679 | HONTHORST |
| 3099 | Attributed to Gentile BELLINI | 3266 | PUVIS de CHAVANNES | 3682 | De WITTE |
| 3100 | Attributed to Gentile BELLINI | 3267 | PUVIS de CHAVANNES | 3683 | HACCOU |
| 3101 | Attributed to RAFFAELLINO del Garbo | 3268 | RENOIR | 3686 | FRENCH |
| 3102 | GAROFALO | 3269 | T. ROUSSEAU | 3714 | C. FABRITIUS |
| 3103 | COSTA | 3270 | STEVENS | 3725 | DUTCH |
| 3104 | COSTA | 3271 | VUILLARD | 3726 | FANTIN-LATOUR |
| 3105 | COSTA | 3285 | COROT | 3808 | HARPIGNIES |
| 3106 | After BONIFAZIO | 3286 | DELACROIX | 3811 | De NOME |
| 3107 | SUSTRIS | 3287 | DELACROIX | 3812 | GAINSBOROUGH |
| 3108 | ITALIAN | 3289 | GAUGUIN | 3816 | COROT |
| 3109 | Style of BONIFAZIO | 3290 | INGRES | 3817 | ITALIAN |
| 3110 | Style of BONIFAZIO | 3291 | INGRES | 3818 | Attributed to RUBENS |
| 3111 | Attributed to PREVITALI | 3292 | INGRES | 3819 | Attributed to RUBENS |
| 3112 | After CIMA | 3293 | INGRES | 3826 | Attributed to MASTER of MARRADI |
| 3113 | Attributed to CIMA | 3294 | MANET | 3829 | P. ROUSSEAU |
| 3114 | MAZZOLINO | 3294.1 | MANET (Transferred to the British Museum) | 3831 | ITALIAN |
| 3115 | Workshop of PATENIER | 3296 | T. ROUSSEAU | 3832 | Van HOOGSTRATEN |
| 3116 | NETHERLANDISH | 3297 | RICARD | 3858 | MANET |
| 3117 | ITALIAN | 3314 | Van BORSSUM | 3859 | RENOIR |
| 3118 | Attributed to GAROFALO | 3315 | Attributed to van EVERDINGEN | 3860 | DEGAS |
| 3119 | Attributed to GENGA | 3318 | G.D. TIEPOLO | 3861 | Van GOGH |
| 3120 | ITALIAN | 3319 | G.D. TIEPOLO | 3862 | Van GOGH |
| 3121 | JACOMETTO Veneziano | 3336 | BUTINONE | 3863 | Van GOGH |
| 3122 | BORDONE | 3337 | DEGAS | 3864 | OCHTERVELT |
| 3123 | MORONI | 3375 | UGOLINO di Nerio | 3879 | The LE NAIN Brothers |
| 3124 | MORONI | 3376 | UGOLINO di Nerio | 3881 | De HOOCH |
| 3125 | ITALIAN | 3377 | UGOLINO di Nerio | 3883 | Attributed to LARGILLIERRE |
| 3126 | CARRIERA | 3378 | UGOLINO di Nerio | 3892.1–2 | F. ZAGANELLI |
| 3127 | After CARRIERA | 3379 | NETHERLANDISH | 3893 | ITALIAN |
| 3128 | MORONI | 3391 | FRENCH | 3894 | MASTER of the LEHMAN CRUCIFIXION |
| 3129 | MORONI | 3401 | After STANZIONE | 3895 | ITALIAN |
| 3130 | ITALIAN | 3402 | GIOVANNI di Paolo | 3896 | GIOVANNI di Nicola |
| 3131 | After El GRECO | 3403 | ITALIAN | 3897 | Attributed to LORENZO |
| 3132 | Style of Van DYCK | 3404 | Van SANTVOORT | 3898 | MASTER of the CASSONI |
| 3134 | VERSCHURING | 3417 | Follower of Fra ANGELICO | | |

5577	After BRUNSWICK MONOGRAMMIST?	6276	De CHAMPAIGNE	6363	Studio of Van DYCK
5581	Follower of Fra ANGELICO	6277	POUSSIN	6364	Studio of Van DYCK
5583	BOILLY	6278	MONET	6368	BECCAFUMI
5584	FRENCH	6279	PITTONI	6369	BECCAFUMI
5585	LARGILLIERRE	6280	JONSON	6370	LAWRENCE
5586	NATTIER	6282	MASSYS	6372	PRETI
5587	NATTIER	6284	DOMENICHINO and Assistants	6373	VUILLARD
5588	ROSLIN	6285	DOMENICHINO and Assistants	6374	BOUCHER
5589	G.D. TIEPOLO	6286	DOMENICHINO and Assistants	6375	Follower of PONTORMO
5590	TOCQUE	6287	DOMENICHINO and Assistants	6376	TITIAN
5592	Style of DÜRER	6288	DOMENICHINO and Assistants	6377	Follower of CAMPIN
5593	F. MILLET	6289	DOMENICHINO and Assistants	6378	After de VRIES
5594	PORTUGUESE	6290	DOMENICHINO and Assistants	6379	RUBENS
5595	ITALIAN	6291	DOMENICHINO and Assistants	6380	VELAZQUEZ
5597	POUSSIN	6292	Studio of VOUET	6381	BERNINI
5631	FLEMISH	6293	JORDAENS	6382	A. SACCHI
5633	Van DYCK	6294	UCCELLO	6383	MONET
5637	STEEN	6295	DEGAS	6384	Attributed to de VOS
5641	MANTEGNA	6296	DUJARDIN	6385	CEZANNE
5655	ZURBARAN	6297	Attributed to DE BELLIS	6386	Follower of DUCCIO
5656	BOL	6298	ROSA	6387	G.B. TIEPOLO
5751	CATENA	6299	LE SUEUR	6388	VUILLARD
5752	Attributed to de PREDIS	6300	REMBRANDT	6389	CARAVAGGIO
5762	FRENCH	6301	GAINSBOROUGH	6390	POUSSIN
5763	POUSSIN	6302	G.B. TIEPOLO	6391	POUSSIN
5769	Attributed to MASSYS	6303	G.B. TIEPOLO	6392	SPRANGER
5781	T. ROUSSEAU	6304	G.B. TIEPOLO	6393	RUBENS
5786	Attributed to PACHER	6305	G.B. TIEPOLO	6394	Workshop of van der WEYDEN
5787	HEDA	6306	RENOIR	6395	MONET
5800	Van BRUSSEL	6307	GIORGIONE	6396	COURBET
5841	P. LONGHI	6308	BATONI	6397	SOLIMENA
5846	S. van RUYSDAEL	6309	BOUDIN	6398	KONINCK
5847	Ter BORCH	6310	BOUDIN	6399	MONET
5848	LE PRINCE	6311	BOUDIN	6400	SCHOLDERER
5851	TENIERS the Younger	6312	BOUDIN	6401	SCHOLDERER
5852	P. LONGHI	6313	BOUDIN	6402	De WITTE
5866	Van UDEN and TENIERS	6316	BATONI	6404	I. van OSTADE
5867	LANCRET	6317	RENOIR	6405	CUYP
5868	LANCRET	6318	RENOIR	6406	Van de CAPPELLE
5869	LANCRET	6319	RENOIR	6407	W. van de VELDE
5870	LANCRET	6320	ALTDORFER	6408	KONINCK
5871	VIGEE LE BRUN	6321	STROZZI	6409	G.B. TIEPOLO
5930	Attributed to ALLEGRETTO Nuzi	6322	GOYA	6410	QUAST
5931	MURILLO	6323	DAUBIGNY	6411	F. HALS
5962	Attributed to MASACCIO and MASOLINO	6324	DAUBIGNY	6412	NETHERLANDISH
5963	Attributed to MASACCIO and MASOLINO	6325	HARPIGNIES	6413	HALS
5982	RENOIR	6327	GIORDANO	6414	DUTCH
5983	COURBET	6328	PELLEGRINI	6415	Attributed to CORNEILLE de Lyon
5984	GAINSBOROUGH	6329	LA HYRE	6416	Follower of COROT
5985	REYNOLDS	6330	DETROY	6419	S. van RUYSDAEL
6022	JACKSON	6331	The LE NAIN Brothers	6420	TITIAN
6138	HOBBEMA	6332	PELLEGRINI	6421	H. ROUSSEAU
6153	MURILLO	6333	HOPPNER	6422	LANCRET
6154	Van GOYEN	6334	WTEWAEL	6423	Van GOYEN
6155	Van GOYEN	6335	Attributed to FYT	6424	VELAZQUEZ
6156	GUARDI	6336	Attributed to HEDA	6425	RUYSCH
6157	GUARDI	6337	LEONARDO da Vinci	6426	TAILLASSON
6160	Imitator of COQUES	6338	S. van RUYSDAEL	6427	PARMIGIANINO
6161	NETHERLANDISH	6339	COROT	6428	RIGAUD
6195	CEZANNE	6340	COROT	6429	STUBBS
6196	WILSON	6341	JUEL	6432	REMBRANDT
6197	WILSON	6342	CEZANNE	6433	DELACROIX
6204	RENOIR	6343	MONET	6434	KLIMT
6209	GAINSBOROUGH	6344	CRANACH the Elder	6435	PERRONNEAU
6229	GIAQUINTO	6345	CRESPI	6436	MOREAU
6253	Follower of J.-F. MILLET	6346	LEPINE	6437	Van DYCK
6254	ITALIAN	6347	Ter BRUGGHEN	6438	REDON
6260	El GRECO	6348	S. van RUYSDAEL	6439	COROT
6262	DELACROIX	6349	Attributed to ANDRIEU	6440	DROUAIS
6263	P. WOUWERMANS	6350	REMBRANDT	6441	PARMIGIANINO
6264	VELAZQUEZ	6351	PISSARRO	6442	STEEN
6265	Workshop of van der WEYDEN	6352	BRITISH	6443	CORNELIS van Haarlem
6266	ITALIAN	6353	BRITISH	6444	KALF
6269	E. van de VELDE	6355	COURBET	6445	FRAGONARD
6270	RENI	6357	ITALIAN	6446	SARACENI
6271	After MADERNO	6358	BLANCOUR	6447	J.-F. MILLET
6272	LASTMAN	6359	CEZANNE	6448	MURILLO
6273	G.B. TIEPOLO	6360	MASTER of RIGLOS	6449	PICASSO
6274	Follower of REMBRANDT	6361	Attributed to MASTER of SAINT FRANCIS	6450	MATISSE
6275.1–3	MEMLINC	6362	HONTHORST	6451	PONTORMO

The Sir Hugh Lane Bequest

In his will of October 1913 Sir Hugh Lane bequeathed thirty-nine pictures to the National Gallery, 'to found a Collection of Modern Continental Art in London'. Lane drowned with the *Lusitania* on 7 May 1915 and after his death an unwitnessed codicil was found in his papers that apparently revoked the first bequest and left his pictures instead to Dublin. The thirty-nine pictures thus became the focus of considerable debate and controversy. Eventually, in 1924, a Government Committee was established to investigate the matter and confirmed the National Gallery as legal owner.

In 1959 an agreement was reached whereby the pictures were divided into two groups, each of which was rotated for exhibition in Dublin and London every five years. This arrangement was reviewed in 1979 and for conservation reasons the five-yearly rotation was discontinued. Some thirty pictures were lent to Dublin, while the National Gallery retained only those works which were most relevant to its collection.

Under the new agreement of November 1993 – valid for twelve years with a possibility of renewal for a further twelve years – the disposition of the pictures remains broadly similar except that the Impressionist pictures have been divided into two groups that will be shown alternately in London and Dublin every six years. From 1993 to 1999 Group A will be shown in London and Group B in Dublin.

GROUP A
Manet *Eva Gonzalès*
Morisot *Summer's Day*
Pissarro *View from Louveciennes*
Renoir *The Umbrellas*

GROUP B
Degas *Beach Scene*
Manet *Music in the Tuileries Gardens*
Monet *Lavacourt under Snow*
Vuillard *The Mantelpiece*

The following pictures will remain on loan at the Hugh Lane Municipal Gallery of Modern Art in Dublin for the duration of the new agreement

Barye *The Forest of Fontainebleau*
Bonvin *Still Life with Books, Papers and Inkwell*
Boudin *The Beach at Tourgéville-les-Sablons*
Brown *The Performing Dog*
Corot *Summer Morning*
Corot (attributed) *A Peasant Woman*
Courbet *Self Portrait*
Courbet *In the Forest*
Courbet *The Diligence in the Snow*
Courbet *The Pool*
Daubigny *Portrait of Honoré Daumier*
Diaz *Venus and Two Cupids*
Fantin-Latour *Still Life with Glass Jug, Fruit and Flowers*
Forain *Legal Assistance*
French School, 19th Century *A Black Woman*
Gérôme *Portrait of Armand Gérôme*
Jongkind *Skating in Holland*
Madrazo *Portrait of a Lady*
Mancini *The Customs*
Mancini *On a Journey*
Mancini *The Marquis del Grillo*
Mancini *Aurelia*
Maris *A Girl feeding a Bird in a Cage*
Monticelli *The Hayfield*
Puvis de Chavannes *A Maid combing a Woman's Hair*
Rousseau *Moonlight: The Bathers*
Stevens *The Present*

Other Lane Bequest paintings on view in London
Corot *A Peasant Woman*
Daumier *Don Quixote and Sancho Panza*
Ingres and Studio *The Duc d'Orléans*
Puvis de Chavannes *The Beheading of Saint John the Baptist*

Subject Index

Names in bold refer to artists represented in the collection; **bold page numbers** indicate main entries for each artist, or the illustration and main entry for a painting.

259, 301, 334, 372, 373, 394, 395, 412, 457,
501, 576, 649, 669, 715, 725
groups 51, 216, 344, 345, 373, 387, 499, 674, 714
Confraternity members 344, 345
La Barre and musicians 674
signing of the Treaty of Münster 51
identified
Agostino della Torre, Dr Giovanni 394
Agostino della Torre, Niccolò 394
Albani, Francesco (?) 96
Albert, Archduke of Austria 599
Albert, Prince Consort 586
Amsterdam Coopers and Winerackers
Guild 216
Andrews, Robert and Frances Mary 241
Angerstein, John Julius 371
Anne, Countess of Albemarle 576
Archinto, Francesco di Bartolomeo 344
Ariosto, Lodovico (?) 515
Arnolfini, Giovanni (?) and Cenami,
Giovanna (?) 220
Averoldi, Ghirardo (?) 528
Avogadro, Gerolamo II (?) 473
Balbi children 210
Balletti, Marie-Madeleine (Manon) 486
Banning Cocq, Captain Frans 398
Barbarigo, Marco 220
Beaumont, Sir George 321
Bendz, Wilhelm 362
Benivieni, Girolamo (?) 257
Bewick, William **737**
Bianchini, Bartolomeo 229
Bischoffsheim, Ellen Odette 579
Blaauw, Jacobus 176
Bona of Savoy (?) 344
Bonaparte, Emperor Napoleon 702
Boulangier, Andreas (?) 493
Bracci, Monsignor Mario 269
Brongniart, Alexandrine-Emilie 709
Caetani, Costanza 18
Carafa, Elena 178
Carriera, Rosalba 103
Casio, Gerolamo (?) 46
Cattaneo, Marchese Giovanni Battista 213
Cazotte, Jacques 523
Cerri, Cardinal Carlo 712
Cézanne, Louis-Auguste 106
Chambre, Jean de la 300
Charles I, King of England 212
Charles Louis, Count Palatine 214
Charlotte Sophia, Queen of England **370**
Christina of Denmark, Duchess of
Milan 317
Cock, Cunera Cornelisdr. van der 455
Cockburn, Lady Augusta Anne, and
sons 576
Coislin, Mademoiselle de (?) 673
Coltman, Thomas and Mary 730
Coninckx, Catharina 360
Considérant, Victor 236
Cornelisen, Ensign Jan Visscher 398
Correr, Antonio (?) 371
Correr, Vittore (?) 371
Cruis, Hermanna van der 52
Cuyp, Jacob (?) 165
Daumier, Honoré 170
Dawkins, Henry 370
Dinteville, Jean de 316–17
Dorothy, Viscountess Andover 212
Dürer, Albrecht the Elder 205
Dyck, Anthony van 215
Edzard the Great, Count of East
Friesland 499
Eeckhout, Jan van den 216
Eliott, George Augustus 577
Elizabeth Stuart, Queen of Bohemia 319
Ellis, Wynn 739
Este, Lionello d' 266
Fabriano, Blessed Costanzo da (?) 390
Fayd'herbe, Lucas 134, 228
Feilding, William, Earl of Denbigh 211
Ferdinand-Philippe, Duc d'Orléans 325
Fiera, Battista 151
Fleury, Cardinal André-Hercule 580
Forlenze, Dr Joseph-Nicolas-Blaise 687
Fracastoro, Girolamo (?) 672
Gage, George 210
Gainsborough, Mary and Margaret 242
Gainsborough, Thomas, and family 241
Gallia, Hermine 362

Gallo, Cardinal Marco 249
Geer, Margaretha de 565, 566
Geest, Cornelis van der 209
Gerbier children (?) 595
Gérôme, Armand 254
Giuliano, Giovanni 335
Giusti family of Verona (?) 259
Goes, Damião de (?) 277
Gondi, Jean-François-Paul, Cardinal de
Retz 233
Gonzalès, Eva 405
Graham children 313
Greenway, Joseph 361
Grilleau, Jean Michel de 673
Grillo, Marquis Giorgio Capranica del 403
Grimston, Edward 113
Gritti, Andrea, Doge of Venice 105
Hallett, William and Elizabeth 244
Heathfield, Lord 577
Hensbeeck, Jan van, and family 192
Heusden, Adriana van, and daughter 725
Hoecke, Robert van den 133
Hollond, Mrs Robert 620
Holwell Carr, Reverend William 354
Horn, Catharina Hendrika, and baby 412
Howard, Thomas, 2nd Earl of Arundel 596
Huygens, Constantijn, the Elder 361
Isabella Clara Eugenia, Archduchess of
Austria 599
Johann Friedrich the Magnanimous 157
Johann the Steadfast, Elector of Saxony 156
Julius II, Pope 558
La Barre, Michel de 674
Larp, Marie (?) 299
Layard, Sir Austen Henry 739
Le Nain, Antoine 373
Le Nain, Louis 373
Le Nain, Mathieu 373
Lewis, William Thomas 627
Liotard, Jean-Etienne (?) 381
Lister, Thomas 614
Long, Charles, Lord Farnborough 736
Longoni, Giovanni Cristoforo 634
Loredan, Doge Leonardo 31
Louis, Dauphin de France 586
Lucasz., Philips 561
Lunden, Susanna (?) 594
Mantegna 738
Marcello, Doge Niccolò 28
Marcus Curtius 12
Margaret of Austria 491
Mariana, Queen of Spain 443
Martinengo, Ludovico 19
Martinengo Cesaresco, Fortunato (?) 474
Medici, Cosimo de' (?) 75
Medici, Cosimo I de', Grand Duke of
Tuscany 76
Medici, Ferdinand II de', Grand Duke of
Tuscany, and wife 650
Medici, Cardinal Ippolito de' 269
Medici, Piero de' 76
Mehmet II, Sultan 28
Melbourne family 649
Metternich, Princess Pauline de 177
Milbanke family 649
Mocenigo, Giovanni, Doge of Venice 350
Moitessier, Marie-Clothilde-Inès 325
Moll, Greta 441
Montagu, Edward Wortley (?) 381
Montefeltro, Federigo da, Duke of
Urbino, and children 334
Mornauer, Alexander 433
Morosini, Pellegrino (?) 666
Morosini, Vincenzo 665
Nani, Stefano 379
Nero, Bernardo del (?) 257
Netscher, Caspar 51
Neve, Don Justino de 483
Nonnius, Ludovicus 595
Norvins, Jacques Marquet de
Montbreton de 323
Orme, Captain Robert 575
Oswald, Mary 733
Pareja, Don Adrián Pulido 443
Pâris, Antoine 580
Paul, Sire d'Andouins, Vicomte de
Louvigny 232
Penza (or Pensa), Caterina Giovanna 386
Peral, Don Andrés del 278
Philip the Fair of Castile 491

Philip IV, King of Spain 688, 690
Pio, Alberto 394
Pivot, Monsieur 139
Plampin, John 242
Pompadour, Madame de 196
Porcel, Doña Isabel de 279
Presser, Aechje Claesdr. 560
Purmerent, Suitbertus 712
Rákóczi, Princess Charlotte Amelia 369
Reus, Jan de 402
Ribblesdale, Lord Thomas 614
Rich, Robert, Earl of Warwick 215
Richelieu, Cardinal 110
Rihel, Frederick 565
Rinaldi, Leonardo 738
Rockox, Nicolaes 209
Rogers, Samuel 381
Rouart, Hélène 179
Rousseau, Jean-Baptiste (?) 369
Rovere, Vittoria della 650
Rupert, Prince, Count Palatine 213
Ruytenburch, Lieutenant Willem van 398
Sagredo, Gerardo 387
Salvagno, Leonardo (?) 479
Savalette, Geneviève, Marquise de
Gléon (?) 233
Savelli, Cardinal (?) 551
Savonarola, Girolamo 342
Schomberg, Dr Ralph 243
Schurman, Anna Maria van 380
Schwiter, Louis-Auguste 181
Scott, John 24
Seguier, William 355
Seignelay, Marquise de, and children 457
Selve, Georges de 316–17
Serl, Misia 574
Sforza, Costanzo 359
Siddons, Mrs Sarah 243
Spangen, Anna van 498
Spiegel, Geertruyt 613
Stefan, Susanna 502
Steurwaldt, Luise 623
Stoffels, Hendrickje 563, 564
Stuart, Lord Bernard 212
Stuart, Lord John 212
Stuart, Prince Charles Edward 233
Surpele, Govaert van, and wife 360
Tarleton, Colonel Banastre 576
Temanza, Tommaso 386
Teodoro da Urbino, Fra 33
Terzi, Canon Ludovico di 477
Thielen, Jan Philip van (?) 133
Thimbelby, Lady Elizabeth 212
Trip, Jacob 565
Tron, Andrea 486
Uylenburgh, Saskia van 561
Valdés, Archbishop Fernando de 689
Valier, Lucrezia (?) 395
Vaudreuil, Comte de 196
Vecellio, Marco (?) 670
Velázquez, Diego (?) 260
Vendramin Family 669
Vilain XIIII, Vicomtesse, and daughter 176
Volta, Giovanni della, and family (?) 395
Wellington, Duke of 279
Widmer, Abel 180
Wormser, Madame André, and
children 715
self portraits
Antonello da Messina (?) 8
Boxall, Sir William 71
Cézanne, Paul 107
Courbet, Jean-Désiré-Gustave 152
Dou, Gerrit 194
Dujardin, Karel (?) 203
Eyck, Jan Van (?) 219
Fabritius, Carel (?) 221
Flinck, Govert 226
Gainsborough, Thomas 241
Giordano, Luca 260
Gossaert, Jan (?) 275
Lievens, Jan 379
Memlinc, Hans (?) 448
Mieris, Frans van the Elder 456
Murillo, Bartolomé Esteban 483
Rembrandt 562, 566
Rosa, Salvator 583
Ter Borch, Gerard 51
Titian (?) 670
Vigée Le Brun, Elizabeth Louise 709

Portuguese 540
The Mystic Marriage of Saint Catherine **540**
Post, Frans **540**
Landscape in Brazil **540**
Pot, Hendrick **540**
A Merry Company at Table **540**
Potter, Paulus 203, 365, **541**, 690, 699
Cattle and Sheep in a Stormy Landscape **541**
A Farmyard with Horses and Figures (location
unknown) 541
*A Landscape with Cows, Sheep and Horses by
a Barn* **541**
Poussin, Gaspard *see* Dughet
Poussin, Nicolas 68, 109, 232, **541–6**
The Adoration of the Golden Calf **542**
The Adoration of the Magi (Dresden,
Staatliche Kunstsammlungen) **543**
The Adoration of the Shepherds **543**, 545
The Annunciation **545**
A Bacchanalian Revel before a Term of Pan **542**
Cephalus and Aurora **542**
Christ healing the Blind Man (Paris, Louvre) **545**
The Crossing of the Red Sea (Melbourne,
National Gallery of Victoria) **542**
The Finding of Moses **545**
Landscape with a Man killed by a Snake **544**
*Landscape with a Man washing his Feet at a
Fountain* **544**
Landscape in the Roman Campagna **543**, **544**
*Landscape in the Roman Campagna with a
Man scooping Water* **543**, **544**
Landscape with a Roman Road (London,
Dulwich Picture Gallery) **544**
The Nurture of Bacchus **541**
Sleeping Nymph with Satyrs **545**
The Triumph of Bacchus (Kansas City) **543**
The Triumph of Pan **543**, 545
After Poussin
*The Holy Family with Saints Elizabeth and
John* **546**
The Plague at Ashdod **546**
Attributed, *Bacchanalian Festival with
Silenus* **545**
Poussin, Pierre-Charles **547**
Pardon Day in Brittany **547**
Pozzoserrato, Ludovico **547**
Attributed
Landscape with Mythological Figures **547**
The Sons of Boreas pursuing the Harpies **547**
Prague, Narodni Galeri 690
predellas
Florentine 4–5, 168, 255, 417
Italian 103, 163–4, 266–7, 392, 555, 628, 630, 641
Predis, Giovanni Ambrogio de **548**
Attributed, *Profile Portrait of a Lady* **548**
Preti, Mattia 346, **548**
The Marriage at Cana **548**
Previtali, Andrea 114, **548–51**
Salvator Mundi **549**, **550**
The Virgin and Child **549**
The Virgin and Child with a Donor **549**
*The Virgin and Child with Saint John the
Baptist and Saint Catherine* **548**
Attributed
*Scenes from an Eclogue of Tebaldeo: Thyrsis
asks Damon the Cause of his Sorrow /
Thyrsis finds the Body of Damon* **550**
*Scenes from an Eclogue of Tebaldeo:
Damon broods on his Unrequited Love /
Damon takes his Life* **550**
The Virgin and Child with Two Angels **551**
Prévost, Jan *see* Provoost, Jan
Procaccini, Giulio Cesare 329
Procris 125, 128, 529
Provoost, Jan **551**
Attributed, *The Virgin and Child in a
Landscape* **551**
Prud'hon, Pierre-Paul, *Christ on the Cross*
(Paris, Louvre) 181
Prussian blue 433, 666
Psyche 127, 227, 597
Pulzone, Scipione **551**
Portrait of a Cardinal **551**
Puvis de Chavannes, Pierre-Cécile
The Beheading of Saint John the Baptist **552**
Death and the Maidens **552**
A Maid combing a Woman's Hair **553**
Summer **552**
Woman at her Toilette (Paris, Musée
d'Orsay) **553**